Mother of God. *Representations of the Virgin in Byzantine Art*

Mother of God

Representations of the Virgin in Byzantine Art

edited by Maria Vassilaki

Skira editore

Design
Marcello Francone

Editing and layout
Claudio Nasso, Serena Parini

Cover
Icon of the Virgin and Child
(Arakiotissa)
Late 12th century
Nicosia, Cyprus

Benaki Museum

Textual editor
Alexandra Doumas

Translators
David Hardy
John Leatham
Richard Witt

First published in Italy in 2000 by
Skira Editore S.p.A.
Palazzo Casati Stampa
via Torino 61
20123 Milano
Italy

Printed and bound in Italy. First
edition

ISBN 88-8118-738-8
ISBN 960-8452-79-1

Distributed in North America and
Latin America by Abbeville
Publishing Group, 22 Cortlandt
Street, New York, NY 10007, USA.
Distributed elsewhere in the world
by Thames and Hudson Ltd., 181a
High Holborn, London WC1V 7QX,
United Kingdom.

Mother of God

Representations of the Virgin in Byzantine Art

Benaki Museum
20 October 2000 - 20 January 2001

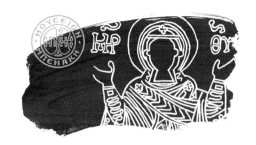

Committee of Honour

His All-Holiness,
The Ecumenical Patriarch Bartholomaios

His Excellency The President of the Hellenic Republic,
Mr Konstantinos Stefanopoulos

His Beatitude
Archbishop Chrysostomos
of Cyprus

His Beatitude
Archbishop Christodoulos
of Athens and All Greece

His Eminence,
Archbishop Damianos
of Sinai, Phara and Raitho

The Foreign Minister
of Greece
Georgios Papandreou

The Minister of
Education and Religions
Petros Efthymiou

The Minister of Culture
Theodoros Pangalos

The Alternate Minister
of Foreign Affairs
Ms Elissavet Papazoi

The Deputy Minister
of Foreign Affairs
Prof. Angeliki Laiou

The Major of Athens
Dimitrios Avramopoulos

The President
of the Benaki Museum
Board of Trustees
Marinos Yeroulanos

The Director of the
Byzantine and Christian
Museum of Athens
Dimitrios Konstantios

The Director of the
Museum of Byzantine
Culture at Thessaloniki,
Eftychia Kourkoutidou-
Nikolaidou

Scientific Committee

Mrs Chryssanthi
Baltoyanni, *former
Director of the Byzantine
Museum, Athens*

Dr David Buckton, *former
Curator of the Early
Christian and Byzantine
Collection, Department
of Medieval and Later
Antiquities, The British
Museum*

Prof. Robin Cormack,
*Deputy Director Courtauld
Institute of Art, University
of London*

Dr Athanassios
Papageorgiou, *former
Director of Byzantine
Antiquities, Cyprus*

Dr Yannis Tavlakis,
*Ephor of the 10th
Ephorate of Byzantine
Antiquities, Thessaloniki*

Dr Gary Vikan, *Director,
The Walters Art Gallery,
Baltimore*

Prof. Valentino Pace,
Università di Udine

Prof. Olga Popova,
University of Moscow

Prof. Annemarie Weyl
Carr, *Southern Methodist
University, Dallas Texas*

Prof. Nikos Zias,
University of Athens

Catalogue published with the generous sponsorship of the J.F. Costopoulos Foundation

To the supplicants, beloved brothers and children of our Humbleness in the Lord, we grant grace and peace from God.

The exhibition 'Mother of God', mounted by the renowned Benaki Museum, over and above the fact that it brings visitors into closer touch with works of art inspired by the Most Holy Theotokos and Ever-Virgin Mary, provides a pretext for profounder consideration of the Mystery of the Incarnation of God and the participation in it of Man in the person of the Theometor, Mother of God.

Following the transformation that the human mind underwent from the moment it turned aside from being in communion with God, that is, from the moment it denied love as an attracting and binding movement which makes communion with one another the reason and cause of gratification and bliss, it revolved around itself, grew selfish, lost the joy of giving and was filled with anxiety, being held fast in the grip of its self-confinement within its thoughts of self-righteousness and self-salvation. But the transcendence of individuality and the re-creation of the relationship of personal communion with another as a source of life, of the existence and of the happiness of existing in communion is impossible for him whose original social nature has been corrupted and transformed into one self-centred, for the latter necessitates the death of the former. By reason, therefore, of the rupture in Man's loving communion with God through his own culpability, commonly known as the Fall, the restoration of this relationship through human effort is impossible.

Accordingly, just as the mind of the ancient Greek, illumined by some reflection or other of divine light, awakened, mankind would have been asleep until God would have taken the action needful to restore this relationship, that is, the action needful for the reconciliation and reconnection of the persons of the divinity and humanity through love.

However, the effecting by God of this restorative action presupposed the existence of at least one human being who would willingly respond positively to it, for love is a relationship of absolute freedom, and the response to love, the mutuality of love, is not amenable to compulsion.

All forms of love which mankind experienced after the Fall, after the rupture of this loving communion with God, were debased by a certain kind of selfishness, that is, by the lover's anticipation of personal gain. The people of Israel loved God because God was their protector. It was inconceivable that love, instead of offering the lover certain satisfaction, should be attended by sacrifice.

The virgin maid Mary self-sacrificingly responded directly to the self-sacrificing love of God for Man in unhesitantingly accepting to bear a child without being married to another human being, thus exposing herself to death by stoning. By offering her whole being to the will of God, through transcending herself, the Virgin Mary fulfilled the presupposition of the mutuality of selfless love between God and man which made possible the Incarnation of God, that is, the perfect kenosis *of Divinity through its assumption of the human form so that the love of Man for his fellow creature Christ the Man might be made more attainable and effected, since Christ has first loved us.*

The Incarnation of the Word of God through the Mother of God is a great Mystery and is not explained by means of juridical intellectual categories that ignore the nature of God as love.

The approach to this Mystery can be made only within the environment of love and by thoroughly delving in its essence and characteristics.

Mankind owes infinite gratitude to the Virgin Mary, the Mother God, for she opened the way of love, was an accessory to the restoration of communion between Man and God and sacrificed herself by seemingly denying her human destination. Through her Son who likewise selflessly sacrificed himself in his human nature, she became an instrument of the restoration of the communion of the love of Man and God, which was disrupted by the egocentric move of our foremother Eve towards the object that was pleasing in her human eyes.

Our admiration of the Mother of God, which has given rise to innumerable works of art inspired by her and dedicated to her, of which a considerable portion is recorded in the catalogue in your hands, is an admiration for the selfless and sacrificial love that allowed the love of God to be incarnated, to assume human nature, to suffer, to be sacrificed, and by way of selfless and sacrificial love to elevate Man close to the throne of perfect love of God in heaven. This signifies that he restored the existence and life of Man as a person to the only true and real life and existence, that is, to existence and life in loving communion with the Supreme Person, for personal life in individual existence confined within itself is inconceivable. Personal life presupposes that other person and personal communion with that person.

A large part of mankind continues even today to live a self-centred existence. Human relations are built upon a utilitarian foundation. The 'I' is secured in a variety of ways from all danger of being sacrificed, of being offered to the 'you'. In this manner, the individual does not exist as a person, as a being capable of existing in communion and in a relationship of selfless love with another person.

The Mother of God opened the way to the Incarnation of God and to the re-attainment of this relationship which was the original relationship of the first human couple with God. It rests with each one of us to tread in selfless love the already opened road of the new life which is the life of the Deity, or to remain within the confines of egocentric selfishness that constitutes the death of the human person as a person.

May we discover, through the love of the Mother of God, the selfless, giving, sacrificial and binding love that is life, joy, blessedness and the restoration of the human person in personal existence in communion, which is the only true human existential condition.

2 September, indiction 8, 2000

The year 2000 signals the beginning of a new century and is an appropriate occasion not only for anniversary celebrations but also for pausing a while and reviewing things. Precisely such an intention underlies the monumental exhibition 'Mother of God. Representations of the Virgin in Byzantine Art', with which the Benaki Museum participates in the worldwide celebration of the 2000th year since the Nativity of Christ. Images of the Virgin portray her human nature as a mother and illuminate their relationship with observances of the Orthodox Church.

The Greek State has gladly lent its support to this exhibition which at once confirms the country's international standing and offers the people of Greece an opportunity to appreciate at first hand rare and valuable treasures of Byzantium, brought together here for the first time from forty museums around the world.

In assisting in this project the Ministry of Culture demonstrates its awareness of the need for sponsorship of outstanding cultural events with an international appeal. The underlying aim is to introduce new elements into the cultural scene that will expand the Greek public's familiarity with exceptional works of art and so extend education in the Fine Arts.

The Benaki Museum, an institution that meets the exacting standards of contemporary museum design and practice, is both hosting this important exhibition and promoting it with a diverse programme of educational and scientific events whose purpose is to instruct as broad a spectrum of the public as possible.

Theodoros Pangalos
Minister of Culture

**Special thanks for their contribution
to the Sponsoring Programme:**

The Minister of Culture
Mr Theodoros Pangalos

John S. Costopoulos and
Anny Kostopoulou, Demetrios
Katsikis and Katerina Koskina
of the J.F. Costopoulos
Foundation

Nikolaos Manassis, Evangelos
Martigopoulos and Marlena
Fatsea of COSMOTE S.A.

Evangelos Mytilineos and Sofi
Daskalaki-Mytilineou of
Mytilineos Holdings S.A.

Alexios Skanavis and Irini
Manousaki of Pegasus
Publishing and Printing S.A.

J.-P. Teyssandier and Nikolaos
Harikiopoulos of Gefyra S.A.

Pavlos Psomiadis,
Konstantinos Karatzas,

Thanos Christianos and
Christos Dimopoulos of Aspis
Pronoia A.E.G.A.

Photis Papathanassiou,
Vice-Mayor of the
Municipality of Athens,
President of the Board of
Directors of Technopolis
of the Municipality of Athens.

Ioannis Drosos, Director
General of the Directorate-
General for Defence Industry,
Research and Technology of
the Hellenic Ministry of
National Defence.

Konstantinos Konstantinidis,
President of the Hellenic-
French Chamber of
Commerce.

Konstantinos Angelopoulos
of Halyvourgiki S.A.,

Panagiotis Moscholios of
Pyrkal S.A.,
Georgios Goulios of Hellenic
Aerospace Industry S.A.,
Georgios Karavias and Stavros
Kahrimanis of Lloyds-Karavias,
Martha Dertili of Kathimerini,
Ioannis Delivanis of
Aluminium de Grèce S.A.I.C.,
Evangelos Zambaftis
of ACS S.A.,
Demetrios Giakoumettis
of DHL Hellas S.A.

Ioannis Anastasopoulos,
Agis Chrysis,
Konstantinos Kalyviotis,
Mania Kostopoulou,
Aspasia Louvi,
Nikos Manolopoulos,
Ioannis Stefanidis,
Stratis Stratigis,
Vassilios Voutsakis.

The Exhibition is made possible by

HELLENIC MINISTRY OF CULTURE

**THE J.F. COSTOPOULOS
FOUNDATION**

Sponsorship is provided by

Support is provided by

The year 2000 marks the calendric and symbolic opening of a new age. It is the occasion of important events and celebrations, some in the form of historical stocktaking and appraisals, others drawing upon and examining various historical and cultural periods.

To mark the passing of 2000 years since the Nativity of Christ the Benaki Museum has mounted the exhibition 'Mother of God. Representations of the Virgin in Byzantine Art'. The exhibition brings together important objects of outstanding artistic merit dating from the sixth to the fifteenth century. This assemblage of icons, ecclesiastical treasures, devotional objects and liturgical vessels is drawn from some of the most eminent public and private collections of Byzantine art in the world.

Veneration of the Virgin, an act of overriding importance throughout Christendom, holds a special place in the Orthodox Church on both the theological and the aesthetic plane, expressed in original iconography and diverse techniques. Apart from their profoundly spiritual character, images of the Mother of God reveal the age-old relationship between worship and art, evident in primitive portrayals of the twin concepts of Maternity and Divinity. They display both the continuity of ancient Greek painting and Early Christian and Coptic art and the influences exerted upon each other by the Churches of East and West.

The J.F. Costopoulos Foundation looks upon this exhibition as an event of major cultural significance and is particularly glad to assist in bringing it to pass, and is confident that its presentation in the new galleries of the Benaki Museum and the exhaustive catalogue will make a substantial contribution to a revaluation and appreciation of Byzantine art.

<div align="right">

Yannis S. Costopoulos
President
The J.F. Costopoulos Foundation

</div>

The universal celebration of the 2000th anniversary of the Nativity of Jesus Christ coincides with the reopening of the Benaki Museum, a repository of civilization that has enshrined for the past seventy years the history of Greece as related in its art.

The initiative taken by the Director of the Museum, Professor Angelos Delivorrias, to enhance this unique conjuncture by organizing a splendid event of unparalleled significance, an exhibition devoted to the veneration of the Mother of God, could not fail to appeal to COSMOTE.

At a time marked by rapid advances in technology and science, Orthodox Christianity remains the guide and support of every Greek.

We acknowledge the Theotokos – the Mother of God – the very expression of Orthodoxy, as the supreme symbol to which we bow our heads with reverence and respect.

The exhibits, sacred images of the Virgin, priceless icons and objects dedicated to her, have been brought together for the first time in this exhibition at the Benaki Museum.

COSMOTE is highly honoured to sponsor an event that makes Greece the focal point of international cultural attention.

In giving its support to outstanding projects and events of an essentially Greek character, COSMOTE, the Greek mobile telephone company, fulfils its objective of promoting and strengthening the cultural identity and heritage of Greece.

COSMOTE is convinced that every Greek will welcome the Benaki Museum's initiative and will take advantage of the exhibition 'Mother of God' to honour the celebration of the 2000th anniversary of the birth of Man made God.

Evangelos Martigopoulos
Managing Director, COSMOTE S.A.

Preface

When the problems inherent in organizing the exhibition 'Mother of God' first began to concern me almost four years ago my thoughts were guided by the discharge of an obligation to the Mother of Man in her fullest, and most universal expression. In order to avoid conceptual overlapping of the content of the exhibition, as well as fragmentation of the available material, I embarked upon a thorough investigation of what similar Greek and other organizations were planning to contribute to the worldwide celebration of the new millennium. In defining the temporal span of the exhibition as the historical course of the Byzantine Empire and the revelation of its symbolisms as far as these can be perceived by our own era, the dominant social parameter, that is the human aspect of the subject, is delineated distinctly through the basic components of History, the History of Art, the History of Civilization and the History of Religious Consciousness.

Four years ago I would never have imagined it possible for the Greek participation in these joyous events to be vitiated by fireworks displays and official banquets. This was because I believed that other foundations, like ours, would have given timely consideration to what playing an active role in international festivities associated with the cultural event entailed, as well as to what the imperatives of 'globalization', really signify. But once again I was deceiving myself, not as regards the potential of a dynamic promotion of Greek cultural creativity but in respect of the willingness and readiness with which we perform our duty. Alas, the difficulty of counterpart bodies in responding to today's demands follows that of the Greek Church in mounting in time the exhibition 'Great and Singular Mystery' which, in conjunction with the Benaki Museum exhibition, would have enhanced the quality of Hellenic spiritual creativity beyond the geographical limits of Greece.

To accomplish the exhibition I relied largely upon the exceptional importance of its subject, the fraternal response of the foundations that were to provide the required material and the ever favourable reception of my requests submitted to the Board of Trustees of the Museum. Although I was not preoccupied at first with securing the far from negligible funds needed for this ambitious project, I had, wrongly perhaps, placed great expectations in the recently much vaunted climate of sponsorship and in so doing overlooked the implications of such involvments and the passive, non-participatory stance adopted by the State. But I shall not cite the countless appeals made in this connection and the excuses advanced in successive refusals. When all is said and done, prefatory messages are written to trumpet the end result. And the end result of all the effort expended owes far more to the financial support of certain bodies than the Foundation's gratitude can express by a mere listing of them in the credits presented in the exhibition and the catalogue.

My regret at the eventual unwillingness of The Holy Mountain to participate in the exhibition is mitigated by the ready response of many other ecclesiastical and museum foundations, both at home and abroad. In reciprocating with the warmest and most heartfelt thanks for their confidence in the Benaki Museum, I would like to stress their sensitivity and service to the public by naming them individually. I also wish to make special mention of the enthusiastic support of Eftychia Kourkoutidou-Nikolaidou and of Dimitris Konstantios, Directors respectively of the Museum of Byzantine Culture in Thessaloniki and of the Byzantine and Christian Museum of Athens, as well as of the response of the Holy Monastery

of St Catherine on Mt Sinai, of the Holy Community and of His Eminence Damianos, Archbishop of Sinai, with all of whom I have strong ties of friendship and past collaboration.

I am deeply indebted to all those distinguished colleagues who undertook to compile the scientific catalogue of the exhibition and in so doing paid their own tribute to its subject and to its host. Warm thanks are due above all to those valued colleagues at the Benaki Museum — Maria Vassilaki, Electra Georgoula, Panoraia Benatou, Phyllia Kanari and Christos Margaritis — for bringing the project to fruition, often overcoming seemingly insurmountable difficulties and, attaining the highest standards in achieving the ultimate goal. Thanks are also due to Angelos Vassileiou, Kostis Mavrakakis and Alekos Levidis for their inspired design of the exhibition spaces and the aesthetic display of the exhibits; to Makis Skiadaressis for his superb photographs of objects in Greek collections; to the Skira Publishing House, and particularly to Eric Ghysels, for the splendid exhibition catalogue, the fruit of his collaboration with the Museum.

Finally, on behalf of the Board of Trustees of the Benaki Museum, I whish to extol the moral support given by members of the Committee of Honour, by the Right Honorable Theodoros Pangalos, Minister of Culture, His Beatitude Christodoulos, Archbishop of Athens and All Greece, and His Excellency Konstantinos Stefanopoulos, President of the Hellenic Republic, who has placed the exhibition 'Mother of God' under his aegis.

While acknowledgements neatly conclude any preface, it is not easy to express those inner emotions of euphoria that arise from the profounder relationships engendered by shared endeavours undertaken with one accord. Never is this more true than when such endeavours are crowned with the spiritual authority of His All-Holiness The Ecumenical Patriarch Bartholomaios, who consented to head the Committee of Honour of the Exhibition.

Angelos Delivorrias
Director of the Benaki Museum
Athens, September 2000

Foreword

I have no clear recollection of the precise moment when Angelos Delivorrias first confided in me his wish to mount at the Benaki Museum an exhibition dedicated to the Virgin as Mother of God. The truth of the matter is that he had long entertained this wish and had voiced it frequently. However, what I do remember is that just four years ago he asked me to organize the exhibition 'Mother of God' as the Museum's contribution to the worldwide celebrations of the 2000th anniversary of the Nativity of Christ.

In undertaking this task, I decided that its central theme should be the veneration of the Virgin and the visual material (icons, mosaics, textiles, illuminated manuscripts, metalwork, miniatures and sculpture) upon which this rested. The years to be covered were those between the fourth and fifteenth centuries, so that the exhibition would span the entire duration of the Byzantine Empire and be associated fully with its fortunes. In addition, the exhibition was to illuminate the very special relationship the Virgin had with Constantinople, capital city of Byzantium. This relationship can be traced back to the earliest years of the capital's existence and only ended in 1453 with its Fall to the Turks.

The exhibition is divided into six sections, each of which throws light on a different aspect of the veneration of the Theotokos. The first section, 'Early Representations of the Mother of God', revolves around the first years of devotion to the Virgin and includes objects dating from between the fourth and seventh centuries; they are the earliest attempts to depict her.

The second section, 'The Cult of the Mother of God in Private', comprises objects for private use and worship with portrayals of the Virgin and invocations to her. These works suggest a remarkably personal relationship between the owner-user and the Theotokos, to whom a protective, almost magical character is attributed.

The third section, 'The Mother of God in Public', examines the public and official image of the Virgin in Byzantium, but chiefly in Constantinople, the centre of her worship.

The fourth section, 'The Veneration of the Virgin Hodegetria and the Hodegon Monastery', focuses largely on the manifestation par excellence *of the public cult of the Theotokos.*

The fifth section, 'Between East and West', contains works in which elements of Byzantine and Italian art are combined. Some of these works were produced in Byzantium, others in the West. The section is intended to spotlight these objects and the circumstances of their production.

The sixth and last section, 'Representations of the Virgin and Their Association with the Passion of Christ', is structured around works in which the Virgin Brephokratousa prefigures and presages the coming Passion of her Son. The same section features two-sided icons borne in processions and associated with services for Holy Week.

The catalogue accompanying the exhibition endeavours to fill a lacuna: the absence of a comprehensive study of the Virgin in which issues of cult, theology and art are considered. Whether it succeeds in filling this void or not, the reader will judge for himself. To this end, the texts describing the exhibits are minor

studies rather than summary entries. I wish to thank all those colleagues in Greece, in the rest of Europe and in America, who gladly undertook, each according to his own speciality, to contribute to the realization of this project. The names of all of them are recorded elsewhere in this volume.

Grateful acknowledgement of all those who have played a part in bringing the Exhibition to fruition are to be found on another page. But here I wish to thank especially the Board of Trustees of the Benaki Museum and the Museum Director Professor Angelos Delivorrias who gave me the opportunity to curate an exhibition, a unique experience, an experience I know every scholar dreams of having. I owe special thanks also to the members of the Scientific Committee, who gladly rallied to my side and helped whenever called upon to resolve those numerous problems that arise in the course of organizing an exhibition. I wish to express my thanks particularly to my colleagues the Byzantinists Dr Phyllia Kanari and Panoraia Benatou, who toiled away, often in difficult circumstances, to ensure that the exhibition and its catalogue acquired the character they now possess; Electra Georgoula who, in her inimitable methodical manner co-ordinated the administration of the exhibition; Eirini Yeroulanou, Deputy Director of the Museum, for the readiness with which she invariably responded to diverse needs; the architects Angelos Vassileiou and Kostis Mavrakakis, who were invaluable collaborators in designing the display, and the painter Alekos Levidis who revealed great sensitivity in his artistic supervision of the exhibition; Alexandra Doumas who edited the texts and prepared the index of the English catalogue; David Hardy, John Leatham and Richard Witt who translated the Greek texts into English, Elizabeth Yawn who translate the Italian text and Leo Marshall for his skilful revisions; Pitsa Tsakona, Librarian of the Benaki Museum, who met our constant demands with her customary insight and forebearance; Maria Kretsi, Elena Tombouloglou and Katerina Iliopoulou for their painstaking computer-processing of the texts, and, last but not least, all the personnel of the Benaki Museum for their support throughout the strenuous years of our work.

It would be remiss of me not to express my thanks to all those who toiled away in Italy to bring the production of this book to a happy end: the Skira Publishing House and in particular Carlo Mion, Eric Ghysels, Marcello Francone and Marzia Branca, as well as Claudio Nasso, Serena Parini and Franco Peruzzi of Graphic Project.

An exhibition should have a beginning, a middle and an end; it should express directly what it has to say; and it should help to unfold a fascinating story. I believe that the veneration of the Virgin and the art created to serve it offer not only one but many fascinating stories.

Maria Vassilaki
Curator of the Exhibition
September 2000

Acknowledgements

The Exhibition 'Mother of God' would never have been accomplished without the co-operation of a number of institutions, ecclesiastical and other, museums and individuals. We express to them our deepest thanks and we hope that we have omitted no one from the following list:.

Bulgaria, Sofia: Prof. Dr Yordanka Yourukova, Director of the Archaeological Institute and Museum; Dr Georgi Gerov, Curator of the National Gallery of Art.

Cyprus: His Beatitude The Archbishop of Cyprus, Chrysostomos; Dr Athanasios Papageorgiou, former Director of Byzantine Antiquities; Mr Constantine Chatzistefanou, Director of the Byzantine Museum of the Archbishop Makarios III Foundation.

Egypt: Mr Faruk Hozny, Minister of Culture; Dr Gabala Ali Gabala, President of the Supreme Council of Culture; Mr Abdala El Atar, Director of the Islamic and Coptic Museums; Mr Abdelhafiz Diab, Director of South Sinai; H.E. George Assimakopoulos, Ambassador of Greece to Egypt. His Eminence The Archbishop of Sinai, Damianos, Abbot of the Holy Monastery of St Catherine at Sinai and all the brothers of the Holy Community. Mr Nikolaos Vadis, Administrative Director of the Holy Monastery of St Catherine at Sinai.

England, London: Dr Robert Anderson, Director, Dr David Buckton, former Curator of the Early Christian and Byzantine Collections, Mr Chris Entwistle, Curator of the Late Roman and Byzantine Collections, The British Museum; Dr Alan Borg, Director, Dr Paul Williamson, Curator of the Sculpture Collection, Dr Marion Campbell, Acting Head, Department of Metalwork, Silver and Jewellery Collection, Victoria and Albert Museum.

France, Paris: Daniel Alcouffe, Conservateur général chargé du Départment des Objets d'art, Jannic Durand, Conservateur, Départments des Objets d' art, Marie-Hélène Rutschowscaya, Conservateur en chef chargé de la section copte, Département des Antiquités Egyptiénnes, Musée du Louvre.

Germany, Berlin: Prof. Dr Arne Effenberger, Director and Curator of Sculpture, Staatliche Museen zu Berlin, Museum fur Spätantike und byzantinische Kunst; Dr Hein-Th. Schultze Altcappenberg, Curator of Italian Prints and Drawings, Kupferstichkabinett-Staatliche Museen zu Berlin-Preussischer Kulturbesitz. *Munich:* Dr Christian Schmidt, Christian Schmidt Collection.

Greece, Athens: Theodoros Pangalos, Minister of Culture; Isidoros Kakouris, Director of Byzantine Antiquities; Despina Evgenidou, Jenny Albani, Department of Byzantine and Post-Byzantine Monuments, The Hellenic Ministry of Culture; Dr Dimitris Konstantios, Director, Dr Faidra Kalafati, Curator of Icons, Byzantine Museum; Ismini Trianti, Director, and Nikoleta Saraga, Curator, the Kanellopoulos Museum; *Larissa*, Dr Lazaros Deriziotis, 7th Ephorate of Byzantine Antiquities; *Naxos*, The Reverend Emmanuel Remoundos; *Patras*, Dr Myrto Georgopoulou, 6th Ephorate of Byzantine Antiquities; *Rhodes*, Maria Michailidou and Dr Angeliki Katsioti, 4th Ephorate of Byzantine Antiquities; *Tinos*, His Grace The Catholic Archbishop Nikolaos, the Council of the Holy Foundation of the church of the Evangelistria; *Thessaloniki*, Dr Eftychia Kourkoutidou-Nikolaidou, Director, and Dr Anastasia Tourta, Curator, the Museum of Byzantine Culture; *Veroia*, Antonios Petkos, 11th Ephorate of Byzantine Antiquities; *Zakynthos*, Bishop Chrysostomos.

Holland, Utrecht: Dr Henri L.M. Defoer, Director, Museum Catharijneconvent.

Italy, Bari, Dr Carla Gelao, Director, Pinacoteca Provinciale, Arch. Gian Marco Jacobitti, Soprintendente per i B.A.A.S. della Puglia; *Pisa*, Dr Mariagiulia Burresi, Soprintendente per i B.A.A.S. per le province di Pisa, Livorno, Lucca, Massa Carrara; Mons. Waldo Dolfi, Arcivescovado di Pisa, Ufficio per i Beni Culturali Ecclesiastici; *Rome*, Prof Claudio Strinati, Soprintendenza per i B.A.A.S. Ufficio Mostre.

Russia, Moscow: Prof. Irina Rodimtseva, Director, Ms Galina Khatina and Dr Elena Ostashenko, Curator, The State Museum of the Moscow Kremlin.

Serbia, Belgrade: Dr Bojana Borić-Bresković, Director and Dr Aleksandra Nitić, Curator, The National Museum.

Spain, Cuenca: Ramon del Hoyo López, Bishop of Cuenca, Don Santos Saiz Gomez, Presidente de Ilmo. Cabildo de la Catedral de Cuenca, and H.E. Mr Javier Jiménez-Ugarte, the Ambassador of Spain to Greece.

Ukraine, Kiev: Dr Vera Ilinitsa Vinogratova, Director, The Museum of Western and Oriental Arts, and Dr Natalia Koshenko, Cultural Attachée of the Embassy of Ukraine in Greece.

U.S.A., Baltimore: Dr Gary Vikan, Director, The Walters Art Gallery; *Cleveland,* Dr Katherine Lee Reid, Director, and Dr Diane De Grazia, Curator, The Cleveland Museum of Art; *New York,* Philip de Montebello, Director, Dr Helen Evans and Ms Barbara Drake Boehm, Curators, The Department of Medieval Art and The Cloisters, Mr Stefano Carboni, Associate Curator, The Department of Islamic Art, The Metropolitan Museum of Art; *Washington D.C.,* Dr Susan Boyd, Curator, Stephen Zwirn, Assistant Curator, Dumbarton Oaks, Byzantine Collection; Earl A. Powell III, Director, Dr Alan Shestak, Deputy Director, The National Gallery of Art.

We would also like to extend our thanks to all those individuals who have offered their constant assistance and support throughout this project:
Prof. Polymnia Athanassiadi, University of Athens;
Dr Michele Bacci, Scuola Normale Superiore, Pisa;
Mrs Arlene Jacquette, Counsellor for Public Affairs of the Embassy of U.S.A in Greece;
Mr and Mrs Costa Karras;
Dr Panagiotis Kizeridis, Director of the Italian Institute of Culture in Athens, Cultural Attaché of the Embassy of Italy in Greece;
Dr Emmanuel Mutafov, Art History Institute, Bulgarian Academy of Sciences;
Thomas Pierce, Press Attaché of the Embassy of U.S.A.

in Greece;
Dr Victoria Solomonides, Cultural Attachée of the Embassy of Greece in Great Britain;
Prof. Gojko Subotić, member of the Serbian Academy of Sciences;
Prof. Mariča Suput, University of Belgrade;
Dr Yannis Varalis, French School at Athens.

Angelos Delivorrias
Director of the Benaki Museum

Electra Georgoula
Co-ordinator of the Exhibition

Maria Vassilaki
Curator of the Exhibition

Lenders to the Exhibition

Bulgaria
Sofia, National Gallery:
Cat. no. 86

Cyprus
Nicosia, Byzantine Museum of
the Archbishop Makarios III
Foundation: Cat. no. 62
Nicosia, church of the Virgin
Chrysaliniotissa: Cat. no. 76
Paphos, The Holy Bishopric:
Cat. no. 36

Egypt
Sinai, The Holy Monastery of
St Catherine: Cat. nos 1, 28,
55, 71

England
London, The British Museum:
Cat. nos 3, 11, 16, 32, 43, 60
London, Victoria & Albert
Museum: Cat. nos 17, 20

France
Paris, Musée du Louvre:
Cat. nos 6, 9, 21, 39

Germany
Berlin, Museum für
Spätantike und byzantinische
Kunst: Cat. no. 37
Berlin, Staatliche Museen
Preussischer Kulturbesitz,
Kupferstichkabinett:
Cat. no. 54
Munich, Private Collection of
Christian Schmidt: Cat. nos 4,
5, 10, 13, 14, 18, 22, 27

Greece
Athens, Benaki Museum:
Cat. nos 23, 24, 25, 26, 40, 41,
42, 44, 45, 46, 47, 48, 49, 50,
51, 52, 53, 73, 85
Athens, Byzantine Museum:
Cat. nos 63, 64, 74, 75, 84
Athens, Museum of P.&A.
Kanellopoulos: Cat. nos 7, 15
Athens, Private Collection:
Cat. nos 35, 79
Kastoria, Byzantine Museum:
Cat. no. 83
Naxos, Roman Catholic
cathedral: Cat. no. 67
Rhodes, Byzantine Collection,
Castello: Cat. no. 66
Tinos, Holy Foundation of the
Evangelistria: Cat. no. 82
Thessaloniki, Museum of
Byzantine Culture:
Cat. nos 80, 81
Veroia, Archaeological
Museum: Cat. nos 33, 65
Zakynthos, Museum of
Zakynthos: Cat. no. 34,
The Monastery of Strophades
and Hagiou Dionysiou:
Cat. no. 77

Holland
Utrecht, Museum
Catharijneconvent: Cat. no. 57

Italy
Bari, Pinacoteca Provinciale:
Cat. no. 72
Pisa, church of Santi Cosma
e Damiano: Cat. no. 70
Pisa, Museo Nazionale
di San Matteo: Cat. no. 69

Russia
Moscow, The State Museum
of the Moscow Kremlin:
Cat. no. 29

Serbia
Belgrade, National Museum:
Cat. no. 61

Spain
Cuenca, Cathedral-Museum:
Cat. no. 30

Ukraine
Kiev, Museum of Western
and Oriental Art: Cat. no. 2

United States of America
Baltimore, The Walters Art
Gallery: Cat. no. 59
Cleveland, The Cleveland
Museum of Art: Cat. no. 19
New York, The Metropolitan
Museum: Cat. nos 8, 31, 58
Washington, Dumbarton Oaks
Collection: Cat. nos 12, 38
Washington, National Gallery:
Cat. no. 68

Contributors to the Catalogue

Savvas Agouridis, Professor Emeritus, School of Theology, Aristotle University of Thessaloniki, Thessaloniki
Christine Angelidis, Dr, Institute of Byzantine Research, National Research Foundation, Athens
Michele Bacci, Dr, Scuola Normale Superiore, Pisa
Elka Bakalova, Dr, Art History Institute, Bulgarian Academy of Sciences, Sofia
Chryssanthi Baltoyanni, Former Director of the Byzantine Museum, Athens
Charles Barber, Professor, University of Notre Dame, Notre Dame, Illinois
David Buckton, Dr, Former Curator of the Early Christian and Byzantine Collections, Department of Medieval and Later Antiquities, The British Museum
Averil Cameron, Professor, The Warden, Keble College, Oxford
Annemarie Weyl Carr, Professor, Division of Art History, Southern Methodist University, Dallas, Texas
Robin Cormack, Professor, Deputy Director, Courtauld Institute of Art, London
Rebecca W. Corrie, Professor, Department of Fine Arts, Olin Arts Centre, Bates College, Lewiston, Maine
Antony Cutler, Professor, Department of Art History, College of Art and Architecture, The Pennsylvania State University, University Park, Pennsylvania

Johannes Deckers, Professor, Institut für Byzantinistik, Neugriechische Philologie und Byzantinische Kunstgeschichte, Ludwig-Maximilians-Universität, Munich
Lazaros Deriziotis, Head of the 7th Ephorate of Byzantine Antiquities, Larissa
Anastasia Drandaki, Curator of the Byzantine Collection, Benaki Museum, Athens
Jannic Durand, Conservateur en chef, Département des Objets d'art, Musée du Louvre, Paris
Antony Eastmond, Dr, Research Fellow in the History of Art University of Warwick
Arne Effenberger, Dr, Director, Museum für Spätantike und Byzantinische Kunst, Staatliche Museen zu Berlin, Berlin
Chris J.S. Entwistle, Curator, Late Roman and Byzantine Collections, The British Museum, London
Maria Georgopoulou, Associate Professor, Department of the History of Art, Yale University, New Haven
Sharon Gerstel, Associate Professor, Department of Art History and Archaeology, University of Maryland, College Park
John Hanson, Professor, Department of Art, Indiana University of Pennsylvania, Indiana
Kalliopi-Faidra Kalafati, Dr, Curator of the Byzantine Icons Collection, Byzantine Museum, Athens

Ioli Kalavrezou, Professor, Harvard University, Cambridge MA
Ioannis Karavidopoulos, Professor, School of Theology, Aristotle University of Thessaloniki, Thessaloniki
Angeliki Katsioti, Dr, Curator, 4th Ephorate of Byzantine Antiquities, Rhodes
Alexei Lidov, Dr, The Research Centre for Eastern Christian Culture, Moscow
Eunice Dauterman Maguire, Dr, Johns Hopkins University, Baltimore, Maryland
Henry Maguire, Professor, Johns Hopkins University, Baltimore, Maryland
Cyril Mango, Professor Emeritus, Exeter College, Oxford
Marlia Mundell Mango, Dr, Lecturer, Institute of Archaeology, Oxford
Aleksandra Nitić, Curator, National Museum, Belgrade
Elena Ostashenko, Curator of the Dormition Cathedral Collection, Moscow Kremlin
Valentino Pace, Professor, Università di Udine
Athanasios Papageorgiou, Dr, Former Director of Byzantine Antiquities of Cyprus
Titos Papamastorakis, Dr, University of the Aegean
Vasso Penna, Dr, Professor of Byzantine History and Art, The Athens Centre
Bissera V. Pentcheva, Department of History of Art and Architecture, Harvard University, Cambridge MA
Brigitte Pitarakis, Dr, CNRS, Collège de France

Myrtali Acheimastou-Potamianou, Dr, Former Director of the Byzantine Museum, Athens
Marie-Hélène Rutschowscaya, Conservateur en chef, chargé de la section copte, Départment des Antiquités Egyptiénnes, Musée du Louvre, Paris
Nancy Patterson Ševčenko, Dr, Philadelphia, PA
Jeffrey Spier, Faculty Research Associate, Oxford University
Anastasia Tourta, Dr, Curator, Museum of Byzantine Culture, Thessaloniki
Euthymios Tsigaridas, Professor, School of Theology, Aristotle University of Thessaloniki
Katia Loverdou-Tsigarida, Dr, 9th Ephorate of Byzantine Antiquities.
Niki Tsironis, Dr, National Research Foundation, Athens
Yannis D. Varalis, French School at Athens
Mary Aspra-Vardavakis, Professor, School of Architecture, National Technical University, Athens
Maria Vassilaki, Professor of Byzantine Art, University of Thessaly
Paul Williamson, Dr, Curator of the Sculpture Collection, Victoria and Albert Museum, London
Aimilia Yeroulanou, Benaki Museum, Athens
Stephen R. Zwirn, Curator of the Byzantine Collection, Dumbarton Oaks, Washington

Contents

Part One
On the Cult and Theology of the Virgin

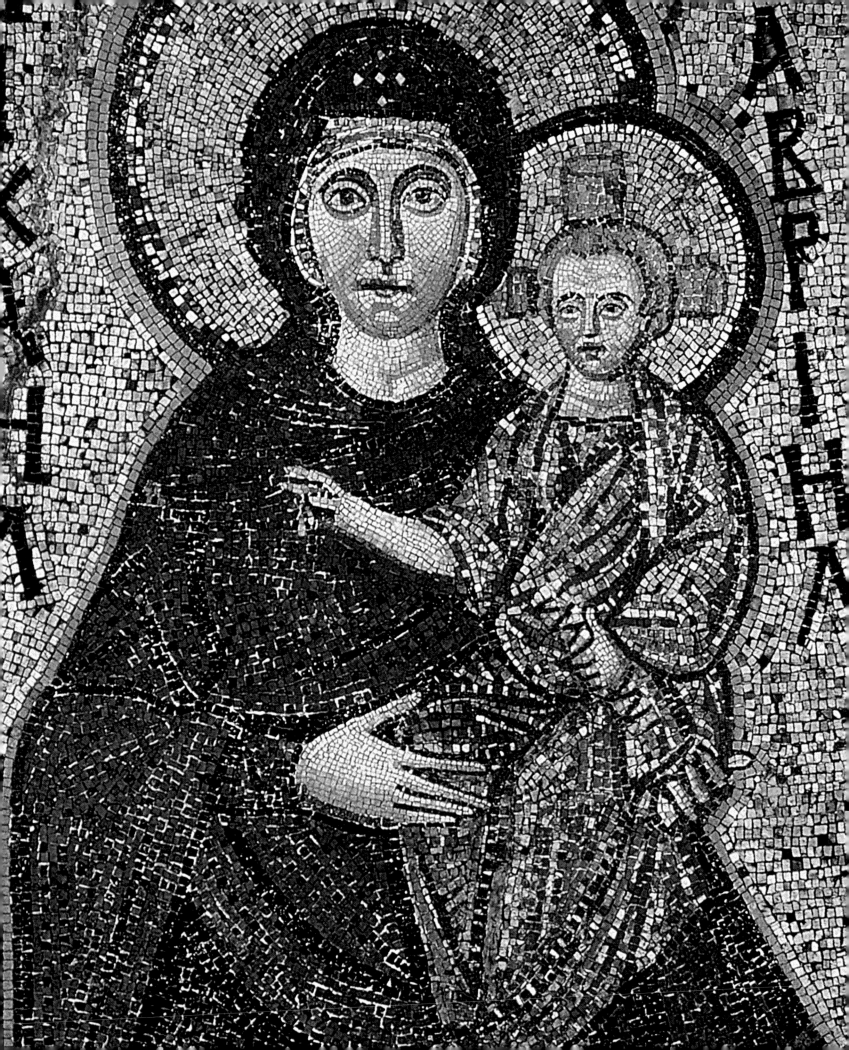

Averil Cameron

The Early Cult of the Virgin

It is both difficult and fascinating to attempt to trace the development in Christian consciousness of the figure of Mary, the mother of Jesus (Pls 1 and 2). Her place in the history of Christianity has been studied by countless theologians, historians and art historians, and she has been and is the subject of devotion and veneration to millions of the faithful all over the world. Mariology—the study of Mary—is a recognized field of study, not only among Roman Catholics, with its own very numerous publications, including journals, and its own centres of research.[1] This exhibition focuses on one particular aspect, the figure of Mary as she appears as the Mother of God in Eastern Orthodox art, but the history of Mary in the early period of Christianity, and indeed for many centuries thereafter, is a shared one, not divisible between a Western and an Eastern tradition. These were the formative centuries for the faith, and the figure of Mary the mother of Jesus very quickly came to be seen as occupying a pivotal position in the Christian understanding of the Incarnation of Christ. As the faith spread and as it underwent critical stages of development, so also did Christian understanding of Mary deepen and develop. Moreover, when Christianity emerged as a major and public religion when it received imperial support in the fourth century, both the nature of the faith and the role of Mary were influenced by, just as they in turn influenced, the character of Late Antique society and culture. While the most prominent doctrinal issues of these centuries centred on problems of Christology, the figure of Mary was in some ways also a touchstone for other developments. She attracted intense interest and popular devotion, and pre-iconoclastic images of the Virgin and Child (Pl. 3) greatly outnumber surviving or known images of Christ alone.[2] It is the purpose of this contribution to trace the stages by which this history took shape.

In theological terms, the doctrine of the Virgin Mary, or the Mother of God, as she is more usually called in Eastern circles,[3] belongs to the realm of tradition and (in its technical sense) 'development'. References to her in the Gospels are very limited, confined in the main to the stories of the events later known as the Annunciation, the Visitation, the Nativity, with the Adoration of the Magi and the Flight into Egypt, and the scene of Mary and St John at the foot of the Cross. Thus there is little or no Scriptural authority for the role she came to play later in both the Eastern and the Western Church. The doctrines of the Immaculate Conception and the Assumption of the Virgin were declared canonical in the Roman Catholic Church by papal decree only in 1854 and 1950, respectively.[4] Neither did other beliefs such as her perpetual virginity find direct Scriptural reference. But as Christians reflected on the meaning of the life and death of Christ, and on the narratives which told the story, the desire to find authority for Mary's role gave rise, at an early stage, to the search for both Old and New Testament references which, though not explicit, could nevertheless be held to refer to her. The same impulse found a response in writings later labelled as apocryphal (and therefore non-official in the Church's eyes, despite their enormously wide circulation and influence). In addition, modern scholars and Byzantine homilists alike have sought to resolve the dilemma by explaining the silence in the canonical texts as in some way intentional, either an indication of her extreme holiness or a sign of theological reserve.[5]

1. *Virgin and Child.*
Church of the Virgin
Angeloktisti at Kition, Cyprus,
detail of Pl. 3.

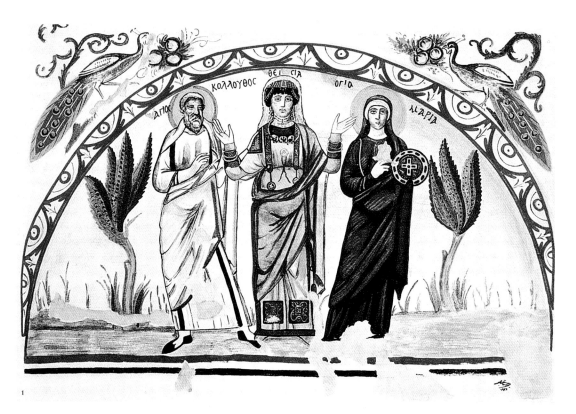

2. *The Virgin Mary with St Kollouthos and Theodosia.* Funerary chapel of Theodosia. Antinoe, Egypt (watercolour of a now lost fresco).

An important development in the first category was to trace Mary's descent from the line of David, even though this is not made explicit in the Gospel accounts.[6] This provided the essential link for the lineage of Jesus between the Old and the New Testament. In the second century, Justin Martyr and Irenaeus of Lyons developed the concept of Mary as the second Eve, who played a role in relation to Christ, the second Adam, parallel to that of the first Eve in relation to the first Adam, and whose virtue would cancel out the transgression of the first woman.[7] A passage in the latter's *Demonstration of the Apostolic Preaching* encapsulates the several themes contained in this comparison: 'Adam had to be recapitulated in Christ, so that death might be swallowed up in immortality, and Eve in Mary, so that the Virgin, having become another virgin's advocate, might destroy and abolish one virgin's disobedience by the obedience of another virgin'. Here we already find the themes of Mary's crucial role in the Divine Economy (recapitulation), her advocacy or mediation, her obedience, and her virginity. The emphasized disobedience of Eve, and Mary's contrasting simplicity, obedience and virginity, were themes pursued in detail by many later Fathers, with corresponding implications for their views on women, sexuality and marriage.[8] Other attempts to find Old and New Testament pointers to the role of Mary also continued in later exegesis: Mary's virginity found an Old Testament foreshadowing in the reference in the Song of Songs to a *hortus inclusus*, 'an enclosed garden',[9] and she was seen as the woman clothed with the sun in the Book of Revelation.[10] In the second and third centuries there was still as yet no clear doctrine about Mary, but Clement of Alexandria already likened her in her purity, her love and her motherhood to the Church itself,[11] and Origen too emphasized her virginity, her motherhood and her holiness; for him, following Ignatios of Antioch, her betrothal and marriage to Joseph were God's way of protecting her virginity from the world.[12] In contrast, while accepting that Jesus's descent from the line of David came through his mother, Tertullian did not accept that Mary remained a virgin and has earned the disapproval of Catholic scholars for seeming to be critical towards her.[13]

Nevertheless, even Tertullian accepted the virgin birth of Christ, and these early testimonies in general, even without going into great detail, lay stress on the mystery of Mary's status as the virgin mother of Christ, and on her obedience to God's planned role for her in the salvation of

the world. A different type of writing altogether, which was to become extremely important for later generations, was the apocryphal text known as the *Protevangelium of James*, also of the second century. This expanded the bare details offered by the Gospels into a charming narrative of Mary's own birth, infancy and childhood, in which she too, like her Son, was marked out from before her birth by God for her divine destiny.[14] This belongs within a wider group of infancy narratives and stories of Mary's early life, and already contains many of the features which were later to become so well known in visual art, and especially in the Byzantine cycles of the life of the Virgin. Her parents are named as Joachim and Anne, and the birth as a divinely sent answer to their prayers for a child; Anne receives a visitation from an angel who tells her that she will conceive. Anne vows her child to God, and the baby is born, and takes her first steps at only six months old. Anne sings a song of joy and, like many parents in similar circumstances in later saints' lives, she and Joachim present her at a young age to be brought up in a holy place, in their case in the Jewish temple, where she is marked out by the priests as the subject of prophecy and is fed by angels. A husband, Joseph, is found for her at the appropriate time of puberty when she must leave the temple, but this is in fact a way of guarding her virginity, which is later, after Christ's birth, attested by the midwife and her assistant Salome, who appear in so many Byzantine Nativity depictions. The individual elements from which this story is constructed are clearly recognizable, though little is known of its composition or early circulation. One of its chief concerns was certainly to underline the theme of Mary's virginity. Nevertheless it also provided an imaginative scenario for the background and childhood of the Virgin which complemented the laconic statements in the canonical Gospels and which was to have tremendous appeal to subsequent generations.

The date and origins of the first Christian art, especially the art of the catacombs, remain highly controversial, but it seems that scenes of Jesus and Mary in the Roman catacombs did not appear before the late third or fourth century, and even then they are few in number.[15] When Mary does appear it is typically in scenes of the Annunciation or the Adoration of the Magi, which also feature, though here in Roman imperial style, in the surviving fifth-century mosaics in the Roman church of Santa Maria Maggiore.[16] It took the major strides in Christian church building (Pl. 4), which followed the support of the Church by Constantine and his successors in the fourth century, before Christian schemes of decoration developed, and even then depictions of the Virgin were extremely slow to become established. As a female figure of Christian devotion one might say that she was outranked by Thekla, the virginal heroine of the late second-century *Acts of Paul and Thekla*, whose important shrine at Meryemlik, near Silifke in Isauria was visited by the pilgrim Egeria in the late fourth century.[17] This comparative lack of representation of the Virgin in visual art makes the proliferation of images of the Virgin and Child from the sixth century onwards all the more remarkable; it would seem then that, despite the *Protevangelium* and despite her increasingly important role in doctrinal debates, the personal veneration of the Virgin known to later generations was not yet the norm, even in the fourth century. It is in practice only after the Council of Ephesus and the recognition of her title as Theotokos in AD 431 that we find the real development of the cult of the Virgin which was to find expression in the sixth century in particular in the establishment of Marian feasts, increasing numbers of images of the Virgin for both private and public use, stories of her appearances and of miracles performed by her, and a new note of Marian spirituality struck by such key literary texts as the Akathistos Hymn and the *kontakia* of Romanos the Melodos.

First, however, we must consider the place of the Virgin in the great debates of the fourth century and in the writings from what has often been called the golden age of patristic literature. Two main aspects need to be borne in mind: first, the complex relation of the theology of the Virgin and the general trend towards asceticism in fourth century Christianity, and second, the increasingly prominent role which the figure of the Virgin came to play within the Christological debates which so dominated the fourth and fifth centuries. In practice, the two aspects often interlocked. Mary was cited as a perfect example of ascetic virginity, especially of course for women,

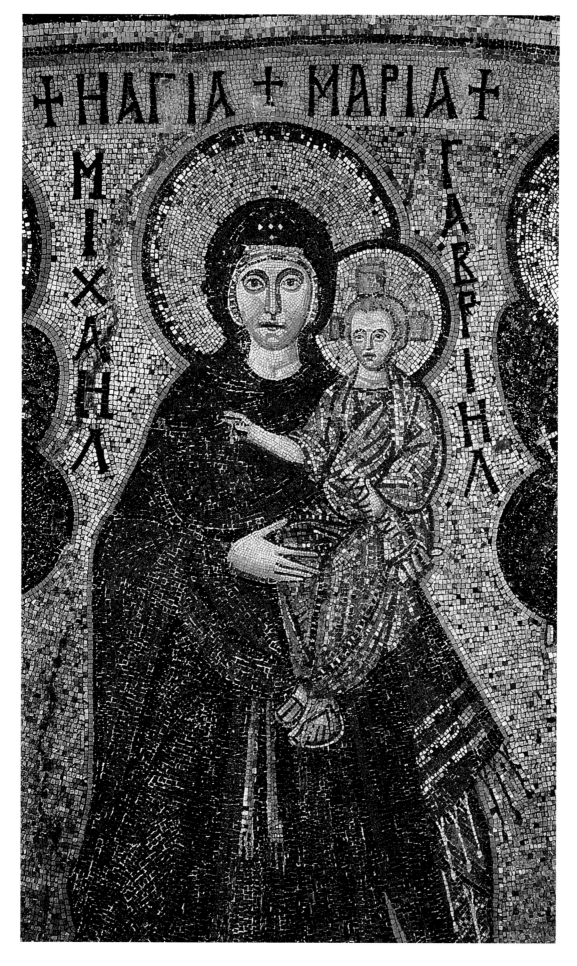

† HAΓIA † MAPIA †

MIXAHΛ ΓAΒPIHΛ

while the identification of the exact physical details of the birth of Christ became more and more critical to ascetic debates. At the same time, it was Mary who was seen as having made possible the union of two natures in Christ, which now became the central issue of several centuries of intense Christological argument. Indeed, on one reading of Byzantine Iconoclasm, the discussions which took place in the eighth and early ninth centuries about the possibility of depicting the divine marked the final struggle in this Christological debate. As the human mother of Christ the figure of Mary necessarily lay at the heart of these doctrinal arguments, and while they were willing to whitewash or destroy her images even the Iconoclasts drew back from attacking her own status and holiness.[18] The roots of these debates, as of the proliferation of images of the Virgin before and after Iconoclasm, belong in the patristic thought of the fourth century to which we must now turn.

While the impulse towards asceticism in both pagan and Christian thought itself began much earlier, the beginnings of its formalization as a way of life for Christians are generally put at the end of the third century, whether as organized monasticism or in more individual forms.[19] Not long afterwards Methodios of Olympus composed his *Symposium*, a dialogue on virginity conceived as a Christian counterpart to Plato's famous dialogue of that name on the nature of *eros*.[20] Its heroine, tellingly, is not the Virgin Mary but a virgin called Thekla. But Mary's reputation did benefit from the growing literature on virginity, which included commentaries on the Song of Songs as well as treatises on the topic itself.[21] She was seen as a model of virginity, and her own virginity was prefigured by female figures in the Old Testament.[22] According to Cyril of Jerusalem, the Virgin provided an ideal of virginity which rendered the lives of those who possessed it like the life of angels.[23] The privileging of virginity also lay behind fourth-century writing about marriage, and again the chaste marriage of Mary and Joseph provided a touchstone. For Augustine, it proved that it was not sexual relations but consent that constituted a marriage.[24] The few Scriptural references to Mary were also interpreted according to ascetic principles[25] and Augustine was only one of several authors who were at pains to explain that the references to Mary as *gyne*, at Galatians 4:4 and John 2:4, did not necessarily imply that she was a married woman in the full sense of having had sexual relations with her husband.[26] This issue did pose difficulties; Basil of Caesarea, for example, admits that Matthew 1:25 might imply the reverse, but concludes that the universal confidence of Christians in the continued virginity of the Theotokos is sufficient to establish it as truth.[27] Jerome's opponent Helvidius had also taken the commonsense view of the text, and Jerome vigorously refuted it in his treatise against him.[28] Equally, according to Jerome, only John, himself the virginal disciple, was worthy to be entrusted with the care of the Virgin Mary at the Crucifixion.[29] For many fourth-century writers on virginity, for instance Gregory of Nyssa, the opening chapters of Genesis were crucial; sexuality, and even marriage itself, could be seen as a punishment for Eve's transgression, symbolized in the 'coats of skins' with which Adam and Eve were clothed on their expulsion from the Garden of Eden.[30] It was an essential part of the argument of Gregory's treatise *On Virginity* that it was the virginity of Mary, the Mother of God, that cancelled out death, which had come to mankind through the sin of Adam and Eve. It was equally important to argue, as for example Jerome and John Chrysostom did, that Adam and Eve had been virginal while in Paradise; correspondingly, although John Chrysostom also produced practical arguments in favour of virginity and against the troubles and distractions of marriage, Mary's virginity was logically required in order to balance the equation. It was logically necessary too, according to Gregory of Nyssa's interpretation of the Song of Songs, that Mary the virgin should give birth in joy, in contrast with Eve, whose sin had condemned her and all other women to give birth in sorrow.[31] Moreover, it was important, as we have seen, that Mary should have remained a virgin *in partu*, that is, even during and after the birth of Christ. This mystery caused Gregory of Nyssa to liken her in a homily to the Burning Bush, which burned but was not consumed, an analogy which found its way into many later icons of the Virgin.[32] But it was Jerome who debated the matter in the most minute detail, both in his treatise against Hel-

7

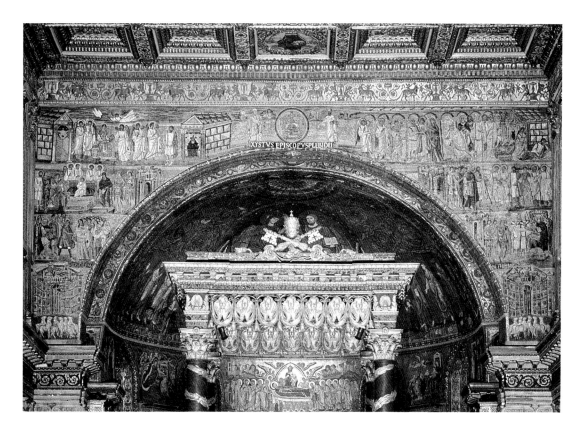

vidius and in his later defensive arguments after the condemnation of Jovinian, who had taken the opposite position.[33] Even so, he cannot explain the mystery, and is compelled to leave it as such.

There was as yet no 'Western' or 'Eastern' position on the doctrine of the Virgin.[34] Ambrose, Bishop of Milan from 373/4 until 397, is one of the most important Marian writers of the fourth century, author of treatises on virginity, on virgins and on the dedication of a consecrated virgin, and of many references to Mary in his other works.[35] He expresses attitudes and views on the Virgin similar to those expressed by the Eastern Fathers, including some of the devotional and indeed emotional language that is so apparent in Ephraim the Syrian and later Byzantine writers. Mary is an example for all virgins, although truly the Mother of God; she is also the type of the Church. But for Ambrose the figure of Mary had a crucial local importance, both in his defence of consecrated virgins against considerable contemporary opposition and in his arguments against what he saw as incorrect doctrine about the Incarnation. He was also deeply engaged with the problem of human sinfulness and sexuality, a debate to which the virgin birth was of critical importance.[36] Later in his life he addressed the contemporary debate about Mary's perpetual virginity, which he passionately defended. It symbolized for him not only the true nature of Christ, but also the purity of the Church and the ideal of virginity which he energetically promoted against much opposition as a social and ecclesiastical aim.[37] His praise of Mary therefore belonged, at least in his later years, in a context of intense social as well as theological debate about the place of virginity in family life and in the Church generally, a debate which deeply concerned the noble families of Rome and Milan and which is apparent in the writings of Jerome, Ambrose and Augustine.

In his memorable account of his own conversion in the garden at Milan in 386, Augustine records his personal debt to Ambrose, by whom he was subsequently baptized, and the impact on him of the Latin translation of Athanasios's *Life of Anthony*, the classic ascetic text which had recently been taken up in his circle.[38] From both sources he absorbed the enormous importance attached to virginity, and despite already having a son by a loved companion, who was now entering his teens, proceeded to take steps towards living a life of chastity henceforth himself. Like Ambrose he wrote directly about virginity, and in relation to Mary he emphasized her own free choice as well as her membership of the Church as the mother of Christ, its Head. He works with

the idea of motherhood to attribute motherhood to the whole Church, and to say of Mary that she is spiritual sister and mother to Christ as well as his physical mother.[39]

Augustine accepted the centrality of the virgin birth in the understanding of Christology and did not question the now accepted role of Mary in other respects. He did however take the doctrine of Mary in new directions which, in the context of his theology as a whole, can be labelled 'Western'. Two fundamental issues critical to his life and thought also dominated the rest of his thinking about her: the problem of human sinfulness and the issue of marriage. Throughout the rest of his life, Augustine was troubled by the problem of human sexuality: was it part of man's fallen nature, an evil in itself? If so, how should Christian marriage be understood? He approached these problems with a psychological depth rarely seen in other patristic writing, and they influenced his thinking about Mary just as they shaped the rest of his theology. As Bishop of Hippo on the coast of North Africa, Augustine was far removed from the politics of asceticism within Late Roman families as they were experienced in the aristocratic circles of Italy, and his thinking revolved much more round the questions of authority and division within the Church itself which were so central a part of Christian life in North Africa. A major strand in his thinking concerned exegesis of the book of Genesis, to which he kept returning. What was the significance for mankind of the expulsion of Adam and Eve from Eden, and where did sexuality and marriage fit in God's intentions?[40] It would be fair to say that as a result of pondering these problems in *On the Literal Interpretation of Genesis* and later works Augustine arrived at a more complex understanding than most other ascetic writers. For him Adam and Eve were not sexless creatures in Eden, but possessed the ideal harmony of body and soul intended for humanity. Conversely, only Mary at the moment of conception and in the virgin birth restored this ideal equilibrium. There was however a darker side to Augustine's conclusions. Even in marriage, sexuality as it actually was in the real world was inescapably a sign of the fall, a view which Augustine propounded in his answers to the more relaxed views of contemporaries like Julian of Eclanum, and which led him into a detailed examination of the mechanics of the sexual act.[41] This too had implications for his view of the role of Mary. He was prepared to concede that she was the single exception to the universal sinfulness of mankind after the fall of Adam and Eve,[42] a view which has been taken by many to point to the Catholic doctrine of the Immaculate Conception. And because of his conclusion that marriage in itself was not intrinsically a sign of sin, but something good in itself, he was able to see Mary as exemplifying not simply female virginity but also the dignity of women in general.[43]

Both the general debate over asceticism in the fourth century and the promotion of the ideal of virginity as an aim even at the highest levels of society, by certain writers, necessarily involved its advocates in appealing to the example of the Virgin Mary. The doctrine of Mary was also, if paradoxically, deepened and clarified by the vigorous arguments which took place on particular points, especially her perpetual virginity. Equally, the ascetic agenda also entailed interpreting the limited Scriptural references to her in ways which supported the ascetic view, and in applying the same methods to the exegesis of other relevant Scriptural texts, such as the Song of Songs. However, it is important to note that this Marian exegesis was also increasingly accompanied by an emotional and imaginative spirituality focused on the person of Mary. The analogy of Mary with Eve, already spelt out in the second century, was deepened and reinforced, and we find in fourth-century writers such as Gregory of Nyssa further signs of the typology of Mary which was to become so much a feature of later homiletic and visual art. One of the most important writers from this point of view was Ephraim the Syrian, whose deep influence can be felt in the hymns of Romanos, the sixth-century deacon of Hagia Sophia, and whose thinking passed into the treasury of Byzantine imagery of the Mother of God. Ephraim's career began at Nisibis on the Persian frontier, and when that city was ceded to the Persians in 363 he migrated to Edessa and continued his activity there until his death in 373. In Ephraim's Syriac hymns are already displayed the emotional attachment and personal devotion to the Virgin which are such features of later

Byzantine artistic and literary expression.[44] He repeatedly dwells on the holiness and purity of the Virgin, and on the mystery of her motherhood of Christ, beyond human comprehension: 'Our Lord, no one knows how to address Your mother. [If] one calls her "virgin", her child stands up, and "married" – no one knew her. But if Your mother is incomprehensible, who is capable of [comprehending] You?'[45] Her virginity was prefigured for him by the virgin earth which gave birth to Adam, the virgin Eve and the burning bush. Christ bursting from the tomb was like the triumphal opening of Mary's womb. Mary is a model for all chaste women, and the figure of the Church. Ephraim's imagery applied to Mary is the richest so far encountered. She is the second Eve, but utterly different from the first: while Eve was, as it were, the left, blind eye of the world, Mary is the right and luminous eye. And for the first time, Mary is the bride of Christ, as well as sister, mother, handmaiden and daughter.[46]

The second strand in fourth-century attention to Mary was the dogmatic and Christological. The virgin birth was not a theme at the Council of Nicaea in AD 325, nor even the Council of Constantinople in AD 381. But by the early fifth century it was quite natural that debate at and before the Council of Ephesus of AD 431 should have centred on Mary's status in the context of the birth of Christ. The Council confirmed her title as Theotokos, literally 'she who gave birth to God', a term which had been in frequent use for a century at least and which was used in distinction to Christotokos, 'she who gave birth to Christ', as signifying beyond doubt the divine nature. Like the matter of Mary's virginity after as well as before the birth of Christ, the application of the term Theotokos was still controversial.[47] At the Council of Ephesus its justification was upheld by Cyril of Alexandria against Nestorios, Patriarch of Constantinople since 428. A Council held in Rome in 430 had already pronounced against Nestorios, and Cyril sent legates to anathematize him; he was formally deposed by the Ecumenical Council convened at Ephesus in 431.[48]

After this, although Christological dispute continued unabated, focusing on the dual or single nature of Christ, Mary's status was assured and she was now formally recognized as the Mother of God. This was commemorated in Rome by the building there, by Pope Sixtus III, of the great church of Santa Maria Maggiore with its mosaics of the Annunciation and the Adoration of the Magi (Pls 5 and 6), one of the most impressive and also the earliest churches dedicated to the Virgin, and one which represents a milestone in her depiction in visual art.[49] Before the Council a notable homily in praise of the Theotokos had been preached in Hagia Sophia at Constantinople, in the presence of Nestorios, by Proklos, a priest and effectively chaplain to the Patriarch Attikos (406-425), who, though a candidate for the patriarchate after the death of Attikos's successor Sisinnios, had been passed over in favour of Nestorios himself.[50] Proklos eventually did become patriarch in 434. His homily, however, delivered shortly before Christmas in the year 430,[51] was in the circumstances highly inflammatory, and did much to raise the level of feeling against Nestorios and in favour of the Theotokos title. It also took to unprecedented heights the imagery and typology of Mary which we have seen presaged in the writings of Ephraim and others, and it set a pattern for all later Byzantine homiletics on the subject.[52] The theme of Mary as the New Eve is here expanded by a mass of other Biblical images: Mary as the Ark, the Ladder of Jacob, the Fleece of Gideon, the Red Sea, the Temple of Solomon, the Unopened Gate, the Jar Filled with Manna and many others.[53] The Biblical however represented only one type of imagery; Proklos ranged much more widely, and Nicholas Constas has also examined his striking imagery of weaving, whereby the Virgin's womb is likened to a workshop containing the loom on which the flesh of God is woven.[54]

Proklos's homily, closely followed as it was by the affirmation made by the Council of Ephesus, seems to mark a critical moment in the history of devotion to the Mother of God. From now on the gates were open for both personal piety and formal cult; equally, we now gradually begin to see a development in Virgin's representation in visual art which will soon lead to the icons of Virgin and Child with which this exhibition is concerned, and to similar representations

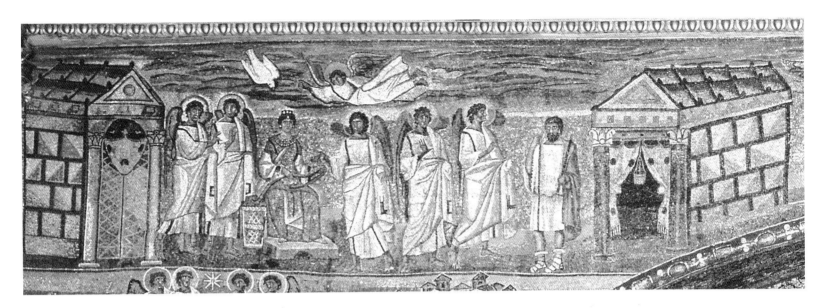

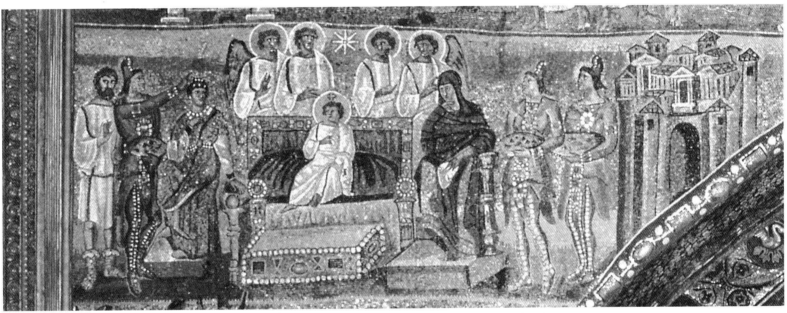

5. *The Annunciation.*
Santa Maria Maggiore, Rome.

6. *The Adoration of the Magi.*
Santa Maria Maggiore, Rome.

in monumental form.[55] And in Byzantine homiletic and liturgical hymns alike, the full glory of the poetic presentation of Marian themes is released. Fifth-century homilies continue Proklos's treatment of the theme and prefigure the sixth-century hymns of Romanos and the works of later authors, where the representation of the Mother of God is more emotive and less Christological than before.[56]

With the outcome of the Council of Ephesus, therefore, the way was opened for fuller development — liturgical, artistic and doctrinal. In Constantinople this soon took effect through the initiative of the imperial family, when in the reign of Emperor Leo III (457-474) and his wife Verina, as described in later accounts, the robe or veil (usually known as the *maphorion*) of the Virgin was solemnly brought to the city and deposited in a reliquary in a church dedicated to her. We are told that the imperial *translatio* was depicted in a mosaic which showed Mary seated on a throne, with the emperor and empress on either side, with their daughter Ariadne and their son, mistakenly named here as the future Emperor Leo II.[57] Furthermore, a second large image was set up in the church showing the Virgin flanked by angels, as in a number of early icons including the icon of the Virgin from the monastery of St Catherine on Sinai, and with St John the Baptist and St Conon (*sic*), while two officials, Galbius and Candidus, were shown in front of the Virgin and Child, in attitudes of prayer. There is a number of difficulties surrounding these accounts,

11

for instance whether the veil and the robe of the Virgin were in fact the same. An alternative version ascribes the deposition of the robe at Blachernai (one of the churches of the Virgin which she is said to have founded) to the Empress Pulcheria, while the chronicler George the Monk tells of its finding in Jerusalem by a pious Jewess and its deposition at Blachernai under Leo I;[58] later generations produced variant versions. Nor is it clear whether the icon of the Virgin that was paraded round the walls of Constantinople during the siege of the city by the Avars and Persians in 626 was in fact a fifth-century icon of Blachernai.[59] Nevertheless, Constantinople was now the home of relics of the Mother of God and began to have its own images of her. In contrast to Rome, where early icons of the Virgin are still known, none of the early Constantinople images survives to this day.[60] If it can be relied upon, the description of the decoration of the Blachernai church would fit well with other surviving sixth-century images, such as the Sinai icon (Cat. no. 1) and the well-known textile now in Cleveland, Ohio, where the seated Virgin is also surrounded by archangels and saints.[61] In the surviving apse mosaic at Kition in Cyprus she is standing, but still flanked by an archangel on either side (Pls 1 and 3). In these early examples, the Virgin is often enthroned, as she is also in Santa Maria Maggiore, but the way is also being paved for her transformation into the tender figure standing or seated alone with her Child and wearing a simple veil rather than a queenly crown.[62]

An important element in this development is the parallel increase, especially during the sixth century, in the liturgical and poetic celebration of the Mother of God. The *kontakia* or hymns of Romanos, written under Justinian (527-565) mark an important stage; among them we should mention in particular his *kontakion* on Mary at the Cross, written for Good Friday, on the reading John 19: 25, and incorporating a dramatic dialogue between Christ and his Mother as she laments his suffering. Romanos's vivid treatment of the Virgin's lament, a theme already found in Ephraim, drew on deep sources of emotion and poetic imagination, and was to prove a model for later homilists in their recreation of Mary's anguish.[63] Elsewhere, for instance in the *kontakion* on the Presentation of Christ in the Temple, he represents Mary as speaking directly in wonder at the birth of her Son, with an emphasis on her as a dramatic figure in the dynamics of the life of Christ. Although the doctrinal content of Romanos's hymns should not be underestimated, this poetic treatment contrasts with the much more theoretical approach to the Virgin in earlier patristic theological treatises, and it made possible, or was perhaps rather itself a symptom of, a growing personal devotion to her during this period. From the same period we have examples of Coptic hymns surviving on papyrus, written as acrostics, glorifying the Virgin under the well-known types encountered since Proklos.[64] Also during the sixth century we find the development of Marian liturgical feasts, in particular that of the Assumption, or, in the Eastern tradition, the Dormition, celebrated on 15 August, which was to become one of the Twelve Great Feasts in the Byzantine Church. This was formally recognized in the reign of Emperor Maurice (587-602), and celebrated at Blachernai.[65] Eventually this too was to pass into the repertoire of representations of the Mother of God in visual art and to become the most important of all her feasts. As in earlier centuries, devotion to the Mother of God was also expressed in apocryphal narratives, which told the story of her falling asleep and being taken up to heaven.[66] Justinian's nephew and successor, Justin II (565-578), made benefactions in her honour at Blachernai and Chalkoprateia, the two churches in Constantinople holding her robe and her girdle, and his wife Sophia is represented as praying to her in Corippus's Latin poem celebrating Justin's accession.[67] Other hints in the same poem indicate how fast her cult was growing in the city, and how commonly she now appeared in various forms of visual art — textiles as well as the more familiar icons. She also featured in anecdotes of miraculous intervention, such as the story told at the end of the sixth century by the ecclesiastical historian Enagrios of the rescue by the Mother of God of the boy thrust into a furnace by his father, a Jewish glassblower, and the child's subsequent conversion together with his mother.[68] This is only an early example of many later stories, variations of which featured miraculous appearances by the Mother of God or miracles associated with her

icons. It is however indicative of a very clear general development in piety towards her, and in the increasingly prominent role which she played in Christian faith. Depictions of the Virgin with the Child were a central feature in the general growth in religious images which also belongs to this period, for it was through the Mother of God that Christ's human as well as divine nature could be shown; he was rarely shown alone except as the Ruler of All. But this very concentration of iconographic theme led in itself to the focus on the Mother of God herself as the central subject.

In the early seventh century Constantinople came under threat from the Avars and then also from the Persian siege in the great war launched against Byzantium by Chosroe II. The landward side of the city and the walls were the most vulnerable, and in 619 the relic of the Virgin's robe was removed from Blachernai to Hagia Sophia for safekeeping, and after the danger was past returned to its home in solemn procession, which was commemorated in an annual feast celebrated on 2 July.[69] In the narrative of these events and in the institution of the feast by the patriarch of the day, the robe emerges as a wonder-working relic, and the Mother of God herself as patron of the capital city. The account, probably by the same Theodore Synkellos who also wrote a homily on the siege of 626, records how, when the casket was opened, the purple silk in which the garment was wrapped had shrivelled away, while the simple cloth of the robe itself was completely unharmed by time, proving that the robe partook of divine grace, in that 'it not only clothed the Mother of God but that in it she actually wrapped the Word of God Himself when he was a little child and gave him milk, whence rightly this divine and truly royal garment is not only the cure for every illness, but justly is incorruptible and indestructible, proclaiming the indestructibility and incorruptibility of its wearer'.[70]

By this date, the Virgin's doctrinal role could be taken for granted, and she was increasingly represented as the ideal of tender maternal protection. While images of her enthroned and flanked by angels and saints still emphasized her majesty, a rather different conception was also expressed in the many stories of her miraculous intervention and in the idea of her robe as a protection for individuals and for the city.[71] Now, too, the narrative of her life took shape in the Akathistos, the best loved of all Byzantine hymns to the Virgin. This long celebration of the Virgin, later sung regularly on the fifth Saturday in Lent and written in twenty-four stanzas arranged in acrostic form, each followed by a refrain, rehearses first the episodes of the Annunciation and Nativity and then the Virgin's doctrinal role, praising in its treatment of these two themes the Mystery of the Incarnation. Throughout the hymn she is hailed under her many differing types and titles, and in the final stanza she is addressed and invoked as the supreme Mother and protectress of all who call upon her.[72] According to later tradition the Akathistos was first sung after the deliverance of Constantinople from the siege of 626, and composed by Patriatrch Sergios himself (alternatively by Patriarch Germanos after the siege of 717-718), but the substance of it more probably took shape earlier, some time in the sixth century. If so, it clearly belongs in the same context as the *kontakia* of Romanos, to whom it has sometimes been attributed, and is an important example of the contemporary development in devotion to the Mother of God which also led to her being seen as the one who, through her relics and her icon, saved the city from attack in the early seventh century. In the Akathistos Hymn the scenes from the Virgin's life combined with later homiletic and doctrinal developments to form a mature and at the same time poetic whole which found immediate recognition within the liturgical life of the Byzantine Church. In later centuries it was made the basis for cycles of the life of the Virgin in monumental painting and in manuscript illustration, and it certainly contributed greatly towards the firm establishment of devotion to the Mother of God at the heart of Byzantine religiosity.

It was not surprising therefore, especially after the attribution of the city's deliverance from the Avars to the efficacy of the Virgin's robe, that the people of Constantinople should have turned to her for protection during the dangerous siege of 626. According to the contemporary *Chronikon Paschale*, her prayers successfully prevented the enemy cavalry from damaging the church at Blachernai and the city was saved by the intercession with God of 'his undefiled Mother, who is in truth

our Lady Mother of God and ever-Virgin Mary'.[73] Another contemporary text, the homily written by Theodore Synkellos, tells of how the patriarch put her icon on the gates, and of how she intervened in battle to sink the enemy ships.[74] The court poet George of Pisidia also begins his epic poem on the siege with an allusion to an icon of the Virgin,[75] and while different details appear in the contemporary and later sources her saving role is repeatedly emphasized. She is even depicted in the texts as leading the Byzantine forces into battle as their general, and sinking the enemy fleet in the waters of the Golden Horn like the chariots of Pharaoh in the Red Sea. Homilists writing of later sieges of the city in 674-678, 717-718 and 860 were to develop the ideas still further; not only has the Virgin Mary become the Mother of God of later Byzantine art and liturgy, but she has also become the special defender of Constantinople.[76]

Over this long period of something more than six hundred years, therefore, we can trace a steady development in attitudes to Mary and to the way in which she was represented in art and literature. She was from an early date the object of vivid curiosity, then of doctrinal speculation and theological debate about the nature of the Incarnation. Gradually, though not until Late Antiquity, she attracted devotion, prayer and even worship, and was increasingly depicted in icons, mosaics and in other media such as ivory and textiles, commissioned by individuals, churches and rich patrons. Though later authors naturally traced back later highly-venerated icons to much earlier periods, and the origins of the famous Constantinopolitan image of the Virgin known as the Hodegetria, for example, are wrapped in mystery, by the early seventh century Constantinople was the home both of revered images of the Virgin and of her robe and girdle, and the Virgin was the subject both of much-loved religious poetry and of a number of accounts which ascribed to her the city's very survival. It was not surprising therefore if the attitudes of the Iconoclasts towards the Virgin were somewhat ambivalent, for in one sense she was classed with the saints whose images they attacked, and yet in another she was given a status close to God and almost divine herself, 'Higher than the Cherubim', and above reproach. But it was the personal devotion and attachment which by the early seventh century she so widely attracted which most of all gave her the central role that she enjoys today in the art and devotion of the Orthodox Churches.

[1] Some idea of the scale is given by the notes and bibliography in Gambero 1999 (a useful handbook to the texts compiled by a Roman Catholic position). There is also much wide-ranging bibliliography cited in Pelikan 1996, a helpful general survey, though weaker on the Eastern side and with some omissions, and see e.g. *Theotokos*. Graef 1985 is briefer on the early period but has more on Byzantine developments.

[2] Only five 6th-century items appear in this exhibition (Cat. nos 1, 2, 3, 8 and 9).

[3] See below for the title Theotokos.

[4] *Ineffabilis Deus* (Pius IX); *Munificentissimus Deus* (Pius XII).

[5] For the latter, Gambero 1999, 27-29, noting a similar general silence on the part of the Apostolic Fathers.

[6] Luke 2:4; Matth. 1:1-17; Luke 3:23-28.

[7] Justin, *Dialogue with Trypho* 100, *PG* 6, 709-712; Irenaeus, *Adv. Haer.* 3, 22, 5, 19, *PG* 7, 959-960, 1175-1176.

[8] Clark 1983, ch. 1; Pagels 1988.

[9] Song of Songs 4:12.

[10] Rev. 12:1.

[11] *Paedagogus* 1.6, *PG* 8, 300-301.

[12] Origen, *Comm. on Gal.*, *PG* 14, 1298; *Comm. on John* 32.16, *PG* 14, 784; *Hom. on Luke*, 17.6-7, SC 87 (1962), 256-58; *Hom. on Luke*, 6.3-4, SC 87, 144-146.

[13] Graef 1985, 42-43; Gambero 1999, 59-66 (attributing Tertullian's attitude to the 'uncertain mentality' of Christians towards her in the early centuries).

[14] Elliott 1993; Strycker 1961. The *Gospel of Thomas* fills out the 'missing' years Jesus's childhood in much the same way.

[15] Corby Finney 1994; cf. also depictions on sarcophagi, Lowden 1997, 48-51.

[16] Lowden 1997, 54-55.

[17] For a description of the complex, Hill 1996, 208-225.

[18] See the essay by Niki Tsironis, *The Mother of God in the Iconoclastic Controversy*, in the present volume, 27-39.

[19] In general Brown 1988. The extraordinary intensity of the debate can be seen in Clark 1999.

[20] For Methodios, Brown 1988, 183-188; Cameron 1991, 177-178.

[21] Briefly Clark 1999, 87-88.

[22] Clark 1999, 89, 104.

[23] *Catechesis* XII, 34, *PG* 33, 768-769.

[24] *Catechesis* XII, *PG* 33, 254.

[25] In Tatian's earlier Syriac *Diatessaron*, or harmonization of the Gospels, the problem was solved by omitting Mary's marriage to Joseph altogether.

[26] Clark 1999, 116-117.

[27] Basil, *Homily on the Holy Generation of Christ*, 5, *PG* 31, 1468B.

[28] *Against Helvidius*, 5, *PL* 23, 198.

[29] *Against Helvidius*, 5, *PL* 23, 165, 202.

[30] Gen. 3:21, a passage which gave rise to lively discussion. Clark 1986, 353-385; Cameron 1989, 184-205.

[31] Greg. Nyss., *Comm. on the Song of Songs*, 13, *PG* 44, 1052D-1053B.

[32] *Hom. on the Birth of Christ*, *PG* 46, 1133D-1156B.

[33] For the latter, Hunter 1987, 45-64.

[34] *Contra* Gambero 1999, 189 and *passim*.

[35] Neumann 1962; Brown 1988, 353-356.

[36] Brown 1988, 351-352.

[37] Brown 1988, 357; 359-362 on the differing views held e.g. by Jovinian.

[38] For Augustine's famous account of his conversion see his *Confessions*, book 8.

[39] *On Holy Virginity*, 5, *PL* 40, 399.

[40] Brown 1988, 397-407.

[41] Brown 1988, 407-419.

[42] *On Nature and Grace*, 36.42, *PL* 44, 267.

[43] *Serm*. 51,3, *PL* 38, 334-335.

[44] For an introduction to the huge *oeuvre* of Ephraim, Brock 1983; *The Luminous Eye*; McVey 1989.

[45] McVey 1989, 131.

[46] McVey 1989, 150.

[47] Kelly 1985, 494-499; Pelikan 1996, ch. 4.

[48] For the background, Grillmeier-Bacht 1975².

[49] See n. 16 above.

[50] Constas 1995, 169-194, with full bibliography.

[51] For the date, van Esbroeck 1987, 149-64, n. 2; for its later reception, Constas 1995, 175, n. 24.

[52] Cunningham 1988, 53-67; Caro 1971.

[53] Constas 1995, 177.

[54] Constas 1995, 180-183.

[55] In the case of apse mosaics, Spieser 1998, 63-73, gives a list of known relevant examples.

[56] Cunningham 1988, 53-67.

[57] Translated in Mango 1972, 34-35, Wenger 1952, 54ff.; Baynes 1949a, 87-95; Baynes 1949b, 165-177. For the complex textual tradition and for the Greek texts and French translation, Wenger 1955.

[58] Wenger 1955; Geo. Mon., de Boor, 2, 617.5.

[59] Cameron 1979b, 47.

[60] For the early icons of the Virgin in Rome, Belting 1994, 63-72, 115-124.

[61] *Age of Spirituality*, no. 477 and pl. XIV.

[62] For the apse mosaics, Spieser 1998, 63-73.

[63] Alexiou 1974; Alexiou 1975, 111-140.

[64] Kuhn and Tait 1996, I.

[65] Jugie 1944; Wenger 1955; Cameron 1978, 95ff. The source for Maurice's regularization is late: Nikephoros Kallistos. *HE* 17.28, who despite the dating in fact puts it in the context of the reign of Justinian. The belief itself was already well established, and a homily by Theoteknos of Livias on the Assumption (Wenger 1955, ch. 2) probably dates from the 6th century.

[66] For their many versions, Wenger 1955; Van Esbroeck 1995.

[67] Jugie 1913, 308ff.; Sophia: Corippus, *In laudem Iustini* II.52-69, on which see Cameron 1978, 82-84.

[68] Evagrius, *HE* 4.36; also in Gregory of Tours, *De gloria martyrum* 9; 8, 10, 19. The Virgin's power is regularly associated in the texts with the discomfiture of Jews.

[69] Cameron 1979b; Wenger 1955, 116-18. Speck 1980, 57-58 rightly points out the assimilation in later texts of the Virgin's role in the attack of 619 and the siege of 626.

[70] Speck 1980, 53-54.

[71] For the development of the latter, Belting-Ihm 1976.

[72] Trypanis 1968, 17-39.

[73] Bonn 725-726, 716 (trans. Whitby and Whitby 1989, 169ff., with notes ad loc.).

[74] Sternbach 1900.

[75] *Bell. Avar.* 1-9, Pertusi 1959; also *Anth. Pal*. I, 120-121.

[76] Belting 1994, 58-63; some extracts: Belting 1994, 495-498; Speck 1980, 58-59; Frolow 1944, 16-27.

15

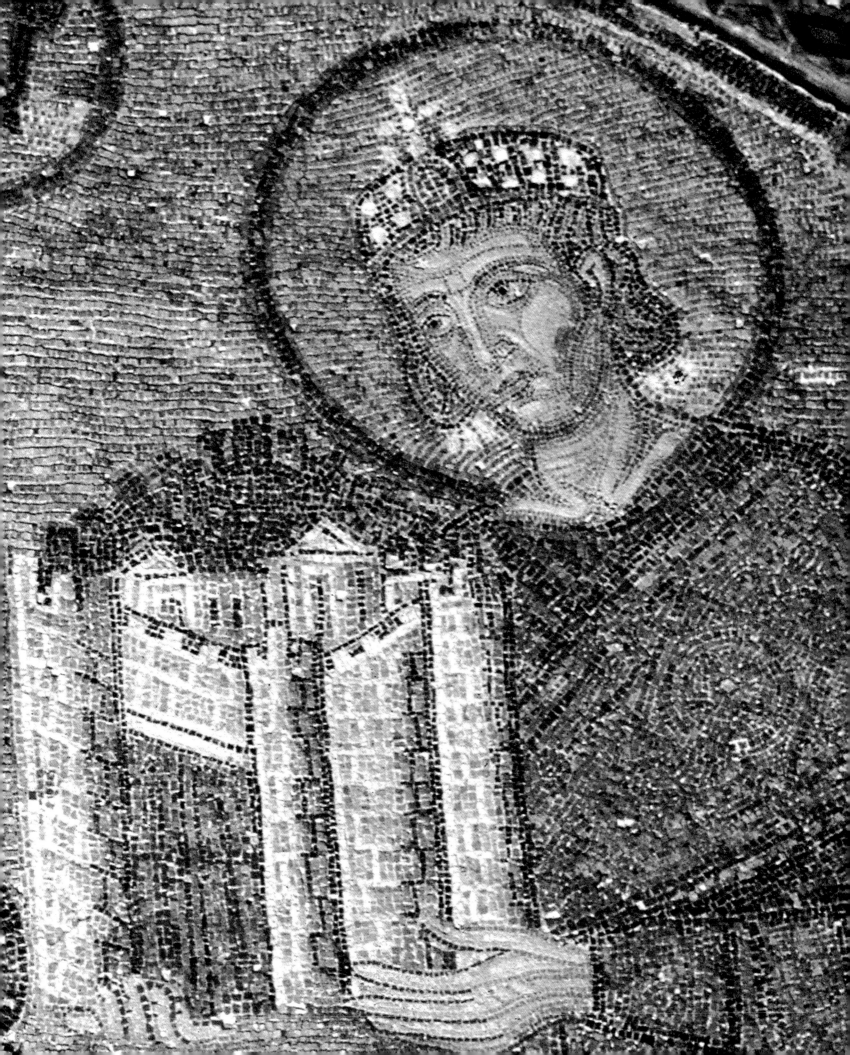

Constantinople as Theotokoupolis

When the pilgrim Egeria stopped at Constantinople on her return journey from the Holy Land (384), she was impressed by the city's numerous churches, but did not single out any one of them for special comment. She did not fail, however, to visit the *famosissimum martyrium* of St Euphemia across the water at Chalcedon, evidently the most important pilgrim attraction of the conurbation.[1]

In about 425 a semi-official statistical account of the city, the *Notitia urbis Constantinopolitanae*, lists twelve churches. Three of them are called martyria (St Menas, St Acacius and the Holy Apostles), three have abstract names (Irene, Anastasia, Homonoea), three descriptive names (*ecclesia magna*, *ecclesia antiqua*, Caenopolis), one is designated by the name of Bishop Paul (who ruled intermittently between 337 and 351) and two are nameless.[2] None is dedicated to the Virgin Mary. Yet two centuries later Constantinople (Pl. 8) had become, so to speak, a terrestrial fief of the Theotokos. When and how did that transformation happen?

A complete answer is not within our reach for the simple reason that popular devotion does not lend itself to objective analysis, especially after a lapse of fifteen centuries. There are, however, certain tangible manifestations that are susceptible to study: the construction of Marian churches, the presence or absence of relics and renowned icons, the institution of feasts and processions, the composition of sermons and hymns, the incidence of reported miracles. In this essay I shall comment on only some of these tell-tale indications with particular emphasis on the formative period, which I am placing between about 425 and about 625. By the ninth/tenth century the Constantinopolitan myth of the Theotokos was complete in its essentials, and I shall stop at that point.

Let us begin at the two ends of the period I have indicated. In a well-known passage the Church historian Sozomen eulogizes Constantinople for being, as he puts it, conducive to faith in Christ.[3] Many of its Jewish inhabitants, he says, and nearly all who were pagan had converted to Christianity. Unsullied by pagan altars and sacrifices, it deserved the name of Christoupolis. Indeed, God himself confirmed the founder's purpose by working miraculous apparitions (ἐπιφανείας) in the city's churches, which were thereby proved to be salutary. And Sozomen goes on to describe at some length the most famous example of such supernatural phenomena associated with the Michaelion at Hestiai on the European side of the Bosporos. He had experienced them himself and names two further witnesses of distinguished status, an advocate and a physician, who had been healed by the Archangel.

Later on Sozomen mentions[4] a second centre of supernatural potency, namely the church of Anastasia. This started as a small house chapel in which Gregory of Nazianzus had famously preached. Not long thereafter, probably under the Patriarch Nektarios (381-397), a big basilica was added to the chapel and it was there that the divine manifestations took place. A certain *dynamis* would appear both when one was in a waking state and in dreams, and cured many people of various ills. 'It is believed (πιστεύεται) that this is Mary, Christ's Mother, the holy Virgin, for she appears in that guise (τοιαύτη γὰρ ἐπιφαίνεται).'[5] There follows a story about a pregnant woman who once fell down from the gallery in the course of a service and was revived from the dead by the prayers of the congregation.

7. *Constantine the Great Offering the Walls of Constantinople to the Virgin*, detail of Pl. 10.

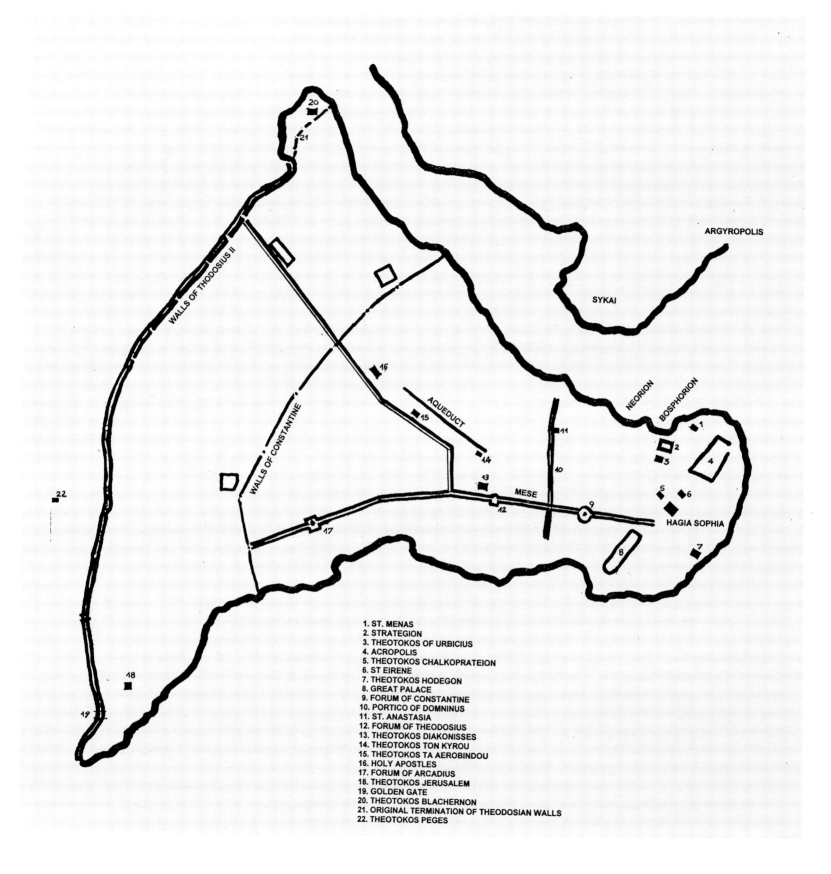

ARGYROPOLIS

SYKAI

WALLS OF THODOSIUS II

WALLS OF CONSTANTINE

AQUEDUCT

NEORION

BOSPHORION

20

21

22

16

15

14

13

11

10

MESE

12

9

5 6

3

2

1

4

HAGIA SOPHIA

8

7

17

18

19

1. ST. MENAS
2. STRATEGION
3. THEOTOKOS OF URBICIUS
4. ACROPOLIS
5. THEOTOKOS CHALKOPRATEION
6. ST EIRENE
7. THEOTOKOS HODEGON
8. GREAT PALACE
9. FORUM OF CONSTANTINE
10. PORTICO OF DOMNINUS
11. ST. ANASTASIA
12. FORUM OF THEODOSIUS
13. THEOTOKOS DIAKONISSES
14. THEOTOKOS TON KYROU
15. THEOTOKOS TA AEROBINDOU
16. HOLY APOSTLES
17. FORUM OF ARCADIUS
18. THEOTOKOS JERUSALEM
19. GOLDEN GATE
20. THEOTOKOS BLACHERNON
21. ORIGINAL TERMINATION OF THEODOSIAN WALLS
22. THEOTOKOS PEGES

8. *Topographical Map of Constantinople.*

To my knowledge, this is the first appearance of the Virgin Mary as an active miracle-worker at Constantinople. It may be noted that in the eyes of Sozomen, a highly educated man writing in the 440s, piety was no longer sufficient: it needed to be validated by miracles. Both cult centres he mentions worked by a process of incubation. The Michaelion was the older of the two and may, indeed, have gone back to pre-Christian times,[6] whereas the Anastasia church could not have acquired its miraculous reputation before it was enlarged, i.e. AD 400 at the earliest. The Virgin Mary — I do not know if there is any significance in the fact that Sozomen calls her Mother of Christ rather than Mother of God[7] — was not here on home ground in the sense that the church was dedicated not to her, but to an abstraction (Resurrection, or so the name was understood at the time). A little later it was renamed St Anastasia, after the relics of the homonymous saint had been translated to it from Sirmium,[8] and it remained for several centuries a centre of healing by incubation, specializing in cases of magic, poisoning and insanity, but no longer under the auspices of the Virgin.[9]

There is no clear evidence that in the days of Sozomen any more than in about 425 there existed at Constantinople a single church named after the Theotokos.[10] According to later legend the first such church within the walls was built by Kyros,[11] who was Urban Prefect in 426 and 439-441 and concurrently Praetorian Prefect (439-441), and while it is probably true that he did build a church known as Theotokos τῶν Κύρου,[12] the date of its foundation remains unknown. After being dismissed from office and serving as Bishop of Kotyaion (Kütahya), he returned to Constantinople and lived on until after 462, devoting himself to good works.[13] It may well be that he built the church in the 450s or 460s.[14] There is no indication that it was particularly lavish.

The attribution to the Empress Pulcheria (d. 453) of three important Marian churches, those of Blachernai, Chalkoprateia and the Hodegoi,[15] is in my opinion unhistorical. I have discussed this matter elsewhere[16] and shall here summarize my conclusions:

1. At Blachernai, which was at the time outside the walls, a reliquary chapel (soros) was built shortly before 475, almost certainly by the Empress Verina to house the famous relic of the maphorion. I see no reason to doubt that the latter was brought to Constantinople from a village near Nazareth in the reign of Leo I (457-474). A big basilica measuring about 50 by 23 m was added by Justin I.

2. The Chalkoprateia church, concerning which several conflicting traditions may be found in the sources, was built by the same Verina, perhaps after 474.[17]

3. The church of the Hodegoi, which was to acquire great fame from the twelfth century onwards, is never mentioned before the ninth.[18]

These conclusions are a little surprising, especially when we remember that in Rome the stupendous basilica of Santa Maria Maggiore was built by Pope Sixtus III (432-440). Why was Constantinople so comparatively slow to react to the enhanced status of the Virgin Mary proclaimed by the Councils of Ephesus and Chalcedon? And why was the response in architectural terms so modest? The church of the Chalkoprateia measures only some 30 by 20 m. Can it be that anti-Nestorian feeling was not as prevalent as it is usually represented? In any case, the somewhat disreputable Verina, rather than the virginal Pulcheria, emerges as the chief promoter of Marian devotion in the fifth century.

Turning briefly to relics, I have already expressed qualified acceptance of the translation of the maphorion. The story was in circulation in the sixth century and, although its chronology is a little shaky, it contains nothing that is inherently implausible, even if its protagonists, the 'patricians' Galbius and Candidus, are not attested. It may be simply that legend elevated them to patrician rank. The other principal Marian relic of Constantinople, the girdle or cincture (ζώνη), kept in the Chalkoprateia church, was a much more dubious article. All that need be said about it here is that it is first attested in the early eighth century and that it was represented as a companion piece of the maphorion, sharing the same origin.[19] A second zone was brought from Zela (south of Amaseia) in or about 942.[20]

We may now advance to our terminal date and consider a key text, the sermon In depositionem pretiosae vestis by Theodore Synkellos, a high patriarchal official.[21] The sermon was occasioned by

recent events, 'which all of us who inhabit this great God-guarded city have witnessed and seen', namely the unexpected Avar raid of June 623, in the course of which the Emperor Herakleios was nearly captured and the environs of Constantinople were devastated. Before alluding to these events, the author tells us that Constantinople was adorned with numerous churches, of which the majority were of the Virgin Mary, so much so that it deserved the name of Theotokoupolis. 'One can hardly find a public place, an imperial palace, a pious establishment or an official's residence that does not have a church or chapel of the Theotokos.' Of all of them the church of Blachernai was the head and metropolis; it was so famous that in other cities, too, people had named their churches Blachernai.[22] The one at Constantinople performed numberless cures. Emperors, bishops and their subjects hastened thither to offer thanks for benefits received.

After alluding to the founding of Byzantium by the Megarians[23] and retelling the familiar story of Galbius and Candidus, Theodore goes on to the recent events which his audience had witnessed. The Empire was in a bad way; former prosperity had led to carelessness, which was now being punished by God. In particular, barbarian 'locusts' had destroyed the suburbs of the city. The emperor (who, incidentally, had fled rather ignominiously from the Avars) lay prostrate in the church of the Virgin Mary called Jerusalem,[24] inside the Golden Gate. Fear was expressed that the barbarians, whose movements were as yet unknown, would come back and remove the precious ornaments of Blachernai and so a body of soldiers was detailed to salvage them. They hacked away hastily the silver and gold and dared to lay their hands on the holy *soros*, which they opened. The Patriarch Sergios intervened: he sealed the reliquary and had it removed to the sacristy of Hagia Sophia. When the danger had passed, he appointed a day for the relic's redeposition. Amidst a great concourse of people the sealed *soros* was carried to Blachernai and opened to reveal the *maphorion* wrapped in a piece of imperial purple. It was put back in its place and Sergios celebrated mass in the sanctuary of the *soros* (here the chapel), which he had restored in the meantime.

The importance of this sermon for us lies in the fact that it predates the great siege of 626, having been delivered probably in 624 or 625 on the anniversary of the redeposition. No miracle is claimed on behalf of the *maphorion*: it had not put the enemy to flight, but was itself carried to safety and brought back when the danger had passed. It was not, therefore, the 'miracle' of 626 (of which more below) that launched the Virgin Mary as heavenly patron of Constantinople: she had acquired that status earlier.

When we examine the period between about 460-470 (when the first major Marian shrines were put up) and 625, we find a steady spread of the cult unpunctuated by any dramatic developments. The following catalogue is not meant to be exhaustive.

Possibly before 500 was built at the Strategion (still the commercial centre of the city), the important church of the Virgin Mary named after Urbicius,[25] the long-serving *praepositus sacri cubiculi*, who is also recorded to have donated (in 504-505) 10 lbs of gold to the Bishop of Edessa to build a church of St Mary.[26] The same Urbicius obtained in Jerusalem a rock on which the Virgin Mary was believed to have rested on her way to Bethlehem. He had it shaped into an altar, with the intention of conveying it to Constantinople, no doubt to deposit it in his church, but his design was miraculously frustrated. The altar was installed instead in the church of the Anastasis at Jerusalem and Constantinople was deprived of a relic that might have acquired great fame.[27]

The Patriarch Timothy (511-518), who was a Monophysite, is credited with organizing a weekly procession (λιτή) at the church of Chalkoprateia.[28] At about the same time Anicia Juliana, an ardent Chalcedonian, built a church of the Virgin Mary at Honoratai, an Asiatic suburb.[29] Lists of Constantinopolitan monasteries, dated 518 and 536, include seven establishments dedicated to the Virgin Mary, more than to any other saint.[30]

Justin I, as we have seen, built the Blachernai basilica, which was to remain the biggest of all Marian churches at Constantinople. This was clearly a *démarche* of major importance. The church,

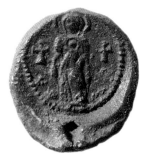

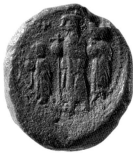

9. *Lead seal from the reign of Herakleios* (610-641). Numismatic Museum, Athens, Inv. no. 1909/10. ΚΘ´ 1.

though extramural, adjoined a palace to which the imperial court often repaired on its *processus*[31] and was served by a numerous clerical establishment.[32]

Justinian is represented as being particularly devoted to the Theotokos[33] and built in her honour the famous extramural church of the Source (which later tradition attributed to Leo I), another at Hiereia, where there was also an imperial palace, and one dedicated to St Anne at Deuteron. We may note the prophetic statement of Procopius[34] that the churches of Blachernai and Pege (the Source), marking as they did the two ends of the Land Walls — a slight exaggeration in the case of Pege —, were to serve as 'invincible safeguards of the city's enclosure' (ἀκαταγώνιστα φυλακτήρια τῷ περιβόλῳ τῆς πόλεως). This is clear evidence of a belief in the Virgin's role as protector of the city already in the reign of Justinian. As we shall see, the two shrines singled out by Procopius were to assume a miraculous role in the siege of 626. A chapel of the Theotokos in the imperial palace, presumably the one later called πρωτόκτιστος,[35] hence relatively ancient, is of uncertain date, but surely existed by 626.[36]

Justin II and Sophia remodelled the Blachernai basilica[37] and redecorated that of Chalkoprateia.[38] Much has been made of two passages of Corippus's *In laudem Justini* (composed in 566). In the first (I.32-65) the Virgin, *purpureas velata comas oculisque benigna*, appears in a dream to Justin to announce his (wholly expected) accession to the throne and place the crown on his head. In the second (II.52-69), after a prayer addressed to God by Justin in a chapel of St Michael (surely in the palace), Sophia repairs to a church of the Virgin Mary (unfortunately unnamed) and prays to her, laying stress on her role as protectress of the Empire (*tutare imperium... vestro semper tutamine vivam*). In spite of arguments to the contrary,[39] I do not see that there is anything startlingly new here, i.e. anything that could not have been expressed before the second half of the sixth century.

Rather more significant is the first appearance of the Theotokos in the place of the traditional figure of Victory on the reverse of imperial lead seals. This change seems to date from the last years of Justin II. Initially, the Virgin was represented in bust with the Christ-Child placed frontally in front of her breast, but subsequently a full-length figure was adopted and the Child was enclosed in a mandorla (Pl. 9).[40] Two explanations may be envisaged: either the Virgin was meant to represent the guarantor of imperial victory or the adoption of that particular iconographic type (the one later identified as the Blachernitissa) carried an anti-Monophysite message, as I tentatively suggested on a previous occasion.[41] To be more precise, the inclusion of the Child in a mandorla marked him off as belonging to the realm of the divine, thus underlining the notion of the ἀσύγχυτον, the union of the two natures without confusion, on which the Chalcedonians insisted.

In 577, the Patriarch Eutychios, on being restored to his throne, stopped a plague by organizing an expiatory procession from Hagia Sophia to Blachernai.[42] Under Maurice were built the Marian churches τῆς Διακονίσσης (by Patriarch Kyriakos) and τὰ Ἀρεοβίνδου.[43] The luxurious monastery of Chrysopolis, founded by Maurice's brother-in-law Philippicus, was also dedicated to the Theotokos.[44] A poorly attested tradition ascribes to Maurice the institution of the feast of the Koimesis (Dormition).[45] Finally, it is alleged that when Herakleios arrived at Constantinople to oust Phokas (610), he had icons of the Theotokos affixed to the masts of his ships.[46] That brings us to the Avaro-Persian siege of 626. We have three contemporary accounts of that event[47] and all three credit the Virgin Mary with the city's salvation. We are dealing, therefore, not with a later story, but one that gained immediate acceptance on the part of eyewitnesses. Nor is that surprising. Fervent prayers had been addressed to the Theotokos, her images had been displayed on the city gates,[48] the besieged had been dispirited and probably had little hope of coming out alive; yet, against all expectation, they were saved. But what exactly was the miracle? Setting aside the fanciful report that the Chagan of the Avars had seen a lone woman in 'decorous' attire rushing round the walls,[49] the following events were singled out. The Slav allies of the Avars launched a multitude of *monoxyla* into the far end of the Golden Horn and these were destroyed with much loss of life by units of the Byzantine fleet. The massacre of the Slavs occurred directly in front of the Blachernai shrine. There was also a minor skirmish near the church of St Mary of Pege in which the Byzantines had the upper

hand. Finally, we are told that the enemy had entered the Blachernai church, but were divinely prevented from causing any damage in it. Hardly a string of miracles in the ordinary sense of that word. At a later time the story was improved: the Slav canoes were destroyed by a sudden storm and their crews drowned like the Egyptians in the Red Sea. That indeed would have been a miracle on a placid stretch of the Golden Horn in July. We may note one detail. In the course of the procession round the walls organized by the Patriarch Sergios the most sacred object that was carried was not the *maphorion* (which does not appear in contemporary accounts), but an *acheiropoietos* image of Christ.[50] We are not concerned here with the question of which *acheiropoietos* it was.[51] Only in later, embellished accounts is it accompanied by the *maphorion*, the holy cross and icons of the Virgin.

The intervention of the Theotokos was also used to explain the failure of the next two sieges of Constantinople, those by the Arabs in 674-678 and 717-718. In both cases the 'miracle' consisted in the destruction of the Arab fleet after it had already departed and was at a considerable distance (off the coast of Asia Minor by Sylaion and in the Aegean respectively).[52] Rather more striking were the circumstances of the Russian siege of 860. According to the most widely diffused version of that event, the Patriarch Photios and the Emperor Michael III dipped in the sea the Virgin's *maphorion*, whereupon a storm arose and smashed the ships of the barbarians (as allegedly in 626).[53] But again we have a contemporary source, namely two sermons by Photios himself, and while he confirms that he (but not the emperor) carried the maphorion round the walls, he says nothing about a storm and offers no explanation of the Russians' sudden departure.[54]

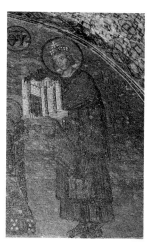

10. *Constantine the Great Offering the Walls of Constantinople to the Virgin.* Detail from the vestibule mosaic in Hagia Sophia, Constantinople.

Even if the notion of the miraculous was treated with considerable elasticity as regards the successive sieges of Constantinople, there can be no doubt that by 860 the fame of the Theotokos as supernatural defender of Constantinople had been firmly established.[55] It is also clear that the main agent of her intervention was the maphorion. Whether the girdle played any part is much less certain.[56] The absence of any major miraculous icon is, however, striking. Indeed, in the period before Iconoclasm we do not find at Constantinople an icon of the Theotokos that enjoyed a measure of renown. In writing to Thomas of Claudiopolis shortly before 726, the Patriarch Germanos cites only one well-authenticated miraculous icon, that of the Virgin Mary at Sozopolis in Pisidia, and even that one, he admits, had ceased to function.[57] If such a miraculous icon had existed at Constantinople, he would not have failed to mention it. Nor do we find at Constantinople any early trace of an icon allegedly painted by St Luke, identified with that of the Hodegetria in a much later period.[58] As for the Blachernitissa, the only relatively early reference known to me occurs in the Life of St Stephen the Younger, where the saint's mother, who had no male child, is represented as praying to it so as to conceive a son. The Virgin, we are told, was pictured carrying the Christ-Child in her arms and appeared to the woman in a vision, looking just as she was painted, to reassure her that she would have a son.[59] This is alleged to have happened in 714, but we are dealing here with an openly tendentious iconophile tract written nearly a century later.

The evidence we have examined suggests the following observations:

1. The first wave of major Marian church-building at Constantinople took place in the 460s and 470s, i.e. in the reigns of Leo I and Zeno. It was, incidentally, at the same time that the ancient temple of Cybele at Kyzikos was converted into a church of the Theotokos;[60] possibly also the Parthenon of Athens.[61]

2. Initially, Mary's role at Constantinople was associated with healing. The Blachernai church, too, was primarily a healing shrine as stressed by Theodore Synkellos and confirmed by George of Pisidia.[62] That is in line with the pattern of popular religiosity in the capital as known from numerous other sources. Within the ritual of healing, icons played some part (at least from the sixth century onwards), but not a major part. The presence of relics was more important.

3. Not later than the reign of Justinian the Theotokos became identified as a (or the) supernatural defender of Constantinople. It is difficult to be more precise because several relevant texts are either of uncertain date or admit both of a general and a more specific interpretation. When Romanos

the Melodos addresses the Virgin Mary as τεῖχος καὶ στήριγμα... ἣν πᾶς Χριστιανὸς ἔχει προστασίαν,[63] is he stating a general truth or one having a more particular application to Constantinople? There can be no such doubt about an early *kontakion* to the Holy Fathers, which says of Constantinople,

> καὶ τῆς Θεοτόκου τιμίαν ἐσθῆτα φρουρεῖ,
> ὑφ' ἧς καὶ μᾶλλον σκέπεται
> λέγουσα· Δέσποινα, ὥσπερ παιδίσκην
> ὑπὸ τὰς χεῖρας σου ἀεὶ μὲ φύλαξον,
> ὃν τρόπον καὶ ἤδη ἐρρύσω μαχαίρας
> καὶ οὐκ ἀπώσω τὴν προσευχήν μου.
> τοὺς ἐχθρούς μου ἀπέστρεψας, καὶ ἔφυγον οἱ διώκοντες.

> 'It guards the precious garment of the Theotokos,
> by which it is protected all the more,
> saying, "Lady, do always preserve me like a maidservant
> under your arms,
> in the manner you have already delivered me from the sword
> and did not reject my prayer.
> You have turned away my enemies, and the pursuers have fled".'

Paul Maas wished to date this text before 548,[64] whereas other scholars have seen in it a reference to the siege of 626.[65] We cannot be certain, especially when we remember that Constantinople had suffered serious threats that are less familiar to us, e.g. the Bulgar incursion of 540, when special measures were taken to secure the imperial palace and all trees to a distance of 100 cubits from the Land Walls were felled.[66] Then there was the Kotrigur invasion of 559. We do not know if the Theotokos intervened on these occasions. What we do know is that her aid was invoked by Justinian's architect Victorinus to protect the fortifications of the isthmus of Corinth, which he helped construct.[67]

In the texts we have examined so far one question has been left in suspense: setting aside the presence of the *maphorion*, what historical connection was there between Constantinople and the Theotokos? Even the learned Theodore Synkellos did not find it necessary to fill that lacuna. Eventually, two alternative explanations were offered. The first, which enjoyed little success, used the Apostle Andrew as a peg. Since the sixth century it was told that the widely-travelled apostle had stopped at Byzantium on his way either to or from the Black Sea coast and Scythia.[68] According to one version, he was unable to enter the city because its governor, called Zeuxippos (*sic*), had the nasty habit of throwing all Christians in the sea. So Andrew had to be content with dwelling in a neighbouring settlement called Argyropolis (modern Tophane), where he made 2,000 converts and ordained Stachys as their bishop.[69] The story was later emended: Andrew did enter Byzantium and built next to its acropolis a chapel of the Theotokos in a district later called *ta Armasiou* (rather than *ta Armatiou*).[70] This version is found in the Life of St Andrew by the monk Epiphanios, which dates from the period of the Second Iconoclasm.[71] It was picked up later by Niketas David the Paphlagonian.[72] The chapel, small, but well built, was still to be seen in the tenth century. Eventually, the story found its way into the printed Menaia (30 November),[73] with the comment that by founding this chapel Andrew made the Theotokos guardian and πολιοῦχος of the Orthodox Empire that was to come later.

A second explanation proved to be more credible: it was Constantine who dedicated his city to the Theotokos. To be more precise, Christ appeared to him at the vision of the Milvian Bridge and said, 'You will build a city for my mother, the Theotokos Maria, towards the rising sun in the place I will indicate to you'. Constantine, after first choosing Thessaloniki, then Chalcedon, was

supernaturally directed to Byzantium. This story, still absent from the ninth-century chronicle of George the Monk, is found in the so-called Patmos legend of Constantine,[74] the chronicle of pseudo-Symeon,[75] that of Kedrenos[76] and later sources. The late Alexander Kazhdan considered it an iconophile invention directed against Constantine V, who allegedly held the Theotokos in low esteem.[77] He was certainly accused of harbouring such impious feelings, yet the *maphorion* did survive Iconoclasm unharmed. The Constantinian dedication is depicted in the famous mosaic (Pls. 7 and 10) of the southwest vestibule of Hagia Sophia[78] and so may be said to have gained official sanction. At the cost of what to us appears a glaring anachronism, the myth of Theotokoupolis finally acquired a satisfying coherence.

[1] *Itinerarium*, 23.7-9.

[2] Seeck 1876, 229-243.

[3] Sozomenos *HE* (Bidez and Hansen 1960), II. 3.7-13.

[4] Sozomenos *HE* (Bidez and Hansen 1960), VII.5.1-4.

[5] Probably meaning that she was clad in purple. For other mentions of this costume, Chadwick 1974, 65, n. 5.

[6] Cf. my remarks in Mango 1984, 59ff.

[7] That was the formulation favoured by Nestorios. E.g., his *Livre d'Héraclide de Damas*, trans. Nau 1910, 92. The loss of the final part of Sozomen's History prevents us from judging his attitude to Nestorianism, which is not likely to have been positive considering his fulsome praise of Pulcheria.

[8] Theophanes, de Boor, 111 (first year of Leo I); *Vita Marciani oeconomi*, in Papadopoulos-Kerameus 1897, IV, 260, 262 (deposition of relics without any mention of Sirmium); *PG* 86/1, 216B as from Theodore Anagnostes; Cedrenus (Bonn) I, 608 and other chronicles. For the church see most recently Wallraff 1998, 1-29; Snee 1998, 158ff.

[9] Anastasia's epithet φαρμαϰολύτρια has caused some puzzlement. It may be due to the tradition that she was imprisoned as a magician (*veluti maga atque sacrilega*). Delehaye 1936, 223.

[10] I cannot attach much weight to the statement of John Rufus on the authority of Peter the Iberian that Nestorios (428-431) made disobliging remarks about the Virgin Mary in a church called Maria: *Plérophories*, Nau, *PO* VIII/1 (1912), 12. The anecdote obviously gained in piquancy by being placed in such a setting.

[11] The legend is edited by Gedeon 1900, 127ff.

[12] This is confirmed by Theophylact Simocatta, 8.8.11. Note also an inscription from Miletus, attributed to the late 5th or the 6th century, reading, [τῆς δεσποί/νης ἡμῶν τῆς ἁγίας ἐνδόξου Θεοτόϰου ϰαὶ ἀειπαρθένου Μαρίας τῆς εἰς τὰ Κύρρου: Gregoire 1922, no. 224. It may have been set up by a member of the clergy of that church.

[13] *Cyrus* 7 in *PLRE*, II.

[14] The allegation that Kyros was dis-

missed from office (shortly after 441) on the grounds that he was a pagan does not square with his having built a church at an earlier date.

[15] Theodoros Anagnostes (Hansen 1995²), *Epitome*, no. 367, 102. I regard the passage in question as a late interpolation.

[16] Mango 1998, 65-66.

[17] *Nov.* 3.1 (a. 535). A hagiographic text of the early 9th century attributes the construction to Zeno, which is possible seeing that Verina retained her authority at Constantinople until 478. Lackner 1985, 850.

[18] Angelidi 1994, 114-115.

[19] Setting aside an alleged *troparion* by Maximus the Confessor, preserved only in Georgian, the earliest piece of evidence is a sermon by Patriarch Germanos (715-730), *PG* 98, 372ff., which associates it with the infant Christ's swaddling clothes (376A-B). The fiction of its having been brought to Constantinople in the reign of Arcadius (395-408) first appears in an Encomium by Euthymios, the future patriarch (907-912), in Jugie, *PO* XVI (1922), 511; cf. Menol. Basilianum, 31 Aug., *PG* 117, 613. I do not know why van Esbroeck 1988, 182, associates the girdle with the winding sheet at Gethsemane, 'quoi qu'on en pense à première vue'.

[20] *Synaxarium CP* 12 April, 600: in the year 6450 in the reign of Constantine and Romanos born in the purple. In 942 Romanos Lekapenos was still on the throne, whereas Romanos II was not crowned until 945. The famous Limburg reliquary contained fragments of both the Chalkoprateia and the Zela girdles.

[21] Theodore Synkellos (Combefis 1648), 751-786.

[22] Notably at Ravenna and Cherson, although the author may have been thinking of other cases.

[23] Combefis 1648, 755D-E, naming a certain Deinias, rather than the more familiar Byzas, as the founder. The relevance of this brief excursus is not immediately apparent.

[24] First attested as a monastery in 518. Janin 1953, 185-186, who misses the present reference.

[25] It is singled out in a Novel of Herakleios concerned with the limitation of clergy: Zepos, *Jus*, I, 31. It was in its baptistery that the future Patriarch Eutychios received his clerical tonsure: Eustratius presbyter, *Vita Eutychii*, *CCSG* 25 (1992), 14-15.

[26] *The Chronicle of Joshua the Stylite*, Wright 1882, 87.

[27] Theodosius, *De situ Terrae Sanctae*, 28, O. Geyer ed., *CSEL* 39, 148-149.

[28] Theodoros Anagnostes, *Epitome* 494, 140.

[29] Theophanes, 158. Mentioned in an epigram on the frame of Juliana's portrait in the Vienna Dioscorides MS. Premerstein et al. 1906, 12ff.

[30] In all, there are eight lists: *ACO* III (1940), 33ff., 44ff., 68ff., 128ff., 142ff., 150ff., 163ff., 172ff.

[31] Mansi VIII, 946 regarding the Council of 536.

[32] In the early 7th century the Blachernai had a clergy of 68 plus 6 janitors, an exceptionally high total, next only to that of the cathedral: Zepos, *Jus*, I, 29, 30. We do not know what the number was in Justinian's time because the relevant Novel of that emperor (3.1) speaks only of the cathedral clergy. All other churches financed from central funds were enjoined not to appoint clergy additional to the founder's *statutum*.

[33] Procopius, *De aedificiis*, 1.3.1.

[34] Procopius, *De aedificiis*, 1.3.9.

[35] *De Cerimoniis*, Bonn I.1, 7. Cf. I.9, 71 and I.32, 174 (church of the Theotokos in the Daphne).

[36] Theodore Synkellos, *Hist. Avarorum* (Sternbach 1900), 303.

[37] Theophanes, 244; *Anthol. Pal.*, I.2-3.

[38] Lackner 1985, 851.

[39] Cameron 1978, 81-108.

[40] For a summary of the evidence Seibt 1987, 36-37.

[41] Mango 1993-1994, 168.

[42] *Vita Eutychii CCSG* 25 (1992), 75.

[43] *Theophanes*, 277.

[44] *Theophanes*, 272.

[45] Nikephoros Kallistos, *HE*, XVII.28, *PG* 147, 292A.

[46] *Theophanes*, 298, quoting George of Pisidia as his source. The latter, however (*Heraclias*, II.13ff., Pertusi 1959, 252), says nothing about ships or masts.

[47] The *Bellum avaricum* by George of Pisidia, the sermon (*Hist. Avarorum*) by Theodore Synkellos and the *Chronicon Paschale*.

[48] *Hist. Avarorum*, (Sternbach 1900), 304.

[49] *Chron. Paschale*, (Bonn), 725.

[50] *Hist. Avarorum*, 305: τοῦ μονογενοῦς Θεοῦ τὸν τύπον... φασὶ δὲ τοῦτον τὸν ἀχειροποίητον. Pisides, *Bell. avaricum*, 373: τὸ φρικτὸν εἶδος τῆς γραφῆς τῆς ἀγράφου.

[51] Lengthy discussion by van Dieten 1972, 174-178, who suggests it may have been the obscure *acheiropoietos* of Melitene, of which there is an account in *Synaxarium CP*, 883-884.

[52] *Theophanes*, 354, 397-398.

[53] Leo Grammaticus, (Bonn), 240-241 and other chronicles of the Logothetes family.

[54] See discussion of sources in Mango 1958, 74ff.

[55] The oft-quoted study by Baynes 1949b, 165-77, rightly underlines the function of miracle as a historical factor, but does not investigate the development of the myth.

[56] This is claimed in the anonymous *Encomium on the Deposition of the Precious Girdle*, Combefis 1648, II, 799C. Germanos, *PG* 98, 377B is less specific: the girdle guards the city, βαρβαρικῆς ἐπιδρομῆς ἀνεπιβούλευτον διασώζουσα.

[57] *PG* 98, 185A-B. The icon of Sozopolis was famous for exuding oil from its painted hand. This substance must have been exported, seeing that Patriarch Eutychios used it at Amaseia when he was in exile there, i.e. between 565 and 577: *Vita Eutychii*, *CCSG* 25 (1992), 42. A little later Theodore of Sykeon went on pilgrimage to Sozopolis and was cured by the gushing oil of an eye disease: Festugière 1970, ch. 106, 108.

[58] The statement in Theodoros Anagnostes, *Epitome*, 353, 100, that Empress Eudokia sent to Pulcheria from Jerusalem an image of the Theotokos painted by St Luke is certainly an interpolation. In the fragment entitled *De sanctarum imaginum veneratione*, attributed to Andrew of Crete, *PG* 97, 1304, icons painted by St Luke are said to be preserved at Rome and Jerusalem, hence not at Constantinople. For a possible date of the latter work (730-740?), Auzépy 1995b, 7. The tradition that St Luke painted a portrait of the Theotokos was allegedly quoted by monks of the monastery of the Abramites in front of Emperor Theophilos, but without reference to the existence of such a portrait at Constantinople: Theophanes Continuatus (Bonn), 101.

[59] Auzépy 1997, 92-93.

[60] *Malalas* (Bonn), 77-78; *John of Antioch*, fr. 15 in Müller, *Fragm. hist. graec.*, IV, 548.

[61] Cf. my remarks in Mango 1995, 201-203.

[62] *Anthol. Pal.*, I.121: ἐνταῦθα κρουνοὶ σαρκικῶν καθαρσίων / καὶ ψυχικῶν λύτρωσις ἀγνοημάτων. ὅσαι γάρ εἰσι προσβολαὶ παθημάτων, / βλύζει τοσαύτας δωρεὰς τῶν θαυμάτων.

[63] Maas and Trypanis 1963, no. 35.10, dated by them before 548.

[64] Maas 1910, 23, 31.

[65] Grosdidier de Matons 1977, 209ff.

[66] This piece of information was recorded only by John of Ephesus, an eyewitness. Pseudo-Dionysius of Tel-Mahre-Witakowski 1996, 83.

[67] Feissel 1988, 136-137.

[68] Earliest mention in Gregory of Tours, *Liber de miraculis Andreae apostoli*, ch. 8 in *Acta Andreae*, *CCSA*, 5 (1989), 587.

[69] So in Pseudo-Dorotheus (6th century?), (Schermann 1907), 146-147.

[70] These two localities need to be distinguished. *Ta Armasiou*, near the martyrion of St Menas at the acropolis (*Synaxarium CP*, 834.32, apparatus), may have been named after Armasius, Praetorian Prefect (East) in 469-470. *Ta Armatiou*, with which it is often confused, was higher up the Golden Horn and was probably named after Armatus, Consul in 476.

[71] *PG* 120, 244C.

[72] *Orat. in laudem Andreae*, *PG* 105, 68-69; *Acta or Laudatio Andreae*, *AB* 13 (1894), 335. The latter text, published as being anonymous, is ascribed to Niketas David in *BHG*, 100. It repeats to a considerable extent the *Vita* by the monk Epiphanios, but contains several interesting additions.

[73] Venice 1889, 206.

[74] Halkin 1959, 79, 83-84.

[75] Halkin 1960, 13, 17-18.

[76] Bonn, I, 495-496.

[77] Kazhdan 1987, 248.

[78] The mosaic is usually ascribed to the end of the 10th century. It is mentioned in a pious tale copied into a MS dated 1021/2. Halkin 1989, 200: μεσαία πύλη... ἐν ᾧ ἄνωθεν αὐτῆς διὰ λεπτῶν ψηφίδων ἐκτετύπωται ὁ χαρακτὴρ τῆς ὑπεραγίας Θεοτόκου.

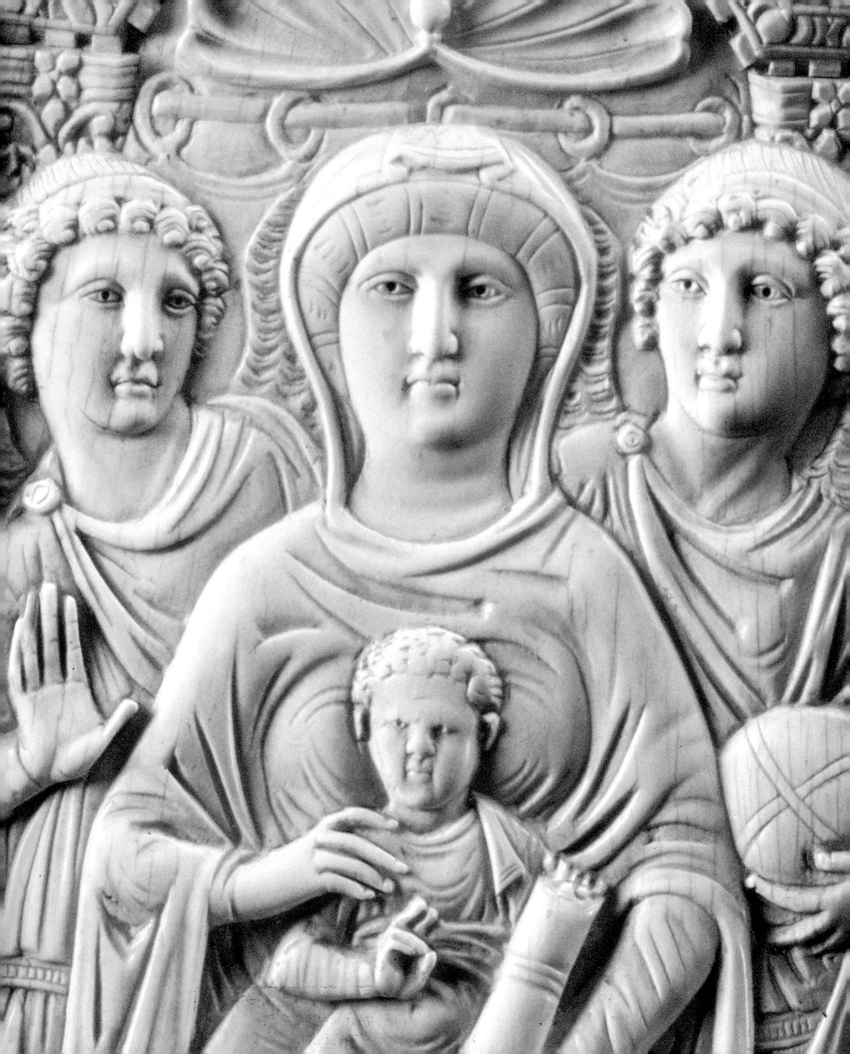

The Mother of God in the Iconoclastic Controversy

The place of the Mother of God in the last of the Christological debates held in Byzantium, the Iconoclastic Controversy, has not yet been clarified, notwithstanding that opinions on the issue have been expressed in the past by George Ostrogorsky and more recently by Kenneth Parry. Ostrogorsky holds that the Iconoclasts were against the cult of the Virgin,[1] whereas Parry believes that Iconoclasts were accused of ascribing excessive honour to the Mother of God.[2] The contradiction between the views of the two scholars is not surprising, especially if one considers the fact that the place of the Mother of God in the Iconoclastic Controversy has not been studied in its own right up to now. Research is made even more difficult by the lack of critical editions of the literary texts of the period, and by the fact that most of the iconoclastic sources were destroyed by the Iconophiles after the Triumph of Orthodoxy in 843. None of the stated opinions resolved the problem, magnified as it is by the complex symbolism of the rhetoric of the time. But there are some facts that should be looked into and evaluated, as they may lead to a resolution of the problem.

The historiographic sources of the Iconoclastic period refer repeatedly to the Mother of God, who is also the main subject matter of most of the homilies written during the eighth and ninth centuries, and of numerous hymns of the same era. Noteworthy too is the place of the Virgin in the hagiographic literature of the time. Moreover, the art produced during the centuries that followed the Restoration of Icons reveals the Mother of God to have been the most favoured subject of painters, who drew endlessly upon the literary texts of the Iconoclastic period for their inspiration. In doing so they introduced new iconographic types such as the Virgin Eleousa, the Virgin of the Passion etc.[3] Both the quantity and the quality of this literary and artistic output make one question the place of the Mother of God, at a time when the predominant topic was undoubtedly the worship of icons. In what way, then, was the Virgin related to icon worship and why do most contemporary literary texts refer at length to her person rather than to icons?

The Mother of God was an object of veneration from the earliest years of Christianity, when the dogma of the Orthodox Church was still evolving. Always connected with the elucidation of the nature of Christ, the honour rendered to the Virgin stresses different aspects of her being in different periods of the history of Byzantium, depending upon the questions engaging the Christological dialectic of the day. These different points of emphasis do not disappear as the relevant periods end; on the contrary, they persist as constituents of the rhetoric surrounding the subject and are accentuated by additional arguments in each. The period of 'typology', that is the period in which the New Testament and those mentioned in it are represented as the continuum of the Old Testament,[4] invests the Mother of God with attributes such as the New Eve and the Burning Bush.[5] These attributes testify to the 'truth' of the Old Testament prophets, for they are corroborated in the New Testament and are adopted by Christian writers in successive centuries.[6] During the Early Byzantine period particular emphasis was lead on the virginity of the Mother of God, by means of which was revealed the miraculous conception of Christ and his theanthropic nature.[7] In the fourth century the Theotokos was used as a model of virginal and thus of monastic life,[8] while in the course of the sixth and seventh centuries the Virgin became the protectress of

11. Virgin and Child.
Detail of Pl. 12.

Constantinople, following the precedent of the ancient Greek Pallas Athena, protectress of the city of Athens.[9]

During the Iconoclastic Controversy, as in the fifth century during which the Council of Ephesus was held, the Theotokos was once again at the centre of the latest Christological dispute in Byzantium (Pls 11 and 12). It should be made clear at the outset what is meant by the term 'Christological dispute' in relation to the Iconoclastic Controversy and what was the connection between the Mother of God and contemporary events. At the core of the conflict that arose over the veneration of icons was the fundamental question about the nature of matter. The Manichaean core of the Christological heresies that had split the Empire during preceding centuries was revealed at this historical moment and posed the question of how could the divine be portrayed on corruptible and evil matter. The place of the Virgin in this dispute is never explicitly set out in the homilies or hymns that were written in her honour during the eighth and ninth centuries. However, taking for the sake of comparison the fifth century in the manner in which the attribute Theotokos (Mother of God) was used at the time to define the proper Christological doctrine, and carefully studying the literary corpus of the period of the controversy enables us to comprehend the symbolism that the Byzantines never needed to explain since it was an intrinsic part of their semantic code.

The Iconoclasts reasoned that their refusal to venerate icons rested on their belief that matter is an unworthy medium for the depiction of the divine. Consequently, even if they were paying only lip-service in countenancing and supporting the concept that honour should be paid to the saints and the Mother of God, in reality the burden of meaning attached to these expressions of faith and the practices associated with them were contrary to the iconoclastic beliefs. The common denominator was of course matter or, rather, the materiality-physicality of these practices. The iconoclast position stresses the spirituality of God and so maintains it is proper that God, who is spirit, should be worshipped in a similarly spiritual manner.[10] It is self-evident that each of the two factions which clashed in the conflict should assert the 'orthodoxy' of its own position and its unbounded devotion to the Mother of God. Irrespective of the interpretation placed on the sources and the conclusion one may draw, it is obvious that the honour to be paid to the Virgin was among the thorny issues in the controversy. Since in her person is imprinted the corporeality of the divine, which embodies matter derived from the Theotokos. Moreover, the reverence shown to Mary was the chief symbol of the metonymic language used by the Iconophiles in their defence of the veneration of icons.

One of the points the Iconoclasts made in their argumentation was that the prohibition of the portrayal of Christ should be extended to the Mother of God and the saints and their relics. The undisputed rendering of honour to the Virgin by the iconoclast faction follows upon the clarification that the Mother of God exists outside the human dimension, because she was overshadowed by the Holy Spirit and it was through her that the inaccessible light shone forth. How, then, can anyone portray, after the 'coarse manner of the Greeks', the being that is higher than the Heavens and more holy than the cherubim?[11] Propositions of this kind have led some scholars to the conclusion that the Iconoclasts paid particular reverence to the Mother of God.[12] The Iconophiles responded to this argument at the Second Council of Nicaea by adopting a highly defensive attitude not to the Mother of God, but to matter.[13] The reason for the shift of emphasis was none other than the inductive reasoning which lies at the heart of Christology: the Virgin is venerated because it was through her that the matter which Christ assumed at his birth, was hallowed.[14]

The entire symbolism of the Mother of God rests upon this line of argument, which is also the reason why the end of the Iconoclastic Controversy and the Triumph of Orthodoxy elevated the Virgin to pre-eminence as the symbol of Orthodoxy, a fact borne out by historiography, literature and art.

The important contemporary historical source, the chronicle of Theophanes, makes frequent

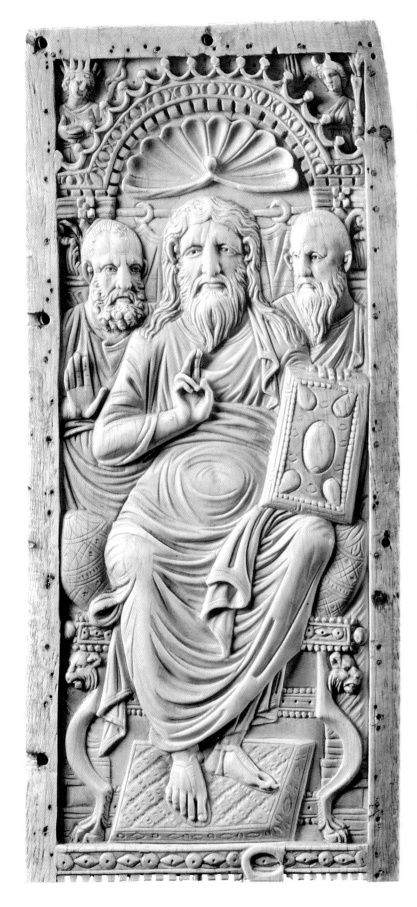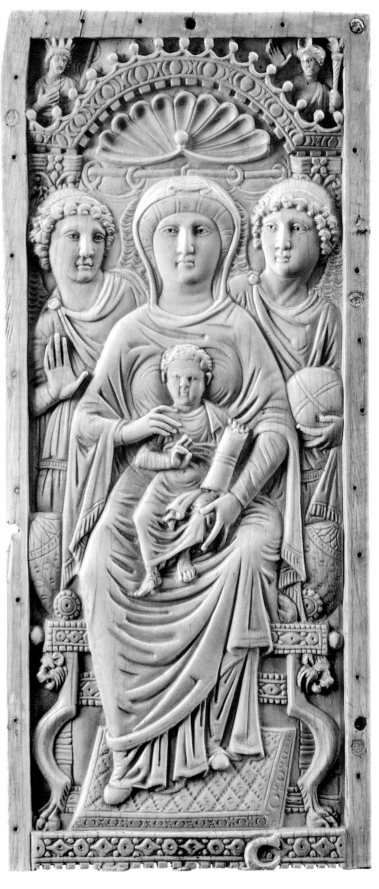

29

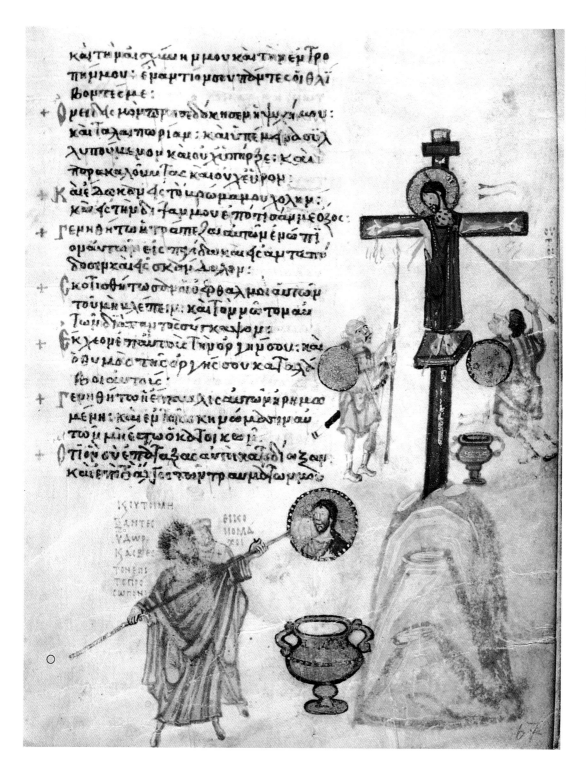

13. *Miniature with the
Destruction of Images
and the Crucifixion*,
9th century.
Chludov Psalter MS gr. 129,
fol. 67r.
State Historical Museum,
Moscow.

mention of the Virgin and her intercessionary role in the deliverance of Constantinople from a variety of dangers. Many of these references concern the period preceding the Iconoclastic Controversy. Besides, by referring to the Virgin as the protectress of Constantinople, Theophanes refers to the mediation of the Mother of God in the war waged by Leo III against the Arabs in 717 and 718.[15] Thanks to Greek fire, in August 717 the Byzantines succeeded in defeating the fleet of the Arab Caliph Maslama, while the following year, after an exceptionally severe winter, the Arabs suffered many reverses which persuaded them that God and the Virgin Mother of God protected the city and the Christian Empire.[16] Besides this, most of the events which Theophanes describes in his chronicle refer to the Virgin during Iconoclasm. The first such event marks the beginning of the controversy, and although it cannot be considered historically reliable, the chronicle is of inter-

est in that it links the veneration of icons with the paying of honour to the Theotokos. The episode in question, which is recorded in other historical accounts, is the well-known story of the siege of Nicaea.[17] During the procession of the icons around the city walls one of Artavasdos's generals, Constantine, observing an icon of the Virgin, picked up a stone and threw it at it. The icon fell to the ground and the general trampled on it. A little later the Virgin appeared to him in a dream and warned him that his action had put his life in danger. Indeed, the next day when the Arabs assaulted the city, Constantine, a courageous soldier, ran towards the walls and was killed by a stone that struck his head.[18] Theophanes ends his account of the incident by stating that Constantine not only opposed the veneration of icons but also rejected the intercession of the Virgin and the saints, and the revering of their relics.[19]

The chronicle contains two other incidents which occurred in the reign of Constantine V Kopronymos. In the first Theophanes recounts that Patriarch Anastasios swore before the people and on a relic of the True Cross that the Emperor Constantine had told him he believed the Virgin Mary did not give birth to Christ, but to an ordinary human being, and moreover that Mary gave birth (to Christ) in the same manner as his own mother had given birth to him.[20] This incident is repeated in the chronicles of George the Monk, Leo Grammatikos, Kedrenos-Skylitzes and Zonaras.[21] Theophanes mentions also that Patriarch Constantine II was asked by Emperor Constantine if it would matter if the Mother of God were to be named 'Christotokos' (Mother of Christ). Taken aback, the patriarch replied by citing the impious Nestorios, who was the first to use the term 'Christotokos' and was anathematized by the Church.[22] The associating of topical 'heretical' doctrines which earlier heresies, such as Patriarch Nestorios's teaching on the Mother of God, was no longer a novelty but, rather, a customary practice, for one opposing faction would accuse the other by attributing to it the position adopted by earlier notorious heretics, preferably ones already condemned by the Church.

George the Monk a most unreliable source, but an interesting one, since he reflects the most extreme iconophile positions, repeats the events recounted by Theophanes, enriches them with detail and other facts that apparently support the conclusion that Iconoclasts, especially Constantine V, were opposed not only to the veneration of icons, but also to the revering of the Mother of God, the saints and their relics. What is more interesting than the historical truth in the present instance is the record of iconoclast views stated in iconophile sources. The extravagance with which the Iconoclasts' stance against the Virgin is stated cannot be accidental. The same extravagance is to be observed in the iconophile work *Adversus Constantinum Caballinum*.[23] The author of the tract presents Constantine as opposed not only to the veneration of icons, but also to the revering of the Mother of God and the saints, rejecting even the use of their appellation and adding that her death left the Virgin Mary shorn of her power.[24] Another such example is given in the chronicle of Leo Grammatikos, which characteristically states that, shortly before he died, Emperor Constantine admitted his belief in the Virgin and his acceptance of her.

It is clear that iconophile sources are anything but objective; consequently, in no case can they be used to establish the actual attitude of the Iconoclasts (Pl. 13). The lack of iconoclast sources makes research even more difficult and precludes any final conclusion. Nonetheless, the study of the sources shows at least that iconophile sources relate icon veneration directly to veneration of the Mother of God and the saints. Moreover, it seems that at a very early stage of the Iconoclastic Controversy veneration of the Mother of God was considered to be one and the same as veneration of icons and that to a great extent it was used as synonymous with devoutness and 'Orthodoxy' in the literature of the time. Theophanes presents us with one such example, in which he refers to the reign of Leo IV and equates the reverence paid to the Virgin with political tolerance of monks.[25] Theophanes, who is held to be a generally reliable source,[26] was probably the model whom other contemporary chroniclers imitated. It is particularly interesting that his references to the Mother of God are echoed in the accusations and refutations found in the acts of the Seventh Ecumenical Council. Even if we accept the fact that the incidents mentioned simply restate Theophanes' chronicle and are nothing other than typical iconophile reasoning, they do

not cease to reflect the iconophile position. In the eyes of this faction the hostility shown towards venerable icons was nothing less than hostility towards the Theotokos herself, through whom God assumed matter and thus sanctified it. The opposition of the Iconoclasts was the result of an erroneous understanding of the Incarnation and its redemptive significance. In this context the means for the sanctification of matter, that is, the Virgin, and the possibility of matter being used to represent the divine were invested with equal weight and made up a fundamental ingredient of iconophile reasoning.

In hagiographic sources of the period (though most of them were probably written in the post-Iconoclastic era)[27] the Virgin appears as protectress, guide or the prototype of the saints. The role ascribed to her emphasizes the smallness of the distance that separates her from the human beings whom she guides and on whose behalf she intercedes with God. Something else that should be mentioned is the protection which the Virgin seems to extend to monasticism, for in most hagiographic sources she appears either to be protecting a monk or acting as protectress of a monastery.

In the strictly chronological structure followed by most hagiographic texts, the Theotokos appears before the birth of a saint and in many instances the birth is the result of her effective mediation. In the *Life of St Stephen the Younger*, perhaps the most important and most symbolic saint of the Iconoclastic period, the Virgin responds to the daily prayers of his mother Anna, who, though she has two daughters already, considers herself barren because she has no son.[28] The Theotokos appears to Anna in a dream and assures her that she will conceive a son. The iconophile Patriarch of Constantinople, Germanos I, prophesies the name of the future saint when the mother goes to seek his blessing.[29] After giving birth to the saint, the mother again resorts to the icon of the Virgin Mary, on this occasion to thank her for the son with whom she has favoured her and to entreat her to accept him as a dedication.[30]

Anna was also the name of the mother of Peter of Atroa; according to the saint's *Vita*, she too had been barren.[31] Before the child was born his mother dedicated it to the church of the Virgin, where he was to be baptized when he was but forty days old and where he was tonsured a monk at the age of twelve years.[32] The same story is told in the *Vita* of Michael Maleinos. According to its author, Michael was the answer to the prayers his parents, directed to the Mother of God who appeared in a dream to the priest of her church at Kouka, foretelling in a symbolic manner the birth of the couple's seven children and of St Michael whom they would dedicate to her.[33]

The icon of the Virgin plays an important role in the *Life of St Stephen the Younger*, as a point of reference and as a code shared between the author and his readers. Deacon Stephen hands down two references to icons by Patriarch Germanos I of Constantinople. The first is to the icon of Christ known as the *acheiropoietos* icon of Edessa and the second to the icon of the Mother of God held to have been painted by the Evangelist Luke.[34] The Life itself, clearly enlisted in support of the Iconophiles since it tells the story of the pre-eminent martyr of the controversy, also refers to the church of Blachernai, which the 'tyrant' Constantine V decorated with depictions of trees and birds, and to the iconoclast Synod of Hiereia, where the participants denied the possibility of the Theotokos and the saints mediating with Christ for the salvation of the faithful.

Notable contemporary texts often include miracles worked through the Virgin Mary or one of her icons. Stephen the Younger, exiled by the iconoclast Emperor Constantine V to Prokonisos, miraculously healed a soldier by praying and asking him to pray to two icons, one of Christ and one of the Mother of God.[35] While in prison the saint only accepted food from a certain woman when he had been convinced she was an Iconophile; the woman showed him three icons she kept locked in a drawer: one was of the Mother of God, the other two of the Apostles Peter and Paul.[36]

In the *Vita* of Irene, Abbess of the convent of Chrysovalanton in Constantinople, the Theotokos helps her to grapple with the temptation tormenting one of her young nuns from Cappadocia. In this incident mention is made of the procession of the icon of the Mother of God from the church of Blachernai to the chapel of the *Hagia Soros*.[37] The miraculous appearance of the Virgin Mary

14. *Gold reliquary diptych pendant*, 9th-11th century. Axia, London.

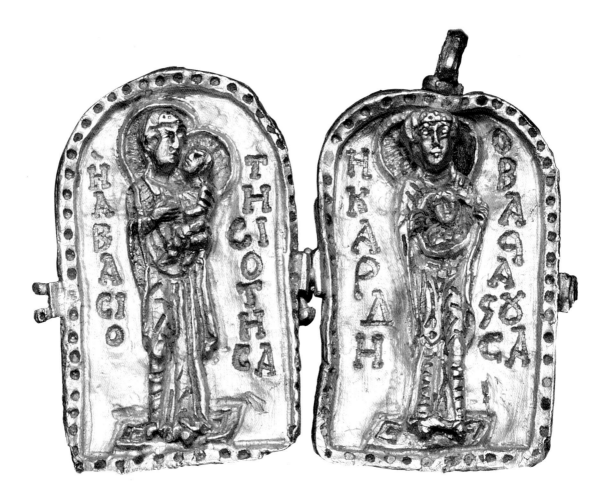

in the church of Blachernai during a night-long doxology is attested also in the *Vita of Andrew the Fool*.[38] The same source refers to the miraculous cure of a robber possessed by a devil.[39] According to the testimony of her *Vita,* Empress Irene was healed of an appalling haemorrhage when she resorted to the *hagiasma* of the Theotokos of the Source (Pege). In thanksgiving for the miracle the empress endowed the church with magnificent gifts and mosaics.[40] In the *Vita* of Peter the Athonite, invocation of the name of the Theotokos repeatedly put demons to flight,[41] while in the *Vita* of Michael Maleinos, the Mother of God, accompanied by the saint, appeared to a sleeping monk who had stolen money by pretending it was for the purpose of the Church. The thief woke in terror, imagining that the Theotokos and Michael were holding him by his arms; he went to his abbot, confessed his deed and repented.[42]

The erection and dedication of churches and monasteries to the Mother of God is an occurrence often recorded in writings about saints. In the case of the *Vita* of Peter the Athonite the saint was the first receive the prophecy of the Virgin Mary regarding the role the Holy Mountain (Athos) had to fulfil as a place uniquely dedicated to her.[43] The incident happened while the saint, then a young soldier, was held captive by the Arabs; he saw a vision of his protector St Nicholas, who revealed to him that he would be taken to Rome and there tonsured a monk. While returning home, the saint dreamt that he saw St Nicholas asking the Theotokos to reveal to him the place where he was to spend the rest of his life. The Virgin foretold that it would be on Mt Athos, which Christ had granted her as a refuge for those seeking to escape the world and to dedicate themselves to spiritual life, invoking the Virgin as their help. Mary is represented as saying that monks of the Holy Mountain will increase in number until they occupy the peninsula from one end to the other, from the north of Athos to its southernmost point and from sea to sea, that she will make their name known to the farthest parts of the earth and will protect them from all perils.[44] The particular passage in the Life is to be found in the *Patria* of Mt Athos and is quoted in many similar anthologies.[45]

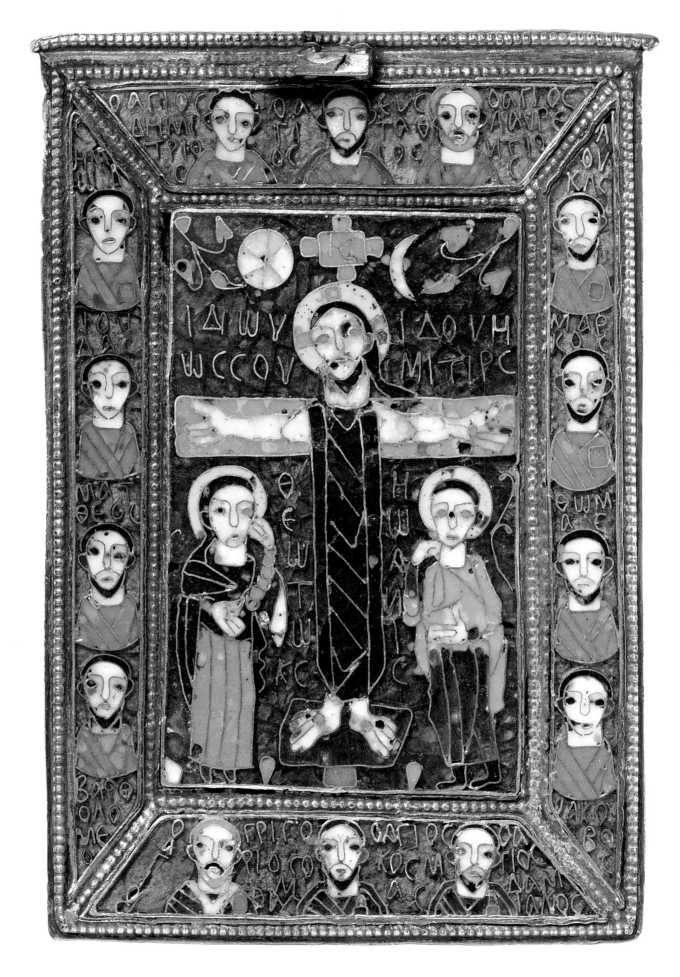

34

When Empress Irene was exiled by Nikephoros I, who ascended the throne in 802, she built a church dedicated to the Virgin Mary in the place of her exile, the island of Prinkipos. Her *Vita* recounts that Irene not only built a church but that she also founded a convent, to the abbess of which she entrusted 'her flock'.[46] We find Mary protecting the saints against not only the assaults of demons, but also external perils. In the passage from the *Vita* of Peter the Athonite, quoted above, her promise to protect the Mountain from every outside enemy recalls the image the Virgin protectress of Constantinople in the sixth and seventh centuries. Furthermore, she assists the saint to find the place where he will become a solitary (in the Life itself the place is the Holy Mountain). An identical incident is recounted in the *Vita* of Michael Maleinos who, prior to settling in Bithynia, wandered at large acquiring the reputation of an ascetic. Maleinos's first concern on reaching Bithynia was to build a large church and to dedicate it to the Mother of God.[47]

In hagiographic texts about women, *Vitae* are based on the prototype provided by the Virgin, while virtues that are lauded are powerfully reminiscent of homilies and hymns written in honour of the Virgin during the period of the Iconoclastic Controversy. Irene, Abbess of the Chrysovalanton convent, lived an ascetic and profoundly self-disciplined life, a regime that enabled her to repulse demons and to provide spiritual guidance to the enclosed community of the convent. The saint found it almost impossible to gaze on the face of the Virgin in the vision she had of her, described in her *Vita*, because of the incredible effulgence that emanated from it. On another occasion, recounted in the same *Vita,* Irene herself appears in a vision to the emperor, begging him to free a relative of hers who was being unjustly held in prison.[48] The emperor sent a delegation to the convent to meet with Irene. Among the delegates was a painter whom the emperor had instructed to make a portrait of the abbess so he could see whether the face that had appeared in his vision was indeed that of the abbess of the Chrysovalanton convent. Irene presented herself before the emperor's delegation and was the first to prostrate, enjoining the men to follow her example. When they lifted their eyes so blinding was the light that covered the abbess's face that they could not look upon it and they fell to their knees again, the entire church being now flooded with brilliancy.[49] The delegation returned to the palace and placed the abbess's portrait in the hands of the emperor; when he raised his eyes to study it an inexplicable radiance again filled the whole place.[50] The similarity of the descriptions of the visions of the Virgin and Irene is obvious, for the face of each is hidden behind the exceeding splendour which they emit. Radiance, a symbol of sanctity, is used also in identifying the original of an icon in the sense of its relationship to the individual portrayed. Thus, behind the rather simple rendering of the miraculous appearance of the Virgin and the saint lies the established dogmatic concept of the theology of icons, as formulated in the course of the Iconoclastic Controversy. Perhaps it is no mere accident that this symbolic language and these close comparisons are expressed in terms directly relevant to the Mother of God.

The last part of this summary review of eighth- and ninth-century literature concerns homiletics, a poorly explored source of material for the study of the symbolic language with which orators and their audience were familiar, but which are difficult for the modern researcher to penetrate, obscured as they are behind literary conventions and commonly held premises that are hard to date and interpret with accuracy. Before proceeding to a thematic analysis of the contents of homilies written during the eighth and ninth centuries, it is worth noting that a simple quantitative analysis reveals that three-quarters of the homilies delivered in this period were devoted to the Mother of God. This evidence must be used with discretion, for it may derive from the accident of manuscript tradition. On the other hand, a comparison with corresponding examples of earlier as well as later periods does lead to the conclusion that it is not accidental. Further support is provided by the fact that the literature devoted to Mary contains certain elements which might persuade one to classify it as a particular kind of homiletic that blossomed in the period we are considering.

The best known and most important orators of the time were ardent Iconophiles who composed numerous homilies and hymns for the various feasts of the Virgin Mary. Their homilies

extol the role of the Theotokos in the Divine Economy, in the Incarnation of the Word and the Redemption of Mankind. It is a fact that in Orthodox thinking occupation with the Theotokos was always concerned with her part in the Incarnation. In addition to the Incarnation, particular stress is laid on corporeality and the various manifestations of religious faith which are connected with the senses. On the whole it may be said that the Theotokos is portrayed in the homilies and the hymnography of the Iconoclastic period in a manner far more personal and emotional than in homilies dating to earlier periods. Matter is undoubtedly the common denominator in the veneration of the Theotokos, the icons, the corporeality — stressed in the homilies and the hymns of the time —, and of the tangible manifestations of faith (Pl. 14). Out of the common experience and the common notional code of orators and the faithful there developed the symbolic language used in the hymns and homilies of the day, a language which equated the constant elements of the case advanced by the Iconophiles. Thus it was that the defense of the veneration of icons, implicit in the apologetics, the homilies and the hymns, was stated explicitly in references to the Mother of God.

The individual most closely connected with the outbreak of the Iconoclastic Controversy in 730 was the Patriarch of Constantinople, Germanos I, who seems to have fallen out with the Emperor Leo III over the latter's opinions regarding the veneration of icons. It is certain that in 730 Germanos was dethroned as patriarch and Anastasios succeeded him. According to a contemporary source, Germanos examined the Paulician Gegnesios with a series of dogmatic tracts including the veneration of the Virgin.[51] According to Alexander Kazhdan, the most likely cause of the clash between Leo and Germanos was the veneration of the Virgin, to which subject the patriarch devoted a large number of homilies and hymns.[52]

Other famous authors of homilies and hymnographers of that era were Andrew of Crete, a near contemporary of Germanos, John of Damascus, Cosmas Maiouma, the brothers Theodore and Theophanes Graptoi, and Theodore the Studite. In their homilies and hymns these writers, who in general share many superficial similarities, use images and epithets taken from the Song of Songs and the Old Testament. Applying the typology in the broadest sense, they refer to the Virgin Mary as the divinely-made vessel (ἱερότευκτον σκεῦος), the new Zion, the divine Jerusalem, the saintly city of the great king God.[53] It would seem that Germanos is hinting at the Iconoclastic Controversy when he addresses the Theotokos with the words: 'Hail, most gracious one, doorway of the distressed and fearful protection of those who in sincere heart acknowledge you to be the Mother of God'. In another homily Germanos speaks of those who do not acknowledge in good faith the Mother of God and who will be judged at the Second Coming. The acts of the Second Council of Nicaea record that the Iconophiles repeatedly doubted the sincerity of the Iconoclasts when acknowledging the Theotokos. Among the known homilies by Germanos nine are devoted to the Virgin Mary; these do not take account, of course, of any unpublished homilies by him and furthermore there are no critical editions of his writings.[54]

In his work on holy icons, of which only fragments survive, Andrew of Crete mentions the famous icon of Edessa and also the icon of the Virgin from Lydda, formerly known as Diospolis. According to the writer, the latter dates back to apostolic times and was still venerated in his day. Rejecting the accusation of idolatry, Andrew states that not even Julian the Apostate harmed the icon when the Jewish artist who examined it assured him of the truth of this story.[55] It is interesting that elsewhere Andrew tells his audience that undoubtedly the Virgin Mary is wherever her icon is. In the same text the writer refers to the icon of the Virgin which tradition held to have been painted by Luke the Evangelist. Andrew of Crete compiled homilies also on the Conception, the Nativity, the Annunciation and the Dormition of the Virgin. Noteworthy is his incorporation of the *Theotokia* into the Great Canon, each canticle of which ends with a verse dedicated to the Mother of God. In these verses Andrew beseeches the Virgin to save the faithful and addresses her by attributes, most of which originate in Old Testament images. Most persistent of all, however, is the image of the Virgin protectress of the City.[56] The Virgin occupies a promi-

nent place in both the *triodion* and the *troparia*, published in the *Patrologia Graeca* under the name of Andrew of Crete. Of these, two-thirds are dedicated to the Virgin, while even the Lazarus Canon is rich in hymns to the Theotokos, which it seems were at that time beginning to be an essential element of hymnography.[57] It has often been noted that hymns to the Theotokos were a characteristic feature of compositions by Cosmas Maiouma or the Melodos.[58] In his hymns to the Mother of God Cosmas extols both the Virgin and the paradox of the Incarnation. In the corpus of his homilies[59] Andrew of Crete writes that Mary must be paid due honour and revered, since it was through her that the salvation of the world was made possible. A parallel is drawn between her paradoxical birth and the paradox of her own child-bearing and the innate paradox of the Incarnation of the Word.[60]

Perhaps the best known of all apologists for the veneration of icons, John of Damascus, rests his argument on the Incarnation of the Word. John's homilies and hymns about the Virgin are less known than his theoretical writings. In his homily on the Nativity[61] the writer combines the typological images of the Virgin with the Incarnation: 'Σήμερον ἐκ ῥίζης' Ιεσσαί ῥάβδος ἐφύη, ἐξ ἧς ἄνθος ἀναβήσεται τῷ κόσμῳ θεοϋπόστατον' (Today from the Roof of Jesse a rod was sprouting, from this a flower of divine hypostasis was opening to the world).[62] The vocabulary used in typological references occasionally hints at the contemporary controversy about the portrayal of the divine. Thus, when John of Damascus mentions the prophetic reference to the Virgin in the Old Testament he employs composite words such as 'prefigured', 'predescribed', and 'preimpressed'.[63] Theophanes Graptos, one of the heroes of the controversy, also uses typological references in the hymn he wrote for the Annunciation of the Theotokos.[64] The angel is represented as discoursing with the reluctant Virgin Mary, and the hymn ends with confirmation of the joyous news and the doxology of the Virgin by the Angel of the Lord.

The lyrical tone that pervades most homilies of the time about the Mother of God is evident in the first homily on the Dormition, in which John of Damascus addresses her with these attributes: '...bestower of good, giver of riches, pride of the human race, boast of all creation'.[65] The Theotokos is likened to a bridal bed on which the Incarnation occurs; elsewhere John likens to a nuptial bed the tomb of the Virgin from which, after her Dormition, she passed into the heavenly regions.[66]

Rhetorical *ekphrasis,* that is, the vivid description of persons, objects and circumstances in such a manner that the listener feels himself to be present at the events related, is employed in a superb manner by John of Damascus in order to describe the person of the Virgin: a living, divine statue with its gaze ever turned upon God, eyes that always contemplate the eternal and inaccessible light, ears that hear the divine work and the lyre of the Spirit through which the Word entered and was made Incarnate.[67]

The second homily on the Dormition stresses the power of the body, to which the author attributes most eloquently the gravity and respect with which the apostles embrace the lifeless body of the Virgin, the body that after her death works miracles, curing illnesses and repelling demons. Here corporeality is correlated on the one hand with the rejection of matter and on the other with the rejection of the veneration of the relics of saints by the Iconoclasts, and is itself an indirect apology for the 'sound doctrine' which was to prevail when the controversy was brought to its end in 843. All these three homilies on the Dormition of the Theotokos conclude with a prayer by the author for salvation, while the invocation of the Virgin is accompanied by a confession of faith. Faith in the Virgin and her power to intercede for the salvation of man is essentially equated with faith in the Incarnate Word of God.[68] In his homily on the Dormition of the Theotokos, Theodore the Studite stresses respectively her eternal presence and her mediation on behalf of the salvation of man, juxtaposing the former to physical absence.[69]

It is widely admitted that Byzantine literature does not readily reveal its meaning to its readers and scholars. Its syntax and vocabulary, its complex conceptual and allusive symbolism, give rise to such a tissue of footnotes that it often appears as a deliberate obfuscation. Moreover, the

respect in which Byzantines held rhetoric, their education in this art and the oral character of many texts (especially those belonging to homiletic tradition) make the analysis of the symbolism of this language an objective difficult to attain (Pl. 15).

The question of the position of the Mother of God in the Iconoclastic Controversy demonstrates precisely this great difficulty, for her central role both in the conflict itself and in the post-Iconoclastic period is plain to see, if one judges from the quantity and the quality of the literature dedicated to her. The 'distorting mirror' of Byzantine rhetoric on the one hand and the tension between the two factions on the other, may explain why the writers of the period artfully cover their confession of faith in icons under their confession of faith in the Theotokos, which was after all a subject that could not put them in danger, as it was not at the centre of the dispute, and, at least in theory, both sides agreed on the honour that was to be ascribed to the Theotokos. The difference between the two sides did not lie in the veneration of the Theotokos but in the way the issue was approached: for the Iconoclasts the Virgin had to be honoured, as Christ himself, *in spirit*, as it is pure spirit that is appropriate to God, whereas for the Iconophiles the spirit was unified with matter after the Incarnation of the Word and so, matter freed from its gravity, could be used for the depiction and veneration of the divine. The eventual victory of the iconophile side gave Orthodox worship a character that singles it out among all other Christian denominations, in that matter participates in the worship of God and a distinct corporeality is expressed in the full participation of the senses in its liturgical life.

Setting aside the continuing compilation of hymns and homilies in honour of the Theotokos in post-Iconoclastic years, we also find a rapid growth in the number of new types of iconographic representations of the Virgin. Perhaps, the most characteristic of them all is the icon of the Triumph of Orthodoxy, the centre of which is dominated by the Virgin Hodegetria. Although no such icon of the ninth or even the tenth century has come down to us, knowing the manner in which icon-painters followed subjects already revered in literature and dogma, it is hard to imagine that this icon was first conceived in the Late Byzantine period. The history of Byzantine art, on which others are more competent to comment, also provides us with a mass of evidence that confirms the central position occupied by the Virgin in the period following the Restoration of the Icons.

The study of historiographic and hagiographic sources, as well as of homilies and hymns of the eighth and ninth centuries, shows that during this period the veneration of the Virgin becomes a central theme for the iconophile writers, who dedicate to her numerous homilies and hymns and very often associate her closely with the cult of icons. The place allotted to the Virgin is not a contrivance or an innovation of iconophile partisans, but a plausible and ingenious way of expressing dogmatic Christology by means of metonymy, the transposition of names. The absolute truth of the Incarnation of the Word, the irrational and paradoxical sanctification of matter through the Incarnation and its profound significance for the salvation of man were summarized and found expression in the person of the Mother of God, who as a human made feasible the central and definitive mystery of the Christian religion, the Incarnation.

[1] Ostrogorsky 1970. I would like to thank Sanja Mesanovič who helped with the translation of these articles.
[2] Parry 1996, 191-192.
[3] See the essay by M. Vassilaki and N. Tsironis in the present volume, 453-463.
[4] Young 1997, 192-195, esp. n. 23.
[5] Lash 1989, 310-321, esp. 311.
[6] In the characteristic example of the Gospel according to St Matthew, the writer sacrifices historicity for the sake of typology, presenting the Messiah as the fulfilment of all prophecies (esp. Matt. 5:17). For the use of typology in

the theology of Justin the Martyr, the study by Sarksaune 1987.
[7] Sherwood 1962, 384-409; Gordillo 1954; Aldama 1970. Also the writings of Ignatios of Antioch (early 2nd century), Camelot 1969, Eph. 7.2, 18.2, Trall. 9.1.
[8] See e.g. the work of Alexander of Alexandria (312-328) Opitz 1934-1935, 6-11 and 19-31.
[9] Cameron 1978, 79-108 and Cameron 1979b, 42-56.
[10] John 4:24. Emphasis on spiritual worship is also reflected in the Iconoclastic *Horos* that survives in the Acts

of Nicaea II. Mansi 1960, XIII, 216.
[11] Mansi 1960, XIII, 277 C, D.
[12] See e.g. the otherwise thorough study by Parry 1996, 191.
[13] Mansi 1960, XIII, 272 A, B, D.
[14] Mansi 1960, XIII 280 A, B.
[15] Mango and Scott 1997, 544-546; Theophanes (de Boor), I, 395-398.
[16] Mango and Scott 1997, 546; de Boor, I, 397-398.
[17] Mango and Scott 1997, 560-561; de Boor, I, 406, 1-25.
[18] Mango and Scott 1997, 560; de Boor, I, 406, 5-14.
[19] Mango and Scott 1997, 561, n. 16;

[19] de Boor, I, 406, 22-25. Also Cedrenus-Skylitzes, II, 3.

[20] Mango and Scott 1997, 576; de Boor, I, 415, 24-29.

[21] Georgius Monachus, *Chronicon,* de Boor 1978, 756. George gives a detailed account of the incident describing in detail the punishment of the patriarch. Also Leo Grammaticus 182, Cedrenus-Skylitzes, II, 4-5 and Zonaras, III, 266.

[22] Mango and Scott 1997, 576; de Boor, I, 415, 24-29; Zonaras III, 273-274.

[23] For the question of authorship and dating of the work, Auzépy 1995a, 323-338. *Adversus Constantinum Caballinum, PG* 95, 309-344.

[24] *Adversus Constantinum Caballinum,* 337C-D.

[25] Mango and Scott 1997, 620; de Boor, I, 449, 14-15. Turner 1990, 172-203.

[26] See the introduction of Mango and Scott 1997, xliv-lxiii and esp. lxii-lxiii, where the editors focus on the weak points of Theophanes. With reference to the historical circumstances of the life of Theophanes, Euthymiades 1993, 259-290.

[27] Rapp 1995, 31-44.

[28] Auzépy 1997, 92, 3-10. For the procession of the icon that was taking place at Blachernai every Friday, also Mango and Scott 1997, 387, n. 18 on 388; de Boor, I, 265-266.

[29] Auzépy 1997, 92-94.

[30] Auzépy 1997, 95 2-15.

[31] Laurent 1956, 2. 6-7.

[32] Laurent 1956, 2.8-12, 25-28 and 3.1-4.

[33] Petit 1902, 543-594.

[34] Auzépy 1997, 99 16-22, 63, 192. Also Cameron 1983, 80-94.

[35] Auzépy 1997, 154, 1-4.

[36] Auzépy 1997, 159, 1-31.

[37] Rosenqvist 1986, 56-58. Also, Rydén 1976, 63-82, esp. 67-72.

[38] Rydén 1995, 254. 3732-3758. Also, Moran 1986, 126-127.

[39] Rydén 1995, 108-112, 1460-1497.

[40] Treadgold 1982, 237-251, esp. 238.

[41] Lake 1909, 27-30. Also published in the *AASS,* 12 June, as well as in *PG* 150, 996A-1040C.

[42] Lake 1909, 1940-1941, 35-50. For the *Vita,* also Papachryssanthou 1992, 85-87 and Papachryssanthou 1974, 19-61.

[43] Lake 1909, 25.

[44] Lake 1909, 25.

[45] Lambros 1912, 123-126 and 135-137. Also, Gedeon 1885, 297-300 and 308-309.

[46] 'τῆς ἐμῆς βακτηρίας τό ποίμνιον'... Vat. gr. 2014, fol. 135r and Treadgold 1982, 244.

[47] Petit 1902, 15.4-7.

[48] Rosenqvist 1986, 92.

[49] Rosenqvist 1986, 94, 96.

[50] Rosenqvist 1986, 96.22-26.

[51] Peter of Sicily, *PG* 104, 1284B-1285A.

[52] *ODB,* 846-847.

[53] Germanos I of Constantinople, *In Annunciationem,* (*BHG* 1145n-q, *BHG* 1145n-r), *PG* 98, 320-340, esp. 305C-D.

[54] Geerard, *CPG* III, 8007-8015.

[55] Andrew of Crete, *De Sanctarum Imaginum Veneratione, PG* 97, 1304A.

[56] Andrew of Crete, *Great Canon,* in Christ and Paranikas 1871, 147-161, esp. ode VIII, 331-336.

[57] Andrew of Crete, *Canon in Lazarum, PG* 97, 1385-1397.

[58] See e.g., Cosmas the Melodos, *Τριώδιον Μεγάλης Παρασκευῆς,* Christ and Paranikas 1871, 194-96 and *Κανόνας του Μεγάλου Σαββάτου,* 196-201. For questions related to the biography of Cosmas the Melodos, the monograph by Detorakis 1979, 84-91 and Kazhdan 1989, 122-32; Kazhdan 1990, 329-346.

[59] *PG* 97, 805-1109 and Themelis 1907, 826-833.

[60] See e.g. the homily *In Nativitatem Sanctissimae Deiparae, PG* 97, 804-820, esp. 809.

[61] Kotter 1969-1988, V, 169-182.

[62] Kotter 1969-1988, 171, 3.4-5.

[63] προεχάραξαν, προεξωγράφει, προετύπωσεν. Kotter 1969-1988, V, 492, 8.26-29.

[64] For the *Vita* of Theodore and Theophanes Graptoi, Eustratiades 1936, 343 and Cunningham 1991, 84-88 and comments on 156-158. For the Canon of the Annunciation, Christ and Paranikas 1871, 236-242, esp. ode 3.

[65] Christ and Paranikas 1871, 485, 3.3-4.

[66] Christ and Paranikas 1871, 550, 2.20-24.

[67] Christ and Paranikas 1871, 179, 9.34.

[68] Christ and Paranikas 1871, 499-500, 14.6-14.

[69] Theodore the Studite, *In Dormitionem Deiparae, PG* 99, 720B-729B and esp. 721A-721C. Also 721D, κοιμηθεῖσα, φημί, ἀλλ᾽ οὐκ ἀποθανοῦσα. Μεταστᾶσα, ἀλλ᾽ οὐ καταλιποῦσα ὑπερασπίζεσθαι τοῦ γένους...

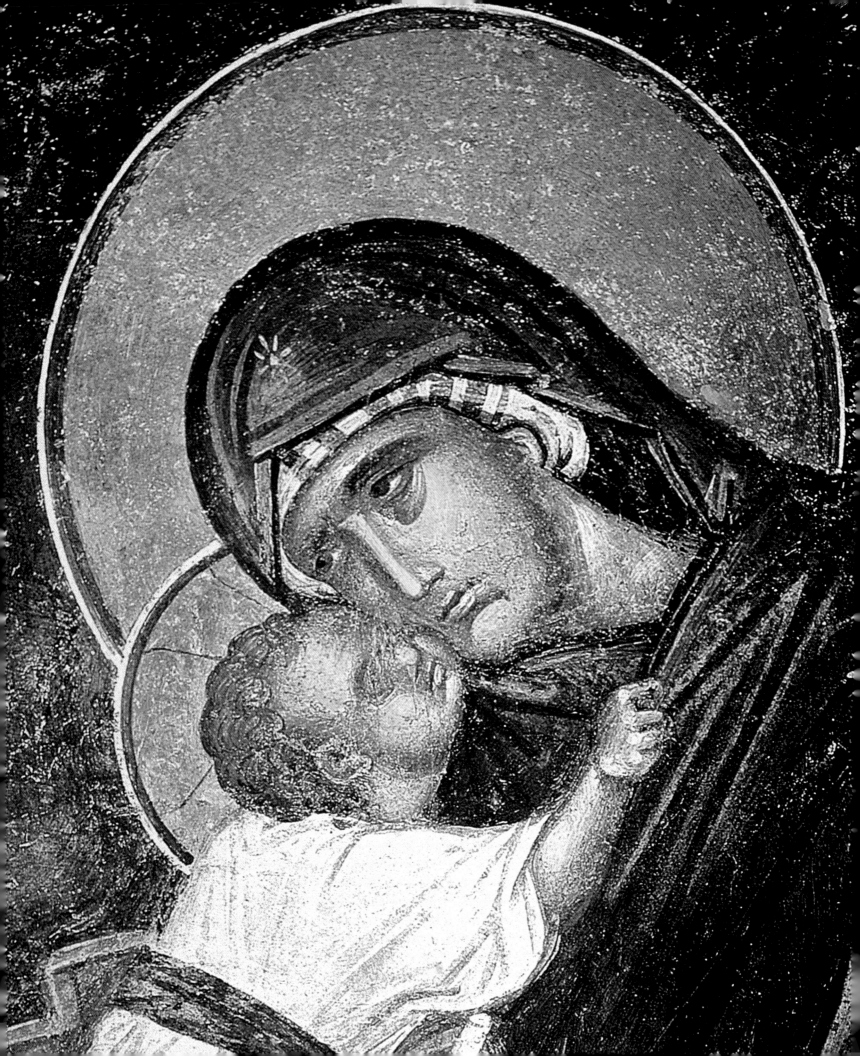

Ioli Kalavrezou

The Maternal Side of the Virgin

To celebrate the closing of the second millennium since the birth of Christ, and an important moment in our history, the Benaki Museum has organized an exhibition devoted not to him but to his Mother, the Virgin Mary. In this exhibition the focus will be the Virgin's motherhood, and representations in her role as mother will be exhibited in a variety of media, dating from the Early Christian period to the fifteenth century. At an earlier and differently critical moment in history, during the period of Iconoclasm, when the Byzantines were trying to solve matters of state and religion, and images of holy figures were not allowed, they too turned to the motherhood of the Virgin to resolve the debate and with it to celebrate the end of Iconoclasm.

The human and maternal aspect of Mary's person became critical in the discussions during Iconoclasm on the question of Christ's depiction. After all, the iconophile emphasis on Christ's human nature depended on his mother's humanity. Immediately after Iconoclasm her maternal side, not much exploited until then, was made visible in images. It is her aspect as the Mother of God that this paper will discuss: What is meant by this characterization, When did it occur, Why, and How did it affect her images?[1]

When we think of the Byzantine representations of the Virgin the images that most often come to mind are those of the Virgin holding the Christ-Child in her arms, either standing or only shown half length. She holds the Child close to her chest, often inclining her head and sometimes even touching her cheek against his. What more motherly an image than the child being held so tenderly in the arms of his mother! However these representations, which are so familiar and leave a memorable impression on the viewer, took many centuries to develop.

The early visual language of the Christians on the walls and burial chambers of the catacombs in Rome has left some images that could be interpreted as representing Mary as a mother. But these examples are few and it is not certain if the woman depicted is the Virgin.[2] In the later centuries, when religious art is more in the hands of the Church and thus in more official places, the motherly side of Mary is hardly expressed. She is plainly identified as Maria or Hagia Maria. In most of her depictions she is shown enthroned, holding the Child before her, presenting it to the world.[3] She is the holy Virgin Theotokos, as defined at the Council of Ephesus in 431: '... not as though the nature of the Word or his divinity took beginning of being from the holy Virgin, but that of her was begotten the holy body animated with a rational soul...'. These are the words of Cyril of Alexandria which were adopted in the official records.[4] As Theotokos she remains 'the bearer of God' and the term avoids saying anything about the person who gave birth to him. It also does not imply any further specific relationship between the two. Only in a few icons of the sixth century (Cat. nos 1 and 2) do we see the Virgin holding the Child on her arm as a mother would.[5] The textual evidence of the early centuries supports this position. The terminology developed for Mary's relationship to her son is in metaphors and mainly in relation to Old Testament imagery. She is the New Eve, the Gate, the Heavenly Ladder, the Burning Bush, the Ark, the Tabernacle, the Vessel, the Rod of Aaron and so on. This imagery transmits ideas of her as a passage, a container, a plant that sprouts, all to be understood as the means through which Christ was born. Probably, it was felt more appropriate or easier to express the Mystery of the Incarnation in these terms rather than through a phys-

16. *Wall-painting of the Virgin Eleousa*, detail of Pl. 20.

41

ical human birth. However, although the imagery was appropriate, all these comparisons avoided the most obvious image, that of the mother.[6]

During the debates of the Iconoclastic period in the eighth century however, the definition of the Council of Ephesus of 431, that through the Virgin's humanity Christ became man, was brought to the fore by the Iconophiles to argue in favour of depicting the human nature of Christ. Her human qualities, rather than her utility as a source of doctrine, had to be brought out directly. Thus the promotion of the motherhood of Mary after Iconoclasm became explicit in texts and images. The major event in Christ's human existence, the Crucifixion, provided the iconophile side with the evidence needed to base its case from the Gospel text itself. It is one of the fascinations of visual rhetoric that opposing sides use the same material to construct their argument. The Crucifixion, and from it the symbol of the cross, the only visual sign that the Iconoclasts allowed, were used by the Iconophiles to prove their position.[7]

A man who influenced religious thought during the second half of the ninth century was George of Nikomedia, a deacon and *chartophylax* of Hagia Sophia, and a personal friend of Patriarch Photios. In one of his homilies, which is entitled 'When his Mother stood next to the cross at the Crucifixion', he lets Christ himself explain what he actually meant when he said to his mother: Ἴδε ὁ Ὑιός Σου (Behold, thy Son). It was an ingenious way to put words into Christ's mouth, to express newly introduced ideas by the Church and to publicize more widely contemporary exegesis. When Christ says to his mother that now she will live with John and the other disciples, he gives her the following explanation for all to hear: 'You will give them your bodily presence in place of mine. Be for them all that mothers are naturally for their children, or rather all that I should be by my presence; all that sons and subjects are, they will be for you. They will pay considerable respect to you because you are the Mother of the Lord and, because I came to them through you, they acquire in you the placable intercessor toward me'.[8] This text unambiguously makes Mary the mother for all the disciples, words to be understood in the widest sense — a mother for all, for mankind. She is to be considered the most approachable intercessor between the faithful and Christ. With Christ's statement .Ἴδε ἡ μήτηρ σου (Behold, thy Mother) to John his disciple, George of Nikomedia lets Christ further consolidate her role and place as mother. The purported words of Christ are: 'It is not only for you but also for the other disciples that I have made her mother and guide, and it is my will that she should be honoured in the fullest sense with the dignity of mother. Though I have forbidden you to call anyone on earth father, I wish nonetheless that you call her Mother and honour her as such, she who was for me an abode more than heavenly, and showed me an affection with which nature is unacquainted'.[9] These further statements give a clear picture of Mary's special place as the mother and *hodegetria* of mankind.[10] She is to be called Mother by all, because she was the abode, the *skenoma* for Christ. This was the more traditional way of seeing her role in the Mystery of the Incarnation. Now, another side of her character is brought forth. As a mother she had *proairesis*, a rare quality of affection and devotion that can only be connected to her maternal feelings and disposition.[11]

The result of this kind of exegesis helped to introduce an increased human emotional content in representations of the Crucifixion in this period. The message, that is the words uttered by Christ before dying on the cross, Ἴδε ἡ μήτηρ Σου (Behold, thy Mother) and Ἰδού ὁ Ὑιός Σου (Behold, thy Son) begin to be included in the scene of the Crucifixion under the arms of the cross almost as an authenticating factor. Henceforth the Virgin is also to be identified as Μήτηρ Θεοῦ (Mother of God), a label that officially confirms her rightful place in the Mystery of the Incarnation. An early example where these quotes are included at the Crucifixion is the Fieschi-Morgan cross-reliquary, now in the Metropolitan Museum of Art in New York.[12] They occur once on the cover, badly misspelt and a second time in the interior (Pls 15 and 17). The reliquary has been dated to the early ninth century and in this case we see that the identification of the Virgin is still Theotokos and not yet what would become the standard title of Mother of God. The name Maria or Hagia Maria will by the end of the ninth century totally disappear. Probably one of the last times that it is used is

17. *The Fieschi-Morgan reliquary*, reverse of the cover, 9th century.
The Metropolitan Museum of Art, New York.

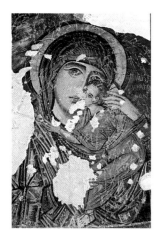

18. *Wall-painting with the Virgin Eleousa*.
Tokali Kilise, Cappadocia.

also at the same time the first time that the Virgin is represented on a gold coin issue. Leo VI introduces on the obverse of his *solidus* an orant Virgin with the label MARIA above her head. At the same time she is invested with the new title of Mother of God, which is placed on either side of her head.[13] Identified as the Mother with her arms raised in prayer, she becomes the most appropriate intercessor for what were Leo's problems of succession. The choice of the Virgin as his personal intercessor is clear, however, the precise date of the issue is not known. It could have been before the birth of Constantine Porphyrogennetos, but also possibly afterwards, to express her divine assistance.

By the ninth century the importance of the Incarnation for the iconophile position had found solid ground. The motherly side of Mary was emphasized and new images of her were elaborated.[14] In connection with the Crucifixion and Passion of Christ, the role of the mother begins to be visible. For example, she appears in the newly created scene, the Deposition.[15] The first known image of this scene is in the Homilies of Gregory in Paris. gr. 510 of the 880s.[16] Her presence in the taking down of her Son from the cross states the emotional bonds between them. By the tenth century we see her, for example, on the early tenth-century cross-reliquary in the Vatican, in the Crucifixion scene on the lid of the box, bending over and kissing the feet of her Son while he is still on the Cross.[17] These are clearly actions appropriate to the tragedy that she experiences as a mother.

Representations of the caring and affectionate mother begin to appear in the tenth century. One type which will become popular is the image of the Virgin holding the Child in her arms, in a loving embrace. One of the earliest and most remarkable examples is the wall-painting in the New Church of Tokali (Pl. 18).[18] She presses the small Child against her cheek and looks out towards the viewer, establishing eye contact. This image appears to have a special devotional and intercessory nature, at least in Cappadocia.[19] Although an emotionally charged image, it is clearly a composition of the iconic type, which means that it is an image of private as well as communal prayer and devotion.

In the narrative compositions that develop in connection with Christ's Passion the Virgin becomes one of the main characters, who displays the pain and suffering that his death has brought about. In the Lamentation scenes of the end of the twelfth century, she kneels on the ground and, opening her legs holds her Son's body to rest on her lap (Pl. 19). Visually this composition is the most explicit of her maternal passion for her dead Son. On the one hand it makes a direct reference to his birth, and on the other, through her passionate embrace around his body and the tender pressing of her cheek against his, it reminds us of her icons where she lovingly cuddles the Christ-Child. It combines the simultaneous emotional feelings of motherly love and suffocating pain.

One of the greatest creative moments in Byzantine visual experience was the transfer of these human expressions of sentiment from the narrative to the iconic representation. What was depicted in the scenes of the Crucifixion, the Deposition and the Lamentation, through images of the tragedy of the Mother of God, was extracted from these scenes and portrayed in the devotional icons of the Virgin holding the Child in her arm in the fashion of the Hodegetria. The most famous of all is the twelfth-century two-sided icon from Kastoria (Cat. no. 83). The Virgin has placed Christ on her left arm and with her right she directs the viewer's gaze towards him. He sits almost frontal, looking out. His face is motionless, older and rather serious. The Virgin is even more distant. She holds her Child in her arm, but her face displays an expression of anguish and worry. The joyfulness of holding the Child in her arms has faded. Her eyes are turned to the side, hinting at the tragic representation of her dead Son depicted on the reverse of the icon. The love and pain of the mother is manifested on her face. The knowledge of her Son's death has marked her countenance. It seems that from this period onwards this foreknowledge will never again leave the portraits of the Virgin.

Varying in the degree to which intensity of this sadness was displayed, her facial expression always remained distant and withdrawn even in the most loving embraces of her playful Child. A representative example depicting the juxtaposition of her sentiments is the twelfth-century panel icon in the Byzantine Museum, Athens (Cat. no. 75).[20] Two centuries later we still find the same

19. *Wall-painting of the Lamentation*, detail. Church of St Panteleimon, Nerezi.

expression in the wall-painting in the *parekklesion* in the Chora monastery at Constantinople (Pls 16 and 20). Standing tall, she holds the Child before her and bend over to kiss him. Her cheek touches his, but her face looks sorrowful. The words of Patriarch Photios, who first described Mary's maternal qualities the day the mosaic in the apse of Hagia Sophia was revealed, in 867, still are appropriate for both these late images. He says that she 'fondly turns her eyes on her begotten Child in the affection of her heart, yet assumes the expression of a detached and imperturbable mood'.[21] What language could do already in the ninth century became visually possible only after a long process of interaction and participation with the narrative of Christ's Passion and the Virgin's suffering.

The desire to represent the visible nature of Christ in the ninth century, in the defence of images, revealed Mary's identity as the Mother of God. Accepting motherhood with its emotive powers, in turn extended the pictorial language of religious imagery into human expression, a territory not found before in Christian art. The images resulting from this expansion into the world of humanity were those which in the centuries that followed brought about the 'Renaissance' in Western culture.

20. *Wall-painting of the Virgin Eleousa*, detail. Chora monastery, Constantinople.

[1] Several of these questions were addressed in an article published some ten years ago, Kalavrezou 1990, 165-172.

[2] One early example is in Grabar 1968b, 99, fig. 95.

[3] The examples are numerous: Grabar 1967, figs 176, 180, 193, 203.

[4] *PG* 77, 44-49.

[5] E.g. the icon of Virgin and Child in Santa Francesca Romana in Rome, 6th century (Grabar 1967, fig. 206) and the icon of the Virgin and Child in Kiev from Mt Sinai (Bank 1977, no. 109). One exception is the mosaic in the apse of the Angeloktisti church at Kition, Cyprus, where the Virgin is shown holding the Christ-Child on her left arm and with her right directing the viewer's gaze towards him like the later Hodegetria (Grabar 1967, fig. 144).

[6] See the lengthier discussion of this topic in Kalavrezou 1990, 166-168. Romanos the Melodos in the 6th century is the one author of this period who in his *kontakia* brings out the motherly aspect and her devotion towards her son, Maas and Trypanis 1963.

[7] Kartsonis 1986, 105-107 and 118-120, has argued that already during the interim period after the Seventh Ecumenical Council in 787 pectoral crosses with images on them were worn.

[8] *PG* 100, 1476D: Σοὶ γὰρ δι᾽ αὐτοῦ καὶ τοὺς λοιποὺς παρατίθημι μαθητάς· καὶ ἐφ᾽ ὅσον βούλομαί τε [ἴσ. σε] συνεῖναι τούτοις, καὶ ἐν τῷ βίῳ διατελεῖν, τῆς σαρκικῆς μου παρουσίας τὴν οἰκείαν αὐτοῖς ἀντιπαρέχοις. Γένου μὲν αὐτοῖς, ὅσα μητράσι πρὸς υἱοὺς γενέσθαι πέφυκε· μᾶλλον δὲ, ὅσα ἐγὼ συμπαρών· αὐτοὶ δὲ τὰ τῶν υἱῶν καὶ ὑπηκόων σοὶ γενήσονται. Ἀξιόλογόν σοι τὸ σέβας, ὡς τοῦ οἰκείου Δεσπότου ἀποτίσουσι Μητρί, ὡς διὰ σοῦ τούτοις ἐπιδημήσαντός μου, καὶ μησιτείαν σε πρός με εὐδιάλλακτον κεκτημένοι.

[9] *PG* 100, 1477B: Νῦν γὰρ ταύτην, οὐ μόνον σοῦ, ἀλλὰ καὶ τῶν λοιπῶν, ὡς τεκοῦσαν, καθηγουμένην τίθημι μαθητῶν, καὶ τῷ τῆς Μητρός ἀξιώματι τιμᾶσθαι βούλομαι κυρίως. Εἰ τοίνυν καὶ πατέρα καλεῖν ὑμῖν ἐπὶ γῆς ἀπηγόρευσα, ὅμως θέλω ταύτην Μητέρα καὶ τιμᾶσθαι καὶ καλεῖσθαι παρ᾽ ὑμῶν, ὑπερουράνιόν μοι χρηματίσασαν σκήνωμα, ξένην τῆς φύσεως ἐπιδεδειγμένην προαίρεσιν.

[10] This text is interesting for the history of the Virgin Hodegetria in Byzantium. With the word καθηγουμέ/νη it makes reference to the Virgin in her capacity as guide or leader without the use of the later established term.

[11] The Virgin as a close and effective intercessor was recognized from earlier centuries and her ability to speak for others was already established at the wedding at Cana, where Christ performs his first miracle. Kalavrezou 1990, 167.

[12] Kartsonis 1986, fig. 24f-g. The enamel icon is a very nice 12th-century representation of the Crucifixion, with the two quotes placed under the arms of the cross.

[13] Grierson 1973b, 508, 512, pl. xxxiv.

[14] It seems that new ideas and concepts were more easily introduced in a literary form than in images. As well as George of Nikomedia, Photios in his sermon on the newly placed image of the Virgin in Hagia Sophia, uses a language much more expressive than any image of the time to describe the mother-child relationship of Mary to Christ in this mosaic, that actually does not show it. It also does not have the inscription Mother of God to identify her. There is no inscription. Other churches which received the image of the Virgin and Child after Iconoclasm and do not have either the Mother of God or any other inscription are St Sophia in Thessaloniki and the church of the Koimesis in Nicaea. Photios was also influential in the creation of the images of the Gregory manuscript in Paris. gr. 510, where not only the Virgin, but also other women are given prominence. Brubaker 1999, 403-408.

[15] The theme was already addressed and described in the sermons of George of Nikomedia (*PG* 100, 1476D and 1477B) and in Photios' eleventh homily (Mango 1958, 198-202).

[16] Brubaker 1999, 297 where the image is also labelled as Η Καθέλκυσις and not the later Αποκαθήλωσις. In the Crucifixion scene of the same manuscript the newly added inscriptions Ἴδε ὁ Ὑιός Σου and Ἰδού ἡ Μήτηρ Σου is placed above the arms of the Cross almost as a title to the whole scene.

[17] Lowden 1997, 214, fig. 12.

[18] Epstein 1986, 9, 26.

[19] Thierry 1979, 59-70.

[20] *Glory of Byzantium*, no. 71.

[21] Mango 1958, 290. The emotional expression projected here by Photios on the mosaic in Hagia Sophia, was, however, not yet possible in images. Kalavrezou 1990, 170.

45

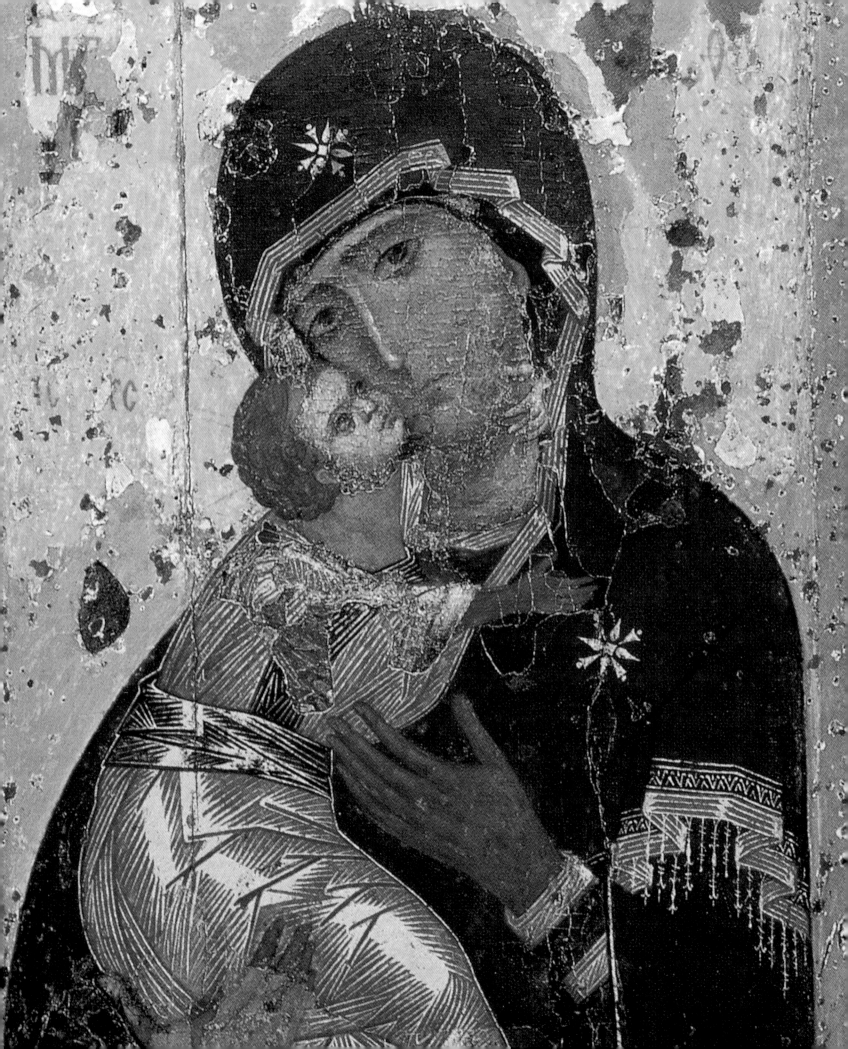

Alexei Lidov

Miracle-Working Icons of the Mother of God

W	e can only study a miracle by destroying the object of our study — a paradoxical statement, but in many respects a true one. Yet if we try to define the historical and cultural component in the phenomenon of the miraculous, the study of the object becomes not only possible, but extremely fruitful. We immediately discover the important fact that a great deal of valuable historical information often not to be found in other sources has accumulated around the miracle. It is also interesting that the apparently simple task of separating the 'miraculous' from the 'historical' proves to be a rather difficult one requiring much time and a change of intellectual stereotypes. This is probably why the value of studying East Christian miracle-working icons has only been realized comparatively recently.[1] And even today there is a tendency to allow this special phenomenon to become 'lost' in the more general and familiar view of the sacred image.

For a long time miracle-working icons remained outside the sphere of historical research. Suffice it to say that in the ramified and advanced research by Russian humanitarian scholars in the nineteenth and the early twentieth century, which made a careful study of the most varied aspects of East Christian culture, there is not a single academic work on miracle-working icons, in spite of the fact that ecclesiastical collections of stories about miracle-working icons of the Virgin were published over and over again.[2] Many authors produced their own versions of compilations consisting of literally hundreds of subjects by copying the stories from one another without any textual or historical criticism. The aim of these publications was purely apologetic was essentially to extol the Virgin and her 'blessings to mankind'. It must also be said that compilations with such an approach still exists today.[3] It is deeply rooted in Orthodox circles and goes back to the compilations of Byzantine prodigies relating to the age of Iconoclasm, such as *The Acts of the Seventh Ecumenical Council* (787), John of Damascus's three discourses in defence of holy images or *The Letter of the Three Patriarchs to the Emperor Theophilos*,[4] in which collections of stories about miracles performed by holy icons served as proof of their divine origin.

The criticism of miracles and exposure of individuals making fraudulent use of icons for their own economic, political or other ends was another form of study. In its most direct form such criticism could be found in Soviet atheist literature which denounced the Church for deceiving the people. Yet paradoxically even this approach was rooted in Orthodox tradition. In Byzantium and in Medieval Russia investigations were carried out to establish the authenticity of miracles said to have been performed by images of the Virgin. The tenth-century historian Eutychios of Alexandria has left an account of an investigation during the reign of Emperor Theophilos.[5] In a certain monastery a wall-painting of the Virgin miraculously began to emit drops of milk that 'on her feast day … come out of the breasts of the image'. The emperor sent a commission to investigate which discovered that the milk was poured along a pipe hidden in the wall and denounced those responsible. This led to a new wave of repression against the Iconophiles. Special investigations of miracle-working icons were regular practice in the Russian Orthodox Church from the seventeeth to the nineteenth century.[6] During this period the number of miracle-working icons increased with amazing rapidity and miracles were recorded in the most remote villages.

21. *The Virgin of Vladimir,* detail of Pl. 24.

Since these new miracles could have been the result of purely pragmatic economic interests, such as the desire to attract pilgrims bringing gifts, the Church deemed it essential to investigate literally each case of miracle-working. And only when the special commission had pronounced judgement could the icon be recognized as locally-revered and the new cult receive the official blessing of the Church authorities.

It must be said that nothing has impeded the historical study of the phenomenon as much as the question of the authenticity of miracles. In the vast majority of cases the truth cannot be established scientifically and, as with the New Testament miracles of Christ, it is a matter of faith, and cannot be demonstrated to atheists. In our view, the only positive approach is to recognize any miracle recorded by written or oral testimony as a historical and cultural fact. This assumption naturally suggests the need to draw up a compilation of such facts which are known in East Christian culture, but have not yet been assembled.

In 1991 work began in Moscow on compiling an encyclopaedic dictionary of 'Miracle-Working Icons in East Christian Culture' in which more than forty authors from different countries are taking part.[7] The first two volumes are devoted to icons of the Virgin, of which there are several times more than all the other icons taken together. At present about 1,500 articles have been written on existing miracle-working icons and only on those known from written sources. The chronological framework is unlimited, from the beginning of Christianity to the present, because we are dealing with an Orthodox tradition which is still alive today. Geographically this project covers the whole East Christian world, including the historical territories of the Byzantine Empire, Russia and the Orthodox countries of Eastern Europe, the Balkans and the Caucasus, and the countries of the Christian East.

The dictionary includes only those icons which have been historically recorded. In accordance with the unifying structure and depending on the information available, it aims at filling in the following sections: 1) historical records; 2) stories about the icon; 3) historical forms of veneration; 4) special iconographic features; 5) subjects, including representations; 6) data on a prototype or the earliest copies; and 7) sources and main literature. The plan is to create the fullest possible collection of historical and iconographic data. Special artistic features have deliberately been excluded from the sphere of investigation, as well as the vast majority of icons about which there is no testimony. Reference is made to stylistic characteristics only when it is necessary in order to attribute the originals of miracle-working icons. Work on the compilation has raised many questions of a theoretical and methodological nature, some of which were discussed at the international symposium 'Miracle-Working Icons in Byzantium and Medieval Russia', organized by the Research Centre for East Christian Culture (Pl. 22) in Moscow in 1994,[8] and are presented in a number of other publications.

The present short article does not attempt to examine all the problems connected with miracle-working icons of the Virgin. A long monograph would not be enough for this either. Yet it would seem to be useful to systematize some of the main themes which arise in studying this phenomenon, without limiting oneself to the framework of traditional art history. Let us first examine the above-mentioned sections for the description of each icon in the encyclopaedic dictionary.

Historical records

These are given at the beginning of each article according to chronological order of the sources. The typology of the sources varies: the records by Byzantine historians, Medieval Russian chronicles, pilgrims' *proskynetaria*, hagiographic texts, *ekphraseis*, hymnography, memorial inscriptions on the icons themselves, and the earliest dated copies. In some cases the records appear in later texts which require a careful checking of sources. A classic example of this problem is the story of the appearance of the icon of the Virgin Hodegetria in Constantinople, as recorded in Nikephoros Kallistos's *Ecclesiastical History*.[9] The fourteenth-century historian quotes a non-extant record by Theodore Anagnostes (6th century) that an icon of the Virgin painted by St Luke was

sent to Pulcheria by Empress Eudokia from Jerusalem. Nikephoros Kallistos Xanthopoulos identifies this icon with the Hodegetria. This would appear to be a very old source, close in time to the actual events. However, this record is not confirmed by other sources, the statements by Nikephoros Kallistos himself being contradictory.[10] And this means that the real history of the Constantinopolitan Hodegetria can begin only in the ninth century.

Quite a different case is the history of the famous Russian miracle-working icon of the Virgin of Bogoljubovo, which is quoted only in the eighteenth-century chronicle of the Bogoljubovo monastery.[11] It records Prince Andrei Bogoljubsky's vision in 1158 of the Virgin praying with a scroll in her hand and the subsequent painting of a miracle-working icon on the basis of this vision. In spite of the very late source, an analysis of the historical testimony and archaic language make it possible to assume that the eighteenth-century author had some very old manuscripts at his disposal. An important additional argument is the existence of a twelfth-century icon of the Virgin of Bogoljubovo and the details of the old ornament. All this information enables us to regard the eighteenth-century monastery chronicle as an important Medieval source. Work on the encyclopaedia has shown that even very late records may contain unique data about the Byzantine period. They are worthy of attention not only as legends, but as a special type of historical document, for which the correct method of research has not yet been elaborated.

The miracle story of the icon

A study of the stories about miracle-working icons could become a special sphere of research requiring the joint efforts of historians, art historians and philologists. Promising research areas are the study of the structure of these stories and of the interrelationship between archetypal, legendary, literary and real historical motifs. One of the difficulties is that archetypal models are sometimes not invented by the author, but are an integral part of the actual event. A common *topos* is the connection of miracle-working icons with holy water. Sources can be found in stories about antique miracle-working statues. The theme of miracle-working water connected with a sacred icon can be found in the oldest Christian prodigies. The stories of many miracle-working icons of the Virgin are inextricably linked with their presence beside a miraculous healing spring (the icons of the Blachernai church, the monastery of Zoodochos Pege and the Hodegon monastery in Constantinople).

The *topos* of holy water is an important element in the very early story of the first miracles by the icon of the Virgin of Vladimir, compiled by an eyewitness of the events in 1163-1164.[12] Half of the ten miracles concern various healings with the help of holy water, which occurred after a special ritual of washing the miracle-working icon. We can speak of the existence of a special cult of miracle-working water in twelfth-century Russia. There can be no doubt that it grew up under the influence of a firmly established archetype. Yet it is also clear that the author of the story is describing real historical events, rich in unique details, and a real practice of consecrating water with an icon. In this case the archetypal, legendary and historical are completely inseparable.

At a later stage the preference given to this or that *topos* in the story can serve as an element which helps to date not only the literary text itself, but also the time when the cult arose (the written text could have arisen must later). In constructing an historical typology of Medieval Russian stories about icons Ebbinghaus and Turilov draw attention to the *topos* of the icon's discovery, which changed at different times.[13] The oldest icons, before the middle of the thirteenth century, are copies of famous Byzantine images brought to Russia. From the mid-thirteenth to the mid-sixteenth century the motif of the miraculous appearance of the icon dominates in accounts of the discovery. In the late sixteenth and the seventeenth century it is the commissioning, sale or finding of a hidden icon that predominates, which usually takes place after the Virgin appears to someone in a vision. The historical mythology can serve not only as one of the criteria for determining the time when a concrete story appeared, but also as a kind of source testifying to the changing psychology in people's perception of the miraculous.

49

The study of miracle-working icons in the Balkans is further complicated by the fact that the written records are late, not before the sixteenth century. For a long time the stories existed as oral accounts of prodigies only. This is characteristic of the Mt Athos monasteries. Many stories appeared in the Byzantine period, as can be seen from the age of the surviving icons themselves. How detailed and ramified this oral tradition was can be seen from the recently published Story of the miracle-working icons of the Chilandari monastery,[14] which was compiled by Russian scribes on the basis of oral accounts by members of an embassy from the monastery who came to Moscow in 1558 to seek financial assistance. A valuable feature of this Story is that the miracle-working icons, mainly icons of the Virgin, are described as a living complex. They interacted in numerous rituals and processions of the monastery. Nearly all of these icons, most of which can be dated to the fourteenth-century,[15] have survived in different parts of the monastery. There is every reason to believe that these prodigies, which were written down in the sixteenth century, actually appeared in the Byzantine period. The Athonite monasteries, particularly the miracle-working complexes of Chilandari and Vatopedi, provide a rare opportunity to compare Late Medieval stories with surviving icons and liturgical practice dating back directly to the Byzantine tradition.

Forms of worship and liturgical use

This section will include all known information about historical forms of reverence shown to particular miracle-working icons. They include the following questions: the time and reasons for fixing the special days when the icon is celebrated (some Russian miracle-working icons are celebrated three times a year); the content and structure of the liturgical texts; the part played by the icon in processions and other special rites (for example, memorial services); the organization of the icon sanctuary, including its architecture, and special groups of servants or fraternities dedicated to the icon; special forms of veneration such as the precious covers, votive gifts and veils used to adorn miracle-working icons. Important evidence of the Constantinopolitan tradition of the liturgical use of miracle-working icons has been collected and analysed in a recent article by Nancy Patterson-Ševčenko.[16] A particularly valuable aspect of this work is the author's comparative analysis of both written and iconographic data, which makes it possible to reconstruct two most important processions with miracle-working icons in the Byzantine capital.

The best known were undoubtedly the Tuesday processions with the Hodegetria of Constantinople, which are reflected in written records by pilgrims from various countries and in numerous representations in the Akathistos cycles and individual compositions. Considerable attention is paid to this important ritual of the Byzantine capital in the scholarly literature.[17] Yet a number of questions require further study. It is essential to provide a detailed reconstruction of the ritual and establish its symbolic meaning. It should be noted that it consisted of two different rites. The first was a procession round the city, stopping at different churches depending on the particular day. This is recorded in descriptions by Latin pilgrims in the eleventh century[18] and, if we are to believe the story of the Virgin of Rome (Maria Romaia), was introduced after the victory of the Iconophiles in the ninth century.[19] The other rite took place in the market square in front of the Hodegon monastery and is first mentioned in the twelfth century.[20] It is depicted in detail in a late thirteenth-century wall-painting from the Blacherna monastery (Pl. 211) near Arta.[21] Similar accounts at different times by pilgrims from various countries indicate the strict repetition of one and the same carefully elaborated Tuesday ritual. Its focal point was the reproduction each week of the miracle of the carrying of this extremely heavy icon, which was placed by several people on the shoulders of one man who could carry it easily. The man was a member of a special family of servants of the icon. He carried the icon round the market square several times, probably creating a special sacral space in it.

In our view, this rite could be regarded as the miraculous appearance of the Virgin in real urban space and analysed as a kind of icon-image which can be studied by iconographic methods. There is still no clear answer to the question of the main symbolic idea behind this rite, which

ЧУДОТВОРНАЯ ИКОНА
В ВИЗАНТИИ И ДРЕВНЕЙ РУСИ

22. Cover of the book
*The Miracle-Working Icon
in Byzantium and Old Rus'*,
Moscow 1996.

was obviously seen as being of prime importance in Constantinople.[22] It is not known why the rite took place on a Tuesday. We believe that the Tuesday rite was a reproduction of the siege of Constantinople in 626, which was saved by the intercession of the Virgin and her miracle-working icon.[23] In the Middle Byzantine period people regarded this siege and the miraculous liberation of the capital from the Avars by the Virgin as a most important event. The miracle was ascribed to the Hodegetria of Constantinople. It is interesting that one of the oldest accounts, by Theodore Synkellos, says that the patriarch carried an icon 'not made by human hands' round the walls of Constantinople, mystically guarding and protecting the city by the divine strength in the icon.[24] It is noteworthy, that this event took place on a Tuesday. So the weekly Tuesday rite could have been an important supplication by the city for salvation and protection, which reproduced through ritual the establishment of a mystical link between the citizens and their main intercessor. The Mother of God confirmed her supernatural presence in the city's main palladium, the icon of the Hodegetria, with the help of a miracle which invariably took place.

The Tuesday rite and procession were part of an elaborate system of ritual with miracle-working icons in Constantinople.[25] What we have here is a special type of Byzantine spiritual creativity, which one might call a liturgical performance. Like iconography and other forms of spiritual culture it underwent historical changes. The liturgical performance developed exclusively in Russia during the sixteenth and seventeenth centuries, when we find a carefully elaborated system of church processions with various miracle-working icons and other rituals with the participation of icons and relics as, for example, the Washing of the Relics on Good Friday.[26] By analysing the 'iconographic' structure of this rite we find both ancient Byzantine proto-elements and important innovations defining a different historical age.

It is interesting that the Constantinopolitan rituals themselves have the status of iconographic patterns, which are reproduced in other regions of the East Christian world. Thus in a twelfth-century *Vita* of the Russian Princess St Euphrosinia of Polotsk, we read that by analogy with the Hodegetria procession in Constantinople she introduced a Tuesday procession with a miracle-working icon of the Virgin.[27] The icon in question was the Virgin of Ephesus, probably a specially consecrated twelfth-century copy sent to the princess from Constantinople by Emperor Manuel and Patriarch Luke Chrysoberges (1157-1170) in the 1150s. The icon of the Virgin of Ephesus, which was regarded in Polotsk as one of the three icons painted by St Luke, is identified with the icon of the Hodegetria, the best known of the three. The liturgical performance of the Constantinople icon was reproduced as a sacred model. With the help of the procession with the icon the urban environment of Polotsk is likened to the sacred space of the Byzantine capital; thus the Medieval Russian town became the icon of this second Rome and New Jerusalem. It seems quite likely that the weekly miracle of the Tuesday procession might also have been reproduced.

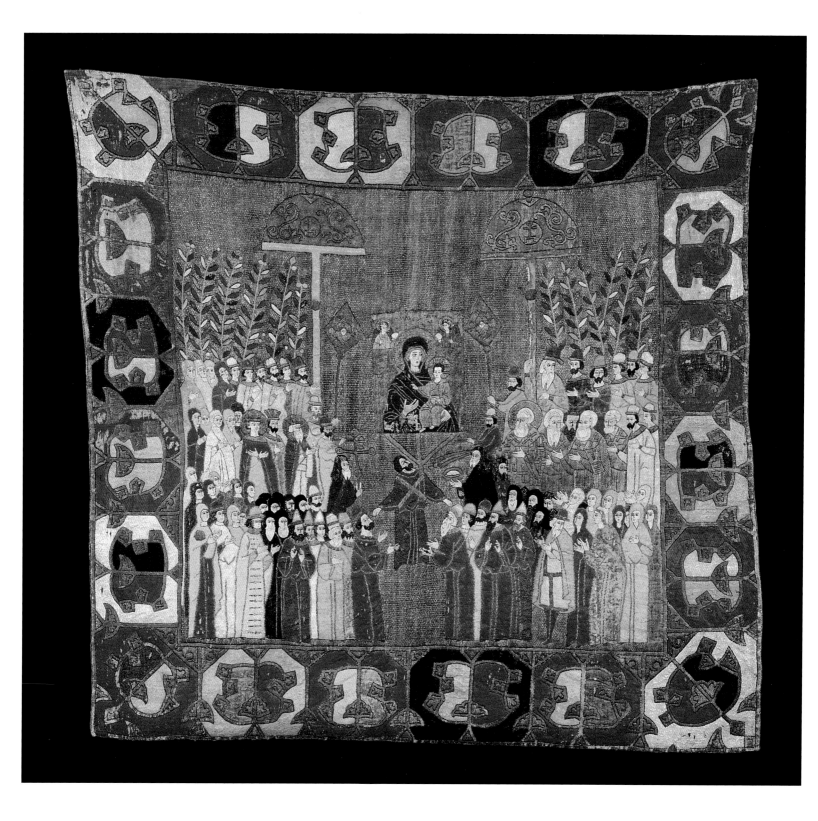

23. *The Procession of the
Hodegetria Icon in Moscow*.
Embroidered Icon of Helena
Voloshanka, 1498 (?)
State Historical Museum,
Moscow.

Confirmation of this assumption can be found in a representation on the Moscow embroidered icon (*podea*) of Helena Voloshanka, of 1498 (Pl. 23).[28] It shows the procession of the Hodegetria icon, but in this case, taking place in Moscow in the presence of recognizable members of the princely family and the Russian Church. The remarkable authenticity in the depiction of the Moscow scene makes possible a fairly accurate dating of the piece, which records not only the Moscow practice of the Tuesday procession, but also the important historical event associated with it (according to a new interpretation it could be the ceremony of the coronation).[29] Helena Voloshanka's *podea* was most likely made for the icon of the Hodegetria in the Moscow Kremlin, a miracle-working copy of the Constantinople one. Together with the representation, the ritual and its most important miracle were taken over. All of this together was intended to indicate the Virgin's growing protection, in space and time, of the new Orthodox capital.

A most important source for the study of fraternities associated with miracle-working icons is the charter which has survived in the original late eleventh-century manuscript of a special religious society for the icon of the Virgin 'Nepaktetisa' (of Naupaktos), founded in 1048 in the Greek town of Thebes in Boeotia.[30] It is interesting that the confraternity consisted of men and women, clericals and laymen living in different parts of Greece. They formed not only an ecclesiastical but also a social structure, which would appear to be rather traditional for Byzantium at that time. The serving of this specific miracle-working icon of the Virgin, about which we know nothing from other sources, is presented as an important factor of not only religious, but also social life.

The main form of activity of the confraternity of the Virgin Nepaktetisa which belonged to the convent of Naupaktian women in Thebes, was the carrying of the icon from one church to another, where special services were held throughout the month in its honour. This carrying from place to place was characteristic of other miracle-working icons of the Virgin. It should be recalled that as well as the Tuesday processions the Constantinople Hodegetria was carried out of the Hodegon monastery on certain days to Hagia Sophia, the Imperial Palace, the Blachernai church of the Virgin and the Pantokrator monastery.[31] The mystical significance of the procession lay in the sanctifying of the space by the presence of the Virgin. Yet there could also have been a purely economic factor, the role of which in the cult of the miracle-working icon has been pointed out by Oikonomides in his article.[32] Among a number of examples he quotes an agreement of 1401 on the distribution of the income from the miracle-working icon of the Virgin Koubouklaraia, which was rented out by its owners to one of the churches in Constantinople.[33]

The similarities and differences between the fraternities of miracle-working images in Byzantium and the Latin West is an interesting and as yet little studied aspect of the question. The extraordinary rituals and the use of exotic robes are noteworthy special features. The best known examples are the special linen robes with cap-hoods like masks which the members of the Constantinople Hodegetria fraternity wore. They are to be found both in pilgrims' accounts and in a number of representations. For example, an icon of the Triumph of Orthodoxy, in the British Museum (Cat. no. 32), shows angels supporting an icon of the Hodegetria and dressed in similar robes with high caps and narrow white ribbons on their shoulders.[34] The iconographic context stresses the enormous symbolic significance of the red robes, the meaning of which is still not clear. In this connection, two points should be noted. The Hodegon monastery was the Constantinople residence of the Antioch Patriarchate and consequently had very close links with Syria. Pilgrims note that the servants of the Hodegetria belonged to one family, without giving its name. However, the early fifteenth-century Russian chronicles have preserved a unique record which clearly goes back to a Byzantine source, according to which, 'the tribe of Luke serves the icon to this day'. It is quite likely that this refers to the descendants of the Apostle Luke, the legendary painter of the icon. According to an old legend the Empress Pulcheria received an icon painted by Luke and other relics of the Virgin from Antioch. This suggests that some aspects of the Hodegetria cult may derive from Syrian sources.

Another interesting subject is the organization of a sanctuary of the miracle-working icon. Not a single systematic description has survived, but there is much indirect evidence which enables us to imagine the structure of the space of such important sanctuaries of the Virgin as the Blachernai church complex, the Hodegon monastery or the church of Zoodochos Pege in Constantinople. The descriptions[35] can be significantly enriched by archaeological data (for example, the excavations on the site where the Hodegon monastery is thought to have stood).[36] In a number of cases iconographic material can be used. Thus, as was recently pointed out, a fourteenth-century Russian icon of Pokrov or The Intercession of the Virgin (in the Blachernai church), shows three fairly accurately depicted church buildings, places where the miracle-working icons in Blachernai were kept: the basilica, the *Hagia Soros* rotunda and the so-called *Hagiasma*.[37] It is characteristic that in all three Constantinopolitan sanctuaries the miracle-working icon was next to a miracle-working spring. In spite of radical rebuilding these three springs even now, in modern Istanbul, serve as a place of worship in Blachernai and Zoodochos Pege. A well-preserved example of the organization of a sanctuary for a wonder-working icon has survived in the Greek monastery of Mega Spelaion (Pl. 40).[38] The icon of the Byzantine period is executed in high relief from ceromastic and attributed to St Luke. Apart from the icon itself, which has been badly damaged by fire and is now in the south corner of the iconostasis of the church dedicated to it, there is a cave in the monastery where the icon is said to have been discovered and a miracle-working spring nearby. It is significant that the space round the miracle-working image is organized on the principle of the 'Holy Land' in miniature.

Also noteworthy in this connection is the ancient *topos* of the icon, which chooses the place where it is to be, occasionally changing it several times. Here one might also recall the Portaitissa from Iviron (Pl. 42) on Mt Athos,[39] and the many stories about Russian icons, including the Virgin of Vladimir (Pl. 24) who chose herself a place in the first Kievan church in Vyshgorod,[40] or the Virgin of Tikhvin which, according to the Story, appeared four times in the forests nearby Novgorod in the summer of 1383, before indicating the holy place of its future monastery on the Tikhvinka river.[41]

A special form of revering miracle-working icons was the donating of votive gifts, which could be in the form of precious mounts, crowns, special necklaces and other pendants, sometimes ordinary female jewellery. A characteristic and relatively early example is the precious frame of the Virgin of Vladimir (Pl. 24). A brief chronicle entry under 1155, which describes the bringing of the miracle-working icon from Kiev to Vladimir, mentions, as a most important event, that Prince Andrei Bogoljubsky created an incredibly rich mount for the icon, which contained more than twelve pounds of gold and many precious stones.[42] The creation of this precious mount for the miracle-working icon is presented by the chronicle as an event of national political importance. Prince Andrei was not simply giving the icon a pious gift, but also indicating the exceptional status of the miracle-working relic that belonged to him and was destined to become the palladium of the new centre of Medieval Russia. The icon was given the role of a consolidating social force, which it performed first in the Vladimir-Suzdal principality, then as the main relic and defender of the Tsardom of Muscovy.[43]

The mount of the Virgin of Khakhuli (Pl. 120) was of similar significance. In the reign of King David the Builder (1089-1125) it was brought to the Gelati monastery near Kutaisi and became the palladium of the kingdom of Georgia.[44] In accordance with the will of David the Builder, his son Dimitri (1125-1156) created a precious mount-case in the form of an enormous triptych of gold and silver, which included all the main treasures of a crown—cloisonné enamels and precious stones. The mount, which has survived to this day, has preserved its donor inscription in verse, in which King Dimitri as the creator of the mount-case is compared to King Solomon who built the Temple. Evidently the erection of the *ex-voto* mount in Georgia, as in twelfth-century Russia, was regarded as a most important religious and political act, comparable with the building of the Temple of Solomon.

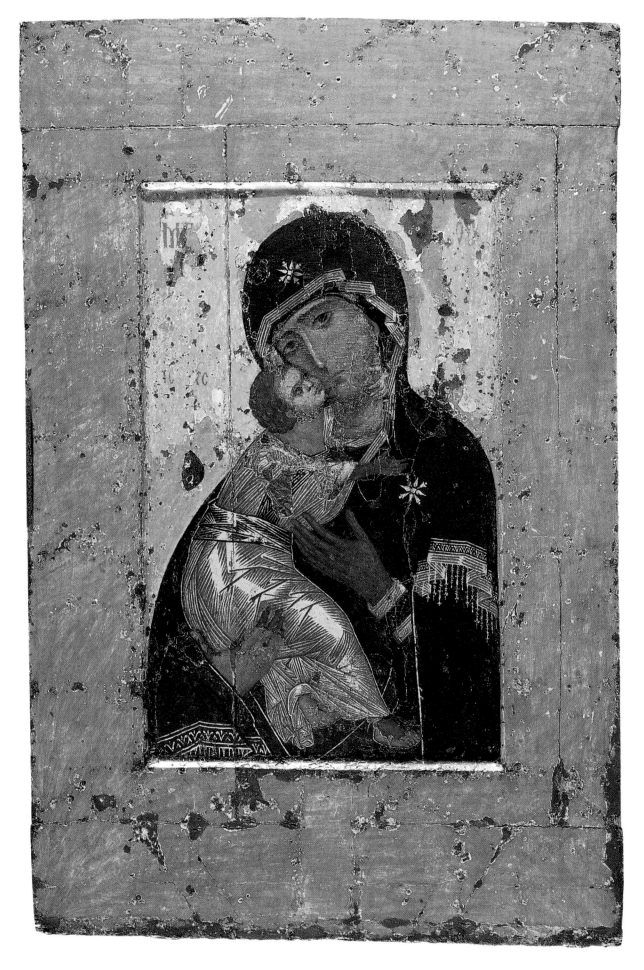

Considerations of state in the cult of the miracle-working icon were combined with deep personal piety. A twelfth-century Story about the miracles of the Virgin of Vladimir as a traditional gift contains several references to donations of female jewellery to the icon in gratitude for healing.[45] There were also special sets of ornaments for icons, which have survived in Medieval Russian monuments beginning with the eleventh century. They were called a *priklad* or *kuzn* and included special crowns or haloes, necklaces (*tsaty*), earrings, and a special headdress often made of pearls, which was fixed to the icon and sometimes covered the painted image almost completely.[46] The precious ornament on a miracle-working icon was completed by various veils. So-called *podeai* were hung under the icons.[47] They often bore icon compositions which duplicated or added to the main image.[48]

There were also upper veils, called *encheirion* or *peplos* in the texts. A number of Byzantine *ekphraseis* have been dedicated to such textiles, which were usually embroidered with gold and silver thread and sprinkled with pearls.[49] These hangings-*encheiria* were the traditional form of rich votive gifts which, judging by the epigrams, were usually connected with a miraculous healing performed by the icon. Four late twelfth-century epigrams have survived which relate to a *peplos-encheirion* and were donated to four miracle-working icons of Christ Chalkitis and the Virgin of the Life-Giving Source (Zoodochos Pege), the Kyriotissa and the Hodegetria. They were all commissioned by the *Sebastokratorissa* Irene as a prayer for the well-being of her family.[50]

Such textiles concealed the sacred relic under a precious cover and were lifted at a certain moment like a stage curtain, making the sacred image accessible to comtemplation. The best known example of such a sight is the miracle which took place each Friday in the Blachernai church in Constantinople.[51] It is recorded in several descriptions, of which the recently published testimony of an eleventh-century Latin pilgrim is particularly important.[52] The veils and covers were often made of purple silk and decorated with gold embroidery. They created the image of rich imperial attire on the divine icon, a theme which originates in the robes donated in Antiquity to miracle-working statues, such as Pallas Athena in the Parthenon.[53] It is interesting that the Byzantines believed the miracle-working power of an icon could pass into the veils covering it. The historian Zonaras says that a miraculous veil hung over the icon of Christ on the Chalke Gate healed Emperor Alexios Komnenos.[54] The mount, precious ornaments and veils frame the icon like relics. Like the *brandea* (a contact relic) they acquire through contact with the sacred relic some of its miracle-working power.[55]

The *topos* of the concealing of a miracle-working icon deserves special attention. The best known example is that of the Virgin Kykkotissa in Cyprus, which was entirely concealed by a cover that no one was allowed to lift.[56] In eleventh-century Constantinople a similar ban was placed on a miracle-working icon of the Mandylion, which was in the church of the Virgin of Pharos in the Great Palace, concealed from human gaze in a gold casket.[57] Gold mounts, jewellery and veils almost completely covered the representation on other miracle-working icons too, creating an effect of the mystical inaccessibility of the relic, similar typologically to the effect of an iconostasis which conceals the sacrament in the sanctuary. The symbolic origins of the *topos* in question can be found in the archetypal image of the Old Testament Ark, which concealed the relic and could be viewed by the high priest only once a year.

There are some other important issues connected with the miraculous icons of the Virgin. Among them the creation of copies and replicas of these icons and their impact on iconography. It is noteworthy, that most of the Byzantine icons of the Virgin were the copies of particularly venerated miraculous images. However, we deliberately put aside traditional art-historical matters here and focused our attention on presenting major structural elements of this significant but still unstudied phenomenon of Byzantine culture.

[1] Among these studies: Cormack 1985a, 121-133; Cormack 1988, 55-60; Ševčenko 1991, 45-57; Belting 1990, 1994 analysed in various aspects, the numerous testimonies to miraculous icons found reflection in the papers given at the symposium 'Holy Image', held by the Dumbarton Oaks Byzantine Center, 1990. These materials partly appeared in print in: *DOP* 45 (1991). A special symposium dedicated to the topic was held in Moscow in 1994, the papers were published in *Chudotvornaja ikona*. In conjunction with this symposium programme an album-catalogue has been published recently: *The Miraculous Image*. Also Carr 1997, 81-99.

[2] There were several Russian collections. Among the most complete and wide spread, available in some editions: Snessoreva 1891, 1898, 1909; *Bogomater' / The Mother of God*, including short miracle stories of nearly 800 icons. Complete bibliography of the old Russian publications in Bentchev 1992.

[3] Recent Greek compilations in Marinakis 1994 and richly illustrated Tsoulias 1996.

[4] Munitiz et al. 1997.

[5] Griffith 1982, 166-67, 174-175.

[6] A characteristic example was a special investigation of the miracle-working by the icon of the Hodegetria in Shuia in 1667. Sidorenko 1996, 321, 546.

[7] *Chudotvornyie ikony* forthcoming.

[8] The material from the symposium is published in *Chudotvornaja ikona*.

[9] *PG* 86.1, 165A.

[10] Wolff 1948, 319-328; Walter 1997, iv-v.

[11] Aristarkh 1878, 2-3.

[12] *Chudotvornaja ikona* 505-507; Miller 1968, 657-663.

[13] Ebbinghaus 1990; Turilov 2000, 64-67.

[14] Turilov 1996.

[15] Some of these icons are published in Bogdanović, Djurić and Medaković 1978.

[16] Ševčenko 1991, 45-57.

[17] Ševčenko 1991, 48 (major bibliography). The historical testimonies were collected in Janin 1953, 212-214. The Russian Pilgrim's accounts in Majeska 1984, 36-37, 138-139, 160-161, 182-183, 362-366.

[18] Ciggaar 1976, 249; Ciggaar 1995, 127.

[19] von Dobschütz 1903, 202.3-10.

[20] The earliest account known to me is the 12th-century Danish description: '*De profectione Danorum in Terram Sanctam*' in Gertz 1920, 490-491.

[21] Acheimastou-Potamianou 1981, 4-14.

[22] Recenly Irina Shalina connected this rite with the Jerusalem procession to the Mount of Olives, with the celebration there on Holy Tuesday and a commemoration of the earthquake in Constantinople, possibly stopped by the St Luke's icon in 438-439: Shalina 1999, 58-62.

[23] Lidov, in *Chudotvornyie ikony* (forthcoming).

[24] Makk 1975, 9-47, 74-96.

[25] Ševčenko 1991, 45-57; Carr 1997, 81-99.

[26] Golubtsov 1908.

[27] Shalina 1996, 200-9, 543.

[28] *Medieval Pictorial Embroidery*, 60-61, no. 17.

[29] Evseeva 1999, 430-438.

[30] Nesbitt and Wiita 1975, 360-384.

[31] Carr 1997, 95-98.

[32] Oikonomides 1991, 35-44.

[33] Oikonomides 1991, 41-42.

[34] *Byzantium*, no. 140.

[35] Talbot 1994, 135-165, esp. 141-146.

[36] Demangel and Mamboury 1939, 75-111.

[37] Etingof 1999, 290-305, esp. 291, 294.

[38] *The Monastery of Mega Spelaion. Brief History*; Κτητορικόν και Προσκυνητάριον της ιεράς και βασιλικής μονής του Μεγάλου Σπηλαίου.

[39] Ανωτέρα Επισκίασις επί του Άθω, 59-67; Ebbinghaus 1990, 56-60; Bentchev 1992, 153-158.

[40] *Chudotvornaja ikona*; 503-504.

[41] Benchev 1992, 245-248; Ebbinghaus 1990, 174-188; *The Miraculous Image*, 28-29.

[42] 'Lavrent'evskaia letopis' (Lavrent'evskaia Chronicle), *PSRL* 1 (1997), 346.

[43] Schennikova 1996, 252-302, 544.

[44] Amiranaschvili 1972; Flemming 1981, 41-48; Flemming 1989, 525-540; Bentchev, 115-116.

[45] *Chudotvornaja ikona*, 507-508.

[46] Sterligova 1996, 123-132, 540; Sterligova 2000.

[47] Frolow 1938, 461-504.

[48] Sometimes one could see an image of a Byzantine emperor on a *podea* depicted in the 14th-century wall-paintings: Babić 1973, 178, figs 4, 6.

[49] Nunn 1986, 73-102.

[50] Nunn 1986, 94-97.

[51] Papadopoulos 1928, 46-48; Grumel 1931, 129-146.

[52] Ciggaar 1995, 121-122, 137.

[53] On the ancient tradition of protective veils, Belting-Ihm 1976, 14-37.

[54] Ioannis Zonarae, *Epitomae Historiarum* (Bonn 1897), III, 751.9-15.

[55] Cf. Nunn 1986, 84.

[56] Carr 2000, forthcoming.

[57] Ciggaar 1995, 120-121; Lidov 2000, forthcoming.

57

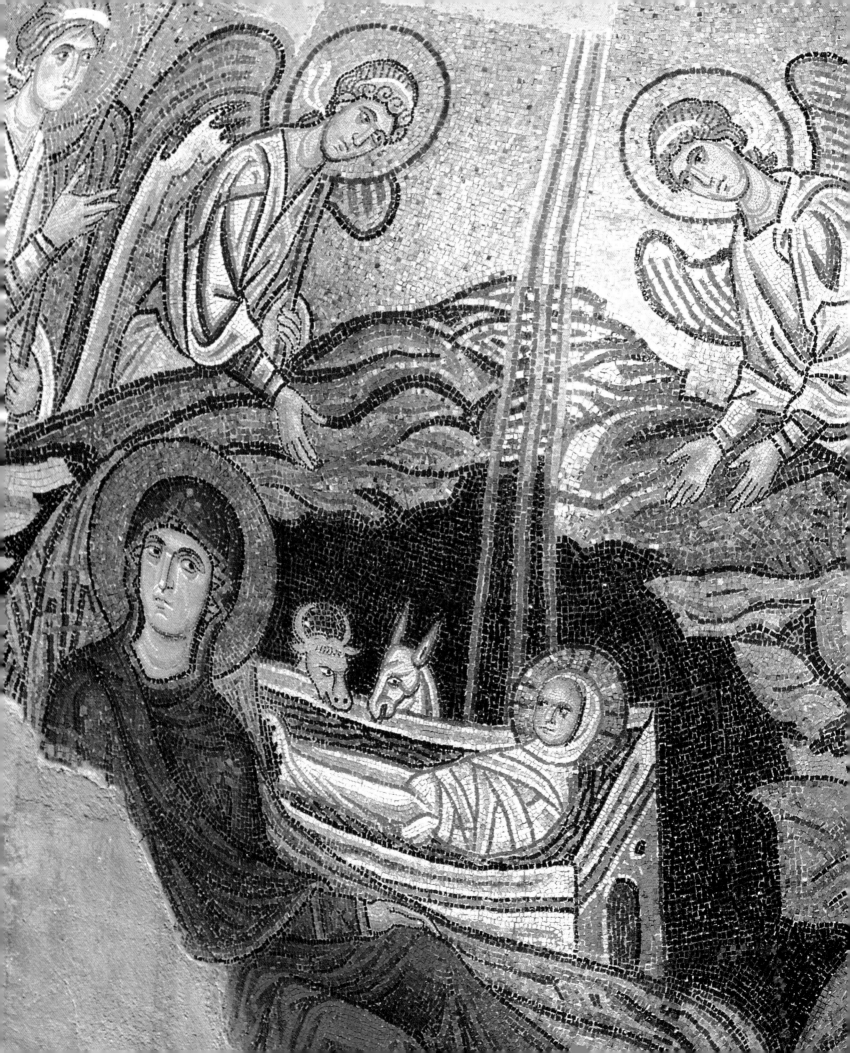

Savvas Agouridis

The Virgin Mary in the Texts of the Gospels

What follows concerning the Virgin Mary, mother of Jesus, is not a biography. Such a thing would be impossible. Here, quite simply, all we shall do is gather from the four Gospels what scraps of information they contain about Mary, and so present, in an entirely fragmentary fashion, approximately all of the material which, in greater or less detail, relates to her.

It is true that some of these references could also perhaps be mentioned in some other more or less related connection, but what we shall attempt here is on the one hand not to omit any essential information provided by the Gospels on the subject and on the other not to miss the actual import of these scattered fragments.

The Virgin Mother of Christ, Mary or Mariam (a word derived from a Hebrew root meaning 'plump'), bore a name that many other women we are acquainted with from the Gospel story also bore. From the information we have about her derived from the Gospels (but also from non-Gospel sources of historical significance) it is impossible to compile even a sketchy account of her life, for the Gospel information is fragmentary and insufficient, and the non-Gospel information (deriving from the apocryphal texts) is unreliable. The Church, in any case, was interested in the redemptive or divine significance of Jesus, and his family ties — those, that is, involving his parents and siblings — did not sort well with this interest. While on this matter, it is useful to reflect that of the four canonical Gospels of the Church which we possess, the accounts written by two of the authors, Mark and John, open with the Baptism of Christ in the river Jordan and the beginning of his work of Salvation, without concerning themselves at all with his earlier life. For both of them (Mark 1:10-12; John 1:32) it is the Holy Spirit, in other words, the relationship of Christ with God, that interests them. Undoubtedly, we learn much more about the Virgin Mary from the Evangelists Matthew and Luke who, though they wrote at different times and in different places, both adopted the same course: they added to the text of the Evangelist Mark two introductory chapters in which each in his own way tells us that Jesus was not proclaimed Messiah at his Baptism in the Jordan, but was born the Messiah. In order to support this theological end they were obliged to bring in Mary and Joseph, not because they were interested in them for their own sake, but because the subject of the Messianic nature of Jesus is linked to them.

Moreover, on this latter subject it should be noted here that wherever mention is made of his family in the context of the public life of Christ, such mention is not intended to inform us about them or establish something or other about them, but has to do with the work of Jesus's divine mission, which is not in any way connected with the personalities of those of his relations who are mentioned. Such is the case in the accounts by Mark and Matthew, while in Luke's the same situation pertains in the Gospel narrative, greater prominence being given to the Virgin Mary not only in the Prologue to the Gospel (chapter 1) but also in chapter 2. The same is the case with the Prologue to the Acts (chapter 1). In St John's Gospel, too, while the 'brothers' of Jesus declare their want of faith in him, his mother at the Wedding in Cana (in all probability, Pl. 26) and at the foot of the Cross on which Jesus was crucified, showed that she knew who her son was (Pl. 27). These matters concerning Christ's relations with his mother will be examined briefly, but with some degree of completeness. What we have concerning his family are mere fragments of information scattered

25. *The Nativity*, detail of Pl. 29.

59

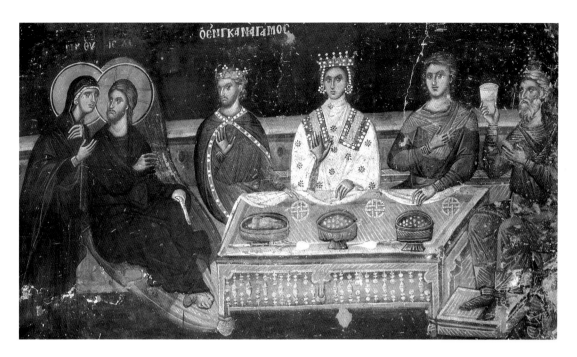

throughout the Gospels, given that the family of Jesus did not begin to interest the nascent Church until after Peter's flight from Jerusalem to Antioch in AD 44, when power in Jerusalem was seized by James the Adelphotheos (Brother of Jesus), through his becoming (let us call it that) bishop. He was succeeded, after his death by martyrdom, by two other brothers of Jesus in a local political climate reminiscent of dynasticism.

The Gospels tell us very little about Mary's descent. The *Protevangelium of James* (2nd century) relates that her parents were Joachim and Anne, and these may really be their names. In the genealogies of Jesus supplied by Mark (1:2-16) and Luke (3:23-28) Joseph descended from David, but we do not know whether his wife Mary was from the same tribe, something that may be inferred from relevant texts as most probable. That, certainly, was the belief in the early Church. Nevertheless, in Luke 1:36 Elizabeth, the mother of John the Baptist and wife of the priest Zacharias of the tribe of Levi, is called a 'relative' of Mary, hinting at her Levite descent. But it is quite possible that Elizabeth came from a tribe that was not her husband's. The requirement that priests marry women of their own tribe was not an absolute one. Moreover, according to both evangelists, Jesus was born 'of the Holy Spirit'. In other words, Jesus is connected to history and the past through being born of Mary and through the legal status he derives from Joseph, while his being born of the Holy Spirit gives meaning to the future more particularly, but also to the past. History cannot secure its own redemption. Redemption takes place within it, but not with its own resources. Mary and Joseph ensure the continuity of the past and the future, while Christ's being born of the Holy Spirit constitutes a break with the past, the renewal of history and a new future within the continuity of the world. The Evangelist Luke begins his Gospel from the viewpoint of the profound political changes in world history brought about by the birth of the man-God; Jesus, though born under Roman Rule, is destined to supercede it. As the face of the future, Jesus is the ruler of the world and it is he who will deliver the kingdom of God to the apostate world; he will also bring, however, the priest, the mediator between frail humanity and omnipotent God.

Mary's pregnancy before her wedding, that is before her husband had received her into his home, according to Jewish custom, troubled Joseph greatly, as was natural. Eventually, with the guidance of angelic forces, Joseph understood what was happening and co-operated in the divine plan (Pl. 28). At all events, where the birth of Jesus by divine intervention is concerned, it is not improbable that both Matthew (1:16; 1:18ff.) and Luke (1:26ff; 2, 33 and 2:48) made use of different sources. All the evangelists write, for instance, about the Resurrection, while John writes also about the Incarnation. It is not at all surprising either that Matthew and Luke were convinced of

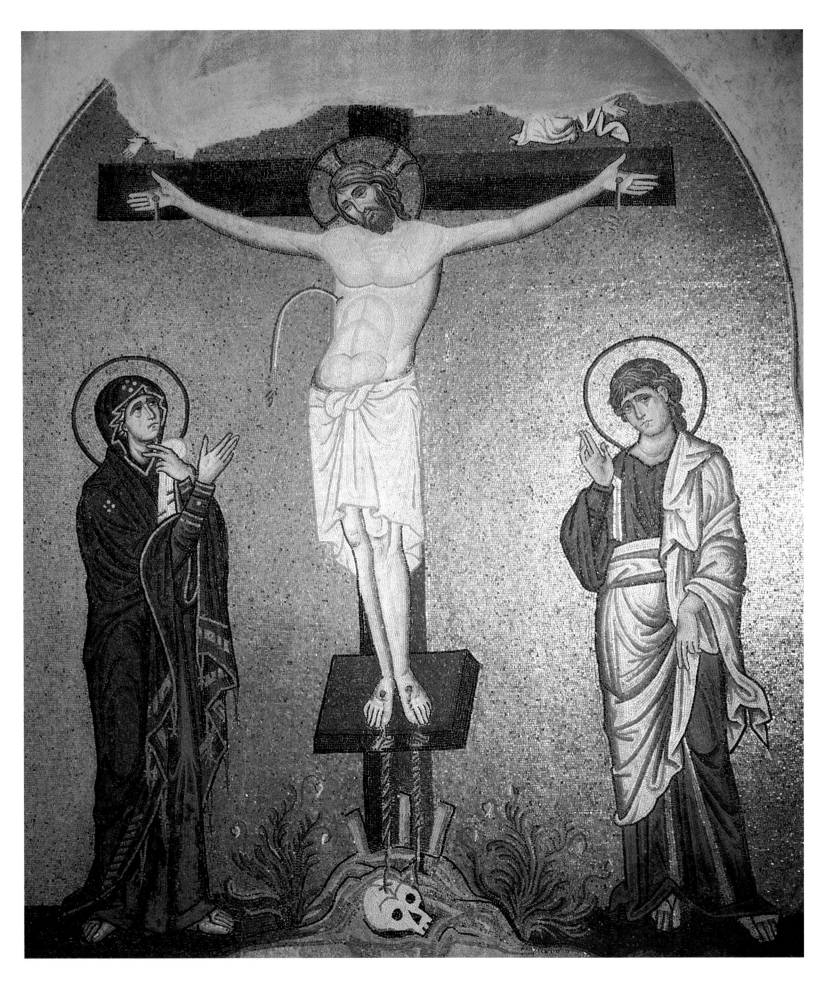

61

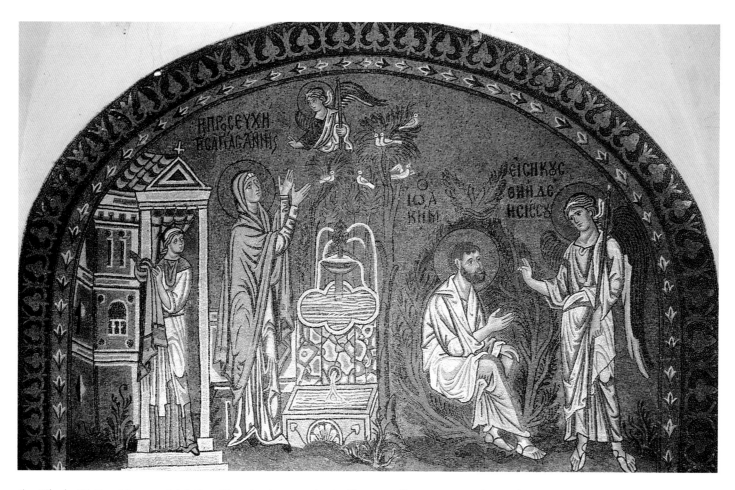

28. *The Prayer of St Anne*; *The Annunciation to Joachim*. Monastery of Daphni, Attica.

the Virgin Birth of Jesus, which the Church at once adopted because it gave expression to its own theology (Pls 25 and 29). The Virgin Birth was fundamental to the concept of the majesty of Jesus; however, explanations of this by others, outside the Church, especially the Jews, were turned against him.

When Jesus came into our world he was not met with a splendid welcome; that is the point that the Gospel of St Matthew wants to stress. If we except the splendour of the Adoration of the Magi (Pl. 30), the relevant text goes on to recount the Massacre of the Innocents in Bethlehem, the Flight of Jesus into Egypt and the miraculous return as well as the settling down in an insignificant village called Nazareth, in all of which Joseph plays the leading part.

Evangelist Luke is a Mariologist: in chapter 2 he concerns himself with Mary, not only for theological reasons, but principally for apologetic ones. The religious faction of St John the Baptist gave great prominence to his own miraculous birth, and his followers, particularly after his death, made great play of the godlike manner in which he entered into the life of humanity. In these chapters, however, Mary the Mother of God plays a prominent role; she makes statements of great consequence, while theologically important events are mentioned that concern the Son and his Mother.

First comes the Annunciation to the Shepherds, which includes divine promises, and the shepherds' address to the infant Jesus. Here the Evangelist adds: 'But Mary kept all these things and pondered them in her heart' (2:19).

When they went into the temple to present the Divine Child to God, the priest, Prophet Symeon, foretold that a sword would pierce Mary's heart and that this would be for the good of the world.

Another brief episode, involving the twelve-year-old Jesus in the Temple at the time of the feast of Passover, should be mentioned here. Parents and son become separated in the procession, an occurrence that prepares us for an understanding of the independence shown by Jesus as he entered upon the age of puberty. They found him where they never expected to: 'in the midst of the doctors, both hearing them, and asking them questions' (Luke 2:46-48). There were some things

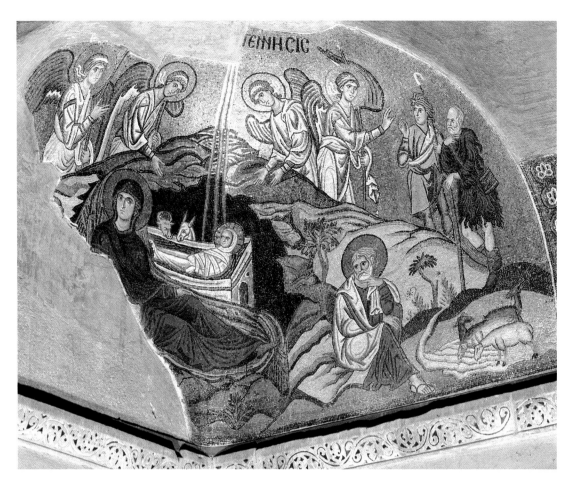

29. *The Nativity.*
Monastery of Daphni, Attica.

that Jesus said which not even his own family understood, as for example, 'How is it that ye sought me? Wist ye not that I must be about my Father's business?'.

What meaning does the birth of Jesus to the Virgin Mary have for Christians? Clearly it does not mean what the birth of divinities (such as that, for instance, of Dionysos to a mortal who had lain with one of the immortal gods) meant in ancient Greek tradition. The Gospels give no explanations. But Hebrew tradition offers some similar occurrences, that is, other births of wondrous persons through divine intervention. Apart, that is, from the Greek model of 'virginity' there is also the Hebrew one, and there may be others of so far unknown provenance. Of Judaic models a passing reference may be made to the Essene text *Genesis Apokryphon*, which includes the miraculous birth of Noah whose father was Lamech and grandfather Methuselah. When Noah was born 'his flesh was as white as snow and as red as the flower of the rose, and the hair on his head and his curls were beautiful and when he shook them out they lit up all the house like the sun and all the family became unusually radiant. And when he left his mother's arms he opened his mouth and spoke to the Lord of Justice'. Both father and grandfather were wholly perplexed and hastened to question their ancestor Enoch on the matter, since Lamech had accused his wife of having the child after sleeping with one of the fallen angels (Genesis, 6), and this despite the protestations of Bathenosh that she was innocent and had had no intercourse with another man. What Noah maintained so insistently to his father was that his miraculous birth had to do with the fact that he was to be the progenitor of the new world which would come about after the Cataclysm or Deluge.

The same happens in Enoch II, the 'Slavonic Enoch', which originated in about AD 70, when the temple and all Jerusalem were totally destroyed. It is extraordinary what the Hebrew spirit was able to produce in novel-like manner during the difficult years in which so much that had been lost had to be restored. Some Jews believed that the high-priesthood of the temple of Jerusalem was an extremely ancient institution and that it was associated with the creation of the world and the time of the Deluge.

Ner, the second son of Lamech, was very advanced in years as was his wife Sopaneim, and they were unable to have children. How then was the high-priesthood in the world that was to follow upon the Deluge to be preserved? Thus arose the tale that Melchizedek was sired by Ner 'without seed', and born, moreover, after the extended pregnancy of about three years of his mother, who gave birth to him at the very hour when her husband and Noah were interring her. Noah and Ner together exclaimed, 'Behold, according to his pleasure God renews the high-priesthood from the blood that is related to ours'. Noah and Ner made haste to bathe the child and they dressed him in the garments of the high-priesthood and gave him the sacred bread and he ate of it. And they gave him the name Melchizedek. Cutting the story short here, we must stress that in the Epistle to the Hebrews in the New Testament (6:19; 7:3) regarding the high priest, Jesus compares his own case with that of Melchizedek, who was 'fatherless', 'motherless' and 'unborn' (He was neither born nor did he die; how he came into the world no one knows). Such Hebrew legends kept the tradition of virgin birth, as something occurring whenever God creates something new in the world, very much alive in the religious consciousness of the Jews.

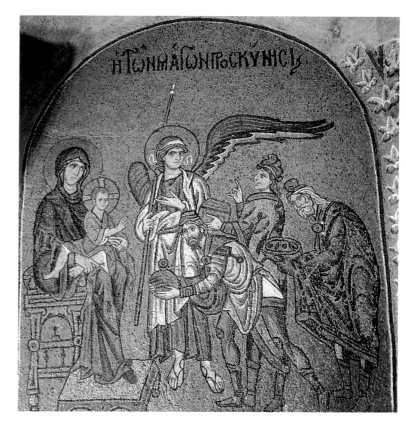

30. *The Adoration of the Magi.* Monastery of Daphni, Attica.

Joseph and Mary had a large family of boys and girls. The sons were named James, Iosis, Judas and Simon. The daughters were not usually referred to by name but collectively as Jesus's family. The Gospels inform us that Joseph was a carpenter and that Jesus followed the same trade. It is well known that early on in the Christian Age diverse opinions were formed about the relationship of Joseph, Mary and Jesus with the last's named brothers and sisters. The Roman Catholic Church accepts that all these brothers and sisters were the children of a deceased brother of Joseph, who were taken into Joseph's own family on the death of their father. The Eastern Church accepts that they were Joseph's children from a previous marriage, whom Joseph received into his new family. What is most probable is that these traditions represent an attempt to account for the ever-virgin nature of Mary, believed in by the Church. One sees and hears of many children who, however, have no direct connection with Mary, since their descent may be from either a deceased brother or a deceased spouse of Joseph. There are many members of Christian confessions today who maintain that however miraculous was the Nativity of Jesus, all these children were the offspring of Mary and Joseph. What sort of relations, though, were there within the family? Such details as we have are fragmentary and of such a nature that we cannot tell. Which is why, in what follows, some episodes, will be mentioned that do not permit us to reach any single exclusive conclusion. In Mark's Gospel, Jesus chooses his first disciples and performs his first miracles. The scribes from Jerusalem said that Beelzebub dwelt in him and that it was with the power of the prince of devils that he cast out devils. The response Jesus gave to this accusation (Mark 3:23-30) was that Satan could not make war upon Satan. Only when one breaks into the home of the devil and steals from him what is the source of his strength can one heal the possessed. At this point his family arrived at the house where he was preaching, but the crowd prevented them from entering. The people pressing around him told him of their arrival: 'Your mother and your brothers are outside and asking for you'. And he answered them, saying: 'Who is my mother and who are my brothers?' He glanced about him at those who surrounded him and said: 'Here are my mother and my brothers. For whosoever does the will of God that person is my brother and sister and mother'. Is this a sign of a rift in Jesus's

family? Recognizing the danger he was in, his family tried their utmost to prevent him from presenting himself as a prophet of Israel with all the tragic consequences that would follow, trying to keep him in the house on the pretext that he was 'out of himself', or, in other words, that he had taken leave of his senses.

Another incident related in the Gospel, according to Luke (11:27-28), may be quoted in this context. While Jesus was delivering one of his sermons, out of respect for the mother who had borne him, a woman cried out: 'Blessed is the womb that bare thee, and the paps which thou hast sucked'. Jesus's reply is open to different interpretations: 'Yea rather, blessed are they that hear the word of God and keep it'. The elemental meaning of what he said is that it is not the woman who bore him who is blessed simply because she gave birth to him, but she who hears God's word and keeps it. This does not prevent Luke in the Acts of the Apostles from presenting Christ's mother and his brothers as members of the first Church of Jerusalem after the Resurrection; and commentators are not wrong who single out the role of his mother in the first Church as the person who was effective in securing peace and compromise among the opposing factions within its bosom. In the group of Apostles who assembled to solemnize Christian worship Mary had a central place.

The picture the Gospel according to St John gives us of the relations between Jesus and his family is different. In the first chapter Jesus as Messiah takes over a number of disciples from St John the Baptist's circle of followers, and with his mother and disciples is invited to a wedding at Cana in Galilee. It was there that Jesus transformed water into wine, symbolizing the transformation of Judaism and Greek religiosity into a true spiritual religion. In this passage it is his mother who urges him to perform the miracle of turning the water into wine. This means not only that she believed he was capable of doing so, but also that she took the initiative in the prelude to such an act. All this suggests there is a different kind of relationship between Mary and Jesus in the fourth Gospel. This becomes clear in the dialogue between Mother and Son as he hangs on the Cross at Calvary. As John relates (19:25-27), though he has many brothers, Christ commits the care of his mother not to one of them but to John 'whom he loved'. What is strange is that in the Gospel according to John, Christ's brothers did not believe in him (7:5). After the Resurrection, however, it seems there were changes which also affected his brothers. And so, when in AD 44 the ruler Herod Agrippa imprisoned Peter, the head of the Church of Jerusalem, James the Adelphotheos (Brother of Jesus) succeeded to the leadership. This was the beginning of a succession of leaders of the Church of Jerusalem drawn from among the brothers of Jesus (James, Iosis, Judas) who were known as *desposynoi* (belonging to the family of the master). Writing on this subject, Renan speaks of the founding in Palestine of a Jewish caliphate by the relatives of Jesus.

As noted in the opening paragraphs of this article, the information provided by the four Gospels is very fragmentary and, in consequence, the relations between Jesus and his brothers and sisters have been subject to a variety of interpretations in tradition. What one may conclude at a theological level from the above is this: according to the Creed of the Church, Jesus was born in such a manner that his coming made the past qualitatively distinct from the future. That he grew up in a large family, no matter what its descent, emphasizes his upbringing as one among the rest of the children, with all the consequences arising from the circumstances of a large family. The continuation of the Gospels in the Acts reveals the family of Jesus, albeit with some delay, participating fully in the activity of the Christian community in Palestine and as 'brothers' of Jesus keeping in their own hands the leadership of the local Church until about AD 120.

The Gospels provide no further information about the Virgin Mother of Jesus. Other texts in the New Testament, such as the Epistles of St Paul and the Book of Revelation supply a few fragmentary and on the whole symbolic details, which however cannot be examined within the context of a discussion of the Gospels.

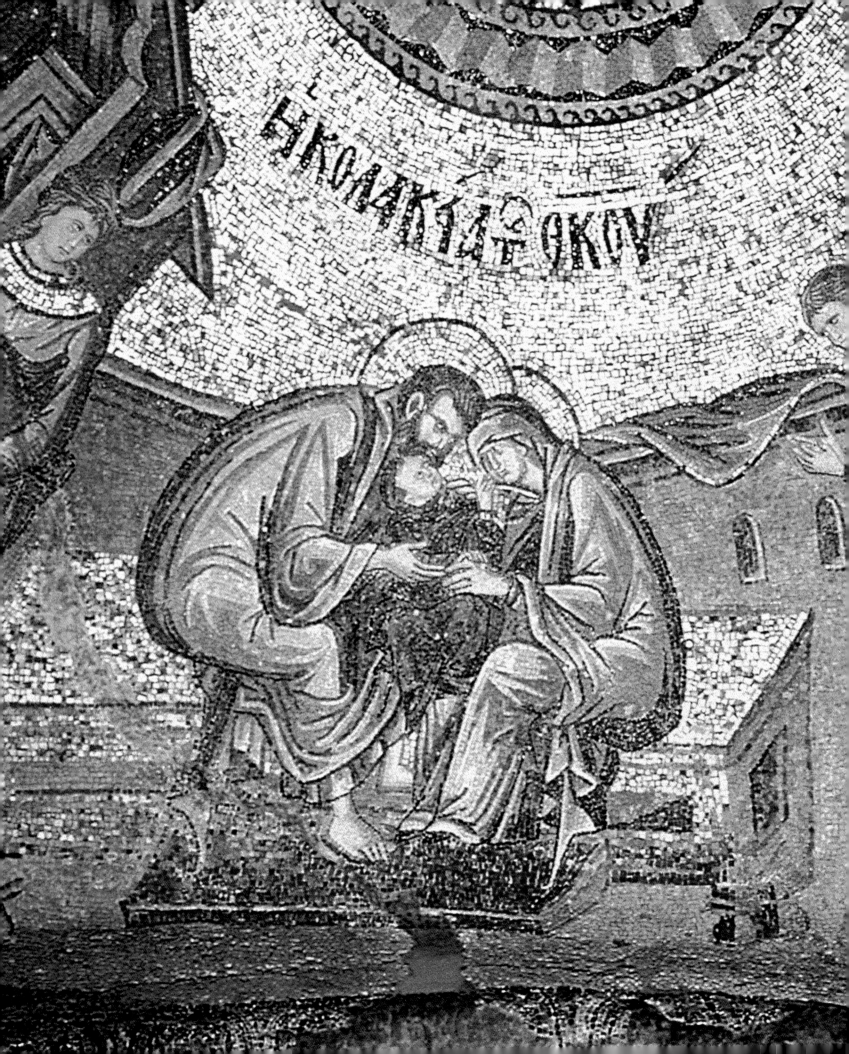

Ioannis Karavidopoulos

On the Information Concerning the Virgin Mary Contained in the Apocryphal Gospels

The four Gospels belonging within the New Testament Canon, the Gospels according to Matthew, Mark, Luke and John that we all know, are not purely biographical in character. This means they are not primarily concerned with giving us full historical biographies of Jesus Christ and the people connected with him, but focus their attention on the central events of his Life, Death and Resurrection and on the message of Redemption for Mankind that flows from these and his teachings. Of his Virgin Mother no mention is made in her own right, but only in relation and with reference to the person of her Son. It is therefore natural that the Gospels should provide only limited biographical information about the Virgin. Most of the information about her life derives from the so-called Apocryphal Gospels. A word or two, first, about the nature and aims of these texts.

As 'apocryphal Christian texts' — or in accordance with another current usage, as 'The Apocrypha of the New Testament', as distinct from 'The Apocrypha of the Old Testament' — is how various anonymous or pseudonymous Christian texts have come to be known, which were written in the second and subsequent centuries AD and which were not included in the canon of the twenty-seven books of the New Testament, but were either simply read or else rejected by ecclesiastical writers in the first centuries of Christianity. They are, however, related to the New Testament (which explains the title by which they are known) by reason of their literary form (they are Gospels, Acts, Epistles and Apocalypses as well as Dialogues, Questions, etc.) and of their content, since these texts refer to events and persons mentioned in the New Testament, often modifying them or presenting their sequel.

What though were the causes leading to the creation of this apocryphal literature?
1. Firstly, the pious imaginations of certain unknown authors, who attributed their writings to well-known figures in the Church and wished to make good 'gaps' in the New Testament, particularly regarding the life of Jesus and the Virgin, but also of the Apostles, sometimes with apologetic ends in view. The statement by the Evangelist John (20:30), 'And many other signs truly did Jesus ... which are not written in this book' provided sufficient biblical grounds for apocryphal writers to proceed with the compiling of their own texts. Certain other passages also sparked off the writing of an apocryphal text. For instance, what St Paul wrote in his Second Epistle to the Corinthians (12:2), 'I knew a man ... caught up to the third heaven ... and he heard unspeakable words, which it is not lawful for a man to utter', provoked the writing of the apocryphal *Apocalypse of St Paul*.

Often minor or unnamed New Testament figures are referred to in the Apocrypha by specific names, names that have survived in Church tradition, especially liturgical tradition. They become leading figures or play a more prominent role in them. The anonymous centurion at the Crucifixion, for example, is rendered in the Apocrypha as Longinus (the name by which he is known in the Lives of the Saints and the rest of tradition); the two thieves are called Gistas and Dismas, the woman with a flow of blood Berenike, and so on. Usually they present us with ficti-tious and fantastic narratives about periods in Jesus's life for which the Gospels provide no informa-tion. There are also accounts of the Birth and Childhood of the Virgin Mary, of the miracles Jesus

31. *The Virgin Caressed by her Parents*, detail of Pl. 34.

67

worked as a child, of the Flight into Egypt and the collapse of the idols there, the Descent of Christ into Hell and what occurred there, the Resurrection, the Apostles' missionary activity in various parts of the then-known world, etc.

2. Apocryphal literature became at once the vehicle and the means of formulating and promulgating heretical teachings. Church writers, especially the early ones, made reference to apocryphal writings which they claimed were in the possession of the various heretical sects, especially the Gnostics, and were used by them to seduce unsuspecting and illiterate Christians. Irenaeus, for example, at the end of the second century, in referring to the Gnostics wrote that they possessed 'a vast amount of apocryphal and spurious writings which they themselves have produced' and which 'they present to the stupefaction of fools and others ignorant of what is written concerning the truth' (*Adversus Haereses* I, 20). Does he mean, one wonders, the Apocrypha that are known to us today? Clement of Alexandria too mentions the 'apocryphal books' of the heretics (*Strommateis* I 15, III 4), and Origen, commenting on the prologue to the Gospel according to Luke, writes, 'since many have attempted...', where by 'many' he means the writers of the Apocrypha who had 'attempted' but been unable to write 'gospels' because they wrote 'without grace' (Homily 1 on Luke). Nevertheless, he says that some of his information regarding the martyr's death suffered by Isaiah is derived from an apocryphal text (Epistle to Africanus 11, 65), as well as that regarding the murder of Zacharias between the temple and the sacrificial altar (On Matthew 10,18).

As to the heretical or otherwise nature of the Apocrypha, this is a subject currently under discussion amongst researchers. In fact the history of apocryphal texts is rather complex, either because, being indeed heretical, they have undergone revision by Orthodox hands, or because having, on the contrary, initially been Orthodox, they have undergone revision at the hands of heretics, who have added their own teachings. Similarly complex is the history of their manuscript tradition. It sometimes happens that an ancient translation is either longer or shorter than its Greek original. Furthermore, some of the Apocrypha survive in several manuscripts which do not everywhere agree amongst themselves. In some instances an apocryphal text has been preserved in both a longer and a shorter version. Sometimes the Latin translation of a Greek original is longer, sometimes shorter. Many survive in the original Greek, but also in ancient translations (Latin, Coptic, Syrian, Ethiopian, Armenian, etc.). Some indeed survive only in these translations.

In the course of time apocryphal texts have been variously treated. At times they were condemned by the Church (especially in the West), at others they fostered secular piety or inspired works of art. Byzantine art includes scenes derived from the Apocrypha. It suffices to mention here by way of example wall-paintings in Cappadocian churches, the mosaics in the narthex of the Chora monastery in Constantinople, the wall-paintings in the katholikon of the Chilandari monastery on Mt Athos and of the Peribleptos monastery at Mystras, etc. — all are inspired by the *Protevangelium of James* and include scenes from the childhood of the Virgin. An important iconographic cycle from the life of the Virgin is preserved in illuminated manuscripts of the homilies of the monk James of Kokkinobaphos. Similarly, the iconographic subjects of the cave as Jesus's birthplace, of the parting of the mountain so that St John the Baptist might escape the soldiers of Herod, etc. are taken from apocryphal texts which might in turn embody pre-Christian traditions.

Even though the Apocrypha do not in essence add any new elements to Christian revelation and, as compared with the canonical New Testament texts, they clearly lack in theological profundity in their treatment of the workings of Divine Providence, one can justify the interest shown in them in earlier times and by contemporary scholarship. Preserved in some of them are the traditions on which certain of the feasts of the Church rest, especially feasts of the Mother of God.

Some of them moreover — which are not the work of heretics — have nourished many generations of Christians down the centuries, and though they may not have been at the centre of Church life they have nonetheless had a life and history of their own. As popular reading among the laity they exercised a peripheral influence, while their silent peripheral existence frequently

surfaced in a more pronounced manner nearer the centre and affected art and worship, the foundations of ethics and the character of apologetics.

These texts that have sustained the life of the Church — which drew upon whatever was positive from whatsoever source and turned it to good account — were the main source for authors of the Lives of the Saints and of ecclesiastical writings on the Birth, Life, Dormition and Metastasis of the Mother of God.

The earliest and most important of the Apocrypha, known as the *Protevangelium of James*, was written in the second half of the second century, probably in Egypt, and affected the devotional life of the Church in both East and West. The celebrations of the Mother of God quoted below either originated in the story related in the *Protevangelium* (for example, the Presentation in the Temple) or were influenced by it liturgically (as regards iconography and hymnology): 1. The conception of the Virgin by St Anne (9 December); 2. The Birth of the Virgin (8 December); 3. The Presentation of the Virgin (21 November); 4. The Annunciation to the Virgin (25 March); 5. The Synaxis of the Mother of God (26 December); 6. The Massacre of the Innocents (29 December); 7. The Synaxis of Joachim and Anne (9 September); and 8. The Commemoration of Zacharias (5 September).

More particularly, one might note that most, if not all, liturgical, hymnographic, iconographic and 'synaxaric' or biographical traditions associated with the life of the Virgin appear to have their beginning in this text which, if one is to judge from the abundance of manuscripts, both Greek and Latin, one has to conclude was widely disseminated in both East and West. Moreover, certain other Latin Apocrypha (such as the *Gospel of Pseudo-Matthew*) to a large extent reproduce the information given in the *Protevangelium of James*. Many writers and Fathers of the Church also make use of information provided by this text.

Below are the basic details concerning the Virgin which have their origin in this text and were the source of inspiration for Byzantine iconography.

1. The barrenness of Mary's parents, Joachim and Anne, gives rise to their fervent supplication to God that they might have a child; Anne's prayer, offered up in the garden, is particularly lyrical (3:1-3), for in it she observes that both animate and inanimate nature are creative and reproduce while she herself remains without a child.

2. The Annunciation to Anne and Joachim, to each individually by an angel of the Lord, that they will bear a child and their promise to dedicate it in the temple to the service of God (4:1-3).

3. The return of Joachim from the desert, where he remained forty days fasting and praying, the meeting with Anne and their embrace (4:4), which is portrayed in Byzantine art with delicacy and tenderness. (The apocryphal *Gospel of Pseudo-Matthew* places the meeting and embrace at the Golden Gate of Jerusalem, a tradition followed in the West.)

4. The Birth of Mary (Pl. 32).

5. The first seven steps taken by the Virgin when she was six months old, which inspired the scene known as the 'Heptabematizousa' (Pl. 33).

6. The Virgin tenderly embraced by her parents, known as the 'Kolakeia' (the Caressing) or 'loving care of the Mother of God', is not mentioned in the Greek original of the *Protevangelium* but in its Syrian and Armenian versions (Pls 31 and 34).

7. The celebration of the first anniversary of the birth of Mary, to which Joachim invites the priests, high priests, scribes, the house of elders and all the people. The blessing of the child by the priests and high priests (6:2-3).

8. The Presentation in the Temple of the three-year-old Virgin by her parents, accompanied by virgins holding candles (Pl. 35). Their reception by the priests. The dance performed by the young Mary (7:2-3).

9. The Nourishing of Mary in the Temple at the hands of an angel (8:1).

10. The Betrothal of the Virgin. When the dedicated girl was twelve years old the high priest Zacharias prayed to God and begged him to tell him what he should do. He was urged to invite the widowers

69

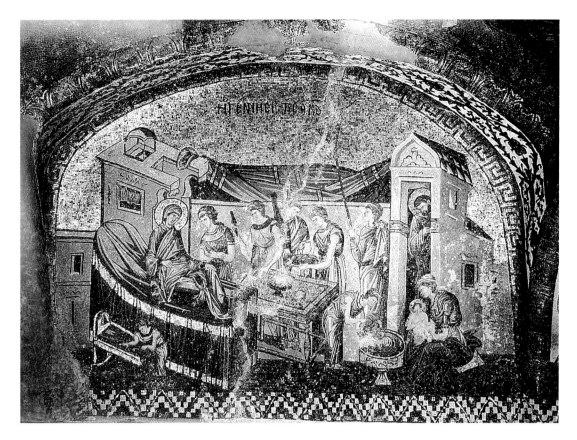

among the people to come to the temple, each holding a rod in his hand, and to await a sign from heaven. Joseph came along too. The high priest gathered the rods from them all and prayed. When he gave back to each man his own rod, a dove flew out of Joseph's rod and hovered over his head. 'The lot has fallen to you', the high priest told him, 'to take the Virgin of the Lord into your protection' (Pl. 36). Notwithstanding Joseph's objections that he was an old man and had sons of his own and was risking the ridicule of the Israelites, he agreed to receive Mary into his house (8:2 - 9:3).

11. The priests drew lots and charged virgins with the weaving of the temple curtain, the authentic purple and the red falling to the lot of Mary (10:1-2).

12. An angel of the Lord announces to Mary, while she stands at a well drawing water, that through the power of the Lord she shall conceive and give birth to a son (this is the so-called Annunciation at the Well) (Pl. 37). The scene is repeated when Mary returns to her home (11:1-3). The incident occurred when she was sixteen years of age.

13. Anxiety and suspicions on the part of Joseph when he returns after an absence of some months spent on a building site and finds the Virgin pregnant. An angel reveals to Joseph the Mystery that has taken place. But when a scribe, Annas, discovers the virgin girl to be pregnant in Joseph's house he reports the fact to the high priest who summons Joseph and Mary and makes them drink 'the bitter water that brings a curse'. The outcome was to prove them both innocent (13:1 - 16:3).

There follows the account of the Nativity of Jesus (17: 1ff.), in which the detail that is added and is reflected in the iconography is that the event takes place in a cave.

Another apocryphal text with details of the life of the Virgin Mary is the *Gospel of Pseudo-Matthew* which was written in Latin in the eighth or ninth century and draws upon the *Protevangelion of James* and other earlier apocryphal texts for some of its material.

The *Gospel of Pseudo-Matthew*, another source of inspiration for Byzantine and Western artists alike, tells us about the devotion of the Virgin as a young child to prayer: 'From the morning hour till the third hour she prayed without cease, from the third to the ninth hour she was occupied at the loom, while from the ninth she again devoted herself to prayer. She did not leave off

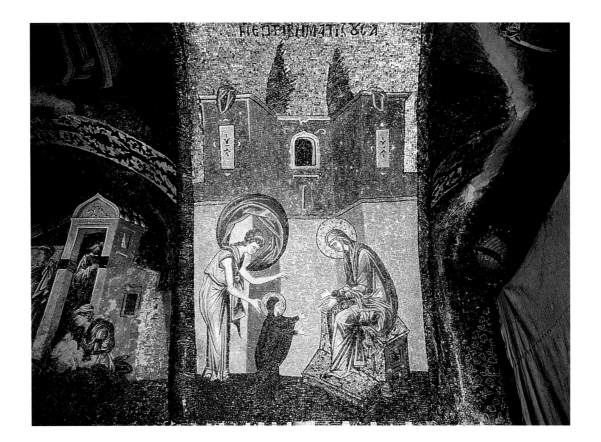

33. *The First Seven Steps of the Virgin.* Chora monastery, Constantinople.

praying until there appeared before her an angel of the Lord from whose hand she received food'. And her face 'was of so great a beauty and radiant a nature that it was difficult for anyone to look upon it'. No one ever saw her angry or heard her utter abuse or blasphemy. 'Her every word was so full of grace that it was clearly God who governed her speech' (6:1-3).

Leaving aside these laudatory and rhetorical phrases, let us consider the account of the Nativity of Christ from which Byzantine artists conceived the setting of the event: 'And so the time arrived for the blessing which the descendants of Abraham were to receive to be bestowed upon all the nations. As soon as he had said that, the angel ordered the beast of burden to halt, for the hour of delivery had come and he intimated to the blessed Mary that she should dismount from the animal and go into a deep cave, where the light never entered and darkness always prevailed since it could not admit the light of day. And when the blessed Mary entered therein it began to be bathed in a bright light throughout as if it had been the sixth hour of day: the divine light so flooded the cave that light was not wanting either during the day or during the night so long as the blessed Mary was present there. And in that place she brought into the world a boy whom the angels at once surrounded from the moment of his birth and who no sooner than he was born in a short while stood on his feet, and they adored him with the words: "Glory to God on high and on earth peace and grace among men"' (13:2). 'And on the third day after the Nativity of our Lord Jesus Christ the most blessed Mary left the cave and entered a stable where she placed her son in a manger, whom the ox and the donkey worshipped. Then was the word of the Prophet Isaiah fulfilled: "The ox knew his Lord and the donkey the manger of his Lord". And so these creatures, the ox and the donkey, having him in their midst, worshipped him without cease. Then was the word of the Prophet Habbakuk fulfilled: "You shall appear in the midst of two creatures". Joseph remained with Mary in that place for three days' (14).

The same text recounts that during the Flight into Egypt many wonderful events occurred, such as the protection given to Mary and Joseph and the Child in the desert by the wild beasts which accompanied them. There is also the delightful incident of the palm tree that lowered its branches to refresh Mary with its fruit: 'And it happened on the third day of their flight as they

went on their way that the blessed Mary was suffering greatly from the intense heat of the sun in the desert, and seeing a palm tree she said to Joseph: "Let me rest a while in the shade of that tree". So Joseph made haste to lead her to the palm tree and helped her dismount from the beast of burden. And when the blessed Mary had seated herself there, she turned her gaze upon the leafage of the palm and saw it was heavy with fruit, and said to Joseph: "Would that I could pick some fruit from this palm tree". And Joseph said to her: "I'm surprised you say such a thing, for you can see how tall the palm is and yet you think of eating the fruit of the tree. I'm thinking rather of the lack of water, for we've none left in our water skins and we've nothing with which to refresh ourselves and the beasts". Whereupon the infant Jesus, cradled with a joyous expression in his mother's arms, said to the palm tree: "Lower your branches, O tree, and refresh my mother with your fruit". And at once on hearing that voice the palm tree lowered its top to the soles of the blessed Mary's feet and they picked its fruit with which all were refreshed' (20:1-2).

Many important events recounted in the four New Testament Gospels are retold in the Apocrypha, either unchanged or with modifications to some parts of them. The Annunciation to the Virgin which we came across in the *Protevangelium of James*, acquires a more dramatic quality in the apocryphal *Gospel of Bartholomew*, dating to the fourth century. The Apostles gathered together in order to ask Mary how she had conceived the Lord in her womb, how she had given birth to and borne him who is beyond bearing? But they hesitated, and each asked the other to be the first to speak. In the end, Bartholomew went up to her and said, 'Hail, Tabernacle of the Highest, O immaculate one, we all the Apostles, ask you to tell us how you conceived the unconceivable, how you bore him who is beyond bearing, how you gave birth to such a glorious one as he?'. But Mary said to them: 'Ask me not about that Mystery. For if I were to begin to tell you, fire would issue from my mouth and would consume the entire universe'. But they were even more persistent in questioning her. And she, since she could not refuse to listen to the Apostles, said: 'Let us rise and pray'.

And once she had prayed, she continued speaking to them: 'When I lived in the temple of God and received my food from the hand of an angel, one day there appeared to me someone

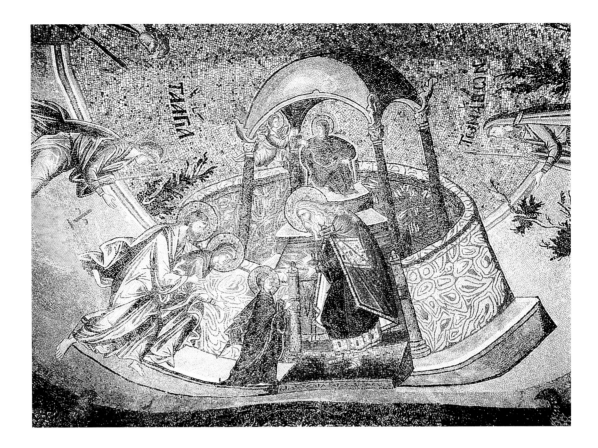

who looked like an angel, but his countenance passed all understanding and in his hand he did not hold bread or a glass like the angel who visited me on other occasions. That instant the curtain of the temple was rent and a very great earthquake occurred and I fell to the ground for I could not endure the sight of him. He stretched forth his hand and lifted me up. I looked far into the heavens and there came a refreshing cloud and showered me from head to foot and he wiped me with his garment. And he said to me: "Hail, full of grace, chosen instrument". He then struck the right side of his garment and lo! a truly large loaf of bread appeared and he placed it on the altar of the temple and he was the first to eat of it and gave some also to me. And again he struck the left side of his garment and lo! a truly large glass of wine appeared and he was the first to drink and then gave it to me. And I noticed the bread and the wine to be entire as before. And he said to me: "Another three years and I shall send my word through you and you shall conceive a son and by him shall all creation be saved. Peace be to you, my beloved, and my peace shall be with you for ever". Then he vanished from my sight and the temple became as it was before. As she recounted these things fire issued from her mouth and the world seemed to be drawing to its end. But of a sudden the Lord appeared and said to Mary: "Reveal not this Mystery or else all creation shall this day draw to its end". And the Apostles were afraid lest the Lord be angry with them' (2:1-22).

A complete story has a beginning and an end. Just as the Apocrypha recount the Birth of Mary, beginning indeed with the announcement of her coming birth to her parents, so do they tell the story of her earthly end, her Dormition and her Metastasis. A large number of manuscripts in various ancient languages, based on a Greek original dating back to the fifth or early sixth century, and containing a number of variations, relate the story of her Dormition. Many homilies by the Fathers of the Church and the iconography of the feast of the Dormition (15 August) either draw upon this text or, in the case of the Apocrypha themselves and the patristic homilies, reflect Church tradition. The excerpts quoted below are taken from the homily *On the Dormition of the Holy Mother of God* by Pseudo-John the Theologian.

The Archangel Gabriel who, according to the Evangelist Luke (1:26-38), announced to the

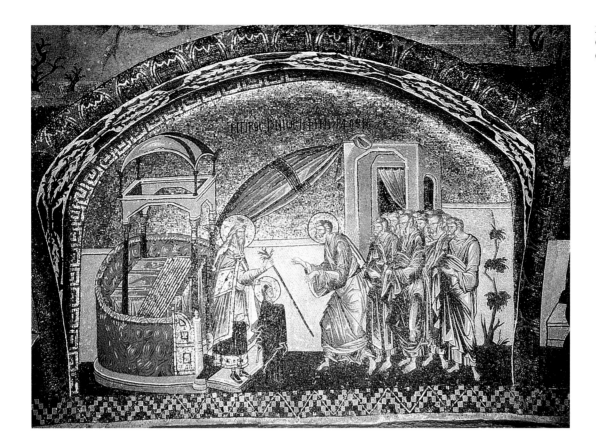

Virgin Mary the supernatural manner of Jesus's conception, also announced her end to her, while she was praying, as she did every day, at the tomb of her Son. The heavens opened and he appeared before her and said to her: 'Hail, thou who gavest birth to Christ our God. Your prayer has reached the heavens and been granted by him to whom thou gavest birth. After this, in accordance with your request, when you abandon the world you will depart for heaven, which is to say for your Son in eternal and true life'.

The Virgin returned to Bethlehem, rested there a while and sitting up on her bed prayed in these words: 'My Lord Jesus Christ, thou who accepted out of your great goodness to be born of me, hearken to my prayer and send me your Apostle John, so that seeing him I may begin to rejoice. Send me too the rest of your Apostles, that is, those who are already with you and those among the living wherever they be on earth, with a holy order from you, so that on seeing them I may glorify your much extolled name'. With a cloud, John appeared first and said to her: 'Hail, the mother of my Lord who gave birth to Christ our God, rejoice now that you leave this life with such great glory'. There followed the arrival of the other Apostles each relating whence he came: Peter from Rome, Paul from the district of Tiberii on the banks of the river Tiber, James from Jerusalem, Mark from Alexandria, Matthew from the vessel he was sailing in, Bartholomew from the Thebaid and Thomas from the depths of India, while Andrew, Philip, Luke, Simon the Canaan and Thaddeus, who had departed the world, came from their graves.

The writer of this narrative adds various miracles which the Virgin performed at the time. 'I saw many miracles occur', writes the author, hiding behind the name of John, 'that is, blind men who regained their sight, deaf men who recovered their hearing, lame people who walked normally, lepers who were cured and sick men troubled by unclean spirits who were made well. In addition every sick and ailing person, on touching the outer wall of the house in which the Mother of God lay, cried out: "Holy Mother, thou who gave birth to Christ our God, have mercy on us". They were at once cured.'

Carrying the bed of the Mother of God, the Apostles set out towards Jerusalem, 'and a cloud swallowed them all up and brought them to the house of Our Lady in Jerusalem. There for five days they sang praises to God without ceasing'. After the Mother of God had prayed for the world,

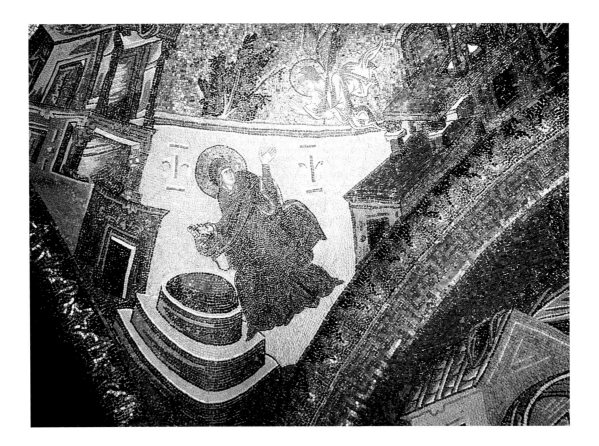

Christ came in dazzling glory and he said to Peter: 'The hour has come, begin the songs of praise'. As soon as Peter began to sing all the heavenly powers responded with Alleluia. 'Then did the countenance of the Mother of the Lord shine more brightly than light, she raised herself up and with her own hand blessed each one of the Apostles and all glorified God while the Lord stretched forth his immaculate hands and received into them her pure and holy soul.'

In representations of the Dormition of the Theotokos we see a figure in the foreground opposite the Apostles with his hands severed by an angel. Let us see how Pseudo-John recounts the scene. Following the peaceful Dormition of the Virgin, the twelve Apostles laid out her body on the bed to carry her thence. At that moment 'a sturdy Jew named Jephonias assailed the bed which the Apostles were carrying. But that instant an angel of the Lord with a fiery sword and unseen might severed his two arms below the shoulders so that they hung in the air by her bed. The Jew began to cry out: "Holy Mary, thou who gavest birth to Christ who is God, forgive me". Then Peter turned to him and said to him: "In the name of him who was born of her, your severed arms shall be restored". Before Peter had finished speaking, Jephonias's arms, which were hanging from the bed of Our Lady, moved through the air and were restored to Jephonias, who believed and praised Christ who is God and was given birth by her.'

Once this miracle had been performed the Apostles carried away the bed and placed her holy and precious body in a new tomb in Gesthemane. 'At once sweet-smelling myrrh began to pour forth from the holy tomb of Our Lady the Mother of God. For three days, the voices of unseen angels were heard praising him who was born of her, that is, Jesus Christ who is our Lord. After the third day, as the voices stopped, all who were there realized that the pure and precious body had been taken to Paradise. And we Apostles who were witnesses to this sudden removal of her holy body glorified God who had shown us his miracles during the dormition of the Mother of our Lord Jesus Christ.'

Some references to the Virgin Mary are to be found in the apocryphal Apocalypses, this time in an extra-terrestrial setting, for example, in Paul's *Apocalypse*, where the Apostle is being shown the various regions of Hell and Heaven, and, while in the second, meets the Virgin. 'Though my

attention was fixed upon the tree and I was admiring it', writes the unknown third-century author, 'I saw a woman approaching in the distance and a host of angels praising her. And I asked the angel: "Who is that, O Master, who is so beautiful and so greatly honoured?" And the angel said to me: "That is Holy Mary, the Mother of God". She came up to me and greeted me and said to me: "Hail, Paul, beloved of God and of angels and men, you who have made known the Word of God to the world and who have founded churches and whom all those praise who have been saved because of you, and who, having been saved from the error of idolatry by your teaching, have come here"' (*Apocalypse of Paul*, 46).

When comparing the accounts in the Apocrypha with those in the canonical Gospels (canonical in the sense that they belong to the Canon of the New Testament, as the Church defined it in the early centuries) we discover the following:

1. Each of the four canonical Gospels has its special character, of course, and lays particular stress on the theological notions of its author, but taken together the four reflect the belief of the Church in the person of Christ. In other words they are works of the Church, to which they belong; they are read during its gatherings for worship and it is the Church that preserves them and hands them down to successive generations, the Church that is their legitimate interpreter. On the other hand, the Apocrypha are the works of individuals and are not recognized by the whole body of the Church, though they have enjoyed authority among certain groups and have been read for longer or shorter periods of time.

2. While in the New Testament Gospels the person of the Virgin is only mentioned in relation and with reference to the central figure in the New Testament, which is Jesus Christ, and in no instance independently and separately from the Mystery of the Incarnation of the Son of God and its redemptive significance, the apocryphal gospels provide details of the Virgin's life that do not necessarily always relate to her Son. These texts relate the annunciation of her conception by her mother Anne, her Birth and childhood years, her Presentation in the Temple, her Annunciation, the Nativity of Christ, her Miracles, her Dormition and Metastasis. Clearly, the unknown writers of these texts considered the details provided by the Gospels too few, and drawing evidently upon oral tradition, where they did not rely entirely upon their own imaginations, they 'completed' the picture of the Virgin.

3. The narratives of the New Testament Gospels are distinguished by their austerity and Doric character. The narratives in the Apocrypha, on the other hand, are not content with simple reporting or narration, their principal aim being to persuade the reader, conferring on persons and events a more impressive scale and resorting to lyrical outpourings. They want to persuade one, at all costs and for primarily apologetic ends, of the supernatural character of events.

4. The Divine Plan for the Salvation of the World, or rather, the Mystery of Divine Providence, is both the core and the purpose of the New Testament Gospels, with all the consequences of that Mystery for humanity and its redemption. To tell the story, real or imaginary, and to impress are the objects of the Apocrypha. One has to say again, though, that in comparison with the New Testament, these apocryphal texts are clearly inferior both as regards theological profundity in the treatment of the workings of Divine Providence, and as regards historical detail, spiritual value and moral depth. They have, however, nurtured many generations of the faithful and inspired both hymnographers and hagiographers of the Church.

Excerpts from the Apocryphal Gospels are translated from the version in Karavidopoulos 1999, I. The original texts may be found in the classic edition by Tischendorf 1853, rpr. 1966 and 1987, and in De Santos Otero 1984[4]. References to Byzantine Art are based on Kalokyris 1972.

Part Two
Representing the Virgin

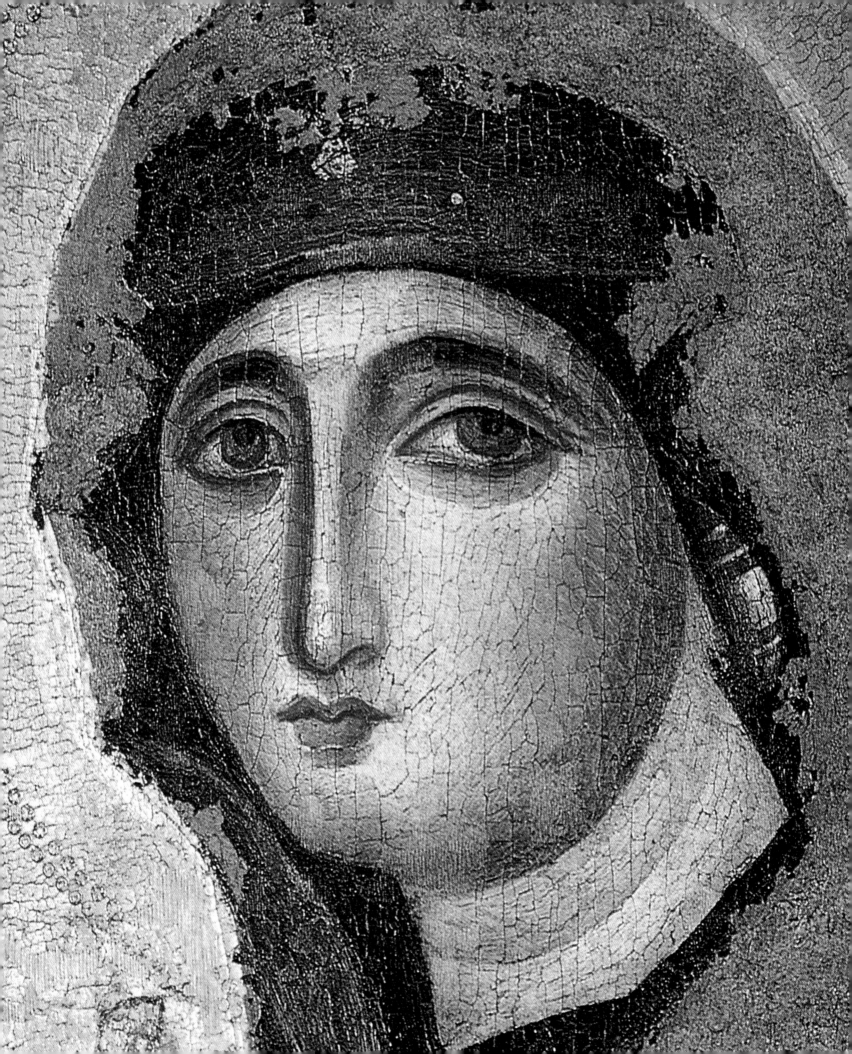

Michele Bacci

With the Paintbrush of the Evangelist Luke

In the prologue to his famous Ἑρμηνεία τῆς ζωγραφικῆς τέχνης (*Hermeneia = The Painter's Manual*), the Athonite monk Dionysios of Fourna, longing to assert the authority of Byzantine iconographic tradition as a legacy of apostolic times, addresses his prayer to the Theotokos in these words: 'Oh Mary Mother of God, St Luke, wishing he might clearly manifest to everybody the most holy affection he felt for Thy Highness beloved of God, realized that it was not sufficient to present Thy noblest Majesty with any of his most numerous spiritual gifts as an offering of first fruit, but that he, who had been such a careful eyewitness (αὐτόπτης), should carve and paint on panels with colours and gilded tesserae, by means of his pictorial skill, the admirable image, full-of-grace, of Thy appearance ...'.[1]

Father Dionysios had no doubt in identifying Luke as the originator of Christian pictorial art and the model of all Orthodox painters, and he recommended the utterance of this invocation to the Lord, who had been the Evangelist's real inspiration: 'Thou, who by means of the Holy Ghost has inspired Thy divine Apostle and Evangelist Luke to reproduce the appearance of Thy irreproachable Mother, holding Thee, as a Child, in Her arms and saying: "The grace of my son will be through me with them"'.[2]

When the *Hermeneia* was written, in the first quarter of the eighteenth century, the tradition concerning St Luke's activity as a painter had been confirmed by a great many authors and was most probably known to Dionysios in the form of the liturgical *akolouthia* included in the Great Menaia of October and eventually included by Bishop Maximos Margounios in his 1620 edition of the Lives of the Saints, in which the following is written: 'It is said that he executed by pictorial art with wax first one image of the holy Theotokos, holding in Her arms Our Lord Jesus Christ, and then another two; he showed them to the Mother of the Lord, [asking] whether She liked them: and it seems She said, "The grace of my son will go with them through me", as well as with the images of the holy apostles and saints: and that good and devout and venerable work was spread by him (Luke) everywhere on earth'.[3]

In describing Luke as an eyewitness, however, Dionysios is echoing the earliest texts that shaped the legend, assigning to Luke his place as the person who executed the first portraits of the founders of the Christian faith and as the first Christian painter. Already in the pre-Iconoclastic period, local traditions concerning authentic handmade reproductions of Christ and the Virgin Mary had appeared sporadically in the Christian East. For all that it may have appeared unorthodox in some Church Fathers' eyes (St Augustine, for example, wrote that nobody knew the actual features of the Virgin's face), there seems to have been a feeling that some minor person in the evangelical narration was likely to have recorded Christ's or the Virgin's outward appearance in works of art: if the Carpocratians, a gnostic sect that flourished in the third century, used to attribute the first images of Christ to Pilate, Orthodox Christians themselves soon spoke of a statue erected by the *haemorrhoissa*, named Berenike, in Paneas, while the first version of the mandylion legend, the fifth-century Syrian *Doctrina Addai*, described how King Abgar of Edessa sent his painter and archivist, Ananias, to portray Christ's face. At the end of the sixth century the *Narratio de rebus Persicis*, possibly a Greek translation of an earlier Syrian text, told how, before leaving

38. *Encaustic icon of the Virgin*, detail of Pl. 39.

79

Bethlehem, the three Magi ordered a skilled young painter to portray the Virgin Mary with her Child and so execute the first Christian image, which was later installed, on their way back, in the main temple of the Persian capital.[4]

The importance of such traditions was recognized by Iconophiles in the eighth and ninth centuries, when they suggested that the existence of original 'portraits' of Christ and the Theotokos not only legitimized the Christian practice of painting and venerating sacred icons, but also testified to the reality of the Incarnation by reproducing the human appearance of the Lord. Modern scholars usually accept that images of the Virgin and Child were charged with doctrinal significance, in as much as they exhibited the paradoxical relation of a mother holding a child who is also her pre-eternal Creator; and, significantly, such an iconographic theme was later thought of as having played a role in the confutation of Nestorios during the Council of Ephesus, as we learn from the Russian abbot Daniel in 1107.[5] Literary descriptions of the sacred personages' outward features played a similar role, and, apart from that of the Virgin Mary in the *Narratio de rebus Persicis* itself, we encounter such prosopographical texts more and more frequently from the eighth century onwards. As stated in the list of miracles included in the ninth century *Letter of the Patriarchs of the East to the Emperor Theophilos*, the subjects of the iconographic tradition were based on the actual description of Christ's earthly appearance, preserved by the apostles – who were eyewitnesses (αὐτόπται) and servants of the Logos—and transmitted by them to subsequent generations.[6]

If we exclude a suspect and most probably spurious passage from the fifth-century writer Theodore Anagnostes,[7] the first text to mention St Luke as the portrayer of Christ and the Virgin is the treatise *On the veneration of holy icons,* traditionally attributed to St Andrew of Crete, written shortly before the beginning of the Iconoclastic Controversies and most likely drawing on older traditions which only came, however, to have an officially-accepted literary formulation in the eighth and ninth centuries.[8] This text, in stressing how the holy personages' earthly features had been preserved both in images and literature, combines a reference to the Evangelist's paintings with the citation of a passage attributed to the first century historian Joseph Flavius: 'Of the Evangelist and Apostle Luke all his contemporaries said that with his own hands he painted both Christ the Incarnated himself and his purest Mother, and their images are preserved in Rome, so it is said, with great honour; and in Jerusalem they are exhibited with meticulous attention. Joseph the Jew, too, says that this was what the Lord looked like when he was seen by the people: with eyebrows that met, fine eyes, a large and prominent face, and great stature, as he was clearly seen when he spoke to the people; and the same can be said as to the reproduction (σχηματισμόν) of the Mother of God, which we see also today and somebody calls "the Roman"'[9].

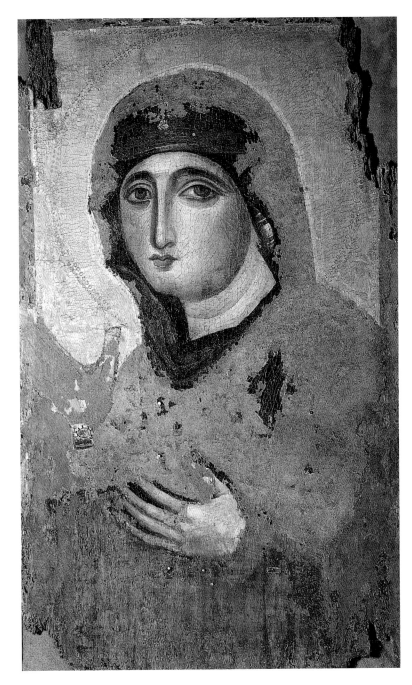

39. *Encaustic icon of the Virgin.* Monastero del Rosario a Monte Mario.

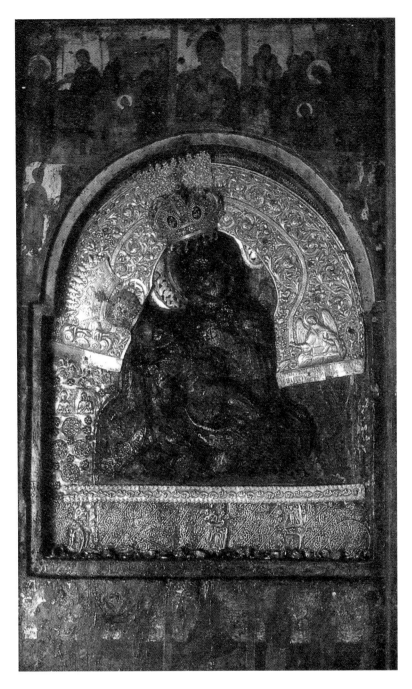

40. *Icon of the Virgin Megaspilaiotissa.* Monastery of Mega Spilaion, near Kalavryta, Greece.

Later iconophile texts gave greater and greater emphasis to the evangelist's role as the initiator of Christian icon-painting: since his work had, like written sources, documented the actual appearance of Christ and Mary in the sacred images, which had preserved their memory through generation after generation and had, therefore, to be included among the most venerable traditions of the Church, going back to the apostles themselves: πατϱοπαϱάδοτοι διδασκαλίαι (teachings passed on by the Fathers).[10] Most of the authors seemed to associate the value of the portraits executed by the evangelist with his literary activity: Patriarch Germanos, in a homily quoted by the ninth-century chronicler George the Monk, spoke of 'an image of the most pure and still-living Mother of God', which St Luke painted and sent, as a gift, to the Roman citizen Theophilos, that is, the mysterious dedicatee of both the Gospel and the Acts.[11] Details such as this were then expanded in subsequent texts, such as the *Oration against Constantine V* and Stephen the Deacon's *Life of St Stephen the Younger*.[12]

These passages clearly suggest that a functional equivalence, or better a complementary role, was attributed to both sacred portraits and Holy Scripture since they actually witnessed Christ's historical truth. Undoubtedly this conceptual association was, as scholars have often recognized, partly lexical in origin: the sources of this period often employed the verb ἱστοϱεῖν (to tell, to relate; cf. ἱστοϱία, history) to describe the act of executing images, while the term ζωγϱαφία itself, composed by ζῷον (living being) and γϱάφειν (act of writing), suggested an interpretation of painting as a 'description' of its subject. In eighth- and ninth-century texts concerning Luke's works, however, the most significant clue lies in the frequent employment of the term αὐτόπτης (eyewitness), which explicitly alludes to a passage in the prologue of the Gospel (Luke 1:1-4), where the evangelist, probably inspired by Hellenistic historiography and also by medical literature (such as Dioscorides' *De materia medica*), asserts the reliability of his narration on the grounds that the information was supplied by αὐτόπται and 'servants of the Logos'.[13]

The care with which Luke describes the Saviour's deeds and words from his birth onwards sufficed for him to be treated as an actual eyewitness of evangelical times, as the treatise *On the veneration of holy icons* and other texts repeated with some insistence (although the Nicaean fathers, during the iconophile Council of 787, avoided referring to him). This view based on the distinctive literary characteristics of Luke's texts clashed with the relatively sparse and confused biographical information about him: Holy Scripture only tells us that he was a doctor (born in Antioch according to Eusebius of Caesarea) who followed the Apostle Paul when he travelled through Bithynia, Macedonia and Palestine and to Rome (AD 50-58), and Early Christian writers did not agree about his life and deeds. Although the third-century *Codex Muratorianum* asserted that Luke had never seen Christ, Epiphanios of Salamis made him one of the 70 or 72 apostles, and Gregory of Nazianzus,

followed by Symeon Metaphrastes and later authors, identified him with one of the pilgrims at Emmaus. Some traditions have it that after St Paul's death Luke was active in Boeotia and Achaia, where, according to Jerome, he had written his Gospel and the Acts; other texts, such as the *Apostolic Constitutions*, made reference to his journey to Egypt, where he had ordained the second Bishop of Alexandria. His death would have occurred when he was 84 years old, in Thebes of Boeotia (sometimes confused with Thebes of Egypt), whence Emperor Constantios (Constantine's son), translated his relics to the church of the Holy Apostles in Constantinople, in 357.[14]

Once the Byzantine Church had, in response to the threat of Iconoclasm, accepted and legitimized the tradition concerning the archetypal icons executed by St Luke, authors asserted that, besides being a physician, the evangelist had also been a painter (ζωγράφος). The twinning of these professions probably did not sound too odd to ninth-century people: both physicians and painters were artisans and worked with their hands, the former needing paintings and miniatures as a means of transmitting pharmaceutical knowledge and the latter, as R. Cormack has argued,[15] needing to draw on medical literature because of their professional interest in colouring agents and other natural substances. Liturgical writers had absolutely no reservations about including in their texts explicit references to St Luke's training in the pictorial arts: the *Menologion* of Basil II, where we encounter his *akolouthia* of 18 October in its basic form, described him as 'a physician by trade and a painter',[16] while the Synaxarion of the Constantinopolitan Church recorded that he had been 'a physician by trade and a great expert in the art of painting'.[17]

In his own *Menologion*, summing up earlier texts, Symeon Metaphrastes worked out a more detailed account of St Luke's virtues and deeds, which constituted a model for all later authors. The evangelist's authoritativeness was established by pointing out the depth of his learning: educated in the best schools of Greece and Egypt, he had learnt Syrian and Hebrew, studied grammar, rhetoric and philosophy, mastered medicine and explored all the fields of ancient knowledge, before he heard of Christ's teachings and left his native town, Antioch, in order to join him in Palestine. As he had later become an actual eyewitness to the Resurrection of the Saviour at the Supper with him and Cleophas at Emmaus, he was introduced to the other apostles and started to preach throughout the desert-filled lands of the East, then he joined Paul in his journeyings round the Mediterranean sea. The primary result of his activity and of his time spent with Christ's first disciples was the writing of the Gospel and the Acts, which so vividly described the mystery of the Incarnation; but, as Metaphrastes observed, he also deserved praise because 'by employing wax and colours [i.e. by encaustic technique], he first passed on, in the form of an icon honoured still today, the pattern (τύπος) of Christ's Incarnate nature, as well as the image of the woman who bore Him and gave him his Incarnate nature, for he thought that those would not be satisfied, who wished to see an image and pattern that was the fruit of great affection'.[18]

The full and final characterization of St Luke as the first portrayer of the Incarnate Christ would only later result in the production of iconographic representations in which he was painting the Virgin and Child: though a miniature in an eleventh-century manuscript in Jerusalem (Greek Patriarchate, MS Taphou 14, fol. 106v), which represents the young skilled painter of the *Narratio de rebus Persicis* as a bearded man, may be reminiscent of an already widespread scheme, we encounter the first occurrences of this subject, both in Byzantine and Western traditions, only in the thirteenth and fourteenth centuries.[19] On the other hand, the literary glorification of St Luke's pictorial practice stimulated the emergence of cult-icons worshipped as autograph works by the evangelist. It was not by chance that, in about the eleventh century, the first images attributed to him made their appearances almost simultaneously both in Constantinople and Rome (Pls 38 and 39), the two patriarchal sees, which were competing for supremacy while magnifying their own apostolic origins. Already in the eighth or ninth century the Armenian Church had managed to delineate its own distinct cult-space by working out the legend of the *Hogeak Vank* icon, which, although paraphrasing the traditions about St Luke, attributed the execution of the Virgin's portrait to another evangelist, St John; some time after, probably in the tenth century, a

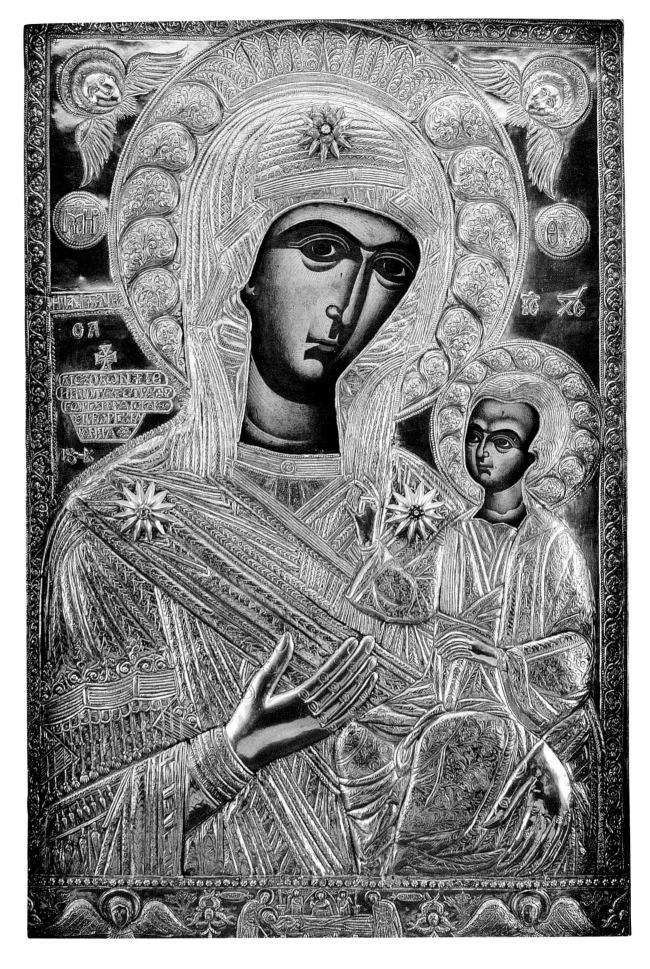

41. *Icon of the Virgin
Proussiotissa*.
Monastery of Proussos,
Evrytania, Greece.

Georgian legend laid claim to evangelical roots for the local Church by speaking of an *acheiropoietos* icon made by the Virgin herself and donated by the Apostle Andrew to the village of Astkveri, on the Mtkvari river.[20]

In Constantinople, the attribution of the icon in the Hodegon monastery to St Luke (first recorded in an eleventh-century Latin text in Tarragona, Spain, which was based on a now lost Greek source) was probably the final outcome of its more and more intense involvement in imperial symbolism and ceremonies, which exalted this image as the palladium of the city and the *basileis,* and as one of the most precious relics of Christendom.[21] In my view, it is likely that, apart from such other factors as the association of the monastery with the Greek Patriarchate of Antioch (the evangelist's native town), its very renown as a miracle-working and prophetic image may have suggested Luke's authorship, since it manifested the embodiment of the supernatural grace granted by the Virgin herself (according to the *Letter of the Patriarchs*) to her first portraits. As the Hodegetria cult managed to provide the Christian Empire with a distinctive reminder of its apostolic roots and very soon came to attract the attention of Latin and Russian pilgrims, alternative traditions made their appearance in Rome, as we learn from texts composed before the Schism of 1054 concerning the ancient icons of Santa Maria in Tempulo and the Lateran Sancta Sanctorum. In virtue of the biographical data provided by the evangelist's works, the Roman See could boast of Luke's actual stay in the city during his journeys as a member of Paul's entourage; the passage in the treatise attributed to St Andrew of Crete concerning the two icons painted by St Luke,

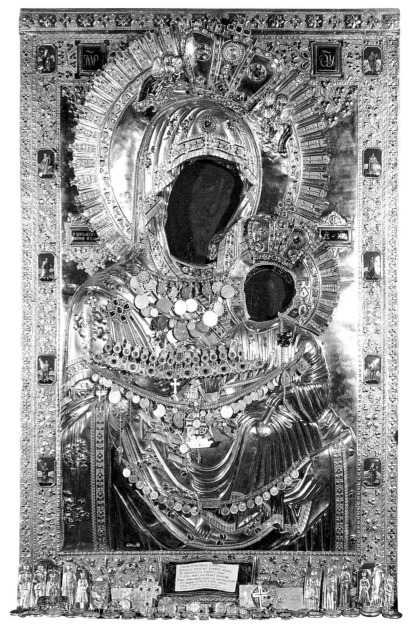

42. *Icon of the Virgin Portaitissa*. Iviron monastery, Mt Athos.

which was preserved in the papal city and had been known to western culture from the mid-twelfth century onwards, provided, in the form of an assertion by the authoritative Church Father, John of Damascus, a solid argument for Rome's claims to apostolic priority.[22]

The Byzantines, however, had a quite different outlook. The evangelist had lived in their own domain, in the ancient Greek-speaking area of Achaia. He had probably been the first Bishop of Thebes, before dying at a great age: in his long stay in Greece he had most probably composed both the Gospel and the Acts, and had, similarly, brought the authentic portraits of the Virgin and Child there with him and executed further copies. Since Luke's relic had been translated to Constantinople in early times, the capital's most ancient and thaumaturgic icons, rescued from iconoclastic persecutions, could be regarded as autograph works by the evangelist; taking the Hodegetria as their own model, other sacred images, such as the Blachernitissa, the Virgin in the Chalkoprateia church, etc., were described by pilgrims as icons painted by St Luke.

Outside the imperial city, analogous attributions are mainly known from the Palaiologan period onwards, although even as early as the twelfth century an icon that was attributed to St Luke, being an exact reproduction of the Hodegetria, was venerated in the Palestinian Orthodox monastery of Our Lady of Kalamon on the River Jordan (the present-day Dair Hajla).[23] As com-

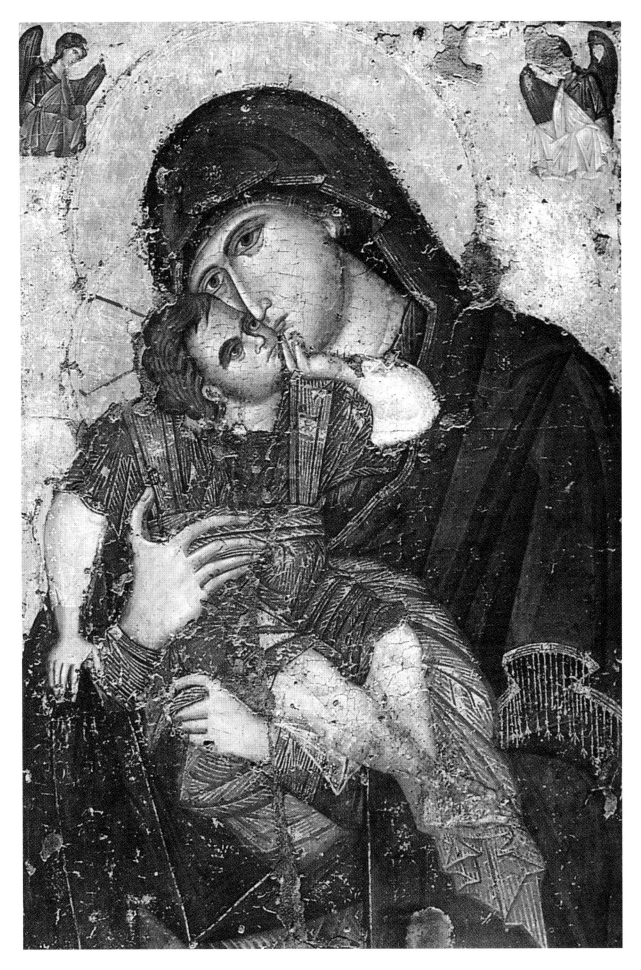

pared with the Holy Land, Greek centres had fewer opportunities for advancing historical grounds in demonstration of their lawful *ab antiquo* possession of original sacred portraits; nonetheless, the first claims made their appearance where connections with Luke's life were better documented. In the fourteenth century the monastery of Mega Spilaion near Kalavryta in Achaia, as we learn from a chrysobull of Emperor John Kantacuzenos (1341-1359), had gained widespread renown on account of an image whose attribution to the evangelist was probably made as a direct consequence of his stay in that area, where, according to Gregory of Nazianzus and Jerome, he had even written his Gospel. The icon (Pl. 40), which still survives today, is a rare object, probably dating from the eleventh century, on which the half-length Virgin and Child is executed in moulded wax painted in colour: its very unusualness may suggest that the veneration of the Megaspilaiotissa was partly occasioned by a misunderstanding of Symeon Metaphrastes's and other authors' description of Luke's encaustic technique (κηρῷ καὶ χρώμασι, by wax and colours).[24]

Significantly, a precious cult-image of this sort, which competed with the Hodegetria in renown, made its appearance in the monastery that was enlarged by the Despots of the Morea to celebrate the Frankish rulers' defeat in the Peloponnese, so that there was to its veneration self-evidently a political aspect. In the same period, probably, although the first source dates from 1399,[25] there was an analogous phenomenon in Latin-ruled Athens: exploiting in all likelihood an existing tradition, the Frankish, Catalan and, later, Florentine dukes, had promoted the public worship of an ancient icon, attributed to the evangelist, in a side-chapel of the city's cathedral, that is the Parthenon, rededicated to the Virgin of Athens. According to subsequently documented traditions concerning the *Panaghia Soumela* — the palladium of the Greek Empire of Trebizond in the fourteenth and fifteenth centuries[26] — , the Atheniotissa had been painted by St Luke during his stay in Thebes, whence it had been transferred to Athens in the fourth century. Similarly, the 'political' promotion of St Luke's icons in public worship was, from the Late Middle Ages on, one of the hallmarks of Russian cults, where legends describing their transfer from the Byzantine East frequently disguised the tsars' awareness of the historic legacy of Constantine's Empire.[27]

Especially after the Fall of Constantinople and the destruction of the Hodegetria by Mehmet II's janissaries in 1453, a great many images all over the Christian world attempted to equal it in renown and even to claim identity with it: the emergence of cults such as those of the *Madonna di Costantinopoli* in Italy or the *Konstantinopol'skaja* in Russia may well illustrate such a process; even in Ottoman Constantinople, in the sixteenth and seventeenth centuries, the Dominican church of Pera claimed to have preserved in it the ancient city palladium.[28] Attributions to the evangelist became, step by step, more widespread and can still be encountered as far away as Ethiopia and even among Malabar Christians in southern India.

On the other hand, however, the increasing number of 'originals' by St Luke soon made it evident that there was a need for a new reading of the ancient traditions concerning his activity as a painter. As early as the Late Middle Ages some traditions clearly stated that only three icons were true-to-life portraits approved and blessed by the Virgin herself, and that these should be distinguished, because of their greater preciousness, from those painted by St Luke after Mary's Metastasis. In the fourteenth century, the 'Egyptian Virgin' in the Greek quarter of Attalia (in Turkish-ruled Pamphilia) was praised as the first of these, the others being the Hodegetria and an icon in Rome;[29] afterwards, however, analogous claims were made in relation to different famous cult-images.

When, in 1422, the Cypriot hieromonk, Gregory of Kykkos, wrote the narrative concerning the miraculous icon preserved in his monastery — the famous Kykkotissa — he managed to link together former traditions of the Greek Orthodox world.[30] In his curious telling of it, the Virgin Mary, acknowledging Luke's wonderful talent, asked him for a portrait that was to be transmitted to subsequent generations; having received a fine panel from the angel Gabriel, the evangelist reproduces her in the Hagiosoritissa scheme, but the Virgin Mary does not approve it, as she wants the Christians to see her as a mother. Luke goes back to the angel and receives two pan-

els 'not cut by human hands', where he reproduces the Theotokos first as the *aristerokratousa* (with a Crucifixion on the back face), then as a *dexiokratousa.* Mary welcomes them with joy and invokes God's grace on them: 'The grace of my Son be with you! And if anyone will honour these icons as much as Myself, he will have both spiritual and material salvation: in fact, I transfer to these sacred images the grace I received from my Son'.

Some years later, Luke moves to Egypt, where he starts living as a monk. From there he sends the first icon to Attalia as a gift. The second one was later rediscovered by Constantine and transferred to Constantinople into the Hodegon monastery, while the third one was donated to Athens as a reward for the great scholars who lived there. In short, Gregory excluded Rome from the holy places which preserved icons by St Luke, while attaching great importance to the three most famous icons in the Greek Orthodox world: the Hodegetria, the Atheniotissa, and the Egyptian. But what about his own icon, the Virgin of Kykkos? He inferred that, as a monk, the evangelist continued to paint a great number of Marian images, so giving birth to the Christian practice of icon-painting.

This great number was later estimated to be 70 or 72, being equivalent to that of the apostles after Christ's Ascension. In Ottoman-ruled Greek lands, several monasteries claimed to preserve such minor manifestations of Luke's devout art: for example, those of Proussos in Evrytania (Pl. 41), Iviron (Pl. 42), Philotheou (Pl. 43), and Chilandari on Mt Athos, Machairas, Chrysorrhogiatissa, Trooditissa, and the Chrysaliniotissa of Nicosia in Cyprus (Pl. 44), etc. As monastic institutions became real strongholds both of Orthodox worship and Greek language and culture, the frequent attribution of sacred icons to St Luke constituted a devotional *topos,* strengthening the inner cohesion of local communities; as miracle-working objects, they protected their believers from a hostile world, whilst their very ancientness itself asserted their possessors' uninterrupted observance of the traditions inherited from their Byzantine past. The devotion of common people to such icons was so strong that Moslem individuals living in their communities also got into the habit of honouring them—which was interpreted as a further demonstration of their great spiritual value. Greek folklore has sometimes preserved local variants of St Luke's legend: in Naxos, for instance, it is said that the evangelist painted 72 icons—36 reproducing the Virgin and Child and 36 the Mother of God alone—blessed as works transmitting God's grace. The numerological value of the number three is here adjusted to the islanders' perspective: the most venerated icons of Naxos— the Glykophilousa, the Ayia, and the Argokoiliotissa—are attributed to St Luke, the last one being praised as a gift of the Theotokos herself to the island.[31]

It is worth noting that the Greek War of Independence in 1821 did not interrupt this process. On the contrary, there was a burgeoning of new shrines, which, not infrequently, were embellished by icons attributed to the evangelist. In those same years, after the visions seen by the holy nun, Pelagia, the inhabitants of Tinos celebrated the excavation of an Early Byzantine building and the subsequent discovery of an ancient icon reproducing the Annunciation. This event was welcomed as a miracle by everyone in newly independent Greece and the Greek diaspora: a sumptuous shrine was erected on the site and the sacred image, which soon manifested its thaumaturgic powers by protecting an English ship during a terrible storm, came to be viewed as an autograph by St Luke, and even as one of the three true-to-life portraits of the Virgin Mary.[32]

Ancientness, thaumaturgic qualities, powerful associations with communal and cultural (or, broadly speaking, 'political') symbols, may be considered to be frequent features of the sacred icons that, according to local traditions, were painted by the evangelist's skilled and God-inspired hand. Such traditions are so deeply rooted in the cultural history of Orthodox Greeks that they are still alive today among believers, even though ecclesiastical writers may sometimes be dubious of the truthfulness of some attributions. In any case, we can undoubtedly share the sentiments expressed in the following words by the nineteenth-century abbot, Kyrillos Kastanophyllis,[33] when he was writing about the history of the sacred icon venerated in the monastery of Proussos: 'Does it matter, however, if it is not certain that the Proussiotissa icon is one of those painted

by the Apostle? Were these the only ones to receive grace? Besides, we see so many others, which are not the work of the Evangelist Luke, but which perform miracles. And then, even if this icon is not one of those the Apostle Luke painted, that should not concern us, since it lessens neither our faith nor our reverence for Her'.

* The title of this essay repeats that of my monographi Bacci 1998. I provide here a summary of it, although focusing more specifically on the history of St Luke's images in the Byzantine and Post-Byzantine Greek-speaking world. References will be restricted to few essential works; a more complete bibliography will be found in the afore-mentioned book.

[1] *Hermeneia*, 1.

[2] *Hermeneia*, 5.

[3] See the text of an 18th-century *akolouthia* in the Great Menaia at 18 October, cited by Lipsius 1883-1890, vol. II/2, 361 n. 2 and 358 n. 2, and the slightly different Cypriot version edited by Tsiknopoulos 1971, 255-274, esp. 270-271. Both apparently rely on the text published by Margounios 1620, 18; cf. *ΘHE*, VIII, 364-366, esp. 366.

[4] See esp. Siotis 1994², 78-100; Bacci 1998, 78-96.

[5] Daniel the Abbot, Life and Pilgrimage, Khitrowo 1889, 7: '... the image of the Holy Virgin which was useful to the Holy Fathers when they confused the heretic Nestorius'.

[6] See the text and its versions in Gauer 1994, 37, 82, 152, 154; see also Munitiz et al. 1997. Munitiz 1997, 115-123, has indicated AD 875 as the *terminus ante quem* for the dating of the list of miracles.

[7] Theodore's passage is only known from the 14th-century writer Nikephoros Kallistos Xanthopoulos (*PG* 86, 165), citing it in his *EH*; it describes legendary features and ceremonial traditions which are peculiar to the Hodegetria icon and are witnessed only from the 11th century onwards.

[8] The attribution to Andrew of Crete has been recently questioned by Auzépy 1995b, 1-12, esp. 7.

[9] Andrew of Crete (?), *On the venera-tion of holy icons*; *PG* 97, 1304.

[10] So Symeon Metaphrastes, *Menologion*; *PG* 115, 27, in a sentence attributed to St Theophanes: 'Οὐ τῆς Θεοτόκου μορφῆς τὴν ἐκτύπωσιν ὁ ἀπόστολος ἡμῖν Λουκᾶς ἱστορήσας παραδέδωκε; Τί δαὶ φήσοις ἐν ταῖς πατροπαραδότοις διδασκαλίαις;'.

[11] George Hamartolos, *Chronicon*, IV, 248; *PG* 110, 920.

[12] Pseudo-Damascenus, *Oration against Constantine V*, 6, *PG* 95, 321; Stephen the Deacon, *Life of St. Stephen the Younger*; *PG* 100, 1085: for a new edition of this text, Auzépy 1997.

[13] On Luke's literary sources, Howard Marshall 1978, 39-44; Plümacher 1972; and Corsini 1967, 7-22.

[14] On these sources, Lipsius 1883-1890, 354-371.

[15] Cormack 1997b, 45-76, esp. 67.

[16] *Menologion* of Basil II; *PG* 117, 113.

[17] *Synaxarium CP*, 147-148: 'ἰατρὸς τὴν τέχνην καὶ ἄκρος τὴν ζωγραφικὴν ἐπιστήμην'.

[18] Symeon Metaphrastes, *Menologion, Praise of St Luke*, 6; *PG* 115, 1136.

[19] Cf. a Palaiologan wall-painting in Mateić (Former Yugoslav Republic of Macedonia); the miniatures in the Codex latinus III, III of the Biblioteca Marciana in Venice and the Gospel-book Cod. 1182 (dated 1368 and signed by Canon Johann of Troppau) of the National Library of Vienna; a late 14th-century fresco in the ciborium of Santa Maria Maggiore in Tuscany (Italy), as well as a contemporary wall-painting, showing Italianate devices, in the Nestorian church of Famagusta (Cyprus). On the first examples of the iconographic theme, Klein 1933, 36-61.

[20] Bacci 1998, 187-195.

[21] Among the most recent contributions to the Hodegetria history, Angelidi 1994, 113-149, and Ciggaar 1995, 117-140. Cf. also the essay by Angelidi and Papamastorakis in the present volume, 373-387.

[22] The related passage from *On the veneration of holy icons* was included in the manuscript of John of Damascus's treatise *On the Orthodox Faith*, translated into Latin by Burgundius of Pisa in 1153 (Bacci 1998, 259-262). On Medieval Roman icons, also Wolf 1990.

[23] As we learn from John Phokas (*PG* 133, 953).

[24] See esp. Oikonomos 1864; Soteriou 1918, 46-80; Xyngopoulos 1933, 101-119.

[25] Nicola de' Martoni, *Liber peregrinationis ad loca sancta*, Le Grand 1895, 566-669, esp. 651.

[26] Nowadays the icon is preserved in the sanctuary of Kastania, not far from Veroia in Macedonia.

[27] See the stimulating remarks by Shchennikova 1996, 252-302.

[28] See esp. Giustiniani 1656, 80-82.

[29] Its title was due to a detail in its legend, which, following a variant of the evangelist's biography, told how he had spent the last part of his life as a monk in the Egyptian deserts, from where he had sent the image to Attalia as a gift. The first source on the Attalia icon veneration is Ludolph of Südheim's *De itinere terrae sanctae* (about 1340), Deycks 1851, 35.

[30] The text has been edited by Spyridakis 1949, 1-29, and Chatzipsaltis 1950, 39-69.

[31] Imellos 1958-1959, 200-228, esp. 220-223; Kephalliniadis 1990-1991, I, 95-96.

[32] Among the contemporary sources, Vlassopoulo 1860 and Pyrros 1866, 9-10.

[33] Kastanophyllis 1992, 24-26.

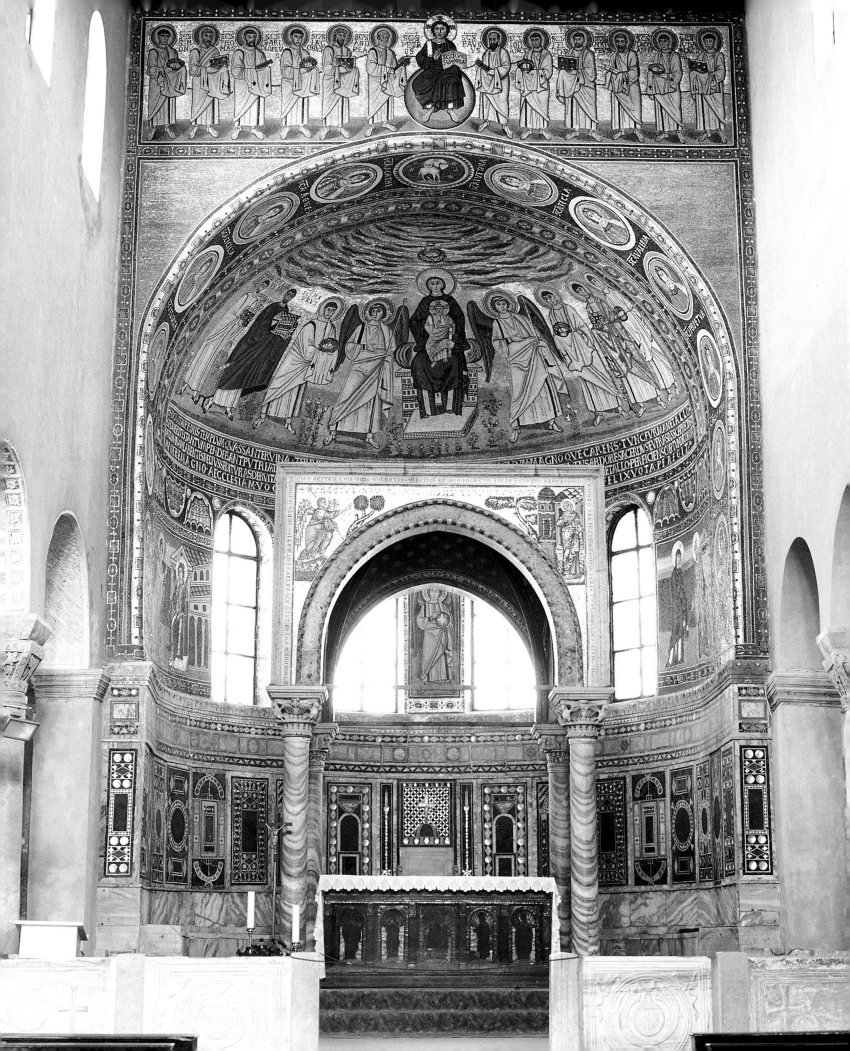

Robin Cormack

The Mother of God in Apse Mosaics

U p to the year 1054, the Mediterranean Christian community was nominally unified and held the same doctrines and beliefs.[1] One effective and conspicuous way in which the Church establishment could communicate its agreed faith was by way of mosaic images. Inevitably, as the definition of the Incarnation and nature of Christ was debated, clarified, refined and agreed as the 'correct' Christian doctrine, so the Mother of God and her place in the order of things became of increasing importance. She directly personified the fact of his birth and life on earth. For this reason it was her visual representation as much as that of Christ which developed as one of the prominent subjects for church decoration. The most favoured place for her image became the eastern apse, and in the most highly endowed churches this position was likely to be decorated with mosaic.[2] But this location in the church also had other associations in the minds of the viewers, both ecclesiastical and lay, since the apse lay directly above the altar on which the rite of the Eucharist was performed. Any representation in the apse was at a certain moment in the liturgy positioned literally above the flesh and blood of Christ and so took on highly-charged associations. The apse was also the sacred space most prominently open to the gaze of the faithful, both at prayer and during the services, as they looked into the sanctuary at the east end of the church. Only in the Late Byzantine church, with the development of the high iconostasis, did the apse lose its dominating presence.[3]

While the enactment of the Eucharist in the sanctuary was a permanent and continually repeated ritual, refinements and developments in the liturgy did occur over the centuries.[4] But more pronounced than the sacramental words of the liturgy were the changes and redefinitions in the expression of dogma as successive theologians questioned and debated previous (and contemporary) decisions. This was a recognized situation up to the seventh and last Ecumenical Council, Nicaea II (787). Thereafter the 'clarification' of doctrine in the Orthodox Church was a matter for synods, and their decisions were entered also into the *Synodikon of Orthodoxy* (its first version was probably written in or soon after 843), which was recited annually on the first Sunday in Lent.[5] But where there was continuing debate and dispute, there should also have been variation and deviation in the ways of representing the Mother of God. Indeed the forms of representing and labelling Mary in art may be sometimes analysed in order to discover heterodox thinking in a particular community. In the period before Iconoclasm—or to put it in another way, before the Seventh Ecumenical Council at Nicaea in 787 made the final definition on the nature of Christ and his mother and the manner of their representation—the viewer of the Virgin in mosaic may expect to find either the current Orthodox thinking expressed or alternative strongly held views. If the various regions of the Mediterranean Christian community acted as pockets of resistance to change from the central establishment, or if indeed were places where Orthodox views needed to be proclaimed to dissidents, then one way of reading the mosaic imagery of the apse is as a firm and permanent expression of theology and faith.

Much recent interest in the iconography of the apse has been dedicated to the interpretation of the representation of Christ. A polemical approach by Mathews attempted to reduce the debate to the simple level of how far the imagery of Christ did or did not 'translate' the imagery of the Roman emperor into an image of a new 'Pantokrator'.[6] Although this particular form of the debate

45. Sanctuary apse.
Basilica Euphrasiana,
Parenzo.

has been useful in showing that the Early Christian conception of Christ was not a simple shift from the public veneration of emperor into that of Christ, yet it would be extreme to deny some of the imperial associations which must have affected Late Antique perceptions of divinity. After all, although Augustus was portrayed as *divi filius*, and so not as the 'son of god' but as the 'son of the divine or godlike', his successors were individually often described as *dei filius* 'son of god', and so the Christian understanding of the status of Christ was inevitably intertwined with perceptions of the emperor. While Mathews has correctly emphasized other associations of Christ which stem from pagan Antiquity, such as his role as teacher, the amalgam out of which Jesus Christ was created is immensely complex and his image is not the outcome of a single strand.[7] Only by working through the many texts that encapsulate and illuminate early Christian thinking as well as the imagery which is equally part of the 'argument' can we hope to achieve a full understanding of all the intricate evocations of the religious thinking of the period.[8]

It is clear that apse decorations from the fourth century onwards can illuminate many aspects of the Byzantine conception of Christ. But side by side with these directly Christological schemes we need also to study the representations of the Mother of God in order to understand their theological, spiritual and emotional roles.[9] Their significant appearance from an early date should not be underestimated: despite the inevitable losses of material from this early date, the series of images of the Mother of God began in the fifth century. Putting together the archaeological and literary evidence, there is persuasive (if not fully definite) evidence of apses with the Mother of God in the fifth century, in Santa Maria in Capua Vetere (about 430) and Santa Maria Maggiore at Rome (432-440), and in the sixth century in Santa Maria Maggiore at Ravenna, St Sergios in Gaza and the basilica Euphrasiana at Parenzo (Pl. 45).[10]

The church of Santa Maria Maggiore at Rome (Pls 4-6) stands out as a key monument, although our interpretations of its conceptual thinking about the visual portrayal of the Mother of God must be derived from the triumphal arch mosaics, as the apse was altered in the thirteenth century and the Coronation of the Virgin in it belongs to this period. Although this was a major papal commission, various details of the iconography seem to derive from apocryphal and non-canonical texts about Mary; the recent examination and cleaning of the mosaic in 1999 has shown that, apart from some later restorations, most of the mosaics belong to the original decoration of Pope Sixtus III. The theological climate of its period is recorded for us in the acts

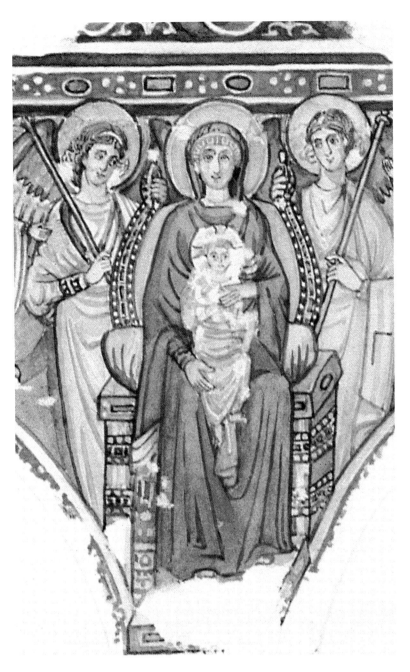

47. *Enthroned Virgin and Child* (now destroyed), watercolour by W.S. George. Church of St Demetrios, Thessaloniki.

of the Council of Ephesus (431) which has as its major conclusion the proclamation of Mary as *Theotokos*, Mother of God; the view of Nestorios and his followers that she was *Christotokos* was refuted and passed out of Orthodox vocabulary. The term rapidly came to evoke the doctrine of the two natures in Christ and was affirmed again as the Orthodox in the Council of Chalcedon in 451, when Christ was declared to be one person in two natures (the divine of the same substance as the Father and the human the same substance as us). Yet the fact is that while this did become Orthodox doctrine, it was the subject of challenge for the next two centuries, until around 700. It follows that images which declared the Orthodox view did nevertheless contain an element of polemic in the fact of making their declaration. The Marian mosaics in Rome were a papal project, and while they no doubt reflect contemporary debates on the theology of the nature of Christ, they also engage with other issues about the status and role of Mary. The mosaics of the triumphal arch effectively raise the issue of the 'proper' texts which underpin the truth about Mary, for they incorporate notions from the Apocryphal Gospels, notably by representing Mary as Queen of Virgins. The representation of Mary as a crowned queen *(Maria Regina)* is hereafter relatively frequent in the West, but uncommon in Early Byzantine art in the East (the 6th-century mosaic panel of the Virgin with archangels and donors in the funerary chapel at Durrës in Albania is a rare example). However the notion of the enthroned Virgin is frequent in both East and West: it occurs in the apse at Parenzo, and on the nave walls of Sant' Apollinare Nuovo (Pl. 46) and St Demetrios at Thessaloniki (Pl. 47), which both seem to be compositions equally well suited to apses. Since the idea of the Queen of Heaven is articulated in the Apocryphal Gospels as well as the Akathistos Hymn, it is perhaps best to regard the concept as common to East and West, but expressed visually in much more concrete terms in art at an early date in Italy. In other words, the first mosaic representations of the Virgin indicate careful attention to the theological implications of her attributes by the planners, and this in turn indicates a no doubt equally sensitive response to these visual clues by the viewers. This prompts the question whether the representation of Theodora on the imperial panels in the sanctuary in San Vitale at Ravenna, in the 540s, had a resonance for its viewers in the West. The empress stands in a conched apse and is shown with halo and crown. Was this an attempt to elevate the status of the earthly queen? Such an unsayable idea could perhaps daringly be evoked through the visual.

Three pre-Iconoclastic apse decorations are known from Cyprus, and each one chose a different iconography of the Mother of God. In the apse of the church of the Virgin Kanakaria at Lythrankomi (Pl. 48), Mary was shown enthroned, holding Christ, and represented within a large coloured mandorla. In addition she was attended by archangels and the apse mosaic was surrounded by the twelve Apostles. All commentators have seen the choice of the mandorla as a reference

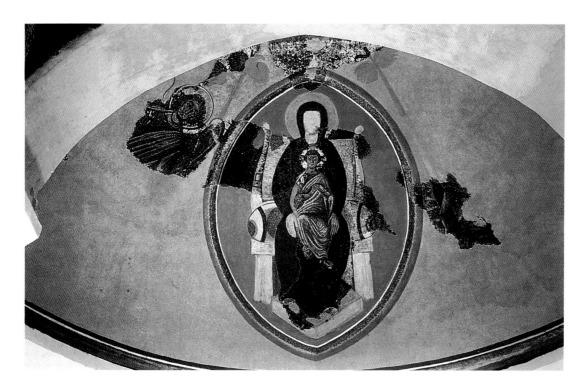

to the special status of the Virgin, as defined at Ephesus in 431 and Chalcedon in 451, but they differ on how precisely the imagery reflects doctrinal definitions and whether the mosaic can be precisely dated to the decade of 520s as a topical expression of the thinking of that moment in Constantinople.[11] The apse at Kition (Pl. 49) shows the Mother of God standing and holding the Child (the type is similar to that of the Hodegetria), and attended by two archangels with flamboyant peacock's wings; the conch is framed with a decorative border which includes animals and fountains (presumably referring to the 'source of life'). One clue here to a theological interest of the composition is the large text above the Virgin referring to her as ΑΓΙΑ ΜΑΡΙΑ. Rather than call this an 'old-fashioned' appellation, and documented in Egypt among other places, it is clear that this was a signal to emphasize the holy nature of the human woman to whom Christ was born. The question is why this was signalled in this church? The third early church on Cyprus with a mosaic apse of the Virgin was the tiny church of the Virgin Kyra at Livadia. This mosaic (now lost) was an orans type of the Virgin standing on a footstool. Although the precise dates of all three mosaics are controversial, and there are few archaeological clues since these apses are preserved in later churches rebuilt around them, they may all belong to the sixth century (or soon after). They indicate not only the importance of the imagery of the Mother of God in this position in the church by this period, but also the opportunities for expressive variation in the way in which she is presented to the viewer in the church.

By the period around 700, the mosaic representation of the Mother of God has become the arena of even more explicit modes of communication. In Rome, the (Greek) Pope John VII (705-707) put the image of Mary as an orant at the centre of a cycle of images in mosaic which formed the decoration of his oratory (and tomb) in St Peter's. At the centre of the oratory, which was dedicated to the Mother of God, was an image of the Virgin as Queen of Heaven and the pope with a square halo venerating her.[12] A text written in mosaic reads: '*Beati Dei genetricis servus Ioannes indignus episcopus*' (John, unworthy bishop, slave of the Blessed Mother of God).[13]

At about the same time in the East, the first decoration of the Koimesis church at Nicaea (the monastery of Hyakinthos) was probably set in place (about 700).[14] The church was dedicated to the Mother of God.[15] Again a text is used to specify the theological and doctrinal interest of the Mother of God, who was shown standing, and probably holding the Christ-Child, as at Kition (Pl. 49). In this case the attendant archangels were shown in their ranks, in the arch in front of

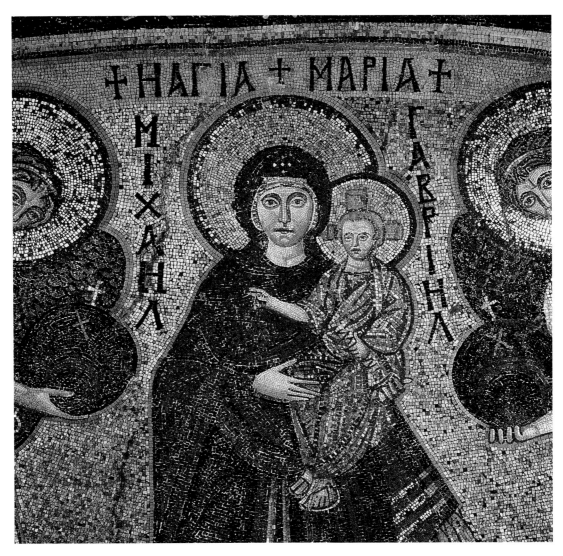

the apse. The text, which belongs to the first setting phase of the mosaic, is based on verse 3 of
Psalm 109 (110) which says: 'From the womb of the morning I gave birth to you'.[16]

It is clear that some time before Iconoclasm, the apse was regularly the place where repre-
sentations of the Virgin were featured, and that they gave a strong emphasis to the corporeality
of Christ on earth. Indeed the choice of Christological imagery developed around the central fea-
ture of Christ was perhaps relatively short-lived and the apse was rapidly felt to be a more appro-
priate place for the Mother of God. It has been suggested that the key moment for this transi-
tion took place during the reign of Justinian: a case where it is almost seen in action is in the com-
parison between the apse of San Vitale at Ravenna (540s) and the apse at Parenzo (543-553) —
the general compositional formula is the same, but the Mother of God replaces Christ on a globe
at Parenzo.[17] The intensification of devotions to the Mother of God in this period does seem to
be marked in a number of texts and is equally quantified by the rise of Marian icons and Marian
church dedications; her powers of mediation and help for salvation were increasingly invoked. By
the time of the evocative account of Church symbolism in the *Ecclesiastical History and Mystical
Contemplation* by Germanos (Patriarch of Constantinople from 715 to 730), a symbolic justifica-
tion has been given for the choice of the Mother of God in this location: the apse, according to
section 3, 'corresponds to the cave in Bethlehem where Christ was born'.[18] The importance of the
cult of Mary is further demonstrated in other writings of Germanos. In his homilies on the Mother
of God, he emphasizes her role as intercessor in the life of every Christian.[19]

While the extensive attention given to Mary in the period before the outbreak of Iconoclasm
no doubt reflects the nature of the reverence given to her in both icons and spiritual literature,

as well in everyday devotions, there is no cogent evidence that the Iconoclasts themselves were any less fervent in her cult. The conspicuous difference was that from the 720s up to 842 (except for the break in Iconoclasm between 787 and 815), images of Mary must have been rarely made, and it was most unlikely that any new mosaic of the Virgin was made for an apse in Constantinople or the Byzantine world. The Iconoclasts thought that Mary was too exalted and too holy to be subjected to material representation. But the situation was entirely different in the West, where the cult and her representation continued unabated. Among the churches of Rome, the chapel of San Zeno in Santa Prassede and the apse of Santa Maria in Domnica have retained their mosaic imagery, despite some later restorations (Pls 51 and 52). They are both commissions of Pope Paschal I (817-824).[20] These two churches offer the best preserved evidence of the nature of art in Rome during the period of Byzantine Iconoclasm. The record of their production which is set down in the *Liber Pontificalis*, a chronological account of the achievements of the Medieval popes, describes both as works of restoration. The apse of Santa Prassede showed a standing Christ with saints (and the pope) in the heavenly Jerusalem. It is quite clear that the composition is directly derived from the earlier sixth-century church of Sts Cosmas and Damian in Rome. The church itself contained relics which Paschal I collected from many sources (according to the later records there were 2,300 items). The oratory of San Zeno, constructed off the south aisle, contained further relics, and also the body of Paschal's mother Theodora. This small vaulted funerary chapel was decorated with mosaics, marble revetment and other precious ornamentation. These included saints, the Mother of God (later restored) and other images, including the Anastasis, which was still a new image in church decoration which emphasized the corporeality of Christ (and in this case the hopes of Paschal I for an eternity in Paradise for himself and his mother).[21] The scheme, with a bust of Christ in a medallion supported by angels, can be derived from a model like the sixth-century archiepiscopal chapel in Ravenna, but there is one significant difference. Whereas that chapel had a cross in the central medallion, San Zeno has an anthropomorphic Christ. The pope is making an 'iconophile' statement in direct opposition to current 'orthodox' thinking in Byzantium. This makes the information recorded in the *Liber Pontificalis* particularly significant: Paschal I constructed a monastery here, and gathered a community of Greeks, to praise God by day and night, chanting the psalms in the Greek manner. It may be no coincidence that the first iconophile Patriarch of Constantinople after Iconoclasm, Methodios, was in Rome after 815 as the representative of Patriarch Nikephoros to the pope, and seems to have been in this monastery. The mosaic decoration of Santa Maria in Domnica includes a striking apse image of the Mother of God enthroned with Christ and attended by a retinue of angels; at her feet is a kneeling figure of Paschal I dressed in the papal pallium and with the square halo that signals he was living at the time of the commission of the mosaic. He is at the edge of a carpet of gold, which is spread out in front of Mary's golden throne, and he touches her shoe; she extends her right hand towards him, showing her favour to him. The *Liber Pontificalis* records that

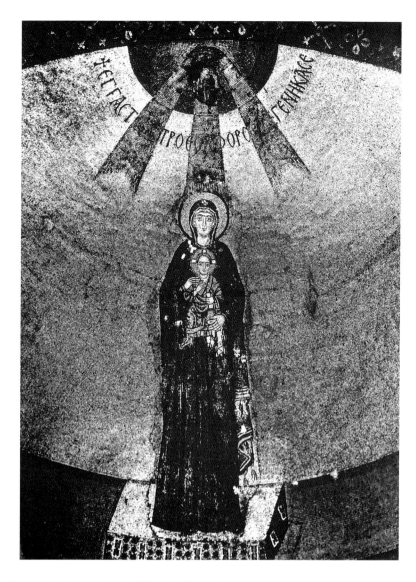

50. Sanctuary conch, now destroyed. Koimesis church, Nicaea (Iznik), Turkey.

96

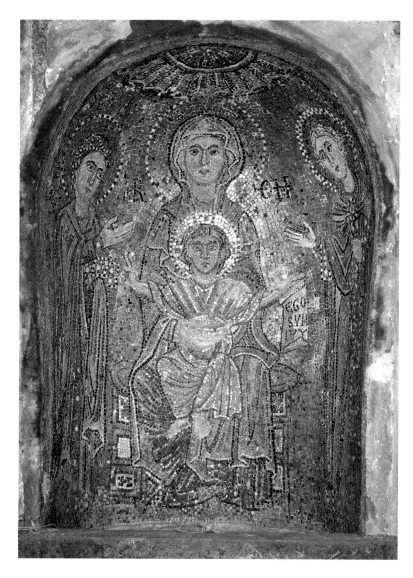

51. Chapel of San Zeno, Santa Prassede, Rome.

he gave among other treasures to this church a gold-studded cloth for the altar, on which was represented the Nativity of Christ. The decoration is a clear indication of the complexities of Marian apse decoration, with its combinations of dogmatic and doctrinal statements together with the personal and emotional pleas for intercession to the Mother of God. These two churches are only a part of the massive expansion of distinctive mosaic imagery in Rome in the first half of the ninth century, which depended both on Italian traditions and ideas from Byzantium. It is not surprising that when figurative art was revived in the churches of Constantinople after Iconoclasm, influences from Rome and the West have been detected in the production and schemes of Byzantine art.[22]

The collapse of Iconoclasm in 842 may have begun with apparent 'revival' of past traditions, but to underestimate the impetus for innovation which the Triumph of Orthodoxy unleashed is a superficial view of the period. Although the first steps in the ninth century towards the rehabilitation of church decoration might seem conservative, the fact that Orthodoxy now meant the conspicuous use of icons led to new thinking about the appropriate forms of church decoration. However, in the case of the Mother of God, the pre-Iconoclastic thinking that had favoured the apse as an ideal place for her representation did continue; and while it was not a rigid 'system' which prescribed her obligatory presence here, it was often probably a guiding principle in domed churches. But the full range of possibilities which were open to church planners is amply demonstrated by the variations in apse decoration in the rock-cut churches of Cappadocia after Iconoclasm.[23]

The church of the Mother of God at Nicaea (the Koimesis church) seems to be the first church with mosaics which we know was redecorated with figurative images after Iconoclasm (Pl. 50). The new patron was Naukratios, very likely the Studite monk who died in 848. His redecoration succeeded in minutely reinstating the pre-Iconoclastic imagery of the apse and sanctuary, either by careful observation of the sutures in the mosaic surface, which had been altered by the Iconoclasts when they tore out the first phase Mother of God and replaced her with a plain cross, or with the help of written or visual records made by the Iconophiles about the original scheme. The procedure which was followed at Nicaea, an accurate replacement of the first scheme, was not unique in this period. According to a text of the ninth century, a late sixth-century apse mosaic representing the Annunciation, in the church of the Chalkoprateia at Constantinople (and similar presumably to the scheme at Parenzo, Pl. 45), was torn out by the Iconoclasts under Constantine V and replaced with a cross; but it was restored as in the original scheme during the break in Iconoclasm by Patriarch Tarasios (784-806).[24] Even if the details recorded by an Iconophile may not be historically accurate in all respects, the notion of exact restoration of an original image destroyed by Iconoclasts was clearly a Byzantine concept of the ninth century. The effect of the reinstatement of the Mother of God was that the original text above her head and below the hand of God regained its spiritual power. During Iconoclasm the words must have been meaningless to the viewer of a single cross in the apse. Another feature of the restored mosaic was the prominence and iso-

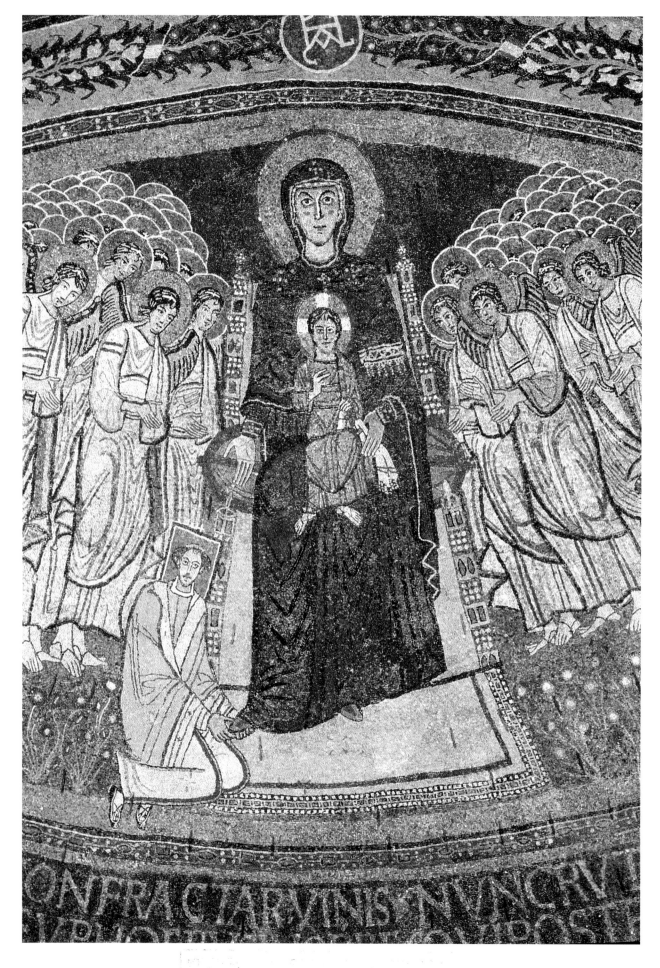

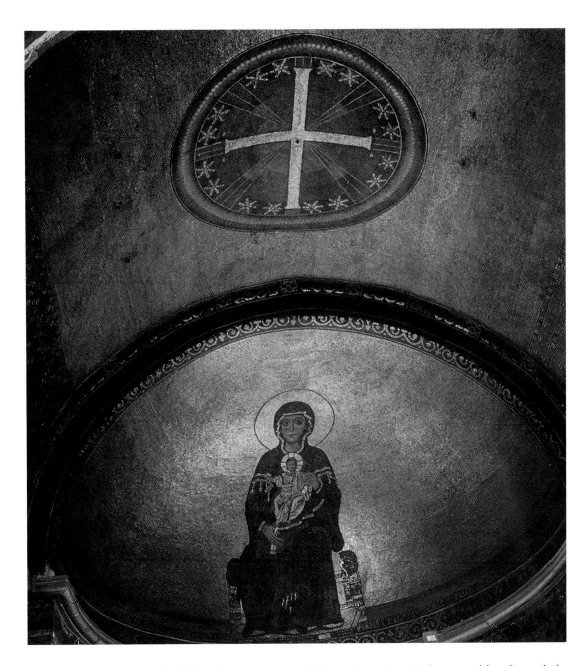

lation of the Virgin and Child in the apse, very different from the whole ensemble of angels in the church of Santa Maria in Domnica at Rome (Pl. 52). A feature of Byzantine apses from this period onwards was to select a scheme in which either archangels were excluded or, if included, were placed in the arch of the sanctuary or, as in Nea Moni on Chios in the eleventh century, in the conches of the apses of the side chapels.

The other major 'restoration' of the period after Iconoclasm was the apse of Hagia Sophia at Constantinople.[25] This did not happen, however, until 867. Although in his inauguration homily and in the epigram around the apse mosaic of the Mother of God the Patriarch Photios refers to the destruction of images in the church, there is no evidence that the new decoration replaced a pre-Iconoclastic Mother of God. The original Justinianic decoration of the east apse of the church was non-figurative, and there is no evidence that any changes were made in this part of the church before Iconoclasm — only in the Patriarchal Palace is there evidence of the insertion of figurative mosaics which included the Mother of God in the late sixth century, and these, it is true, were removed by the Iconoclasts. Perhaps Photios is making a creative allusion to this circumstance.

The seventeenth homily of Photios, delivered on Holy Saturday 867, is the richest Byzantine text which includes an *ekphrasis* of a work of art that we can still see and appreciate.[26] The import-

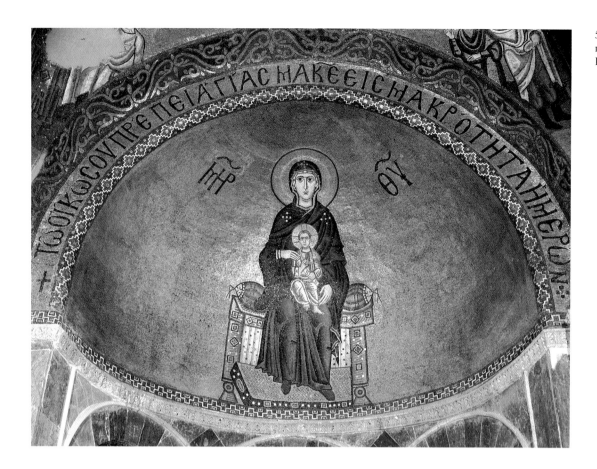

ance of it for the understanding of changing perceptions of the imagery of the Mother of God in the apse is to observe the subtle mix in his writing of Photios's understanding of the power of art. He speaks sometimes of the theological ideas communicated by the mosaic, sometimes of the intellectual power of art, sometimes of the pure emotional effect of the image on the viewer in the church. One is bound to suspect that such an image, so high and remote in this position, gave more of an impression of the 'other world' than of that in which the Byzantines lived and worshipped. The apse Virgin of Hagia Sophia seems to be at the beginning of a development in which mosaic imagery enveloped the spectator as part of the pomp of ritual and worship, while icons at ground level became the everyday focus of personal veneration and prayer. Such a mosaic created sacred space.[27]

While Photios gave intense attention and notice to the importance of the redecoration of Hagia Sophia after Iconoclasm as a re-establishment of Orthodoxy and tradition, apparently no attempt was ever made to replace the single cross in the apse of St Irene, the sister patriarchal church of Hagia Sophia. It has remained there to the present day. It appears that the archbishop at Thessaloniki likewise felt no urgency in replacing the cross in the apse of St Sophia after 843 (Pl. 53). Perhaps this was because the monograms in the sanctuary mosaics (and perhaps the church archives) recorded that the cross was the work of the iconophile Empress Irene, her son Constantine VI and the Archbishop Theophilos, who signed the acts of Nicaea II in 787.[28] Precedence was given in the cathedral church of St Sophia at Thessaloniki to a redecoration of the dome with a ninth-century mosaic of an Ascension, which does of course include a prominent image of the Mother of God on the east side. At the same date in Thessaloniki, the apse of the Rotunda church was also decorated: its wall-paintings of the Ascension are identical in style and in many iconographic details with the dome of St Sophia. It seems that in the city of Thessaloniki after Iconoclasm there was a greater interest in monumental decoration which gave emphasis to the final moment of Christ's life on earth, and the importance of Mary and the apostles as witnesses to the faith and his Resurrection.

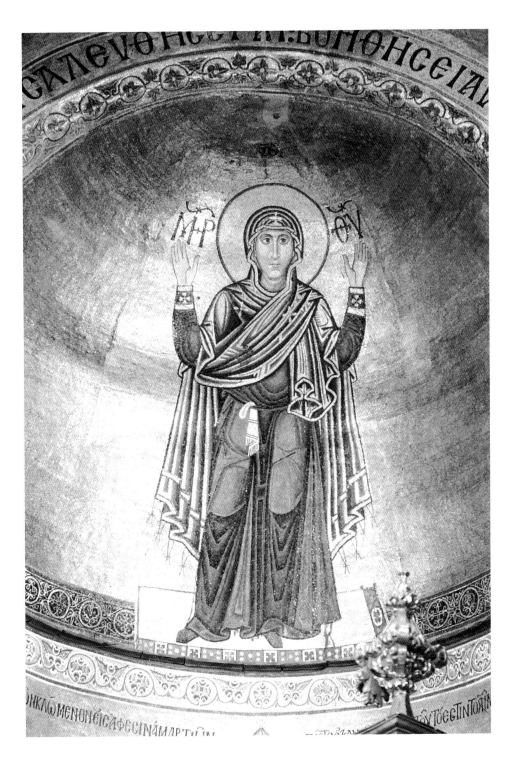

When the apse of St Sophia at Thessaloniki was finally redecorated in the first
half of the eleventh century, the placement of an image of the Virgin in the apse of
any church was the norm, whatever its dedication. By this time, more attention was
given to the precise choice of the imagery in which the Virgin was presented to the
viewer. In St Sophia at Thessaloniki, in the monastery of Hosios Loukas in Phokis
and at Daphni, near Athens, the Virgin is enthroned and holds the Child (Pl. 54);
in Nea Moni on Chios and in St Sophia at Kiev, she stands and holds up her arms
in the orant position (Pl. 55). Each choice must represent a legacy of theological and
conceptual planning, and an intentional choice to evoke special meanings and asso-
ciations. For example, although the type of the orant Virgin appears in a small church
at Livadia on Cyprus in the sixth century, after Iconoclasm it seems to be frequently

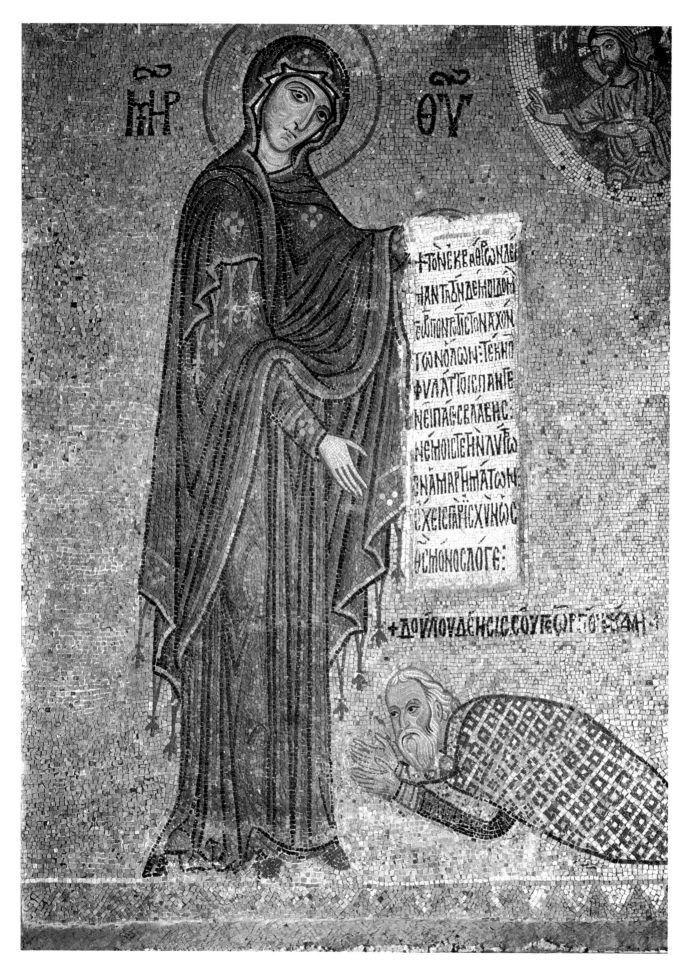

56. St Mary of the Admiral (Martorana). Palermo, Sicily.

57. Cathedral of Torcello, Venice.

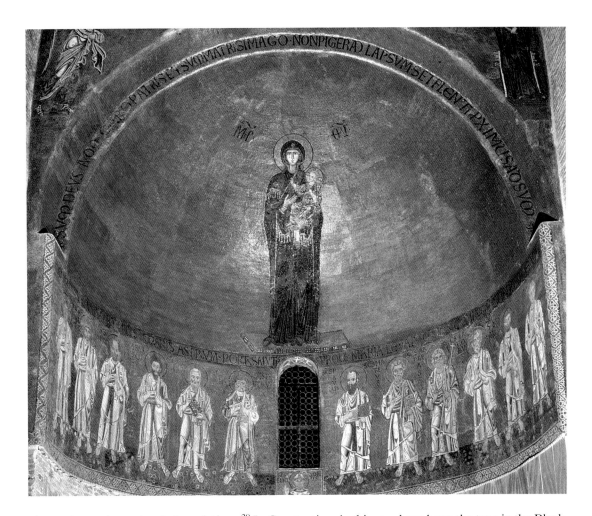

chosen in royal or princely foundations.[29] In Constantinople this may have been the type in the Blachernai church, and it was certainly chosen for the Pharos church of Michael III in 864 in the Great Palace, for Photios (in his Homily X) describes the image of the Mother of God in the apse in the following words: 'stretching out her stainless arms on our behalf and winning for the emperor safety and exploits against foes'. If this iconography was seen as a special sign of God's favour to the ruler, it makes a logical choice for the katholikon of Nea Moni on Chios, an imperial foundation particularly connected with Constantine IX Monomachos. It also would seem to explain the choice of this imagery not only in St Sophia at Kiev but also in the three other churches with mosaic, built in this period by the princes of Kiev.

The great image of the Mother of God in the apse of St Sophia at Kiev (Pl. 55) gained a local description as 'the Unshakable Wall'.[30] This may have arisen from the size and visual power of the actual image, but it reflects hymns about the Virgin in which she is called 'unshakable' and 'immovable'. It is clear that church dedications to the Virgin are particularly favoured in outlying and isolated locations. Procopius tells us, for example, that this was the dedication of the Justinianic church in the monastery of St Catherine at Sinai. It was chosen on Sicily for the church of St Mary of the Admiral (the Martorana), and the patron, George of Antioch, showed himself prostrate in veneration in front of the Mother of God (Pl. 56).[31] The mosaic decoration and its choices helped to proclaim the Orthodoxy of the immigrant patron in a foreign cultural world in 1143.

The lagoon at Venice has two images of the Virgin in the apse, whose visual power comes from their isolation in an aura of gold. The cathedral of Torcello was in the eleventh century the place where Byzantine church decoration and mosaic first entered the Venetian orbit (Pl. 57); soon San Marco and Santi Maria e Donato at Murano also gained mosaic decoration which marked the transplantation of Middle Byzantine techniques to Italy (soon to spread to Sicily, Rome, Flor-

103

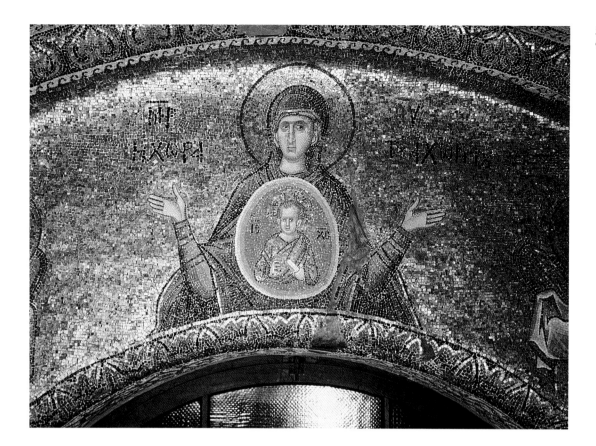

ence and Grottaferrata).[32] The apse image in the cathedral of Santa Maria Assunta at Torcello is a striking Mother of God who is standing holding the Child, in the Hodegetria type. The apostles below belong to the first mosaic decoration of the church in the middle of eleventh century, and the Virgin is an addition, made when the church was massively redecorated in the second half of the twelfth century. Such an image is a declaration that the Mother of God, the protectress of Constantinople, is also the support and refuge of Venice.

Only a few Byzantine churches received new mosaic decorations after 1204, and it was clearly a declining medium (whether because of its expense or for aesthetic reasons is hard to clarify). In the church of the Porta Panagia in Thessaly the mosaic was limited to the representations of Christ and the Virgin on each side of the sanctuary screen. A more pretentious monument was the church of the Parigoritissa at Arta in the Despotate of Epirus, but its mosaics are limited to the Pantokrator in the dome. Of course Hagia Sophia at Constantinople continued to display and add to its mosaics well into the fourteenth century, but of the three major churches with mosaic after 1261 — the Virgin Pammakaristos (the Fetiye Çamii), the Kilise Çamii and the Chora monastery (the Kariye Çamii), it is the Chora which sets new parameters for the imagery of the Virgin (Pl. 58).[33] The main naos of the monastery represented the Virgin as a devotional image with Christ, in the type of the Hodegetria, to the right of the sanctuary (a pendant to the figure of Christ in the left). She is here at one of the focal liturgical positions in the church, beside the templon screen. In the narthexes, she is shown in a full and intricate narrative of her life (developed far beyond such a narrative cycle as that of the twelfth century in the narthex at Daphni). On the lunette above the entrance door, facing an image of Christ Pantokrator, she is shown as an orant figure with Christ in a medallion on her breast and accompanied by two angels (Pl. 59). The intellectual and theological sophistication of Theodore Metochites, the patron, and his advisers is underlined by the choice of texts with these images. Christ has 'Jesus Christ, the dwelling place *(Chora)* of the living'. Mary has 'The Mother of God, the dwelling place *(Chora)* of the uncontainable *(Achoritou)'*. Since we can see that Mary is indeed a container (but of the uncontainable), image and text between them communicate the immensity of the Mystery of the Incarnation.

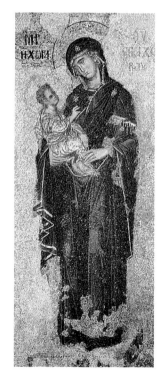

One has to admit that a chronological review of the representation of the Mother of God in the apse appears to lead to the conclusion that with time and tradition came cumulative complexity. This would probably be a mistaken conclusion. When we have texts which illuminate the thinking of the donors, as in the cases of Photios and Theodore Metochites, we can appreciate all the complexities of Byzantine thinking. In those cases where we have the images but not the supporting writings about their production, we might be wise to assume that the circumstances and intellectualization of art which led to their production were equally profound. At any rate the imagery, once set in place, served generations of Byzantine viewers.

[1] For the faiths of the Eastern Churches, Atiya 1968, which remains a useful history of the Churches which diverged from Mediterranean 'norms'. For a recent emphasis on the significance of the Schism, Lidov 1998, 381-405.

[2] The classic survey of apse decoration is Ihm 1960. For a recent reappraisal of Christ in the apse, Spieser 1998, 63-73; also Spieser 1991, 575-590.

[3] Walter 1993, 203-228; *The Iconostasis*.

[4] Schulz 1986, and Taft 1995.

[5] Gouillard 1967, 1-316.

[6] Mathews 1993.

[7] Hopkins 1999, esp. 357, n. 12 on Mathews 1993; and 290-291 and 376, n. 2 on 'Son of God'.

[8] Kessler 1993, 59-70 and Cameron 1992, 1-42; and, more theologically, Parry 1996.

[9] Carroll 1992 is a recent attempt to set out a theory of the prevalence of Mary as a 'mother goddess' from the 5th century.

[10] Spieser 1998, nos 18-19 for the documentation, but add Mango 1972, 34-35 for a translation and discussion of the 10th-century manuscript Paris gr.

1447 with its (later) reference to 5th-century images of the Mother of God in the sanctuary of the Chalkoprateia church in Constantinople.

[11] Megaw and Hawkins 1977: the mosaics have since been looted though mostly recovered. Also Sacopoulo 1975.

[12] The detached mosaic of the Virgin is in San Marco in Florence, and of the pope in the Vatican Museums.

[13] Nordhagen 1965, 121-166.

[14] Barber 1991, 43-60.

[15] Mango 1994a, 343-357.

[16] Underwood 1959, 235-244.

[17] This moment of the construction of a 'new image in an old form' is argued by Spieser 1998, 71; however his argument may be criticized for exaggerating the evolution rather than the parallel development of these iconographies.

[18] Meyerdorff 1984. This passage is also quoted in the paper on the mosaics of Hagia Sophia in this volume, 111.

[19] Parry 1996, esp. 191ff.; also the documentation in *Preacher and Audience*.

[20] For the documentation, Davis 1995, esp. 9-14.

[21] Kartsonis 1986, esp. 88-93. She also discusses the use of reliquaries in this period, many of which included imagery of the Mother of God.

[22] For the context, Brubaker 1999.

[23] Jolivet-Lévy 1991.

[24] Lackner 1985, esp. 851-852; also Mango 1994, esp. 350.

[25] See the essay on the mosaics of Hagia Sophia in the present volume, 107-123 for documentation.

[26] Mango 1958, esp. 279ff.

[27] The idea of decorated monumental space is developed in a series of articles, but with the emphasis on the representation of Christ rather than the Mother of God, by Mathews 1995, esp. Studies XII, XIII and XIV.

[28] Cormack 1989a, esp. Study V.

[29] Mouriki 1985, esp. 107ff. For the associations of the orant Virgin with a medallion of Christ on her breast, Carr and Morrocco 1991, esp. 43ff.

[30] Lazarev 1966, esp. 226.

[31] Kitzinger 1990.

[32] Demus 1984.

[33] For a recent important study and bibliography, Nelson 1999, 56-82.

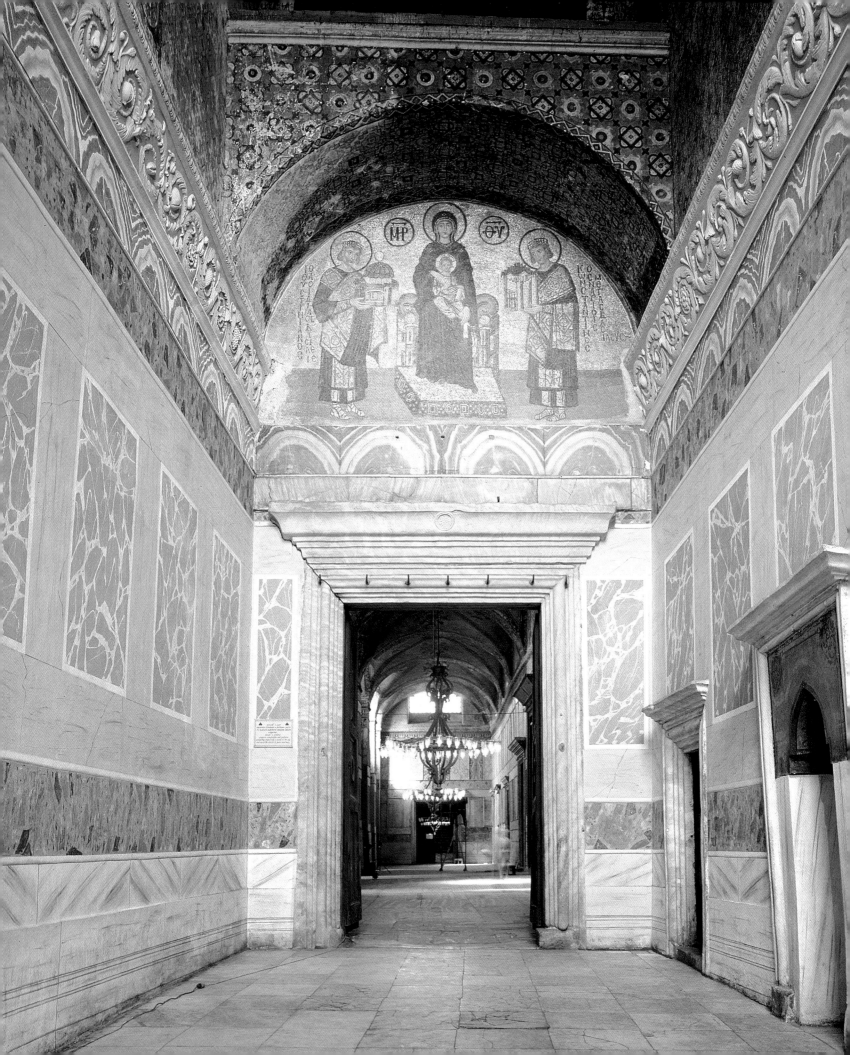

Robin Cormack

The Mother of God in the Mosaics of Hagia Sophia at Constantinople

The first mosaic which the visitor to Hagia Sophia sees is the lunette over the entrance door from the southwest vestibule into the south bay of the inner narthex (Pl. 60). In it the prominent imagery of the Mother of God communicates visually the idea of the protection of the Virgin over both Constantine's city and Justinian's church (Pl. 61). This high mosaic panel was visible in the Byzantine period to the privileged spectator who approached the church either from the court of the Augustaion (which held the monumental equestrian statue of Justinian) or who came from the Patriarchal Palace, which was situated at this corner of the church from the late sixth century. This door into the south section of the inner narthex was known as 'the beautiful door'. The mosaic represents the Virgin and Child receiving the gifts of the city and the church from the pious Roman emperors whose reigns are evoked here as the twin highpoints in the establishment of the imperial Christian capital. Yet the emphasis on the Virgin in the sacred landscape of the cathedral may be regarded as a relatively late development and the mosaic is generally dated to either the late ninth century or to the tenth century.[1] In the early city of Byzantium, the prestige of Mary developed more conspicuously in other sites in the city. The dedication of the Great Church complex with its two magnificent churches was to Christ as Holy Wisdom and Peace (Hagia Sophia and St Irene). Indeed the enthroned Christ in the lunette mosaic at the centre of the inner narthex (perhaps planned as a pendant to the vestibule mosaic) announced through his Gospel text, held up over the ceremonial entrance door to the nave, that he gave Peace and was the Light of the World. The aim of this paper therefore is to examine how the mosaic decoration of the church of Hagia Sophia gradually developed and enhanced the cult of the Mother of God over the course of the Byzantine period.

The idea of the supernatural protection of Constantinople by the Virgin was developed firmly in the years before Iconoclasm, but the location of the main Marian relics and connections were outside the Great Church.[2] The charismatic site of the church of the Chalkoprateia, which contained the girdle of the Virgin, was close-by the precinct of the Great Church, but Hagia Sophia itself was richer with relics connected with Christ than with the Virgin. The Russian visitors in the Late Byzantine period made mention of one important Marian object in Hagia Sophia. This was the miraculous icon of Mary which had forbidden St Mary of Egypt to enter into the church of the Holy Sepulchre in Jerusalem. It was displayed in Hagia Sophia to the right of the central door into the nave (the 'beautiful door' or 'imperial door' above which was located the narthex mosaic panel). This icon was kissed and venerated by the faithful and by pilgrims, and the marble revetments on each side of the door have dowel holes at head level; this icon of the Virgin was on the right and an icon of Christ was to the left. The marble flooring in front of the Virgin icon was replaced in the course of the Byzantine period; it was no doubt worn down by generations of visitors.[3] This profile of Marian relics in Constantinople is confirmed by a western account of the city in the twelfth century.[4] This records that the Great Palace had a number of Marian relics—her robe, her veil, part of her girdle, and her shoes. Equally rich, if not richer, were the three main Marian sanctuaries: the Hodegon monastery, near Hagia Sophia, which owned the miraculous icon painted by St Luke, the Chalkoprateia with its silver shrine with the girdle of Mary, and the Blachernai monastery which had fur-

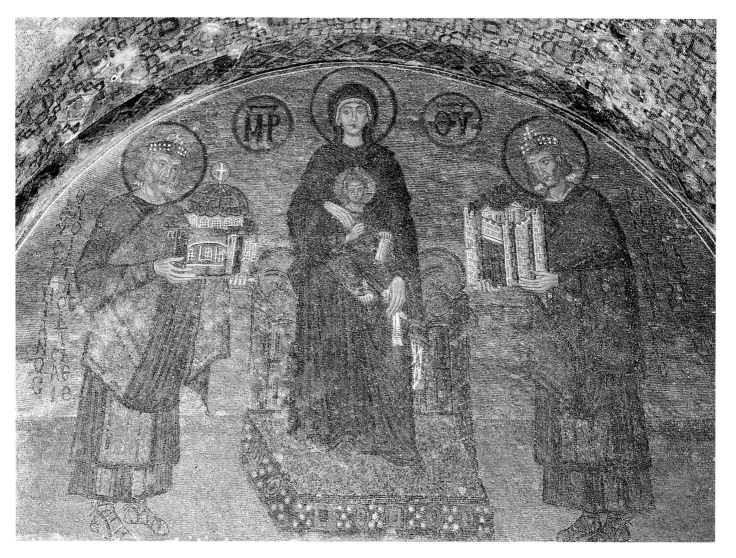

ther icons and parts of her relics. Hagia Sophia in comparison had only the icon which spoke to Mary of Egypt and the icon of the Virgin and Child which bled when a Jew stabbed the neck of Christ.[5]

The Great Church before Iconoclasm was nevertheless influenced by the rising cult of Mary. This can be seen, for example, from Byzantine descriptions of its fittings and decoration. The poem of Paul the Silentiary, which was written to celebrate the restoration of the dome and the consequent second consecration of the church on 24 December 562, and recited early in 563 (probably at Epiphany on 6 January), describes the new silver screen around the sanctuary which included an image of the Mother of Christ. He speaks also of an image of Mary among other figures on the silk altar cloth of the church – in one section Justinian and Theodora seem to have been depicted blessed by Mary and Christ.[6] And within a few years, the new Emperor and Empress Justin II and Sophia are portrayed in the poetry of Corippus as making direct prayers to Mary in front of her icon (Bk II, 48ff.).[7] To their reign can be attributed the first mosaic figurative images of the Patriarchal Palace (between 565 and 577), which were in time to be removed by the Iconoclasts in 768/9. These may have included a representation of the Virgin in the medallions of the Small Sekreton.[8] But despite these images of the Virgin in Hagia Sophia, when in the seventh century the salvation of the city over its invaders was attributed to the intervention of the Virgin, her relics and icons came from elsewhere in the city and not from the Great Church.[9]

By the time in 867 that Patriarch Photios was involved in the practical planning of a new decoration in Hagia Sophia, that would proclaim the Triumph of Orthodoxy, the importance of the Virgin within the decoration of any church had been developed and established. Germanos (Patri-

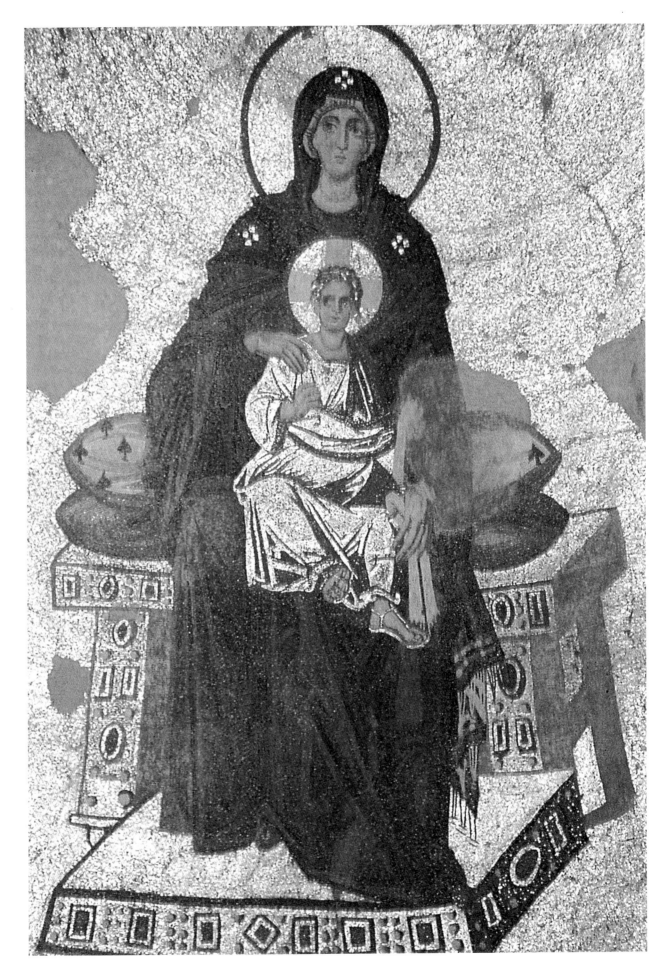

63. *Detail of the Virgin,*
apse mosaic.
Hagia Sophia.

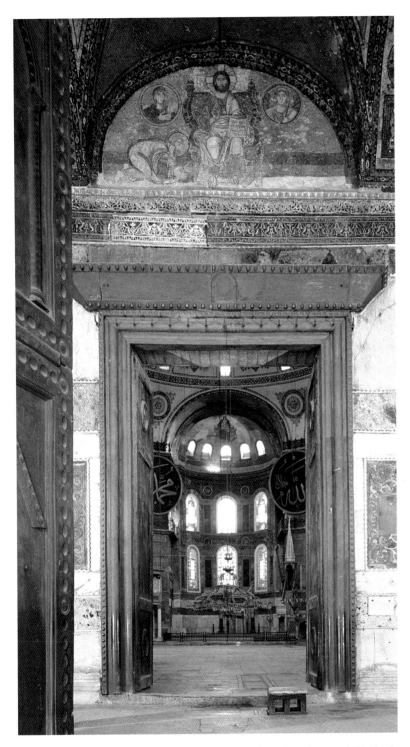

64. *The doorway under the narthex mosaic*, general view. Hagia Sophia.

arch of Constantinople from 715 to 730) had set out an evocative account of church symbolism in a popular text, *Ecclesiastical History and Mystical Contemplation,* which might easily have been regarded by its readers as referring to Hagia Sophia.[10] The apse, he tells us (section 3): 'corresponds to the cave in Bethlehem where Christ was born'. This would give an instant justification for the representation of the Virgin with the Incarnate Christ in the new apse decoration. But the choice of an image of the Virgin and Child in the apse of Hagia Sophia was probably not simply due to past tradition; Photios was presumably involved with the planning and there may be a case for connecting his own special devotion to the Virgin as a factor in the decision. This would explain the choice as in part Church tradition and in part personal motivation. Not only is the inauguration homily full of hyperbolic praise of Mary, but Photios also wrote hymns to the Virgin, despite the refrain of inadequacy in the face of this task always expressed by Marian hymnographers.[11] Photios also had chosen, like Methodios before him, to represent Mary on his patriarchal seals. Methodios had chosen the Hodegetria type, and Photios used both this type and a Platytera (possibly one type belongs to his first period in office and the other to the second).[12]

The apse mosaic of the Virgin and Child between Archangels Michael and Gabriel (Pl. 62) is an artistic work of great magnificence. It also stimulated one of the major examples of an *ekphrasis* of an existing Byzantine work.[13] It has a multiplicity of meanings and functions in this position, and this allowed Photios to explore his *ekphrasis* in several directions. In terms of Orthodoxy, on which Photios puts great emphasis by starting the homily with a passage on the heresies which have recently surrendered to Orthodoxy, the apse mosaic is a Christological representation which emphasizes the literal Incarnation of Jesus. The main theme of Photios's homily is the transformation of a church stripped of images into a holy place of renewed beauty. The new visual image of the Mother and Christ is emphasized as a means of teaching and proclaiming Christian faith which both supplements and more vividly confirms holy writ. As for the character of the artistic imagery of the apse mosaic, Photios describes it as so 'lifelike' that one can see the Virgin's fond gaze towards her son, although her expression and emotions are properly controlled in the face of his divinity.

It is clear that Photios is setting out through an elevated passage of grand writing a definitive statement on the power of art to communicate the basic truths of Orthodox Christianity. This homily is not in any sense to be regarded as a literal description of the mosaic, but it does rely for its vocabulary on the traditional critical discourse of realism which had dominated *ekphrasis* since Antiquity. One senses that Photios constructed his homily in the study rather than gazing high up into the apse in the church. Nevertheless, compared with the post-Iconoclastic mosaics in the church of the

111

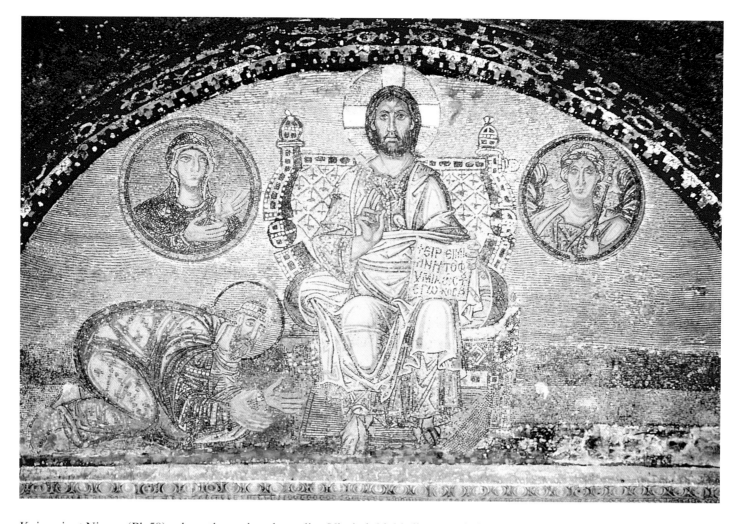

65. *The narthex mosaic.*
Hagia Sophia.

Koimesis at Nicaea (Pl. 50), where the replaced standing Virgin is highly linear and abstract in style, one might argue that this image is relatively naturalistic in appearance and that Photios's words to communicate the ninth-century reaction to an image are not totally inaccurate.[14] After all, viewing imagery in churches during the last century of both active Iconoclasm and reduced artistic production must have been a limited experience, and Photios's public was experiencing a novel phenomenon in Hagia Sophia. Notably the artist has accentuated the fullness of the bodies, by the bold modelling against the backless throne in perspective, and in such details as the device of foreshortening the left foot of Christ. In comparison with Nicaea, where the figures are strictly frontal, both the Virgin and Child here look away from the viewer towards the left. Photios has attempted to interpret this pictorial treatment in his 'description': 'As it were, she fondly turns her gaze on her begotten Child in the affection of heart, yet assumes the expression of a detached and imperturbable mood at the passionless and wondrous nature of her offspring, and composes her gaze accordingly'.[15]

The image of the Mother of God (Pl. 63) in the apse of Hagia Sophia must have been her most frequently viewed representation in the Byzantine world. As the main church of the state, it was the home of the most impressive celebrations of the liturgy, the site of a great collection of relics, including pieces of the True Cross, and the location of magnificent mosaics in the vaults. Yet the mosaic was out of human reach, dim and distant to the viewer, and could not be venerated like an icon. It was, however, imitated in small scale on patriarchal seals and presumably reproduced in more accessible images. Stylistically the apse mosaic influenced other mosaics in Hagia Sophia, such as the Virgin in the Deesis mosaic in the Large Sekreton and the archangel in the medallion on the right side of the narthex mosaic. Yet in looking at these other images of the Mother of God in Hagia Sophia, their significance lies less in the fact that the artistic additions to the church were made with knowledge of previous work and may have been deliberately harmonized into the dec-

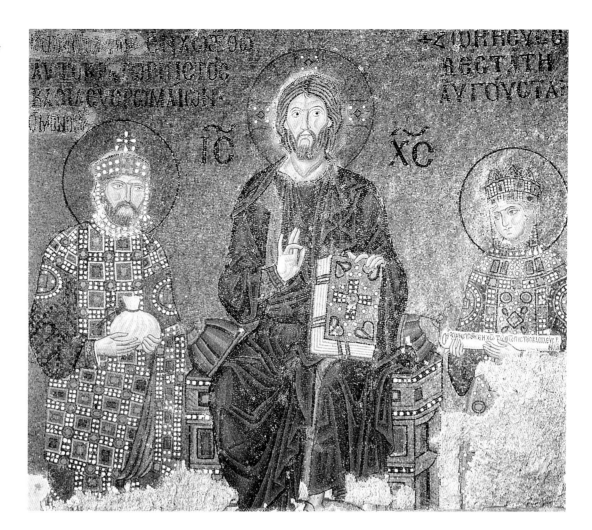

oration, and more as documents of the variety of ways in which her cult functioned in the church. In the case of the post-Iconoclastic cycle of the Large Sekreton of the Patriarchate, this decorated a relatively private and intimate part of the church. It was used for formal meeting and ceremonial meals, and it was also the place where the patriarch prepared himself and his retinue before their public entrance into the gallery.[16] The single-figure decoration for this room had the theme of Orthodoxy, with an emphasis at the south end of the room on four famous iconophile patriarchs – Germanos, Tarasios, Nikephoros and Methodios. Over the entrance door into the south end of the east gallery of the church was a Deesis with the Virgin, St John the Baptist and Christ (on a lyre-backed throne) which symbolically represented a moment of prayer at the threshold between Patriarchate and church proper. In this particular scheme of imagery, the Mother of God is hierarchically represented in the Orthodox community as the human who in heaven is closest to God. It is her accessibility to human prayer and willingness to act as an intercessor that is a feature of any Deesis group.

The threshold panels at the 'beautiful door' and the 'imperial doors' both include an image of the Mother of God. In the vestibule mosaic, she is enthroned with Christ at the centre of the panel between the two haloed emperors. The throne type, as in the apse mosaic, is backless (the *thokos*), and an echo of the apse mosaic in this mosaic is that the left foot of Christ is foreshortened. The Virgin looks slightly to the left, and Christ to the right, and so, as in the apse, frontal contact with the viewer is eschewed. The dynamics of the panel are in this sense self-contained, as the two emperors look inwards towards the sacred figures. This mosaic could not be perceived by the viewer as a devotional panel or icon; this distinguishes the character of the mosaic from the pre-Iconoclastic pier panel of the seventh century in St Demetrios at Thessaloniki, which shows the bishop and prefect on each side of the cult saint, and which effectively invites the viewer to pray to the secular figures who are represented in the presence and favour of the saint. While both these mosaics

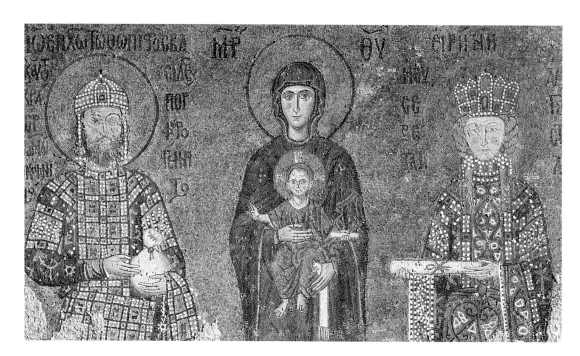

67. *The John Komnenos and Irene panel*. Hagia Sophia.

68. *The Virgin from the John Komnenos panel*. Hagia Sophia.

may, through their references to secular power, have political connotations, they are best regarded as deeply religious images. This is equally true of the famous panels of Justinian and Theodora in the church of San Vitale at Ravenna; their presence in the city may communicate the political orientation of Ravenna within the control of the Orthodox Byzantine state, but the meanings conveyed are full of religious evocations by showing the emperor and empress participating in the liturgy in the presence of Christ at the Second Coming in the apse.[17]

The most complex imagery in Hagia Sophia is contained in the narthex mosaic (Pls 64 and 65) of an emperor in *proskynesis* in front of Christ Enthroned, and interpretations have ranged here from a predominantly political interpretation to theological and religious ones.[18] However, few of the studies have given much attention to the significance of the Virgin in the medallion on the left, with its pendant on the right containing an archangel. An issue is whether her gesture is one of mediation, for example on behalf of the emperor below, who may, in view of the lack of an identifying inscription, be regarded either as an individual or as a generic symbol of imperial power, or whether the gesture has some other significance. Grabar has given the most positive suggestion for an interpretation of the combination of Mary, Gabriel, Christ and an emperor by linking the imagery with a sermon of Leo VI.[19] This is a sermon (Homily I) delivered by the emperor in the early years of his reign on the occasion of the feast of the Annunciation of 25 March.[20] The special feature of the presentation is that Leo addresses the archangel and asks him to bring his message again, this time to Constantinople, and to acclaim Christ's glory in his sacred palace as ruler of earth and heaven. The sermon also addresses the Virgin and speaks of the Light of the World, reminding us of the text on the book held by Christ in the mosaic ('I am the light of the world; peace be with you'). Grabar suggested that theologically there was a linkage here between the historical event of the Annunciation and the symbolic gift of Holy Wisdom to the emperor. This important Marian sermon by the Emperor Leo VI (himself a pupil of Photios and the clear source of many ideas in his homilies) deserves continuing attention, either as containing ideas derived from this mosaic, or as documenting the theological climate in which it was produced.[21] More attention may also need to be given to the formal aspects of the mosaic. Does the representation of the Mother of God in a circular medallion evoke the round icons held by Patriarch Nikephoros in miniatures in the Chludov Psalter (now in the collection of the State Historical Museum, Moscow, Pl. 13), which was most likely produced in the Patriarchate of Hagia Sophia, and so make this panel another celebration of the Triumph of Orthodoxy? Finally another aspect of the importance of the imagery of the Virgin in an imperial context is documented in another medium, the ivory sceptre of Leo VI (now in

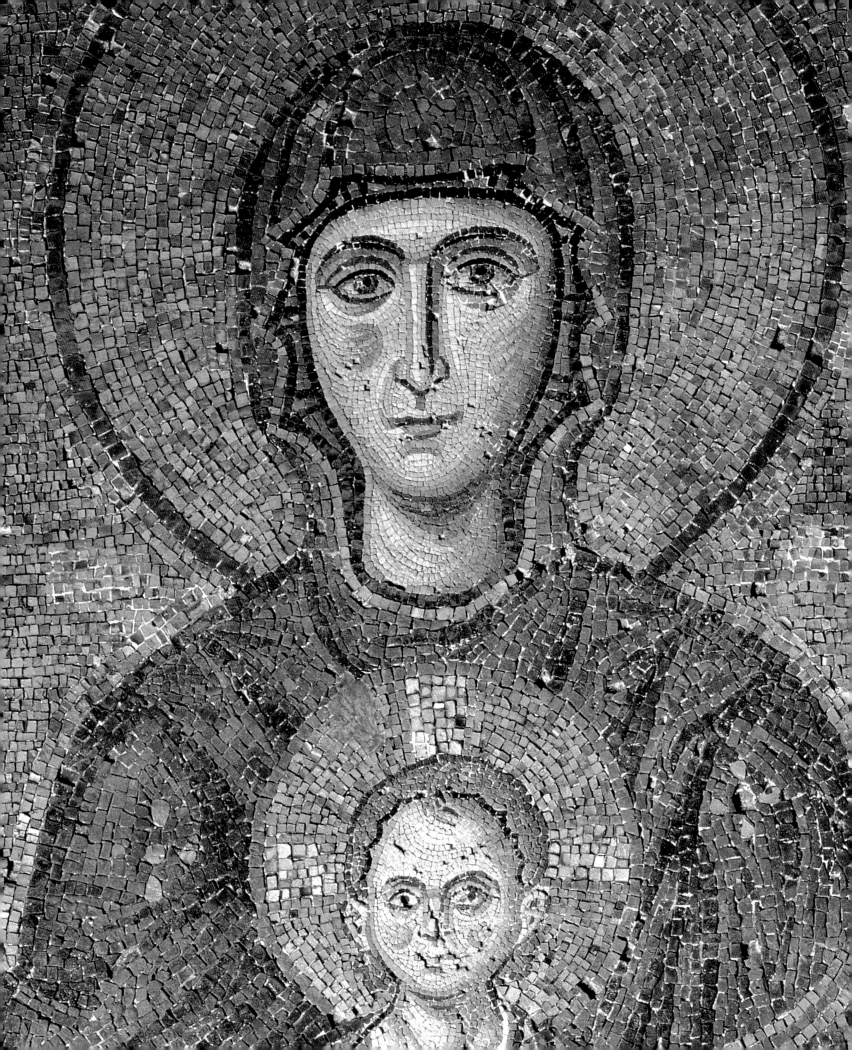

Berlin),[22] (Pl. 111). The scene on the back of the sceptre has the figures arranged against an architectural background which resembles Hagia Sophia; these figures are Gabriel on the right, the emperor on the left, and in the centre the Mother of God, who is portrayed adding a jewel to his diadem. The action is described in the text on the ivory: 'You set a crown of fine gold on his head' (Psalm 20:3). Such gemstones in the imperial regalia are connected in Byzantine thinking, it can be argued, with wisdom and piety. The connection of the emperor on this side of the ivory with the Virgin and Gabriel, the texts and the representation of Christ on the other side all make the same kind of statement as the narthex mosaic: Maguire has characterized the sceptre as representing the divinely sanctioned political power of the individual emperor and acting as a prayer for his reception into the mansions of heaven. As a visual prayer, it is of course stronger than a verbal prayer, for pictures imply a successful outcome. In the narthex mosaic we do indeed see the emperor haloed and in the presence of Christ. It is the prayer of the sceptre realized.

The prominence of the Mother of God in the symbolism of the Great Church is therefore made clear by the points at which her image punctuates the vision of the faithful in the church; she is at the threshold of the three main entry points into the church for the patriarch and the emperor. It seems also that a potent factor of her imagery is the support of the emperor and state ideology. The meaning of the vestibule mosaic does seem to encompass the idea that Mary was the special protector of the city of Constantinople, equivalent to a palladium of the capital. At the 'imperial doors', patriarch and emperor both regularly kneeled down below the mosaic with its imagery of both Christ and the Virgin before they made the entrance into the nave. The Mother of God also overlooked the whole congregation from her position in the eastern apse. In contrast, it must be said, with the relative scarcity of relics or cult images of the Virgin in Hagia Sophia, the monumental treatment of her symbolism seems especially powerful. There are two further representations of the Virgin in the church that need taking into account in this interpretation. They were set up in architecturally fragile parts of the structure, and have correspondingly suffered from damage and restoration. Only one of these has survived, and it has not yet been consolidated as part of the decoration of the church.

The section of the great eastern arch which contained an image of Mary has recently been uncovered. This mosaic was in fact the latest Byzantine addition to the decoration of the church.[23] After a series of earthquakes, the great eastern arch (together with parts of the dome, pendentives and eastern semidome) had eventually collapsed on 19 May 1346. The structures were rebuilt and eventually redecorated. The mosaics of the arch were completed around 1354-1355. At the summit was a Hetoimasia (the prepared throne of Christ); on the upper part of the north side was an orant Mother of God (of the Blachernitissa type) and on the upper part of the south side was St John the Baptist. The Emperor John V Palaiologos was represented below the Virgin. Beside the Virgin were the words of the Magnificat (Luke 1:45-47): 'My soul magnifies the Lord, and spirit rejoices in God my Saviour'. It is hard at present to understand how such an image, so high in the church, was viewed in the church. There was an equally remote image of the Virgin on the great western arch. This arch was first decorated around 870, very soon after the decoration of the apse, and was part of the decoration which Photios inaugurated, which continued with the representation of Christ in the dome and with the heavenly community in the tympana, down to the surviving zone of the Church Fathers. The western arch, according to Byzantine accounts, had an image of the Virgin and Child with Sts Peter and Paul. This ninth-century mosaic was destroyed when the arch collapsed, together with a portion of the dome and western semidome, in 989. Major repairs were soon undertaken and the *Chronicle* of Skylitzes records the great expense of the scaffolding (1000 pounds of gold).[24] The arch was redecorated with the same scheme as before and the church ceremonially opened in 994 (probably on 13 May). This mosaic, unfortunately, no longer seems to exist.

All this imagery of the Mother of God in Hagia Sophia can be emphasized for its public symbolic character, however much its actual initial sponsorship represents the benevolent intervention

116

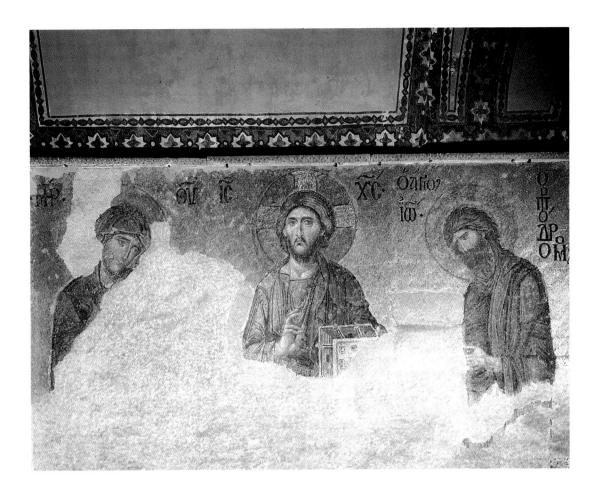

of certain emperors. The mosaics represent ways in which the community at large would view the Virgin and the ways in which Christian thinking was embedded in social attitudes. Imperial thinking about the Mother of God and her imagery was of course informed and created by broader social attitudes. In one part of the church, however, we must allow that the mosaics of Hagia Sophia might represent the more private concerns of the emperor and the patriarch. This is the enclosed area of the south gallery. This section was partitioned off from the rest of the church, and it seems that from the east end of this gallery there was private access to the Great Palace. However, its functions must have overlapped between the church clergy and the imperial court, and it should not be considered as the exclusive domain of one or other of these groups.[25] Two out of the three mosaic panels in this area include a representation of the Virgin. These panels are relatively low in height and are more icon-like than the great panels of the rest of the church. Indeed the Deesis mosaic in the south gallery was originally set within an oratory and is, in effect, a vast icon for personal devotions.

The two panels on the east wall of the south gallery commemorate specific cases of imperial patronage to the Great Church.[26] On the left, the Zoe panel (Pl. 66) must record two separate acts of generosity to the church by the imperial family: firstly by Romanos III Argyros (1028-1034), whose donation was an additional annual income paid to the church out of the imperial treasury (and at the same time the capitals of the church were gilded); and secondly by Constantine IX Monomachos (1042-1055), who further supplemented the income of the church so that the liturgy could be celebrated daily and not just on great feast days, Saturdays and Sundays. By the technical and piece-meal substitution in the mosaic of the head of Constantine for the head of Romanos, the two donations were celebrated by only one (updated) panel. The donations are shown here as literal gifts of money to Christ, as the patron of the church of Holy Wisdom. The composition of this panel with Christ enthroned at the centre between the emperor and empress can be dated to the first phase of production (between 1028 and 1034). The choice of Christ was the obvious one in view of the

117

dedication of the church which is granted the donation. It is therefore a surprise to look at the panel to the right of the Zoe panel and to see its chosen iconography (Pl. 67). The Emperor John II Komnenos (1118-1143) is on the left, his wife Irene on the right, and on the pilaster at right angles to the panel, their son Alexios. The central figure is the Mother of God (Pl. 68). She is depicted standing, with her head higher than those of the imperial couple, and so she was presumably set on a footstool (the lower section of the mosaic has been lost). The monograms of the Mother of God are inscribed on either side of the head. She holds the Child in front of her, apparently seated. The surprise is that, once again, it records an emperor holding the visible proof of his pious donation to the church, but despite the precedent offered by the Zoe panel, the planners of this mosaic chose to deviate from its iconography and to represent instead the Virgin and Child at the centre. Whittemore concluded from this imagery that the meaning was different, and he saw this as a commemoration of the coronation of the emperor in 1118. The figure of Alexios was, on this logic, assumed to be an addition to the panel in 1122, when he was proclaimed co-emperor. The problem with this interpretation and dating is that there is no visible suture between Alexios and the main section of the mosaic. It is true that the position of the figure seems awkward to us and is even perhaps not part of the preliminary plan, but there is no technical evidence in our present state of knowledge to indicate that Alexios is not homogeneous in date with the rest of the panel. This would lead to a dating for the whole panel after 1122 and before 1134, when Irene died, and would suggest that this panel, like the Zoe panel, did intend to record imperial piety and generosity, marked by a major donation, rather than to celebrate a political event. If this is the correct interpretation, it follows that a positive decision has been made to portray the Mother of God with her Child rather than to represent Christ enthroned. Whittemore proposed that the solution to the choice might lie in the iconographic type of Virgin selected for representation. He argued that the type was of the Virgin Kyriotissa, and that it copied a famous miraculous icon which was chosen because of the particular and fervent imperial devotion to that image.[27] This attempt to identify particular famous images from a supposed pattern of iconographic types is probably unjustified. It cannot be supported from the terms used for the representation of the Virgin in Byzantine literature, and there is the further difficulty that among surviving imagery some representations of the same iconographic type have inscribed labels with different appellations. This point has recently been reiterated in a study of the Kyriotissa monastery at Constantinople, in which images labelled 'Kyriotissa' have been discovered. In the diakonikon of the Kalenderhane, the icon labelled Kyriotissa is in fact of the type often described as Nikopoios.[28] The evidence from this monument is that there was no regularized iconographic type for the Kyriotissa. Another way to explain the choice of the Virgin and the form in which she is represented in the Komnenian mosaic may be to explore the imagery of Komnenian coins; there is evidence of considerable experiment in this medium in the twelfth century and of the choice of particular images of the Virgin.[29] For the present the most obvious general conclusion is that this choice is an indicator of the character of the piety of the imperial donors and the wish to be seen in the presence of the Mother of God. Could it even be relevant that Irene, unlike Zoe (the last of her dynasty), was a successful mother.

The most accessible imagery of the Virgin in Hagia Sophia is her representation in the Deesis mosaic in the imperial south gallery (Pl. 69). The impact of this figure is that despite her monumental size and the rigid medium of mosaic, she is presented to the viewer as an approachable intercessor with a human look (Pl. 70). Nowhere else in the church is Photios's vocabulary of a 'lifelike imitation' so instantly appropriate. Whittemore connected this delicate style with the Vladimir icon of the Virgin and Child, which was sent to Kiev from Constantinople around the year 1120, and he accordingly dated the mosaic to the twelfth century as part of a new humanizing style in Byzantine art in this period.[30] An opposing view is to recognize a stylistic affinity with Siennese painting of the thirteenth and fourteenth centuries and even to query which was the earlier, Duccio or the Deesis mosaic. It does seem that the understanding of the expressive qualities of the figures portrayed in the Deesis mosaic do depend in great part on its date and context in Byzantine art.

70. *The Virgin, from the Deesis mosaic*. Hagia Sophia.

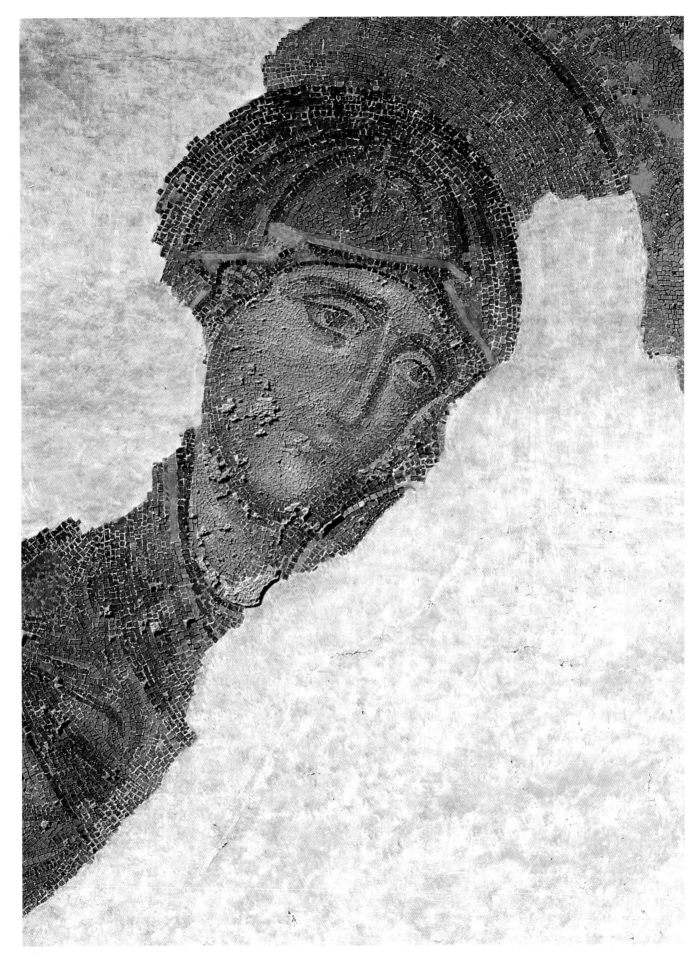

The Deesis mosaic was installed in the central bay of the south gallery of Hagia Sophia when the area in front of it was partitioned off by a low parapet (recorded in the eighteenth century), in order to create a small oratory. A candlestand was set up in front of the image, and the viewer would venerate the image while facing to the west, not as one might have expected towards the east. The mosaic tesserae are all of one date and they were set within a framed panel which was made by pirating a number of materials from elsewhere. The cornice along the top of the panel was reused from elsewhere and inserted into the wall, an operation which displaced a few tesserae of the sixth-century ornamental mosaic belonging to the vaulting of this bay. The original height of the Deesis mosaic was 5.20 m and its width 6.03 m.[31] To the left of the Virgin, the border was a strip of red painted plaster, and it seems that the mosaic was set up at a time when the marble revetment of the south wall had been removed. This most likely indicates that the stripping of the marbles of the church, which took place during the Latin Occupation of the city between 1204 and 1261, precedes the setting of the mosaic. The first operation in the church after the reconquest of the city in 1261 was to remove its Latin fixtures and to make it ready for the coronation ceremony of the return-ing Orthodox Emperor, Michael VIII. As all this activity took place between 25 July and Christ-mas Day 1261, the most likely time for the renovation and redecoration of the south gallery fits into this short interval. Since so much of the lowerpart of the panel is lost, the possibility is that this composition, like that in the Chora monastery, included a representation of the emperor, per-haps denoting a prayer for Michael VIII at the moment of the Last Judgement. Such a dating of the style of the Deesis mosaic fits well with such comparative monuments as the wall-paintings at Sopoćani in Serbia and the icons of the Virgin and Christ at Chilandari on Mt Athos. Perhaps the most striking and provocative stylistic comparison between the mosaic and an icon is that between the Sinai icon of Christ, attributed to the sixth century, and Christ in the Deesis mosaic. No doubt the training of the mosaicist was in icon-painting—we know of no monumental mosaics in the Byzan-tine world in the period of the Latin Occupation of Constantinople.

The modelling of the face of the Virgin in the Deesis mosaic is exceptionally delicate, and every device to make her appear 'living' is brought into play. It may be helpful to record a description made from scaffolding which shows how in this mosaic the artist was able to convey the notion of the humanity of the Virgin and the divinity of Christ through the treatment of the faces.[32]

An examination of the mosaics in the head of the Virgin must take into account the condition of the panel. Due to the losses of tesserae, parts of their painted setting-bed can be seen, and these areas supply information about the colours used in planning the design. It was the normal proced-ure throughout the Byzantine Age to paint a fully-worked design over the setting-bed just before the tesserae were set into the wet plaster. The colours to be seen here are: black, earth red, raw umber, burnt umber, grey, terraverte, and yellow ochre. Blue was apparently not used among the setting-bed colours for the Virgin; this is indicated from the setting-bed of the maphorion veil around the face which has its design painted in black, although blue tesserae were in fact set here. The very soft modelling of the flesh, which is an outstanding feature of the style of the Virgin Mary in this mosaic, is achieved by the handling of tone and hue. Although in all the three faces in the Deesis panel the tesserae are set in lines, the system of modelling contours differs in each case; but the faces of Christ and the Virgin are relatively similar, and noticeably unlike that of the St John the Baptist. In the face of the Virgin the lines of tesserae run directly across the cheeks and achieve the modelling of the curves by colour. In the face of the Baptist the lines of the tesserae follow the forms and curves. The pallor of the Virgin's face is strikingly different from that of Christ, despite the general similarity in the method of modelling of both these faces. This difference in pallor is achieved through the choice of colours for the half-shadows; whereas the choice made for Christ was a set of green glass tesserae, in the face of the Virgin a set of blue glass tesserae was used, giv-ing a warmer and softer appearance. This is just one of the devices used by the artist to convey an impression of the humanity of the Virgin in contrast to the divinity of Christ. The lightest tone of the blues used for this shading was a light blue-grey, a noticeably opaque glass.

The investigation of the colours used in the representation of the Virgin emphasizes that, as in the case of Christ, it is the great range of tones which is remarkable. There are five tones of purple glass (if one includes in this number the black glass of purple quality); five tones of blue glass (including another kind of black, this time of a blue quality); two tones of red glass; and tones of olive ranging from light olive to brown olive and green. In the stone tesserae, the same range of off-white, cream and pinks is found as in the representation of Christ. Contrary to the statement in the description by Whittemore, white highlights do appear in the face of the Virgin. The material which is used for these highlights is white limestone, which the same stone used for highlighting in the face of Christ. The limestone in the Virgin's faces has, however, deteriorated and discoloured. A similar fate has overtaken other limestone tesserae used in Hagia Sophia; in the case of the room over the southwest ramp the white limestone used for the ground of the vaults is now so discoloured that it is easy from floor level to mistake it for gold.

One notable feature of the face of the Virgin is what may be described as the 'spatial' projection of her mouth; this is a stylistic aspect of the figure which Demus had immediately noticed and correctly pointed out as a significant point of expression. No observer, even from the floor in front of the panel, can fail to note the prominence of the full lips of the Virgin; they stand out from her softly modelled cheeks and help to give her the distinctive character of her face. In technical terms the lips are in pink marble tesserae of three tones, with dark red tesserae for shadows. But the distinctiveness of her lips derives from one further technical factor. For, prominent though her lips may now appear, the surface of the tesserae happens not to be in the original condition in which it was left by the artist. This is something which only a close examination from the scaffolding can definitely reveal. From close to the mosaic, one can still see the slight traces of an earth red paint spread over the tesserae of the lips. What this means is that the mosaicist, after all the tesserae of the mosaic of the face had been set in place, must have finally stood back and assessed the overall visual effect of the rendering. He must have been dissatisfied with what he saw; and decided the remedy was to make the lips look larger and more striking. The only way to achieve this effect at this stage was to touch them up with paint on a brush. It is the remnants of this final refinement on the part of the painter, to satisfy his perfectionist eye, that have now survived, despite all the vicissitudes of the history of the surface of this mosaic.

It was, as a matter of fact, a common enough practice for mosaicists to use paints for final touching up in this way: in several other mosaics of Hagia Sophia, it has been possible in the course of the close observations made during conservation work to see examples of the use of pigments. The practice has been found not only as a way of enlarging the lips of figures, but was also used even more extensively; this was the case in the boots of the emperor in the narthex panel and in the shoes of the Virgin in the apse and in the south west vestibule. In these cases and in other monuments where the same pragmatic practice has been observed, a distinction can usefully be made between two separate procedures: on the one hand, the use of tesserae dipped in paint in order to produce colours which were in short supply or difficult to manufacture, and, on the other hand, the use of the paint brush to modify or intensify effects on the finished mosaic. Since the artist would need painting materials on his scaffold in order to carry out the setting-bed design, it is not difficult to imagine the use of the same materials in the finishing-off process. But in this case, the addition of the paint is even more striking than usual. Since Demus, an observer who had not seen the Deesis mosaic from a scaffolding, could still appreciate the strong modelling achieved in the lips when the paint had almost entirely flaked off, it is surely clear that the original artist has the definite intention of exaggerating this feature of style. This artist's need to reiterate the stylistic impact through the pragmatic addition of paint to the lips is an important indicator of a Byzantine awareness of stylistic expressive techniques.

The attention given to each and every detail of the face of the Virgin in the Deesis mosaic no doubt indicates the level of perfection expected by both craftsman and sponsor in the production

of such an image, and also in the viewing audience. The disruption of Byzantine art in the city of Constantinople during the Latin Occupation must have added to the tensions of making a mosaic at this time, and in addition to the highly 'painterly' appearance of the icon, the technical details of the tesserae are unusual. This technical information solves one question, but opens up another. An examination of the whole of the Deesis mosaics gives the following technical information:

1. There are some stone tesserae with a ceramic-like appearance; most of these tesserae are yellow in colour.

2. Some glass tesserae have a surface which looks crystalline and granular.

3. Some glass tesserae are distinctively opaque.

4. The choice of tesserae shows a preference for pastel colours throughout.

5. There is a remarkable range of tones in use.

6. The gold tesserae both in the nimbi and in the figures are distinctive. The base glass of each tessera observed was in most cases light and clear in colour. This is distinctively different from the other mosaics of Hagia Sophia, where the normal base colour is dark greenish brown. If the base glass of these tesserae is compared with the ninth- and tenth-century mosaics of Hagia Sophia, its sanding is not as heavy and pitted as in the cubes of that period. The gold leaf sandwiched in the glass, compared with other mosaics in Hagia Sophia and elsewhere, is exceptionally thin. The consequence of this is observed in many parts of the Deesis panel: the gold leaf is frequently torn. The glass wafer at the top of the tesserae over the gold leaf is also unusually thin.[33]

These are the six clearest technical details which distinguish the mosaic surface of the Deesis panel. The question that their evidence solves is one that has often been raised in the literature — whether the Deesis panel is all of one period. Clearly their congruence over the whole area of the panel constitutes the basic technical argument for the homogeneity of the work. The case is simple enough: since all three figures contain distinctive tesserae of a kind rarely, if at all, found in other mosaics, it is unlikely that they were manufactured in more than one place at one time. If one of the figures was of a different date from the others, it would be most unlikely to contain a similar range of unusual tesserae. And it should be pointed out that we have here not just one kind of special tesserae but the congruence of all sorts of distinctive features in the choice of materials — surface character, colour and the extraordinary range of tones.

The less easily resolved issue that these tesserae raise is the reason for their use. Since some of these features seem parallelled in the mosaics of San Marco at Venice, one explanation is that the mosaicist had access to Venetian glass, or at least to Venetian glass-making sources. The Byzantine parallels for the style do not support the idea that the artist was western. But for the moment we must observe that East and West come closest in Hagia Sophia in the style and technique of the Deesis mosaic, and that the striking imagery of the Mother of God here might be taken as a sign of the merging of Byzantine and Western attitudes to the Virgin in the middle years of the thirteenth century.

[1] Whittemore 1936; Nordhagen 1965, 121-166.

[2] Cameron 1981; Limberis 1994. Also Baldovin 1987.

[3] Majeska 1984, esp. 206-209.

[4] Ciggaar 1976, 211ff. quoted by Belting 1994, 527-528 (who also references the earlier more complete text published by Mercati).

[5] Galavaris 1959, 229-233.

[6] Mango 1972, esp. 87-89 for a translation and commentary. Also Macrides and Magdalino 1988, 47-82.

[7] Cameron 1976.

[8] Cormack and Hawkins 1977, 175-251, esp. 205ff.

[9] Baynes 1955, especially The Finding of the Virgin's Robe and The Supernatural Defenders of Constantinople.

[10] Meyendorff 1984.

[11] Topping 1997, esp. 277-290.

[12] Galavaris 1960-1961, 153-181, Oikonomides 1986, esp. 58-62, and Zacos and Veglery 1986.

[13] James and Webb 1991, 1-17.

[14] Schmit 1927.

[15] Mango 1958, 290.

[16] Cormack and Hawkins 1977, pp. 176-252. A dating after 854 has been indicated by dendrochronology, Ousterhout 1998, 115-130, esp. 128.

[17] For an empirical approach, which however loses sight of the religious meanings of the panels, Andreescu-Treadgold and Treadgold 1997, 708-723. For an important corrective to political interpretations of art, Walter 1982.

[18] Cormack 1997c, esp. ch. 4 for a bibliography. Also Tougher 1997, esp. 160ff. and 194 for a documentation of the facts of Leo's exclusion, after his fourth marriage, from the church of Hagia Sophia. He was prevented from the entering the 'imperial doors' on Christmas Day 906 and at Epiphany 907, but he was allowed into the *metatorion* (does this imply he might attend the service upstairs in the south gallery?). Otherwise his penance meant that he was allowed into the church,

but not into the sanctuary. Tougher does not interpret the narthex mosaic in the light of his new analysis of the events of the reign.

[19] Grabar 1984, esp. 313.

[20] *PG* 107, 21-28.

[21] The recent study, Antonopoulou 1997, esp. 166-170 makes no attempt to contextualize this homily within the artistic production of the period. She does not refer to Grabar's important discussion of this homily.

[22] *Glory of Byzantium*, no. 138.

[23] Mango 1962, 66ff.

[24] Mango 1962, 76ff.

[25] The best source for understanding the functions of the various parts of the church is the 10th-century collection of the rituals in the *Book of Ceremonies,* Cameron 1987, 106-136.

[26] For a bibliography, Cormack 2000.

[27] Whittemore 1942, 31.

[28] Striker and Kuban 1997, esp. 124-126.

[29] Grierson 1982, esp. 220.

[30] For a bibliography, Cormack 1989, Study VIII.

[31] 'Compared with this the great Italian paintings were no bigger than postage stamps' (privately reported remark made by Thomas Whittemore to Ernest Hawkins in front of the Deesis mosaic).

[32] The technical information given in this paper was obtained by an examination from scaffolding in the summer of 1975, made by the author and Ernest Hawkins.

[33] There are also two features in the setting of the gold tesserae (either technical or artistic): one of these is that several of the gold tesserae are set reversed, with the gold sandwich set into the plaster, and the rear surface showing. The second feature is that a few silver tesserae are mixed in with the gold. This happens in the section of gold ground near the right shoulder of Christ, no doubt for some particular visual effect.

123

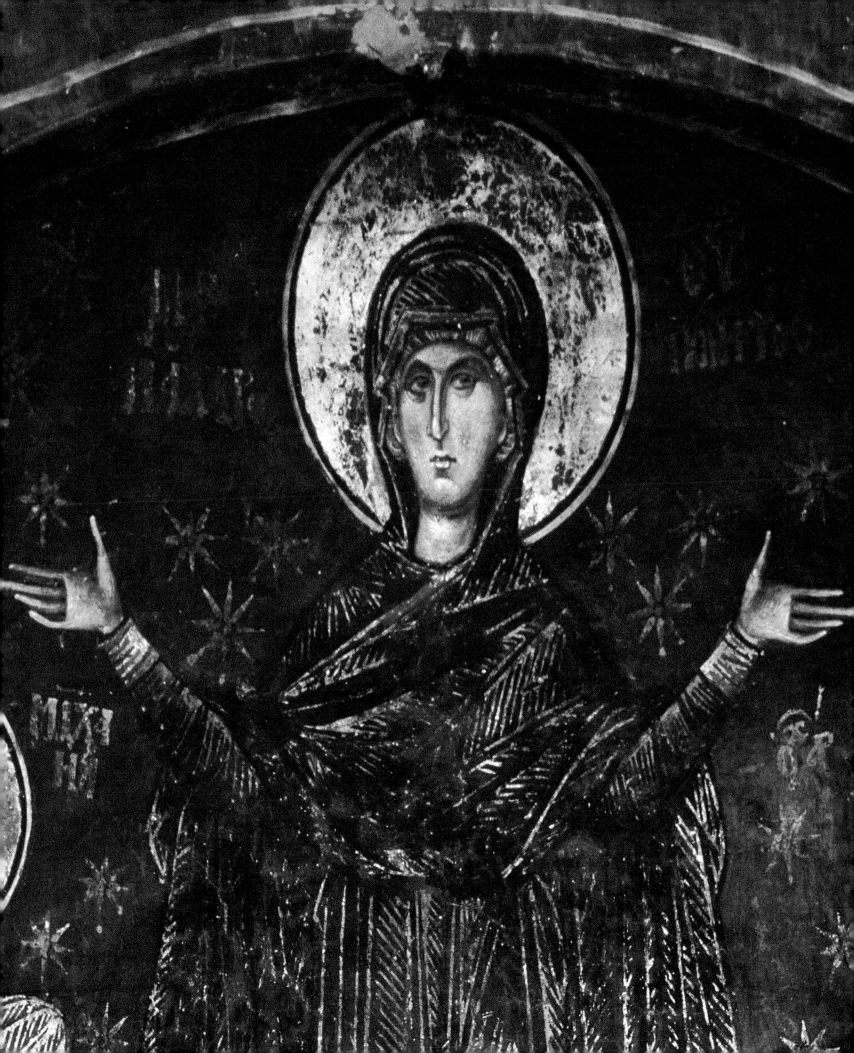

Euthymios Tsigaridas

The Mother of God in Wall-Paintings

The Virgin as Mother of God occupies a special position in the iconographic programme of churches. The extent and variety of iconographic cycles in which she was included, and of iconographic types in which she was depicted, was dictated both by Church doctrine, following the recognition of her as the Theotokos (the Mother of God) at the Council of Ephesus in 431, and by the exalted position she came to occupy in the consciousness of the Church after the Restoration of Icons in 843. Literary sources that determined the place of the Virgin in the iconographic programme of a church include the Old and New Testaments, canonical and apocryphal ecclesiastical writings, the Church hymns and the divine liturgy.

Individual representations of the Virgin in the iconographic programme of churches

The extent to which the Virgin as Mother of God was honoured, as well as the qualities she possessed, which are known from the appellations that accompany her, are expressed in individual depictions of her holding the Christ-Child, in various parts of the church and in a range of iconographic types. Appellations of the Virgin may derive from Church hymns, or relate to her fundamental role in Church doctrine as Theotokos, or be connected with her qualities, as well as with her sacred shrines and the miracles accomplished by her.

In monumental painting, for example, the Virgin is accompanied by appellations such as Mother of God, *Platytera ton Ouranon* (Wider than the Heavens), *Amolyntos* (Immaculate), *Gorgoepekoos* (Swift to Hear, in the church of the Virgin at Ljeviška), *Chora tou Achoretou* (Dwelling-place of the Uncontainable, in the Chora monastery at Constantinople), *Elpis ton Apelpismenon* (Hope of the Hopeless), *Paraklesis* (Intercessor, in Sts Anargyroi at Kastoria, St Nicholas Orphanos in Thessaloniki and elsewhere), *Episkepsis* (Shelter), *Zoodochos Pege* (Life-bearing Source), *Timiotate ton Cherubim* (Most Honoured of the Cherubim, in St Nicholas Tzotza at Kastoria), *Panton Chara* (Joy of All), *Pantanassa* (Queen of All, in the church of the Virgin at Ljeviška, St Alypios at Kastoria), *Kyria ton Angelon* (Mistress of the Angels), Blachernitissa (Chora monastery), Arakiotissa (Virgin of Arakos at Lagoudera on Cyprus), etc.

The Virgin and Child was introduced into the sanctuary apse during the Early Christian period and became established in the Middle Byzantine period in a variety of iconographic types, as an expression of Church doctrine. The decisions taken by the Council of Ephesus, and the Church hymns and homilies of the Church Fathers relating to the Theotokos, which enjoyed a great flowering from the fifth century onwards, formed the starting point for the depiction of the Virgin as the Mother of God, the visual symbol of the Divine Incarnation. The representation of the Virgin as Theotokos in the sanctuary apse, a location that, in the iconographic programme of the church, links the heavenly with the earthly, became 'the bridge leading from earth to heaven, the heavenly ladder descended by God'. From the literary sources, the Virgin and Child is known to have been painted in the sanctuary apse of the katholikon of the Blachernai monastery in Constantinople (473), which became a model for subsequent depictions.

The earliest surviving examples of the depiction of the Virgin and Child in the sanctuary apse in the Eastern Church are that in the church of the Virgin Kanakaria on Cyprus (first half of 6th

71. *Sanctuary apse.*
Church of St Nicholas
Orphanos, Thessaloniki, detail
of Pl. 75.

century), of the Angeloktisti at Kition, also on Cyprus (early 7th century), and the Virgin in the type of the Nikopoios at Drosiani on Naxos (first half of 7th century). In the Kanakaria mosaic the Virgin is depicted holding the Christ-Child and enthroned in a mandorla — an element not commonly found in her iconography — the purpose of which was to give prominence to her role in the Divine Incarnation and her capacity as Mother of God. From the Eastern Church the motif was introduced into the West during the Early Christian period, the earliest surviving examples being those in the basilica Euphrasiana at Parenzo (540-550), the catacomb of Comodilla (528), and Santa Maria Antiqua (6th century) in Rome.

In Early Christian Egypt the Virgin orans, or enthroned holding the Christ-Child — sometimes in the type of the Galaktotrophousa — and accompanied by apostles, angels, or local saints is depicted in the lower zone of the apse and associated with a representation of Christ in Glory in the upper zone. Two-zone scenes like these are preserved in the chapels of two monasteries — that of St Apollo at Bawit in Upper Egypt and that of St Jeremiah in Lower Egypt. In these representations, the depiction of the Virgin and Child was designed to give prominence to his divine rather than human nature, and at the same time to stress the Virgin's witness to God's presence on earth, the purpose of which was the salvation of the human race.

After the end of Iconoclasm, the Virgin and Child in various iconographic types — or more rarely, the Virgin alone — became the predominant motif in the sanctuary conch, where it served as a visual representation

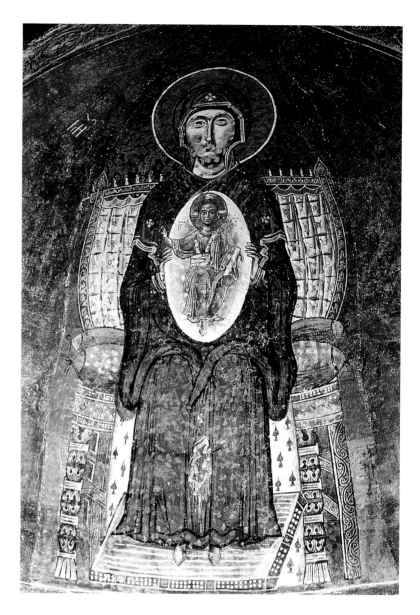

72. *The Enthroned Virgin and Child.*
Church of St Sophia, Ochrid.

of her role in the Divine Incarnation. From the second half of the ninth century onwards, the Virgin, either full-length or enthroned, and holding the Christ-Child, replaces the iconoclastic cross in the churches of Hagia Sophia at Constantinople (Pl. 62), the Koimesis at Nicaea (Pl. 50), and St Sophia at Thessaloniki (Pl. 53). After this, she became a basic element in the iconographic programme of churches, occupying a fixed position and with a variety of iconographic types and particularly appellations, which identified the quality associated with her.

During the Middle Byzantine period, the Virgin was normally depicted on the semidome of the sanctuary apse, either enthroned or full-length and holding Christ in her arms, or full-length but without Christ and orans; she is normally accompanied by the appellation МΗΤΗΡ ΘΕΟΥ (Mother of God). From the twelfth century on she is usually attended by the Archangels Gabriel and Michael. In small aisleless churches the Virgin is depicted in bust on the semidome of the apse.

The enthroned Virgin and Child is depicted in St Sophia at Ochrid (mid-11th century) (Pl. 72), at Bačkovo in Bulgaria (mid-12th century), in Sts Anargyroi at Kastoria (about 1180), in St George at Kurbinovo on Lake Prespa (1191), in the Virgin of Arakos on Cyprus (1192) (Pl. 73), in the chapel of the Virgin on Patmos (about 1180), in Ai-Stratigos at Boularioi in Mani (late 12th century), in the chapel of St Euthymios in the church of St Demetrios at Thessaloniki, at Studenica (1315) in Medieval Serbia, in St George of the Mount at Kastoria (about 1385).

The type of the full-length Virgin orans, already known from the art of the catacombs in Rome

126

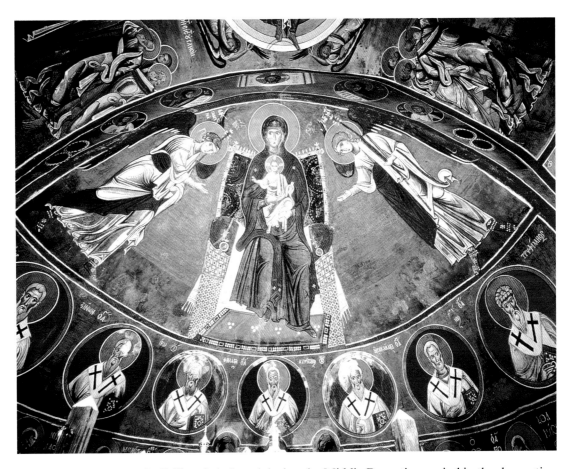

(St Priscilla, St Agnes, St Callistus), is found during the Middle Byzantine period in the decoration of the apse of the Panagia Chalkeon at Thessaloniki (1028), St Nicholas at Manastir (1271) in greater Macedonia, the Peribleptos (Pl. 74) at Ochrid (1295), the church of Christ (1315) and St Vlasios at Veroia (1315-1320), St Nicholas Orphanos (Pl. 75) at Thessaloniki (1315-1320), at Gračanica (1318-1321) in Medieval Serbia, in St Nicholas Kyritzis at Kastoria (about 1385). In the last two of these churches, the Virgin is accompanied by the appellation ΜΗΤΗΡ ΘΕΟΥ Η ΑΧΕΙΡΟ-ΠΟΙΗΤΟΣ. This alludes to an icon made without the intervention of a painter and is associated with the devotional icon of the monastery of the Virgin Acheiropoietos in Thessaloniki.

The Virgin is also depicted orans, full-length or in bust, with Christ Emmanuel in a medallion in front of her chest. This representation, which shows the Virgin pregnant, is a visual expression of the doctrine of the Divine Incarnation, depicting the 'dwelling place of the uncontainable', which appellation accompanies a depiction of the Virgin with Christ in front of her breast, in the Chora monastery (Pl. 59) at Constantinople (1318-1321). The iconographic type of the Virgin, which bears the appellation Blachernitissa and is associated with the church of the Virgin at Blachernai in Constantinople, where the Theotokos was particularly honoured, was introduced into the iconographic programme of churches in the ninth-tenth century. Typical examples of this type are preserved in churches on Cyprus dating from the twelfth century, such as the church of the Virgin at Trikomos, the Holy Apostles at Perachorio, and Christ Antiphonitis at Kalogrea, and also at Studenica (1208-1209), in the church of the Virgin Ljeviška (1307-1310) in Medieval Serbia, in Zaum at Ochrid (1361), and elsewhere.

The Virgin, with or without Christ, is depicted not only in the sanctuary apse but also in other positions in the iconographic programme of the church. In these cases she is either treated as an individual motif, or forms part of a Deesis or the Last Judgement. The Virgin was depicted on the front of the left pillar of the sanctuary from the tenth century on, in the iconographic type of the frontal, enthroned or full-length Brephokratousa, normally in the type of the Hodegetria, serving as an icon of veneration. She is depicted in this position in the monastery of Hosios Loukas (10th

127

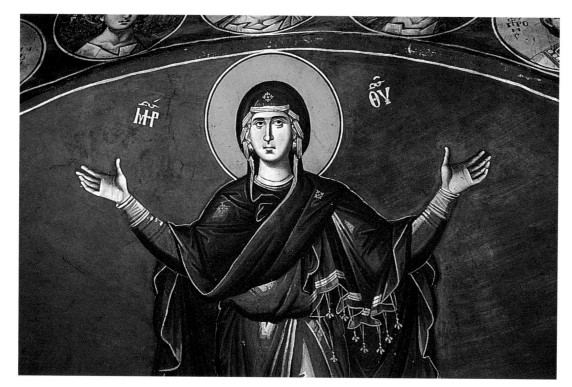

century), at Qeledjilar in Cappadocia, in St Sophia at Ochrid (mid-11th century), in the church of the Virgin at Samari in Messenia (late 12th century), in the Old Cathedral at Veroia (about 1295), etc. In Hosios David at Thessaloniki, she is rendered in the type of the Virgin of the Passion, which is uncommon in monumental painting. The Virgin is also found as an icon/wall-painting in the position of a despotic icon on built iconostases, in the Evangelistria at Yeraki (late 12th century), in the type of the Hodegetria, or in the type of the Virgin Eleousa in St George at Yeraki (12th-13th century) and at Staro Nagoričino in Medieval Serbia (1316-1318), etc.

From the twelfth century on the Theotokos is found as an individual representation in the iconographic type of the Virgin Paraklesis, normally in association with Christ. Here she is rendered three-quarters, holding an inscribed scroll or with her arms extended in an attitude of supplication, as intercessor between Christ and men, for whose salvation she is praying. In this iconographic type, the Virgin is sometimes depicted on the east face of the pillars of the iconostasis, as an icon of veneration (church of the Saviour at Pskov in Russia, 1156; Virgin of Arakos at Lagoudera on Cyprus, 1192; St Nicholas Orphanos (Pl. 76) at Thessaloniki, 1315-1320; Virgin Olympiotissa at Elasson, etc.), and sometimes near the iconostasis (Sts Anargyroi at Kastoria, about 1180; St George at Kurbinovo, 1192, etc.). She is also depicted in the narthex, normally either side of the 'beautiful doors' (Dečani-Lesnovo) or on the west face of the pillars separating the nave and the narthex (Staro Nagoričino).

The Virgin is also depicted as part of the Deesis, in which case she prays for the salvation of the human race. In this motif, which was inspired by the divine liturgy, specifically by the prothesis prayer or *proskomide* (offertory), Christ occupies the centre and is normally shown enthroned and flanked by the Virgin and St John the Baptist in attitudes of supplication. This motif, the earliest example of which goes back to the seventh-eighth century (Santa Maria Antiqua at Rome, Virgin Drosiani on Naxos), is sometimes painted in the sanctuary apse (see churches of Georgia, Cappadocia and elsewhere), sometimes on the tympanum of the east wall of the nave (St Nicholas Kasnitzis at Kastoria) or the east wall of the narthex, as part of the Last Judgement (Virgin Mavriotissa at Kastoria). More rarely, it serves as a summary representation of the Last Judgement and occupies the entire east wall of the narthex (katholikon of the Pantokrator monastery on Mt Athos) or is placed on the blind arch above the royal doors (katholikon of the Vatopedi monastery). The same motif is depicted very frequently during the fourteenth and fifteenth centuries on the north wall of aisleless churches at Kas-

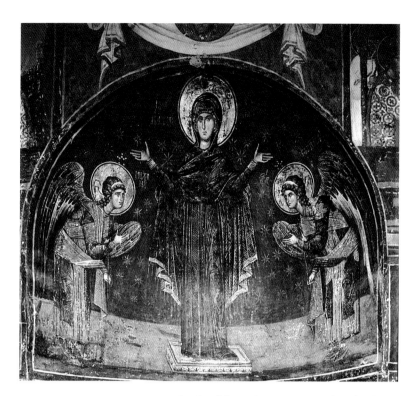

75. Sanctuary apse.
Church of St Nicholas
Orphanos, Thessaloniki.

toria, Ochrid, and in greater Macedonia. In certain cases, such as that of St Athanasios Mouzaki (1384-1385), St Nicholas of the nun Eupraxia at Kastoria (1485-1486), etc., the Virgin is rendered as a queen. The depiction of the Virgin as queen, the earliest surviving examples of which goes back to the seventh-eighth century (Santa Maria Antiqua and basilica of St Clement in Rome), has its origins in Psalm 44:10-12.

The Virgin and Child is also painted in other parts of the church, in a variety of iconographic types independent of the appellation accompanying her. When the church honours the memory of the Virgin, for example, she is depicted on the south wall of the nave in a prominent position next to the iconostasis (Virgin of Arakos at Lagoudera on Cyprus), sometimes in a niche (St Alypios at Kastoria), and sometimes in a tympanum above the entrance to the church (Virgin Mavriotissa at Kastoria). At Lagoudera (1192), the iconographic type in which she is rendered is an early version of the Virgin of the Passion, which became particularly widespread in the fifteenth century. In St Alypios at Kastoria she is depicted in the type of the Virgin Eleousa and is accompanied by the appellation ΜΗΤΗΡ ΘΕΟΥ Η ΕΛΕΟΥΣΑ (Mother of God, the Merciful), which refers to the devotional icon of the monastery of the Virgin Eleousa, founded in Constantinople by John Komnenos. In the type of the Virgin Eleousa, she is also placed above the entrance to the nave, as in the church of the Virgin Eleousa at Prespa (1408-1409) and the church of the Virgin Rasiotissa (1411), while the type of the Virgin Hodegetria is adopted in the church of the Virgin Mavriotissa.

The Virgin, occupying various parts of the church, is sometimes rendered in the type of the Virgin of the Passion, as at Konče in Medieval Serbia and the Virgin Koumbelidiki at Kastoria, or in the type of the Virgin Hodegetria, as in the Holy Apostles at Thessaloniki, the church of the Virgin at Studenica. The 'austere' iconographic type of the Virgin Hodegetria, which was popular in Byzantine art, took as its model the palladium of Constantinople, the portable icon called the Hodegetria kept in the Hodegon monastery. In the iconographic type of the Virgin Zoodochos Pege (Lifebearing Source), which is associated with her veneration at the miraculous spring of this name in Constantinople, now known as Balukli, she is found from the fourteenth century on in the iconographic programme of churches such as the Aphendiko and Sts Theodore at Mystras, at Lesnovo, in the chapel of St George in the monastery of St Paul on Mt Athos.

The Virgin also occurs in dedicatory scenes, in which the founder offers her a model of the church. No particular iconographic type is adopted in these cases. She is sometimes rendered standing and holding the Christ-Child, as in the Sts Anargyroi at Kastoria, and sometimes as the Virgin Eleousa (church of Joachim and Anne at Studenica).

The iconographic cycle of the life of the Virgin

The iconographic cycle of the life of the Virgin is essentially inspired by the apocryphal *Protevangelium of James*, with influences from Church hymns and the homilies of the Church Fathers. The aim of the anonymous composers of the apocryphal gospel was to rectify the silence of the canonical gospels about the life of the Virgin and her parents, and to show that she really was a virgin by including realistic detail. The text dates from the second half of the second century and influenced the liturgical life of the Church and the iconographic programme of churches. The festivals celebrating the Theotokos, such as the Conception of the Virgin (9 December), the Birth of the Vir-

129

gin (8 December), the Presentation of the Virgin in the Temple (21 November), the Synaxis of the Virgin (26 December), take the *Protevangelium of James* as their starting point.

We should also note that after the Council of Ephesus, at which the Virgin was recognized as the Mother of God, a cycle devoted to her life began gradually to take shape. Archaeological evidence, such as the motifs drawn from the life of the Virgin on column A of the ciborium in San Marco at Venice, suggests that this cycle was fully formed by the sixth century(?). Account should be taken, however, of the fact that, during the Iconoclastic Controversy, the cycles relating to the life of the Virgin that had existed in churches prior to it were destroyed.

The scenes which compose the iconographic cycle of the life of the Virgin vary from monument to monument. A complete cycle, however, like the one preserved in the Virgin Peribleptos at Mystras (1360-1370), normally includes the following scenes: the Offerings of Joachim and Anne, the Annunciation to Joachim, the Prayer of St Anne, the Parents of the Virgin at Home, the Meeting of Joachim and Anne, the Birth of the Virgin, St Anne Feeding the Virgin, St Anne Holding the Virgin Child, the Virgin Caressed by her Parents, the First Seven Steps of the Virgin, the Virgin Blessed by the Priests, the Presentation of the Virgin in the Temple, the Virgin Receiving the Skein of Purple, the Blossoming Rod of Joseph, the Virgin Entrusted to Joseph, the Annunciation at the Well, the Annunciation to the Virgin, the Visitation, Joseph's Dream, the 'Bitter Water that Brings a Curse', the Virgin's Journey to Bethlehem, the Enrolment for Taxation, the Prayer and Farewell of the Virgin, and finally the Dormition of the Virgin.

The earliest preserved cycle of the life of the Virgin in monumental painting is that at Kizil Çukur in Cappadocia. Its iconography probably goes back to pre-Iconoclastic models, according to Lafontaine-Dosogne. In the eleventh-twelfth century, the cycle of the life of the Virgin became an established feature of church decoration and is found at Daphni in Attica, Ateni and Akhtala in Georgia, St Sophia at Kiev, the church of the Saviour at Pskov in Russia, etc. The subjects drawn from the life of the Virgin are naturally not the same in all these monuments, and not all the scenes originally painted are preserved.

During the Palaiologan period, the cycle of the life of the Virgin underwent considerable development in the iconographic programme of churches and came to be rendered with a large number of scenes, mostly, indeed, narrative in character, as in the Peribleptos at Ochrid (1295). During this period the cycle was usually painted in the nave (Metropolis at Mystras, Peribleptos at Ochrid, katholikon of the Vatopedi monastery, Sušica and Studenica (Pl. 77) in Medieval Serbia, katholikon of the Chilandari monastery, Peribleptos at Mystras), in the gallery surrounding the nave (Holy Apostles at Thessaloniki) and in the narthex (Gradać in Medieval Serbia, Chora Monastery in Con-

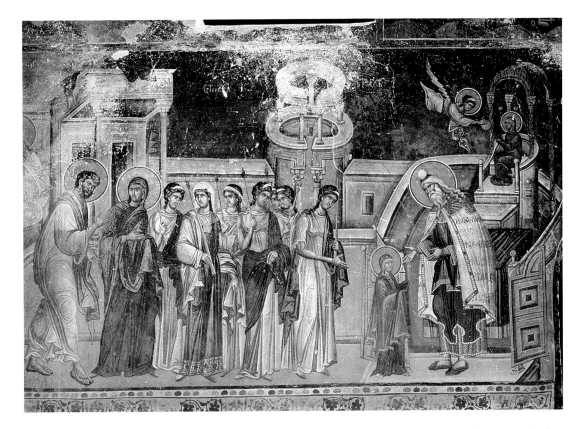

stantinople). In some cases, too, the cycle is presented on the sanctuary walls, in direct association with the prefigurations of the Virgin depicted there (Staro Nagoričino, Dečani, Matejić in Medieval Serbia).

The most fully developed cycles in churches of the first Palaiologan period are preserved in the Virgin Peribleptos at Ochrid (12 scenes), the Holy Apostles at Thessaloniki (15), the katholikon of the Chora monastery, Staro Nagoričino (11), the katholikon of the Chilandari monastery (10) and at Gračanica. The most extensive cycles of this period are preserved at Dečani, and, above all, in the Peribleptos at Mystras (1362-1370), in which 25 scenes are depicted, undoubtedly inspired by an illuminated manuscript of the *Protevangelium of James*. During the Post-Byzantine period, the iconographic cycle devoted to the life of the Virgin is found at Pelendri on Cyprus (15th century), in the refectory of the Great Lavra on Mt Athos (1535-1542), in the Diliou monastery (1543) and elsewhere.

During the Palaiologan period, the cycle of the life of the Virgin was broadened, with the inclusion of scenes referring to her earthly end, her Dormition (Pl. 78) and Assumption. The source of inspiration here was a vast number of manuscripts in various ancient Eastern languages, the starting point for which was presumably a Greek manuscript of the fifth-sixth century. This manuscript tradition influenced many of the homilies of the Church Fathers (see On the Dormition of the Holy Mother of God, by Pseudo-John the Theologian), which in their turn influenced the iconography of the Virgin.

This cycle of the Virgin includes the following scenes: the Annunciation of the Death of the Virgin, the Prayer of the Virgin, the Virgin Bids Farewell to the Apostles, the Virgin Announces her Death to her Friends, the Virgin Distributes her Clothes to Two Widows, the Dormition of the Virgin — which is also one of the Dodekaorton scenes — and the Funeral Procession, Entombment and Assumption of the Virgin. Scenes from this cycle are found in late thirteenth-century monumental painting in the Peribleptos at Ochrid, the funeral chapel of the Pammakaristos at Constantinople, at Staro Nagoričino, Gračanica, Dečani, Matejić and Markov manastir in Medieval Serbia, the Aphendiko at Mystras, St Nicholas at Curtea de Arges in Romania, the katholikon of Diliou monastery on the island at Ioannina.

131

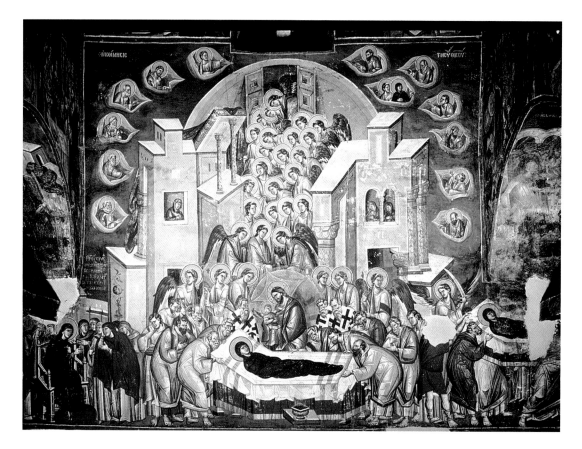

The Virgin in the cycles of the Dodekaorton, the Passion of Christ, and the Resurrection

In scenes from the Dodekaorton inspired by the canonical gospels and ecclesiastical literature, the Virgin is invariably depicted in association with the main figure, Jesus Christ, as the instrument of the Mystery of the Incarnation — that is, as Theotokos — and also as witness to Christ's death on the cross and his Resurrection. Thus, on the basis of the canonical gospels, the Virgin is depicted in scenes of the Annunciation, the Nativity (Pl. 79), the Adoration of the Magi — when this appears as an independent scene — the Presentation in the Temple, the Wedding at Cana, and the Crucifixion.

Before they became an established part of the iconographic programme of the Dodekaorton, during the time of the Macedonian dynasty, some of these subjects were familiar in the art of the Early Christian period. The Annunciation, for example, was depicted in the mosaics of Santa Maria Maggiore in Rome, a church dedicated to the Virgin; the aim was to emphasize the role of the Virgin as Mother of God, in accordance with the decree issued by the Council of Ephesus. The Adoration of the Magi as an independent subject within the Nativity is already found in the paintings of catacombs (2nd-4th centuries), such as the catacombs of St Priscilla, Sts Peter and Marcellinus, St Domitilla in Rome, etc. The Wedding at Cana, too, in which the Virgin appears, is found in the cemetery of Sts Peter and Marcellinus in Rome, and also in the mosaics of the baptistery of Naples cathedral. The Nativity, the Presentation in the Temple, and the Crucifixion, in which the Virgin forms part of the iconography, are also depicted in the Early Christian period in Santa Maria at Castelseprio and Santa Maria Antiqua at Rome, and became an established part of the Dodekaorton from the period of the Macedonian dynasty.

In the other subjects of the Dodekaorton cycle, such as the Descent from the Cross, the Lamentation, the Holy Women at the Tomb, the *Noli me Tangere*, and the Ascension, the presence of the Virgin stems from the apocryphal texts, homilies of the Church Fathers, the *akolouthia* for Holy Week, the religious play *Christos Paschon* (Christ in his Suffering), Church hymns, etc.

The Christological conflicts of the fourth and fifth centuries, and the proclamation of the Virgin as Mother of God at the Council of Ephesus led to an increase in her worship and by extension an emphasis on her presence in scenes of the earthly life of Christ, and even in scenes of the

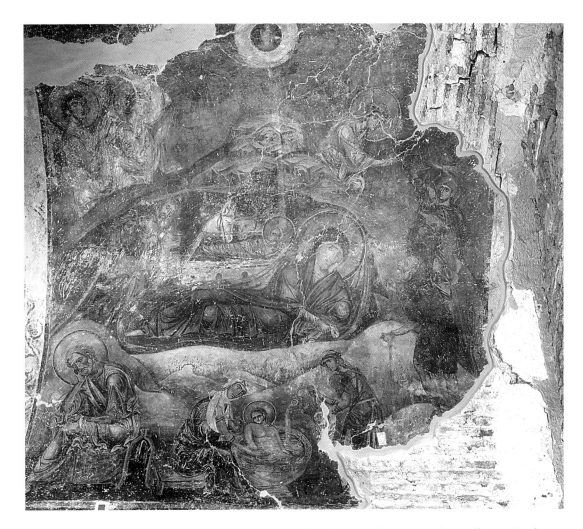

Resurrection, her presence at which is not attested in the New Testament. According to Professor Kalokyris, this is due to the fact that there has never been an official teaching of the Orthodox Church on this matter, but only theological opinions. The theologians and hymnographers were undoubtedly influenced by a general sentiment abroad in the Christian world, that it was inconceivable that the Mother would not have been first amongst the Holy Women at the tomb, or that the Son would not have responded to his mother's love.

In this theological climate, the Virgin came in the sixth century to be included amongst the Holy Women at the Tomb, which constitutes the narrative scheme for the Resurrection of Christ, as opposed to the doctrinal scheme of the Anastasis or Descent into Hell. During the Middle Byzantine period, the presence of the Virgin in the Descent from the Cross and the Lamentation became a predominant feature of the iconography of these scenes. Representative examples are to be found at Nea Moni on Chios, Hosios Loukas in Phokis, St Panteleimon at Nerezi near Skopje. Within the same type was established the iconographic scheme of the *Noli me Tangere*, with the two Marys depicted kneeling either side of the risen Christ. Some Palaiologan artists, influenced by ecclesiastical literature (by Romanos the Melodos, George of Nikomedia, Theophanes Karameus, and Gregory Palamas), depicted the Theotokos as one of the two Marys. Indeed, to avoid confusion between the two figures, the Virgin has a halo and is sometimes accompanied by the letters MP (Μήτηρ) ΘΥ (Θεοῦ).

Similarly, the presence of the Theotokos at the Ascension of Christ is not attested in the Gospels or the Acts of the Apostles, and is not found in any of the apocryphal or patristic texts relating to the Ascension. Nevertheless, under the influence of the Christological conflicts of the fourth and fifth centuries, and the Church hymns, the Virgin occupies a dominant position in the iconography of the Ascension from the sixth century on (chapel at Bawit in Egypt, Drosiani on Naxos), which became an estab-

133

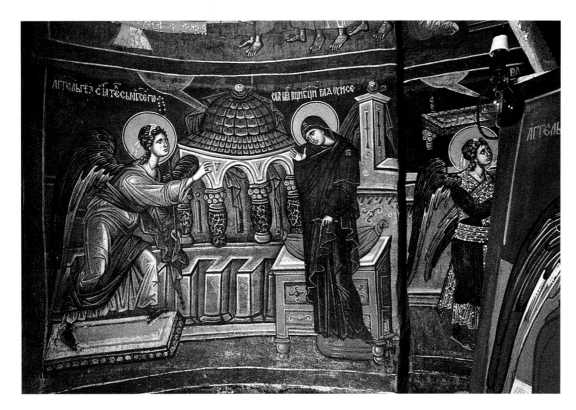

80. *The Annunciation from the Akathistos Hymn.* The Peribleptos, Ochrid.

lished part of monumental painting from the ninth century (St Sophia and Rotunda of St George at Thessaloniki, El Nazar, Göreme and Çavusin in Cappadocia, Virgin Chalkeon at Thessaloniki).

Prefigurations of the Virgin

Prefigurations of the Virgin, inspired by the Old Testament, ecclesiastical literature, and hymnology (Romanos the Melodos, John of Damascus, Andrew of Crete, etc.), were painted in the area of the sanctuary and also in the nave. In these scenes, which honour the virginity of the Mother of God and prefigure the Immaculate Conception of Christ, the Virgin is represented by a variety of symbols, such as the Burning Bush, the Tabernacle of Witness, Jacob's Ladder, the Seven-Branched Candlestick, the Closed Gate, the Pitcher of Manna, the Ark of the Covenant, Gideon's Fleece, Mount Zion, the Blossoming Rod of Aaron, etc. Mention should also be made of the Three Boys in the Fiery Furnace and Daniel in the Lion's Den, which also refer to the virginity of the Theotokos. Some of these subjects also occur in Early Christian art (katholikon of the monastery of St Catherine on Sinai, San Vitale at Ravenna, etc.). There, however, they are narrative in character, in as much as they refer to things or events in the Old Testament.

The symbolism of these subjects and their connection to the Virgin made their appearance in art during the Palaiologan period, a period in which Church hymns and ecclesiastical literature played a dominant role in shaping the iconographic programme in churches. More specifically, subjects prefiguring the Virgin are to be found in the decoration of the church of the Protaton (about 1290), the Peribleptos at Ochrid (1295), the Virgin at Ljeviška (1307-1313), the katholikon of the Vatopedi monastery (1312), St Nicholas Orphanos at Thessaloniki (1315-1320), the Chora monastery (1315-1320), Gračanica (1318-1321), the Holy Apostles at Thessaloniki, Dečani (mid-14th century), Lesnovo (1346/1347), the katholikon of the Lavra monastery (1535), the chapel of the Virgin in the Dionysiou monastery (1615).

The Virgin in scenes inspired by hymnography

During the Palaiologan period, subjects inspired by the hymns of the Church, such as the Akathistos Hymn, the 'Prophets from Above', the 'In Thee Rejoiceth', the 'What Are We to Bring Thee, Christ?', etc., were introduced into church painting.

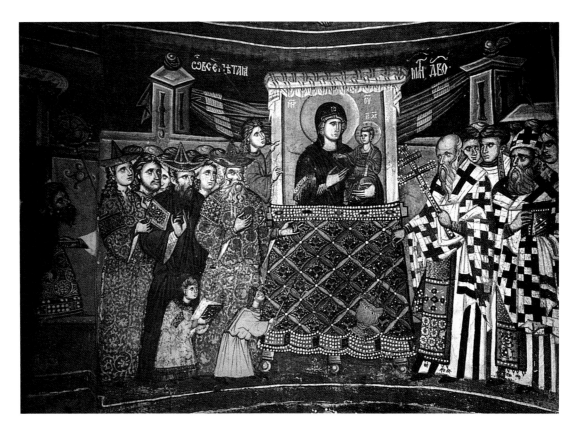

The cycle of the Akathistos Hymn

The Akathistos Hymn is a *kontakion* of anonymous authorship sung in honour of the Mother of God during Lent. According to tradition, the hymn was sung for the first time in 626 in honour of the Virgin, the patron saint of Constantinople, in order to avert the capture of the city by the Avars. The date of composition and the identity of the author of the Akathistos Hymn are still unresolved. Romanos the Melodos and Cosmas the Poet have been proposed as authors, and the date of composition is placed between 431 (Council of Ephesus) and 626. The Akathistos Hymn is divided into two parts on the basis of its content. The first part (stanzas 1-12) refers to events relating to the childhood of Christ. The second part (stanzas 13-24) is doctrinal in character, and refers to the Incarnation and dual nature of Christ, at the same time lauding Christ and the Virgin.

In the iconography of the first part of the Akathistos Hymn, which has, as we have seen, a narrative character, the models used were mainly scenes of similar content inspired by the canonical gospels, and to a lesser extent by the apocryphal gospels. For the second part of the hymn, which is of a doctrinal character, the lack of models obliged artists to resort to iconographic devices that vary from monument to monument, in which they revealed their compositional skills.

The cycle of the Akathistos Hymn, which was obviously originally composed in Constantinople, was introduced into church decoration in the late thirteenth century and became firmly established in the fourteenth. The earliest known example in monumental painting is preserved in the katholikon of the Olympiotissa monastery at Elasson (1296?), and it is found a few years later in St Nicholas Orphanos (1315-1320) and the Panagia Chalkeon at Thessaloniki. Under the influence of monastic, anti-Unionist circles and Hesychasm, the iconography of the Akathistos Hymn became widespread over a large area having Thessaloniki as its centre, becoming particularly so in Medieval Serbia and establishing itself in the Orthodox world of the Balkan peninsula as one of the most popular subsidiary cycles in church painting. The cycle of the Akathistos Hymn is preserved in monumental painting from the middle of the fourteenth century on at Dečani, the Matejić monastery (1355-1364), the church of St Peter on the island of Veliki Grad, Prespa (about 1360), in the chapel of St Gregory the Theologian (1364-1365), in the church of the Virgin Peribleptos at Ochrid (Pl. 80), at Markov manastir (1367-1377 or 1380-1381) (Pl. 81), in Cozia in Wallachia (1381-1382), St

Phanourios at Valsamonero on Crete (early 15th century), the church of the Virgin at Meronas Rethymnon, (mid-14th century), the church of St John the Baptist of Concord at Kastoria (14th-15th century), etc. In some churches, such as St George the Less at Veroia (late 14th-early 15th century), the cycle of the Akathistos Hymn replaces the cycle of the Dodekaorton in the iconographic programme of the aisleless church.

In the Post-Byzantine period, the cycle of the Akathistos Hymn became very popular and is commonly found in monastery katholika or refectories. Examples includes the katholikon of the Therapontos monastery in Russia (about 1500), the refectory of the Lavra monastery (1535-1541), the Stavronikita monastery (about 1546) and the Chilandari monastery (1622), the katholikon of the Philanthropinon monastery, the old katholikon of the St Stephen monastery at Meteora (16th-17th century), the katholikon of the Docheiariou monastery (1568), the katholikon of the Dousiko monastery in Thessaly (1557), the chapel of the Molyvokklisia on Mt Athos (1537), the katholikon of the Perivolis monastery (after 1550) and the church of the Transfiguration at Papiani, Kalloni on Lesbos (about 1600), at Suçevita in Romania (about 1600), the chapel of the Three Hierarchs in the Barlaam monastery at Meteora (1637), the katholikon of the Pantanassa monastery at Mystras (17th-18th century).

'What Are We to Bring Thee, Christ?'
This subject, and the iconographic elements of which it is comprised, is inspired by the *sticheron idiomelon* of Christmas vespers. The central and dominant position is occupied by the Virgin enthroned, holding the Christ-Child and accompanied by detailed elements of the iconographic composition, such as the angels, the star, the Magi, the shepherds, the cave, the manger and the race of men. The subject, which is also found in portable icons, occurs in monumental painting of the late thirteenth century in the Virgin Peribleptos at Ochrid, the katholikon of the Blachernai monastery at Arta, the Aphendiko at Mystras, the Holy Apostles at Thessaloniki, at Ziča, Matejić and Ravanica in Medieval Serbia. In Post-Byzantine painting, the Christmas *sticheron* is found mainly in monastery katholika rather than in portable icons, examples being the katholikon of the Docheiariou monastery (1568), the narthex of the katholikon of the Barlaam monastery (1566), the katholikon of the Prodromos monastery at Serres (1630).

'The Prophets from Above'
In the 'Prophets from Above', the Virgin is depicted at the centre of the composition, enthroned or in bust, holding the Christ-Child. She is surrounded by the prophets Jacob, Moses, Aaron, Gideon, David, Solomon, Jeremiah, Ezekiel, Daniel, Habakkuk and Zachariah. In one hand the prophets hold an inscribed scroll and in the other symbols that prefigure the virginity of the Theotokos and the Mystery of the Incarnation. Jacob, for example, holds the ladder, Moses the burning bush, Aaron the rod, Gideon the fleece, David the ark, Solomon the bed, Isaiah the tongs with the live coal, Ezekiel the closed gate, Daniel and Habakkuk the mountain, and Zachariah and Jeremiah point to the seven-branched candlestick and the Virgin respectively.

This iconographic scheme, which contains the prefigurations of the prophets relating to the virginity of the Theotokos, derives from the *troparion* 'The prophets from above worship thee...', which was set to music in the eleventh-twelfth century and was probably introduced into the iconographic programme of churches during the same period, under the influence of the theological debates surrounding the doctrine of the Incarnation.

The subject is known in portable icons from Sinai from the twelfth century. In monumental painting it was placed in the sanctuary and above all in the narthex of the church. It is found in the fourteenth century in the Virgin at Ljeviška and Peć in Medieval Serbia, in St George Platanitis (1401) in the village of Viannos in the prefecture of Herakleion, Crete, in the church of the Virgin at the Podithou monastery on Cyprus (1502), at Humor (1539) and Vatra Moldovitei (1536) in Romania, in the katholikon of the Philanthropinon monastery (1560) and the katholikon of the Diliou

monastery on the island at Ioannina, the katholikon of the Transfiguration monastery at Dryovouno in Macedonia (1562), the katholikon of the Mardaki monastery in Messenia.

'In Thee Rejoiceth'

The iconographic theme 'In Thee Rejoiceth' draws its inspiration from the hymn composed by John of Damascus: 'In Thee rejoiceth, gracious Virgin, all Creation, the hierarchy of angels, and the race of men'. This hymn, which glorifies the Virgin, through whom the salvation of man is achieved, is sung as a *megalynarion* during the divine liturgy of Basil the Great. The centre of the composition is occupied by the Virgin and Child, around whom, disposed in circles, is set 'all Creation' – that is, the 'hierarchy of angels and the race of men'. In addition to the angels, there are depictions of hierarchs, martyrs, holy monks, female saints, etc.

This theme, which is very widely found in portable icons of the fourteenth-fifteenth century in Russia, is depicted even more frequently in Post-Byzantine icons. It occurs in fourteenth-fifteenth century monumental painting, normally in the narthex and more rarely in the sanctuary or the nave. One of the earliest examples is preserved in the narthex of the Virgin Rasiotissa at Kastoria (1411), and the chapel of the Molyvokklisia on Mt Athos (1536). From the seventeenth century on, representations of this theme multiply, and are found in the katholikon of the Transfiguration monastery at Dryovouno in Macedonia (1562), the katholikon of the Voulkano monastery (1608) and the Mardaki monastery (1635) in Messenia, the Zerbitsa monastery in Lakonia (1699), the Pantanassa at Mystras (17th-18th century), the Phaneromeni monastery on Salamina (1735), St Panteleimon in Thessaly (early 18th century), St Athanasios at Moschopolis (1745?) in North Epirus and the Holy Trinity monastery at Vytho, Kozani.

Kondakov 1914; Millet 1916; Kotta 1937; Grabar 1968, I; Vloberg 1952, II; Lazareff 1938; Der Nersessian 1960; Lafontaine-Dosogne 1964; Velmans 1968; Babić 1968; Mouriki 1970a; Mouriki-Charalambous 1970; Grigoriadou 1971; Pallas 1971; Tatić-Djurić 1972; Kalokyris 1972; Velmans 1972; Babić 1973; Grabar 1974; Grabar 1975a; Lafontaine-Dosogne 1975; Belting-Ihm 1976; Grabar 1977; Thierry 1979; Velmans 1980-1981; Gioles 1981; Hadermann-Misguich 1983; Lafontaine-Dosogne 1984; Acheimastou-Potamianou 1985-1986; Karakatsani 1985-1986; Gounaris 1986; Tatić-Djurić 1987-1988; Paetzold 1989; Gligorijević-Maksimović 1989; Drandakis 1999; Belting 1990; Aspra-Vardavakis 1992; Kondakis 1998.

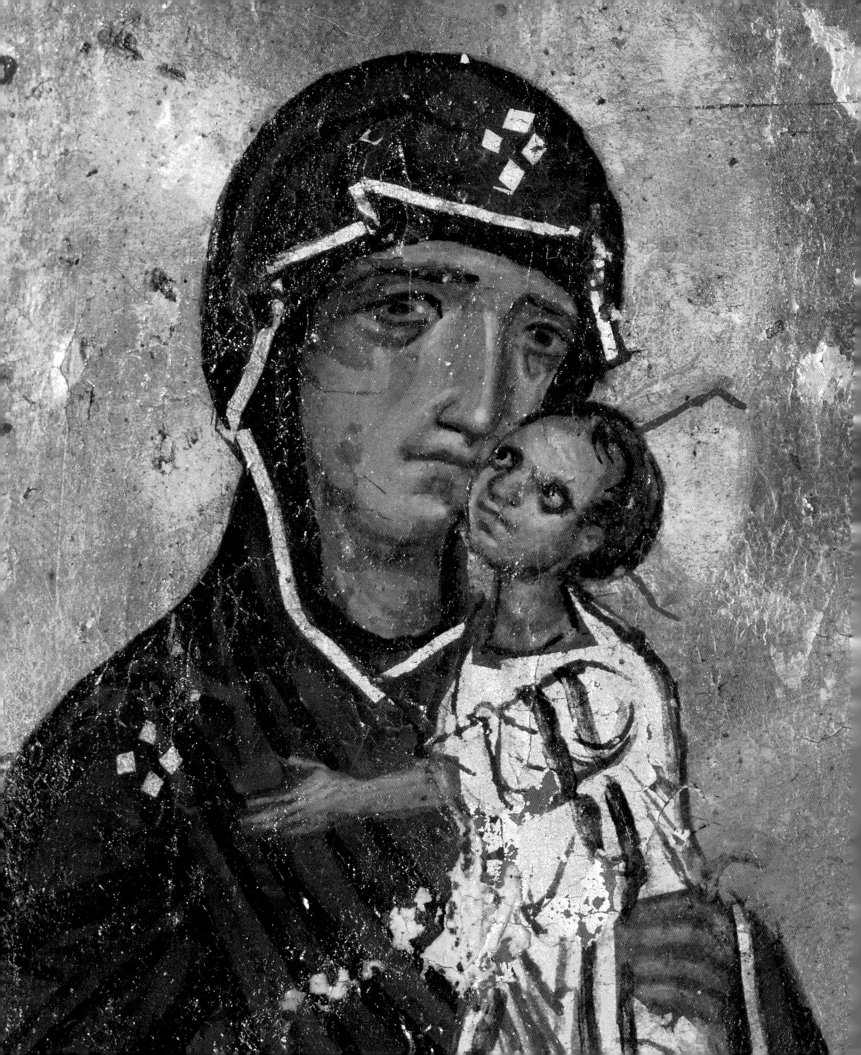

Chryssanthi Baltoyanni

The Mother of God in Portable Icons

The Virgin Mary, as St Mary, Mother of God, Theotokos and Panagia, is depicted from Early Christian times onwards in iconographic types bearing specific theological meanings that frequently dictated the iconography of these representations. The figure of the Virgin, emphasizing the doctrine of the Incarnation, was portrayed from a very early date in every form of visual expression of Byzantine art, with icons being one of the most important media. As early as the fourth century, the Theotokos seems to have been included amongst the holy figures depicted on the bezels of finger-rings, in icons, on bowls, and on the walls of rooms, to all of which Chrysostom alludes: 'In ornaments of rings and in various reliefs and in phiale and in walls of special rooms' (*PG* 50, 519D).

The portable icons of the Virgin surviving from the time before Iconoclasm are insufficient to allow any particular conclusions to be drawn. Furthermore, the evidence for icons as objects of veneration in this period is drawn from much later sources. Nevertheless, there is some information from before the Iconoclastic Controversy relating to the veneration of icons of the Theotokos. The tradition that St Luke painted an icon of the Virgin was already known, as attested by St John of Damascus (*PG* 95, 349C), who also refers to miracles worked by it: 'Many signs and wonders showeth the icon of the Mother of God' (*PG* 95, 352B). Sophronios also mentions the veneration of an icon of the Virgin: 'I see the figure of the Theotokos standing and I address her as Virgin' (*PG* 87, 3713D). Great interest attaches to the Early Byzantine icons of the Virgin on Sinai (Pl. 83) and to the few early icons in Rome, which are important examples of Christian painting in this period.

Icons of the Virgin with Christ in a medallion

This iconographic type occurs in monumental art in a fairly developed form, the most important example being the well-known seventh-century wall-painting in Santa Maria Antiqua at Rome, in which the Virgin holds the medallion of Christ slightly displaced to the side. The representation, which is surrounded by a painted border, resembles a portable icon and has been attributed to a workshop in the Byzantine capital.[1] In another wall-painting in this same church, the Virgin is depicted standing between the holy mothers Anne and Elizabeth, with the medallion in front of her chest.[2] It should be noted here that this important iconographic type, which is also found in Coptic wall-paintings of the Early Christian period, has recently been identified in the church of the Katapoliani on Paros[3] and in the north apse of the Drosiani on Naxos.[4] The wall-painting in the Katapoliani depicts two frontal female figures side by side, which have been identified as the holy mothers Elizabeth and Anne. On the left, as viewed by the spectator, Elizabeth holds a child, as does Anne, who also has a medallion containing a figure that is badly faded. The painting has been dated to the early eighth century.

In the Drosiani on Naxos, in contrast, the wall-painting of the Virgin, depicted in the type of Nikopoios, is one of the rare examples of early seventh-century mural painting in Greece. The inscription, with the word ΦΩC (Light), detected behind the cross on Christ's halo by Professor Drandakis, seems to link the type conceptually with the much later wall-painting of the Blachernitissa

82. *The Virgin and Child, from a hexaptych.* Monastery of St Catherine, Sinai, detail of Pl. 88.

at Trikomo on Cyprus, which has the inscription ΧΑΙΡΕ Η ΤΕΚΟΥΣΑ ΤΟ ΦΩΣ (Hail to the one by whom the light was born).

In the portable icon of ΑΓΙΑ ΜΑΡΙΑ on Sinai, the Virgin orans holds a medallion of Christ. However, alongside this type, that of the Virgin orans without the medallion of Christ evolved. The representation is found fully developed already in the early years after Iconoclasm and is particularly common in icons of the Middle Byzantine and Palaiologan periods. The figure of the Virgin, now orans, with the medallion of Christ on her chest, has been given the appellations Blachernitissa, Nikopoios, Platytera, and Episkepsis.

One of the earliest examples is the portable icon dating from the eighth-ninth century, from the church of the Phaneromeni at Nicosia, Cyprus, now in the Byzantine Museum in the Archbishop Makarios III Cultural Foundation.[5] The Virgin is rendered in the same iconographic type in the icon in the Museum of History and Architecture at Novgorod, which has been dated

83. *The Virgin*, detail from the icon of St Peter. Monastery of St Catherine, Sinai.

to just before 1169,[6] in that in the Tretyakov Gallery (1224),[7] and in the well-known icon on Sinai (1224), in which she stands between Moses and the Patriarch of Jerusalem, Euthymios (Pl. 84).[8] The by now standardized form of the Virgin in bust with a very large medallion occurs in the icon on Sinai (Pl. 85), dated to the thirteenth century, which is of great interest for the stage of development of the type.[9] Here the Virgin is accompanied by two angels censing, who frequently form part of mural depictions of the subject, mostly in monuments on Cyprus. This iconographic type has been thought to give conceptual expression to the Incarnation of Christ during the Annunciation, as depicted in twelfth-century icons in which the Incarnate Christ is represented within the folds of the Virgin's maphorion.[10] This homiletic depiction of the doctrinal meaning of the Annunciation was also transferred to the representation of the Virgin with the medallion of Christ, as can be seen from its details.[11]

The wall-painting of the same subject in the sanctuary apse of the church of the Virgin at Trikomo, which dates from the early twelfth century, is of importance for the meaning of the representation.[12] The Virgin is accompanied by a majuscule inscription of relevance to our subject: ΧΑΙΡΕ Η ΤΕΚΟΥΣΑ ΤΟ ΦΩΣ ΚΑΙ ΜΗ ΓΝΟΥΣΑ ΤΟ ΠΩΣ (Hail to the one by whom the light was born, though she could not know how this occurred). The inscription refers to the verses of the Akathistos Hymn: 'Hail to you who in an ineffable way you gave birth to light. Hail that the how you taught to nobody. And you will become pregnant and give birth to a son', and reveals the Virgin's role in the Incarnation of the Word. Here, the Word is Light, as in the phrase used by Christ in the Gospel: 'I am the light' (John 8:12).

The second verse of the Trikomo inscription – ΚΑΙ ΜΗ ΓΝΟΥΣΑ ΤΟ ΠΩΣ – may perhaps help to interpret the iconography of the Virgin with her arms held in a gesture of supplication. It may be noted that this gesture, combined with the presence of Christ in a medallion, is not simply one of supplication, but alludes to the overshadowing of the Virgin by the Holy Spirit at the time of the Annunciation, stressing essentially the purity of the Virgin Mary. This idea is expressed in icons of the Annunciation of the Middle Byzantine period, in which the Virgin Mary, while engaged in conversation with the angel, holds her right hand to her breast, palm outwards.

This gesture is found already in Early Christian times as an expression of supplication and also of purity.[13] According to the Gospel (Luke 1:24-38), after the archangel greeted Mary and told her: 'Behold, thou shalt conceive in thy womb and bring forth a son', she was perplexed, since

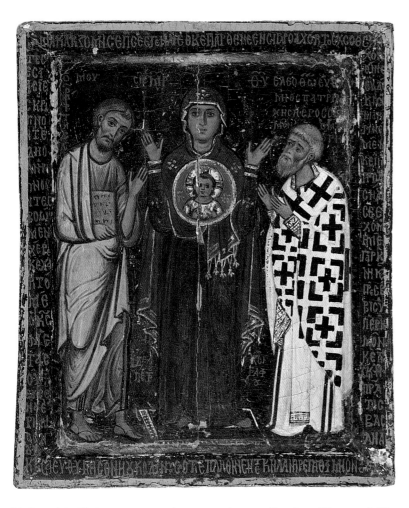

84. *Icon of the Virgin Blachernitissa flanked by the Prophet Moses and the Patriarch of Jerusalem, Euthymios.* Monastery of St Catherine, Sinai.

she was a virgin: 'Then said Mary unto the angel, How shall this be, seeing that I know not a man?'. Gabriel's reply to this: 'The Holy Ghost ... shall overshadow thee', stated clearly what was about to happen.

In the Akathistos Hymn, with which the Trikomo wall-painting is associated, the Virgin of the Annunciation is also extolled for her purity. 'Seeing herself in purity, Mary herself asks Gabriel: "how is it possible to have a birth out of a pure womb"'. Finally, the Mystery is perhaps set forth more clearly in the prelude to the Akathistos Hymn, in which its meaning is summed up. As is well known, the prelude to the Hymn is not 'to the all-victorious general', but the 'secret command', which is sung, according to the official order of the Church, before the Salutations, and refers exclusively to the Annunciation. According to the 'secret command', the angel addressed Mary and said: 'He who bowed the heavens by coming down is contained wholly and unchanged in thee. Seeing him take the form of a servant in thy womb, I stand in awe and cry out to thee: Rejoice O Bride unwedded'.

The inscription accompanying the Virgin in the wall-painting of the Annunciation at Trikomo on Cyprus: 'Hail to the one by whom the light was born, though She could not know how this occurred', may therefore provide an interpretation for her pose with her arms in supplication. The medallion of Christ she wears on her chest as Platytera contains the verse of the prelude: 'is contained wholly and unchanged in you'. The appellation Episkepsis follows the text of the Gospel: 'The Holy Ghost shall come upon thee, and the power of the Highest shall overshadow thee'. Accordingly, the Virgin with a medallion of Christ on her chest and her arms raised is not a form of the Virgin orans, but of the Virgin Mary, who at the time of the Annunciation is overshadowed by the Holy Spirit and becomes the Mother of God.

Icons of the Virgin Galaktotrophousa

The creation of the theme of the Virgin Galaktotrophousa in portable icons is also assigned to the period before Iconoclasm. Scholars had long ago debated whether the type was derived from the West or from Byzantium.[14] Its iconography has also been a matter of concern to modern scholarship.[15]

The type of the Virgin Galaktotrophousa appears fully developed in Coptic wall-paintings, a good example being the representation from the monastery of St Jeremiah at Saqqara (6th century), now in the Coptic Museum in Cairo.[16] The Virgin, who nurses the Christ-Child, holds him very close and turns her head towards him. He reclines in his mother's arms with his legs crossed, and, turned towards her, holds her left hand. Similar iconography is used in the Virgin Galaktotrophousa in an eleventh-century icon from Sinai, which is part of the Flight into Egypt.[17]

The pose of the Child reclining, with his legs crossed, in his mother's arms, recalls icons of the Virgin Eleousa, which are thought to allude clearly to the Virgin's vision of the future Passion of Christ.[18] Depictions of the Virgin Eleousa are also recalled by the miniature of the Galaktotrophousa in the Smyrna manuscript of Cosmas Indikopleustes.[19] In the mosaic of the Return from Egypt, in San Marco at Venice, the Child is depicted reclining and with his bared left leg protruding from the folds of the Virgin's maphorion.[20] The iconographic detail of the bared leg

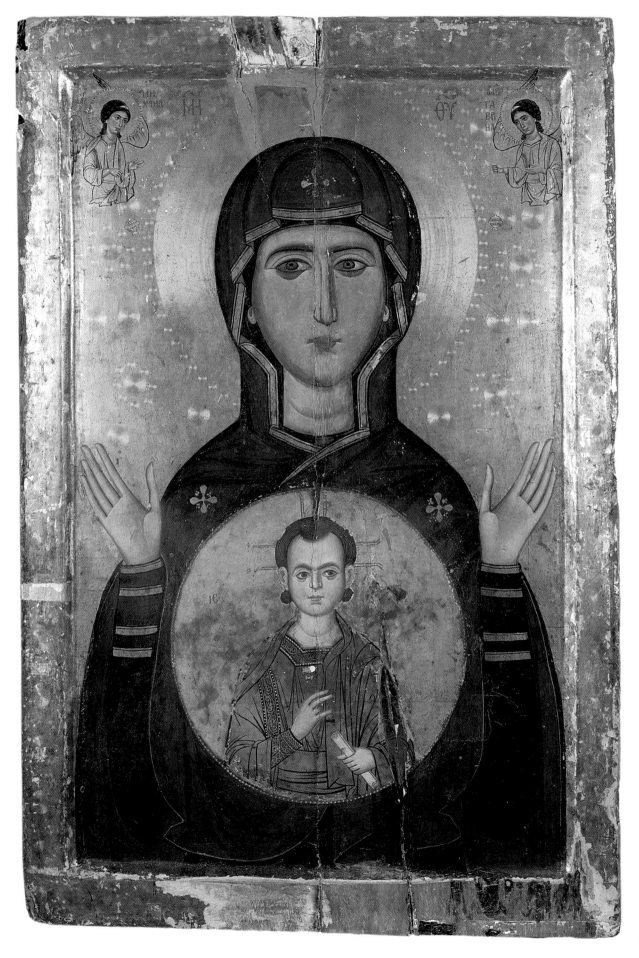

86. *Panel of the Virgin Galaktrophousa.* Byzantine Museum, Athens.

142

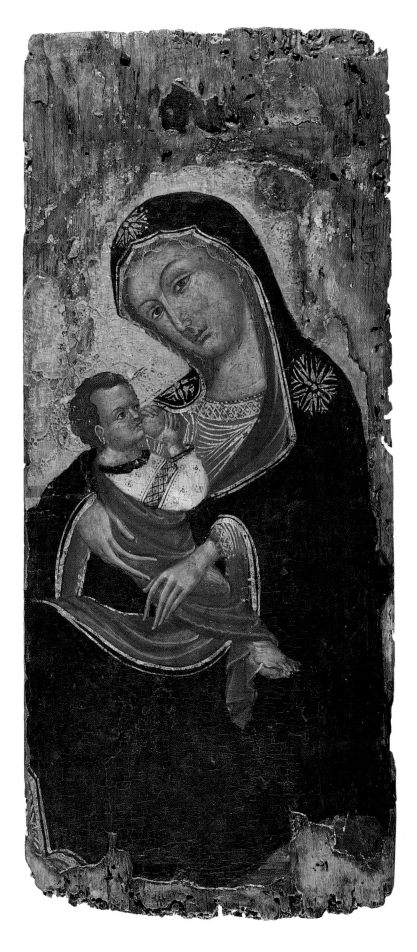

or legs of the Christ-Child is also thought to allude to his future Passion.[21]

The suckling of Christ was first connected with the Incarnation by St John Chrysostom, who states quite clearly: 'He was understood as a man because this does not simply take shape, but gestation is needed and ... feeding with milk ... and it is in this way that the Mystery of Divine Economy is accepted by all'. However, the suckling was at a very early date also associated with Christ's future Passion. St Clement of Alexandria, for example, states: 'One therefore must not be astonished when we allegorize the blood of the Lord with milk' (*PG* 8, 305B), and also: 'Therefore the blood as well as the milk of the Lord are symbols of His Passion and His Teaching' (*PG* 8, 309). The latter reference is also indicated in the Galaktotrophousa miniature in the Smyrna manuscript of Cosmas Indikopleustes, in which the image is accompanied by the appellation τράπεζα, which is known to be a symbol for the altar: 'It is an altar is and it is called, the Holy Table, which we have instead of the place of His burial'.

This specific visual expression, which is used with some restraint in Byzantine painting, is found more boldly formulated in thirteenth-century icons attributed to western workshops (Pl. 86).[22] A representative example of this trend is provided by the icon of the Galaktotrophousa at Mola, Bari, which probably dates from the late thirteenth century. The Virgin, Byzantine in feeling, restrained in expression and with the appropriate Byzantine painterly style, is shown holding the Child on her right side and turning her head towards him, as in the detached wall-painting from St Jeremiah at Saqqara. The Child no longer holds his mother's hand, but suckles and holds her breast with both hands. Apart from the actual posture of the Child, which alludes to the reclining infant, there are no prominent elements, at least, referring to the future Passion.[23]

In the thirteenth century, the representation of the Virgin Galaktotrophousa was reproduced from earlier models, with particular emphasis placed on the elements of the Passion that were so attractive in the Medieval West. Good examples of this type of Galaktotrophousa of the Passion are provided by the two thirteenth-century icons on Sinai.[24] The special temper of these is conveyed more clearly in the bolder of the two. The Virgin, in bust, holds the Child on her left. Clad in a diaphanous garment that reveals the whole of his naked body, the infant Christ is shown reclining in the ring formed by his mother's arms, with his legs arranged like a cross and the sole of his left foot turned

143

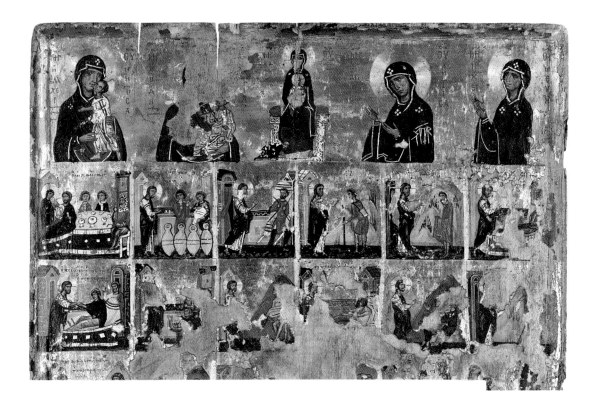

87. *Detail from a hexaptych*. Monastery of St Catherine, Sinai.

upwards. He suckles, holding the barely discernible breast with both hands. The Virgin's head is inclined towards the Child but she gazes beyond him at the spectator. She wears an additional veil of mourning over the veil of her maphorion, an element that brings her close to depictions of the Eleousa in the Kykkos monastery.

The Palaiologan icons associated with Constantinople appear to reproduce more restrained versions of the Virgin Galaktotrophousa. This, at least, is suggested by an icon from Rhodes,[25] in which the Child sits upright in his mother's left arm and suckles. The Virgin seems to be helping him, holding her right hand in front of her chest in a reminiscence of the type of the Hodegetria. The Rhodes icon dates from the late fourteenth or early fifteenth century.

The icon of the Virgin Hodegetria

The iconographic type of the Virgin Hodegetria, with the wide variety of applications it had in all forms of Byzantine art, was associated with the palladium-icon of Constantinople, which was widely known from at least as early as the ninth century and bore the appellation Hodegetria.[26] Once established as a miraculous icon, it was faithfully copied in a series of icons down to Late Palaiologan times. It was destroyed during the Fall of Constantinople.[27]

Iconographically, the Hodegetria may be recognized principally in representations of the Virgin standing or in bust, holding Christ in her left arm and with her right across her breast, accompanied by the appellation Hodegetria. In this context, its inclusion amongst the four miraculous icons of Constantinople painted in the top register of the eleventh-century hexaptych from Sinai[28] is most useful (Pl. 87). The Virgin, though accompanied by the inscription 'Hodegetria', does not follow the familiar iconographic type but is rendered in bust, turned slightly towards the Child, who is also turned slightly towards his mother. The soles of his feet seem to rest on a semicircular fold of the Virgin's maphorion in front of her chest, a reference to the medallion of Christ known in other representations. The depiction of the Infant appears to follow that of Christ in a medallion on his mother's chest.

Another representation documenting the type of the Hodegetria is the late thirteenth-century miniature in the Hamilton Psalter (Cat. no. 54).[29] This depicts a highly venerated icon in the type of the Hodegetria, along with realistic elements associated with her cult. The icon is set on a tri-

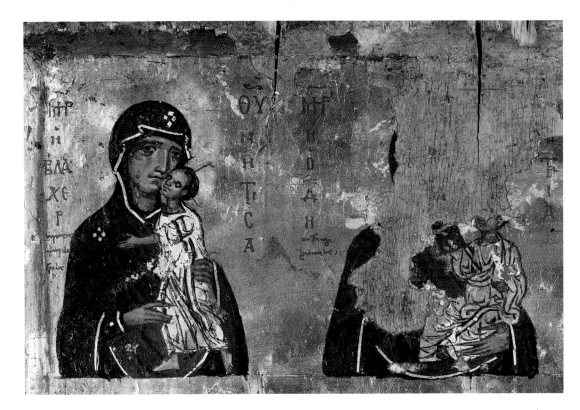

pod stand inside a ciborium which is fenced in by an elaborate grille. This last element is possibly to be identified with the metal rectangular structure in which the icon was kept, as remarked on by the Spanish traveller Clavijo (1403-1406): *e esta metida en una casa di fierro*.[30] If the above observations are correct, the Hamilton Psalter furnishes a faithful rendering not only of the Constantinopolitan icon of the Hodegetria, but also of its stand and the metal structure in which it was kept, according to Clavijo.

Both the representation on the eleventh-century hexaptych on Sinai, showing the Hodegetria (Pls 82 and 88) as one of the four miraculous icons of Constantinople, and the late thirteenth-century miniature in the Hamilton Psalter belong to periods much later than those in which, according to Byzantine literary sources, the icon was painted by St Luke and brought to Constantinople by the Empress Pulcheria.[31] However, the type of the Hodegetria was rendered before Iconoclasm in both mural painting and portable icons. In the icon in the Pantheon in Rome (Pl. 200), which is dated to the seventh century, the Virgin is shown holding the Child on her left side, almost frontally, and leaning slightly towards him, with her hand in front of her breast.[32] The fingers of the Virgin's right hand, in the *Madonna del Pantheon*, rest lightly on the knee of the Child, who is held in front of her chest in a pose similar to that of the Hodegetria. The gesture, which is still functional here, suggests an early period in which the more precise theological concepts were not yet applied as fully as they were by the seventh century. This means that the Rome icon is a copy of an earlier representation, probably, as has been suggested, the Hodegetria of Constantinople.[33] This is supported by two elements that coincide with more or less reliable sources describing the Hodegetria of the Byzantine capital. The *Madonna del Pantheon* in Rome is painted on wood in the encaustic technique, and its present impressive dimensions (1.00 × 0.475 m) would be increased if, as Bertelli suggests, the icon was part of a larger representation of the Virgin Hodegetria standing (estimated dimensions: 2.40 × 0.85 m).

The intense public veneration of the Hodegetria in Constantinople also accounts for the survival of the iconographic type, which is repeated with slight divergences and variations in countless works of both the Byzantine and Post-Byzantine periods. We may note here the well-known mosaic icon of the Hodegetria from the Pammakaristos (Pl. 89),[34] now in the church of the Ecumenical Patriarchate at Constantinople, which is dated to the eleventh century, the mosaic Hodegetria in

145

the Chilandari monastery,[35] the Portaitissa in the Iviron monastery (Pl. 42),[36] also of the eleventh century, an icon of the twelfth century with the same subject at Kastoria,[37] (Cat. no. 83), etc.

Conceptually, the representation on the Constantinopolitan icon of the Hodegetria is connected mainly with the Mystery of the Incarnation. This apparently derives from the fact that it seems to have been associated with the Annunciation and the Akathistos Hymn, judging by the reference in Pseudo-Kodinos.[38] According to this, the icon of the Hodegetria was taken to the palace of the Komnenoi in the fifth week of Lent and stayed there until Easter Monday. The fifth week of Lent, however, is known to have been the week in which the 24 stanzas of the Akathistos Hymn were read, according to the official order of the Church. Pseudo-Kodinos informs us that during the time it was kept in the palace, the icon of the Hodegetria stood next to the icon of the Nikopoios, in which the Mystery of the Incarnation is also prominent. This association of the Hodegetria with the Incarnation is revealed moreover by depictions of processions of the icon during all-night vigils in Constantinople, connected with the service of the Akathistos Hymn.[39]

The icon of the Hagiosoritissa and the Eleousa

The representation of the Virgin Hagiosoritissa is connected with the *Hagia Soros* in the church of the Chalkoprateia at Constantinople.[40] The *Hagia Soros* (a reliquary containing the Virgin's girdle) was kept there on the sanctuary altar and was the object of particular veneration. The surviving literary evidence on the church of the Chalkoprateia does not permit the identification of the icon honoured in it. The iconographic type of the Virgin with the appellation Hagiosoritissa is preserved on Byzantine coins and lead seals: the Theotokos, standing or in bust, has her head turned to the left, as viewed by the spectator, and her arms held out in supplication.[41] The existence of this icon is also attested by the well-known eleventh-century hexaptych on Sinai, in which one of the four miraculous icons of Constantinople (Pl. 90) is accompanied by the inscription Η ΑΓΙΟΣΟΡΗΤΙΣΑ.[42] In it the Virgin is shown in bust and turned three-quarters towards the left, as viewed by the spectator. She wears a maphorion fastened high on her neck, her arms are open in supplication, though held close to her body, and her head slightly inclined.

One of the earliest examples of the Hagiosoritissa is the icon of the *Madonna di Tempulo* (Pl. 39) in Rome,[43] now in the church of Santa Maria del Rosario in the same city. This icon is con-

nected with the Hagiosoritissa because it is identical in iconographic type with the Sinai Hagiosoritissa and because of the name of the monastery – *Tempuli* –, which is simply the Latin translation of the appellation Soritissa.

The icon of the Hagiosoritissa from the Machairas monastery on Cyprus[44] is the most faithful translation to a portable wooden surface of the iconographic type of the Hagiosoritissa of the Chalkoprateia. Probably produced by a Constantinopolitan workshop in the late eleventh century, it contains iconographic elements that link the representation with the funerary character of the Hagiosoritissa. The serious expression of the figure with her severe features is largely shadowed by the dark purple maphorion, which covers the head and falls on to the forehead, leaving part of the inner black veil exposed. The Virgin is in bust and turned three-quarters to the left, in relation to the spectators. She holds out her arms in supplication, though not far from her body, with the palms parallel. Her face and eyes are turned slightly to the right. The gesture of the arms exposes the cuffs of the chiton, rendered a dark brown to black. The star on her left shoulder is here replaced by a cross and transferred to her breast. The star on the veil of the maphorion, above the forehead, is also cruciform in shape. The entire representation is charged with grief, befitting the Hagiosoritissa.

The iconographic type of the Hagiosoritissa has in recent years been associated[45] with the Virgin found in the eschatological theme of the Deesis, in which her supplication is directed to Christ and she turns, of necessity, towards the centre of the scene, with her arms held to her left. It is, of course, possible that she should be identified with the Virgin in the Deesis of the Last Judgement, since the supplicating Hagiosoritissa has a similar mission. Nevertheless, the complexity of the portrayal's presentation and the connection with the *Hagia Soros* in the Chalkoprateia may carry with them meanings more specific to it. These may link the Hagiosoritissa icon with particular liturgies and account for its role in funeral services.

In an important article, Nancy Patterson-Ševčenko investigates the place of icons in the liturgy, making use of elements drawn from the *Typikon* of the Pantokrator monastery (1136), relating to a special all-night vigil called the *Presbeia*.[46] The *Presbeia* was held every Friday in the Pantokrator monastery, more specifically in the church of the Eleousa in the north part of the complex. On this evening the clergy of the church, together with cantors and laity, carried the icon *Signon tes Presbeias* in procession along with other *signa*, as stated in the *typikon*, and proceeded to the church of the Eleousa. When the procession arrived at the monastery, the icons were carried around the tombs of the Komnenoi in their funerary chapel there, accompanied by supplications and prayers by the clergy and laity for the souls of the dead. The interest of this description of the procession lies in the specific reference to the *Signon tes Presbeias* and the fact that after the supplications were over the procession ended at the *Hagia Soros* – that is, in the church of the Chalkoprateia. Could this last fact be taken to imply that the *Signon tes Presbeias* was the icon of the Hagiosoritissa? This seems quite likely when one considers that the *Presbeia* in the funerary chapel of the Komnenoi was a service for the dead. Consequently, the icons to which

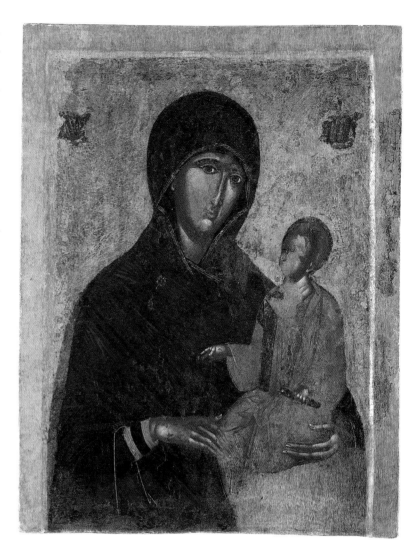

91. *Two-sided icon:*
A: *The Virgin Hodegetria.*
Byzantine Museum, Athens.

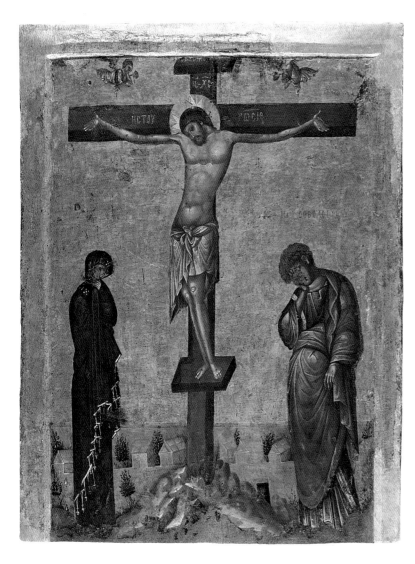

92. *Two-sided icon:*
B: *The Crucifixion.*
Byzantine Museum, Athens.

the supplications were addressed in the funerary chapel ought to be associated with them at least conceptually. The Hagiosoritissa, with its special relationship to the *Hagia Soros* and the homiletic iconography of the supplicating figure, could well have been the icon honoured during this vigil. It may be noted that, in addition to the icon in the Machairas monastery, both the other icons under examination here, that is, the Sinai icon and the *Madonna di Tempulo* in Rome, present the Virgin wearing a maphorion of dark colour, which seems to indicate mourning. The icon that accompanied the funeral procession carrying the body of Stefan Nemanja[47] from Chilandari to Studenica, which was depicted in the exonarthex of the latter church, is also in the type of the Hagiosoritissa. Moreover, it may not be fortuitous, in the context of the icon's association with the period of the Komnenoi, that important objects of veneration like the Hagiosoritissa of the Machairas monastery and a good number of lead seals, coins, medallions and gem stones dating from the eleventh and twelfth centuries, bear the figure of the Hagiosoritissa.[48]

The Eleousa and the Virgin of Tenderness

After the end of Iconoclasm, theological circles in the Byzantine capital, with Patriarch Photios figuring most vocally in them,[49] promulgated teachings in accordance with which Church doctrine was, whilst not losing sight of the Mystery of the Incarnation, to focus also on the Passion, which legitimized and demonstrated it. Art, for its part, once again responded to the messages of the times, initially by giving greater prominence to the scenes of the Passion in the wall-painting ensembles in churches. Quite soon, however, it turned to the artistically and doctrinally well-established potrayal of the Virgin Brephokratousa (Virgin and Child), in which it found the means to render the essence of this complex concept. This doctrinal combination came now to be rendered in superb depictions of the Virgin of Tenderness with many variations, which, though charged with emotion and foreboding, have lost nothing of their serious Byzantine and theological ethos.

The iconographic type of the Virgin of Tenderness,[50] has, as we know, been linked with the Virgin Eleousa. In accordance with the iconography of the Komnenian icon of the Virgin of Vladimir,[51] in the Tretyakov Art Gallery (Pl. 24), Moscow, the Virgin holds the Child in her right arm and deeply inclines her head towards him, so that her face tenderly touches his. The tradition that this icon had its origins in Constantinople, the high quality of its art, and the very iconography itself, which is charged with emotion and doctrinal significance, might connect the Virgin of Vladimir with a copy of the Eleousa in Constantinople. This identification, however, is not without problems, since in addition to the Virgin of Vladimir, which is described as Eleousa, the appellation Eleousa is applied to other icons of the Virgin with a different iconography. What is needed is to catalogue the icons of the Eleousa and to classify them into works from Constantinopolitan or from provincial workshops and into large devotional icons or icons from small private chapels.

The Middle Byzantine icon of the Virgin from the iconostasis of the Enkleistra of St Neophytos on Cyprus,[52] which has the majuscule inscription: Η ΕΛΕΟΥϹΑ, might also be considered

149

a copy of the icon in the church of the Eleousa at Constantinople. It is dated to around 1183 and is very close to the type of the supplicating Hagiosoritissa, though the figure of the Virgin is turned to the spectator's right.

The 1136 *Typikon* of the Pantokrator monastery[53] provides a detailed description of a nocturnal vigil known as the *Presbeia*, involving a procession to the church of the Eleousa. It also states that at the various stations, prayers were addressed to the icon *Signon tes Presbeias*, the representation on which is not indicated. After it arrived at the church, the priests of the Eleousa, and the cantors and laity, carried the *Signon tes Presbeias* and other icons around the tombs of the emperors in the funerary chapel of the Komnenoi in the Pantokrator monastery, to the accompaniment of long memorial supplications.

If the *Signon tes Presbeias* was indeed associated with the icon of the supplicating Hagiosoritissa and linked with funeral prayers, then the *Signon* was essential to the holding of this memorial service. And since the icon was brought from elsewhere, to the accompaniment of prayers, there was obviously no icon with this liturgical function in the church of the Eleousa. At a later date, however, there does seem to have been such an icon in the church: in an inventory of the property of the monastery dated 1449, it is noted amongst other things that the *Signon tes Presbeias* of the church stood near the devotional icon of the Eleousa.[54] It follows that in 1449, the church of the Eleousa housed the *Signon tes Presbeias* of the church,[55] which was clearly distinguished from the devotional icon of the Eleousa. It may therefore be supposed that in 1136, when the description of the *Presbeia* of the dead was composed, the icon honoured in the church of the Eleousa was the devotional icon of the church and was not in the type of the Hagiosoritissa, but possibly in that of the Virgin of Tenderness, which is copied by the Virgin of Vladimir. It may be concluded that the supplicating Eleousa from St Neophytos on Cyprus, which belongs to the iconographic type of the Hagiosoritissa, was perhaps a copy of the *Signon tes Presbeias* of the church of the Eleousa. If the above is true, the church of the Eleousa will, from the twelfth century, have housed at least two honoured icons with the appellation Eleousa, copies of which will possibly have been produced with equal frequency.

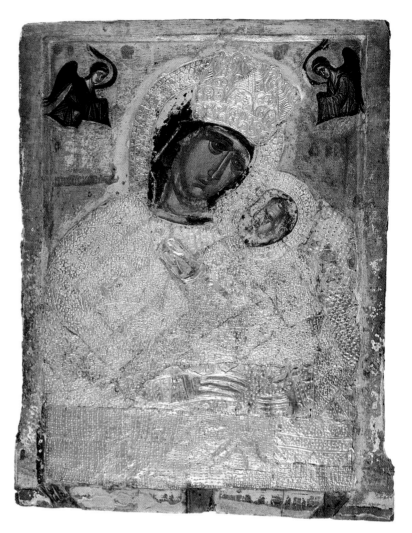

93. *Two-sided icon:*
A: *The Virgin Brephokratousa.*
Church of the Virgin
Theoskepasti, Naxos.

Parallel types of the Virgin of Tenderness

One of the best-known parallel iconographic types of the Virgin of Tenderness, which seem to have multiplied from the late eleventh century on, is that of the Virgin holding Christ as a reclining infant, as the Patriarch Photios characterizes it. In his well-known sermon from the pulpit of Hagia Sophia at the inauguration of the mosaic representation of the Virgin and Child in the sanctuary apse, Photios speaks of: '(the Virgin), bearing in her pure embrace, the Maker of All ... as a reclining child'.[56] According to the accepted interpretation of the verb *anaklinomai*,[57] in the depiction inaugurated by Photios, Christ must have been depicted as *anapeson* (lying horizontal).[58] It follows that the type of the Virgin with the reclining infant, which contained iconographic symbols of the Passion, must already have been established by the time of Photios.[59] The type of the reclining infant is to be found also in the icon in Santa Maria Nuova at Rome,[60] dating from before Iconoclasm, and in that of the Virgin Galaktotrophousa from St Jeremiah at Saqqara.[61] Indeed, the latter depiction contains

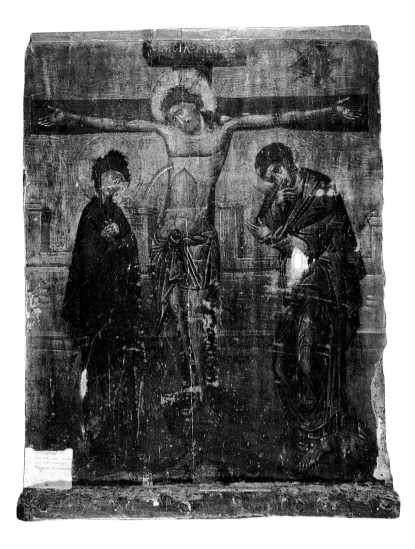

94. Two-sided icon:
B: *The Crucifixion.*
Church of the Virgin
Theoskepasti, Naxos.

the iconographic detail of the Child's crossed legs, a feature characteristic of Christ *Anapeson*. The earliest depiction of Christ *Anapeson* is in the Utrecht Psalter (9th century),[62] in which Christ is rendered as a child lying on a bed with his legs crossed and his face resting on his hand, which is turned upwards. The entire iconography, which has its roots in Late Antiquity, is suggestive of Sleep-Death.[63] The representation is accompanied by a passage from Psalm 43: 'Rise up, get up, Lord, while you pretend sleeping', referring to the Entombment. All these elements are deployed in the twelfth-century icon of the Virgin of Tenderness in the Byzantine Museum, Athens (T137)[64] (Cat. no. 75). The same is true of the icon in the Philotheou monastery (Pl. 43) on Mt Athos (early 14th century),[65] in which Christ is also depicted with his bare legs crossed.

Another representation related to the Virgin of Tenderness in the Byzantine Museum is the depiction of the Virgin of Kykkos, known principally from the icon of the Chrysaliniotissa (Cat. no. 76)[66] and other copies. The type of the Kykkotissa seems to be associated with specific theological concepts. The reclining Child has neither halo nor himation, but only a sleeveless chiton, and his bare legs are posed untidily. His head rests on his shoulder and he holds out his hands to his mother. The same posture, gesture, and movement are given to the Child in a twelfth-century wall-painting in the church of the Virgin of Arakos on Cyprus,[67] in which Christ is depicted in Symeon's arms. The Child clutches the prophet and pulls his himation with his left hand. The representation of the Virgin Eleousa which lies opposite this is thought to have been executed at the same time, as part of an abbreviated rendering of the Presentation in the Temple.[68] In this case, the concept of the vision of the future sacrifice of the Child is expressed through the Prophet Symeon. This interpretation of the two representations is further supported by the figure of St John the Baptist in the background, holding a scroll with the majuscule inscription: ΙΔΕ Ο ΑΜΝΟΣ ΤΟΥ ΘΕΟΥ Ο ΑΙΡΩΝ ΤΑΣ ΑΜΑΡΤΙΑΣ ΤΟΥ ΚΟΣΜΟΥ (Behold the Lamb of God, that taketh away the sins of the world), a reference to Christ the Lamb and his sacrifice on the cross. This iconographic rendering, which would come to know yet bolder variations,[69] is thought to reproduce the icon of the Virgin in the Kykkos monastery and was established, if not created, at the time of the Macedonian dynasty and of the Komnenoi.

From the same period comes the twelfth-century icon on Sinai with the Virgin enthroned, depicted as the Kykkotissa (Cat. no. 28).[70] The Virgin and Child, the central subject of the icon, is surrounded by prophets whose scrolls contain references to prefigurations of the Mystery of the Incarnation, with which the triumphal presence of Christ as Pantokrator at the middle of the top border of the icon is associated. This complex icon, which is probably the product of a Constantinopolitan workshop, reproduces some now unknown model.

Komnenian art adds to depictions of the Virgin and Child other elements in the rendering of Christ that clearly refer to the Passion, such as the vulnerable heel with the upturned sole, the diaphanous garment, the naked shoulder, the golden loros encircling the torso, and the globe in his hand.[71] All these seem to stem from the theological discussions that took place in highly sophisticated philosophical circles in the Byzantine capital.

151

The association of the Passion with the Virgin and Child is even more obvious in two-sided icons[72] in which the Virgin and Child occupies on side and a scene of the Passion the other. The two-sided icon (Cat. no. 84) in the Byzantine Museum, Athens (T157a)[73] is of particular interest; on one side is the Crucifixion, the larger part of which preserves the ninth-century representation, and on the other is the Virgin Pammakaristos, which is an over-painting of an earlier layer that can just be made out in the X-ray of the icon. It is not possible to determine whether the original two sides of the icon are contemporary with each other. If they are, this could make the Byzantine Museum icon the earliest two-sided icon in which one of the first efforts was made to crystallize doctrine in the years just after Iconoclasm.

In Palaiologan times, veneration of icons of the Virgin, with their great doctrinal and emotional charge, went hand in hand with veneration of the Theotokos herself. The support given to this veneration by the imperial court, which had become evident as early as the period of the Komnenoi, would assume even greater dimensions from the moment that Andronikos II declared the whole of August to be the month of the Virgin.[74]

The iconographic type of the Virgin Hodegetria was to enjoy a great flowering in Palaiologan icons and was enriched with iconographic elements characteristic of the Virgin of Tenderness.[75] In the new variation of the Hodegetria, more full of foreboding, as it appears in highly important icons that adorned churches in Constantinople or were sent from there as valuable gifts from the emperor,[76] the Child turns his head, bringing it closer to his mother's body. Of the preserved icons, mention may be made of the one in the Byzantine Museum, Athens (T169, Pl. 91), with the Virgin Hodegetria on one side.[77] She turns slightly towards the Child and inclines her head in his direction while gazing beyond him at the spectator. Christ responds to this movement by turning to the centre and holding out his hand in blessing. The rendering of the Virgin Hodegetria retains a number of elements known in depictions dating from before Iconoclasm (*Madonna del Pantheon*), such as the left hand held in front of the chest, and the tips of the fingers touching the Child's knee. The other side of the Byzantine Museum icon is adorned with one of the most precious representations of the Crucifixion (Pl. 92), which is characterized by the profound grief of the Virgin, who, tightly wrapped in the deep blue of her lapis lazuli mourning maphorion, and 'bearing the Passion in seemly fashion', stands beneath the Cross like a funeral candle. The high quality of its art and its conceptual content suggest that this work was the product of an early fourteenth-century Constantinopolitan workshop.

The two-sided icon in Ochrid,[78] with the Hodegetria on one side and the Crucifixion on the other, appears to be a forerunner of the one in the Byzantine Museum. The depictions on each side are thought to be contemporary and are dated to the thirteenth century. The icon on the iconostasis of the Virgin Theoskepasti in Chora, Naxos is of interest for the origins, meaning, and function of two-sided icons (Pls 93 and 94).[79] The side with the Virgin faces the nave of the church, while the Crucifixion is painted on the back, facing the sanctuary. The two sides are contemporary, are dated to the fourteenth century and attributed to a workshop in Trebizond.

This great productivity in the creation of new types and in the renewal of much earlier ones during the Palaiologan period also led to an increase in the prestige of miraculous icons of the Virgin, which were carried in processions, in acts of worship and special services, and signalled the need for hope felt by Byzantium, which had already foreseen its end, both as a world and as a civilization.

1 Grabar 1966a, pl. 182.

2 Grabar 1966a, pl. 180.

3 Drosoyanni 1998, 58, 63-65, figs 1, 4.

4 Drandakis 1988, 73, pls VII, VIII.

5 Papageorgiou 1992, 3, no. 1; Sophocleous 1994, 76, pl. 2. For a special treatment of the medallion of Christ, Maguire 1981, 57.

6 Lazareff 1983, pl. 12.

7 Lazareff 1983, pl. 21.

8 Sotiriou 1956-1958, 138, fig. 158; Mouriki 1990a, 113, pl. 48.

9 Sotiriou 1956-1958, 117, fig. 61; Mouriki 1990a, 117, pl. 61.

10 Grabar 1980, 128, 305.

11 Grabar 1956, 259; Grabar 1980, 37, 128, pl. 304.

12 Stylianou 1997, 498.

13 Grabar 1980, 76.

14 Lasareff 1938, 27.

15 Cutler 1987, 335.

16 Grabar 1966b, pl. 194.

17 Sotiriou 1956-1958, 59, figs 43-45.

18 Baltoyianni 1991-1992, 219-38; Baltoyianni 1994b, 79-120.

19 Lasareff 1938, 30, pl. 1.

20 Demus 1987, 155.

21 Baltoyianni 1994b, 17-40.

22 *Icone di Puglia*, no. 39.

23 It is worth noting at this point that Coptic stelai had a funerary function, as did the votive statuettes of the 4th and 5th centuries depicting mothers suckling their infants (Lasareff 1938, 28). The scene on a marble krater in the Archaeological Museum, Rome, which has been dated to the 4th century, also served a funerary purpose; on one side is depicted the Adoration of the Magi, with the Virgin Galaktotrophousa, and on the other the eschatological subject of the Last Judgement (Severin 1970, 211-32, figs 2, 3). This exceptionally large vase probably comes from a Christian cemetery in Rome.

24 Mouriki 1991, pls 29-30.

25 Papatheophanous-Tsouri 1979, 1-14, pls 1-2.

26 Kondakov 1914, 2; Wellen 1960, 176-178. For the Hodegetria enthroned, Lasareff 1938, 46-65. For a more extensive bibliography, Mouriki 1991, 176-182. For the variation of the type referring to the future Passion of the Infant Christ, Baltoyianni 1994a, 211-237. Also Angelidi and Papamastorakis in the present volume, 373-387.

27 Doukas XXXVIII and XXXIX (Bonn, 272 and 288).

28 Sotiriou 1956-1958, 125, 146-147.

29 Grabar 1976, fig. 3.

30 Le Strance 1928, 84; Ševčenko 1995, 548, n. 11.

31 Nikephoros Kallistos, *PG* 146, 1061A; 147, 44A.

32 Bertelli 1961, 24-32.

33 Bertelli 1961, 24-32.

34 Sotiriou 1933, 359-68; Belting et al. 1978, 9-10; Demus 1991, 19, 39; Gioles 1993-1994, 249-257.

35 Bogdanović et al. 1978, pl. 37.

36 Pelekamidis et al. 1975, fig. on 23.

37 Chatzidakis 1976, 184, pl. XXXVII; Belting 1980-1981, 143ff., figs 49-50.

38 Verpeau 1966, 231; Mouriki 1991, 156-157.

39 Ševčenko 1991, 48ff.

40 Janin 1969, 3, 161ff.; Ebersold 1921, 57.

41 For the representation of the Hagiosoritissa on coins, Bertelé 1992, 233-234. For a full catalogue of the coins and lead seals, Touratsoglou 1992, 603-605; Koltsida-Makri 1996, nos 159, 389, 391; also Penna in the present volume, 209-217.

42 Sotiriou 1956-1958, 125, figs 146-147.

43 Bertelli 1961, 80ff.

44 Papageorgiou 1992, 7, no. 3; Sophocleous 1994, 77, no. 4, pl. 4.

45 Der Nersessian 1965, 77ff. Papadaki-Oekland 1973-1974, 31-54.

46 Ševčenko 1991, 50ff.

47 Todić 1986, 257, fig. 129; Ševčenko 1991, 55ff.

48 Touratsoglou 1992, 601-605.

49 Grabar 1984, 282.

50 For the iconography of this type and the problem of its origins, Lasareff 1938, 36-46, with the bibliography to date, Grabar 1974, 3-14; Grabar 1975, 25-30. For its frequent occurrence on 10th- and 11th-century monuments in Cappadocia, Thierry 1979, 59-70.

51 Alpatov and Lazarev 1925, 140-45; Felicetti-Liebenfels 1956, 51, 52, pl. 77; Lazarev 1967, 204, pl. 325.

52 Papageorgiou 1992, 16, no. 7; Sophocleous 1994, 82, pl. 13.

53 Ševčenko 1991, 50ff.

54 Ševčenko 1991, 55, n. 72.

55 The *Signon tes Presbeia*s is associated with the Hagiosoritissa by Ševčenko 1991, 54, n. 68.

56 Aristarches 1900, 299; Mango 1958, 290.

57 Liddell-Scott, 172; also ανάκειμαι and αναπίπτω, 171, 184.

58 Grabar 1928, 256-262.

59 Baltoyianni 1991-1992, 219-238; Baltoyianni 1994, 79-120, pls 50-68.

60 Grabar 1966, pl. 191.

61 Grabar 1966, pl. 180.

62 Duffrenne 1978, 135, pl. 84.

63 Baltoyianni 1994, 79-120, pls 50-68.

64 Chatzidakis 1976, 184; Baltoyianni 1998, 38, pl. on 40.

65 Tsigaridas 1992, 654, n. 37, pl. 355.

66 Papageorgiou 1969, 89, pl. on 18; Mouriki 1986, 26, fig. 24.

67 Stylianou 1985, 171, fig. 90; Baltoyianni 1993-1994, 53-58; Maguire 1980-1981, 261-269.

68 Belting 1981, 130.

69 Lazareff 1938, 42-46.

70 Sotiriou 1956-1958, 73, figs 54-55; Mouriki 1990a, 105, fig. 19. Belting 1981, 130 (Sinai).

71 For the vulnerable heel of Christ, Baltoyianni 1994b, 132-134. For the diaphanous tunic worn by Christ, 278, the gold loros, 213-215, for the [symbolism] of Christ the lamb, 17-21, and for the globe, 277.

72 Pallas 1965, 91-92.

73 Baltoyianni 1998, 31, pl. on 33, with earlier bibliography.

74 Grumel 1932, 257-263.

75 Grabar 1975, 25-30.

76 The two icons, of the Virgin Psychosostria and Christ Psychosostes now in the Ochrid Art Gallery (Djurić 1961, 24, nos 14-15) come from the Psychosostria monastery in Constantinople; according to literary evidence, they were presented by Andronikos II to the Archbishop of Ochrid, Gregorios I.

77 Baltoyianni 1998, 76, pl. on 78-79, with earlier bibliography.

78 Djurić 1961, 19, no. 4.

79 Drandakis 1964, 420-435.

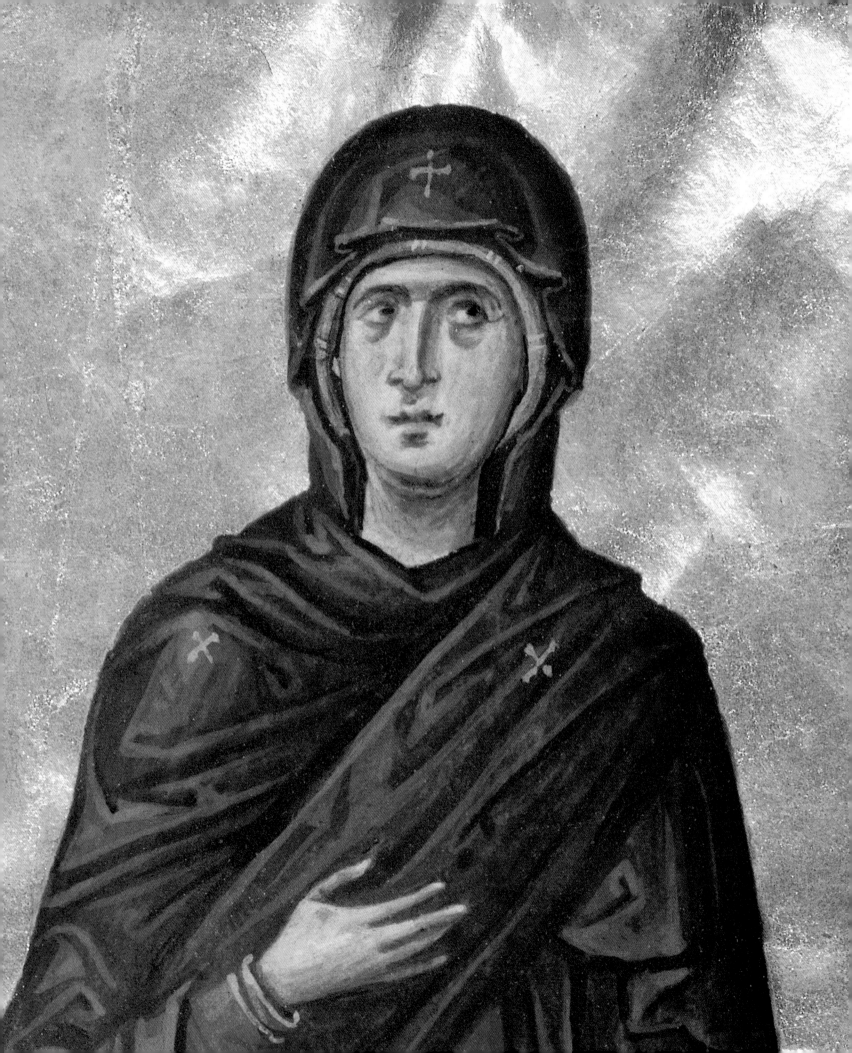

Nancy Ševčenko

The Mother of God in Illuminated Manuscripts

For all the major role the Virgin plays in Byzantine church decoration, Byzantine ivories and metalwork, her role in Byzantine manuscript illumination is surprisingly limited. At first her images in manuscripts are attached to and focused upon the texts they accompany: a crucial figure in the events of Christ's life and in the events in her own, she appears regularly in illustrated Gospelbooks that have narrative cycles, and she appears in typological contexts in Old Testament manuscripts, above all in psalters. In the Middle Byzantine period, however, as certain types of manuscripts assumed an increasingly private devotional function, and their frontispiece miniatures detached themselves from direct dependence on the text, images of the Virgin begin to play a new and active role in conjunction with the viewer.

In Gospel narrative illustration, such as those Gospelbooks in Paris and in Florence of the eleventh and twelfth centuries (Pl. 96), the Virgin, a slender figure clothed in dark blue with her head covered by the maphorion, comes into view every couple of pages during the sections relating the conception, birth and early life of her son, and again in the sections describing his death on the cross, at which she was present.[1] She is an essential part of the narrative but completely embedded within it; her gestures and actions spur on the narrative, but have little specific resonance outside it.

This changes somewhat in the manuscripts known as Gospel lectionaries, service books in which passages from each Gospel have been excerpted and rearranged to fit the annual cycle of Gospel readings for the major feasts of the Church year.[2] In the illustrated lectionaries the narrative element is reduced, and the role of the individual participants is increased. The manuscript versions of the Annunciation, Nativity, Crucifixion and Ascension, all of which involve the Virgin, are now closely associated with the liturgical celebration of the feasts, and differ little from the focused depictions of these same events in other media.

Not every feast in the year celebrated an event described in the New Testament: some of the Marian feasts derived not from the Bible at all but from the Apocrypha. Illustrated lectionaries therefore may contain images of the Birth of the Virgin, of her Presentation in the Temple and of her Dormition (Koimesis) (Pl. 97), scenes which are missing from the narrative Gospel manuscripts for the simple reason that these events are not recounted anywhere in the New Testament. These feast scenes first appear in manuscripts only from the tenth century on, and probably derive from versions in other media, since events drawn from the Apocrypha had been represented from at least as early as the sixth century.[3]

No illustrated versions of the apocryphal texts of the life of the Virgin, even of the popular second-century *Protevangelium of James*, have survived. But one astonishing sequence of narrative miniatures relating to the Virgin's early life has come down to us in the illustrations to a set of homilies dedicated to the Virgin, written in the twelfth century by a certain James of Kokkinobaphos. James based his homilies freely on the *Protevangelium* and the illustrations to his six homilies on the Virgin, which survive in two twelfth-century manuscripts, are the richest group of Byzantine miniatures relating to the Virgin that we have (Pl. 98).[4] The homilies are dedicated to the Conception, Birth, Presentation and Marriage of the Virgin and to the Annunciation and Vis-

95. *The Virgin*, Gospelbook Sinait. gr. 204, detail of Pl. 103.

itation. Rich in typology as well as in lively dialogue between the characters, these homilies exalt the Virgin as the beginning of a new era in the story of salvation, and stress her qualifications for the role she will play in man's eventual return to Paradise.[5] There are 82 miniatures in all, many of them depicting several episodes within a single frame; the figure of the Virgin appears in the majority of them, a small child already clad in adult robes, growing steadily in size as she nears the time of her marriage, always humble and reverent and focused on her role. The settings are insistently aristocratic: elegant interiors with fancy furniture and textiles, attendants holding peacock fans, milling relatives, and lush garden landscapes suggestive of Paradise. The circumstances of the production of these two manuscripts remain unclear. The homilies never did enjoy a wide circulation, and the cycles may not have crossed over into other media until Post-Byzantine times.[6] These Kokkinobaphos cycles of the early life of the Virgin are therefore specific to manuscript illumination, the medium for which they were invented.

The Virgin is by no means unknown in Old Testament manuscripts, even if the texts obviously never mention her by name. In Byzantine psalter manuscripts, marginal illustration was often used to provide a kind of commentary on the Old Testament text: references to the New Testament discovered in the Old were brought out and given visual form by images placed next to the relevant psalter passage.[7] If a passage was thought to refer to the Nativity, Crucifixion, or Ascension, then an image of the event was placed in the margin, its iconography following that of New Testament manuscripts or images in other media. Essentially restricted to psalter illustration are other more typological images, such as that of the Virgin holding the Christ-Child (Pl. 100), which shows Daniel's vision of the mountain and the stone that dislodged and fell from it, in conjunction with Psalm 67:16-17; this miniature indicates that the mountain should be understood as a reference to the Virgin who bore the stone (Christ) that detached itself from the mountain to crush the enemies.[8] The Virgin appears with Christ also in conjunction with passages concerning Mt Zion, the place of the New Covenant.[9] It is the Virgin's role in the Incarnation that is of primary concern in this psalter imagery. In an eleventh-century psalter, Vat. gr. 1927, figures prostrate themselves before a bust of the Virgin and Child to illustrate Psalm 71, with its implied reference to the Incarnation in verse 6: 'He shall come down like rain upon the mown grass'.[10] In the frontispiece to a psalter in Oxford, of around 1105 (Bodl. Barocci 15), David opens a codex in the presence of the Virgin, who appears this time in the form of her icon, as the Virgin Eleousa, a process of substitution that can be observed in other kinds of manuscripts as well.[11]

One New Testament passage was incorporated verbatim into Old Testament manuscripts, namely the Magnificat, the words of praise voiced by the Virgin after the Visitation (Luke 1:46-55). Her words became one of the nine odes appended to a psalter, for liturgical use. The Old Testament odes being often accompanied by portraits of the prophets who had composed them, it followed that the Magnificat came to be accompanied by an image of the Virgin, depicted alone, as were the prophets, in rapt communication with God, either orans or, more often, turned to one side and praying up to Heaven.[12] But there are interesting variants. In the Theodore Psalter of

96. *The Virgin and Joseph seek Christ in Jerusalem*, Gospelbook Laur. VI 23, fol. 106r. Biblioteca Laurenziana, Florence.

97. *The Dormition of the Virgin*, Lectionary Lavra Skevophylakion, fol. 134v. Monastery of the Great Lavra, Mt Athos.

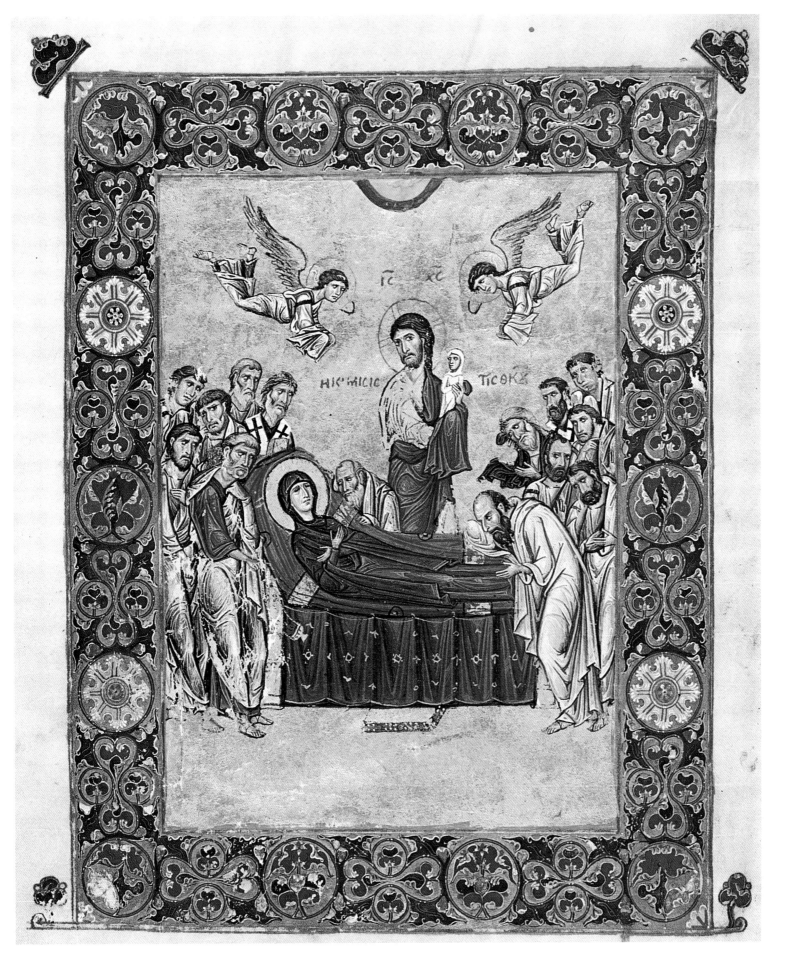

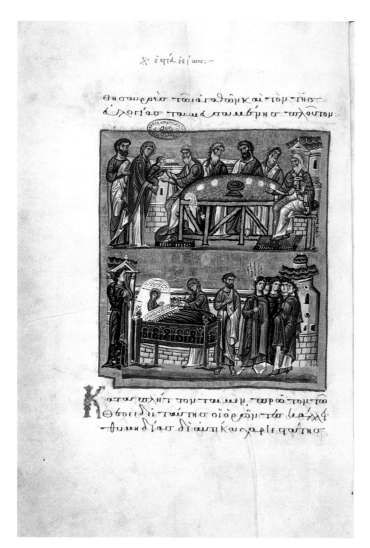

1066 in London (B.L. Add. 19352), the Virgin of the Magnificat is depicted as a standing Hodegetria, holding Christ on one arm (Pl. 99).[13] In another psalter of the late twelfth century (Athos, Vatopedi 851), she is presented as the Virgin of Blachernai.[14] These examples show a growing tendency toward presenting the Virgin in the guise of one of her iconographic 'types'. Some Magnificat images also show the influence of contemporary donor compositions: in another psalter of around 1200, in Jerusalem (Greek Patriarchate, Taphou 55), the Virgin of the Magnificat is not only presented as the Hodegetria, but as receiving the donor of the manuscript, the monk Matthew, who kneels at her feet.[15] She gestures down to him, as does her son, with the result that all immediate connections with the text — her song of praise to God — have been interrupted: the Virgin of the Magnificat has become a figure to whom prayers are addressed, not a figure addressing God herself.

In the Middle Byzantine period, it is as this recipient of prayers, and as intercessor with Christ, that the Virgin comes into her own in manuscript illumination. She receives penitent monks in Paradise and leads them to Christ.[16] She frequently adorns manuscript frontispieces, full-page images that are no longer tied to texts and play an increasingly devotional role.[17] In psalter frontispieces, she appears in the Deesis, the widely used visual formula of intercession in which she and St John the Baptist are shown flanking Christ and praying for him to show mercy to mankind.[18] In Gospel and lectionary frontispieces, she, as bearer of the Word, is frequently associated with Christ and the four Evangelists, the six figures being depicted on successive pages at the beginning of the manuscript (Pls 95 and 103).[19] Occasionally she appears quite separately, seated with Christ on her lap, a composition that evokes Byzantine apse mosaics.[20]

98. *The parents of the Virgin present her to the priest*, Homilies of James of Kokkinobaphos Vat. gr. 1162, fol. 44v.
Vatican Library, Rome.

99. *The Virgin Hodegetria*, Theodore Psalter of 1066, B.L. Add. 19352, fol. 206v.
The British Library, London.

100. *Daniel prophesies about the great mountain*, Chludov Psalter MS gr. 129, fol. 64r.
State Historical Museum, Moscow.

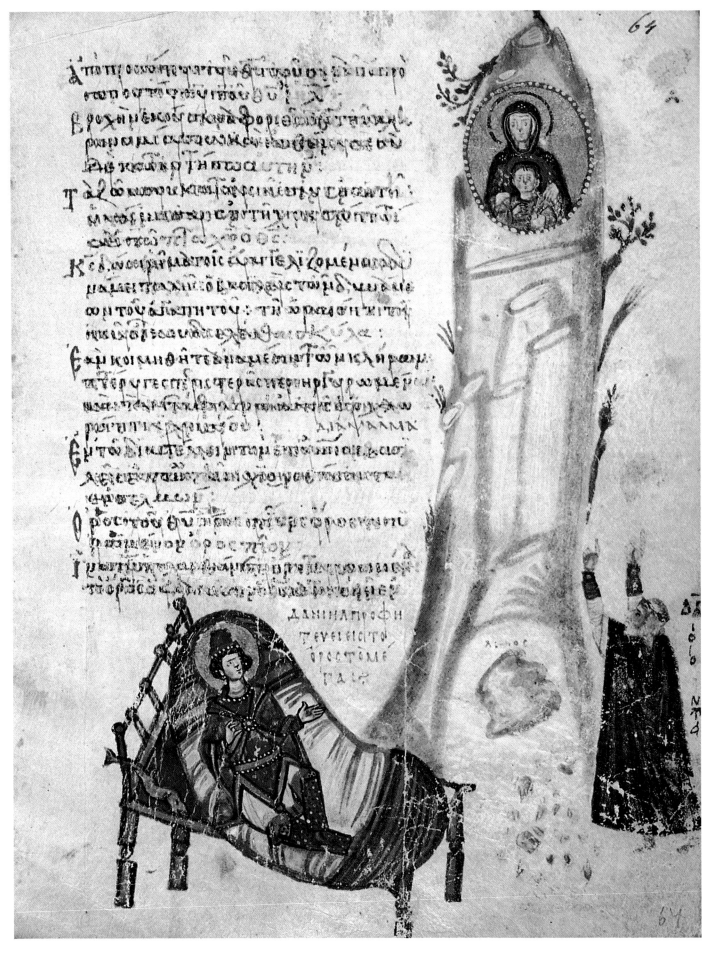

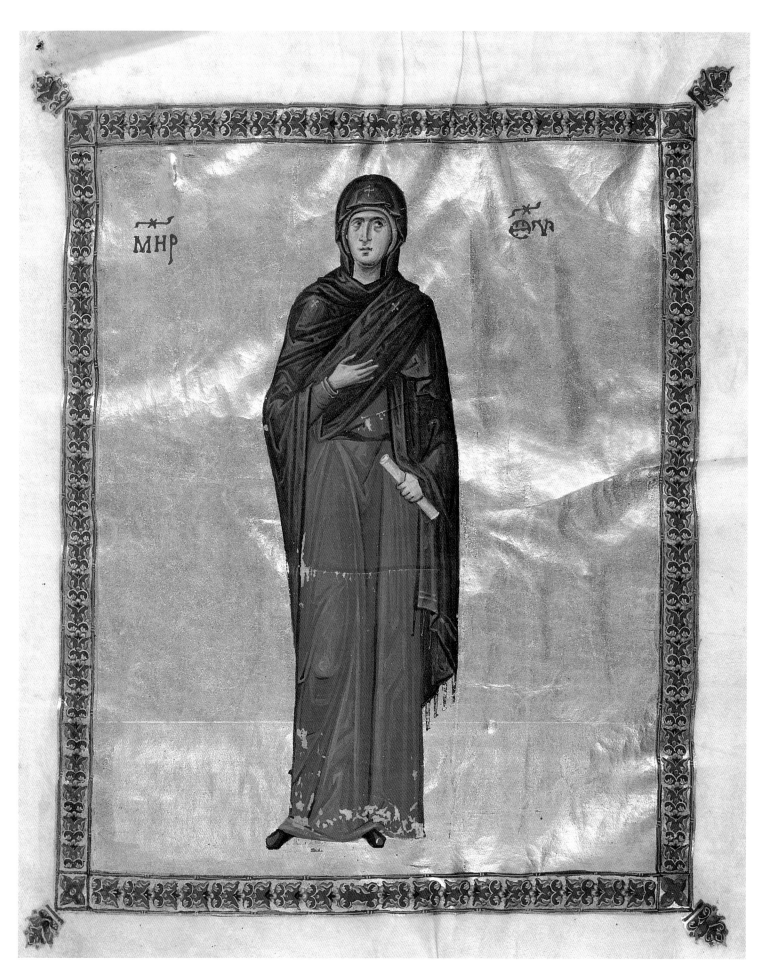

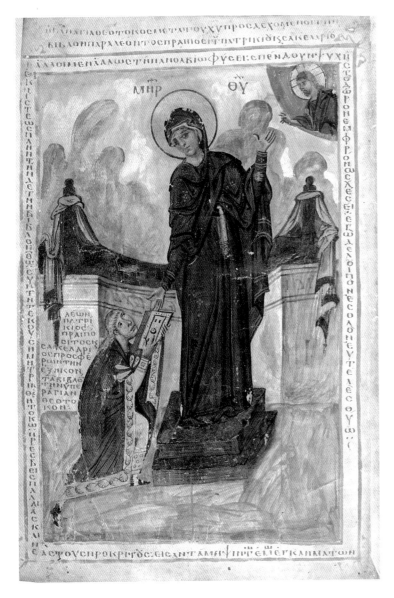

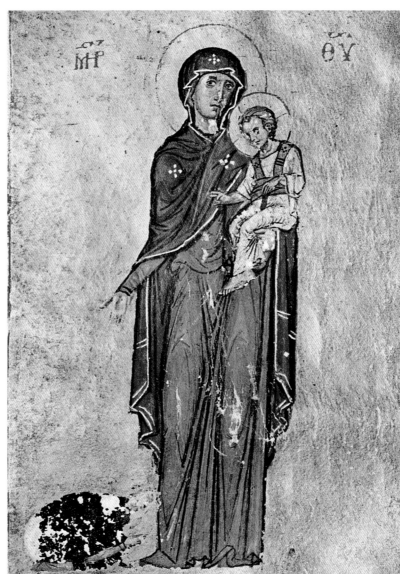

101. *The Virgin and Leo Sakellarios*, the Leo Bible, Vat. Reg. gr. 1, fol. 2v. Vatican Library, Rome.

102. *The Virgin and the monk Sabbas*, Psalter Dionysiou 65, fol. 12v. Dionysiou monastery, Mt Athos.

It is in the donor compositions that the Virgin comes most alive. In the famous Leo Bible of the mid-tenth century (Vat. Reg. gr. 1) there is a frontispiece miniature in which the donor of the manuscript, Leo Sakellarios, is shown presenting his book to a towering figure of the Virgin; she acknowledges the gift with one hand, and transmits the message to Christ in heaven above, with the other (Pl. 101).[21] She has become the perfect intermediary, the conduit through which the gifts and prayers of mortals will reach the ear of God. Two centuries later, we find basically the same formula in a twelfth-century lectionary on Athos (Lavra A 103), although here the donor's appeal, the Virgin's address and Christ's response to it from heaven have all been written out on the background to the miniature.[22] In two twelfth-century manuscripts, a psalter on Athos (Dionysiou 65) (Pl. 102), and the Melbourne Gospels (National Gallery of Victoria 710/5), the turning Virgin of the Leo Bible is presented as the Hodegetria carrying her Child; Christ now turns in her arms to address the donor directly.[23] The formula reappears in the Palaiologan manuscript known as the Lincoln College Typikon (Oxford, Lincoln College gr. 35): the Virgin, patron of the monastery whose regulations are being established in this document, stands on a verso page receiving a pair of female monastic founders approaching from the facing recto.[24]

The Virgin's ability to intercede for the individual after death sometimes led the composition of donor and Virgin to take a more concrete and dramatic turn. On an eleventh-century frontispiece page now in the St Petersburg Public Library (gr. 291), the Virgin takes Irene Gabras,

103. *The Virgin*, Gospelbook Sinait. gr. 204, p. 3 Monastery of St Catherine, Sinai.

161

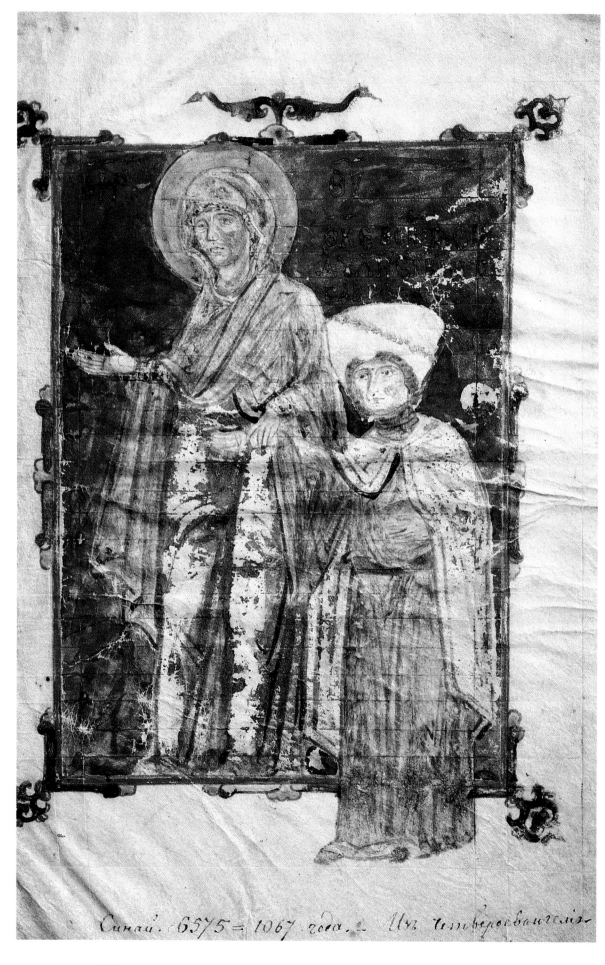

104. *The Virgin and Irene Gabras*, Gospel gr. 291, fol. 111r.
State Public Library, St Petersburg.

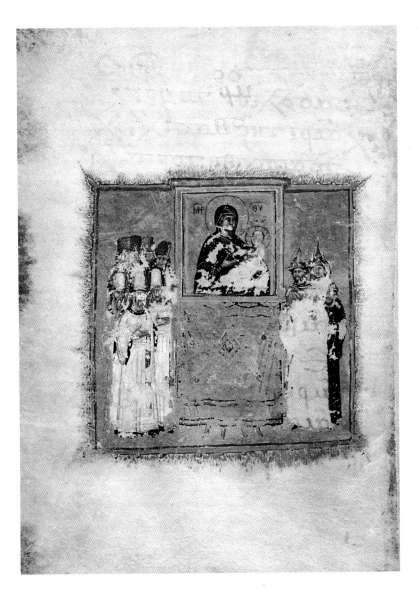

105. *Stanza 24 of the Akathistos Hymn*, MS gr. 429, fol. 33v. State Historical Museum, Moscow.

who, with her husband, commissioned the Gospelbook, by the hand and leads her toward a standing figure of Christ on the facing verso (Pl. 104);[25] in a thirteenth-century Gospelbook on Athos (Iviron 5), the Virgin takes the donor John by the hand to present him personally to Christ, who is seated in judgement, a notary by his side.[26] In the Wake Psalter dated 1391 (Oxford, Christ Church Arch Wake gr. 61), the Virgin is shown forcibly pulling the monk Kaloeidas out of his sarcophagus to face an enthroned Christ on the opposite page.[27] The practice of painting the Virgin and donor on a folio opposite to Christ is a particularly effective way afforded by the manuscript medium of showing at once the dramatic relation between the figures, and the inevitable gulf that separates Christ and the mortal who is approaching him.

In some manuscripts, it is evident that a very specific icon of the Virgin is being depicted. This is the case on a folio in the Hamilton Psalter (Cat. no. 54) of around 1300 (Berlin, Staatliche Museen Kupferstichkabinett 78 A 9), which depicts a family reverencing an icon of the Hodegetria installed in its shrine.[28] An icon of the Virgin Nikopoios on a stand is shown being venerated by laymen on an inserted folio in the Benaki Psalter (Athens, Benaki Museum 68).[29] A miniature of the seated Virgin and Child is labelled the Tiberiadiotissa in a lectionary of 1152 in Jerusalem (Greek Patriarchate, Anastasis 9); whether the miniature represents an icon of this Virgin, or an image in the apse of the church of the Virgin of Tiberias, the church for which the manuscript was made, is not clear.[30]

The expansion of the role of the Virgin in Byzantine manuscript illumination is mainly a feature of the Middle Byzantine period. During these years we sense a desire to transform any image of the Virgin, whatever the context, into a figure who is actively involved in protecting and interceding. But there is also a growing ambivalence regarding the nature of her image, with the Virgin being increasingly represented by an icon of herself. Freely moving images of the Virgin are gradually replaced by specific recognizable 'types' of the Virgin, suggesting that though the Virgin on the page was deemed to be the recipient of prayers, it is through her icon that she is to be most effectively approached.

Behind all this lay developments in both manuscript and in icon painting. As books, like psalters and Gospels, became devotional objects, their frontispieces, now detached thematically from the main body of manuscript imagery, were being more and more designed for private veneration. Through her pose and gestures, the Virgin of these frontispiece pages not only offered visual confirmation of the prospect for salvation of the manuscript's patron, but also invited the prayers of any individual opening the manuscript. At the same time, under the growing influence of icons in general, and of icons of the Virgin in particular, images of the Virgin and Child, even in psalters, came to be presented more as *icons*, even if not always framed as such. The Palaiologan Akathistos manuscript in Moscow (State Historical Museum 429) provides a case in point (Pl. 105).[31] The narrative stanzas of this venerable hymn dedicated to the Virgin are illustrated with narrative miniatures based for the most part on traditional Gospel iconography; those glorifying the Virgin, by

contrast, show a sequence of frontal images of the Virgin and Child, almost like a sequence of icons. In the last strophe of the hymn, the Virgin is in fact entirely replaced by her icon, with members of the clergy and a choir assembled around it: the veneration expressed in the words of the hymn is being actually acted out before our eyes.[32]

These venerating figures, though they proclaim her glory, in effect distance us the viewers from the Virgin. It would appear that the direct access to the Virgin enjoyed by the viewer in the earlier manuscripts has been replaced in the Palaiologan period by the liturgical process and by her icon at work within it. The frontispiece image of the intercessory Virgin, so favoured in Middle Byzantine times, has become a rarity, and manuscript illumination became once again a relatively minor medium, at least by comparison with that of other media, in which to encounter and venerate the Virgin.

[1] Paris, B.N. gr. 74: Omont n.d.; Florence, Biblioteca Medicea-Laurenziana, Plut. VI 26: Velmans 1971. Only the two Last Judgement scenes in the Paris Gospels (on fols 51 and 93) show a different, less narrative, side, one not called for in the text, and of more immediate concern to the viewer: the Virgin already enthroned in Paradise, and interceding with the judging Christ. On these pages, Spatharakis 1976, 61-67, fig. 31 (fol. 93); Lowden 1997, fig. 176 (fol. 51 in colour); Ševčenko, forthcoming.

[2] On illustrated lectionaries, Weitzmann 1980, and Dolezal, forthcoming.

[3] Lafontaine-Dosogne 1992[2], 1. For the apocryphal life of the Virgin known as the *Protevangelium of James*, James 1924, 38-49; Hennecke and Schneemelcher 1963, 1, 370-388.

[4] The homilies have not been translated into English. For the Greek, *PG* 127, 544-700. On the author James of Kokkinobaphos, Jeffreys 1982, 63-71. The illustrated versions are Vatican gr. 1162 and Paris, B.N. gr. 1208. There is a facsimile of the Vatican manuscript with an invaluable introductory volume by Hutter and Canart 1991. For the Paris manuscript, Omont 1927. On the relation between the two manuscripts, and the works relating to the Kokkinobaphos master, Anderson 1982, 83-114. Also Maguire 1983, 377-392, esp. 381-383 on the Annunciation sequences in this pair of manuscripts.

[5] See the succinct summary of the content of these homilies by Hutter 1991, 15-16.

[6] Lafontaine-Dosogne 1992[2], 1, 196-201, 211-212; Hutter 1991 (introduction to the facsimile), 17, no. 2.

[7] Corrigan 1992.

[8] Corrigan 1992, 37-40.

[9] The actual Zion church in Jerusalem was dedicated to the Virgin, and the miniature in the Chludov Psalter appears to be aiming at depicting the actual church when explicating this passage visually: Corrigan 1992, 52.

[10] Fol. 126v: De Wald 1941, pl. XXX.

[11] Fol. 39v: Hutter 1977, 1, fig. 204; 3, 332; Cutler 1984, fig. 226.

[12] Cutler 1984, passim; Weitzmann 1976b, 67-84, esp. 79-80, rpr. in Weitzmann 1980.

[13] Fol. 206v: Der Nersessian 1970, fig. 323. The same image occurs in another 11th-century psalter (Vat. gr. 752, fol. 485r): DeWald 1942, pl. LVIII. In this case, the image accompanies a commentary to the Magnificat. On a late 13th-century leaf in St Petersburg (State Public Library gr. 269, fol. 4r) taken from a psalter on Sinai (gr. 38), the setting is like that of an apse: the Virgin sits on a throne under a large dome, with the Child on her lap, flanked by the angels Michael and Gabriel: Cutler 1984, fig. 156. The opening words of the Magnificat are written on a scroll the Virgin holds.

[14] Fol. 190v: Cutler 1984, fig. 87.

[15] Fol. 260r: Cutler 1984, fig. 152. This is the only such portrait in this manuscript: the prophets accompanying the other odes are enclosed in roundels. The kneeling figure of Matthew the monk is essentially praying before the image, as the lower part of his body is outside the frame.

[16] For the Virgin as intercessor in illustrations to the penitential canon, see the Vatican Climacus manuscript (Vat. gr. 1754): Martin 1954, figs 249, 257, 269, 277; Ševčenko, forthcoming.

[17] Carr 1982, 3-20; Carr 1980, 130-161, esp. 136.

[18] For example, in a psalter of around 1100 in Berlin (University Library 3807, fol. 2r: Cutler 1984, fig. 101), and in one of the early 12th-century in Cambridge, Mass. (Harvard College Library gr. 3, fol. 8v: Cutler 1984, fig. 110). In the latter, a donor kneels at the feet of the Deesis figures.

[19] For example, Princeton University Garrett 6 of the 9th century, fol. 11r: *Illuminated Greek MSS*, fig. 1; Sinai 204 of the late 10th century, 3 (=2r), Weitzmann and Galavaris 1990, 1, 44, fig. 94 and col. pl. IV. The Princeton miniatures have been inserted into a 12th-century Gospelbook, but they

were surely designed as frontispieces.

[20] Carr 1982, esp. 6-7. Examples include the frontispiece (fol. 12v) to the 12th-century Gospelbook Princeton University Garrett 5: *Illuminated Greek MSS*, fig. 58, or that to a psalter in Vienna of around 1077 (Österreichische Nationalbibliothek theol. gr. 336, fol. 16v): Cutler 1984, fig. 314.

[21] Fol. 2v. Facsimile: Dufrenne and Canart 1988.

[22] Fol. 3v: Spatharakis 1976, fig. 45. Cf. Ševčenko 1994a, 255-285, esp. 266.

[23] Dionysiou 65, fol. 12v: Pelekanides et al. 1973, fig. 123; Melbourne Gospels, fol. 1v: Galavaris 1995, fig. 141; Buchthal 1961, 1-13.

[24] Fol. 10v Hutter 1997, pl. 15; Hutter 1995, 79-114, esp. 87, figs 8-9. The Virgin is entitled ΄Η ΑΙ ΑΙ \Ε , although the 'type' used is that of the Hodegetria.

[25] Fol. 3r: Weitzmann and Galavaris 1990, fig. 225; Ševčenko 1994a, 275; Cutler and Spieser 1996, fig. 258 (col.). These prefatory miniatures were removed from Sinai gr. 172 in the 19th century. The Virgin is enclosed within the picture frame; Irene stands slightly before it. The donors commissioned the manuscript in 1067.

[26] Fol. 457r; Spatharakis 1976, figs 54-55. The Virgin's words to Christ on behalf of John are written on the scroll she carries.

[27] Fol. 102v: Hutter 1993, fig. on 238.

[28] Fol. 39v. For bibliography on this manuscript and for a discussion of whether this image is meant to represent the Virgin Hodegetria in Constantinople, or another icon of the Virgin Hodegetria, even one owned by the family itself, see the entry for Cat. no. 54 in this exhibition. The Constantinopolitan Hodegetria icon is shown being visited in her shrine by the Emperor Herakleios, in a 14th-century Slavic version of the *Chronicle of Manasses* (Vat. slav. 2, fol. 122v): Dujčev 1962, fig. 43. An icon of the Virgin captured from the Bulgarians by Emperor John Tzimiskes is repre-

sented in the form of a Virgin Eleousa in the 12th-century manuscript of the *Chronicle of Skylitzes* (Madrid, Bibl. Nac. vitr. 26.2, fol. 172v): Grabar and Manoussacas 1979, fig. 221.

[29] Fol. 194r: Cutler 1984, fig. 358. On the psalter itself, also Carr 1987, no. 2, and Lappa-Zizeka and Rizou-Kouroupou 1991, 56-57.

[30] Fol. 150v: Spatharakis 1976, fig. 283; Carr 1987, no. 47.

[31] Proxorov 1972, 239-252, and Lixačeva 1972, 255-262. On the text of the Akathistos Hymn, attributed to the 6th-century poet Romanos the Melodos, Wellesz 1957. For a full publication of an illustrated Greek Akathistos of the early 7th century, Aspra-Bardabakes 1992.

[32] Fol. 33v: Proxorov 1972, fig. 1. The association of the Virgin Hodegetria with the Akathistos occurs as early as the 11th-12th century: in a Menologion in Messina (Biblioteca Universitaria, San Salvatore 27, fol. 202r), the reading for the Akathistos feast is prefaced by an image of the Virgin Hodegetria (here a *dexiokratousa*): Ševčenko 1990, 77 and Fiches 2D4-2D5.

165

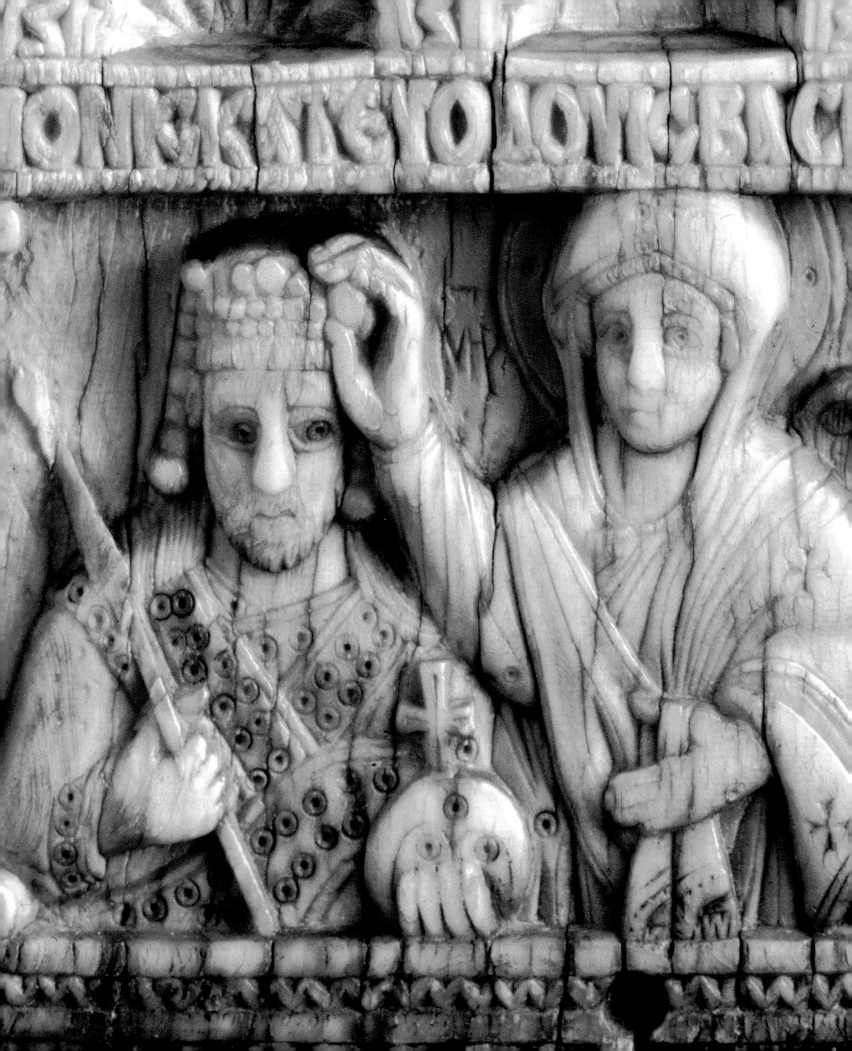

Anthony Cutler

The Mother of God in Ivory

To the mind of a Byzantine of the tenth or eleventh century, the image of the Mother of God in ivory represented a synthesis of the world's most perfect woman and most perfect material. Both the figure depicted and the medium of her depiction were lustrous, immaculate and immortal. Preternaturally pure, silky and durable as no other substance known at the time, ivory was a consummate equivalent of the qualities attributed to the Virgin. About the year 1000 it was regarded as the very emblem of earthly splendour.[1] A century and a half later the historian Anna Komnene found in it the most apt for her mother's beauty: 'from the shape of her hands and fingers you would have said that they were wrought in ivory by some artificer'.[2] These twin connotations of wealth and grace raised ivory above other materials in which images were made, for it displayed the essential quality of the iconic, that is, it was in itself a sign that shared properties with the image inscribed upon it.

Whether or not Anna was actually contemplating an icon of the Mother of God as she wrote, she surely had one in mind. If the number of surviving examples in ivory is a fair expression of the number made, then by the end of the first millennium the Virgin holding the Christ-Child had by far surpassed her son alone as the favourite object of devotion.[3] This predominance represents the confluence of two, quite independent forces: the development of a body of imagery, itself denoting cultic attention, in which the Mother was emancipated from her role as a secondary element in Christian devotion; and the fact that ivory was obtainable in Constantinople to an extent approaching that of Late Antiquity and far exceeding its availability in and after the twelfth century.[4] In the fifth and sixth centuries, when supply of the material was abundant and resulted in the creation of artefacts far larger and in greater number than in any other period before the Gothic era, Mary, enthroned between angels, shared pride of place with Christ on diptychs, occupying either the entirety of the leaf as a counterpart to her son seated between saints,[5] or more often as a large figure flanked by the Magi and set above or among scenes from the infancy of Christ (Cat. no. 3). These scenes, said to be drawn from the Apocryphal Gospels,[6] furnished parallels to the canonical Gospels' accounts of Christ's life and Passion that surround his image in those instances where both leaves survive. In the case of the sixth-century St-Lupicin diptych in Paris, for example, the conceptual and formal symmetry between the two halves of the object requires no demonstration beyond its reproduction (Pls 107 and 108).

Yet clearly the Mother here, for all her manifest equivalence, is a pendant to her son rather than the object of single-minded devotion. While far from incidental, she remains instrumental, the vehicle through which God took on human form and exerted his saving power. Mary, by contrast, works no miracles: she is a means, not an end, and the events of her life, displayed about her, culminate not in her resurrection but in Christ's entry into Jerusalem, the beginning of the Passion that allows the possibility of human redemption. This ancillary role is similarly proclaimed on other ivories of the time. Among the many scenes on Maximian's throne in Ravenna,[7] the relatively few devoted to the Virgin's life fail to stand out within the cathedra's larger programme of depicting the Economy of Salvation. Most revealing of all in this respect is the infrequency of Mary's appearance on the pyxides, cylindrical vessels cut from sections of elephant tusk and apparently used for

106. *Coronation of Leo VI,*
detail of Pl. 111.

107. *St-Lupicin diptych:*
A. *The Virgin and Child between Angels*.
Bibliothèque Nationale, Paris.

purposes that ranged from containing the elements of the eucharist to receptacles for unguents, medications and incense. The testimony is especially telling, if only because of the number in which they survive: among more than 40 pyxides with Christian iconography, only eight depict the Virgin at all and of these only one, now in Berlin (Pl. 109), is devoted to her biography.

This survey of Late Antique and Early Byzantine examples suggests that although there developed in ivory, as in early icons on wood,[8] the motif of the Mother of God treated frontally and adored by other holy figures, the number of instances in which her image can be described as 'autonomous'[9] is slight beside the frequency of her representation as an adjutant of Christ or as part of a sequence in which the interest is narrative rather than devotional. The question therefore arises why there should be lacking in the second half of the sixth and the early seventh century expressions in ivory of the woman the florescence of whose cult has been so ably explored.[10] That this cult was imperially sponsored lends strength to the belief that our material was not much worked in Constantinople between the end of Justinian's reign and the end of Iconoclasm. Yet it is noteworthy that even where ivory was available in these intervening centuries — as it was in Egypt or Palestine to the craftsmen

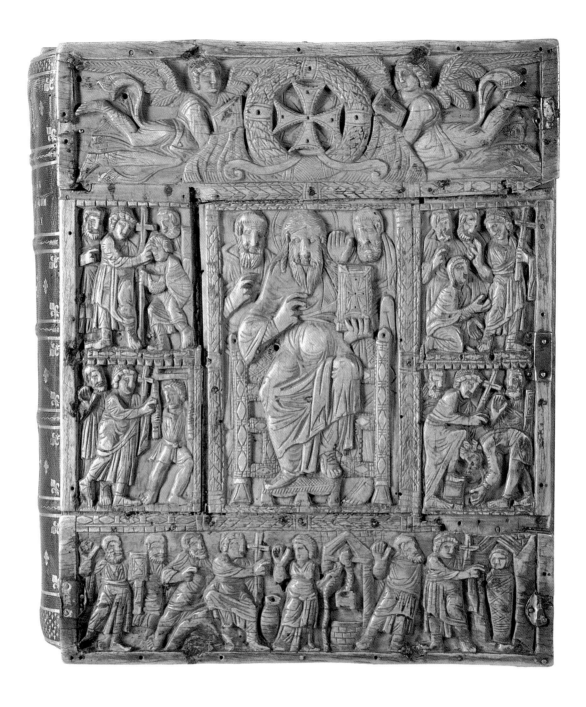

the makers of the 'Grado throne' revetments[11] — there are no surviving equivalents to the diptych leaves bearing the image of the Mother of God, not to speak of the huge number of Middle Byzantine plaques that focus exclusively on her. The only exception to this rule is a Nativity at Dumbarton Oaks (Pl. 110), where she dwarfs the other figures in the scene in contrast to her relatively normal scale on the cathedra of Maximian.[12] This massive slab of ivory comes, however, from a casket or piece of furniture of whose other scenes we know nothing and are therefore unable to say whether, as a whole, it celebrated Mary as its primary figure. There is as yet no evidence of the alteration in her size and significance that would find expression in Middle Byzantine ivories.

Even in the ninth century, after and perhaps because of the Triumph of Orthodoxy, the Mother of God continued to play a part established for her much earlier. On one side of an object formerly believed to be a sceptre tip, but more likely the handle of a box that contained a crown,[13] she is shown crowning the Emperor Leo VI in the company of the Archangel Gabriel (Pls 106 and 111), reproducing the role that Corippus had assigned to her more than three hundred years earlier.[14] Not only is she scarcely taller than the lateral figures but she is once again a pendant to Christ, on

169

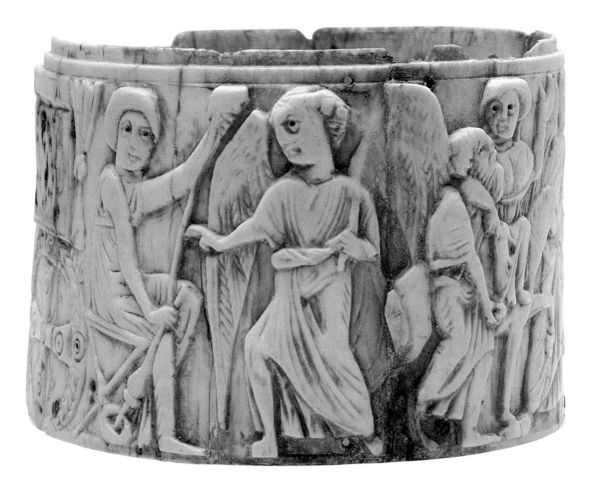

109. *Pyxis with Marian scenes*
Museum für Spätantike und
byzantinische Kunst, Berlin.

the other side of the ivory, flanked by Sts Peter and Paul, as he appears on a great sixth-century diptych in Berlin.[15] But it would be a mistake to limit Mary's function at this time to that of coronation, for she evidently answered many needs. In his second homily, delivered after the Russian attack on Constantinople in 860, Photios describes how 'we were spiritually led on by holding fast to our hope in the Mother of the Word, our God, urging her to implore her Son, invoking her for the expiation of our sons, her intercession for our salvation, her protection as an impregnable wall for us'.[16] Mediation, safekeeping and redemption were evidently now within her domain.

The delay in giving visual expression to long-established beliefs, as in the case of Mary's role in imperial imagery, is even more apparent — precisely because examples of it are so numerous — where the Dormition is concerned. The commemoration of her 'falling asleep' (Koimesis) had been established as a fixed feast of the Church by the time of the Emperor Maurice (582-602), but the earliest surviving examples of its depiction do not seem to antedate the middle of the tenth century. The theme is known first in ivory carving, a medium not usually celebrated as a site for innovation. This suggests that earlier versions may have existed in other materials, perhaps as yet lacking the motif of the *Analepsis* — the ascension of the Virgin represented by the figure of Christ who holds her soul in the form of a swaddled child before transmitting it to the angels above. Be that as it may, the iconography appears remarkably well-established and stable in the 19 examples known in ivory.[17] Minor variations include details such as the woman at the rear of the left group of apostles on the version in Munich (Pl. 112)[18] and the frequent (but insignificant) reversal of the direction in which the Virgin faces.

These ivories of the Dormition represent a twofold enfranchisement of the Mother of God. First, she is emancipated from the narratives characteristic of the early Byzantine world[19] and, secondly, she is honoured as an iconic figure in her own right. Although such 'iconization' had long before been applied to Christ — the Crucifixion standing free of the Passion cycle is the obvious

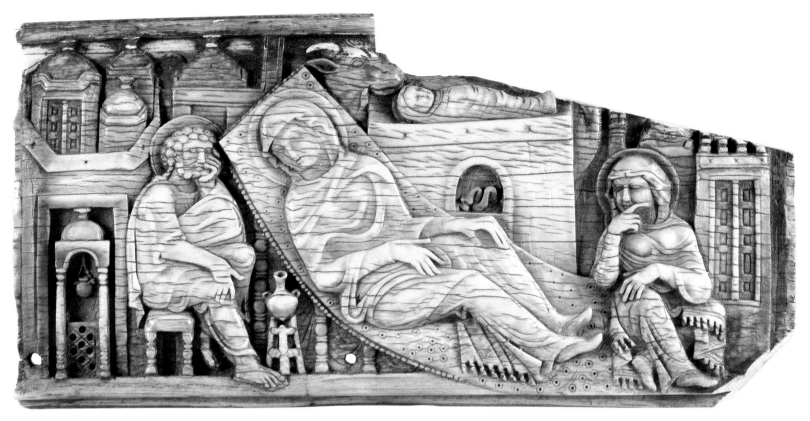

110. *Nativity plaque*
Byzantine Collection,
Dumbarton Oaks,
Washington.

example – tenth-century ivories show Mary holding her son, either enthroned in a manner known on early panels[20] or, more often, as the centrepiece of a triptych where she is attended by saints and/or angels. We do not know whether the plaque from which the Metropolitan Museum's Hodegetria comes (Cat. no. 58) was once part of a triptych or similarly cut from its ground, as on a version at Dumbarton Oaks,[21] and flanked by saints. But that she was the principal figure in whatever constituted the original arrangement is beyond question. No less certain, the craftsman who carved the figure in New York was responsible for the magnificent Mother of God in Utrecht (Cat. no. 57). Given the variety and dispersal in the modern world of the Byzantine heritage, it is a rare event when we can affirm that any two (or more)[22] ivories were products of the same hand.[23] But beyond the obvious stylistic and iconographic resemblances, such technical features as the translucency of the ground around the figures,[24] the succession of graduated folds below the Virgin's neck and in the Child's lap, and the alternately sharp and rounded arrises in the drapery[25] leave no doubt on this point.

By the same token we can distinguish this sculptor from the individuals who carved the three other ivories in the Benaki exhibition. Although they emulate the type of the Utrecht Hodegetria they attain this end by different technical means. The carver of the Walters triptych (Cat. no. 59), while he achieved a comparable translucency, avoided the painstaking undercutting employed on this much finer plaque. He also left traces of the tools he had used (e.g., pick marks in the nimbus of the Child). By contrast, while the makers of the London triptych (Cat. no. 60) and the enthroned Virgin in Cleveland (Cat. no. 19) polished off most such vestiges, the sculptor of the first of these undercut the materials behind Christ's head, around the angels' hands and of course behind the lacy canopy above the Hodegetria; while the maker of the second took similar pains to hollow the hem of her mantle above her right arm and behind her left wrist, not to speak of the amount of ivory he removed from behind the lobes of her throne's dossal.

If this brief account of differences among several craftsmen gives some idea of the diversity of workmanship in tenth- and eleventh-century Constantinople, it will help to understand the range of iconography on display, and, more important, serve to undermine the common illusion that even details of subject matter were somehow 'regulated' by a watchful Church. Even the speediest glance

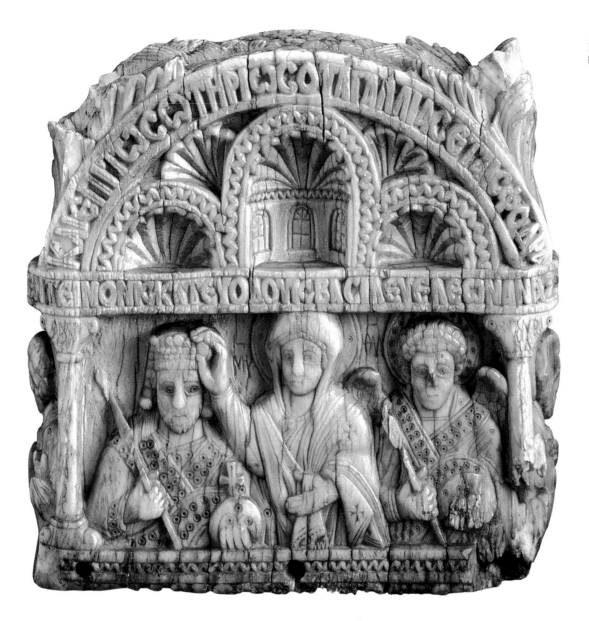

111. *Coronation of Leo VI.*
Museum für Spätantike und
byzantinische Kunst, Berlin.

shows that minutiae of decoration—on Mary's maphorion, for instance, or the moulding on her footstool—vary considerably. But even elements of content that might be supposed to be more important differ markedly from one image to another: the attitude of Christ's 'blessing' hand on the Baltimore triptych for example, departs radically from the corresponding position on the large plaque in Cleveland. Despite this formal variety, the signifying role of these gestures did not differ.

But what of the larger 'programmatic' divergences among our objects? On the plaque just considered the Mother of God is flanked by angels; on the Baltimore triptych, as on that in the British Museum, these creatures are removed to the wings which they share with saints. Yet on the Walters triptych there are no angels whatsoever, while the identity of the saints depicted is quite different even within the small sample of ivories under discussion here. Whether or not the choice of holy men was determined, at least in commissioned works, by the client's preference or the setting in which he or she would install the icon, it is clear that within the broad norms of representation suggested by the objects on display considerable latitude obtained and, since this exists, must have proved acceptable.

Such freedom of choice is surely a more important explanation of the diversity that we have noticed than such practical considerations as size. The height of the central triptych member in Utrecht (Cat. no. 57) and the solitary plaque in Cleveland (Cat. no. 19) is in each case slightly over 25 cm, yet both ivories are dominated by a single large figure. Conversely, the height of the triptych wings

112. *The Dormition
of the Virgin.*
Bayerische Staatsbibliothek,
Munich.

172

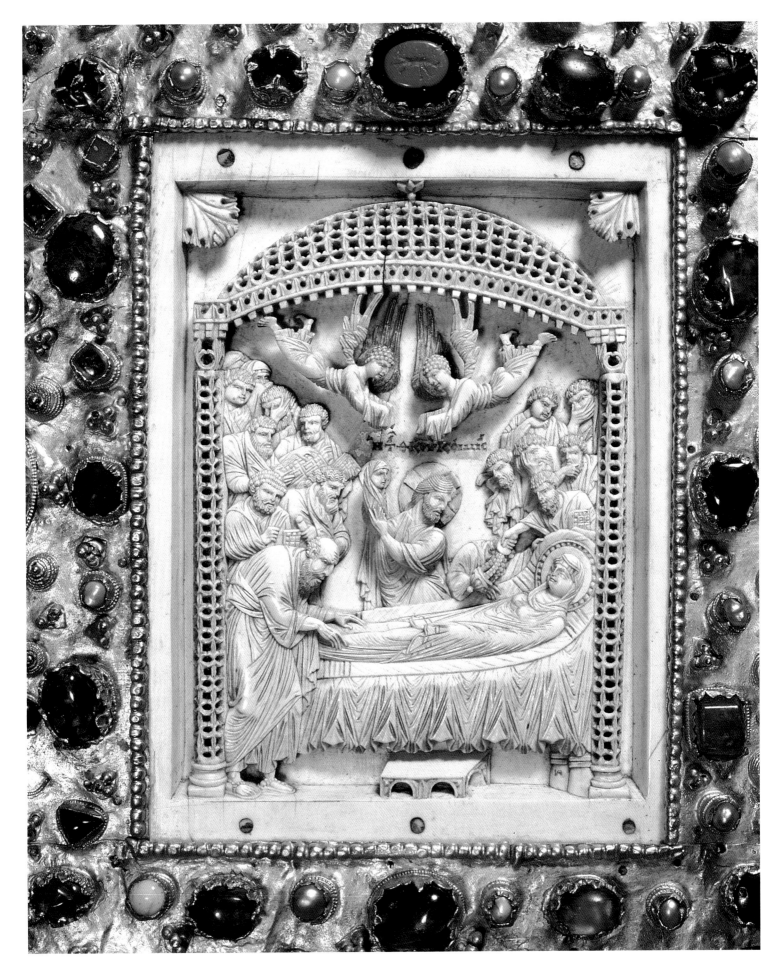

in London (Cat. no. 60) and those in Baltimore (Cat. no. 59) differ by less than half a centimeter,[26] yet the former each carry three figures while the latter have only two. Nonetheless, there are areas where individual sculptors' judgements can be seen to intersect with those of the society of which they formed a part. One such is the relationship between the raw material and the patron's wishes. As we have just seen, the Hodegetria plaques in Utrecht and Cleveland are all but the same height. The main differences between them are, first, the type of Virgin represented and, second, the width of the sections of ivory (13.6 as against 17.5 cm) available to the craftsman. There is an intrinsic connection between these factors. Satisfaction of the client's desire for an image of the Mother on an impressive throne (one without parallel, incidentally, in Byzantine carving),[27] required a panel far broader than that normally to be had in Medieval Constantinople.[28]

A patron's request could be shaped by his or her (rather than the sculptor's) awareness of a venerable model. Thus it seems entirely possible that the commission for the enthroned Virgin on the Cleveland plaque was prompted by an antique exemplar such as the leaf on the sixth-century diptych in Berlin discussed above.[29] The frontal attitude of both the Mother of God and her son, although set up in 867 in the apse mosaic of Hagia Sophia,[30] was, by the end of mid-tenth century, unusual: in ivory at least it had been supplanted by the long series depicting the Hodegetria, consideration of which must be the last topic to be treated in this short essay. But more is involved here than the substitution of Mary standing with her Child on one arm for the more austere image of Christ, erect and central in his mother's lap, regally addressing the beholder. Despite his changed position, the Saviour on the Walters ivory (Cat. no. 59) still commands his audience. But on the London triptych (Cat. no. 60) his gaze is averted and, correspondingly, Mary turns her head slightly toward him, still slightly, it is true, but more obviously than on the plaque in Utrecht (Cat. no. 57). It is tempting to map this iconographic evolution onto a chronological schema, yet the truth is that we have no independent grounds on which to suppose that the apparent increase in tenderness represents a development over time rather than a difference of attitude between distinct but contemporary sculptors.

It has been suggested that one of the earliest surviving depictions of such sentiment is the wall-painting depicting Mary pressing the Christ-Child to her cheek in a niche at Tokali Kilise (Pl. 18) in Cappadocia, now usually assigned to the tenth century and thus roughly coeval with our images of the Hodegetria.[31] Yet, even if this image is correctly dated, it does not help us understand the development of our ivories, a medium which never displays so overt a sign of material feeling. Rather, we can discern a variety of expressiveness, demonstrated in objects that could belong to the same period or, conceivably, evolving by minute stages that we are unable to connect with a timetable measured in decades. We can recognize but not date the elements in a gamut of sensibility that runs from the severe to the compassionate, in which the Mother of God turns frequently and in a variety of ways, but not necessarily in temporal progression, toward her son.[32] It would be nice to know that the plaque that carries this movement furthest was truly made at the end of the tenth century, as has been presumed,[33] or that one in which the Christ-Child touchingly looks up at Mary while tugging on her mantle belongs to the eleventh.[34] Neither these nor the majority of the ivories that display Mother and Son in this relationship bear any inscriptions; we are thus in a different cognitive universe from one in which epigraphy is supposed to reveal transformations in the realm of human emotion.[35] But we can be sure that ivory plaques, limited in size by nature and in availability by geography and economics, provided the most fortunate inhabitants of the Middle Byzantine world with a vehicle that gave expression to their sense of aesthetic and their need for the holy.

[1] Thus Symeon Metaphrastes, *Vita S. Charitonis*, *PG* 115, 910B, on the ivory beds and soft covers enjoyed by the rich as they sleep.

[2] *Alexiade*, Leib 1937, 112, lines 21-22.

[3] Goldschmidt and Weitzmann's (1979²) standard corpus of Middle Byzantine ivories, which is incomplete but representative of the number of pieces that we now know, lists 32 examples in which she is the main figure as against 20 of Christ.

[4] Cutler 1985, 20-30.

[5] Volbach 1976, no. 137; Cutler 1994, fig. 3.

[6] *ODB*: 1744-1745.

[7] Morath 1940.

[8] Weitzmann 1976a, 13-18, pls III-VI; Belting 1994, 30-35, 57-59, pls III, IV, VII.

[9] Freytag 1985.

[10] Cameron 1978, 79-108.

[11] Cutler 1985, fig. 16; Weitzmann 1972, 43-91.

[12] Cf. Volbach 1976, pls 73, 111.

[13] Cutler 1994, 200-201.

[14] On the 'coronation dream' in the eulogy of Justin II by Corippus, Cameron 1978, 82.

[15] See n. 5, above. Christ, Sts Peter and Paul are described as set below arches on a textile in Paul the Silentiary *Descriptio Sanctae Sophiae*, much as they are represented on the Berlin ivory. Mary, who is described on another textile as having 'joined the monarchs' by her hand, clearly appears on the ivory in a setting dependent on that of Christ.

[16] Trans. Mango 1959, 102.

[17] Later accretions in other media would include the cloud-borne apostles arriving at the scene and Jephonias the legendary Jew who tried to upset her bier.

[18] Goldschmidt and Weitzmann 1979², 2, no. 1, saw two women in this situation, but there is only one.

[19] Although in the form of the much-contested 'Feast cycle' collective representations of this sort persist in ivory either as images framing a central scene, as in a Nativity in the Louvre (Goldschmidt and Weitzmann 1979², 2, no. 4), or else as sequences in their own right (Goldschmidt and Weitzmann 1979², 2, nos 42, 59, 198).

[20] Weitzmann 1976, pls IV-VI; Belting 1994, pl. II.

[21] Weitzmann 1972a, no. 26.

[22] The same individual was also the sculptor of the half-length Mother of God on a plaque in Berlin (Goldschmidt and Weitzmann 1979², 2, no. 50), the frame of which was inscribed with the name of Bishop Bertold of Toul (996-1018) after this ivory was transmitted to the West. Cutler and North, forthcoming.

[23] For another example, Cutler 1998, study XV.

[24] This feature of the New York Virgin is no doubt enhanced by the removal of material from the reverse to create a reliquary. But it would be defeated by the insertion of a relic, leading us to believe that the excavation of the back is a later, and probably western, alteration to the ivory's original state. The translucency of the Utrecht plaque is all the more remarkable in light of its unusual thickness (11 mm). The maximum thickness of the New York Hodegetria is 14 mm.

As in the case of other ivories in which central figures have been cut free from their supports (Cutler 1994, figs 4, 13, 112, 197), it is a fair assumption that such steps were taken in modern times to remove the vestiges of broken, paper-thin grounds.

[25] See the detail-photographs in Cutler 1994, figs 30, 134.

[26] The frames of all three parts of the Baltimore triptych have been cut down. Before this modification its dimensions would have been very nearly those of the British Museum triptych.

[27] It has recently been demonstrated that the enthroned Virgin and Child from the Dutuit Collection in Paris is a western derivative of the Cleveland plaque. Koenen 1998, 199-227.

[28] It might be supposed that in order to achieve a wider image, the carvers could simply turn a long section of ivory through 90°. But this would be to ignore the axis of the grain: ivory sculptors always preferred to work with, rather than across, the grain. Cutler 1994, 79-81.

[29] See n. 5, above. For this pose in other media, Kalavrezou 1990, figs 4, 5.

[30] Cutler and Spieser 1996, fig. 92.

[31] Kalavrezou 1990, 172, fig. 16.

[32] For more extended consideration, Cutler 1994, 174-184, figs 195-209.

[33] Goldschmidt and Weitzmann 1979², 2, no. 145.

[34] Goldschmidt and Weitzmann 1979², 2, no. 116, pl. XLIIIb. The archangels are identified by painted inscriptions, but the Virgin is not.

[35] Kalavrezou 1990, 168-171.

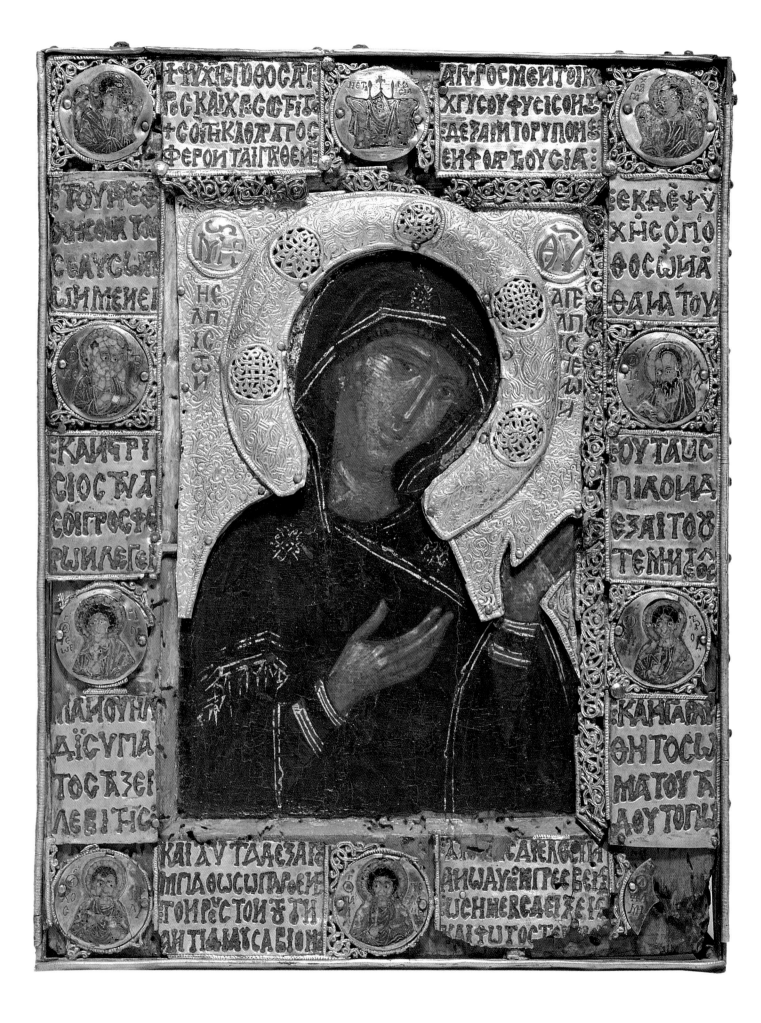

David Buckton

The Mother of God in Enamel

Representations of the Mother of God alone are rare in enamel. Usually she either takes her special place in a series of saints or is seen in such compositions as the Annunciation, the Crucifixion or the Deesis. Even where she appears on her own, on one side of a reliquary cross, for instance, that side is patently intended to be viewed in conjunction with the other, which normally features a representation of Christ, usually crucified. Enamelled metal frames and revetments decorate a number of icons of the Mother of God, but the icons themselves are generally either painted wood or repoussé metal panels: the icon belonging to the cathedral of Freising (Pl. 113), near Munich, is a notable example of the former type.[1]

No enamelled depiction of the Mother of God survives from the Early Byzantine period. Only some half-dozen examples of Early Byzantine enamel are known, dating from the late sixth and early seventh centuries. These are small pendent crosses and other pieces of gold jewellery with motifs—mostly birds—fashioned in a technique more reminiscent of the ancient Hellenistic tradition of filigree enamel than of cloisonné-work, which was at the time primarily associated with the cold inlay of glass and semi-precious stones, notably garnet.

For about a hundred years following the end of Iconoclasm in 843, Byzantine goldsmiths produced western-style cloisonné enamel, with saints' figures and busts, as well as other motifs, in backgrounds of translucent enamel, which was almost always green. The Mother of God is seen in Crucifixion scenes on the Fieschi-Morgan staurotheke in New York[2] (Pls 15 and 17) and on a quatrefoil mounted on the Khakhuli triptych in Tbilisi,[3] (Pl. 120) both probably dating from soon after the defeat of Iconoclasm. Slightly later in the ninth century, she appears twice on the Beresford Hope cross in London,[4] (Pl. 173) half-length in a Crucifixion scene on the obverse and full-length in an orant pose on the reverse, surrounded by busts of St John the Baptist, St Peter, St Andrew and St Paul, and on one of two medallions on the Khakhuli triptych.[5] A Deesis on a small triptych from Martvili, also now in Tbilisi,[6] can be dated to around the year 900 by its technical and stylistic development and by its close relationship with a reliquary-cross mounted on a book-cover in the treasury of San Marco, Venice[7] (Pl. 114). The two halves of the cross are divided between the front and the back cover; the half on the front is enamelled with a figure of Christ crucified, while the half on the back shows the Mother of God full-length in an orant pose, surrounded by Greek monograms decipherable as: 'Theotoke, help thy servant Maria *magistrissa*'. At any one time there were two *magistroi* in the Byzantine empire, as well as honorary ones, and more than one may have had a wife called Maria, but a Maria *magistrissa* is known to have been healed by the Mother of God of the Pege around 900,[8] which is close to the date suggested by the style and technique of the cross on the book-cover. The orant figure twice represented on an early tenth-century necklace found at Preslav, Bulgaria, is probably intended to represent the Mother of God.[9]

From around the middle of the tenth century, the cloisonné enamel subject-matter, instead of having a background of translucent enamel, was set into and surrounded by the metal of the plaque; this development produced what is popularly regarded as the 'typical' Byzantine enamel—representations of saints silhouetted against gold. The earliest securely datable example of this new style of enamelling is on the famous staurotheke in Limburg an der Lahn, made between 963 and 985,

113. *Icon of the Virgin Paraklesis*. Diözesanmuseum, Freising.

177

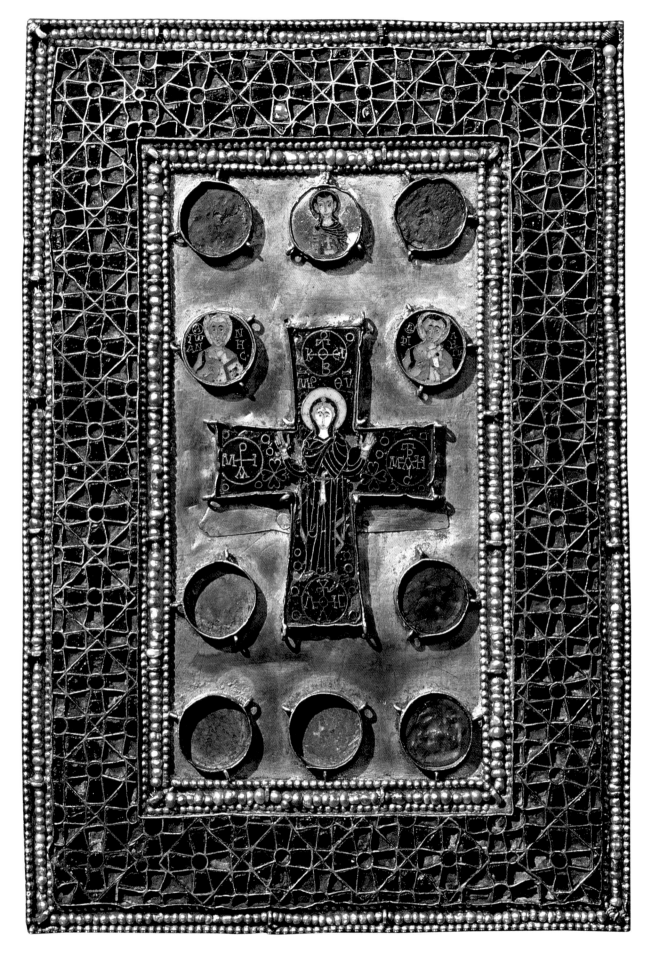

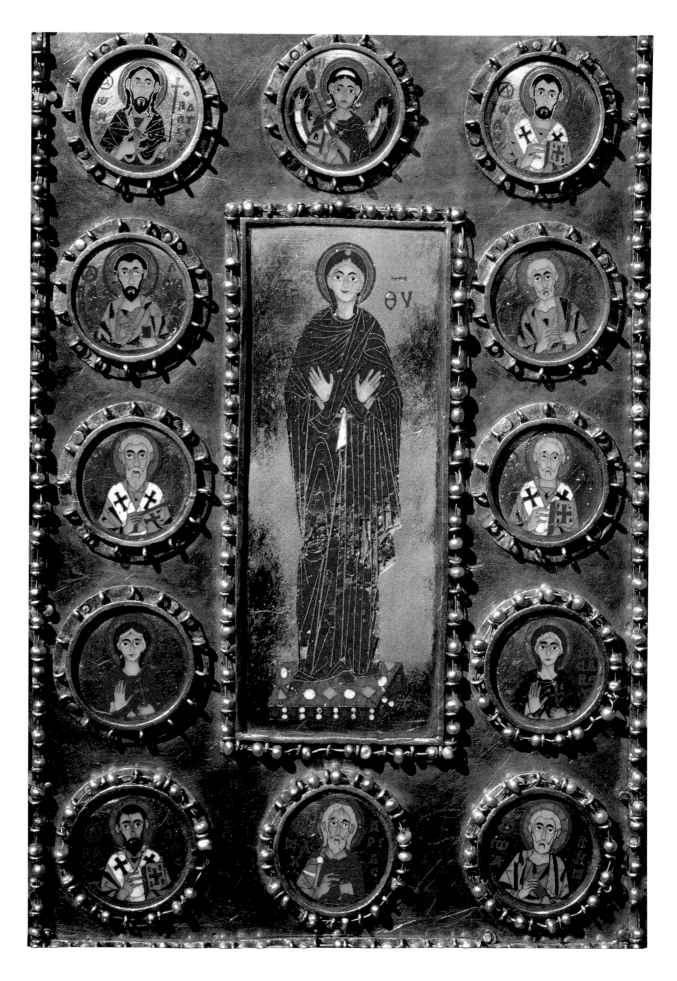

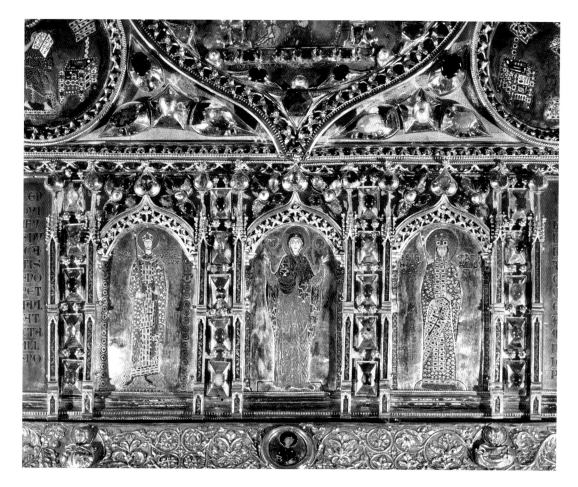

116. *Pala d'Oro*, detail of the lower part with the Virgin. San Marco, Venice.

where the Mother of God appears in an extended Deesis composition, unusually to Christ's left.[10] However, two chalices of an Emperor Romanos in the treasury of San Marco, each of which has a bust or half-figure of the Mother of God (Pl. 135) in the company of Christ and other saints, were almost certainly made for Romanos II (959-963).[11] Rather later, another book-cover in Venice has particularly elegant depictions of Christ and the Mother of God, on front and back respectively (Pl. 115).[12] On the *Pala d' Oro*, the great altarpiece in the church of San Marco commissioned from Constantinople in 1105, a full-length figure of the Mother of God in an orant pose (Pl. 116) occupies the central position below an enthroned Christ.[13]

A tiny oval Mother of God Hodegetria in Washington (Pl. 117) probably dates from the early eleventh century: it has the simplified facial features associated with ninth- and early tenth-century enamels but is executed in the technique that made its appearance only in the middle of the tenth century.[14] Other examples of the 'typical' Byzantine enamel but with simplified facial features include a quatrefoil enkolpion in Richmond, Virginia, on the obverse of which is a full-length figure of Christ flanked by busts of St Peter and St Paul, with, on the reverse, a full-length figure of the Mother of God between busts of St Luke and St John the Evangelist.[15] On a gold reliquary-cross in London (Cat. no. 16) a closely comparable Mother of God is flanked by busts of St Basil the Great and St Gregory Thaumaturgos; the enamel plaque is missing from the obverse.[16]

In the late twelfth and the early thirteenth century enamelled backgrounds were again the fashion, but this time the enamel was opaque; well known examples of this revival include the crucifix found in the tomb of either Queen Dagmar of Denmark (†1212) or her sister-in-law, on the obverse of which the Mother of God is shown in a Deesis arrangement, with St Basil and St John Chrysostom above and below, all represented as half-figures in medallions.[17] The 'typical' Byzantine enamel was not displaced by this new style but continued in production, as is shown by the well-known enkolpion in Maastricht (Pl. 118).[18] Here a generous half-figure of the Mother of God Hagiosoritissa turns in entreaty to Christ, represented three-quarter length in a small seg-

117. *Hodegetria*. Byzantine Collection, Dumbarton Oaks, Washington.

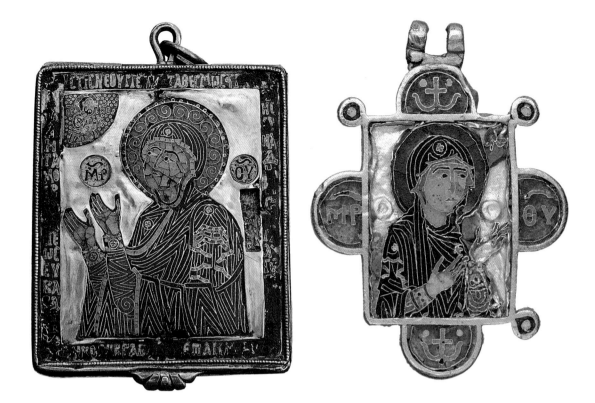

ment of enamel to her right, at the top of the plaque. The abbreviated, partly monogrammatic, inscription MHP ΘY, divided between two medallions let into the gilt ground, and a lengthy inscription surrounding the whole composition are in letters outlined in gold strip and filled with opaque enamel, against contrasting opaque grounds. While the figure of the Mother of God is silhouetted against the metal of the plaque in the 'typical' style current since the middle of the tenth century, Christ and the inscriptions are in the style of the later twelfth and thirteenth centuries, with backgrounds of opaque enamel. Half-figures of Christ Pantokrator and the Mother of God Hagiosoritissa appear back-to-back on opposite sides of a tiny enkolpion in New York (Pl. 119). The Christ is set into and silhouetted against the gold of the plaque, whereas the Mother of God had an opaque enamelled background, now largely lost; abbreviated inscriptions on both sides are in the style and technique associated with the second half of the twelfth century and the beginning of the thirteenth.[19]

The same period saw the introduction of relief enamelling, the precursor of the *émail en ronde bosse* of the Gothic period in Western Europe. The most famous example is on the icon with the full-length figure of St Michael, in the treasury of San Marco, where the face of the saint is enamelled almost 'in the round'; another is on the icon of St Demetrios in the Guelph Treasure, in Berlin.[20] As well as raised, convex, relief, the St Demetrios icon exhibits sunk, concave, relief enamelling, which is also found on a fourteenth-century funerary censer in Athens[21] and on the Sacro Volto icon in Genoa,[22] made not long before the Fall of Constantinople in 1453. The technique, which entails firing the enamel in repoussé or embossed depressions and chased or engraved channels, decorates an enkolpion of the Mother of God Hagiosoritissa in Sofia.[23] Here the full-length figure is cast in gold, with enamel in the halo, the footstool and the fringes of the maphorion, as well as in medallions bearing the customary abbreviated inscription. A small segment in the top right-hand corner of the plaque, from which emerges the hand of God, contains enamel, and round the whole composition is a rectangular step-patterned border in cloisonné enamel.

The Maastricht and Sofia Hagiosoritissa representations are rare survivals in Byzantine enamel of the Mother of God alone or in pride of place. Earrings in Berlin, with filigree enamel depictions of the Mother of God and an emperor by the name of John[24] were certainly made in the late nineteenth or early twentieth century, and several bizarre images of the Mother of God in cloisonné

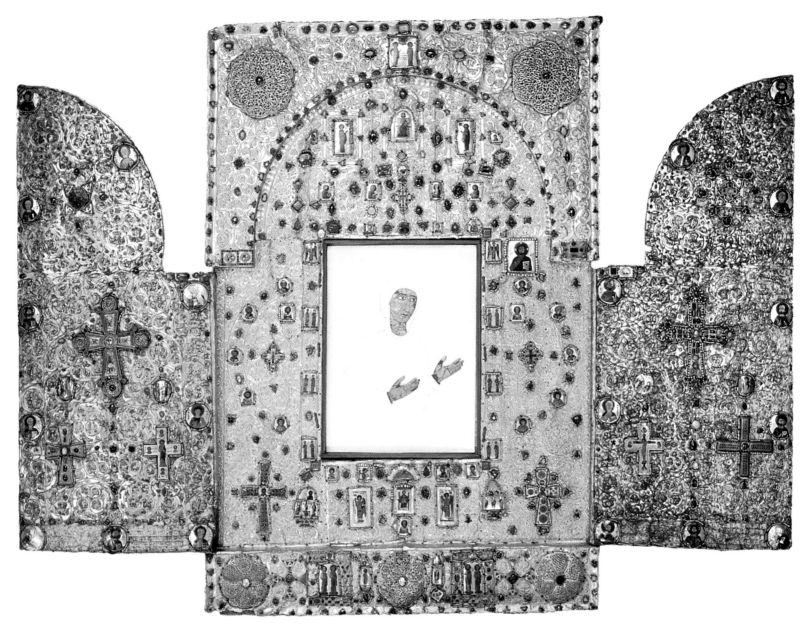

enamel once in the collection of Mikhail Petrovich Botkin (1839-1914) are now known to have been made in St Petersburg between 1892 and 1909.[25]

120. *The Khakhuli triptych.* Georgian State Museum of Fine Arts, Tbilisi.

 The largest and most startling of all representations of the Mother of God in enamel now forms the centrepiece of the Khakhuli triptych, in the Georgian State Museum of Fine Arts in Tbilisi (Pl. 120). It consists of the cloisonné enamel face and hands of a Mother of God Hagiosoritissa, together measuring some 116 × 95 cm. N.P. Kondakov saw the Khakhuli triptych in 1890 and noted that it served as 'a *kiot* (icon-case) for an icon of the Mother of God, consisting in a modern copy of the ancient miracle-working image painted after the model of the Mother of God Chalkoprateia...'.[26] Kondakov would hardly have mistaken a cloisonné enamel representation for a panel-painting: the nineteenth-century icon he saw probably replaced the enamelled face and hands which by 1892 were in Botkin's collection in St Petersburg. These, however, could not have belonged to the original Khakhuli Mother of God, since an account of 1650 describes the face and hands as 'painted beautifully and white', whereas the cloisonné enamel is distinctly purple. A nineteenth-century illustration of the triptych shows a metal *oklad*, set with gems, covering all but the face and hands of the icon,[27] which are subtly different in shape from the enamelled face and hands.

 Kondakov observed that the seventeenth-century description related to 'the original wonder-working icon, now missing, together with the precious stones, when, in the present century, it was

abducted from the church and plundered'.[28] The icon had been stolen from the church of the Gelati monastery in 1859. A metal replacement, based on a drawing, was commissioned from a Moscow goldsmith and presented to the monastery in 1865.[29] The enamelled face and hands now in the centre of the Khakhuli triptych were almost certainly part of this commission, looted between 1865 and 1892 and returned to Georgia in 1923.

[1] Freising, Cathedral, Icon, F 1. Kalligas 1937, 501-506, A', figs 1-3; Xyngopoulos 1957, pl. 17-18, pl. 1.2; *Byzantine Art, an European Art*, no. 214; Wessel 1967, no. 65; Grabar 1975a, no. 16, pls XXIV-XXV; *Rom und Byzanz1*, no. 84.

[2] New York, Metropolitan Museum of Art, 17.190.715a, b. Wessel 1967, no. 5; *Glory of Byzantium*, no. 34.

[3] Wessel 1967, no. 10; Khuskivadze 1984, no. 1.

[4] London, Victoria and Albert Museum, 265/265A-1886. Wessel 1967, no. 8; *Byzantium*, no. 141.

[5] Wessel 1967, no. 9; Khuskivadze 1984, no. 3.

[6] Tbilisi, Georgian Museum of Fine Arts, O.7/b. Wessel 1967, no. 2; Khuskivadze 1984, no. 5.

[7] Venice, Biblioteca Marciana, cover of Lat. I, 101. Wessel 1967, no. 13; Hahnloser 1971, no. 35; *Treasury of San Marco*, no. 9.

[8] *AASS* November III (1910), 884. I am indebted to Nicholas Oikonomides for this reference.

[9] Totev 1983, figs 8, 10; *Glory of Byzantium*, no. 227.

[10] Limburg an der Lahn, Cathedral Treasury. Wessel 1967, no. 22; Ševčenko 1994b, 289-294, pls 166 and 167.

[11] Venice, San Marco, Tesoro, 65 and 70. Wessel 1967, nos 19, 23; Hahnloser 1971, nos 41-42; *Treasury of San Marco*, nos 10-11; *Glory of Byzantium*, no. 31.

[12] Venice, Biblioteca Marciana, cover of Lat. I, 100. Wessel 1967, no. 27; Hahnloser 1971, no. 36; *Treasury of San Marco*, no. 14; *Glory of Byzantium*, no. 41.

[13] Wessel 1967, no. 46. Hahnloser and Polacco 1994, no. 5, pl. IV.

[14] Washington, D.C., Dumbarton Oaks Byzantine Collection, 47.20. Ross 1965, no. 145; Wessel 1967, no. 16; Buckton 1995, 591-596, esp. 591-592.

[15] Richmond, Virginia Museum of Fine Arts, 66.37.8. Gonosová and Kondoleon 1994, no. 41; *Glory of Byzantium*, no. 109.

[16] London, British Museum, M&LA 1965,6-4,1. Beckwith 1975, 29-31; *Byzantium*, no. 165; *Glory of Byzantium*, no. 121.

[17] Copenhagen, Nationalmuseet, 9088. Wessel 1967, no. 59; Lindahl 1980; *Glory of Byzantium*, no. 335.

[18] Maastricht, Onze Lieve Vrouw. Wessel 1967, no. 39; de Kreek 1994, 208-17, no. 8.1; *Glory of Byzantium*, no. 113.

[19] New York, Metropolitan Museum of Art, 1994.40.3. *Glory of Byzantium*, no. 112.

[20] Berlin, Kunstgewerbemuseum, W3. Wessel 1967, no. 55; Buckton 1998, 277-286, col. pl. 20.

[21] Athens, Benaki Museum, 11469. Bouras 1981, 64-70, esp. 67-68.

[22] Genoa, San Bartolommeo degli Armeni.

[23] Sofia, Natsionalen Arkheologicheski Muzei, 487. Vaklinova 1981, no. 25; *Glory of Byzantium*, no. 226.

[24] Berlin, Museum für Spätantike und Byzantinische Kunst (SMPK), 9596, 9597. Schlunk 1940, 42-47, esp. 43, figs 1-2; *Kunst der Spätantike im Mittelmeerraum*, no. 88; Effenberger and Severin 1992, no. 135; *Glory of Byzantium*, no. 167.

[25] Buckton 1988, 11-24; Faberzhe, Goryna and Skurlov 1997, 341-349.

[26] Kondakov and Bakradze 1890, 6.

[27] Kondakov and Bakradze 1890, fig. 1.

[28] Kondakov and Bakradze 1890, 6-7.

[29] Leila Khuskivadze, personal communication. Khuskivadze 1981, 77-78.

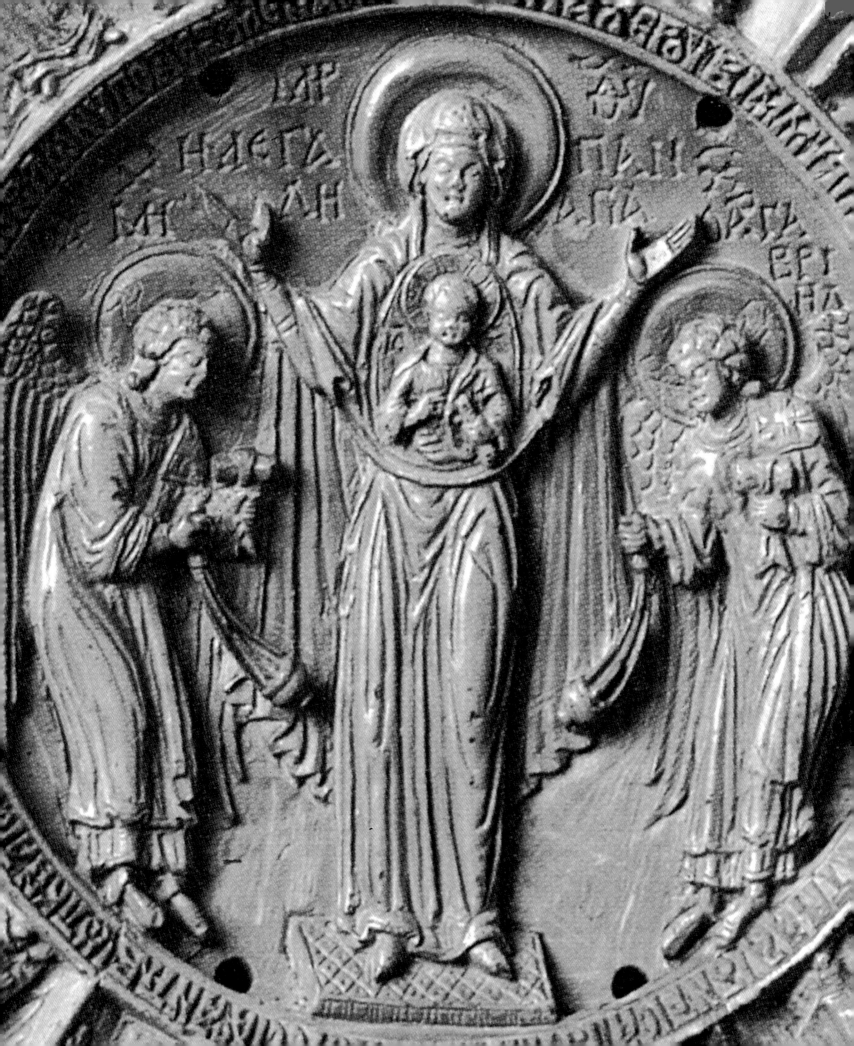

Ioli Kalavrezou

The Mother of God in Steatite

Light green steatite, a soft but very dense stone, served the Byzantines as a material for carving small-scale objects such as enkolpia and portable icons (Pls 122 and 123). From the tenth century onwards steatite became their most favoured material for icons in relief, since ivory, the other material that allows small-scale images to be carved on it, was expensive and not easy to acquire. Steatite however, in the way the Byzantines used it, has one drawback: it is a stone that breaks easily when cut into thin plaques and whose surface wears down easily when rubbed. Thus we have only a relatively small number of whole icons surviving and only a few enkolpia not worn through use. Still, the surviving pieces give us a very good sense of the beauty of these icons, of their variety in size and colour, and of the varying carving styles used through the centuries.

These icons and pendants are privately owned objects and together they make up a body of material that represents the devotional interests and practices of their times. Thus it is important to see what subjects they bear and who the most popular saints are. The figure most often represented, on both icons and pendants, is the Virgin Mary. She is followed by Christ Pantokrator and Christ Emmanuel. In the category of saints, the military saints, as a group, are the most popular. These facts are not surprising since the Virgin had become the most loved and venerated figure among all saints.[1]

In the steatites all the representative types of the Virgin can be found, since the material covers over half a millennium of production. The largest number of these images is found among the category of pendants, that is the most private devotional images. In most cases these are quite small and were framed originally in metal, mostly to protect the steatite and to provide a safer system of suspension. These objects are, however, important, in that they provide the iconographic subjects popular for prayer and protection at the time. For example, the small, thirteenth-century roundel with the Virgin orans, now in Paris (Pl. 122), shows one of the types that best depicts her role as the intercessor.[2] Here she does not hold the Child, but, as the one who knew him best, raises her arms to intercede for humanity, an appropriate theme for an enkolpion. Another is a small plaque which could have been a pendant but also a small icon. It is of the twelfth century and is now in Toronto (Pl. 124).[3] Mary is here depicted seated on a backless throne flanked by two angels standing in veneration with their hands covered. She is shown frontally with the Christ-Child standing on her right knee. He extends his right arm to reach her shoulder, while she inclines her head to embrace him. This scene is not a common one. Although hierarchical in its arrangement, it is a scene of playfulness between mother and child, a depiction of a moment of tenderness and love expressed through the intimate gestures of the figures. Again it is a theme well chosen for an object of private devotion.

One of the best-preserved pendants with the representation of the Mother of God is the small steatite icon of the twelfth century now in Cleveland (Pl. 125).[4] This piece has gained fame because of its unusual history. Since the seventeenth century it is known as the 'Lukasmadonna', and is recorded to have been one of the three pendants that were found in the tomb of Charlemagne. Now mounted in a fourteenth-century frame, the steatite depicts Mary holding the Christ-Child

121. Panagiarion, detail of Pl. 127.

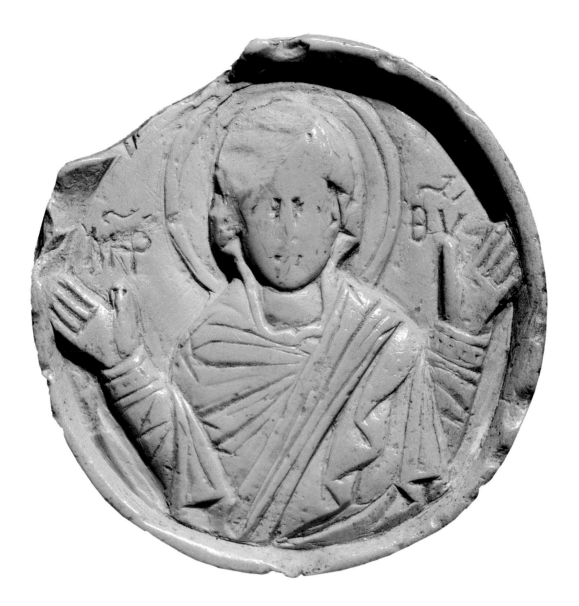

in her right arm and pointing towards him with her left. An inscription on the metal frame claims that the image was made by St Luke. What makes this piece interesting is the fact that, although it was a Byzantine enkolpion, or, perhaps better, because it was a Byzantine image of the Virgin and Child, it was chosen to be placed as a protective amulet around the neck of one of the greatest emperors of the West. This shows the great respect and the popularity that Byzantine images of the Virgin and Child had in the West. It also helps to support the idea that because of the popularity of this Byzantine image of Mother and Child in the West, a number of ivory pieces considered Byzantine, especially in German collections, are most likely western copies of Byzantine prototypes of this image.[5]

The type of Virgin and Child on the Cleveland enkolpion is typical of twelfth-century steatites. Among the larger icons, even fewer of which had survived, is a finely carved plaque with a representation very close in type to the Cleveland image. It is an icon of a full-length figure of the Virgin and Christ, measuring about 15 × 9 cm, which dates from the twelfth century and is now in Stuttgart. Most larger icons depict narrative scenes from the life of Christ, in several of which, the Virgin figures: the Annunciation, the Nativity, the Presentation and the Koimesis (Pl. 123). The Stuttgart icon (Pl. 126) is devoted fully to her. Mary is standing under an arch, holding the Christ-Child on her right arm with her shoulders and head turned slightly towards him. She also directs the viewer's glance towards Christ, through the gesture of her left hand. When the Child is placed in the Virgin's right arm, as it is here, the iconographic type is called the *dexiokratousa.*

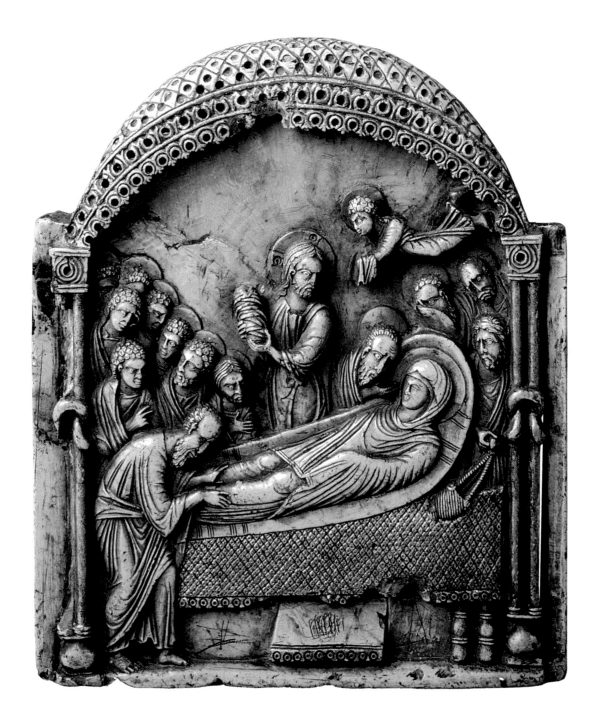

This term identifies the position of the Child and helps distinguish it from the common type of the Hodegetria which looks in pose and gesture exactly the same, only in reverse, so that the Virgin uses her right hand to guide our gaze to Christ. It is interesting to point out that among the steatite icons and enkolpia the *dexiokratousa* is a common type. It is not clear why a certain type of image has become more popular in one medium than in another. For example, I do not believe that among all the ivories we find a *dexiokratousa*. Perhaps this has something to do with prototypes and workshop traditions, which we do not yet fully understand. If a steatite icon with the Virgin and Child was chosen then it seems that the *dexiokratousa* was an option, especially in the twelfth century, to which most of these are dared.[6]

A very nice example of the Hodegetria type in bust is a piece in London in the British Museum (Pl. 128). It is small, only 5 × 4 cm, and unfortunately it has discoloured, possibly from an oily substance that it might have come in touch with, and is slightly brownish in colour. The half-length figure is depicted under an arch, which is supported by columns with animal capitals.

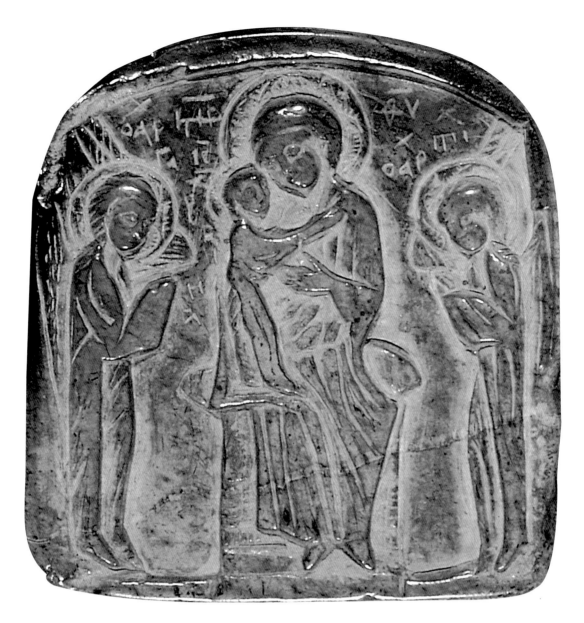

Hymnographers are placed in the two spandrels. Inscriptions identify them as St John of Damascus and St Cosmas the Melodos. Unfortunately the quotes on their scrolls with references to the Virgin are no longer legible. The Virgin, in a majestic pose, holds the Child in her left arm, while with her right hand and the slight turn of her head, she directs the viewers gaze towards him. His head, on the other hand, is turned towards the viewer and he blesses with his right hand. The Virgin on this small icon is further given the epithet ἡ Ἄλυπος, a term that means 'without pain' or 'without grief', an unusual condition for the mother who will lose the son she holds in her arms.[7] The Byzantines stressed from early on, even in visual terms, the sadness and grief that was part of Mary's motherhood and from the eleventh century it is most common to see her sad face while holding the young Child. The most famous of those icons is the two-sided processional icon from Kastoria (Cat. no. 83).[8] An image of the Mother of God 'without grief' is a contradiction in terms, but perhaps here we have a very personal and strong wish of a mother who might have owned this icon. The reading of the quotes held by the hymnographers above would help to solve the meaning of this image.[9]

Beyond the expected popularity of the Virgin in privately owned icons, steatite as a stone had a special relationship to the Virgin Mary. Steatite was the perfect stone for representations of the Virgin. The Byzantines had given steatite the name of Ἀμίαντος λίθος.[10] *Amiantos* in Greek means 'without spot', unstained, pure, undefiled and so on, and *lithos* of course means stone. Most likely

125. *The Virgin and Child.*
The Cleveland Museum
of Art, Cleveland.

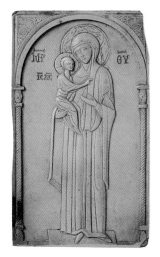

126. *The Virgin and Child.*
Württembergisches,
Landmuseum, Stuttgart.

this name was chosen because of certain qualities of the stone, specifically the availability of a large enough surface, that was not spotted or veined, which could be carved. The prized colour for these icons was a light jade green. These small-scale carvings of pure, unblemished steatite provided a visual contrast to other stones which, even if semiprecious, were usually much darker and veined, and the image thus more difficult to read.

This stone called *amiantos lithos*, pure and unspotted, was the perfect material to receive images of the Virgin. Not surprisingly, *amiantos* is one of the many epithets used to describe and characterize the Virgin. She is the ἄχραντος Virgin, the immaculate and spotless one. The Byzantines enjoyed creating associations and connections between objects, their qualities and their imagery, as much as they enjoyed playing with the etymological meaning of their names. For example, among the poems of Manuel Philes we find several addressed to steatite icons.[11] In these the poet not only plays on the parallel purity of the stone and the Virgin, he also introduces another quality of steatite, which made it special in the eyes of the Byzantines: it did not burn. Thus the poet, while speaking to the icon, reveals the qualities of steatite considered precious. For example, in the following poem he expresses these qualities, with intricate word-plays: [12]

Εἰς ἀμίαντον εἰκόνα τῆς θεομήτορος

Ἄφλεκτος ὑπάρξασα πυρφόρος βάτος
Ἄμεμπτος εἰς ἄχραντον ἐξέσθης λίθον·
Πρὸς γὰς τὸ πῦρ σίδηρος οὐ λίθος μένει·
Κατάσκιον δὲ πάλιν εὑρέθης ὄρος
Τῷ συνδετικῷ τῶν διεστώτων λίθῳ
Ἐγὼ δὲ πηγὴ εὐτυχῶν τεραστίων
Τῷ τοῦ χρυσαργύρου σε κοσμῶ θριγγίῳ
Ναὶ κῆπε Χριστοῦ, ναὶ θεόδροσον φρέαρ,
Τοὺς σοὺς ἀγωγοὺς δαψιλῶς ἀναστόμου·
Τῆς πίστεως γὰρ τὴν χρυσῆν κάλπιν φέρω.

To a Steatite Icon of the Mother of God.

You unburnt burning bush
You have been carved perfect into pure stone.
Before fire iron does not endure, but stone does.
You were found again a mountain full of shadow
For stone binds together things that are apart.
I adorn you, source of marvellous blessings
With a border of gilded silver.
Indeed, garden of Christ, indeed, a well of god-like dew,
Open your channels in abundance,
For I am carrying the golden vessel of faith.

To read and interpret this poem we need to realize that Philes' poems are highly rhetorical. They are structured around elaborate figures of speech and established comparisons, and they use an object, for example, the icon and its subject, as a starting point for metaphysical reflections. Although they never describe the object *per se* for which the poem is written, certain facts about it are being communicated. Here the word ἄφλεκτος (not burnt or consumed by fire) describes the Virgin as the Burning Bush but at the same time refers to the non-flammable quality of steatite. While ἄφλεκτος suggests a physical quality, the adjectives in the second line bring up various nuanced meanings of ἀμίαντος, one appropriate to the Mother of God as the 'blameless' thus perfect mother,

the other to the 'pure' and 'undefiled' stone. The reference to the Mother of God/icon as the garden (κῆπος) of Christ is another reference to the stone icon as having the colour green.[13] In lines six and seven we further find out that the steatite icon received a silver-gilt frame.

One other example, which reinforces the connection between the physical and the metaphysical meaning of ἀμίαντος, is a poem on an icon of the Nativity. Probably not written by Philes himself but included among his poems, it repeats the word ἀμίαντος first in reference to the stone and the second time to the Mother of God.[14]

Στίχοι εἰς λίθον ἀμίαντον ἔχοντα ἐγγεγλυμμένην τὴν Χριστοῦ
γέννησιν καὶ ἄνωθεν τὸν Χριστὸν λεμίον. Τοῦ Ἁγιοαναργυρίτου

Τιμῶ σε, λίθε, κἂν μικρός μὲν τὴν θέαν,
Ἀλλὰ τὸν ἀχώρητον ἐντὸς εἰσφέρεις·
Ἀλλ ὡς ἀληθῶς ἀμίαντος τυγχάνεις,
Τὴν ἀμίαντον ἐντυποῖς γὰρ μητέρα,
Ἥν παρθένον σύνοιδα, κἂν λεχὼ βλέπω
Βρέφος θεὸν κύουσαν, ὦ ξένου τόκου

Verses on a Steatite, which has the Nativity of Christ carved on it
and above the bust of Christ. By the Hagioanargyrites.

I honour you, O stone; although you are small to look at,
Nevertheless you contain within you the uncontainable.
But you are truly unspotted,
because you represent the unspotted mother.
I know she is a Virgin, although I see her in childbed,
Giving birth to an infant God. What strange birth!

Here we see the quality of the material matching the Mother of God in perfection. Despite its small size the poet honours the stone because it contains the uncontainable. Being unblemished (*amiantos*) itself, it is appropriate for the images of the unblemished mother.

The Byzantine connection of the Virgin to steatite is further worked out in the use of steatite for the creation of panagiaria. A panagiarion is a liturgical paten where the prepared bread for the Eucharist is placed. On Mt Athos there are two such panagiaria, one in the monastery of Xeropotamou, the other of St Panteleimon (Pls 121, 127 and 129).[15] The panagiarion has received this name because of its metaphorical imagery and function; it represents the Virgin Panagia as the container of Christ. She is usually depicted at its centre either holding the Child or with the Child in a medallion before her chest. She is the instrument of the Incarnation, and the panagiarion functions itself as the container of the liturgical bread. In the Xeropotamou panagiarion the Virgin is represented in the central medallion, standing full-length with her arms raised and the hovering medallion of Christ before her chest. She is labelled ΜΗΤΗΡ ΘΕΟΥ Η ΜΕΓΑΛΗ ΠΑΝΑΓΙΑ (Mother of the God, the Great All Holy). Two angels cense her, recalling the liturgical censing before Communion. Represented in the outer circle, directly above her head, is an altar under a baldachin, where the Christ-Child as *Melismos* lies on the altar cloth. His sacrifice is made clear through the inscription: Ο ΑΜΝΟC ΤΟΥ ΘΕΟΥ ΤΟ ΑΓΙΩΝ ΘΗCΙΑCΤΙΡΗΟΝ (The Lamb of God, the Holy Tabernacle). On either side Christ as priest administers the Eucharist with the assistance of a series of angels. Here is a typical Byzantine parallelism of imagery and function: the panagiarion is the container of the eucharistic bread, while the Virgin is the container of Christ who will be sacrificed. In visual terms the image of Mary as the Platytera, as this type is often called, is the most direct in depicting the theme of the Incarnation.

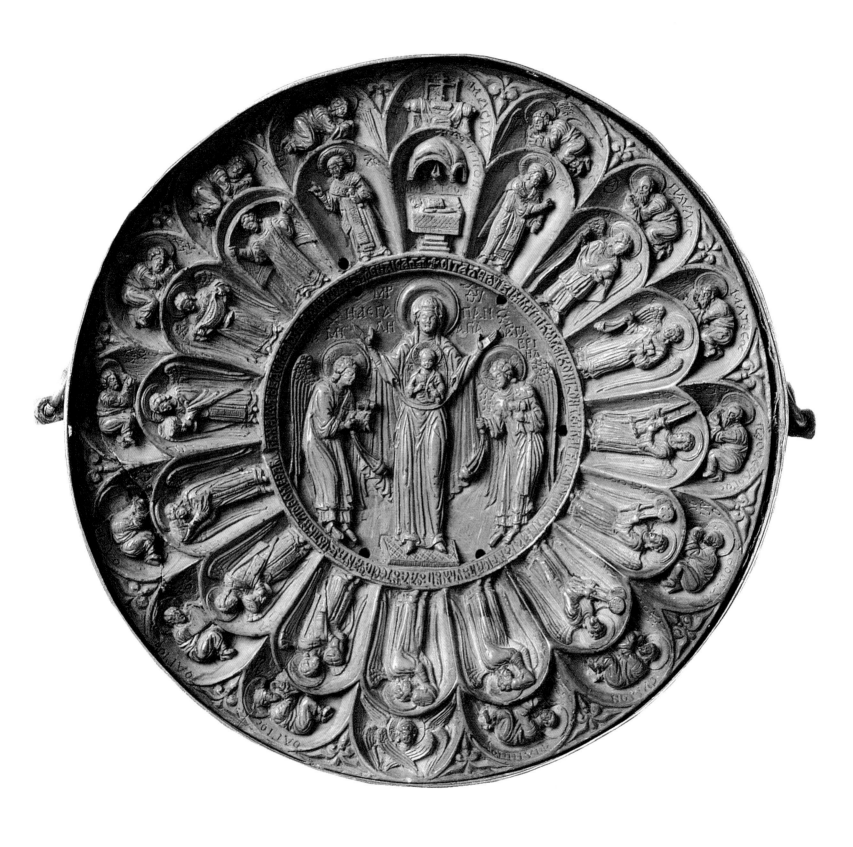

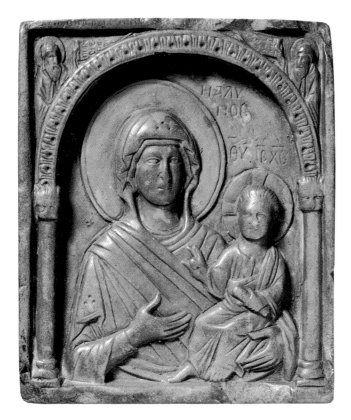

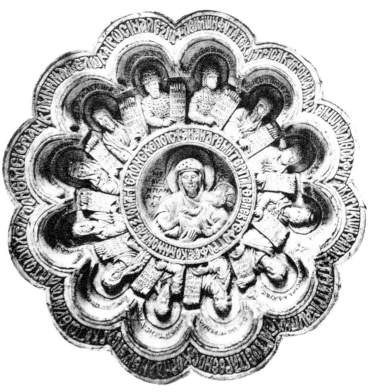

The last poem I would like to discuss is actually carved on the steatite panagiarion of the monastery of St Panteleimon. This panagiarion was intended as a gift to a church by Alexios III Komnenos Angelos, Emperor of Trebizond (1349-1390). This emperor is known for the founding of the Dionysiou monastery on Mt Athos in 1374 and from several of his other gifts to that monastery.[16] His name is mentioned on the panagiarion in two inscriptions. The shorter runs along the inner circle and is a prayer to the Virgin Mother: ΑΝΑΝΔΡΕ ΜΗΤΗΡ ΠΑΡΘΕΝΕ ΒΡΕΦΟΤΡΟΦΕ, ΚΟΜΝΗΝΟΝ ΑΛΕΞΙΟΝ ΑΓΓΕΛΟΝ ΣΚΕΠΟΙΣ. (Mother without husband, Virgin nourishing a child, protect Alexios Komnenos Angelos). The long inscription is the actual poem. It is carved in raised letters and runs along the outer border of the paten. It is written in dodecasyllabic verse:

Λειμών φυτά Τε καί τρισάκτινον σέλας

Λειμών ὁ λίθος, φυτά κηρύκων φάλαγξ.
Τρία τρισαυγιή (sic) Χριστός, Ἄρτος, Παρθένος.
Κόρη δανείζει σάρκα τῷ θεοῦ λόγῳ
ἄρτῳ δ' ὁ Χριστός προσμένει σωτηρίαν
Κομνην Ἀγγέλῳ καὶ ῥῶσιν Ἀλεξίῳ.

The meadow and the plants and the light of three rays.

The stone is a meadow and the rows of prophets are the plants.
The three beams are Christ, the bread and the Virgin.
The maiden lends flesh to the Word of God,
and Christ by means of bread distributes salvation
and strength to Alexios Komnenos Angelos.

Here the poet compares the stone of the panagiarion to a meadow because of its green colour and the depicted prophets to plants. The triple rays of light must symbolize the divine as they

touch the paten: one is the bread and the other two the images of the Virgin and Christ at the centre. Christ is here shown reclining in his mother's arms, so he is at the same time shown as *Melismos*, the young figure of Christ lying on the altar. The theme of the Incarnation in this representation is thus transformed into a liturgical image relevant for a paten. It is through the Incarnation, through Christ's actual body, the bread of Communion held in the panagiarion, that salvation and support will come to Alexios and to all mankind.

These examples, I believe give a good sense of the way the Byzantines used steatite and the close relationship they found to explore between it and the Virgin Mary. It is the poetry that has enriched our perception and understanding of a world of devotional images. *Amiantos lithos,* as pure unblemished stone, suited perfectly the images of Mary as Mother who remained virgin, pure and unconsumed.[17]

[1] For the role of the Virgin as the beloved intercessor for mankind see my introductory essay on the Maternal Side of the Virgin in the present volume, 41-45.

[2] Kalavrezou-Maxeiner 1985, no. 108, 188.

[3] Kalavrezou-Maxeiner 1985, no. 101, 179.

[4] Kalavrezou-Maxeiner 1985, no. 32, 124-125.

[5] This is a topic that needs further research. Some twenty years ago in Munich I remember discussing this problem with Florentine Mütherich who also believed that many of the pieces in German collections are most likely western copies. Recently, a few articles have appeared, which address some of these questions, e.g. Koenen 1998, 199-227 or Borkopp and Schellewald 1995, 147-171.

[6] For examples of the *dexiokratousa,* Kalavrezou-Maxeiner 1985, nos 31, 32- 34, 156, A-36, A-60.

[7] It is for example not listed in Eustratiades 1930.

[8] For a colour plate and bibliography, , *Glory of Byzantium*, no. 72, 125-126.

[9] Some of the letters can be read, e.g. in John of Damascus' scroll ΠΙΑΝΘΙC ΠΑCΙ...? and on the other THN THMOT ? and with further research the quotes might be identified.

[10] For the history and use of the name *amiantos lithos* and the colour, Kalavrezou-Maxeiner 1985, 31-32 and 69-73.

[11] Miller 1855-1857, I, 133, 430, 431; II, 146, 147; etc. The English translations here are by the author.

[12] Miller 1855-1857, II, 146. The typological allegory between the Burning Bush and Mary's virginity can be found in psalter imagery but also in the *Smyrna Physiologus*, Evangelical School, cod. B 8, 166 now destroyed. In this miniature Moses is listening to God's voice which is emanating from the bush. Above him, however, is a suspended icon of the Virgin and Child, which visualizes what cannot be made visible. Strzygowsky 1899.

[13] A similar comparison is made with the panagiarion in steatite discussed below, where the stone is referred to as a meadow.

[14] Miller 1855-1857, I, 430.

[15] Kalavrezou-Maxeiner 1985, nos 131, 132, 205-208. The St Panteleimon panagiarion is now missing. This is most unfortunate since it is the only steatite that, through its inscriptions, can be given a precise date. There is another panagiarion of slightly later date and made of horn in the monastery of Chilandari.

[16] Alexios III's chrysobull can still be seen in the monastery of Dionysiou, where he is depicted with his wife Theodora as their rule is blessed by Christ above, Pelekanidis et al 1978, 36-40

[17] The study of steatite as a material for icons, in conjunction with the close reading of Manuel Philes' poems, bore unexpected fruit. It made sense out of these poems, previously regarded as silly and nonsensical. Philes' poetry is not only sound but sensitive and responsive to the work of art.

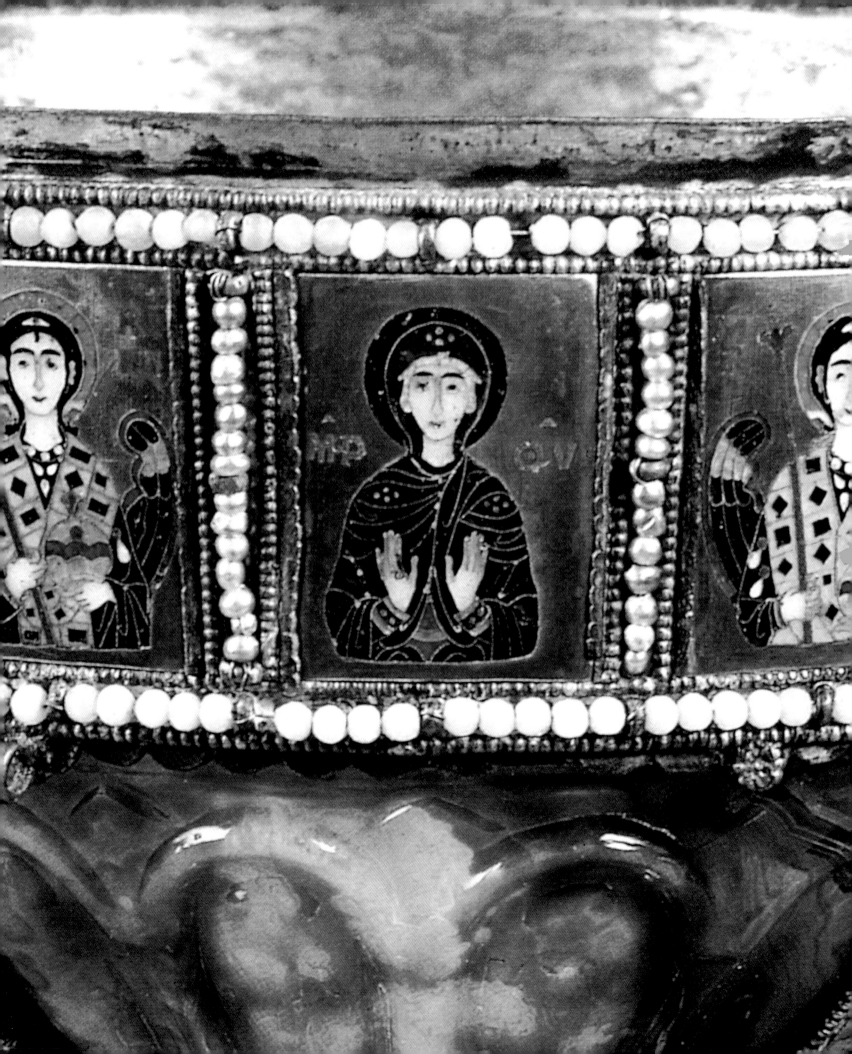

Marlia Mundell Mango

The Mother of God in Metalwork: Silver Plate and Revetments

In contrast to her frequent appearance in other media of Byzantine art, the Virgin Mary is relatively rarely represented on either silver plate (i.e. vessels and related objects) or silver revetments (i.e. sheets of silver used to cover furniture, other extensive surfaces and painted icons). The following paper will examine the evidence relating to the portrayal of the Virgin on silver vessels or revetments, but will exclude related items such as pectoral reliquaries, rings, or bracelets in silver (with versions in other metals) that are classified as jewellery.[1] Similarly, the discussion will take only occasional account of related vessels in gold, enamel-inlay or copper-alloy. The reasons for the relative rarity of the Virgin in Byzantine silver are varied but may be sought first in the nature of the medium and in rates of survival. In the Early Byzantine period, silver plate was made for both domestic and church use. The former continued to feature mostly mythological subjects until the mid-seventh century;[2] Christian motifs eventually appear but figural religious subjects remain rare. A small cross, usually inlaid with niello, occupies the centre of serving plates that were numerous in the seventh century.[3] Religious themes featured on secular domestic vessels include only the Sacrifice of Isaac on a plate in Geneva, the Old Testament cycle of David on a set of plates (stamped around 630) found in Cyprus, the bust of a military saint (with *maniakion*) on a bowl (stamped 641-651) also from Cyprus, the equestrian portrait of a medical saint (?) on a plate reputedly from Homs, Syria, and a pair of angels flanking a cross on another plate.[4] In the Mytilene Treasure in Athens one finds a mix of both Christian and 'pagan' within a single domestic silver service, namely a set of serving plates with a central cross and a wash basin with a naked Aphrodite on the handle (all these objects stamped 613-629/30).[5]

Unsurprisingly, the Virgin is more often — but not often — portrayed on silver objects of church use, many dated to the sixth and seventh centuries. These include chalices, a flask, ewers and a cross, in addition to several censers and reliquary caskets. On most of these she appears with other single figures, while in a few other cases she is part of a narrative scene. On the three Beth Misona chalices and the Homs ewer ('Vase'), the Virgin, Christ, Peter and Paul, and — on the ewer — two angels and other saints, are all portrayed in bust form in medallions[6] (Pl. 131). The Virgin and other figures (Christ and saints) are shown full-length on the Hama flask and Attaruthi and Phela chalices.[7] The Čaginkom cross (stamped 527-547) (Pl. 132), inscribed on the obverse in Armenian, has five incised busts on the reverse: Christ at the top, the Virgin in the centre (Pl. 133) flanked on the lateral ends by angels and an unidentified female saint at the base.[8]

Three censers — one (stamped 540-565), once in New York, and two, one from Mesembria, the other now in Munich (both stamped 582-602) — are adorned with bust or standing figures of Christ flanked by Peter and Paul and the Virgin flanked by angels.[9] The censer (stamped 605-610) in the First Cyprus Treasure has a similar layout of bust figures, except that the angels are replaced by saints.[10] The sarcophagus-shaped reliquary (stamped 550-565) found at Cherson (Pl. 134) also has the same bust portraits,[11] which appear on the contemporary censer in New York. By contrast, the late fourth-century reliquary in Milan and the fifth-century Castello Brivio reliquary are both ornamented with the Virgin featured in the narrative scene of the Adoration of the Magi,[12] which reappears on a sixth-century silver ewer in the Metropolitan Museum.[13] A cycle of scenes featur-

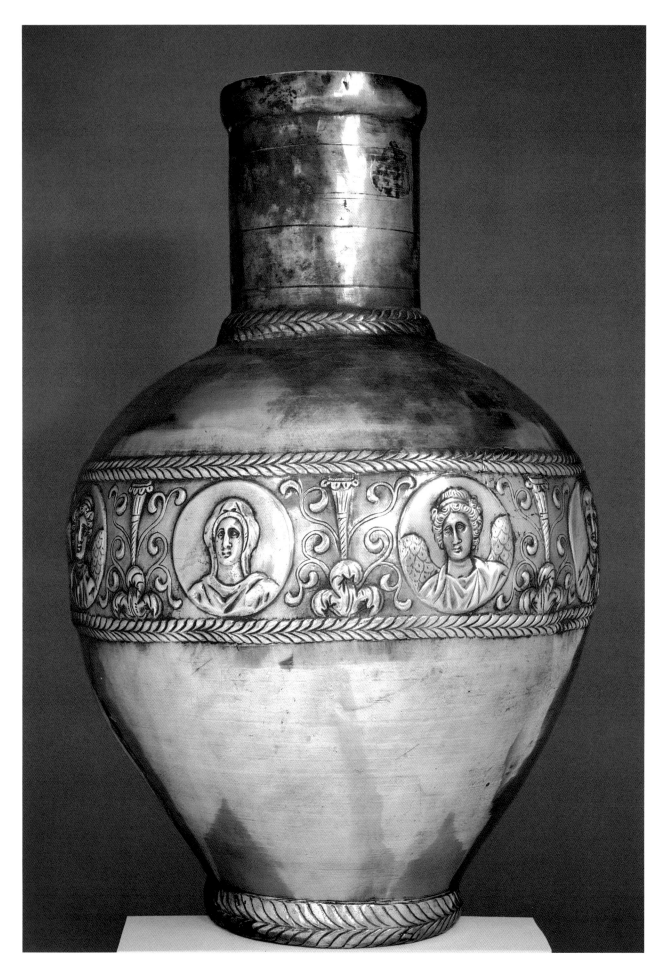

ing the Virgin (Annunciation, Visitation, Journey to Bethlehem, Nativity) decorates the sides of the cylindrical censer (stamped around 550-565) dedicated to the Theotokos, which forms part of the Sion Treasure.[14] The iconographic distribution on these silver objects may be tabulated as follows, with the exception of the Attaruthi chalice about which insufficient details are published:

Table. *Iconographic distribution of the Virgin and other figures on Early Byzantine silver objects.*

	Beth Misona chalices	Mesembria censers	Munich censers	Cherson reliquary	Homs ewer	Cyprus censer	Čaginkom cross	Phela chalice	Hama flask	Milan reliquaries	Castello Brivio reliquaries	MMA ewer	Sion censer
Christ	O	O	O	O	O	O	O	O	O				
Peter & Paul	O	O	O	O	O	O							
Virgin	O	O	O	O	O	O	O	O	O				
Angels		O	O	O	O		O						
Other saints					O	O	O	O	O				
Narrative scenes										O	O	O	O

There is relatively little written evidence for figural decoration on the numerous examples of silver furniture revetments documented in literary sources in the early period.[15] One notable exception included an image of the Virgin: in 563, Paul the Silentiary mentions (*Descr. S. Sophiae*, 682-719) her bust in medallion among those ornamenting the silver covering of the entablature of the chancel screen of Hagia Sophia at Constantinople. Other busts were those of Christ, archangels, the apostles and prophets. If Christ's bust was placed over the central door of the screen, it may have been flanked by those of the Virgin and St John the Baptist, thus forming a Deesis of the type that later appears on Middle Byzantine marble templon epistyles.[16]

In all these cases the Virgin portrayed on Early Byzantine silver is in a subsidiary position, shown either as part of a group of single figures or in a narrative scene. None is a portrait of her alone or holding the Christ-Child. One would expect her portrait to have appeared prominently on a silver reliquary containing, for example, her *maphorion* or other prized relic. Yet it is said that when the church of Blachernai was built in around 468 by Leo and Verina, the casket containing her pallium/omophorion, was of 'gold', not silver, and was adorned with an inscription; no image is mentioned. Instead, according to the text, images of the enthroned Virgin flanked by the emperor and empress with their daughter and her son were set over this reliquary, either in the apse or, less likely, on a silver-revetted ciborium.[17] Again, the Virgin is not carrying the Christ-Child. If, as it has been stated,[18] most pictures of the Virgin in Byzantine art emphasize her role as the Theotokos—explicitly showing her in relation to her Son—, her portrayal in Early Byzantine silver provides the exception, although the Sion censer illustrates a Theotokos cycle. The same is true of Medieval portraits in silver where the iconographic types are again very limited.

The Virgin is as little in evidence on Medieval Byzantine silver plate due, perhaps, to the general scarcity of ecclesiastical—or other—objects made in silver with figural decoration from this period. Comparing the representations of the Virgin on silver of the early and Medieval periods, one can comment on the following types of religious objects: the chalice, paten, cross and reliquary. In general, iconographic types are limited to the orans/Deesis and the Crucifixion, with a few additional feast scenes. Discussing comparanda is complicated by the fact that in the Medieval period,

197

many extant objects are in more expensive materials (gold enamel plaques, carved sardonyx, etc.) or less expensive ones (tinned copper, etc.); few are in silver whether in repoussé or incised.

The Early Byzantine type of figural decoration on a chalice – seen on those from Beth Misona, Phela and Attaruthi, as well as on the Hama flask, the Cherson casket (Pl. 135) and the Homs ewer (Pl. 132), where the Virgin appears together with other figures in bust or orant standing form, reappears on the chalice cup in variant forms in the Medieval period. Among extant objects, the closest iconographic comparison to be made with the early chalices is that of the pair of silver Slavonic-inscribed Russian 'kraters' in Novgorod which feature the standing Virgin orant, together with Christ, St Peter and one other saint each.[19] The figure of the Virgin as shown on the Early Byzantine chalice bowl is also perpetuated in Medieval Byzantium in the more costly type of chalice having gold enamel plaques attached to the top of a carved sardonyx bowl as, for example, on one of the chalices of Romanos and another contemporary one, both in San Marco. On the Romanos chalice the Virgin is flanked by two angels on one side of the bowl (Pls 130 and 135), with Christ and St John the Baptist flanked by Sts Peter and Paul on the opposite side. This is an iconographic arrangement nearly identical to that of the early period (Pl. 131); a comparable layout features on the other chalice.[20] On both the Virgin is in orant position but with the arms now held in front of the chest rather than extended from the body. The early silver chalice was also imitated in the ninth to the eleventh century in cheaper tinned copper, where the chalice bowl is adorned with up to four crosses, cruciform monograms (of '*phos zoe*'), or busts of the four Evangelists; the Virgin appears on none of these.[21]

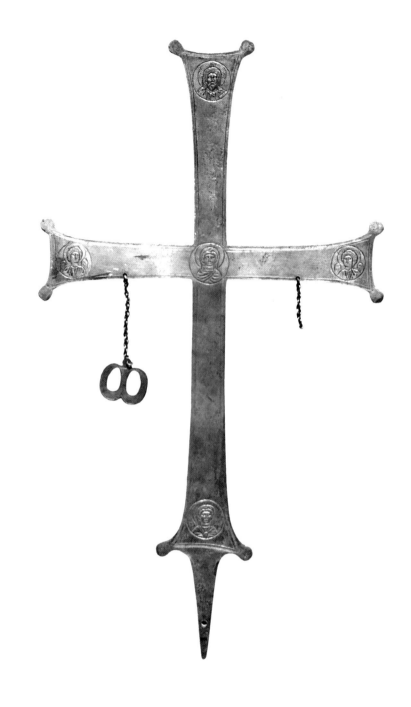

132. *The Čaginkom Cross* Archaeological Museum, Istanbul.

By contrast, in the same period, the Virgin appears on at least two church patens. In the early period the paten was normally decorated with a large or medium-sized cross;[22] exceptionally a narrative scene appears on two or three patens dated to the 570s or later, where the subject portrayed is directly related to the Eucharist, namely the Communion of the Apostles.[23] In the Middle Byzantine period few patens in precious materials survive, but one in agate, gilded silver and enamel inlay continues the earlier iconography and displays the related scene of the Last Supper at its centre.[24] The contemporary silver repoussé Halberstadt paten replaces the aniconic cross of the earlier silver patens with a Crucifixion which is flanked by the Virgin and St John the Theologian.[25] The ninth-to eleventh-century series of tinned copper types of liturgical objects includes patens decorated with Christ, or with an archangel, or with the Virgin orans[26] (now in Oxford) (Pl. 136). The appearance of the latter is iconographically exceptional and requires an explanation which may be sought via the examination of two other types of objects, namely the cross and the reliquary.

A distinction has been made between the cross and the crucifix with regard to figural decoration.[27] It was stated above that most early patens had aniconic crosses; the same is true of the early

198

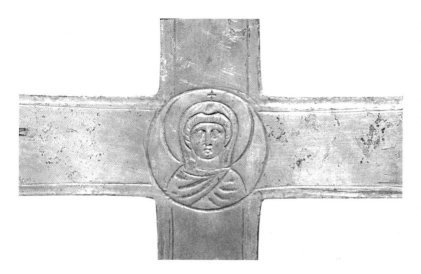

133. *Detail of the Virgin from the Čaginkom Cross.* Archaeological Museum, Istanbul.

silver processional and other crosses. They are largely without figural decoration—displaying prominently a bold dedicatory inscription on the obverse.[28] Although a number of early copper-alloy crosses display figures of the Virgin and other holy persons, there is no corpus of Christ. This first appears on metal crosses in the Middle Byzantine period, on, for example, the copper-alloy cross in the Benaki Museum (Cat. no. 41).[29]

On Medieval crosses with figural decoration the most common theme is that of the Deesis, which can be seen to continue certain features already observed on early church objects—Christ, Virgin, archangels and saints (see Table on p. 197). The silver processional cross of the tenth century in the Lavra Monastery on Mt Athos has on the obverse a bust of Christ in the centre flanked on the lateral terminals by the Virgin and St John the Baptist, thus forming the Deesis, while Michael and Gabriel occupy the ends of the vertical arms.[30] This arrangement reappears on the silver cross at Matzkhvarichi in Georgia[31] and, with some variations, on the obverse of the silver-revetted crosses on an iron core, now in the Cleveland Museum, the Metropolitan Museum, the Cluny Museum (Pl. 138), where the Virgin occupies the centre), the Dumbarton Oaks Collection, the Musée d'art et d'histoire in Geneva and the Ortiz Collection.[32] On the Adrianople cross in the Benaki Museum (Pl. 140), the centre may have once held a relic or precious stone, while Christ is placed at the top and the Virgin at the bottom flanked at the extremities by two archangels; the Baptist has been moved to the reverse.[33]

Another Medieval silver cross to consider as related to the processional crosses discussed above, is that in Genoa, restored in the thirteenth century, but originally made in the ninth or tenth century. This is a cross serving as a reliquary, having a cruciform container on its back. Its front is decorated, not with the Deesis seen on the other silver crosses, but with what appears to be a variant composition: the top is dominated by Christ, the Virgin occupies the centre, St John the Theologian appears on the base and Sts Michael and Gabriel are placed in the lateral terminal discs.[34]

134. *Silver reliquary from Cherson*, detail. The State Hermitage Museum, St Petersburg.

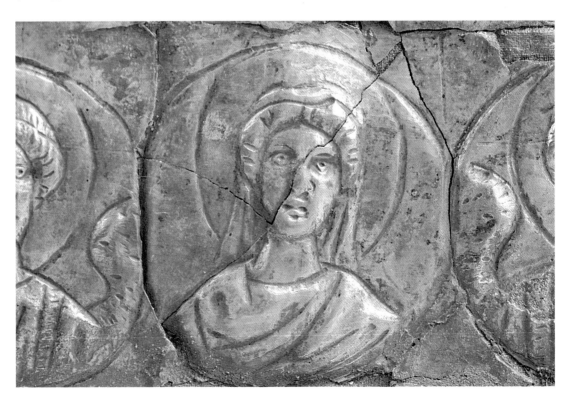

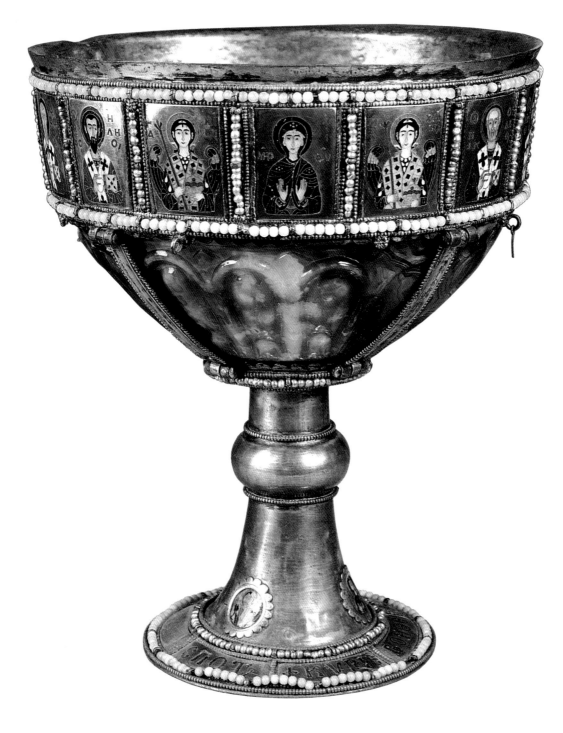

The contemporary copper-alloy cross in the Benaki Museum has on the front busts of the Virgin
and St John the Theologian flanking the Crucifixion[35] (Cat. no. 23). The iconography, displayed
on the four arms of the obverse of the Genoa and Benaki crosses—and on other copper-alloy crosses
in Vienna, Berlin, Princeton and Munich[36]—is directly related to the Medieval Crucifixion icono-
graphy already encountered on the Halberstadt paten, in a central medallion on the Matzkhvarichi
cross and at the top of crosses at Cluny (Pls 138 and 139) and Dumbarton Oaks.[37] In this Cruci-
fixion iconographic composition, which often incorporated Sts Constantine and Helen, the role of
the Virgin opposite St John the Theologian echoes the role that she shares with St John the Bap-
tist in the Deesis. Examples of the scene appearing on larger oblong reliquaries made of silver (as
opposed to those with gold enamel-inlaid plaques, etc.) include several in Paris (Pl. 141), St Peters-
burg, Rome, Brescia and Mt Athos.[38] While the essential scene of Christ on the Cross flanked by
the Virgin and St John adorns the cloisonné enamel top of the Fieschi-Morgan cross reliquary (Pl.

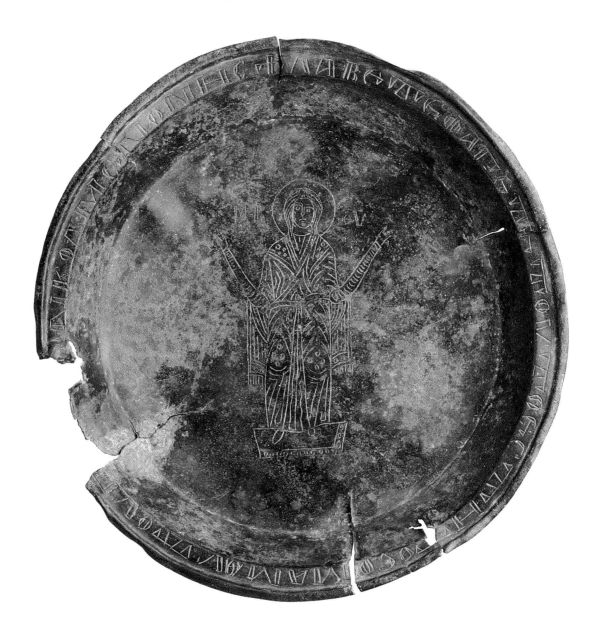

15), now considered to date to the ninth century, the inside of its lid is made of silver decorated with niello-inlaid scenes from Dodekaorton (Pl. 17), three of which feature the Virgin (Annunciation, Nativity, Crucifixion). These latter relate technically and stylistically to the nielloed scenes appearing on small cruciform pectorals, some of which include the feast scenes.[39] The Crucifixion iconography on the outside of the Morgan lid was also transferred on a reduced scale to expensive cruciform pectoral reliquaries in gold and niello-inlaid silver,[40] as well as to related mass-produced pendants in copper-alloy.[41]

The Virgin occupies the centre of several of the large crosses discussed above. She appears in a central medallion on the obverse of the Genoa cross and on the reverse of the Lavra cross. On the iron-core silver cross in the Cluny, a repoussé bust of the Virgin is placed at the centre of the Deesis on the obverse (Pl. 138). In the early period, the cross with Justinianic control stamps and an Armenian inscription has a layout closely related to that of one side of the Genoa and Cluny crosses. Christ appears at the top of the cross, the Virgin occupies the centre, flanked by angels at the two lateral extremities and an unknown female saint (rather than St John the Theologian or the Baptist) at the bottom of the cross. But, in this case the cross is explicitly dedicated in its obverse inscription to St George, not the Virgin.[42] The argument for a dedication of the Lavra cross to the Virgin[43] is supported by evidence on the reverse of the Cluny cross. There, the centre has a full-length portrait of

137. *Processional Cross.*
Monastery of the Great Lavra,
Mt Athos.

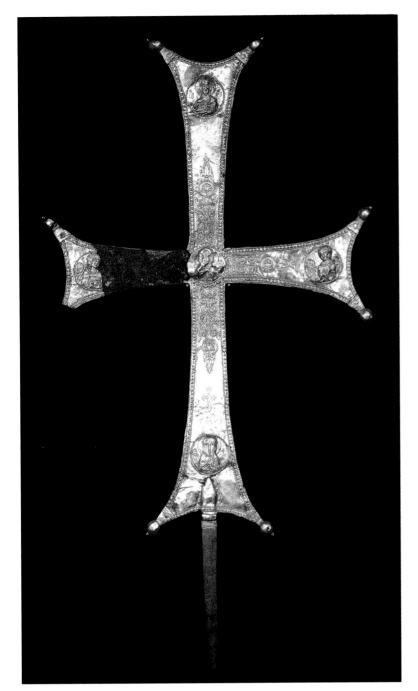

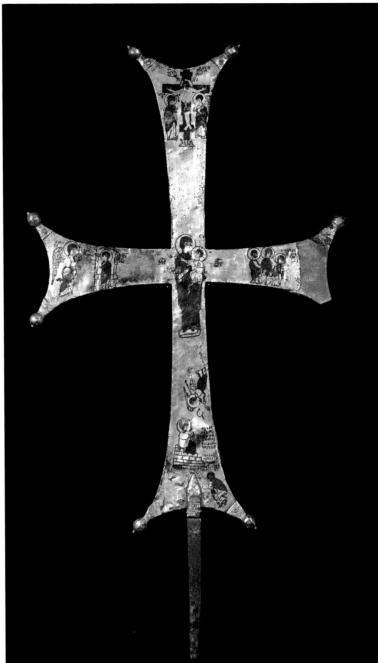

138. *Silver cross*, obverse.
Musée de Cluny, Paris.

139. *Silver cross*, reverse.
Musée de Cluny, Paris.

the Virgin and Child painted in niello, which is accompanied by scenes featuring the Virgin (Cruci-fixion, Annunciation, the Virgin Fed by the Angel, the Marys at the Tomb) on the arms (Pl. 139).[44] At the base is a portrait of the prostrate donor and his inscribed dedication which is understood to refer to the Virgin standing above him. A full-length figure of the Virgin also occupies the centre of the reverse of the copper-alloy cross in the Benaki Museum, where she is shown orans and is inscribed Blachernitissa (Cat. no. 41). In this case, the dedication by one Leo Boreas is placed next to the fig-ure of Christ on the obverse. The Virgin on the Benaki cross bears a strong resemblance to the Vir-gin on the Oxford paten (Pl. 136), although the shape of their arms differs. Looking to the Cluny cross, one may argue that the figure of the Virgin is used on the paten to indicate a donation to a church in her name, since the inscription on the rim is liturgical not dedicatory.

Narrative scenes of the type featuring the Virgin as represented on the reverse of the Cluny cross may also indicate a dedication to the Virgin. On the Matzkhvarichi cross an enamel-inlaid plaque with the enthroned Virgin and Child is placed at the base of the front, just above the ded-

icatory inscription addressed explicitly to the Virgin, which is written on the tang. On the back are niello-inlaid medallions with the Annunciation (at the top) and the Crucifixion (in the centre).[45] Fragmentary upper arms of silver cross revetments at Dumbarton Oaks are likewise adorned with a repoussé scene of the Annunciation and a niello-painted Crucifixion, respectively.[46] Comparable iconic portraits and scenes of the Virgin are found in the early period on the Sion silver censer dedicated to the Theotokos. They also appear singly at the centre of some copper-alloy crosses, namely as 1) an orant figure flanked by flying angels beneath a standing Christ; 2) an enthroned Virgin and Child between angels and under Christ; 3) the Annunciation accompanied by Christ and saints; 4) the Adoration of the Magi.[47] On another copper-alloy cross, the enthroned Virgin and Child occupy the top.[48] While these prominent positions would indicate a dedication to the Virgin, the inscriptions on four of these crosses do not refer specifically to her.

Medieval silver revetments often take the form of frames or covers of painted icons. In the latter case, the cover repeats the contour of the painting underneath. Given the popularity of the Virgin and Child as a subject of icon painting, there are numerous silver covers repeating these compositions. In the case of icon frames, the Virgin often features as part of the Deesis, in the intercessory role noted repeatedly elsewhere in Byzantine silverwork. The eleventh-century icon of the Virgin and Child Korsunskaja in the cathedral at Novgorod and the icon of the Virgin of the Annunciation of around 1300 in Ochrid (Pl. 142) illustrate both types of Virgin appearing in silver: the revetment of the icon itself (here the silver covers only the background of the figures) and on the frame where she appears in repoussé in the Deesis.[49]

In sum, because of its utilitarian origins, silver plate has a tradition of function-linked iconography. On domestic silver, Dionysiac scenes decorate drinking vessels, aquatic subjects adorn washing vessels, etc. This convention was taken over into the 'new' system of ecclesiastical silver. The silver paten bore the symbol of the sacrificial cross linked to the Eucharist or the figural scenes of the Last Supper or the Communion of the Apostles; the silver flabellum used to protect the elements of the Eucharist was decorated with the wings of the seraphim, recalling the peacock feathers which often fulfilled the same function. But many a silver vessel was donated to a church and had, therefore, a secondary function as an *ex-voto*. And so its decoration could illustrate this spiritual function of an object given as a form of prayer, rather than simply relate to its primary utilitarian function. The Adoration of the Magi— a scene of gift-giving—may have been used on donated objects, particularly in the early period, to underscore this message.[50] The intercessory role of the Deesis on chalices (Pl. 135), crosses (Pl. 138) and icon frames (Pl. 142) was noted above in the Medieval period and linked to a looser iconographic scheme (of Christ, the Virgin, Peter and Paul, archangels) in fairly consistent use

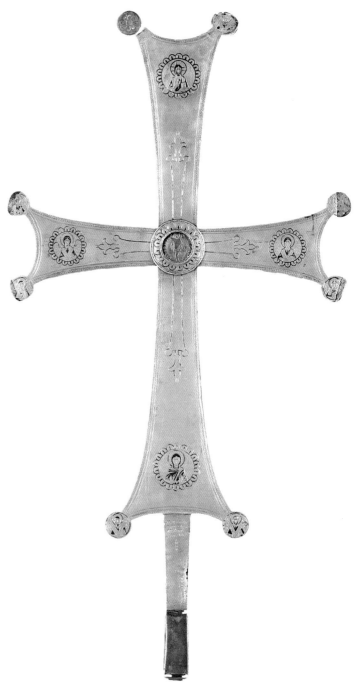

140. *The Adrianople Cross.* Benaki Museum, Athens.

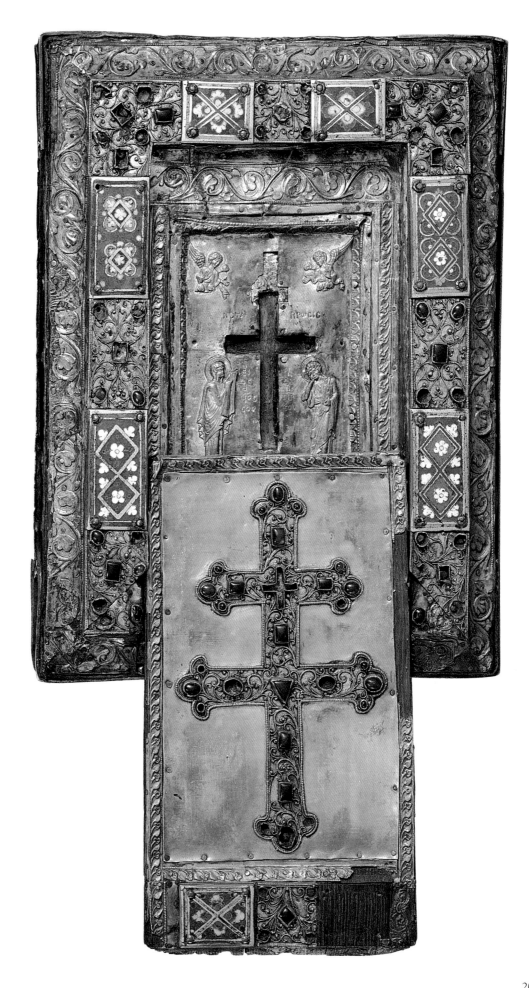

141. *Reliquary of the True Cross.*
Musée du Louvre, Paris.

205

on vessels in the early period (Pl. 131). The importance of the *ex-voto* character of these objects could explain the limitations of the iconography of the Virgin in silver: her image was rarely chosen to explain the liturgical function of a given vessel; her appearance in the Crucifixion on the Halberstadt paten is an exception. In the Crucifixion scene and in the Deesis, the Virgin enjoyed an important intercessory role between Christ and Christians, which was invoked by the images used to adorn these silver objects. Thus, she appears alone (orans, etc.) probably in that context on the tinned copper paten in Oxford (Pl. 136) and on various processional crosses (Pl. 140). That she rarely appears on silver objects holding the Christ-Child (Pl. 139) is perhaps surprising, but this iconographic type does feature on silver revetments of painted icons.

[1] *Kaper Koraon*, nos 92-94; Pitarakis 1998b, 81-102.

[2] Dodd 1961, nos 70, 75; Mundell Mango 1997, 83-92.

[3] *Kaper Koraon*, nos 103-105.

[4] *Age of Spirituality*, nos 425-433, 482; Lazović et al. 1977, 9, no. 6; *Byzantium*, no. 135; *East Christian Art*, no. 5.

[5] *Byzantine Art, an European Art*, nos 503, 506.

[6] *Kaper Koraon*, nos 57-59, 84; *Byzance*, no. 62.

[7] *Kaper Koraon*, nos 15, 62; *Mirror of the Medieval World*, no. 46.

[8] *Kaper Koraon*, no. 76.

[9] Nesbitt 1988, no. 3; *Kaper Koraon*, no. 85; personal observation of the Munich censer.

[10] Dodd 1961, no. 35; Dalton 1901, fig. on 88.

[11] Dodd 1961, no. 17; Buschhausen 1971, no. B21, pl. B59.

[12] Buschhausen 1971, nos B11 and B14, pls B39, B47.

[13] *Kaper Koraon*, no. 86.

[14] *Ecclesiastical Silver Plate*, 9, no. 19.

[15] Mundell Mango 1992, 126-132.

[16] Mango 1986[2], 87-88 and nos 153-156.

[17] Mango 1986[2], 34-35 and Mango 1998, 70-71.

[18] *ODB*, 2175.

[19] *Glory of Byzantium*, no. 197.

[20] *Treasury of San Marco*, nos 11, 17; *Glory of Byzantium*, no. 31.

[21] Mundell Mango 1994, 222.

[22] *Kaper Koraon*, nos 4-6, 36, 39, 60, 63-64, 74-75.

[23] *Kaper Koraon*, nos 34-35; there is a third paten with a variant composition limited to Christ, Sts Peter and Paul, in the Menil Collection, Houston; Mundell Mango and Northover 1990, lot 433.

[24] *Glory of Byzantium*, no. 28.

[25] *Glory of Byzantium*, no. 30.

[26] Mundell Mango 1994, 222.

[27] Cotsonis 1994, figs 40-46.

[28] *Kaper Koraon*, nos 7-8, 42, 65, 67, 68, 76.

[29] Cotsonis 1994, 42-43, n. 80.

[30] Grabar 1969, 99-125.

[31] Mango 1988, 42.

[32] Mango 1988, 41-49; Cotsonis 1994, nos 2-3; *Glory of Byzantium*, nos 24-27.

[33] Bouras 1979; *Glory of Byzantium*, no. 23.

[34] Mercati 1959, 29-43; Bouras 1979, 25, n. 34; Cotsonis 1994, 29, 32, n. 63, figs 12a-b.

[35] *Byzantine Art, an European Art*, no. 550; Cotsonis 1994, 42-43, fig. 18a-b.

[36] Noll 1958, no. 15; Coquin, Leroy and Van Moorsel 1989, 73-80; *Byzantium at Princeton*, no. 68; *Rom und Byzanz*, no. 62 ; Temple 1990, no. 66.

[37] *Glory of Byzantium*, no. 30; Cotsonis 1994, figs 5b, 14b, 30.

[38] *Byzance*, nos 237, 249; Frolow 1965, figs 44-45, 51, 57, 66.

[39] Kartsonis 1986, 94-116, figs 24g, 25-26.

[40] *Byzantium*, fig. 36a; *Glory of Byzantium*, nos 121, 123; *Byzance*, no. 229.

[41] Pitarakis 1998b.

[42] *Kaper Koraon*, no. 76.

[43] Perhaps by Nikephoros II Phokas, founder of the Lavra monastery; Grabar 1969; Bouras 1979, 25-26.

[44] Mango 1988, 43-44; Cotsonis 1994, 47; *Byzance*, no. 243; *Glory of Byzantium*, no. 26.

[45] Mango 1988, 42, figs 3-4; Cotsonis 1994, 46, 48, fig. 5a-b.

[46] Cotsonis 1994, nos 4 and 6.

[47] Cotsonis 1994, nos 8-11 and an unpublished cross on loan to the Ashmolean Museum, Oxford.

[48] *Age of Spirituality*, no. 557.

[49] Grabar 1975a, nos 4, 10, 24, figs 6, 27.

[50] On the significance of the scene Grierson 1961, 223-224.

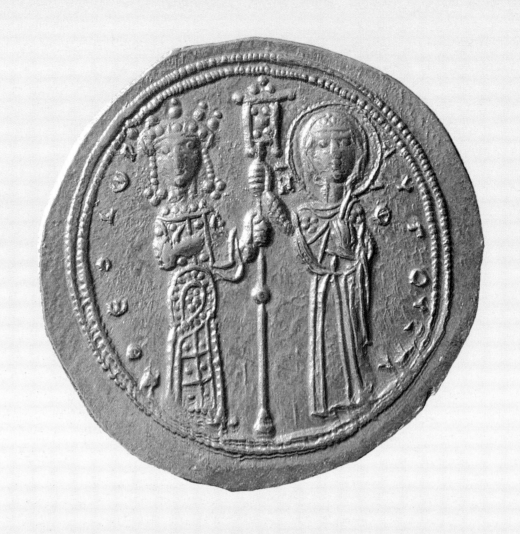

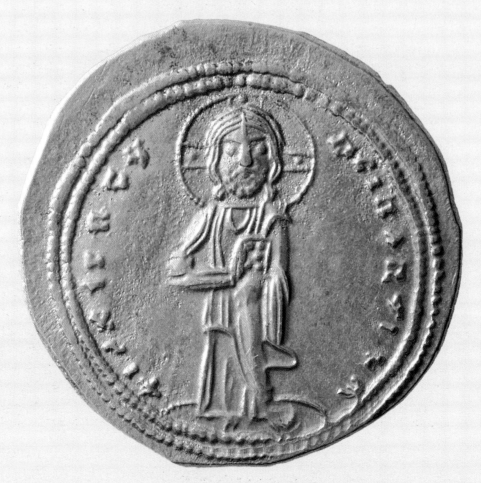

Vasso Penna

The Mother of God on Coins and Lead Seals

Byzantine coins, the symbol and reflection, the foundation but also the weapon of a great empire, came to be an ideal medium for imprinting and transmitting powerful symbolism and propaganda centred on the personality of the emperor. Through coins, the centre of government broadcast messages, both to its subjects and to other peoples, and it is significant that the first concern of every emperor who ascended the throne, whether legally or by force, was to issue coins in his name as a way of consolidating his power.

Byzantine coins may be said to have functioned as an official visual expression of the promotion of the imperial ideal.[1] On the tiny circular surface the emperor is transformed into a cult image, in which all sense of depth, volume or the three-dimensional is deliberately avoided.[2] Emphasis is placed on the symbolism, which is expressed through the insignia of imperial dress and authority and made more precise through the juxtaposition of the imperial figure on one side with the divine or religious figure on the other.[3] Through this symbolism, the emperor's religious mission, his earthly role, the source of his power and authority, and his political prestige, are expressed.

The secular and the divine coexist harmoniously in Byzantine coins, which provide an excellent sketch of the long history of Byzantine thought. This harmony is governed by an implicit mutual understanding, in which 'religious' feeling bows to political expediency, and in which 'political' thinking is nurtured and based on a sense of the 'religious'. Throughout the early period at least, this understanding led to conservatism in the choice of the religious repertoire for the coins — a conservatism that preferred to express itself by means of symbols. In a world still closely linked with Roman customs and values, the triumph of Christianity was emphasized on coins by means of the cross of Calvary, the symbol of Christianity. During the early decades of the seventh century this had replaced the frontal figure of an angel, a recollection of the Roman figure of Victory, which had been transformed into a messenger of the Christian triumph on earth and a protector of the emperor-custodian of the Faith.

The first representation of a Christian figure on a Byzantine coin was executed at a fairly late date, in the years of the first reign of Justinian II (685-695). Christ is shown frontally and in bust, with long hair and a beard, on the obverse of the *solidi* issued by this emperor. The combined iconography of the two sides of these coins represented a further symbolic development in the depiction of the Byzantine emperor: the terrestrial king appears before the celestial king, the King of Kings, from whom he derives power and protection.[4]

The dominant presence of Christ on the obverse of coins issued after the end of the Iconoclastic Controversy until the reign of Leo VI (886-912) indicates the perpetuation of the above conception. Gradually, however, beginning in the early tenth century, the numismatic iconography was enriched by the addition of a variety of other Christian figures. This practice, which became more systematic after the time of the Komnenoi, derived from the fact that the personal preference of the emperor now became a factor in the choice of subject for the iconography of the coins. The emperor's choice sometimes stemmed from acts of political expediency and sometimes from personal devotional habits. At the same time, the emperor, normally depicted on the reverse, now began to be accompanied by a religious figure of his choice. The ruler is crowned by Christ, or the Virgin, or a patron saint, or even by the hand of God himself (*Manus Dei*) emerging from a small cloud. On occasion, he is depicted

143. *Histamenon of Romanos III and Theodora.*
Byzantine Museum, Athens
(Avgeris Collection N 799).

209

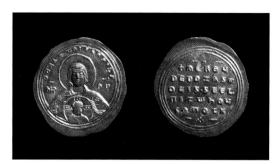

144. *Miliaresion of Constantine IX Monomachos.* Byzantine Collection, Dumbarton Oaks, Washington (7a.1).

145. *Miliaresion of Romanos III.* Byzantine Collection, Dumbarton Oaks, Washington (3a.1).

146. *Histamenon of Zoe and Theodora.* Byzantine Museum, Athens (Avgeris Collection N 792).

147. *Miliaresion of Basil II.* Byzantine Collection, Dumbarton Oaks, Washington (19.1).

holding an imperial standard or cross on equal terms with a religious figure.[5] These representations, which first appear on rare issues of the Macedonian dynasty and gradually multiply during the eleventh and especially the twelfth and thirteenth centuries, point to the transformation of the emperor, by the grace of God, from a powerful ruler into an earthly god. At the same time, a tendency may be detected to search for some form of mediation with the heavenly Lord, a search motivated not by specific events, but by an intellectual conception of the divine, by the need to stress the personal, equal status of man with that which both seems and is remote.

Against the background of these developments in numismatic iconography, the depiction of the Theotokos played a leading role. Her appearance on coins as early as the time of the Macedonian dynasty is an interesting aspect of the regenerative trends of this period.[6] In particular, the choice of the Virgin for the first time on coins issued by Leo VI the Wise (Cat. no. 44) reflects the emperor's desire to strengthen his dynasty at a difficult point in its history, when his own private life had provoked serious reactions from the clergy and the people. Viewed in this light, it seems highly probable that the coin issue in question should be set in the context of Leo VI's fourth marriage, to Zoe Karbonopsina, and the conferring of legitimacy as successor on his illegitimate son.[7] The existence of a rare pattern issue from the joint rule of Zoe and Constantine VII (914), with a depiction of the Virgin,[8] appears to lend confirmation to the above rationale for setting the coin of Leo in the context of his marriage to Zoe in 906. Although the type of the Virgin on the later issue is different from that on the coin struck by Leo VI,[9] its choice, particularly at a period when the consolidation of the positions of Zoe and her son was highly desirable, directs us to the miraculous role of the Mother of God and the favour shown by her to the queen mother. The accompanying inscription is indicative: 'All Holy Mother of God, assist Constantine and Zoe, King and Queen of the Byzantines'.

The motives dictating the choice of the Theotokos for the iconography of the coin of Leo VI aside, however, the identification of the iconographic type with a specific monumental work or a specific devotional icon, remains an unsolved problem. The relatively rare type of the inscription accompanying the bust of the Virgin, with the appellation MAPIA, suggests that the model should be sought in the sphere of mosaic mural decoration, rather than in a devotional icon.[10] Grierson suggests that the source of inspiration was the mosaic decoration of the church of the Virgin at Pharos, where the emperor celebrated his fourth marriage with Zoe.[11] This view seems fairly likely, given that the Virgin in the apse of the church in question was depicted in similar fashion, according to a literary source.[12] During the eleventh century, representations of the Virgin on Byzantine coins are of great interest. She is present on the reverse of the *histamena* of Romanos III (Cat. no. 47) and Theodora (Pl. 143),

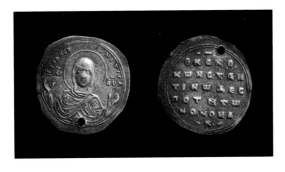

as companion and patron of the emperor, an iconographic type that also first appears at the time of the Macedonian dynasty (Nikephoros Phokas, John Tzimiskes).[13] The Virgin is also presented as an independent figure on the obverse of several issues, mainly of *tetartera* (Cat. nos 48, 49) and *miliaresia*,[14] rendered in a variety of iconographic types (Pl. 144). By way of example, we mention the type of the Hodegetria on *miliaresia* of Romanos III (Pl. 145), of the Episkepsis on *histamena* of Zoe and Theodora[15] (Pl. 146), and of the Nikopoios on several eleventh-century issues, the first occurrence of which is on *miliaresia* attributed to Basil II and Constantine VIII [16] (Pl. 147). Representations of the Virgin orans in bust form a distinct majority. On rare fractions of the *miliaresia* issued by Constantine IX (Pl. 148), Theodora, and Michael VI, this particular iconographic type is defined by the accompanying inscription as the Blachernitissa (H RΛAXEPNITICA).[17] The definition of the precise iconographic type of the Blachernitissa is, of course, a complex matter. It should be stressed, however, that numismatic iconography always carries official approval, and consequently challenges us to re-examine the matter. A review of the problem becomes even more attractive when it is noted that the inscription naming the type appears on issues dated between 1055[18] and 1057, which suggests that the choice of this particular type for these rare issues was dictated by special circumstances. Grierson, for example, believes that they should be associated with the sixtieth anniversary of the founding of the Blachernai monastery,[19] which fell within this interval, and which was presumably an important event celebrated extensively in the capital. It is, of course, difficult to determine whether the type of the Blachernitissa as represented on these specific issues corresponds with the main icon of the church, or with one of the other many icons kept in it, or even with the mosaic decoration of the church apse.[20]

During the period of the Komnenoi and the Angeloi, the representation of the Virgin on coins occurs with roughly the same frequency as during the previous century. Some significant differences can now be observed, however, particularly in the iconographic types on the obverse. Moreover, the presence of the Virgin on the reverse of coins, combined with the figure of the emperor, now becomes more widespread. In these cases, the predominant representation is of the emperor's coronation,[21] while on *hyperpyra* of John II and on electrum *trachea* of Manuel I, the Virgin is shown holding a patriarchal cross, together with the emperors in question.[22] The numismatic term *theotokion*, which is found in the *Typikon* of the Pantokrator monastery, presumably refers to the *hyperpyra* of this category issued by John II (Cat. no. 50).

The first appearance of the Virgin enthroned in the numismatic iconography is the most important innovation of this period. The Mother of God is depicted with a medallion of Christ on her breast, seated on a throne with or without a backrest, on the obverse of electrum *trachea* and *billon trachea* issued by the Komnenoi Alexios I[23] and Manuel I.[24] The same representation also occurs on the *hyperpyra* of Andronikos I[25] and Isaac II Angelos (Cat. no. 52),[26] in what is an interesting departure from standard practice, since the corresponding issues of earlier emperors were dominated exclusively by the figure of Christ. It is worth noting at this point that the Virgin is virtually the only figure to appear on the issues of Andronikos I and Isaac II. In the case of the former, the representation of the Virgin is not confined to the type showing her enthroned. On the electrum *trachea* (cat. no. 51) is the type of the full-length Virgin orans with a medallion of Christ on her breast[27] (Episkepsis), while the *billon trachea* show her holding the medallion with both hands (Nikopoios).[28]

Representations of the Virgin were particularly common on twelfth-century *tetartera*. By way of example, we may note the type of the Blachernitissa on issues of John II,[29] Manuel I[30] and Isaac of Cyprus,[31] and the type of the Episkepsis on coins struck by Andronikos I[32] and Isaac II.[33] Particular interest attaches to the representation of the Virgin in the type of the Hagiosoritissa,[34] which is a further innovation in the numismatic iconography at the time of the Komnenoi. The type of the Virgin

Hagiosoritissa is known to be connected with the cult icon of the Mother of God in the church of the Chalkoprateia in Constantinople — the church in which one of the most holy Christian relics, the Virgin's Girdle, was kept in a special reliquary called the *Hagia Soros*.[35] This same type, without an inscription, occurs on *tetartera* of Manuel I,[36] Isaac of Cyprus,[37] and Alexios III.[38] A depiction of the Hagiosoritissa complete with inscription may be noted on two types of the coins known as Latin imitations, which were issued by the Franks after the capture of Constantinople in 1204[39] (Pl. 149). Systematic investigation of the criteria on which the choice of particular representation for these issues was based, in conjunction with the historical evidence, might point to a different conclusion with regard to the authorities responsible for issuing them.[40] The question that arises is whether these rare issues, and others in the same category, should be attributed to Byzantine or to Balkan ruling families of the period. Provisionally, we may note the 'heraldic' nature of the representation — viewed, of course, in the context of the Eastern Christian approach and taken in combination with the fact that the representation of the Hagiosoritissa is found particularly on objects of minor art (small icons, gem stones, lead seals, etc.) — that is, on objects of personal use or devotion.

The representations of the Virgin on coins issued by the empires of Nicaea (1204-1261) and Thessaloniki (1224-1261) continued the tradition of the Komnenian period.[41] The *hyperpyra* of John III Batatzes, in particular, have the same iconographic types as the corresponding issues of his Komnenos namesake, in which the Virgin is represented beside the emperor on the obverse, sometimes crowning him and sometimes with the two figures holding a patriarchal cross between them.[42]

On the obverse of coins of this period, the Virgin is shown sometimes enthroned,[43] sometimes full-length,[44] and sometimes in the type of the Blachernitissa[45] or the Hagiosoritissa.[46] On *aspra trachea* issued by Theodore Komnenos Doukas of Thessaloniki, the inscription ΑΓΗΟCΩΡΗΤΗCΛ accompanies the representation of a full-length, frontal Virgin orans.[47] This interesting departure from the iconography of the Hagiosoritissa probably resulted from a lack of familiarity on the part of the local engraver with the established Constantinopolitan type, in which the Virgin is depicted full-length, in bust or three-quarters, sometimes facing right and sometime left, her arms extended in a gesture of supplication, and most commonly with her gaze turned towards the hand of God, which emerges high in the field.

Representations of the Virgin on the coins of the Palaiologan period are set in roughly the same typological context as those of the previous period.[48] At the same time, the bitter experiences of the past and the harsh reality of the present gave rise to some significant changes. On the obverse of the *hyperpyra* of Michael VIII (Pl. 150), Andronikos II (Cat. no. 53), and John V, the Virgin appears for the first time in association with the capital city.[49] The eternal protectress of Constantinople, shown three-quarters and frontal, prays for the salvation of the Byzantine capital, and the stylized towers of the fortifications by which she is surrounded exude sorrow and anguish for the contracted empire. The capital city is being strangled by a variety of pressures and adverse circumstances.

The role played by the Virgin as protectress of the Byzantine capital and therefore of the empire as a whole had a great effect on the iconography of imperial lead seals, especially in the period prior to the Iconoclastic Controversy. Her appearance is attested as early as the sixth century and her figure dominates almost all imperial lead seals until 730.[50] She is depicted sometimes in bust, sometimes full-length and frontal, holding Christ on her breast in a medallion and flanked by crosses or floral decoration; finally, from the second half of the seventh century to the formal beginning of Iconoclasm, she occurs in the type of the Hodegetria (Pl. 151). The same type recurs for a short period after the end of the first phase of the religious dispute. The early appearance of the Virgin in the iconography of imperial lead seals is evidence for the widespread devotion accorded her within the walls of the capital, while the adoption of the type of the Hodegetria recalls the miraculous intervention of the icon of the Virgin, presumably in the same iconographic type, to save the city from critical enemy raids in the seventh and eighth centuries. After the end of the Iconoclastic Controversy there is a reduction in the frequency with which the Virgin is represented on imperial lead seals, the religious iconography of which now largely marches in step with the corresponding iconography of the coins,[51] in which the pre-

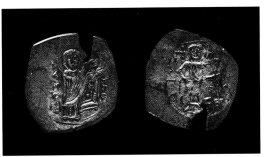

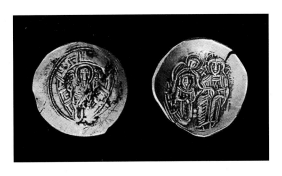

149. *Latin imitation, type S.*
Byzantine Collection,
Dumbarton Oaks, Washington
(19.1).

150. *Hyperpyron of Michael VIII Palaiologos.*
P. Protonotarios Collection,
Athens.

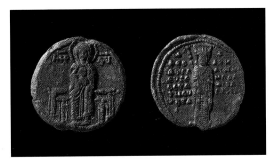

151. *Lead seal of Leo III Isauros.*
Byzantine Collection,
Dumbarton Oaks, Washington
(no. 55.1.3431a).

152. *Lead seal of Theodora Doukaina Palaiogina.*
Numismatic Museum, Athens
(Konstantopoulos no. 284).

dominant figure is now that of Christ, either enthroned or in the type of the Pantokrator. Nevertheless, the female members of the imperial family showed a strong preference for depictions of the Virgin. We note, by way of example, the representation of the Virgin orans on lead seals of Eudokia Makrembolitissa, while in the Late Byzantine period, the predominant type is that of the Virgin enthroned (Pl. 152).

The Virgin, as intercessor with the heavenly kingdom, hope for the salvation of the soul, and succour and support for humans, for whom she secured health, well-being and longevity, was, in every social stratum, one of the most popular motifs in the iconography of lead seals.[52]

A glance at the iconographic indexes of published collections of lead seals is enough to reveal the wide typological spectrum of representations of the Virgin on lead seals.[53] Many of the types are variations of the standard iconography—the iconography which, as we shall see below, is either identified by an inscription or whose identity is self-evident from the specialized nature of the depiction, such as the Galaktotrophousa, or is attested with great frequency, as in the case of the Virgin enthroned or Hodegetria. The variations relate to the manner in which the Virgin's body is rendered—full-length, in bust, three-quarters, etc.—the position of the figure with regard to the spectator—facing left or right—and details such as the inclusion or non-inclusion of a footstool in the case of full-length figures, or of a backrest in the case of the Virgin enthroned. There is also some variation in the manner in which Christ is depicted on the breast of the Virgin enthroned, sometimes projected in a medallion and sometimes shown as a figure in his own right, in bust or full-length.

Of the standard types defined by an inscription, we may note the Blachernitissa (frontal Virgin in bust, with her arms raised parallel to her body in an attitude of supplication),[54] the Nikopoios (frontal Virgin, in bust, holding a medallion of Christ with both hands)[55] (Pl. 153), the Episkepsis (frontal Virgin standing in an attitude of supplication, as in the Blachernitissa type, with a medallion of Christ on her breast),[56] and the Hagiosoritissa (full-length Virgin turned three-quarters with her arms extended in a gesture of supplication towards the hand of God, which is projected high in the field)[57] (Pl. 154). In some cases the defining inscription does not correspond to the iconographic type of the representation it accompanies. The inscription Hagioritissa, for example, accompanies a depiction of the Virgin and Child,[58] and the inscription Nikopoios is found with a representation of a full-length Hodegetria.[59]

The appellation Μήτηρ Θεοῦ (Mother of God) ἡ Μαχαιρωθεῖσα (Stabbed with a knife), which occurs very rarely on lead seals with a representation of the full-length Virgin in the type of the Nikopoios, probably has reference to a specific icon in Hagia Sophia, which, according to the literary sources,

213

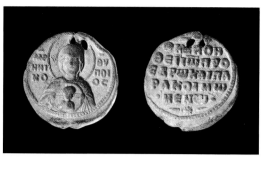
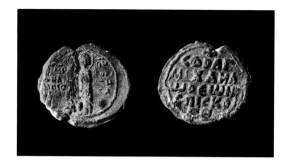

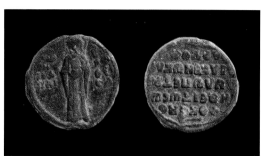
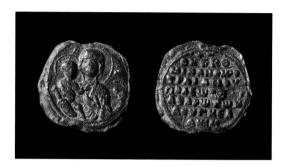

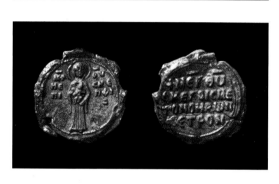
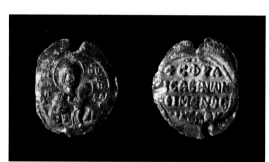

153. *Lead seal of John, proedros and parakoimomenos.* Byzantine Collection, Dumbarton Oaks, Washington (Collection of the Fogg Museum of Art, no. 1344).

154. *Lead seal of Michael, Bishop of Oreoi.* Byzantine Collection, Dumbarton Oaks, Washington (no. 58.106.154).

155. *Lead seal of Peter, deacon and chartophylax.* Byzantine Collection, Dumbarton Oaks, Washington (no. 47.2.291).

156. *Lead seal of Michael Bishop of Traianoupolis.* Dumbarton Oaks Collection, Washington (58.106.5678).

157. *Lead seal of Peter, Bishop of Thebes.* Byzantine Collection, Dumbarton Oaks, Washington (55.1.4049).

158. *Lead seal of John, Bishop of Athens.* Byzantine Collection, Dumbarton Oaks, Washington (55.1.5007).

bore traces of desecration with a knife by an infidel Jew[60] (Pl. 155). The explicit depiction of a knife next to the Virgin Hodegetria on a lead seal of Michael, Bishop of Traianoupolis and president of the *protosynkelloi*[61] is probably a similar case (Pl. 156). However, it is difficult to trace the place in which the icon to which Michael's seal refers was kept, though the honorary title of president of the *protosynkelloi* points to close relations with the clerical establishment of the capital, and particularly of Hagia Sophia.

Occasionally the accompanying inscriptions on lead seals define rare iconographic types, such as that of the Kyriotissa.[62] The Virgin Kyriotissa is depicted full-length or in bust, holding Christ in front of her breast with both hands, roughly as in the representation in the apse of the Koimesis church at Nicaea[63] (Pl. 50) and in the later mosaic of John II Komnenos in Hagia Sophia at Constantinople[64] (Pls 67 and 68). The iconographic affinity between the Kyriotissa and the Nikopoios apparently caused occasional confusion, as suggested by the seal of Romanos Argyropoulos, in which the inscription Kyriotissa accompanies a depiction of the Nikopoios, with the Virgin holding a medallion of Christ on her breast.[65] A characteristic example here is the depiction of the Virgin in the type of the Kyriotissa accompanied by the inscription 'the Episkepsis' on the lead seal of Peter, Bishop of Thebes (Pl. 157). Two divergent views have been expressed with regard to the origins of the appellation Kyriotissa. Laurent associates the name with the church founded in Constantinople by the Eparch Kyriotis in the reign of Theodosios II,[66] while Tatić-Djurić connects it with appellations of the Virgin of the type Lady of the Angels, Mistress of the World, Bearer of the Lord, etc.[67]

The range of variations is extended even further by inscriptions that sometimes refer to names of churches, monasteries or places, and sometimes deriving from a personal initiative on the part of the owner of the seal. Examples of the former are the type of the Hodegetria accompanied by the appellations Basiotissa,[68] Avydini,[69] Traianopolitissa,[70] Atheniotissa or Athenais[71] (Pl. 158), the type

214

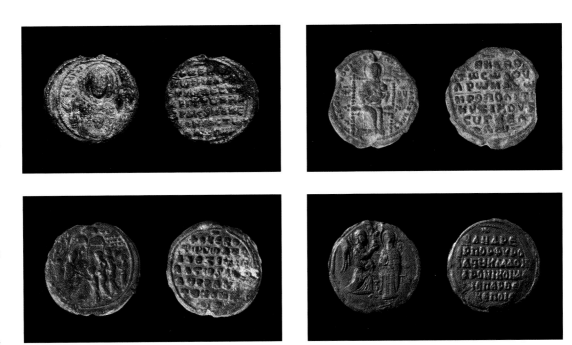

159. *Lead seal of Konstantinos Alopos.*
Byzantine Collection, Dumbarton Oaks, Washington (55.1.2342a).

160. *Lead seal of Romanos, Bishop of Kyzikos.*
Byzantine Collection, Dumbarton Oaks, Washington (Collection of the Fogg Museum of Art, no. 707).

161. *Lead seal of Alexios Komnenos Doukas of Dyrrachium.*
Byzantine Collection, Dumbarton Oaks, Washington (Collection of the Fogg Museum of Art, no. 1397).

162. *Lead seal of Andronikos Doukas.*
Numismatic Museum, Athens (Stamoulis Collection, no. 3207).

of the full-length Nikopoios with the appellation Kosmosoteira,[72] and the type of the full-length Blachernitissa with the appellation Theoskepastos.[73] We may note, by way of parenthesis, that the inscription Theotokos or Peribleptos[74] on a seal of the monastery of this name in Constantinople, accompanies a rare iconographic type in which the position of the arms of the Virgin orans, held in front of the breast, recalls her depiction in the scene of the Ascension.[75] The inscription *Lysiponos* (Pain-healer)[76] accompanying the Virgin in bust in the type of the Episkepsis is clearly the result of a personal initiative by the owner of the seal, Konstantinos Alopos, and was intended as an expression of entreaty and respect directed at her person (Pl. 159).

The iconographic types of the Virgin enthroned include the Galaktotrophousa[77] (Pl. 160). In the case, indeed, of the seal of Romanos, Bishop of Kyzikos, the accompanying inscription: Κύριε ὁ Θεός μου, ὁ εἰς σε ἐλπίζων οὐ καταισχύνεται (My Lord God, he who hopes in Thee has no shame), encircling the Virgin, seems to refer indirectly to the unusual and to many, perhaps, daring choice of representation. Whatever its thrust, whether it be apologetic or didactic, or directed at the representation of the Galaktotrophousa, the content of the seal's inscription is a strong clue to the personality of its owner. A Church official, bishop and *synkellos*, but, above all, a human being who is intellectually assured and has an optimistic outlook on everyday life, who is fully conscious and in control of what he is doing, he chooses the rare representation of the Galaktotrophousa for his seal. It is difficult to say, however, whether the model for this depiction was a specific icon in a church in the capital city or its surrounding area, or was an icon owned personally by Bishop Michael.

Devotional family 'palladia' such as portable icons or pictorial steatite and ivory plaques probably served as sources of inspiration for the choice of narrative subjects closely bound up with the life of the Virgin. The Presentation of the Virgin in the Temple, for example, was depicted on a seal of the *Sebastos* Alexios Komnenos Doukas of Dyrrachium[78] (Pl. 161), the Dormition on a seal of Georgios Panaretos,[79] and the Annunciation on seals of Andronikos Doukas[80] (Pl. 162), Konstantinos Pepragmenos[81] and Zoe,[82] of whom nothing else is known. The inscription: Χαράν λαβοῦσα τῇ Ζωῇ χαράν δίδου (Thou who hast received joy, give joy to Zoe) on the reverse of the last seal, when combined with the inscription: Χαῖρε Κεχαριτωμένη (Hail, Full of Grace) on the obverse, constitutes an ingenious entreaty for personal happiness. The representation of the Deesis[83] with the Mother of God surrounded by patron saints was another popular subject, especially in ecclesiastical circles; through it the owner of the seal sought protection, assistance, guidance and intercession for his eternal salvation.

Lead seals, personal objects with which the Byzantines secured and validated their correspondence,

clearly record people's devotion to the Mother of God. Most Holy, Immaculate Maiden, All-hymned Virgin, Hope of the hopeless, Passage of Joy—these are some of the qualities of the Virgin included in the metrical inscriptions of intercession with which the owners of seals were accustomed to embellish the details of their professional or family identity.

[1] Grabar 1936; Bellinger 1956, 70-81.

[2] Galavaris 1997, 105-119.

[3] Galavaris 1958, 99-117. Also, Hendy 1999, 143-176.

[4] Breckenridge 1959, 1-104.

[5] For numismatic iconography in the Middle and Late Byzantine periods, Grierson 1973a, 146-176; Grierson 1999a, 74-81.

[6] The Virgin appears on issues of Leo VI, Nikephoros Phokas and John Tzimiskes (Cat. nos 44, 45, 46).

[7] Cat. no. 44. Since this coin type cannot be attributed a specific date in the reign of Leo VI, the choice of the Theotokos might accordingly be considered to reflect another aspect of the turbulent personal life of the emperor—his equally scandalous second marriage to Zoe Zaoutzaina. The driving of the evil spirit from Zoe's body with the intervention of the miraculous girdle of the Virgin kept in the church of the Virgin Chalkoprateia might also be thought to be a subject that was made immediately and widely known, the aim being to fulfil the imperial desire, despite the objections of the Patriarch Antonios Kauleas. However, in the light of the arguments advanced in the present article regarding the connection between the Virgin and Leo VI's fourth marriage, this version seems less likely. For the miracle in question, Janin 1953, 172, 248, 253-254.

[8] Grierson 1973b, 533, 541, n. 37.

[9] The Virgin is represented in bust, holding a medallion with Christ before her breast.

[10] A similar inscription accompanies the much earlier mosaic decoration in the apse of the church of the Virgin Angeloktisti at Kition on Cyprus, N. Chatzidakis 1994, 231, nos 21-22.

[11] Grierson 1982, 179.

[12] Mango 1986[2], 186.

[13] Cat. nos. 45, 46.

[14] For a detailed list of the types by reign, Grierson 1973a, 170-171.

[15] The type of the Episkepsis, as defined by lead seals which have an accompanying inscription, corresponds with that of the Virgin orans in bust, with a medallion of Christ on her breast. The Virgin is in some cases rendered full-length, as we shall see below.

[16] Grierson 1973b, 611, 631, no. 19. Grierson associates the appearance of the Nikopoios on this particular *miliaresion* with the battle of Abydos and the death of Bardas Phokas, which was of decisive significance in bringing Basil to the imperial throne. The type of the Nikopoios is also defined by lead seals with an accompanying inscription. The Virgin is represented in bust, holding a medallion of Christ in both hands.

[17] Grierson 1973a, 171, 173.

[18] The issue of Constantine VII (2/3 *miliaresion*) cannot be dated accurately within the thirteen years of his reign. It should perhaps be assigned towards the end of the reign, however, since the same type appears on an issue by his successor Theodora.

[19] Grierson 1973a, 173, n. 509.

[20] For a fully documented description of the Blachernitissa and the problems connected with the iconographic type, *ODB*, 2170.

[21] Scenes of the emperor being crowned by the Virgin are encountered during the following reigns: Alexios I: *electrum trachea* (Hendy 1969, Pl. 6,6-9); John II: *hyperpyra* (Hendy 1969, Pls 9,6-9 and 11-14); Manuel I: *electrum trachea* (Hendy 1969, Pls 13,1-2 and 14,1-5), *billon trachea* (Hendy 1969, Pls 16,1-15 and 17,1-4); Isaac II: *tetartera* (Hendy 1969, Pl. 21,13). See also type A of the 'faithful imitations', or Bulgarian imitations according to Hendy (Pl. 24,1-9), and type F of the Latin imitations (Hendy 1969, Pl. 26,2).

[22] Hendy 1969, Pls 9,1-3, 13,3-4 and 14,6.

[23] Hendy 1969, Pl. 6,2-5.

[24] Hendy 1969, Pls 14,7-9 and 15,1-13.

[25] Hendy 1969, Pl. 18,9-10.

[26] Hendy 1969, Pls 20,1-13 and 21,1-7.

[27] Hendy 1969, Pl. 18,11-12.

[28] Hendy 1969, Pl. 18,13-16.

[29] Hendy 1969, Pl. 11,8-10. The types of the Virgin are defined on the basis of the evidence of the coins and lead seals. See also nos 15-16.

[30] Hendy 1969, Pl. 17,11-12.

[31] Hendy 1969, Pl. 19,12.

[32] Hendy 1969, Pl. 19,2.

[33] Hendy 1969, Pl. 21,8-9.

[34] Touratsoglou 1992, 601-605.

[35] *ODB*, 2171.

[36] Hendy 1969, Pl. 17,7-8.

[37] Hendy 1969, Pl. 19,15.

[38] Hendy 1969, Pl. 23,8.

[39] Hendy 1969, Pl. 27,8-11.

[40] Penna 1997.

[41] Generally speaking, the coinage of the period continued the Komnenian tradition with regard both to numismatic questions and to iconography, though the latter was enriched with new motifs. E.g. the representation of the emperor with wings (Hendy 1969, Pl. 41,17), of St Demetrios offering the walls of the city of Thessaloniki to the ruler (Hendy 1969, Pl. 39,11), and a series of decorative motifs.

[42] Hendy 1969, Pls 31, 11-15 and 32, 1-5. The identification of the coins of Batatzes is based on the smaller flan and pictorial differences (e.g. the figures are more contracted), and by divergences of style and manufacture. Scenes of the emperor being crowned by the Virgin are found in the following reigns: Theodore II: *hyperpyra* (Hendy 1969, Pl. 34,9-14) and *billon trachea* (Hendy 1969, Pl. 35,6); Michael VIII: *hypepyra* (Hendy 1969, Pl. 36,1) and *billon trachea* (Hendy 1969, Pl. 36,3); Manuel Komnenos Doukas: *aspra trachea* (Hendy, Pl. 39, 1); John Komnenos Doukas: *billon trachea* (Hendy 1969, Pls 40,6 and 41,2). For other representations of the emperor together with the Virgin, Hendy 1969, Pls 33,4; 38,6-7; 40, 1,12-13.

[43] Representations of the Virgin enthroned are encountered in the following reigns: John III Batatzes: *aspra trachea* (Hendy 1969, Pl. 32,7, 10, 11), *billon trachea* (Hendy 1969, Pl. 33,7-8, 10); Theodore Komnenos Doukas: *aspra trachea* (Hendy 1969, Pl. 37,5-6), *billon trachea* (Hendy 1969, Pl. 38,1-2); Manuel Komnenos Doukas: *billon trachea* (Hendy 1969, Pl. 39,4-5); John Komnenos Doukas: *billon trachea* (Hendy 1969, Pl. 40,3); John III Batatzes (Thessaloniki): *billon trachea* (Hendy 1969, Pl. 42,9-10).

[44] John III Batatzes: *billon trachea* (Hendy 1969, Pl. 33,3); Theodore Komnenos Doukas: *billon trachea* (Hendy 1969, Pl. 38,5); John III Batatzes (Thessaloniki): *billon trachea* (Hendy 1969, Pl. 43,1-2).

[45] John III: *billon trachea* (Hendy 1969, Pl. 33,13); Theodore Komnenos Doukas: *tetartera* (Hendy 1969, Pl. 38, 12); Manuel Komnenos Doukas (Hendy 1969, Pl. 39,6); John Komnenos Doukas: *billon trachea* (Hendy 1969, Pl. 41,17).

[46] John III Batatzes: *tetartera* (Hendy 1969, Pl. 34,8).

[47] Hendy 1969, Pl. 37,3-4.

[48] For a concise but well-documented description of the iconographic types of the Virgin during the Palaiologan period, Grierson 1999a, 75-77 with relevant bibliography.

[49] Grierson 1999b, Pls 1-2 (Michael VIII), 14-30 (Andronikos II), 63, 1193 (John V and John Kantakouzenos).

[50] Penna 1998, 262, n. 5.

[51] Morrisson and Zacos 1978, 57-72. Also Penna 1998, 263-265.

[52] Seibt 1987, 35-56. Also Seibt and Zarnitz 1997, 104-106 with relevant bibliography.

[53] E.g. *DOSeals* I-III, Zacos and Veglery 1972 and Zacos 1984.

[54] E.g. Zacos 1984, no. 522.

[55] Seibt 1987, 43, fig. 7. Also Grierson 1973a, 171.

[56] Zacos 1984, no. 788 and *DOSeals*, II, no. 21.2.

[57] Zacos 1984, no. 648. Also, Touratsoglou 1992, 604-605, n. 34.

[58] Laurent 1952, no. 466.

[59] Zacos 1984, no. 654 and Laurent 1981, no. 900.

[60] Galavaris 1959, 229-233. Also Seibt 1987, 45, n. 28.

[61] *DOSeals*, II, no. 61.2.

[62] Laurent 1981, no. 1028 and Laurent 1965, no. 1156.

[63] Lazarev 1967, pl. 77.

[64] N. Chatzidakis 1994, 64, no. 40.

[65] Laurent 1981, no. 209.

[66] Laurent 1965, no. 1156.

[67] Tatić-Djurić 1981, 758-786; also, *ODB*, 2176 and Vloberg 1952, 403ff.

[68] Zacos 1984, no. 551 and *DOSeals*, II, no. 52.2. The appellation probably alludes to an icon in the Monastery *ton Bassou* in Constantinople.

[69] Zacos 1984, no. 587.

[70] Laurent 1965, no. 692.

[71] Laurent 1963, nos 605 and 607.

[72] Zacos 1984, no. 515.

[73] Seibt and Zarnitz 1997, 141-143, no. 3.3.6. The appellation probably alludes to the Theoskepastos monastery at Trebizond in Pontos. Also, Pennas 1998, 287-288, no. 9.

[74] Zacos 1984, no. 767.

[75] Seibt 1987, 52, no. 58; Seibt and Zarnitz 1997, 105, nos 3.1.14, 5.2.9-10. A similar type is also found on a seal of the Oxyviasousa monastery: Laurent 1965, no. 1292.

[76] *DOSeals*, I, no. 43.6.

[77] *DOSeals*, III, no. 53.8. Also Cutler 1987, 335-350, pls 1-2.

[78] *DOSeals*, I, no. 12.1.

[79] Konstantopoulos, no. 676.

[80] Stamoulis Collection, no. 3207.

[81] Konstantopoulos, no. 669.

[82] Zacos 1984, no. 771.

[83] E.g. Zacos 1984, nos 404, 488, 518, 539, 599, 621, 635, 687.

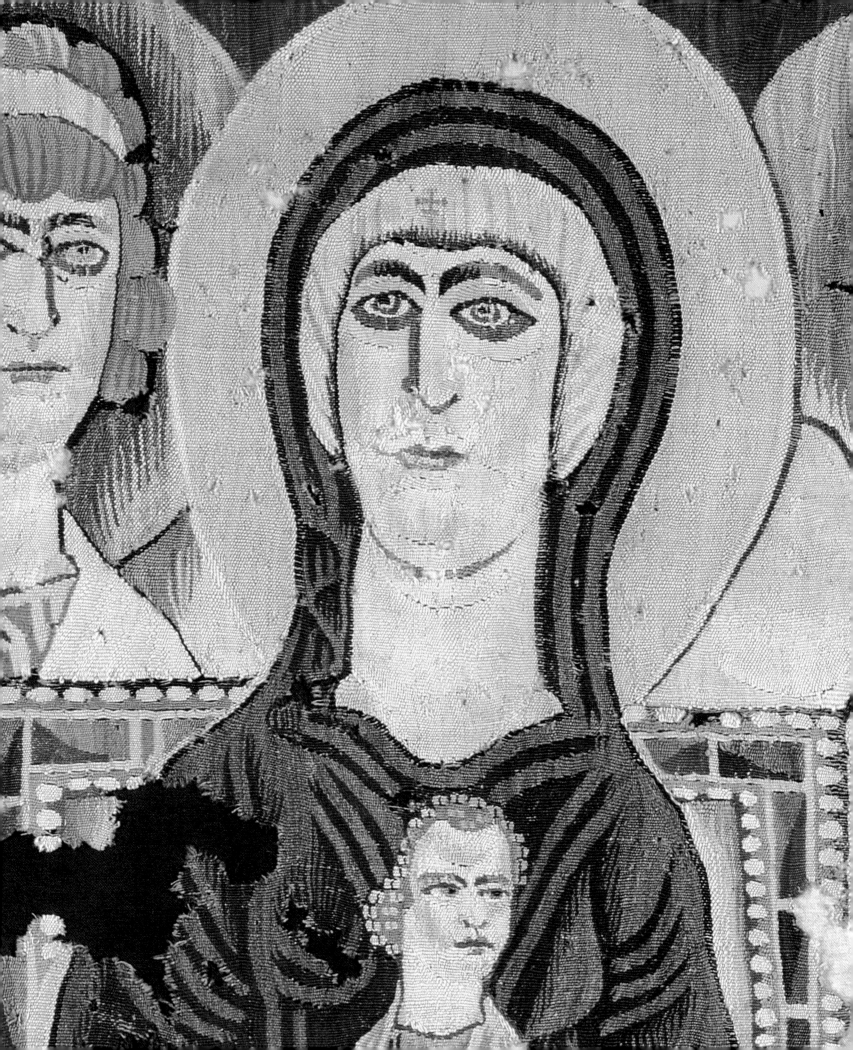

Marie-Hélène Rutschowscaya

The Mother of God in Coptic Textiles

Whether in narrative cycles or showing her enthroned, representations of the Mother of God in Coptic art are both numerous and varied. The doctrine of the Immaculate Conception of the Virgin, formulated by St Cyril and confirmed by the Ecumenical Council of Ephesus in 431, reinforced the veneration accorded to the Theotokos, which was already widespread in Egypt before 431. The Virgin was depicted mostly in wall-paintings in monasteries, thanks to the special veneration accorded to her by the monks, who founded churches and chapels in her name. She also occurs, of course, in numerous miniatures in lectionaries and icons. Reliefs carved in stone, wood or ivory, and metal objects, whether liturgical items (crosses, censers, incense-boxes) or parts of liturgical structures (doors, boxes, chancel screens) also lent themselves to the image of the Mother of God.

In contrast, we can count no more than a dozen representations of the Virgin on textiles and tapestries, whether made of linen and wool or of silk. This small number may be due to the disappearance of pieces of fabric through lack of proper care. Nevertheless, amongst the large number of Coptic textiles surviving to the present day, those adorned with scenes drawn from the Christian repertoire (with representations inspired by the Old and the New Testament and depictions of saints) are in the minority. It is possible, therefore, that commissions of that sort, placed by churches and, to a lesser extent, by private individuals, were much less frequent than commissions for secular or even pagan subjects. Archaeological excavations and the written sources nevertheless enable us to determine the function of these textiles, which are often preserved only in fragments. In his Homilies, for example, Bishop Asterios of Amaseia (4th century) denounces the practice of wearing garments adorned with scenes drawn from the Holy Scriptures: 'Among the wealthy many of the devout, choosing the Gospel story, have handed it to the weavers; him, I say, Christ our Lord and all his disciples. ... and in doing this, they think themselves pious and clothed in garments pleasing to the Lord. If they would heed my advice, they would sell them, and they would honour the living images of God' (Asterios of Amaseia, Homily on the Gospel according to Luke, on the rich man and Lazarus). This practice thus appears to have been fashionable, and indeed an excellent example is provided by the cloak of the Empress Theodora, which is adorned with a scene of the Adoration of the Magi, in the church of San Vitale at Ravenna (6th century) (Pl. 164). Textiles were also used as altar coverings, and were sometimes hung on walls or between columns and in front of doorways, as curtains. In his description of Hagia Sophia in Constantinople, Paul the Silentiary (6th century) states that the altar was adorned with a depiction of Christ between Sts Peter and Paul.[1] The Ravenna church owned a number of precious textiles, one of which depicted all the episodes from the life of Christ.[2] The inventory of the possessions of the church of St Theodore in Ashmounein, Middle Egypt (8th century?), which is recorded in Coptic, mentions large curtains, altar coverings, door curtains, embroidered tablecloths, a cloth for a canopy, and some covers.[3]

Textiles dedicated to the Virgin were executed in a variety of techniques. Owing to their fragility, linen textiles with printed decoration frequently survive only in very fragmentary condition. This technique, considered by Pliny the Elder (*NH* XXXV 42) to be specific to Egypt, was used to make large panels, probably intended to be hung on walls. Only three fragments have survived, one rep-

resenting the Nativity, the second the Annunciation (London, Victoria and Albert Museum) (Pl. 165)[4] and the third the Adoration of the Magi (The Cleveland Museum of Art).[5] The last formed part of a larger ensemble, of which all that survives are fragments of three bands of decoration with various scenes from the Old and New Testaments. The Magi, dressed in oriental fashion, with Phrygian caps, short tunics, and boots, advance briskly towards the Virgin with Child, who is seated on a stool with a footrest. On the other two fragments, only two scenes survive — the Nativity and the Annunciation — though there may have been others from the lives of the Virgin and Christ. Two large panels dating from the fourth century and adorned with pagan scenes enable us to form some idea of how the decoration on these textiles was arranged, and also constitute oustanding evidence of the tradition recorded by Pliny: one depicts Artemis accompanied by hero-hunters (Riggisberg, Switzerland, Abegg-Stiftung)[6] while the other is the so-called 'veil of Antinoe' (Paris, Musée du Louvre) (Pl. 166).[7] The latter is of particular interest in that it is adorned by a Dionysiac procession, surmounted by a narrow frieze depicting the childhood of Dionysos. The narration of the events, between two ribands decorated with stylized vines and anthemia, may be compared to the two textiles in the Victoria and Albert Museum; on the other hand, the pose of Semele, who is reclining on a palliasse between two women in the scene of the young god's birth, may be compared to the figure of the Theotokos in the representation of the Nativity of Christ. These correspondences, even if there is no direct connection, do nonetheless point to a community of style, technique and iconography, which had been bequeathed intact to Christianity by the pagan world.

In contrast, embroideries executed in silk thread on linen are works falling within the sphere of Byzantine influence. The appliqué roundel in the Victoria and Albert Museum unites the Annunciation and the Visitation (Pl. 167); in the latter scene, the Virgin may be identified on the left from her garment, which is dotted with stars. The band in the Louvre (Cat. no. 9) was probably combined with the Annunciation to the Shepherds (?) and a number of other scenes; another band in the Victoria and Albert Museum is so fragmentary that all that can be seen are the Theotokos' seat and the legs of two magi or shepherds (?).[8]

A silk *examiton* (Riggisberg, Abegg-Stiftung)[9] (Pl. 168) decorated with a cycle devoted to the Virgin, has the distinction that it was buried, probably in Egypt, along with a wall-hanging adorned with large-scale Dionysiac figures, the profoundly Roman style of which enables it to be dated to the fourth century. Despite the many gaps, it has proved possible to identify the Presentation of the Virgin, the Lot that Fell upon Joseph, the Annunciation at the Well, the Nativity, and the Bathing of the Infant Christ (the last two scenes are the most fragmentary of all). The iconography and style of the silk cloth in question patently bear the marks of Graeco-Roman influence: the lifelike movement and fluid attitudes of the figures (for example, the kneeling Virgin and the gestures of the figures) are combined with a wingless angel, who resembles an ancient herald, and with the personification of water: a nymph leaning on an amphora.

164. *The Empress Theodora mosaic*, detail. San Vitale, Ravenna.

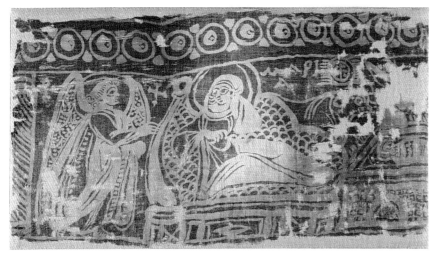

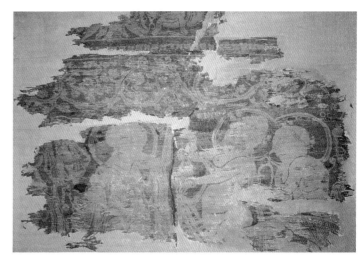

165. *Panel of linen with
The Annunciation*.
Victoria and Albert Museum,
London.

166. *The Veil of Antinoe*.
Musée du Louvre, Paris.

167. *Roundel with
The Annunciation
and The Visitation*.
Victoria and Albert Museum,
London.

221

The Visitation was probably depicted on a circular piece of a linen-and-wool wall-hanging in the Victoria and Albert Museum.[10] Mary is depicted as a young woman, on the left, opposite the elderly Elizabeth; they are shown closely embracing one another in a building with a fanciful roof carried on two columns. The Adoration of the Magi is depicted on a medallion in a private collection in Paris.[11] The infant Christ, with a halo containing an inscribed cross, is seated on his mother's knees. Despite the stylistic distortion, the Three Magi can clearly be made out, moving forward and carrying their gifts; higher up, above the Virgin, the small figure apparently welcoming the pilgrims, is probably to be identified as Joseph. A wall-hanging of large dimensions, 4.55 × 2.85 m (Geneva, Musée d'art et d'histoire),[12] also fragmentary, is divided into two bands. The lower is decorated with large Greek bejewelled crosses bordered by anthemia and medallions with inscribed crosses. The upper band, lying between two ribands of voluted foliage and anthemia, is divided into panels by richly decorated columns, each one different. A figure is standing in each of the spaces between the columns: the Theotokos, praying between the two archangels, Michael and Gabriel; the other figures, either monks or martyrs, can no longer be identified. Although the treatment of the faces and drapery is linear rather than painterly, the Byzantine influence is quite distinct, as in the wall-paintings of the monastery of St Jeremiah at Saqqara and of the Bawit monastery (Pl. 169), which reproduce the same iconography.[13] The iconography and dimensions of the piece clearly point to its use as a wall-hanging, evidently in imitation of the wall-paintings of Saqqara and Bawit. A piece of textile, also of exceptional quality, in the Cleveland Museum has been composed like a real icon (Pl. 170).[14] The Virgin with Child is seated on a throne and is flanked by the Archangels Michael and Gabriel. Their names and that of the Virgin herself are written on the architrave carried by two columns, which frame the figures. The archangels are holding sceptres, but Gabriel is also holding a celestial sphere divided into four parts, each of which

168. *Drawing of a silk textile with scenes from the life of the Virgin.*
Abegg Stiftung, Riggisberg (after L Kötsche).

169. *Wall-painting from Bawit.*
Coptic Museum, Cairo.

222

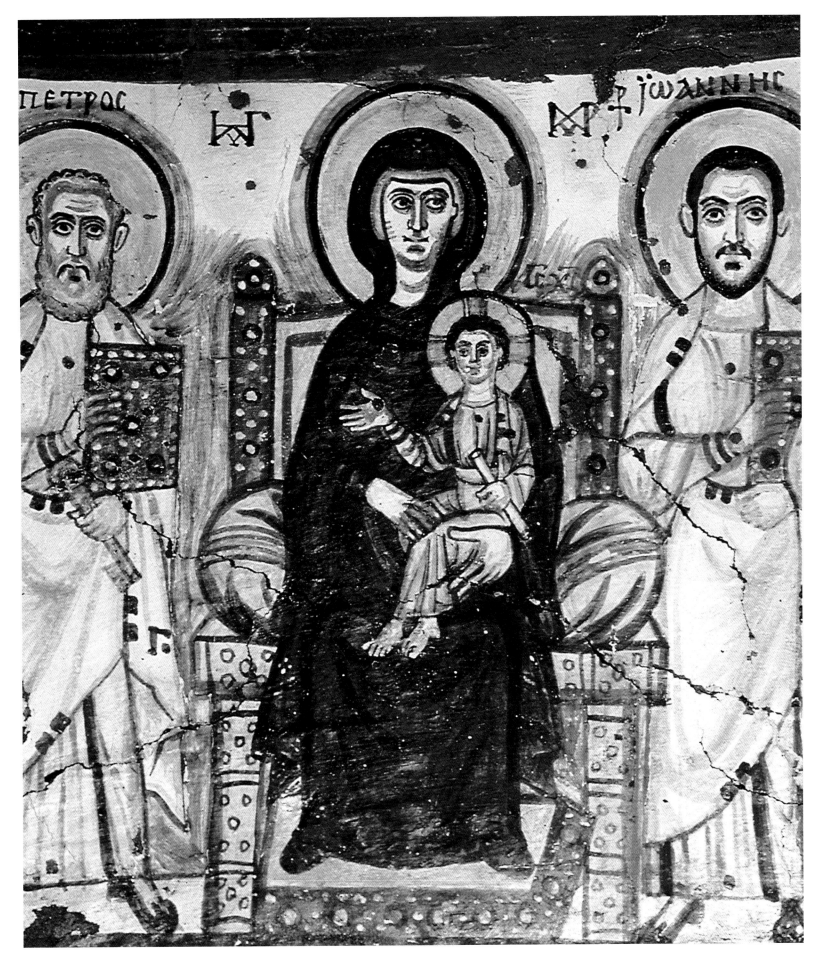

ΠΕΤΡΟC · · · jωΑΝΝΗC

223

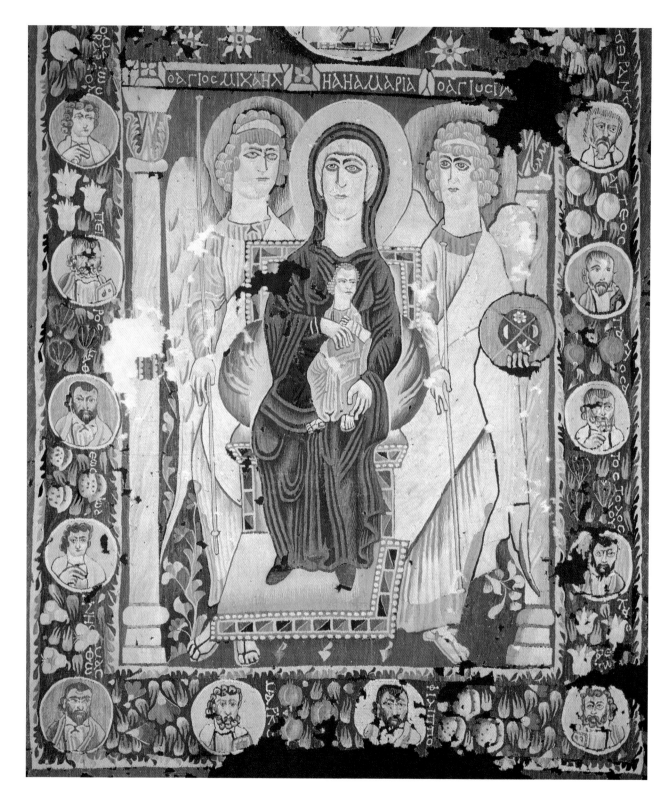

170. *Textile with the Enthroned Virgin and Child.* The Cleveland Museum of Art, Cleveland.

224

decorated with two anthemia (sun and star) and two half moons. These symbols represent the universality of imperial authority, and hence also that of Christ, whose image is based closely on that of the emperor. This is readily apparent in the upper zone, where he is shown enthroned in the heavens, like a king, and borne in a mandorla by two angels, recalling the theme of the Ascension. As for the Theotokos, she may be likened to an empress:[15] her throne, encrusted with precious stones, is typically Byzantine; her blue garment contrasts with the red of her shoes — a clear allusion to the imperial purple. A painted icon from the monastery of St Catherine on Sinai (Cat. no. 1) depicts her in an identical manner, flanked by saints and angels (6th-7th century).[16] The latter replace the soldiers or dignitaries framing the emperor or eparch in consular diptychs made of ivory.[17] An elaborate framework of foliage, full of flowers and fruit, contains the busts of the Twelve Apostles, each named by a Greek inscription. This arrangement in two bands derives from monumental art, such as the wall-paintings in the apses of the side-chapels in the Bawit and Saqqara monasteries. At Bawit, the most important position is occupied by Christ: in accordance with the description of the apocalyptic vision of John or Ezekiel, his throne is a chariot of fire drawn by wings of seraphim and the four zodiacs;[18] the Theotokos occupies a subsidiary position in the lower band, surrounded by apostles. Nevertheless, as at Saqqara, the apse may have been dedicated to the Virgin; in that case it is the Brephokratousa or Galaktotrophousa *(Lactans)* framed by angels that is depicted.[19] In the Cleveland wall-hanging, the emphasis given to the figure of the Virgin derives from the larger scale on which she is depicted, thus, as laid down by the Council of Ephesus (431), stressing the doctrine of the Incarnation, which constitutes the beginning in the unfolding plan of the Divine Economy, brought to its conclusion, in the upper band, with the scene of the Ascension.

[1] *DACL* XV, 2408.
[2] *DACL* XV, 2408.
[3] *DACL* VII 1, 1410-1414.
[4] Kendrick 1922, nos 785 and 786.
[5] *Age of Spirituality,* no. 390.
[6] Baratte 1985, 31-76.
[7] Rutschowscaya 1990, 28-29.

[8] Kendrick 1922, no. 782.
[9] Flury-Lemberg 1988, 367-383.
[10] Kendrick 1922, no. 715.
[11] Volbach 1966, fig. 37.
[12] Martiniani-Reber 1991, no. 186.
[13] Maspero 1943, pls XXI-XXIV, XXXI-XXXIII, XLVII-L.

[14] Rutschowscaya 1990, 135-137.
[15] Volbach 1952, no. 52.
[16] *Age of Spirituality,* no. 478.
[17] Volbach 1952, nos 3, 8, 15, 24, 31.
[18] Badawy 1978, figs 4.25, 4.26, 4.27.
[19] Badawy 1978, figs 4.28, 4.38, 4.39.

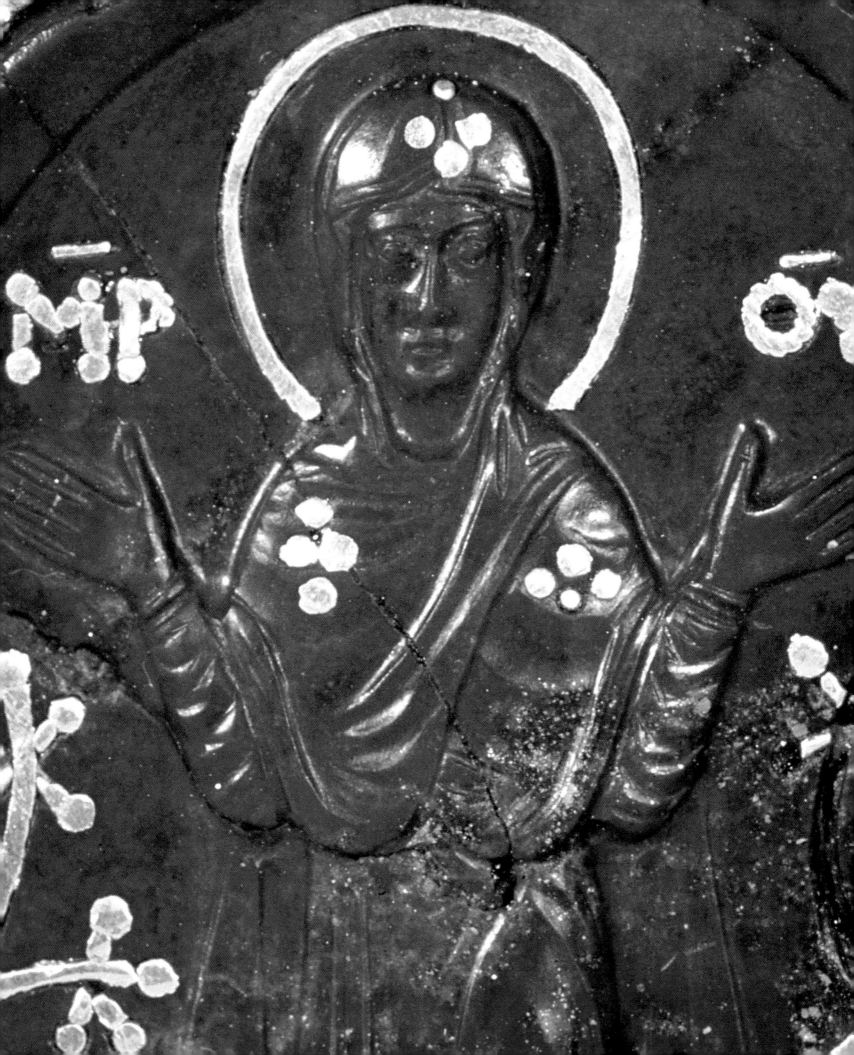

The Mother of God in Jewellery

From the fourth century Byzantine jewellery, an art form with clearly discernible roots in the Hellenistic tradition, developed and acquired characteristic forms which, with minor variations, were to become predominant over the entire Byzantine Age.[1] Typical examples are provided by the mounted coins that are commonly found as a means of storing wealth from the time of the third-century economic crisis. These developed into large medallions,[2] often imperial gifts, or into enkolpia, to which representations of deities or religious scenes gave a protective character.

Finger-rings set with stones, earrings with pendent attachments, strap bracelets adorned with a wide central element, brooches with shapes and decoration akin to those of the pendants, belts with jewellery attached to the leather or material of which they were made, buckles and fibulae used to fasten chitons at the shoulders — these are some of the forms that were inherited from the Greek tradition and through which its character was transmitted later to Byzantine jewellery.

Despite the strong objections of the Church Fathers to the excessive use of jewellery, the Church conceded that the head of the family might wear a finger-ring adorned with Christian symbols, in the form of either a signet-ring or a wedding-ring.[3] Although protests and prohibitions did not succeed in stopping the spread of the production of precious jewellery, they did perhaps direct the range of motifs used towards the Christian repertoire, gradually leading to the establishment of the iconographic content predominantly found in Byzantine jewellery. The earliest examples, of the fourth century, however, derive their forms and their designs from Classical models, using mainly floral and geometric motifs, which gradually acquired symbolic meanings associated with the new religion.[4]

Christograms, small crosses, and symbolic representations of the vine also timidly made their appearance during the fourth century.[5] From the sixth century on references to Christ or the Virgin are found in inscriptions of invocation accompanying respective representations.[6] Greatly cherished and pre-eminently personal objects, which gave expression to prevailing taste, to fashions in dress adornment and, not infrequently, to excesses of ostentation, pieces of jewellery often acquired the apotropaic properties of amulets.

Depictions like that of the Medusa[7] in Roman jewellery were associated with the idea of warding off evil spirits and protecting the owner of the object from a variety of dangers. At the same time, the protection was invoked of foreign deities such as Isis, who guaranteed a favourable childbirth,[8] or Mithras, whose cult is attested by numerous sanctuaries in the forts on the borders of the Roman Empire.[9]

A gradual shift is traceable away from the apotropaic character of the earlier amulets toward the Christian concept of an appeal, usually to Christ and the Virgin, for assistance and protection, expressed through a simple inscription or appropriate images, or at times through a combination of the two. Mention was usually made in the inscriptions of the name of the owner, as, for example, in those of the type: KYPIE (Lord) or ΘΕΟΤΟΚΕ ΒΟΗΘΙ ΤΟΝ ΔΟΥΛΟΝ / (Mother of God, help thy servant) THN ΔΟΥΛΗΝ, or simply MAPIAC (of Maria) or TH ΦΟΡΟΥCA (the wearer).[10]

The forms of jewellery on which representations of the Virgin are to be found are fairly well defined, and the preference for them is not without significance. Enkolpia are naturally the most

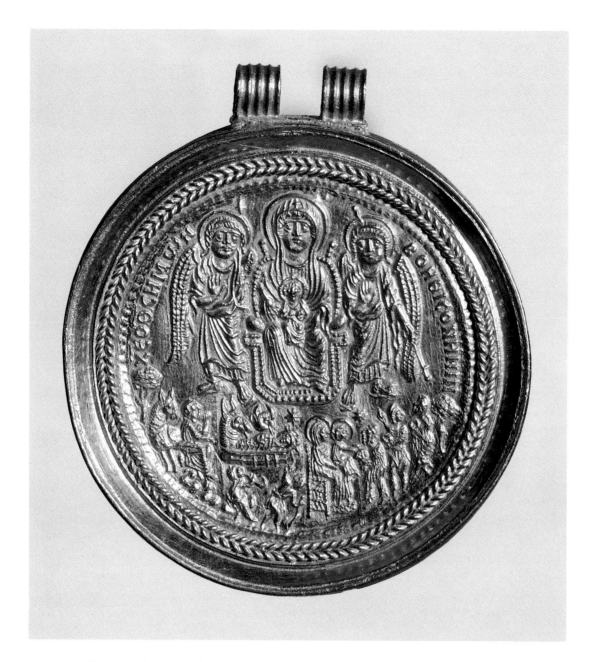

172. *Gold enkolpion.*
Byzantine Collection,
Dumbarton Oaks,
Washington.

common, since they hung on the chest and thus placed the favourite piece of jewellery bearing the image of the protector close to the heart.[11] Finger-rings continued to be identified with symbolic scenes, as dictated by tradition, and similar representations were found by extension on bracelets. Divine figures are not found in other kinds of jewellery, such as earrings, belts, or brooches, although these items did bear symbolic motifs, such as confronted peacocks flanking a cross or a fountain.

Three gold medallions are connected by their date, style and motifs, and demonstrate the symbolic meaning and protective character that scenes, in this case from the life of the Virgin, could acquire. The mounted medallion in the Dumbarton Oaks Collection,[12] from the second Cypriot Treasure, has a representation of the Virgin enthroned flanked by two angels, with scenes of the Nativity and the Adoration of the Magi below, and the Baptism on the back (Pl. 172). The medallion, from the Assiut Treasure, in the Berlin Antikensammlung[13] is suspended from a torque in which are set coins dated up to 602. It has a representation of the Annunciation on one side and the Wedding at Cana on the other. Finally, the medallion in the Schmidt Collection (Cat. no. 10) seems to date from the same period. This has a representation of Christ blessing a newly married couple on one side, and the Annunciation and Nativity on the other.

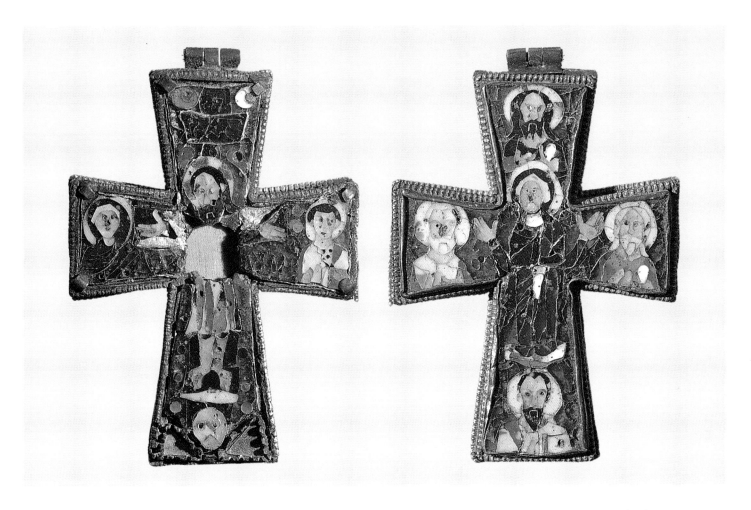

173. *The Beresford Hope Cross.*
Victoria and Albert Museum,
London.

It is apparent, therefore, that medallions with representations of these particular scenes were intended to protect marriage and childbirth.[14] It is also characteristic that they are dated to around the seventh century, a period in which medallions or enkolpia with individual divine figures do not seem to have been common, and when it was no longer fashionable to wear necklaces with mounted coins bearing figures of emperors. In contrast, there are pilgrim flasks in a similar style to these medallions, an example being the silver pilgrim flask in Monza cathedral, in which the scenes display a great affinity with those on the medallions.[15]

After Iconoclasm and starting from the time of the Macedonian dynasty, which ushered in a phase of unprecedented development in Byzantine art in general and the goldsmith's art in particular, full-length depictions of the Virgin orans[16] became common on enkolpia or cross-amulets in the Middle Byzantine period. Enamel and intaglio semiprecious stones were the materials mainly used in the manufacture of these items of jewellery, though corresponding scenes are also found on bronze, indicating the broad scope of the devotion and faith invariably accorded to the figure of the Virgin.

One of the earliest depictions of the Virgin orans in enamel is that on the back of the cruciform reliquary from the Beresford Hope Collection in the Victoria and Albert Museum (Pl. 173), which is executed in a fairly naive style.[17] The iconographic elements in this artefact, however—the representation of the Crucifixion on one side and the saints flanking the Virgin—are features that were to become predominant in later depictions on crosses and enkolpia.

Another enkolpion-reliquary, in the Virginia Museum of Fine Arts (Pls 174 and 175),[18] belongs to a more advanced stage of enamel-working. Christ is again depicted on one side, though not as part of a Crucifixion scene, but standing, flanked by busts of the Apostles Peter and Paul. The back of this quatrefoil enkolpion has the Virgin, full-length and orans, flanked by busts of the Evangelists John and Luke. The treatment of the figures and the excellent workmanship recall the outstanding large-scale examples of the art of enamel from the late tenth to the twelfth century.[19] Similar work-

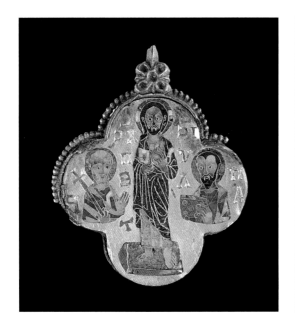

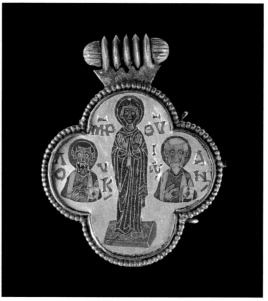

manship is accorded to the figure of the Virgin, also full-length and orans, on the cross-reliquary in the British Museum (Cat. no. 16),[20] which is accompanied by busts of St Basil and St Gregory Thaumatourgos (the Miracle-Worker). The last two examples are linked by other features, such as the grooved suspension ring and the edging of incised wire which imitates a string of beads. These features and the affinity of the enamel style point to a similar date for the two ornaments, which are assigned to the early eleventh century.[21]

The figure of Christ is rendered in the scene of the Crucifixion in the established type between the Virgin and St John, while on the enkolpion, where he is standing and blessing, he is flanked by the Apostles Peter and Paul, a composition symbolizing the Triumph of Christianity in the East and the West. In contrast, the image of the Virgin is flanked by Evangelists and Church Fathers, allowing the owner of the piece the freedom to invoke the saint of his choice, according to the particular circumstances. The representations of the Virgin thus acquire an immediate personal character associated with the idea of the personal amulet.

The type of the Virgin Hagiosoritissa, with the bust of the Virgin turned to the side, her arms raised in supplication, is found on two more enkolpia. On one of these, in Maastricht (Pl. 118), the figure of Christ is depicted in the top corner, projected against a starry background, while the back is adorned by a repoussé depiction of the Annunciation.[22] On the small enkolpion, in New York, the Virgin is shown on one side and Christ blessing on the other[23] (Pls 203 and 204). Another enkolpion-reliquary from Bulgaria has a repoussé depiction of the Virgin in the type of the Hagiosoritissa. Only some of the details, such as the border and the halo, are rendered in enamel, and the reverse has a niello representation of a cross on a high base, flanked by two cypresses.[24] The small gold reliquary (Cat. no. 15) in the Kanellopoulos Collection is of a different kind, without enamel decoration and related more to the pilgrims' flasks. It bears the bust of Christ on one side and the Virgin on the other, and should be dated to about the eleventh century.

Several enkolpia have been preserved with images of the Virgin on mounted intaglio semi-precious stones, which are dated to the eleventh and twelfth centuries on the basis of the technique, style and analogies with figures depicted on ivories of the same period. More specifically, the two-sided, small icon-pendant of lapis lazuli in the Louvre[25] (Pls 176 and 177), with Christ standing on one side and the Virgin orans on the other, gives a good idea of the standards of luxury and care associated with these small, highly popular objects.

A similar small icon with the figure of the Virgin turned to the side, in the type of the Hagiosoritissa, rendered in intaglio in haematite, in the Walters Art Gallery, Baltimore,[26] probably comes from a larger composition. The view has been advanced that horseshoe-shaped stones of

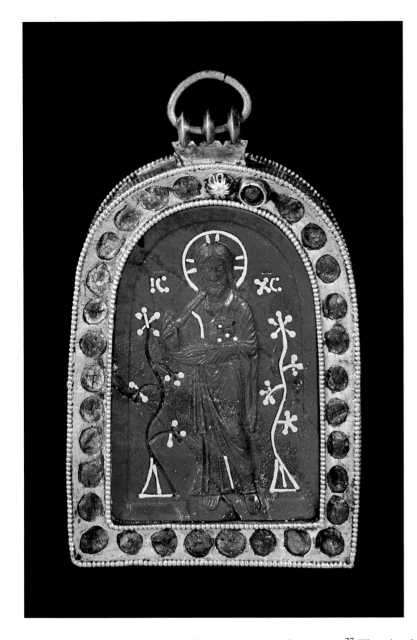

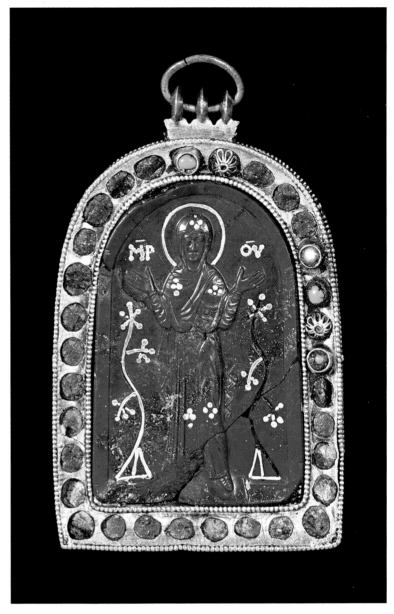

176. *Icon of lapis lazuli:*
A. *Christ Enthroned.*
Musée du Louvre, Paris.

177. *Icon of lapis lazuli:*
B. *The Virgin orans.*
Musée du Louvre, Paris.

this type were set in crowns.[27] The slenderness of the figure, its expression and the treatment of the drapery, link the piece with Constantinopolitan workshops. The jasper cameo in the British Museum,[28] with a standing figure of the Virgin, her arms extended in prayer, is also considered to date from the eleventh-twelfth century. The icon of the Blachernitissa adorns another small haematite cameo (Pl. 178) in the Victoria and Albert Museum, London,[29] and two further examples in the Cabinet des Médailles of the Bibliothèque Nationale, Paris, have intaglio representations of the Virgin in jasper, in one case praying with her arms in front of her breast,[30] and in the other in the type of the Hodegetria;[31] both date from the twelfth century.

Semiprecious stones are frequently engraved with scenes that also give the enkolpia the character of an amulet, as in the case of the scene of the Annunciation on the agate sealstone in the Benaki Museum[32] (Pl. 179). A number of glass enkolpia with gold settings, two in Berlin originating from Italy, one in the Cabinet des Médailles[33] and an identical one in the Stathatos Collection (Pl. 180) of the National Archaeological Museum, Athens,[34] have representations of the Virgin, full-length and frontal, with her arms raised in supplication and flanked by two small palm-trees; the figures on the small lapis lazuli icon in the Louvre[35] and on the crown of Constantine IX Monomachos in the National Museum, Budapest,[36] are flanked by similar trees. The final group of enkolpia consists of crosses and cross-reliquaries sometimes of bronze with repoussé decora-

231

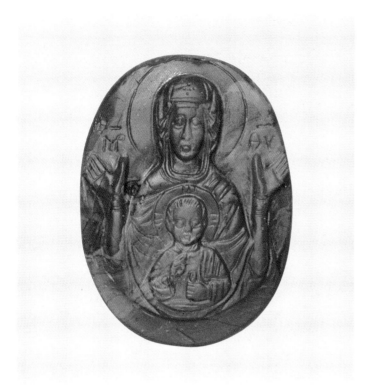
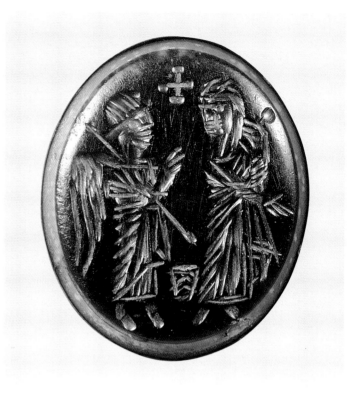

178. *Haematite cameo.*
Victoria and Albert Museum,
London.

179. *Agate sealstone.*
Benaki Museum, Athens.

tion, frequently of silver and in exceptional cases of gold with engraved scenes inlaid with niello.

Small bronze crosses were known as early as the seventh century and were used as amulets which were probably mass-produced. A characteristic example is the cross-reliquary in the Benaki Museum (Cat. no. 24) with a scene of the Crucifixion on one side and the Virgin in an attitude of prayer on the other.[37] Many other examples were produced from the seventh to the tenth-eleventh century, with slight variations.[38]

There are also several silver cross-reliquaries with engraved decoration inlaid with niello, dating from the ninth to the eleventh century. The cross-reliquary in the Benaki Museum is a notable example, with two attached crosses and an internal one in which a piece of the True Cross was kept. The Crucifixion, with the rigid figure of Christ wearing a long tunic, and that of the Virgin, standing in an attitude of prayer or in the type of the Nikopoios, surrounded by medallions with the Evangelists, are some of the elements that continued unmodified for many centuries. An outstanding example in this series is the cross-reliquary from Pliska[39] in Bulgaria; in addition to the Virgin and the Crucifixion, depicted on the inner cross, the outer faces of the reliquary are adorned with a wealth of representations drawn from the life of Christ.

Finger-rings are another form of jewellery that acquired the character of amulets through representations of the Virgin or related scenes. A group of wedding rings dated to about the seventh century acquire their character as amulets from the scene of the blessing of the marriage depicted on the octagonal bezel, while the polygonal hoop is occupied by scenes from the Gospels.

On a finger-ring from Palermo[40] the marriage is blessed by the Virgin alone, depicted between the bride and groom, while on a similar ring in the British Museum[41] and another in the Dumbarton Oaks Collection[42] Christ and the Virgin together bless the marriage (Pl. 181). In these rings there are some differences in the scenes depicted on the facets of the hoop, and there are also some in which the marriage is blessed by Christ alone. Rings of similar form, with engraved decoration inlaid with niello, have a variety of scenes on the bezel, though the central figure is invariably the Virgin, to whom an entreaty for some kind of protection is addressed; these rings may accordingly be regarded as amulets. One in the Walters Art Gallery[43] has a scene of the Ascension on the bezel, while others in the Benaki Museum,[44] the Stathatos Collection,[45] and the Cabinet des Médailles in Paris[46] have the Annunciation, treated fairly simply; a ring in the Musée des Arts Décoratifs in

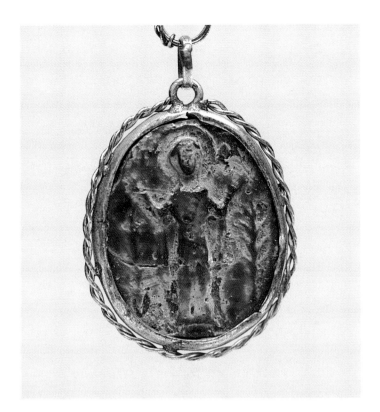

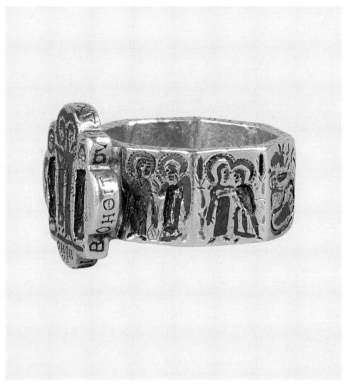

180. *Glass enkolpion.*
The Stathatos Collection,
National Archaeological
Museum, Athens.

181. *Octagonal marriage ring.*
Byzantine Collection,
Dumbarton Oaks,
Washington.

Paris[47] has a quatrefoil bezel with a representation of the full-length Virgin and Child, and an angel on either side.

The finger-ring from the Christian Schmidt Collection, Munich (Cat. no. 13) dates from the same period, though it belongs to a different type with an open-work hoop on which there is an inscription, and a bezel with a full-length figure of the Virgin Hodegetria, in this case worked in repoussé. Two enamelled rings in the Dumbarton Oaks Collection[48] are of particular interest in that both have a depiction of the Virgin in bust accompanied by the inscription: ΘΕΟΤΟΚΕ ΒΟΗΘΙ (Mother of God, Help); in one case the inscription refers to Michael Attaleites (Pl. 182), a jurist and historian who came to Constantinople in 1034 and died in 1080, and in the other (Cat. no. 12) to Admiral Michael Stryphnos, mentioned by Nikephoros Choniates as δουξ του στόλου (*dux* of the fleet) under Alexios III Angelos (1195-1203); both rings are thus accurately dated. Moreover, the fact that highly placed persons in Byzantine public life used amulets and invoked the aid of the Mother of God gives a good idea of the wide extent of the private veneration of the Virgin. The finger-ring in the Benaki Museum with a bust of the Virgin in enamel[49] should be assigned to the same group.

Coming now to the category of bracelets,[50] the one in the British Museum (Cat. no. 11) is an outstanding example, with a repoussé bust of the Virgin orans in the circular central medallion of the bezel. The bracelet type, the technique, and the figure of the Virgin link this piece with Constantinopolitan workshops of the sixth century. Particular interest attaches to the running scroll adorning the hoop, with depictions of birds, each symbolizing some quality of the Theotokos—the swans purity, for example, and the guinea-fowl immortality.[51]

The bracelet in the Stathatos Collection[52] (Pl. 183) should be assigned a considerably later date, in the eleventh or the twelfth century; two intertwined cylindrical elements terminate in two horse-shoe-shaped plaques with repoussé busts of Christ and the Virgin, the treatment of which is fairly closely related to the technique of coins.

As we have already observed, there appear to be no other kinds of jewellery on which the figure of the Virgin is represented. The only examples of earrings with a representation of the Virgin are one in the Kanellopoulos Collection[53] and a pair in the Dumbarton Oaks Collection,[54] concerning which Ross has already reported the reservations of Ševčenko regarding their authenticity. Susan

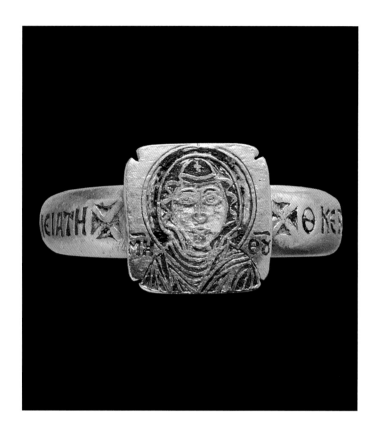

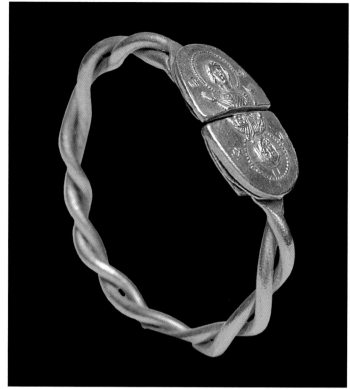

Boyd and Gary Vikan[55] set out in detail the reasons that lead them to believe that all three earrings were made in the same period. The main argument is furnished by the Greek Σ, used in the inscription ΦΩΣ-ΖΩΗ (Light-Life) in place of the Byzantine C. Moreover, the craftsman clearly had no contact with the Byzantine tradition that governed the rendering of the figure of the Virgin, in which, in the usual attitude of prayer, the hands do not stand out from the folds of the maphorion. We may therefore conclude that representations of the Virgin were not found on earrings, though compositions involving peacocks on crescent-shaped earrings are symbolic of marriage.

All the above examples, however, point to the conclusion that the intimate and personal nature of the relationship between the believer and the amulet-ornament is a special aspect of the veneration of the Theotokos. Even iconographic elements like the prayer and supplication of the Virgin, whose intervention was invoked by the faithful for man's salvation, and scenes such as the blessing of the marriage and the Annunciation, clearly reveal the more human dimension of the Virgin and the hopes that were placed in her protection.

182. *Enameled ring of Michael Attaleiates.* Byzantine Collection, Dumbarton Oaks, Washington.

183. *Golden bracelet.* The Stathatos Collection, National Archaeological Museum, Athens.

[1] Yeroulanou 1999, 30-75.

[2] Vermeule 1975, 5-32.

[3] Clement of Alexandria, *Paedagogus*, 3.56.3-5.

[4] Yeroulanou 1999, 87-107 and 151-163.

[5] Buckton 1983-1984, I, 15-19.

[6] Hadjidakis 1944, 174-206.

[7] Higgins 1961, 187, pl. 57b and Ruseva-Slokoska 1991, nos 127-128.

[8] Coche de la Ferté 1974, 265-289, pl. XVII 1-4.

[9] I am grateful to Yannis Karavas for this information. Also Vermaseren 1959-1960, and on the fortifications of Hadrian in particular Richmond and Gillam 1951, 1-92.

[10] Hadjidakis 1944, 193-206.

[11] To this category should be assigned the necklace from Preslava in Bulgaria (*Glory of Byzantium*, no. 227), in which the central plaque and the attached pendant feature a figure in an attitude of prayer, who is probably the Virgin. This piece displays remarkable similarity to the general decoration and style of a bracelet in Thessaloniki (*Glory of Byzantium*, no. 165), except that a human figure is not represented in the latter.

[12] Ross 1965, no. 36, pl. A.

[13] Greifenhagen 1970-1975, 66-68, pls 46.2, 47-48.

[14] See the bracelet in the Cabinet des Médailles in Paris, Coche de la Ferté 1974, 265-289, pl. XVII 1-4.

[15] Volbach 1961, pl. 254.

[16] A distinction should perhaps be drawn between the figure of the Virgin orans, as found in the three-figure scene of the Deesis, turned to the side with her arms extended before her as she supplicates the Lord for the salvation of mankind, and that in depictions in which the Virgin stands frontally with her arms raised in an attitude of prayer. This latter scene might be designated the Virgin orans, in contradistinction to the stance of the Virgin in supplication. The rendering of the Virgin frontally with her palms open in front of her breast, would be a variant of the Virgin orans. Also Hadjidakis 1944, 94.

[17] *Byzantium*, 1994, no. 141.

[18] Gonosová and Kondoleon 1994, 41.

[19] Gonosová and Kondoleon 1994, 119.

[20] *Byzantium,* 1994, no. 165.

[21] Gonosová and Kondoleon 1994, 119; *Byzantium,* 1994, 151.

[22] *Glory of Byzantium,* no. 113.

[23] *Glory of Byzantium,* no. 112.

[24] *Glory of Byzantium,* no. 226.

[25] *Byzance,* no. 195.

[26] *Glory of Byzantium,* no. 135.

[27] *Splendeur de Byzance,* no. St. 2.

[28] *Byzantium,* 1994, no. 172.

[29] *Glory of Byzantium,* no. 134.

[30] *Byzance,* no. 196.

[31] *Byzance,* no. 199.

[32] *Greece at the Benaki Museum,* no. 362.

[33] *Byzance,* no. 218.

[34] *Collection Hélène Stathatos* III, no. 58, pl. V.

[35] *Byzance,* no. 195.

[36] *Glory of Byzantium,* no. 145.

[37] *Greece at the Benaki Museum,* no. 403, and the corresponding cross-reliquary in the Kanellopoulos Museum, *Greek Jewellery,* 332, fig. 251.

[38] See cross-reliquaries such as one from the Case Collection of the University of Chicago, *Early Christian and Byzantine Art,* no. 299 and another in the Detroit Institute of Art, *Early Christian and Byzantine Art,* no. 305.

[39] *Glory of Byzantium,* no. 225.

[40] Hadjidakis 1944, 202.

[41] *Byzantium,* no. 106.

[42] Ross 1965, no. 69.

[43] *Jewellery Ancient to Modern,* no. 427.

[44] *Greek Jewellery,* no. 119.

[45] *Collection Hélène Stathatos* III, no. 41, pl. V.

[46] *Byzance,* no. 88.

[47] *Byzance,* no. 85.

[48] Ross 1965, nos 156, 158.

[49] Segall 1938, no. 262.

[50] See the bracelet in the Cabinet des Médailles in Paris, Coche de la Ferté 1974, 265-289, pl. XVII 1-4.

[51] Yeroulanou 1999, 180.

[52] *Collection Hélène Stathatos* III, no. 32.

[53] *Greek Jewellery 6,000 Years of Tradition,* no. 281.

[54] Ross 1965, no. 133.

[55] *Question of Authenticity,* no. 9.

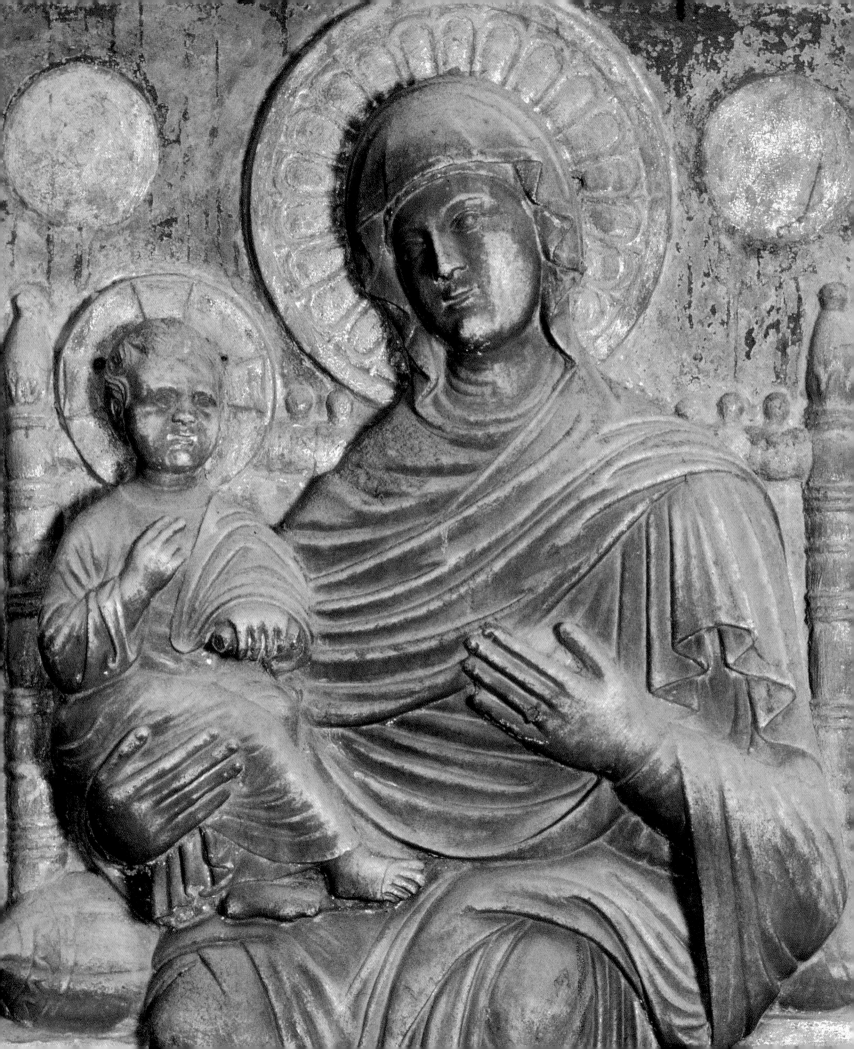

Katia Loverdou-Tsigarida

The Mother of God in Sculpture

The idea of a sculpted icon is at variance with all our preconceptions concerning the relations between Christianity, or more particularly Orthodoxy, and sculpture.[1] A survey, however, of the extant remains reveals that sculpted icons were already known in the Early Christian period. Something which is confirmed both by ecclesiastical tradition and historical sources.[2] Paul the Silentiary refers to the relief icons on the silver-revetted iconostasis beam in the church of Hagia Sophia in Constantinople (7th century), and there are earlier allusions in the writings of the Church Fathers to relief icons of Christ and the apostles, which are confirmed by finds from the excavation of the church of St Polyeuktos in Constantinople.[3]

Many theories have been advanced concerning the reasons that led to the creation of carved representations of holy persons. The view that links them with the sculpted grave monuments of Late Antiquity, such as grave stelai,[4] offers what is in my view the most likely explanation, and furnishes them with a similar origin to that of painted icons. Moreover, as Sodini observes,[5] the relief completely accorded with an existing civic, funerary, and decorative tradition without threatening the new religion, and recourse was frequently made to marble as a substitute for silver, at least in liturgical vessels, iconostases and icons.

The form carved icons took was simple: low relief usually, which corresponded to the concept of the painted and two-dimensional, elements that were by this time predominant in the Byzantine Empire. They were executed on slabs that were normally rectangular in shape, usually with a raised frame and frequently with an arched top.[6] These slabs were carved and then set in the position for which they were intended. Consequently, though the concept of the portable icon is weakened, they are morphologically so close to wooden icons that they should not be classed together with other carvings that are contemporary with them.[7]

The number of preserved relief icons is small[8] and we cannot, therefore, speak with any certainty of their place of production. We know only of a few pieces that were found, and probably also made, in Constantinople and Thessaloniki. Examples, however, like those preserved in San Marco in Venice, cannot be assigned a provenance with any confidence. Nevertheless, certain stylistic features can be discerned that are suggestive of workshops and trends present in at least these two Byzantine cities.[9]

There is no certain evidence as regards the position occupied by relief icons in churches. Most of them were probably built into the structure of the church, where they were mainly set in the pillars at the east end—especially the icons of the Theotokos—in front of the sanctuary, and were in consequence incorporated into the iconostasis. One example of a church with a large number of relief icons *in situ*, both on the façades and inside the building, is furnished by San Marco in Venice, though this cannot be regarded as typical.[10] Icons were also built into the walls of a city so as to protect it,[11] into fountains (in which case they were mainly icons of the Theotokos, thus linking the figure of the Virgin with the blessed water), but in other public places too, such as streets and squares.

As well as carving large icons out of marble, the Byzantines used semiprecious stones to carve smaller ones, which, with a suitable setting, would be used by private individuals as pectoral amulets. Workshops producing such works of miniature sculpture were located in Constantinople, at least

184. *Marble relief icon of the Enthroned Virgin and Child,* detail of Pl. 194.

until the Middle Byzantine period, where they were associated with the ivory-carving and goldsmiths' workshops. Later, they spread to other areas and to neighbouring lands. The style of their treatment follows the predominant artistic currents of large-scale art. The Mother of God is considered to have been one of the most popular subjects, though rendered in a relatively limited range of iconographic types and compositions. The number of different types of the Virgin in relief icons carved in marble or limestone may also be said to be limited. In the few surviving examples, the predominant type is that of the Virgin orans, in a number of different versions, while types such as the Virgin Hodegetria, or the Virgin Eleousa, which are very commonly found in wooden icons, are quite rare.

The earliest carved representations of the Theotokos date from the Early Christian period. They are worked in a variety of materials, such as precious metals, ivory, marble, limestone, semiprecious stones, and so on. From the few preserved representations in stone, it emerges that relief or engraved images of the Virgin are to be found on Egyptian stelai, probably of a funerary character, and that as early as the fifth century fully formulated iconographic types were used.[12]

Two of the earliest depictions of the Virgin and Child in the very rare type of the Galaktotrophousa[13] occur in icons made of limestone.[14] In one of these (Pl. 185), the subject is rendered with engraving supplemented by paint, which is fortunately very well preserved.[15] The Virgin is shown seated beneath an architrave supported on unfluted columns with Attic bases and papyrus-shaped capitals; she is flanked by two Greek crosses. A few incised lines, resembling brushstrokes following a preliminary sketch, render the young mother, who is offering her breast to the naked Christ-Child. The

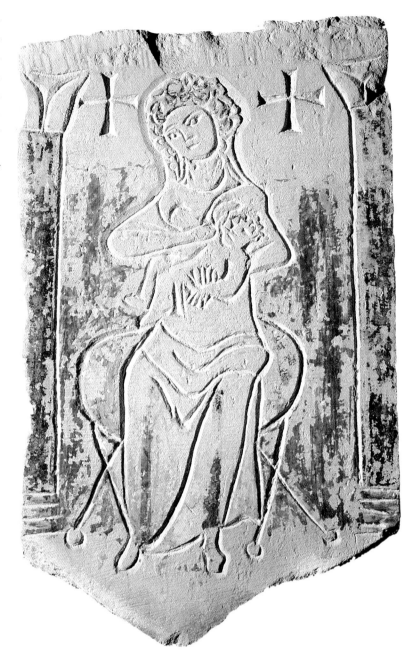

185. *Limestone icon of the Virgin Galaktotrophousa.* Museum für Spätantike und byzantinische Kunst, Berlin.

naturalistic forms of the work derive from the use of simple, sure, incised lines, whose role has been underestimated by the theory that they are simply a way of consolidating the preliminary sketch.[16] Iconographically, the subject is thought to be influenced by similar depictions of Isis. The icon is dated to before the Synod of Chalcedon (451).[17]

In the second icon, which is now in Cairo, the subject is rendered by a combination of *champlevé* and engraving. Its iconography is closer to the formal style of imperial art. The Virgin, seated frontally in hieratic immobility, offers her breast to the Infant without looking at him. Two curtains are drawn around her, and there is a small Greek cross above her head. She is flanked by two supplicating figures in frontal poses that recall court sentinels. In this work, the artist's main aim must have been to create an impression of grandeur, in contrast to the former icon, in which humanity predominates. The artistic distance separating the two works is great, though they do not appear to be far removed from each other in date.

The Coptic Museum in Cairo houses two stelai with the Theotokos enthroned, framed by a niche in the shape of a shell.[18] In addition to the hieratic immobility and frontality of both figures, the grandeur of the larger, sixth-century composition is intensified by the tall, semicircular, gem-

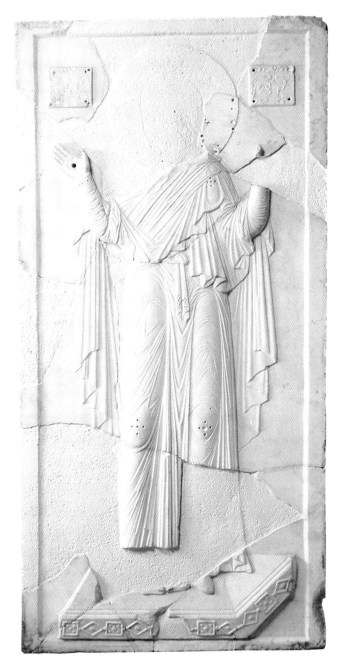

186. *Marble relief icon
of the Virgin orans*.
National Archaeological
Museum, Istanbul.

studded backrest of the throne. She is surrounded by angels, as celestial sentinels or celebrants. According to Wessel,[19] this is the Virgin in the type of the Nikopoios.

The miniature sculpture of the sixth and seventh centuries preserves a number of representations of the Virgin as part of the iconographic scheme of the Annunciation. Two sardonyx cameos in the Bibliothèque Nationale in Paris,[20] and two more from the State Hermitage Museum in St Petersburg[21] exhibit the same iconography in their treatment of the Annunciation, and the same style in the relief carving. The two figures that stand facing each other, the Virgin on the left and the archangel on the right, are shown in profile. The haloes and the archangel's words of salutation[22] are engraved on the background. Between the two figures is the basket containing the wool that the Virgin was spinning. The choice of subject for the two cameos is probably not fortuitous, but should be attributed to some official model and associated with the workshop that produced them.

After the end of Iconoclasm (843), icon-carving entered a period during which it developed freely and enjoyed a particular flowering, having almost exclusively as its subject, the Theotokos.[23] Many of the known iconographic types of the Virgin were worked in relief. The most common is the type of an icon from the Blachernai monastery in Constantinople, which had been hidden in the church during the Iconoclastic period, but which, sometime around the year 1030, in the reign of the Emperor Romanos III Argyros,[24] was found again and became the protector of the imperial dynasty of the Macedonians.[25] The type is that of the Virgin orans depicted frontally and full-length and raising the hem of her ample maphorion with her arms.[26]

One of the most interesting examples from the middle of the eleventh century is the Virgin orans from the area of St George Manganon[27] (Pl. 186). The surviving right hand has a hole pierced in the palm and is associated with a miraculous spring at Blachernai.[28] This work, which is considered to be one of the masterpieces of Constantinopolitan art, is distinguished by a kind of archaism in which an attempt is made to regain the classical form and harmony of the models of the Macedonian renaissance. Another example of the Virgin orans is the relief icon from Berlin, which also comes from the Byzantine capital and dates from the late eleventh century.[29] The two works differ distinctly in style. The drapery in the latter icon is stiffer and more stylized, and deprives the figure of all charm or youth, making it more 'earthly' and closer to Komnenian art.

The carved icon of the Virgin in Porto, found in Ravenna, is also attributed to Constantinople both by tradition[30] and on stylistic grounds. This is a work of fine quality, whose iconography links it with the Virgin orans of Manganon, though its style, particularly as regards the drapery, is influenced by late eleventh-century painting.

Thessaloniki, one of the production centres of carved icons, provides another example of the Virgin orans (Pl. 187),[31] in the same iconographic type. The graceful pose, with the weight of the figure supported on the right leg and the relaxed left leg drawn slightly back, brings it closer to ancient art and dates it to the eleventh or twelfth century.[32]

Another Virgin orans from Thessaloniki in the same type[33] (Pl. 188) has the relief executed in a different technique.[34] The figure of the Virgin is sharply detached from the background, though the

239

outlines are rounded. The geometric treatment of the drapery constituted the primary reason for identifying anti-classical trends in this work, despite the balance which can be seen in the volumes and proportions of the figures.[35] In my view, this icon should probably be dated to the eleventh century.

During the twelfth century, the repertoire of relief icons was extended to include holy figures other than the Virgin, and scenes from the Dodekaorton are also found. At the same time, a certain differentiation of styles in the treatment of the subjects can be detected, that is probably to be associated with the decentralization of workshops consequent upon the spread of Byzantine art to neighbouring peoples. Versions of the Virgin orans at half-length or in bust also make their appearance.[36]

The subject of the Virgin orans was also found as part of compositions involving other holy figures, such as archangels. An example of a composition of this type is provided by two marble slabs in Berlin[37] (Cat. no. 37) with the Virgin depicted on one slab, full-length, frontally, and orans, with her arms raised and wide apart, and Archangel Michael, full-length, frontal, with imperial dress and symbols, on the other. The ensemble was probably completed by a third slab with Archangel Gabriel. These sculptures are from the church of the Peribleptos in Constantinople, which was founded by the Emperor Romanos III Argyros (1028-1034). The column-like figure of the Theotokos is framed by the zigzag edges of the shallow drapery, which have been influenced by painted works of Komnenian art. These trends date this sculpted ensemble to the twelfth century.

187. *Marble relief icon of the Virgin orans.* Museum of Byzantine Culture, Thessaloniki.

From the Middle Byzantine period we have a number of interesting works of miniature sculpture on semiprecious stones,[38] in which the Virgin is the subject. A green jasper cameo dating from the eleventh century, which is rectangular in shape with an arched top, has a full-length Virgin orans, with her arms open and the palms over-emphasised.[39] The drapery is soft but summary, and the relief is somewhat carelessly worked. Another, oval, jasper cameo with a raised frame, depicts the same subject. The pose of the Virgin, which is closer to that of the orans of Thessaloniki, dates the work to the eleventh-twelfth century.[40] A small two-sided icon made of lapis lazuli, with a depiction of Christ full-length in the type of the Pantokrator on one side, has a full-length Virgin orans on the other. Inlaid strips of gold leaf form the haloes, the decoration of the garments and the floral border framing the two figures. This rare form of decoration,[41] together with the technique used in the carving, date this work too to the first half of the twelfth century. The Virgin is depicted in bust on a jasper cameo in the Louvre,[42] the superb technique of which indicates that it comes from a workshop in the Byzantine capital. The engraved patterns on the Virgin's dress, and the head, worked in high relief with a full face, recall marble relief icons such as that of Ravenna and date this work to the late eleventh-early twelfth century. There is another, slightly different type of the Virgin orans that is found on works of miniature sculpture, though this does not mean that its absence from relief icons is not fortuitous. The type is known in monumental paintings, especially in compositions of the Ascension, in which the Virgin holds her arms parallel, with the palms turned towards the spectator, in front of her breast rather than to the side.[43] One of the best-known and most securely

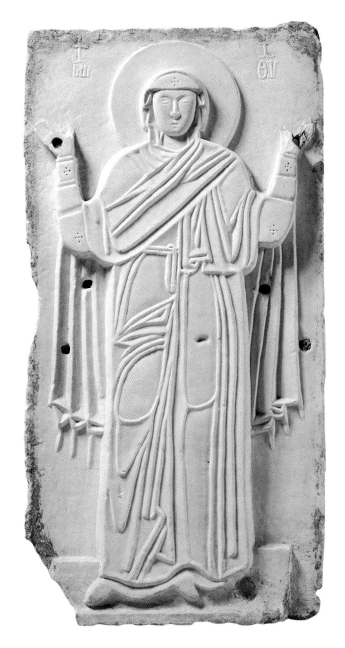

188. *Marble relief icon of the Virgin orans*. Museum of Byzantine Culture, Thessaloniki (formerly in the Byzantine Museum, Athens).

dated works is the serpentine cameo in the Victoria and Albert Museum, London,[44] (Cat. no. 17) which belonged to the Emperor Nikephoros Botaneiates (1078-1081). This has a monumental style which is intensified by the austere face and hieratic stance.[45]

Another iconographic type of the Virgin orans, known as the Blachernitissa, is believed to derive from the Blachernai church. The Theotokos, with her arms in an attitude of supplication at her sides, has a medallion with a bust of Christ Emmanuel on her breast; the type, known by the appellation Blachernitissa, is believed to have been worked in marble.[46] Another example of this type is provided by the Byzantine icon from the church of Santa Maria Mater Domini in Venice (Pl. 189), which probably dates from the twelfth century, and the similar thirteenth century icon from the church of the Virgin at Makrynitsa in Pelion, which comes from the sculptural decoration of a monastery founded about 1209 and bears the inscription Mother of God Η ΟΞΕΙΑ ΕΠΙΣΚΕΨΙΣ.[47] This type, which was very common in monumental painting, is also found in works in the minor arts (ivories, lead seals, and coins) dating from the time of the Komnenoi. There is an example on a haematite cameo in the Victoria and Albert Museum, London.[48] The Virgin, in bust, with the figure of the Christ-Child not enclosed in a medallion, but bordered only at the bottom by a semicircular fold of the maphorion, is rendered with stylistic features that assign the icon to the second half of the twelfth century.[49]

The subject is also common in another category of miniature works of art, panagiaria.[50] A jasper panagiarion of the Chilandari monastery on Mt Athos[51] (Pl. 190) depicts the Theotokos in the type of the Blachernitissa, with the Christ-Child, also in bust, standing free, rather than in a medallion, in front of her breast; the icon bears the inscription Η ΠΑΝΑ-ΓΙΑ. She is surrounded by four archangels arranged in the form of a cross around the rim of the sacred vessel. An engraved inscription on the rim confirms the association between the decorative motif and the doctrine of the Incarnation of Christ.

The Virgin was one of the main figures in the composition of the Deesis, which forms the core of the Last Judgement. A typical example is to be found in the church of San Marco, in which the Deesis is composed of three marble slabs built into the structure (Pl. 192). This is thought to be a Byzantine work, and was probably taken to Venice after 1204.[52] The figure of the Virgin, which occupies the left slab, stands beneath a lavishly decorated arch supported on columns with spiral flutes and Corinthian-style capitals; she is three-quarters turned towards Christ, with her arms extended and open. Unhappily, the slab was reworked in the thirteenth century, and is distorted by modifications, particularly to the head.[53] Nevertheless, the elongated figure, which is typical of the eleventh century, the volume of the drapery, and the quality in the relief of the body, combine to suggest a date between the eleventh and the twelfth century. A similar figure of the Virgin from a Deesis is to be found on a marble slab in the Dumbarton Oaks Byzantine Collection[54] (Cat. no. 38), the pose of which, however, with the arms slightly raised, is similar to that of the Constantinopolitan type of the Virgin Hagiosoritissa known from the tenth century.[55] The plasticity in the treatment of the drapery and the highly expressive and refined facial features indicate a work of the middle of the eleventh[56] or the twelfth century.

A haematite cameo with the Virgin in the type of the Hagiosoritissa and dating from the late twelfth century is now in the Walters Art Gallery in Baltimore.[57] It is now an amulet, carved on both sides, with a cross on the back and the full-length Virgin on a pedestal, facing right, which is

241

assigned to the twelfth century. A small amethyst enkolpion in the Vatopedi monastery on Mt Athos (Pl. 191)[58] has the Virgin in bust, in the type of the Hagiosoritissa, facing left. It has a silver-gilt and enamel setting engraved with an inscription,[59] and its stylistic features, above all the treatment of the face, are considered to belong to the late twelfth and the thirteenth century.

The subject of the Deesis was also rendered in sardonyx with decoration on both sides and a depiction of the Annunciation, dating from the sixth-seventh century on the front. It is a ninth-century incised work[60] with a votive inscription mentioning the servant of the Lord, Anna, who was initially thought to be the daughter of Alexios I Komnenos (1081-1118).

In addition to the Virgin orans, the predominant type amongst relief representations of the Virgin in marble, the type of the Hodegetria is also found. This iconographic type,[61] so popular on wooden icons, has survived in very few relief ones. One of the rare examples, dating from the late eleventh century (Pl. 193) is in the Istanbul Archaeological Museum. The upper half of the Virgin is preserved.[62] The archaizing tendency evidenced by the linear treatment of the drapery contrasts with the plasticity in the treatment of the heads and arms. The movement of the Virgin's right hand in supplication and the corresponding movement of Christ's left arm in blessing, combined with the votive inscription on the frame, suggest the icon had a narrative character (funerary monument?).

A second icon of the Virgin Hodegetria, on stone that has been worked before, comes from the church of St Athanasios in Thessaloniki. In this relief icon, the Virgin differs from the standard type only with respect to the gesture of the right arm, which suggests the presence of some person under the Virgin's protection.[63] The icon was also clearly influenced by monumental art, specifically the art of mosaic.[64] The date suggested for it, in the twelfth century, seems convincing.[65] The established type of the Virgin *dexiokratousa* is reproduced in a low relief icon from Italy, on the frame of which is preserved an engraved votive inscription mentioning Delterios, *tourmarchis* in Byzantine Italy in 1039.[66] The iconography of this work is patently influenced by painted icons; a number of imperfections—the poor handling of space, the excessive emphasis on the Virgin's hands, the positioning of Christ too high, so that he almost seems to be sitting on his Mother's shoulders—are to be attributed to the artist's incompetence. It is probably a work that had been commissioned by the Byzantine official from a workshop in Constantinople that was not of the first rank.

The type of the Hodegetria is also found in cameos such as those in the Bibliothèque Nationale in Paris[67], and in the Vatican,[68] which date from the twelfth century and come from Constantinople. The Virgin's delicate features, the soft drapery, and the softening of the austere grandeur of the Hodegetria type by the tender inclination of the Virgin's head towards the Child, are considered to be elements associated with the twelfth century and foreshadowing the thirteenth. A cameo of

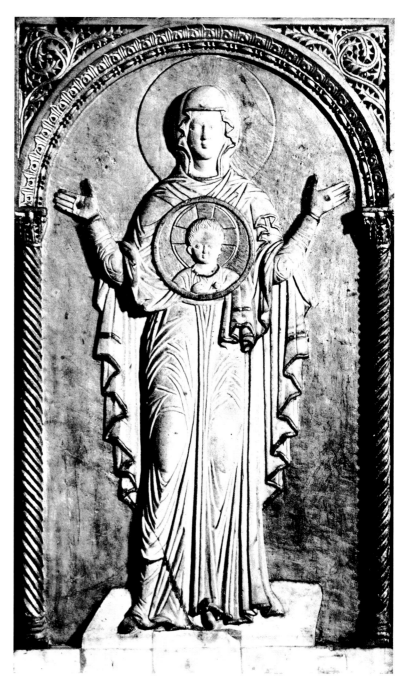

189. *Marble relief icon of the Virgin orans.* Santa Maria Mater Domini, Venice.

dark blue lapis lazuli with a silver-gilt setting, in the Kremlin Museum, offers another rendering of the Hodegetria.[69] The Virgin is seated on a throne with a backrest in the shape of a lyre, which was probably decorated with inlaid gems, now lost. The sculptural quality of the drapery and the delicacy of the execution of the faces betray a work of the late eleventh-early twelfth century.

From the thirteenth century comes a superb relief icon of the enthroned Virgin and Child, which is built into the chapel of St Zeno in the church of San Marco in Venice (Pls 184 and 194). This type displays an innovation in the representation of the Christ-Child, who is standing upright on his mother's knees and resting his cheek against hers, while she supports him with her right hand and makes the familiar gesture of supplication with her left. The presence of two venerating angels in bust in the top corners, and the engraved inscription Η ΑΝΙΚΗΤΟΣ (The Invincible) accompanying the Theotokos represent the donor's personal choice. According to Grabar,[70] this powerfully proclaims the advent of a Palaiologan style in reliefs. The drapery, though softer and with rounded edges, continues to have an excessive number of folds, recalling older, classically-inspired works. The type, familiar from wooden icons, does not, in the treatment it receives in the relief, permit the place of origin to be identified.

The existence of relief compositions with subjects drawn from the Dodekaorton in which the Virgin played a dominant role suggests that carved icons may also have adorned iconostasis beams. Icon subjects have even been used in the decoration of architectural stonework, as on the arches of the church of the Parigoritissa in Arta. These last, however, constitute isolated examples of the influence of western architecture. Relief compositions of small dimensions, in contrast, appear despite their limited number to have been comparatively widespread. The Thebes Museum, for example, houses a fragment of a slab with a relief representation of the Annunciation. It is worth recalling here that in the Early Christian period there were, as we saw above, depictions of the Annunciation on cameos. Of the Thebes composition,[71] all that survives is the upper half of the figure of the Theotokos, whose face has unfortunately been destroyed. Her pose, and the gesture of refusal she makes with her right hand are typical of scenes of the Annunciation in the ninth century and on up into the eleventh century, to the beginning of which the Thebes icon is assigned.

The execution of another Annunciation, now preserved in the church of Santi Giovanni and Paolo in Venice, also dates from about the same period.[72] The composition covers two slabs, each provided with a frame in imitation of the integral frames in wooden icons. The slabs are works of particularly high quality, certain elements of which, such as the proportions and the facial features, recall classical models, according to Lange.[73]

Pictorial sculpture of the Palaiologan era (mid-13th-mid-15th century) is to be found mainly in Constantinople, most of it *in situ* in churches. The other large urban centres, such as Thessaloniki or Mystras, do not seem to have produced any during this period. An exception is the capital of the Despotate of Epirus, Arta, whose reliefs have features characteristic both of workshops and of certain small monastic centres associated with large families. Pictorial sculpture in general appears, moreover, to have been confined to funerary monuments, arcosolia, and ciboria, and to architectural stonework, arches, column capitals, etc., and to have been used more rarely for compositions that were incorporated into the exterior walls of churches and also, no doubt, of palaces.

The Byzantine Museum of Athens houses a fragment of a composition of the Presentation of Christ in the Temple, whose dimensions (35 × 25 cm) suggest that the original slab was probably much larger. Of the composition, which comes from the monastery of the Oxeia Episkepsis at Makrynitsa in Pelion (early 13th century), all that survives are the headless bodies of the Virgin and the Child, whom she holds in her extended arms above the altar.[74] The drapery, with its deep and abundant folds, is the only feature that helps to date it to the early thirteenth century, which is in agreement with the historical evidence for the founding of the monastery from which it comes.

Finally, in the large church of the Paregoritissa at Arta, built by the despots of Epirus between 1283 and 1296, along the span of two of the four arches of the central dome, those, that is, on the north and west sides, there are pictorial reliefs arranged so as to form two compositions. Concen-

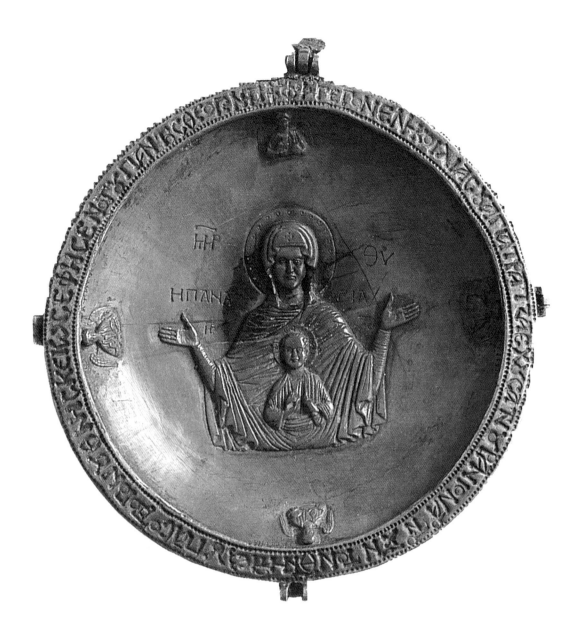

190. *Jasper panagiarion*.
Chilandari monastery,
Mt Athos.

trated together on the northern one are the figures normally associated with the Nativity — the Virgin with the Christ-Child, the manger, angels, shepherds, the Three Magi, and four prophets. The Theotokos, who occupies the keystone of the arch has her back turned to the Infant and the manger. The style of these reliefs has been described as westernized[75] and they are associated with a small number of similar reliefs, mostly of a funerary character, found elsewhere, which are considered to be the work of westernized Greeks in the thirteenth century.

After the capture of Constantinople in 1204, a striking number of carved icons was taken to the West, as we saw above, where they played a decisive role in the creation of local workshops[76] and the development of artistic idioms which were local in character and combined Byzantine and western features.[77] A good example is the Virgin orans that was placed on the west façade of San Marco about 1250-1265,[78] which is a copy of a Byzantine icon of the Blachernitissa, but whose style is closer to the Late Romanesque Mannerism of the end of the thirteenth century. Another icon of the Virgin in Venice also follows a Byzantine iconographic model. This is the *Madonna dello Schioppo*, which copies the type of the Aniketos, in which Christ holds the Virgin's right hand instead of a scroll.[79]

A small group of three relief icons are examples of works probably made in Italy by a Byzantine craftsman, which accordingly exhibit an abundance of elements influenced by western art. Two are icons of the Theotokos in the type of the Kyriotissa, in Venice and Berlin, and the third is the Virgin and Child enthroned, also in Berlin.[80]

191. *Enkolpion with the Virgin Hagiosoritissa*.
Vatopedi monastery,
Mt Athos.

244

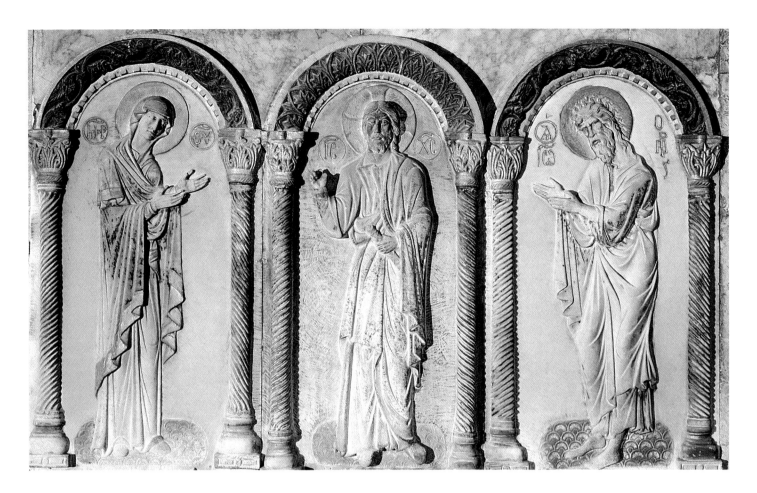

192. *Marble icon of the Deesis.*
San Marco, Venice.

In conclusion, we may note the following:

1. Pictorial sculpture in Byzantine art is represented mainly by a fairly small number of relief icons in marble. To these should be added the small icons carved in semiprecious stones, which mostly came to have the character of amulets.

2. Of the relief representations, most of them executed in marble, those of the Theotokos are the most common and are found already in the Early Christian period. They occur in two main iconographic types, the Galaktotrophousa and the enthroned Virgin and Child.

3. The predominant iconographic type in the Middle Byzantine period is the Virgin orans. This type is sometimes associated with the symbolism of the Zoodochos Pege (Life-bearing Source), sometimes with the doctrine of the Incarnation, and sometimes with the Last Judgement (Lesser Deesis, Hagiosoritissa) and funerary monuments.

4. Other iconographic types of the Virgin, which are particularly favoured for wooden icons, such as the Eleousa and Hodegetria, are rarer.

5. Relief icons are rare in the Palaiologan period. There are, however, representations of the Virgin in small-scale scenes drawn from the Dodekaorton, which probably come from iconostasis beams or belong on architectural stonework.

6. Carved icons of the Middle Byzantine period, most of them of the Virgin, were taken to the West, where they played a role in the creation of local workshops there, giving rise to idioms in which Byzantine and western elements were combined.

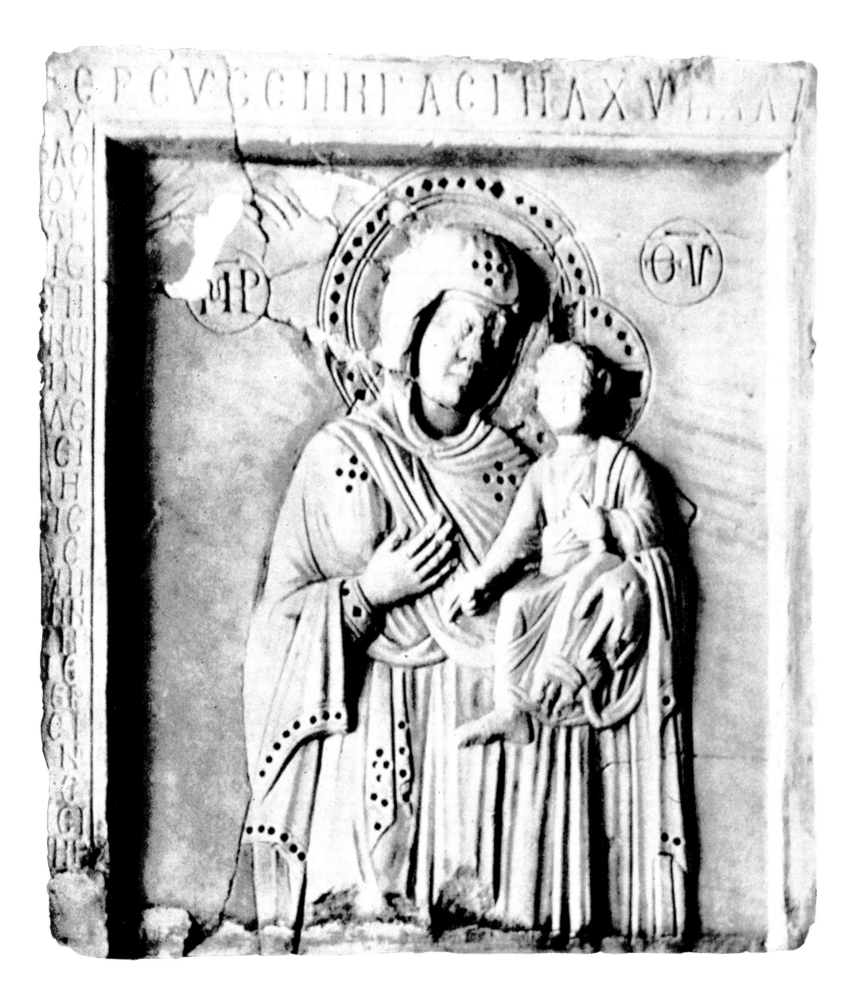

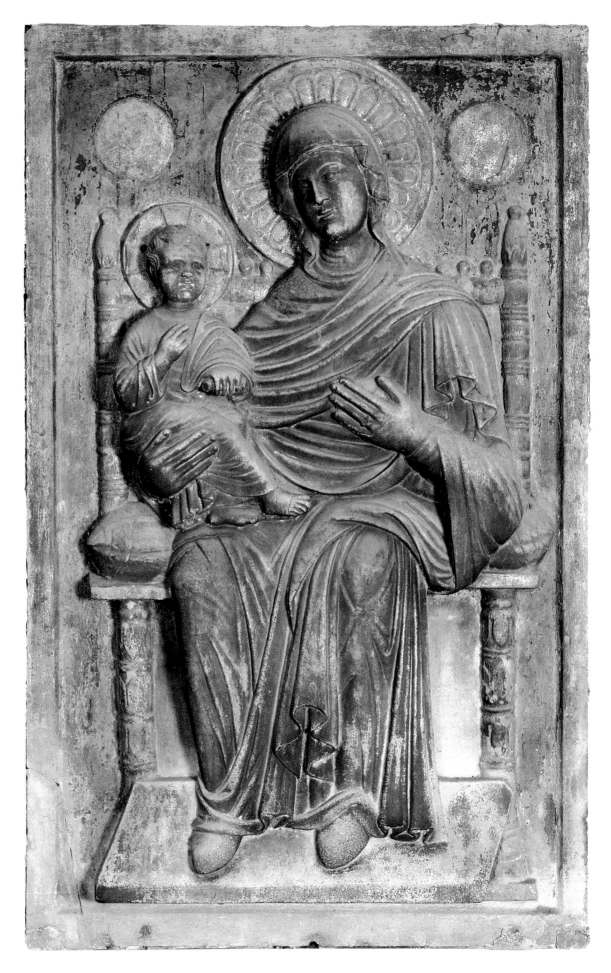

193. *Marble relief icon of the Virgin Hodegetria*. Archaeological Museum, Istanbul.

194. *Marble relief icon of the Enthroned Virgin and Child*. San Marco, Venice.

[1] On Byzantine sculpture, Sodini 1992, 30-33.

[2] Lange 1964, 19, nos 7, 8; 31, n. 3; Tsilipakou 1998, 291.

[3] Harrison and Firatli 1966, 235, figs 33-38.

[4] There are even examples of ancient stelai being converted into icons, or icons that copy ancient grave stelai, Tsilipakou 1998, 303.

[5] Sodini 1992, 31-32.

[6] The arched top of the icon has been associated with sarcophagi dating from Late Antiquity in Asia Minor, in which prominence is given to the figures by placing them beneath arches supported on columns. Tsilipakou 1998, 303. I believe that the origins of this feature should probably be associated with ciboria beneath which were placed distinguished persons, especially members of the imperial family, as a sign of honour.

[7] Grabar 1976a, 23.

[8] When Christian churches were converted into mosques, the conquerors were particularly aggressive towards sculpted figures. This accounts for the small number that survive, and the damage to them. Bréhier 1973[2], 16.

[9] Tsilipakou 1998, 357-367.

[10] After the fall of Byzantium to the Franks during the Fourth Crusade (1204), a large number of figural and architectural sculptures were amongst the spoils that found their way to the church of San Marco. The sculptural decoration of this church thus surpasses that of any contemporary church in Constantinople or on Byzantine soil.

[11] Lange 1964, 133, who attributes an apotropaic character to them.

[12] A vital role was played in their formulation by icons that were thought to be made without human intervention (Acheiropoietoi), and by the icon attributed to St Luke the Evangelist, which were thought to be authentic representations and were accordingly generally copied. For acheiropoietoi icons, Kalokyris 1972, 63-65.

[13] For this type, Kalokyris 1972, 59-60.

[14] Wessel 1963, figs 5-6.

[15] Now in the Staatliche Museen of Berlin; its dimensions are 55 × 34 cm.

[16] Wessel 1963, 17.

[17] Wessel 1978, 190ff.

[18] Stelai 8003 and 8006, in which the niche is incorporated into the subject, and the shell, symbolizing the Divine Creation, takes the place of the halo. Atalla 1989, 35.

[19] Wessel 1963, 36, no. 34.

[20] Byzance, nos 40-41.

[21] Bank 1977, nos 107-108.

[22] 'ΧΑΙΡΕ ΚΕ/ΧΑΡΙΤΩΜΕΝΗ Ο Κ(ΥΡΙΟΣ) ΜΕΤΑ ΣΟΥ' (Hail, full of grace, the Lord is with thee).

[23] Silver-gilt and enamel icons of the Archangel Michael preserved in the treasury of San Marco in Venice from the 10th and 11th centuries reveal that this is probably the result of chance. Also Bréhier 1973[2], 16.

[24] Bréhier 1973[2], 16.

[25] According to Constantine Porphyrogennetos, De administrado imperii (CB 1555), this type derives from the icon kept in the shrine at Blachernai. The type dominated sanctuary apses after the establishment of the doctrinal iconographic programme for churches, especially those founded by members of the imperial family.

[26] For the type, Kalokyris 1972, 53-56.

[27] Found in 1921 during excavations near a fountain. It measures 0.99 × 2.00 m, and the head, right shoulder, and legs from the shins down are missing. It is now kept in the Archaeological Museum in Istanbul, no. 3914.

[28] Lange 1964, 43-44 describes it as a forerunner of the type of the Zoodochos Pege. Grabar rejects this view, however, on the grounds that there is no corresponding painted depiction of the subject. Grabar 1976a, 36. An early 14th-century mosaic with the half-length Virgin orans, accompanied by the inscription 'Zoodochos Pege' in the Chora monastery has the meaning of the Fountain of New Life, to which the Virgin gave birth. Kalokyris 1972, 204.

[29] Lange 1964, no. 3. It is a marble piece measuring 1.02 × 1.55 m, now in the Staatliche Museen, Berlin, no. 3248.

[30] According to tradition, the icon was miraculously removed from the Byzantine capital in 1100, Lange 1964, no. 5, with earlier bibliography. A category of relief icons relevant here consists of icons of Byzantine origins that have received later modifications which have altered their appearance to the degree that they were formerly considered to have been made in Venice. Dalton 1961. Good examples are the Virgin orans from Venice, now in the north part of San Marco (Demus 1960, 136) and dated to the 11th century, and the Virgin orans from Messina in Sicily, now in the National Museum (Lange 1964, 66-67; Glory of Byzantium, no. 291) in which the naturalistic approach to style is characteristic, and which is dated to the middle of the 12th century. Finally, mention should be made of a group of six relief icons with the same type of the Virgin orans, usually with her hands pierced, which are now built into various parts of the church of San Marco in Venice. Most of these works are believed to have been modelled on a relief icon in the north aisle of the church (Lange 1964, no. 2), the Byzantine origins of which are now barely recognizable on account of later modifications.

[31] Found during the laying of the foundations of the prison to the north of the church of Prophet Elijah in 1926, and now in the Museum of Byzantine Culture (no. ΑΓ 772). It measures 0.755 × 0.95 m and the relief is bordered by a raised frame. The head and both arms are missing, and it is therefore impossible to say whether the hands were pierced.

[32] Grabar 1976a, 122, no. 120; Pazaras 1999, 11-12. For a summary of the dates assigned to the icon, Tsilipakou 1998, 347-348, n. 111.

[33] Bakirtzis (1988, 158ff.) identified the figure with St Theodora and believes that this is the slab that was set above the saint's grave in the Stephanou monastery, Thessaloniki. For opposed views, Acheimastou-Potamianou 1995, 9-13; Pazaras 1999, 11; Tsilipakou 1998, 311-12, n. 111.

[34] The relief has been described as excessively plain and flat, with broad surfaces bordered by chamfered glyphs, giving the impression that the relief was originally supplemented by the ceromastic technique and a thick layer of paint (Grabar 1976a, 66).

[35] Pazaras 1999, 11. For the different views that have been expressed, Tsilipakou 1998, 316-17.

[36] The Virgin orans is depicted on a semicircular tympanum with a raised frame, in which she is shown in low relief; its poor condition makes this difficult to date (Grabar 1976a, no. 164). The summary drapery of the maphorion with folds of irregular depth and width are consistent with a date in the 12th, or according to Grabar, the 14th century.

[37] Effenberger and Severin 1992, 245-47; Glory of Byzantium, no. 12.

[38] Most of these were made in Constantinople, the home of what are believed to have been the only workshops producing them in this period. The iconographic types used are similar to the ones found in marble sculptures and ivories. These works, however, make greater use of engraving, especially for details such as haloes, inscriptions, etc.

[39] This cameo comes from the Hermitage Museum in St Petersburg and is associated with one of similar form depicting the full-length Christ Pantokrator. (Bank 1977, 300, nos 164-165, inv. no. W358).

[40] It is now in the British Museum, Byzantium, no. 172.

[41] For three more examples of this technique, Byzance, no. 196; Glory of Byzantium, no. 133.

[42] Byzance, no. 194.

[43] This gesture is interpreted as rendering her strong intervention 'of double intercession' with the Saviour

Felicetti-Liebenfels 1956, 50; Kalokyris 1972, 55, pl. 17.

[44] *Byzantium*, no. 171 with earlier bibliography.

[45] This type of Virgin orans is found in a good number of cameos, mainly of jasper, in which the engraving style is not necessarily associated with the Byzantine capital, and which date from the 12th to the 13th century.

[46] Kondakov 1914-1915, II, 55. The type is considered by some to have been created in the 10th century, and by Bréhier 1973, 17, in the 13th. In 6th-century Coptic churches, however, the Virgin enthroned and holding a medallion of Christ Emmanuel is found in the sanctuary apse. The Blachernitissa is believed to be a variation of the well-known type of the Platytera (Kalokyris 1972, 74-76), imbued with the symbolic meaning of the pregnant Virgin.

[47] Lange 1964, no. 6. For the type of the Episkepsis, Sotiriou 1926, 134ff.

[48] *Glory of Byzantium*, no. 134.

[49] Ousterhout 1995, 94-96.

[50] Panagiaria are small pectorals on which the principal decorative motif is the Theotokos, accompanied by figures associated with her, such as prophets, referring to her role in the Incarnation.

[51] *Treasures of Mt Athos*, no. 9.8.

[52] Grabar 1976a, no. 117 with earlier bibliography.

[53] Demus 1960, 122.

[54] Grabar 1976a, no. 121.

[55] For some details of the type, Kalokyris 1972, 70. The appellation is associated with the church of the Virgin in the district of Chalkoprateia, whence the name the church of the Chalkoprateia, in which the Holy Girdle of the Virgin was kept ʻεντός αγίας σωρού'.

[56] Belting 1972, 263-70; Vikan 1995, 100-3; *Glory of Byzantium*, no. 11.

[57] *Glory of Byzantium*, no. 135.

[58] Loverdou-Tsigarida 1996, 467, fig. 406; *Treasures of Mt Athos*, no. 9.10; Loverdou-Tsigarida 1997, 279-84.

[59] For the inscriptions, Oikonomaki-Papadopoulou et al. 2000.

[60] *Byzance*, no. 184.

[61] For the type and its origins, Kalokyris 1972, 61-62 and Tsilipakou 1998, 330.

[62] Lange 1964, no. 9; Grabar 1976a, no. 3.

[63] Grabar 1976a, no. 119.

[64] Tsilipakou 1998, 335, where this element is said to be diagnostic of a 'subgroup' of relief icons from a Thessaloniki workshop.

[65] Tsilipakou cites all the views that have been expressed on this, Tsilipakou 1998, n. 56.

[66] Lange 1964, no. 10.

[67] *Byzance*, no. 199.

[68] Wentzel 1956, 271, pl. B.10.

[69] The cameo comes from the church of the Annunciation in the Kremlin, now in the Kremlin Museum (no. DK 144). Bank 1977, 298, nos 153-154.

[70] Grabar 1976a, no. 123, with earlier bibliography.

[71] Sotiriou 1926, 125-127.

[72] Lange 1964, no. 8, dates it to the late 11th century.

[73] A difference can be detected in the rendering of the Virgin, which is considered to be less influenced by the 'klassische Zug' (= classical trend); this distinction cannot be used to date the works, however.

[74] Grabar 1976a, no. 165, with earlier bibliography.

[75] Orlandos 1963, 78ff., notes the affinity with reference to figures from the escutcheon of San Clemente of Casauria at Ambruggia.

[76] Demus 1960, 120.

[77] Typical examples are the relief icons of Sts Leonardo and John the Evangelist, which are built into the north façade of the church of San Marco. Demus 1953, 87-107.

[78] This belongs to a group of three icons made by Venetian craftsmen to supplement a group of six Byzantine icons dating from various periods that were taken to the *Serenissima Republic* after 1204. Demus 1953, 97ff. and Demus 1960, 124ff.

[79] Demus 1960, 189-190, fig. 107.

[80] Lange 1964, 80-82.

Part Three – The Catalogue

Section One

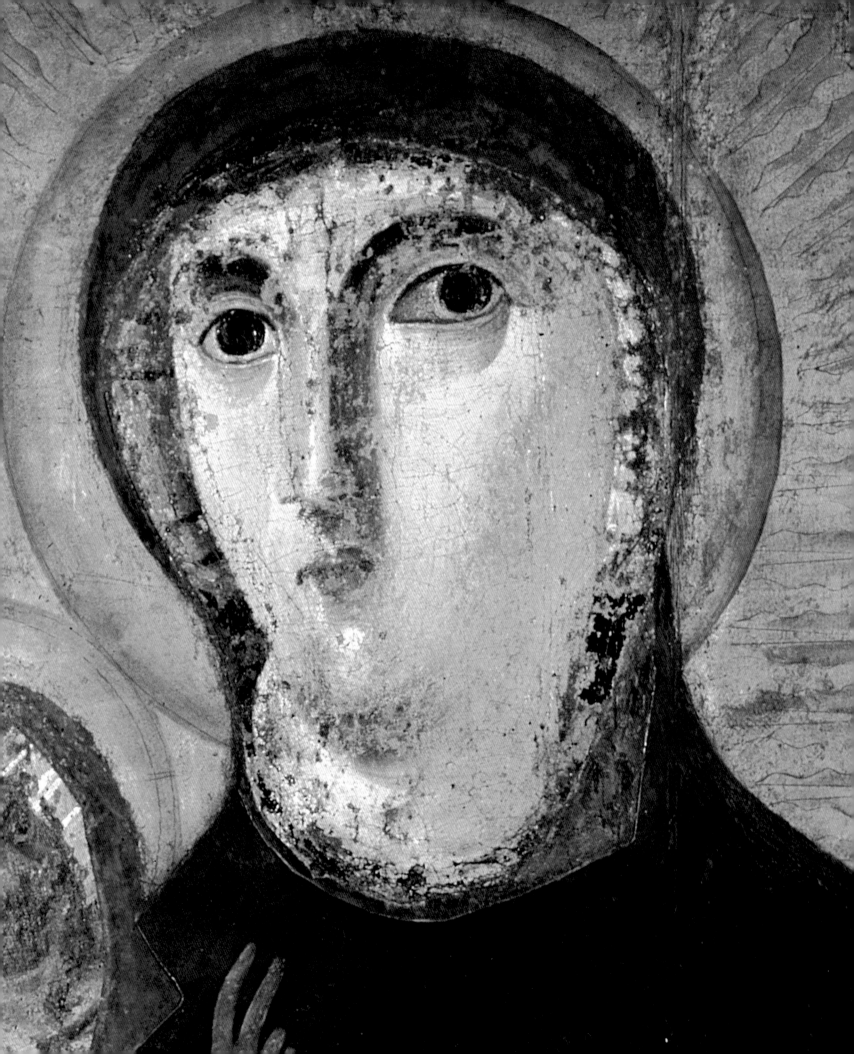

Charles Barber

Early Representations of the Mother of God

Among the more intriguing problems that confront the modern audience for a Byzantine icon are those of learning how to look at and speak of this work of art.[1] Conditions of display, whether in the museum, the home, the auction house or the church, affect and complicate our initial response to a given icon. This encounter becomes more complex whenever we ask if our present circumstances for reception and interaction, including the assumptions that we as beholders bring to bear on the icon, are valid as readings of a work produced in a specific time and place in the distant past. Can we call the icon a work of art? What changes as the icon moves from church to museum to sale room? What stays the same? In contemporary Orthodox practice an icon might be embraced, serve as the focus of prayer, or be the recipient of gifts. It can be assumed that these practices mark a continuation with a longstanding tradition, and indeed such an assumption underlines much of the discourse on icons. Yet, can we be certain that these were considered valid interactions at the time of our earliest Theotokos imagery? While Christian iconography is identifiable from the second century, the exact relationship between this art and its audience is unclear until the seventh century.[2] Few texts or traces of physical evidence survive that address the question of the incorporation of the image into the life of the early Church.[3] It is only in the last years of the sixth century and throughout the seventh that a consistent body of writings emerges to address this question. These varied writings have been used to argue for an increased cult of images in this period.[4] A construction that has held wide sway for many years. Recently, however, this reading has come into question.[5] Doubts have been raised about the authenticity of the narratives told, and arguments have been made that the pre-Iconoclastic cult of icons is largely a construct of iconophile writers of the period of Iconoclasm and its aftermath. The construction and deconstruction of this notion of a cult of icons has been largely based on texts. Given the strongly divergent readings of these texts it appears appropriate that in the context of an exhibition of objects we should consider the material evidence for the cult of images as it pertains to the imagery of the Theotokos.[6]

The late sixth- or early-seventh century icon from Sinai of the Virgin and Child with Archangels and Saints provides a useful point of departure for this essay (Cat. no. 1). It is not a straightforward image.[7] The enthroned Virgin and Child occupy a central position within the work. Behind them, two archangels turn gracefully within the narrow space of this scene and direct their gaze up towards the hand of God. Light issues from this hand and descends upon the Theotokos and Child. While Christ directs his gaze at the viewer, the Mother of God turns her eyes to the side. This act distinguishes her from the two military saints who stand rather stiffly on either side of the throne. These saints are unnamed but are commonly identified as St Theodore and St George. This pair gazes directly out of the icon at the viewer.

My reading of this panel is shaped by formal cues found within the icon itself, where the lack of uniformity in figure style and the varied points of attention of those depicted make this a remarkably complex visual text. One consequence of this variety is the relative difficulty in determining the viewer's primary entry point into the icon. For example, with her eyes averted can we assume that the Mother of God is the necessary focal point of this work? Originally this image was probably supplemented by an inscription on a now lost frame. This text might have referred to the image, and might even have

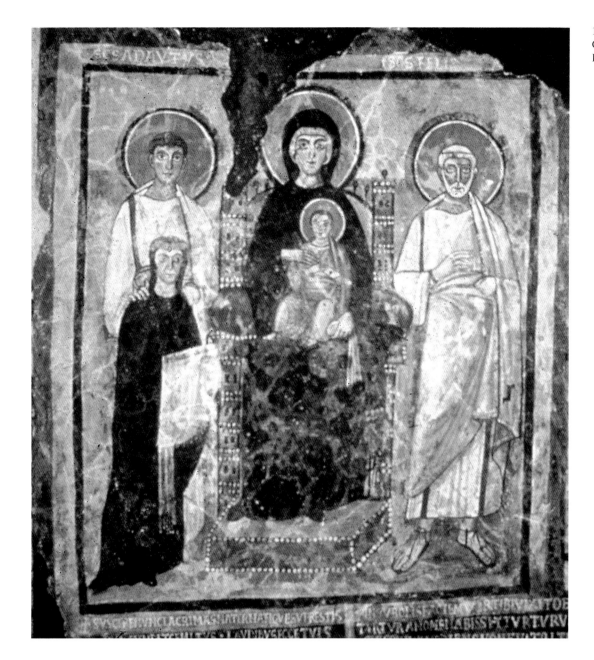

196. *The widow Turtura fresco.*
Catacomb of Comodilla,
Rome.

defined a way of viewing the work. Alas, this hypothetical opportunity is lost, and we are left to as-semble comparisons that might facilitate an understanding of the viewer's relation to this icon.

The most compelling point of comparison for the Sinai icon is a fresco painted in commem-oration of the widow Turtura and found in the catacomb of Commodilla in Rome[8] (Pl. 196). Dated to around 530, this image provides suggestive clues as to how one might respond to the Sinai panel. In the fresco the Virgin and Child are enthroned at the centre of the image. They are flanked by two saints, Felix and Adauctus, who were buried in this catacomb. These saints introduce the diminu-tive figure of the widow Turtura to the Virgin and Child. An inscription accompanies the image. This offers an account of the widow written by her son. The text praises Turtura for remaining cel-ibate for thirty-six years following the death of her husband Obas. She is likened to a turtle-dove, who has no other love after the death of its mate. It is this chaste fidelity that 'alone brings a woman to honour' in the estimation of her son.[9]

The Turtura fresco and its location can help us clarify some possibilities for reading the role of the Theotokos and Child in the Sinai icon, by helping define the function of the saints in the image. The elaborate praise of the chaste mother and also her costume suggest a direct correla-tion of the Theotokos and Turtura.[10] Against this, we witness an initial mediation by the local saints.

254

Felix rests his right hand on Turtura's right shoulder, while Adauctus makes a gesture of speech. These two acts make it clear that these saints should be understood as Turtura's advocates, presenting her to the Theotokos and Christ. Here, it is important to remember that this image is located in the catacomb of Felix and Adauctus. It is near their bodies that this woman has chosen to be buried. It is their intercession she seeks. While the Theotokos and Child are the final recipients of Turtura's devotion, it is the local saints that act as her advocates and serve as the initial objects of her devotion.[11]

In turning back to the Sinai icon it is now possible to argue that the first point of attention within the image lies with the two military saints who flank the Mother of God and her Child. It is these saints who directly address the viewer with their gaze, providing the primary access to the economy of intercession represented here in the icon. This reading of the Sinai icon and the Turtura fresco implies a privileged role for the local saint. It should not, however, be understood to claim a diminished level of importance for the Theotokos. Rather, we should understand a hierarchical structure in the process of intercession.

Such a hierarchy can be found in one of the decorations found in the church of St Demetrios in Thessaloniki[12] (Pls 197 and 198). In the now lost late sixth-century Maria cycle, located in the north inner aisle of the basilica, Maria is shown in four scenes from her early life. These portray the young Maria presented before two intercessors, the Theotokos (her namesake) and St Demetrios. In the first scene the infant Maria is shown before the saint's ciborium located in this basilica. Demetrios sits before the open doors of this structure. He touches the child with his right hand and gestures with his left towards Christ, who is shown in a medallion above. The success of this act of intercession is marked by the fact that Christ reaches out of his medallion towards the saint in answer to his mediation. This image of intercession is complete in itself, yet we notice that the Theotokos is shown standing next to Christ's medallion. The position of her arms indicates that she is also engaged in an act of intercession, even though she does not share the immediate contact with the child that is Demetrios's privilege. As if to develop this role, the second scene is focused upon the Theotokos alone as an intercessor. An older, but still very young Maria is held up to the standing Mother of God, who offers a prayer towards a now lost medallion of Christ. The third scene shows a standing Demetrios in a position of prayer. A still older Maria together with her female companions present candles to the saint. Demetrios's prayer is directed at a medallion of Christ. Two points complicate this third scene. First, the prayer inscribed beneath the saint reads: 'And the Lady, the Holy Theotokos'. The Mother of God is thus verbally incorporated into the panel.[13] Second, a medallion containing the Theotokos is placed to the left of the Christ medallion, thus including her as a mediating figure in this image of intercession. The fourth scene is significantly damaged. It appears to show Maria with her family standing before Demetrios. It is probable that Demetrios was again shown as an intercessor with Christ. There is no evidence to suggest that the Theotokos was represented here. Beneath this last scene is the following text: 'And you, my lord St Demetrios, help your servants and your servant Maria, whom you gave to us'. Read as a complete visual text, this short cycle undoubtedly places great importance upon the role of Demetrios. He is the local saint, whose relics in this church make him the most immediate intercessor on behalf of Maria. Having said this, the prominence given to the Mother of God in both text and image demonstrates that she is tightly woven into the fabric of intercession. While the first scene shows Demetrios in a close relation with Christ, the presence of the Mother of God here and her role in the next two panels reiterate the privileged relationship between the Theotokos and Christ within this economy of intercession.[14]

The Turtura fresco and the Maria cycle both make use of the presence of their local saints' bodies to mark a point of departure for the acts of intercession shown. In the case of the Theotokos, this physical presence, did so much to localize the holy, was compromised by the fact that she left no body and few other relics. This relative lack of relics does give rise to an important consideration. By the seventh century dedications of churches to the saints were normally marked by a mass

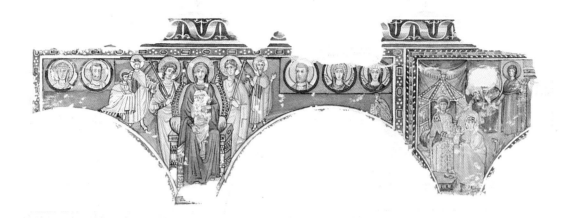

197. *Maria cycle* (now destroyed) Basilica of St Demetrios, Thessaloniki (watercolour by W.S. George)

198. *Maria cycle* (now destroyed) Basilica of St Demetrios, Thessaloniki (watercolour by W.S. George)

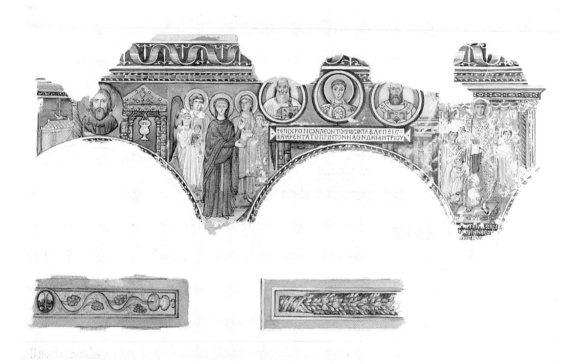

and by the deposition of primary or secondary relics.[15] Since relics of the Mother of God were not plentiful, it appears that icons of the Theotokos could fill this lacuna.[16] Our primary evidence regarding this point derives from Rome. Bertelli has argued that the Hodegetria icon in the Pantheon functioned as a relic in the conversion of this pagan temple into the church of Santa Maria ad Martyres in 609 (Pl. 199).[17] A second example is offered by the transfer of the sixth-century icon of the Theotokos from Santa Maria Antiqua to Santa Maria Nova in 847 (Pls 195 and 200). This transfer marked the replacement of the Antiqua church, which had been largely destroyed in an earthquake in 847, by the Nova church. The transfer of the icon, the primary relic of Santa Maria Antiqua, marked this change.[18] Similarly, we first hear of the Theotokos icon found in the church of Santa Maria in Trastevere in Rome in the period following the rededication of this church from the *titulus* of *Juli et Callisti* to that of a church dedicated to Mary[19] (Pl. 201). These examples suggest a link between the dedications of these churches and the icons that they contain, and consequently enable us to consider the icon in terms that normally apply to the relic alone. We need, however, to strengthen the notion of the icon-as-relic in order to develop this point.

The icon in Santa Maria in Trastevere is a problematic work, but it also allows us to bridge the gap between an icon and a relic. The panel shows the Theotokos and Child enthroned. The

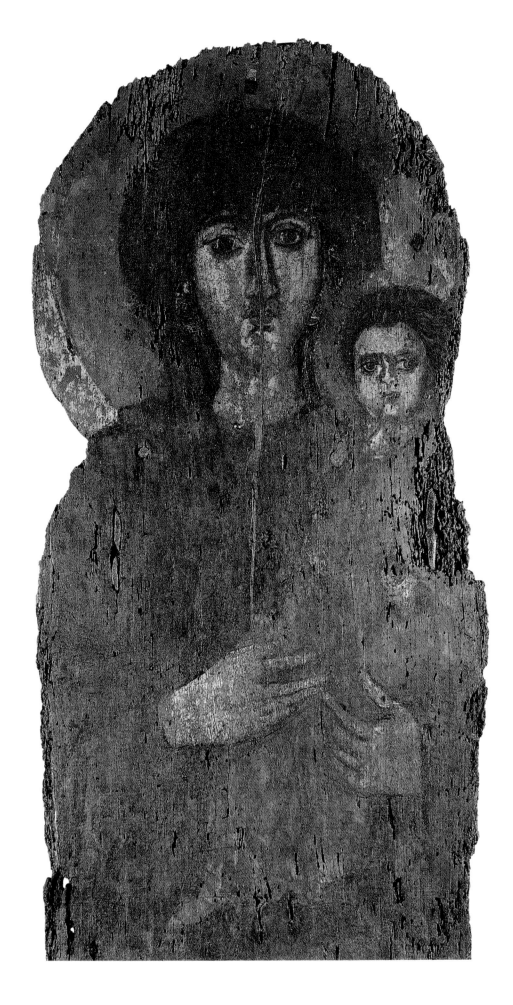

199. *Icon of the Virgin and Child.*
Santa Maria ad Martyres,
Rome.

257

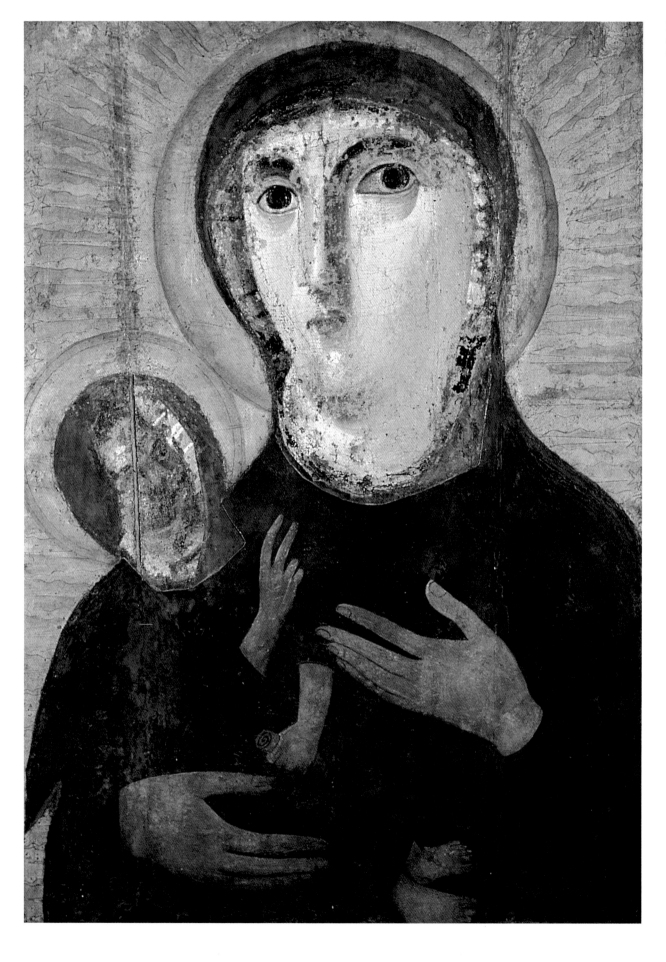

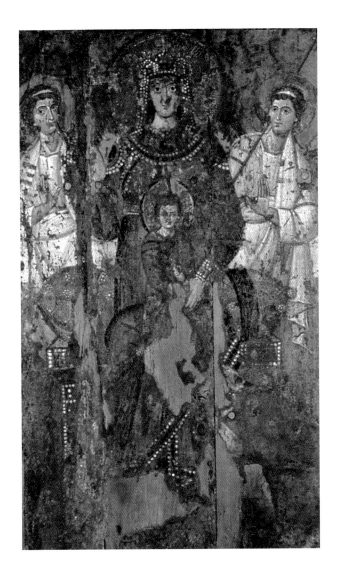

201. *Icon of the Virgin and Child.*
Santa Maria in Trastevere, Rome.

Mother of God is a *Maria Regina* type, probably adapted from a standing figure. She holds a staff cross in her right hand. Archangels stand to either side. At the foot of the enthroned Theotokos is the fragmentary image of a pope at prayer. A partial inscription survives on the frame. The first part of this refers to the archangels and comments on their witness of the Incarnation (+ ASTANT STYPENTES ANGELORUM PRINCIPES GESTARE NATYM ... A ...). The second part appears to develop this notion by referring to the divinity as made by itself (DS QYOD IPSE FACTYS EST). Read on its own terms the first of the two texts could be considered a commentary on the Incarnation itself, and upon the possibility of our witnessing this.[20]

The second part of the inscription can, however, be read in a different manner. Pilgrimage texts of the 640s speak of an *acheiropoietos* image in the church of Santa Maria in Trastevere in Rome.[21] The image is described as being '*per se facta est*', thus recalling, if not repeating, the phrase written onto our icon. The existence and fame of a miraculous Theotokos icon in Santa Maria in Trastevere is underlined by a Greek text, perhaps composed in Rome in the eighth century, which includes an icon of the Theotokos in this church in its list of *acheiropoietoi* images.[22] The continuing significance of this particular icon throughout the Middle Ages indicates that we should accept that the texts indeed refer to the icon that remains in the church.[23] Given this, it is now possible to confirm the existence of an icon of the Theotokos that can be considered a relic.

Having made this point, the complex imagery of the Santa Maria in Trastevere icon raises further issues concerning the relationship of depiction and devotion in the imagery of the Theotokos. Brubaker has recently defined devotional imagery in these terms: 'the "icon" was a devotional image that served as an intermediary between the viewer and the person represented ... the sacred portrait is best understood as a transparent window that the viewer looks through (to the "prototype", the actual person represented) rather than at: the gaze does not stop at the surface of the panel, but goes on to the prototype'.[24] The origins of this definition are to be found in texts from the last decades of the seventh century, its codification can be considered completed by 800. In arriving at this formulation, Brubaker rejects the existence of a cult of images prior to the end of the seventh century. In the rest of this paper, I shall suggest that both the definition and this chronology can be altered.

The Santa Maria in Trastevere panel raises a number of concerns regarding the definition of the icon as a transparent window. In the first place, the miraculous nature of this icon (defined above) calls attention to the object itself as a relic. At this point it is also necessary to contend with a second feature of the depiction that nuances our own understanding of a miraculous icon, namely the presence of the papal portrayal. An obvious sign of manufacture such as this historical portrait would seem to undermine the claims to a miraculous origin for the work. Yet, this modern distinction was unnecessary for an Early Medieval audience, for whom this icon could be a copy of a miraculous original and still claim the same status as the original.[25] Given this, we must understand this painted icon to be both a depiction and a relic. This dual nature implicates the object in the representation of its prototype, to such an extent that it is necessary both to engage in the 'surface of the panel' and to contemplate its prototype.

The value of the object itself is underlined by a second feature of the icon. The cross that the Mother of God holds is not painted in the encaustic found on the rest of the icon, instead its medium is tempera painted directly onto the blue encaustic ground of the panel.[26] This is later painting,

259

replacing an original use of a metal cross that was held in the Theotokos's right hand. This original cross fits into a pattern of gift-giving to icons in Rome. Most notably, the church of Santa Maria Antiqua in Rome offers a number of examples of such devotion. St Demetrios and St Barbara received golden lips. Salome, the mother of the Maccabees had a brooch placed at her throat. A standing Virgin perhaps held a rosary in her hands.[27] These instances muddy the transparency that separates the viewer from the viewed, raising questions about the very nature of representation in the Early Middle Ages.[28] The practice has been characterized by Nordhagen as a form of 'transgressive' illusionism in which 'a synthesis between the real and the unreal became feasible'. Furthermore, these examples suggest that the image itself becomes the site for exchange. These gifts add to and rewrite the pictorial surface, acting not just as memorializations, but as the continuing site of an exchange. It is this marking of the image that turns the icon from a transparent doorway between viewer and viewed and into the specific site of their mediation. Above all else, this act calls attention to the icon's surface.

From the discussion of the cross, it is now possible to return to the figure of the pope. The presence of the pope not only raises questions concerning the miraculous nature of the object, but it should also force us to consider the notion of transparency proposed by Brubaker. Such a model negates the surface of the icon itself, but it is precisely here where an intended viewer, the pope, and the object of his devotion, the Theotokos, can meet. Rather than overlooking the surface of the icon, it can be suggested that it is a space of primary importance for the imaginary encounter with the holy.[29] The icon of the Virgin in Santa Maria in Trastevere, therefore, not only offers evidence for the correlation of the icon and relic in the representation of the Theotokos, but also raises important points concerning our understanding of representation in this period. It is apparent that the icon itself as an object mediates the relationship between the viewer and the viewed. Rather than simply looking through the icon, one is asked to imagine oneself in the icon, and to understand this space as a site for imaginary encounter.

[1] My essay will not directly address the important Christological implications of the representation of the Theotokos. For discussion of this subject one can refer to the following surveys, Wellen 1961 and Freytag 1985. A recent essay on the implications of the representation of the Theotokos on the eve of Iconoclasm is Barber 1991, 43-60.

[2] Here one might compare the readings of Early Christian Art in Kitzinger 1954, 83-150 and Murray 1977, 303-345.

[3] A notable exception is the much-discussed text of Hypatios of Ephesus, Diekam 1938, 127-129. One should compare the discussions of Alexander 1952, 177-184 and Gero 1975, 208-216.

[4] The classic statement on this subject is Kitzinger 1954. To which should be added, Cameron 1979a, 3-25.

[5] The textual criticism of this issue has been vigorously pursued by Paul Speck. E.g., Speck 1989, 114-17; Speck 1990; Speck 1991, 163-247; Speck 1994, 293-309; Speck 1997, 131-176.

[6] Grabar 1984[2] offers the most fundamental survey of this material. More recently the question of the material evidence for the cult of icons has been most consistently addressed by Gary Vikan: especially, Vikan 1982; Vikan 1984, 65-86.

[7] The fundamental studies on this icon are offered by Sotiriou 1958, 21-22 and Weitzmann 1976a, 18-21. Perhaps the most sensitive reading of its visual qualities is offered in Cormack 1991, 8-16.

[8] Osborne 1985, 278-328; Russo 1979, 35-85; Russo 1980-1981, 71-150.

[9] The transcription of this text is from Bagatti 1936, 42:
Suscipe nunc lacrimas mater natique suprestis,
quas fundet gemitus; laudibus ecce tuis,
post mortem patris servasti casta mariti
sex triginta annis. Sic viduata fidem
officium nato patris matrisque gerebas
in subolis faciem. Vir tibi vixit Obas
Turtura nomen abis set turtur vera fuisti
cui coniux monens non fuit alter amor
unica materia est quo sumit femina laudem
quod te coniugo. Exibuisse doces.
Hic reqiexcit in pace Turtura
que bisit PLM annus LX

[10] This possibility has led to the use of this icon as an example of a specifically female devotion to icons, Herrin 1982, 56-83. Note the critique of this reading in Cormack 1997a, 24-51.

[11] For consideration of these questions of the value of the saints and their accessibility, Brown 1981.

[12] Cormack 1969, 17-52; Cormack 1985a, 88-89; Cormack 1985b, 70-71; Grabar 1978, 64-77.

[13] It can be suggested that this inscription is part of a single prayer that was inscribed beneath the four scenes.

[14] One might note the 7th- or 8th-century seal of an Archbishop Peter of Thessaloniki, which shows on its obverse a portrait of St Demetrios framed by a prayer to the Theotokos. The seal (Fogg, no. 1307) is discussed in Oikonomides 1986, 46-47. Oikonomides attributes the seal to a mid-8th-century archbishop. It is possible that the seal can also be ascribed to a late 7th-century metropolitan.

[15] For overviews of this topic, Ruggieri 1988, 79-118; Willis 1968, 135-173.

[16] *Ampullae* with oil from sites associated with the Theotokos and cloths that had been in contact with her relics might have fulfilled a similar function.

[17] Bertelli 1961a, 24-32, esp. 28-29.

[18] This icon perhaps provided the name for the church of Santa Maria Antiqua. In the life of Gregory III (731-741) from the *Liber Pontificalis* we have an uncertain reference to his having 'silvered the ancient image of God's Holy Mother' (*imaginem antiquam Sancte Dei Genitricis deargentavit*) (*Lib. pont.*

I.385). It is probable that the icon referred to is the one that still survives in the church of San Francesco Romano (formerly Santa Maria Nova) in Rome, Weiss 1958, 17-61.

[19] Andaloro 1972-1973, 167. This renaming took place between 595 and around 640.

[20] Bertelli 1964, 57.

[21] *Istae vero ecclesiae, CChr, ser. lat.* 175, 321, ll. 177-78: 'The Basilica called Santa Maria Trastevere; an image of St Mary which was made by itself is there' (*Basilica quae appellatur Sancta Maria Transtiberis; ibi est imago sanctae Mariae quae per se facta est*).

[22] The complete text is published in Alexakis 1996, 348-350.

[23] Nilgen 1981, 3-33.

[24] Brubaker 1998, 1216.

[25] A point most tellingly made by Vikan 1989, 47-59. For further thoughts on the implication of the copy, Babić 1988, 61-78 and Babić 1984, 189-222.

[26] Bertelli 1961b, 71.

[27] These examples and their bibliography are well discussed in Nordhagen 1988, 453-460.

[28] While these frescoes are products of the 7th century, the date of the gift-giving might be held to be in question. Santa Maria Antiqua was largely buried by an earthquake in 847, so we can assume that these gifts must pre-date this event. One piece of evidence to support an early date is suggested by an image of the Theotokos in a niche on the northwest pillar of this church. The frescoed image in this niche is probably not the earliest image at this location. The version that we now see dates to the papacy of John VII (705-707). In this final repainting the top right corner of the niche includes an extended frame. It appears to have been intended to encompass an existing *ex voto* at this location, whose presence was marked by nail holes (Nordhagen 1968, 75-76 and Tea 1961, 292). That these gifts might belong to the 7th century can be suggested from the evidence of two mosaics that are datable to the later 6th or early 7th century. The first of these is found high on the west wall of the south inner aisle of St Demetrios in Thessaloniki. The image shows the saint receiving a young supplicant at his ciborium. The saint has his hands portrayed in gold and in a gesture of prayer. Similarly, a mosaic of St Stephen in the amphitheatre at Dürres shows the saint in the act of praying, his now blackened hands were once gilded, Nikolajević 1980, 59-70 and Cormack 1985a, 50-94. On the possible significance of the hand as a sign of help, Zalesskaja 1967, 84-89.

[29] The Santa Maria in Trastevere icon is not an isolated example. From the same period, we can cite numerous mosaics in St Demetrios in Thessaloniki, in which the distinction between the sacred and the secular is overcome within the image itself. For example, in the representation of the city's eparch and bishop with St Demetrios on the north face of the pier to the right of the sanctuary. For some varied considerations of such imaginary encounters, Barber 1993, 7-16; Cormack 1985a, 215-251; Ševčenko 1994a, 255-285.

1

Icon of the Virgin and Child Between
Archangels Accompanied by Two Saints

68.5 × 49.7 × 1.5 cm
Encaustic on wood
6th century (?)
Constantinople (?)
Egypt, monastery of St Catherine at Sinai

The central figure of the icon is Mary, who is seated on a throne set slightly asymmetrically into a curved exedra. She wears a purple-blue tunic and maphorion, and red shoes. There is a gold star on her maphorion over her forehead, but not on the shoulders. The throne has a round back and a rectangular step in front. Above the Virgin is the hand of God and a beam of light coming down from heaven. Behind her throne are two winged angels with staffs, dressed in white. The Virgin holds the Christ-Child who, with his large infant head, strains to sit upright on her lap. He holds his right hand out and clutches a scroll in his left. His halo has a cross nimbus and is ornamented with a ring of small round stamped circles (the haloes of Mary and the two saints have the same ornamental device). Two saints holding martyr's crosses stand on each side of the throne. They wear a tunic and over it a patterned silk chlamys decorated with a ceremonial tablion. Over the shoulder, the chlamys is clipped together with a large fibula (as is that of Justinian in the San Vitale mosaics of the 540s). The saints wear white socks and black shoes, and shadows are cast from their feet.

The pointed beard of the saint on the left has satisfied all commentators that this is the portrait type of St Theodore. Sotiriou (1958, 21-22) identified the saint on the right as St George and in this he was followed by Weitzmann, who argued on the grounds of statistical probability, noting that six tenth-century ivories have this combination of saints. St George has been the generally accepted identification. However, Kitzinger identified the saint as St Demetrios, on the grounds of a comparison with a seventh-century wall-painting in Santa Maria Antiqua in Rome. Belting (1994, 129) states that the two saints are clearly the soldier-saints Demetrios and Theodore (and following Kitzinger dates the panel to the seventh century). These two saints are found together in a similar composition in the mosaics of St Demetrios at Thessaloniki. This mosaic group, now known only from copies and photographs, belongs to the first phase of the north inner aisle

panels and dates some time after the construction of the church and before the fire of around 620. It can be reasonably assigned to some time in the sixth century (Cormack 1989). Weitzmann dated the saints to the seventh century and saw them as more abstract and less classical than the icon and therefore of a later period.

As in the case of many other icons in the Sinai Collection, we cannot be sure when and in what circumstances they arrived in the monastery. Weitzmann speculated that this icon, together with the icon of Christ (Weitzmann 1976a, no. B.1), which he dated slightly earlier on grounds of style (agreeing with Chatzidakis 1967), was a gift from Justinian, probably at the time of the founding of the monastery between 550 and 565. This offered him a tentative date and a provenance from Constantinople. He added that the St Peter icon (Weitzmann 1976a, no. B.5), might come from the same workshop tradition in Constantinople, but slightly later (550-650). Sotiriou had previously published the Virgin icon as sixth-century. Kitzinger proposed a later date for it in the seventh century, in comparison with paintings in Rome, particularly those of Santa Maria Antiqua. Weitzmann and Kitzinger concurred in attributing the painting to an artist in Constantinople, and diverged from the suggestion of Sotiriou that it was produced in Syria or Palestine. No firm evidence for a decision on its place of manufacture has emerged. Galavaris (1990) repeats the view that it was an imperial gift of the sixth century, although the caption dates the icon broadly between 550 and 650. What does seem clear is that the style of each of these three icons is not homogeneous and the encaustic technique in particular is handled differently; in this icon the pigment is thickly applied in places, like impasto.

It has been emphasized that the various figures are handled stylistically in a set of different ways, ranging from the traditional classicism of the angels to the frontal and abstract treatment of the male saints, whose gaze meets the eyes of the viewer. Kitzinger developed the vocabulary of 'stylistic modes' to explain this divergence, but recent literature has moved away from the concept. Belting (1994, 129-134) prefers to speak of conventions rather than stylistic modes, whereas Andreescu-Treadgold and Treadgold (1997) more negatively 'refute' the theory of modes. The large brown eyes of the Virgin look to the right and do not meet the eyes of the viewer. She appears to look away from and beyond the person who contemplates the icon.

Despite the formal composition of the icon and the courtly and ceremonial appearance of the imagery, this is presumably a devotional panel, particularly accessible for private veneration and prayer. It works pictorially through a hierarchy of images carefully designed to express their relative powers between earth and heaven. The viewer is invited to look into the eyes of one of the two military saints who can then act as a vessel for prayers and pass them onto the Virgin who is seen to dwell in the realm of heaven. It owes its pictorial success to this tension between formality and intimacy.

Robin Cormack

Conservation:
Restored by Tassos Margaritof. The panel has seriously warped and is split down the middle. It is relatively thin (1.5 cm) and tapered near the edge with a 1-2 cm wide unpainted border that was not painted. Originally it seems to have had a frame that was flush with the reverse side, but projected in front, and was wide enough to have contained an inscription (this procedure is discussed by Corrigan 1995, 57, n. 2).

A patch above the right thigh of the saint on the right and patches of his hair have been repainted (work attributed to Father Pachomios by Weitzmann). The paint has flaked in a number of places and there are scratches on the Virgin's tunic and the chlamys of the saint on the right. Otherwise the thickly applied encaustic paint is well preserved.

Literature:
Sotiriou 1939, 325, pl. 1; Sotiriou 1956-1958, 21-22, pls 4-7; Weitzmann 1976a, no. B.3, 18-21.

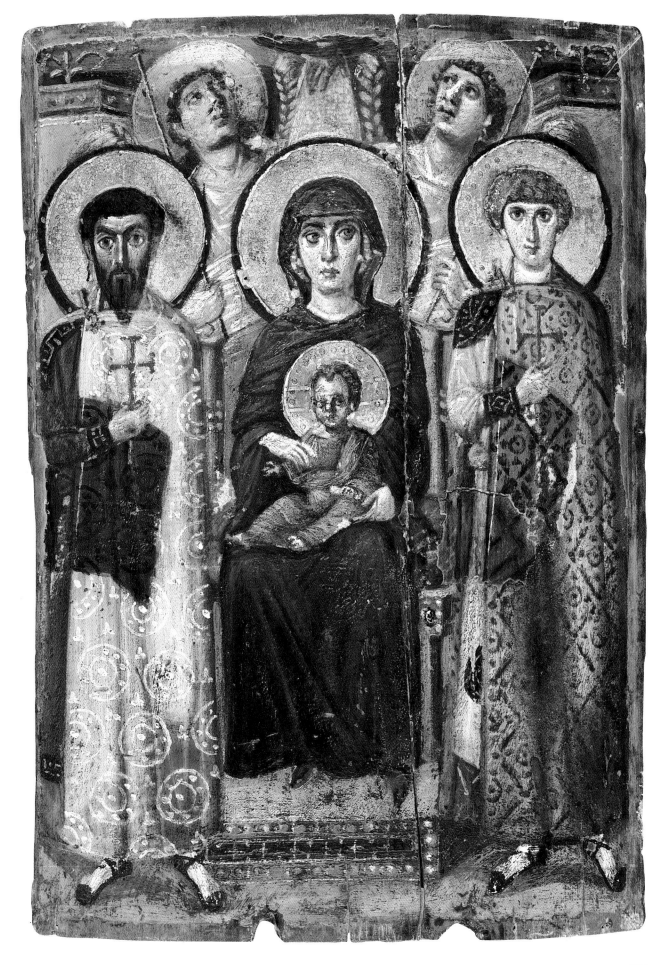

263

2
Icon of the Virgin and Child

35.4 × 20.6 × 0.7-0.8 cm
Encaustic on wood
6th century (?)
Constantinople (?)
Brought to Kiev from the monastery of
St Catherine at Sinai in the mid-19th century.
Ukraine, Kiev, City Museum of Western
and Oriental Arts, Inv. no. 112.

The Virgin clasps the Christ-Child in her crossed arms and holds him up over her shoulder. Her body is turned towards him, but her head is turned to the left. He likewise looks out to the left and extends his right arm and open palm in the same direction.

The Virgin is interpreted by Weitzmann (1976) as wearing three different garments: a violet purple maphorion which is loosely slung over her head and shoulders (decorated with a gold cross over her forehead), beneath this a yellowish chiton covered with gold striations beneath the maphorion which is seen below her shoulder, and a purple sleeve with a broad gold embroidery over her right arm, which belongs to a garment (a stole) worn beneath the other two. Christ wears brownish purple garments (tunic and mantle), with a double clavus on the sleeve of the tunic. The faces are painted in white with pink on the cheeks and red on the lips. Both figures have large hazel eyes emphasized by the white of the eyeballs. They each have a gold-leaf halo with a red outline, and the surface is enlivened with regular punched patterns. The background of the icon is blue, lighter in hue at the top. Weitzmann identified a vertical gold stroke to the right of the Virgin's halo as a remnant of an inscription, probably the right monogram of the title Η ΑΓΙΑ ΜΑΡΙΑ. He also identified the three gold strokes above the halo of Christ as a monogram, in this case the XP monogram. Both monograms are found in other works of the pre-Iconoclastic period.

The icon has been cut down all around, except on the right edge. It has been reshaped by diagonal cuts on each side of the Virgin's halo, which does not sit symmetrically in the picture space. A broad, grooved frame was probably originally laid around the icon, as in other early encaustic icons (there is a ridge of blue paint indicating the edge against which the frame would have rested). There are therefore two main questions to be solved; the original size and composition, and the character of the major alteration to the panel, marked by its new shape.

The emphatic gaze of both figures towards the left and the lack of direct contact with the viewer led to the suggestion by Ainalov (1902) that the icon originally represented the narrative scene of the Adoration of the Magi, who would have been kneeling before the Virgin and Christ and placed on a missing section on the left side of the panel (some other early icons have such a 'landscape' shape). Most commentators before Weitzmann (1976a) had accepted this idea, except for a modification by Kondakov (1914, 163-164), who thought the ultimate model was an Adoration of the Magi but that this was an abbreviated version with the Virgin and Child only. Weitzmann argued against this interpretation of the icon on the basis of the following points. Christ's open palm gesture does not imply the presence of further figures on the icon, as on other icons Christ gestures to the side without the presence of figures there. Although neither figure looks at the viewer, this averted gaze is a feature of other Virgin and Child icons and does not imply a larger composition. Weitzmann also argued that this icon showed the Virgin as a principal hieratic figure and that in such a composition she would have been placed at the centre. If this was an Adoration of the Magi, therefore, they would have been placed symmetrically and at least one would be visible on the right side of the panel. If they had all been placed to the left, then the Virgin's pose is meaningless, as it would imply she was turning her back towards them. Finally, in the Adoration of the Magi she is normally placed on a throne, but there is no sign of the arms of a throne on the right. Weitzmann's logic is circumstantial but quite cogent. He concluded that only a strip of 3.5 to 4 cm had been lost from the left side of the panel and accepted that, conceivably, the original composition was not of a bust of the Virgin, but a full-length figure. In this case a considerable section has been cut from the lower part of the icon.

If it is accepted that the icon is only slightly trimmed to left and below, then it was close in size to another icon from this period at Sinai, the (much damaged) bust of Christ (Weitzmann 1976a, no. B.6, 26-27, dim. 35 × 21.5 cm), and this raises the possibility that this icon might have originally formed the right leaf of a diptych with a Christ on the left.

All commentators have pointed out that the pose of the Virgin has no parallel, and that it is not of the Hodegetria type. Nordhagen (1987) describes a fresco of a standing Virgin and Child in Santa Maria Antiqua, of the mid-seventh century, which has a similar iconography of crossed hands; he suggests that in this example the Virgin held an actual donation of a precious votive gift and the icon recorded her acceptance of it. He thought the iconography was designed for the purpose of displaying costly gifts. The lively movement of the Child is paralleled in the mosaic of the Presentation in the Kalenderhane (Kyriotissa monastery) at Constantinople, which is dated by Striker and Kuban (1997, 121-124) to the reign of Justin II (565-578) or slightly later. Kondakov and most other commentators have dated the icon to the sixth century, although the dated phases of painting in the church of Santa Maria Antiqua in Rome have not in this case been brought into the argument. Belting (1994, 69) dated it to the fifth century. Weitzmann (1976) compared the encaustic style and technical details with the famous Christ icon at Sinai (such as the chipping of the back with a plane and the punched ornament of the halo of Christ), and saw the Kiev icon, as well as the Christ icon and the Virgin and Saints icon, as Constantinopolitan works of the sixth century and probably from the reign of Justinian (527-565). Kondakov attributed the production of the icon to Alexandria, but Weitzmann insisted it was the work of an artist from Constantinople.

The cutting of the icon has been given various explanations and dates. Kondakov compared its shape with Fayum panels inserted into mummy cases, but this hardly seems a relevant parallel. Another explanation was that it was cut down by Uspenskij in the nineteenth century. Far more convincing is that this was a significant Medieval alteration, and that the icon was adapted to fit into a Gothic-shaped gabled frame. Such shapes are found on Sinai, as for example in two leaves of a triptych of Sts Peter and Paul where the inscriptions are written in Latin (Weitzmann 1976a, 16). The implication is that the work was done by a western artist, commissioned to reset a highly venerated image into a new devotional setting. This is supported by an examination of the elaborate punched pattern of the Virgin's halo, with small rosettes within a scroll ornament, which can be compared with Italian designs of the second half of the thirteenth century (and with some of the first half of the fourteenth century, Frinta 1965; Skaug 1983; *Art in the Making, passim*). It may be significant that the Christ icon was also restored in this period. Whether they were already venerated images at Sinai or brought from elsewhere in the Crusader period might be a consideration. But clearly this 'antique' icon became the focus of new attention in the Middle Ages.

The icon came to Kiev in the mid-nineteenth century when the Russian Archimandrite Porphyrij Uspenskij travelled to the Near East in 1845 and 1850, and among many acquisitions brought back a collection of icons from Sinai, including this and three other pre-Iconoclastic icons (it seems that those brought from the later period were destroyed in the Second World War). He bequeathed them to the Ecclesiastical Academy of Kiev on his death in 1885, where they remained until the Russian Revolution. They were in the Kiev Central Antireligious Museum until they were transferred to the current museum in 1940. This was one of the best-known early icons before the expeditions of Sotiriou and Weitzmann to Sinai.

The wood is larch (according to Bank 1977); the back is chipped by a plane (like other early icons from Sinai) and left blank. The painting has been touched up and restored several times (early photographs indicate varnish and soot over the surface). Weitzmann records a recent restoration by Kirikov. Two cracks in the wood in the lower part of the icon have caused flaking and there are patches of repaint (above the Virgin's right hand in Christ's garment); parts of the Virgin's nimbus and the ground around it are missing. The left side of the Virgin's face, around the nose and eye, has flaked, and overall much of the top layer of encaustic paint has rubbed off (including that on the head and hair of Christ).

Robin Cormack

Exhibitions:
Από τα Πορτραίτα του Φαγιούμ, Vikelaia Library, Iraklion, Benaki Museum, Athens and Museum of Byzantine Culture, Thessaloniki 1998.

Literature:
Uspenskij 1850; Strzygowski 1891, I, 113ff.; Kondakov 1902; Ainalov 1902, 343-377; Petrov 1912; Weitzmann 1976a, no. B.2, 15-18; Bank 1977, no. 109 and 290-291; Από τα Πορτραίτα του Φαγιούμ, 15-21.

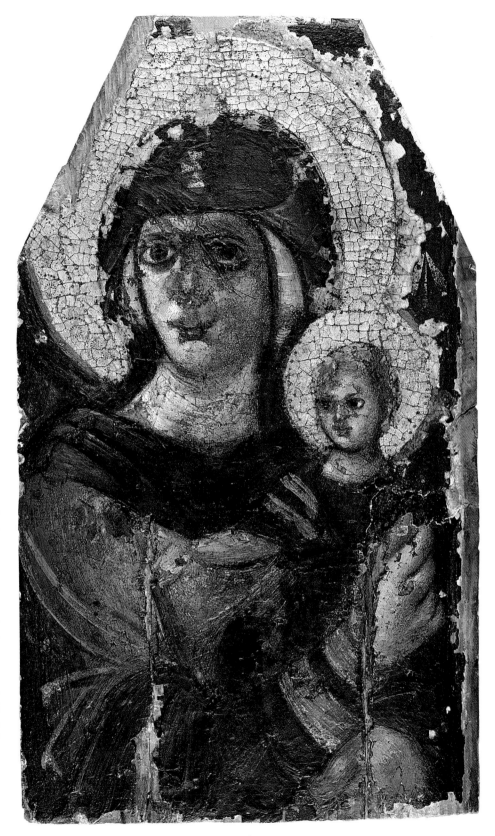

3

Plaque of the Adoration of the Magi
and the Miracle of Salome

21.5 × 12.3 cm
Ivory
First half of the 6th century
Eastern Mediterranean: possibly Bethlehem
or Syria
London, Trustees of the British Museum,
M&LA 1904. 7-2. 1

This magnificent ivory plaque is dominated by the figure of Mary, Mother of God, who sits on a low, backless throne, with the Christ-Child seated on her lap. Neither holy figure has a halo. Mary is attended by an angel holding a cross-headed staff, and by the three Magi, who all hold bowls containing gifts in their covered hands. The figures are framed by an arch supported on spiral columns, which were originally surmounted by crosses (subsequently cut away). The Virgin wears a simple cloak, which also covers her head, and stares out at the viewer through large, almost circular eyes. Interaction with the viewer is direct and unavoidable. Mary is by far the largest figure on the plaque. Christ, considerably smaller, also looks out at the viewer and makes a gesture of blessing with his right hand, while holding a scroll in his left. The three Magi, one of whom is bearded, are all dressed in similar clothes, tight trousers, short tunics clasped over the right shoulder and Phrygian caps. They all cover their hands in deference to the sanctity before them. Small holes in the Magi's caps and in the cross held by the angel suggest that the ivory was once adorned with coloured gems or paste.

Rather than display the scene as a narrative in which the Magi appear before the Virgin and Child, this image of the Adoration is presented as a hieratic icon to glorify the Virgin and Child, and to act as a focus of veneration. All narrative elements have been removed in order to demonstrate the magnificence of the holy couple, and the Magi and angel are placed symmetrically around the central figures. This more iconic presentation can be compared to many other sixth- and seventh-century images of the Virgin and Child in all media, including mosaics in the church of St Demetrios, Thessaloniki (Cormack 1969, pl. 3), icons on Mount Sinai (Weitzmann 1976a, no. B.3), and the tapestry in the Cleveland Museum (*Age of Spirituality*, no. 477).

A more telling insight into the importance of the Virgin is given in the lower scene on the plaque, which tells the story of Salome. This is taken from the apocryphal *Protevangelium of James* (19-20). Salome was a witness to the Nativity but denied the virgin birth, and her hand withered when she insisted on verifying the truth. She was healed when an angel instructed her to touch the Christ-Child. On the ivory, Mary is shown on the left-hand side, reclining on a pallet and looking towards her son. Christ lies in swaddling bands in a very sturdy looking crib, over which hovers a star. An ox and an ass (which still has its saddle on) look on from either side while Salome uses her left arm to support her withered right hand, which she raises up to touch Christ.

This iconography is rare in Byzantine art, and is only known on a number of ivory plaques and pyxides, all carved before Iconoclasm (Volbach 1976, nos 127, 174, 199), as well as on the sixth-century cathedra of Maximian in Ravenna (Cecchelli 1944, pl. 25), which depicts the moment when Salome's hand withered away. The scene is depicted in western art as late as the twelfth century, but even there its appearance is sporadic (for lists Nordhagen 1961, 334, n. 8 and Lafontaine-Dosogne 1992, 95, n. 6).

In Byzantine art, the Salome miracle was quickly supplanted by the more familiar image of the bathing of Christ. According to *Pseudo-Matthew* (13) one of these midwives was named Salome, which indicates one way in which the older scene was incorporated into the new. The existence of the Salome scene in the sixth century and its subsequent disappearance tell us much about the development of the cult of the Virgin and of the way in which the Nativity was interpreted before Iconoclasm. It provides evidence of a shift in emphasis in the meaning of the Nativity over this period. The story of Salome acts as a testament to the power of the Mother of God, since it concerns the fate of those who doubt the truth of the virgin birth. Although the miracle cure is performed by the Christ-Child, the emphasis in the story is on the power of Mary. Salome, the sceptical witness, is shown the veracity of the virgin birth. This iconography can be seen as the culmination of the pre-Iconoclastic cult of the Virgin, which had grown through the fifth century, when the Ecumenical Council of Ephesus in 431 declared Mary to be the Theotokos.

However, soon after this ivory was carved Christian interest in the Nativity shifted. As the validity of Christian art came under pressure from Iconoclasts, theologians sought to promote the Nativity as evidence of the dual nature of Christ, of his Incarnation as man (Parry 1996, 70-80). Emphasis in the story and interpretation of the Nativity moved away from the fact of the virgin birth to that of the Incarnation of Christ as man. This was then used to support arguments in favour of the efficacy of painting images of Christ, since it was his human form that was being depicted. In this, Salome was transformed from the sceptical tester of the virginity of Mary to the devoted witness of the Incarnation (Deshman 1989).

The plaque is generally in good condition, but much of the detail, particularly in the lower Salome scene, has been worn away through rubbing, and there are two areas of fire damage, in the bottom centre and top right-hand corner. At some point the frame and edges of the plaque were carved away to form a flange. This resulted in the loss of the feet of all the animals and figures in the Salome scene, of the back of the left-hand Magus, and of the cross which was originally carved over the left-hand column. This later groove suggests that the plaque was altered for reuse as the central panel of a larger icon. Several other sixth-century ivories were made up of five pieces (a large central panel with four border pieces, which extend the range of the narrative), and it seems that the London panel was subsequently altered to fit in to such a scheme. An ivory plaque in Manchester, with almost identical iconography (but of inferior quality), once formed part of such a diptych, the plaques of which included scenes from the life of the Virgin's mother, St Anne, and other events leading up to the Nativity. This iconography mostly comes from the *Protevangelium of James* (*Age of Spirituality*, nos 457-461).

It is difficult to isolate a place of origin for this plaque as there are few stylistic comparisons that can be made with objects of secure provenance. Suggestions have varied from Constantinople in the West to Syria in the East (Weitzmann 1973, no. 476 for a full list). There is now general agreement that an eastern location is most probable, either Syria on stylistic grounds, or Bethlehem as the focus of an important cult of the Virgin which may well have been reflected in the decoration of the west façade of the basilica of the Nativity.

Antony Eastmond

Exhibitions:
Age of Spirituality, The Metropolitan Museum of Art, New York 1977; *We Three Kings*, Buckinghamshire Art Gallery, Aylesbury 1995.

Literature:
Age of Spirituality, no. 476; *We Three Kings*, no. 1; Volbach 1976, no. 131.

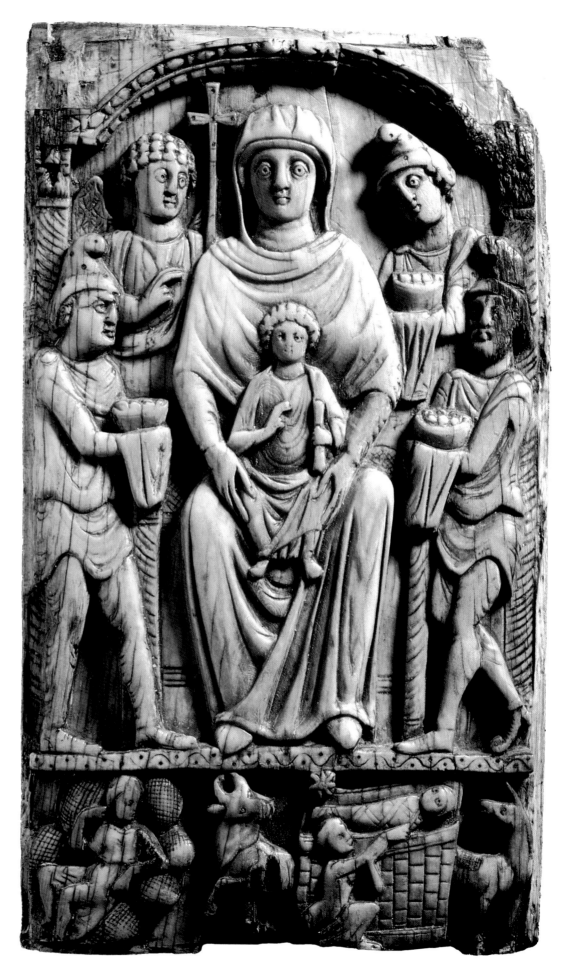

4

Sarcophagus Fragment with the Virgin and Child

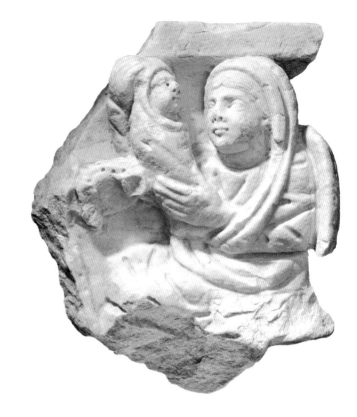

30 × 25 × 9.4 cm (max. h. 5.5 cm)
Marble, white, fine-grained with soft tones
of light grey
About 320-350
Probably Roman
Munich, Christian Schmidt Collection,
Inv. no. 1072

This fragment is part of the front elevation of a sarcophagus with a decorative frieze that was framed at the top by a flat cornice. Slightly sunk behind the cornice (which is 3.5 cm wide) there is a step to which the lip of the lid must have fitted. The back of the fragment bears a typical feature of sarcophagus interiors: slantwise, slightly wavy, incised grooves.

The front elevation's relief figures belong to a representation of the Adoration of the Magi (Matthew 2:1-12). Mary turns to her left and is seated on a throne with a curved back. She wears a chiton with long, tight sleeves and over it a rich mantle, almost completely hiding her body and also covering her head. From this covering there peeps out the tender, childlike face of the young Mother of God. Her hair is parted in the middle: the delicate curls are drawn sideways, almost completely concealing her ears. She looks hesitant about showing her baby to the Magi. She holds the Christ-Child protectively in her left arm, while carefully supporting his head with her right arm. The faces of Mother and Child poke out of their wimples, but are still turned towards each other. All the Magi can see of the swaddled babe is his back.

The representation of the adoring Magi would have been to the Child's left. They will have been bringing their gifts of gold, frankincense and myrrh to the future Lord and King of All. The present fragment unfortunately only preserves the back half of a crown that the first Magus intends to present to the Child. Matthew's Gospel mentions no such crown; but in later Antiquity gold crowns were ritually offered to emperors by their subjects as a mark of honour and a token of allegiance. In representations with a Christian content, dating from after Constantine's conversion in 313, we often find residual elements of imperial ioconography (Deckers 1982). It is at around this time that the representation of the Adoration of the Magi makes its first appearance in Late Antique art. Better-preserved representations show that further elements could be incorporated which, though not found in the gospel text, were typical for Late Antique imperial ceremonial: an example is the covering of the arms. An 'imperial' representation of this kind was obviously intended to extol the omnipotence of Christ the future Pantokrator, for it was Christ who had, from the time of Constantine the Great onwards, to assume the role of protecting deity for the emperor and his realm. Of course the display of the new-born Christ's power could not lag behind that of a new-born heir to the imperial throne: for which reason, a gold medallion was issued — probably to celebrate the birth of the imperial *princeps* Constantius at Trier in 324 — showing the infant lying peacefully in the lap of his mother Fausta and crowns of honour being offered to him (*RIC*, 7, 1966, 443).

The representation of the Adoration of the Magi is often encountered in reliefs on Roman sarcophagi in the first half of the fourth century (Deichmann 1967; Lange 1966, 33-34; Dresken-Weiland 1998), but it is fairly rare to find in these the detail of the Infant turning towards his mother (and not towards the Magi). From the findings of the summary studies just mentioned, the Adoration of the Magi appears on seventy-two sarcophagi in all. Of these, only in sixteen cases does Christ turn towards his mother (Deichmann 1967, nos 145, 159, 352, 526, 618, 662, 735, 745, 803, 835, 887, 903, 949; Dresken-Weiland 1998, nos 32, 209, 210).

In these sixteen representations, the Infant does not receive the gifts, as in the majority of the reliefs on the other sarcophagi, but turns towards Mary his mother. A similar detail occurs in a whole series of reliefs on second- and third-century Roman sarcophagi with scenes from everyday life. Here we often find the picture of a mother or nurse sitting on a chair with an infant in her arms and turning towards her (Amedick 1991, 63-65, no. 273, pl. 64.1). By thus 'adopting' an older portrayal, it was possible, in the fourth century, to project the close bond between the Virgin and her Son more clearly.

The technique of the relief has features showing that it was made in a Roman workshop, some decades after the completion of the Arch of Constantine. On the friezes of Constantine's triumphal monument, built in around 320, there are lapidary idiosyncrasies comparable with the style of our sarcophagus: shadowy folds on the clothing incised deep into the material of the sculpture, or the holes that, like black pips, emphasize and build the details of faces and objects.

Johannes Deckers

Literature:
Unpublished.

5

Eulogia Dish

Diam. 14 cm
Bronze
6th century
Munich, Christian Schmidt Collection,
Inv. no. 854

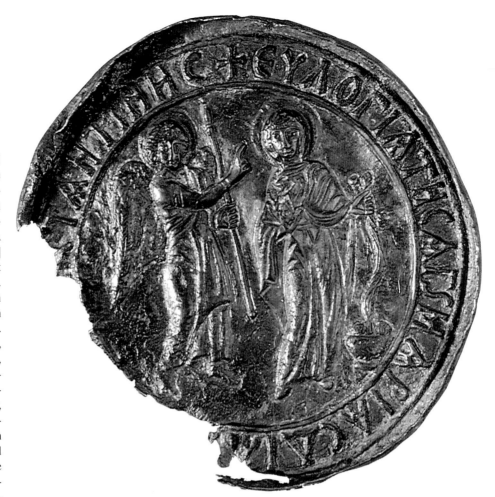

A bronze dish with relief decoration formed by impression on a mould. The scene of the Annunciation in the central roundel is surrounded by a fragmentary rim with an incomplete inscription. One possible reading of the inscription might be: ΕΥΛΟΓΗΑ ΤΗC ΑΓΗΑC ΜΑΡΙΑC ΔΙΑ [ΚΟΝΙΑ] ΤΗC ΚΟΝCΤΑ[ΝΤΙΝΗC] (Blessing of St Maria from the *diakonia* of Konstantini). Konstantini, or Tella (Viransehir in modern Turkey), was a metropolitan see in northern Mesopotamia (Mundell Mango 1991, 497). According to this reading of the inscription, the eulogia probably belonged to a *diakonia*, a welfare institution which is usually regulated by a monastery and is intended to provide charity and other assistance to the poor, together with facilities for prayer. The institution of the *diakonia* first appeared in coenobitic centres of Lower Egypt. It gained popularity as an institution in Palestine toward the mid-sixth century, before extending progressively to all parts of the Byzantine Empire (Laurent 1965, 125-126). The metalwork tradition of the northern Mesopotamian area helps to corroborate the reading of the place-name Konstantini in the inscription (Pitarakis 1998a, 174-176). This region, known for its copper mines, has been traditionaly associated with the production of bronze censers with Christological scenes. The style and iconography of these bronze censers bear strong resemblance to this Annunciation eulogia (Richter-Siebels 1990, 49-54).

This bronze dish provides an interesting complement to current knowledge of Early Christian 'blessings' (*eulogies*) usually connected with pilgrim shrines. These are lead or earthenware flasks and clay tokens whose sacred value lies in the blessed substance they contain — oil, water, or earth — which have entered into contact with the Holy (Vikan 1998). The purpose of the bronze eulogia with internal decoration is not well understood. The most adequate interpretation defines it as a small dish intended to carry the blessed bread, also named eulogia, which is distributed in church at the end of the eucharistic liturgy, or on the feast days of specific saints (Galavaris 1970).

The Annunciation is a popular image on a range of objects of amuletic character, including cameos, gold medallions, crosses, and pilgrim flasks and tokens that are dated from the fifth to the seventh century (van Dijk 1999, 428-432). The Annunciation on this bronze eulogia depicts a standing Virgin, approached from the left by the Archangel. The Virgin holds a skein of yarn which is unfolding into a basket. This iconographic formula derives from the *Protevangelium of James* (11:1-2), according to which Gabriel appeared to the Virgin while she was spinning the purple yarn for the Temple curtain. The iconographic pattern of the basket of wool originates in fifth-century depictions of the scene, which usually feature a seated Virgin with the angel approaching her from the right (Lemerle 1949). The iconography of the standing Virgin, together with the standard Byzantine formula of the Archangel approaching from the left, developed from the sixth century onward. The Annunciation iconography of this bronze eulogia is also attested on sixth-century pewter pilgrim flasks from the Holy Land (Grabar 1958, pl. VI). A similar composition can be found as well in the miniatures of the Rabbula Gospels (586) (Leroy 1964, pl. 22.2). An

inscription with a similar content to the one on the bronze eulogia is found on the circumference of a sixth-century clay medallion in Monza, decorated with an image of the Annunciation at the Well (Grabar 1958, pl. XXXI). The inscription on this object can be restituted as ΕΥΛΟΓΙΑ ΤΗC ΘΕΟΤΟΚΟΥ ΤΗC ΠΕΤΡΑC Θ(ΕΟ)Υ ΔΙΑΜΟ[ΝΗ]. A sixth-century dating for the bronze eulogia, supported by its iconography, is also consistent with the uncial-letter forms of the inscription — further epigraphic parallels are found on a series of sixth-century silver vessels (Ševčenko 1992).

Brigitte Pitarakis

Exhibitions:
Rom und Byzanz 1, Bayerisches Nationalmuseum, Munich 1998.

Literature:
Rom und Byzanz 1, no. 18.

6

Relief of the Virgin of the Annunciation

28.5 × 14.2 × 2 cm
Fig wood
5th or 6th century
Coptic Egypt
Purchased at auction (1945)
Paris, Musée du Louvre, Département des
Antiquités égyptiennes, Inv. no. E 17118

This fragmentary relief represents the Virgin of the Annunciation. Mary is seated on a high stool. Her legs are rendered in profile; her torso and face, frontally. In her left hand she holds a skep with purple for the curtain of the Temple at Jerusalem. Her right hand is raised and might well have held a spindle for spinning thread. That is what the apocryphal gospels describe her doing (*Protevangelium of James*, 11:1-3; *Pseudo-Matthew*, 9:1-2) when the Archangel Gabriel came to announce the birth of Jesus to her. Of the four Evangelists, only Luke (1:26-28) mentions this incident, touching on it briefly. Mary wears a long chiton and maphorion, and she perhaps had a wimple on her head. Of Gabriel, who stood upright in front of her, nothing remains but his left leg and part of his clothing. The picture of the Virgin at her spinning (Wasowicz 1990, 163-177) is standard for the Christian East, which borrowed the model from Classical art, and especially from Classical Greek art. It is the iconographic type of the woman at her spinning—whether standing or sitting—in company with a second young woman standing beside her. The model was reproduced repeatedly on funeral stelai and Attic red-figure vases. The woman at her spinning, symbol of women's moral priorities and social status, was bequeathed to Christian iconography, just as were many other pagan subjects: the Virgin Mary, first among women, could readily be identified with this archetype. The writers of the apocryphal gospels drew on the ancient stock, the symbolism of which could be transferred with ease to suit new religious circumstances.

The relief still bears traces of colour: black in the field and on the pupils of the eyes; violet and rose-red for the garments. The lower border of the relief is bevelled, probably to allow it to be inserted as a panel into a piece of furniture (a door-panel of a chancel barrier, a casket, a door etc.): this panel would have been decorated with a number of scenes from the life of Christ and Mary, after the model of the sixth-century cathedra of Maximian at Ravenna (Ravenna, Museo Arcivescovile) or the fifth-century doors of Santa Sabina at Rome. In Egypt, this tradition is followed in the eighth-century doorway lintel and the thirteenth-century door panels (the latter now in the British Museum) of the church of al-Moallaqa in Cairo.

The earliest representation in Egypt of the Annunciation is in the fifth-century dome of the chapel of St Irene at El Bagawat in the Kharga Oasis. Mary, praying, is placed between St Paul (who is talking to St Thekla) and Noah's Ark, itself placed between the Old and New Testaments. Instead of the archangel, there is the Dove of the Holy Spirit, with an inscription, flying close to the Virgin's face to bring her the joyful tidings. The dove renders pictorially the Mother of God's conception by the Holy Spirit, at the very moment of Gabriel's greeting, in keeping with the doctrine of the Incarnation of the Divine Word. This particular example is unique: normally the dove is shown between the Mother of God and Gabriel. Obviously the neighbouring scene of Noah's Ark, with a dove with an olive-branch in its beak flying towards it, was meant as a reminder of the symbolic link between the two Testaments. There are many other such works from the fifth to the seventh century, most of them akin to the Louvre relief. On a piece of stamped linen cloth from Akhmim, and now in the Victoria and Albert Museum, Mary's pose is essentially identical. She spins purple thread, gathered in a basket on the ground. But she watches the archangel, who is portrayed frontally and in a very static pose with legs apart in a manner reminiscent of Greek models. Inscribed between the two figures is the Virgin's name. On a gold medallion found in the environs of Assiut, and now in Berlin (Antikensammlung), Mary grasps a length of purple thread from the basket on the ground in her right hand, and makes a gesture of what is probably surprise with her left, as she turns in bewilderment towards the onlooker. The archangel lifts his arm in a speech gesture: this same iconography could well be restored for the Louvre relief. A third work is a circular sew-on linen appliqué embroidered with silk thread (London, Victoria and Albert Museum). Mary is at her spinning under a canopy as the archangel comes forwards, raising his arm. Between the two of them is the skep filled with purple thread, with two needles pushed into the wool that sticks out of the top. The embroiderer has left space round the angel to insert the scene that followed, the Visitation. The Annunciation again appears, set in a roundel, in Chapel 51 of the Bawit monastery in central Egypt, with the two principal figures turning their faces frontwards, as in the Louvre relief. They are met with once more, in the same sequence, at the seventh- or eighth-century el Baramus monastery in Wadi Natrun. Here the elegance of the technique is unhappily marred by the flaking of the wall-paintings and great gaps.

In 1180 the same iconographic type, rendered more laconically, was used in a miniature in a Coptic manuscript (Paris, Bibliothèque Nationale, cod. Copt. no. 1). The Virgin Mary, spindle and distaff in hand, bends her head towards the archangel, whose lifted wing rests on her halo. Southwest of Alexandria, at Abu Girga, is a small building in the crypt of which there is a perhaps an eighth-century portrayal of the Annunciation. Only Gabriel's figure is well preserved: dressed in a chiton of *opus plumatile* (featherwork embroidery) and a long mantle, he comes forward frontally, in a vigorous, stylized movement, to greet Mary. A few words of what he is saying to her have been preserved between the two figures. Precisely the same composition is used in a manuscript dated to 914 (New York, Pierpont Morgan Library), with the names and the words of greeting inscribed. In the apse of the church of the Mother of God in the Syron monastery at Wadi Natrun, the Annunciation is next to the Nativity (11th or 12th century). The monastery was bought from Syrian monks in 710, which is why there are inscriptions in Syriac side by side with inscriptions in Greek. Mary is no longer spinning: both principal figures are standing and prominent against their architectural background.

The same composition is encountered in a series of bronze censers, examples of which have been found in Syria and Palestine. The scenes from the life of Christ and of Mary that adorn their bowls are rendered in a completely stylized way and in a technique that differs from one censer to another: Mary is sometimes seated, and sometimes standing in front of the angel. The same figures appear in the same poses on a thirteenth-century wooden panel from the Sitt Miriam church in Cairo, and now in the British Museum: on a ground charged with the typical Islamic motif of arabesques, Gabriel and Mary look at one another, the folds of their garments treated in the Byzantine manner. The Virgin has exchanged her spindle and distaff for a book, a feature of western iconography.

An Annunciation, overpainted with an Ascension in about 1225, was discovered in the church of the Syron monastery in 1991;

it may date from before 710. This work is notable both for its magnificent technique and for its rich iconography. Against an architectural background showing the town of Nazareth, the Virgin, seated on an elaborately carved throne, is spinning as she hears Gabriel's greeting. Between them, on a column with carving, is a vessel holding incense, its blue flame rising perpendicularly. Also shown in the scene, to either side of the principal figures, are four prophets. Each of them offers his prophecy of the event, and their names — Isaiah, Ezekiel, Moses and Daniel — are written in Coptic on the inside of a scroll. This iconography, unique in Egypt, does not reappear until 1294, in the church of the Peribleptos at Ochrid. In the St Makarios monastery, not far from the Syron monastery, this incident is placed between the arches of an octagon, and forms a companion scene to a picture of the Annunciation to Zacharias. Mary is spinning and sits in front of a water-jet with an elegant piece of construction above it. According to the apocryphal gospels, a first Annunciation had taken place near a spring or well, a subject encountered from time to time in the Christian East. Thus on a fourth-century silk *examiton*, possibly from Egypt, and now in the Abegg-Stiftung (Riggisberg, Bern), Mary is kneeling to draw water and is taken aback by Gabriel's greeting. Both traditions fuse in this unusual example. Thus the doctrine of the Incarnation, laid down by the Ecumenical Council of Ephesus in 431, is clearly corroborated in Egypt by the profusion of scenes from the Virgin's life, and especially scenes of the Annunciation. Even though the technique of works from Egypt is a special case, their iconography shows that they belong to the Mediterranean Christian mainstream.

Marie-Hélène Rutschowscaya

Exhibitions:
*Koptische Kunst-Christentum am Nil*1, Villa Hügel, Essen 1963; *L'art copte*, Petit Palais, Paris 1964; *Koptische Kunst-Christentum am Nil*2, Kunsthaus, Zurich 1963-1964; *Frühchristliche und Koptische Kunst*, Akademie der bildenden Künste, Vienna 1964.

Literature:
*Koptische Kunst-Christentum am Nil*1, no. 145; *L'art copte*, no. 93; *Koptische Kunst-Christentum am Nil*2, no. 126; *Frühchristliche und Koptische Kunst*, no. 125; Vandier 1945, 250-255; Lemerle 1949, 98-118; Rutschowscaya 1986, no. 3; Rutschowscaya 1997, no. 127.

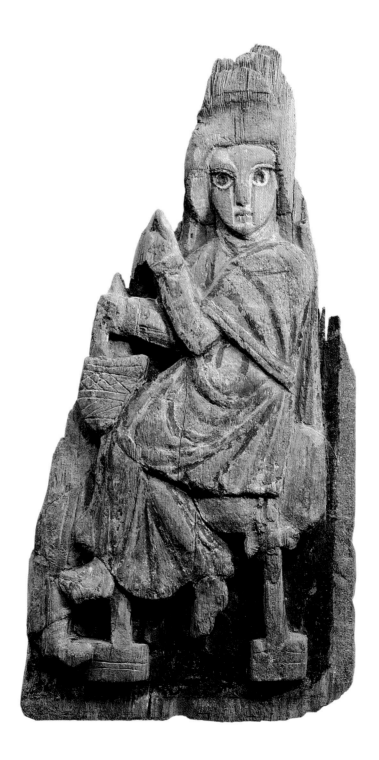

7

*Statuette of a Woman Holding a Child
in Her Arms*

H. 23 cm
Painted wood
6th-8th century
Coptic Egypt
Athens, P. and A. Kanellopoulos Museum,
Inv. no. 2538

This statuette is carved in the round on a single piece of timber which is cut across its width. It represents the figure of a woman standing on a base and holding an infant with both hands on the left side of her breast. The baby's position, seated in the woman's arms, its legs dangling freely, is due to the naturalistic picture of the mother holding her child; but in this particular work it is rendered very schematically. The two-figure group has been carved in a series of sawing cuts by a chisel or knife, forming rough-hewn sides. The faces are rendered by two curved planes cut on the axis of the nose, and are framed by hair falling in a regular fringe in front. The legs are hidden in a heavy garment of six curved planes which seems to be tied with a belt (?). Part of the statuette's painted decoration is preserved, something that is very rare. The hair is black, the flesh, where exposed, is perhaps white, and on it the eyebrows, eyes, nose, and mouth are drawn in lines of black. The mother wears a chiton decorated with red ochre piping in front, on the back, and at the neck. There are traces of white on the back, probably indicating that the chiton was originally all white, with decorative geometric or vegetal (?) motifs. This type of dress, made of a single piece of cloth side-sewn, appeared in the Roman period, throughout the Empire, and remained in use in the Byzantine Age and for part of the Islamic period. The infant wears a garment decorated with straight lines and chevrons and with black and ochre dots. The fashion for *opus plumatile* (featherwork embroidery) garments came from the Orient. In Egypt, from the New Kingdom onwards, there were expensive woven and embroidered fabrics with a mixture of Oriental and Egyptian motifs. Chiefly from the Roman period onwards, a chiton or himation would be embroidered with woven patterns in shimmering colours. The weavers vied with one another in imaginative design, coupling pictorial motifs — from pagan myth or Christian art — and vegetal or geometric motifs.

The schema of the mother with the child in her arms cannot fail to recall the Virgin Mary with the infant Christ. Yet the depiction of motherhood is age-old and is a commonplace of many ancient religions. In Egypt, the most popular example was that of the goddess Isis suckling the infant Horus lying in her arms. This detail of giving the breast was rare in other civilizations, but had already reappeared in Egypt by the sixth century, in Coptic wall-paintings of the Virgin Galaktotrophousa. It was a subject that was to become familiar in the West and in Byzantium from the twelfth century onwards. This particular human scene, proof positive of the perfect human nature of the Holy Child, and hence of the Incarnation of the Word, evinced the truth of the doctrine of the Incarnation through the Virgin Mary, the Mother of God, a doctrine that was supported by St Cyril at the Ecumenical Council of Ephesus in 431.

In all likelihood, however, the present statuette does not depict the Virgin Mary. Gayet's excavations at Antinoe and Ranke's excavations at Karara turned up similar objects in the graves of children. Some of them, obviously from the graves of boys, depict small horses and their riders. From a number of undamaged examples it can be seen that wheels were attached to the baseboard so that they could be pulled along on a string, much like today's toys (Rutschowscaya 1986, no. 290). The carpentry is exactly the same as in the present statuette and the traces of painted decoration are very similar. Moreover, many of the examples are of female figures not carrying a child but simply with their arms crossed in front of the abdomen; and this excludes their identification with the Virgin Mary.

Marie-Hélène Rutschowscaya

Literature:
Brouskari 1985, 138, fig. on 143.

 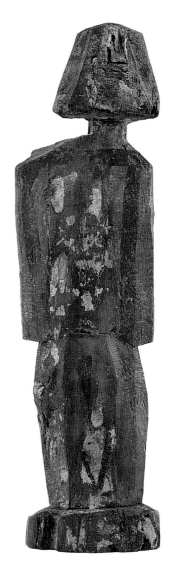

8

Textile Band with Christological Scenes

8.5 × 26 cm; 9.6 × 27.5 cm
Red, blue, and green wool; bleached silk;
undyed linen; warp-faced compound twill
6th century
Eastern Mediterranean
New York, The Metropolitan Museum
of Art, Inv. no. 90.5.11 a-c
(Gift of George F. Baker, 1890)

This band, the original function of which is unknown, is recomposed from five fragments woven on a draw-loom. It depicts four episodes from the early life of Christ in a horizontal strip against a background of plants. The first preserved scene is the Annunciation to the Virgin, with the Angel Gabriel approaching from the right, and the Virgin sitting on the left. In her left hand the Virgin holds up a long skein of wool which she has drawn from the wool basket in front of her footstool. Her throne has a high rounded back; the intermittent hatching in red wool on the sides and back of the throne was probably intended to indicate wickerwork, as the Virgin sits in a wicker throne in other Early Byzantine representations of this scene (e.g., the cathedra of Maximian, Volbach 1976, fig. 74). The next scene depicts the Nativity. The Virgin reclines on her left elbow on a four-legged couch with a curved headpiece. This type of bed is unusual in scenes of the Nativity of Christ, although it had appeared in portrayals of the births of pagan heroes such as Achilles (Hermann 1967, pl. 5a; Kötzsche 1993, 190-191). In front of the couch the nimbed Christ-Child is shown in his bath. He appears frontally from the waist upwards, with his arms stretched out on either side of his body. The Child appears again on another fragment of the band, lying swaddled in a masonry-built crib overlooked by the heads of the ox and the ass. Between the heads of the two beasts appears the star, above the body of Christ. The scene to the left of the manger has lost its central section, as the band is broken at this point. Visible on the right is half of a shepherd, standing beside a tree below which one of his flock reclines. On the left is a better preserved shepherd, who is identified by the crook with a scrolled top that he cradles in his left arm. With his right hand this shepherd gestures towards the next scene, the Adoration of the Magi. Here we see the Virgin on the right, holding the nimbed Child on her lap. As in the Annunciation, she sits in a wicker throne with a high arched back. Immediately to the left of Christ's head is the star. The Three Magi approach in a line from the left, bowing slightly, and bearing their gifts. They wear trousers, cloaks, and Phrygian caps.

Like all Early Byzantine textiles, this band is hard to date. It has been assigned to the fifth or the sixth century (Dimand 1925, 57; Weibel 1952, 83; Hermann 1967, 64; Stauffer et al. 1995, 38, no. 26). In the medium of textiles, the closest parallel is a fragment of draw-loom silk which was found in Egypt and is now in the collection of the Abegg-Stiftung near Bern (Kötzsche 1993). This fragment, which appears to date from the late fourth or the early fifth century, was woven with scenes from the early life of the Virgin and of Christ, including the Annunciation at the Well, the crib flanked by the ox and the ass, and the Child's first bath. In the silk weaving these scenes follow each other in a strip, so that there is a certain similarity with the band in the Metropolitan Museum. On the other hand, the details of the iconography differ, an indication that the silk is considerably earlier. For example, in the scene of the Child's first bath, on the silk, the baby is not shown with his lower body enclosed by a basin, as would be the case in later Byzantine iconography, but rather he appears like a new-born pagan hero in the company of a personified spring (Hermann 1967, 75, pl. 5a; Kötzsche 1993, 190).

The closest iconographic parallels for the images on the band in the Metropolitan Museum are to be found in ivories and metalwork. For example, an ivory plaque of the Nativity made for Archbishop Maximian of Ravenna between 546 and 553 also shows the Child lying in a high masonry crib with the rosette-shaped star placed directly above it, so that the astral body is framed by the heads of the ox and the ass (Volbach 1976, 93-94, no. 140, pl. 73). Half of the surviving length of the band is taken up by the two scenes of the shepherds in the fields and the Adoration of the Magi, which were arranged symmetrically to right and left of the enthroned Virgin and Child. This composition, of the enthroned Virgin and Child flanked on the left by the three Magi and on the right by the shepherds, has a parallel in the late sixth- or early seventh-century pilgrim flasks from the Holy Land, now preserved in Monza (Grabar 1958, 16-20, pls 2, 4, 8). On the flasks, as on the textile, the shepherd who stands closest to the Virgin on the right raises his right hand in acclamation, while he holds his staff in his left hand. Such comparisons argue that the band in the Metropolitan Museum of Art should be dated to the sixth century, a period when jewellery decorated with Gospel scenes became increasingly popular among the Byzantines.

Eunice Dauterman Maguire and Henry Maguire

Exhibitions:
Textiles of Late Antiquity, The Metropolitan Museum of Art, New York 1995.

Literature:
Dimand 1925, 57, fig. 5; Peirce and Tyler, II, 1934, 88, pl. 58; Weibel 1952, 83-84, no. 25; Hermann 1967, 64; Kötzsche 1993, 190-191; *Textiles of Late Antiquity*, 13, 38, 45, no. 26.

9

Textile Band with the Nativity

18.5 × 7.3 cm
Needlework, silk thread on linen
6th-8th century
Coptic Egypt
Fouquet Collection; thence De Grüneisen
Collection
Purchased at auction by R. Dimitriou (1930)
Paris, Musée du Louvre, Département des
Antiquités égyptiennes, Inv. no. E 13945

This cloth is a fragmentary strip from what looks like the ornamental part of a garment (a church vestment [?]) with circular sew-on appliqués like those in the Victoria and Albert Museum (Kendrick 1922, 777-780). Because of two major gaps in the upper register, some elements have disappeared but it is not hard to reconstruct the scene depicted. Two wide borders have a decoration consisting of heart-shaped motifs alternating with rosette motifs set in dark roundels. The motifs are linked to one another by a small plant stem or by two leaves unfolding. The central scene shows Mary lying on a braided palliasse. She has a halo and is raising her arm. To the right is Joseph, seated. He too has a halo and is raising his arm. Facing the Virgin stands a woman pointing at the makeshift bed. This must be the midwife Salome. According to the *Protevangelium of James*, Salome doubted Mary's virginity and so saw her hand wither: it only became well when she believed and took the Christ-Child in her arms. The Child is shown further up, in a manger obviously of stone construction. There are the two traditional animals round him. The veneration by the ox and ass is mentioned in the Apocryphal *Gospel of Pseudo-Matthew*: here the ass, left, is recognizable by its neck and muzzle, and the ox, right, has two dark horns between the ears. Above are two facing angels, placed symmetrically: because of the gap we cannot reconstruct whether this is a pose of worship and whether or not they are holding an object of some sort. If they are (which seems the more probable), it may have been a medallion within which was the star shedding its divine light, as in so many Early Christian ivories from Mediterranean lands and on the Monza pilgrim flasks. The angels will have been connected with the scene in the upper register: we can indeed make out most of the body of a large animal, a sheep perhaps. What was portrayed in this section may therefore have been the incident of the Annunciation to the Shepherds and their coming to the manger. In the lower register there are traces of two heads with haloes, one

very close to the other, so that we can assign this to the scene of the Visitation. The compositional pattern and poses of the figures are proof that the work was strongly influenced by Byzantine artefacts. Some scholars are of the opinion that silk-thread embroideries, a homogeneous group, were introduced into Egypt from Byzantium. However, their technique is often very close to Coptic linen and wool fabrics, and there is nothing to say that Byzantine silks may not have been imitated in Egypt.

There are two other wooden reliefs with these same features. One is a small panel affixed to the sanctuary door in the church of St Sergius in Cairo. Here details of clothing and the floral frame, which can be traced to the Samarra style, date the affix to the ninth or the tenth century. Below, the manger is framed by the Adoration of the Shepherds; the Virgin at rest, pointing to the Holy Infant; Joseph asleep; and the ox and the ass. It is decorated with wainscoting filled with fleurs-de-lis, anthemia, and crosses. On the top part two angels have been set on either side of a medallion within which planets and stars flood the Infant with abundant heavenly light. The second relief, also from Cairo, is of a later date (London, British Museum, 13th century), and is a panel from the Sitt Miriam church. Apart from the subjects mentioned above, there are secondary incidents with a large number of human figures seemingly moving around the Virgin and Child group: the bathing, the Three Magi, the shepherds, and a host of angels form a link between the star of Bethlehem and the Nativity scene.

The influence of Byzantine art of the Palaiologan era (13th and 14th centuries) is marked by the throng of figures and their distinctive intense movement. To approximately the same date (late 13th or early 14th century) can be assigned the Nativity scene discovered in 1983 in a chapel of the Al-Moallaqa church in Cairo (Urbaniak-Walczak 1993). The Virgin is resting next to the Christ-Child. The manger is decorated with arcatures, and has hollow niches in which there are pieces of white cloth. The latter must be the Lord's swaddling-bands: we meet them again, laid out in the same way, in a Byzantine ivory in the Dumbarton Oaks Collection at Washington D.C., and in a tenth-century wall-painting in the church of Abdallah Nirqi in Nubia. The manger thus becomes both the eucharistic altar and Christ's tomb, already foreshadowing the Child's destiny at his Nativity. Next to Christ is the Prophet Isaiah, foretelling the birth of a Saviour (Isaiah

7:14), whose first miracle will be the incident involving Salome, also shown here. Next to Joseph are the shepherds, who point to the star as they come forward: they have almost completely disappeared. Narrative representations of the Nativity with a large number of figures also appear in religious painting in a number of the larger monasteries in Egypt. Today these have, unhappily, largely flaked away in many cases, for instance at the Al-Baramus monastery and the St Makarios monastery in Wadi Natrun. The Syron monastery, however, has preserved an impressive Nativity, close to its Annunciation, with pure Byzantine iconography. The Paris manuscripts Copt. 13 (dated 1179-1180) and Copt.1 (dated 1249-1250) each have a Nativity miniature with striking freedom of draughtsmanship and vivacity in the figures' movement.

There is a large number of examples, on the other hand, where there is a simplified portrayal of the Nativity. On a small fifth- or sixth-century icon painted on wood (Moscow, Pushkin Museum) the Nativity is placed above the Baptism. Joseph and the Virgin are placed side by side, he sitting and she lying down. Above them is the Christ-Child in the manger; and further up is the ox, or all of it that is visible. On a sixth-century stamped linen cloth in the Victoria and Albert Museum, Mary is accompanied by an angel, who is reproducing the same gesture of greeting as in the Annunciation. But the Virgin's position here, lying on a palliasse, and the presence of the manger, barely visible among the gaps, leave us in little doubt about how the scene should be interpreted.

Braiding and medallions, probably of the Arabo-Coptic period, surround the wholly essential elements of the representation—the Virgin Mary, the Christ-Child, the ox and the ass, and (sometimes) Joseph. The technique is entirely schematized and geometric, so that it is often hard to recognize what scene this is (del Francia 1976). This makes it difficult to identify the highly schematic representation of the Nativity on bronze censers: the reclining Virgin and Joseph are placed symmetrically on either side of the manger, with the ox and the ass above them. There is a quite idiosyncratic painting of the Nativity in Chapel 51 of the Bawit monastery in central Egypt: the cycle comprising the Annunciation, the Visitation, and the departure of the Virgin Mary from Elizabeth's house is immediately followed by a portrayal of Mary lying down, with Salome next to her. This cannot be a Nativity, for the Christ-Child is not

shown. Obviously the painter wanted to make an emphatic pictorial statement about the doctrines of Mary's virginity and the birth of God. So these two figures were detached from the Nativity, possibly to empty the scene of any narrative character and to lay pictorial emphasis on the foundation of this incident in doctrine.

In the Coptic Church the feast of the Nativity is celebrated on the twenty-ninth day of the month Kyhak in the Coptic calendar (7 January). The feast is preceded by forty days of fasting, for, according to the apocryphal gospels, the Virgin Mary fasted for forty days after Joseph's rebuke, since he did not know that she was with child. In ancient Egypt the Mysteries of Osiris were celebrated in this same month, a month dedicated to the begetting of children and to life-giving energy. Little clay statues of Osiris were made and the Egyptians grew corn seeds on them, to symbolize the god's passage from death to life. This is a tradition that may well have continued into our own time, in the custom of cultivating seeds on wet cotton. During the vigils of the Coptic Church, the 'Lauds of Kyhak' are chanted in honour of the Virgin Mary as she awaits the birth of the Holy Infant. The feast of the Nativity was probably adopted in Egypt by St Athanasios, Bishop of Alexandria, in around 346. According to Coptic tradition, Christ was born at Ehnis (Herakleopolis Magna), the ancient pharaonic city of Khenen-nesut, the city of the 'child-king'.

Marie-Hélène Rutschowscaya

Conservation:
Patricia dal Prà, 1985.

Exhibitions:
La Seta e la sua via, Rome, Palazzo delle Esposizioni, Università degli Studi di Roma 'La Sapienza', 1994.

Literature:
La Seta e la sua via, no. 57; de Grüneisen 1930, 70, no. 385, pl. XIX; Duthuit 1930, 77-79; du Bourget 1964, E 67; del Francia 1976, 223, pl. XVI; Rutschowscaya 1990, 129, 233.

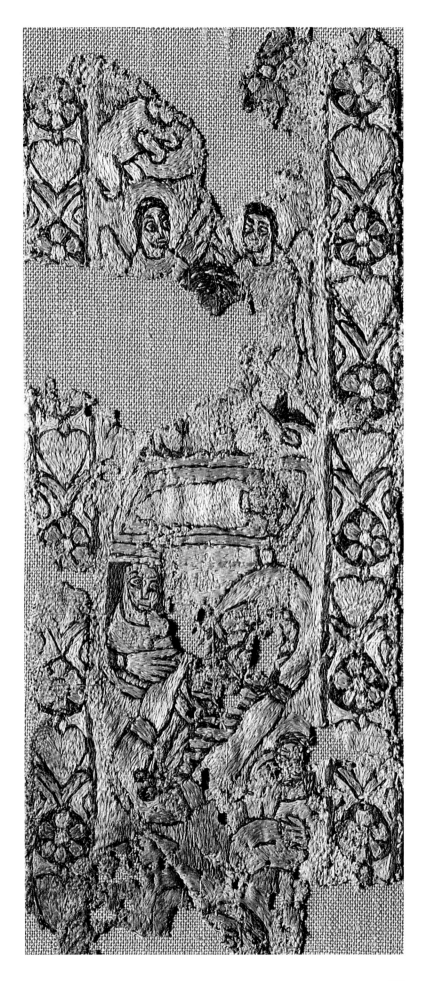

Section Two

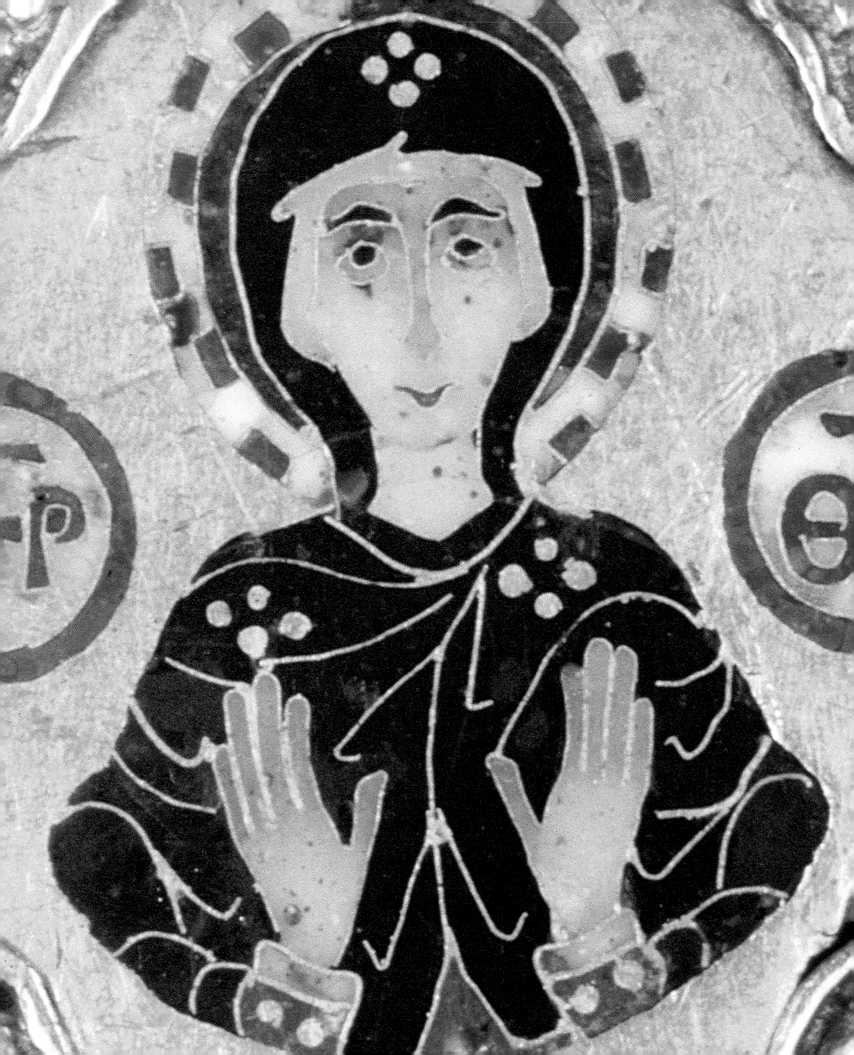

The Cult of the Mother of God in Private

It is difficult to distinguish between a 'private' as opposed to a 'public' cult of the Virgin as reflected in the material culture of Byzantium, because objects could move from one sphere to the other. For example, many people of the Early Byzantine period decorated their tunics with images of the Virgin or of scenes from her life. When worn at home, such garments belonged to the 'private' sphere, but when worn outside the house they became a part of the public arena. In a famous mid-sixth-century mosaic in the church of San Vitale in Ravenna, the Empress Theodora (Pl. 164) is shown making an offering of a golden chalice to the church, while on the hem of her purple robe the Three Magi are depicted making their offerings on the occasion of the Nativity of Christ.[1] This garment of an empress, with its public assimilation of the ruler's generosity to that of the Magi, is anything but private, yet there also survive much humbler tunics decorated with scenes of the Adoration of the Magi which were made to ensure the safety and well-being of ordinary people both at home and abroad.

In the following essay I shall not attempt to distinguish between objects that belong to the 'public' or the 'private' sphere on the basis of where they were used, but rather on the basis of their type. My focus will be on objects such as clothing, jewellery, crosses, amulets, or reliquaries that were made to be worn on the person. Although such items of attire had a public dimension, they were private at least in the sense that their imagery was usually selected by the individuals who wore them. In many cases this imagery had an additional private character, in that it was cryptic in nature, or else literally hidden inside the clothing, as in the case of enkolpia which were worn around the neck. I shall consider in this survey objects dating from the late fourth to the twelfth century. Over this period, the imagery of the Virgin in domestic attire changed in ways that reflected the changing nature of her cult. This change can be summarized as a shift from a more impersonal to a more personal view of the Virgin. In the earlier period, up until the seventh century, there was a greater emphasis on the events of the Virgin's life. In the later centuries the emphasis was on her role as an intercessor, on her personal relationship both with the wearer and with Christ, her son.

In the Early Byzantine period, images portraying the Virgin appeared on a great variety of objects that were worn on the person, especially on medallions and reliquaries that used to be worn around the neck, on rings and bracelets, and on clothing. In a brief essay there is not enough space to list every one of the many surviving examples of each of these classes of objects, but only to describe the most significant examples.

In the collection at Dumbarton Oaks, in Washington, D.C., there is a late sixth-century gold medallion (Pl. 172) mounted so as to be worn hanging from the neck by a chain. On the front side is the Virgin enthroned frontally, between angels, and holding the Christ-Child on her lap. Below her, to the left, appear small scenes of the Nativity, including the Child in the manger, and the Adoration of the Magi on the right. In the latter scene the Virgin appears a second time holding Christ on her lap, but now seen in profile as she receives the three Magi who approach with their gifts from the right. Around the upper half of the medallion is an inscription, framing the Virgin, which reinforces the message of the images: 'Christ Our God, help us'.[2]

202. The Virgin orans, gold and cloisonné enamel necklace clasp, detail of Pl. 204.

An even more magnificent pectoral of the early seventh century was discovered in Egypt and is now in Berlin. This piece consists of two parts. The upper part incorporates fourteen gold coins on either side of a large imitation medallion depicting the bust of an emperor turned to the right. The emperor is framed by an inscription reading: 'Lord, protect her who wears [this piece]'. In this period, coins and imitation coins were believed to have a protective, prophylactic value. The lower part of the pectoral consists of a large framed gold medallion depicting the Annunciation.[3]

The Annunciation also appears on the front faces of a pair of identical fifth- or sixth-century gold medallions now in the Archaeological Museum in Istanbul, which were provided with loops at their tops so that they could be worn as pendants. Here the Annunciation opened a sequence of six miniaturized scenes from the Nativity of Christ, shown in three separate registers on the front faces of the medallions. In the top register, the Annunciation is followed by the Visitation, in which the pregnant Virgin and her kinswoman Elizabeth are seen coming together in an embrace. In the second register we see the Nativity on the left, represented simply by the Child in his crib, over-looked by the heads of the ox and the ass. Then follows the Flight into Egypt, which is arranged so that the image of Mary, seated frontally on the ass with the Christ-Child on her lap, appears in the centre of the medallion. Finally, the bottom register shows the shepherds in the fields and the Adoration of the Magi.[4] The central emphasis given to the image of the Virgin and Child riding on the donkey may be explained by its assimilation to the common motif of the 'Holy Rider', which had a prophylactic significance.[5]

On some gold medallions the Adoration of the Magi was portrayed on its own, as can be seen on a pseudo-medallion found at Siderno, in Calabria, now in the Museo Nazionale di Reggio Calabria.[6] The same subject appears on bronze fibulae of the sixth or seventh century that were imported into Western Europe from the Holy Land; on some of these fibulae the scene is accompanied by the invocation: 'Lord help [the wearer]'.[7]

People of the Early Byzantine period wore lockets, or small reliquaries, around their necks, displaying scenes from the life of the Virgin. A gold locket of the seventh century, in the British Museum, is engraved on its front with nielloed images of the Nativity and the Adoration of the Magi, while on the back is the prophylactic inscription: 'The secure deliverance and deflection of all the evils'. Around the edge of the locket's lid is written: 'of Sts Cosmas and Damian'. Since these particular saints were doctors, the evils referred to in the inscription may well have been related to ill-health. The locket may have contained some of the blessed wax that was distributed at their shrine.[8] A medical function for the locket is also suggested by its octagonal shape, for rings of octagonal hoops were specifically recommended as a cure for colic in a therapeutic handbook written by Alexander of Tralles, a sixth-century physician.[9]

Rings in the sixth and seventh centuries were frequently decorated with scenes from the life of the Virgin, or, more rarely, with her portrait image. The most elaborate are the three octagonal gold marriage rings which were produced in Constantinople in the seventh century,[10] and which are now preserved in collections in London, Palermo, and Washington, D.C. On the bezels of the rings in London and Washington (Pl. 181) are engraved and nielloed images of Christ and the Virgin standing back to back and raising their right hands in order to bless, or to crown, the groom and the bride who stand before them. On the ring in Palermo only Christ is shown blessing the couple. On each of the seven remaining facets of the hoop a different scene from the life of Christ is engraved, beginning in each of the rings with the Annunciation, the Visitation, and the Nativity. These images are accompanied by inscriptions. On the ring in Palermo we read: 'Thou hast crowned us with a shield of favour', a quotation from Psalm 5, verse 12.[11] On the ring in Washington we find around the edge of the bezel: 'Lord help thy servants Peter and Theodote', and under the figures of the bride and groom the word 'Harmony'.[12] The same word appears under the figures on the ring in London.[13] These rings, small though they are, carry a considerable weight of meaning. In the first place they express, most obviously, the blessing of Christ and the Virgin on the marriage. In addition, they may refer to the mystical marriage of Christ and the Virgin, which was a guarantee of

the continuing beneficent presence of Christ among mortals. The seventh-century writer George of Pisidia expressed this idea as follows in one of his poems:

> And how did the bridechamber of the unwed Virgin
> come to earth ...?
> She is by all means mystically near the bridegroom;
> always through her he is close to those below.[14]

Another desire projected by the rings is the wish for the harmony of the marriage itself, the ideal evoked by the inscriptions on the bezels. The Byzantines in this period believed that marital disputes could be caused by demons (even the names of these malevolent spirits were known; they were given in the popular magical treatise, *The Testament of Solomon*).[15] Finally, the rings probably had a medical function, assured by the octagonal shape of their hoops.[16]

Some of the scenes that encircled the hoops of the marriage rings also appeared individually on the bezels of other rings in gold and bronze. For example, the British Museum possesses a seventh-century gold ring that has an engraved and nielloed scene of the Annunciation on its bezel. Around the hoop, which is octagonal, are inscribed the words of the archangel's salutation to Mary (Luke 1:28): 'Hail, full of grace, the Lord is with thee'.[17] A similar ring in Paris has the Annunciation on the bezel and an octagonal hoop, but here the inscription reads: 'Mother of God, help your servant Giora'.[18] In the Benaki Museum, Athens there is a gold ring engraved and nielloed with the Annunciation on the bezel and with busts of saints on the hoop.

In addition to rings bearing Gospel scenes such as the Annunciation, a few specimens survive with images of the Virgin holding the Child. For example, a gold ring at Dumbarton Oaks in Washington D.C., which was probably made in Constantinople towards the end of the sixth century, is engraved on its bezel with the Virgin standing between two crosses and holding her child on her left arm.[19]

Related to the rings is a group of silver and bronze armbands which date from the mid-sixth to the mid-seventh century. To judge from the invocations that appear on them, these armbands were worn by women. It is also possible that they were worn in pairs, one on each arm, since among the nineteen surviving complete examples there are two sets of twin armbands with identical imagery. The Marian images that appear engraved on these armbands include the Virgin enthroned frontally with the Christ-Child on her lap, the Annunciation, the Nativity, and the Adoration of the Magi. On many of the bands the Christian subjects are interspersed with others of a more magical nature, such as the Holy Rider, the Chnoubis (a lion-headed snake with seven rays), ring signs, and the Evil Eye. The amuletic and protective character of the armbands is also made explicit by their inscriptions, such as 'Mother of God, help Anna!' or 'One God (who) preserves, guard (your) servant Severinam'. Eighteen of the surviving armbands preserve quotations from the first verse of Psalm 90: 'He that dwells in the help of the highest, shall sojourn under the shelter of the God of heaven'. This verse was frequently used as a protective charm in the Early Byzantine period. On one of the armbands, now preserved in Toronto, the word 'Health' is inscribed, indicating that the desired protection in this case was medical.[20]

As well as these armbands engraved both with Christian subjects and with magical or semi-magical signs, the Byzantines wore bracelets bearing Christian imagery. A handsome example is a gold bracelet in the British Museum (Cat. no. 11), which displays a bust of the Virgin embossed in relief upon its central medallion; the Mother of God is shown frontally in the orant pose, raising her two hands on either side of her head in order to pray on behalf of the wearer of the piece. The hoop of the bracelet has an openwork design of plant scrolls growing from a vase and containing land and water birds — motifs that were not only decorative, but also evocative of well-being and prosperity.[21]

As can be seen in the mosaic of the Empress Theodora in the church of San Vitale, the Byzan-

203. *Gold and cloisonné enamel necklace clasp, with Christ on the obverse.* Byzantine Collection, Dumbarton Oaks, Washington.

tines of the early centuries not only wore images of the Virgin and of her life in the form of jewellery, but also as designs incorporated into their clothing. Our earliest surviving evidence for this custom is a fragment of draw-loom silk weaving, dating to the late fourth or the early fifth century, which was found in a grave in Egypt and is now in the collection of the Abegg Stiftung near Bern (Pl. 168). This silk was woven with repeated strips containing superimposed identical images of the early life of the Virgin. Reading from the left to the right of each strip, we find: her Presentation to the Priest in the Temple, the selection of Joseph as her betrothed, the Annunciation at the Well; the crib of the Christ-Child flanked by the ox and the ass; and the Child's first bath.[22] Although it is not certain, it is likely that this silk was originally part of a garment, since a contemporary bishop, Asterios of Amaseia in northern Turkey, complains of rich people wearing clothing densely woven with scenes from the Gospels, so that: 'when they come out in public dressed in this fashion, they appear like painted walls to those they meet'.[23]

A less expensive version of the silk in the Abegg Stiftung Collection survives in the Metropolitan Museum of Art New York (Cat. no. 8). This narrow band is woven in linen and dyed wool, with some threads of white silk, and has been dated to the fifth or sixth century. Its imagery is similar to the Abegg Stiftung silk, except that here the scenes proceed in chronological order from right to left: the Annunciation to the Virgin; the Nativity, with the Virgin reclining on a bed, the Child in his first bath, and the Child lying in the crib between the ox and the ass; and, finally, the Adoration of the Magi.[24]

A relatively large number of tapestry-weavings of Christian subjects survive from tunics produced for wear between the sixth and eighth centuries.[25] These examples, like the fragments in the Abegg Stiftung and the Metropolitan Museum, were all found in Egypt, where the dry climate favoured their preservation. However, the custom of wearing clothing woven with Christian imagery was certainly not confined to Egypt, as is witnessed by the complaints of Asterios of Amaseia and by the mosaic of the Empress Theodora in Italy. A relatively well-preserved tunic of the seventh century is kept in the Field Museum in Chicago. Like many other linen tunics of the Early Byzantine period, it is decorated with in-woven bands and small roundels containing figured subjects. The surviving bands encircled the sleeves of the garment and descended vertically in two 'clavus' strips on the front from either side of the neck. The roundels were proba-

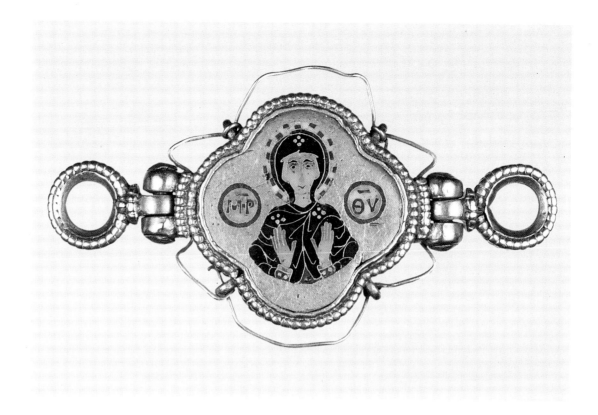

204. *Gold and cloisonné enamel necklace clasp, with the Virgin on the reverse.* Byzantine Collection, Dumbarton Oaks, Washington.

bly placed one on each shoulder and two on the front and two on the back of the lower part of the tunic, so that the four lower roundels were approximately level with the knees.[26] This arrangement of the roundels, which was common on Early Byzantine tunics, provided four points of protection on the front and the back of the body, two at the shoulders and two at the knees. The disposition of the roundels may be compared to formulas contained in contemporary magical papyri preserved in Egypt, such as this example of an invocation to the angels to protect a woman during her pregnancies: 'I adjure you by your names and your powers and the powers of God almighty to dwell here comfortably. Watch and protect the four sides of the body and the soul and the spirit of Sara daughter of Pelca and her child, her and the child with whom she is pregnant … so they live yearly without disease'.[27]

The scenes in the roundels of the tunic in the Field Museum are difficult to read, as is often the case with tapestry-weaves from the Early Byzantine period. It appears, however, that at least three of the roundels depicted the Nativity, with the infant Christ shown at the centre distinguished by a cruciform halo and wrapped in swaddling clothes. He is flanked by two figures who may represent the Virgin and Joseph. The subjects portrayed on the 'clavus' strips and sleeve bands of this tunic are more distinct. At the top of one of the 'clavus' strips there is a scene of the Visitation, with Mary and Elizabeth embracing each other, while the Nativity appears again at the centre of the same strip. Here the weaver showed the Nativity in an abbreviated form, depicting just the baby in the crib flanked by the heads of the ox and the ass—the same form in which the Nativity appears on the gold medallions in Istanbul. The Adoration of the Magi was portrayed twice on each of the sleeve bands, in an abbreviated form; we see only one Magus approaching the Virgin, who sits with her body in profile holding on her lap the Christ-Child, once again identified by a cruciform halo.[28]

Two features of the decoration of this tunic are especially noteworthy. First, many of the Gospel scenes were repeated—at least four times in the case of the Nativity and the Adoration of the Magi. Secondly, the scenes are abbreviated to the point of becoming ciphers. Clearly their function was not to tell the Gospel story, nor to serve as the focus of veneration. Rather, they functioned as amulets, repeated for maximum effect.

The subjects from the life of the Virgin that appear on the tunic in Chicago also appeared on

other seventh-century tunics, but in most cases only the individual roundels from these tunics are preserved. There are several surviving tapestry-weave roundels depicting the Visitation, the Nativity, and the Adoration of the Magi.[29] In some cases we know that almost identical medallions portraying the same subject were repeated several times on one garment, as in the case of a tunic in the British Museum, on which the Adoration of the Magi is repeated six times in the large roundels, and again in abbreviated form on the 'clavus' strips.[30] A band of silk embroidery on linen, which depicts the Nativity in a vertical format, is preserved in the Musée du Louvre, Paris (Cat. no. 9). It may have decorated a tunic, and is noteworthy for its clear illustration of the apocryphal story of the midwife, Salome, whose hand withered when she disbelieved the Miracle of the Virgin birth. On the textile, she stands to the left of the Virgin's bed, holding out her hand, which the artist emphasized by making it unnaturally large.[31]

In the imagery that we have reviewed, both on jewellery and on clothing, we have seen that during the Early Byzantine period the Virgin was invoked much more frequently through episodes from the Gospels than through her portraits. Four subjects, in particular, were especially popular, the Annunciation, the Visitation, the Nativity, and the Adoration of the Magi. A study of each of these subjects will reveal how the objects on which they were depicted worked in the spiritual world to benefit their wearers.

Many of the images of the Annunciation that appear on jewellery are accompanied by inscriptions giving the words of Gabriel's salutation: 'Hail, full of grace, the Lord is with thee'. These words were seen as a guarantee of the Virgin's special powers to intercede on behalf of those who sought her aid.[32] In addition, on some objects the Virgin is simply accompanied by the word *charis*, i.e. grace. For example, on a silver armband now in the Royal Ontario Museum in Toronto, the word *charis* appears under an engraving of the enthroned Virgin holding the Child. On either side of the Virgin appears the inscription: 'Mother of God, help Anna'. The opening words of Psalm 90 are also inscribed on the band.[33] This amulet was made to help a woman, but the *charis* of the Virgin could also help a man, as we learn from the following charm preserved on a fifth-century papyrus now in Berlin: 'Having received grace (*charis*) from your only-begotten Son, stop the discharge, the pains of the eyes of Phoebammon, son of Athanasios'. This formula is followed, as on the armband, by the first verse of Psalm 90.[34]

In the case of the Virgin, then, *charis* was her god-given power to come to people's aid, but the concept of the protective power of *charis* had more ancient roots. For example, it had been believed that springs and bath-houses could be defended from envy and supernatural malice by their *grace*, that is, by their beauty and charm. This sentiment was frequently expressed both in literary epigrams and in inscriptions placed in the baths themselves.[35] The Virgin, who herself was frequently associated with healing springs and with fountains, became the new source of *charis*, a gift which she received first at the Annunciation.

The Visitation appeared with some frequency in the domestic arts of early Byzantium, even though it was never adopted as an official feast by the Church.[36] It is likely that its function for the wearers of the jewellery and clothing on which it was portrayed was analogic, for Elizabeth was an exemplar of successful pregnancy as a result of prayer. The early ninth-century Life of Stephen the Younger, an iconodule saint, records how his mother, who was childless, 'considered the similar cases of Sarah, of Anna, and of Elizabeth', and prayed to an image of the Virgin for a child.[37] In later Greek magical charms in aid of childbirth, we find a similar appeal to the pregnancy of Elizabeth. For example, in a spell contained in a fifteenth-century manuscript now in Naples, we find Christ instructing the angels to say into the woman's right ear: 'Give birth, woman, as Mary gave birth to Christ, as Elizabeth gave birth to the Forerunner'.[38]

As this charm suggests, the principle of analogy may also have been a factor in the popularity of the Nativity as a motif on the jewellery and clothing worn by women. However, a papyrus amulet of the seventh or eighth century shows that the image of Christ in his crib could also embody his power to heal in general. The charm begins with an evocation of Christ's healing miracles, then

concludes with the following appeal: 'Holy and strong is He whom the chorus of bodiless angels doth glorify; holy, immortal is He who was made known in the crib of the dumb [beasts]. Have mercy on us'.[39]

The fourth of the Gospel scenes depicting the Virgin that appears with some frequency on early Byzantine jewellery and clothing is the Adoration of the Magi. The popularity of the Magi must in part have been due to their role as archetypal travellers,[40] but in addition they were exemplars of gift-givers, who in return received favour from God. The frankincense that the Magi offered to Christ was associated with prayer. John Chrysostom wrote: '[The Magi] offer gifts, gifts, that is, not as to a man, but as to God. For the frankincense and myrrh were a symbol of this... they approached [him] not as a mere man, but as God and benefactor'.[41]

In conclusion, the images of the Virgin that appeared on the clothes and jewellery of the Byzantines in the period before Iconoclasm, up to the early eighth century, were primarily evocations of her role in the birth and infancy of Christ; the schematic narratives acted as exemplars or reminders of divine intervention in human affairs. While portrait images of the Virgin did occur, they were less favoured than the Gospel episodes. The first evidence for the appearance of scenes from the life of the Virgin on clothing is as early as the late fourth century, but she was much more frequently portrayed on Byzantine costume in the sixth and seventh centuries, in common with other Christian subjects.

In the period after the onset of Iconoclasm, in the eighth century, we encounter significant changes in depictions of the Virgin on domestic apparel. Most importantly, there was a shift in balance between images of the Virgin's life and her portrait images, as the latter came to predominate. Among the Gospel episodes, the Visitation and the Adoration were eliminated entirely, being no longer illustrated on items of dress,[42] leaving only the Annunciation, the Nativity, and a new scene, the Koimesis (Dormition) of the Virgin, to make an occasional appearance. It also seems that depictions of the Virgin, in common with other Christian images, no longer appeared on the clothing of the laity in Byzantium after the eighth century; henceforth, the Virgin was only depicted on jewellery or on crosses and reliquaries that were worn around the neck. It has been suggested that these pectoral crosses and reliquaries, which could be worn hidden under the clothing, were favoured during the unsettled period of eighth- and ninth-century Iconoclasm because they were more discreet. At this time the open display of Christian images in Byzantium would have been problematic, or even risky.[43] Certainly, the flaunting of repeated Christian subjects on a tunic would have been out of the question during the Iconoclastic period.

In the period of the ninth to the twelfth century images of the Virgin were incorporated most frequently into the small crosses of gold, silver or bronze that people wore around their necks. It appears that many of these crosses may have been produced in Constantinople.[44] Frequently, they took the form of hinged reliquaries, which could contain either pieces of the True Cross or else relics of saints. These relics enhanced the prophylactic powers of the images on the cross. The pectoral crosses can be divided into two basic types. In the first type, we find an image of the Virgin on the reverse, standing at the centre and surrounded by four busts of saints placed in the arms of the cross, while on the obverse is a portrayal of the crucified Christ[45] (Cat. no. 23). The second type of cross portrays a varying selection of Gospel episodes, often including the Annunciation and the Nativity.[46] These crosses with several narrative scenes are less common than the crosses of the first type, which portrayed only the standing Virgin and the Crucifixion. The prototypes of the first type of cross have been sought in a small group of bronze pectoral crosses that can be dated to the late seventh or the eighth century. On the front of these crosses the crucified Christ is shown in relief, while on the back we see the Virgin standing with her hands on the shoulders of the Christ-Child.[47]

Over the centuries, significant changes took place in the depiction of the Virgin on the pectoral crosses. Many of the earlier crosses show the Virgin standing and holding the Child in front of her body.[48] Gradually, however, another type of image became more popular, which showed the

Virgin standing frontally in the orant pose, with her two hands raised in prayer. The orant Virgin appeared already engraved on a gold pectoral cross discovered at Palermo together with a hoard of coins dated to the eighth century.[49] A luxury reliquary-cross incorporating an image of the Virgin in prayer is preserved in the British Museum. This object, the Beresford Hope Cross (Pl. 173), is manufactured of silver gilt, set with enamelled plaques portraying the crucified Christ on the front and the orant Virgin on the back. The enamelling technique places this cross in the second half of the ninth century.[50] The British Museum also preserves a later gold and enamel reliquary cross (Cat. no. 16), of the early eleventh century, that shows on its back the Virgin standing with her hands raised before her chest in prayer (the front panel is missing).[51] These luxury crosses were imitated by cheaper versions (Cat. nos 23, 25-26) in bronze, which were manufactured in quantity after the late ninth century.[52]

Like the crosses portraying the Crucifixion and the standing Virgin, the historiated reliquary crosses which displayed several Gospel scenes were produced in a variety of materials, from gold to bronze. The Gospel episodes portrayed on the fronts and backs of these crosses included the Annunciation, the Nativity, the Presentation, the Baptism, the Transfiguration, the Anastasis (Resurrection), and the Ascension. In their presentation of a selection of Gospel episodes, these crosses resembled the rings and armbands of the pre-Iconoclastic period, except that the sequence of scenes was no longer circular, but presented in a cross-shaped arrangement. In addition, the magical motifs such as the ring signs and the Evil Eyes that had marked some of the pre-Iconoclastic jewellery were rigorously excluded from the crosses, so that their content became completely Orthodox.[53]

In addition to the cross-shaped containers, the Byzantines after Iconoclasm wore pectoral reliquaries of other shapes, such as an exquisite four-lobed container now in the Virginia Museum of Fine Arts (Pls 174 and 175). This reliquary, which measures just 4×3.1 cm, has enamelled images of Christ standing and blessing on its obverse, and of the Virgin on its reverse, standing in an attitude of prayer with her hands held up, palms outward, in front of her breast. This piece is dated to the late tenth or early eleventh century.[54]

On some later pectoral reliquaries we find a different portrayal of the Virgin, in which she does not stand in a frontal pose of prayer, but instead is seen in three-quarter view raising her hands toward a miniature image of Christ, or of the hand of God, that appears in the upper corner of the frame. A beautiful rectangular pectoral reliquary of this type, probably dating to the last quarter of the eleventh century, is preserved in the treasury of the church of St Mary at Maastricht. Here the brilliantly enamelled image of the praying Virgin (Pl. 118) on the front is framed by a now mutilated inscription that begs the 'radiant one' to intercede for the owner, one Irene Synadene, so that she will not be condemned for her sins. The reverse of the reliquary depicts the Annunciation in relief on a silver-gilt plaque.[55]

Often related in their imagery were the simple pendants that were designed to be worn around the neck, but did not contain relics. A fine example from the late eleventh or early twelfth century is a small double-faced enamelled pendant now preserved in the Metropolitan Museum of Art. On the front is a bust of Christ, who raises his right hand in a gesture of speech and benediction and turns his eyes to one side, as if to acknowledge the Virgin who is portrayed on the back of the pendant (Pl. 119), turning toward her son with her hands raised in prayer.[56] Such miniature pectoral icons were produced in a variety of shapes and materials. A fine lapis lazuli cameo of the first half of the twelfth century, now in the Musée du Louvre (Pls 176 and 177), is set in an arched frame that was provided with a suspension loop at the top, presumably so that it could be worn on the body. Like the enamelled pectoral pendants, it depicts Christ on the front face and the Virgin on the back, in this case standing frontally and holding her hands up in the orant pose.[57]

The same juxtaposition, of Christ and the Virgin, was portrayed on the clasps of necklaces during the post-Iconoclastic period. A gold and cloisonné enamel clasp in the Dumbarton Oaks Collection (Pls 203 and 204) displays the busts of Christ on the front, making a gesture of speech and holding a book, and of the Virgin on the back (Pl. 202), with her hands raised in prayer before her

chest.[58] A less expensive necklace clasp with a similar juxtaposition executed in nielloed silver is also preserved in the collection at Dumbarton Oaks.[59]

In the post-Iconoclastic period the Byzantines also wore images of the Virgin on their finger-rings. Two gold rings in the Dumbarton Oaks Collection are especially interesting for their inscriptions, which identify their owners. One of these rings (Pl. 182) has an enamelled bust of the Virgin on its bezel, and on its hoop the words: 'Mother of God, help your servant Michael Attaleiates'. Michael Attaleiates is known as a historian and a high Byzantine official who died around 1080.[60] The second ring also bears an enamelled bust of the Virgin on the bezel, and is accompanied by an inscription invoking her aid for 'Michael, the Admiral Stryphnos' (Cat. no. 12). This individual was responsible for the Byzantine fleet under Alexios III Angelos (1195-1203), on the eve of the Fourth Crusade.[61]

Narrative scenes from the Gospels are relatively infrequent on post-Iconoclastic jewellery. Mention should be made, however, of a large group of over 200 cameos made out of glass paste which, since they have both Greek and Latin inscriptions, have been attributed both to Constantinople and to Venice. Their date range has been placed between the eleventh and the thirteenth century. A few of the cameos are mounted with hoops for hanging around the neck. Most of the specimens depict individual saints, but some of them display New Testament episodes such as the Nativity.[62] In general, however, they do not contradict the overall picture that is presented by the post-Iconoclastic pectoral crosses and jewellery, namely that images of individual saints predominate over narrative scenes, whereas in the pre-Iconoclastic period this ratio had been reversed.

This shift in emphasis, from narrative to portrait, from the event to the person, reflected a change in the cult of the saints after Iconoclasm, and in particular in that of the Virgin. In the later period, the Byzantines made direct appeals to the Virgin through her portrait icons, asking her to use her powers of intercession on their behalf. In the earlier period they wore scenes from her life as schematic types or reminders of divine intervention. For an illustration of how the Byzantines came to relate in a personal manner to portrait icons, we can return to the story of Anna, the mother of Stephen the Younger, which is contained in the saint's early ninth-century biography. We are told that the childless Anna went every day to the shrine of Blachernai, where she prayed for a son before an image of the Virgin holding the Child, begging the Virgin with streams of tears to relieve her despair.[63] A part of the personal, emotional appeal to icons was the projection of human feelings onto the image. The humanity of the Virgin, her human feelings for her son and his human feelings for her, underlay the effectiveness of her intercessions with Christ. At the same time, the Virgin's human emotions brought her closer to the supplicant, who could emphasize with the Virgin and hoped, in return, that the Virgin would emphasize with his or her own human frailties. These wishes were expressed by Byzantine epigrams, many of which were composed to be inscribed on icons. For example, in an anonymous ninth-century group of poems, we find an epigram entitled: 'On the All Holy Mother of God Praying to Christ'. The poem begins:

> While I raise a mother's hands in prayer, my son,
> since you wished that appellation [i.e. son], you do not turn away from it.
> Pity the [human] nature that you took from us.
> For you honoured me, your servant, in your birth.[64]

This poem, with its emphasis on the praying hands of the interceding Virgin, is echoed in a later epigram on the Deesis by the tenth-century writer John Geometres:

> Be moved by the hands of your mother ... O Word,
> ... the hands by which you were embraced.[65]

These poems had their counterpart in the increasing popularity of the crosses and pendants

that depicted the Virgin praying with raised hands, which in the small images were often exaggerated in size.

In the eleventh and twelfth centuries the epigrams devoted to narrative scenes from the New Testament became more overtly emotional, as they dwelt both on the suffering of the Virgin as a human mother, and on the vicarious participation of the viewer. For example, the eleventh-century writer John Mauropous followed a poem on an icon of the Crucifixion with another addressed to the weeping Virgin:

> O mistress of the passions, are even you in tears?
> What help is there for our own tears,
> if you too suffer a fate worthy of lamentation?
> What other hope is there? What comfort?.[66]

In the same sequence of poems, John Mauropous addresses the viewer of an icon of the Nativity, inviting the beholder to participate in the joy evoked by the scene:

> Let us approach that we may understand.
> Go with the shepherds,
> for over there, as you see, they are hurrying
> Join together with them, be filled with yearning
> You should accompany them in song, and not disbelieve,
> for all these things combine to bring you grace
> Be glad, therefore, with them and make obeisance with them.[67]

These, and similar poems may help to explain why the narrative scenes from the life of the Virgin became relatively less frequent on the crosses and jewellery of the Byzantines after Iconoclasm. The emotive impact of the narrative image, the maternity and suffering of the Virgin as a guarantee of her ability and willingness to help, could best be experienced in larger-scale images. The participatory mode of viewing was more suited to the contemplation of larger icons than it was to the miniaturized and often abbreviated narratives of pre-Iconoclastic clothing and jewellery, which were designed to function as amuletic exemplars of salvationary events. On the other hand, the individual images of the Virgin in prayer that still appeared on the post-Iconoclastic crosses and jewellery, small though they were, could effectively bring to mind her continuing intercessions on behalf of the wearer.

[1] Deichmann 1958, pls 358, 367.

[2] Ross 1965, 33-35, pls 28-29.

[3] Maguire 1997, 1041, fig. 4, with further references.

[4] van Dijk 1999, 425-426, fig. 9.

[5] Vikan 1984, 75, n. 57 and 82, n. 111.

[6] Maguire 1990, 221, fig. 30.

[7] Maguire 1990, 221, n. 57; Vikan 1990b, 104, fig. 24.

[8] Vikan 1984, 84.

[9] Alexander of Tralles, 8,2, Puschmann 1878-1879, II, 377.

[10] Vikan 1990a, 157-161, fig. 26; Vikan 1991, 1992, 38.

[11] Vikan 1984, 83.

[12] Ross 1965, 58-59, no. 69.

[13] *Byzantium*, no. 106.

[14] *Georgii Pisidiae carmina inedita*, Sternbach 1892, 54, no. 40.

[15] *The Testament of Solomon*, McCown 1922, 53, 55-56.

[16] Vikan 1984, 76, 83.

[17] Dalton 1901, 20, no. 121, pl. 4.

[18] *Byzance*, no. 88.

[19] Ross 1965, 138, no. 179, 'O'.

[20] Vikan 1991, 1992, 33-51, figs 1-10.

[21] *Byzantium*, no. 99.

[22] Kötzsche 1993, 183-194, fig. 1.

[23] *Homily* I, *PG* 40, 168. Trans. in Mango 1972, 50-51.

[24] *Textiles of Late Antiquity*, 38, 45, no. 26.

[25] Abdel-Malek 1980, 161-173, 224-229.

[26] Maguire 1990, 220, figs 25-26.

[27] Meyer 1999, 120-125.

[28] For the identification of these scenes I am indebted to the observations of Vasileios Marinis.

[29] Abdel-Malek 1980, 161-173, 224-229.

[30] Maguire 1990, 221, fig. 29.

[31] Rutschowscaya 1990, 128-129.

[32] van Dijk 1999, 428-429.

[33] Vikan 1991, 1992, 41, no. 22, fig. 5.

[34] Daniel and Maltomini 1990, 72-73, no. 26.

[35] Russell 1987, 39-49.

[36] *ODB*, 2180.

[37] Auzépy 1997, 92.4.

[38] Delatte 1927, 619.24-620.6. For similar instances of the formula, Daniel and Maltomini 1990, II, 235, 246-247.

[39] Preisendanz 1974, 234, no. O3.

[40] Vikan 1990b, 105.

[41] *In Matthaeum homilia* VIII, 1, *PG* 57, 82-83.

[42] Kartsonis 1986, 102-103.

[43] Kartsonis 1994, 99, n. 77, and 101-102.

[44] On bronze crosses, Pitarakis 1998b, 81-102, esp. 98.

[45] Pitarakis 1998b.

[46] Kartsonis 1994, 87-89.

[47] Pitarakis 1998b, 92-95.

[48] Pitarakis 1998b, 85-98.

[49] Pitarakis 1998b, 101, n. 80.

[50] *Byzantium*, no. 141.

[51] *Byzantium*, no. 165.

[52] Pitarakis 1998b, 85, 98.

[53] Kartsonis 1994, 86-101.

[54] *Glory of Byzantium*, no. 109.

[55] *Glory of Byzantium*, no. 113.

[56] *Glory of Byzantium*, 165, no. 112.

[57] *Glory of Byzantium*, 178-179, no. 133.

[58] *Handbook of the Byzantine Collection* 1967, 69, no. 249.

[59] *Handbook of the Byzantine Collection* 1967, 59, no. 213.

[60] Ross 1965, 107, no. 156, pl. 72.

[61] Ross 1965, 108-109, no. 158, pl. 72.

[62] Ross 1962, 88, 90-91, no. 108, pl. 57; *Byzantium*, no. 204; *Glory of Byzantium*, no. 336.

[63] Auzépy 1994, 92.7-14.

[64] Browning 1963, 296, no. 5.O.

[65] *PG* 106, 965, no. 146.

[66] *PG* 120, 1130-31, no. 7.

[67] *PG* 120, 1123-25, no. 1.

10

Medallion: A. *Christ Blessing a Newly-Married Couple*; B. *The Nativity*

Diam. 7.64 cm, w. of frame 1.1 cm, h. of link
0.44 cm, wt 41 gr
Gold sheet
6th-7th century
Eastern Mediterranean
Munich, Christian Schmidt Collection,
Inv. no. 378

This pair of round gold discs is decorated with representations in relief. The discs touch on their reverse and are framed in a slightly thicker circular gold casing with fine pierced decoration in *opus interrasile* technique.

The obverse shows a newly-married couple joined by Christ and grasping each other's right hand (*dextrarum iunctio*). Christ wears sandals, a mantle and a chiton. A halo with a superimposed diamond-studded cross encircles his bearded face. He rests a hand on one shoulder of each of the couple. The bridegroom's opulent clothing is an indication of his high social status. His chiton has rich trimmings, while his girdle is embroidered with jewels and pearls. His wide chlamys is pinned to his right shoulder by a large brooch with a clasp. The bride's chiton is likewise embroidered with gems and pearls. She wears a drop pearl necklace. In her hair is a broad pearl-framed diadem with three clasps at its centre, also terminating in pearls (Koenen 1996). The top of her head and the diadem are covered by a wimple framing her face. In her left hand the bride holds a kerchief. A sun can be seen slantwise above the groom's head, and a crescent moon slantwise above the bride's head. The inscription on the circumference reads: EIPHNHN THN EMHN ΔIΔΩMI YMIN (My peace I give unto you) (John 14:27).

Directly comparable with this medallion are two representations of weddings on girdles, one in the Dumbarton Oaks Collection in Washington (Ross 1957, 258; *Age of Spirituality*, no. 262) and one in the Louvre (*Byzance*, no. 89). But the curious thing about the scene on the medallion is the bride's diadem. She could, that is to say, be an imperial consort. From the first half of the sixth century there is a portrayal on consular diptychs of the Empress Ariadne wearing just such a diadem (Vollbach 1976, nos 16-18 and 20-21). In representations which can be confirmed as those of imperial weddings, however, the bride always wears not only the diadem but the broad chiton (Kantorowicz 1960, 7). Since

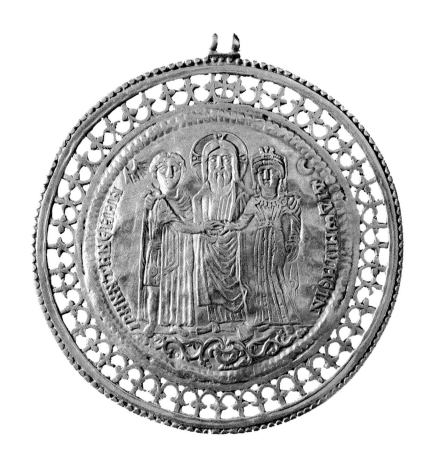

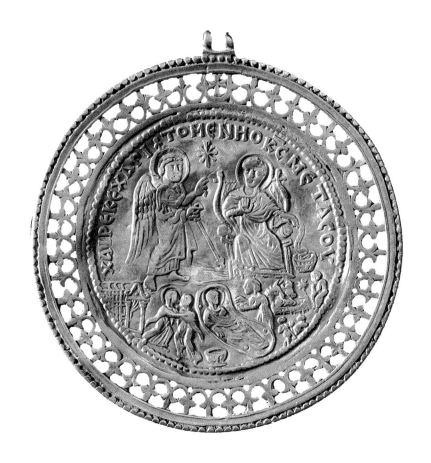

the groom here wears neither the diadem nor the round imperial brooch, he is evidently from the upper ranks of the officers of state. It is therefore sure that the medallion does not depict an imperial wedding.

The representation on the reverse of the medallion is in two parts. The top, occupying some two-thirds of the whole surface, tells the story of the Annunciation to the Virgin. The inscription round the outside reads: XAIPE KEXAPITΩMENH O KC META COY (Hail, full of grace! The Lord is with thee) (Luke 1:30). The angel, winged and nimbed, has drawn near and has raised his right hand in a gesture of salutation. He wears a chiton, a mantle, and sandals. In his left hand he holds a long staff, both ends of which are decorated with an orb emerging from a pair of leaves. Mary wears a chiton and a mantle rich in folds that covers her head and shoulders. The dread of the woman who is about to become the Mother of God is expressed by her gesture of terror with the right hand, by the backwards tile of her haloed head, and by her staring eyes. Her left hand still grasps the thread she had just been spinning: its end disappears into a round basket. Mary sits on a pearl-studded cushion set upon a lyre-back throne, her feet resting on a jewelled footstool. Above the angel's right hand can be made out the star-like monogram of Christ (where the letter X is combined with a cross, on the upper arm of which the hook of the letter P has been superimposed).

The bottom third of the surface has three further scenes that follow the Annunciation. These are: the Visitation (Luke 1:39-56); the Nativity (Luke 2:1-2); and the incident of the midwife Salome's withered hand (*Protevangelium of James* 19:3-20:4; *Pseudo-Matthew* 13:3). But at the very centre of this composition of many figures is not the Holy Child but the figure of the Virgin Mary with her halo, as she rests, torso slightly raised, on a palliasse.

In the left part of the picture we see the Visitation. Two heavily pregnant women have put their arms round one another. Shown to the right of Elizabeth (the mother of St John the Baptist) is Mary, conspicuous by her halo. Behind her is a small tiled building that might be seen as a 'temple': an allusion to the place where Mary stayed before the Nativity of Christ, or an intimation of her Son's royal lineage (Deckers 1988, 332).

The central figure in the representation of the Nativity which follows is the reclining Mary

(*Spätantike und Frühes Christentum*, 347-359). In the right-hand corner of the picture the stone manger can be seen, with a star hovering above it. The ox and the ass turn their heads towards the tiny swaddled Infant lying in the manger. Joseph sits beside the manger, propping his chin on his right hand and looking thoughtfully at the Infant Christ. In front of the manger is a sheep turned towards its shepherd, who rests his right arm on his staff, raises his left in a gesture of amazement and looks at the Babe and the star above him. Discernible between Mary and the manger is the figure of a woman, her hands with their huge fingers stretched towards the Mother of God. This must be the disbelieving midwife Salome, whose fingers withered when she would test Mary's virginity after Christ's birth: now she is begging to be healed. In front of Mary's palliasse is a deep, wide vessel—the basin to bathe the Infant in.

Various details of the iconography suggest that the medallion was crafted between the early the sixth and the early seventh century. The shape of the Empress Ariadne's diadem dates to between 515 and 517. Representations of lyre-back thrones are encountered from the sixth century onwards, for instance in the apse mosaic in the church of the Virgin Kanakaria in Cyprus (Megaw 1977, 140). The oldest surviving dated representation of the Visitation (about 540) is in the apse mosaic of the basilica Euphrasiana at Parenzo in Istria. It was at about the same time that representations of the Nativity enriched with the Salome incident began to make their appearance, as for example in the reliefs on the cathedra of Maximian (545-553) at Ravenna (Volbach 1976, no. 140).

The medallions in the Dumbarton Oaks Collection at Washington and the medallion found at Lampousa in Cyprus (*Wealth of the Roman World*, no. 192), are relevant in style and technique. Both date to the late sixth century. Also linked to the style and iconography, lastly, are the seventh-century lead pilgrim flasks from Palestine now at Monza and Bobbio in Italy (Grabar 1958, nos 2, 18, 19).

A medallion was, properly speaking, a round enkolpion suspended from a neck chain. Medallions were worn not only by women, but also by men and boys. They were decorative objects as well as marks of honour and reminders of private, public and religious holidays. They also served as amulets, protecting the wearer from bodily and spiritual harm, and as reliquary cases, normally decorated with 'lucky' protective symbols,

images, and mottoes. People used to swear by medallions and exchange them as 'confirmation of contract'. Relatives of a newly-married couple would also exchange medallions at a wedding 'as a sign of unalterable acceptance and support of the marriage contract' (Gerstinger 1962, 329-330). The general 'message' of the representations combined on the present icon—a wedding scene, the Annunciation, the Visitation, and the Nativity—can be paraphrased as follows: 'May the bride have the social graces of a princess, and may she be blessed like Mary the mother of Christ'.

Johannes Deckers

Exhibitions:
Rom und Byzanz2, Prähistorische Staatssammlung Munich 1998.

Literature:
Rom und Byzanz2, no. 308.

11
Bracelet

Max. diam. of hoop 6.2 cm, max. diam.
of medallion 4.4 cm
Gold
About 600
Eastern Mediterranean
Said to have come from Syria; purchased
in Alexandria
Bequeathed to the British Museum by
Sir Augustus Wollaston Franks in 1897
London, British Museum, M&LA AF 351

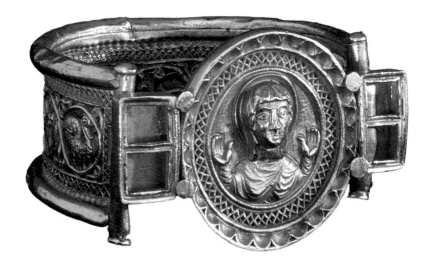

Gold bracelet with an openwork hoop and a
clasp in the form of a medallion decorated
with a nimbed bust of the Virgin Mary orans
in high relief. The Virgin is represented as an
almost half-length frontal figure with both
hands raised, palms outward. She wears a
himation, the folds of which are articulated
symmetrically across her breast in broad
swathes. This portrait is enclosed by two con-
tiguous decorative borders: the inner of open-
work lozenges, the outer a scalloped rim.
Flanking the medallion are two empty set-
tings for gem or glass inlays. The hoop is con-
structed of two tubes of gold sheet and an
inner band of openwork lozenges containing
an *opus interrasile* design of a central vase
from which emanate two running scrolls con-
taining pairs of peacocks and swans.

This bracelet once formed part of a pair; the
other, whose whereabouts is now unknown,
was once in the collections of Count Michael
Tyszkiewicz and Alessandro Castellani
(Froehner 1897, 74-75, no. 198, pl. 17). This
companion piece apart, there are no direct
parallels for the bracelet although both
iconic and narrative representations of the
Virgin in Early Byzantine jewellery are com-
mon. Examples of the latter include the
Annunciation to the Virgin, as witnessed by
three enkolpia, one from the Assiut Treasure,
now in Berlin (Dennison 1918, pls XV, XVI,
XVII), a second, reputedly from Sardinia,
now in a German private collection (*Rom un
Byzanz* 2, no. 308), and lastly, one from Pales-
tine (Iliffe 1950, pls XXXII, XXXIII,
XXXIV). To these could be added a further
enkolpion with the Adoration of the Magi,
which can be seen on one side of a medallion
in the British Museum (Tait 1986, no. 501),
while more extended narrative sequences
involving the Virgin can be observed on, *inter
alia,* the Adana medallions in Istanbul, which
include the Annunciation to the Virgin and
the Visitation, the Nativity, the Flight into
Egypt and the Adoration of the Magi (Tal-
bot Rice 1959, no. 66, 302), an enkolpion in

the Dumbarton Oaks Collection depicting the
Virgin and Child with two angels above the
Nativity (Ross 1965, no. 36), and finally, a
gold and nielloed octagonal amulet in the
British Museum with both the Adoration of
the Magi and the Nativity (Dalton 1901, no.
284). Iconic representations on the other
hand are reserved almost exclusively for cross
pendants. These, however, are highly schem-
atic and are part of a predictable iconographic
programme including either the evangelists,
angels, or the soldiers casting lots, all juxta-
posed with a central image of the crucified
Christ (Ross 1965, nos 6B and 15, this with
detailed bibliography for other comparanda).
Other non-narrative depictions can be seen
on a group of sixth- or seventh-century mar-
riage rings whose bezels are decorated with
the standing figures of Christ and the Virgin
blessing the bride and groom (Ross 1965, no.
69).

The closest iconographic parallel to be found
in Early Byzantine jewellery is on a small gold
pendant in the British Museum, supposedly
from Alexandria, though here the figure of
the Virgin is standing and the workmanship
considerably inferior. Representations of
the Virgin in other media provide better par-
allels: for example, an ivory pyxis in the Met-
ropolitan Museum of Art, New York (*Age of
Spirituality*, no. 520), a silver reliquary in the
Hermitage, St Petersburg (*Age of Spirituality*,
no. 572), the Homs vase in the Louvre (*Age
of Spirituality*, no. 552), and an icon of St Peter
with a medallion of the Virgin in the
monastery of St Catherine at Sinai (*Age of

Spirituality, no. 488). A sixth- or early seventh-
century date is suggested not only by these
parallels, but also by the form of the bracelet
itself, which stands at the end of a long Late
Antique tradition of bracelets with openwork
hoops. The much less tightly organized *opus
interrasile* of this bracelet is typical of late
sixth- or early seventh-century jewellery.

Chris J.S. Entwistle

Exhibitions:
Jewellery through 7000 years, British Museum,
London 1976; *Wealth of the Roman World*,
British Museum, London 1977; *Byzantium*,
British Museum, London 1994.

Literature:
Dalton 1901, no. 279; Dalton 1911, 541, fig. 325;
Dalton 1921, 135, fig. 81; Grabar 1966a, 318, fig.
372; *Jewellery through 7000 years*, no. 355;
Wealth of the Roman World, no. 170; Tait 1986, 206,
no. 499; *Byzantium*, no. 99; Yeroulanou 1999,
no. 230.

Ring of Admiral Michael Stryphnos

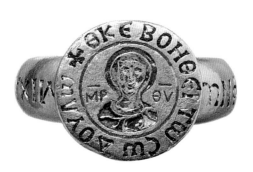

Diam. of hoop 2.3 cm, diam. of bezel 1.5 cm,
wt 22.4 gr
Gold and enamel
Late 12th-early 13th century
Constantinople (?)
Washington, D.C., Dumbarton Oaks,
Byzantine Collection, Acc. no. 34.3

This heavy gold ring is enamelled on both its circular bezel and hoop. The bezel, which tapers towards the hoop, shows a bust of the Virgin flanked by the abbreviation: ΜΡ ΘΥ (Mother of God). The image is framed by an inscription with a Greek cross between the first and final letters: ✣ Θ(EOTO)KE BOH-ΘΕI Tω Cω ΔΟΥΛω; the inscription continues around the hoop with letters read upside down relative to the orientation of the Virgin: ΜΙΧΑΗΛ ΝΑΥΑΡΧω Τω CΤΡΥΦΝω. The complete inscription reads: 'Bearer of God, help thy servant Michael the Admiral Stryphnos'. The haloed Virgin has a pale pink face covered by a light blue maphorion, while her body is covered by a dark green mantle. She has black eyebrows, white eyes and a red mouth. Also red are the halo, the abbreviations and the line encircling the figure. The inscribed letters on both bezel and hoop are black.

The cloisons used to delineate the Virgin are wide in proportion to the size of the figure and have irregular and rough contours. When the bezel was polished, the top edge of several cloisons was bent over the enamel, creating an overhang that is noticeable in areas where enamel is missing. The surface is in poor condition, except for the face, and there are major losses in the mantle. However, the overall effect is one of sure design and competent, though not highly skilled, craftsmanship. The ring was in all probability made for Michael Stryphnos, the Admiral of the Byzantine fleet under Alexios III Angelos (1195-1203). Evidently with the collusion of court officials and counting on the protection of his sister-in-law, the Empress Euphrosyne Doukaina Kamatera, he unscrupulously sold the stock of the naval arsenal for personal gain and did not order new ships to be built for the navy. This graft and neglect left the Empire extremely vulnerable to naval aggression, a condition exploited by its adversaries from the fall of Zara in 1202 to the humiliating loss of Constantinople in 1204.

The invocation to the Virgin as intercessor was a well-established formula used through many centuries. It is seen on other rings, such as the niello-decorated example of Maria Patrikia at Dumbarton Oaks (Ross 1965, no. 110), where the retrograde inscription is the sole ornamentation of the bezel; and on another gold and enamel ring at Dumbarton Oaks (Ross 1965, no. 156) bearing the image of the Virgin and, significantly, belonging to another eminent figure, Michael Attaleiates, named on the hoop. The prayer for help was also often directed to Christ, addressed as Lord (KYPIE), e.g., on the back of a silver and niello double-sided medallion at Dumbarton Oaks (Ross 2001, Add. no. 197).

Ross and Wessel suggested that this ring may have been presented to Stryphnos at his investiture as Admiral. The significant weight of the ring supports its identification as an insignium, rather than only as an object of personal piety and protection. This may be true of the ring of Michael Attaleiates, mentioned above, with its similar inscription and image of the Virgin on the bezel.

Stephen R. Zwirn

Exhibitions:
Exposition de 1865: Union centrale des Beaux-Arts appliqués à l'industrie. Musée retrospectif, Palais de l'Industrie, Paris 1865; *Exposition International d'Art Byzantin*, Musée des Arts Décoratifs, Paris 1931; *Arts of the Middle Ages*, Museum of Fine Arts, Boston 1940; *A Selection of Ivories, Bronzes, Metalwork and other Objects from the Dumbarton Oaks Collection*, Fogg Museum of Art, Cambridge, Mass. 1945.

Literature:
Arts of the Middle Ages 1940, no. 205; *Handbook* 1946, no. 135; *Handbook* 1955, no. 277; Ross 1965, no. 158; *Handbook of the Byzantine Collection* 1967, no. 257; Wessel 1967, no. 57; Cutler 1981, 776, fig. 7.

13

Ring Engraved with the Standing Virgin Holding the Christ-Child

H. 2.4 cm, w. 2.1 cm, bezel: 1.16 × 0.93 cm, wt 7.5 gr.
Gold
7th century
Constantinople (?)
Munich, Christian Schmidt Collection,
Inv. no. 949.

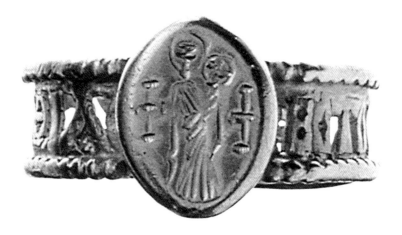

The oval bezel of the ring is engraved with an image of the standing Virgin holding the Christ-Child on her left arm (the so-called Hodegetria type); both the Virgin and Christ are nimbed, and a cross appears on either side of them. The hoop of the ring is a flat gold band, 7 mm wide, with a beaded wire border, which has been pierced with a small chisel to create an openwork inscription reading ΘΕΟΤΟΚΕ ΒΟΗΘΙ ΕΥCΤΑΘΙΑC (Mother of God, help Eustathia).

The goldsmith's technique of chiselling patterns in openwork, termed *opus interrasile* (Yeroulanou 1999 for a full study of such jewellery), was widely used in Roman jewellery by the mid-third century. Rings bearing openwork inscriptions, often including personal names, were especially common in the third quarter of the third century (Guiraud 1992, 46; Yeroulanou 1999, 164-166 and 255-257, nos 302-312; Johns 1996, 60-62). The technique continued in the fourth century, notably employed on a group of very fine pendants of the late Constantinian period (Buckton 1983-1984, 15-19; Yeroulanou 1999, 84-88), and is found in the fifth century, for example, on a number of fine fibulae and on an elaborate reliquary pendant now in Dumbarton Oaks (Yeroulanou 1999, 95-97 and 195; Ross 1965, 30-31, no. 31; Spier 1987, 10-12). Throughout the sixth and into the seventh century, Byzantine jewellery often made use of openwork design, either chiselled from sheet gold or pierced through embossed gold foil. Such work is found most frequently on necklaces and earrings, notably crescent-shaped examples decorated with peacocks and florals. A fine earring of this type, in the Benaki Museum, bears in addition an openwork monogram (Yeroulanou 1999, 290, no. 554, fig. 322;). Occasionally inscriptions appear on *opus interrasile* jewellery of the sixth and seventh centuries, such as on the large embossed plaque in Baltimore decorated with an eagle, peacocks, and florals in registers, along with the inscription ΘΕΩΤΟΚΗ ΒΩΕΘΙ ΤΙ ΦΟΡΟΥCΑ (Mother of God,

help her who wears [this]) (Yeroulanou 1999, 233, no. 167, fig. 232; Yeroulanou 1988, 2-10).

A number of rings with openwork decoration on the hoop are known. Some are simple bands with floral decoration (Yeroulanou 1999, 257, nos 314-315; Orsi 1942, 138, no. 4, pl. 9, from Pantalica, Sicily; Pierides 1971, 59, pl. 40, 8, from Kyrenia, Cyprus), but many have beaded wire borders and bezels which take the form of a tall, six-petalled floral calyx, usually set with a gemstone and bordered with pearls, although some are set with an engraved gold disc (Yeroulanou 1999, 258-260, nos 323-333). Several of these rings have inscriptions chiselled in openwork on the hoop. One such ring in Dumbarton Oaks is believed to be part of a hoard of gold jewellery which included chains, crosses, amulet cases, earrings, a belt buckle, two rings, and two *solidi* of the Emperor Herakleios (610-641) (Ross 1965, 10-12, no. 6E; Yeroulanou 1999, 168, 259-260, no. 332, fig. 320). The bezel is of floral calyx type and is set with a rare example of a contemporary engraved amethyst depicting a standing saint with the fragmentary inscription ΑΓ... ΒΟΗΘΙ (Saint ... help). As with the ring under consideration, the hoop bears the name of a woman, ΚΥΡΙΗ ΒΟΗΘΗ ΜΑΡΙΑC (Lord, help Maria). Another ring, in New York, also has a bezel in the shape of floral calyx, in this instance set with a gold disc engraved with a representation of the Virgin and Child enthroned; the openwork hoop bears an invocation for an anonymous female owner, ΚΥΡΙΕ ΒΟΗΘΙ ΤΙ ΦΟΡΟΥ[C]Ι (Lord, help her who wears [this]) (New York, Metropolitan Museum of Art, inv. no. 17.190.1654; Van Den Hoek, Feissel, and Herrmann 1994, 48, 57, Group G(c), n. 27, fig. 13; Yeroulanou 1999, 168, 260, no. 333, fig. 321). A ring once in the Baurat Schiller Collection has a simple bezel encasing an unen-

graved emerald and on the hoop the inscription ΚΑΤΥΛΛΑ Η ΧΑΡΙC (Catulla, the graceful one) (Zahn 1929, 31, no. 36, pl. 51; Yeroulanou 1999, 258, no. 320). Of similar construction, although the stone is missing, is a ring inscribed ΚΥΡΙΕ ΒΟΗΘΗCΟΝ ΜΑΡΙΝΟΝ ΚΑΙ ΜΑΡΙΑΝ (Lord, help Marinos and Maria), which perhaps served as a marriage ring (Yeroulanou 1999, 168, 258, no. 322).

All these rings derive from related workshops that no doubt produced other types of jewellery, such as earrings and necklaces, which share many stylistic and technical details. Such items belong to the broad *koine* style of Byzantine jewellery produced during the sixth and seventh centuries. The presence of coins of Herakleios in the Dumbarton Oaks hoard, which contained one such ring, suggests a date of manufacture for the rings in the first half of the seventh century. Seibt has proposed that the letter forms found on the present ring are consistent with a date around 700 (*Rom und Byzanz* 2, no. 337).

The image of the standing Virgin of Hodegetria type was especially popular on rings of the sixth and seventh centuries. A very fine example in gold with niello inlay, said to be part of a sixth-century hoard of jewellery, is now in Dumbarton Oaks (Ross 1965, 138, no. 179 O); another gold and niello example was found at Syracuse in Sicily (Orsi 1942, 156, fig. 70; Cavallo 1982, 414, no. 224, fig. 297); a gold ring in a private collection has a hoop inscribed ΑΓΙΟC ΑΓΙΟC ΑΓΙΟC ΚΥΡΙΟC (Holy, holy, holy, is the Lord) (Christie's, New York, *Antiquities*, 4 June 1999, lot 117); a silver bezel (missing the hoop) inscribed ΘΚ ΒΟΗΘ ΚΟCΜΑΝ (Mother of God, help Kosmas) is in Berlin (Volbach 1930, 133, no. 6398, pl. 5); a similar, unpublished, silver bezel in Oxford is inscribed ΧΕ ΒΟΗΘΙ ΝΙCΙΦΟΡΟΥ (Christ, help Nikephoros); and

there are some cruder example in bronze (Vikan 1987, 40-41, fig. 19), as well as a number of other unpublished examples.

Lead seals, too, often carried the image of the Virgin Hodegetria. Most examples appear to date from the seventh century (Zacos and Veglery 1972, nos 1137, 1140-1142, 1144, 1146, 1148, 1150, 1152, 1160, 1171, 1178-1179, 1186-1188, 1197, 1223, 1228, 1235-1236, 2954; all thought to be of seventh-century date), although some date from the eighth and ninth centuries. That this particular image had special political significance is shown by its adoption for use on imperial seals, beginning no later than the reign of Emperor Constantine IV (681-685) and continuing through the reign of Leo V and Con-stantine (813-815) (Zacos and Veglery 1972, nos 23, 25, 27-33, 43, 46, 48). In addition, Methodios I (843-847), the first Patriarch of Constantinople after the Restoration of Icons and himself a proponent of the veneration of icons, displayed this representation on his personal seal (Zacos 1985, 4-5, no. 5). Only from the eleventh century onward was the icon depicting the standing Virgin holding the Christ-Child on her left arm known as the Virgin Hodegetria, probably named after the Hodegon monastery at Constantinople in which it was kept. According to popular tradition, the icon was painted by the Evangelist Luke, and the image enjoyed tremendous popularity and existed in numerous copies. The icon often appeared in special processions through the capital, and in the twelfth century it was carried onto the walls of the city to protect it against attack. Although there is no conclusive evidence for an earlier occurrence of this practice, the icon may have been used in the same way in the seventh century, which may account for the popularity of the image on rings and imperial seals at that time (*ODB*, 2172-3).

Jeffrey Spier

Exhibitions:
Rom und Byzanz2, Prähistorische Staatssammlung, Munich 1998.

Literature:
Rom und Byzanz2, no. 337; Yeroulanou 1999, 258, no. 321A.

14

Two-Sided Medallion

Diam. 1.5 cm
Silver, with traces of gilding
12th century
Munich, Christian Schmidt Collection,
Inv. no. 403

This small, cast, silver medallion with suspension loop and partly gilded surface bears a relief bust of the Virgin. The drapery of the maphorion is animated with linear folds enhanced with deep engraving. The border of the medallion is decorated with irregular depressions, probably imitating decorative pearls that encircle more precious jewellery. The Virgin is represented in profile with both hands raised high in prayer, while her head is turned in almost frontal view. The maphorion is decorated on the forehead and shoulders, with the traditional pellets arranged in the form of a cross. The sigla MP ΘY is engraved on both sides of the bust.

The sideways pose of the Virgin on a medallion recalls larger Deesis compositions. A monumental example is the medallion of the Virgin on the tenth-century mosaic panel of Leo the Wise in Hagia Sophia. Parallels are also found on the transverse bar of processional crosses of the tenth and eleventh centuries. But, whereas the hands of the Virgin of the Deesis are placed near chest level, her hands on the silver medallion are directed upward as if an invisible figure were set higher up, outside the field. The Virgin on the silver medallion therefore belongs to a group of images which introduce the figure of Christ in medallion or the hand of God in the upper corner of the field. The variants of this group, some of which are on lead seals of the eleventh and twelfth centuries, usually bear the appellation Hagiosoritissa (Laurent 1965, nos 1431, 1462, 1548; Laurent 1981, no. 1167). The same type is present on a twelfth-century icon in Sinai, the upper register of which displays a row of various iconographic types of the Virgin (Cutler and Spieser 1996, fig. 310). However, the fragmentary letters that flank the Virgin of Hagiosoritissa type on an eleventh-century enamel enkolpion in Maastricht seem to point toward a reading of the label as Blachernitissa (*Glory of Byzantium*, no. 113). An icon of a similar iconographic type in the Enkleistra of St Neophytos in Paphos and dated to the late twelfth century, is named Eleousa (Vocotopoulos 1995, fig. 43). The link between iconographic type and epithet of the Virgin does not appear to obey rigid conventions.

The place-name/epithet Hagiosoritissa has been traditionally connected with the reliquary chapel of the girdle of the Virgin in the church of the Chalkoprateia at Constantinople, but the model may also have its origins in the *soros* of the *maphorion* in the Blachernai complex. The growing popularity of the Hagiosoritissa in addition to other intercessory types of the Virgin in eleventh- and twelfth-century Byzantium, coincides with an intensification of the Marian cult in Constantinople. This pietistic trend was strongly enhanced by the move of the Komnenos family to Blachernai, which became the permanent imperial residence. The closest parallel to the Virgin on the silver medallion appears on coin issues of Manuel I Komnenos (1143-1180) (Hendy 1999, pl. XVI). The original model may have been one of several icons which were taken in the weekly procession of the *Presbeia*, from Blachernai to the church of the Chalkoprateia (Ševčenko 1991, 50-55). The Virgin Hagiosoritissa is also attested on an eleventh-century seal belonging to Ioannis Patrikios, *protos* of the *Presbeia* of the Blachernai (Laurent 1965, no. 1200). From documentary sources, it is clear that an icon of the type of the Hagiosoritissa was taken into processions by a religious confraternity based in Central Greece (Nesbitt and Wiita 1975). The Hagiosoritissa is undoubtedly an image which had a strong impact on both corporate and private acts of devotion.

The suppliant attitude of the Virgin Hagiosoritissa, also shared by a multiplicity of saints, became a standard feature in the illustrations of liturgical books—menologia, psalters, liturgical rolls—in the eleventh and twelfth centuries. Liturgical implications of this attitude explain the pairing of icons of the Hagiosoritissa with Christ in frontal view on either side of a templon screen and its flanking piers. On the other hand, in the sphere of private devotion, the Virgin Hagiosoritissa and Christ are paralleled on diptych icons such as the ones held by St Stephen the Younger, a martyr of the iconophile cause, in manuscript illustrations in the second half of the eleventh century (Der Nersessian 1960, 80; Piltz 1998, 133, fig. 19). Both figures are also juxtaposed on a twelfth-century, double-sided, enamel enkolpion in New York (*Glory of Byzantium*, no. 112). Apart from jewellery enkolpia, the Virgin of Hagiosoritissa type was also popular on cameos and steatites of the eleventh and twelfth centuries. Modest versions of this image in base metal do not seem to have been common.

The reverse of the silver medallion with the

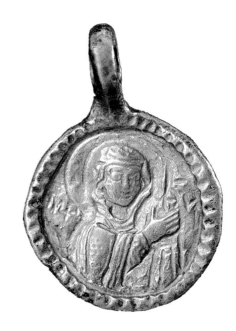

Hagiosoritissa bears an engraved inscription invoking the protection of the Lord: KYPIE BOHΘEI TON ΦOPONTA TO (Lord help the wearer). This is a stereotyped formula on jewellery artefacts of the Middle Byzantine period. These include pectoral crosses, medallions, and rings produced in series. Personalized inscriptions in enamel or niello, which introduce the name of the owner, indicate objects of a more privileged status. The composition which juxtaposes the invocative inscription with the image of the Hagiosoritissa relates to eleventh- and twelfth-century manuscript illustrations which insert the text of the Virgin's prayer in the field, while the prostrate donor is shown at her feet. In another related instance, the petition of the Virgin, usually called *Paraklesis*, is recorded on an open scroll that she holds in her right hand (Ševčenko 1994, figs 7, 8, 11). With its emphasis on the dialogue between the Virgin and Christ, the iconographic type of the Hagiosoritissa was particularly suited for the decoration of an object of protective character, intended to be worn around the neck. The closest parallels to this image and the stylized folds of the maphorion support a twelfth-century date of manufacture.

Brigitte Pitarakis

Exhibitions:
Rom und Byzanz2, Prähistorische Staatssammlung, Munich 1998.

Literature:
Rom und Byzanz2, no. 311.

15

Two-Sided Enkolpion: A. *Christ*.
B. *The Virgin*

3.6 × 1.7 cm
Gold
10th-11th century
Athens, P. and A. Kanellopoulos Museum,
Inv. no. 86

This little amulet enkolpion is of gold sheet. Below a broad suspension link, there is a cylinder decorated with two plain engraved chaplets. The cylinder rests on a circular case consisting of two concave sheets of gold bearing embossed busts, of Christ on one side, and of the Virgin Mary on the other. A fragment of the True Cross is preserved within the case, and this lends further weight to the view that this ornament is a kind of amulet.

Small phials of similar form are also found earlier, as women's dress accessories hanging from the neck by a chain and usually containing aromatic oils. Even at an early date, however, the example in the Museum of Fine Arts at Boston (Gonosová and Kondoleon 1994, no. 34), assigned to between the fifth and the seventh century, is thought probably to have contained sacred myrrh from the Holy Land, by analogy with metal *eulogies* from Palestine. The present enkolpion must be later in date, around the tenth or eleventh century, a time when it had become standard to represent divine figures on amulet and reliquary boxes. There are enkolpia and reliquary boxes for pieces of the True Cross which are significant art works, executed with enamels and other simpler materials such as bronze.

The enkolpion is of gold, with engraved details on the rather roughly rendered figures. As regards iconography, Christ is presented as Pantokrator, with a cross-inscribed halo, holding the Gospel in his left hand and making a gesture of blessing with his right; while the Virgin Mary is shown frontally, with bold folds in her maphorion, which covers her hands and their gesture of blessing.

The combination of the representation of the Virgin with that of Christ is a commonplace of amulet enkolpia, and the appeal for protection by the Mother of God is obvious. Such an appeal was particularly frequent in ornaments made specially for women. Here, though, since there was wood from the True Cross in the amulet, it would have been quite natural to depict the figure of Christ, or the Crucifixion. This was what normally happened on pectoral crosses without excluding the combination of the two figures. The figure of the Virgin was often combined with other saints as well. This is the case on a small haematite icon, also in the Kanellopoulos Collection (*Byzantine and Post-Byzantine Art*, no. 235), on the back face of which there is a representation of St Panteleimon carrying medical instruments. The use of haematite here makes it probable that this icon was credited with healing and protective properties.

Aimilia Yeroulanou

Exhibitions:
Byzantine Art, an European Art, Zappeion, Athens 1964; *Οι Πύλες του Μυστηρίου*, National Gallery, Athens 1994; *Greek Jewellery 6,000 Years*, Villa Bianca, Thessaloniki 1997.

Literature:
Byzantine Art, an European Art, no. 195; *Οι Πύλες του Μυστηρίου*, no. 150; *Greek Jewellery 6,000 Years*, no. 234.

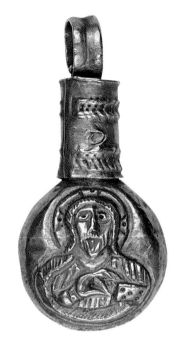

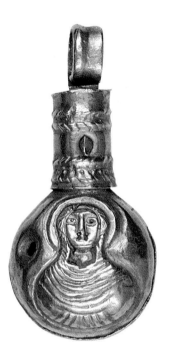

297

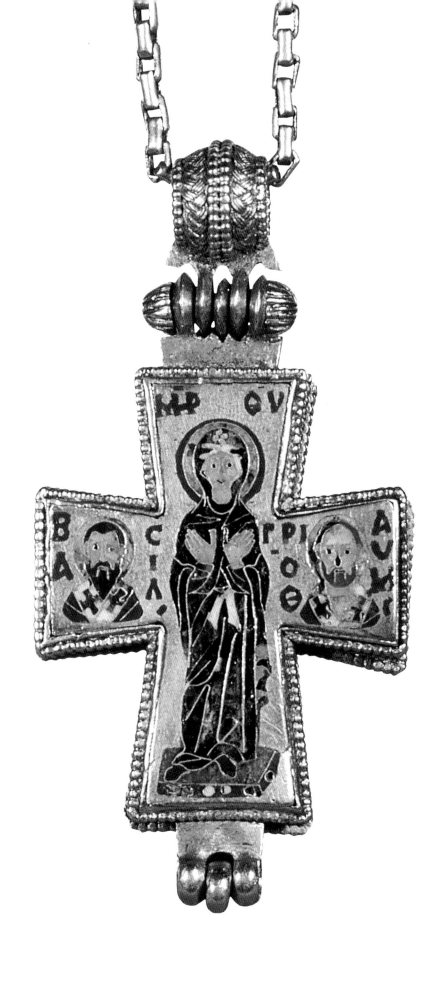

16
Reliquary-Cross

6.124 × 3.09 × 0.872 cm, enamelled plaque
3.36 × 2.814 × 0.112-0.124 cm
Gold and enamel
Late 10th or early 11th century
Constantinople
Said to have been excavated in the Great
Palace, Constantinople (sale catalogue).
Adolphe Stoclet Collection, Brussels,
subsequently in the possession of Philippe R.
Stoclet. Purchased by the British Museum in
1965 (Sotheby's, *Medieval Works of Art* sale,
London, 27 April 1965, lot 34).
London, British Museum, M&LA 1965, 6-4,1

The cross has flared arms and is hinged to
open. Both the obverse and the reverse were
originally fitted with cruciform plaques in set-
tings of plain strip; only that on the reverse,
a cloisonné enamel plaque, survives. On the
obverse, immediately above and below the
space for the plaque, is a cast quatrefoil motif
with hollowed-out petals and central roundel.
The barrel-shaped suspension loop is of gold
sheet with beaded wire round the hole at each
extremity and a double ring of beaded wire
round the widest part of the circumference;
between the single beaded wire at either end
and the central double ring is a triple plait,
each strand made up of three plain wires. Sol-
dered into a slot in the underside of the loop
is a flared plate with three grooves to accom-
modate three of the five pierced lugs of a two-
way hinge; the remaining two lugs are sol-
dered to the flared plate between the grooves.
The central component of the hinge is a
pierced lug cast in one with the quatrefoil at
the top of the obverse of the cross, and the
outermost components are pierced lugs sol-
dered to the reverse, with radially grooved
domed finials concealing the hinge-pin. The
hinge at the bottom of the cross comprises
three pierced lugs: the centre one is a com-
ponent of the quatrefoil motif at the bottom
of the obverse, while the flanking components
are soldered to the reverse of the cross. The
sides of both the obverse and the reverse of
the cross are covered by a three-wire triple-
strand plait between beaded wire.

The plaque is missing from the front. On the
cruciform cloisonné enamel plaque set into
the reverse of the cross is a figure of the
Mother of God, standing on a *suppedaneum*
in an attitude of prayer, her hands in front of
her breast, palms outward, the abbreviated
and partly monogrammatic inscription MHP
ΘY (*Μήτηρ Θεού*, Mother of God) above her
head. On the transverse arm of the cross to

her right is a bust of St Basil the Great and, to her left a bust of St Gregory Thaumaturgos; each is flanked by letters of an abbreviated identifying inscription, ΒΑCΙΛ/ (Basil) and ΓΡΙ-Ο ΘΑΥΜ/ (Gregory the Miracle-worker) respectively.

The enamelling technique is *Senkschmelz 'sunk enamel'*: the figures are set into and silhouetted against the bare metal of the plaque. The enamelling base is composed of two gold sheets: the face-plate, with sawn-out shapes to contain the cloisonné enamel, is thinner than the backing-plate (approximately 0.1 and 1.07 mm respectively). The inscriptions are engraved into the face-plate. The cellwork comprises gold strip of various gauges (from 0.05 to 0.175 mm). Cloisons (lengths of gold strip) are soldered to one another and to the face-plate; many joins have an excess of solder, resulting in small areas of gold in the surface of the enamel. 'Dummy cells' (deliberately contrived areas of gold) are employed. Some of the gold has been dragged over the surface during the finishing process, and one cloison is submerged below the enamel. There are some losses of enamel.

The silhouettes cut into the face-plate take account of the outlines of the garments in which the figures are depicted. The lower extremity of either bust is rounded and does not therefore conform to the shape of the plaque. The inscriptions are composed of squat letters with cuneiform serifs; these are filled with opaque red enamel. The elliptical haloes are enamelled in a semi-translucent green, which was probably originally transparent; Mary's halo has an opaque red border. The facial features are greatly simplified: the eyes are simple roundels filled with black enamel, and the eyebrows, indicated by a single strip of gold without any added colour, are fashioned from the cloison which also defines the nose.

The figure of the Mother of God is 30 mm high. Her flesh is of medium tint; her face is broad at the cheekbones, narrowing sharply to a rounded chin. Her eyebrows are high above her eyes; one is arched, the other fairly horizontal. Her nose is of medium length and breadth, with a rounded lozenge tip. Her mouth is V-shaped, enamelled opaque red. The broad hands are expressive and effective, although one is much better drawn than the other. She is depicted wearing a translucent blue chiton, a translucent blue maphorion with an opaque yellow border, and opaque red shoes. The maphorion has a quatrefoil of

dummy cells on the hood, which is lined in white and provided with a white veil; a white *mappa* is tucked into the girdle. The draperies, drawn with strips of different gauges, are not particularly coherent, although the representation of the garments and the pose of the figure are successfully rendered. The *suppedaneum*, depicted in reverse perspective, is enamelled in semi-translucent green, with six round cells decorating the vertical edges; two contain opaque white enamel, while the remainder are empty.

The bust of St Basil is 8.8 mm in height. His hair, worn short, and slightly receding at the temples, is translucent brown; it may originally have been black. The flesh is a medium shade; the face would be quite long if the saint were clean-shaven. The eyebrows are horizontal, one of them very slightly arched; the nose is broad, of medium length and with a rounded vaguely lozenge tip. The ears are shown as if in side-view, one rather like a cup-handle, the other narrower, and are attached to the cloison which defines the face, without any separating strip of hair. The moustache, defined by the cloison which outlines the face, curves downward from either side of the nose near the tip. The beard, appearing to grow from behind the ears, is long, pointed and slightly wavy; beard and moustache are the same colour as the hair of the saint's head. The opaque red mouth, slightly double-cusped, is little more than a slot, with the cloison outlining it doubled and drawn downward and outward at the corners. St Basil's beard fits into the 'V' of his omophorion, which is white with black crosses, worn over a blue and red paenula. The indication of drapery is minimal: on either arm a single straight cloison separates the colours of the paenula.

The bust of St Gregory is 9.4 mm high. The saint's hair, blue-grey in colour, is fairly short and slightly wavy; from near the centre of a receding hairline descend two short cloisons. The face is fairly broad. The eyebrows are horizontal; the nose is rather short and broad, ending in something of a blob. The ears, shown in side-view, are attached to the cloison circumscribing the face. St Gregory's moustache curves downward from either side of the nose near the tip; it is defined by the cloison outlining the face. His beard is short, rounded, and blue-grey in colour, stopping short just below his ears. The opaque red mouth is off-centre; it is double-cusped, with the doubled cloison drawn downward at the corners. The saint wears a white omophorion with black crosses, over a blue and red paenula, under which is a semi-translucent

green chiton. The depiction of drapery is confined to a single short cloison separating the colours of the paenula.

By analogy with other reliquary crosses, the obverse of the exquisite British Museum cross would originally have borne a Crucifixion scene, doubtless also in cloisonné enamel. Examples of Middle Byzantine reliquary crosses with a cloisonné enamel Crucifixion scene on the front, and, a full-length figure of the Mother of God, on the back, include the Beresford Hope cross in the Victoria and Albert Museum (*Byzantium*, no. 141) and the cross divided between front and back covers of Marciana Lat. Cl. I 101 (*Treasury of San Marco*, no. 9).

The enamelling technique is *Senkschmelz*, in which the cloisonné enamel figure or motif is set into and silhouetted against the bare metal of the plaque, instead of being provided with an enamelled background (*Vollschmelz*, 'full enamel'). The cross belongs to a group characterized by simplified facial features reminiscent of *Vollschmelz* representations of around the year 900, such as those on the votive crown of Leo VI 'the Wise' (886-912) in the treasury of San Marco, Venice (*Treasury of San Marco*, pl. on 121). The similarity is, however, deceptive, and there are good reasons for dating the *Senkschmelz* group at least a hundred years later (Buckton 1995).

David Buckton

Exhibitions:
Jewellery through 7000 Years, British Museum, London 1976; *Byzantium,* British Museum, London 1994-1995); *Glory of Byzantium,* The Metropolitan Museum of Art, New York 1997.

Literature:
Beckwith 1975, 29-31; Oddy and La Niece 1986, 24-27, no. 18, fig. 11; Tait 1986, 206-207, no. 503; *Byzantium*, no. 165; *Glory of Byzantium*, no. 121.

17
Roundel with the Virgin Orans

Diam. 17.5 cm
Serpentine
1078-1081
Constantinople
In the Monconys Collection in Lyons by the
17th century; after 1661 in the abbey of
Heiligenkreuz near Vienna. Acquired in
1927.
London, Victoria and Albert Museum,
Inv. no. A.1-1927.

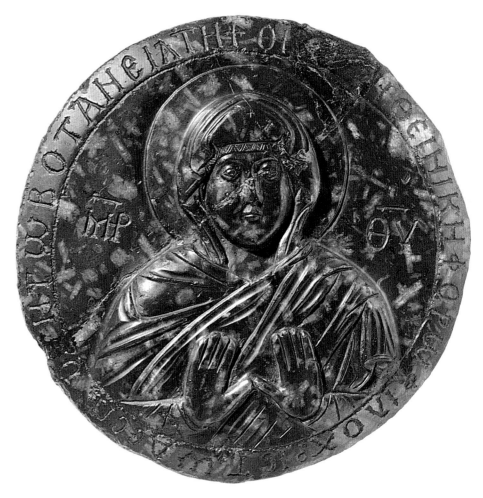

The serpentine medallion is carved with a bust
of the haloed Virgin in prayer, wearing the
maphorion, her hands raised with the palms
facing outwards in the orans position. She is
identified by an abbreviated inscription [M̄P
Θ̄Ȳ] to each side of her head. A longer inscrip-
tion runs around the edge of the disc, invok-
ing the help of the Virgin for the aged
Emperor Nikephoros III Botaneiates (1078-
1081), who was seventy-six when he reached
the throne: +Θ[EOTO]K[E] [BO]HΘEI
NIKHΦOPω ΦIΛOXPICTω ΔECΠO[T]H
Tω BOTANEIATH. On the back is a roughly-
scratched outline of the bust of the Virgin and
the letter M. The medallion was broken diag-
onally across the middle and repaired before
it was acquired by the Museum.

Datable Byzantine reliefs are of the greatest
rarity, so this circular carving occupies a cen-
tral position in the study of the sculpture of
Constantinople. Because it is so firmly asso-
ciated with the Emperor Nikephoros III
Botaneiates, it has been related to two further
marble reliefs of the standing Virgin orans and
the Archangel Michael, now in Berlin, which
come originally from the monastery church of
the Theotokos Peribleptos in Psamatia, Con-
stantinople, but which may however be some-
what later in date (Belting 1972). This church
was especially favoured by the emperor: he
retired there after his abdication and was
buried there, and it has been suggested that
the present relief may have formed part of the
decoration of his tomb (*Glory of Byzantium*,
no. 130). Certainly, in contrast to other hard-
stone cameos of the same date it is too large
and heavy to have been worn, so an archi-
tectural setting—albeit of the highest luxury—
is plausible. Known to have been in France by
the seventeenth century, it was probably
looted from Constantinople during the Fourth
Crusade in 1204.

The iconographic type of the Virgin seen
here—with her hands raised and palms fac-
ing outwards, in front of her chest—is a

slightly different version of the more common
Virgin orans, usually shown with her arms
raised to each side of her body. This variant
also became widespread in the eleventh and
twelfth centuries, being employed on lead
seals, in wall-paintings and in the closely
related medium of cameo carving (for three
examples of the latter, *Byzance*, nos 196-198).

Paul Williamson

Exhibitions:
Exposition internationale d'art byzantin, Musée
des Arts Décoratifs, Paris 1931; *Masterpieces of
Byzantine Art*, Royal Scottish Museum, and Vic-
toria and Albert Museum, Edinburgh-London
1958; *Byzantine Art, an European Art*, Zappeion,
Athens 1964; *Splendeur de Byzance*, Brussels
1982; *Byzantium*, British Museum, London
1994; *Glory of Byzantium*, The Metropolitan
Museum of Art, New York 1997.

Literature:
Chifletio 1661; de Mély 1899; Longhurst 1927a
(with earlier literature); *Exposition internationale
d'art byzantin*, no. 121; *Masterpieces of Byzantine
Art*, no. 100; Wentzel 1959, 10-11, fig. 1; Talbot
Rice 1959, no. 150; Beckwith 1961, 118-119, fig.
152; *Byzantine Art, an European Art*, no. 119;
Belting 1972, 266, fig. 9; Beckwith 1979, 245, fig.
208; *Splendeur de Byzance*, no. St. 3; Fillitz and
Pippal 1987, no. 13, 110-111, 421; *Byzance*, 276,
fig. 1; Williamson 1998, 90-91.

18
Medallion of the Mother of God

Max. diam. 3.03 cm
Gold and enamel
12th century
Byzantium
Munich, Christian Schmidt Collection,
Inv. no. 219

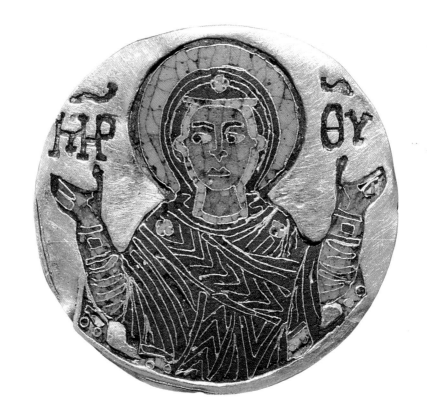

The enamelling base is constructed from a single sheet of gold hammered into a shaped depression to contain the gold cloisonné enamel. The half-figure of the Mother of God has an intricate silhouette, with the outline of the hands articulated and with reserved metal below the elbows. The cellwork, which is particularly concentrated in the rendering of draperies, with herringbone and other parallel fold-systems, was proud of the enamel surface after firing and was slightly distorted during the finishing process. The enamel, all of which is opaque, is in good condition, although there are losses and there is some cracking and pitting. The standard inscription, MHP ΘY (*Μήτηρ Θεοῦ*, Mother of God) is rendered in ornate letters enamelled(?) in a dark purple-blue; the halo is turquoise with a red border. The face is a round oval with heavy black eyebrows; the black irises are set in the corners of the eyes, so that the Mother of God looks to her right. The nose is long, with a pointed trefoil tip; the mouth has a shaped upper and a flat lower lip. The garments are a dark blue maphorion with a yellow quatrefoil on the hood and each shoulder and a yellow band visible at the bottom of the hanging sleeves, worn over a yellow coif and a greyish blue undergarment, with turquoise *perikarpia* each set with a dark blue oblong representing a gem.

The combination of single-sheet base and saturated, opaque colours supports a date in the twelfth century for the manufacture of this medallion. The closest parallel is probably the Byzantine Mother of God medallion which is now the centrepiece of the Kievan Rus collar reconstructed from fragments found at Staraia Riazan (*Glory of Byzantium*, no. 209).

David Buckton

Exhibitions:
Rom und Byzanz2, Prähistorische Staatssammlung, Munich 1998.

Literature:
Rom und Byzanz2, no. 26.

19

Icon with the Enthroned Virgin and Child

25.5 × 17.5 cm
Ivory; some traces of red from the original gilding
Late 10th-11th century
Cleveland, The Cleveland Museum of Art, Purchase from the J.H. Wade Fund 1925, Inv. no. 25.1293

This rectangular icon is an impressive piece of ivory sculpture because of its large size and high quality carving. The ivory of the plaque is covered with hairline cracks. The Virgin is represented seated frontally with the Christ-Child on her lap. Two half-length angels hover above on either side of the throne and turn towards the Virgin with their hands raised in awe. Although the image of the enthroned Virgin and Child is known as early as the fifth century, it is not a common subject on icons. The most famous example of this iconographic theme on an icon is that on Mt Sinai, where the enthroned Virgin with the Child on her lap is flanked by angels and two saints (Cat. no. 1). On the other hand, the enthroned Virgin became the standard monumental iconographic theme for the conch of church apses, especially after the period of Iconoclasm. The two angel busts of the ivory correspond to the commonly found archangels flanking the Virgin in monumental apse decorations. The solemnity of this ivory is due to its subject matter. The Virgin is in frontal pose while the Child is turned slightly towards the left with only the head in a frontal position. She rests her left hand on Christ's shoulder and with her right touches his foot. She sits on a large cushion and the throne itself is elaborately carved and studded with pearls and jewels. It is set on a pedestal where only the front legs are visible. A Greek inscription is written by an untrained (private) hand on the pedestal: ΑΛΛΟΝΗC ΜΑΡΤΥΡΟC ΔΟΥΛΟC (Servant of the Martyr Hallones). A footstool is supplied for the Virgin to rest her feet.

The most impressive yet most unusual feature in this image is the construction at the back of the throne. It is a high, arched, shell-like form, of the width of the throne at its base, that frames the Virgin as it curves upwards and behind her, up to the middle of her head, leaving her halo to extend as a solid disc all the way to the top of the plaque. Large star-like rosettes carved on its surface also define its lobed border. As far as we know, there is no other representation with such an arrangement behind a throne. Byzantine thrones which have backs, either end with a straight top, like the lyre shaped back or the straight rectangular, or an arched one (Goldschmidt and Weitzmann 1934, nos 54, 32, 61 etc.). The peculiar form and design of this piece is not only unique but is also difficult to conceive as an element of the throne. Is it just an integral part of the throne or has it been chosen to represent physically symbolic qualities or concepts of the Virgin? Perhaps this arched and curved shape behind the Virgin should be seen as a kind of mandorla or starry cloud of light? The suggestion for this interpretation is based on the star-like patterns of its surface, which together with its shape create an apse-like star-studded space, which surrounds and emphasizes the enthroned Virgin and Child. Light and stellar comparisons are plentiful in the Theotokia and hymns addressed to her. She is referred to as the annunciating light, the ὄρθρος (dawn), the gate of light, and the rising light of the East (Ledit n.d., 101 with references). Old Testament typological comparisons exist as well. The Virgin is seen, for example, as the golden candelabrum with the seven arms. An interesting Byzantine illustration of this identification of the Virgin could be seen in the eleventh-century (?) Physiologus manuscript, once in Smyrna but now lost (Strzygowsky 1899, pl. 28, fig. 1). The Virgin is enthroned and holds the Christ-Child before her. She is placed at the top of this candelabrum in the place of the seventh flame. An inscription calls her η επτάκαυλος λυχνία (seven-wick lamp). This synthetic image of the Virgin is quite unusual but succeeds in conveying its message. For the creation of the unusual 'aura' behind the enthroned figure on the ivory, I would like to suggest that it too might be a visual expression derived from literary language and imagery. The verse below is a good example of one such source, which could have inspired the artist in his creation (Eustathiades 1931, 121):

Ἀνατολήν σε νῦν ὀνομάζομεν
τοῦ ἀνατείλαντος
ἐκ λαγόνων σου
ἡλίου, ἄχραντε, ὅν ἐκδυσώπει
σκότους ἡμᾶς ῥύσασθαι
τούς σε μακαρίζοντας.
(We now call you the sun-rise
of the Sun that rose
from your womb,
O pure one, beg him to pull us
out of darkness,
us, who deem you happy).

This ivory has a close relationship with a piece now in Paris in the Musée du Petit Palais (Goldschmidt and Weitzmann 1934, no. 82, Pl. XXXIII; Koenen 1998, 199-227). There, the Virgin with the Christ-Child is seated on a very similar throne but the composition is set under a baldachin. Koenen has suggested the possibility of a 'Gloriole' behind the throne, but prefers to reject it for an interpretation of this back as a derivative from a (western) tradition of depicting the Virgin before a row of arches (Koenen 1998, 210-212). It is important to point out that the Paris plaque has a somewhat rougher carving style than the Cleveland piece, which leads to the observation that the carved star-like rosettes have been simplified and are clearly represented as stars. This fact, however, reinforces the interpretation of the back of the throne as a starry mandorla.

A close comparison of the two plaques suggests that the Paris piece is a derivative of the Cleveland ivory and most likely a western one, copied during the Middle Ages. (There are also other pieces which are copies of this particular ivory, a metal cast in Spain and another ivory, but these seem to be modern, Koenen 1998, 221-226).

Ioli Kalavrezou

Exhibitions:
Early Christian and Byzantine Art, Baltimore 1947; *Glory of Byzantium*, The Metropolitan Museum of Art, New York 1997.

Literature:
Milliken 1926, 25-29; Goldschmidt and Weitzmann 1934, no. 79, pl. XXXII; *Early Christian and Byzantine Art*, no. 126, pl. XXXI; *The Cleveland Museum of Art* 1966, no. 81; Volbach and Lafontaine-Dosogne 1968, 201, no. 98, fig. 98; *Glory of Byzantium*, no. 87; Koenen 1998, 199-227.

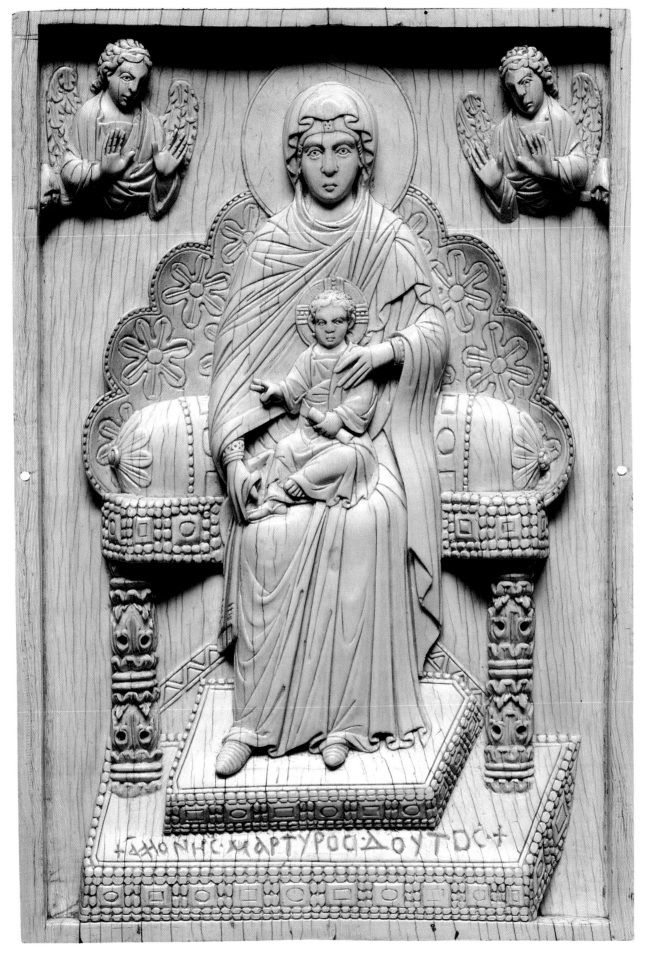

303

20

Plaque with the Virgin Hodegetria

21.5 × 14.5 cm.
Gilt copper, repoussé
Second half of 11th century
Constantinople(?)
Collection of Robert Curzon (1810-1873),
latterly Lord Zouche; on loan to the Victoria
and Albert Museum, 1876-1891, and stated at
that time to have been 'obtained from
Torcello'; acquired from the Zouche
Collection in 1891
London, Victoria and Albert Museum,
Inv. no. 818-1891

The standing Virgin, veiled and haloed, is shown in the manner of the Hodegetria, supporting the Christ-Child on her left arm and gesturing towards him with her right hand. As usual, she is identified with the abbreviated inscription $\overline{\text{MP}}$ $\overline{\Theta\Upsilon}$, punched into the metal to each side of her head. Lower down there is another inscription, running across the plaque, calling on the Virgin to help the Bishop Philip: Θ[ΕΟΤΟ]ΚΕ ΒΟΙΘΗ ΤΟ/ ϹΟ ΔΟΥΛΟ ΦΗΛΙ/ΠΟ ΕΠΙϹΚΟΠΟ. The plaque has been trimmed at the bottom and sides and regilded. A hole in the middle of the ornamental border at the top was presumably pierced in post-Medieval times to facilitate hanging the plaque on a wall.

Objects such as the present plaque most probably brought from Constantinople after the Fourth Crusade in 1204 or possibly imported into Venice before then, inspired the production of the Byzantine-style silver altars in Caorle, Torcello and San Marco in Venice (*Venezia e Bisanzio*, nos 55, 64 and 77). Although often dated to the twelfth century, this elongated and elegant figure of the Virgin standing on a *suppedaneum* would seem more likely to be a product of the second half of the eleventh century: its closest parallels, both iconographic and stylistic, are with Constantinopolitan ivory reliefs of the Virgin Hodegetria, such as those in Utrecht, London and New York, all of which can be dated to the late tenth or eleventh century (Talbot Rice 1959, nos 106, 123, 143; *Glory of Byzantium*, nos 85-86). Another silver-gilt Virgin Hodegetria in Plovdiv in Bulgaria, which shows the Virgin supporting the Christ-Child on her right arm, is of a slightly cruder quality and is probably somewhat later in date (Miiatev 1932).

The original context of the plaque is unknown. The presence of the personalized inscription suggests that it was an icon used for private

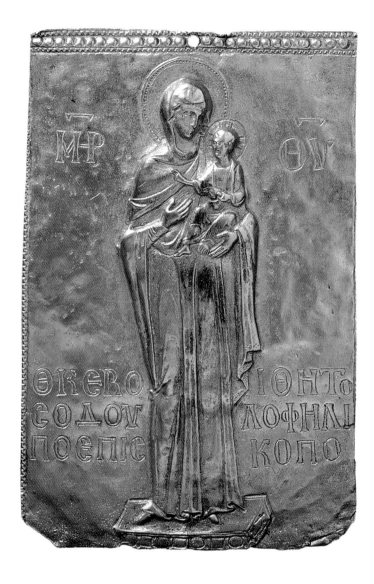

devotion, rather than once forming part of a larger ensemble such as an altarpiece. The Bishop Philip named in the inscription has not so far been identified conclusively, and it is possible that the inscription was added to the plaque some time after it was made; a number of oddities in the lettering support this view. If this was the case, the plaque may have been adapted under Filippo (Balardo), Bishop of Torcello from 1373-1405, who had previously been attached as sub-dean to the cathedral of Modon in Greece (Eubel 1913, 489; information provided by Anna Somers Cocks in the files of the Metalwork Department, Victoria and Albert Museum). The icon was probably originally mounted on board and embellished further with a jewelled frame and even wings — like the ivory plaques mentioned above, which occupied the central panel of a triptych. Alternatively, as has been suggested for the serpentine roundel made for the Emperor Nikephoros III Botaneiates (Cat. no. 17), it may ultimately have had a funerary

function, calling on the protection of the Virgin for the soul of the bishop.

Paul Williamson

Exhibitions:
Masterpieces of Byzantine Art, Royal Scottish Museum, Edinburgh 1958; *Byzantine Art, an European Art*, Zappeion, Athens 1964; *The Year 1200*, The Metropolitan Museum of Art, New York 1970; *Venezia e Bisanzio*, Palazzo Ducale, Venice 1974; *Splendeur de Byzance*, Brussels 1982; *Glory of Byzantium*, The Metropolitan Museum of Art, New York 1997.

Literature:
Miiatev 1932, 39; Talbot Rice 1935, 209; Talbot Rice 1959, no. 159; *Masterpieces of Byzantine Art*, no. 189; *Byzantine Art, an European Art*, no. 560; *The Year 1200*, no. 134; *Venezia e Bisanzio*, no. 40; *Splendeur de Byzance*, no. Br. 25; *Glory of Byzantium*, no. 331.

21

Plaque of the Virgin Hagiosoritissa

8.5 × 5.9 cm
Steatite, with traces of painting and gilding
Middle or second half of the 11th century
Constantinople (?)
Previously in the Mutiaux Collection (Drouot
Sale, Paris, 9 May 1952, Lot 99).
Paris, Musée du Louvre, Inv. no. AC 124

This bas-relief plaque, although truncated from top to bottom of the right side, preserves in its entirety the representation of the Mother of God at prayer, with the usual abbreviations incised on either side to identify her. The Virgin has a halo and is portrayed full-length in profile, standing on a *suppedaneum*, turning to the right, her hands lifted in prayer. She faces the starry arc of a circle, from which the hand of God emerges in blessing. The artist has placed her below a round arch resting on slender twin columns with protuberant bases and with high capitals decorated with stylized vegetal ornaments. The round arch has no decoration, and in the top left corner of the plaque there are merely some very sketchy reliefs. The technique is one encountered in other steatite work as well (Kalavrezou-Maxeiner 1985, nos 31, 41): painting or gilding, traces of which can still be made out on the Louvre plaque, could replace the incised motifs for detail at certain points. The style of the plaque has an air of archaic dignity: the proportions are relatively elongated, the eye is given vitality by a hole bored with a gimlet and the folds are almost as if of metal. All these features place the steatite work within the same tradition as the Louvre Hetoimasia (*Byzance*, no. 175) and three plaques with St Demetrios, St John Chrysostom and St Nicholas, respectively, now shared between the Louvre and the Bibliothèque Nationale (*Byzance*, no. 176). Hence it can be assigned to the middle or second half of the eleventh century.

The profile representation of the Virgin Mary half-length or full-length, in isolation and praying, in her great role of intercessor, is found again on lead seals from the early eleventh century onwards (Der Nersessian 1960; Seibt 1987, 48-49) and on coins of the Komnenian period (Bertelè 1958; 1978, pl. IV, no. 61). Since her pose is reminiscent of that adopted for representations of the Deesis, it may well be derived from the latter. This had already been proposed by Der Nersessian, commenting on an eleventh-century marble relief icon of the Virgin, now in Washington (*Glory of Byzantium*, no. 11, Cat. no. 38). The

spirituality and religious feeling of the eleventh century resulted in a proliferation of 'cult icons' of all types. On the Louvre plaque, however, God's hand of blessing is shown emerging from a starry heaven, with the Virgin extending her own hand and looking in the same direction. This particular subject may perhaps explain her pose: she is turned further towards God and in a more pronounced gesture of supplication, for her hands are lifted high to her face. This iconography is exactly like that of a miniature in a Jerusalem Patriarchate manuscript of the year 1061 (codex Megalis Panaghias 1, fol. 1v). There, the Mother of God intercedes for the donor, Basil, seen bending low in homage, and she turns towards the hand of God which emerges from part of a starry heaven (Spatharakis 1981, pl. 127). The pose is one in which prophets and saints send up their prayers to God: this is attested as early as the tenth century, in a representation of St Anne in the famous Paris Psalter (Paris. gr. 139, fol. 428v). Thus we might well ask if this variation on the

iconographic theme of the Virgin at prayer also derives partly from the normal iconographic type of figures interceding.

The little Louvre plaque is not alone in combining the figure of the Virgin Mary with the subject of the hand of God extended in blessing. It belongs to a small group of representations with the same distinctive and easily recognizable features. These include an enkolpion cover, now in Belgrade (*Bulgarie médiévale*, no. 354), a small enamelled reliquary box, in Notre-Dame at Maastricht (*Splendeur de Byzance*, no. E4), where the Virgin, in bust, is—as in the Louvre plaque—turning to the left; and a porphyry jasper cameo in the Dumbarton Oaks Collection (Der Nersessian 1960, fig. 2). A steatite in the Belgrade National Museum, slightly smaller in height and width than the Louvre plaque but more robust in technique, adopts the same iconographic type—though with the Virgin's face turned rather oddly towards the viewer (Kalavrezou-Maxeiner 1985, no. 82, pl. 45)—

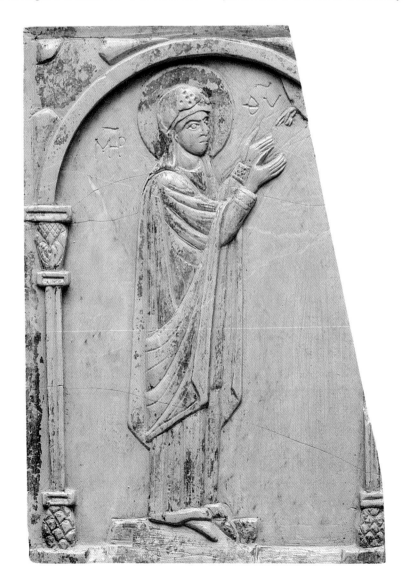

as a small medallion which was recently featured in the Munich exhibition (*Rom und Byzanz* 2, no. 311), and is in the present exhibition (Cat. no. 14).

We have called all these representations of the Mother of God at prayer 'the Hagiosoritissa'. This is an appellation proper to the icon of the Virgin of the *Hagia Soros*. It probably refers to the reliquary of some church at Constantinople with a celebrated precious relic of the Mother of God. This may have been a remnant of her precious girdle, kept in the church of the Virgin Chalkoprateia; or even her mantle, the proud possession of the Blachernai monastery. There was indeed a chapel at this monastery called *Hagia Soros*. In that case, the iconography of the Virgin Hagiosori-tissa may be descended from the icon of the Mother of God that people venerated at Chalkoprateia or Blachernai. The appellation Hagiosoritissa also appears on a seal of around 1040, now in the Dumbarton Oaks Collection (Seibt 1987, fig. 11); and the type of the Virgin at prayer again bears the same appellation in a late eleventh- or early twelfth-century Sinai hexaptych leaf which has, side by side on the upper register, five different iconographic types of the Mother of God. The hand of God does not appear in these representations; but elsewhere there are seals with the Virgin praying in the direction of the hand of God and having the appellation Hagiosoritissa (Laurent, 1965, nos 1431, 1462 and 1538). Thus we may assume that even within the group of isolated portrayals of the Virgin at prayer there were variants, and that for these variants the appellation Hagiosoritissa does not perfectly reflect the actual variety of the iconography.

Jannic Durand

Exhibitions:
Vingt ans d'acquisitions au musée du Louvre, 1947-1967, Orangerie du Tuileries, Paris 1967; *Byzance*, Musée du Louvre, Paris 1992.

Literature:
Coche de La Ferté 1961, 77; *Vingt ans d'acquisitions au Musée du Louvre*, no. 217; Coche de La Ferté 1982, doc. 544; *Byzance*, no. 177.

22
Pendant with the Virgin and Child

H. 2.9 cm, w. 2.25 cm, th. 0.8 cm
Steatite, very bright green
14th century(?)
Munich, Christian Schmidt Collection,
Inv. no. 1357

The small pendant is in relatively good condition. The boss from which it was suspended at its arched top has broken off. A small chip on its lower border, left, and a cut on the right arched border are the only damaged surfaces. The bottom left side on the front face seems to be more worn than any other area. Overall, the pendant has been quite rubbed since it is shiny on all its surfaces and has a uniform strong green tone.
The Virgin holding the Christ-Child in the type of the Hodegetria is represented on the obverse. Both figures are identified by an incised inscription just above the head: MP ΘY for the Virgin and IC XC for Christ. They are framed by an arch supported by thin, twisted columns which rest on relatively tall bases composed of two bars and a slightly flattened sphere with diagonal striations. The arch itself is decorated with a running 'omega' (ω) motif.
These framing devices bring this piece close to two other steatites, both from the fourteenth century, one depicting St George, in Vienna (Kalavrezou-Maxeiner 1985, pl. 67, figs 140, 141) and the other St Basil, in the Vatican. In both these examples although an arch frames the figure below, the stone is kept rectangular in shape, which is the case with all steatite pendants that have columns and arches as a framing device for figures. In the Virgin and Child pendant however, the columns and arch determine the shape of the top border. This detail makes the piece unusual.
A unique feature is a diamond-shaped cross carved in high relief on the reverse, creating the impression that it is attached to the back of the small plaque. These kinds of crosses are common in steatite but are usually double-sided and carved as independent small enkolpia (Kalavrezou-Maxeiner 1985, pl. 1). The cross is decorated with designs often observed on this type of cross: circular indentations at the ends of the arms and triangular fillers between the arms. It is, however, unusual to find such a cross on the back of an enkolpion. This combination is not only of a peculiar nature but also at variance with the common traditions of Byzantine aesthetics.

Ioli Kalavrezou

Literature:
Unpublished.

23

Pectoral Reliquary Cross

H. 9.5 cm, w. 5.5 cm
Copper alloy
11th century
Benaki Museum, Inv. nos 21990, 21991

Copper-alloy reliquary cross made of two separate pieces and hinged to open at top and bottom. The hollow interior was designed to hold relics. The relief decoration on both sides of the cross was cast. The anatomical details and drapery of the garments are enhanced by engraving. On the front, Christ crucified is shown between the diminutive figures of the Mother of God (left) and St John the Evangelist (right), inserted at the ends of the horizontal crossbar. Christ is clad in a colobium and stands on a *suppedaneum*. Above his head are the symbols of the sun and the moon. The *tabula ansata* is inscribed IC XC. Beneath each of his arms is a Greek inscription which reads: ΙΔΕ Ο ΥΙΟC COY ΙΔΟΥ Η ΜΗΤΗΡ COY (Behold thy son ; behold thy mother) (John 19:26-27). On the back is the Mother of God in orant pose, standing on a *suppedaneum*. She is wrapped in a maphorion, crossing over the chest and falling lengthwise over a tunic with fan-shaped folds. In roundels at the terminals of the cross are busts of the four Evangelists. In the field are the initials of their names.

The double-sided decoration of the Benaki cross is a standard feature of a large series of bronze crosses ranging in date from the tenth to the twelfth century. Crosses of the same iconography and technique represent 20% of a corpus of 700 pieces (Pitarakis 1996, group I3, 243-254). These crosses relate to more elaborate models such as the nielloed silver reliquary cross in the Benaki Museum (Cat. no. 24). Close parallels to the Benaki cross were found in graves in the atrium of the church of St Polyeuktos at Constantinople (Harrison 1986, no. 635, 270), in a cemetery which lay to the west and northwest of the church of St Dionysios the Areopagite in Athens (Travlos and Frantz 1965, 166-168), and in the substructures of a funerary church at Nicaea (Aslanapa et al. 1989, 226-227, 238, 244).

The workshops in which these objects were mass-produced were scattered throughout the Byzantine Empire, from Asia Minor, Greece, and the Balkans, to the Danubian area, as well as in Italy and the Crimea. The reliquaries they produced were not linked to specific pilgrim shrines. They were intended to hold a variety of relics together with fragments of wood of the True Cross. In the absence of internal compartmentation, relics were wrapped in separate pieces of cloth. Probably, they were secondary relics which had been in contact with an original relic. Bone fragments, scraps of cloth and stones have also been recorded in a few bronze reliquary crosses whose contents have survived. Some of them preserve residues of balsam, or incense and fragrant substances, that might also have been sanctified through contact with a primary relic (Pitarakis 1996, 35-40). Their sweet odour, perceived as a sign of holiness, may also have been considered to have the beneficial effect of ensuring good health. The practice of placing various anonymous relics of saints in a pectoral reliquary gained great popularity in the period following Iconoclasm. Worn around the neck, these crosses used to be the privileged amulets of the Byzantines. Archaeological contexts show that reliquary crosses of the same type were worn by individuals of both sexes and all ages, in life and in burial. The frequent occurrence of such crosses in monastic contexts, as well as in the fortresses in the Balkans, suggests that they were popular among monks and among soldiers of the Byzantine army (Atanassov 1995, 486).

Brigitte Pitarakis

Exhibitions:
Οι Πύλες του Μυστηρίου, National Gallery, Athens 1994.

Literature:
Xyngopoulos 1951, no. 33, pl. 27; Coche de La Ferté and Hadjidakis 1957, no. 62, pl. VI; Οι Πύλες του Μυστηρίου, no. 81.

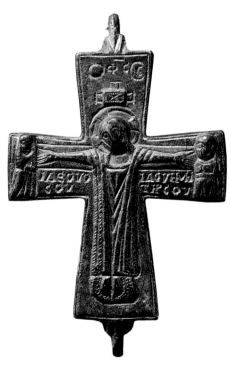

24

Pectoral Reliquary Cross

H. 7.1 cm, w. 3.3 cm
Silver and niello
11th century
Benaki Museum, Inv. nos 21992, 21993,
21994

Nielloed silver reliquary cross made of two box-like plates, fastened together at top and bottom by pins. The upper pin passes through loops projecting from the suspension ring. This cross was designed to be worn around the neck and contains an inner, openwork cross intended to hold the holy relic. It is paralleled by another silver reliquary cross, also in the Benaki Museum, that shares the same interlocking system (Inv. no. 11438). A precious prototype is the ninth-century gold reliquary cross from Pliska, made of three separate crosses, each placed inside the other. Through the apertures of the interior Pliska cross, decorated with a Crucifixion, a wooden cross with tiny bits of bone fixed to it is visible (Donkeva-Petkova 1976, 59, fig. 5). In 811, an enkolpion of the same type was sent as a gift by the Patriarch Nikephoros to Pope Leo III (Kartsonis 1994, 79). This multi-layered construction is borrowed from more elaborate reliquary boxes, such as the Fieschi Morgan staurotheke (*Glory of Byzantium*, no. 34). This internal compartmentalization is dictated by the juxtaposition in the same container of a variety of relics together with True Cross fragments.

On the obverse, this Benaki cross shows Christ crucified, clad in a long, sleeveless tunic or colobium, with two vertical clavi. Symbols of the sun and the moon are placed on either side of the *tabula ansata*, which is inscribed with the letters IC XC. The reverse bears the image of the Virgin orans standing on a *suppedaneum* and flanked by two winged angels holding staffs. The hand of God, represented descending from above, replaces the usual letters that identify the Mother of God.

The Benaki cross is related to a distinctive group of pectoral reliquaries, ranging in date from the ninth to the twelfth century. Apart from the jewellery examples made in gold or silver, mass-produced crosses in base metal were appreciated throughout all levels of Byzantine society (Galavaris 1999, 174-181). In types that appeared in the ninth century, the Crucifixion is usually combined with the Virgin Kyriotissa, shown holding the Child in front (Pitarakis 1998b). The two-sided iconographic scheme of the Benaki cross is found on the late ninth-early tenth century Beresford Hope cross decorated in enamel (Kartsonis 1986, fig. 31), and on an enamelled book cover in the treasury of San Marco, Venice, of the same date (*Treasury of San Marco*, no. 9). The combination of the Virgin orans and the Crucifixion recurs on the tenth-century Vicopisano reliquary cross in nielloed silver (Kartsonis 1986, fig. 25). Yet, on this example the orant Virgin is the central figure of the Ascension scene. A nielloed Virgin orans similar to the one on the Benaki cross is found

on a bronze reliquary cross in Sofia, dated to the tenth-eleventh century (*Bulgarie Médiévale*, no. 29). On the Sofia cross, however, the Virgin is surrounded by the four evangelists in medallions. The grouping of the four Evangelists around an image of the Incarnation, a standard feature of tenth-twelfth century reliquary crosses, may be linked to the iconography of Gospel lectionaries (*Glory of Byzantium*, no. 43). The bilateral composition of the Benaki cross and related examples is intended to stress the dogma of Incarnation and Salvation, which is re-enacted in the sanctuary of the church in the course of the eucharistic liturgy. The beneficial effect of this object of private piety also lies in its connection to the liturgy and the decoration of the sanctuary.

The presence of the hand of God, oversized in relation to the remaining figures, brings to mind the apse decoration in the Koimesis church at Nicaea, restored soon after the Iconoclastic Controversy (post-787 or post-843). Around the hand of God is an inscription adapted fom the text of Psalm 109:3: 'I have begotten thee from the womb before the morning', a remnant from an original pre-Iconoclastic composition (Mango 1993-1994, 168-170). The Nicaean composition compares with the mid-sixth-century apse mosaic in the basilica Euphrasiana at Parenzo, where the enthroned Virgin and Child is flanked by two archangels, while the hand of God holding a crown extends from the sky (Prelog 1994, 74, pl. 50). This iconography is intended to

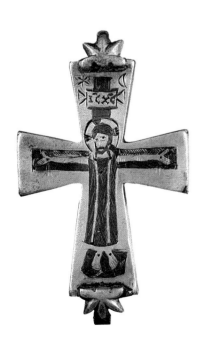 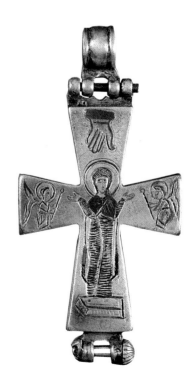

underline the divine nature of the Incarnate Child and the pre-existence of the Word. At the same time, it stresses the intercessory power of the Virgin and the soteriological message of the Incarnation. In Middle Byzantine programmes, the hand of God is attested in the apse of the Virgin Chalkeon (1028) at Thessaloniki, where the Virgin is also flanked by two angels. The two angels in a bent pose with outstretched hands are closely related to the iconography of the Benaki cross. The dedicatory inscription on the triumphal arch of this church begs for the intercession of the Virgin in the remission of the sins of the founders, who are buried in the same church (Gerstel 1999, 81-82). The relation between the image and invocative prayer in the context of the Virgin Chalkeon church explains the protective value of the cross and its salvationary message. In other apsidal compositions of the eleventh-century, such as in the funerary chapel of the church of Eski Baca in Cappadocia, the hand of God is replaced by the bust of Christ Pantokrator in a medallion (Lafontaine-Dosogne 1972, 167-178). The association of the hand of God or the Christ in a medallion with an image of the Incarnation reflects the growth of interest in representations of the different ages of Christ-the Word in the eleventh and twelfth centuries (Boespflug-Zaluska 1995, 298-302).

The eleventh-century was marked by an overall intensification of the cult to the Virgin and a proliferation of the intercessory types and appellations of her. The image of the Virgin orans, named Blachernitissa, was introduced on coin issues of Constantine Monomachos (1042-1055) who also chose this image for the decoration of the Nea Moni on Chios (Grierson 1973b, 736 and 745-747; Mouriki 1985, 107-108, 201, fig. 1). In addition to the iconography of the Virgin, the colobium-clad Christ on the cross is also paralleled by eleventh-century psalter illustrations, such as the Bristol (Dufrenne 1966, fol. 110r, pl. 54) and the Theodore psalter (Der Nersessian 1970, fol. 23r, fig. 41, pl. 15; fol. 87v, fig. 142, pl. 48). In the light of the above considerations, an eleventh-century date is probable for the Benaki reliquary cross and the group to which it belongs.

Brigitte Pitarakis

Exhibitions:
Gold of Greece, Dallas Museum of Art, Dallas 1990; *Οι Πύλες του Μυστηρίου*, National Gallery, Athens 1994; *Glory of Byzantium*, The Metropolitan Museum of Art, New York 1997.

Literature:
Gold of Greece, pl. 61; *Οι Πύλες του Μυστηρίου*, no. 84; *Glory of Byzantium*, no. 123.

Pectoral Reliquary Cross

H. 7.3 cm, w. 4.3 cm, th. 0.7 cm
Copper-alloy
11th century
Mellon Donation
Athens, Benaki Museum, Inv. no. 35552

Copper-alloy pectoral reliquary cross made of two separately cast hollow plates, front and back, hinged with a clasp. A suspension ring was originally attached to the upper arm. The decoration on both sides is engraved. The Crucifixion on the front is combined with the Virgin orans on the back. Christ is shown on the cross, with outstretched hands and wearing the colobium. He stands erect on a *suppedaneum*, while the symbols of the sun and the moon are placed above the *tabula ansata*. In contrast to the traditional iconography that is found on reliquary crosses with cast decoration, the Virgin and St John the Evangelist are absent from the composition. Furthermore, the traditional words that Christ addressed to his mother and disciple (Cat. no. 23) are replaced by the victorious formula: IC XC NHKA. The standing Virgin, identified as Theotokos, has her hands raised in the gesture of prayer and wears the maphorion decorated with dense linear folds. Stars are placed on either side of her torso and above her head.

The Benaki cross finds close parallels in a large group of 70 reliquary crosses that have been gathered in a corpus of 700 pieces. All the pieces of this group share in common the same iconographic details and a similar treatment of the bodies and the costumes. 25% of these related examples originate from archaeological contexts (Pitarakis 1996, group III1, 265-273). Four reliquary crosses bearing the same iconography were found in the basilica of St John the Evangelist at Ephesus (Pitarakis 1996, nos Eph. 005-Eph. 008). These finds were mostly concentrated in the Middle Byzantine cemetery, which developed around the grave of the evangelist on both sides of the transept (Keil and Hérmann 1951, 193-194). Another example of the same type was found in the substructures of a funerary church at Nicaea (Aslanapa et al. 1989, 226-227, 238, 243). Other examples were found in domestic contexts in Medieval fortresses in the Balkans. At Djadovo, Bulgaria, the cross was found in a dwelling containing an anonymous *follis* dated to the eleventh century (Djadovo 1989, 274-275, fig. 320a). At Branikevo, Serbia, it was found in a twelfth-century context (Popović and Ivanisević

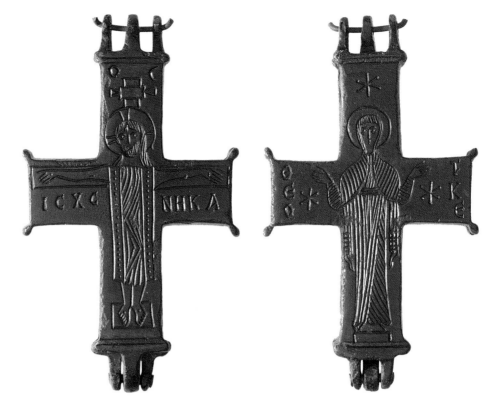

1988, 140, 177, fig. 11). Most of these mass-produced objects are characterized by a cursory drawing. The delicate treatment of the figures on the Benaki cross, the regularity of the deeply engraved lines, and the movement of the folds in the costume of the Virgin, as well as the punched circles along the vertical clavi of the colobium are signs of a piece of higher workmanship.

The Crucifixion on the Benaki cross and group to which it belongs is an abstract composition with a strong symbolic power. The image is intended to stress the Victory of Christ over Death. The combination of the *victorius* formula and the Crucifixion is not common in Byzantine iconography: usually the letters IC XC NHKA are placed between the arms of aniconic crosses. On ivories it can also be found on crosses bearing medallions of saints. An example are the crosses on the outer lateral wings of a tenth-century triptych with the Crucifixion in the British Museum (Cutler and Spieser 1996, fig. 128). The presence of the *victorius* device on the Crucifixion enhances the amuletic function of the cross and the relics that it contains.

Crosses of this type were popular in the eleventh-twelfth centuries, when Byzantine armies were active on both fronts of the Empire, the Balkans and Anatolia. Their

probable use by the soldiers of the Byzantine army may have influenced their iconography. At the same time, the message of salvation that is inherent in the iconography of these crosses is related to the eucharistic liturgy. The letters IC XC NHKA were traditionaly stamped on the eucharistic bread *(prosphora)*. However, the origins of this practice are difficult to determine with certainty (Walter 1997a, 198-201).

Brigitte Pitarakis

Literature:
Unpublished.

26
Pectoral Reliquary Cross

H. 8.0 cm, w. 4.5 cm, th. 0.8 cm
Copper-alloy
11th century
Mellon Donation
Athens, Benaki Museum, Inv. no. 35556

Copper-alloy pectoral reliquary cross made of two plates with engraved decoration. On the front, the Virgin orans is flanked by busts of Sts Peter and John, identified by inscriptions. On the back is the standing figure of St Stephen in the same attitude of prayer, flanked by two stylized censers that reproduce the costume ornament on his torso.

From the eleventh century on, workshops producing bronze reliquary crosses introduced a great variety in their iconographic repertoire. Together with the standard composition which combines the Crucifixion with the Virgin orans (Cat. nos 23, 24), a range of saints represented in an attitude of prayer is encountered. The Mother of God, shown in combination with intercessors of privileged rank, was accorded a wide variety of appellations, such as ΜΗΤΗΡ ΘΕΟΥ (Mother of God), ΠΑΝΑΓΙΑ (All Holy), ΜΗΤΗΡ ΧΡΙΣΤΟΥ (Mother of Christ), that add to the label 'Theotokos' often found on earlier crosses (Kalavrezou 1990). These are standardized figures characterized by very simple linear drawing. In the pictorial language of this group of objects, figural representations merge with basic geometric ornaments. This shared language, common to a network of workshops scattered throughout the empire, is not borrowed from the higher levels of society. Rather these imitations operated horizontally within the broad base of the economic pyramid. In contrast to the overall tendency in other artistic media, including precious enamelled or nielloed pectoral reliquary crosses, the iconography of bronze reliquary crosses does not make any formal distinction between the categories of saints. Emphasis here is given to their conventional orant pose. The same figures, with minor changes in the ornament of their costume, often appear on both sides of reliquary crosses. These are distinguished by a superscripted identifying inscription. Crosses of this type were made in series in all parts of the Byzantine Empire. Their major area of distribution is Asia Minor, but they are also found in the Balkans, the Danubian region and Italy.

St Stephen the Protomartyr is a relevant figure to be placed on a cross-shaped reliquary.

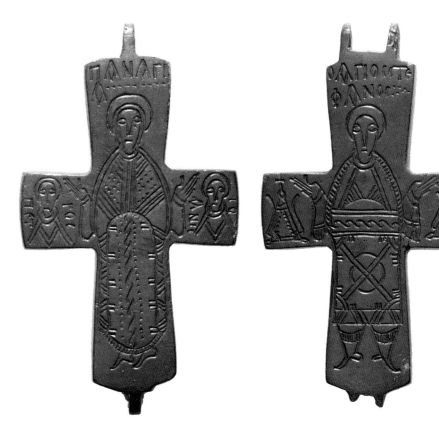

The victorious connotation of his name, which alludes to the crown of victory, strengthens the power of the cross. St Stephen is also a major intercessor, often associated with healing saints (Jolivet-Lévy 1991, 77). As a deacon saint, Stephen is usually part of the decorative programme of the sanctuary in Middle Byzantine churches. The link that he brings with the eucharistic liturgy is another element enhancing the beneficial effect of the cross. The selection of Sts Peter and John as flanking figures of the Virgin orans can also be perceived as an allusion to the eucharistic liturgy. In representations of the Communion of the Apostles, which developed from the eleventh century onwards, these two saints are often shown as leaders of the apostolic collegium (Gerstel 1999, 50-51).

In the iconography of bronze reliquary crosses, Stephen is usually shown with the attributes of deacon saints. He wears the characteristic orarion, a narrow stole decorated with crosses, and carries a censer in his right hand. A hook-attachment for suspending the censer often hangs from his left hand. Among numerous examples, we cite a reliquary cross in the British Museum (*A Guide to the Early Christian and Byzantine Antiquities*, 30, fig. 16). A similar reliquary cross combining St Stephen with the Virgin, shown with the Christ-Child

in front of her chest, is now in Berlin (Wulff 1909, 197, no. 927, pl. XLV). This iconography of St Stephen in orant pose is also recurrent on flat pectoral crosses without a cavity for relics, as well as on larger crosses for processional use. There is a pectoral cross of this type in Berlin (Wulff 1909, 198, no. 938, pl. XLV). A processional cross with the engraved figure of the same saint was found in a room identified as the *skevophylakion* (sacristy) in a Middle Byzantine church at Porto Lagos Thrace (Kourkoutidou-Nikolaidou 1972, 374-380, esp. 376, fig. 4). This group of crosses with Stephen orant can be dated to the eleventh-twelfth century.

Brigitte Pitarakis

Literature:
Unpublished.

27
Medallion with the Virgin Orans

Diam. 6.8 cm
Bronze
12th century
Munich, Christian Schmidt Collection,
Inv. no. 919

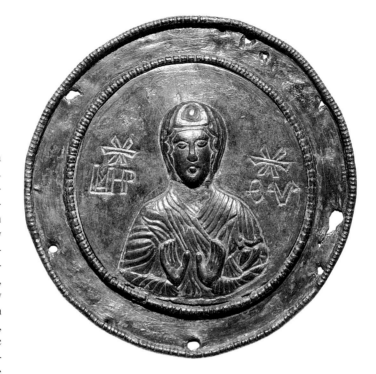

A cast bronze medallion soldered onto a larger circular plate with a beaded border. The frame of the plate is drilled with irregular holes intended for affixing it to some surface. The medallion bears the orant Virgin with open hands in front of her chest. It may have served as a revetment plaque on a reliquary box or a book cover. Medallions of similar type, in enamel set in a beaded border, are fixed on an eleventh-century copper-alloy reliquary box in the treasury of the Sancta Sanctorum, Lateran (*Splendori di Bisanzio*, no. 69). The central roundel without its frame may also have once belonged to a large processional cross. A tenth-century parallel is the repoussé medallion of the Virgin on the large silver cross in the Lavra monastery on Mt Athos (Grabar 1969). This iconographic scheme became a standard feature on eleventh-twelfth century crosses of varying dimensions, intended for both private and public use. The same image was also widely reproduced on seals, cameos, and a variety of jewellery artefacts, the dates of manufacture of which range from the second half of the tenth to the twelfth century.

The popularity of the iconographic type of the Virgin on the bronze medallion coincides with a general proliferation of images of intercessory types of the Virgin in all kinds of media. Byzantine emperors of the eleventh and twelfth centuries expressed an ever increasing piety toward the Virgin, regularly introduced into their coin iconography. At the same time, the contemporary eucharistic ritual increasingly emphasized the Virgin's intermediary role between God and mankind. In the decorative programme of the church of Nea Moni on Chios (1042-1056), commissioned by Constantine IX Monomachos, a monumental Blachernitissa orans rules over the apse, while the Virgin orans in medallion with open hands in front of her chest, surrounded by martyrs in a similar attitude, is located in the small cupola of the narthex (Mouriki 1985, 139-140). A parallel of larger dimensions made in a precious material is the serpentine roundel of Nikephoros Botaneiates in the Victoria and Albert Museum (around 1078-1081) which is identified by the inscription that runs around the frame (Cat. no. 17).

It has been suggested that this medallion had been an element in the emperor's tomb (*Glory of Byzantium*, no. 130). A request for similar treatment is known from the will of Isaac II Komnenos, who wished his enkolpion with the Virgin to be set on his tomb as a sort of revetment (Ševčenko 1984, 137).

The double-stroke script used for the sigla MP ΘY is common on a group of copper-alloy liturgical vessels dating from the tenth to the twelfth century (Mundell Mango 1994). The crosslet at the centre of the superscript bar is a decorative device that was widespread in mosaic inscriptions from the eleventh century, such as in Hosios Loukas in Phokis (N. Chatzidakis 1996, pls 31, 32, 35) and St Sophia in Kiev (N. Chatzidakis 1994, pls 125-126). The stylistic approach to the image of the Virgin on the bronze medallion, the ornamental treatment of the garments, such as the undulating edges of the maphorion and areas of rounded folds, point to a date in the early twelfth century.

Brigitte Pitarakis

Exhibitions:
Rom und Byzanz2, Prähistorische Staatssammlung, Munich 1999.

Literature:
Rom und Byzanz2, no. 20.

28

*Icon of the Virgin Brephokratousa with
Figures from the Old and the New Testament*

48.5 × 41.2 cm
Egg tempera on wood
Mid-12th century
Constantinople(?)
Egypt, monastery of St Catherine at Sinai

This icon is one of the earliest surviving examples of a way of depicting the Virgin Brephokratousa that not only provided Byzantine art with some of its most attractive icons of the Virgin with the Child in her arms, but also furnished models for panels of a similar kind by the great Italian masters of the international Gothic style and hence for the Madonnas of the Renaissance. The present icon perfectly epitomizes a major change of direction in Byzantine art. This change can first be traced in eleventh-century works and is linked to a broader shift in world-view also found in Byzantine literature of the same date.

One characteristic feature here is the choir of figures from the Old and New Testaments. The figures are in the compartments surrounding the central image of the Virgin Mary seated on her throne. This they annotate, for all the world like a company of actors, in a number of different ways, enhancing its content with a complex system of theoretical associations. So artful and so carefully planned is this system that, when projected onto the central representation, so far from overloading the latter's aesthetic qualities, it actually brings them out, at the same time elucidating the figures' human dimension. It is precisely this human dimension that is the icon's fundamental innovative element, both with regard to content and with regard to the pictorial means of rendering the elements of nature and the behaviour of the persons portrayed: so that this work seems a 'living icon' (Belting 1994, 261ff.).

The figures set in a row on the icon's vertical axis are, reading from top to bottom: Christ Pantokrator, the Virgin Brephokratousa and Joseph. They are accompanied by the figures from the Old and New Testaments that frame them. This composition forms a single well-articulated plan, joining in logical sequence all the elements that are of significance in one way or another for the procession of the Incarnation of the Word. These elements are grouped into four interrelated thematic units, which make up a 'ladder' of four steps that can be read in either direction. The ladder's steps can be defined as follows: 1) the

declaration of the Word unchanged with time; 2) the foretelling of the Incarnation of the Word; 3) the natural origin of the Word Incarnate; and 4) the recognition of the Word Incarnate. The first step refers to the figure of Christ Pantokrator, and the other three refer to the figure of Mary with the Child in her arms. The icon's space around the Virgin Brephokratousa is organized by means of these steps, which enhance her as the central subject, the first functioning as a roof for the whole of the upper section, the second and fourth as vertical walls with absolute symmetry between them, and the third being exactly underneath the central image.

In the first of the steps there is articulate speech involving four male figures. right and left of the panel, with the figure of Christ Pantokrator. These figures are St John the Theologian, St John the Baptist, and the two great Apostles Paul and Peter. Their speech serves as both prologue and epilogue, for it connects the past and the future of the Incarnate Word, whose timelessness the very inscriptions written on their scrolls proclaim. God the Word, as 'King of Glory', is seated on a rainbow; is escorted by cherubim and seraphim; and stands upon a circular halo from which the four symbols of the evangelists project. There are two pairs of figures conversing, gesturing to each other, turning their heads towards one another: St John the Theologian talking to the Apostle Paul, and St John the Baptist to the Apostle Peter. The pictorial result has a sense of theatre and tends to produce a flow between the pictorial space and the viewer's space. This sophisticated way of representing figures is linked to an interest in pictorial rendering of everyday human life, the object being the emotive effectiveness of the icon. This seems to be an eleventh-century development, that was to lead to 'living icons'.

In the second of the steps there is articulate speech involving the eleven prophets. These are arranged two by two in the lower side panels: Aaron, Moses, Jacob, Ezekiel, David, Isaiah, Daniel, Barlaam, Habbakuk, Solomon and Gideon. With the inscriptions on their scrolls and their accompanying symbols, all these foretell the Incarnation of the Word by the Virgin Mary. The linking of the figures of the prophets (who are placed symmetrically in respect of the vertical axis) with the Virgin Brephokratousa is achieved by turning their heads and by their gestures, depending on what place they occupy on the vertical sides of the icon. The diametrically opposed prophet figures seem to be in dialogue one with another, their movements, their poses

and the texts written on their scrolls answering each other. This has the effect of a continuous conversation involving the icon's whole space. At the head of the prophets is the Patriarch Jacob. He is shown twice in one and the same compartment: first as a young traveller lying down and dreaming his dream of the Ladder to Heaven — a classic prefiguring of the Virgin Mary — and second as an old man, his outstretched arm pointing to the Virgin Brephokratousa in the centre, who has now been perfected in the fullness of time. At the extension of Jacob's arm the painter placed the Magus Barlaam, whose scroll notes Jesus' descent from Jacob, with the Star of Jacob to accompany him.

The third step refers to the natural descent of the Word Incarnate. This is shown in the figures of Christ's first and last natural ancestors. We can identify the figures framing Joseph (exactly beneath the Virgin Brephokratousa) as these ancestors, thanks to a majuscule inscription under the Virgin's footstool, which reads as follows: 'Joachim and Anne begat children, and Adam and Eve were set free'. This is a variation on the opening lines of Romanos the Melodos's hymn for the Nativity of the Virgin (Maas and Trypanis 1963, 276). Anne and Eve, as like as two peas in a pod, and their husbands Joachim and Adam, make a frame for Joseph, the earthly husband of Mary. Anne's and Joachim's childlessness is removed by the miraculous conception and birth of their daughter Mary, the main means of incarnating the Word and therefore the salvation of the entire human race, represented by Adam and Eve.

In the fourth step there is articulate speech involving the four elderly figures of the New Testament coeval in time with the Word Incarnate. They are organized into two opposite pairs, inserted into the vertical series of prophets halfway up the icon. Together with the central picture, they form an isosceles cruciform pattern: the High Priest Symeon, Accepter of God, and Anna the Prophetess to the left; and the High Priest Zacharias and Elizabeth, to the right; all recognizing the Saviour of the world in the Child of the central picture. Elizabeth's childlessness is removed; and her pregnancy is officially acknowledged in the course of Mary's visit, and recorded in the inscription on her scroll. Diametrically opposite is the figure of the Prophetess Anna. Now widowed and well on in years, she goes about the temple awaiting the coming of the Messiah, whom she at last finds in the person of Christ, this likewise being recorded on her scroll.

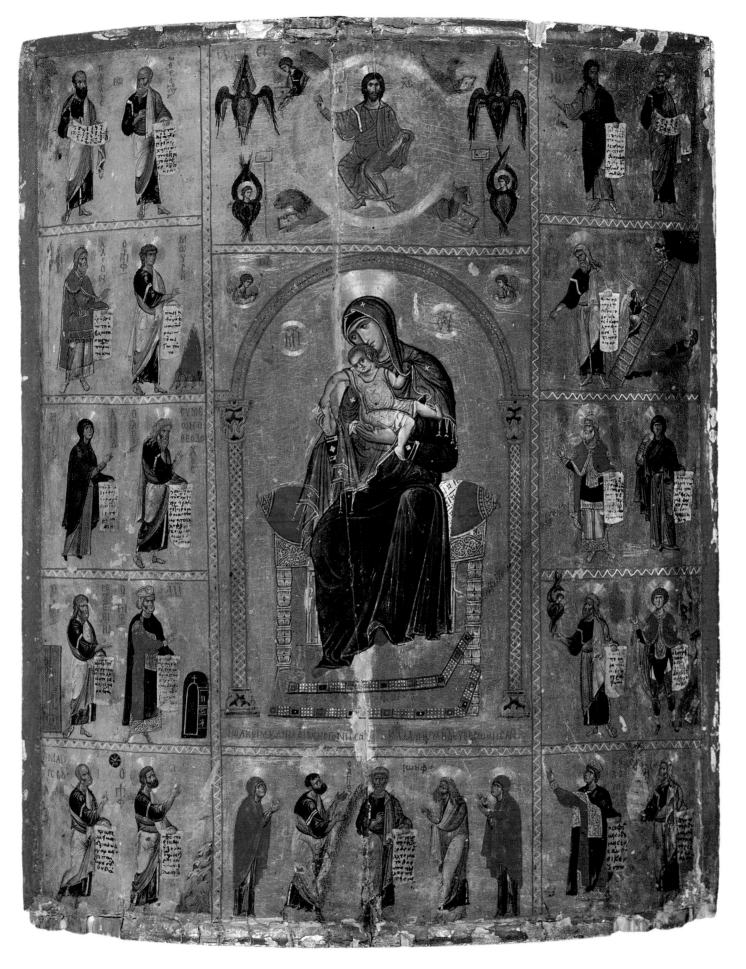

It is on Symeon that the Virgin's gaze seems to rest. The inscription on his scroll prefiguring her future sorrows (Maguire 1980-1981, 267) accounts for her melancholy, in contrast to the unsuspecting Infant, carefree and out of harm's way in his mother's arms, playing with her maphorion and looking as if ready to toss the closed scroll with its ribbon, symbol of the Law, high in the air when his mother offers it to him—here using it as a child's toy. His slight smile chimes with the gaze full of curiosity with which he looks straight at the viewer. The Virgin's motherly care is expressed in the way in which she leans her face on the dark hair of her little child. The postures of mother and child express a strong emotional relationship, even though their eyes do not meet.

As regards his pose, movement and attire, the Christ-Child is at some remove from the usual representations, which show him seated in his mother's arms, a child with the face of an old man, dressed like a classical philosopher, in chiton and himation, with one hand holding the teacher's closed scroll and the other lifted in blessing, as he looks the viewer straight in the eye with awesome seriousness (Antonopoulos 1986, 276; Antonopoulos 1998, 226-228). Here the short, sleeveless tunic, slightly lifted above his diaphanous underclothing, gives him the freedom to move his arms and legs vigorously, in a display of natural good health and robustness. In the figure of Jesus this painter has rendered, with great liveliness, the good-looking, agile, pampered infant of some aristocratic family, in costly baby clothes. There are literary parallels for this pictorial treatment of the Child in the present icon: for example, Michael Psellos's *Encomium* to his grandson, or his *Ekphrasis* of a sleeping cupid, two texts that accord with the emphasis given to the years of infancy and strike a note new in Byzantine literature (Littlewood 1985, nos 38 and 34; Angelidis 1998, 84). Other pictorial manifestations of a greater feeling for infancy can be seen in the miniatures of a manuscript of the *Homilies* of James of Kokkinobaphos (Vat. gr. 1162), dating to the mid-twelfth century (Anderson 1991a, 100ff.). In his paintings of the Virgin's birth and upbringing, the artist of the miniatures has caught the aristocracy's tender care for its young sprigs, his inspiration evidently being the courtly surroundings of the donor of the manuscript, the Sebastokratorissa Irene.

All the female figures in the Sinai icon appear with their husbands (except for Anna the Prophetess, who is shown with Symeon), and they make up four nuclear families occupying the four ends of the icon's diagonals. The couples Zacharias-and-Elizabeth and Joachim-and-Anne, who are completing their biological cycle by begetting children through the will of God, are paired with the archetypal couple Adam-and-Eve and the earthly couple Joseph-and-Mary. Once we link these four marital couples related by blood, and their descendants, to the special relationship seen between the Virgin Mary and the Holy Infant, and to the rendering of the Christ-Child as an aristocratic baby, we can clearly see the new importance of descendants and of the institution of the extended family in the twelfth century (Kazhdan and Epstein 1985, 99ff.).

The upgrading of the years of infancy and the emphasis here on the institution of the family—as seen in the Holy Child, the Holy Family, and the rest of the marital couples—is far removed from the ideals of monastic life. One must therefore infer that this icon was not created in the Sinai monastic environment. Its bourgeois character and high artistic quality make it one of the works produced in the Constantinopolitan workshops of the twelfth century (Belting 1994, 290; Mouriki 1990b, 105). Since its model was one of the venerated icons in the celebrated Blachernai monastery, the Sinai icon must have been commissioned by some aristocratic family of Constantinople for its own private use, on the occasion of the birth of a new member in the family, whose social features were reproduced by the painter in the figure of the Holy Child.

Titos Papamastorakis

Exhibitions:
The Glory of Byzantium, The Metropolitan Museum of Art, New York 1997; *Η Δόξα του Βυζαντίου στο Όρος Σινά*, Benaki Museum, Athens 1997.

Literature:
Sotiriou 1956-1958, 73-75, pls 54-56, 2; Galavaris 1980, 9-10; Maguire 1980-1981, 267, pl. 12; Weitzmann et al. 1982, 17, pl. on 18; Babić 1988, 63-65; Etinhof 1988, 142, 146, 153; Belting 1994, 290-291, 294-296, pls 174, 178; Mouriki 1990, 105, pl. 19; Carr 1993-1994, 239-248; Corrie 1996, 45-52, pl. 3; *Glory of Byzantium*, no. 244; Etinhof 1997, 38-40.

29
Icon of the Virgin Hodegetria

30 × 20 cm (37 × 30 cm with frame)
Egg tempera on wood
Early 14th century
Constantinople(?)
In the State Museum of the Moscow Kremlin
since 1927
Moscow, State Museum of the Moscow
Kremlin, Inv. no. 1886/I

The Virgin is shown in bust with the Christ-Child in her left arm, in one of many variants on the Hodegetria type. Here—in contrast to portrayals of the 'austere' type—her pose clearly suggests her personal relationship with He, for she bends her head slightly towards him. Christ, too, turns in her direction, and makes a gesture of blessing with his right hand. A distinctive feature of the icon is the way the Virgin's left hand gathers the edge of Christ's robe between thumb and forefinger. This iconographic detail conveys one of the most famous motifs in Byzantine hymnography, where Christ's flesh is likened to the fabric woven in the Virgin's womb. Yet one more individual feature of the icon is the position of the Virgin's right hand, lifted relatively high in a gesture of prayer. This pose is evidently directed not simply towards Christ, but towards the person revering the icon, for whose safety the Mother of God is also praying. The Virgin must therefore combine tenderness and intercession in her gesture (Kondakov 1915, II, 239).

Icons of the Virgin Hodegetria in the 'tender' (as distinct from the 'austere') iconographic type are discussed in the literature from early on. Kondakov (1915, II, 211-249) placed them in a special group. Antonova (1960) has also dealt with this type. For Tatić-Djurić (1969, 335-354), the 'tender' type derives from the icon in the monastery of the Virgin Peribleptos at Constantinople, founded by Emperor Romanos III Argyros (1028-1034). This monastery was destroyed during Latin rule and rebuilt on the return of the Palaiologoi (1261). In the view of Tatić-Djurić, the Peribleptos icon and that of the Virgin Hodegetria were the two most prized icons of the Mother of God in the Byzantine world.

Though no traces of an appellation have survived on the Kremlin icon, it displays close similarity to an early fourteenth-century Ochrid icon of the Virgin bearing the inscription 'Peribleptos' (*Trésors Médiévaux*, no. 25). The Child's pose, as if he has just tipped backwards, his facial expression and, his monochrome scarlet-ochre garment, with gold stri-

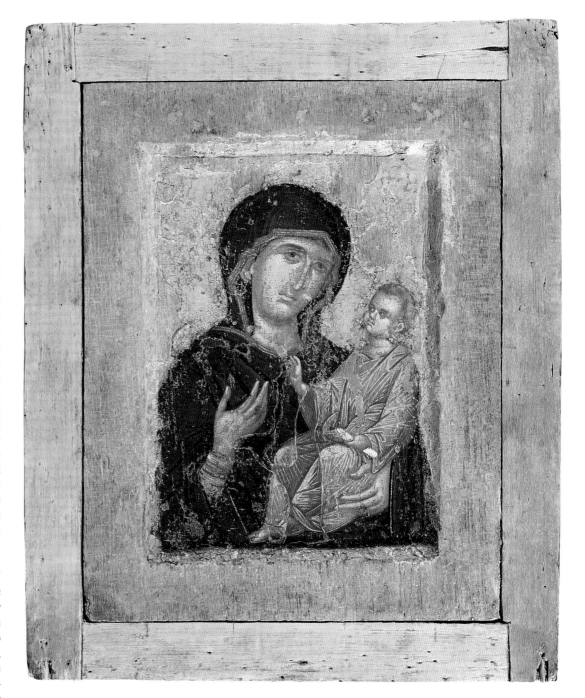

ations, the type of the Virgin's face, the motion of her right hand and, lastly the angular crease in the mantle on her forehead are all repeated in both icons.

One further Byzantine icon of the Virgin Brephokratousa, now in the Sergievo-Posad Museum, and dating from the late fourteenth century, has elements similar to those in the above icons, though not identical (Nikolaeva 1977, pl. 98). In her study of this icon, Nikolaeva establishes that the appellation 'Peribleptos' is not encountered in Byzantine hymnography, and therefore cannot be regarded as a widespread honorific name for the Virgin, but must have been more of a toponymic nature. There is also another icon of the same type in the Sergievo-Posad Museum (Nikolaeva 1977, pls 32, 95-96). These comparisons enable us to infer that the archetype of all the above icons was in fact at Constantinople, in the monastery of the Virgin Peribleptos, which was restored in the course of the fourteenth century.

The Kremlin icon of the Hodegetria was published by Iakovleva, who dated it to the last third of the fourteenth century (Iakovleva 1991, 109-113). Approximately the same date has been proposed by Popova (1991, 37-39). As has been argued elsewhere (Ostashenko 1997, 24), both the iconography and the technique suggest that the icon should be given an earlier date. The choice of specific iconographic elements — for instance the postures of the Virgin and the Christ-Child, and in particular the motion of the Virgin's hands — are characteristic of Middle Byzantine art (Kondakov 1915, II, 264; Tchubinashvili 1957, pls 32-33) and above all of the thirteenth century (Papastavrou 1993, 141-168), but they are not met with in ripe fourteenth-century art. Features such as the Virgin's large face, her broad shoulders, the lively expression on Christ's face, their gestures and the volumes of their bodies, as well as the choice of bright, vivid colours, all have their counterparts in the art of the early fourteenth century, but were abandoned afterwards.

The technique of the Kremlin icon allows us to compare it with the greatest monuments at Constantinople — such as the mosaic decoration of the Pammakaristos monastery (Fethiye Çamii) — and to advance the hypothesis that it was made in one of the capital's finest workshops.

The icon is painted on a single panel of walnut wood, with limewood trusses. Its painted surface has suffered slight damage and has at certain points disappeared, along with the priming.

Elena Ostashenko

Conservation:
The icon was cleaned in 1986-1990 by the Kremlin Museum's conservator, A.I. Iakovleva.

Exhibitions:
Vizantija. Balkany. Rus'-Ikony XIII-XV vekov. Tretyakov Gallery, Moscow 1991; *Moskva I greceskaja Kul'tura*, Church of the Annunciation, Kremlin, Moscow 1997.

Literature:
Popova 1991, 37-38; *Vizantija. Balkany. Rus'.* 1991, no. 42; Iakovleva 1996, 109-113; Ostashenko 1997, 24.

318

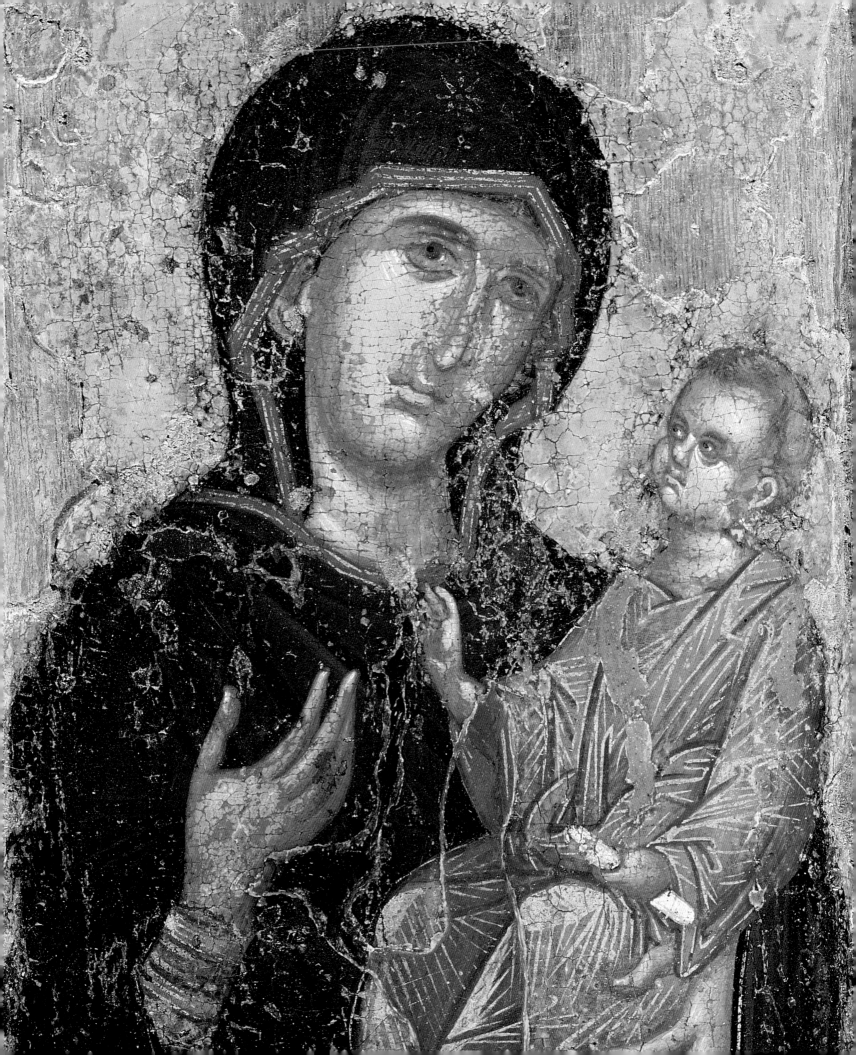

30

Reliquary Diptych. A. *Virgin with Christ-Child.* B. *Christ Pantokrator*

27.5 × 38.5 cm (each leaf)
Egg tempera on wood
1367-1384
Cuenca, Santa Iglesia Catedral Basílica
de Cuenca

The sumptuous Cuenca cathedral reliquary diptych consists of two leaves with similar iconographic layout. The right leaf shows Christ at the centre, standing, with fourteen saints in bust around him. The left leaf shows the Mother of God at the centre, standing, with (once more) fourteen saints in bust around her.

Both leaves are covered with silver-gilt revetment decorated with plant motifs either incised or repoussé. Jewels and pearls adorn the contours of the frames, defining the figures of Christ and the Virgin, their bodies, the border lines between the saints, all the haloes and the rectangular openings for saints' relics. On the haloes of Christ and the Virgin there are decorative enamels. Of an original 954 pearls, 239 gemstones, and 73 large stones, 939 pearls and 67 stones remain.

On both leaves the space is divided into rectangular panels, their straight lines lending an impression of orderliness, stability, and austerity.

On the right leaf the Pantokrator stands lissom and bolt-upright, as Emperor of Heaven. Clad in a purple chiton and a blue himation, he makes a gesture of blessing with his right hand and holds a Gospel in his left. At Christ's feet and to his left there was originally a portait of Thomas Preljubović, Despot of Ioannina, crouching: this figure was obliterated after Thomas' death in 1384. The saints round Christ are distributed as follows. In the top row are four of the Apostles: (reading from left to right) Andrew, Luke, Thomas, and Bartholomew. In the bottom row (reading from left to right) are the deacons Laurence and Stephen the Protomartyr, and the saints Stephen the Younger and Theodore Sykeotes. On the left side (reading from top to bottom) are the bishop saints John Eleimon, Spyridon, and Eleutherios. On the right side (reading from top to bottom) are St Blaise, St Antypas, and St Paul the Confessor.

On the left leaf the Virgin is shown upright at centre, as Empress, the Holy Infant in her arms. She wears a maphorion and a blue ankle-length himation, with red and gold hem.

The Christ-Child wears an ochre chiton with touches of white.

The Mother of God is, like Christ, surrounded by fourteen saints. They are distributed as follows. In the top row are four saints: (reading from left to right) Theodore Teron, Theodore Stratelates, Anne and Prokopios. In the bottom row are four more saints: (reading from left to right) Pelagia (this may be Pelagia the Martyr or Hosia Pelagia), the Anargyroi Cosmas and Damian, and Panteleimon. On the left side (reading from top to bottom) are the saints Artemios, Eustratios and Barbara. On the right side (reading from top to bottom) are the saints Nicholas the Younger, also known as Nicholas of Vounaini (Thessaly), Gourias and Samonas.

Crouched at the Virgin's feet there is a tiny portait of a richly-dressed female figure wearing a crown with painted pearls. The figure would be difficult identify, were it not for an inscription above her body, reading (in translation): 'The Empress Maria Angelina Doukaina, the Palaiologina'. This must be the wife of the Serb Thomas Preljubović, who made himself Despot of Ioannina from 1367 until 1384, when he was assassinated. The Empress Maria Palaiologina was the daughter of Symeon Urosh Palaiologos, Emperor of 'the Romans (i.e. the Byzantines), the Serbs, and every Albanian'. Symeon's seat was at Trikala in Thessaly. Maria's brother, John Urosh Palaiologos, abdicated his succession to the throne, to become a monk in the monastery of the Transfiguration at Meteora, during the lifetime of its original founder, Athanasios of Meteora. John (to give him his secular name), or Ioasaph, as he became on assuming the monastic tonsure, succeeded Athanasios. After his death he officially became 'St Ioasaph' and the 'second founder' of the monastery. His sister Maria assisted the monastery's expansion by her donations, enabling Ioasaph to build the first katholikon. Among these donations, as Nikolaos Bees was to discover in 1908, was an icon, similar to the left leaf of the Cuenca reliquary box. He published his find under the title 'A Meteora panel dedicated by the empress Palaiologina' (Bees 1911, 177ff., fig. 1).

The 'panel', as he called it, is still in the monastery today. It is clearly not, as later scholars have mistakenly argued, a leaf from a second diptych, but an icon with the same iconography as on the left Cuenca leaf. In the latter, the openings cut for the saints' relics are empty: this must be because the relics were removed deliberately, at some date

unknown. The Meteora icon has, however, two differences from the Cuenca diptych. The figures of the Mother of God and the saints were not adorned with jewels or pearls, and the inscription above the Empress Maria Palaiologina is not identical: it reads (in translation), 'The most-pious Empress Maria Angelina Komnene Doukaina, the Palaiologina'. As can be seen, the term 'most-pious' is missing from the Cuenca inscription, which is also less 'grammatical'.

There are also marked differences of style and technique between the two works. The painter of the Meteora icon renders the flesh high lights over the shadowy underpaint with thin parallel lines, to lay emphasis on the projecting points, but in a restrained way. The Cuenca painter overdoes the same technique, with the result that the figures are flaccid and lifeless. These details make it certain that the two works were painted by different artists. The similarity of the works raises the question of which is the prototype, and which the copy. It is generally agreed, though it has not been proved, that the Cuenca reliquary is a copy of the Meteora icon.

Confusion reigns as to what workshop these two pieces were imported from. All who have committed their views to print so far are of the opinion that these works originated either in Ioannina or in Meteora; but they have not yet managed to place their conclusions beyond doubt. It has also been proposed that the Cuenca reliquary was the product of a workshop in Constantinople or on Mt Athos.

All that can be said with certainty is that the donations of the Empress Maria Palaiologina to her brother the monk are noteworthy specimens of, possibly, provincial art of the second half of the fourteenth century and that the diptych probably dates to between 1367 and 1384 (the year of Preljubović's death).

Lazaros Deriziotis

Exhibitions:
Exposición Iberoamericana de Sevilla, Seville 1929; *Exposition Internationale d'Art Byzantin*, Musée des Arts décoratifs, Paris 1931; *Byzantine Art, an European Art*, Zappeion, Athens 1964; *De Creta a Toledo*, Museo de Santa Cruz, Toledo 1999.

Literature:
Radojčić 1962, pls 50-51; Cirac Estopañan 1943; Xyngopoulos 1964-1965, 53-67; *Byzantine Art, an European Art*, no. 212; *De Creta a Toledo*, 32-34, fig. 17.

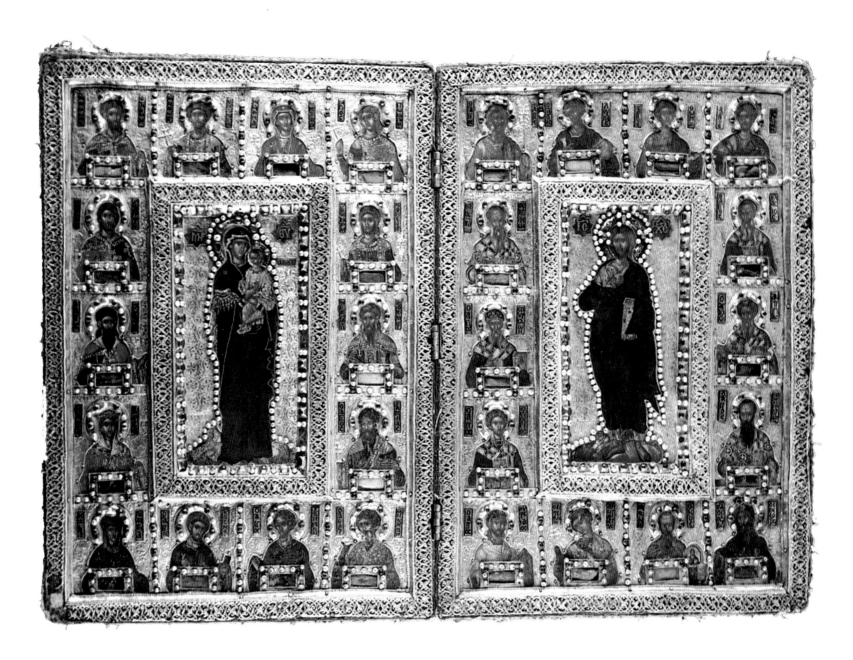

Section Three

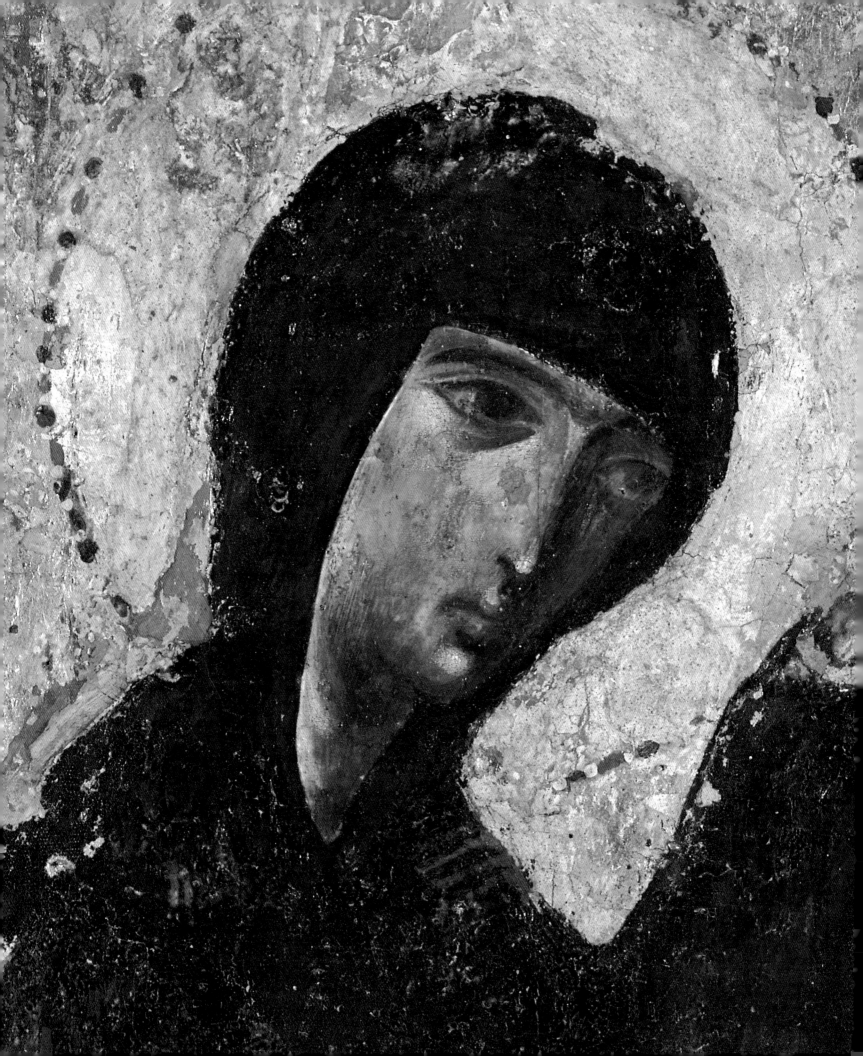

The Mother of God in Public

The prestige of the Mother of God in Byzantium was promoted by her icons, both in private and in public settings.[1] Increasingly over the centuries, such images took on a dominant role in public life, both in civilian events and on special state occasions. The infiltration of the Virgin into the civic, military, and imperial self-image of Byzantium can be traced throughout the empire, especially in the churches and ceremonies of Constantinople. It will be explored here through a number of revealing cases.

'Public' is taken here to mean engaged with the lay public, either in rituals of lay character like war, or in religious rituals engaging lay people. Our concern is less with the Virgin herself than with the artefacts in which her public presence was expressed. To a striking degree, the city of Constantinople is central to their formulation.

The Mother of God and Constantinople

Jerusalem pioneered both the civic celebration of the Virgin and the miraculous sanctity of her image, and it was from Jerusalem that the Virgin's relics reached the capital.[2] But it was in Constantinople that the public Mother of God was invested with her distinctively Byzantine body of content. Key components of this process occurred already well before Iconoclasm. The events of 626 at Blachernai prove that a civic conception of the Virgin as the city's defender had been formed by this date. Her relics had been welcomed into Constantinople with imperial ceremonies elevating her to a status akin to that of a civic goddess;[3] regular vigils and processions had woven her into the rhythm of the city's life;[4] and emperors had adopted her as their mediatrix with God: we read of Leo I depicted before the Theotokos at Blachernai, and when in around 570 the seal of the emperor abandoned pagan for Christian imagery, it did so by replacing the figure of Victory holding the clipeate portrait of the emperor with one of Mary holding the clipeate form of her Son, as if one figure of eternal victory and its protection of the populace had succeeded another.[5] Imperial, military, and civic, these components formed a matrix within which the public imagery of the Mother of God unfolded.

The image of Mary that emerged from these developments is seen in the famous encaustic icon preserved on Mt Sinai (Cat. no. 1). Her frank, full form is clothed in her familiar blue 'Virgin Mary' dress and veil, but she is seated formally on a heavy throne. As goddesses (but rarely empresses) had done before, she bears her child on her enthroned lap. He wears a ruler's golden robe, and she herself is flanked by angels, for as God's most intimate associate she was the Queen of Heaven and the intermediary between him and his angels. The *manus Dei* explodes in a thunderclap of light above her head, manifesting her agency as a bridge to the very presence of God. It startles the angels, who turn to it amazed. Before her throne loom the taut forms of two male saints in courtly attire. They are customarily identified as the warrior saints, Theodore and George.[6] Like the nearly contemporary image of the Virgin on the emperor's seals, these saints link her with the theme of eternal victory. The icon is small; for all its civic implications of rulership and military protection, it is not of public scale. Yet it finds an echo in monumental images like the apses of Parenzo (Pl. 45) and Bawit (Pl. 169) and the textile icon in Cleveland (Pl. 170),[7] and lends plausibility to the existence of comparable civic images, such as the portrait of Leo I at Blachernai.

The Sinai icon tells us that key themes of the Virgin's public image were forged before Iconoclasm. But it is only after Iconoclasm that we can observe the processes of its development. We might begin with the great tenth-century mosaic above the south entrance to Hagia Sophia (Pl. 61) in Constantinople.[8] It is strikingly akin to the earlier image in the Sinai icon. But now it is public, monumental and outspokenly civic. The enthroned Virgin, her gold-swathed Child before her, sits flanked by full-length figures of two emperors. Constantine, on her left, offers a model of the city; Justinian on her right, offers a model of Hagia Sophia. Both wear the loros, the heavily jewelled golden sash that identified emperors with members of the angelic court of God.[9] If the chlamydes of Sts George and Theodore in the Sinai icon had linked Mary to the court of the emperors on earth, the loroi of Constantine and Justinian point to the angelic court of Heaven, showing them as counterparts of the angels. But who is the Mary whom they honour?[10] That Constantinople in the wake of 626 should have become the city of the Virgin is understandable; its cathedral church, however, had been consecrated to Christ. Instead, Justinian seems to lodge the very church of Christ in the monumental lap of the Virgin, throne of wisdom. The elision is eloquent. The emperors prayed to God, as the famous mosaic over the central, imperial portal to Hagia Sophia showed Pl. 65).[11] But the guardian of their church and city, of their faith and victory, was the Virgin.

The Mother of God in Public Imagery

The emergence of an explicit imagery relating the Virgin to city and state is seen in three developments in her iconography that became visible in the late ninth and tenth centuries. One of these developments is her incorporation into the civic imagery of the emperors. This is exemplified by coins. It is in this period that the Theotokos first appears in the coinage of Byzantium. A rare set of *solidi* from the end of Leo VI's reign (886-912) shows a half-length figure of the orant Virgin on the obverse[12] (Cat. no. 44). The frontal orant would be among the most widespread public images of the Virgin in the Middle Byzantine period. Mary had assumed a prominent role in Leo's imagery already at an earlier date, for she is shown crowning him in an intricately carved ivory knop (Pl. 111) that may have capped a sceptre or even the box containing the crown itself.[13] Leo, loros-clad, stands to Mary's right here, balanced by a similarly clothed archangel on her left. Christ and two saints echo them on the opposite side of the knop. Mary, mediator in the court of Heaven between Christ and the angels of his host, assigns to the angelically-clad Leo the task of empire. In the same way she takes her son's place on certain of Leo's coins, her hands extending protectively over his realm as she raises them in prayer to Christ. Leo's last wife, Zoe, repeated his experiment in one coin issue during her regency for their son, Constantine VII (913-959), this time not with the Virgin orans but with the Virgin holding a medallion with the bust of her son before her breast.[14] With this, a second of the most eminent public images of the Mother of God in the Middle Byzantine centuries was introduced into currency. Occasionally named 'Nikopoios', the Victory-bringer, this image is associated by some scholars with the one that had replaced Victory herself on the seals of the emperors in the sixth century,[15] and so with the great imperial theme of eternal victory.

More than a century would pass before the Virgin's image would again occupy the obverse of a gold coin in Byzantium, but she did not vanish: in place of the simple imperial bust on the reverse of their *solidi*, the warrior emperors Nikephoros II Phokas (Cat. no. 45) and John I Tzimiskes (Cat. no. 46) displayed the image of Mary holding the *labarum* or crowning them under a *manus Dei*,[16] and Mary holding the medallion bust of Christ occupies the obverse of a remarkably beautiful silver issue of Basil II[17] (Pl. 147). Then throughout the middle third of the eleventh century, the Virgin occupies the obverse not only of silver but of gold coins in a range of guises.[18] The prominence of the Mother of God in these decades is surely due in some degree to the presence of women as rulers: both Zoe and Theodora (1042) (Pl. 206) and Theodora alone (1055-1056) used the Virgin on their issues. The self-consciousness of their bond with Mary is brought out

326

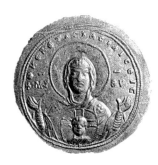

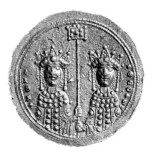

206. *Histamenon of Zoe and Theodora* (1042). Byzantine Collection, Dumbarton Oaks, Washington.

clearly by a silver weight in the British Museum[19] (Cat. no. 43). Theodora's image is paired here with an image of the Virgin identical to that used in her coins, Mary's familiar, fiscal imagery sealing the authority of the weight. But it was not the *Augustae* who first introduced the Virgin to the obverse of eleventh-century gold issues. It was Zoe's first husband, Romanos III (1028-1034) (Cat. no. 47). Romanos's choice seems to have been motivated not by gender but by another, far more powerful Marian theme: protection in war.

If the public currency of the Virgin in such civic media as coinage is one clear sign of her mounting public significance, another sign emerges in the context of protection in war. This is the definition of her relic at Blachernai as her *maphorion*.[20] 'Maphorion' is the name that historians customarily give to the garment of Mary preserved at Blachernai, but the term appears in Byzantine literature only in the tenth century. Both the identity and the terminology of the relic at Blachernai had shifted over time. Initially associated severally with Mary's funeral shroud, one of her two dresses willed to needy friends on her deathbed, and her belt dabbled with milk from nursing the Christ-Child,[21] the relic acquired a stable name as '*maphorion*' only in the tenth-century chronicles recounting how Romanos I (920-944) wrapped his body with it when departing Constantinople on 9 November 926 to negotiate for peace with his mighty Bulgarian adversary, Tsar Symeon.[22] That the relic at Blachernai acquired a stable form and nomenclature, and one that bound it unequivocally to the Virgin's veiling 'cover and protection' for Constantinople, signals the overt crystallization of the Virgin's public role and image.

The third development in Marian imagery occurred in the wake of the defeat of Iconoclasm, and concerns her icons. As Marie-France Auzépy has pointed out, the defeat of Iconoclasm did not entail simply the affirmation of the image; it entailed affirmation of the icon: of the image as a focal point for miraculous interventions.[23] By processes yet to be sorted out fully, the image of Mary became the pre-eminent vehicle of such interventions. The centrality of the Theotokos in Byzantine icon theory is confirmed already by the Patriarch Photios, who focuses upon her image in his adornment of Hagia Sophia.[24] Hers is the image that validates others — that in rising, 'raises along with herself the likenesses of the saints' — ,[25] and it is to her image, rather than to that of her Son in the dome, that his dedicatory celebration was directed. But Marian images were not only central in theory. They were equally central in the body of exemplary miracle stories that eddied around the debate over — and eventual triumph of — holy images.[26] Though icons must have figured in the vigils and ceremonies of pre-Iconoclastic Constantinople, it is only in the Middle Byzantine centuries, as the implications of the triumph of images took root, that icons as such took precedence over relics and churches as the focus of public cult. The public cult of Mary was deeply implicated in and affected by this process. Slowly, her cult became associated with icons, and her icons became the pre-eminent holy images.

The Public Icon

The icon's most usual role in Byzantine public life was chorographic: icons marked special places. We see this in the shrines of healing saints: those petitioning the saints' intervention sought their relics; their icon marked the way to them.[27] It did so physically, and no doubt also psychologically by putting pilgrims in mind of the saint whom they sought. But it was not the pilgrims' goal. Many Marian icons, too, served this chorographic function. One can see this very well in the *Book of Ceremonies* of Constantine VII Porphyrogennetos (913-959). With one exception, the icons that figure in the *Book of Ceremonies* are icons of the Virgin. But the icons do not constitute the goal of the emperors' processions; rather, they serve as stations along the rulers' path as they make their way from site to site. The emperors pause to venerate them and then proceed along their elaborately cadenced path.[28]

The icons in the *Book of Ceremonies* functioned in an essentially passive way. They were neither the goal of the processions, nor the source of the site's special significance; rather, they signalled the sanctity conferred by relics, an altar, or a sacred spring. There were cases, however, in

207. *John I Tzimiskes Returns in Triumph to Constantinople.* Chronicle of John Skylitzes, cod. 338, fol. 172v. Biblioteca Nacional, Madrid.

which icons played a more active role, actively establishing the special character of a site. A long-standing example of this constitutive role is offered by *apotropaia*, images that guard the space in front of them. Mary was certainly used in this role: recurrently, we hear about images of Mary being placed on the walls or gates of Constantinople during the Crusader sieges, and similar reports are imputed already to the siege of 626. But there are many less militant examples, as well. Thus the marble reliefs of the Virgin orans (Pls 186, 188 and 189) with holes in the hands to accommodate conduits for water, presumably made to adorn fountains, worked to transform the water by their presence, turning it from a simple source into a sacred gift—a blessing.[29]

A more complex instance of the constitutive role of icons is seen in legal proceedings. Certainly icons played a role in legal proceedings: oaths were taken on icons, and sometimes icons were used to affect the courtroom atmosphere.[30] But in some cases icons actually established the spaces of judicial proceedings. The evidence here centres on icons of the Virgin. Thus, the eleventh-century historian Michael Attaleiates relates a story of Romanos IV Diogenes exercising martial law, during one of his campaigns, to punish a thieving soldier. Romanos set up his tribunal, Attaleiates tells us, under: '... the immaculate icon of our much-hymned lady the Theotokos Blachernitissa, which is customarily carried on campaigns by the pious emperors as an invincible weapon in war'.[31] The icon's presence literally established the site as a place of authority, and it was within the space constituted by the icon that justice was meted out.

A more dramatic instance in which an icon constituted the space of judgement is reported in 1075 by the great humanist-politician, Michael Psellos.[32] He had been asked by the Emperor Michael VII (1071-1078) to report on a case at law in which the ownership of a mill in Thrace was under dispute by a local lord and a monastery. At the monks' instigation, determination of the case had been turned over to the icon of Blachernai. This cannot have been the icon of the same name that Romanos IV carried in war, for the icon invoked by Psellos was affixed to the southeast wall of the church and concealed by a richly embroidered veil. It was the subject of a world-famous weekly spectacle in which the veil mysteriously rose without visible human agency each Friday night, and the icon became radiant with light until Saturday morning. The event was called the 'usual miracle', and a lapse in its occurrence was viewed as a judgement. In the case that Psellos reported on, the veil rose, giving victory to the Lord. This is clearly an instance of an

icon being accorded an active role in public life. It does not simply mark a special place; it itself makes the place special.

The judgement at Blachernai, though indicative of legal procedure, involves more than a case at law. It engages an icon of spectacular public prominence. This icon was no longer simply, or even actively, chorographic. It was a cult icon: it was itself the object of the cult ceremonial that occurred in front of it. No aspect of the icon in Byzantium is more notable than the potency and prominence of its great icon cults, and the Theotokos is by far the figure most frequently favoured with such cults. The public cult icon and the character of Marian devotion evolve in a close symbiosis. One sees this in the full range of Marian functions: civic, military, and devotional.

Cult Icons and the Mother of God

Hitherto, we have spoken of Marian images as images simply of Mary herself. In the eleventh century, however, a new dimension of Marian imagery emerges: images get named. The coinage of Romanos III, Zoe, Theodora, and Constantine IX Monomachos, with its proliferation of Marian types, marks a threshold in this respect: one of them is labelled 'Blachernitissa', invoking the Virgin of Blachernai;[33] the same name had been given by Psellos to the icon beneath which Romanos IV held his court martial. Like many of these names, 'Blachernitissa' is a toponymic; it refers to a site of special sanctity. By means of the toponymic, the potency of the site gets associated with the named image. There is no evidence that the name 'Blachernitissa' was ever associated with a single icon or iconic type; it appears with a range of iconographic types.[34] But in other cases the name clearly identifies a particular icon. Such icons were recipients of cult in their own right, and their replicas evoked the icons as well as the saint. The saint most frequently represented by such potent icons by far was Mary.

Eleventh- and twelfth-century Constantinople offers vivid examples of Marian cult icons and the spectacle that could surround them. Among the most dramatic was the 'usual miracle' at Blachernai. A description of the events surrounding an icon named 'Maria Romaia', orchestrated for it by a specially dedicated confraternity, conveys the texture of these cult events: 'Her parents then seeing the child tormented by the unclean spirit, moved by faith in Jesus Christ and God, and heartened by the *presbeia* of the Theotokos, rose and took their daughter and went to this holy icon. Taking holy water from her pure and worthy presence, they drank and anointed [her] with it. The demon, unable to bear the power of the holy water, knew how to torment and harrow the girl and made blashphemous words come from her mouth. But the company of those pledged to the Virgin [the brotherhood], raising their hands to the highest God, cried and said without delay: "O Lord, Lord, hearing quickly, heed our prayer asking for your help, that as you freed the Canaanite woman's daughter from the evil and bitter demon and healed the lunatic child, revealing your divine glory and power to your people, you will now, Lord, turn your countenance upon us and chase from this, your servant, the evil and unclean demon that torments her, implored by the prayers of our all-holy lady Theotokos, your Mother, and all your saints". And at the mass of these prayers the unclean spirit said through the mouth of the child: "Holy Theotokos Mary, who hastened from Rome, quickly I come out by the way in which I entered this body, commanded by your power. For I know that you are the Mother of the one living God". These things having been said, the head of the brotherhood said: "No naughtiness, evil spirit, when you come out of this girl". And the demon said: "The all-holy Theotokos Mary orders me to come out of this body without harming it". Having said this, the girl bent her head before the holy icon and was still for a while. When she straightened up she found that she was free of the unclean spirit ...'.[35]

These dramatic displays were clearly focused upon the icon itself: this was the magnet that drew both afflicted devotees and ogling onlookers, and no doubt attracted pious donations, as well. Repeatedly, it is icons of the Virgin that figure in them. The events were directed to private needs—physical and mental health, death and bereavement, pain and depression. But their staging was public, sometimes very spectacularly so. How these cults evolved remains to be studied,

but it may be that charitable confraternities incubated them.[36] The earliest fully documented testimony to a confraternity devoted to the veneration of an icon of the Mother of God is offered by a funerary brotherhood founded in Greece in 1048.[37] But a manuscript of 1027 preserves the liturgical *typikon* of a brotherhood that maintained the bath at Blachernai; these men convened on Friday nights in observances that included prayers to icons and invocations for healing.[38] Since it was, in turn, on Friday nights that the spectacles associated with Blachernai occurred—including eventually the showy 'usual miracle'—it may well be that these spectacles were developed and slowly 'hyped' by the brotherhood. A famous confraternity oversaw the healing baths at the Constantinopolitan monastery of the Hodegon, as well, and this also became the site of a great icon cult: the cult of the Hodegetria.[39] Another icon known as Hodegetria in the city of Thessaloniki was managed by a confraternity documented in the twelfth century by Eustathios.[40] An icon in the exhibition that is known to have been the focus of a brotherhood is the majestic Virgin Episkopiani from Zakynthos[41] (Cat. no. 34). Its stentorian size makes it hard to imagine its being carried in processions, though. The members of the brotherhood of the 'Maria Romaia' were instructed to carry their icon each week in the Tuesday procession of the great Hodegetria,[42] and it is clear from pilgrim accounts that—if the needs addressed were private—the spectacles surrounding icons like these were of urban scale and operatic splendour. Eventually, as we will see, they came to define the very character of the cityscapes they traversed.

Along with these urban ceremonies, warfare offered a stage for publicly acknowledged cult icons. War offers a particularly clear view of the process by which the Virgin's public persona was crystallized in icons. The role of religion in the discipline of the Byzantine army is amply reflected in military treatises,[43] which cite the Theotokos along with Christ as the object of regular invocation;[44] for civilians, too, the centrality of Mary in military defense was deeply rooted. Her role as defender in war had been crystallized by the events of 626, and George of Pisidia's paean to this event conjured her image as the triumphant victory standard:

> If a painter wished to show the tropaion of this battle,
> he would raise high the one who conceived without seed,
> and paint her image.
> She alone can triumph forever over nature,
> first in her conception and second in battle.[45]

George's formulation of Mary's image as a *tropaion* was a potent metaphor, but it was just that: a metaphor and not reportage. Rather than with an icon as such, it was with the relic lodged at Blachernai that the defensive miracle was associated, and it was the relic in turn that was invoked for divine help in the repulse of two further sieges of the city, in 718 and again in 860. By the time of Romanos I Lekapenos (924-944) it had acquired its own name and form as a protective veil. It was, in turn, a fragment of this veil—and not, so far as we know, an icon—that accompanied the military campaigns of his porphyrogennite co-emperor, Constantine VII, for while the Limburg staurotheke preserves a portion of the relic,[46] the emperor's military treatises are mum on the subject of an icon, speaking only of battle standards, crosses, and reliquaries.[47] The battle standards bore, among others, the images of Christ and the saints, serving, as they unfurled their silken banners, to surround the soldiers with a veritable heavenly host of holy helpers. It is impossible to imagine that the Mother of God was not among this heavenly army. The word for the battle standards, *signa*, was the same word used for the icons borne in religious processions. Nonetheless, we have no concrete evidence that the *signa* of the Byzantine army included any specific icon of Mary with a cult of its own at this time. To the extent that the Virgin's presence was lodged in an object with a history and identity of its own, it was lodged in her relic.

It is with the Emperor Basil II (976-1025) that we first have a concrete reference to an icon of the Virgin in battle. Michael Psellos relates that in his battle with the usurper Bardas Phokas,

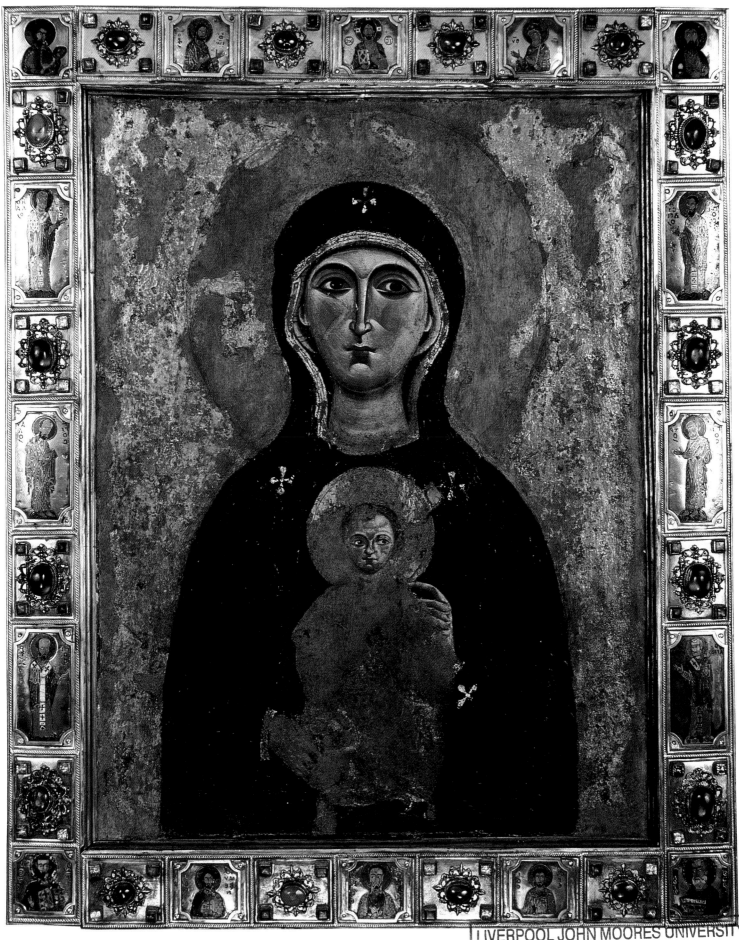

Basil '... took his stand there, sword in hand. In his left hand he clasped the image of the Saviour's Mother, thinking this ikon the surest protection against his opponent's terrific onslaught'.[48]

Psellos does not tell us whether this was customary behaviour or a special precaution adopted for a battle of particular and highly personal importance.[49] We learn more, however, as the eleventh century proceeds. The Emperor Romanos III (1028-1041), devout husband of Basil's niece and eventual successor, Zoe, seems to have made it a habit to carry a particular icon of Mary with him into battle. We learn this once again from Psellos, who uses it as an opportunity to decry Romanos's tastelessly demonstrative emotional piety toward the panel.[50] Michael Attaleiates, in turn, in his description of Romanos IV's court martial, describes the icon he set up as the one that the emperors 'customarily carried on campaigns'.[51] A century after the Limburg staurotheke had been created to carry the protection of Christ and his Mother onto the battlefield in the form of relics, we find Mary's protection embodied in an icon, instead: a specific icon, that was taken recurrently with the emperors into war. How familiar such an object had become in the organization of a Byzantine campaign is reflected in Niketas Choniates's cynical description of John II Komnenos's (1118-1143) calculated exploitation of the Virgin's image to enflame the fervour of his troops in battle.[52]

The defensive role of the Mother of God was ancient by the time John II exploited it. What had changed in the interim was its symbolic locus: it had come to reside in a painted image. War as a locus of the Virgin's intervention had served as a point of incubation for potent images of her. How truly her public presence had come to reside in icons is illustrated by a comparison of two visions of Mary's defensive intervention, one from the tenth and one from the twelfth century. The first took place in the reign of the warrior Emperor John I Tzimiskes (963-976), when a woman saw Mary in the sky over the city, coming to the emperor's defense with a corps of military saints led by Theodore Stratelates and George (the same saints seen centuries before in the icon at Sinai).[53] The second took place when a contemporary of the Emperor Manuel I Komnenos (1143-1180) dreamed he heard the icon in the church of the Virgin Kyriotissa pleading with the same saints to defend the city — in this case in vain.[54] What makes the comparison notable for us is the guise of the pleading Virgin: seen in person in the first, she assumed the form of an icon in the second. More than in her relics, Mary's potent presence resided in her icons.

The progressively greater association of Mary's military role with icons is underscored by the choreography of Byzantine triumphs. Some thirty-two imperial triumphs are recorded between 718 and 1056.[55] In only one of these, the triumph of John I Tzimiskes in 971, do we know of the participation of an icon. Rather than mounting the triumphal chariot himself, he placed upon it an otherwise unidentified icon of the Mother of God[56] (Pl. 207). John had shown his veneration of the Virgin already by depicting her on the reverse of his coins. His gesture to her in his triumph seems to have remained unparalleled until 1133, when his namesake, John II Komnenos, adopted it and integrated it centrally into the ceremonial design of his triumph. He was imitated in this by his son, Manuel I. Niketas Choniates, who describes both emperors' triumphs vividly, speaks of the icon of the Mother of God as 'the invincible ally and unconquerable fellow general of the emperor'.[57] It rode ahead of the emperor on a silver chariot drawn by snow-white horses. The icon was the very image of Mary's overseership of the Byzantine host. The identity of the icon eludes us. Though its epithet as 'unconquerable general' comes from the prelude of the Akathistos Hymn and recalls Blachernai, Choniates says nothing of this, and modern scholars have tended to identify it with the Hodegetria: John II is known to have held the Hodegetria in high esteem; the Komnenian triumphs took place in the acropolis area of the city near the Hodegetria's home at the Hodegon monastery;[58] and we know from Bishop Eustathios of Thessaloniki that the people of Constantinople regarded the Hodegetria as their prime defender.[59] Here we see with sharp clarity the degree to which the Virgin's protection of the city had become lodged in a great icon. Certainly by 1261 the Hodegetria had become the symbol of Mary's triumphal protection, for the Emperor Michael VIII Palaiologos (1258-1282) followed it barefoot into his newly recovered capital city.[60]

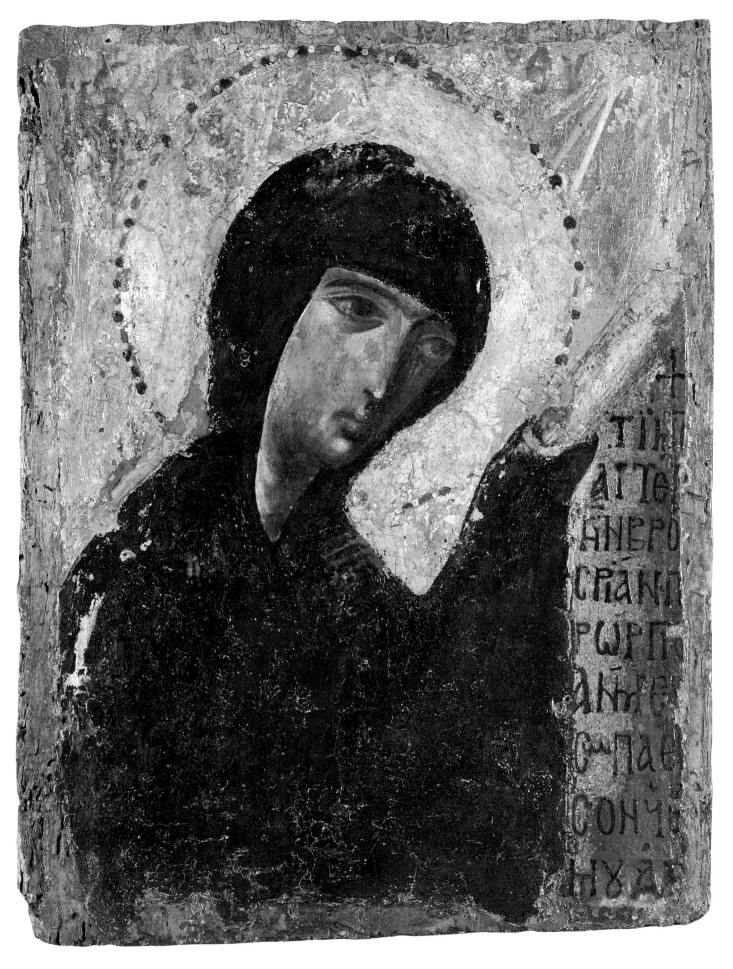

Given the association of Mary with the military defence of the empire, it is notable how rarely she figures in Byzantine imagery with military saints.[61] Warrior saints are the last of the figures who flank her in the ivory triptychs exhibited here (Cat. nos 59 and 60), and after the famous sixth-century encaustic icon on Mt Sinai, with the Virgin between what are generally assumed to be Sts Theodore and George in civilian court dress, we must wait until the Crusader period to find panel paintings that pair the Mother of God pointedly with warriors. The most striking of these — the Virgin Theoskepaste from Paphos (Cat. no. 36) and its copy with St Prokopios made for Mt Sinai (Cat. no. 71) — emerge in areas closely associated with Crusaders, and may be inflected by their taste. Certainly no one iconographic type of the Virgin is regularly paired with military saints. It becomes difficult under these circumstances to guess the form of the military images of Mary. The image that Michael Attaleiates referred to as the one the emperors 'customarily carry on campaign' is called 'Blachernitissa'. But 'Blachernitissa' labels many different poses, and yet a further pose appears on the superb Middle Byzantine icon of the Theotokos supposed to have been captured from the imperial Byzantine war chariot in 1203 by the Venetians, which is still displayed in the church of San Marco (Pl. 208).[62] Thus it is far from clear that there was any definitive form for the *tropaion* of Byzantine victory. The military context does not lead us to particular iconographic forms. It displays instead a process in the public cult of the Virgin, as the public cult of Mary found its focus progressively in icons.

As the triumphal processions reflecting Mary's military role are added to the civilian, devotional icon processions that criss-crossed and gave ceremonial character to the capital city, the third face of Mary's public persona, the civic, emerges, as well. In this arena, we do find a particular image assuming hegemony. Mary's identification with cities, rooted already in Jerusalem centuries before, became clothed by the twelfth century in the tangible form of the great icon, pre-eminently the icon known as the Hodegetria. The Hodegetria protected Constantinople. Thessaloniki, too, had its Hodegetria.[63] The Emperor John VI Kantakouzenos (1347-1354) would give Monemvasia an icon known as the Hodegetria to serve in his absence as its defence;[64] pilgrims to the Acropolis in Athens would venerate in the Atheniotissa an icon sharing the form we associate with the Hodegetria;[65] and in the emerging city-states of Italy, majestic panels of Mary in that same iconographic form of the Hodegetria were painted by famous artists to symbolize the civic polity and its sacred protection.[66]

Icons of the Mother of God in the Late Byzantine Period

Mary retained her public visibility in the Late Byzantine period, as pilgrims continued to flock to her processions, towns invoked her for protection, and a slowly growing number of monasteries throughout the Orthodox world relied for fame and funding upon the exploitation of an icon of Mary: the Megaspilaiotissa, the Pelagonitissa, the Kykkotissa are among the great miracle-workers of Post-Byzantine Mariolatry whose cults are attested already before 1453.[67] Two things distinguish this from the Middle Byzantine era. One is the power of recognized iconographic types. As it had not been in the Middle Byzantine period, it becomes possible now to name and follow iconographic types. Along with the familiar orant and Hodegetria types, a wide and varied range of deliberately affective images, inflected with rich semiotic and symbolic details, circulated throughout the Orthodox and indeed the entire Christian world.[68] It becomes possible on the basis of the geographical range, the frequency and fidelity with which they are replicated to ponder the ways in which particularly famous icons were disseminated, for it is clear that some iconographic types — the one known as the Pelagonitissa, for instance, or the one known as the Kykkotissa — were more likely to acquire miraculous powers than others.

Famous types like the ones just cited helped not only to disseminate but to change and inflect the very image of the Virgin and her powers, and this points to the other factor that stands out about Mary's public persona in Late Byzantium. This is the ease with which her wide-ranging competence is assumed. Poignant appellations — *Phobero Semeion* (the Terrible Sign), *Rhodon to ama-*

334

ranton (the Unwithering Rose), Kardiotissa—no less than militant or civic ones, such as Akata-machetos or Hodegetria appear on images installed in highly public places; in turn, these very public images insinuate their powers into the most private interstices of individual lives. A glimpse of this range is offered by the Byzantine icons that acquired fame as cult objects in the Medieval West, for these do not display the frontal orant or Hodegetria types of postures that had dominated Middle Byzantine public media, such as coins and palladia. Instead, they display the more intimate postures of the pleading profile Virgin Paraklesis as in Spoleto (Pls 205 and 209) or Freising (Pl. 113),[69] or the tender Mother caressing her Son as in Regensburg or Cambrai.[70] Far from developing a specialization of types, Mary's power functions with easy polyvalence from a vast range of iconographic types. This point returns us to the point at which this essay began. It is hard to say that Virgin's capabilities had changed in the interim. What had changed were the images in which they were clothed. It is these that our exhibition permits us to explore.

[1] Any such essay draws upon the fundamental articles of Baynes 1955, 248ff (Baynes 1949a). Cameron 1978, 79; Cameron 1979b, 42-56; Frolow 1944, 61-127; and of course upon the magisterial von Dobschütz 1899.

[2] van Esbroeck 1988, 181-190. Processions through the city from Zion to her tomb in Gethsemane honoured the anniversary of her death, and her miraculously imprinted image was venerated nearby at Lydda. This was cited around 720 by Andrew of Crete: *PG* 97, 1304 B. It figures then in the Letter of the Three Patriarchs to the late iconoclast emperor, Theophilos, Munitiz et al. 1997, liv. 38-41, 7.6. On the list of miraculous images in the Letter of the Three Patriarchs, see most recently Munitiz 1997, 115-123.

[3] Limberis 1994, 59 and passim; Costans 1995, 169-194; van Esbroeck 1988.

[4] On the processions in Constantinople, Ševčenko 1991, 45-57.

[5] On Leo I and his family before the throne of Mary in the apse of the round church dedicated to Mary's garment at Blachernai, Janin 1969², 168. Justinian and Theodora, too, had shown themselves on the textiles at Hagia Sophia, Mango 1972, 89, translated from the *ekphrasis* of Paul the Silentiary. On the seals, Cheynet and Morrisson 1995, 10.

[6] Weitzmann 1976a, 20.

[7] The apse of the basilica Euphrasiana, Parenzo, is reproduced in colour in Lowden 1997, figs 84, 85. For the Cleveland tapestry, *Age of Spirituality*, no. 477, col. pl. XIV. For an interpretation of this image linking Mary with the church, Etinhof 1977, 37-55. Bawit, monastery of St Apollo, with a similar, two-register composition, Grabar 1967, fig. 186.

[8] Whittemore 1936, proposes that it was installed in the interval between 986 and 994, when the church was closed for repairs. However, it is dated in the early 10th century by Lowden 1997, 193, and no later than the sec-

ond half of the 10th century by Lazarev 1967, 147.

[9] Maguire 1997b, 247-258; Jolivet-Lévy 1998, 121-128.

[10] The question is memorably posed by Frolow 1944, 91-92.

[11] Oikonomides 1976, 151-172; Cormack 1981, 131-149; Barber 1993, 11-12.

[12] Grierson 1973b, 508-509, pl. XXXIV, 1a, 1b.2.

[13] Corrigan 1978, 406-417; Cutler 1994, 200-201.

[14] Grierson 1973b, 533, 541, pl. XXXVI, 1.

[15] Grierson 1982, 201, pl. 54, no. 953; Grierson 1963, 111-116. The attribution to Basil has been challenged by Seibt 1985, 549-564, esp. 552-553. I favour the attribution (Carr 1997, 89), but agree with Seibt that the image of Mary holding a medallion with the bust of Christ is different from the one seen in the apse of St Sophia at Ochrid, or the icon in Venice, in which she holds a full-length Christ-Child in a clipeus.

[16] Grierson 1973b, 589, pl. XLI, 4.1-5.3 with Nikephoros II Phokas and Mary holding the labarum; Grierson 1973b, pl. XLII, AV 1a-6c, with John I Tzimiskes being crowned by Mary.

[17] Grierson 1973b, pl. XLVII, 19.1-19.4; see also n. 15 above.

[18] See the following in Grierson 1973b, Gold issues with the Mother of God on the obverse include pl. LVII, AV 2.1-2.2 with Mary holding the Child in bust in medallion and Romanos III on the reverse; and pl. LVIII, AV 1, with Zoe and Theodora on the reverse and the orant Mother of God holding the Child in medallion on the obverse. Silver issues with the Virgin on the obverse include: pl. LVII, AR 3a.1-3a.4, a particularly beautiful issue with the full-length Mother of God in the type of the Hodegetria and Romanos III full-length on the reverse; pl. LIX, AR 7a.1-7b.3, with the standing orant Virgin and Constantine IX Monomachos

on the reverse; pl. LIX, 8a.1 and 8a.5, the orant Mother of God labelled 'Blachernitissa' and Constantine IX Monomachos on the reverse, a type repeated by Theodora and Michael VI (pl. LXII, AR 3; pl. LXIII, AR 3).

[19] *Byzantium*, no. 164; Entwistle and Cowell 1994, 91-93.

[20] Carr, forthcoming.

[21] Three legends are recorded in Byzantium about its origin. One, best told in the 7th century by Theodore Synkellos, relates how two Constantinopolitan patricians named Galbius and Candidus stole from a pious Jewish widow a casket containing one of the two garments that Mary had willed on her deathbed to needy friends (*Narratio in Depositionem Vestis S. Mariae* = Εἰς κατάθεσιν τῆς τιμίας ἐσθῆτος τῆς θεομήτορος ἐν Βλαχέρναις, in Combefis 1648, 751-788). One of the dresses, he says, had drops of Mary's milk on it from the first Christmas night. A sermon delivered at Blachernai and attributed to the 8th-century Andrew of Crete cites droplets of milk on the cloth, but calls it the ζώνη, or belt, of Mary (Andrew of Crete, Ἐγκώμιον εἰς τὴν κατάθεσιν τῆς τιμίας ζώνης τῆς ὑπεραγίας δεσποίνης ἡμῶν θεοτό-κου, in Combefis 1648, 789-804). A second narrative is preserved in the anonymous *Euthymiac History*; this tells how Juvenal, Patriarch of Jerusalem, responding to Empress Pulcheria's demand for a relic of the Virgin Mary, sent a sealed casket containing the Virgin's two dresses (ἱμάτια) and burial shroud (ἐντάφια), which Pulcheria installed with due reverence at Blachernai (preserved as an interpolation into John of Damascus's second sermon on the Dormition and in the 8th-century Sinai MS gr. 491, Wenger 1955, 136-140). A third narrative, finally, given in the late 10th-century Menologion of Basil II (Vatican. gr. 1613) and cited already in a sermon for 2 July by Patriarch Euthymios (907-912), says the Emp-

335

eror Arcadius (395-424) received the belt that Mary had worn at the first Christmas; deposited in Blachernai, the garment was taken briefly from its reliquary in 906 in order to liberate from demons the Empress Zoe, wife of Emperor Leo VI (886-912) (Jugie 1944, 695-696, where the text is quoted; the sermon of Euthymios is given in the *PO* 17, 484-85, 511). These narratives yield at least three definitions of the garment — as belt, shroud, and dress —; they link it with three different moments in Mary's life — her new motherhood, her death, and her assumption —; and they describe three different moments of deposition.

[22] The word maphorion appears in the following sources: in the 10th-century chronicle known under the name of its scribe, Leo Grammatikos (Bonn 1842, 241, ll. 4-12) and its various plagiarisms describing the event of 860; in the chronicle of Theophanes Continuatus describing Romanos I's departure to parley with Tsar Symeon of Bulgaria in 926 (Bonn 1838, 406.19 - 407.7); in a reference to the event of 860 in one of the diatribes of John Oxites against Alexios I Komnenos composed around 1093 (Gautier 1970, 38-39, ll. 17-27); and in a description of Alexios I Komnenos's battle against the Cumans in 1089 in the *Alexiad* of Anna Komnene (Leib 1933, 2: 98).

[23] Auzépy 1995c, 31-46.

[24] Mango 1958, 279-296, excerpted in Mango 1972, 187-190; Aristarches 1900, 1, 294-308.

[25] Mango 1972, 189: 'This is another shaft being driven today right through the heart of Death, not as the Saviour is engulfed by the tomb of mortality for the common resurrection of our kind, but as the image of the Mother rises up from the very depths of oblivion, and raises along with herself the likenesses of the saints'. Aristarches, 1900, 304.

[26] The classic example is that of the mother of St Stephen the Younger, *PG* 100, 1976B. The Life has been translated by Auzépy 1997. See also the legend of the image of the Mother of God at the Chalkoprateia church related in Lackner 1985, 833-860; the legend of the icon thrown into the sea by Patriarch Germanos, that reverberates both in the story of the 'Maria Romaia' icon (von Dobschütz 1903, 196-197; Munitiz et al. 1997, 48-49, 7.14a-b); and in the miracle stories assembled in the *Letter* as a whole, of which many involve icons of Mary (Walter 1997b, li-lxxviii).

[27] Thus, the ancient shrine of St Artemios in the church of St John the Baptist in Oxeia at Constantinople, had icons of the Forerunner and St

Artemios himself at the top of the stairs leading down to the crypt where St Artemios's relics were. Janin 1969[2], 419-420. Sufferers seeking Artemios's assistance would pass the icon on their way to the crypt. In a similar way the icon of the Blessed Luke marks the site of his relics at Hosios Loukas, Connor 1991.

[28] An example might be taken from Blachernai itself, where the emperors paused to venerate several images of Mary along their elaborately cadenced path to the relic shrine and holy-water bath: '...and they go out of the bema, and they go to the right into the episkepsis [where the relic was kept?], and they light candles there and make a proskynesis. And from there they go outside the metatorikion, where the icon of the Mother of God and the silver cross are, and they light candles there, and they go into the metatorikion'. Constantinus Porphyrogennitus, *PG* 112, 1021 C. A similar pattern is seen in the church of St Demetrios, where the procession passed an enamel icon of Mary, Vogt 1967, I, 158.

[29] For examples, Lange 1964, no. 1 in the Archaeological Museum, Istanbul; no. 6 in Santa Maria Mater Domini, Venice; no. 11 in the Byzantine Museum, Athens; and no. 15 in the Museo nazionale, Messina.

[30] Thus Anna Dalassena drew an icon of Christ from under her cloak during her trial by Romanos Diogenes and confronted her judges with the sight of their heavenly judge, Nikephoros Bryennios, *CFHB* 9, 130-131. Her son Alexios I Komnenos seems to have installed a mural painting of the Last Judgement in a court room, Magdalino and Nelson 1982, 124-126.

[31] *Michael Attaliota*, Bonn 1853, 153. The story is a fairly squalid one of a soldier condemned to have his nose cut off for stealing a mule. Confronted with his sentence, he hurls himself howling before '...τὴν πάνσεπτον εἰκόνα τῆς πανυμνήτου δεσποίνης Θεοτόκου τῆς Βλαχερνίτισσας, ἥτις εἰώθει τοῖς πιστοῖς βασιλεῦσιν ἐν ἐκστρατείαις ὡς ἀπροσμάχητον ὅπλον συνεκστρατεύεσθαι'.

[32] Grumel 1931, 129-146.

[33] Grierson 1973b, 747, pl. LIX, 8.a.1 and 8.a.5; 753, pl. LXII, AR 3; 758, pl. LXII, AR 3. These are two-thirds *miliaresia* of Constantine IX, Theodora, and Michael VI; they show a frontal orant Virgin.

[34] Carr 1997, 92 and figs 14-15.

[35] von Dobschütz 1903, 202-203. Also Ševčenko 1995, 549.

[36] On Byzantine confraternities, Ševčenko 1995, 547-556; Magdalino 1986, 165-88; Horden 1986, 25-45.

[37] Nesbitt and Wiita 1975, 360-384; Ševčenko 1995, 550.

[38] Dmitrievskij 1965, II, 1042-52, from Paris, Bibliothèque Nationale, Coislin 213, of 1027.

[39] Ševčenko 1995, 547-549.

[40] Ševčenko 1995, 549-550; Eustathios of Thessaloniki, *The Capture of Thessalonike*, Melville Jones 1987, 142.

[41] Acheimastou-Potamianou 1997, 42-45.

[42] von Dobschütz 1903, 202.

[43] Dennis 1993, 107-117; Frolow 1944; Pertusi 1948-1949, 145-168; Viellefond 1935, 322-330.

[44] E.g., Viellefond 1935, 328.

[45] Pertusi 1959, 176:
"Τῶν ζωγράφων τις εἰ θέλει τὰ τῆς μάχης
τρόπαια δεῖξαι τὴν Τεκοῦσαν ἀσπόρως
μόνην προτάξοι καὶ γράφοι τὴν εἰκόνα
ἀεὶ γὰρ ᾧδε τὴν φύσιν νικᾶν μόνῃ,
τόκῳ τὸ πρῶτον καὶ μάχῃ τὸ δεύτερον'.

[46] Ševčenko 1994b, 289-294.

[47] See in particular Haldon 1990, 245 on crosses, 271 on banners, and *passim*.

[48] Renaud 1926, I, 10.xvi, 2-5; trans. Sewter 1953, 36.

[49] Philip Grierson has suggested that the icon took the form of the Virgin holding the clipeate bust of her Son before her that is seen on the beautiful silver *miliaresion* from the reign of Basil II, see above n. 15.

[50] Renaud 1926, I, 39.x, 21-27; trans. Sewter 1953, 69-70: 'More important than that, somebody came up with the ikon of the Theometor, the image which Roman emperors habitually carry with them on campaign as a guide and guardian of all the army. This alone had not been taken by the enemy. When the emperor saw this beautiful sight (he was particularly reverent in his veneration for this ikon) he immediately took heart, and holding it in his hands — but no words can describe how he embraced it, how he bedewed it with his tears, how heartfelt were the terms in which he addressed it, how he recalled Our Lady's kindnesses in the past and those many times when she, his ally, had rescued and saved the Roman power in moments of crisis'.

[51] See above n. 31.

[52] van Dieten 1975, I, 15.86-93; trans. Magoulias 1984, 10: 'Then John devised a cunning plan for his troops; not only was he valiant and a cunning tactician by nature, but he was also the first to execute the instructions he gave his generals and soldiers. His behavior on the battlefield gave witness to great piety; whenever the Roman phalanxes were hard-pressed by the

enemy falling furiously upon them, he would look upon the icon of the Mother of God and, wailing loudly and gesturing pitifully, shed tears hotter than the sweat of the battle. It was not in vain that he acted thus; donning the breastplate of the power from on high, he routed the Patzinak battalions just as Moses had turned back the troops of Amalek by raising his hands'.

[53] *Ioannes Zonarae Epitomae*, Bonn 1897, 533.6-554.7; trans. Trapp 1986, 39.

[54] van Dieten 1975, 190.92-191.8; Magoulias 1984, 107-108.

[55] McCormick 1986, 186.

[56] McCormick 1986, 173-174.

[57] van Dieten 1975, 158.66-72; Magoulias 1984, 90.

[58] Magdalino 1993, 241-242.

[59] Eustathios of Thessaloniki, *The Capture of Thessalonike*, Melville Jones, 42-43.11-12.

[60] Nikephoros Gregoras, '*Byzantinae Historiae Libri XXXVII*', in *PG* 148, 217C.

[61] On this phenomenon, Maguire 1992, 212.

[62] Rizzo 1980, 290-306. This, too, may have associations with Blachernai, for the ancient icon discovered during restorations at Blachernai under the Emperor Romanos in 1031 may have answered to much that description. Seibt 1985.

[63] See above n. 59.

[64] Kalogeras 1955, 24.

[65] The icon is first recorded by the pilgrim Nicolas de Martoni in 1394-1395, LeGrand 1895, 652. Also Jahn and Michaelis 1976, 30; Lampros 1878, 37-40.

[66] Corrie 1990, 61-75.

[67] On the Megaspilaiotissa, see the chrysobull of John VI Kantakouzenos (1347-1354) dated 1350 and addressed to the hegumen of the 'venerable Peloponnesian monastery of my queen, known by the name of the honoured and all-pure Lady and Mother of God called Megaspilaiotissa'. Miklosich and Müller 1860-1890, V, 191. On the Pelagonitissa, Babić 1988, 61-78. On the Kykkotissa, Carr, forthcoming.

[68] Baltoyianni 1994b.

[69] For the icon in Spoleto, Belting 1994, 241, 282, 323, 333 and fig. 149. For the Freising icon, Belting 1994, 333 and fig. 201; *Ornamenta Ecclesiae* 1985, no. H 69; Wolters 1964, 85-91.

[70] For the Regensburg 'Schöne Maria', Belting 1994, 453-455 and fig. 277; Spanke 1988, 212-221. For the Virgin of Cambrai, Belting 1994, 438, 440-441, 455, pl. X .

31

Replica of the Apse Mosaic of the Virgin and Child, from the Church of Hagia Sophia at Constantinople

226 × 148.6 cm
Painted Plaster Cast
Apse mosaic inaugurated Holy Saturday,
29 March 867
Hagia Sophia, Constantinople
New York, The Metropolitan Museum
of Art, Acc no. 43.48.1, Harris Brisbane Dick
Fund, 1943.

The figurative mosaic imagery of the church of Hagia Sophia was a cumulative addition to the purely symbolic original decoration of Justinian's church (532-537). The ending of Iconoclasm in 843 did not see the immediate renovation of the imagery of Hagia Sophia, and it seems to have been initiated only after a gap of some years. Possibly the interior of the church was soon enhanced with portable icons, but the conspicuous moment of the monumental display of an image of the Virgin was celebrated in the inauguration homily of 29 March 867 by Patriarch Photios, delivered from the ambo of Hagia Sophia in the presence of the emperors (Mango 1958, 139, n. 4 on Homily VII and 279-296 on Homily XVII). The apse Virgin (whose survival in the mosque was signalled by the Fossati restoration of 1847-1849) was uncovered from Ottoman plaster between 1935 and 1939, under the direction of Thomas Whittemore, but he never completed his study for publication. The first report on the mosaics of the apse appeared in 1965 (Mango and Hawkins), and this was preceded by a major new examination of the surface of the mosaic from a scaffolding erected in 1964. The height of this scaffolding to enable viewing from a platform in the apse was nearly 30 m. This investigation produced systematic technical reasons for linking the present mosaic surface with the tesserae of the inscription recorded in the tenth century in the *Palatine Anthology* (I,1). It put the strong circumstantial case for identifying the present mosaic with the image inaugurated by Photios in 867 and identifying the emperors present as Michael III and Basil I. The inscription around the apse, of which only the first and last letters have survived in the church, read: 'The images which the heretics had cast down from here, pious emperors have again set up'.

Contrary to the rhetoric of this epigram, Mango and Hawkins (1965) suggested that the previous decoration of the apse was prob-ably non-figurative, and most likely what was replaced was the original Justinianic scheme, perhaps a cross among foliage or clouds. They could not detect any clear evidence of icono-clast ('heretical') activity in the apse. The credit for its decoration is therefore taken by the joint emperors Michael and Basil.

The dating of the mosaic to 867 has been widely accepted in the literature, although previous guesses on the basis of photographs taken by Whittemore had ranged from the eighth to the fourteenth century. The attempt to refute this dating by Oikonomides (1985) raises far more problems than it solves (Cormack 1989, additional notes on 14). The Russian visitor to Constantinople, Anthony of Novgorod, was told by his guides in Hagia Sophia in 1200 that the artist of the apse mosaic was the famous ninth-century iconophile painter, Lazarus. But this may be only one of the many myths about Hagia Sophia that were current in the thirteenth century and cannot be taken lightly to record the facts of the ninth century.

The Metropolitan Museum has collected both full-size copies and casts of mosaics in the church of Hagia Sophia at Constantinople. This set of materials was produced by different methods. The Deesis mosaic (acc. no. 41.137) was a painted copy and cost $7,500 in 1941 according to the Metropolitan Museum records (Teteriatnikov 1998, 60). The method for making copies was as follows. First, tracings were made over the mosaics in the church. The main artist employed for these tracings was the Russian N.K. Kluge (who as photographer and painter of the Russian Archaeological Institute at Constantinople had in 1912 photographed and copied the mosaics of the Koimesis church at Nicaea for Theodor Schmidt (1927) and who also copied other mosaics, such as the apse at Kition). Other artists who worked on the copies were R. Gregory, Adli Bay and Alwyne A. Green. The tracings were next sent to the Massachusetts Institute of Technology, in Boston, to be photographed. Blueprints backed onto linen mere made there and sent back to Istanbul. These were then painted with tempera, mostly by Alwyne Green. In the case of the Deesis mosaic, the tracings were the work of Kluge and Green, and the painting was done by Green.

The casts were made in a radically different way, using a technique developed in 1937-1938 at the Fogg Art Museum (Teteriatnikov 1998, 61). A cellucotton pad was applied to the moistened mosaic surface and a squeeze of the surface was produced. The pad was removed and coated with shellac. When dry, this new mould was covered with a thin film of oil and a plaster cast containing reinforcing fabric was made from it. After drying, the cast was painted. The Metropolitan Museum purchased five casts, which included the Virgin and Child in the apse and (separately) the Archangel Gabriel on the right (acc. no. 43.48.2). The cost of the five casts was $10,000 in 1939.

Both techniques produced very accurate full-size copies.

Robin Cormack

Exhibitions:
Exhibition of photographs and painted copies and other materials in the Metropolitan Museum in 1944; *Glory of Byzantium*, The Metropolitan Museum of Art, New York 1997.

Literature:
Schmidt 1927; Mango 1958. Laourdas 1959; Mango 1962; Mango and Hawkins 1965, 115-151; Cormack 1981, 131-149; Cormack 1985a; Oikonomides 1985, 100-115; James and Webb 1991, 1-17; Mango and Ertug 1997; Teteriatnikov 1998; Cormack 2000.

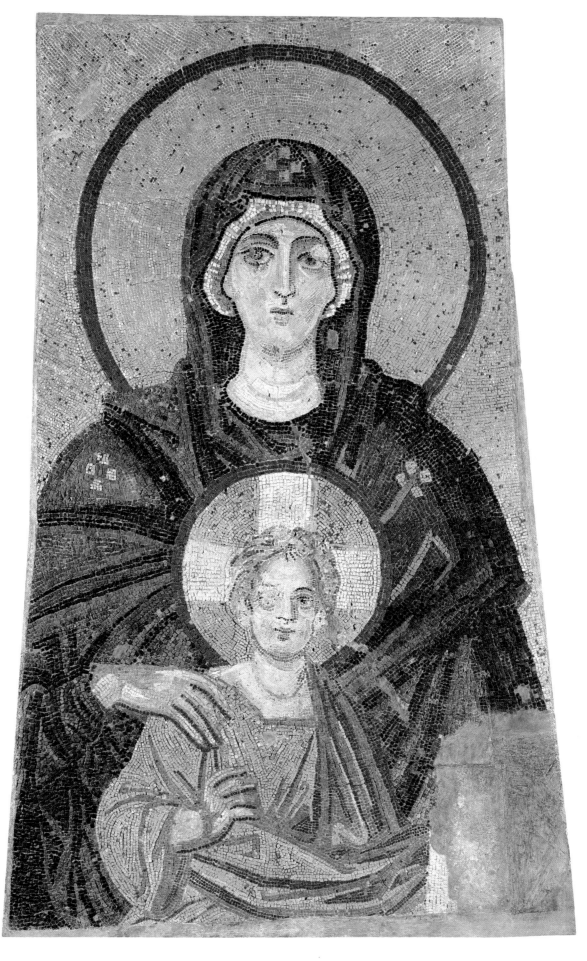

339

32

Icon of the Triumph of Orthodoxy

39 × 31 cm
Egg tempera on wood
About 1400
Constantinople (?)
First recorded in a private collection in
Sweden whose owner sold it in auction at
Sotheby's (London) on 15 February 1984.
London, The British Museum,
Inv. no. M&LA 1988, 4-11,1. (National Icon
Collection, no. 18))

There are traces of a title to the right of the
representation of the icon of the Virgin
Hodegetria The only letters which can be
made out are IA but they are most likely part
of the word OPΘOΔOΞIA, making the sub-
ject the Triumph of Orthodoxy. The icon
therefore commemorates the feast known as
the Restoration of the Holy Images, which
was probably set up to celebrate the official
end of Iconoclasm in 843. This annual feast
of the Sunday of Orthodoxy was held on the
first Sunday in Lent. The subject matter of
this icon (famous icons and Iconophiles) is
described as the Restoration of the Holy
Images in the eighteenth-century *Hermeneia*
of Mt Athos (Hetherington 1974, 64-65).

The panel is divided horizontally into two reg-
isters. The central representation at the top
is one of the most celebrated icons of Con-
stantinople – the icon of the Virgin Hodege-
tria (claimed to have been painted by St Luke
from life and so to represent her authentic
appearance). The prestige of this icon as a
miracle-making image had increased in the
Late Byzantine period, and at the time the
British Museum icon was made it must have
been one of the most familiar images in the
Orthodox world. The miraculous icon of the
Hodegetria is represented here on a dec-
orated red-draped stand (the *podea*), with red
curtains (the *encheirion* or *peplos*) drawn back
to reveal it. The large panel is held up by two
young winged figures with red hats, not
apparently angels. Ševčenko (1991, 48) saw
these as members of the brotherhood who
maintained the cult in Constantinople, sug-
gesting that their wings were a device to ele-
vate both them and the festival to a 'heavenly'
or 'liturgical' level so that 'the image cele-
brates simultaneously the historical event, its
inner meaning, and its eternal re-enactment'.
Dionysios of Fourna speaks of two 'deacons'
with 'shoes woven of gold' holding the
Hodegetria (Hetherington 1974, 64).

The prominent figures on the left in the upper

register are the rulers at the time of the offi-
cial ending of Iconoclasm in 843: the regent
Empress Theodora together with her young
son, the Emperor Michael III. They wear the
dress and insignia of their rank and are
labelled with their titles. All the inscriptions on
the icon are considerably effaced, and some
are more legible than others. However iden-
tification of the figures is helped by the recent
discovery of a later icon in the Velimezis Col-
lection (N. Chatzidakis 1998, no. 5) which
appears to be a close copy of this actual panel
and has a few more readable inscriptions. The
name and title of Emperor Michael III is eas-
ily legible; beside Empress Theodora, we can
read ΘEOΔΩ[PA] and ΠIΣTH (faithful in
Christ). On the right is Patriarch Method-
ios (in office 843-847) with three monks;
beside the figure of the patriarch wearing a
sakkos, ME[ΘOΔIOC] is readable. The fig-
ure beside Methodios in the Velimezis icon
is probably Bishop Theodoros.

In the lower register with eleven figures, the
extreme left saint is clearly inscribed ΘEO-
ΔOCIA. She was the saint who was said to
have protected the icon of Christ on the
Chalke Gate at the outbreak of Iconoclasm,
and this must be the icon which she holds.
The next three inscriptions cannot be read,
but N. Chatzidakis identifies the figure type
of the fourth from the left as St Ioannikios.
The fifth figure from the left is Theophanes
the Confessor; above him are the letters
[ΘEO]ΦAN[HC]. His companion is probably
St Theodore the Studite; the legible letters
are Θ[EOΔOPOC]. They jointly hold an icon
of Christ, perhaps originally in a circular
frame. The next few inscriptions are very
effaced, and it is not entirely clear to which
figures they apply. The seventh figure, the
bishop, may have the letters [Θ]EO[ΔΩPOC]
and the eighth may have been *Graptoi*; prob-
ably they are the two brothers (the Graptoi) who
fought the iconophile cause during Icono-
clasm. The tenth and eleventh figures are
ΘEOΦYΛAK[TOC] and APCAKIOC.

This is the earliest known example of the
iconography. The composition of an icon of
the Virgin surrounded by the faithful reflects
the schemes used for council representations,
in cycles of the Akathistos Hymn (such as
folio 33v of the manuscript Moscow Synodal
gr. 429 which was painted in the Hodegon
monastery between 1355 and 1364) and in
litany scenes of the icon of the Virgin. The
subject is found in several icons and wall-
paintings of the sixteenth century and later.
An icon of the first half of the sixteenth cen-
tury in the Benaki Museum, Athens, studied

by A. Drandaki (1996), is entitled the
Restoration of the Icons and had the forged
signature of the Corfiot painter Emmanuel
Tzanfournaris (around 1570-1575; died after
1631); another icon in the collection of the
church of St George of the Greeks in Venice
has a genuine signature of the same painter
and is entitled 'Orthodoxia'. Three other
icons are listed by N. Chatzidakis (1998). On
Athos the subject is found in several variants
in wall-paintings in the Great Lavra and the
Stavroniketa monastery, both painted by
Theophanis the Cretan, and later at Dochei-
ariou. It also occurs on Cyprus.

On grounds of style and quality, the British
Museum icon has been attributed to Con-
stantinople around 1400. However, N. Chatzi-
dakis (1998, 90), while accepting the date,
attributed it to Crete on the grounds of the
iconography of the Virgin Hodegetria. She
thought that the Velimezis copy of it was
made in Crete around 1500. However the
iconographic type with Christ's outstretched
arm cannot easily be isolated as the product
of Andreas Pavias and Cretan artists alone –
a quite similar scheme is found on the early
fourteenth-century mosaic icon of the
Hodegetria now at Sofia (in the church at
Herakleia on the Marmara coast in the nine-
teenth century). Furthermore, stylistic con-
nections may be suggested with the icons
made for presentation to the Great Meteoron
by Maria Angelina Komneni Doukaina
Palaiologina (wife of the Despot of Ioannina,
Thomas Preljubović) between 1373 and
1384, and this parallel may suggest a slightly
earlier date. Whether or not an icon of this
style and quality should be regarded as the
product of an artist of Constantinople
remains an open question at a period when
artists moved freely to fulfil commissions. The
definition of Orthodoxy was certainly a key
theological interest in Constantinople, and
was the concern of the Constantinopolitan
council of 1341 and those of 1347 and 1351.

Robin Cormack

Exhibitions:
East Christian Art, Bernheimer Fine Arts, Lon-
don 1987; *Byzantium*, British Museum, London
1994.

Literature:
Sotheby's catalogue *Russian Pictures, Icons*, (15
Feb. 1984), lot 156; *East Christian Art*, no. 43;
Cormack 1989b, 93-94; *Byzantium*, no. 140; Cor-
mack 1997a, 24-51.

341

33

Icon of the Virgin and Child Between Archangels

85 × 60 cm
Egg tempera on wood
Late 12th - early 13th century
Church of St Nicholas, Veroia
Veroia, Archaeological Museum, Inv. no. 88

The Virgin holding the Child in her arms, and seated on a throne, is shown on the main axis of the composition, standing between the Archangels Michael and Gabriel. Her torso and head are rendered more or less frontally, but her legs are turned slightly to her left. Her lean, flat body narrows at the shoulders and ends in an exquisitely delicate neck and a broad, oval face, its features in deep shadow. She has large wide-open eyes, with the pupils emphasized, eyebrows and eye-sockets both deep with shadow, a long, flattened nose and a small mouth with pursed lips. She cradles Christ in her arms, holding him firm on exactly the axis of his body and rests her right arm, bent at a right angle, protectively on the Child's chest, while supporting his left leg with her left arm. Her chiton is light blue, and her maphorion and its wimple both aubergine-coloured. The maphorion hangs free on the left side of the body, from top to bottom, falling into folds between the legs and on the right thigh. The Virgin's wooden throne, partly lost and barely visible, is rendered in warm ochre on dark green. It has a high footstool with a border set with pearls; a valance articulated in horizontal registers and a narrow seat with a purple cushion.

Christ is shown sitting in the Virgin's arms, his gaze fixed on infinity. He has a delicate body without much flesh, which rises to a cone of a neck and an egg-shaped head with a few wisps of hair at the temples. He raises his right hand in blessing, outside the body axis; his left hand would have been holding a scroll, but this is well-nigh impossible to make out today. He wears a light blue chiton, and an orangey red himation that leaves the right side of his chest and his left foot bare.

On either side of the Virgin stand the Archangels Michael and Gabriel. They are depicted full-length and half-turning towards the centre of the picture. It is impossible to be absolutely certain about this identification, since the traces of the inscriptions that most probably accompanied the figures have now disappeared from the scarlet ground. The archangels are presented in stiff hieratic poses, and clad in costly garments, with slen-

der wings that come down to about shin-level. One hand holds a long sceptre — the so-called *kerykeion* — and the other the globe. Within each orb is inscribed a cross, with the abbreviations IC XC NK (Jesus Christ Conquers) and Φ Φ (The Light of Christ Shines on All) placed in the angles made by the four arms. The archangels' garments include a purple-and-olive green dalmatic and the imperial *loros*. The dalmatics have square and circular ornamental appliqués, rendered in warm ochre and decorated with jewels and pearls. The loroi are of similar material and made up of successive small pearl-studded squares.

The four figures in the picture all have haloes of gesso, with decorative motifs in bas-relief. On the haloes of the Virgin and the archangels, there is an undulating vegetal motif ending in spirals. There is a cross inscribed within Christ's halo: its arms are filled in with X-shaped motifs, but the rest of the ground is made up of stipples.

The icon panel is in one piece and has a shallow integral frame. It is moderately well-preserved: the wood has been cut away, mainly along the bottom edge; there is severe worming; and there is extensive loss of the paint surface. At some more recent date the icon was overpainted in light green, which can still be seen here and there.

The somatic proportions of the Virgin and the archangels are as normal, and have moved away from the exaggeratedly elongated bodies that first appeared in late twelfth-century painting (Tsigaridas 1986, 110-112). The faces are rendered in rose pink worked with olive-green shadows, while in the detailed modelling of the features, line is played down in favour of chiaroscuro, which dominates in the eye-sockets and the nose of both the Virgin and Christ. The effect of this technique is to make the faces broad and flat, visibly emancipated from the linear mannerism of Late Komnenian painting, although elements of the latter can still be seen in the hair style of the archangels.

Similar features are in evidence in the treatment of the Virgin's and the archangels' garments, where the drapery is clearly treated in flat, sometimes fluid planes, without sophistication in its movement and has a subtle indication of volume best seen in the archangels.

Although the icon has been dated to the late eleventh century (Papazotos 1994, 41-42, figs 1-2), the features just mentioned are reminiscent of the transition from the end of the

twelfth to the thirteenth century. They set the icon firmly among the first affirmations of the new monumental style, for instance the wall-paintings of Ai-Strategos at Boularioi in the Middle Mani (Drandakis 1995, 452-458 and pl.106) or at Studenica (Čirković, Korać and Babić 1986, fig. 60). It is to this period that the icon should be assigned, because it makes use of a scarlet ground. We can cite, as typical examples, four icons from the second half of the twelfth century, all from a single epistyle in a monastery chapel on Mt Athos depicting one version of the Dodeka-orton. Two of these four are today in the Vatopedi monastery; one is in the Hermitage Museum, St Petersburg; and one is in the Byzantine Museum, Athens (Tsigaridas 1996, 362, fig. 306, n. 37, with bibliography). One further icon has been identified as coming from the epistyle: the icon of the Nativity now in the Vatopedi monastery (*Pemptousia* 1999, pl. on 169).

Two other scarlet-ground icons, from the first half of the thirteenth century, are in the Sinai monastery (Mouriki 1990, pls 58-59). The scarlet ground is also met with in a Late Komnenian icon in Cyprus (Papageorgiou 1991, 28 and fig. 16), as well as in monumental painting (Mouriki 1978, 51-52). It recurs in a Studenica wall-painting of the Virgin (around 1235), in imitation of a portable icon (Čirković, Korać and Babić 1986, fig. 2). Moreover, the use of bas-relief for the ornaments on a halo (Kalopisi-Verti 1982, 555-560) is known from late twelfth-century monumental painting: in the churches of St Stephen and Sts Anargyroi at Kastoria (Pelekanidis and Chatzidakis 1984, 13, 30, 32, figs 7, 10) and on Cypriot portable icons (Papageorgiou 1991, figs 13, 15a, etc.).

These considerations lead us to believe that the Veroia icon should be assigned to the late twelfth or early thirteenth century and that it is an early, typically provincial example of the new monumental style the greatest achievements of which were in the second quarter of the thirteenth century.

Euthymios Tsigaridas

Literature
Papazotos 1994, 41-42, figs 1-2.

343

34

Icon of the Virgin Episkopiani

172 × 70 × 2.5 cm
Egg tempera on wood
First half of the 12th century, 1657
A. Constantinople (?),
B. Candia (Herakleion), Crete.
Zakynthos, Zakynthos Museum, Inv. no. 433

The present work is an epigraphic, archival and artistic document; and rarely does a portable icon provide so much valuable information about what was in this case a long and troubled history.

It is a large icon, showing the Virgin standing and at full length — *stasidin*, as Byzantine authors called this pose — with the Christ-Child to her right side. The ground is of gold; the foreground is green and originally went up to the raised frame. As has been shown (Chatzidakis 1979, 389ff.), the face of the Virgin is a masterpiece of Constantinopolitan painting from the twelfth century, and the remainder of the image is by a competent Cretan painter of the seventeenth century.

An inscription (Vlachakis 1979, 257ff.), at bottom left, in white lettering, which has some gaps, reads (in translation): '[When] All the city of the famous island of Crete, which is named Candia, was encircled by the godless Agarenes, with the contribution and expense of the most reverend Lord Philotheos hieromonk Serepetsis and ... Demetrios Logothetis Frankiskos Karkiopoulos and Viktor Tziminos and all the brotherhood in Christ of the holy Monastery of the most holy Virgin Lady of Mercy under the most holy bishopric of Chersonesos this present holy icon was renovated during the year 1657 April 10. Of Mark ...'.

Beginning with a dramatic reference to the city of Candia, 'encircled by the godless Agarenes' (i.e. the Ottoman Turks), this inscription records the icon's restoration, completed in 1657. It was contributed to and paid for by the holy monk Philotheos Serepetzis and other named donors, and by the entire brotherhood of the monastery of the Virgin Eleousa, in the see of Chersonesos. This was a time when all the other castles of 'the famous island of Crete' were in Ottoman hands and it was only the 'Great Castle' — Candia, the modern Herakleion — that held out. There is reason to think (Vlachakis 1979, 261) that the brotherhood of godly Christians at Candia must have arranged for the transport of the icon from

its monastery shortly before 1648, when the conquest of the countryside became total. When Candia fell, in 1669, this icon of veneration of the Virgin Episkopiani — 'the most holy Virgin Lady of Mercy, that was carried from Crete by Messer Menegis Moskopoulos' — will, as a precious relic, have travelled along with the refugees to the island of Zakynthos. By giving the Virgin her appellation, this source confirms that the icon had been the 'icon of veneration' for the Cretan monastery. In 1683 it became an item in a donation by Michael Rousianos in Zakynthos, which made land available at the south end of the city for the building of a church named for the Virgin Episkopiani and the Archangel Michael (Konomos 1964, 126). As the despotic icon, it adorned the iconostasis of the new Episkopiani church, from which it was removed only after the great earthquake of 1953. It acquired a three-leaf silver revetment, and this left only the faces and the ground visible at the top. Revetment and frame were given a new coat of gold leaf. When the silver was taken off in the course of modern restoration work, it became clear that the icon was from two separate periods.

A. As he made his own first preparations for refurbishing the icon, with gesso and a coarse canvas backing, the 'competent Cretan painter' of Candia, to whom the brotherhood of the Eleousa monastery turned in 1657, kept intact what was left of the face of the Byzantine Virgin, and included it in the icon he himself was painting. Integrated into the new icon, it became a guarantee of authenticity for the icon which the worshippers knew so well. The Virgin's superlatively sweet face, softly inclined towards the Child she would have been cradling in the crook of her right arm, is serious, approachable, transparent in its sadness, the eyes full of pity and mercy for the believer. Strikingly clear against the wheaten underpaint, noble in its features and tinged with youth and beauty, the face is modelled firmly, but at the same time with painterly sensitivity, using green *sfumato*, ochre, red and white for the soft shadows and for the medium flesh tints and highlights. The cast of the physiognomy, the pictorial pulse, the fine depiction of emotion, and the mood of calm, are all in the spirit of aristocratic, classicizing painting of the early Komnenian period. The icon shows stylistic affinities with icons of the Virgin of Vladimir in Moscow, and of the Annunciation at Ochrid (Vocotopoulos 1995, nos 25, 48). This allows us to assign the original Eleousa icon to, probably, the first decades of the twelfth

century, and its execution to some important workshop in Constantinople (Chatzidakis 1979, 389-390).

The monastery to which the icon belonged, the Eleousa monastery in the see of Chersonesos, has been identified as the Kera-Eleousa monastery (now ruined), which is documented from the early seventeenth century. It lies close to the villages of Voritsi and Gouves, in the Pediada district, at no great distance from Herakleion itself (Vlachakis 1979, 259ff.). We have a valuable piece of information about the existence of an Eleousa nunnery in the twelfth century 'outside the Castle walls'. It is found in a lectionary of Cretan provenance, Sinait. gr. 221. The scribe dedicated the manuscript, in 1175, 'to that holy convent for women, named for the Supremely-Holy Mother of God, which he himself built'. Elsewhere, and in somewhat greater detail, he refers to '...the nunnery known by the name of the Our All Holy Lady Theotokos Eleousa, which was built anew outside the Kastro (i.e. Herakleion) in Crete, in the month of February, 8th Indiction of the Year 6683 (i.e. 1175)' (Weitzmann and Galavaris 1990, 177, with their translation). Thus an Eleousa monastery was restored, at some time before 1175, by the scribe and donor of this illuminated manuscript. But we do not know whether it was the same one that housed the venerated icon that may (assuming it was at this date that the icon was brought to Crete) have given its name to the monastery. Given the train of thought, which our important piece of evidence sets in motion, the hypothesis is attractive, if unprovable.

B. The preparation for the Post-Byzantine painting was made with gesso and a canvas finer than that which had been used in painting the face of the Virgin. The panel consisted of four pieces reinforced behind with five trusses (three original and two later ones). Two iron lugs at the ends were for the icon to be carried in procession, and there was another lug on top so that it could be hung up. The probability is that it was the twelfth-century face, which was inset into the new icon. But we cannot exclude the opposite possibility, that the 1657 picture was painted (with new priming) on the panel of the original, the face of the Virgin being preserved in its original position. Factors which advocate the second of these theories are, firstly, the icon's size, which led the painter to adopt rather unappealing proportions for the figures, and, secondly, the raised frame inset on the upper side, a rather unusual feature for works of this period.

This 1657 portrayal of the Virgin full-length and standing upright, so familiar from Byzantine iconography, was very unusual for a seventeenth-century Cretan work, which suggests that it must have been paying deliberate homage to the twelfth-century icon. The Virgin Episkopiani is shown on the same scale as the original, carrying the young Christ to her right. He uses both his hands to clutch her hand, which is lifted to her breast in the formal gesture of the Virgin Hodegetria. In a mutuality of attitudes, Christ looks at his Mother and she looks with compassion at the believer. The gestures are of close, tender union, and the Child's feet are crossed below, one of them being turned upwards so as to reveal the bare sole. The icon-painter will have borrowed these features, and the type and arrangement of the clothing, from the traditional representation of the Virgin of the Passion to which they properly belong. Another example, almost contemporary (1641), is an icon in Zakynthos painted by Emmanuel Tzanes in his Cretan period (Acheimastou-Potamianou 1997, no. 38, fig. on 153). The Virgin's garments, in dark blue and dark red, are rendered in long, crisp linear folds, illumined in brilliant red on the maphorion. Both the drapery, and the arrangement in general, demonstrate the painter's skill, as do the multiple fine gold striations and little flat laminae of gold—on Christ's olive-green himation, clavus, and scarlet sash—and the decoration of the off-white chiton. Christ's face, with its robust, accentuated features, is well attuned in its proportions and colouring to the face of the Byzantine Virgin.

At the very end of the inscription of 1657, after the date, the name 'Markos' appears. In this position it could well be the name of the painter, though this is not of itself sufficient to make a secure attribution. We simply note archival evidence to the effect that at this time, in the year 1658 in fact, a painter by the name of Markos Daronas was working on the church of Kera Kainourgia in Candia. There is mention of him in the years from 1626 to 1658. He was the son of the better-known painter Iakovos Daronas (Kazanaki-Lappa 1981, 226), but no works of his have yet come to light. What is important is that somebody—whether Daronas or some other icon-painter—had the wit to intervene and rescue the face of an honoured Byzantine image, Our Lady Eleousa Episkopiani—the oldest icon we know of in Zakynthos and from the Great Isle of Crete.

Myrtali Acheimastou-Potamianou

Conservation:
Zakynthos Museum, 1977-1978, Maria Barba-Roussea.

Exhibitions:
Byzantine and Post Byzantine Art, Old University, Athens 1985.

Literature:
Konomos 1964, 126; Konomos 1967, 52ff.; Vlachakis 1979, 255ff.; Chatzidakis 1979, 387ff., pls ΛΔ'-ΛΖ'; *Byzantine and Post Byzantine Art*, no. 76; Konomos 1988, 51ff.; Acheimastou-Potamianou 1998, no. 1; Acheimastou-Potamianou 1999, 19, fig. 1.

35

Two-sided icon: A. *St Nicholas*
B. *The Virgin Hodegetria*

76 × 56.2 × (max.) 2.1 cm
Egg tempera on wood
First half of the 13th century
West Macedonia (?)
Athens, Private collection

This precious two-sided icon and the three other two-sided icons that are known to portray the Virgin Brephokratousa and St Nicholas form a group (Vocotopoulos 1998, 306-307, nos 2, 16, 18). Unlike the others it is not the Virgin Hodegetria that occupies the principal face but St Nicholas. That both sides are contemporary is indicated by the thinness of the panel and the relief woodwork on the side with the depiction of St Nicholas in bust and scenes from his life. There is very extensive damage: two-thirds of the paint surface of the front is missing, significantly altering the overall impact of the work.

A. St Nicholas. A raised band (1.5 to 2 cm wide) runs round the edge of the icon and again round the edge of the central panel, with a frame (8.3 cm wide) between them. The paint surface is on gesso priming without cloth. The ground is of silver.

In the central panel (57 × 34 cm), St Nicholas is shown in bust, making a gesture of blessing and holding a closed gospelbook. He is portrayed middle-aged and balding, looking intensely at the believer. His lean, ascetic face, with its short nose and pursed lips, has a narrow moustache and a short beard. The saint wears an aubergine-brown phelonion and a white omophorion with black crosses. The pages of the gospelbook, seen side-on, are scarlet, while the binding is fastened with black bands. The saint has a raised gesso halo without relief decoration but with inscribed, rather schematic vegetal motifs, partly picked out in red. In the top left corner there are traces of an inscription: O [A]ΓIOC [NIKO-ΛAOC] (Saint Nicholas). The flesh underpaint is ochre with tones of olive green, the flesh tint is pale ochre, the contours are defined by a thin black line, and there are brushstrokes of red to emphasize the wrinkles on the forehead, the eyelids, nose, cheeks and lips. The beard is rendered in thick black lines painted over with green. The treatment of the drapery is linear, but there is an attempt to render the plasticity of the volumes. Thus the folds on the saint's phelonion are defined by thick black lines accentuated by thin greyish white highlights spreading in a linear manner

through the angulated planes. But on the omophorion the feeling of soft folds is achieved by lines of light green, to some extent echoing the curve of the saint's lean torso with its narrow, bent shoulders.

The icon's wide border must originally have borne scenes from the saint's life, as known from quite a number of representations (Zias 1969; Ševčenko 1983). Because of the extensive damage to the icon, only four of the scenes on the lower border are preserved, and these only in fragmentary condition. Of the episode at bottom left, specifically, there remain only: a house, painted red, with a pitched roof; immediately to its right, below, a blue house with two windows, and below it a bed with a man asleep — this is very probably the Eparch Ablabios, to whom St Nicholas appeared in his sleep (Ševčenko 1983, 120-122). Of the following scene to the right, with a building painted red, discernible, on top of the priming, are the sea and a boat with an open lateen sail that would originally have been painted in ochre. This is probably a representation of one of the saint's marine miracles (Ševčenko 1983, 95-103). All that remains of the final episode, at bottom right, are the two edifices framing the scene; left, a perhaps circular building, and right, a rectangular house with two windows. These might belong to the scene of the saint's dormition. The houses are superbly rendered: thin grey-white and black lines emphasize architectural detail such as the roofs or the window frames and grilles; the bases of the walls have horizontal bands with schematic ornaments and, at the bottom, a grid with darker pairs of triangles. This obviously miniaturist technique bespeaks the painter's virtuosity and the superb original quality of the ensemble.

The type of the saint's physiognomy derives from older prototypes where the beard was not yet white, as in the late tenth-century Sinai icon of St Nicholas (*Glory of Byzantium*, no. 65). The saint's posture and sideways glance, the position of his hand at the base of his omophorion, in a gesture of blessing, and the way he holds the gospelbook, its spine inwards and his hand covered by his phelonion, are all traits reminiscent of the Sinai icon of St Nicholas (Mouriki 1990b, 115, fig. 51) and of a second icon of him, dating from the second half of the thirteenth century, in the Byzantine Museum at Kastoria (Tsigaridas 2000, 132-133, fig. 11). Furthermore, the sleeping figure of the eparch (if that is who it is) in the episode from the saint's life has the hand under the cheek, exactly as in a wall-

painting in the church of St Nicholas of Kasnitzes, dating to the 1170s or 1180s (Ševčenko 1983, 180, figs 2-3). Lastly, the grid motif for the buildings in the scene at the base of the icon recalls two other works: the walls of Jerusalem in the Crucifixion icon in the Pantokrator monastery on Mount Athos, dating from the early thirteenth century (Papamastorakis 1998, 46-48, fig. 19; Tsigaridas 2000, 125, fig. 2), and the ground of the Crucifixion wall-painting in the church of the Mother of God at Studenica, dated to 1208/1209 (Hamann and MacLean 1963, figs 62, 65).

The silver ground, the raised halo and the red brushstrokes emphasizing the features of the saint's countenance are all points of artistic technique which we meet again in works in Cyprus and in works assigned to twelfth- and thirteenth-century Cypriot workshops (Mouriki 1985-1986, 9-112, esp. 54-61; Mouriki 1987; *Holy Image – Holy Space*, nos 10-11; Papageorgiou 1991, figs 9-13, 15a-b, 24-29, 31-35; Papageorgiou 1992, 484-490; Tourta 1992, 607-617). The green tones of the flesh underpaint, the big finely-drawn eyes, with their large light irises and small pupils, the delicate nose and the cherry lips, all comparable with works such as the late twelfth-century icon of Christ from the church of the Virgin of Arakos at Lagoudera (Cyprus), attributed to the painter Theodoros Apseudes (Papageorgiou 1991, fig. 10); the face of an unidentified saint on the early thirteenth-century two-sided icon in the church of the Virgin Theoskepasti at Paphos (Papageorgiou 1992, pl. 256); and, especially, the early thirteenth-century icon of the Virgin Brephokratousa, now in the Byzantine Museum at Kastoria (Tsigaridas 2000, 126-127, fig. 7); the finely-drawn features of the saint's physiognomy, the miniaturist technique in the rendering of the houses — for which it hard to cite an exact parallel — the fact that the halo is without the relief decoration found in most Cypriot icons and the raised integral borders, recalling icons of a much later period made in the workshops of Northwest Greece (*Holy Image – Holy Space*, no. 38) are all elements that set the present icon apart from known Cypriot material.

B. The Virgin Hodegetria. Surrounding the icon is a shallow integral frame, 4.5-5 cm in width, with a red line around its edge. The figures are projected against a silver ground. A priming of cloth and gesso carries the paint surface with the pigments in egg tempera.

The Mother of God holds her Son in her left arm and raises her right in front of her breast.

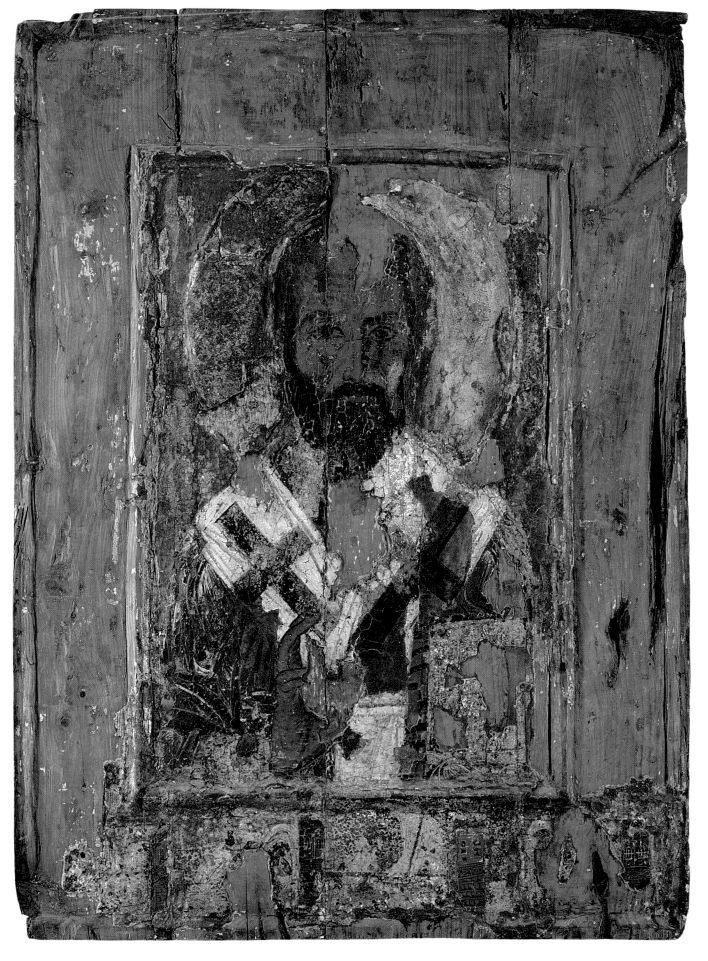

347

She bends her head towards him, but her large almond-shaped eyes and their intense gaze are turned towards the believer. Her reddish purple maphorion has borders emphasized in ochre. Of her chiton only the maniples can be made out: these too are in dark ochre. The maphorion is gathered into a lyre shape at the base of the neck. The Christ-Child makes a gesture of blessing and holds a closed scroll, as he looks sideways out of the image. His figure is rendered without correct proportions and is characterized by a flat face with a high forehead, crowned by wavy brown hair, with a 'widow's peak'. The facial features are robust: an intense gaze, a sturdy nose, pursed lips, large cheeks, an emphatic chin, and elaborate ears with unusual circular lobes. He wears a grey-green chiton with a red clavus on the side and a vermilion robe that leaves the right shoulder and one foot bare. The scroll is white and tied with a scarlet ribbon. Both figures show traces of an original ochre halo, that of Christ is defined by a red line. The flesh underpaint is in both cases olive-green, and the flesh tint is light ochre with just a touch of rose-red. Owing to the damage to the paint surface, the brushstrokes of the white highlights can be made out only here and there. Thus the impression the painting makes today is somewhat misleading, as the figures' spectral faces impose themselves from areas of shadow. The treatment of the drapery on the Virgin's maphorion and Christ's himation is linear, with almost flat volumes lacking in plasticity. Yet the painter has obviously taken great pains, for the drawing is firm, the figures are sturdy, and the facial features austere. They stand out by virtue of their spiritual expressivity and their melancholy mood.

The iconographic type of this composition is in general quite close to that of the famous miracle-working icon of the Hodegetria—a Byzantine palladium—in the Hodegon monastery at Constantinople, which had been painted, according to tradition, by the Evangelist Luke himself. The specific variant on the Hodegetria type that the present icon depicts, with the Virgin's head bent towards Christ, brings it close to two icons with which it shares a number of iconographic affinities: the mosaic icon of the Hodegetria — recently redated to shortly after 1261 (Ghioles 1993-1994) — in the Ecumenical Patriarchate at Constantinople, and a portable icon on the same subject, dating from the first half of the thirteenth century, and today in the Ochrid Icon Museum, from the great Ochrid church of the Sts Anargyroi (*Trésors médiévaux*, no. 14). The main difference from the Patri-

archate icon is in the position of the Christ's legs, which are there crossed in a presaging of his coming Passion. The differences from the Ochrid icon are more minor—the Virgin's head is not so deeply bowed, the border of the maphorion on her left cheek has fewer folds. The Ochrid icon also has the lyre-shaped gathering of the maphorion at the base of the neck, while in all three icons the rendering of the features of physiognomy is almost identical. The Ochrid and Constantinople icons are not, however, remarkable for firm modelling and hard contours, for there is an obvious effort in them to achieve a calm, almost pictorial transition from shadowy to illumined areas. But the conception of monumentality and stereometric substantiality in the bodies is common to all three works. In the present icon the strong contours and the almost flat treatment of the drapery are — on the theory that features of technique develop smoothly — at a less advanced stage than in the other two icons.

There are, however, some specific details of iconography and style that seem *prima facie* to connect the present icon with Cypriot works. The Virgin's maphorion gathered at the base of the throat, for example, is found in a late twelfth-century Hodegetria—the Virgin Arakiotissa (Cat. no. 62) — at Lagoudera (Cyprus), ascribed to the painter Theodoros Apseudes (Papageorgiou 1991, fig. 11). The rendering of the nose and eyes, too, is like that in the Virgin Eleousa icon in the church of the Virgin Chryseleousa at Fasoula, dated to the thirteenth century (Sophocleous 1990, II, 116-117, III, pls 71, 72a; Sophocleous 1993, pl. 7). This icon shares similar flat flesh tints, heavy eyebrows, intense expression, and monumentality with the present icon. It is a physiognomic type for the Virgin that probably developed from that in the great Hodegetria icon (Cat. no. 63) in the Byzantine Museum at Athens, an icon which has been dated to the early thirteenth century and is assigned to a Cypriot workshop (Mouriki 1987; Acheimastou-Potamianou 1998, 24-25, no. 4). The type of the Christ-Child's physiognomy is found again in the angels in the dome of St Themonianos at Lysi, dating to the second third of the thirteenth century (Carr 1991, pls 5-12). Indeed, the detail of Christ's ear, again with the strange lobe, can be seen in the depiction of him in the apse of the same church (Carr 1991, pls 1, 4, 23). And lastly, this type of Christ's physiognomy, similarly rendered, is found in a Sinai Hodegetria dating to the first quarter of the thirteenth century (Mouriki 1991, 157-159, figs 1, 4-5). These several iconographic and stylistic

affinities do not seem enough to justify the attribution of the present icon to a Cypriot painter. The Christ-Child's facial type is also found in a Vatopedi icon of the Hodegetria, yet to be restored, but surely of Macedonian origin and dating to the mid-thirteenth century (Tsigaridas 2000, 137, n. 46, fig. 19). This Vatopedi icon is remarkably similar to the wall-painting of the Virgin Brephokratousa in the chapel of St Nicholas at Velmej, Ochrid, a work of the same period (Miljković-Pepek 1975-1978, 113-121, figs 5-8).

In conclusion, the distinctive technical and stylistic traits of this icon, such as the use of a silver ground, the red lines emphasizing facial features, or the raised halo for St Nicholas, were ones found in regional workshops, in particular those in Cyprus and West Macedonia in the thirteenth century. These taken together with similarities of iconography and style common to wall-paintings and icons from these areas, lead us to regard this superb Athens icon, with all due caution, as the work of an artist active in West Macedonia, and to date it to the first half of the thirteenth century.

Yannis D. Varalis

Conservation:
Photis Zachariou 1960's. Benaki Museum Conservation Department 2000.

Literature:
Unpublished.

348

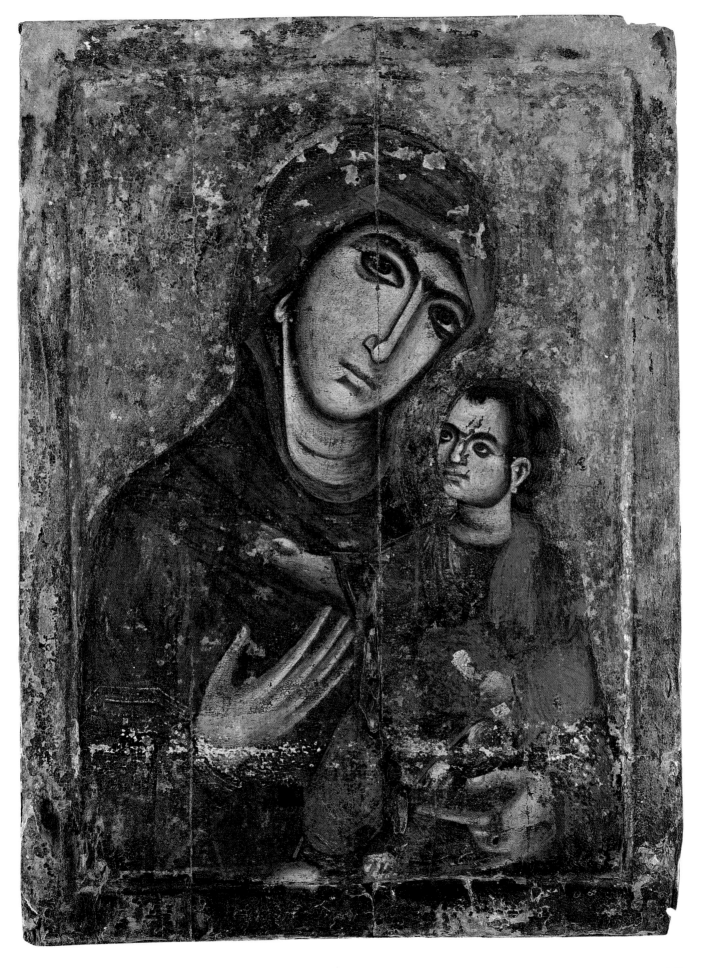

349

36

Two-sided icon: A. *The Virgin Brephokratousa*
B. *St James the Persian (?)*

100 × 72 cm
Egg tempera on wood
Early 13th century
Church of the Virgin Theoskepasti, Kato Paphos, Cyprus
Cyprus, Byzantine Museum of the Holy Bishopric of Paphos

Like many other Cypriot icons (Papageorgiou 1992, 484), the present icon was originally supported on a wooden stanchion projecting from a cubical base, so that it stood firm (Pallas 1986, 529-537). This was necessary because until high, carved, wooden iconostases began to be used at the end of the fifteenth century, the sanctuary was separated from the nave by a painted templon which had no room for icons, its diastyle being closed with a curtain. The stanchion also made it easier to carry an icon in procession. In more recent times the stanchion was trimmed down, as was the lower part of the icon frame, to fit the opening in the present iconostasis of the Virgin Theoskepasti church. One face of the icon was also shallowly cut away, making a flat surface surrounded by a narrow integral raised frame.

It is on this principal face that the Virgin Brephokratousa is painted, straight on to the wood; and it is this face, the one exposed to view on the iconostasis, that has suffered the greater damage. The figure of Christ and the lower part of the Virgin have both nearly disappeared entirely. All that is left of the figure of Christ today are the broad forehead and most of the hair, the eyebrows and eyelids, part of the left eye, part of the raised halo on the right side of the icon, and the soles of the feet on the left side. The Virgin's face and head generally are, however, well preserved, and so are parts of her shoulders. As can be seen from what remains of Christ, the Mother of God held him reclining in her arms, just as with the Virgin Arakiotissa in the katholikon wall-painting of the monastery of the Virgin of Arakos (Stylianou 1997, fig. 85; Nicolaïdès 1996, fig. 3) or the Virgin in the Sinai 'Crusader' icon (Weitzmann 1966, fig. 34). In the latter, Christ, reclining, turns his head away from the Virgin Mary. In the present icon, on the other hand, Christ looks towards Mary, as we can see from the direction of the left eye's gaze. In this sense the Theoskepasti icon is closer to the wall-painting in the church of the Virgin of Arakos.

A. The Virgin has a brown maphorion with many gold striations and a darker broad band with triangular or round scarlet jewels. The top edge of the length of ribbon above the forehead has a number of triangular projections, probably meant to suggest a Western crown. The wimple (*kekryphalos*) — blue, with a gold band — can just be made out underneath the maphorion. Over her maphorion the Virgin wears a slanting red peplos (or overveil), as with the Kykkotissa Virgin (Papageorgiou 1992, 485, n. 5). Falling to the shoulders, it is adorned with gold lozenges and ends in a hem with three gold lines.

The flesh is modelled with green shadow on dark underpaint lightened with yellowy-white on the face, nose and mouth. The eyelids, nose and chin are outlined in red, as with a whole series of late twelfth- and early thirteenth-century icons and wall-paintings (Papageorgiou 1992, 485, n. 6). The lips are red, but there are no flat dabs of red on the cheeks, as there are in other icons (Papageorgiou 1976, 271-273, pl. LVI; 1988, 239ff., pls LXXII-LXXIII; 1991, 16, fig. 9; 18, fig. 11; 20, fig. 12; 21, fig. 13; 23-25, fig. 14; 29, fig. 16).

The face of the Virgin is rather round and fleshy, as for instance in the Glykophilousa (Papageorgiou 1991, 13, fig. 7) and the Eleousa from the church of the Virgin Chrysaliniotissa (Papageorgiou 1999, 329, fig. 1), and the Hodegetria in the monastery of St Catherine on Sinai (Mouriki 1986, 96, fig. 26). The gaze of her great almond-shaped eyes is lost in infinity and her sorrowful expression reflects her utter grief on hearing Symeon's prophecy: 'Yea, a sword shall pierce through thy own soul also' (Luke 2:35). Christ's face is modelled in the same manner. The left eyelid is outlined in red, and the eyebrows are brown with black lines. The hair is brown. The application of the highlights under the Virgin's eyes and next to the side of her nose recalls late twelfth-century wall-paintings, such as those in the katholikon of the Virgin of Amasgou monastery near Monagri (Boyd 1974, 23, 36-37, 39, figs C, D), in the katholikon of the Mirovski monastery of the Transfiguration at Pskov (Lazarev 1966, figs 77-81) and in the church of the Saviour at Neredista (Lazarev 1966, figs 96-97), as well as icons of the same date, such as that of the Archangel in the katholikon of the St John Chrysostom monastery at Koutsoventi (Papageorgiou 1991, 21, fig. 13) — looted by the Turkish invader in 1974.

Mary's halo was originally larger than it is today, and was adorned with a slightly raised,

rigidly regular tendril motif, as on the haloes of two other icons, of the Archangel in the St John Chrysostom monastery (Papageorgiou 1991, 21, fig. 13), and of the 'Hodegetria with the Infant in her arms to the right' at Doros (Papageorgiou 1988, 2, pls LXXII-LXXIII). The more recent raised halo, on the other hand, is embellished with a loose, highly stylized plant motif, very faintly echoing the pearl circles and fleurs-de-lis adorning the haloes on the icons from St Nicholas of the Roof (Papageorgiou 1991, 52-53, figs 32a-b), the Virgin from St Kassianos (Papageorgiou 1991, 51, fig. 31), the Christ and Hodegetria in the church of the Virgin at Moutoullas (Papageorgiou 1991, 47-48, figs 28-29) and so on; all of these dating to the last quarter of the thirteenth century. The treatment of the vegetal motif and the impoverished imitation of pearls and lilies shows clearly that the technique had by now degenerated. The field of the icon of the Virgin is adorned with raised gilt lozenges. This is a fairly unusual ornament, a little like the decoration on the maniples and the epigonation at St Nicholas of the Roof (Papageorgiou 1991, 52-53, figs 32a-b).

Dating our icon is not difficult. Its artistic and stylistic elements occur across a fairly broad timespan, but we can narrow this down. The red outline for eyelids, nose and mouth appears in wall-paintings in the Enkleistra of St Neophytos and in St Marina at Yialousa, as well as on portable icons of the late twelfth and the thirteenth century (Papageorgiou 1992, 487). The olive-green shadowing, too, is a characteristic of late twelfth- and early thirteenth-century wall-paintings (Papageorgiou 1992, 487). However, the Virgin's face is round and fleshy, if compared with icons of the Virgin Eleousa, in the Enkleistra (Papageorgiou 1991, 16, fig. 9), the Virgin Arakiotissa (Papageorgiou 1991, 18, fig. 11), and the Enkleistra wall-paintings (Mango and Hawkins 1966, passim), as well as the katholikon of the Virgin of Arakos (Nicolaïdès 1996, passim). In some of the katholikon wall-paintings of the Virgin of Arakos, however, the Virgin's face is already rounded rather than oval (Nicolaïdès 1996, figs 3 and 64). Raised grounds and raised haloes, on the other hand, appear at the end of the twelfth century, to develop gradually throughout the thirteenth (Papageorgiou 1991, 30-33). To begin with, decoration is very free (Papageorgiou 1991, 20, fig. 12; 32, fig. 18), but later on, the tendril motif is confined to haloes, while the icon's ground is decorated in a quite different way (Papageorgiou 1991, 33). The decoration of the original haloes is a standard plant motif recalling Classical Greek sculp-

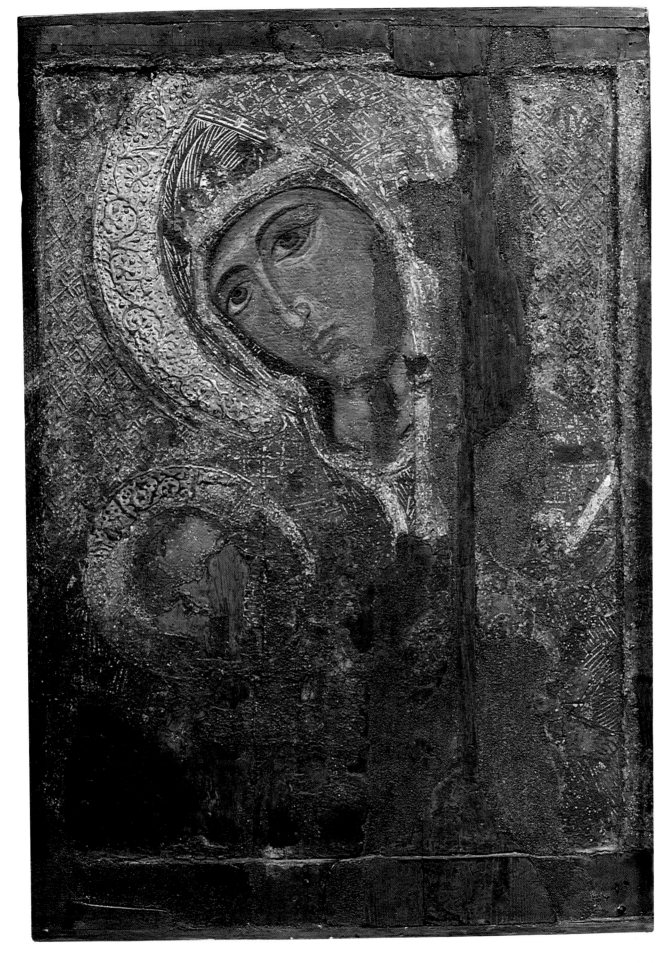

351

ture and mosaics, without any pearls or fleurs-de-lis, as on haloes in icons from the last quarter of the thirteenth century (Papageorgiou 1991, figs 28-34). For all these reasons, the present icon can be dated in the early thirteenth century.

B. The saint on the other face of the icon is shown at waist length, in a frontal pose, against a ground that was originally gold (though it is now grey). In his right hand he holds a spear, which can only just be made out, and in his left a sword and shield. The shield, of which only one quarter is shown on the icon, is adorned with concentric circles on a white ground and with letters in a pseudo-Kufic script. The saint wears a chiton of indeterminate colour, with a hexagonal neck opening and a black clavus dotted with white pearls on the left shoulder, a bright red chlamys pinned at the chest, and a little red Syro-Chaldaean cap, evidently to indicate his Persian origin (Devos 1953, 157-210; 1954, 213-216), just as his Oriental origin is emphasized by an earring in the right ear.

The flesh is modelled in grey-green underpaint, as with the Eleousa icon in the Enkleistra of St Neophytos, and elsewhere (Papageorgiou 1968, 45-55; 1988, 240; 1991, 16, fig. 9; 17, fig. 10; fig. 29; Mouriki 1986, 16-17, figs 1, 8). There is extensive use of red on the forehead and cheekbones, as for the face of the Christ Carrying the Cross in the church of the Holy Cross at Pelendri, and elsewhere (Papageorgiou 1988, 240, pls LXX-LXXIII; 1991, 17, fig. 10; 29, fig. 16). The nose and eyelids are outlined in red, as in a series of wall-paintings and icons of the late twelfth century and the thirteenth (Papageorgiou 1996, 488). The eyebrows are arched and do not meet in the middle. Between the brows and at the base of the nose is traced a schematic φ into which another φ is inserted, as in a series of twelfth-century wall-paintings (Winfield 1971, 287). The lips are bright red. The hair and beard are chestnut-brown: the hair has a parting and tumbles in profusion on both sides of the head, though without reaching the shoulders. At the parting, high on the forehead, there is a small stylized and simplified quiff, as on the forehead of Christ in the icon in the katholikon of the monastery of the Virgin of Arakos (Papageorgiou 1968, 52, fig. 3; 1991, fig. 10). The treatment of the beard recalls the calligraphic rendering of Christ's beard in the icon just mentioned, and elsewhere (Papageorgiou 1968, 52). The area of the chin and throat is given much emphasis, again as in the icon of Christ. The chlamys and cap are of an unusual colour, found again in Christ's robe in the Doros Hodegetria icon (Papageorgiou 1991, 29, fig. 16) and in the maphoria in which St Mavra and St Marina are shown in the churches named after them at Kilani and Pedoulas respectively (Papageorgiou 1991, 34, fig. 16; 56, fig. 34). The modelling of the face, on the other hand, is the standard one for late twelfth- and early thirteenth-century Cypriot icons (Papageorgiou 1991, passim). The use of pseudo-Kufic lettering for shield decoration is not without precedent (de Jerphanion 1925-1942, 1, 468, pl. 130,4; 2, 332, pl. 103; Demus 1949, pls 7a, 41b, 72). The only instance known in Cyprus dates from the twelfth and the early thirteenth century (Megaw and Hawkins 1962, fig. 23; 318, fig. C6; Megaw and Stylianou 1963, pl. VIII; Stylianou 1964, fig. 36; Mango and Hawkins 1966, fig. 30; Nicolaïdès 1996, fig. 73) and is not on shields. The iconographic elements which make up the icon of St James the Persian (?) are restricted to the twelfth and the early thirteenth century. We are therefore justified in dating the icon to the early thirteenth century.

Athanasios Papageorgiou

Conservation:
Archimandrite Dionysios Papachristophorou, 1985.

Exhibitions:
Glory of Byzantium. The Metropolitan Museum of Art, New York 1997; *Byzantine Medieval Cyprus*, Museum of Byzantine Culture, Thessaloniki 1997; Municipal Centre for the Arts, Nicosia 1998.

Literature:
Glory of Byzantium, no. 75; *Byzantine Medieval Cyprus*, no. 48a-b; Sophocleous 1993, 329-337.

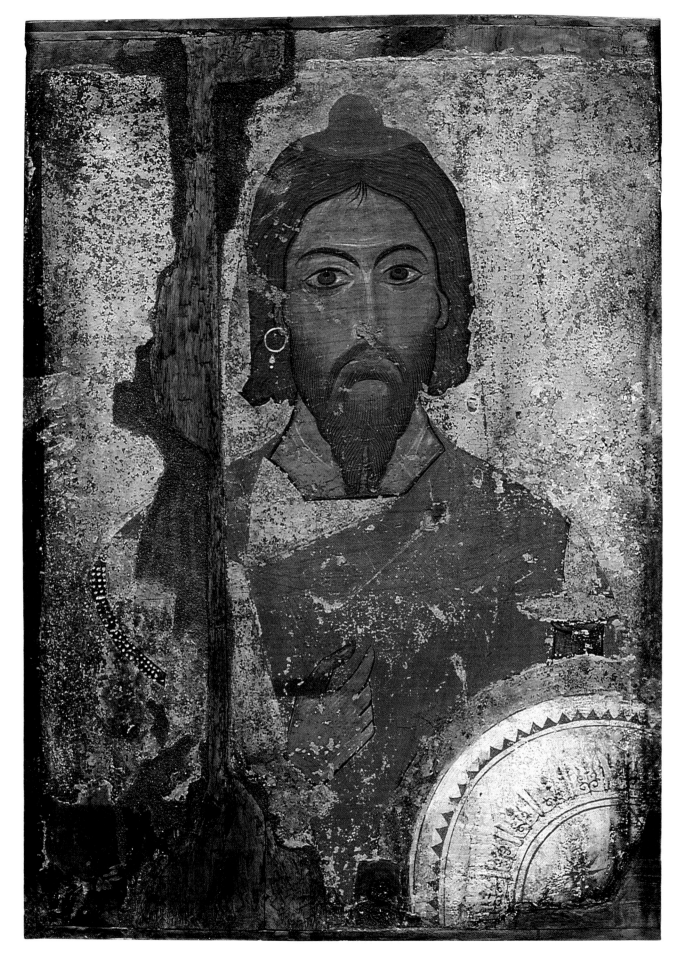

37

Two relief plaques: A. *The Virgin Orans*
B. *The Archangel Michael*

96 × 34 cm
Marble
Third quarter of the 13th century
Constantinople. Discovered at Sulu Manastir,
the former Peribleptos monastery
Berlin, Staatliche Museen, Preussischer
Kulturbesitz, Skulpturensammlung und
Museum für Spätantike und byzantinische
Kunst, Inv. no. 2129a/b

A. On the first plaque is the Virgin Mary, shown in the Blachernitissa type. She stands on a dais, her right leg turned slightly sideways. She wears a long girdled chiton, and a maphorion that covers her head, shoulders and breast, falling down her back in tiers of wide folds, behind her raised arms. Her forehead under the maphorion is covered by a veil or 'wimple'. Her head is framed by a broad halo cutting into the top border of the plaque. To her right and left are carved in relief letters the Greek abbreviations MP ΘY (Mother of God). The treatment of the figure is full of contradictions. The legs are excessively long in relation to the trunk, with its very short arms and tiny hands, and the large surface of the garments heightens to this. While the undergarment is sparsely organized in delicate folds, with a few deep grooves, the maphorion stands out by virtue of its mannered profusion of zigzagging hems and complex folds. The face has full, smooth features that underline the plasticity of volume, but here too, the large eyes and small mouth set up formal oppositions.

B. The second plaque in this composition shows the Archangel Michael. The narrow surface seems ready to burst with the size of this figure, which cuts into the frame at several points. Michael stands in mild *contrapposto* on a dais with broken arches, as if ready to move forward. He wears official imperial dress, consisting of the *skaramangion* (a long tunic), with the jewelled maniples and the hem visible, and over this the broad-sleeved sakkos or *divitision*. He has symbols of rank on his arms, and gold-embroidered selvedges at the neck opening, the hem, and the keyhole-shaped side vents. Last of all, there is the richly-worked loros, worn over the *divitision* and wound round the shoulders, hips and back in a far from simple way: it falls right to the hem of the tunic in front. The loros, which in real life was made of stiff silk brocade, is divided by rows of pearls into square panels filled with gemstones. There are

pear-shaped tassels hanging from its outside edge. The archangel's footwear is embroidered with pearls. He holds insignia of imperial rank in his hands: in his right, a sceptre with a flower-shaped finial and a decorative pommel; in his left, an orb carved with wave pattern and surmounted by a cross. Round his head is a large, solidly-contoured halo. The hair is held neatly in place by a diadem with a central ornament and bands. On the top part of the frame is carved the inscription: Ο ΑΡΧΙCΤΡΑ(ΤΗΓΟC) ΜΙΧΑΗΛ (Michael, Leader of the Heavenly Host). Once again the treatment of the figure is full of contradictions. The excessively long body, with its very small head and strikingly small wings, hands and feet, is completely overshadowed by the abundant modelling of the splendid attire. Each garment (and above all the loros) has been stripped of its logical form. Thus the keyhole-shaped vent of the *divitision*, on the right side of the body, has been moved upwards and forwards, to be downgraded into a simple decorative element. The face alone has a certain defiant liveliness.

Both relief icons were carved on marble that had been used over and over again. They were discovered in the nineteenth century, embedded, along with the Berlin relief of Christ, in a vault under the Armenian church of St George at Sulu Manastir (Ajnalov 1900, 160-164, fig. 4, from an older photograph at the time of discovery, 1896; Effenberger 1990, 79, fig. 2). Their original provenance is unknown. Provisionally they have generally been dated to the late twelfth century. The Michael relief, however, bears a remarkable resemblance in style to a column capital fragment, now in New York, showing the Archangel Michael in bust, which also comes from Sulu Manastir. On the basis of stylistic comparison with sculptures of the Early Palaiologan period at Constantinople, it can be dated to the late thirteenth century (*Mirror of the Medieval World*, no. 108). This further supports the dating of the two Berlin reliefs that has already been proposed, namely to the third quarter of the thirteenth century. It is possible that these two pieces, along with a third piece representing the Archangel Gabriel, were made at the Peribleptos monastery (Özgümüs 1999, 21-32), which was restored by the Emperor Michael VIII Palaiologos (1261-1282), particularly since Archangel Michael was the latter's patron saint.

Arne Effenberger

Exhibitions:
Pamjatniki vizantijskoj skul'ptury iz sobranij Gosudarstvennych muzeev Berlina, Leningrad 1982; *Glory of Byzantium*, The Metropolitan Museum of Art, New York 1997.

Literature:
Wulff 1911, 2, nos 1698-1699; Sotiriou 1926, 135-136; Volbach 1930, 24-25; Lange 1964, 36, 101-102, no. 33a/b on 98; Demus 1966, 387; Volbach and Lafontaine-Dosogne 1968, 206, fig. 107a/b; *Pamjatniki vizantijskoj skul'ptury iz sobranij Gosudarstvennych muzeev Berlina*, nos 21-22; Williamson 1986, 90; Restle 1990, 735; Effenberger and Severin 1992, nos 146-147; *Glory of Byzantium*, no. 12.

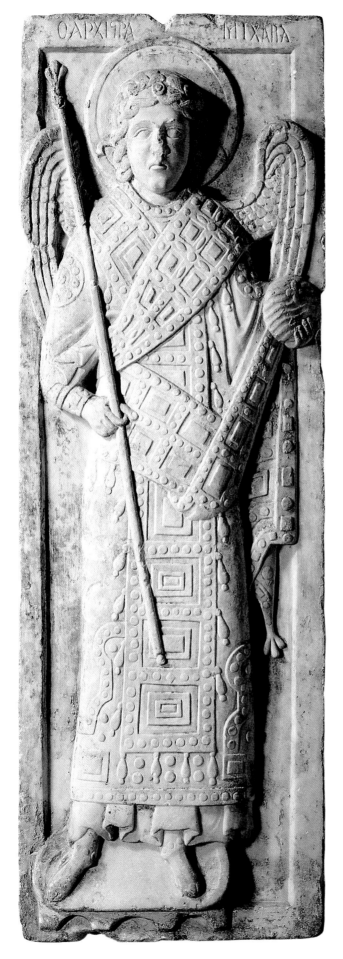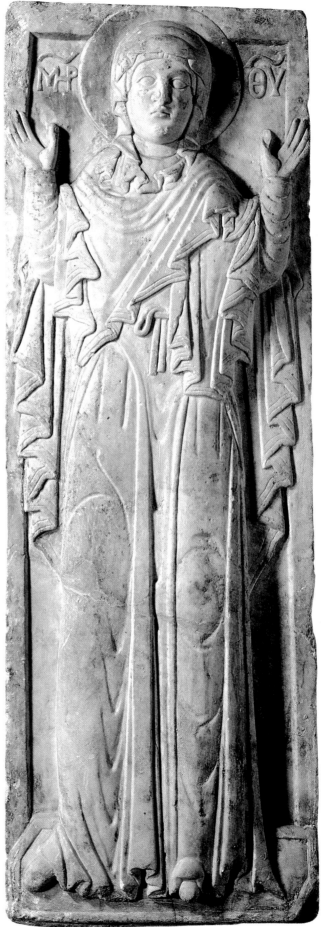

355

38
Relief Icon of the Virgin as Intercessor

104 × 7 cm, depth of relief 7 cm
Marble (Pentelic)
Mid-11th century
Constantinople
Washington, D.C., Dumbarton Oaks,
Byzantine Collection, Acc. no. 38.62;
ex coll. Prince Friedrich Leopold of Prussia

The Dumbarton Oaks relief icon is one of a number of large-scale, carved images of the Virgin from the Middle Byzantine period. Centred within the thick frame of a marble plaque, the Virgin turns to her left with her hands raised and fingers outstretched in the traditional gesture of supplication. The Virgin is represented on the back of a sixth-century carved plaque. The sacred image is enlivened by the contrast of the soft curve of the face and roundness of the brow and eyelids with the sharp folds of the tunic and maphorion. The Medieval sculptor's hand is revealed in several details of the composition; tool marks are visible on the background to either side of the Virgin and a line is scored around the entire figure, a technique associated with ivory carving of the same period (Cutler 1994, 106-107). Although some scholars have suggested that the plaque was originally painted, there are now no visible traces of pigment. Discreet touches of colour, judging from contemporary works, would have been supplied by glass paste that filled the drilled patterns on the Virgin's mantle and maphorion.

The image of the Virgin as intercessor is found in all Byzantine media, from seals and manuscripts intended for private use to large-scale works in stone or paint. This unusual carved portrait of the intercessory Virgin derives from the Deesis composition and is related, in terms of pose and gesture, to representations of the Virgin as Hagiosoritissa or Paraklesis. The absence of a diminutive figure of Christ in the upper right-hand corner of the composition and the lack of a petitioner's scroll in the Virgin's hands argue for a more generic, conservative reading. With her hands reaching toward the object of her supplication, her head bowed slightly in reverence and her eyes facing the beholder, the Dumbarton Oaks Virgin originally served as private intercessor for the faithful and as public recipient of corporate, liturgical invocations in her honour (Ševčenko 1991, 54-56). A reading of the carved, abbreviated label, MH[TH]P Θ[EO]Y, a fairly standard appellation for the Virgin in the eleventh cen-

tury, does not further refine our understanding of this portrait type. Moreover, the crude incision of the letters, their sloppy style, and the curled abbreviation marks hint that the title may have been a later addition.

In its original installation, the relief was most likely paired with a similarly-sized, frontal image of Christ, the recipient of his mother's invocations. The icon's attenuated height and narrow format demonstrate that its initial setting was ecclesiastical. Indeed, the sculptor employed certain artistic devices normally associated with monumental painting to create the illusion that the Virgin mingled with human suppliants within the sacred space of the church; her foot projects beyond the thickness of the relief and, although her body is centered, her mantle pushes dramatically against the icon's frame. In all likelihood the carved representations of the Virgin and Christ were arranged on the narrow north and south piers that guarded the opening of the sanctuary or on the walls flanking the low entrance from narthex to nave. Slight traces of mortar around the plaque's edges and on its reverse may indicate that the relief was placed above the register of marble revetment that generally encircled the church interior at ground level. Clamps on the upper and lower surface may have been used as well to secure the heavy object. The varying depth of the relief, with head and shoulders carved slightly deeper than the lower torso, further suggests the placement of the icon slightly above eye level. In addition to its placement on either side of the sanctuary or narthex portal, it is conceivable that the narrow plaque was inserted, at some point, into the intercolumniations of the screen that divided sanctuary from nave. Evidence in support of this placement includes the decoration of the reverse, which was trimmed and rotated to receive the later obverse decoration. Placed in the frame of the templon, the rhomb, now turned diamond, decoration of the plaque's reverse is mirrored in the painted decoration on the back of many Medieval Byzantine icons, decoration that suggests the veining and patterning of such carved marbles.

That the plaque was carved in Constantinople is demonstrated by local parallels for the sixth-century side and by the later portrayal's artistic kinship a series of Medieval figural reliefs. The reworking of older fragments of valuable marble was not unusual in Byzantium, and the Dumbarton Oaks plaque constitutes a splendid example of this common practice. In its first use, the marble plaque may have belonged to the liturgical

furnishings of a church or to the front side of a small sarcophagus. Both ecclesiastical and burial reliefs from the capital are adorned with rhomboid designs, often ornamented with foliate motifs. It is possible that the elongated, well-preserved tendrils at the top of the plaque represent a second phase of carving on the reverse when the piece was rotated for reuse. The representation of the Virgin fits comfortably within a set of reliefs, including those of the Chora monastery, executed in Constantinople in the second half of the eleventh century (Belting 1972, 263-271). Associated with aristocratic or imperial patronage, these reliefs adorned the most prestigious of monuments. With her right foot stepping beyond the limits of the dais on which she stands, the Dumbarton Oaks Virgin, plainly costumed in her simple maphorion, too, would have mingled with the well-dressed suppliants of the imperial city.

Sharon E.J. Gerstel

Exhibitions:
Glory of Byzantium, The Metropolitan Museum of Art, New York 1997.

Literature:
Ross 1941, 75-76; Der Nersessian 1960, 69-80; Lange 1964, 77-78; Grabar 1976, 122; Cutler and Nesbitt 1986, 162-163; Fîratlî et al. 1990, 74; Zuchold 1993, I, 70-72, figs 41A, II, 27-28; Vikan 1995, 100-103, pls 39A-C; *Glory of Byzantium*, no. 11.

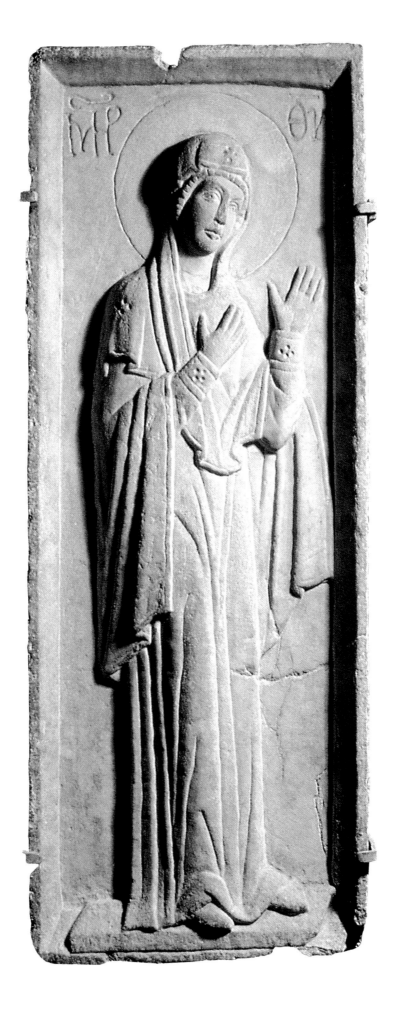

Revetment Plaque of the Virgin Nikopoios

29.5 × 29.5 cm
White clay with polychrome decoration
10th or 11th century
Constantinople
Excavations at Istanbul, perhaps before 1940
Acquired by the Musée du Louvre in 1955.
Paris, Musée du Louvre, département des
Objets d'art, Inv. no. AC 83

This rectangular plaque has been glued together from eleven small fragments, and is preserved almost entire. It shows, within a disc, the Virgin Mary holding a medallion to her breast with both hands. The medallion shows Christ, in profile, making a gesture of blessing. The disc has a broad blue border touching the sides of the plaque: in the centre of the border is a band of white lozenges inscribed with crosses, all on an ochre ground. Placed at the plaque's four corners are four stylized spiral anthemia. The Virgin is portrayed frontally. She has an ochre halo, and wears a white wimple under her blue maphorion, which covers her shoulders. A small cross of red jewels can be seen on the left shoulder. On her maphorion, just above the forehead, the jewel on the lower arm of another such cross can be made out. Logic suggests that there was a third such cross on the left shoulder. In the medallion Christ is shown frontally, with a halo inscribed with a cross. He wears a chiton and an ochre himation, makes a gesture of blessing and holds a closed scroll.

This image belongs to the iconographic type known as the Virgin Nikopoios. It was already a familiar one in the period before Iconoclasm, even if the first surviving examples known to us — seals inscribed with this particular appellation of the Virgin — date only from the eleventh century (Seibt 1985; Ševčenko 1991).

Despite severe flaking to the plaque, the design has remarkable elegance and precision. This is achieved with the help of thin black lines, above all on the Virgin's face with its fine features, and by a subtle colour harmony giving vitality to the composition. The treatment of the drapery has an astonishing feel for volume, multiplying the folds in the shadowy areas and in the hollows formed by the garments, thus leaving broad, well-lit planes for the prominent points of the volumes.

The plaque comes from a superb ensemble of hundreds of fragments of clay polychrome decorative wall revetment plaques, of diverse dimensions, form and ornamentation. This ensemble was probably put together in Istanbul before 1940, following excavations in various parts of the city. Today it is split between the Musée du Louvre, the Walters Art Gallery in Baltimore, and the Musée National de Céramique at Sèvres (Durand 1997). Besides a large number of flat fragments with geometric decoration, mostly at Baltimore, there are also a few dozen with a curved surface, whether convex or concave. With the help of the direction in which their decoration — sometimes geometric, sometimes stylized plant motif — runs, we can put together depictions of colonettes, column capitals, cornices, bases, and so on. These fragments are of an architectural nature, and above all there are some plaques with pictorial subjects — for instance the present Louvre plaque of the Virgin, or the Baltimore plaque of the saints. This allows us to use the fragments in the three museums to make out the probable remains of the decoration of a handful of iconostases, by following Totev's proposed reconstruction (Totev 1987) for a series of similar plaques found in excavations at Preslav in Bulgaria. Three rectangular plaques in the Louvre with the same dimensions as the present plaque similarly depict a central disc with a broad border. In the centre the corresponding elements are a peacock forming a circle with its body, a stylized palmette and a rosette with row upon row of concentric petals. These come from the decoration of the same iconostasis, which may have had, between the diastyles of its colonettes, a series of figural plaques with decorative subjects.

The workmanship (Vogt and Bouquillon 1996), the decorative vocabulary, at once archaizing and orientalizing, the heavily-stylized plant and animal motifs, the sure brushwork, all suggest that most of these clay plaques should be assigned to the art of the Macedonian renaissance in the tenth and eleventh centuries. This is also revealed by the style of the Louvre Virgin, classical in its elegance, making it undoubtedly one of the finest achievements of Byzantine art.

Jannic Durand

Exhibitions:
Vingt ans d'acquisitions au Musée du Louvre, 1947-1967, Orangerie des Tuileries, Paris 1967; *Byzantine Art, an European Art*, Zappeion, Athens 1964; *Splendeur de Byzance*, Musées royaux d'art et d'histoire, Brussels 1982; *Byzance*, Musée du Louvre, Paris 1992.

Literature:
Coche de La Ferté 1957, 187-217; *Vingt ans d'acquisitions au Musée du Louvre*, 213; Coche de la Ferté 1958, 66-69, fig. 65; *Byzantine Art, an European Art*, no. 598; *Splendeur de Byzance*, no. C2; Durand and Vogt 1992, 38-44, fig. 7; *Byzance*, no. 296A; Vogt and Bouquillon 1996, 105-116, fig. 2; Durand 1997, 25-34.

40
Fragment of a Mosaic with the Virgin

34.4 × 26.4 cm (with modern
frame: 55.4 × 39 cm)
Glass, marble, plaster; modern frame
of plaster and aluminium
Late 10th-early 11th century
Constantinople, Stoudios monastery
Athens, Benaki Museum, Inv. no. 9074

This fragmentary bust of a female figure
should probably be identified as the Virgin.
According to the Benaki Museum files it
originates from the Stoudios monastery in
Constantinople, where it was found. The
angle of the Virgin's head, slightly inclining
to the right, the pose, the position of the sur-
viving left shoulder—indicating that the
arms were outstretched—and the figure's
facial expression suggest that the mosaic could
be part of a Deesis scene or a Presentation
in the Temple.

The face is composed of small, densely
packed tesserae (dim. ± 0.3 cm) of alternat-
ing pink and white marble to indicate the flesh,
with light green tesserae added to produce a
chiaroscuro effect. Larger tesserae (dim. ± 0.7
cm) were used for the Virgin's maphorion.
Many of the tesserae, although original, were
reset at a later date. The green and gold halo
is a modern addition. The figure is imbued with
gravitas, nobility and restrained grief. The del-
icate, elaborate modelling of the face and the
accentuated shadows on the cheeks are fea-
tures closely comparable to those of the mosaic
composition with the emperors Justinian and
Constantine flanking the enthroned Virgin, on
the tympanum over the door leading from the
south vestibule into the narthex of Hagia
Sophia at Constantinople, which dates around
the year 1000 (Mango 1967, 58-59, fig. 91; N.
Chatzidakis 1994, 233, fig. 34).

The Benaki Museum fragment is the only one
known to have survived from the group of
magnificent wall mosaics in the Stoudios
monastery (Eyice 1955, 94, no. 142) one of
the most renowned monastic foundations in
Constantinople. Known to have been found-
ed before 454, by a certain Stoudios, build-
ing actually began in 450 (Mango 1978, 115-
122; Peschlow 1982, 429-433). The monastery
came to occupy a leading place in the eccle-
siastical and spiritual life of Byzantium dur-
ing and after the Iconoclastic period
(Eleopoulos 1967; Mathews 1976, 143-158;
Patlagean 1988, 429-460), when its abbots
included such personalities of the time as
Theodore the Studite.

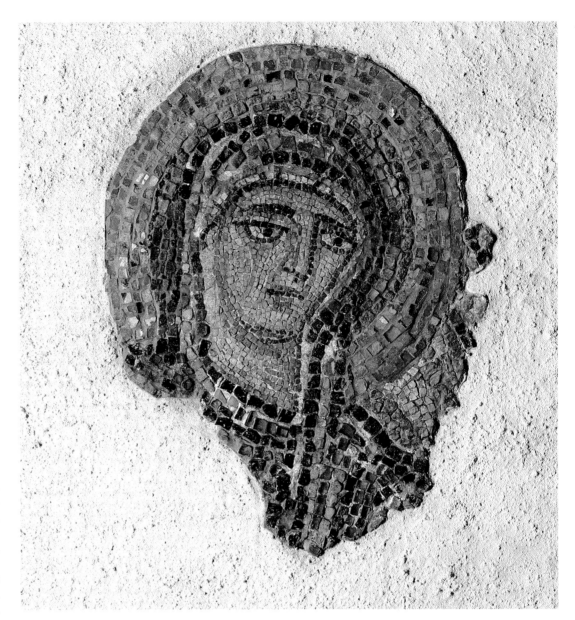

The superb mosaics that adorned the
monastery—now lost—were praised by the
late tenth-century poet John Geometres
(*PG* 106, 942ff.) and were greatly admired by
pilgrims to Constantinople as late as the
Palaiologan period (Majeska 1984, 38-41,
283-288).

Anastasia Drandaki

Exhibitions:
Glory of Byzantium, The Metropolitan Museum
of Art, New York 1997.

Literature:
Benaki Museum Guide 1936, 28, no. 65; Deli-
vorrias 1980, 35-36, fig. 30; *Glory of Byzantium*,
no. 13; *Greece at the Benaki Museum* 1997, 227,
fig. 405.

41

Processional Cross

36 × 30.1 × 0.3 cm
Copper alloy, cast, with additional
hammering, engraved decoration
and punched dedicatory inscription.
First half of the 11th century
Constantinople
Athens, Benaki Museum, Inv. no. 11442

The flaring arms of this processional cross
end in roundels with pairs of undecorated cir-
cular serifs at the corners. The six holes on
the underside of the horizontal arms were for
pentelia (hanging links). Such crosses were
carried in procession, or during the liturgy,
but might also be placed in the sanctuary or
at other points of the church (Cotsonis 1994,
32-37; Galavaris 1994, 95-99).

A. The obverse depicts the crucified Christ,
wearing a short loincloth. At the base of the
cross there is the hill of Golgotha and Adam's
skull. On the upper part, the *tabula ansata* is
decorated with the sign X, and higher up are
depicted the sun and moon. Inscribed within
circles on the facing roundels of the horizon-
tal arms are busts of the Virgin Mary, labelled
M[HP] ΘΥ (Mother of God), and St John,
labelled A(ΓΙΟC) ΙΩΑΝ(NHC) Ο
ΘΕΟΛΟ(ΓΟC) (St John the Theologian).
Both turn towards Christ, completing the Cru-
cifixion scene. Mary has her left hand to her
face, the forefinger outstretched, in an expres-
sion of grief; she holds a kerchief, a detail found
in Crucifixion scenes from the eighth century
onwards (Weitzmann 1976a, B.36, B.51; Cor-
rigan 1995, 45ff., figs 9, 11). Though John is
here shown at the Crucifixion, he holds a closed
jewelled gospelbook, a detail that we see in
other Middle Byzantine examples (Cotsonis
1994, no. 6; *Glory of Byzantium*, no. 92). The
scene is completed by the dialogue between the
Crucified Christ and the two persons with him:
ΙΔΟΥ Ο Υ(Ι)Ο(C) COY (Behold thy Son)
and ΙΔΟΥ H MH(TH)P COY (Behold thy
mother) (John 29:26-29:27). On the upper
roundel, in bust, is St George – A(ΓΙΟC)
ΓΕΩΡΓΙΟ(C) – in court dress. On both faces,
a decorative zigzag line is engraved across the
base of each circular serif.

B. The reverse shows the Virgin Mary full-
length at centre, her hands open in prayer.
She stands on a jewelled rectangular dais.
Cruciform ornaments composed of four circles
can be made out at shoulder and knee. There
is a comparable decorative motif on her man-
iples and on the portion of her maphorion
that covers her head. A kerchief is tucked into

her girdle. Her figure is accompanied by the
inscriptions MH(THP) Θ(EO)Υ (Mother of
God) H BΛAXEPNHTHCAN (The Blacher-
nitissa). Mary is framed, on the roundels, by
four saints: Cosmas – A(ΓΙΟC) KOCMAC –
to the left, Damianos – A(ΓΙΟC) ΔAMH-
ANOC – to the right, Hermolaos – A(ΓΙΟC)
EPMOΛAOC – above, and Panteleimon, who
was shown on a roundel that is now lost,
below, as we can tell from the inscription:
A(ΓΙΟC) ΠANTEΛEHMON. The inscrip-
tions identifying the figures in the roundels
are not inscribed within the circles – in con-
trast to the practice on the other side of the
cross – but are engraved in large, legible let-
ters on the flaring ends of each arm.

On the surface of the cross three dedicatory
inscriptions can also be made out. The first
is written underneath Golgotha, and reads:
KE BOHΘH TΩ CO ΔOY[Λ]O IΩ(ANNH)
(O Lord, help Thy servant John). The in-
scription is punched and, despite differenc-
es in execution, the script is similar to those
identifying the saints. We believe, therefore,
that the inscription was made at the same
time as the cross itself and commemorates the
person who commissioned it (*Splendeur de
Byzance*, no. Br.16). There are two further
dedicatory inscriptions, shallowly incised
and in rather wobbly lettering, on both faces
of the upper arm of the cross. On the Cruci-
fixion face there are the words: (KE)
BOHΘH TΩ CO Δ(OYΛ]Ω] ΛEΩNTAN
[T]ON BOPEAN (O Lord, help Thy servant
Leontes Boreas), and on the Blachernitissa
face the words: KE BOHΘH TΩ CO
Δ(OY)ΛO ΓEΩPΓHON T[O] CYPON + (O
Lord, help Thy servant George Syros). These
two inscriptions, identically lettered and
engraved, are later than the first (Sandin
1992, 307). The mention of successive dedi-
cators on the surface of processional crosses
is by no means uncommon, for the crosses
would have been in use for a long period of
time (Cotsonis 1994, 29-32).

There are parallels for the palaeographic
features of the cross in manuscripts and
inscriptions dating from the second half of the
tenth to the middle of the eleventh century
(Spatharakis 1981, II, figs 58, 64, 80, 88 and
91; Mundell Mango 1994, 223, nos 38-42; 2,
pl. 115.1-2). To the same period belong two
bronze objects that in terms of technique and
palaeography are the closest examples to the
present cross. These are a reliquary cross in
Paris (*Byzance*, no. 234), and part of the ho-
rizontal arm of a processional cross at
Princeton (*Byzantium at Princeton*, no. 68).
The Princeton example shows such close sim-

ilarities with the present cross that there are
grounds for thinking that they are two items
from the same workshop. In both there is the
same iconography on the obverse (the Cru-
cifixion) while on the reverse the Princeton
specimen depicts St Theodore, probably
because the cross was dedicated in a church
of the same name. Comparison of these two
examples of the same kind suggests that on
their reverses – behind the subject of the Cru-
cifixion, which remained constant – the artist
would be commissioned to engrave a portrait
of the saint to whom the cross was dedicated
(Mango 1988, 44).

The iconography of the Benaki Museum pro-
cessional cross – with the Crucifixion on one
side and the Virgin orans on the other –
recalls the decoration of a large group of
tenth- and eleventh-century reliquary crosses
(Sandin 1992, 302; Pitarakis 1998b, 81ff.). In
the case of the Benaki cross, the appellation
Blachernitissa, when coupled with the healer
saints that accompany it, has a dual function.
It indicates the major monument where the
cross was dedicated and it adds special con-
tent to the object's iconography. The import-
ance of this content is underlined by the use
of large easily-legible letters for the identifi-
catory inscriptions.

In Constantine Porphyrogennitos's *Book of
Cerimonies*, in the chapter (II.12, 318-321)
entitled: '...῞Οσα δεῖ παραφυλάττειν τῶν
Δεσποτῶν ἀπιόντων λούσασθαι ἐν
Βλαχέρναις᾽ (What rites should be per-
formed when the Despots depart for the
Ablution at Blachernai), mention is made of
at least three icons of the Virgin Mary at the
Blachernai monastery. One of them, placed
in the inner *tholos* of the baths, is of marble,
and '...ἥτις ἐκ τῶν τῆς αὐτῆς ἁγίων χειρῶν
προχεῖ τὸ ἁγίασμα᾽ (pours out holy water
from its holy hands). The marble icon at
Blachernai was the model for the execution
of a whole series of marble reliefs of the
same type, all of them faithfully reproduc-
ing the iconography of the full-length Vir-
gin orans, just as depicted on the present
processional cross (Lange 1964, nos 1-5, 11-
12, 15, 19-20, 31, and 33; *ODB*, 2170-2171).
This type, already familiar from the dec-
oration of the Virgin of the Pharos (Mango
1958, 182; Belting-Ihm 1976, 49), seems to
have been clothed in especial reverence in
the eleventh century: not only did it feature
in the wall-paintings of major churches such
as the Virgin of Chalkeon at Thessaloniki,
the church of the Koimesis at Nicaea, and
St Sophia at Kiev, but it also appears on
coins, lead seals, and a rare silver weight now

in the British Museum (Cat. no. 43). However, the appellation Blachernitissa does not appear for the first time in conjunction with this iconographic type until the middle years of the century, on a coin minted by Constantine IX Monomachos (1042-1055), and then by Theodora and Michael VI (Grierson 1973b, 747, pl. LIX 8.a.1 and 8.a.4; 753, pl. LXII AR3; 758, pl. LXIIAR3). It is also found on a lead seal dated between 1060 and 1080 (Seibt and Zarnitz 1997, no. 2.1.9).

This appellation is also known to have accompanied other iconographic types of the Virgin (Zacos 1984, no. 522, 272, pl. 53; Carr 1991, 43-46; Sotiriou 1956-1958, 125-128, fig. 148). The subject of depictions of the Mother of God which are related to the Blachernai monastery is not a simple one, and is beyond the scope of the present catalogue entry. But in the case of our processional cross we can safely say that the praying Virgin of Blachernai reproduces the model of the miracle-working holy water icon. This identification is encouraged by the presence next to Mary of the four healer saints: indeed their names, as was noted above, are given special exposure along with the Virgin's appellation (Cotsonis 1994, 52-54). Thus the five figures form an ensemble clearly of a healing nature, and this indicates that the present processional cross was dedicated by John in thanksgiving or in petition for good health. It should also be noted that the miraculous holy water of the Blachernai monastery was at the start of its history associated with a famous pair of healing saints, Cosmas and Damian (Mundell Mango 1994, 189ff.). The two monuments were neighbours up to the seventh century, before the church of Sts Cosmas and Damian remained outside the walls; and it has been proposed that the two churches probably shared the same *hagiasma* (sacred spring). Despite the different paths they eventually followed, the common tradition and the healing nature of the two shrines underline the iconographic message of the processional cross.

The healing role of the Virgin of the Blachernai baths must surely have been reinforced from the late tenth century onwards, thanks to an incident mentioned in the *Patria*, a work compiled in about 995 (Preger 1907, II, 283, 214 [154, ϱπη′]; Dagron 1984, 22 and 48-53). According to this passage, Basil II fell sick of a palsy and when he was cured, evidently thanks to the holy water of Blachernai, he made a costly restoration of the baths: '...καὶ ἐξ ἀργύρου πολλοῦ καὶ χρυσίου εἰκόνισεν καὶ κατεκόσμησεν αὐτό' (and of much silver and gold did he give it both images and decoration).

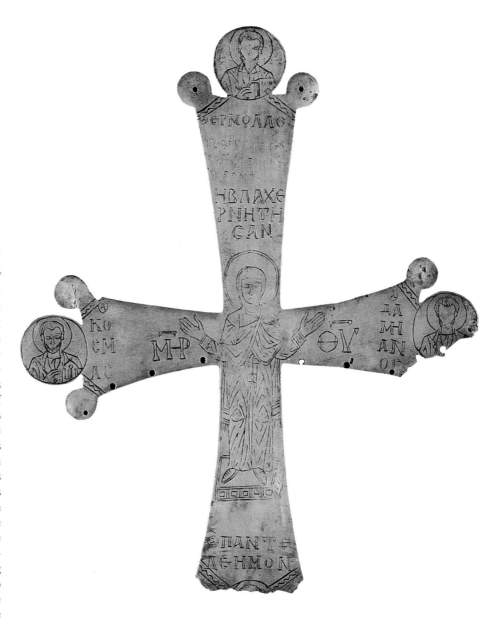

The incident of the imperial cure, and the added lustre which accrued to the refurbished baths, must have revived the confidence of the faithful in the healing properties of this holy water and the icon it flowed forth from. With its iconography and inscriptions, the present cross reflects John's confidence in the holy water of Blachernai, the place where the cross must have been dedicated. From its palaeographic and iconographic characteristics we can date the cross to the first half of the eleventh century. Thus it is, if not the very first, at least one of the earliest extant examples of an iconographic type of the Virgin in which the accompanying appellation is directly linked with the Blachernai monastery.

Anastasia Drandaki

Conservation:
M. Lykiardopoulou, 1982.

Exhibitions;
Byzantine Art, an European Art, Zappeion, Athens 1964; *Splendeur de Byzance*, Musées royaux d'art et d'histoire, Brussels 1982; *Οι Πύλες του Μυστηρίου*, National Gallery, Athens 1994.

Literature:
Byzantine Art, an European Art, no. 550; *Splendeur de Byzance*, no. Br.16; Sandin 1989, 36-37; Sandin 1992, no. 42, 297-307; *Οι Πύλες του Μυστηρίου*, no. 86; *Greece at the Benaki Museum*, no. 404.

42
Handle of a Standing Censer (katzion)

28.6 × 21 cm
Bronze, caste with engraved decorative
details
Early 14th century
Constantinople, Therapia (?)
Athens, Benaki Museum, Inv. no.11402

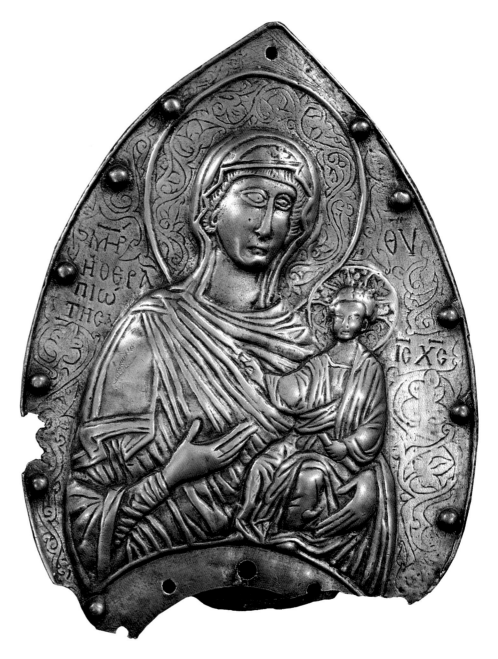

All that survives of this bronze standing censer is its handle, which is in the form of an ogee. The cup (now lost) in which the incense burned was riveted to the handle through holes that can still be seen on the undecorated strip on the lower edge. The handle is decorated with a representation of the Virgin Hodegetria holding the Christ-Child in the left arm. The ground is decorated with incised foliate scrolls, from which spring three- or five-lobed palmettes and half-palmettes. The vegetal motifs include undecorated surfaces on which are engraved the inscriptions MHP ΘΥ Η ΘΕΡΑΠΙΩΤΗCΑ (Mother of God Healer) and IC XC (Jesus Christ). The raised contours of the haloes enclose similar engraved vegetal motifs; Christ's halo with its inscribed cross is diversified with five raised dots at the flaring arms of the cross. Hemispherical studs decorate the edges of the handle.

The handle belongs to a type of standing censer without hanging chains, known as *katzion* (or *katsion*). This term is attested in Byzantine authors as early as the eleventh century, for instance in the *Diataxis* of Michael Attaleiates (Gautier 1981, 91, l.1222). These standing censers were held by their handles, which in some cases were of a shape similar to the example examined here. Such, for instance, is a *katzion* which has been dated to the eleventh century and is now in a private collection (Gòmez-Moreno 1968, no. 87). A similar censer is depicted in the Mateić rendering of stanza 24 of the Akathistos Hymn (Ševčenko 1991, fig. 12). In other instances there is a cylindrical extension to the handle so that the vessel can be held more easily (Xyngopoulos 1930, fig. 5; Bouras 1981, 70; Ševčenko 1991, fig. 9). *Katzia* are often depicted in representations of the Dormition of the Virgin, or of other saints, and this has led scholars to link this type of censer with burial rites (Xyngopoulos 1930, 129-130). It should further be noted that the pierced *katzion* from Mystras was also found in a tomb (Drandakis 1952, 504, fig. 10). But standing censers also appear in scenes showing processions of icons, thus suggesting a wider ritual use for this type of vessel (Ševčenko 1991, figs 9, 12).

In the case of the Therapiotissa *katzion* handle, particularly impressive are the size and above all the weight of the cast metal. Indeed if we add on the cup (now lost), the vessel would originally have been nearly forty centimetres long and its weight would have made it highly impractical for frequent use. If we look carefully at the handle's surface, however, we can see a slight smoothing at the points next to the bent left elbow of Christ and the corresponding points on the opposite side – the points at which the vessel would have been held, using both hands.

Leaving aside the size of the handle, another impressive feature is the Hodegetria's monumentality, underlined by the particularly high relief. Though part of a vessel meant for

ordinary use, the handle also has, by virtue of its decoration, the nature and function of a devotional icon. From this, in conjunction with its cumbersome weight, we can infer that the present *katzion* would most likely have had a permanent place, where it could be viewed as an icon by the worshipper, and that it would not have been moved about to more than a limited extent. (We can tell this, in any case, from the fact that the wear at the points where it was taken hold of is minimal). This is consistent with the *katzion* having been placed at some point in the church, or in a tomb, as the archaeological find at Mystras attests (Drandakis 1952, 504).

The representation of the Hodegetria holding the Child in her left arm is linked with late thir-

teenth- and early fourteenth-century metal-work objects. Comparable treatment of volumes, and faces with pronounced cheekbones and full cheeks, as in the present icon, are found on the revetment of the Hodegetria icon dedicated by Konstantinos Akropolites and his wife, dating to the late thirteenth century, and now in the Tretyakov Gallery in Moscow (Grabar 1975b, no. 18, 45-46, figs 43-44; Bouras 1981, 69). The latter icon and the present censer share a common model both for the treatment of the two-figure group and for the similar layout of the vegetal motifs. The high relief in the present censer and the treatment of the figures' eyes and noses are also characteristic of the figures on the silver frame of an early fourteenth-century mosaic icon of the Brephokratousa in the Vatopedi monastery (Grabar 1975, nos 23, 53, fig. 60). We can also compare a fourteenth-century British Museum steatite where the Hodegetria is rendered with the appellation H ΑΛΥΠΟΣ (Without Pain): similar features are found here, for instance the special attention to moulding the volume of the faces and body, and the geometric arrangement of the drapery (Kalavrezou-Maxeiner 1985, nos 134, 209, pl. 66).

The censer's provenance is particularly intriguing. It is known that as a rule, right up to the late Post-Byzantine period, the patron saint of the church the vessel is dedicated in is depicted on the broad surface of the censer (Oikonomakis-Papadopoulou 1980, 20). So it is reasonable that for the Therapiotissa censer we should search for a church of the same name. In a text dated 1394, from the *Acta Patriarcharum*, there is mention of a theft of silverware — the revetment, obviously — from the venerable icon of the Virgin Therapiotissa (Miklosich and Müller 1860-1890, I, 203; Veglery 1909-1910, 334, n. 2; Oikonomides 1991, 39). This piece of evidence confirms that there was a an icon of the same name, which the *katzion* reproduces. But we still have to settle the question of where this icon was and which church housed it.

When Veglery first published the vessel, he stated that the present handle was found at Therapia — a northerly suburb of Istanbul — not far from the ruined church of St John (Veglery 1909-1910, 327). The find spot looked very reasonable, as it links with the appellation accompanying the Brephokratousa on the censer. However, the evidence of a Russian pilgrim, Stephen of Novgorod, prompts us to look in a different direction. One of Stephen's visits to the pilgrim shrines of Constantinople in the years 1348-1349

(Ševčenko 1953, 168-172; Majeska 1984, 17) was to the relic of St Eudokia (Majeska 1984, 35, no. 114) in the church of the *Panagia Iterapiotica* (or *Iteraopitica* or *Gerapiotyca*). The Russian pilgrim has obviously got the Virgin's appellation — which was also the name of the monastery — not quite right, but it can fairly safely be restored as *Therapiotissa* (as had already been proposed by Majeska in his comments on the passage in question). This monastery, according to Stephen's itinerary, was not in the suburb of Therapia at all, but in the first *regio* of Constantinople, close by St Irene and the Hodegon monastery, an area where there is known to have been a large number of small churches and monasteries from the year 1261 onwards (Majeska 1981, 359-365).

The evidence of Stephen is a reliable source for the topography of mid-fourteenth-century Constantinople, shows fairly conclusively whereabouts the monument our *katzion* refers to stood. Moreover, the *katzion* was made at about the time when the church of the Virgin Therapiotissa was famous enough to be included in a foreign pilgrim's seven-day programme. While there is no reason to reject Veglery's information regarding the at first sight convenient discovery of the Therapiotissa *katzion* at Therapia, neither can the information be checked properly, particularly as Veglery himself starts by saying that 'it was discovered some years ago'.

Anastasia Drandaki

Conservation:
M. Lykiardopoulou 1981.

Exhibitions:
Splendeur de Byzance, Musées royaux d'art et d'histoire, Brussels 1982; Οι Πύλες του Μυστηρίου, National Gallery, Athens 1994.

Literature:
Veglery 1909-1910, 327-336; Bouras 1981, 68-69; *Splendeur de Byzance*, no. 29; Οι Πύλες του Μυστηρίου, no. 89.

43

Weight

Max. diam. 3.2 cm, wt 32.96 gr
Silver with gilding, niello (silver 94.3%,
copper 3.0%, gold 2.3%, lead, zinc 0.05%)
Between 11 January 1055 and 31 August 1056
Constantinople
Purchased by the British Museum in 1992
London, British Museum, M&LA 1992, 5-1, 1

Silver-gilt weight struck on its obverse with a nimbed bust of the Virgin Blachernitissa wearing a tunic and maphorion; in the field to left and right: MP ΘΥ (MHTHP ΘΕΟΥ); above: OYΓΓIA MIA (one ounce). The centre of the reverse, which is in the form of a raised medallion, is struck with a bust of Empress Theodora wearing a crown with cross and *pendilia*, a pearl collar, and a loros. In her left hand she holds a sceptre decorated with pellets, and in her right a *globus crucifer*; in the field to left: ΘΕΟΔΩP. Around the edge of the weight is a nielloed inscription: +ΘΚΕ ROHΘΕI ΘΕΟΔΩPA AYΓΟVTTH ΠΟPΟVP/ΓΕΝΗΤΟ (Mother of God; Help Theodora Augusta Porphyrogenneta). The Empress Theodora ruled for two brief periods in the mid-eleventh century: the first with her sister Zoe between 20 April and 11 June 1042, the second from the death of Constantine IX on 11 January 1055 to her death on 31 August 1056. When compared with contemporary coins it is evident that the weight belongs to Theodora's second reign. With the exception of a number of *histamena* from the Akcacoca Hoard, which bear as their

obverse type a bust of the Virgin Platytera, and their reverse type busts of Zoe and Theodora, few coins have survived from her first reign. In contrast, numerous *histamena* and *tetartera* were issued during her second reign. The latter have as their reverse type an identical bust of Theodora to that found on the weight (Grierson 1973b, 752-753, pl. LXII). The best parallel for the Virgin Blachernitissa is found, however, on the silver coinage as typified by a two-thirds *miliaresion* in the Dumbarton Oaks Collection, Washington, D.C. (Grierson 1973b, 753, pl. LXII). The first appearance of the Virgin Blachernitissa on Byzantine coins occurs during the reign of Leo VI (886-912), where her image is employed on *solidi* as an obverse type; this image continued to appear sporadically on coinage until the reign of Nikephoros Botaneiates. Grierson has suggested that the appearance of the Virgin Blachernitissa on mid-eleventh-century coins 'may have been due to the sexcentenary celebrations of the church (the church of the Blachernai at Constantinople), which had been founded and built by the Empress Pulcheria around 450' (Grierson 1982, 203).

Chris J.S. Entwistle

Exhibitions:
Byzantium, British Museum, London 1994.

Literature:
Entwistle and Cowell 1994, 91-93, pls 47-48; *Byzantium*, no. 164.

44

Solidus of Leo VI (886-912)

Diam. 1.9 cm, wt 4.37 gr.
Gold
Date of issue: before 906 (Grierson 1973b,
512, Class I [b]: 886-908; *Byzance*, no. 309,
before 908)
Mint: Constantinople
Athens, Benaki Museum, Inv. no. 32563

Obv.: +MARIA+ . Frontal bust of the Virgin interceding, in the Blachernitissa type. She wears a maphorion folded back on her breast and a sleeved tunic. Right and left in the field: M̄R Θ̄Ч (Mother of God).

Rev.: LEOhEhCRISJO bASILEЧSRO-MEOh (Leo in Christ Emperor of the Romans). Bust of Leo VI, with long beard. On his head he has a diadem with a finial surmounted by a cross. He wears a chlamys fastened with a brooch at the height of the right shoulder and decorated with a jewelled tablion. In his right hand he holds an orb surmounted by a patriarchal cross. The iconography of this rare coin is particularly interesting. On the reverse, the realistic portrait of Leo VI in the type of the emperor-philosopher is a noteworthy innovation in the numismatic effigy of the imperial figure, which is normally treated conventionally, its individual features being stylized. We find similar portraits on coins of Constantine VII (Grierson 1982, pl. 43, no. 786), on works in the minor arts such as ivories (*Glory of Byzantium*, nos 139-140), on icons (Vocotopoulos 1995, 35 and 192, no. 7), and on mosaic representations (N. Chatzidakis 1994, 57 and 233, no. 33). The Blachernitissa Virgin on the obverse is the very first appearance of the Mother of God in numismatic iconography. It is most probably linked with an unspecified monumental work of the time, now lost. Grierson proposes that the inspiration of this coin's iconography was the mosaic decoration in the church of the Virgin of the Pharos, where the emperor celebrated his fourth marriage, with Zoe Karbonopsina (Grierson 1982, 179). The view that this choice of subject was coupled with the intrigues behind Leo's fourth marriage is not unattractive. On September 3, 903, Zoe—while still the emperor's mistress—gave birth to the son he so much needed, the future Emperor Constantine VII Porphyrogennitos. Gossip said that Zoe became pregnant after passing around her waist a cord previously wound round an icon of the Virgin Mary in the church of the Virgin of the Source (Garland 1999, 114). The miraculous intervention of

the Mother of God in this development was plain and tangible proof of divine approval. The representation of the Virgin Mary on a coin of Leo's could therefore be regarded as serving imperial propaganda, and aim at publicizing the event, to restore Zoe's prestige, and in the final analysis to legitimize the newborn infant and make the emperor's fourth marriage, to his lover, a successful one.

Vasso Penna

Literature: Unpublished.

45

Tetarteron of Nikephoros Phokas (963-969)

Diam. 1.9 cm, wt 4.04 gr.
Gold
Date of issue: 963-969: Grierson 1973b, 583,
Class II
Mint: Constantinople
Athens, Benaki Museum, Inv. no. 32630

Obv.: + IhSXISREXRESNTIhM (Jesus Christ, King of Kings). Frontal bust of Christ in the type of the Pantokrator. He blesses with his right hand, and holds a closed jewelled gospelbook in his left.

Rev.: +ΘEOTOC'bHΘ,hICHF,ƏES[P] (Mother of God, Help the Despot Nikephoros). Left, the bust of the Mother of God: right, the bust of Nikephoros Phokas. The two figures hold between them a patriarchal cross with a long shank. The Virgin wears a sleeved tunic and a maphorion with a dotted cruciform decoration at shoulder height. Right and left in the field: the abbreviation M̄ Θ (Mother of God). The emperor is shown with a short beard. He wears a diadem with *pendilia*, surmounted by a cross, and a jewelled hinged *loros*. (The hinged loros is identified by some scholars with the modified form of the loros that made its appearance from the end of the ninth century onwards: in other words, this was not a long strip of sumptuous material wound round the emperor's body, but a two-piece garment fitting on to the shoulders, with the elaborate forepart shorter than the part behind: Grierson 1982, 343).

An intensely religious quality emanates from the scene on the obverse, with the Virgin and Nikephoros as co-emperors, combined with the accompanying inscription of *epiklesis* (invocation). What is being invoked is the impartial assistance of the Mother of God in governing the empire, not simply as mediating with her Son, but as giving a lead in the actions of the emperor. The Virgin's decisive

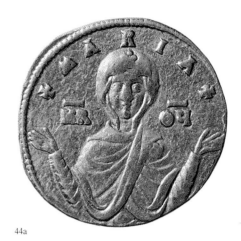

44a

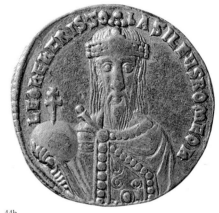

44b

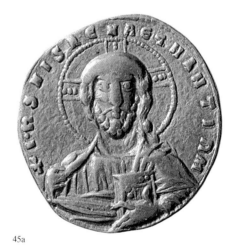

45a

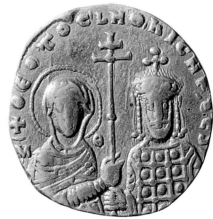

45b

role in the fortunes of the State is firmly emphasized by representing her in a higher position in the hierarchy, in other words in the position normally occupied by the main emperor. Imperial power is subordinated to the will of the Mother of God, and draws from her the power to go ahead and put its commandments into practice.

The symbolism just mentioned doubtless has its source in Nikephoros's piety and his particular devotion to the Virgin Mary. But at the same time it also served imperial propaganda, which was trying to erase the negative impression made on the people and the Church by Nikephoros' marriage to Romanos II's widow Theophano (Bellinger 1956, 78).

Vasso Penna

Literature:
Unpublished.

46
Histamenon of John I Tzimiskes (969-976)

Diam. 2.2 cm, wt 4.43 gr.
Gold
Date of issue: 969-976: Grierson 1973b, 512, Class II(b)
Mint: Constantinople
Athens, Benaki Museum, Inv. no. 31589

Obv.: + IhSXISREXREϹNANTIhM (Jesus Christ, King of Kings). Frontal bust of Christ in the type of the Pantokrator.

Rev.: +ΘΕΟΤΟϹ [b] OHΘ,IWϑЄS (Mother of God, help the Despot John). Representation of the crowning of the emperor by the Mother of God. Left, John I, bearded, and in bust: right, the Mother of God. The emperor wears a diadem with *pendilia*, surmounted by a cross, and a jewelled hinged *loros*. In his left hand he holds a patriarchal cross. The Virgin wears a sleeved tunic and a maphorion with a dotted cruciform decoration at the height of the left shoulder. In the field: top left, the hand of God makes the gesture of blessing on the emperor; right, the abbreviation M̄Θ̄ (Mother of God).

The representation on a coin of an emperor being crowned by some saintly person is an innovation of the Macedonian dynasty first found in the reign of Alexander. It implies the emperor's transformation 'by the grace of God' from sovereign *basileus* to God upon earth; and it emanates a need to stress his personal, co-ordinate relationship with what seems and is far off, while at the same time being an application to the Heavenly Lord for intervention. That John, the brave soldier-

emperor, chose the Mother of God should probably be linked with the Virgin's attribute of protecting the imperial army. It was her miraculous icon, placed on a special carriage, which led John's triumphal entry into Constantinople in 971, after his victorious campaign against the Rus.

Vasso Penna

Literature:
Unpublished.

47
Histamenon of Romanos III (1028-1034)

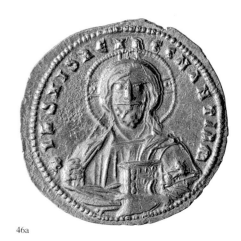

46a

Diam. 2.4 cm, wt 4.38 gr.
Gold
Date of issue: 1028-1034: Grierson 1973b, 716 (c)
Mint: Constantinople
Athens, Benaki Museum, Inv. no. 31514

Obv.: + IhSXISREXRESNANTIhM (Jesus Christ, King of Kings). Christ is shown frontally, seated on a backed throne. He raises his right hand in blessing, while in his left, he holds a closed jewelled gospelbook.

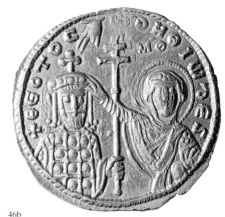

46b

Rev.: +ΘϹЄ bOHΘ' RWMAhW (Mother of God, help Romanos). Representation of the emperor being crowned by the Virgin. Left: Romanos, shown full-length and bearded; right: the Mother of God. The emperor wears a diadem with *pendilia*, surmounted by a cross, and a jewelled, hinged *loros*. In his left hand he holds a *globus crucifer*; his right arm is folded on his breast in a gesture of adoration. The Virgin wears a sleeved tunic and a maphorion with dotted cruciform decoration on the breast and above the forehead. In the field, above, among the capital letters, the abbreviation M̄ Θ̄ (Mother of God).

The iconography of this coin is linked to Romanos's personal attachment to the worship of the Virgin Mary. The emperor founded the Peribleptos monastery at Constantinople in her honour; and it was there that he was buried (Mango 1986, 217-218). He also restored the monastery of the Virgin of Blachernai, and uncovered a long-lost icon of the Mother of God in the church (Mango 1986, 154-155).

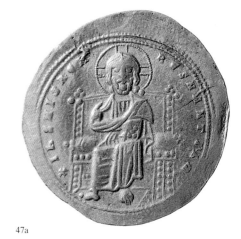

47a

Vasso Penna

Literature:
Greece at the Benaki Museum, 221, no. 386.

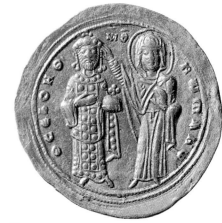

47b

48

*Tetarteron of Constantine I Doukas
(1059-1067)*

Diam. 2.3 cm, wt 4.01 gr.
Gold
Date of issue: 1059-1067: Grierson 1973b,
770 (a)
Mint: Constantinople
Athens, Benaki Museum, Inv. no. 32264

Obv.: Frontal bust of the Virgin making the
gesture of prayer, in the Blachernitissa type.
She wears a sleeved tunic and a maphorion
folded over on her breast, with dotted cruci-
form ornaments at shoulder height and
above the forehead. Left and right in the field:
the abbreviation M̄P̄ Θ̄V̄ (Mother of God).

Rev.: KѠN RACIΛOΔUK (Emperor Con-
stantine Doukas). Frontal bust of Constantine
wearing a diadem with *pendilia*, surmounted by
a cross, and a jewelled, hinged loros. His right
hand is raised and holds a *globus crucifer*, while;
in his left hand he holds the *akakia* (an
insignium of imperial power, consisting of a
cylinder containing a small quantity of earth,
as a reminder to the emperor that even he
belonged to the world of mortals).

Vasso Penna

Literature:
Unpublished.

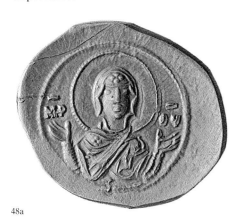
48a

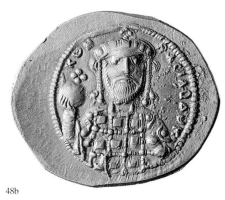
48b

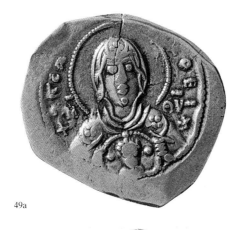
49a

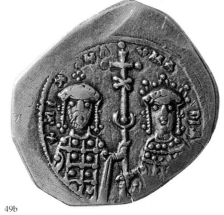
49b

49

Tetarteron of Michael VII (1071-1078)

Diam. 2 cm, wt 3.99 gr.
Gold
Date of issue: 1071-1078: Grierson 1973b,
809, Class III (c)
Mint: Constantinople
Athens, Benaki Museum, Inv. no. 32618

Obv.: +ΘKER ΘEI+ (Mother of God, help
...). Frontal bust of the Virgin in the Nikopoios
type. She wears a sleeved tunic and a
maphorion with dotted cruciform ornaments
on the shoulders and above the forehead. Rep-
resented on her breast is the head of the Christ-
Child, within a medallion. Left and right in the
field: the abbreviation M̄ Θ̄V̄ (Mother of God).

Rev.:+MI X AHΛ SMA PIA (...to Michael
and Maria). Frontal busts of Michael VII and
his wife Maria, holding a processional cross
between them. The emperor wears a jewelled,
hinged loros and a diadem with *pendilia*, sur-
mounted by a cross. The empress also wears
a hinged loros, with a neck selvedge, and a
diadem with triangular turrets.

Vasso Penna

Literature:
Unpublished.

50

*Hyperpyron of John II Komnenos
(1118-1143)*

Diam. 3 cm, wt 4.43 gr.
Gold
Date of issue: 1118-1143: Hendy 1967, 103,
Third coinage, var. A
Mint: Constantinople
Athens, Benaki Museum, Inv. no. 32633

Obv.: [+KERO] HΘEI (Lord, help...). Christ
is represented frontally, seated on a backed
throne. He blesses with his right hand and in
his left holds a closed jewelled gospelbook. Left
and right in the field: IC XϽ (Jesus Christ).

Rev.: in vertical columns, IѠ/ΔEC/ΠO/ TH
(...to the Despot John). Representation of the
emperor being crowned by the Virgin. Left:
John, shown bearded and full-length; right: the
Mother of God. The emperor wears a diadem
with *pendilia*, a *divitision*; and jewelled loros
with a neck selvedge. In his left hand he holds
a *globus crucifer*, in his right an *anexikakia* (cf.
Cat. no. 48). The Virgin wears a sleeved tunic
and a maphorion with a dotted cruciform
ornament in the region of the breast. In the
field, above, among the capital letters, the
abbreviation Θ ([Mother of] God).

Vasso Penna

Literature:
Unpublished.

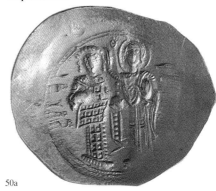
50a

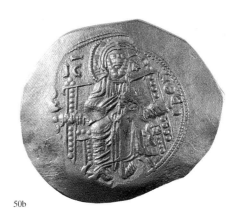
50b

51

Aspron trachy of Andronikos I Komnenos (1183-1185)

Diam. 2 cm, wt 4.67 gr. (the coin has a grommet, due to its later use as an amulet)
Electrum
Date of issue: 1183-1185: Hendy 1967, 132, var. A
Mint: Constantinople
Athens, Benaki Museum, Inv. no. 25840

Obv.: +ΘΚΕRO HΘΕΙ (Mother of God, help...). Full-length figure of Mary interceding, and standing on a dais. She wears a sleeved tunic and a maphorion. On her breast is a medallion with, in bust the Christ-Child. Right and left in the field: M̄P Θ̄V (Mother of God).

Rev.: ΛΝΔΡΟΝΙΚѠ [ΔΕϹΠΟΤΗ] (...to the Despot Andronikos). Representation of the emperor being crowned by Christ. Left, Andronikos, shown full-length, with a typical long forked beard. He wears a diadem with *pendilia*, a *divitision*; and a jewelled chlamys. In his right hand he holds the labarum; in his left hand the *anexikakia* (cf. Cat. nos 48 and 50). Christ wears a sleeved tunic and a kolobion. Right and left in the field: ĪC X̄[C] (Jesus Christ).

Vasso Penna

Literature:
Unpublished.

52

Hyperpyron of Isaac II Angelos (1185-1195)

Diam. 2.9 cm, wt 4.13 gr.
Gold
Date of issue: 1185-1195: Hendy 1967, 143, var. A
Mint: Constantinople
Athens, Benaki Museum, Inv. no. 32656

Obv.: Frontal figure of Mary seated on a backed throne. She wears a sleeved tunic and a maphorion. On her breast is displayed the head of the Christ-Child, within a medallion. Left and right in the field: M̄P Θ̄V (Mother of God).

Rev.: To the left the letters [IϹΛΛΚΙΟϹ], Δ Ε... in a circle; to the right X/AP/M, in columns (Isaac the Despot; Archangel Michael). Left, Isaac; right, Archangel Michael, protector of the family of the Angeloi, portrayed frontally. Between them they hold a sword in its scabbard, in readiness to defend jointly the integrity of the empire. Isaac wears a crown, a *divitision*, and a jewelled loros with a neck selvedge. In his right hand he holds a sceptre surmounted by a crown. Between the two figures is the hand of God making the gesture of blessing on the emperor.

Vasso Penna

Literature:
Greece at the Benaki Museum, 218, no. 387 (reverse only).

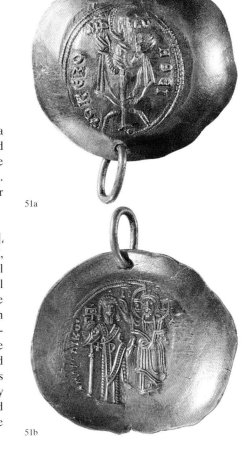

51a

51b

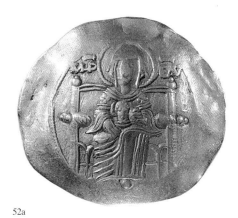

52a

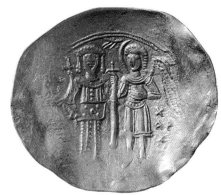

52b

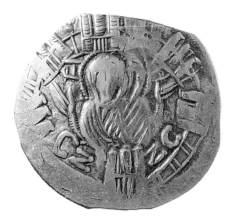

53a

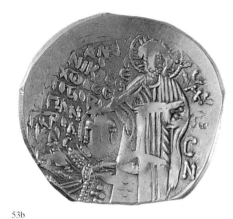

53b

53

Hyperpyron of Andronikos II Palaiologos
(1282-1295)

Diam. 2.4 cm, wt 4.06 gr.
Date of issue: 1282-1294: Grierson 1982,
pl. 81, no. 1290
Mint: Constantinople
Athens, Benaki Museum,
Inv. no. 31544

Obv.: Frontal bust of the Virgin posed as
mediator, in the Blachernitissa type. The figure
is surrounded by the walls of Constantinople,
rendered as six stylized towers. Right and left
in the field: the production-checking cipher
(*sigla*): C N Ⴑ C (with the N placed at an
angle of 45°).

Rev.: ΑΝΔΡ/ΝΙΚΟCЄ/ΧШΔΕC/ΠΟΤΗΟ/Ι
ΠΛΝ...ΟΛ/Δ΄ C (Andronikos in Christ Des-
pot, the Palaiologos), in columns. Right:
Jesus, represented frontally, makes the ges-
ture of blessing over Andronikos II, who is
shown, left, genuflecting in a pose of sup-
plication. Right in the field: I̅C̅ X̅C̅ (Jesus
Christ); and further down the production-
checking cipher (*sigla*): C/N.

In the Palaiologan period, the representation
of the Byzantine emperor conceals a tragic
reality: a pragmatic confrontation of the cur-
rent situation, which portends danger and
stormy seas. A feeling of grief is in the air for
the shrunken empire continuously beset by
foes. The only hope is to call on the power
of God, and so the emperor falls to his knees,
as a suppliant, and, in a posture of contrition,
begs the Almighty to intervene. Andronikos
II Palaiologos, a tragic figure alone in
the wilderness, emanates an ominous and
prophetic anticipation. On the walls of the
City of Constantine, the Virgin shares in the
crisis situation, interceding and praying for
the safety of the last bastion of Christendom.

Vasso Penna

Literature:
Unpublished.

Section Four

τῶν ἀδ(ελ)φῶν † χρο
νίζοντος δὲ τοῦ νυμ
φίου ἐνύσταξαν πᾶ-
σαι καὶ ἐκάθευδον †
μέσης δὲ νυκτὸς ἐγέ-
νετο κραυγὴ · ἰδοὺ ὁ νυμ-
φίος ἔρχεται † ἐξέρ-
χεσθε ἰς ἀπάντησιν
αὐτοῦ † τότε ἠγέρ-
θησαν πᾶσαι αἱ παρ-
θένοι ἐκεῖναι καὶ ἐ-
κόσμησαν τὰς λαμ-
πάδας αὑτῶν † αἱ
δὲ μωραὶ ταῖς φρο-
νίμοις εἶπον † δότε
ἡμῖν ἐκ τοῦ ἐλαίου
ὑμῶν ὅτι αἱ λαμπάδες
δὲ ἡμῶν σβέννυν-
ται † ἀπεκρίθησαν
δὲ αἱ φρόνιμοι λέγου-
σαι † μήποτε οὐκ ἀρ-
κέσῃ ἡμῖν καὶ ὑμῖν †
πορεύεσθε δὲ μᾶλλον
πρὸς τοὺς πωλοῦν-

καὶ ἀγοράσατε ἑαυ-
ταῖς † ἀπερχομένω(ν)
δὲ αὐτῶν ἀγοράσαι ἦλ-
θεν ὁ νυμφίος · καὶ αἱ
ἕτοιμοι εἰσῆλθον μετ᾽ αὐ-
τοῦ εἰς τοὺς γάμους ·
καὶ ἐκλείσθη ἡ θύρα †
ὕστερον δὲ ἔρχονται καὶ
αἱ λοιπαὶ παρθένοι
λέγουσαι † κ(ύρι)ε κ(ύρι)ε ἄνοι-
ξον ἡμῖν † ὁ δὲ ἀποκρι-
θεὶς εἶπεν † ἀμὴν λέγω
ὑμῖν οὐκ οἶδα ὑμᾶς †
γρηγορεῖτε οὖν ὅτι οὐ-
κ οἴδατε τὴν ἡμέραν
οὐδὲ τὴν ὥραν ἐν ᾗ ὁ
υ(ἱὸ)ς τοῦ ἀν(θρώπ)ου ἔρχεται :

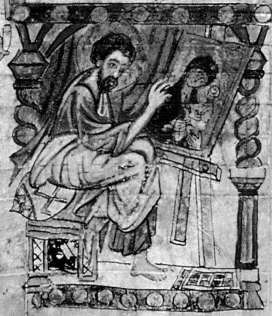

Christine Angelidi
Titos Papamastorakis

The Veneration of the Virgin Hodegetria and the Hodegon Monastery

O n the fifteenth of August 1261, the day commemorating the Dormition of the Virgin, Michael Palaiologos entered Constantinople in triumph. The city had been recaptured at the end of July by Caesar Alexios Strategopoulos, and Michael had made use of the intervening two weeks to attend to the details of his triumph. His choices had been carefully considered: first as regards the date, and then as regards his reception by the Bishop of Kyzikos at the Golden Gate, now open again for the first time after many years. Under the protection of the Mother of God, whose icon had been placed on the city walls, Michael and his retinue attended the ceremony of blessings, on their knees. Then, with the icon of the Virgin leading the procession, Michael entered the capital, the Queen of Cities, and proceeded on foot to the monastery of Stoudios, where he deposited the icon. The procession then moved on to the church of Hagia Sophia, with the emperor now on horseback.

In its general conception, Michael's triumph could be seen as part of an overall endeavour to re-establish the continuity of the empire, a central aspect of which was the dedication of the triumph to the Virgin *systrategos* (fellow-general), the patron saint of the capital. As to the details, Michael chose the ancient route, which led from the Golden Gate to Hagia Sophia by way of the Mese (Pl. 8), a route that had been abandoned at the time of the Komnenoi.[1] The icon of the Virgin had already been accorded a prominent position in the triumphs of two previous emperors — that of John Tzimiskes in 971, after his victorious campaign against the Bulgars, and that of John II Komnenos in 1133, after the recapture of Kastamonu. Palaiologos placed the icon of the Mother of God at the head of the procession, as Tzimiskes had done, and proceeded on foot, like John Komnenos.[2]

The iconographic type of the icon of the Virgin that accompanied the earlier triumphs is not explicitly recorded in the literary sources. However, from the miniature on folio 172v of the Skylitzes manuscript (Pl. 207) we may deduce that the processional icon in Tzimiskes' ceremony was one of those kept in the shrine of the Blachernai.[3] Akropolites and Pachymeres give detailed accounts of the procession of 1261, and according to their testimony the icon in Palaiologos's triumph was called the Hodegetria. Akropolites informs us that the appellation 'Hodegetria' was associated with the monastery of the Hodegon.[4] Pachymeres adds that 'the icon was taken to the walls of the city from the Pantokrator monastery; it was the one painted by St Luke the Evangelist in the presence of the Virgin and sent from Palestine by the Empress Eudokia as a gift to Pulcheria, and it was on this icon that Michael Palaiologos had reposed his hopes of recapturing the Byzantine capital'.[5]

Akropolites and Pachymeres summarize the Byzantine perception of the Virgin Hodegetria at the end of the thirteenth century. The icon was attributed to the brush of St Luke (Pl. 210); its arrival in Constantinople was connected with two fifth-century empresses, Eudokia and Pulcheria; its appellation was associated with the monastery of the Hodegon; its presence in Michael's triumph stressed its establishment as the palladium of the capital. Several decades later, Nikephoros Kallistos Xanthopoulos added to this scheme two further details: the monastery of the Hodegon was founded by Pulcheria, and the icon was deposited in it along with other sacred relics: drops of the

210. St Luke Painting the Icon of the Virgin and Child. Lectionary, cod. gr. 25, fol. 52v, 13th century. Harvard College Library, Cambridge Mass.

milk on which Christ was suckled, the spindle with which Mary had spun the purple thread, garments, drops of Christ's blood, and part of his swaddling clothes. Moreover, Xanthopoulos attributes the institution of the weekly vigil (*lite*) to Pulcheria.[6] The Palaiologan version of the history of the Hodegon and of the veneration of the Hodegetria marked the end of a long process in which events were transformed into narratives, narratives that overlapped each other. What do we in fact know about the monastery, its foundation and founders, the creation of the narrative cycle surrounding the public veneration of the Hodegetria, the identity, and the history of the icon? These are questions to which we shall attempt here to provide some answers.

The complex of the Hodegon comprised the main church and its side chapels, a miraculous spring, a bath-house, and a building for the officials, monks and priests.[7] The foreign travellers who visited Constantinople from the eleventh to the fifteenth century place the complex in the area between the sea and the Great Palace, to the right of the route from Hagia Sophia to St George of Mangana.[8] The location is confirmed by the patriographic collection of the fourteenth century, known as *Anonymus Banduri*, which notes that the Hodegetria was the second point of call on the route that began at the Tzykanisterion and led to the Blachernai by way of the street that ran along the walls of the Golden Horn.[9] The proximity of the monastery to both the sea and the Great Palace is also attested by Choniates and Doukas.[10] The monastery of the Hodegon, therefore, was built in the area known as the first *regeon*, which was bounded by the sea and the line connecting the Palace and the Roman theatre.[11]

In addition to this topographical evidence, there is the important testimony of the *Logos Diegematikos*. According to the cycle of foundation narratives reproduced by this text, the chapel of the Virgin was located near the 'palace' of Marina, in which an imperial textile workshop was functioning at the time the monastery was founded.[12] What is obviously being referred to here is the *domus Marinae*,[13] the building complex that, together with estates and workshops, formed the personal property of the youngest daughter of the Emperor Arcadius and sister of Theodosios II and Pulcheria. After the *domus* lost its administrative character at the end of the seventh century,[14] the name probably survived as a minor place name designating the monastery and its surrounding area.[15]

The property belonging to Marina is also mentioned in the context of the monumental bath-house of the Oikonomion, built, according to the sources, by Leo VI, renovated by Constantine VII in the tenth century, and located within the boundaries of the Palace.[16] On the basis of literary descriptions, however, the original building of the bath should be dated to the fifth century. It might therefore be identified with the Roman-style *thermae* belonging to the original complex of the *domus Marinae*.[17]

In the area near the monastery another bath-house is known to have existed, the *Thermae Arcadianae*, which is known to have been renovated during the reign of Justinian.[18] The bath is not mentioned in the *Patria of Constantinople*, an indication that it was probably abandoned after the seventh century or that the facilities were revived under a different name.[19] Is it possible to identify the *Thermae Arcadianae* with the holy *louma* and the 'public' bath-house of the Hodegon, the renovation of which is recorded in twelfth-century sources? Can we assume that the *Thermae* had been converted by the late seventh or early eighth century to a holy place, comprising a chapel and a sacred spring?[20] If so, we may suppose that the *domus Marinae* was divided into two parts. The southwest section became the property of the Great Palace after the extension of the Tzykanisterion by Basil I or, at a slightly earlier date, by Michael III.[21] To the same section would belong the bath of the *domus*, known in the tenth century under the name of Oikonomion. The rest of the area, comprising the imperial workshop, had been granted in the eighth century to the *hodegoi* (guides), to provide housing for the monks or the attendants of the holy spring already functioning in the old *Thermae Arcadianae*.[22] In spite of the uncertainty of the identifications, it remains clear that the Hodegon monastery was founded in a region with important monuments going back to the fifth century, and that in its final form the monastic complex made use of at least some of the earlier installations.

The first reference to the monastery (or church) of the Hodegon dates from the reign of Michael III. On the eve of his intended departure for his campaign against the Arabs in 866, Caesar Bardas went to the Hodegon to pray. As he entered the church, his cloak slipped from his shoulders and Bardas was overwhelmed by ominous feelings, which were to be fulfilled by his assassination on the following day. The episode refers to no icon, and definitely not to the Virgin's miraculous icon that, according to later tradition, was thought to have always lent its brilliance to the church of the Hodegon.[23]

Our second piece of evidence comes from the *Patria of Constantinople*, and therefore dates from about the end of the tenth century. It is a brief entry, according to which the church of the Hodegon was rebuilt by Michael III on the site previously occupied by an earlier chapel that was renowned for its miraculous spring, which could heal the blind.[24]

Very little is known of Michael's activity as a founder of churches. The silence of the sources probably reflects the hostile attitude of the historiographers of the so-called 'Porphyrogennetos circle', as well as the ambiguous stance they take towards the Patriarch Photios, the leading force behind Michael's endeavours. From the writings of the other contemporary historiographers, known as the 'Logothetes circle', Michael is known to have built one more church, that of the Theotokos of the Pharos. During the construction of this church Michael removed the sarcophagus of Constantine V from the imperial mausoleum at the Holy Apostles. After cremating Constantine's remains at the Amastrianon, he used the Thessalian marble from the sarcophagus in the construction of the church.[25] However, Michael was not the first founder of this church, just as he was not the first founder of the Hodegon. The Theotokos of the Pharos is attested in Theophanes as early as 769, in the last years of the reign of Constantine V.[26] This mention, and the use of the remains of the imperial sarcophagus in the enclosure wall of the church, is not evidence enough for the identification of the Theotokos of the Pharos with one of the churches founded by Constantine V Kopronymos, mentioned by Patriarch Nikephoros.[27] Suffice it to note that the names of the two emperors, Michael and Constantine, are linked to the history of the same monument.

The involvement of Constantine V in the history of the Hodegon becomes clearer, in the *Logos Diegematikos*.[28] The *Logos* is a patchwork of narratives of uneven content and reliability; it nevertheless records all the layers of narratives that composed the 'official' history of the Hodegon in the fourteenth century. The conversion, as the author asserts, of the old church of the Hodegon into a monastery occupies a central place in this text. The events unfold during Iconoclasm; leading roles are played in them by Constantine V and the monk Hypatios, to whom the emperor ceded the old, decayed chapel.[29] Still according to the author, the founding of the original chapel was intended to promote the sanctified miraculous spring that already functioned on the same site. Moreover, the text informs us that the name of the church derived from the special office of the *hodegoi*, who led the blind to the holy water.[30]

Summing up the 'foundation' narratives of the patriographic tradition, we can conclude first that the miraculous spring formed the original focus of the cult, which was served by the group of the *hodegoi*, and second that the building complex of the church and the spring was created in two phases. Our evidence is internally consistent and provides a full account of the foundation. The icon of the Virgin, the weekly vigil, and the fair — the main axes of the cult of the Virgin at the Hodegon from the end of the eleventh century onwards — form a later and different tradition that incorporated some of the older narratives, but was mainly based on 'invented' material.

Between 861 and 865, presumably under the guidance of Patriarch Photios, Michael III rebuilt two churches of the Mother of God, which were associated by tradition with Constantine V, the iconoclast emperor *par excellence*. The renovation of the Hodegon (and also the church of the Pharos) by Michael was probably an act of purification of the sacred buildings, in an attempt to efface the 'pollution' of Iconoclasm as well as the recollection of their original 'heretical' founder from the collective memory. However, the role played in its foundation by Michael, the first emperor after the Restoration of the Icons, was in turn minimalized by the imperial historiography of the Mace-

375

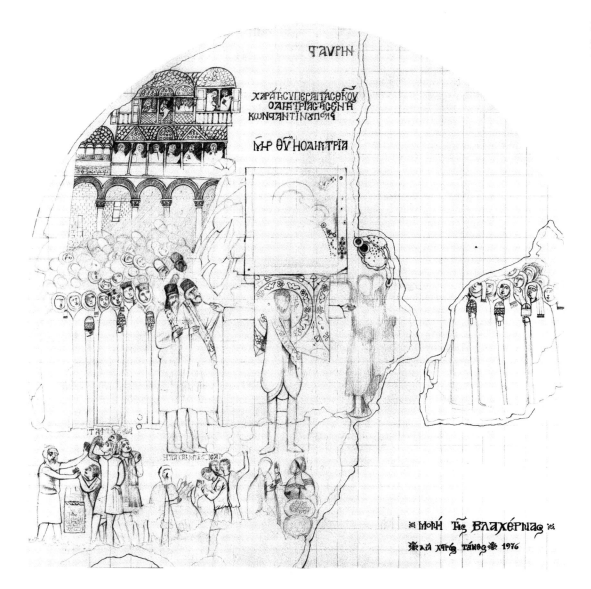

donians dynasty, which promoted Basil I as the ideal monarch. Michael's image having become tarnished, it would have been difficult in the tenth century for the officials and priests of the Hodegon to display their founding charters. Thus, the origins of the monastic foundation would have deliberately been allowed to fall into obscurity.

In the year 970, a chrysobull issued by John Tzimiskes granted the Hodegon to the Patriarch of Antioch, Theodoros I, to serve as the patriarchal residence in Constantinople.[31] In this way, the monastery was transferred from the jurisdiction of the Patriarchate of Constantinople to that of Antioch. After the capture of Antioch by the Crusaders in 1100, the Patriarch John Oxites withdrew to the monastery of the Hodegon. Because of the conditions prevailing in Antioch after the conquest, the patriarchs were obliged to establish themselves in their official residence in the Byzantine capital: Theodore Balsamon, the Patriarch of Antioch, resided in the monastery from 1185 to 1195, and in the thirteenth century, the Patriarch-elect of Antioch, Cyril III, settled there. In the fourteenth century, however, the granting of the Hodegon to Antioch was temporarily repealed by Athanasios, the Patriarch of Constantinople, but the monastery reverted to the Patriarchate of Antioch as a result of collaboration between two distinguished opponents of Palamism, John XIV Kalekas of Constantinople and Ignatios of Antioch. At the beginning of the fifteenth century, the monastery was definitely returned to the jurisdiction of the Patriarchate of Constantinople.[32]

The subjection of the Hodegon to the Patriarchate of Antioch in 970 initiated the second and most brilliant period in the monastery's history. From this time on references to the monastery, the

bath-house, the miraculous spring and its officiants multiply. New stories progressively generated the definitive cycle of narratives on the foundation of the monastery and its most precious asset, the miraculous icon of the Virgin.

The anonymous English traveller who visited Constantinople in the late eleventh century devoted a paragraph of his text to the religious ceremonies which would spread throughout the entire city, emanating from the icon of the Virgin and the church of the 'Hodegetria'.[33] This is our earliest reference to this appellation of the monastery, which departs from the etymological interpretations recorded in the patriographic texts and associates the name of the monastery no longer with the group of the servants of the holy spring, but with the icon of the Virgin. The traveller does not report the iconographic type of the icon, but notes that, according to oral traditions collected by him on the spot, the icon was painted by St Luke the Evangelist. This testimony is the first to associate the icon deposited in the Hodegon with the tradition according to which St Luke had painted a portrait of the Virgin while she was still alive.

The evidence about St Luke as painter derives mainly from three texts of disputed authorship and date. The first is the treatise *On the Veneration of Holy Icons*, attributed by the manuscript tradition to Andrew of Crete and accordingly dated to the eighth century. If the text were really from the hand of the *proedros* of Crete, this would confirm the antiquity of the tradition. However, recent research on Andrew considers the *On the Veneration* to be a work of questionable authenticity.[34] The tradition is also preserved in the so-called *Letter of the Three Patriarchs to the Emperor Theophilos*, and in the *Letter to Theophilos* attributed to John of Damascus. Both texts date from after the Restoration of the Icons in 843, and more precisely to the period between 861 and 866, with 944 being the latest *terminus ante quem* for the composition of the *Letter of the Three Patriarchs*.[35] The tradition concerning Luke was therefore written down for the first time after the Iconoclastic Controversy and forms part of the cycle of edifying stories on miraculous icons, none of which is earlier than the middle of the ninth century.

The story concerning St Luke runs as follows: the Evangelist painted the Virgin while she was still alive, residing on Zion; he showed her the portrait, whereupon she said: 'My grace shall be with this'.[36] We can only deduce that Luke painted the Virgin at an advanced age, certainly after the Passion, and depicted her alone. However, our narrative sources cannot support the identification of Luke's icon with any particular iconographic type. Nevertheless, when the English traveller visited Constantinople at the end of the eleventh century, local tradition had already associated the icon in the Hodegon with the work painted by St Luke and had applied to the monastery the appellation accorded to the icon.

The representation of the Virgin, full-length and holding the Infant on her left side — the Hodegetria type — was engraved on imperial seals from 695 to 720, and in the period after the Council of Nicaea, from 787 to 813.[37] After the Restoration of Icons, the same iconographic type reappears on the seals of Michael III and the patriarchs Methodios and Photios; in the eleventh century it is commonly found on patriarchal and other seals.[38] The representation is first associated with the appellation Hodegetria in the middle of the eleventh century, on seals of Nicholas Skleros, who held the offices of *magistros, epi ton deeseon, vestes* and *protoproedros, megas skevophylax of Blachernai*, and *protos tes presbeias*.[39] We do not know if Skleros, a member of the confraternity of Blachernai, had any connection with the cult of the icon of the Virgin that was kept in the monastery of the Hodegon. It is worth noting though that the Mother of God is engraved on coins issued by Romanos III Argyros, both in the type of the Blachernitissa and in that of the Hodegetria.[40] The same emperor is associated with the miraculous discovery of an icon of the Virgin at Blachernai; the latter icon is described as belonging to the type of the Nikopoios.[41] It seems likely, therefore, that at this period, the associations between iconographic types and appellations of 'toponymic' origin were still fluid.

Skleros's seals make it clear that from about the 1050s onwards, the type of the Virgin holding the Christ-Child on her left had acquired an appellation connecting it with the monastery of

the Hodegon. The English traveller informs us that by the end of the eleventh century the icon in the Hodegon, which he names the 'Hodegetria' and attributes to St Luke, was regularly carried in procession. His extensive account of the religious ceremonies surrounding the weekly feast of the Virgin at the Hodegon reflects the establishment of the public cult of the Hodegetria in the liturgical calendar of Constantinople well before the end of the century. These manifestations of public devotion were supported by a new set of 'foundation' narratives, which ignored the patriographic tradition as well as the importance of the servants of the holy spring in the monastery's appellation. Instead, they related the appellation to the icon of the Virgin and assigned the appropriate antiquity to the origins of the icon. This narrative cycle would most probably have been produced in the monastery itself, the residence of the Patriarchate of Antioch—the only active patriarchate endowed with a *metochion* in a prominent position in the Byzantine capital.

Every Tuesday, according to the traveller, the icon of the Hodegetria was carried in procession through Constantinople, where it encountered other processions. The icon was attended by clerics and accompanied by laymen and women wearing pure silk dresses and holding candles. The icon visited other churches in the city, at each of which a service was sung, and then returned to the monastery of the Hodegon.[42] The testimony of the English traveller is the earliest reference to the weekly procession which, judging by the accounts of later travellers and visual representations, formed the kernel of the cult of the Hodegetria in Constantinople.

The edifying story *On the icon of the Theotokos called Romaia*[43] adds a number of further details to our knowledge of the procession of the Hodegetria. The text, which is transmitted in a manuscript of the eleventh or twelfth century,[44] deals with the icon of the Mother of God that was taken miraculously to Rome to escape profanation during Iconoclasm, was returned to Constantinople after the Restoration of the Icons, and was deposited in the church of the Chalkoprateia by Theodora and Michael III. 'It was at this time', continues the text, 'that the confraternity of the *hodegoi* was founded, the members of which were responsible for the weekly procession of the Hodegetria icon. The confraternity placed the Chalkoprateia icon along with the Hodegetria at the head of the procession, which called at other churches, in accordance with the custom that was still observed.'[45] According to the Maria Romaia story, then, the organization of the procession and the formation of the confraternity date from the middle of the ninth century, which confirms, partly at least, the patriographic tradition that the monastery was founded by Michael III. With regard to the confraternity, here it may be noted that the group, which included the 'finest'[46] amongst the Christian flock, can be identified with the group mentioned in the patriographic texts in connection with the functioning of the holy water source.

From the eleventh century onwards it becomes a commonplace in the literary sources to attribute the icon of the Hodegetria to St Luke.[47] The visual example commonly cited in modern bibliography is the miniature of the first zone on folio 106 (107)v of the codex Taphou 14 (Cat. no. 56), which dates from the eleventh century. The representations in the folio accompany a passage from the *Dialogue at the Sassanid Court*, which is interpolated amongst the orations of Gregory of Nazianzus. The passage in question deals with the meeting of the three Magi, the Virgin and the infant Jesus, and states that the Magi brought an artist with them in order to paint a portrait of the Christ-Child. The miniature depicts this scene.[48] Comparison of the text with the miniature does not suggest that the artist, who in any case wears a Persian cap, is to be identified with St Luke, as is usually stated in the bibliography. For our purposes, however, it is enough to note that both the pose of the seated Virgin and her depiction on the icon painted by the artist do in fact correspond to the specific type of the Hodegetria in bust.

The icon of the Hodegetria in bust is also depicted at the centre of the miniature on folio 39v of the Hamilton Psalter (Cat. no. 54), which dates from about 1300. The large-scale Hodegetria is placed on a tripod inside an elaborate structure, that forms a kind of ciborium. In the lower zone of the scene, the donors of the manuscript are depicted in an attitude of veneration, inside the ciborium.[49] The donors are separated from the icon by a high railing. Behind this railing, five male fig-

ures are depicted as the icon's 'attendants'.[50] The miniature provides important evidence as to the size of the icon, the manner in which it was displayed in the monastery of the Hodegon, the honorary position enjoyed by those who oversaw its veneration, and the fact that this group wore purple clothes.

Elements of this representation correspond with the descriptions given in travellers' accounts and other texts, regarding mainly the organization and the evolution of the procession of the Hodegetria that took place every Tuesday in Constantinople. From this evidence it may be concluded that the large, heavy icon was carried successively on the shoulders of an exclusive group of men, all of whom wore the same purple garments and the same headdress. Officials of the church and attendants of the icon distributed holy water to the sick and holy oil to the faithful, who followed the procession or attended the church fair.[51] The festive atmosphere during the icon's procession and at the fair held in the churchyard is vividly captured in the composition adorning the narthex of the Blacherna monastery at Arta (Pl. 211).

The foreground of the composition, which is inscribed 'Feast of the All Holy Theotokos the Hodegetria', is occupied by vendors displaying their wares — a summary allusion to the fair held every Tuesday. Men and women take part in the procession, which passes in front of a multi-storey building with women leaning out of the windows. In the centre of the composition a man is standing with outstretched arms carrying the large-scale icon of the Hodegetria. On the left, two men are depicted, whose clothes, headdresses and wide sashes are the same as those worn by the central figure.[52] This is obviously the group of attendants of the icon reported in the literary sources as members of the confraternity of the Hodegetria — the ones referred to in the patriographic narratives as *hodegoi*.

Groups of *hodegoi* are also found in other depictions of the Tuesday procession as well as in depictions of the veneration of the Mother of God in the church (Pls 212 and 213).[53] In every case the figures are bare-headed when indoors, like the five male figures in the Hamilton Psalter, or wear a special kind of headdress when the scene takes place in the open; they are invariably dressed in purple. Does this colour denote the confraternity of the monastery?[54] Can we associate this specific colour either with the original use of the monastery buildings as an imperial textile workshop, which probably produced purple fabrics, or with the Virgin's spindle, on which she spun the purple wool, a legendary relic in the Hodegon recorded by Kallistos Xanthopoulos?

There is little evidence on the composition and organization of the confraternity. Nicholas, *protos* of the confraternity of Blachernai, was a member of the distinguished Skleros family. However, the veneration of the Virgin at Blachernai was older, and the church and the holy *louma* were well-established shrines of imperial pilgrimage, as we learn from Porphyrogennetos's *Book of Ceremonies*. The reference in the Maria Romaia story to the 'finest', who were members of the confraternity of the *hodegoi*, probably indicates that, at the time the text was written (late 11th or 12th century), this group included members of social distinction.[55] A hint in this direction is offered by the interpretation of one of the epigrams composed by Nicholas Kallikles for the luxurious veils donated to the icon of the Hodegetria by *Sebastos* John Arbantenos and his wife, Anna Komnene. 'I present myself pure to you as a gift,' proclaims the donor,[56] in an allusion to the expression 'servant of the Theotokos' on a series of seals dating from the seventh to the eleventh century, the lay owners of which held high ecclesiastical offices.[57] This question brings us to the twelfth century, which marks the next stage in the cult of the Mother of God at the Hodegon.

In 1136, the Emperor John Komnenos signed the *Typikon* regulating the internal organization of the Pantokrator monastery, which he himself had founded in Constantinople. In the chapter dealing with the founders' memorial services, to be celebrated in the chapel and family mausoleum of the Archangels, John describes in detail three distinct services, for himself, his wife and his son, to be held during the transfer of the Hodegetria from the monastery of the Hodegon to the Pantokrator.[58] John also makes provision for the sum involved in the cost of transferring the icon: fifty *hyperpyra*, divided between donations to the icon and fees for the *koudes*,[59] the *vastagarioi*, and the other attendants of the icon. We assume that the groups enumerated are those to whom duties relating to the

carrying of the icon in procession had been assigned. This information, however, is not detailed enough to enable us to reconstruct the inner organization of the confraternity, the composition of the groups that oversaw the icon while it was on display in the church, or the identities of those of its members who were involved in the running of the miraculous spring and of the bath-house.

Apart from the regulations in the *Typikon*, the particular piety displayed by John Komnenos towards the icon of the Virgin Hodegetria emerges also from an epigram by Kallikles, according to which the emperor offered donations and *ex voto*s to the icon in return for the protection which it had afforded him ever since his childhood.[60] However, the *Typikon* was composed only one year before the emperor's campaign to recapture Antioch, the patriarchate of which possessed the monastery of the Hodegon. We may, therefore, assume that there were relations of reciprocity between the new dynasty of the Komnenoi and the circle of the patriarchate in exile, which by the twelfth century resided at the Hodegon.

Gifts were presented to the icon of the monastery not only by the emperor himself, but also by members of the wider Komnenos family. According to the epigrams accompanying the gifts the family was the main donor of precious veils. Anna Komnene's husband, John Arbantenos, dedicated a purple and gold veil to the icon. Anna herself presented an equally valuable veil embroidered with the icon of the Hodegetria. Purple and gold veils were also donated by Eudokia Komnene, wife of Theodore Styppeiotes, by the *Sebastokratorissa* Irene, wife of Andronikos Komnenos, and by George Doukas Komnenos Palaiologos, who was related to the family by both blood and marriage.[61] All these precious veils were donated to express the gratitude of the donors to the Mother of God for restoring their own and their children's health, an obvious reference to the healing properties of the holy water of the monastery, which, by this time, was not only thought to rectify problems of sight, but also to cure all kinds of illness, and to protect the health of the faithful. It should be noted, however, that the gratitude for the healing properties of the holy water was addressed to the icon of the Hodegetria kept in the monastery. The merging of the sanctified water, the holy person of the Virgin, and the representation of her form, to which the healing grace was ultimately attributable, can clearly be seen from two epigrams by Theodore Balsamon *On an Icon of the Hodegetria* which was at Panteichion, outside Constantinople.[62]

Four more epigrams are associated with Balsamon's sojourn in the monastery of the Hodegon, which coincides with the reign of Isaac Angelos (1185-1195). According to the lemma of the first, the hierarch is praising the portrait of the Emperor Isaac Angelos that had been painted in the holy *louma* of the monastery. We learn from the epigram that the *louma* was a vaulted structure that had been built at imperial initiative. 'Time that conquers all things', says Balsamon, 'had wrought such damage that the *louma* had ceased to offer its healing services, until the Emperor Angelos provided rivers of gold, by means of which its purifying function was resumed'.[63] The second epigram, a poetic version of the ceremony of the *Nipter*, refers, according to its lemma, to the basin in the 'public bath' of the monastery. The lemmata of the two epigrams inform us that two different establishments functioned in the monastery: a source of holy water (*louma*) and a bath, which is, moreover, designated as public. However, the building referred to as *louma* is described in the first epigram as *sphairoeides thermokentrion*, an expression which suggests a cistern of hot water with a vaulted roof, a structure appropriate to any bath-house. Do we have here one building, described in two different ways in the lemmata, or was it divided internally into two areas, each of which had a different function?[64]

Whatever the case, the miraculous spring of the Hodegon was renovated by Isaac Angelos. Apart from the portrait of the imperial donor, there is no other direct evidence concerning the decoration of the monument. We do, however, have a marble relief icon of the Virgin in the type of the Hodegetria, which is currently housed in the Archaeological Museum of Istanbul (Pl. 193). The work dates from the late eleventh century and is the earliest preserved marble icon of this type. Moreover, the inscription on the border attributes to the icon healing miracles related to problems of physical and spiritual vision. The representation is structured around the axes between the bless-

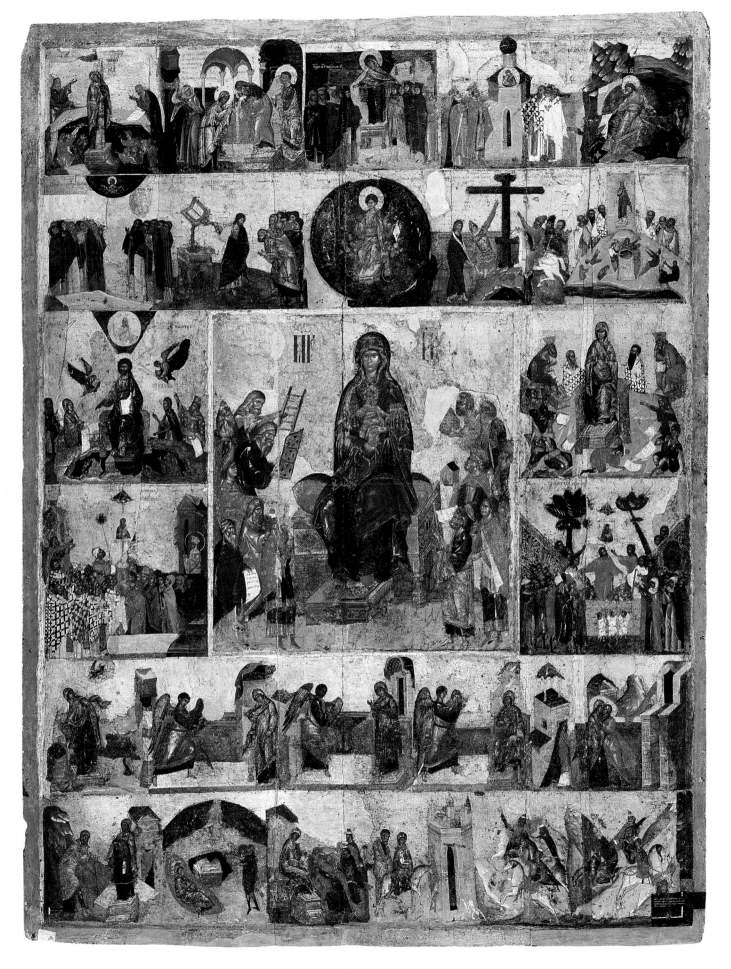

ing by the hand of God at the top, and the hand of Christ, whose blessing is directed toward the bottom left.[65] The size, the material, the iconographic type, the gesture of Christ, and the content of the inscription, all point to the conclusion that the depiction was placed above a source of holy water, probably the *hagion louma* at the Hodegon.

Balsamon composed two further epigrams on funerary monuments in the monastery. The first refers to an abandoned grave, which the lemma places in the chapel of St Anne in the monastery, where Balsamon had arranged that the bones of his relatives should repose. From the second epigram, composed as an elegy, we learn that Stephanos Komnenos built a family tomb at some unknown point inside the monastery.[66] Stephanos, who was the nephew of John II and a member of the wider Komnenos family, was associated with the monastery on his father's side and probably also on that of his mother, who belonged to the Antiochos family, which originated from Antioch.

The donations by the Komnenoi and the Angeloi were directed to the icon of the Virgin which is alluded to as 'the Hodegetria' both in the epigrams and the Pantokrator *Typikon*. The same name is also applied to the monastery from the twelfth century onwards.[67] The new appellation marks the end of a long process of evolution. During the first stage, attested in the patriographic narratives, the monastery was named after the *hodegoi* – those who 'guided' the sick to the source of holy water. At a second stage, during the eleventh century, the icon of the Mother of God in the monastery was given the appellation Hodegetria, with reference to the place in which it was kept; the narratives identifying the painter of this particular icon as St Luke were also composed during this period. The spring that worked miracles under the protection of the Virgin, and the legend of the authenticity of the icon that sanctified Constantinople during its weekly procession, led to the third and final stage, during which it was the icon that gave its name to the monastery.[68] This scheme was supplemented at the end of the twelfth century, when the icon acquired an additional property – that of the protectress of the emperor and, by extension, of the entire city of Constantinople.

In 1186, when the army of the rebel John Branas was approaching Constantinople, the Emperor Isaac Angelos placed the defence of the city in the hands of the Virgin. The emperor set the icon of the Mother of God, 'which is called Hodegetria, since it is kept in the monastery of the Hodegon' on the city walls 'as a fortress that cannot be touched by battle, and an entrenchment that cannot be taken'.[69] With the aid of the icon, Isaac naturally routed his foe. This is the first testimony we have to the use of the Hodegetria to protect the Byzantine capital and the institution of the empire.[70] Isaac's gesture thus lent to the icon of the Hodegetria the character of an imperial symbol, in addition to its function as a symbol of piety and a healing heirloom.

The properties attributed by the Byzantines to the Hodegetria at the end of the twelfth century formed the basis of the conflict between the Latin Patriarch of Constantinople and the Venetians in 1206. The icon was taken to Hagia Sophia for the coronation of the Latin Emperor, Henry of Flanders. After the coronation ceremony the Patriarch Thomas Morosini made sure that the icon remained in Hagia Sophia, from which the Venetians removed it by night, taking it to the Pantokrator monastery, which had been ceded to them. This event initiated the conflict between religious and imperial authority in Constantinople under Latin rule, centred on the management of the icon and its veneration. The sacrilegious Venetians were punished, of course, by Pope Innocent III,[71] but the Hodegetria remained in the Pantokrator monastery until 1261.

The main account of the events of 1206, by Nicholas Mesarites, implies that a new cycle of foundation narratives about the monastery and its icon had been created. Thus, Mesarites interpolates into his description of the mosaic decoration of the church of the Holy Apostles a lengthy passage on the imperial tombs that had been built in the mausoleum of the church. In the entry accompanying his description of the sarcophagus of the Empress Pulcheria, the founding of the monastery of the Hodegon is attributed for the first time to this empress. The process by which both the foundation of the monastery and the veneration of the icon become attributed to Pulcheria is brought to completion, again by Mesarites, who attributes to the empress the institution of the weekly procession as well.[72]

This new cycle of 'foundation' narratives sets a decisive time and an emblematic personality centre stage. The fifth century had seen the conversion of Roman Constantinople into a Christian city, and its implications had been felt at the site of the Hodegon, a monastery that partly incorporated secular Late Roman buildings. At the same time, the virgin Empress Pulcheria, who had promoted the Triumph of Orthodoxy and monasticism through the Council of 451, had been thought of as the symbol of imperial chastity and piety for several centuries.[73] The political, ecclesiastical and theological issues that became relevant once more with the capture of the city dedicated to the Virgin, Constantinople, by the Crusaders, brought the figure of Pulcheria to the fore. In the fourteenth century Kallistos Xanthopoulos added the final piece to the mosaic of the foundation narratives concerning the Hodegon. In this final version not only was Pulcheria established as the founder of the monastery, which was built to house the icon of the Virgin painted by St Luke, but the icon itself was sent from Antioch as a present to Pulcheria by the Empress Eudokia.[74] The series of traditions relating to the monastery is thus completed by the assertion that the icon came from Antioch and was deposited in the monastery that had been granted to the Patriarchate of Antioch. This tradition may be regarded as an endeavour to create titles for the monastery which would validate the granting of the Hodegon to the jurisdiction of Antioch, and may accordingly have been used during the period between the repealing of the Antiochene patriarch's claim to the monastery by Athanasios I and its renewed grant to Antioch by John IV Kalekas.[75]

The earliest act of veneration of the Virgin Hodegetria by an emperor, Andronikos II in 1297, took place in the context of the perception of the icon as protector of the emperor and the palladium of the empire, properties first attributed to it by Isaac Angelos a century earlier. This perception was consolidated later by the Hodegetria's leading role in the triumph of Michael Palaiologos in 1261. Pachymeres offers the following account: Andronikos learns of the defeat of the rebels under Alexios Philanthropenos and attributes it to the assistance of the Mother of God, to whom he owes thanks for the preservation of the state. He proceeds on foot from the Blachernai palace to the monastery of the Virgin 'Hodegetria', venerates the icon, 'kneeling before it in the accustomed manner, and reposes in it his hopes for the just administration of State and Church'.[76]

After 1297, a decree issued by Andronikos institutionalized the dedication of the month of August to the Virgin, the patron saint of Constantinople. The decree makes it clear that August was chosen because of the Dormition, the most important of the feasts commemorating the Virgin, which was celebrated in this month. Three churches were to share the all-night vigils and the services: first, the church of the Hodegon, second, Hagia Sophia, where the Dormition was to be commemorated; thirdly, the month of honours to the Virgin was to culminate on its final day in the church of Blachernai.[77] This decree of Andronikos entailed changes to the ceremonials of the Church of Constantinople, such as the celebration of the Dormition in Hagia Sophia instead of Blachernai, or that of the Holy Girdle in Blachernai instead of the Chalkoprateia. The prominence accorded by Andronikos to the Dormition, and by extension to the month of August, and the elevation of the Hodegon to the status of one of the most important churches in the Byzantine capital was clearly a religious commemoration of the recapture of Constantinople and the triumphal ceremony of Michael Palaiologos on 15 August 1261. We may recall that Michael placed the icon of the Hodegetria at the head of his triumphal procession, and celebrated the doxology for the Dormition along with that for his triumph in the church of Hagia Sophia.

The great piety shown by Andronikos towards the monastery of the Hodegon and the icon of the Hodegetria is also attested by a number of significant moments in his life. At the end of the first year of the civil war, 1321, Andronikos made Syrgiannes swear on the icon of the Hodegetria, as the supreme guarantee, that he would return from the camp of Andronikos III to that of the aged emperor's followers.[78] Towards the end of the civil war, Andronikos transferred the Hodegetria to the palace of Blachernai, seeking protection and solace in the icon of the Virgin. Abandoned by his entourage, alone in the palace, on the eve of his grandson's entry into Constantinople, in 1328, Andronikos turned to the icon again, while the young Andronikos called upon his support-

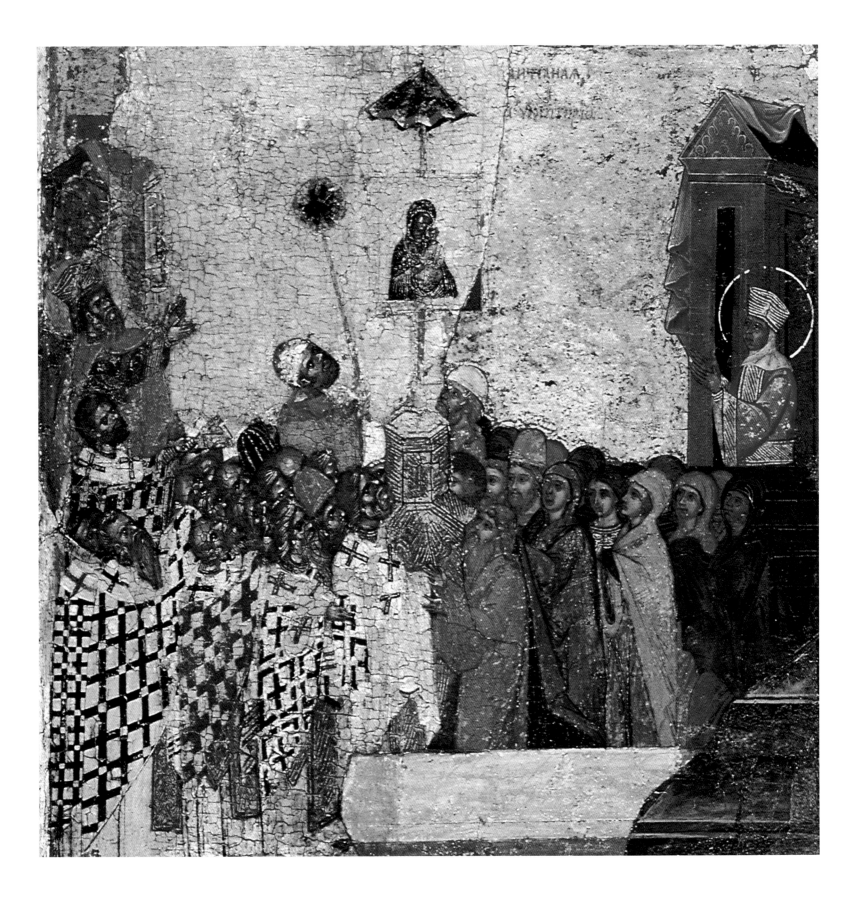

ers to respect the old emperor. It was before the icon that Andronikos II transferred imperial authority to his grandson.[79]

It was probably due to the two Andronikoi that the annual transference of the icon from the monastery of the Hodegon to the palace of Blachernai was introduced into imperial ritual. The icon arrived at the palace on the fifth day of the seventh week of Lent, during the vigil of the Great Canon, and was welcomed by the emperor at the entrance. The Hodegetria was then deposited in the chapel of the Virgin Nikopoios, where it remained until Easter Sunday. The emperor accompanied the icon on its departure and returned to the palace after a brief memorial service.[80]

True to the tradition of the Palaiologos family, Andronikos III attributed his victories to the Hodegetria and invested the icon with great honour. In 1322, after the temporary reconciliation between the two emperors, Andronikos visited the church of the Virgin Hodegetria to convey 'the customary thanks to the one who had secured peace, to Christ and his mother'.[81] This visit in 1322 was the first of a series of pilgrimages by Andronikos III to the monastery of the Hodegon, where he prayed and gave thanks to the Mother of God, who protected his fragile health and secured him victories.[82] He also selected the monastery as his last refuge before his death in 1341.[83]

The evidence of the historical sources concerning the relations between the two Andronikoi reveals that during the first half of the fourteenth century the icon was removed from its *oikos*, the monastery, and housed in another *oikos*, the palace, where it played a dual, public and private, role. However, the fact that the icon was kept for long periods in the palace of Blachernai, did not deprive its original *oikos* of its character as a shrine of pilgrimage. The last testimony in the historical sources on this dual function of the Hodegetria dates from 1347. In his own account of his triumphal entry into Constantinople after the end of the civil war, John Kantakouzenos states that he proceeded on foot to the church of the Hodegetria, where he venerated and gave thanks to the Mother of God for his victory. After this, the emperor vowed in writing that he would protect the defeated John V and would rule peacefully together with him, as father and son. After this, the widow of Andronikos III, Anna of Savoy, ordered the gates of the Blachernai palace to be opened, and Kantakouzenos repeated his oaths before the icon of the Hodegetria.[84] According to this account, the church and icon of the Hodegetria were the guarantors of the oaths of peace and of the smooth transference of imperial power, as they had been in 1322 and 1328.

After 1350, the monastery of the Hodegon continued to be a prominent point of call for visitors to Constantinople in the fourteenth and fifteenth centuries. Their descriptions focus on the icon, the procession and the fair, which was still held regularly every week even after the devastation of the Byzantine capital. The devotional cycle had naturally undergone changes, dictated by the ravages which the urban environment of Constantinople had suffered. In the fifteenth century, the icon was still taken to the palace of Blachernai during the fifth week of Lent. In the spring of 1453, the icon was to be found in the Chora monastery, which was its final resting place.

'On the 29th of May the *azaps*, whom they also call janissaries, entered the Chora monastery and then one of those impious men, brandishing the axe with the support of his sacrilegious hands, broke the icon in four parts. They drew lots and each of them received his share along with the jewellery that came with it.'[85]

[1] Magdalino 1993, 240, 242.

[2] On John Komnenos, Choniates (van Dieten), 18.77-19.97 (esp. 19.89-95); cf. Magdalino 1993, 240-241. On John Tzimiskes, Skylitzes (Thurn), 310.59-69 (esp. 310.60-62); cf. McCormick 1986, 173.

[3] Grabar and Manoussacas 1979, fig. 221 (fol. 172v a) and pl. xxxiv. Cf. Attaleiates (Bonn), 153.6-8, according to whom one of the icons of the Virgin at Blachernai was carried at the head of imperial military campaigns. Cf. also Psellos (Renaud) I: 39.22-27.

[4] Acropolites (Heisenberg and Wirth), 186-187.

[5] Pachymeres (Failler and Laurent), I: 217.11-18. Also Papamastorakis 1989-1990, 221-240.

[6] Xanthopoulos, *HE* XIV.2 (*PG* 146, 1061) and Xanthopoulos, *HE* XV.14 (*PG* 147, 44). On Xanthopoulos's sources, particularly his supposed use of Theodore Anagnostes, Gentz 1966[2], 148 and Wolff 1948, 323.

[7] On the monastery and the cult of the Virgin at the Hodegon, Janin 1953, 199-207 (the view and identifications in which should be treated with some care), and Kidonopoulos 1994, 77-78; on the icon, Mouriki 1991 and Babić 1994.

[8] Ciggaar 1976, par. 4; Majeska 1984, 138, 182; Van der Vin 1980, II, 699.

[9] Berger 1988, 90, 96, 197 (map no. 71).

[10] Choniates (Van Dieten), 527.62-63; Doukas XI (Bonn, 41.7-9).

[11] Seeck 1962[2], 230.2-6.

[12] Angelidi 1994, 113-149 and esp. lines 185-187.

[13] Seeck 1962[2], 230.12.

[14] On the *domus Marinae*, Mango 1991, 321-322.

[15] Leo Grammatikos (Bonn), 251.

[16] Magdalino 1988, 97-118.

[17] Mango 1991, 323-327.

[18] Seeck 1962[2], 230.13. On the bath-house, Berger 1982, 145.

[19] Magdalino and Nelson 1982, 153-154.

[20] The French excavations of 1928-1933 revealed traces of a building between the sea and the Gülhane hospital, which the excavators identify with the bath-house and source of holy water of the monastery of the Hodegon, Demangel and Mamboury 1939, 71-111, pl. XII; also the plan in Müller-Wiener 1977, 497, G7.

[21] Preger 1907, II, 225, par. 29. Also, Mango 1991, 323.

[22] The identification with the building described by Mango 1991, 324, is very tempting.

[23] Theophanes Continuatus (Bonn), 204.12-15; Genesios (Lesmüller and Werner-Thurn), 73.76-77. Bardas's visit to the church was probably due to its proximity to his home. None of

the sources provides supporting evidence for the view that it was a general Byzantine practice to visit the Hodegon before going on campaign.

[24] Preger 1907, 223, par. 27.

[25] Pseudo-Symeon (Bonn), 681, par. 45. Cf. Grierson 1962, 53-54 and Mango 1958, 177-183.

[26] Theophanes (De Boor) I, 444.20-22.

[27] *PG* 100, 341-344; cf. Magdalino 1996, 15-16.

[28] Angelidi 1994, 113.132-133.

[29] Angelidi 1994, 141.125-145.192

[30] Angelidi 1994, 137.56-63 and 145.192-194. Also the passage in the *Patria* from codex VIII of the 14th century: Preger 1907, 223 (*apparatus*).

[31] Grumel 1934, 134 and Benešević 1911, 581. On the relations between the monastery and the Patriarchate of Antioch, Pitsakis 1991, 119-133.

[32] On the historical details, Pitsakis 1991, 119-133. For the term καινουργήσας, which is interpreted in the bibliography (Janin 1953, 200 and Kidonopoulos 1994, 77) to mean a renewal, we have retained the interpretation of Pitsakis 1991, 125, according to which it alludes to a change in the administrative affiliation of the monastery.

[33] Ciggaar 1995, 127.349-353.

[34] Auzépy 1995b, 7.

[35] Chrysostomides 1997, xxxviii.

[36] Munitiz et al. 1997, 39 (par. 7.5); cf. 149 (par. 4.a).

[37] Seibt 1987, 37, 40-41.

[38] Grabar 1984[2], 221, 261 (on Michael) and Babić 1994, 198-199 and n. 41; also, Oikonomides 1986, 61-62, 77-78, 84, 87-88 (nos 54, 74, 84, 88).

[39] The seals are dated down to 1080: Laurent 1965, no. 1202 and Laurent 1981, nos 251-252; cf. Seibt 1976, 93-97, no. 22 and Carr 1997, 94, 96. For the terms *presbeia* and *signon presbeias*, Ševčenko 1991, 50-57.

[40] *Glory of Byzantium*, no. 147.

[41] Skylitzes (Thurn), 384; cf. Seibt 1985, 551-552.

[42] Ciggaar 1995, 127.350-368.

[43] Von Dobschütz 1903, 173-214.

[44] Von Dobschütz 1903, 193 dates the manuscript to the 11th, and Ehrhard, II, 623-624 to the 12th century.

[45] Von Dobschütz 1903, 196-197, par. 9 and 201-202, par. 22.

[46] The designation relates the attendants of the holy *louma* of the Hodegon to the lay confraternities, Magdalino 1990, 179ff. and Nesbitt and Wiita 1975, 360-384.

[47] Ciggaar 1976, 249, par. 4; Pachymeres (Failler and Laurent) I, 217.11-18; Angelidi 1994, 139.72-74.

[48] On the manuscript, Papadopoulos-Kerameus 1891, I, 45 (for the date) and 56 (for the miniature).

[49] ἐν τῷ κουβουκλίῳ Papadopoulos-Kerameus 1909, 150. Cf. Clavijo (Sreznevskij 1881), 83.

[50] Belting 1970, 74ff. identifies the figures with the donors' children, but see also, Cormack 1997c, 58.

[51] For the processions at Constantinople and Thessaloniki, Ševčenko 1995, 548-550; cf. Angelidi 1994, 141. 115-121 and 149.253-257.

[52] Achimastou-Potamianou 1981, 4-14, figs 14-17. The composition is dated about 1300.

[53] E.g., representations of the Akathistos cycle: *Vizantija, Balkany, Rus'*, no. 36 and Maiasova 1991, 60-61, nos 42, 43.

[54] Cf. Nesbitt and Wiita 1975, 382-383.

[55] On the social composition of the confraternities, Magdalino 1990, 180-182.

[56] Nicholas Callicle (Romano 1980), 77, no. 1.

[57] Oikonomides 1995, 162-165; also Ševčenko 1995, 551-552.

[58] Gautier 1974, 81-83.

[59] To the interpretations of the term given by Gautier 1974, 81, no. 21, add Ševčenko 1995, 550, n. 27.

[60] Nicholas Callicle (Romano 1980), 95, no. 20. The epigram concerns the donation of a crown set with pearls and precious stones.

[61] Nicholas Callicle (Romano 1980), 77-78, no. 1, and 104-105, no. 26, and Nunn 1986, 99-100, nos 162a, 162b (for the Arbantenos couple, who gave to the Pantokrator monastery a part of its fortune, Gautier 1974, 45.270-47.288); Theodoros Prodromos (Hörandner 1974), 525, no. 73 and Nunn 1986, 100-101, no. 165* (for Eudokia Komnene; *RHC Historiens grecs*, 692 and Nunn 1986, 96-97, no. A (for Irene); Lampros 1991, 151, no. 228 and Nunn 1986, 101, no. 228 (for George Palaiologos). It has been argued that the epigram published by Lampros 1911, 148-150, no. 224, on a series of imperial portraits painted in a church of the Virgin, concerns the renovation of the Hodegon by George Palaiologos (Janin 1953, 200 and Kidonopoulos 1994, 78). However, this hypothesis is supported neither by the lemma nor by the content of the epigram.

[62] Theodore Balsamon (Horna 1903), 183, no. XIV, 184, no. XV.

[63] Theodore Balsamon (Horna 1903), 190-191, no. XXVII; also Magdalino and Nelson 1982, 153-154.

[64] For the terms *louma* and *loutron*, Magdalino 1991, 183 and no. 83.

[65] Fıratlî 1990, no. 131, pl. 46: Ἔρευσε πηγὰς Ἰ(σρα)ὴλ Χ(ριστο)ῦ πάλαι· τυφλὸς Θ(εο)ῦ [γ]ὰρ εἰς ἐπί[γ]νωσιν βλέπει· [μ]ῆ[τ]ις δὲ [δ]ιπ[λ]ὴν τὴν ἐνάργειαν νέμει. Μή(τη)ρ συ...

[66] Theodore Balsamon (Horna 1903), 181-182, no. XI and 182, no. XII.

[67] τῷ θείῳ τῶν ὁδηγῶν, τῷ νῦν καλουμένῳ Ὀδηγητρίᾳ (sic) σηκῷ:

Vita of St Thomais, *AASS* Nov. IV, 238 (MS of the 12th century). See also the comment of Balsamon on the 69th canon of the Quinisext, Rhalles-Potles, II, 467: τοῦ ναοῦ τῆς ὑπεραγίας... Θεοτόκου τῆς Ὁδηγητρίας...

[68] The icon of Sinai (first half of 12th century) is the oldest example of iconographic types of the Virgin with appellations linking each type with specific Constantinopolitan shrines: Blachernitissa, Hodegetria and Hagiosoritissa (that is the Virgin of the *Hagia Soros* at the Chalkoprateia church) Mouriki 1990a, 39-40 and Belting 1994, 49.

[69] Choniates (van Dieten), 382.55-58. Note that referring to the monastery, the archaizing Choniates uses the term Hodegon.

[70] The sources mention the procession of an icon of the Virgin during the Avar siege of 626, van Dieten 1972, 174-178. The view according to which the icon of the Hodegetria was transferred to the walls of Constantinople during the siege of 717 rests upon an interpolation to the *Diegesis ophelimos* (*PG* 92, 1365). However, the passage dates after the 14th century, that is after the composition of the *Diegesis*, which is attributed to Kallistos Xanthopoulos.

[71] Nicholas Mesarites (Heisenberg 1973), 15-17, pars 1-2. Also Wolff 1948, 320. The sources do not indicate the deposition of the icon at the Pantokrator monastery before its transfer to Hagia Sophia.

[72] Nicholas Mesarites (Heisenberg 1973), 16 and Nicholas Mesarites (Downey 1957), 7, par. XXXIX.

[73] Angelidi 1998b, 87-139.

[74] Kallistos Xanthopoulos, *HE* XV.14 (*PG* 147, 44); cf. Angelidi 1994, 137.63-141.109: according to the text it was Pulcheria herself that Ὁδηγὸν τῶν καλῶν ἁπάντων ἐπονομάσασα (the icon); cf. Angelidi 1998.

[75] For the changes, Pitsakis 1991, 124-126.

[76] Pachymeres (Bonn) II, 231.2-14.

The reposing of ecclesiastical affairs in the hands of the Virgin seems implicitly to indicate the movement of the Arseniates.

[77] Nikephoros Choumnos (Boissonade 1962) II, 107-136; also Grumel 1932, 257-261.

[78] Gregoras VIII.4 (Bonn, 298).

[79] Gregoras IX.6 (Bonn, 421-425).

[80] Pseudo-Kodinos (Verpeaux 1966), 231.1-12. The annual transfer is represented in the iconography of the 23rd stanza of the Akathistos Hymn at Kozia (Romania), which dates to about 1380, Babić 1973, 178-179, 184-189, figs 4 and 6.

[81] Kantakouzenos I.34 (Bonn, I, 166-169).

[82] Gregoras XI.1, XI.5, XI.11 (Bonn, 541-42, 554-55, 559); Kantakouzenos I.59 (Bonn, I, 305).

[83] Kantakouzenos II.40 (Bonn, I, 557).

[84] Kantakouzenos III.99 and IV.1 (Bonn, II, 607, 614 and III, 8-9).

[85] Doukas XXXVIII and XXXIX (Bonn, 272, 288).

54

*Miniature of the Veneration of the Icon
of the Virgin Hodegetria*

27 × 22 cm, 375 folios
Manuscript, Bilingual Psalter with Additional Texts
Paint on parchment
About 1300
Cyprus (?)
Berlin, Staatliche Museen,
Kupferstichkabinett, 78 A 9 (Hamilton 119)

This manuscript contains the text of the Psalter in both Greek and Latin, prefaced by a Latin calendar of saints and followed by a Latin breviary with a litany, thought to be for the use of Famagusta, a Greek horologion, metrical calendar of Christopher of Mytilene, and a canon on all the saints by Michael Psellos. Some texts in French were added later. A note on fol. 1v (inserted) indicates that the manuscript belonged at one time to Carlotta Lusignan, Queen of Cyprus from 1458 to 1475.

The psalter itself is accompanied by copious marginal illustrations, following a tradition of Byzantine psalter illustration that goes back at least as far as the ninth century (Havice 1984; Corrigan 1992). Immediately preceding the psalter is a quire (fols 39-44, though fol. 44 is detached from the rest) of six folios, each illuminated on one side only. Though the parchment is somewhat different and the artist works in an accomplished Constantinopolitan style quite different from that of the artist of the psalter itself, there is no compelling reason to assume the quire was not meant to be part of the manuscript from the beginning. Four of these pages illustrate the life of David as narrated in Psalm 151 (two miniatures per folio), the last shows him composing the Psalms (fol. 44r), while the first of the series (fol. 39v) is a full-page frontispiece showing an icon of the Virgin being venerated by a group of eight unidentified figures.

This particular folio is of special interest to any study of Virgin icons in Byzantium. Its depiction of an icon in its architectural setting, and of lay figures involved in its veneration, provides us with a rare piece of visual evidence for how icons of the Virgin were displayed and approached in the Late Byzantine period. The emphasis here is not so much on the object of veneration (the Virgin herself) as on the veneration of her image, an image which clearly has a very special meaning for the figures in the miniature.

The icon is placed under a wide ciborium with a pyramidal roof and carved architrave supported by a pair of columns. The colour of this structure is grey-green, suggesting either marble or a silver sheathing. At its apex is a three-quarter figure of Christ holding a red scroll and blessing; the figure is labelled IC XC, and is thought to represent Christ Emmanuel, although he wears an unusual broad golden collar (partly flaked) over his light blue tunic. The placement of such a figure on top of the ciborium is in itself highly unusual.

The icon is of the Virgin Hodegetria, in bust, on a gold ground. The face and garments of the Virgin have flaked, but the figure of Christ resting easily on her left arm, dressed in golden robes, is better preserved, as are the two angel busts in the upper corners of the panel. Draped across its upper frame is a bright red hanging, knotted at the corners and falling in short folds down the sides of the icon. At the centre of the lower frame of the icon is another icon, essentially a reduced version of the large one (though it lacks the two angels). Flanking the icon are two lamps, each hanging from a pole that stretches from the corner of the architrave diagonally down to a point just in front of the icon.

The icon is affixed, by means of two diagonal wooden struts and a central bar, to a large two-tiered wooden stand that is roughly square at the bottom and narrows as it rises. Before the stand, in the foreground, is a grey stone floor with an inlaid pattern that includes a porphyry roundel.

Two figures, a man and a woman, kneel on this floor, facing each other to either side of the icon stand. The man, who has bushy dark hair and a beard, wears a long-sleeved and belted red tunic; a small white cloth hangs from his belt. The woman wears a white tunic under a full red mantle with a long train. Her features have flaked, but her head was apparently covered with a pale grey headdress and veil that reaches her shoulders. Both figures extend their hands toward the icon; the man bends slightly forward from the hips with his hands close together as if carrying something; he looks upwards toward the icon. The woman is more erect, and her hands are further apart.

Behind the man, to the left of the Virgin icon and painted on a slightly smaller scale than the couple in the foreground, stand two beardless youths and a child. They are clad in red tunics (those of the two older figures are belted), and they extend their hands toward the icon. To the right stand three more figures, all the same height, all bareheaded, and all gesturing to the icon; they wear the same red tunic as the others, but without a belt, and could possibly represent young women.

Much of the space under the ciborium is closed by a painted grille made of small metal links. One part of the grille forms a low horizontal barrier about waist height that separates the standing figures from the kneeling ones. The upper part of the grille frames the icon on three sides, projecting slightly from the architrave down to a point just over the heads of the standing figures, and continuing down the sides between them and the ciborium columns. The relationship of the two parts of the grille is unclear, but there is no doubt that we and the kneeling couple in the foreground are meant to be outside, in front of it, while the other figures are meant to be standing behind it, inside the icon chapel.

The entire scene, ciborium and all, is then enclosed within an outer gold rectangle, which is trilobed at the top. The trilobe is pale blue and adorned with a row of small black squares. Around the whole miniature and echoing its shape runs a narrow gold rope motif. On the outer edges of the trilobe are two exquisitely painted blue cranes, looking as though they had dropped in from a canontable at the beginning of a gospelbook; they remind us that despite the verisimilitude of the scene below, this is still a miniature in a sacred book.

The identity of the figures is disputed. None is a cleric or monk. They could be all members of a single family, with the parents kneeling in front, the children standing behind, divided according to sex. The bearded man wears some mark of office — the scarf at his waist — but just what office this is cannot be easily determined. The icon could be this family's prized possession: icons were often valuable objects in Byzantium, handed down in a family from generation to generation (Oikonomides 1991, 39-44).

The imposing architectural setting and size of the icon, and the virtually identical dress of the figures suggests that they are more likely either members of a choir (which could include children) (Moran 1986) or members of a lay confraternity dedicated to the service of this particular icon. Brotherhoods of this kind, attested from at least the eleventh century on, were distinguished by their costume, could include women and were sometimes

hereditary, the care of a particular icon being entrusted to members of a single family. The brotherhood carried the icon in procession and managed its activities in the church and the community (Ševčenko 1995).

What icon of the Virgin Hodegetria could this be? The angels in the corners are not particularly indicative: they appear in connection with icons of the Hodegetria as early as the late twelfth century. The red robes worn by the figures do correspond to those worn by the brotherhood of the most famous Virgin Hodegetria of all, the icon of the Hodegon monastery in Constantinople (although the figures here lack the characteristic headgear of that confraternity), and it is quite possible that our miniature represents this very Hodegetria, the palladium of Constantinople, in its architectural setting. We should not forget, however, that many a church outside of Constantinople boasted its own processional icon of the Virgin Hodegetria: the one paraded through the streets of Thessaloniki from the twelfth century into the fifteenth, for example, also had its own brotherhood, as well as its own *oikos* or chapel. The icon in the miniature could represent an important icon of the Virgin in a location other than Constantinople, such as Thessaloniki, Mystras or Cyprus.

Here we wish we knew the exact relationship of this prefatory quire to the Psalter manuscript itself. If the quire was attached later, then the bilingual contents of the manuscript are essentially irrelevant to our understanding of this frontispiece page and it can be assigned to any centre we choose. But if the quire was an integral part of the manuscript from the beginning, then the bilingual character of the texts and the connection of the calendar with Famagusta are significant. It could then be suggested, though proof would surely be required, that the couple was donating the psalter to a church of the Virgin on Cyprus, to one that possessed an important processional icon of the Virgin that was served by a brotherhood, perhaps one venerated by Greeks and Latins alike. Although, with the exception perhaps of the Christ on the apex of the ciborium, there are no elements of this miniature — architecture, costume, gestures of prayer — that could not be considered essentially Byzantine, it is the extraordinarily precise definition of this icon enclosure that is rare, and that encourages us to look outside the confines of Byzantium. The similarities with the Constantinopolitan Hodegetria icon and its brotherhood may even have been deliberate, and point us in the

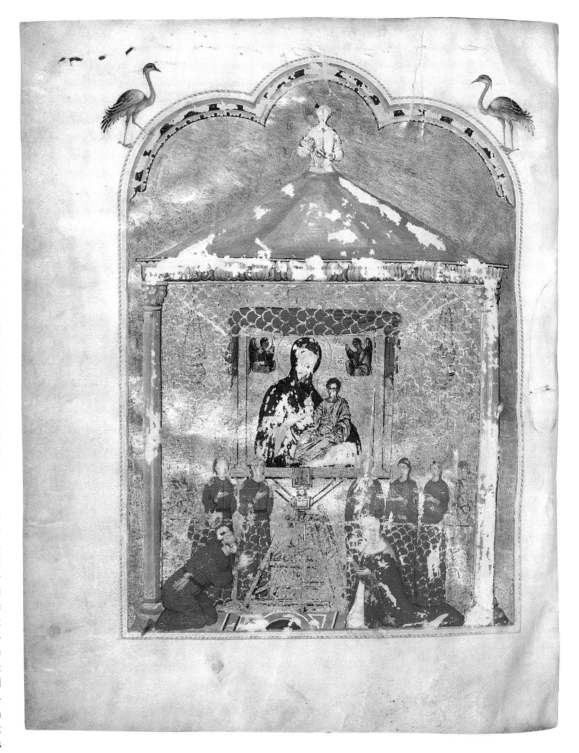

direction of a Cypriot Virgin icon deemed of comparable civic importance. Further research may well reveal the identity of this icon and its red-clad protectors.

Nancy Patterson Ševčenko

Exhibitions:
Kunst der Spätantike im Mittelmeerraum, Berlin 1939; *Byzantine Art, an European Art*, Zappeion, Athens 1963; *Zimelien: Abendländische Handschriften des Mittelalters aus der Sammlungen der Stiftung Preussischer Kulturbesitz*, Berlin 1975.

Literature:
Wescher 1931, 25-30, pl. 25; *Kunst der Spätantike im Mittelmeerraum*, no. 249; Grabar 1960, 128, fig. 8; *Byzantine Art, an European Art*, no. 286; Boese 1966, 66-67; Belting 1970, 5-6, 72-75, figs 1-3; *Zimelien*, no. 6; Buchthal 1975, 143-177, esp. 149-152, figs 10-11; Spatharakis 1976, 45-48, fig. 16; Havice 1984, 79-142; Cormack 1997c, 58, fig. 9.

55

Miniature of St Luke Painting the Icon
of the Virgin and Child

30.5 × 22.5 cm; 273 folios
Lectionary Cod. gr. 233
Paint on parchment
13th century
Egypt, monastery of St Catherine at Sinai

The Mt Sinai Cod. gr. 233 is a Byzantine lectionary of the weekday type. It has no dated colophon, but based on the style of the script it can be attributed to the thirteenth century. Two intercessory prayers for three families are inscribed in the lower margins of fols 65v and 66: 'Δέησις τοῦ δούλου τοῦ θεοῦ Θωμᾶ καὶ τῆς συμβίου αὐτοῦ Εὐδοκίας καὶ κυροῦ Γεωργίου καὶ τῆς συμβίου αὐτοῦ Μαρίας τῆς (σεβαστῆς)' (Prayer of the sevant of God, Phokas and his wife Eudokia, and Sire George and his wife Maria [...]). 'Δέησις τοῦ δούλου τοῦ θεοῦ Ἀθανασίου ἅμα καὶ τῆς συμβίου αὐτοῦ Ἡρίνης καὶ τοῦ τέκνου αὐτοῦ Νικολάου καὶ τοῦ πατρός αὐτοῦ Νικολάου καὶ τῆς μητρός αὐτοῦ Ἡρίνης καὶ τῆς ἀδελφῆς αὐτοῦ Μαρίας' (Prayer of the sevant of God Athanasios together with his wife Irene, and his child Nikolaos, and his father Nikolaos, and his mother Irene and his sister Maria). The codex is written in a minuscule script in two columns with lemmas in Arabic. It has decorated initials and three author portraits featuring Matthew (fol. 32v), Mark (fol. 67), and Luke (fol. 87v). The portrait of Luke is very unusual because it represents the Evangelist in the act of painting the icon of the Virgin and Child. The style of the miniatures is characterized by bulging draperies, strong white highlights and use of bright greens, blues, yellows, and reds. The faces and necks are rendered with a stylized representation of wrinkles and muscles.

The Byzantine lectionary is a liturgical book with excerpts of the four gospels arranged in two cycles according to the order of the liturgical year. The first cycle, called synaxarion, comprises the movable feasts from Easter to Easter. It includes lections of all four gospels: from Easter to Pentecost the readings are from John; from Pentecost to the beginning of the new year in September, from Matthew; from September to Lent, from Luke; from Lent until Palm Sunday, from Mark. The remainder is taken up by lections from all four gospels. The second cycle, the menologion, comprises the fixed feasts and saints' days from 1 September to 31 August with appropriate passages from the gospels

assigned for these occasions. The remainder of the lectionary is taken up by the so-called early morning resurrection lections.

The Byzantine lectionaries appeared after Iconoclasm. Over two thousand examples survive. Most of them are not illustrated. A few manuscripts feature portraits of the evangelists, and even fewer codices, dating mostly from the late ninth to the twelfth century, offer more developed illustrated cycles.

The author-portraits in the Byzantine lectionaries follow the canonical iconography that was first established for gospelbooks. In rare cases, new iconographic solutions are introduced, as in the case of the portrait of St Luke in the Mt Sinai Cod. gr. 233. In contrast to his traditional representation as a writer, the Evangelist appears here as a painter, creating the icon of the Virgin and Child. While a pictorial allusion to the legend of Luke as the painter of the first Marian icon is already made in the eleventh-century manuscript Taphou 14 (Cat. no. 56), the earliest attested representation of the Evangelist painting the Virgin appears in a Byzantine lectionary, Harvard College Library, Cod. gr. 25, fol. 52v at Cambridge, MA. This manuscript was written in the eleventh century, but the images were added a century later. Most likely the miniatures were painted in the Levant, as suggested by the use of cinnabar red for the maphorion of the Virgin, and the dotted rim of the halos. The portrait of St Luke painting the Virgin in the Harvard College Library Cod. gr. 25 (Pl. 210) is framed by an arch resting on spiral columns. Luke sits on a backless chair on top of a cushion. With his right hand he completes the icon of the Theotokos tightly embracing the Child with both hands.

In the Mount Sinai Cod. gr. 233 the portrait of Luke prefaces the beginning of the Lukan section of the synaxarion (Luke 3:19-22). The Evangelist, identified by inscription as 'ὁ ἅγιος Λουκᾶς', sits on a carved wooden throne. A red cushion in front serves as his footrest. Luke is dressed in a blue chiton, while a red himation drapes over his body. In his left hand he holds a small container of paint. With his raised right hand grasping a brush, he adds the finishing touches to a beautiful icon of the Virgin and Child. The Theometer holds the Infant on her right arm and gestures to him with her free left hand. The iconography presents a mirror-image of the type known as the Hodegetria. The Mother and Child have red haloes. Christ wears an ochre chiton and red mantle, while the Vir-

gin is covered in a blue maphorion. Both figures are identified with the usual abbreviations: MP ΘY (Mother of God) and IC XC. (Jesus Christ) The icon is set on an elaborate wooden stand with a small rest for the brushes and the compacts of paint.

Two more figures appear carved on the side of the wooden chair. Both have hats with wide brims. One plays the flute and turns to gaze at the icon of the Virgin and Child. These figures resemble the shepherds in the Nativity scene as featured in an early fourteenth-century icon in Skopje (Weitzmann et al. 1982, pl. on 172), or an early fifteenth-century panel from Cyprus in the British Museum (*Byzantium*, no. 228). In these two icons the shepherds worship the Mother and Child. The similar appearance of the two figures on the Sinai miniature thus evokes the traditional scene of the Nativity.

The Sinai miniature is framed by two garlands of acanthus leaves painted in red, green and blue. The leaves are set like cones one inside the other. Six pairs of birds — peacocks, pelicans, pheasants and doves — perch on the rims of different acanthus beds and entwine their heads on the cones above. The birds appear to be drinking water gathered in the basins of the acanthus shells.

The miniature offers a visual representation of the legend of St Luke who painted the first icon of the Virgin (Bacci 1998, 114-129). The myth was invented during Iconoclasm (726-843) and was intended to prove the legitimacy of icon veneration. By claiming the existence of a portrait of the Virgin made during her life-time by the Evangelist Luke, the perpetrators of this fiction secured the apostolic origins and divine approval of images. Andrew of Crete, writing, in the eighth century argued that the icon was kept in Jerusalem or Rome, and *not* Constantinople (*PG* 97, 1301D, 1304C). Similarly *The Letter of the Three Patriarchs* in the mid-ninth century proclaimed Jerusalem as the place of the Lukan icon (Munitiz et al. 1997, 39). Symeon Metaphrastes (950-1022) also mentioned a Marian panel painted by the apostle, but did not specify the place (*PG* 115, 1136B). Finally the tenth-century *Synaxarion* of Constantinople characterized Luke in the entry for his feast day on 18 October as a physician and painter living in Antioch (*PG* 117, 113D).

Rome and Jerusalem had a number of important Marian icons already in the pre-Iconoclastic period (Wolf 1990; Amato 1988).

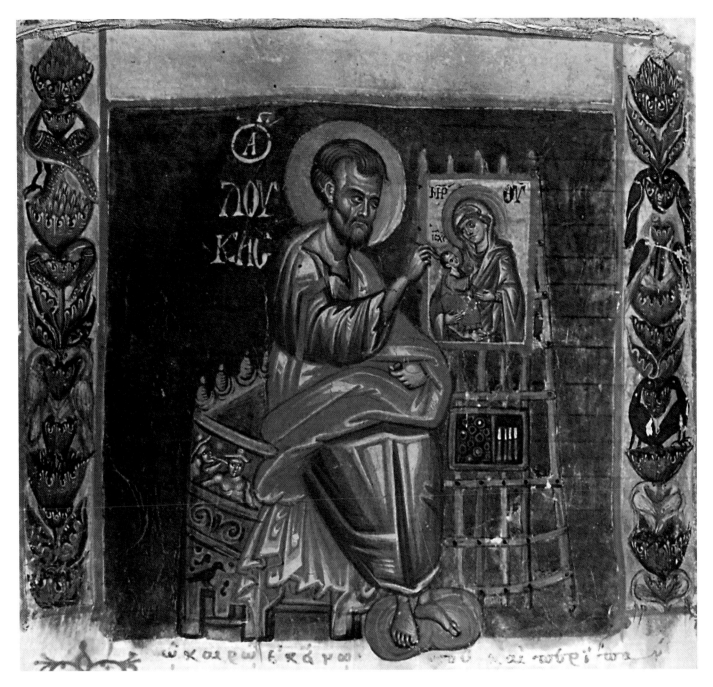

By contrast, Constantinople had Marian cults centred on relics, not on icons, in the pre-Iconoclastic period. Icon cults developed in the capital only after the middle of the tenth century (Pentcheva forthcoming). Once they appeared, they created the need to tailor the old legends to fit the new cult practices.

Curiously enough, the earliest texts about the association of the Lukan legend with a Marian icon in Constantinople come from the Latin West: the pilgrims' accounts *Anonymous Mercati* and the *Anonymous Tarragonensis 55* in the second half of the eleventh century (Ciggaar 1976, 211-267; Ciggaar 1995, 117-140), and a homily of Philagathos Kerameus of Sicily around 1140 (Taibbi 1969,

xix; *PG* 132, 440A, 441A). Philagathos states that the Lukan panel of the Virgin is kept in Constantinople, while the two anonymous accounts identify the image with the Hodegetria icon. On the basis of the textual evidence, we can conclude that by the middle of the eleventh century the Luke legend finally became attached to an icon in Constantinople, more precisely, the Hodegetria. The Mount Sinai Cod. gr. 233 miniature makes this association clear by presenting the icon of the Virgin and Child as a mirror image of the Hodegetria type. Similarly, the Harvard College Library Cod. gr. 25 features an image resembling the famous Constantinopolitan panel. Both manuscripts were produced in the Levant. One wonders if it is just a mere coin-

cidence that both the written sources and the images of the Luke legend came from the Latin West or regions under its influence. Could it be that the Latin West introduced the Luke legend in to the Middle Byzantine perception of Marian icons?

Bissera V. Pentcheva

Literature:
Belting 1990, fig. 14.

391

56

Miniature of an Artist Painting the Icon
of the Virgin and Child

32 × 25.5 cm, 314 folios
Liturgical Homilies of Gregory of Nazianzus
Paint on parchment
11th century (1060-1081)
Constantinople
Jerusalem, Patriarchal Library, Taphou 14

Taphou 14 is one of the most precious manuscripts in the Greek Patriarchal Library of Jerusalem. It contains sixteen Homilies of Gregory of Nazianzus, an oration on the Nativity attributed to John of Damascus, and scholia of Pseudo-Nonnos on the mythological references in four of Gregory's homilies. The text is arranged in two columns with twenty-seven lines each; only the scholia of Pseudo-Nonnos are written in one column. It is possible that the scholia were not part of the original manuscript. There is no colophon to indicate the date and provenance of Taphou 14. A note on fol. 306 (307)v that once existed, has subsequently been erased, yet, the quality of the miniatures and the nature of the applied ornament suggest a Constantinopolitan origin.

Out of the total ninety-three miniatures, more than sixty belong to the Homily on the Nativity by John of Damascus. They are painted in the right column directly on the parchment, which is also the ground. The miniatures in the Gregory sections preface each homily; they are painted across the space of the two columns and set inside rectangular fields of gold ground. The figures are elongated, the draperies are rendered with an emphasis on lines, the modelling is soft with no sharp chiaroscuro, and the colours are gentle pastels with an occasional use of gold. In style the painting of Taphou 14 resembles the Theodore Psalter (British Museum, cod. Add. 19352) and the Tetraevangelium (Paris, Bibl. Nat. gr. 74).

The Homily on the Nativity by John of Damascus takes up only twenty folios, 92 (93)r - 112 (113)v. The text appears to have become popular in the second half of the eleventh century. The only two illustrated editions, Taphou 14 and the slightly later Mt Athos, Esphigmenou 14 (about 1070-1110), date to this period. Both manuscripts display rich visual narrative cycles, which were created independently from each other. The popularity of the homily in the late eleventh century has been attributed to patrons from the circle of Psellos interested in Neoplatonism and astrology (Cacharelias 1995).

The eighth-century homily of John of Damascus on the Nativity incorporates the rather exotic fifth-century anonymous romance, known by its edited title as *Religious Disputes in the Sassanian Court*. In it pagan priestesses and statues of goddesses prophesy the birth of Christ; the Persian King, Cyrus, heeding to their oracles, sends the three Magi to pay tribute to Christ and the Virgin and bring back a painted image of the divine Mother and Child. The text provides an interesting description of the Virgin during her encounter with the Magi; she is small in stature, delicate in body, and her hair is the colour of ripe wheat: ἦν γὰρ αὕτη μικρὸν δὲ τῷ μήκει ἀνανεύουσα, τῷ δε σώματι τρυφερά, σιτοχροοῦσα πως τρίχωμα (Eustratiades 1921, 37). The text provides an interesting description of the blonde hair, which is a rather surprising feature, yet, it occurs in other descriptions of the Theotokos, such as the late eleventh-century text on the 'Maria Romaia' icon (von Dobschütz 1899, 237).

The three miniatures on fol. 106 (107)v, placed in a vertical sequence in the right column, narrate the following events. The topmost scene reveals the Virgin sitting on a backless chair in front of a pitched-roof building. She supports the infant on her lap. Christ holds a scroll and blesses with his right hand. In front of the Virgin and Child sits a painter, his face is raised up. He gazes intently at his living model, while with his right hand he adds the finishing touches to the bust-portrait of the Mother and Child. In front of him stands a low table with paints and brushes. Below this scene the Magi, together with a Persian, approach and venerate the new icon, now set in the tympanum of the Persian temple. The last scene in the row reveals the three Magi holding the Infant. This is an unusual image: the Christ-Child whom the eldest Magus bends to pick up, becomes the bearded-Christ in the arms of the middle-aged Persian, and finally the grey-haired Christ known as The Ancient of Days in the embrace of the youngest Magus. Far left, the Virgin sits on her chair, overseeing this supernatural vision of the divine polymorphic presence.

The scene of the Persian artist painting the Mother and Child is represented in a completely different fashion in the other contemporary manuscript, Esphigmenou 14. Here the interior of a cave reveals the Virgin sitting on a chair and the infant Christ on the ground next to her. The painter, represented as a child as the text narrates, stands on the ground below, with a white sheet in

hand and eyes focused on his model. The iconographic differences between Esphigmenou 14 and Taphou 14 are significant; they indicate the absence of established models in picturing the story, and an experimentation with current visual formulas.

The Persian artist drawing the Virgin in Taphou 14 resembles the much more popular legend of St Luke painting the Mother and Child. The Luke story was created in the eighth century, yet Andrew of Crete refers (*PG* 97, 1304 C) to an icon kept in Rome or Jerusalem, not in Constantinople. It was only at the end of the eleventh century that the legend of the Evangelist painting the Virgin became firmly attached to a Constantinopolitan image: the Hodegetria icon. The Taphou 14 miniature was created around that time; it does not represent the Luke story or the Hodegetria panel, yet, it bears a series of visual similarities. The Persian artist painting the Virgin calls to mind associations with St Luke. Similarly, the painted panel in the hands of the Eastern artist recalls the iconography of the Hodegetria. There are only small pictorial differences between the Taphou 14 image and the Hodegetria icon; the right hand of the Virgin, instead of gesturing towards Christ, gently rests on his knee. In retrospect, the series of iconographic and thematic similarities have been the reason to project a Hodegetria identity on the miniature, and misread its original subject-matter.

The Taphou 14 miniature presents a number of visual and thematic similarities which later formed the identity of the Hodegetria icon and its legendary past. In addition, the Jerusalem illumination gives a statement of Orthodoxy in a pictorial form; the miniature supports the legitimacy of icon veneration by displaying the moment of creation of an authentic portrait of the Virgin and Child.

Bissera V. Pentcheva

Literature:
Papadopoulos-Kerameus 1891, 45-65; Eustratiades 1921, 23-42; Galavaris 1969, 222-227; Avner 1982, 459-467; Lafontaine-Dosogne 1987, 211-224; Cacharelias 1995.

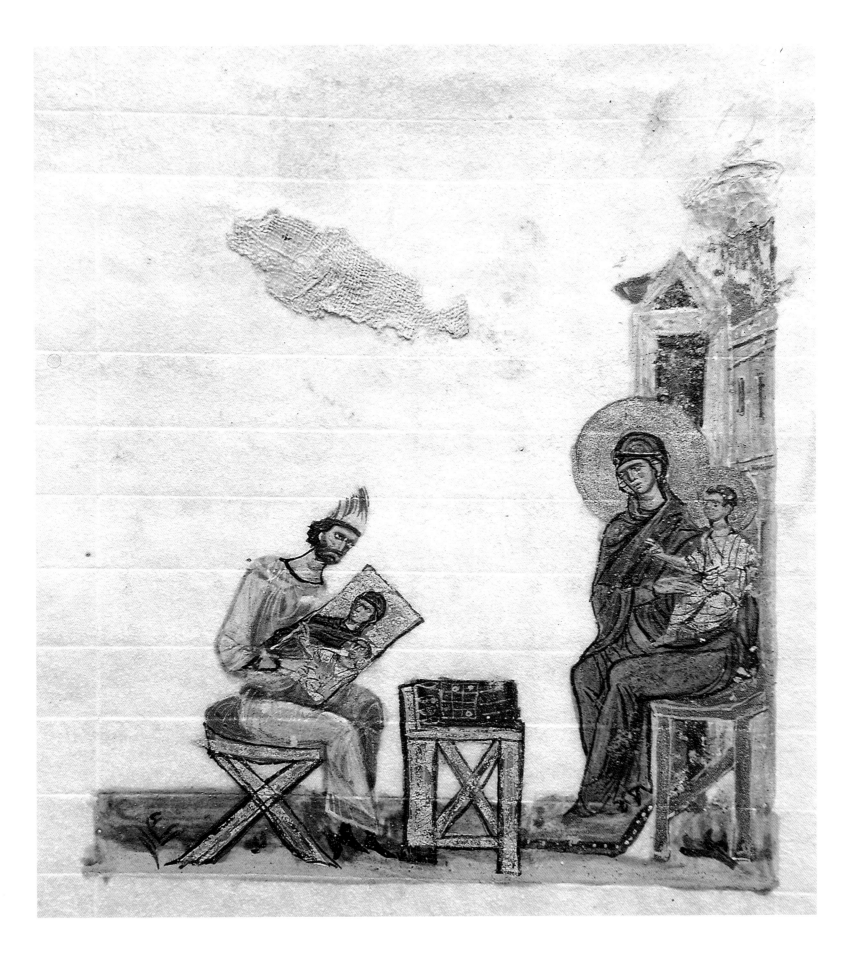

57
Relief Plaque with the Virgin Hodegetria

25.6 × 13.6 cm
Ivory (central leaf of a triptych)
10th-11th century
Constantinople (?)
Utrecht, Catharijneconvent, Inv. no. ABM
b.i. 751

An arch-shaped panel with a standing Hodegetria on a footstool, originally serving as the central leaf of a triptych. The elongated proportions of the Virgin and the subtle treatment of the draperies and face make this leaf one of the most exquisite and best preserved examples of extant ivory carvings of the Hodegetria. The attitude of the Virgin and the stylized draperies on this panel are similar to those in a group of ivories, among which only one example, in Liège, has preserved its back panel. The other objects in this group are free-standing statuettes, from which the backround plaque has been cut away. These include Hodegetrias in Hamburg, New York, and Dumbarton Oaks (*Glory of Byzantium*, no. 86). A final, unique example is the Hodegetria statuette in the Victoria and Albert Museum, carved in the round (*Byzantium*, no. 156). Stylistically, the Utrecht panel can also be compared to a square ivory plaque in Berlin, depicting a half-length Hodegetria in medallion, which has been reused on a Western gospelbook cover (*Glory of Byzantium*, no. 307). The closest parallel for the Utrecht panel is the New York Hodegetria, in the Metropolitan Museum (Cat. no. 58). The harmonious contrast between the vertical fan-shaped folds of the maphorion and the elongated oval which betrays the volume of the underlying leg, as well as the arcaded footstool, are recurring devices. Nevertheless, the statuesque character of the Utrecht panel and gentle carving of the drapery folds are distinctions which qualify it as a piece of the highest order. The Utrecht panel was probably the master model for the related pieces of the group.

The Utrecht panel has traditionally been assigned to the group named after the plaque in the Cabinet des Médailles, Paris which depicts the crowning by Christ of the imperial couple Romanos and Eudokia. In turn, the dating of the set of ivories related to this panel has been connected to the controversial identification of the figure of Romanos, as either Romanos II (959-963) or Romanos IV (1068-1071). The proposed dates vary from the mid-tenth to the last three decades of the eleventh century. This chronological range is appropriate for the classical attitude of the figures and the chronology of iconographic parallels.

In the Middle Byzantine period, the icon of the Hodegetria was one of the palladia of Constantinople. An eleventh-century book of miraculous tales (Paris, Bibl. Nat., gr. 1474) mentions the public processions of the icon on Tuesdays (Carr 1997, 95). The Virgin Hodegetria was also the preferred image of ivory carvers. Replicas of ivory Hodegetrias were also carved in larger-scale sculpture, such as the eleventh-century marble panel found in Istanbul (Fîratlî et al. 1990, no. 131). The Hodegetria was also introduced on a silver coin (*miliaresion*) of Emperor Romanos III (1028-1034) (Grierson 1999c, fig. 66). In the first half of the eleventh century, the image of the Hodegetria was employed on the seals of the patriarchs too (Oikonomides 1986, nos 74, 84, 88).

As for the restitution of the missing lateral wings of the triptych, one might suggest that they were partitioned into registers with rows of saints in medallion, half-length or in standing pose. Angels in a half-length pose might also have occupied the upper register of the lateral wings. Another possibility is that two saints in standing pose, like the ones flanking the Hodegetria statuette in the Dumbarton Oaks Collection, were the sole occupants of these wings (Der Nersessian 1960).

Brigitte Pitarakis

Exhibitions:
Exposition internationale d'art byzantin, Musée des Arts Décoratifs, Paris 1931; *Tentoonstelling Kerkelijke Kunst*, Stedelijke Feestzaal Meir, Anvers 1948; *Uit de Schatkamers der Middeleeuwen: Kunst uit Noord-West-Duitsland van Karel de Grote tot Karel de vifjde*, Amsterdam 1949; *De Madonna in de Kunst*, Koninklijk Museum voor Schone Kunsten, Anvers 1954; *Werdendes Abendland an Rhein und Ruhr*, Villa Hügel, Essen 1956; *Masterpieces of Byzantine Art*, Royal Scottish Museum, Edinburgh 1958; *Byzantine Art, an European Art*, Zappeion, Athens 1964; *Splendeur de Byzance*, Musées royaux d'art et d'histoire, Brussels 1982; *Ornamenta Ecclesiae*, Schnütgen Museum, Josef-Haubrich-Kunsthalle, Cologne 1985; *Glory of Byzantium*, The Metropolitan Museum of Art, New York 1997.

Literature:
Goldschmidt and Weitzmann 1934, 2, no. 46; Cutler 1994, 18, 94, 109-14, 237-38; *Glory of Byzantium*, no. 86 (with all previous literature).

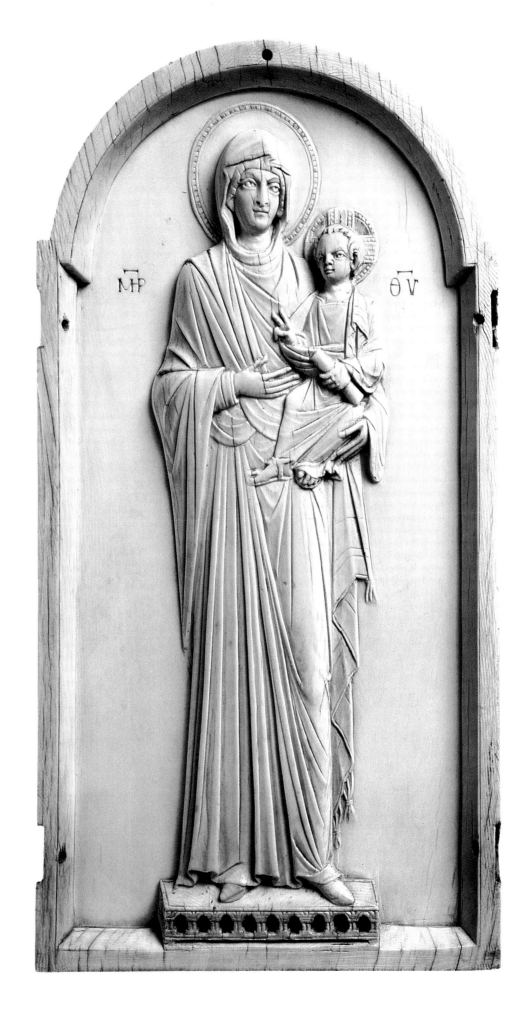

Part of a Relief Plaque with the Virgin Hodegetria

23.3 × 7.2 cm
Ivory
11th century
Constantinople (?)
Collection of Durighello, Greece; bought by
Raphael Stora before World War I;
purchased by J. Pierpont Morgan; gift to The
Metropolitan in 1917.
New York, The Metropolitan Museum
of Art, Acc. no. 17.190.103

This work belongs to a group of ivory carvings of the full-length standing Virgin Hodegetria, two of which are included in this Exhibition (Cat. nos 57 and 60). Two similar ivories are preserved in Liège and Hamburg (Goldschmidt and Weitzmann 1934, 40, nos 47 and 49), reminding us how important it was to preserve the original aspect of the miraculous image of the Virgin Hodegetria in every copy that was made. Mary is shown holding the Christ-Child in her left arm, standing on a decorated dais or *suppedaneum*. The Christ-Child is shown as a miniature Roman magistrate, holding a scroll and blessing with his right hand. Slender and elegantly executed, the Morgan ivory belongs to the famous Romanos ivory group. Adolph Goldschmidt has also compared this ivory stylistically with a plaque in Berlin that contains a medallion with a bust of Christ at the centre (Kaiser-Friedrich Museum, Inv. no. 2394; Goldschmidt and Weitzmann 1934, 40, no. 50).

The relief was cut out of its original plaque and now appears as a quasi three-dimensional statuette of the Virgin (a little more than one centimetre thick), a fairly atypical object in Byzantine art; there is a twelfth-century ivory statuette of the same type in the Victoria and Albert Museum. Remains of the plaque that originally formed the background of the Morgan piece can be seen in between the Mother and Child, where the halo of Christ would have been, as well as under the left hand of the Virgin. The separation of the relief from its flat ground has resulted in the loss of substantial parts of the figures, namely the haloes of both Mother and Child as well as a section of the left part of the Virgin's mantle that would have fallen from her left arm below the Child's body (cf. Cat. no. 57). The disappearance of this part of Mary's garment results in an unbalanced composition that gives an impression of instability to the whole piece. There are other ivory reliefs that are cut out from their plaques, two of which (in Hamburg and in the Victoria and Albert Museum) are closely related in their iconography to the Morgan Virgin and Child. It is generally believed that this cutting out followed a break in the plaque and was not a deliberate attempt to create a freestanding statue of the Virgin (Peirce and Tyler 1941, 13-14).

The drapery folds are elegantly carved, following almost identical linear and curvilinear patterns to those of the Utrecht Virgin (Cat. no. 57). Special attention should be paid to the folds above the Virgin's left foot, the left thigh, the abdomen, and her right sleeve (Casson 1935, 184). Many details betray a close similarity to the Utrecht ivory, to the point where it has been suggested that the Morgan Virgin is a direct copy of the Utrecht one in a later period (Milliken 1922, 184). Not only is the Morgan Virgin more slender and elongated, but on closer inspection, the linearity of its drapery folds gives an impression of rigidity and flatness that is not seen in the Utrecht ivory. This is particularly evident in the treatment of the folds of the garment between the feet of the Virgin: in the place of the deeply undercut plastic curves of the Utrecht ivory the Metropolitan piece opts for a more linear, spread-out effect that makes the surface of the ivory appear more two-dimensional.

Based on comparisons with the Utrecht ivory, which definitely formed part of a triptych, it is believed that the Metropolitan piece originally functioned as the centrepiece of a triptych too, a devotional object of considerable monetary value that would have been used in the private sphere. It is possible that two figures of ecclesiastics or Church Fathers would have flanked the Mother and Child as is suggested by the ivory ensemble of the Virgin, St John the Baptist, and St John Chrysostom in the Dumbarton Oaks Collection (Peirce and Tyler 1941, 13, fig. 1).

Although the now-lost miraculous icon of the Hodegetria seems to have portrayed Mary in bust holding the Child, the standing Hodegetria enjoyed great popularity in Byzantium. Clearly the standing Hodegetria was thought to reproduce the original or at least to share some of its intrinsic sanctity. After all the icon/Virgin was seen walking on the ramparts of Constantinople during the 626 siege of the city by the Avars, so a full-length image would embody the essence of this miracle and would make perfect sense in this context. The special devotion of the people of Constantino-ple to the Virgin Hodegetria must have played a critical role in the proliferation of her images at this time, in monumental art, icons, and other media. The image of the standing Hodegetria replaced that of the Virgin Nikopoios on imperial seals from 695 onwards, e.g. the early seals of Leo III or those of Nikephoros I. The type became predominant on patriarchal seals immediately after Iconoclasm. Between the time of Patriarch Photios and that of Constantine III Leichoudes (1059) the standing Hodegetria is the sole type used on patriarchal seals clearly becoming a symbol of their office to be eventually replaced by the seated Virgin and Child (Kalavrezou 1990, 171). She also appears on an anonymous coin, a silver *miliaresion* attributed to the reign of Romanos III Argyros (around 1030), a pious man with a special relationship to the Virgin (Grierson 1982, 202-203, fig. 955). A fragment of a marble relief of a standing Hodegetria (her upper body) found near the mosque of Sokollu Mehmet Pasha in Istanbul, is a good example of her appearance in monumental art. Now in the Archaeological Museum in Istanbul, it is dated to the second half of the eleventh century. The Virgin turns her head and bends toward the Child to show the intimate relationship between Mother and Son, a feature that betrays a later development in the iconography of the Hodegetria type than the Morgan ivory.

Of particular significance is the unusual treatment of the back of the ivory: it was carved to form a cavity of an irregular shape that follows the outline of the figure. Small pinholes in the bottom corners and across the top indicate that at some point it must have had a cover, but there is no staining of any sort to allow us to identify if the cover was made of metal or wood. Holes of similar size are also seen in the bottom reverse of the plaque presumably to mount the piece onto something. This recessed opening may have been used as a receptacle for relics (Goldschmidt and Weitzmann 1934, 40) but we possess no information about its actual contents. Although we usually think of metal and enamelled staurothekai in this context, literary sources also attest to the use of icons as reliquaries as in the case of an icon in the monastery of St John on Patmos (*Glory of Byzantium*, no. 138 and *ODB*, 1783).

Maria Georgopoulou

Exhibitions:
Early Christian and Byzantine art, Baltimore
Museum of Art, Baltimore 1947; *The Pierpont
Morgan Treasures: Loan Exhibition in Honor of
the Junius Spencer Morgan Memorial*,
Wadsworth Atheneum, Hartford 1960; *Byzan-
tine Art, an European Art*, Zappeion, Athens
1964; *Glory of Byzantium*, The Metropolitan
Museum of Art, New York 1997.

Literature:
Graf 1890, 22, no. 162, pl. viii; Molinier 1896,
101; Breck 1920, 15; Milliken 1922, 197-202;
Breck and Rogers 1925, 48; Longhurst 1927b,
1, 41-42, pl. XIX; Casson 1935, 184-187; *Early
Christian and Byzantine art*, no. 125, 44; Gold-
schmidt and Weitzmann 1934, 40, no. 48, pl.
XX; Peirce and Tyler 1941, 13-18, figs 3-4;
Weitzmann 1947, 404; Borchgrave d'Altena
1956, 133-144; Diehl 1957, 278; Hyatt Mayor
1957, 90; *Byzantine Art, an European Art*, no. 65;
Europe in the Middle Ages, 48, no. 40; Cutler
1994, 32, 131, fig. 30; *Glory of Byzantium*, no.
85.

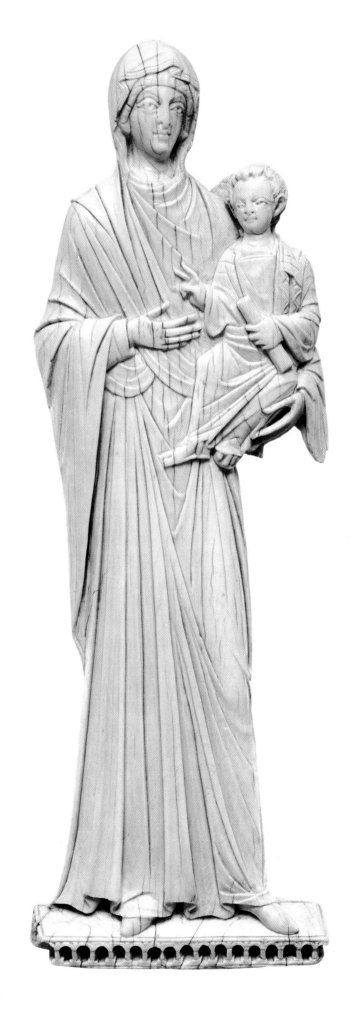

59

*Triptych with the Virgin Hodegetria
and Saints*

12.1 × 11.6 cm (central leaf), 10.8 × 5.6 cm
(wings)
Ivory
Second half of the 10th century
Constantinople (?)
Given in 1867 to the pilgrimage church at
Altötting in Bavaria by Bishop Henry II of
Passau; purchased in 1929 by Henry Walters
from Tycon and Smith, Paris
Baltimore, The Walters Art Gallery, Bequest
of Henry Walter, 1931, Inv. no. 71.158

The triptych survives in an altered state, all
three panels having been cut down at some-
time unknown. In the case of the central
panel, the lower frame has been removed
completely , but a portion of the upper frame
remains. Similarly, a slender portion of each
wing's upper frame was left, but the lower
edge was more extensively cropped, remov-
ing parts of the standing figures' feet. It may
have been, that all three plaques were ori-
ginally of equal height, but the modification
has left them unequal. Some traces of colour
and gold survive.

The central leaf shows the Virgin holding the
Christ-Child on her left arm, as she gestures
towards him with her right hand. Christ rests
his left hand on the end of a scroll, tied in a
criss-cross pattern, and raises his right in a
gesture of blessing. The haloes are inscribed
with double lines, and Christ's is crossed, each
arm being composed of rows of double lines,
and a row of pearls down the centre. The
group is situated in a baldachin with twisted
columns, Corinthian capitals, a canopy of
acanthus leaves, and vegetal akroteria. The
baldachin is conceived as a decorative frame
rather than as a spatial setting, as the figures
are overlapped by the right column but over-
lap the left. Each wing is divided horizontally
into two unequal compartments, a full stand-
ing figure in the lower one and a bust in the
upper. All figures are nimbed in the same
fashion as the Virgin and incline towards the
central panel. The left leaf shows a standing,
youthful, beardless saint wearing a chlamys
over a jewelled robe. Above him is a bearded
saint in a bishop's stole and with a codex in
his left hand. On the right leaf stands a youth-
ful, beardless saint holding a cross in his right
hand. Above him is a beardless saint with long
hair, raising his right hand in a gesture of
blessing. Their identities are not certain, but
Demetrios, Prokopios, Nicholas, and George
have been suggested (Goldschmidt and

Weitzmann 1934, no. 84; Randall 1985, 120).
On the reverse of each wing a cross is carved
in low relief. The arms have two lines
inscribed and terminate in discs that are
partly truncated at the bottom. The central
plaque is not carved on the back (Cutler 1994,
89, fig. 92).

This piece belongs to a stylistic group of ivory
carvings dated to the second half of the tenth
and beginning of the eleventh century. The
dating of the group is secured by two pieces
with inscriptions, one a staurotheke in Cortona
containing a piece of the True Cross, that
belonged to Emperor Nikephoros II Phokas
(963-969), and the other the plaque in the
Cluny Museum showing Christ crowning the
Holy Roman Emperor Otto II (973-983) and
the Byzantine noblewoman Theophano, who
were married in 972 (Goldschmidt and
Weitzmann 1934, 18-20). Certain aspects of
the 'Nikephoros group', such as the self-
possessed bearing of the figures, and the clas-
sical modelling of the draperies suggest a
close relationship to another group of more
classicizing style, called the 'Romanos group',
(Cat. nos 57 and 58). The 'Nikephoros group'
is distinguished from the 'Romanos group' by
such aspects as the formulaic treatment of the
baldachin and the figures' eyes and hands,
and the facial type, being a broad, round
head, with a wide nose, and thick lips. The
group has been characterized as exhibiting
lower quality, though more recently the diag-
nostic value of these stylistic groups has been
called into question (Peirce and Tyler 1927,
130-135; Cutler 1994, 185-197). Generally,
though, most of the objects in the
'Nikephoros group' are accepted as being late
tenth-century works.

The relatively small size of the triptych indi-
cates that it was meant for private rather than
communal devotion. In its imagery, it is a
pared-down version of the 'great triptychs',
which include greatly expanded galleries of
saintly intercessors grouped around the en-
throned Christ (Goldschmidt and Weitzmann
1934, nos 31-33). This triptych is reduced not
only in the number of additional intercessors,
but also in the main image itself. The Deesis
image of the great triptychs is here reduced
to its essential personages, Christ and his
Mother.

The central image is clearly a version of the
famous Hodegetria icon, supposed to have
been painted by St Luke and kept in the
Hodegon monastery at Constantinople. The
conventions of the traditional Hodegetria are,
for the most part, closely observed. Many

Hodegetria icons of the Romanos group show
a full-length figure of the Virgin, standing,
holding Christ over her bent left leg (Cutler
1994, 237-238). This statuesque version of the
image is a remarkable variation on the tra-
ditional configuration, and creates a consid-
erably different impression. An imposing
presence results, that removes the images
from the traditional modesty and informal-
ity of the tradition. The standing Hodegetria
is not unknown in painted examples, but it is
comparatively rare. The present piece, on the
other hand, shows the Virgin, as the original
icon certainly did, as a half figure only. The
choice itself suggests a certain degree of con-
servatism in the artists of this group, as com-
pared to the more affected Romanos ivories.
This image does have some minor diver-
gences from the familiar formula, such as the
short, squat scroll that Christ holds; he norm-
ally grasps a long, slender scroll around the
middle, (Cat. nos 57, 58 and 60). Another
irregularity is the fact that his feet are cut off
by the bottom edge of the image. Both of
these elements occur together in other ivory
icons, such as one in the Württembergisches
Landesbibliothek in Stuttgart, and another in
the Dumbarton Oaks Collection in Wash-
ington, D.C. (Goldschmidt and Weitzmann
1934, no. 87; Cutler 1994, 183). These do not
alter the image's significance, however, and
most likely accrue to artistic idiosyncrasies,
rather than to the properties of the medium.
By and large, the artists of this group may be
characterized as taking a certain freedom in
approaches to details, but avoid tampering
with the image as it was known from so many
painted icons.

John Hanson

Exhibitions:
Early Christian and Byzantine Art, Walters Art
Gallery, Baltimore 1947; *Byzantine Art, an Euro-
pean Art*, Zappeion, Athens 1964; *Glory of
Byzantium*, The Metropolitan Museum of Art,
New York 1997.

Literature:
Riehl 1905, I.3, 2375, pl. 274; Goldschmidt and
Weitzmann 1934, no. 84, 19, pl. 34; *Early Chris-
tian and Byzantine Art*, no. 124; Diehl 1957, 254;
Byzantine Art, an European Art, Athens 1964, no.
84; Randall 1985, no. 182; Cutler 1994, 88, 89,
182, figs 91, 92, 206; *Glory of Byzantium*, no. 84.

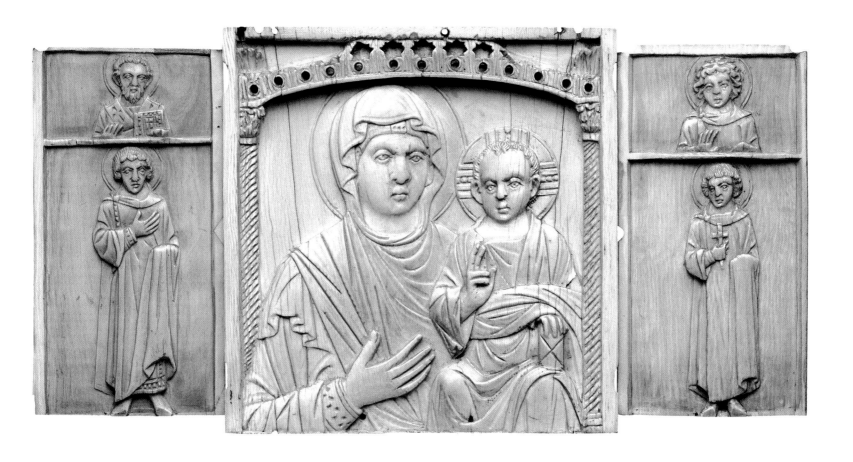

399

60

Triptych of the Virgin Hodegetria, Angels and Saints

18.4 × 11.3 cm (central leaf); 16.7 × 5.1 cm (left wing); 16.9 × 5.9 cm (right wing)
Ivory
Second half of the 10th century
Constantinople
Formerly in the collections of Soltykoff, Paris 1861; Seillière, Paris 1888; Spitzer, Paris 1893; Hartmann, Alsace; Gibson-Carmichael, London 1902; Wernher, Luton Hoo 1912; London, British Museum, M&LA 1978. 5-2. 10

In the central leaf, the Virgin Hodegetria stands on a podium holding the Christ-Child in her left hand, and gesturing to him with her right. Christ holds a scroll in his left hand and raises his right in a gesture of blessing. They are surrounded by spiral columns with foliate capitals, which support a heavily undercut canopy with akroteria at each end. The carving of this canopy to create a latticework without breaking the ivory is a feat of great skill, and overall the quality of the carving of the figures is exceptionally high.

The very elongated proportions of the Virgin and the elaborate canopy and columns surrounding the figures give the composition great majesty and solemnity, but this is balanced by the intimacy of the relationship between Mother and Son. The tenderness of the representation is shown in the way the Virgin inclines her head towards Christ, and by the concentration of all detail and visual emphasis in its upper third. It is a very elegant and moving image, which captures the love and pathos of their relationship.

The two wings contain three pairs of figures, each in a medallion with a zigzag border. The medallions are separated by acanthus leaves. In the top pair are the Archangels Michael (left) and Gabriel (right), each named in red, painted inscriptions which are now badly effaced. Below them are two Church Fathers, each wearing a pallium and holding a book, while at the bottom are two soldier-saints holding spears in their right hands, and clutching swords in their left. These figures, were originally named in painted inscriptions, that have been scraped off, presumably in relatively modern times. However, the distinctive facial types of all these figures allow them to be identified as Sts Nicholas and Theodore (left wing) and Sts John Chrysostom and George (right wing). The pairings of soldier-saints and of Church Fathers appear on a number of other Middle Byzantine ivories

(Goldschmidt and Weitzmann 1934, nos 130, 131, 182, 189, 73).

In many places the ivory is stained, presumably as a preliminary to gilding in these areas. This is most apparent on the haloes of the Virgin and Child, and on parts of the Virgin's robes; on the pallia, cuffs and books of the Church Fathers; on the acanthus leaves between the medallions as well as on the frames of the wings. This is probably original and would have made a strong contrast against the white of the ivory and the red of the inscriptions. No other evidence of colour remains, but it is clear that at some point the ivory was scoured clean, and scratch marks are visible where the inscription naming St Nicholas was erased. This was probably done in the nineteenth century when many ivories were cleaned and bleached to produce white objects which were deemed purer and more aesthetically pleasing.

It has been suggested that the right wing is a later replacement, but there seems to be no evidence to support this: stylistically it is very close to the left one. The faces are slightly broader and more frontal, but otherwise the same.

When the triptych is closed, the wings reveal two crosses, while the reverse of the main leaf has an arch supported on columns, from which hangs a small cross under a crown. The external reliefs are very lightly incised and have none of the delicacy of the internal carving. This was partly because once the main images had been carved the ivory was very thin (and there are areas on the cover under the central canopy where the ivory has broken through), and partly because the exterior of the triptych needed to be able to stand up to the wear and tear of transportation.

Technically and stylistically, this piece is very closely connected to an ivory reliquary in San Francesco at Cortona. They share the same elongated proportions, the same distinctive depiction of ears with broad lobes curling to a thin line at the top, and the same bunching of hair across the forehead. The Cortona staurotheke is dated by an inscription on its reverse to the reign of Nikephoros II Phokas (963-969), and so a similar date can be applied to this triptych. It was almost certainly produced as a court commission in Constantinople.

The whole triptych is in good condition and the details of all the figures are remarkably well preserved. The main areas of loss are in those areas where holes were drilled through

the ivory in order to provide means of attaching the wings to the central panel. Where this was done, the ivory has broken and in some places (such as the inside top corner of the right wing, and inside bottom corner of the left wing) it was repaired. The chains that now link the three pieces are relatively modern.

Antony Eastmond

Literature:
Goldschmidt and Weitzmann 1934, no. 78.

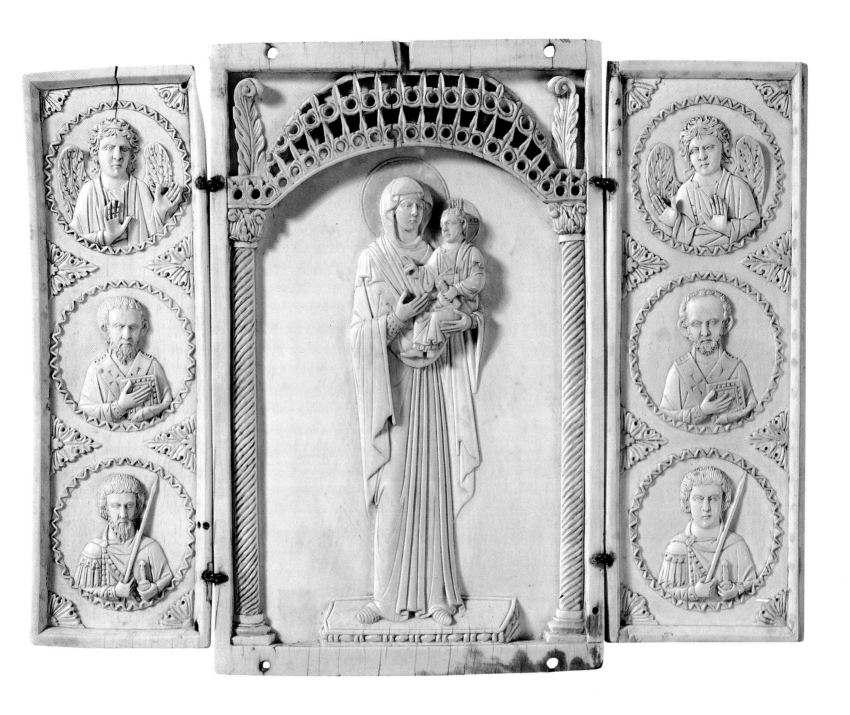

61

Two-sided icon: A. *Virgin Hodegetria*
B. *Annunciation*

99 × 73 cm
Egg tempera on wood. Revetment: silver gilt
Third quarter of the 14th century
Ochrid, church of the Virgin Peribleptos
Belgrade, National Museum, Inv. no. 2316

The icon has been housed in the National Museum in Belgrade since 1951. Before that it was in the royal chapel at Dedinje, to which it had come in 1930 as a gift from the town of Ochrid to King Alexandar Karadjordjević (Milošević 1958, 187).

A. On the front of the icon the Virgin holds Christ in her left arm, while making a gesture of prayer with her right hand. It belongs to the iconographic type which has its origins in the famous prototype of the Virgin Hodegetria, showing the route to Salvation through Christ. The Virgin wears a dark red mantle with bright red folds, a *kekryphalos* and a blue tunic. Christ blesses with his right hand and holds a red scroll, an attribute of the Messiah and the emperor, in his left. He is dressed in a blue tunic and an ochre himation hatched in gold. Both figures face the spectator. A white ground with inscriptions in red, MHP ΘY and IC [XC] and haloes executed with a thin layer of paint, show that a revetment was intended.

B. The Annunciation, on the back of icon, is heavily damaged. On its left, the Archangel Gabriel (Ο ΑΡΧ ΓΑΒΡΙΗΛ) steps towards the Virgin (MHP ΘY), blessing with his right hand, while holding a bright red rod in his left. He is dressed in a blue-green chiton with ochre clavi hatched with gold. His himation is ochre with brown folds and white illumined planes. The wings of Gabriel are blue-green and ochre, with striations in gold. The Virgin, holding a red skein, is seated on a throne, with her feet resting on a stool. She is shown in half profile, turned away from the archangel, but lifting her head in his direction. In her lap is a container for yarn, a rare detail in paintings of the Palaiologan era. The Virgin is clad in a dark red maphorion with gold stars on the front, the shoulders and the edges, a *kekryphalos*, a blue-green tunic, and red shoes. The throne is ochre hatched with gold and the bright red cushion on the seat is also decorated with gold. The ground of the composition is gold with a segment of heaven from which a ray of the Holy Ghost beams towards the Virgin. Behind the figures there is a low olive-green wall.

The choice of the Annunciation to accompany the Hodegetria indicates a desire to proclaim the idea of the Incarnation through which Salvation comes, as well as to emphasize the role of the Virgin in it. The iconography of the Annunciation scene is based on the Gospel of St Luke and the apocryphal *Protevangelium of James*, and is represented in a variation which follows the Palestinian tradition of the Virgin who sits and spins (Millet 1916, 67-69). The iconographic details rely on a simple austere composition. There is no complex throne, nor is there a setting such as the Virgin's house or a church built on its site, all there is a wall as a symbol of Nazareth (Fournée 1968, 225-235).

On the silver revetment which covers the ground and the haloes on the front of the icon, three medallions with inscriptions are conserved (MHP, ΘY, XC). Of all the figures on the border only the busts of Apostle Peter and Archangel Gabriel survive. When Kondakov published the icon, there were, in addition to these two, on the upper part of the frame, busts of Christ, the Apostle Paul and the Archangel Raphael, while on both sides of the panel there were standing figures of apostles (Kondakov 1909, 257, pl. VIII). The revetment is dominated by an ornament of double circles made of interlaced vine stems. The ground and haloes have schematic, three-petalled flowers, while the flowers on the frame are more complex and varied. On the edge of the haloes and plaques of the frame there is a series of palmettes. The representations on the revetment widen the painted iconographic scheme, introducing alongside the themes of Incarnation and Salvation, the motif of prayer, which Christians, with the intercession of archangels and apostles living in the Garden of Eden indicated by the interlaced vines on the revetment, send to Christ and the Virgin (Grabar 1975a, 4-6, 16). The revetment also carries the multiple symbolism of precious and noble materials.

The basic drawing is incised in the icon's gesso priming. Incarnate beings have basic coats of bright olive-brown paint which creates shadows of even width round the contours of the face. The flesh is modelled in chiaroscuro, achieved with gradual layers of bright ochre and using fine white linear highlights. Eyelids and cheeks are rose-coloured and details are drawn in red. On the back of the icon, the faces are modelled in the same way, but more deftly, with visible brush strokes, and the head of the angel is in the best classical tradition. On the simple draperies, without much stylization, the lines

of the folds are mostly in a darker shade of the base colour. Solemn, austere and harmonious painting, with monumental figures, and beautiful features with white highlights, connect the icon to works from the 1460s and 1470s. As a stylistic analogy, we could cite the icon of Archangel Michael, in the Byzantine Museum, Athens, of around 1360 (Babić 1980, pl. 29). A similar spirit, notwithstanding differences in painterly treatment, is encountered on icons on the iconostasis in the Chilandari monastery, of around 1360 (Weitzmann et al. 1981, pls on 188-191). Djurić has suggested a date for the Ochrid icon, in the National Museum, Belgrade, by comparing the front with a wall-painting from the Sts Anargyroi chapel in Vatopedi (about 1370), and concluded that both are the work of two Thessaloniki workshops that operated close to each other (Djurić 1961a, 133-134, figs 13, 15).

Parts of the icon have been over-painted, which, combined with the damage and new retouching, make it difficult to see and study the original painting. There was uncertainty as to whether its front and back were the work of the same workshop (Djurić 1961a, 133) as well as to whether their dating should be the same (Tatić-Djurić 1984, fig. 28). Therefore it is important to point out that they are by the same painter. The misunderstanding was certainly due in part to the fact that this composition was unusual for the Annunciation in the fourteenth century. The himation of Gabriel on the back of the icon was partially over-painted, probably in the fourteenth century. On the front of icon, there were further interventions in the seventeenth century, mostly affecting the draperies, while there is some new paint on Christ's face. Bright red paint covers the original maphorion of the Virgin except on a small part underneath her hand; her *kekryphalos* and Christ's tunic are also over-painted.

In addition to the usual stylistic features of the period, emphasizing plasticity, movement and variety of gesture, the revetment of the icon has elongated proportions and beautiful draperies with whirling hems on the standing figures. Kondakov had long ago noticed its similarity to revetments on icons from Ochrid, such as Christ Saviour of Souls and Virgin Saviour of Souls (Kondakov 1909, 257, pls V, VI, VIII), from the early fourteenth century (Grabar 1975a, 38-39, nos 12-13, figs 31-36). The similarities are to be found in the system of decoration and in characteristics of the style. With respect to the ornamental surfaces, the icon is in no way inferior to the two

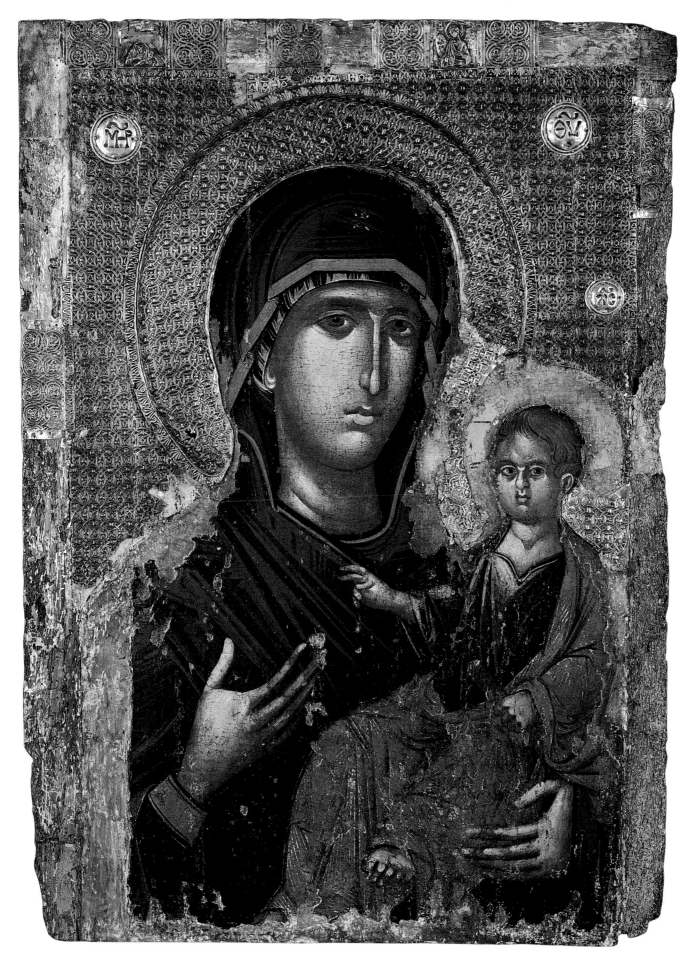

other icons already mentioned, something which cannot be said of the figures, especially the faces. In the simplified treatment of faces and hands it is akin to Dodekaorton scenes on two icons in the Vatopedi monastery, the Virgin Hodegetria (14th century) (Grabar 1975a, 49-52, no. 21, figs 47-52) and a mosaic icon of the Crucifixion (early 14th century) (Grabar 1975a, 52-53, no. 22, figs 53-59). The revetments of this mosaic icon and an icon of St Demetrios from Dyonisiat have the same motif of palmettes on the edges (Milošević 1958, 197). Double circles as ornament, with flowers as well, occur on two icons from Ochrid and on an icon of the Virgin with Christ from St Nicholas in Melnik (14th century) (Grabar 1975a, 25-26, no. 5, fig. 7). Judging from the stylistic features of the painted panel, which date in the fourteenth century, and the technical details of the revetment, we may conclude that they are contemporary.

Aleksandra Nitić

Conservation:
Sofija Kajtez, revetment: Miroljub Stamenković, Zoran Pavlović (1995-2000).

Exhibitions:
Ikone iz Jugoslavije, Belgrade 1961; *Sredwovekovna umetnost u Srbiji*, Belgrade 1969; *Antica arte serba*, Rome 1970; *Antica arte serba*, Venice 1970; *Mittelaltärliche Kunst Serbiens*, Berlin 1970; *Staré srbské uměni, XII-XVIII stoleti*, Prague 1974; *Slikarstvo u sredwovekovnoj Srbiji od 12. do sredine 18. veka*, Belgrade 1974; *Umetnost u sredwovekovnoj Srbiji od 12. do 17. veka*, Belgrade 1980; *El arte en la Servia medieval de los siglos XII al XVII*, Madrid 1981; *Srednjovjekovna umjetnost Srba*, Zagreb 1985.

Literature:
Kondakov 1909, 257, VIII; Kašanin 1938, 306; Milošević 1958, 187-205 (with previous bibliography); Djurić 1961a, 133-134, pl. 15; Djurić 1961b, 25, 90, no. 23, pl. XXXV (with previous bibliography); *Sredwovekovna umetnost u Srbiji*, no. 39; Radojčić 1975, 69-70; *Umetnost u sredwovekovnoj Srbiji od 12. do 17. veka*, no. 22; Weitzmann et al. 1981, 182; Tatić-Djurić 1984, no. 28.

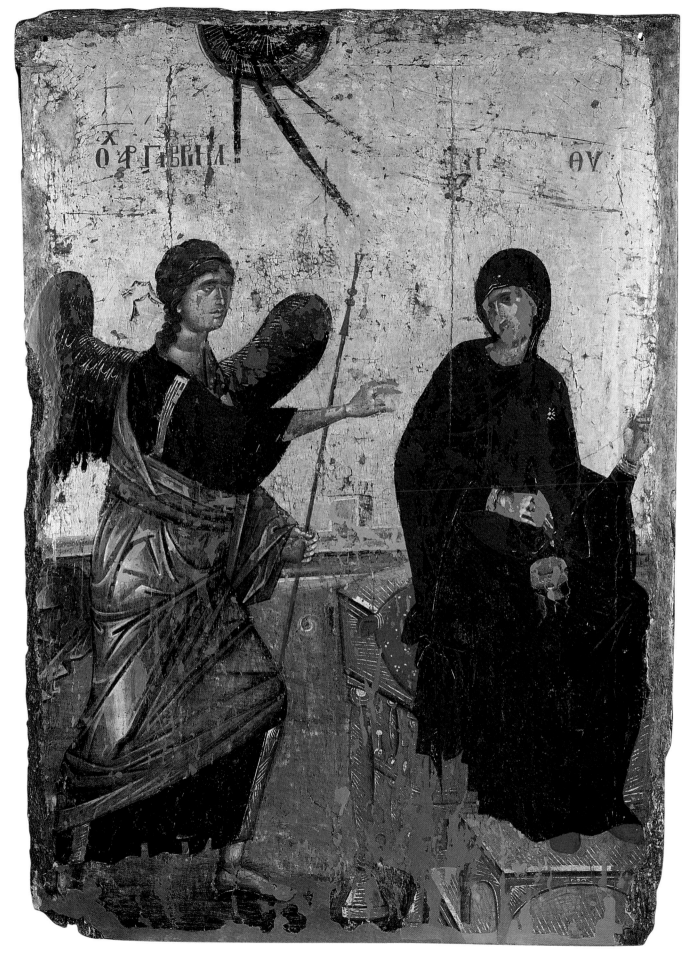

405

62

Icon of the Virgin Arakiotissa

103.5 × 73.5 cm
Egg tempera on wood
Late 12th century
Cyprus
Nicosia, Byzantine Museum,
Archbishop Makarios III Foundation

The Virgin, with the inscribed appellation 'Arakiotissa', is painted in the standard type of the Hodegetria. She is shown waist-length, turning to the left, with her torso and head erect, holding Christ in her left arm and raising her right in a gesture of prayer. She wears a sleeved blue chiton, where each cuff visible only at the right wrist has two decorative beige bands with three gold lines. Her whole body is enveloped in a deep cerise maphorion the folds of which are rendered as broad black lines. Its border round the face is decorated with a braid, gold as on the maphorion round the face in three other icons in Cyprus: the Eleousa in the Enkleistra of St Neophytos, the Hodegetria of Moutoullas, and the St Marina from the homonymous church at Pedoulas, and now in the Byzantine Museum of the Archbishop Makarios III Foundation, Nicosia (Papageorgiou 1991, figs 9, 29, 34). The maphorion is adorned with three bands on the upper left arm, and ends in fleur-de-lis tassels, just as in three other depictions of the Virgin: the Eleousa in the Enkleistra, the Eleousa (thus inscribed, though in type a Hodegetria), once in the church of St Sabbas of Karon, and now in the Byzantine Museum of the Metropolis of Paphos, and the Eleousa (i.e. Paraklesis) wall-painting in the church of the Virgin of Arakos at Lagoudera (Papageorgiou 1991, figs 9 and 20; Nicolaïdès 1996, fig. 77). The second of these bands deserves comment: it consists of lozenges, not a common motif in iconography, but one which occurs again, in what is a much later work, the 'Virgin of the Paraklesis' wall-painting in the church of the Virgin of Moutoullas, on the Virgin's maphorion (Mouriki 1984, pl. LXXIV, 7). On only two other icons in Cyprus are there bands of lozenges: the Christ Philanthropos in the Enklcistra of St Neophytos, and the Christ in the Great Agros monastery at Agros. In the first, the gold lozenges are used to decorate the clavus on the left shoulder of Christ's chiton, and also the fore-edge of the book he holds. In the second, they adorn the selvedges at the neck opening of Christ's chiton, the end of its right sleeve, and the fore-edge of the book he holds in his left hand (Papageorgiou 1991, fig. 8;

1997, 108, fig. 49; Sophocleous 1992, 57, figs 5 and 19; 1994, 80, fig. 10). Outside Cyprus, lozenges appear in a small number of thirteenth-century icons (Mouriki 1986, 12, 14).

Christ sits easily in the Virgin's left arm, erect, with the sole of the right foot horizontal as if stepping on the raised frame, and with the left leg slightly lifted. He wears an olive-green chiton with light-hued illumined planes and dark-hued shadows, a black clavus on the right shoulder, and a vermilion himation with lavish gold striation. He extends his right hand towards the Virgin's neck in blessing and props a closed scroll on his left leg with his left hand. The way in which Christ makes the gesture of blessing has been seen as 'Western' (Mouriki 1986, 14): in Cyprus it occurs in early twelfth-century wall-paintings (Boyd 1974, figs 10-11; Papageorgiou 1999, fig. 3) and in thirteenth-century and later icons (Papageorgiou 1991, figs 29, 55, 67, 72; and cf. figs 26, 77-82).

The flesh is modelled with dark olive-green underpaint, lightened with warm ochre. Broad dabs of red bring out the Virgin Mary's cheekbones. There is a red line to emphasize the eyelids, nose, and mouth, as in the wall-paintings in the sanctuary and *cella* of the Enkleistra of St Neophytos, which date from 1183, the wall-paintings of the now derelict church of St Marina in the Pyrgos area of Yialousa, and in a whole series of twelfth- and thirteenth-century icons (Papageorgiou 1976, 268; 1991, figs 10-13, 15a-b, 16, 25, 28-29, 32a-b, and 33-35). Christ's face is modelled in colder colours: there are no dabs of red on the cheekbones, but there are white high-lights, executed with semicircular brush strokes, for the chin and nose, under the left eye, and above all on the forehead. The characteristic features of the Virgin's face recur in wall-paintings in the Enkleistra of St Neophytos (Mango and Hawkins 1966, figs 69 and 72) and in the church of the Virgin of Arakos (Nicolaïdès 1996, fig. 3). The characteristic features of Christ are found again in the wall-paintings of the church of the Virgin of Arakos (Nicolaïdès 1996, figs 62-65).

Despite her proud pose, the Virgin's expression is rather melancholy. Her gaze is lost in infinity, as if she were envisaging the Passion prophesied to her by Symeon at Christ's Presentation in the Temple. The painter conveys well the intense emotions evoked by the vision of the future Passion (Mouriki 1986, 13).

Despite severe damage to the top and bottom of the icon's frame, these can be seen to

have been decorated with a tendril motif in red on dusky ochre, gold on black, and green on gold. On the sides of the frame the decoration, far better preserved, is of gold lozenges between horizontal rectangular bands on a brown ground. A red border with astragal pattern runs round the frame. The ornamentation on this frame is, as far as I know, unique for Cyprus. In two icons in the Enkleistra of St Neophytos — the Christ Philanthropos and the Virgin Eleousa — the frame is decorated with a stylized plant motif in triangles alternately upright and inverted (Papageorgiou 1991, figs 8-9); while on an icon of St James the Persian, from the church of St Kassianos, the top of the frame is decorated with a stylized tendril motif. An icon in the Ochrid Museum also has a frame decorated with lozenges (Weitzmann et al. 1964, pl. 167). The frame decoration of the present icon displays, however, many similarities with so-called 'Crusader' miniatures and icons (Buchthal 1957, pl. 57a; Weitzmann 1963, figs 3-4; 1966, figs 22-24, 29-40; 1982, 182, figs 3-4 and 18). The red border with astragals round this frame reappears on the frame of a Grottaferrata Hodegetria icon. The latter was thought by Weitzmann to be the work of a Western painter who had visited the East and learned to paint in the Byzantine style, and had then returned to Italy. For Pace, the icon was painted in Cyprus and taken overseas to Italy later on (Weitzmann 1966, 75, fig. 52; Pace 1979, 265-268, figs 4-5).

It has been argued that this decoration is due to Western influence, in so far as it appears on many thirteenth-century Sinai 'Crusader' icons. These are later than the present icon, however. But lozenges on the side of the frame are found again in a two-sided icon, with the Crucifixion/the Hodegetria now in the Ochrid Museum. As has been argued, all the examples of 'decorated sides' come from the Cyprus or the Palestine-Sinai area. The Ochrid icon is the exception: it very probably comes from Thessaloniki (Papageorgiou 1976, 269). The combination of geometric and plant motifs is also a feature of miniatures in Syriac manuscripts (Mouriki 1986, 16-17). In all probability, then, the decoration on the sides of the present icon's frame was due to an influence from Constantinople, not Italy. It has also been argued (Hadermann-Misguich 1979, 255-84; 1985, 243; Winfield n.d., 13 and 15; Mouriki 1986, 17) that the painter of the wall-paintings in the church of the Virgin of Arakos was none other than Theodoros Apseudes, who nine years later — in 1183 — painted the sanctuary and *cella* wall-painting

in the Enkleistra of St Neophytos. It would also seem that Apseudes painted the icons of the Enkleistra and of the church of the Virgin of Arakos, to judge by the common elements of technique in these wall-painting and icons.

Athanasios Papageorgiou

Conservation:
Photis Zachariou, 1973.

Exhibitions:
Icons from Cyprus, Benaki Museum, Athens 1976.

Literature:
Papageorgiou 1976, 267-270; *Icons from Cyprus*, no. 6; Papageorgiou 1991; Papageorgiou 1992; Mouriki 1986.

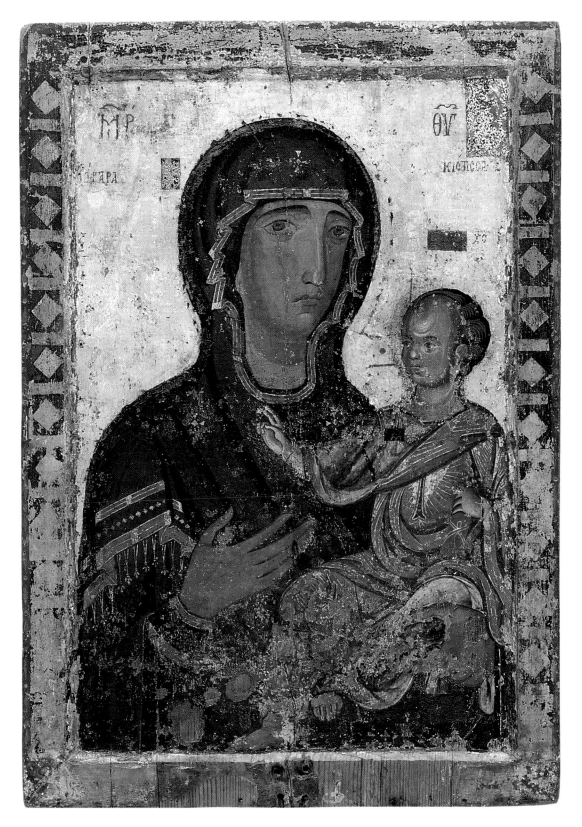

63

Icon of the Virgin and Child

117.5 × 75 cm
Egg tempera on wood
Early 13th century
Cyprus (?)
Athens, Byzantine Museum,
Inv. no. BM7779, T2512

Removal of a more recent paint layer covering the icon revealed the original subject in excellent in condition, which raised questions about why it had been painted over in the first place.

The Virgin is shown in bust, holding the Christ-Child, in a variant of the Hodegetria type. She holds the Child in her left arm and inclines her head slightly towards him, while with her right hand she supports his bare heel, which protrudes between the thumb and forefinger.

A great many of the elements of this icon's iconography and style diverge from Byzantine tradition, posing problems of origin and dating. What sets this portrayal completely apart from the standard iconographic pattern of the Brephokratousa is the figure of Christ, so inordinately large in physical size and presence, that he can hardly even be called a child. Sitting with knees bent and torso upright, the figure covers three-fifths of the height of the composition, and approximately half its horizontal axis. Christ's legs are uncovered, crossed, and of imposing size, while the detail of his bare heel in his mother's hand is given striking prominence. The folds of the garment round his waist are ample, while the clavi on his shoulders are very large by comparison with the general scale of the icon. Disproportionately large and a brilliant scarlet, is the upright scroll propped on Christ's left thigh. Other elements that are alien to the Byzantine tradition include the rendering of the face, with the large shadowy eye-sockets and their whorled contour, the tiny mouth, the lifted chin, the markedly stylized ear, the chubby cheeks and the long shoulder-length hair that seems to be gathered behind, high on the neck. The arrangement of the hem of Christ's chiton is another detail alien to Byzantine iconographic methods and principles. It seems here to loop round his left thigh, leaving an elliptical opening through which his bare legs project. Interesting too is the way in which the end of his himation falls broad and free, with an undulating edge and massed compound folds.

Certain of the above elements, while not common to the Byzantine type of the Brephokratousa, can nevertheless be found in a short-lived series of early thirteenth-century Cypriot icons. The closest parallel is an icon of the Virgin from Moutoullas in Cyprus (Mouriki 1987, 404-414, fig. 5). Since the present icon is obviously closely related stylistically and in other ways to this work, and to other representations in Cypriot wall- and icon-painting, it has been assigned to a Cypriot workshop (Mouriki 1987, 404-414). Elements favouring this ascription include the priming of the back of the wooden panel with canvas and gesso, and the rudimentary decoration of parallel painted vertical wavy lines. Certain devices in the iconography and style also suggest a Cypriot workshop. These include Christ's scarlet scroll, the extravagant drapery of the Virgin's maphorion under her right arm, and the equally emphatic articulation of the clavicle on the neck of both figures.

However, the present icon's most serious divergences from standard traditional Byzantine pictorial means are those not found in the icon from Moutoullas. These are the somewhat naïve treatment of the Child, his features, at odds with observation from nature, the arrangement of the hair, and the strange opening through which his disproportionately large left leg protrudes. Elements of this kind are, by contrast, fairly common in Romanesque painting. For instance, the Christ-Child, bulky and out of all scale in his mother's arms, is frequent in Western paintings, a typical example being the fresco of the Virgin and Child in the central apse of the Castello Appiano (Bologna 1964, pl. 32). Elliptical openings—of the form seen in Christ's chiton, with the bare leg protruding, and above all in curved chiton sleeves, usually with the arm protruding—are also common in Western paintings of the 1200s. There is a very close and suggestive parallel to these trends in the same features in two miniatures, a Crucifixion and a Nativity, in a Pierpont Morgan Library manuscript (M.710) dated to between 1215 and 1232 (*The Year 1200*, pls 280 and 281).

Also of interest for the study of the icon is the telling detail of the Child's bare heel (Baltoyianni 1994, 29). This is connected with Christ's coming Passion and can be linked to his words to his disciples immediately after the Washing of the Feet, hinting at Judas' betrayal: '...but that the scripture may be fulfilled, He that eateth bread with me hath lifted up his heel against me' (John 13:21). This passage from the Gospels is anticipated

in the Psalms of David (41:9): 'Yea, mine own familiar friend, in whom I trusted, which did eat of my bread, hath lifted up his heel against me'. It was interpreted by the Church Fathers and by the exegetical writers as a foreshadowing of Christ's Passion. Seen in that light, this iconographic element, which is present in the Brephokratousa in the sanctuary conch at Kurbinovo, was the commonest and most adaptable of all iconographic references to the Virgin and Child in Western painting. The Christ-Child's bare heel, lovingly guarded by Mary's hand, was standard in other later Western works, such as Cimabue's *Madonna Intronizzata* (1280) in Bologna, where the detail of the Child's bare leg is also present (Bonnafos 1968, pl. IV). In a variant from the same workshop, a fresco in the lower church at Assisi shows the Virgin enthroned with angels (Bonnafos 1968, pl. XIII). This was widely adopted in the West during the fourteenth century, to be passed on to the fifteenth-century 'Italo-Cretan' icons of the Virgin (Baltoyanni 1994, 29-30), which frequently show the Child's sole upturned—Christ's vulnerable 'Achilles heel' being exposed.

Lastly, there is in the present icon an obvious misunderstanding of traditional Byzantine iconographic elements of important doctrinal content, such as the clavi on the shoulders of Christ, which here seem to function as appendages to his pleated and over-blown girdle. This is no accident, and it very probably indicates the painter's confusion about their true function and meaning. There are no inscriptions on the icon: not even the *nomina sacra* which normally accompany the Virgin Mary (MP ΘOY) and Christ (IC XC).

All these features of the icon, together with the unaccountable absence of abbreviations and other inscriptions, would seem to belie a craftsman ignorant of the Greek language and quite unfamiliar with the iconography and pictorial means of Byzantine painting. He did however have first-hand knowledge of twelfth-century Cypriot representations and copied them, as is clear from the relationship of our icon to Cypriot work of the same date.

Thus the Byzantine Museum's Brephokratousa was painted not in a Cypriot workshop, but by a Latin painter, probably living and working in Cyprus, in the early years of Lusignan rule. The reasons for overpainting the icon—which had not been seriously affected by time when the later layer was removed—now become clear. Its strongly Latin feel was perhaps unacceptable to the community of

Orthodox monks to whom the icon was to belong for hundreds of years: probably from as early as the fifteenth century, the period to which the over-painting is assigned.

Chryssanthi Baltoyanni

Conservation:
M. Michailidis, Maria Michailidou, Maria Stavridou.

Exhibitions:
Έκθεση για τα 100 χρόνια της ΧΑΕ, Byzantine Museum, Athens 1984.

Literature:
Έκθεση για τα 100 χρόνια της ΧΑΕ, 16, pl. 5, fig. on 17; Acheimastou-Potamianou 1985, 85; Mouriki 1987, 403-414, figs 1-3.

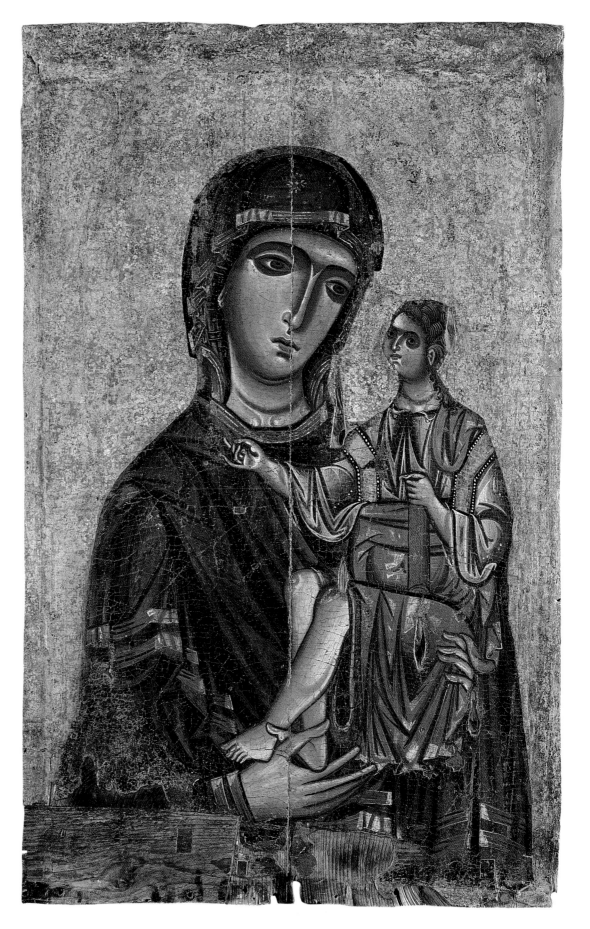

64

Two-sided icon: A. *The Virgin Hodegetria, with the Dodekaorton.* B. *The Hetoimasia*

107 × 93 cm
Egg tempera on wood, gesso with priming
Second half of the 14th century
Constantinople (?)
Athens, Byzantine Museum, Inv. no. T177

This icon came to the Byzantine Museum from an assemblage of treasures in Messina, Sicily. The central rectangular slots on both sides for inserting a pole show that it was at one time carried in procession. The icon was trimmed at the ends for some later use: this is most obvious at the top, where on the principal face a significant part of the miniature scenes of the Dodekaorton has disappeared, along with its glistening gold ground. On the reverse there is a painted ground, colour often doing duty for gold in icons of this kind. It is very probable that this large processional icon originally graced some church of the Virgin.

A. This is the Virgin Hodegetria, as indicated by the inscriptions above her and to her left ΜΗΡ ΘΥ Η ΟΔΗΓΗΤΡΙΑ. She is shown frontally and in bust, holding the Christ-Child in her arms to her left. Escorting her, at the top corners, are the Archangels Michael and Gabriel in miniature and in bust: they stand in veneration beside her, their hands covered by the himation. Mary and the Christ-Child, who is in a similarly frontal and formal pose, look directly at the viewer: Christ makes the gesture of blessing. This is the 'austere' Hodegetria type, the same as in the archetypal processional (and probably two-sided) icon, the palladium of the capital city, in the Hodegon monastery at Constantinople.

The central representation is marked off from the wide surround by a bevelled raised band. On the surround, and at a slightly higher level than the panel, there are depictions of the Dodekaorton. These are free-style miniatures, bold and expressive in their modelling, painted on small rectangular icons in compartments, four to all but one of the sides. The bottom is without decoration, having only a narrow border of gold and underneath it a broad border of red. This adds greatly to the effect, giving the icon a solid foundation and lightening the image, which is generally rather subdued, with calm colour tones. There are glints of red here and there in the panels as well. The representations of the Twelve Great Feasts start from top left and are as follows: the Annunciation, the Nativity, the Presentation, the Baptism, then on the

two sides, with inscribed labels: the Transfiguration, the Raising of Lazarus, the Entry into Jerusalem, the Crucifixion, the Resurrection, the Ascension, Pentecost, and the Dormition of the Virgin. There is a uniform gold ground. On the top only there are vertical lines separating the scenes and here the Nativity and the Presentation elongate to the centre, with the Virgin's halo obtruding into their space, whereas the representations on the lateral sides elongate upwards, their layout giving emphasis to the standing Hodegetria. The composition of the whole is managed with symmetry, orderliness, and harmony.

B. On the back, the ground is green and the foreground ochre, while a red border runs round the frame. What is depicted here is the Hetoimasia, the 'Preparation of the Throne'. This was a subject of central importance in compositions with the Last Judgement, whose eschatological meaning it epitomized. Rarely is the Hetoimasia met with on its own, as here. On the Kingdom of Heaven's doomsday throne are Christ's robe and the Gospel, signifying the Lord's invisible presence, while looking out from behind its sides are two six-winged seraphim in mid-air. The Gospel is open at the appropriate page: ΔΕΥ/ΤΕ ΟΙ/ [Ε]ΥΛΟ/ ΓΙΜΕ//ΝΗ ΤΟΥ/ Π(ΑΤ)Ρ(Ο)C/ ΜΟΥ Κ/ΛΗΡΩ/ΝΟ (μήσατε τὴν ἡτοιμασμένην ὑμῖν βασιλείαν) (Come, ye blessed of my Father, inherit the kingdom prepared for you from the foundation of the world) (Matthew 25:34). Behind the throne rises the Cross, with the crown of thorns, the lance, and the sponge; on the footstool in front is the vessel with the nails, a normal detail in fourteenth-century representations of the Hetoimasia. Various elements, notably the use of colour, imply that the paintings on both sides of the icon are of the same date; if not exactly contemporary, at least not far apart in time. The Hetoimasia as an independent subject complete in itself is known from one other representation, of the early fifteenth century, on the back of the Komnenian Virgin of Vladimir in Moscow (Belting 1980-1981, 9, figs 12-13). This is a sparer, simpler work, which has no seraphim.

So self-contained and rich an iconographic language, with the Hodegetria, the Dodekaorton, and (on the reverse) the Hetoimasia, in a single conceptual ensemble, was unusual in two-sided icons of the Virgin, and when taken in conjunction with the quality of the painting, it is indicative of a leading artistic centre — either Constantinople or Thessaloniki. This impressive icon brings out lofty theological ideas that condense the

essence of the Christian message and focus on the Divine Economy of Salvation. Christ's First and Second Coming are made plain in the sequence of images. The triumphant 'Virgin of the Incarnation' is surrounded by 'ἡ τῶν ἑορτῶν δωδεκὰς τῶν ἐνθέων' (the dozen feasts inspired by God), to quote Manuel Philes, using the main events of the Gospels to narrate Christ's first presence on Earth, making clear the work of Divine Economy and at the same time exalting the person of the Theotokos. The apocalyptic Hetoimasia, with the symbols of the Passion in the background, extols the salvationary power of the sacrifice on the Cross and foreshadows the Second Coming of Christ in glory, to which man looks forward in dread or hope. Similar in composition plan and ideas is a two-sided icon of the same date in the church of the Virgin Pantobasilissa (Queen of All) at Rafina, which has the Twelve Great Feasts preserved only in very few places and the commoner subject of the Crucifixion on the back (Acheimastou-Potamianou 1991, 8ff., pls 9-10).

The controlled figures and certain of the typological hallmarks of the Byzantine Museum Hodegetria are the main reasons for linking it with two later icons of the Virgin: that by Georgios Akropolites, dating to the late thirteenth century, and now in Moscow (Ševčenko 1993-1994, 158, fig. 3), and the early fourteenth-century icon from the Christ church, Veroia (Papazotos 1995, 47ff., pl. 21). The linking elements are the Virgin's broad figure with its similar proportions; the treatment of her maphorion and the delicate gesture of her hand, pointing out Christ the Word made Flesh to the believers and compassionately passing on their prayers; the facial features, above all those of the Christ-Child with his extraordinarily high forehead, the way Christ holds the scroll, and the archangels' pose with the hands covered by the himation. One difference from the present icon is the way the Child makes the gesture of blessing here, bringing his hand out in front. Christ is shown with his robe leaving both shoulders bare, with a similar countenance, and with the scroll similarly propped on the leg, in the late fourteenth-century icon of the Virgin Demosiana icon in Corfu (Vocotopoulos 1990, no. 2, fig. 4; Babić 1991, 59ff., pls 11, 12a, 14).

The depiction of the Dodekaorton enhances the significance of this icon as a work using an uncommon iconographic ensemble to bring together very interesting details. Here were types of the great painting of the fourteenth

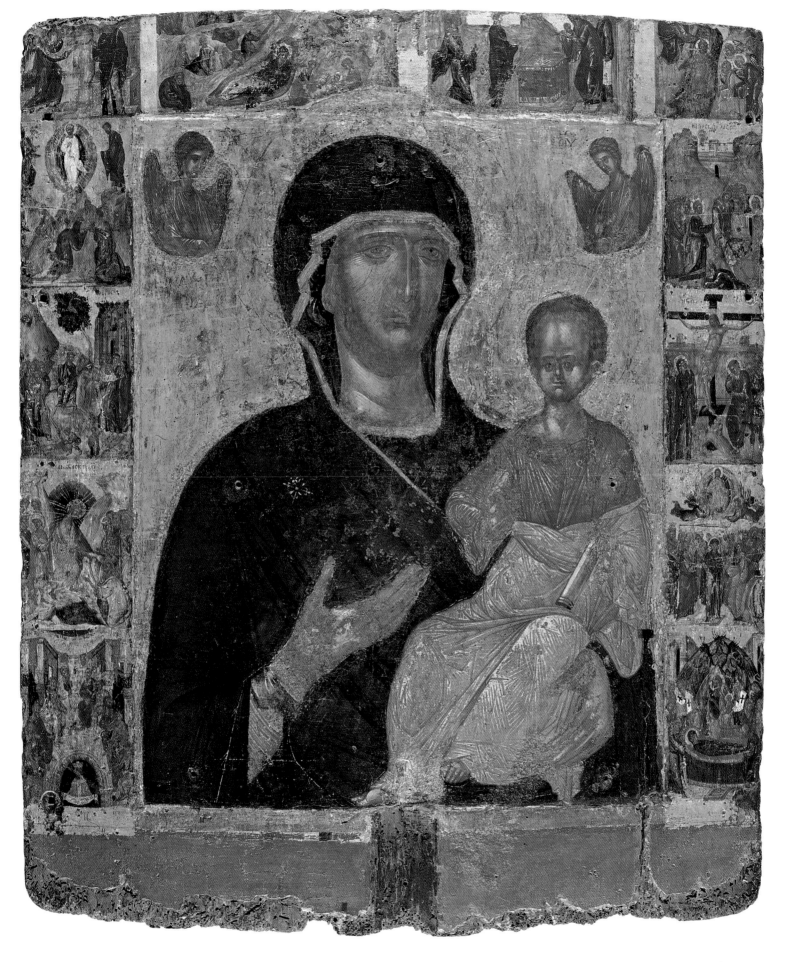

century in the aristocratic tradition of Constantinople. They were types that would also find their way to Crete and provide exemplars for the development of the Cretan School of painting from the fifteenth century onwards. A few specimen representations will suffice to establish the Constantinopolitan iconographic roots of the Dodekaorton: the mosaic decoration in the Pammakaristos monastery at Constantinople itself (N. Chatzidakis 1994, no. 170); the wall-paintings of the Peribleptos church at Mystras (Millet 1910, pl. 121.2); the codex Paris. gr. 1242 with theological works of John VI Kantakouzenos (Galavaris 1995, no. 224). Also important is the icon's typological connection with the late fourteenth-century wall-paintings in the church of the Presentation of the Virgin at Sklaverochori, Crete, the characteristic example being the Baptism (Borboudakis 1991, 387ff., pl. 194). There are many points in these wall-paintings at which we can see the common origin of Post-Byzantine Cretan painting types.

The probable dating of our icon to about 1370 (Acheimastou-Potamianou 1998, 63) is supported by its particular affinities of technique and style with a couple of two-sided icons in the Pantokrator monastery on Mt Athos, which must be contemporary with the founding of the monastery's katholikon in 1363 (Acheimastou-Potamianou 1998-1999, 309ff., figs 1-4; Papamastorakis 1998, 48ff., figs 21-27) and with the wall-paintings of the same date in the Peribleptos at Mystras (Acheimastou-Potamianou 1994, 29ff., nos 151-153). Of their common elements, the modelling, light and use of colour enable us to perceive a transition from the blunt vigour of the art of the first half of the fourteenth century to the evocative, hieratic seemliness of the later figures, combining spirituality and pathos in a quite different quality of expression. Faces are modelled with one orderly brushstroke after another, shadows thicken in their translucence without becoming oppressive, illumined planes shimmer with bold strokes of white. Contours recede, lines taper, chromatic harmonies avoid any strong impact, and expression takes on a deep inwardness. The volumes are pervaded by a discreet plasticity that combines with converging tones of monochromy, often with a movement throbbing with unease, as in the miniature scenes in the icon. The compositional decorum, the nobility of mood and the dignified pathos are all signs that the figures have their spiritual basis in the intellectual world of the time and the theory of Hesychasm.

Myrtali Acheimastou-Potamianou

Conservation:
Byzantine Museum: Tassos Margaritof, 1961; Vassiliki Galakou, 1991.

Exhibitions:
Conversation with God, The Hellenic Centre, London 1998.

Literature:
Sotiriou 1931[2], 79, no. 177, fig. 32; Grabar 1962, 370; Pallas 1965, 102ff., 314; Chrissoulakis and Chatzidakis 1983, 175ff., 181, 183, 193, fig. on 188; Acheimastou-Potamianou 1991, 8, pl. 8; Vocotopoulos 1995, no. 113, fig. 113; *Conversation with God*, no. 14 (with previous bibliography), figs on 98, 99, 102; Acheimastou-Potamianou 1998, no. 15, 60ff., figs on 61-63.

65

Two-sided icon: A and B. *The Virgin Hodegetria*

115 × 85 cm
Egg tempera on wood
A. Early 14th century. B. Second half
of the 16th century
Veroia, Christ church
Veroia Archaeological Museum,
Inv. no. 117

A different variant of the Virgin Hodegetria is shown on each side of the icon; they were painted at different periods.

A. The earlier side depicts the Mother of God to waist length and turning very slightly to her left, in the classic type of the Hodegetria with the Christ-Child in her arms. Her body, broad in volume, ends in a powerful neck and an oval face with noble, finely-drawn features: delicate eyebrows, deeply-shadowed eyes with a sad, unworldly expression, a dainty nose, and a particularly small mouth with pursed lips. She supports Christ's body in her left arm, and lifts her right palm to her breast in a gesture of prayer. Her inner garment is a light-blue chiton, only the right sleeve of which is visible, with a matching wimple (*kekryphalos*). Her brownish purple maphorion, which closes high up on the throat, has an orange hem and a stellar motif in the area of the left shoulder.

Christ, a bulky figure, is rendered almost frontally, with his legs turn slightly towards the axis of the Virgin's body. He has a robust, conical neck and a round, fleshy face with a very broad forehead, deeply-shadowed eyes, a short nose and a small mouth. He stretches out his right hand in blessing in front of the Virgin's breast, and with his left he props a closed scroll with a purple cord on his knee. His chiton and himation are both orange, lightened by dense gold striations, most of which have are effaced.

This icon used to have a silver ground, now almost completely lost, along with the haloes and inscriptions that once framed the figures.

The icon is painted on a single panel with a shallow, integral, raised frame, around which runs a purple and golden-yellow band. The work is in a relatively good state of preservation, damage being limited essentially to the loss of the silver ground, the flaking of the colours on Christ's garments and some paint loss to the faces.

With its hieratic poses for the Virgin and Christ, the Veroia icon belongs to the 'austere' iconographic type of the Hodegetria that was particularly widespread in Byzantine and Post-Byzantine art. Its archetype derives from the *acheiropoietos* icon venerated, in the Hodegon monastery at Constantinople, and traditionally regarded as having been painted by St Luke the Evangelist.

The high forehead of Christ led Xyngopoulos to date the icon to the thirteenth century (Xyngopoulos 1967, 77, fig. 3). Papazotos attributed it to a famous painter from Thessaloniki, Kalliergis, who also executed the wall-paintings in the Veroia church, dating to 1315 (Papazotos 1980, 167-174; Papazotos 1994, 47-48, pl. 21).

However, loss of colours and highlights from the Veroia icon and comparison of it with the wall-painting of the Brephokratousa in the sanctuary apse of the Veroia church (Pelekanidis 1973, pl. 12), makes it unsafe to ascribe the icon to Kalliergis. In particular, there are important discrepancies between the type of Christ's physiognomy in the icon and in the wall-painting; and these amount to a difference of style.

Be this as it may, the type of physiognomy – the Virgin's fine noble features and the features of Christ – recurs in wall-paintings and portable icons of the late thirteenth century and the first two decades of the fourteenth. Typical examples are a Vatopedi icon of the Hodegetria (Tsigaridas 1996, fig. 317), the Brephokratousa wall-painting at Studenica in Medieval Serbia and in St Nicholas Orphanos at Thessaloniki (Babić 1987, pl. XXXII; Xyngopoulos 1964, fig. 144), and a Chilandari icon of the Hodegetria (Vocotopoulos 1995, fig. 99; *Treasures of Mount Athos*, no. 2.16).

On this basis, the Veroia icon is consistent with the artistic tradition of Thessalonikan workshops in the first twenty years of the fourteenth century. In my view, since the church of Christ is older than its mural decoration (Papazotos 1994, 101-102 and 172), it is highly probable that its Hodegetria icon was specially made for its iconostasis in the early fourteenth century, thus predating Kalliergis's wall-paintings of 1315.

B. The more recent side of the icon shows the Virgin, again to waist length, half turning to her left, in a variant of the type of the Hodegetria with the Christ-Child in her arms to her left. She inclines her head slightly towards the Child, but her penetrating sideways gaze is fixed on the beholder. Her body, with its slender torso and flat base, ends in narrow shoulders, a cylindrical neck, and an oval face with robust features. She holds Christ in her embrace with her left hand, and lifts her right in front of her breast, in a gesture of prayer. Her chiton and headband are both dark blue; her maphorion is reddish brown, with a border simulating gold embroidery, and is decorated with the standard stellar motifs and dense gold fringes from about the mid-height of the right arm.

Christ, who is slim, with a long, narrow torso, turns towards his mother. He too lifts his right hand in a gesture of prayer, while with the left he holds a closed red scroll. His chiton is a verdant green variegated with heart-shaped motifs and bound close to his chest by a broad purple band. His orange himation, which covers only his legs is enlivened by a streak or two of colour, imitating gold stiations.

The figures' haloes, marked off from the ground by an incised double line, are stippled and bear a continuous undulating tendril motif. On the gold ground there are nominative inscriptions in red letters: ΜΗΡ ΘΥ Η ΠΑΜΜΑΚΑΡΙΣΤΟΣ (Mother of God Pammakaristos) and IC XC (Jesus Christ).

This side of the icon has no integral raised frame. It is in excellent condition with only minimal flaking of paint, limited to its borders.

The 'tender' Virgin and Child, as a specific iconographic type, is radically different from the 'austere' Hodegetria type seen on the icon's principal face. The 'tender' type comes from the Middle Byzantine period and is indicative of the Passion yet to come. It links the Veroia icon with some outstanding later fifteenth-century icons of the Cretan School associated with the name of Andreas Ritzos and his workshop. They include a Hodegetria now in the City Museum at Trieste (Bianco Fiorin 1975, no. 10; Czerwenka-Papadopoulos 1984, pl. 3), the Campo Santo Teutonico icon in the Vatican (Cattapan 1973, pl. Z'2; Czerwenka-Papadopoulos 1984, pl. 1), the Hodegetria in the Greek church of the Holy Trinity in Vienna (Kreidel-Papadopoulos 1981, fig. 18; Czerwenka-Papadopoulos 1984, 203-212), an Eleousa in Corfu (Vocotopoulos 1990, no. 6, fig. 6); a Hodegetria icon in the Byzantine Museum, Athens (Baltoyanni 1994, no. 64, pls 122-123); and an Eleousa in the Gonia monastery at Kissamos, Crete (*Εικόνες Κρητικής Τέχνης*, no. 163). For comparable icons of the sixteenth century, we cite a Hodegetria by Theo-

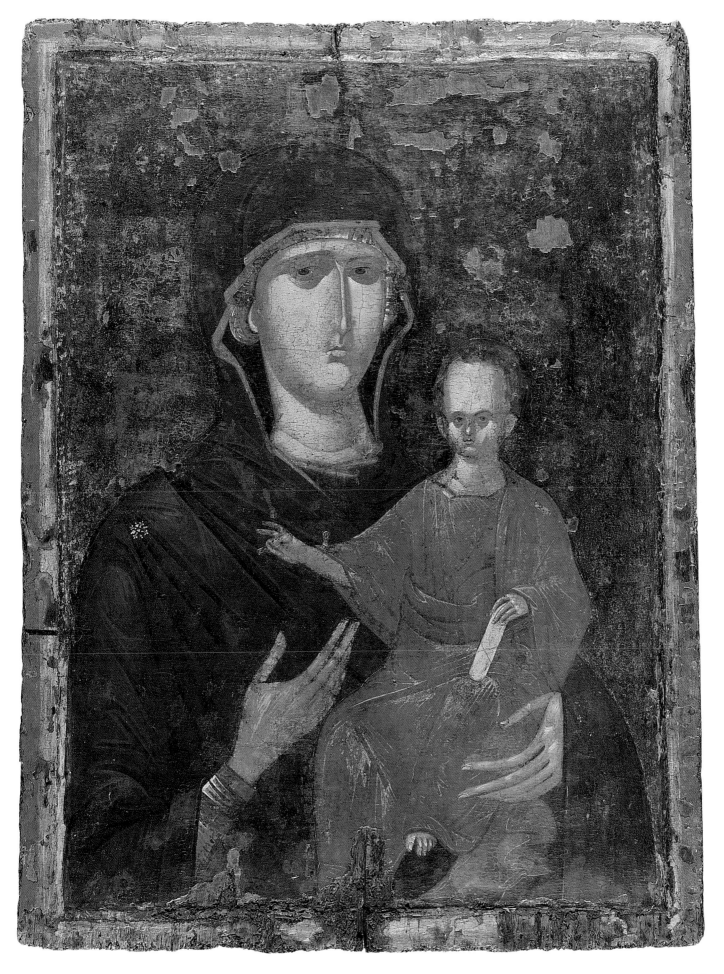

415

phanis the Cretan, in the Stavronikita monastery (Chatzidakis 1969-1970, fig. 83), the Virign Pammakaristos in the Byzantine Museum at Athens (Acheimastou-Potamianou 1998, no. 1b; Baltoyanni 1998, no. 1), and the Eleousa in the church of St Jason and St Sosipater in Corfu (Vocotopoulos 1990, no. 66).

The present icon has been linked (by Papazotos 1994, 75-76, pl. 133) with the work of an anonymous painter active in Veroia and credited with not only wall-paintings but also portable icons. The same artist is credited with an icon of Christ, also in the church of Christ at Veroia, which was placed together with the present Hodegetria on the sixteenth-century iconostasis as the joint despotic icon (Papazotos 1994, 75, pls 130-131). In iconography and — to some extent — style, this artist, active in Veroia between 1565 and 1570, followed the fifteenth- and sixteenth-century Cretan School in his Hodegetria. Where he differed was in painting the Virgin with a markedly flat body culminating in narrow shoulders, and with a facial expression that, so far from exhibiting a gentle melancholy, is a shade disdainful. A similar difference is observable in the treatment of Christ, where the slim proportions of the body are over-emphasized and the long narrow head has an exaggeratedly high forehead.

In his rendering of the face and garments of Christ and the Virgin, this anonymous artist followed mannerisms of the Cretan School that can be seen in icons of the second quarter of the sixteenth century (*Treasures of Mount Athos*, nos 2.45 and 2.47). But he diverged from them in the relationship and relative intensity of light and shade, as well as in the mood expressed. This element and the attenuated corporeal proportions distance the icon from the works of the Cretan School, and place it within the context of painting from Northern Greece in the third quarter of the sixteenth century, influenced by sixteenth-century Cretan painters on Mt Athos.

The Veroia icon can be linked to works from Northern Greece such as the Pammakaristos icon mentioned earlier, via the halo with its vegetal decoration unfolding against a stippled ground (Vocotopoulos 1990, 103) and via the appellation Pammakaristos for the Virgin, which recalls the mosaic icon from the Pammakaristos monastery, now in the Patriarchate at Constantinople (Gioles 1993-1994, 249ff. and fig. 1, with previous bibliography).

Euthymios Tsigaridas

Exhibitions:
Byzantine Art, an European Art, Zappeion, Athens 1964; *Byzantine Murals and Icons*, National Gallery, Athens 1976; *Byzantine and Post-Byzantine Art*, Old University, Athens 1986; *Affreschi e icone*, Palazzo Strozzi, Florence 1986; *From Byzantium to El Greco*, Royal Academy of Arts, London 1987; *Holy Image - Holy Space*, The Walters Art Gallery, Baltimore 1988.

Literature:
Xyngopoulos 1963, 77, fig. 3; *Byzantine Art, an European Art*, no. 221; Chatzidakis 1965, 13, pl. 11a-b; Talbot-Rice 1968, 115, pl. 101; *Byzantine Murals and Icons*, no. 102; Papazotos 1980, 167-174, pls 1-4; *Byzantine and Post-Byzantine Art*, no 79; *Affreschi e icone*, no. 32; *From Byzantium to El Greco*, no. 15; *Holy Image - Holy Space*, no. 16; Papazotos 1994, 47-48, pl. 21 and 75, pls 130, 131, 133.

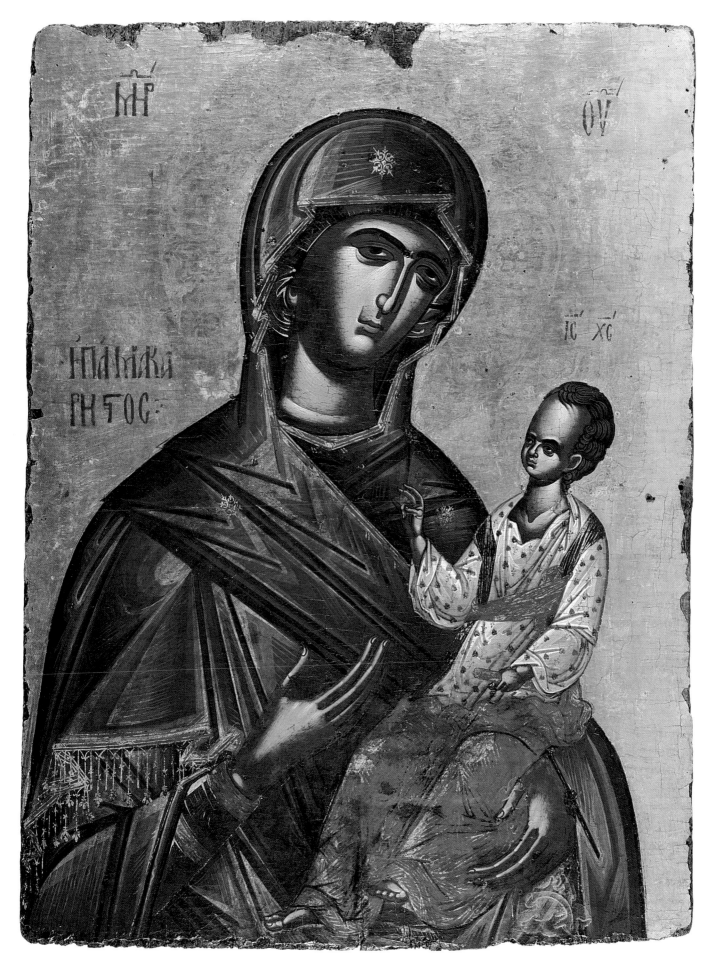

ΜΡ ΘΥ

ΙΣ ΧΣ

Η ΠΑΝΜΑ
ΓΗΤΟΣ

417

66

Two-sided icon: A. *The Virgin Hodegetria*
B. *St Nicholas*

115 × 69 cm
Egg tempera on wood
Third quarter of the 14th century
Constantinople (?)
Rhodes, Niochori, church of the Presentation
of the Virgin
Rhodes, Castello

Though much of this icon is badly damaged, the faces of the figures are nearly intact.

A. The Virgin is shown in the Hodegetria type: its prototype was probably the *acheiropoietos* icon at Constantinople – the capital city's palladium – in the Hodegon monastery. She makes a gesture of prayer with her right hand, turning slightly towards Christ, who makes a gesture of blessing with his right hand and holds a closed scroll in his left. Holes in the gold haloes and the garments were for affixing later metal revetments. One or two letters of the inscription [H O]ΔH[ΓHTPIA] are preserved to the right, as is the abbreviation IC XC (Jesus Christ). In the top corners there are two fragmentary half-length miniature angels, one on each side of the Virgin. The flesh is modelled in yellow-brown, with broad highlight planes radiating towards the cheeks, tinged in pale red. The Virgin's violet maphorion is rendered in flat folds, whereas Christ's himation is in tones of warm ochre with streaks of gold.

B. St Nicholas is shown to waist length, blessing with his right hand and holding a closed closed book in his left. At the top, in miniature, are the Virgin and Christ (preserved only fragmentarily), who offers the saint the gospel and omophorion that are the symbols of priesthood. This is the iconography of a miracle that happened during the First Ecumenical Council at Nicaea, in 325. The dominant colour on the saint's face, over the flesh underpaint, is reddish brown.

Traits in the painting of this icon point in the direction of works from the third quarter of the fourteenth century. The style of both front and back strongly suggests the Chora monastery (1321), while the Hodegetria is stylistically consistent with two double-sided Pantokrator icons, one in the Metropolis Museum at Mytilene (*Byzantine Art, an European Art*, no. 200) and the other in the Pantokrator monastery on Mt Athos (Papamastorakis 1998, fig. 21), both dating to the third quarter of the fourteenth century. The

icon of Archangel Michael in the Byzantine Museum, Athens (Vocotopoulos 1995, fig. 95), which is of about the same date, uses related concepts: a mesh of highlights, monumental posture, and soft modelling for the face.

The side with St Nicholas is dominated by developments in technique: that is to say, innovations in the use of highlights and colour. The saint has individualized features, a physiognomy which is almost earthly, and a palette that sets him well apart from most representations with this type of subject at any time in the fourteenth century. The painter reveals an eclectic tendency, and a certain familiarity with Western tradition, though the latter is absorbed into the superbly balanced and homogeneous whole. All this implies a deeper engagement with Western art as expressed, until the mid-fourteenth century, in the work of Pietro Cavallini and Paolo Veneziano. The representation of St Nicholas is predicated on artistic processes in some great centre of icon production, which existed in embryo in the second quarter of the fourteenth century and were fully elaborated from 1340-1350 onwards. The Rhodes icon should therefore be dated after the mid-fourteenth century, most probably to the third quarter of the century, and in any case before the last decade. Both sides are from the same period, but it is unclear if they are by the same painter. We cannot exclude the possibility that this was a gifted artist familiar with Byzantine tradition, at least as regards depicting the Hodegetria, and in a position to satisfy his client's taste by producing a St Nicholas that was largely individualized and well attuned to Frankish preferences.

The Rhodes icon is one of the earliest of a series of ten two-sided icons in the Dodecanese. (There are two earlier icons in this series: one of the Chrysopolitissa Virgin/St Symeon Stylites, now in the Castello, and one of the Hodegetria/St John the Theologian and St Christodoulos, now in Lipsoi). Three of the series in the Castello – the present icon, an icon of the Pantokrator/the Crucifixion, and an icon of the Hodegetria/St Luke – are works of the highest quality and virtually contemporary. The hypothesis has been advanced that they are of Constantinopolitan origin (Acheimastou 1966, 77; Acheimastou-Potamianou 1986, 88), and there seems no good reason to doubt this.

That an icon such as the present one should be in Rhodes is intriguing. The subject and the iconographic type were repeated in a two-

sided icon on the iconostasis of the Virgin Spiliani in Nisyros. This is a superb work but displays incipient stylization, a hallmark of late fourteenth-century art. Another icon of St Nicholas, now on Patmos, and of the same period, has recognizable affinities, *mutatis mutandis*, with the two-sided icon from Rhodes (Chatzidakis 1977, pl. 11, fig. 56-57). It is probable, in my view, that these were products of a workshop active in the Dodecanese. Furthermore, the St Nicholas of the final phase of the second layer of wall-paintings in the church of the Taxiarch at Ebola Vathy on Kalymnos is linked with our two-sided icon as regards the type of the saint's physiognomy, the detailed modelling, and the earthly features that make him look like a portrait study (Katsioti 1994, 250-51). The two works do however differ in coloration and volume, and in the Kalymnos wall-painting the free brushstrokes that enliven the face go to the very limits of fourteenth-century art.

Who might have commissioned this superb icon? The side with the representation of St Nicholas is the one that has suffered the greater damage, necessitating its overpainting in about 1500 (Acheimastou 1966, 80-83). From this we can infer that the icon was intended for the iconostasis of some church dedicated to St Nicholas. This cannot have been the church where the icon was found, with its sides truncated – the church of the Presentation of the Virgin, at Niochori, Rhodes, for, like the original icon, it is the wrong width for the iconostasis (Acheimastou 1966, 64). If we take into consideration the fact that most of the churches in the purlieus of the Medieval town of Rhodes are fairly recent, and are in settlements that developed only under Ottoman rule, from 1522 onwards, it seems to us logical that the icon must originally have been in a church in the Medieval town. But there is no surviving church dedicated to St Nicholas *intra muros*, nor is any mentioned in the records, apart from the one instance that we shall now proceed to examine.

A leading figure in Rhodes at this time, until his death in 1415, was the Rhodian *grand bourgeois* Dragonetos (or Dragoninos) Klavelles. A notarial document of the year 1428 informs us that Klavelles built and 'dowered' a chapel dedicated to St Nicholas, where he was ultimately buried, as was his wife Agni Krispa (Tsirpanlis 1995, 248-249). It is not clear when he built this chapel. Our information about Klavelles from published records starts in 1382, at which time he belonged to

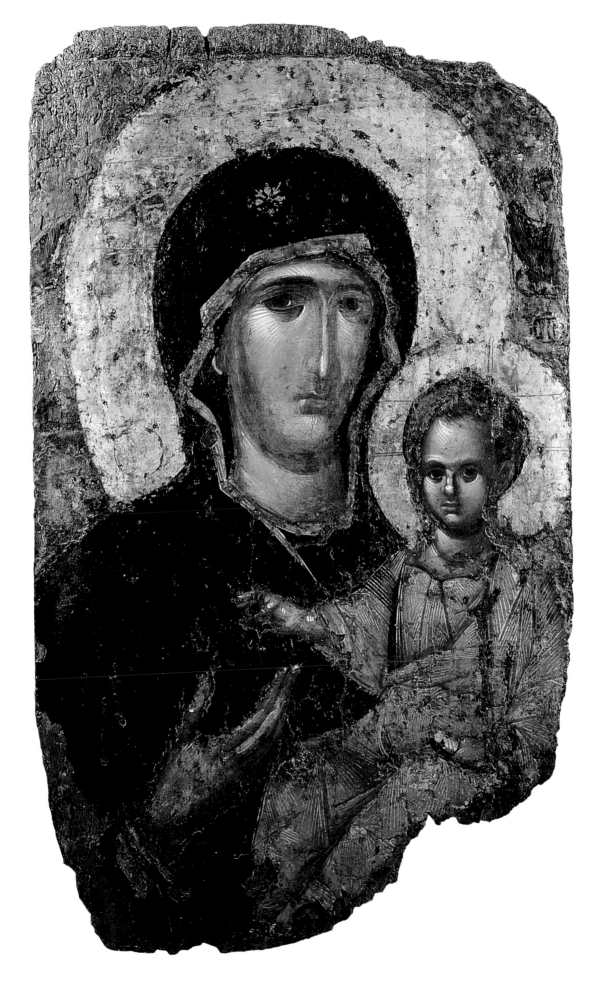

419

the close circle of the great humanist Heredia, Grand Master of the Order of the Knights of St John of Jerusalem, and so was clearly a grown man. It has been suggested that the chapel of St Nicholas mentioned in the deed is the church of St Nicholas at the junction of Andronikou and Omirou streets in the Medieval town (Dellas 1996, 58-59). Until recently, accepting the conjecture of the scholar Gabriel, this church was known as St Bernardin. Only when wall-paintings from the last quarter of the fifteenth century, with scenes from the life of St Nicholas, were discovered, was the correct dedication restored. The building of the chapel can be dated to the second half of the fourteenth century, a period dominated by the presence and activity of Klavelles.

This burgher of Rhodes – an Orthodox or a Roman Catholic we do not know – had his family crest stamped on a silver processional cross in the cathedral church at Mdina in Malta, whither it was brought in 1522, and also, according to the records, on a gilded silver cross that in 1475 was in the church of the monastic community of St John of the Collachium. From the quality of the Malta cross, it is clear that commissions from a personage such as Klavelles would have been of high artistic merit, especially where his private chapel was concerned. The Rhodes two-sided icon truly measures up to these standards. The Constantinopolitan workshops were then the best in the world. Moreover, the portrayal of St Nicholas – those individualized, worldly features of his visage – would doubtless suit a more personal commission with specific requirements from a man who lived and moved in an ecletic milieu such as Rhodes. Taking into account Klavelles' economic standing, his fine taste in art, and the private chapel that he built and endowed in honour of St Nicholas, he may well have been the person who commissioned the icon. When the records relating to the life and work of this illustrious Rhodian are published, they will perhaps shed more light, indirectly at least, on this question.

Whether or not this particular church of St Nicholas in the Medieval town was Klavelles' chapel, the information contained in the notarial deed of 1428 is perhaps an indication of the icon's later fortunes. Why did it not take the path of escape to Malta (as did other private icons, for instance the Eleemonetra and the Damascene)? When the couple Klavelles and Krispa died without issue, Krispa's heir, Safredo Calvo, inherited one half of the chapel as his *jus patronatus.* The other half went to the Order of St John of Jerusalem, which acquired the right to manage the chapel and if need be to dispose of it. The icon's adventures can thus be briefly summed up as follows. In about 1500 the damage to the face with St Nicholas necessitated overpainting. In 1522, when the Knights of St John and many citizens of Rhodes made their escape, the icon was not the personal property of any one private citizen, and hence it remained in the church. When, in about 1530, the church that housed it was turned into a mosque (St Nicholas in Andronikou Street becoming the Abdul Çelil mosque), the icon found its way to one of the purlieu churches, where it was trimmed down to fit into an intercolumnar space on the iconostasis.

Angeliki Katsioti

Conservation:
Tassos Margaritof, F. Kalamara, S. Papageorgiou, P. Asimakou, 1964.

Exhibitions:
Byzantine Art, an European Art, Zappeion, Athens 1964; *Byzantine and Post-Byzantine Art,* Old University, Athens 1986; *Affreschi e Icone,* Palazzo Strozzi, Florence 1986; *From Byzantium to El Greco,* Royal Academy of Arts, London, 1987; *Holy Image - Holy Space,* The Walters Art Gallery, Baltimore 1988.

Literature:
Byzantine Art, an European Art, no. 216; Acheimastou 1966, 62-83; *Byzantine and Post-Byzantine Art,* no. 80; *Affreschi e Icone,* no. 33; *From Byzantium to El Greco,* no. 18; *Holy Image - Holy Space,* no. 18.

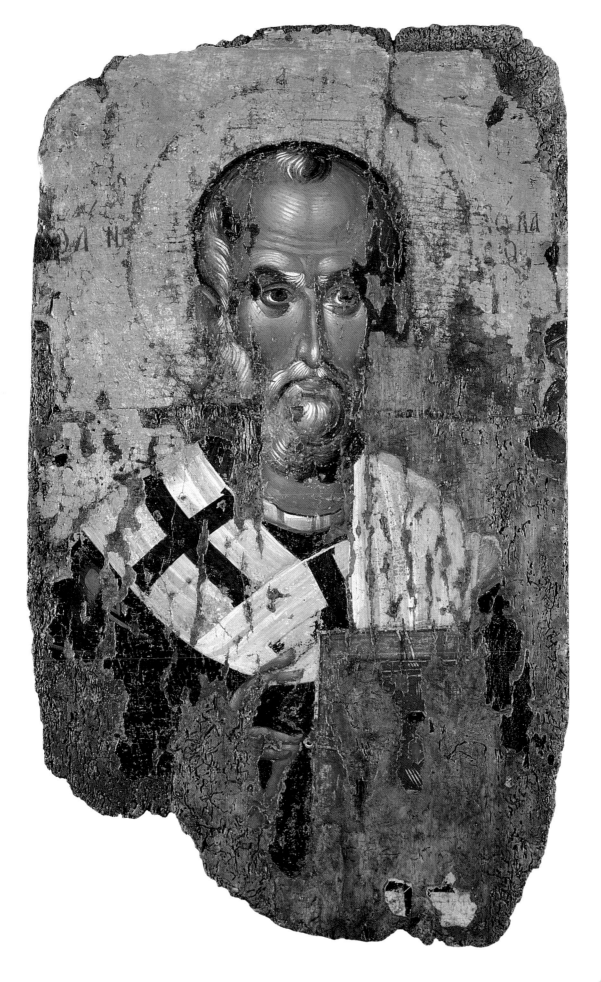

Section Five

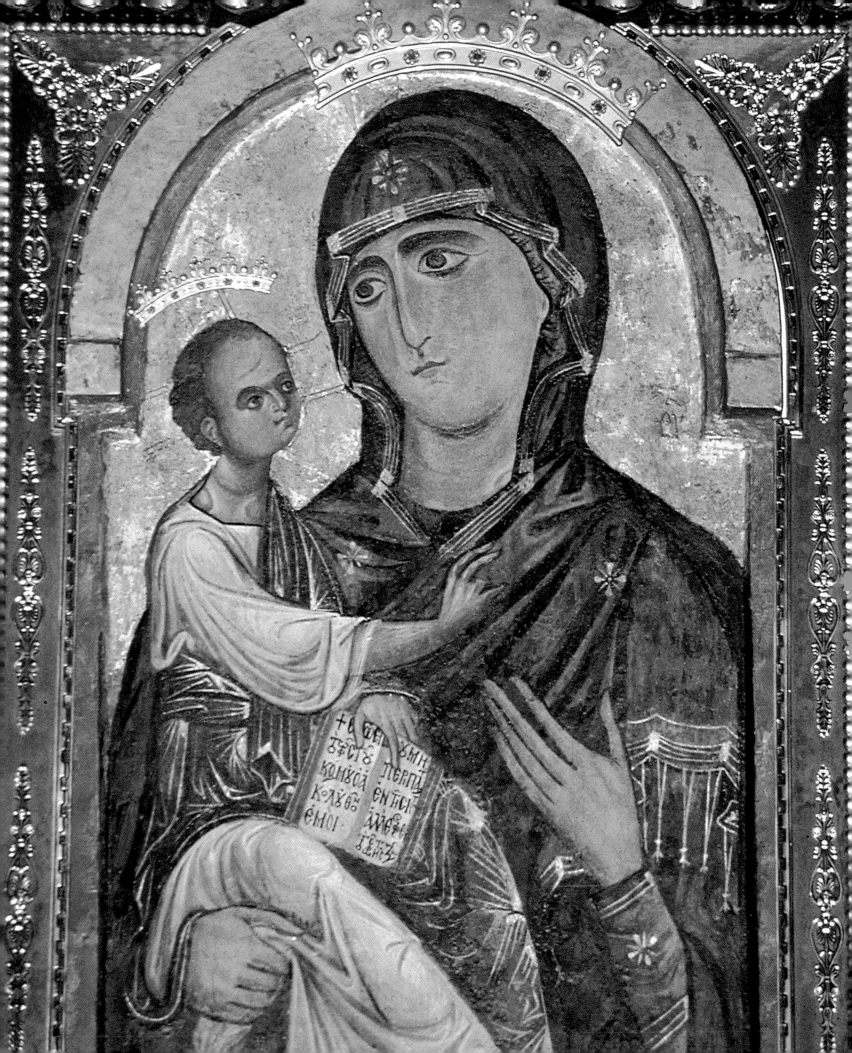

Valentino Pace

Between East and West

In Italy Marian devotion took substance very early, with the dedication of churches to the Virgin Mary—edifices that subsequently housed prestigious iconographic models. Santa Maria Maggiore constitutes an exemplary point of reference, but other ecclesiastical institutions are no less significant: Santa Maria Antiqua, Santa Maria ad Martyres and Santa Maria in Trastevere, three of the most important in Rome, were all endowed with 'ancient' icons.[1] (Pls 199-201). These images were executed according to visual formulas often shared with their counterparts in the Greek church, and inasmuch as they diverge from that repertoire (on a par with similar divergences in other centres of Christianity), they show the specificity of 'local' devotion. This is true of the *Madonna della Clemenza* of Santa Maria in Trastevere (Pl. 201), which, for the first time as far as we know, presents a cult image specific to a single city—or, more precisely, to its Church—with no comparisons in the whole ambit of the Christian commonwealth of Greece and the East.[2] Made at the request of Pope John VII (705-707), this image established and popularized the 'type' of the *Maria Regina* (queen), a variety of image already present on the apsidal arch of Santa Maria Maggiore and on the wall of the pre-existing space of Santa Maria Antiqua, where it presented itself to the devotion of the faithful with unprecedented majesty.[3]

In the territories of the Orthodox Church, this message of royalty was never accepted.[4] It was taken up almost immediately, however, in southern Italy: in the monastery of San Vincenzo al Volturno, as attested by the celebrated crypt of 'Abbot Epiphanios (824-842), and in the much less widely known *Cripta del Peccato Originale*' in the Materan countryside (Longobard Apulia).[5] If in the first case the image's connotation is powerfully symbolic and lends itself to the equation Mary = Church, in the second the devotional charge prevails through an image showing Mother and Son flanked by two female saints. The Virgin's lavishly displayed royal headdress has an odd expressive force and participates in declaring what must be an explicit obedience to Rome, a fealty reinforced by the centrality of St Peter, who is depicted on the nearby apsidal niche.

There is another witness to the phenomenon, however, that not only indicates the propagation in southern Italy of iconographies connected with Rome but also bears witness to our dramatic dearth of information about the network of iconographic and cultural communication. The image in question is the *Acheropita* located in Rossano Calabro and therefore in a centre of great prestige in the Greek world of southern Italy.[6] Painted in fresco on a pilaster of the cathedral, it shows the Madonna and Child in a pose that is precisely that of the celebrated *Salus populi romani* of Santa Maria Maggiore, the latter connected, as is well known, with an image in Santa Maria Antiqua and therefore with one of the most important seats of the Greek clergy in Early Medieval Rome. So very likely at a tenth-century date, the Calabrian cathedral offers us a cult image whose iconography might have been derived from Rome (though at a time when the church in the Forum had already been abandoned) or that might be retraced to an ancestry in the Greek lands across the sea via independent, if not parallel, pathways.

Also maintaining a presence in Campania and later in Abruzzo, and attested by a fair num-

214. *La Madonna di Sotto gli Organi.* Detail of Pl. 216.

ber of examples surviving from about 1100, was a type that in Byzantium had been established as the Hodegetria, a variety of devotional image that enjoyed the broadest possible diffusion in southern Italy—and indeed in Italy at large—up to the early fourteenth century.[7] Even if the South-Italian Hodegetria is seldom expressly designated as such by inscriptions, its formulation as an image, including the *dexiokratousa* variant, must have prevailed there due both to the prestige of its imported models and to its expressiveness, which accorded with the requirements of devotion.

Unfortunately, we do not know which models first popularized the widespread Hodegetria type in Italy, and of the two works that we can point to as examples, certainly at least one did not perform this role, for lack of the necessary prestige. Here I am referring to the icons of Andria (Pl. 215), in Apulia, and of Pisa (Pl. 216), in Tuscany, the latter known as the *Madonna di sotto degli organi*.[8] The hypothesis that the latter, more famous image is not Tuscan but rather 'Byzantine' (from Greece?) seems to me to be demonstrated by a gamut of possible comparisons that range from the generic type of the Virgin in the celebrated mosaic icon from Sinai to the icon in the Byzantine Museum, Athens (Cat. no. 63)—comparisons made possible by the Child, who is always shown seated, with an unnaturally elongated body and a very small head.[9] If this is the case, as I believe, then a curious phenomenon must be pointed out: namely, the 'dismissal', on the part of local devotion and historiography of a rare Byzantine presence (notwith-

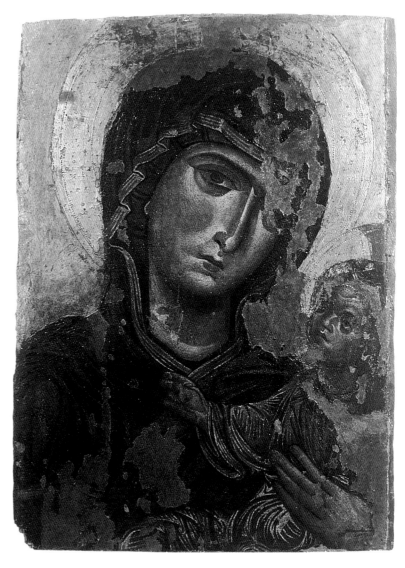

215. *Panel of the Virgin and Child*.
Palazzo vescovile, Andria (Bari).

standing the inescapable evidence of the Greek text on the book) in favour of a presumed provenance from a Tuscan locale. This behaviour is contrary to that frequently taken up in Apulia, where the prestige of sacred images is if anything increased when an 'overseas' provenance can be traced or imagined. We can observe this, for example, in the *Madonna della Madia* of Monopoli (Pl. 217), a Cypriot icon, which tradition holds to have arrived in the Apulian port on a raft (*madia*), or kneading trough; and in the *Madonna della fonte*, an Apulian work, of which it was written '*nell'anno 1234 è venuta in Trani una Madonna dentro una fonte di pietra portata da un grosso pesce di Sabbato Santo*' (in the year 1234, there came to Trani a Madonna within a stone fountain, borne by a large fish on Holy Saturday).[10] Another imported Hodegetria, again a Cypriot image, is that still on the altar of the monastery church of San Nilo at Grottaferrata, where it arrived perhaps in the fifteenth century.[11]

Varying from the canonical iconography of the Hodegetria, although closely related to it in composition, is the image of the Palermitan Madonna of *Santa Maria de Latinis* (Pl. 218), which was defined in the nineteenth century, meaningfully, as an '*Imago gloriosae Virginis Mariae Christum in ulnis tenens*' (Image of the glorious Virgin Mary holding Christ on her forearms).[12] This definition fully embraces the image's symbolic force, which alludes to the Passion and to liturgical celebration, and finds its most complete exposition in the famed Virgin Arakiotissa of 1192 at Lagoudera—which suggests the possibility of a triangulation whose prototype image has been lost.[13] Here in Palermo it is furthermore significant that the image is imbued with royal allusions, clearly implied by the small *tunica clavata* and the imperious expressiveness of the gesture of blessing.

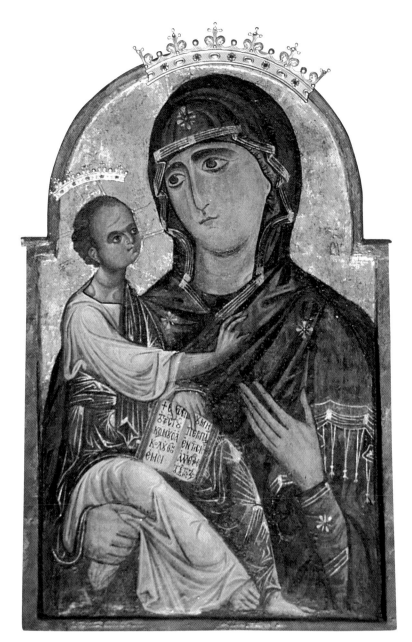

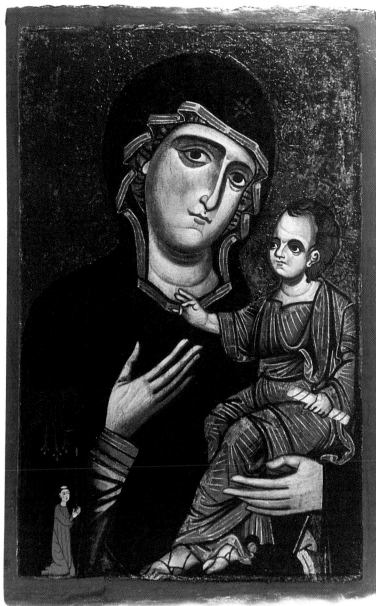

216. *La Madonna di Sotto gli Organi.* Duomo, Pisa.

217. *Madonna della Madia.* Cathedral, Monopoli (Bari).

No traces of an inscription on the ground of the Palermitan Madonna remain. Indeed the images in question seldom adopt the Greek term Hodegetria, bearing instead the appellation Mother of God, written in Greek or in Latin, or no appellation at all. Cases exist in which the devotional image is accompanied by invocations directed to the Virgin by the donor, or on the donor's behalf, using other titles. This is the case with the lunette on the interior wall of the façade of Monreale cathedral (Pl. 219), where the '*Sponsa tue prolis / Stella puerpera solis*' (Betrothed of your progeny / Child-bearing star of the sun) is asked to strive for the salvation of the faithful and, above all, of the king: '*Pro cunctis ora, sed plus pro rege labora*'.[14] The action of models from the Greek Church, an obvious element of the great enterprise decreed by William II, can be observed particularly in the close similarity of the composition to those of works such as the Hodegetria (explicitly designated as such) in the Cypriot church of St Nicholas of the Roof. With the Virgin of Monreale, that Hodegetria shares, for example, the direction of the Mother's gaze toward the believer and the distinctive detail of the 'braces' worn by the Child, an element that in the Greek Church sometimes alluded to the Lord's priestly role, as in St Sophia at Ochrid, but which here appears in an exclusively votive context.

The Mother of God becomes a queen (*regina*) again in a series of images that, as already men-

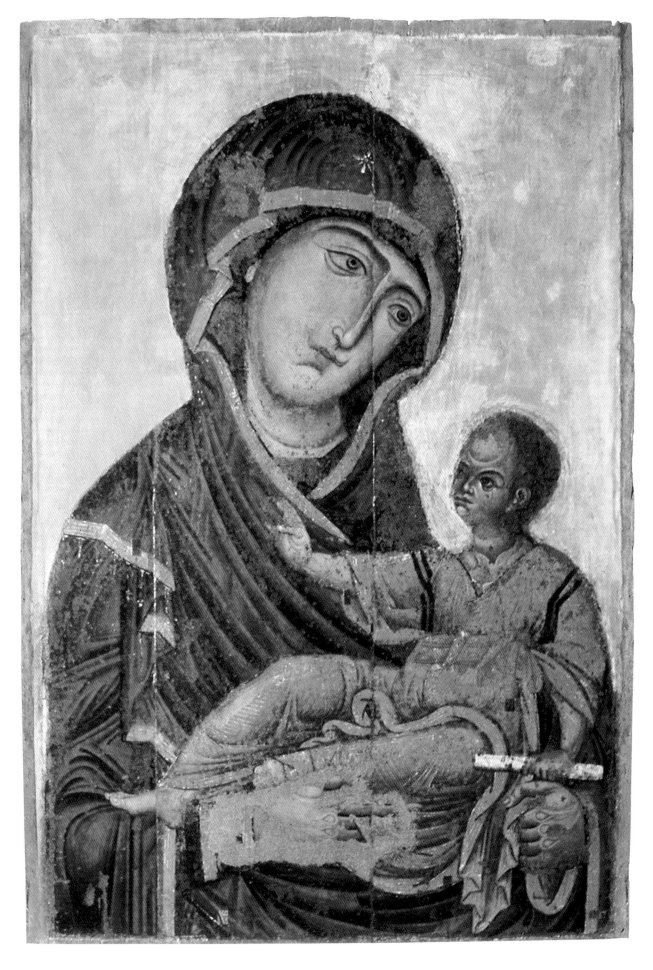

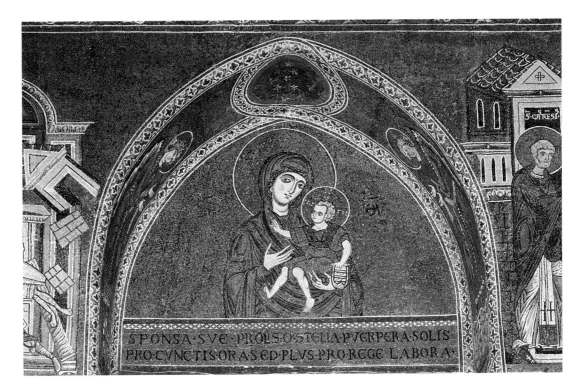

219. *Mosaic of the Virgin and Child.*
Duomo, Monreale.

SPONSA·SVE·PROLS·O·STELLA·PVERPERA·SOLIS·
PRO·CVNCTIS·ORA·SED·PLVS·PRO·REGE·LABORA·

tioned, are located mainly in Campania and Abruzzo. In Campania, the Roman iconographic option must have been operative — an iconography that bore substantial weight above all during and immediately after the Desiderian (and therefore the Gregorian) era. Cases in point include the lost apsidal mosaic of Capua, and the Madonnas of Santa Maria delle Fratte at Ausonia, Sant'Angelo in Formis, Santa Maria di Foro Claudio, and others.[15]

The wall-painting of Sant'Angelo in Formis (Pl. 220) is justly famous and especially important. Invoked in the inscription as *Despoina Theotoke*, the Mother of God is represented in a posture of prayer and rises above the underlying lunette of the archangel-patron, occupying a clipeus supported by angels.[16] Her regality is brought explicitly to our attention by the gem-encrusted crown, matched by aristocratic apparel. The image's deviation from Orthodoxy is nevertheless evident, for in the Greek world the Virgin would never have been portrayed with her hair in sight, even if it were gathered, as here, in two elegant skeins at the sides of the face. This divergence might surprise us in an image marked by an invocation in Greek letters, but it also profitably cautions us about the image's rootedness in the context of a Latin Benedictine community and the consequent necessity of viewing it against its historical background within that context. In this way, the form of the royal crown itself can be understood as a loose translation of models that are remote or, at any rate, simplified.

Sant'Angelo in Formis is not the only such case, however. Indeed, at a later date the Madonna continues to present traits of Heterodox elegance with the display of her hair, which is sometimes finely intertwined with delicate beaded ribbons. This is the most striking (and least noted) item of evidence in a lovely panel-painting from Abruzzo, the *Madonna de Ambro*, worthy of special mention here because of its impressively high quality, as well as the presence in it of other distinguishing features.[17] Once again we encounter a *Madonna Regina*, but in this case the Madonna is also nursing, presenting us with an image that recalls models from the Byzantine world only in the facial features of the Child, attired as he is in a cape and with a disc-shaped fibula displayed showily at the neck. The theme of the *Virgo lactans* who is also 'Queen' was widely diffused in the duecento and not only in Italy.[18] Nevertheless, in Abruzzo and Campania, the force of regional tradition provides the icon with its own persistent line of continuity. This is true of the Madonna of Monreale and especially, because of its high quality, of the *Madonna di San Guglielmo* in the abbey of Montevergine (Pl. 221).[19] Together with the extraordinary *Santa Maria de Flumine* from

429

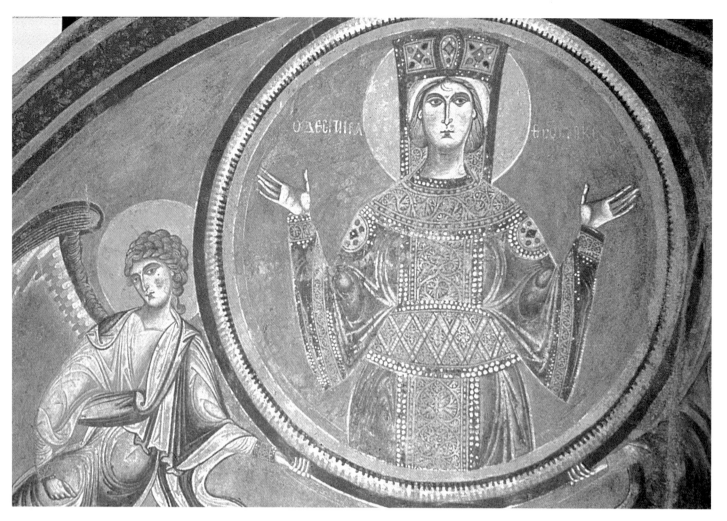

220. *Wall-painting of the Mother of God.* Sant'Angelo in Formis.

Amalfi, the image from Montevergine marks one of the high points of southern Italian panel-painting in the thirteenth century. Compared with the former work, in all of its magnificence, the latter image is more delicately impressed with humanity, in concord with the 'humanization' of the theme just described. A date at mid-century would appear to be appropriate to the 'Byzantine' characteristics of its composition, which are especially discernible in the treatment of the Child's face and in the Mother's hands.

Another Madonna and Child on panel, a work of very high quality though not adequately known (perhaps because, after later repaintings, it was restored only a few years ago to the legibility that it deserves), is an image from the church of Santa Maria a Piazza in Aversa, Campania[20] (Pls 214 and 222). Among the most intense of its iconographic type, which in the Orthodox world would have qualified it as an Eleousa, this painting reaches that rare expressive balance that is the unquestionable mark of masterpieces: it was certainly modelled on an imported *exemplum*, if indeed it does not succeed in making us believe that it comes from overseas. That models, now lost, once circulated is not only obvious but also demonstrable in the case of the Mother of God (as reported in the Greek inscription) painted in Cod. 52 of the Biblioteca Nacional in Madrid (Pl. 223), a work datable to the early thirteenth century and therefore painted somewhat earlier than the Madonna of Aversa.[21]

In Sicily, and within the category of devotional images common to both the Latin and the Greek Church, it is useful to recall another icon: the *Madonna della Vittoria* or *del Vessillo* (of the Standard) from the cathedral of Piazza Armerina. This Madonna shares with only a few other images in Apulia and in Latium an iconography that would have been much more familiar to a believer from Cyprus, corresponding as it does to the celebrated Virgin Kykkotissa, so called because it was typical of the island monastery of Kykkos.[22] We do not know the principal reason for the success of

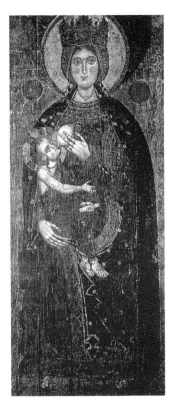 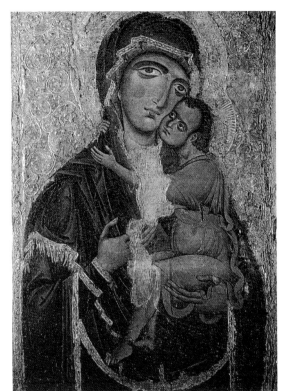 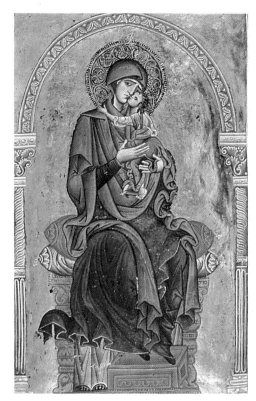

221. *Madonna di San Guglielmo.* Museo del Santuario, Montevergine.

222. *Panel of the Virgin and Child.* Santa Maria a Piazza, Aversa.

223. *Miniature of the Enthroned Virgin and Child* Biblioteca Nacional, cod. 52, fol. 80, Madrid.

this 'new' iconographic option, although we can speculate that it was perhaps due to the strong impact of Cypriot models on southern Italian painting, a phenomenon observable throughout the duecento.[23] Making a name for itself on the basis of its imported status, this iconography in any case provided the cue for assorted variants. Examples include the Madonna of the Virgins, from Bitonto, which offers a reversed version, with some other modifications, the most striking of which is the Child's intensely red tunic, an evident allusion to the Passion.

Pope John VII, whose *Madonna della Clemenza* I mentioned at the beginning, is held to be portrayed kneeling near the Virgin. This was another iconographic possibility that the icons of the Orthodox Church did not accept for a long time. There, the portrayal of the donor was left outside the sacred space of the divine image—though in Rome, by contrast, the inclusion arose again and again, most especially in the monumental mosaics of the city's churches. Throughout the duecento, the image of the donor gradually emerged on icons with varied intensity and ostentation. In the Cypriot icon of Monopoli the donor is present, in *proskynesis*, at the feet of the Child. This is consistent with a use present also in other Cypriot icons and widely diffused in the overseas territories of the Crusades.[24] In the icon of Montevergine, the donor is a tiny and nearly invisible monk, but at the beginning of the trecento, on the splendid icon of the *Maestà* made for the basilica of San Nicola (Pl. 224), the *miles* who kneels in the foreground has an obviousness that the eye cannot ignore.

As we have seen, southern Italy, both insular and continental, offers vast and varied material for the history of the visual expression of devotion to the Mother of God and her Son. The devotional type *par excellence* was that of the Mother with the Child 'in her arms', which corresponds in substance to the Hodegetria, including all of its variants. In the various formulations of that type, just as in the choice of that type or of others, the different requirements of the faith of the donors, who determined the specific requirements of the image, were reflected. More than the 'compositional types', however, whose Greek terminology is perhaps inadequate to southern Italian reality, the visual semantics of these images must be considered 'obliquely' (as is appropriate for Byzantine icons, as well): a semantics that frequently, if not always, underlines the allusion to the Lord's Passion, whether through the pose of the Child, who virtually lies in his Mother's arms; or in the

closeness of the cheeks of Mother and Son as if in a kiss, emphasizing the painful maternal fore-sight of the Passion; or even — and ever more clearly — in the symbolic connotations of the clothing and the use of colours. The contextual underlining of the Son's humanity and divinity was evinced by the nursing Virgin, who is simultaneously the royal Mother of God and as such presents a contrast with the Byzantine Galaktotrophousa, who during that act of human physicality was never accredited royal attributes.

With the invasion of formal novelties from Central Italian painting throughout the trecento, the devotional image was gradually modified and maintained the traditional types only in the 'Veneto-Cretan' sphere — though there, too, there were masterworks, as in the case of icons painted by or attributed to Andreas Ritzos. That, however, is another story for another occasion.

[1] *De vera effigie Mariae*, 18, 26, 34.

[2] Bertelli 1961b. Earlier dates have been proposed by Andaloro 1972-1973, 139-215, and Russo 1979, 35-85; Russo 1980-1981, 71-150.

[3] Nilgen 1981, 3-33.

[4] Bertelli 1994, 238, n. 36, has correctly reasserted the Western exclusivity of the *Maria Regina* type, wrongly doubted by Andaloro (followed by Cutler) who mistakenly interpreted as an image of the Virgin the portrayal of an empress in an Early Byzantine mosaic at Durrës (Albania).

[5] San Vincenzo al Volturno, Mitchell 1993, 75-114. Both monuments, Pace 1994, 270-288.

[6] Castelfranchi 1989, 81-100; Di Dario Guida 1992, 29-41.

[7] Babić 1994, 189-222. For the most recent scholarly contribution, Torp 1999, 583-599.

[8] Andria, *Icone di Puglia*, 105; Pace 1996, 157-165; Pace 1998, 287-300. Pisa, Bacci 1997, 1-59.

[9] The icon from the Byzantine Museum, Athens has been discussed by Mouriki 1987, 403-414.

[10] *Icone di Puglia*, no. 8 (Trani), 119, and no. 18 (Monopoli), 116-117. For the icon in Monopoli, more recently, Pace 1998, 294-298.

[11] Pace 1987, 47-87 (rpr., with updated bibl., Pace 2000, no. XIX, esp. 448-453).

[12] Andaloro 1995, 443-447.

[13] Belting 1981, esp. 176ff.

[14] Demus 1949, 170 (n. 457). Also Krönig 1965, 179-184.

[15] Capua, Bertaux 1903, 187, fig. 76; Ausonia, Macchiarella 1981; for other monuments, Demus 1968, passim.

[16] The inscription has never been paid scholarly attention. Morisani 1962, 81, is the only author who has at least mentioned it.

[17] *La pittura in Italia* 1994, 382, fig. 504.

[18] Cutler 1987, 335-350.

[19] Bologna 1988, 117-143.

[20] This icon is now temporarily displayed in the Museo del Palazzo Reale di Caserta. For a short mention, Di Dario Guida 1992, 74, pls XVII-XVIII.

[21] Pace, forthcoming.

[22] The first scholarly discussion of this group of Italian icons of the Kykkotissa is due to Mannino 1983, 487-496.

[23] Pace 1985, 259-298. Mouriki 1986, 9-112. Disagreement on the 'Cyprus connection' for the widespread use of the Kykkotissa in (South) Italy has been expressed by Carr 1995, 339-357.

[24] Stylianou 1960, 97-128. Also Kühnel 1988, *passim*.

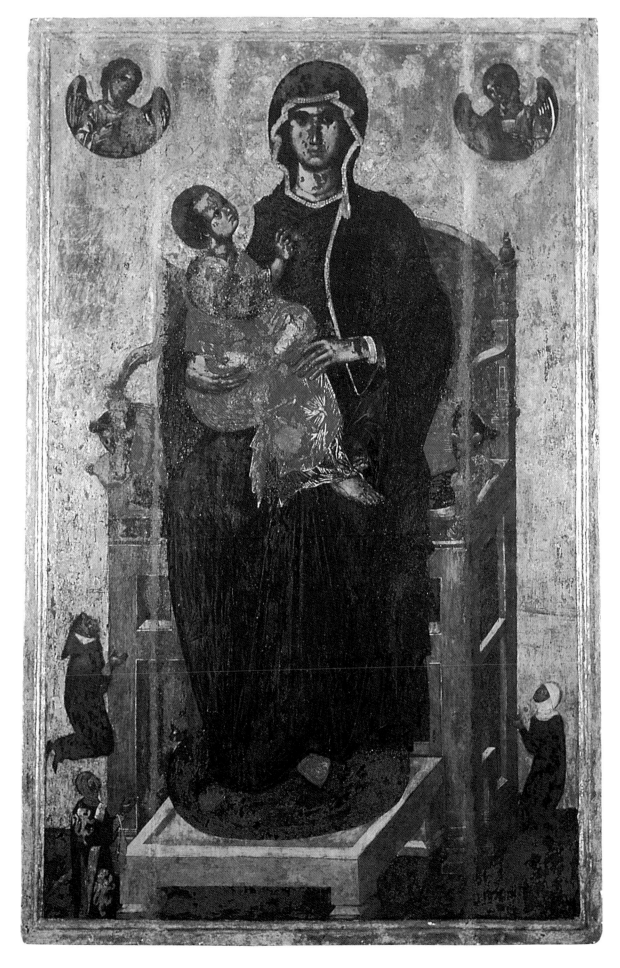

224. *Panel of the Enthroned Virgin and Child with Donors.* Basilica di San Nicola, Bari.

433

67

Two-sided icon: A. *The Virgin Eleousa*
B. *St John the Baptist*

188 × 68.3 cm
Egg tempera on wood
Late 13th century
Constantinople (?)
Naxos, Roman Catholic cathedral

The icon is on the altar in the nave of the
Roman Catholic cathedral in Naxos, and is
one of the island's most precious treasures.

A. The principal side shows the Virgin full-
length and standing, with the Christ-Child in
her arms. She turns slightly to the right —
towards the viewer — while she holds the
Child in her left arm and turns her head
slightly to look at him. She touches his knee
with the fingertips of her right hand. She is
dressed in a dark blue maphorion rich in
folds, its hem decorated with gold braid, and
its ends with fringes, also of gold. To left
and right of her halo are the abbreviations
M[HTH]P and Θ[E]OY (Mother of God) in
two red-ground medallions: above her shoul-
der is her appellation H ΕΛΕΟΥCΑ (The
Merciful). Christ, seated in his mother's arms
with his body upright, turns to her and makes
a gesture of blessing. His legs, seemingly
dangling in mid-air, are crossed; and the sole
of his right foot, seen from below, is towards
the viewer. He wears a sleeved chiton
embroidered in gold, with dark-blue straps
ending in a girdle of the same colour.

Below right, by the Virgin's dais (now almost
completely effaced), kneels a bishop, in
prayer and homage to her. He is vested in the
propers of the Roman Catholic Church, with
tiara and a pallium with crosses. Here it may
be remarked that the figure was overpainted
in Post-Byzantine times and that sample
cleaning at this part of the painting reveals
that in the older representation on the under
layer, the elements and the iconography were
the same. Also due to overpainting is an
inscription in capital letters reading: IΩ:
ΕΠΙCΚΟΠΟC ΝΗΚΟΜΗΔΗΑC (John,
Bishop of Nikomedeia). The limited sample
cleaning at this part of the painting, intended
to uncover the older appellation, revealed
traces of an inscription in minuscule letters
which do not make up, or at least not yet, the
name of the donor bishop.

The icon is mentioned in reports by papal
nuncios as early as the seventeenth century.
One of the earliest pieces of evidence which
we believe to refer to the Eleousa icon is by

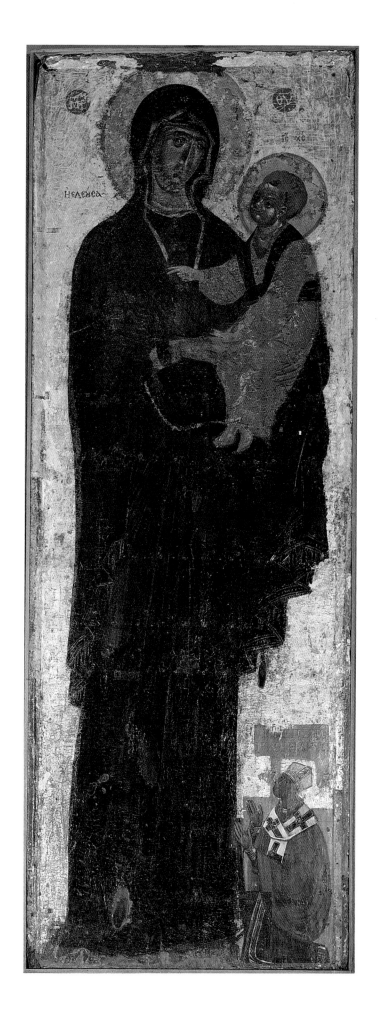

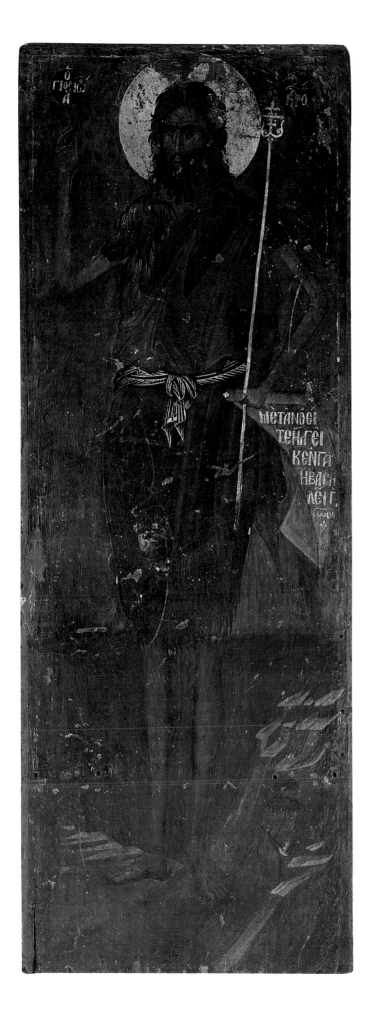

the Nuncio Tulino, in 1638. He speaks of '*La chiesa Metropolitana dedicata alla Purificazione della beata Vergine...*' (The metropolitan church dedicated to the Purification of the Blessed Virgin) and '*l'altare maggiore con l'icona della Purificazione*' (the high altar with the icon of the Purification) (Hofmann 1938, 78). Here the reference is clearly to an icon with the appellation *della Purificazione*. This appellation has reference to Mary's purification in the Temple, forty days after the birth of her Child. This event, for the Roman Catholic Church a Marian feast, is assigned by the Orthodox Church to the Hypapante (the Presentation of Christ). The present icon was also known as Hypapante.

This is the first mention, as far as we can tell, of Hypapante as the name of the cathedral church of the Catholics on Naxos. From 1563 onwards (Hofmann 1938, 13) it had borne the name of the church of the Assumption (in Greek, Metastasis). The change of appellation, coinciding with the first reference to the Eleousa icon as Hypapante, looks to be more than mere chance, and must have been connected with the installation of the Eleousa icon on the central altar. Later on, in 1652, Bernando, a Papal Nuncio from the Order of the Friars Minor Capuchins, describes this same icon. '*Quello altare è dedicato alla Purificazione, con un piccolo quadro nel quale e dipinta la Madonna santissima con il divino Bambino nelle braccia, coperto tutto il quadro di lame d'argento, fuor delle due facie...*' (This [central] altar is dedicated to the Purification, with a small picture on which the most holy Madonna is shown with the Holy Child in her arms, the whole picture being covered with a lamina of silver, except for the two faces) (Hofmann 1938, 85). According to this description by Bernando, the icon on the high altar that was dedicated to the Hypapante was a small one ('*quadro piccolo*') and showed the Virgin as Brephokratousa. And, save for the faces of the two figures, it was covered in a silver revetment.

The icon did indeed have an ornamental silver revetment. This was removed during the process of uncovering and restoration, and is now kept in the church. Some difficulty in identifying the icon arises from the nuncio's description of it as 'a small picture', for it is in fact of large dimensions.

But it was not until 1972 (Zias 1973, 554-555) that the true, large dimensions of the icon were revealed, together with its complete subject: the Virgin standing on a dais, and the image of St John the Baptist on the

435

reverse. This was the result of taking the icon down from the central altar for restoration. So long as it was hidden behind the large high altar, only about one-third of what it depicted was visible, through a rectangular opening, and the Virgin Brephokratousa appeared only to bust length, to a height of no more than 70 cm. So for the Catholic visitor, who would in any case have been more used to the large paintings that adorned the central altars of churches in the West at that time, the icon was not, to say the least of it, large.

Problems arise from the fact that the icon was placed in a frame which displayed only a third of its image. This has prompted the question whether or not the icon's place in the church of the Roman Catholic bishopric was in fact its original one. Above and beyond the tradition that the icon 'came from the sea' in the days of Iconoclasm — a cliché of most island Byzantine icons, that was mentioned by the Papal Nuncio Bishop Sebastiani when he visited the Roman Catholic cathedral of Naxos in 1666 (Hofmann 1938, 108), there has been some discussion about the possibility that it may have been transferred there from the church of St Mamas on Naxos. This was reputedly the island's Orthodox metropolis in Byzantine times, but was converted into a Roman Catholic church in 1207 (Zerlentis 1913, I, 40; Dimitrokallis 1962, 39, with extensive bibliography). This view — that the Greek Orthodox church became a Roman Catholic church immediately after the Latins occupied the island — is opposed by Karpathios, who follows Lichtle in arguing that the church became Roman Catholic only in 1390 (Dimitrokallis 1962). As regards research into the origin of the icon, it is interesting that Zerlentis believes the Byzantine church of St Mamas to have been dedicated to the Presentation of Christ, since it was with the significance and name of this feast that the present icon was connected.

There is also a problem about the beardless John, Bishop of Nikomedeia, wearing a western tiara and painted at bottom right in a pose of prayer and homage. Supposing that his appellation and title, as given in the overpainting, are due to the older inscription that is today mostly covered up, we then have here, praying and doing homage, John the Bishop of the Latin Catholic see of Nikomedeia. Even if this is a canonical rather than a titulary bishop, then a question of identification obviously arises, since the rolls of the bishops of Nikomedeia do not mention any bishop by the name of John. A question of dating arises too. On stylistic grounds the icon can be dated no

earlier than the end of the thirteenth century. But by this time the Roman Catholic Church of Nikomedeia had ceased to exist: Latin bishops of Nikomedeia are recorded until 1223 only (Fedalto 1976, 170). Again, if what we have here is a Roman Catholic titulary bishop at a considerable distance from a Roman Catholic see, and one in abeyance at that, it then becomes very difficult to tell where the icon could have come from. The question will have to remain open until the older inscription, now hidden, is cleaned.

Stylistically the icon has elements of late thirteenth-century painting. One of the more unusual features of the type, which point to this period, and most probably to an older prototype, is the large opening made by the veil of the Virgin's maphorion around her face, with a pointed fold above the forehead. The maphorion opening on the breast is large, and triangular in shape. This is a feature already to be seen in the Virgin of the Deesis on a Sinai epistyle which has been dated to the late eleventh or early twelfth century (Sotiriou 1956, fig. 111; 1958, 109-110).

The treatment of Christ's face points to the thirteenth century: the emphatically childish features, the short nose with the bulbous tip, the spherical cheeks, the round eyes, the deft painterly highlights at the edges of the volumes, as also applied to Christ in a thirteenth-century Sinai icon of the Virgin Hodegetria (Mouriki 1991, 157ff., figs 2, 3).

The archaizing elements in the icon include the very individual shape of the eyes, with a strong curve above the iris; the shadowing below the right eye, and a few parallel white lines at the corner of the eye to lighten it.

The model for the Naxos icon seems to have been quite a well-known one and much respected, for there were apparently many copies of it. An example of what is probably a copy of this common archetype is a Virgin Brephokratousa in the Vatopedi monastery, from the second half of the thirteenth century (Tsigaridas 1998a, 364, fig. 308). The Vatopedi icon shows the Virgin in bust (assuming it has not been trimmed at the bottom). Only the upper part of the full-length standing figure depicted in the original is shown here. From the iconographic point of view, the Vatopedi icon is identical in all its elements with the Naxos Eleousa, yet it still keeps close to the model, even to the maphorion open at the breast, with the undulations of the garment following precisely the same pattern as in the Naxos icon.

But for absolutely identical iconography with the Naxos icon, we must go to a wall-painting representation (1313-1314) of the Brephokratousa on the north wall of Milutin's church at Studenica (Millet 1962, fig. 69.1). The elements of both works that prove their relationship beyond doubt include the identical position, pose, and movement of the Christ-Child, the Virgin's slight turn towards him, the inclination of her head towards him, the maphorion open at the breast, and the position of her right hand on his knee, which is a hallmark for identifying this type.

In short, the stylistic relationship of the present icon and the divergences it shows from the two other works mentioned above mean that it should be dated somewhere between the two, around the end of the thirteenth century.

B. The secondary face shows St John the Baptist, wingless, standing and almost frontal, in slight *contrapposto*. He turns his body leftwards, with his face towards the viewer. John is set against a desert landscape, as can be seen from the two stepped rocks at bottom right. He lifts his right hand in what is either a gesture of blessing or a teacher's gesticulation. In his left hand he has a sceptre surmounted by a cross and a scroll opening downwards and reading: ΜΕΤΑΝΟΕΙΤΕ ΗΓΚΕΙΚΕΝ ΓΑΡ Η ΒΑCΗΛΕΙΑ ΤΩΝ ΟΥΡΑΝΩΝ (Repent ye, for the Kingdom of Heaven is at hand) (Matthew 3:2). He wears the familiar camel-hair pelt covering the top of his arms and leaving his lean shanks bare. Over the pelt he has a short sleeveless chiton with a gold-embroidered girdle tied in a large knot at the waist.

From the iconographic point of view, the type of the Baptist standing and almost frontal looks as though it must have come from depictions of scenes where he was teaching in the wilderness, a faithful rendering of the Gospel texts.

That there is a relationship between this representation of St John the Baptist and scenes of him teaching in the wilderness of Judaea can be seen here in the pictorial elements of the desert landscape at the foot of the icon: and in the text, 'Repent ye', inscribed on his open scroll, a *topos* in the Forerunner's teaching. The same relationship is in evidence throughout the attitude, movement, and presence of John's figure, frequently identifiable in comparable depictions of him. The present icon also seems to be consistent with the Gospel narrative (Matthew 3:4) in which the figure of the Baptist is described in some

detail: 'The same John had his raiment of camel's hair' – as seen here icon – 'and a leathern girdle about his loins' – the girdle being given prominence by its large, complicated knot.

A typical example of the iconography of St John teaching in the wilderness, with which the present icon can be compared, is the eleventh-century miniature on folio 8r of codex 587 in the Dionysiou monastery on Mt Athos. Here the saint stands on a dais as he preaches. He wears a sleeveless himation over his pelt, his left shoulder thus being bare. He holds a sceptre, again surmounted by a cross, and a closed scroll (Pelekanidis et al. 1973, 185, fig. 193). John is again depicted with the attitude and movement repeated on the present icon, in a second teaching scene in the Dionysiou manuscript, on folio 142r (Pelekanidis et al. 1973, 185, fig. 256).

This iconographic type also finds its way into monumental works, with the single figure of St John the Baptist. Representative of this is the wall-painting of him in the church of Sts Anargyroi at Kastoria. There the scroll opens downwards with the 'Repent ye' text. John is standing, his torso slightly turned to the left and holds a stave surmounted by a foliate cross. The repetition of these elements in the present icon is at very least an indication that this transference from a scene of St John the Baptist teaching, already taking place in the Middle Byzantine period, survived in portable icons.

This type is marked here not only by the upwards bend of John's right arm and the identity of attitude and movement with the Middle Byzantine examples mentioned above, but by a further feature, the complex treatment of the saint's clothing, with the short pelt covered by a short, sleeveless himation rich in folds. Here John's legs are bare and, for all the opulence of his presence, scrawny.

The same features mark the depiction of John the Baptist in a wall-painting at Gračanica (1282-1321) (Hamann-MacLean and Hallensleben 1976, fig. 345), with which the present icon displays related stylistic features. There is the same opulence in the two figures; the open scroll in the left hand is identically painted in both works, and it also has the same METANOEITE inscription. The mood of the two figures is comparable as well. The present icon, with its more 'classical' conception, can be assigned to a Constantinopolitan workshop of the late thirteenth century.

For the survival of this type, we need to look above all at the large Dečani icon of St John the Baptist (Djurić 1961b, no. 33, pl. XLVIII), where the subject is the same as, and the scheme and dimensions are very similar to, the present icon. The Dečani icon dates to about 1350. It is identical with the present icon in all elements of its iconography: one notes particularly the iconographic preference for a closed scroll in John's left hand. The differences of style revealed by comparing the two works are an indication of the Dečani icon's more advanced date.

Chryssanthi Baltoyanni

Literature:
Zias 1973, 551-555; *Aegean*, fig. 128.

68

*Panel of the Madonna and Child
on a Curved Throne*

81.5 × 49 cm
Egg tempera on wood
Fourth quarter of the 13th century
Tuscany, Constantinople, Greece,
Macedonia, or Cyprus (?)
Art market in Madrid 1912; Collection
of Carl W. Hamilton, New York, by 1921;
acquired by art dealer, Lord Duveen; sold
to Andrew W. Mellon, 1937; given to
the National Gallery of Art, 1937
Washington, D.C., National Gallery of Art,
Andrew W. Mellon Collection (1937.1.1)

Among the most distinctive images produced in the thirteenth century is the controversial full-length Virgin and Child on a round-backed throne, now known as the Mellon Madonna. Its history begins when it was offered for sale in Madrid in 1912 along with a second, larger image, the so-called Kahn Madonna, with which it is connected in style as well as provenance. Subsequently, the Mellon Madonna was sold to Carl W. Hamilton, then to Lord Duveen, who commissioned an extensive restoration in 1928, and in 1937 sold it to Andrew Mellon who gave it to the National Gallery, where it was eventually reunited with the Kahn Madonna (Shapley 1979, 96-97; Belting 1982, 4; Folda 1995, 501). Efforts to identify the origins of these images, undertaken by numerous scholars, have resulted in associations with art from centres as far apart as Constantinople, Tuscany, Umbria, Sicily, Armenian Cilicia, Cyprus, and the Crusader states.

The two images were first attributed to Constantinople by Bernard Berenson and Otto Demus, who noted their similarity in facial type to the Virgin in the Deesis mosaic at Hagia Sophia, usually dated in the third quarter of the thirteenth century (Berenson 1930; Demus 1958a and Demus 1958b, 87-104). But beginning with Victor Lazarev's proposal for Sicily, several historians have attributed their production to Byzantine painters who had migrated to Italy (Lazareff 1933). Among others, Hans Belting and Ann Hoenigswald convincingly argued that despite their many similarities, the images were made by two different painters, and Belting proposed that the master of the Mellon Madonna was an Italian painter whose work was based on that of the Kahn Madonna master (Belting 1982, 112-113, 117; Hoenigswald 1982). Moreover, James Stubblebine, Belting, and Joseph Plozer, have all argued that the

Kahn Madonna was produced under the influence of Tuscan painting, and that a touchstone for localizing the Mellon and Kahn images is Duccio's *Rucellai Madonna* with a facial type, halo, and chair throne close to those of the Kahn Madonna (Stubblebine 1966; Belting 1982; Polzer 1999a and Polzer 1999b). At the very least, there is agreement that the master of the Kahn Madonna was trained in Byzantium, possibly at Constantinople, although other capitals in the region, such as Thessaloniki and Ochrid, supported similar workshops. Indeed, the left-hand angel in the Kahn Madonna finds a remarkable parallel in a panel on Mt Athos, possibly painted by a Serbian artist around 1321 (Weitzmann et al. 1982, 141, 176). The angels in roundels found in both images abound in the Byzantine world, and their costumes with round, jewelled collars and pearl drops, as well as their blue orbs with red crosses also find striking parallels in Greece, Macedonia, and Serbia (Velmans 1977, figs 21, 24, 28; Weitzmann et al. 1982, 180-181).

Undoubtedly most scholars have focused their attention on the Kahn Madonna because of its relatively pristine condition and intriguing similarity to the *Rucellai Madonna*. Yet the Mellon Madonna provides significant comparisons outside Italy. For example, Belting has implied that the combination of a cherry red maphorion and a bright blue tunic is Italian (Belting 1982, 13). But in fact, the vast majority of Italian images use a dark blue maphorion and a red or purple tunic. It is in the East that we find the colours used in the Mellon Madonna, for example, in the brilliant, twelfth-century Virgin from a diptych of the Annunciation in Ochrid, and later in a series of icons of the Virgin and Child, some with chair thrones, in fourteenth- and fifteenth-century Cyprus, one of the localizations recently suggested for the Mellon Madonna by Jaroslav Folda (*Trésors médiévaux*, 49; Papageorgiou 1970, 74, 95, 101; Folda 1997, 397). Less vivid examples of the red top, blue bottom combination occur throughout the Byzantine world (Weitzmann et al. 1982, 48, 63, 66).

Still, it is the superbly painted, round-backed throne in the Mellon Madonna that suggests a Byzantine training for this painter, and perhaps a Byzantine client or localization for its production. Although a few examples of the round-backed throne can be found in Italian manuscripts of the second half of the thirteenth century, in the same period the type is found throughout the Byzantine world used for the Virgin, as well as for evangelists in

gospelbooks (Buchthal and Belting 1978, pls 3a, 6a, 15, 27). Indeed, images of the Virgin and Child seated on round-backed thrones with newel posts and finials appear in a series of wall-paintings of the thirteenth and fourteenth centuries from Ochrid to Crete (Velmans 1977, 77; Kalokyris 1973, figs 12, 13, 79). Most important are thrones in two manuscripts produced in Constantinople in the second half of the thirteenth century, one for an oft-reproduced Annunciate Virgin (Paris, Biblio. Nat. MS gr. 54), and, even more similar in its details and proportions, another for Joshua (Folda 1995, fig. 6; Huber 1973, fig. 78). Given the likelihood that this latter manuscript (Mt Athos, Vatopedi 602) was made in imperial circles after 1261 and the fact that Biblical texts describe the throne of Solomon as 'round behind' (I Kings 10:19), it is possible that this type of throne had imperial associations.

Complicating analysis of the throne is the fact that the round-backed type is usually depicted from a three-quarter angle, not the virtually frontal view of the Mellon Madonna (Belting 1982, 14-15). Here the throne seems to be positioned in order to accommodate a Virgin with a frontally placed lower body, a type found in Italy, Byzantium, and even in Central and Northern Europe, usually on a backless throne (Corrie 1998, fig. 1; Weitzmann et al. 1982, 48, 63; Corrie 1987, 122, fig. 6; Demus 1970, figs 175-176). The same position can be found in a profoundly Byzantinizing image of the Virgin and Child often associated with the Kahn and Mellon Madonnas, convincingly attributed to Pisa and now in the Pushkin Museum in Moscow (Belting 1982, 17-18; Polzer 1999a, 84-88). Along with a Child type shared with the Pushkin Madonna, the similar placements of the bodies in space might be an argument that the painter of the Mellon Madonna was also Italian. But these common characteristics are not conclusive evidence, for other aspects of the Mellon and Pushkin Madonnas are different including the facial types, throne, and chrysography. Finally, given the presence of Western Europeans throughout the Mediterranean Basin in the thirteenth century, arguments over whether the Child's blessing gestures are Latin or Greek and whether full-length images of the Virgin could be Byzantine icons or must be Italian altarpieces also remain inconclusive (Belting 1982, 11, 16-17; Folda 1997, 505-506).

Despite extensive discussion the central issues remain unresolved. It seems quite certain that the master of the Kahn Madonna

was trained in a major capital in the East, in Greece, Macedonia, or even Serbia. It is also possible, given the remarkable Byzantine throne and the palette of the Mellon Madonna, that its painter was as well. It is also possible that both images were painted in one of these capitals or even in a centre such as Cyprus or Crete. But there is also convincing visual evidence in Italian images of the thirteenth century that these painters, or perhaps others trained in the same style, reached Italy. Indeed, it is difficult to envisage Italian painting without something like these images. Finally, of serious interest is Polzer's recent proposal that the Kahn, Mellon, and Pushkin Madonnas, among others extant, were the products of a group of painters some of whom trained in the East and then moved to Tuscany (Polzer 1999b, 176-177). Such careers would have connected the painting of Central Italy to art produced in other Mediterranean centres including even Armenian Cilicia, Cyprus, and the Crusader states, providing us with evidence of less obvious links forged through trade, politics, and religion (Belting 1982, 19-20; Corrie 1998, 40-41; Folda 1997, 397).

Rebecca W. Corrie

Conservation:
Extensive restoration commissioned by Lord Duveen, 1928. Restorer unknown.

Exhibitions:
Glory of Byzantium, The Metropolitan Museum of Art, New York 1997.

Literature:
Berenson 1930, 1-16; Lazareff 1933, 279-287; Demus 1958a; Demus 1958b, 87-104; Stubblebine 1966, 379-381; Demus 1970, 212-216; Shapley 1979, 96-99; Belting 1982, 7-22; Hoenigswald 1982, 25-31; de Castris 1986, 463; Folda 1995, 501-506; *Glory of Byzantium*, no. 262; Polzer 1999a, 83-90 and Polzer 1999b, 167-182.

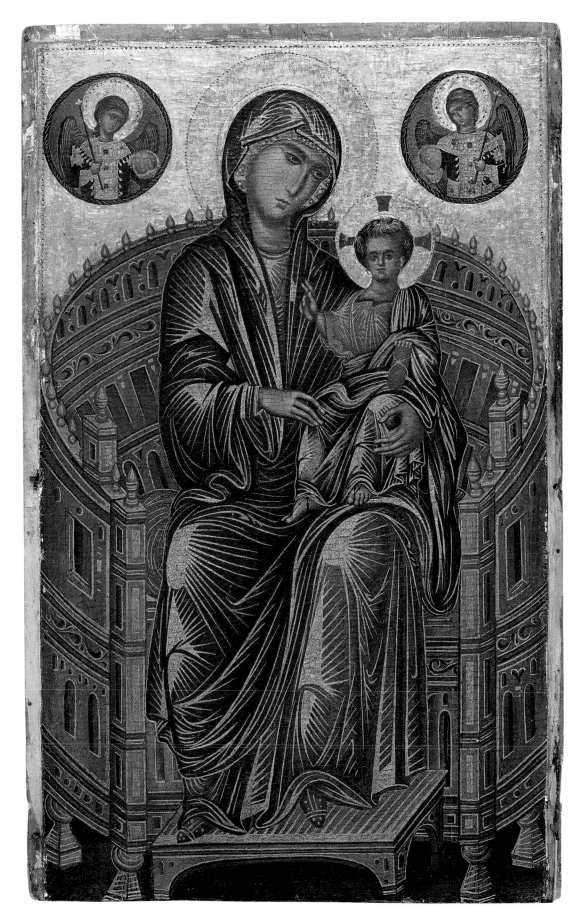

69

Panel of the Madonna and Child Eleousa

73 × 51 cm
Egg tempera on wood
About 1230-1250
Pisa, church of San Michele in Borgo
Pisa, Museo Nazionale di San Matteo,
without inventory number

From the late twelfth century onwards the practice of producing painted panels imitating Byzantine icons, both in their composition and formal iconographic features, became more and more widespread in Tuscany, where a leading role in the diffusion of this new artistic medium was played by the seaport of Pisa, the maritime republic whose merchant ships voyaged throughout the Eastern Mediterranean and which had been granted important privileges by the *basileis* from 1111 onwards (von Falkenhausen 1986; Balard 1991; Borsari 1991).

Pisa has preserved a great number of painted panels from this period, which show distinctive Byzantinizing features. Usually, the scholarly debate on such a phenomenon — which did yield the primitive roots to Tuscan Renaissance painting — has interpreted it merely as an episode of the history of artistic taste or as a direct consequence of the Latin conquest of Constantinople in 1204 and the hypothetical influx of Byzantine painters into Tuscany (an idea dating back to Giorgio Vasari's *Vite*). Nevertheless, it is important to stress how panel-painting emerged in Pisa as a sacred art, based on the reproduction of specific iconographic themes, especially of the Virgin and Child, which must be first explained as a devotional wave, as a consequence of Westerners' fascination with Byzantine cult practices related to sacred icons. As Eastern iconography began to be considered as a venerable Church tradition, which had permitted the transmission, through an uninterrupted series of painters' generations, of the authentic portraits of Christ's and the Virgin's earthly aspect, their reproduction and imitation was perceived as a pious act offering the worshipper's soul special spiritual benefits.

The diffusion of an 'iconic piety' in this period is attested both by hagiographical texts and figurative witness: in the thirteenth-century *Vita* of St Bona, a lay converse, icons are often described as means of meditation and introspective prayer, both in the ascetic practices of monks, such as the 'Pulsanese' (a Benedictine family from Apulia) of San Michele degli Scalzi, and in laymen's devotional life.

Moreover, testamentary bequests from the second half of the thirteenth century record gifts of painted panels of the Virgin and Child to churches, for the sake of the bequeather's soul. Furthermore, the precocious introduction of Marian icon-like panels into Pisan churches is witnessed by works such as the *Madonna di Santa Chiara*, now in the National Museum of Pisa, currently ascribed to a twelfth-century hand (Bošković 1993, 25; Caleca 1994, 170).

The association of such Byzantinizing images with the private devotions of their owners is indicated by their small dimensions and by the frequent occurrence of Marian subjects linked, as in Eastern icons, with soteriological and eschatological references. The *Madonna di sotto gli organi* in Pisa cathedral (probably a Cypriot or an Eastern Mediterranean work, around 1200; Bacci 1997), whose articulated iconography enhances the Child's nature as a universal judge, provides us with a possible model for subsequent images of the Virgin and Child in thirteenth-century Pisa and nearby Lucca.

Early Pisan Madonnas show distinctive features of their models, especially in their compositional solutions: the format is rectangular, the Virgin is represented 'from the navel upwards' and the panel often shows decorative devices (such as *pastiglia* and, from the second half of the century onwards, punched haloes) which aim at reproducing the precious metal revetments of Byzantine icons. They often repeat iconographic subjects unusual in Western tradition; the artists seem to know their models very well and employ freely singular elements of icon-painting formulas: see, for example, dark-coloured lower eyelids with wavy underlinings, almond-shaped eyes, brown pupils with dark irises, arched eyebrows, upper eyelids rendered in red, cavities marking the root of the nose, and double underlinings of the neck. The sources of this production can be detected not only in the metropolitan tradition of Constantinople, where the Pisans had their own quarter and two churches (Nomidis 1996, 137-171), but also in contemporary icon-painting in Cyprus and the Eastern Mediterranean: for example, if we can consider red maphoria and scrolls as hallmarks of Cypriot icons (Mouriki 1985-1986), it is meaningful to find such features in Pisan works such as the *Nellus Madonna*, around 1200-1230, and the great *Madonna di San Martino*, around 1270-1290, both in the National Museum.
The panel from San Michele in Borgo, nowa-

days in the Pisan National Museum, constitutes one of the first witnesses of the introduction of the Eleousa theme into Tuscan painting, together with some contemporary panels produced in the Lucchese milieu of the Berlinghieri family. The half-length Madonna and Child are represented cheek to cheek: The Virgin wears a blue veil decorated with pearl hemmings and chrysography, and holds her son on her left arm, while addressing him with her right hand in a gesture of intercession; the Child wears a brown tunic and a carmine himation, while his legs are left uncovered. In accordance with its Byzantine model, the Virgin has a pensive and sad expression, a scheme expressing her foretelling of her Son's death, as well as alluding to the feeble nature of mankind, which can be redeemed only by Christ's Passion. This is recalled by another detail, the Child's bare crossed legs (Corrie 1996). His furrowed forehead, denoting higher knowledge, is introduced as a means to manifest the contradiction between Christ's representation as a boy-child and his divine and eternal nature. As in Eastern icons, emphasis is given both to the Virgin's intimacy with her Son and her primary role in obtaining Christ's pardon for mankind.

The painter of this panel was unmistakably looking at a Byzantine icon and made efforts to imitate carefully its composition and form; however, in the rendering of singular devices, he seems to introduce graphic solutions whereas its models employed colour effects, as can be seen in the underlining of anatomical details such as the veins of the hands or the furrow in the Child's forehead. Moreover, some devices of the originals were misunderstood: for example, the edge of the himation falling down from Christ's shoulder was coloured carmine, so that it was transformed into a part of the tunic. Generally speaking, the modelling of the faces and the imperfect imitation of Byzantine models recall similar works from the school of the Lucchese painter Berlinghiero, dating from around 1230-1250 (Virgin and Child in Lucca, Villa Guinigi National Museum; Virgin and Child in Riggisberg, Abegg-Stiftung). Consequently, the execution of the present panel in the second quarter of the thirteenth century seems highly probable.

In the fifteenth century a Renaissance painter executed the angels on the upper part of the panel, probably repainting the original figures. The image was placed in the ancient church of San Michele in Borgo, attached to a Benedictine and later a Camaldulese abbey,

already in the sixteenth century, when it was exhibited, as we learn from the local writer Jacopo Arrosti, to worshippers every last Sunday of each month. According to the eighteenth-century Pisan art historian Alessandro da Morrona, the panel was restored in the last decade of the seventeenth century. Damaged during the Second World War, when it split into two in the collapse of some parts of the church building, it has lost part of the pictorial surface on the gilded ground, on the haloes and on the Virgin's veil; a careful restoration was not provided before 1976, when the painting was consolidated and cleaned.

Michele Bacci

Conservation:
1976 by the Soprintendenza A.A.A.S., restorer N. Carusi.

Literature:
Da Morrona 1812, I, 460; Garrison 1949, no. 111, 62; Carli 1994, 18.

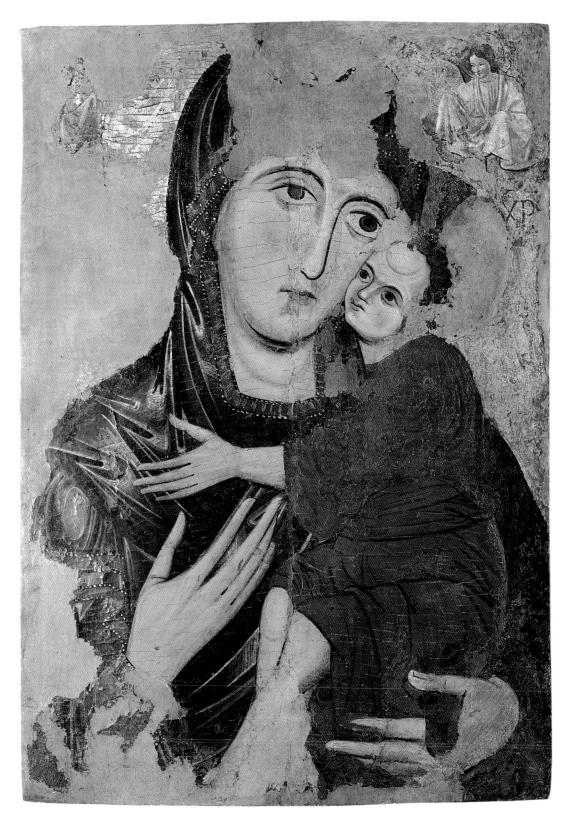

70

Panel of the Virgin and Child
Galaktotrophousa

75 × 49 cm
Tempera on wood
About 1260-1280
Pisa, church of Santi Cosma e Damiano
(destroyed)
Pisa (area of), church of Santi
Cosma e Damiano

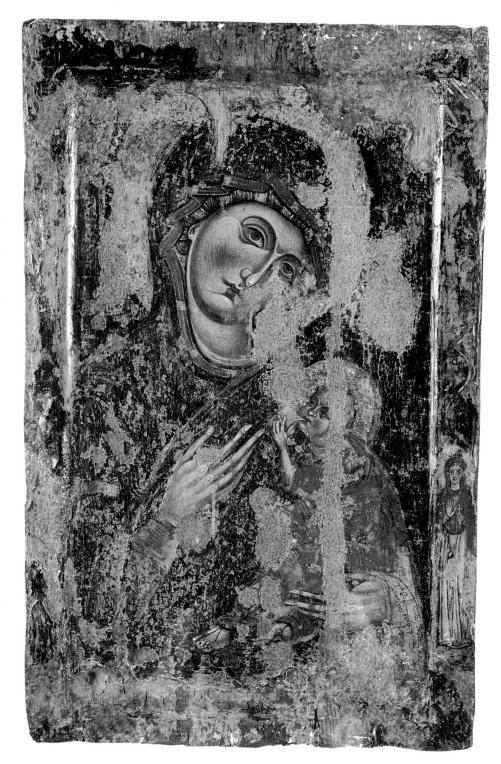

As in the first half of the thirteenth century (Cat. no. 69), so in the second, Pisan painted panels display several affinities with works from the Eastern Mediterranean, especially with thirteenth-century panels from Cyprus and in the Sinai Collection, that is, with icons produced in the hybrid cultural milieu of the Crusader lands. Scholars dealing with the analysis of icon-painting in such centres have occasionally proposed parallels with Pisan and Tuscan panels (Mouriki 1984-1985; Pace 1993; Carr 1995, 351-353), often in order to point out Italianate devices in Eastern works. It is however extremely hard to identify which cultural trend may be the source of the other, since the same hybrid character must be recognized in Pisan panel-painting, whose production, although imitating very deeply Byzantine models, cannot escape from introducing Northern and Gothic devices too. Many affinities between Pisan and Cypriot or Sinaitic works may be due, first of all, to their belonging to cultural milieux with similar conditions of religious and artistic exchange; the cases of the Kahn Madonna and the Mellon Madonna (Cat. no. 68) in the Washington National Gallery or the Virgin and Child in the Moscow Pushkin Museum (Belting 1982; Folda 1995; Polzer 1999a and Polzer 1999b), which have been interpreted both as Pisan and as Cypriot or Crusader works, indicate how difficult it is, even today, to provide scientific interpretations of such 'hybrid' works.

Both in the Crusader lands and Pisa, laymen developed a great interest in icons, particularly in icons of the Virgin and Child, which was motivated, in the first instance, by the meaning of such works as sacred portraits and as means of personal devotion, allowing believers a deeper involvement in the veneration of their holy intercessors. Pisan merchants' and artists' fascination with Eastern icons was a wide spread phenomenon throughout the second half of the thirteenth century and gave rise to the production of a great number of Byzantinizing images of the Virgin and Child. As a whole, imitation of models can be analysed on both stylistic and iconographic grounds, and it is important to keep in mind that the artists' main aim was to simulate an icon-like appearance by introducing and freely combining singular items of the icon-painting repertoire.

From the analysis of extant works we learn that the search for imitation did not imply the production of mechanical replicas, but aimed at suggesting, by different means, the sacred aura of icons, perceived as holy and authentic images portraying the historical appearance of Christ and his mother. Very often such an imitation was obtained by overloading the figures with decorative details, by a proliferation of ornaments such as pendants and pearls, or by emphasizing the richness of the Virgin's maphorion by means of a very fine net of golden striations: the new 'comb-like' and thick chrysography of the first Palaiologan era (Demus 1958a, 98-99) found here a precocious as well as a highly developed application, as shown by the *Madonna*

di Sant'Eufrasia now in the church of Santa Maria Madre della Chiesa (Carli 1994, 18-19). On the other hand, anatomical features, such as those defining the eyes, nose, mouth and forehead, are frequently repeated in a radical and exaggerated manner: chromatic devices were often misunderstood and substituted with graphic patterns in which colours were juxtaposed, not mixed.

Singular elements derived from Byzantine models were probably emphasized as means of suggesting the preciousness and religious worthiness of sacred images, and to point out their association with the spiritual health of the believers. Mary's sorrowful aspect is often over-emphasized in Pisan panels and her eyes gazing at the beholder and involving him in the intercession for his soul's sake are frequently introduced in this period, as demonstrated, for example, by the panel from the church of San Frediano, around 1270-1280 (Carli 1994, 21). Such a device, as some scholars have observed, is not very common in Byzantine iconography, although it can be found in some thirteenth-century works in Thessaloniki, Cyprus, and Sinai (Mouriki 1991). It is probably to be interpreted as a result of the emergence of new personal, inner trends in the religious life of the Byzantines (Kazhdan and Wharton-Epstein 1985), which also fitted well with the pietistic-soteriological devotions of the Latin world.

Among Pisan panels of the second half of the thirteenth century, the Virgin and Child Galaktotrophousa from the church of Santi Cosma e Damiano shows the most strikingly Byzantinizing features. This little panel is surrounded by a relief border decorated with vegetal motifs and, on the right side, by the little figure of an unidentified female martyr, represented full-length, wearing a red veil on a blue tunic and holding a cross in her left hand. The Theotokos is represented half-length, suckling her Child, held in her left arm. She wears a blue maphorion embellished with gold borders and pendants, which covers a two-colour *palla* on her head, while Christ is clad in a brown himation and a red chiton, richly highlighted by a comb-like chrysography. Traces of the wings and himation of a now obliterated angel can be discerned in the right top corner of the panel.

As in Eastern models, the decorated border probably aimed at simulating sumptuous metal revetments, which are so often embellished with vegetal motifs. Painted versions of such motifs as marginal decorations are known already in earlier icons, such as the

St Merkourios on Sinai, possibly tenth century (Mouriki 1990, fig. 11); some examples are known, however, in thirteenth-century Cyprus, where *pastiglia* versions also occur (Mouriki 1990, figs 58-59; Sophocleous 1994, 87, fig. 22). Full-length saints on the borders were also common in the twelfth and thirteenth centuries, both in Constantinopolitan and provincial works.

The Virgin and Child, represented according to the common Galaktotrophousa type (known in panel- and icon-painting only from later examples), imitates very deeply, even radically, a Byzantine model of the first Palaiologan era. The excessive inclination of the Virgin's head, which emphasizes her closeness to the Child, recalls some late thirteenth-century 'hybrid' icons on Sinai, such as the Virgin *dexiokratousa* published by Mouriki (1990b, fig. 62; Mouriki 1991). Some facial features such as the S-shaped eyelids and the almond-shaped eyes in line connected with the arched eyebrows, can be paralleled with analogous devices in Cypriot icons of the twelfth and thirteenth centuries (e.g. the icon of the Virgin Glykophilousa in the Byzantine Museum in Nicosia, Papageorgiou 1991, fig. 7). The use of a series of concentric brushstrokes encircling the irises, as has been noted (Mouriki 1985-1986), is a trait found both in the panel from Santi Cosma e Damiano and in Eastern works such as the icon of the Pantokrator from Moutoullas, Cyprus, of around 1280; another Pisan panel, the Madonna formerly in the church of San Giovannino de' Frieri and now in the Pisa National Museum (Carli 1994, 14), shows a similar shaping of the eyes.

On the other hand, the rendering of the flesh seems to be more clearly indebted to the stylistic trends of the Early Palaiologan period, in particular the filament highlights spread out around the neck, the chin, the mouth and the cheekbones. Such devices are found in important works such as the monumental Virgin Hodegetria and the Pantokrator in the Chilandari monastery on Mt Athos, dating from 1260-1270 (*Treasures of Mount Athos*, nos 2.8 and 2.9) and other Macedonian icons from the second half of the thirteenth century. The Pisan panel, by documenting its precocious reception, confirms the emergence of such stylistic devices in the third quarter of the century; the Western artist's version is however a more radical one, where a tendency to provide graphic solutions instead of chromatic ones is easily recognizable. A reflection of the stylistic features of this panel, although less pronounced, can be

found in other Pisan works, such as the so-called *Madonna dei Mantellini* in the church of Santa Maria del Carmine in Siena, a Marian panel in the Fogg Art Museum at Cambridge, Massachusetts and the aforementioned *Madonna di San Frediano*. All these works have been dated in the period 1260-1280; some scholars have proposed to group them around the anonymous personality of the so-called 'Santi Cosma e Damiano Master', presumably working in Pisa in the same period. Another anonymous painter, the 'San Martino Master', whose paintings (dating from around 1270-1290) are often discussed in connection with Cimabue's first works, seems to employ several devices already shown by the *Santi Cosma e Damiano Madonna*, especially in the modelling of the flesh and the facial features.

Little is known of the former history of the panel. Before the Second World War it was preserved in the urban church of Santi Cosma e Damiano, in the south side of the town. Placed on the altar on the left side of the main one, it was a cult-image venerated under the title of *Madonna del Patrocinio* (Our Lady of the Defence). In 1945, after the bombing and the destruction of the church, the panel was brought to safety in the National Museum. Later transferred to the town archbishopric, where it remained until recently, it was finally put in a suburban church of the same title as the former one.

Michele Bacci

Literature:
Bellini Pietri 1913, 267; Garrison 1949, 29, 61, no. 104; Carli 1958, 55; Tartuferi 1991, 19-20; Carli 1994, 21.

71

Diptych: A. *St Prokopios*
B. *The Virgin Kykkotissa, and Saints*

51 × 39.7 cm (each leaf)
Egg tempera on wood
About 1280
Sinai
Egypt, monastery of St Catherine at Sinai

This striking diptych is in an excellent state of preservation. It shows, on the left-hand leaf, St Prokopios, identified by his inscription Ο ΑΓΙΟΣ ΠΡΟΚΟΠΗΟΣ Ο ΠΕΡΙ ΒΟΓΙΤΗΣ, as an army officer being crowned by two miniature flying angels; and, on the right-hand leaf, the Virgin Mary in a variant on the Kykkotissa type. Shown on the integral frames of the two leaves are saintly figures, in order of hierarchic rank.

A. On the Prokopios leaf, from the names (ungrammatically) inscribed, the representations are as follows. In the top part: Christ, in bust, between the archangels Michael and Gabriel, also in bust, both of them making a gesture of prayer. Inscribed on an open Gospel are the words ΕΓΩ ΕΙΜΙ ΤΟ ΦΩΣ ΤΟΥ ΚΟΣΜΟΥ Ο ΑΚΟΛΟΥΘΩΝ (I am the Light of the World, and he that follows Me...). On the vertical sides, paired and full-length, the saints Peter and Paul; John the Theologian and Thomas, both beardless; St Theodore Stratelates and St George. On the bottom part: St Cosmas, St Christopher, and St Damian, all in bust.

B. On the Virgin Kykkotissa leaf the representations are as follows. In the top part: the Virgin as Burning Bush, in bust, between her parents Joachim and Anne, also in bust, both of them making a gesture of prayer. On the vertical sides, paired: the prophets Moses and St John the Baptist; the Fathers of the Church Basil and Nicholas; and the ascetics John Klimax and Onouphrios. In the bottom part: St Constantine and St Helen, and St Catherine, all in bust. The back faces of the diptych have repeated wavy red brushstrokes.

To interpret the diptych's iconography we need to refer to the *synaxarion* of St Prokopios (*Synaxarium CP*, 805ff.). It was the first time a saint's life had been narrated in a 'secret' mode rather than the familiar narrative mode. Thus the emphasis given to the saint's expensive military equipment is dictated by his rank as 'Duke of Alexandria', and his crowning by the angels is his reward for his terrible martyrdom. The inclusion of Christ and the adoring angels at the top of

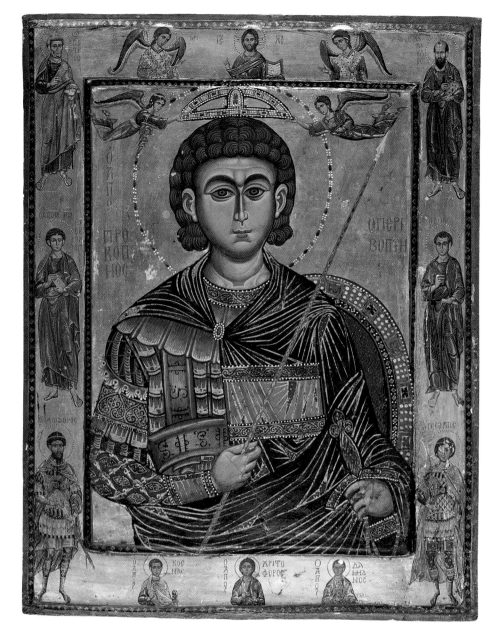

the frame is connected with their presence on the arms of a cross fashioned by Prokopios in order to commemorate a vision he saw on a night march to Alexandria to persecute the Christians of the city: it was as a result of this vision that he became a Christian. The well-known iconographic scheme of the Deesis does not enter into the picture (Weitzmann 1966, 68). The choice of the remaining saints was made on the basis of features they had in common with Prokopios. Paul, for example, was converted to Christianity in the same way (Theophanes Kerameus, Homily XXXVI, *PG* 132, 985 and 988, a text read aloud on the Feast of St Prokopios). Again, Peter and Prokopios shared the ability of being able to impose or lift a curse (Ode VIII and Ode IX for the Feast of St Prokopios, Menaion for July, 43; *Synaxarium CP*, 778).

The rare combination of St John the Theologian with St Thomas was intended to lay special stress on the historicity of salvation, accomplished in the Word made Flesh, an idea not acceptable to the Docetes and Gnostics. As is well known, the name of Thomas was associated with a Gnostic apocryphal text, *Thomas's Words*, discovered at Nag Hammadi (*ΘΗΕ*, 5, 575; *ODB*, 1043; 2076). The iconography of the right leaf of the diptych places, it will be noted, particular emphasis on the fundamental doctrine of the Incarnation, and also of Salvation thereby. St Theodore and St George have been chosen as, like Prokopios, Great Martyrs, and also because they came from Asia Minor. The choice of Christopher is due to the fact that he shares a feast day with the martyr Prokopios of Palestine, identified with Prokopios the Great Martyr (*ΘΗΕ*, 5, 256): Christopher

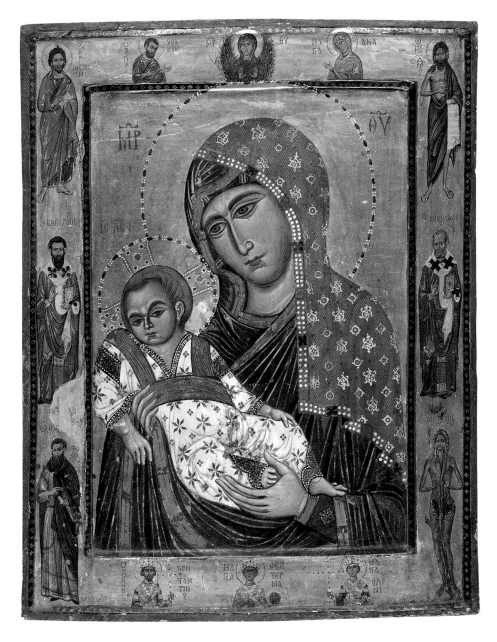

near Sinai in a neighbouring valley. St Catherine and the 'Virgin as Burning Bush' are on the same axis, with St Constantine and St Helen between them. This, up to a point, defines the diptych's provenance, while the presence of the Kykkotissa Virgin seems to bear some relation to Cyprus.

The model for St Prokopios's physiognomy and the way his figure is depicted can be traced in earlier Sinai paintings, and they lead us to the conclusion that this superb diptych must have been painted at Sinai. We think in particular of the painter Petros's icons of St Prokopios, from about the third decade of the thirteenth century (Mouriki 1988, 333ff., fig. 5; 1990, fig. 47) or of the early thirteenth-century icon of St Panteleimon (Mouriki 1990b, fig. 53). There are numerous features in common with the first of these icons: not only the portrait's expression, style and mood, but the diadem type, the finely-wrought jewelled halo, the long hair, the tablion, the sword, the 'mis-spelt' writing of the name as ΠΡΟΚΟΠΗΟC with an H. The basic pattern of the ears, however, was borrowed from a well-known encaustic icon showing the Apostle Peter (Vocotopoulos 1995, fig. 4). Prokopios's figure, on the other hand, emanates the same hieratic dignity, calm, and inner content that mark another Sinai portrait, that of St Panteleimon. The austere frontal pose, the oval face, the hair parted in the middle, the linear treatment of the features, above all of the eyes with their heavy arched brows; the typical protrusion between the eyes, the draughtsmanship of the sides of the nose, the tonal differentiation of the shadow that comes right up to the corner of the mouth; and the trapezoidal shape of the shadow on the lower lip: all these are elements that of themselves demonstrate the dependence of one of these works on the other. There is some difference of style, which can best be explained by the gap in time between the two paintings and, perhaps, by the painter's ethnic origin. The intense olive-green shadows, the emphatic features of the physiognomy, the linear modelling, and the widespread use of lining in gold are also characteristic of miniatures from Cilicia of the same date as the diptych: for instance those of a Gospel dated 1280, Inv. no. 9422 in the Matenadaram Collection at Yerevan (*La miniature arménienne*, 27, fig. 136). We should note the close affinities of style between the Kykkotissa Virgin and the Virgin of the Annunciation on folio 12r of the Gospel; the indiscriminate use of lining in gold on the clothes of all the figures, as in the present diptych; and the frequent use of

was also the name of St Prokopios's father (*Synaxarium CP*, 805). St Cosmas and St Damian are there to underline Prokopios's gift of healing (Ode IX for the Feast of St Prokopios, Menaion for July, 43).

The appellation ΠΕΡΙΒΟΓΙΤΗC represents the adjective περιβόητος (noised abroad), the saint's epithet in Niketas of Paphlagonia's *Lauds in Honour of St Prokopios* (Εἴ τις τὸν περιβόητον ἐν ἀθλοφόροις Προκόπιον', *BHG*, II, 219). The same epithet is given him by Nikodemos the Athonite (Συναξαριστής 1819, II, 252). Thus this adjective, despite the view of Sotiriou and Weitzmann (Aspra-Vardavakis, forthcoming), should not be connected with the word ΠΕΡΙΒΟΛΙΤΗΣ.

On the right-hand leaf of the diptych the Virgin is shown in the Kykkotissa type, with Christ as Anapeson. This combination appears here for the very first time, and must have been meant to give special emphasis not only to the Incarnation but to St Prokopios's vision: 'I am the Crucified Christ...' (*Synaxarium CP*, 805). As for the actual instrument of the Passion, the Cross, this is held by St Constantine and St Helen. The choice of the remaining saints has clearly to do with Sinai. The 'Virgin as Burning Bush' is perhaps the earliest portrayal of this type. Her parents Joachim and Anne are frequently shown beside the Virgin Mary, and their role is mainly intercessory. John Klimax, who lived the life of a hermit on Sinai for forty years, also served as abbot of the monastery shortly before he 'went to his long rest' (Martin 1954). He and the hermit Onouphrios are often shown in Sinai paintings: Onouphrios lived in the same area, and his cell survives

impressive haloes with combinations of jewels and pearls. At the same time, we should not overlook the fact that there are earlier examples in Cypriot wall-paintings (Stylianou 1985, fig. 218). But the lumpy bodies, the somewhat down-to-earth faces with their strong physiognomic types (Christ Anapeson, for example) and Christ Anapeson's clothing, held tight to the legs with sumptuous sew-on appliqués all reveal an Oriental conception that can be put down to, apart from anything else, the painter's ethnic origin. Perhaps he was a Christian monk of Syrian origin who had some connection with Cyprus and Sinai. Moreover, there are similarities of style with Cypriot painting, as we can see by comparing the Kykkotissa Virgin with the Virgin of Moutoullas, dating to 1280 (Sotiriou 1956, 172). All the above considerations make it very improbable that this diptych should be regarded as a 'Crusader' copy of some celebrated Palestine archetype of St Prokopios

(Weitzmann 1966, 69). An icon of Prokopios, now in the Patriarchate at Jerusalem (Garidis 1998, 231, pl. II, fig. 2), with faithful reproduction of the iconographic features of the saint's figure on the present diptych, is seemingly no earlier: we conclude this from its excessively dry modelling and the treatment of the clouds in combination with the angels. On the other hand, quite a number of the miniature scenes on the Jerusalem icon's frame show iconographic and stylistic influences from Sinai *Vitae* icons with various saints. This feature indicates that the Jerusalem icon was probably made at Sinai, and not vice versa.

We can sum up as follows for the St Prokopios diptych. It must have been painted at Sinai as a special commission for some well-educated Church dignitary, perhaps the abbot of the monastery himself. This at any rate is the inference from the unusual 'secret'

mode of narrating the venerable St Prokopios's life, from the saint's opulent appearance, from the iconographic and stylistic borrowings from the monastery's earlier icons, and from the decoration of the back surface of both leaves of the diptych with wavy red brushstrokes. This last is an interesting feature found on many twelfth- and thirteenth-century Cyprus and Sinai icons, and its systematic use shows that it was a local idiom (Mouriki 1990b, 105).

Mary Aspra-Vardavakis

Literature:
Sotiriou 1956-1958, 171-173, pls 188-190; Weitzmann 1966, 66-69, figs 33-40; Weitzmann 1978, 37, 112, pl. 37; Weitzmann 1984, 150, pl. LV, fig. 8; Weitzmann et al. 1982, 205, pl. on 227; Belting 1990, 375, 378, fig. 205; Mouriki 1990b, 119-120, fig. 65; Aspra-Vardavakis, forthcoming.

72

Panel of the Madonna and Child –
Madonna delle Vergini

105 × 61 cm
Egg tempera on wood
Early 14th century
Apulia
Bari, Pinacoteca Provinciale
(on permanent loan from Rome,
Museo di Palazzo Venezia)

The Madonna in half-bust holds the Child in her right arm. The Child performs a gesture of blessing with his right hand (with a mixed formula, bending the thumb and extending forefinger and middle finger) and lightly touches his mother's left hand with his own left. Both figures gaze at the viewer. The Madonna is clad in deep blue, with a maphorion over her head and her face framed by a *kekryphalos*. The Child wears a brilliant red tunic over a diaphanous under-garment. Extensive repaintings have substantially renewed the Virgin head and maphorion. The ground with lilies replaces what may have well been a flat gold ground. The pose and gesture of the Child are strongly reminiscent of the iconographic type of the Kykkotissa, even if there are obvious differences from that particular model. The red of the tunic makes a clear allusion to the Passion of the Lord.

The overwhelming features of the Kykkotissa type set this icon apart from the general trend of the production of devotional images in Apulia, connecting it with a few others from Sicily to Central Italy. It is hard to establish the reasons for this choice, since we lack information about the prestige of a major icon (in Italy) representing that type. In any case the present icon seems to reflect a 'second step' of this diffusion, due to the slight modifications of the authentic type, as it is reproduced more faithfully by other icons.

The painterly quality of Christ's head has prompted an attribution of this icon to the same painter as that of the large hagiographic icon of St Dominic (now in Naples, Museo di Capodimonte), which is ascribed, without compelling reasons, to a Giovanni da Taranto.

Valentino Pace

Exhibitions:
Icone di Puglia, Pinacoteca Provinciale, Bari 1988.

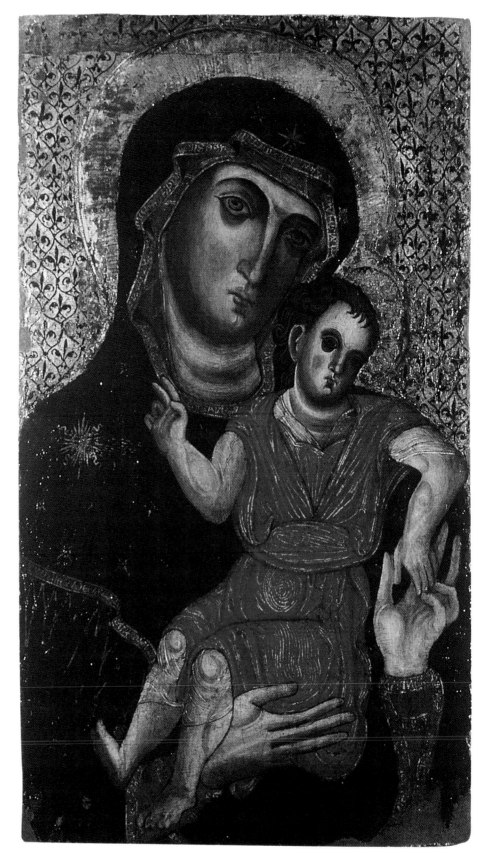

Literature:
Icone di Puglia, no. 30; Gelao 1988, 52-54 (with all previous bibliography).

73

Icon of the Virgin Eleousa, with
Dodekaorton Scenes and Saints

42 × 30 × 1 cm
Egg tempera on wood, stucco, *verre eglomisé*
Mid-14th century
Venice (?)
Athens, Benaki Museum, Inv. no. 2972

The Virgin is shown at the centre of this icon in the type of the Eleousa, in bust, with the Christ-Child in her arms. This central representation is crowned by an arch resting on spiral columns. On the façade of the arch are two small glass plaques in the *verre eglomisé* technique, showing the evangelists Luke and Matthew in medallions with acanthus leaves round the border. The whole composition is surrounded by a wide integral frame divided into twenty rectangular compartments where relief scenes of the Dodekaorton (the cycle of the Twelve Great Feasts) alternate with painted portraits of apostles topped by arches. Of the ten Dodekaorton scenes, six survive; and of the ten apostles' portraits, seven survive. A rope-like moulding surrounds the central representation and the compartments on the frame.

This icon is a unique example of the combining of different techniques on a single wooden surface. The central representation and the portraits of the apostles are executed in the technique traditional for portable icons, that is, in egg tempera on gesso. The compartments with the Dodekaorton scenes are in stucco, and have traces of gold on the haloes and of blue in the ground of every scene. Lastly, the evangelist medals on the faces of the arch are in the *verre eglomisé* technique, where the picture is engraved and then coloured on the reverse of the glass (Eisler 1961; Gordon 1981).

In the icon, features of traditional Late Byzantine painting technique and iconography are coupled with other features found in Italian, and in particular in Venetian, art. One of the purely Late Byzantine features is the iconographic variant on the Eleousa type that occurs in Byzantine icons of the fourteenth century. The essence of this variant is the way that Christ's hands move or are posed, with one resting caressingly on the Virgin's chin and the other falling limply downwards. Christ is in the same pose in a mid-fourteenth-century icon of the Eleousa from the Athonite monastery of Philotheou (Tsigaridas 1992, 654, pl. 355) and in an icon dating from the second half of the fourteenth century, now in the Moscow Kremlin Museum, and thought to be the product of a workshop at Constantinople (Smirnova 1989, no. 6, 260-261). There is also a close relationship between the relief scenes of the Dodekaorton and comparable decorative scenes on the silver revetment of an icon of the Virgin Hodegetria in the Vatopedi monastery, (Loverdou-Tsigarida 1996, 486, pl. 433), thought to be a Constantinopolitan work and dated to the first decades of the fourteenth century. This is yet one more piece of evidence in favour of connecting the Benaki icon with the art of the Late Byzantine period in general, and of Constantinople in particular.

It is, however, Venetian fourteenth-century art that is brought to mind by the treatment of the Virgin's face, her clothing, her punched halo, Christ's halo with incised lines, the three-lobed arches on the frame with their apostle portraits, the glass plaques with the evangelists, and the icon's decorative woodcarving. In detail, the features of the Virgin's face, with its taut, skin, the almond eyes, the delicate arched brows and still more delicate nose can all be found in the panels of Paolo Veneziano (1330-1350) — for instance, in the Madonna from the Coronation, now in the Frick Collection in New York (Muraro 1970, 116-117, pls 120-121). The ornament in pseudo-Kufic style on the border of the Virgin's robe, her wimple (*kekryphalos*), the olive-green lining of her robe, her orange-brown chiton with its tight cuffs ending in even tighter maniples with a long row of little buttons: all these can be found in Paolo's work (Muraro 1970, pls 28-30, 34, 44 and 53). The icon's decorative woodcarving is its most indisputably Venetian element, a typical example of Venetian Gothic style. The spiral columns are almost a cliché of Paolo's decorative woodcarving on polyptychs, such as the one in the Museum of Fine Arts at Tblisi, or the one of St Claire, in the Gallerie dell' Accademia in Venice (Muraro 1970, 36, 64, 122, 127-128, pls 31-32 and 113-114). To these elements can be added others, revealed by technical analysis, that show that the priming of the panel was in the two-layer gesso technique (gesso *grosso* and gesso *sottile*) favoured in central and northern Italy. There is a very detailed account of this technique by Cennino Cennini in his famous manual the *Libro dell'Arte*, which is usually dated around 1390 (*The Craftsman's Handbook*, 70-74, esp. 70-71).

The elements just mentioned can be taken to imply that the panel was produced in a Venetian workshop, but by a Byzantine painter, better acquainted with Byzantine than with Venetian traditions. The dimensions of the icon and its character suggest that this was a private commission, to very precise specifications. If, moreover, the general modality of the icon was laid down by the person who commissioned it, then this must have been somebody familiar with the art of the time both in Venice and in Byzantium. Was this some Byzantine, then, with a taste for Venetian art? Or some Venetian with a clear preference for Byzantine art?

Maria Vassilaki

Conservation:
Kalypso Milanou, 1988-1990.

Exhibitions:
Οι Πύλες του Μυστηρίου, National Gallery, Athens 1994.

Literature:
Xyngopoulos 1936, 1-4, pls 1-4; Beckwith 1966, 285, fig. 14; Delivorrias 1980, 37, fig. 28; Baltoyanni 1985, 49; Vassilaki 1991, 2, 1213; Baltoyanni 1991-1992, 224-226; Baltoyanni 1994, no. 20, pls 39-40; Milanou 1994, 61-68, pls 58-70; *Οι Πύλες του Μυστηρίου*, no. 43; *Greece at the Benaki Museum*, figs 442-443.

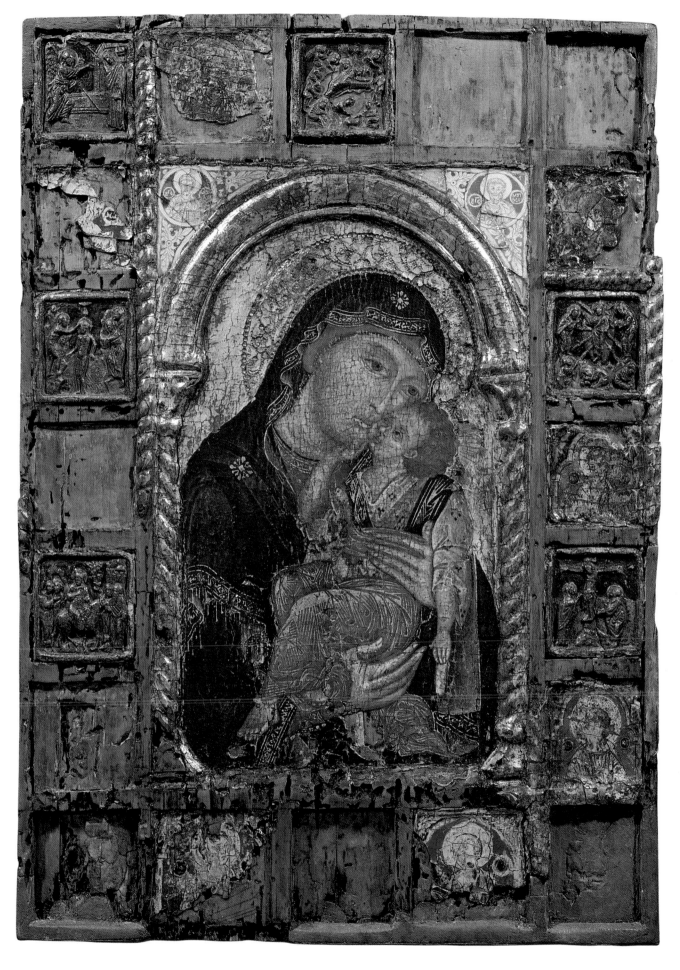

449

Section Six

Maria Vassilaki
Niki Tsironis

Representations of the Virgin and Their Association with the Passion of Christ

The development of the cult of the Mother of God has always been linked to Christology. In the fifth century, at the time of the Nestorian dispute, Mary became a focal point for defining the way in which humanity and divinity coexisted in Christ. Similarly, at the time of the Iconoclastic Controversy, Mary became instrumental for understanding incarnational theology, on the basis of which the veneration of icons was defended by the Iconophiles. The importance of Mary in Iconoclasm is testified by the substantial corpus of homilies and hymns composed in her honour during the eighth and ninth centuries. Accordingly, the veneration of the Mother of God was promoted by iconophile writers of the period as a synonym for the cult of icons.[1] The reason for this association was Mary's crucial role in the circumscription of the Word, that could thus be depicted in matter sanctified at the time of its assumption by Christ.

Along with the cult of Mary, iconophile writers drew increasing attention to the Passion of the Lord as the moment in which his full humanity was exemplified. The lament of the Virgin came to link the cult of Mary with the Passion of the Lord. The *kontakion* of Romanos the Melodos is the first instance in which these two themes are combined. After a break of almost two centuries the lament of the Virgin is encountered in the Iconoclastic period, while the ninth century witnessed the apogee of this literary theme that was subsequently incorporated in the liturgical books of the Church and used as a model by Byzantine artists.

The iconographic theme of the Virgin Eleousa, which predominates in the years after Iconoclasm, exemplifies the distinct emotional tone of the Marian homiletic corpus in the Middle Byzantine period, thus demonstrating that literature served as a model for iconographers. Furthermore, the facial features of the Virgin allude to the Crucifixion of the Lord, for her eyes and mouth are always depicted in an expression of restrained pain. The iconography of the Eleousa is further linked to the iconography of the Passion, the earliest representations of which show Christ alive on the Cross and omit the Virgin. As the theme evolves, and especially in the period after Iconoclasm, it becomes more elaborate, Christ is represented dead on the Cross, the nudity of his body is not concealed and the importance of his death is highlighted by the depiction of Nature in lamentation together with the Virgin (Pl. 226) and John, the beloved disciple, who flank the cross of his martyrdom.

The literature of the Iconoclastic period was dominated by a distinctly emotional spirit and the authors of the Marian corpus adopted the typology employed in previous centuries and adapted it to enrich their own imagery.[2] As a result, homilies in the Iconoclastic period are characterized by a particular emphasis on visual imagery which is combined with their emotional content. The conjunction of these two characteristics of homiletics of the Iconoclastic period is no mere coincidence. They support the iconophile argument for the cult of images that illustrate the human dimension of the incarnate God. Probably this is also the reason why the rhetorical device of *ekphrasis* was used extensively by authors of the Iconoclastic and post-Iconoclastic periods: in the eighth and ninth centuries writers resorted to such devices giving expression to an argument that formed part of the iconophile case in defense of the Incarnation and the cult of images. Hence, emotion and emphasis on the visual imagery of the sermon are the characteristics that define the nature of eighth and ninth century homiletics.[3]

225. *The Lamenting Virgin*, detail of Pl. 227.

453

The defeat of Iconoclasm in the ninth century gave a new impetus to the cult of the Virgin.[4] The first official work of art commissioned after the Restoration of Icons in 843 was the mosaic of the Mother of God that still survives in the apse of Hagia Sophia in Constantinople (Pl. 62). The mosaic was inaugurated by Patriarch Photios of Constantinople on Easter Saturday 867. The event is recorded in one of his homilies.[5] The patriarch is one of the few Byzantine homilists who had no qualms about referring directly to contemporary reality.[6] Hence, his homiletic corpus in general and his homily on the Inauguration of the Mosaic of the Virgin in particular reveal a significant link between the Mother of God and contemporary reality. The sermon is especially interesting not only for the description of the mosaic that has become the subject of modern scholarship, but also for the association of the image of the Virgin with the victory over Iconoclasm.[7] The feast as a source of joy stands out for three reasons, says the patriarch: firstly for the incontestable power of piety, secondly for the eradication of unbelief, and thirdly for the triumph it represents over those who ended their life in unfaith.[8] More specifically, Photios refers to the restoration and the veneration of icons by the imperial authority, and directly connects the icon of the Virgin with the Triumph of Orthodoxy.[9] He speaks of the way in which the icon of the Virgin diverts the mind from everyday concerns to the divine love of the true faith.[10] However, the description of the mosaic by Photios does not correspond to the actual representation. The epithets bestowed upon the Virgin in iconography are countless and, to a great extent, irrelevant to the type of the representation.[11]

The apse mosaic of Hagia Sophia depicts the Mother of God enthroned looking the viewer in the eyes as she holds Christ Emmanuel in front of her, an iconographic type of the Virgin common from the pre-Iconoclastic period.[12] Photios, however, gives the following description:

'A virgin mother, with both a virgin's and a mother's gaze, dividing in indivisible form her temperament between both capacities, yet belittling neither by its incompleteness. The art of painting, which is a reflection of inspiration from above, has set up such an exact imitation of her nature. For, as it were, with the love from her womb, she turns her eyes on the begotten child with feeling, yet assumes the expression of a detached and imperturbable mood at the passionless and wondrous nature of her offspring, and composes her gaze accordingly. You might think her not incapable of speaking ... To such an extent have the lips been made flesh by colours, that they appear merely to be pressed together and stilled as in the mysteries, yet their silence is not at all inert neither is the fairness of her form derivatory, but rather it is the real archetype... But before our eyes stands motionless the Virgin carrying the Creator in her arms as an infant, depicted in painting as she is in writing and visions, an interceder for our salvation.'[13]

The Virgin described in the homily of Photios would correspond to a representation of the Virgin Eleousa or the Virgin of Tenderness.[14] The apse mosaic of Hagia Sophia portrays a Virgin enthroned holding the Christ-Child, not of the Eleousa type and without an inscription. The discrepancy between Photios's text and the apse image was explained by James and Webb, on the basis of a broader interpretation of the rhetorical *ekphrasis* in homiletics. The patriarch goes beyond the realistic description of the image and expresses its spiritual significance. *Ekphrasis* is what the beholder might read rather than an actual description that would add nothing for the believer who can see the work itself. James and Webb write: 'Photios seeks to interpret and flesh out the image ... He aims to convey emotion, as *ekphrasis* is supposed to do, and to say something about the nature of the image in a spiritual context. The mosaic reveals the nature, the being, the *physis,* of the Virgin'.[15] According to this view, the homily of Photios describes the spiritual significance of the figure of the Mother of God holding Christ whereas the image depicts a type that was already widely acclaimed in the pre-Iconoclastic era. In this sense, the icon of the Virgin served most aptly the celebration of the Restoration of Icons since it restored the image of the Virgin depicted in a form familiar to the people.

This interpretation finds further support in the role of the Mother of God in Iconoclasm. In view of the symbolic use of concepts of the Virgin Mary during the controversy, it seems only

454

226.*The Virgin from*
The Crucifixion, detail.
Monastery of Daphni, Attica.

natural that the patriarch should commission a mosaic of the Virgin (and not of Christ) in order to celebrate the Triumph of Orthodoxy. As for the description of the mosaic, it corresponds exactly with the emotional character with which the Mother of God was invested in the literature of the eighth and ninth centuries; furthermore it expressed her character as the compassionate mother, the Virgin Eleousa, who mediates between mankind and her Son for the salvation of the former.[16] One of the earliest surviving examples of the iconographic type of the Virgin Eleousa comes from Tokali Kilise in Cappadocia (Pl. 18) and dates to the tenth century (945-963).[17] It seems, however, that there is a pre-Iconoclastic representation of the Virgin Eleousa in Santa Maria Antiqua, Rome.[18]

The nature of the relationship between text and image, and of the influence of the one upon the other, was discussed by Maguire who argued persuasively that rhetoric played a significant part in pictorial representation in Byzantium.[19] Models first established in homiletics were adopted by artists and eventually incorporated into iconography.[20] Antithesis, hyperbole, and most importantly the lament, the expression of grief, found a place in wall-paintings, mosaics and portable icons, in conformity with the Acts of the Seventh Ecumenical Council: 'that which the narrative declares in writing is the same as that which the icon portrays visually'.[21] In this context it might be suggested that the emotional Mary of the literature of the Iconoclastic period served as a model for the iconographic type of the Virgin Eleousa or of Tenderness. Clear cuts are not to be imagined, either in the literary descriptions of the Virgin or in the relevant iconographic types. For example, the triumphal Virgin of the sixth and seventh centuries, protectress of Constantinople, was not abolished in order to be replaced by the human Mother of God of the post-Iconoclastic period. On the contrary, older literary and iconographic types were retained and enriched with additional characteristic qualities or points of emphasis that served the theological discourse of the time.

So, in the period following 843, the Virgin emerged triumphant. Her crucial role in the Incarnation of the Word justified her role as mediator for the Salvation of Mankind. The Restoration of Icons is celebrated on the first Sunday of Lent, the Sunday of Orthodoxy, and for it a special icon was devised: the feast-icon of the Triumph of Orthodoxy. To date the rarity of icons in honour of such an important feast of the Orthodox Church has not been adequately explained. The famous example in the British Museum (Cat. no. 32) dating around 1400, is the earliest to have survived.[22] It is divided into two registers. The upper register is dominated by an icon of the Virgin Hodegetria whereas the central figures in the lower register hold an icon of Christ Emmanuel.[23] Another icon of Christ is in the hands of a nun who has been identified as St Theodosia of Constantinople.[24] Both icons of Christ depicted in the lower register are far smaller than and do not balance the large image of the Virgin which is identified as the Virgin Hodege-

455

tria.[25] The inscription on the right of the Virgin may be read as ΟΡΘΟΔΟΞΙΑ (Orthodoxy). This direct association of the Virgin with the Restoration of Icons demonstrates the manner in which she represented and embodied iconophile arguments about and beliefs in the Incarnation and the worthiness of matter. In this we glimpse at the symbolic use of the Mother of God, that is her use as a synonym for the cult of icons.

The relationship of the Virgin with the Crucifixion is hinted at in the description of the procession of the icon of the Hodegetria, given by a Russian pilgrim who visited Constantinople in the late 1340s. This pilgrim, named Stephen, described the manner in which the icon seemed to direct its blindfolded bearers.[26] Ševčenko mentions that one of the numerous icons in the possession of the Blachernai monastery was kept in the prothesis of the church; it was covered by a veil that miraculously lifted without human aid every Friday evening.[27] There is no mention of the miracle dating before the eleventh century. The fact that it took place every Friday, the day on which the Crucifixion of the Lord is commemorated by the Church, could suggest an underlying association of the Virgin Mary with the event and, of course, the development of her lament that was introduced into Byzantine literature during the Iconoclastic period and became a source of inspiration for iconographers.[28] The account of the procession mentions that the icon of the Virgin Hodegetria was very large and richly ornamented; the bearer stands upright, 'and he stretches out his arms as if (being) crucified. It is terrible to see how it pushes him this way and that around the monastery enclosure, and how forcefully it turns him about, for he does not understand where the icon is taking him... A marvelous sight: (it takes) seven or eight men to lay (the icon) on the shoulders of one man, and by God's will he walks as if unburdened'.[29] The cruciform pose of the bearer of the icon connects the Mother of God directly with the Crucifixion. The pilgrim's description also evinces the power of the Virgin, while the ceremony itself attests to the widespread popularity of the Mother of God in Constantinople.

The lament of the Virgin at the foot of the Cross forms part of the elaboration of her human qualities by writers of the Iconoclastic and post-Iconoclastic periods. Furthermore, it served the purpose of emphasizing Christ's death on the Cross, a subject that received particular attention from the seventh century onwards and especially during the Iconoclastic Controversy. Mary is portrayed lamenting Christ in a highly emotional manner that urges the congregation to participate in the events of the Passion. She embodies every human mother that grieves for the death of her child and in this way she becomes a link between humanity and the divine realm. However, Mary's lament was also used as a means of catechizing, for it coincided with Good Friday, the day on which catechumens were baptized. However distressed she may be, Mary does not lose her faith and courage, and finally assents to the plan of the Divine Economy.

Photios's homilies on Good Friday are of a catechetical character, full of ethical commands and exhortations to his audience to follow the teaching of the Gospel and to set aside the concerns of earthly life while concentrating on the kingdom of God. The subject of the Passion of the Lord does not lie at the core of the homilies, which refer to it only as a pretext for introducing the admonition. All of Photios's homilies on Good Friday were delivered from the pulpit of the church of St Irene.[30] The first homily is dominated by the theme of the regeneration of mankind.[31] The Mother of God is associated with the Passion of the Lord in a passage that stresses the salvatory importance of the mystery for humanity: 'He, who was made man by the Virgin, is crucified in order to save mankind'.[32] Homilies on the Passion are distinguished by standard themes, such as anti-Jewish polemic, the sympathy of Nature, the humiliation and loneliness of Christ and of the Mother of God. All these themes are expressed vividly through antithetical imagery that serves to intensify the events narrated. In the Paschal homily by Melito of Sardis and the hymn of Mary at the foot of the Cross by Romanos the Melodos, apart from its ritual characteristics the Marian lament is also weighted with a theological gravity determined by contemporary debates.

Photios elaborates on the account in the Gospel (Mark 15:43) according to which Joseph

of Arimathea went to Pilate to ask permission to take and bury the body of the Lord. The theme of the one who is a stranger and abandoned by disciples and friends is introduced into Joseph's address to Pilate.[33] Of particular importance for the study of the lament is what follows upon the permission granted by Pilate: Joseph takes the body of the Lord in order to bury it, and at this point the author introduces a lament which, though not voiced by the Virgin, bears a strong resemblance to her lament at the burial of the Lord.[34] It should be noted that this is the first instance of a homilist introducing a lament for Christ at his Entombment, and not on the way to his Crucifixion or his suffering on the Cross. Antithesis offers itself as a formula often resorted to in homilies of the Passion. The philanthropy of God is contrasted with the ingratitude of the Jews who represent mankind in general,[35] the sorrow over Christ's death with the anticipation and joy of the Resurrection, and so on. The lament of Joseph is characterized by the same antithetical formula expressed in a highly immediate fashion. What 'painterly- speech' could express his mood at that time?[36] He rejoiced at having obtained what he desired, but at the same time he lamented at the sight of the dead Christ. Joseph's lament is notable for the distinct emphasis it lays on his experience of touching the dead body and the emotions this evoked. The features of the dead are referred to one by one and each induces the author to lament the deceased.

George of Nikomedeia, a near contemporary of Patriarch Photios, delivered homilies on the same occasions (Friday and Saturday in Holy Week), in which he employed many elements already encountered in the homilies of Photios, although his interest lay largely in the Mother of God. They do not focus so much on the person of Christ as on that of his mother. This is the reason why George of Nikomedeia represents a landmark in the study of the lament. The imagery he uses in his homily on Good Friday[37] is inspired by relevant texts from previous centuries, such as the Paschal Homily by Melito of Sardis and the hymn on Mary at the foot of the Cross by Romanos the Melodos. As far as we know, George's homily on Good Friday is the first extant example of a Marian homily on the Crucifixion of the Lord.[38] A merely superficial reading suggests that Mary's central place in the narration serves to emphasize the strong link between Christ and his mother. But George, as a preacher, is concerned first with the theological interpretation of the Passion of the Lord, second with the vivid transmission of events to his audience, and third with the participation of his audience in the events narrated.[39] Within this context Mary's central place can be interpreted as the means by which George emphasizes Christ's full humanity. The homily on the Crucifixion and the Entombment of Christ begins with the narration of the events of Thursday in Holy Week: the Last Supper, the Arrest, the Trial and the Way to Calvary. George asserts that the Virgin was present in every one of these scenes, marking the way of the Lord to his death and the way of mankind to salvation.[40] Therefore, it is not the relationship of Jesus and Mary that is at stake but Christ's full humanity, a proof of which is his link with his mother. Similarly, Mary's lament that intersperses the homily voices her distress over the loss of her son and her God within the context of his salvatory mission. The lament represents the combination of the two themes that acquired distinct prominence during the Iconoclastic Controversy: the Passion of the Lord and the place of the Virgin in the Mystery of the Incarnation.

A close reading of the homily on Good Friday reveals that George employs standard themes of the lament: the *topoi* of anti-Jewish polemic, the sympathy of Nature and the solitude of the deceased and of the person who laments, as well as an antithetical imagery that embraces all the themes mentioned above. The lament of the Virgin interpolates the narrative, rendering it more vivid to the audience. George's narrative technique is skilfully contrived. Although it may seem tedious to the modern reader,[41] when read aloud this homily is very finely structured in that the narrative is balanced by poetic interventions that arouse emotion and are pleasant to the listener's ear. Throughout the homily George plays upon emotions, probably as an indirect way of asserting humanity, especially in the narration of the Passion.[42]

The events and the standard themes of the lament are expressed through an antithetical

imagery that contrasts life with death, kindness with murder, gratitude with ingratitude and so on. The pattern of the narrative is antithetical too the goodness of the Lord is contrasted with the wickedness of creatures, the harmless lamb with the wild beasts, and finally the mildness of Christ is contrasted with the anger of men.[43] A sharp distinction is drawn between Mary's fervent love for her son and the rebukes, the whipping, and the mocking of Christ by the Jews.[44] When the narrative reaches the place of the Crucifixion,[45] the Virgin, pushed aside by the soldiers, eventually manages to approach the Cross and there, at its foot, addresses Christ in a long lament that reproduces all the images encountered in the study of the development of the Marian lament. The ingratitude of mankind holds first place,[46] and is contrasted with the miracles of Christ, the Raising of Lazarus, the healing of the blind, and the curing of lepers; finally, his philanthropy in general is contrasted with the blatant murder performed on Golgotha.[47] Another commonplace of homiletics is the contrast between the felicitous past and the afflicted present.[48]

Anti-Jewish polemic is employed by George of Nikomedeia to contrast his community with the outsiders and to give it a sense of righteousness.[49] The Jews represent the whole of mankind that put Christ to death. Christ is described as the innocent lamb: mild, sweet and humble.[50] His qualities are contrasted

227. Diptych: A. *The Lamenting Virgin.* Museum of the monastery of the Transfiguration, Meteora.

with those of his murderers. In order to add intensity to the crime of humanity, George contrasts the ingratitude of mankind with Nature which recognizes and laments the death of the Saviour. Moreover, Nature is called upon by the Virgin who seeks the consolation of others who share her grief. In her lament Mary calls the sun to set, the sky to mourn, the earth to tremble and the meadows to share in her weeping.[51] In this way, George emphasizes Mary's solitude in the foreign land. Similarly, when he describes the scene where the Virgin stands in the courtyard of Annas and Caiaphas awaiting the decision of the court, the homilist stresses her loneliness among the people who were against her son.

The solitude of the Virgin leads on to the lament of the mother at the time that Christ is being judged.[52] George describes in a very vivid and dramatic way the agony of the Virgin waiting outside the court-room[53] and trying to guess what was happening inside from the random comments of passers-by;[54] her despair on learning that they wanted unanimously to put Christ to death;[55] and her total isolation when all his disciples and friends hid themselves or denied their connection with him.[56] Her solitude, that makes her pain even harder to bear, looms large in her lament. In a manner reminiscent of judicial oratory, the Mother of God asks why the court should want to condemn Christ.[57]

The suffering of Christ and his humiliation by the soldiers at Herod's palace are described by the broken-hearted Mary who laments her son: 'How could she bear to see him being led away as a common criminal? How could her spirit bear to see him being condemned and whipped in public, and suffering and rebuked by the soldiers?'.[58] Every torment the Lord was suffering was for Mary a sword pointed at her heart even before the Crucifixion.[59] The mother's pain is described as fire that melts her heart, as a knife that penetrates her very being.[60] Her motherly

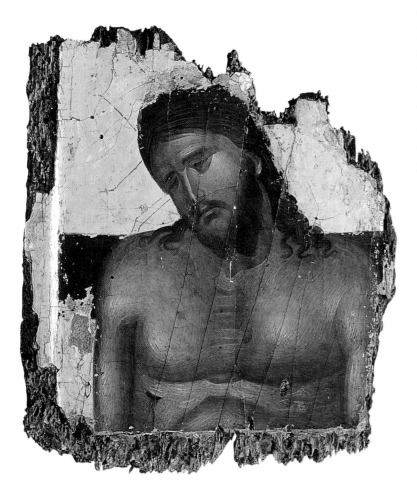

228. *Diptych:* B. *The Man of Sorrows.*
Museum of the monastery of the Transfiguration, Meteora.

love for Christ is expressed in words most apt to convey the emotional tension and gravity of the scene.[61] Mary wishes she could suffer in the place of Christ and calls upon Nature to respond to the injustice.[62] The twin fires of her love for Christ, her son and God, bring to mind the *kontakion* by Romanos the Melodos in which the Virgin laments Christ in a similar way.[63] The accomplishment of the prophecies, the gall and vinegar, the robe for which the soldiers cast lots, the piercing of the side and each successive event of the Crucifixion make the Virgin weep bitterly at the suffering of the Lord.[64]

The exalted status of the Virgin does not contradict her emotional mood as depicted in the homily. According to George, Mary's pain and distress at the time of the Crucifixion are justified by the 'excess of daring' directed against her son.[65] The homilist goes on to assert that Mary is free of the passions of human nature, and so describes her in terms of the all-holy and all-pure Virgin encountered in other homilies of his and in the literature of previous centuries. The fact that George is at pains to establish Mary's exalted status is proved by his recounting an episode that occurred at the time of the Crucifixion. The episode is not encountered in any other written record of the Crucifixion prior to the ninth century. In the dialogue between Mary and Christ on the Cross, George has Christ entrust his disciples and the whole of mankind to his mother, who henceforth was to be their spiritual guide.[66] So it is George who first introduces the ecclesiological character of the Virgin by declaring her to be the Mother of the Church, through whose mediation the faithful could find a refuge.[67] When Christ entrusts his mother to his beloved disciple John (John 20:26-27), George adds the crucial words with which Christ asks him to respect Mary and to accept her as *kathegoumene* of himself and the other disciples.[68]

Even more important in any study of the lament is the attitude taken by the Virgin. In his narration of the Last Supper, George states that it was Mary rather than any of the disciples who retained deep in her heart all the words spoken by Jesus.[69] Despite her affliction, she follows him to the court and later to Golgotha when all his friends and disciples are reported to have scattered for fear of the Jews.[70] After the soldiers have crucified Christ, the Virgin makes her way to the foot of the Cross and addresses her son.[71] Christ recognizes the fire that is consuming his mother's heart and entrusts her to beloved disciple.[72] He urges his mother to overcome her nature and to accept the suffering of his death, for it will bring Salvation to Mankind.[73] The Virgin, who has so far been depicted as the afflicted mother, now changes her attitude and consents to the accomplishment of the Mystery. Although her lament will be reintroduced at the time of the Entombment, at the foot of the Cross the Virgin overcomes her human nature and enters into a deeper communion with God. Perhaps this is the point that George is at pains to convey to his congregation of catechumens. Mary's sorrow is searing her heart, but it is not a godless sorrow. The Mother of God has been made aware of the salvatory mystery that is to be accomplished by the death of Christ and so submits to the will of God. Her 'conversion' to a higher mode of existence reveals the dynamic perception of her person by George of Nikomedeia

and certainly leaves no leeway for her to arrive at an understanding of her son being a humble human being whose greatest virtues were purity and blind obedience.[74]

George pictures the Virgin as devastated by the Crucifixion that has just taken place but nonetheless aware of the Resurrection that is to come and trying to arrange all that is necessary for the burial of the Lord.[75] She herself finds the place where the Lord should be lain, asks to whom it belongs and, on hearing that the owner was a friend of Jesus, seeks him out and begs him go to Pilate and request the body of the Lord.[76] Her address to Joseph of Arimathea is in the form of a lament in which she makes much of the fact that she is a foreigner in his land and utterly alone.[77] The deposition of the body of Christ from the Cross is again described in the lament of the Virgin.[78] George allows the mother's sensibilities full play: the Virgin laments as she receives each member of her son's body into her arms, and wishes she could see her son alive again and hear his voice once more.[79]

George's devotion to Mary is expressed in the epilogue where the homilist speaks in the first person singular.[80] He glorifies the economy, the mercy, the tolerance of God.[81] In a series of clauses that start with the verb 'I venerate', he expresses his devotion to the instruments of the Passion and the tomb of the Lord,[82] but above all to the person of the Mother of God. George draws particular attention to the hands of the Virgin that have assisted the Divine Economy, namely, the Nativity and the Entombment of Christ.[83] Finally, the Mother of God is glorified as the only one who saw and shared the Divine Passion and as the herald of immortality.[84]

George's particular devotion to the Mother of God is also evident in the homily on Saturday in Holy Week, which must have been delivered after the homily on Good Friday. In this he vouches for the presence of the Virgin at Christ's tomb, despite the contrary account given in the Gospel. The silence of the evangelists on the presence of the mother is explained as a deliberate omission by them in order to enhance the credibility of the story of the Resurrection. If the good news of the Resurrection were to be announced by the mother it might not be believed, given the intimate relationship between mother and son. George maintains that Christ appeared to his mother in a more 'familiar' and 'secret' way,[85] and that Mary his mother saw the resurrected Christ even before the angels.[86] The homilist gives a brief account of the events that preceded the Entombment of the Lord and says that it would be only natural for the mother who shared his last hours and was aware of what was to come to remain outside the tomb waiting for his glorious Resurrection. Mary addresses Christ at length, dwelling on the awesome Mystery of his death on the Cross and urging him to show to the world and to her, who longs to see him again, his glorious Resurrection. Emphasis is laid on visual perception: the need of the Virgin to see her son once again, to be in his presence and to hear his voice. Here, Nature too plays an important role: as at the Crucifixion it expressed grief and rage, now it expresses exhilaration, joy and peace.[87] The homily concludes with George urging Christ to reveal to the congregation his radiance and his ineffable beauty. On behalf of his congregation he wishes to be granted the grace to see, to hear and to feel the presence of the Lord.[88]

The literary themes in which the Virgin is associated with the Passion of the Lord obviously serve the function of the theological discourse of the Iconoclastic period and its outcome. The birth and death of Christ were the two moments *par excellence* in which his full humanity was exemplified. On the basis of Christ's humanity Iconophiles were able to argue for the sanctification of the assumed matter and hence, for the depiction of the divine upon matter. From the first Christian centuries the Mother of God was invested with epithets or notions that would clarify the Mystery of the Incarnation of God and would establish a more or less consistent doctrine for the new religion. During the course of the Early and Middle Byzantine periods the Virgin was invested with typological images while she also became protectress of Constantinople, mediator on behalf of mankind and finally, the human mother who laments her son at the hour of his martyrdom on the Cross. The Virgin's pain at the foot of the Cross is also imprinted in her depiction in the Nativity as well as in the various iconographic types in which she is shown

holding Christ in her arms. The sorrowful eyes of the Virgin that are not to be encountered in pre-Iconoclastic depictions, where the Virgin is mainly presented in a frontal pose staring majestically at the beholder, become her main characteristic in the period following 843.

In post-Iconoclastic literature the Virgin is portrayed in a manner that recapitulates all attributes of her person that had been bestowed on her by Christian writers of preceding centuries. The lamenting Virgin expresses both the human qualities of Mary elaborated in the writings of the Iconoclastic period and her association with the death of Christ. In the literature of the ninth century Mary's lament reaches a zenith that can be compared only to the poetic ingenuity of Romanos the Melodos in the fifth century. The person of Mary and the suffering of Christ were essential to comprehension of the Incarnation, through which matter was sanctified and consequently artistic representation was sanctioned as legitimate.

Parallel to this, the Virgin is gradually associated with the Passion of Christ, initially in literature and subsequently in art. Early depictions of the Crucifixion omit the presence of the Virgin at the foot of the Cross altogether. As the type develops Mary and elements of her lament, like Nature, are included in the scene that becomes more common in the post-Iconoclastic period. Apart from the representations of the Crucifixion itself Mary is also seen in other types that emerged during that period, such as the Deposition from the Cross (which is also an artistic echo of a literary theme) and the Lamentation (which became known and popular in the West as the Pietà type). Interesting too are the examples of the two-sided icons often used in processions,[89] that depict on the one side the Virgin and Christ-Child and on the other Christ as Man of Sorrows (Cat. no. 83) or the Crucifixion (Cat. no. 84), as well as the diptychs with the mourning Virgin on one leaf and the Man of Sorrows on the other (Pls 227 and 228) that were used in the Liturgy of Friday and Saturday of the Holy Week.[90] The origins of these iconographic developments are to be found in the literary texts that were produced for the first time in the fifth century (Romanos the Melodos) and were reintroduced in Byzantine literature in the Iconoclastic and post-Iconoclastic periods. The relationship of the Virgin with the Passion, apart from its obvious coexistence in the types mentioned above, is also imprinted in the expression of Mary in the iconographic type of the Virgin Eleousa, the tender Virgin that set its seal on post-Iconoclastic iconography.

[1] See the essay by N. Tsironis in the present volume, 27-39.

[2] Babić stresses the fact that iconophile thinkers appealed to the faithful by addressing themselves to the psychological rather than the rational being. Babić 1994, 198.

[3] The 8th-century example of a believer whose eyes filled with tears as he prayed before an icon is recorded in an epistle of Theodore the Studite, *PG* 99, 500A-B.

[4] Cormack 1985a, 142.

[5] Laourdas 1959, 164-172.

[6] This could also be the reason why his homiletic corpus has not been as popular as the rest of his literary work. For a comparison of Photios with his contemporary George of Nikomedeia and the different nuances of style they employ in their homiletic writings, Tsironis (forthcoming).

[7] On the apse mosaic of the Virgin in Hagia Sophia, Grabar 1957, 185; Mango 1958, 283-85; Mango 1962, 80-82 and 94-95. Also the essay by R. Cormack in the present volume, 107-123.

For the redecoration of other buildings of Constantinople from 843 to 867, Jenkins and Mango 1956, 125-140; Cormack and Hawkins 1977, 175-251.

[8] Mango 1958, 286-296.

[9] Mango 1958, 166-167.

[10] Mango 1958, 167.

[11] Grabar 1979.

[12] The best known example is the 6th-century encaustic icon of the Virgin and Child with Angels and Saints from the monastery of St Catherine at Sinai (Cat. no. 1 with full bibliography).

[13] Mango 1958, 290, 295; Laourdas 1959, 167, 171.

[14] The appellations ascribed to the two basic iconographic types of the Virgin, the Hodegetria and the Eleousa, vary greatly and there is no consistency in the way they are used. It is not uncommon to find a Hodegetria icon accompanied by an inscription of the Mother of God Eleousa, or vice versa. It is generally accepted, however, that this iconographic type, alternatively called Eleousa or Glykophilousa (the

latter in Post-Byzantine times), was widespread in the post-Iconoclastic period. Ševčenko (*ODB*, 2171) asserts that the appellation Eleousa was in use in the 8th and 9th centuries and that it was 'attached with rather little consistency to a wide variety of her images'

[15] James and Webb 1991, 13. For the relationship between text and image, Maguire 1996; Brubaker 1989, 19-31 and esp. 23-25.

[16] For the relationship between the Virgin Eleousa and the liturgy of the Passion, in which special emphasis was placed on the Virgin's love for Christ both as an infant and at his death, Pallas 1965, 169-173. Also, Lasareff 1938, 36-42; Grabar 1975b, 25-30.

[17] Thierry 1979, 59-70, esp. 59, figs 1, 2, 13; Wharton Epstein 1986, 118-119, fig. 7.

[18] Nordhagen 1990, 312ff.

[19] Maguire 1981, *passim.*

[20] Cormack 1977, 147-163 and esp. 151-153 in which the author draws attention to the use of the homily on Good

Friday by George of Nikomedeia as a model for iconography.

[21] Mansi 1960, XIII, 232C.

[22] See the entry by R. Cormack in the present volume, with all the previous bibliography.

[23] Cormack has identified them as Theophanes and Theodore the Studite.

[24] St Theodosia was the woman who tried to rescue the icon of Christ on the Chalke Gate at the outbreak of Iconoclasm.

[25] For the icon of the Virgin Hodegetria, see the essay by C. Angelidi and T. Papamastorakis in the present volume, 373-387.

[26] Majeska 1984, 361-362. Many icons were in the possession of the Monastery of Blachernai. Apart from the icon mentioned in the Life of Stephen the Younger, there is another described in the *Book of Ceremonies*, 555.8-10. This particular icon adorned the imperial bath and depicted the Virgin from whose hands holy water flowed. Mango and Scott 1997.

[27] *ODB*, 2170.

[28] Grumel 1931, 129-46. Belting 1994, 47-48 notes that 'processions played an important role in the presentation techniques of venerated images. In such cult stagings the moving image took on a quasi-personal life; it functioned like an individual and thus could not be confused with all the other images'.

[29] Majeska 1984, 362.

[30] Laourdas 1959, 29.

[31] Photios, *On Good Friday*, I, 1-3.

[32] Photios, *On Good Friday*, I, 27. In the third homily on Good Friday employing triumphant imagery and vocabulary Photios adopts an aggressive stance towards the devil and death as the enemy of man, for the defeat of which Christ came upon earth and was crucified. In the same homily the patriarch concentrates more on the instruments of the Passion and the human actions surrounding the Crucifixion rather than on the theological-speculative aspects of the mystery. Photios, *On Good Friday*, III, 62-63.

[33] Photios, *Homily on the Burial of the Lord*, 110.

[34] Photios, *Homily on the Burial of the Lord*, 111ff.

[35] Photios, *Homily on the Burial of the Lord*, 113-114.

[36] Photios, *Homily on the Burial of the Lord*, 111.

[37] George of Nikomedeia, *Oratio in sepulturam Jesu Christi*, PG 100, 1457-1489; George of Nikomedeia, *In Immaculatae Virginis*, PG 100, 1489D-1504C.

[38] The popularity of the homily is attested by the fact that it was pre-scribed as a reading for Good Friday and art historians regard it as the source of the new iconographic types that emerged in the post-Iconoclastic period, such as the Deposition, the Entombment, the lamenting Virgin, the Man of Sorrows and the Virgin of the Passion. Maguire 1981, 101ff.; Barber 1997, 198-214 and esp. 204-205; Cormack 1997, 113.

[39] For the use of description and narrative by Byzantine homilists, Maguire 1981, 22-23. For discussion of the theological aspects of the Paschal Mystery, von Balthasar 1990, 148-68.

[40] The events of Holy Thursday are described in a concise narrative in which the presence of Mary is particularly emphasized. George of Nikomedeia, *Oratio in sepulturam Jesu Christi*, PG 100, 1464A-B.

[41] Mango 1958, 8.

[42] Cf. the imagery of the homily to the miniatures of the Crucifixion, Deposition and Entombment in Paris. gr. 510, fol. 30v. Brubaker 1996, 9-34 and esp. 11ff. and fig. 1 on 20.

[43] George of Nikomedeia, *Oratio in sepulturam Jesu Christi*, PG 100, 1464B.

[44] George of Nikomedeia, *Oratio in sepulturam Jesu Christi*, PG 100, 1465D-1468A.

[45] Interestingly, the *contrapuncto* between each suffering of Christ finds its counterpart in the heart of the mother. George of Nikomedeia, *Oratio in sepulturam Jesu Christi*, PG 100, 1468D: 'O, as the nail in the hand, was the sword was implanted in her heart...As the drops of blood (flowed) from the wounds, how much more did the tears flow from her eyes...'.

[46] George of Nikomedeia, *Oratio in sepulturam Jesu Christi*, PG 100, 1469C: 'Is this the reward for your great philanthropy? With such honours do the ones who benefited reward you. O, most unjust daring! O, unholy judgement! The unjust condemn the just; the guilty accuse the innocent; the ungrateful kill the benefactor; the wicked slaves put the good master on the Cross...'. Also in 1472A.

[47] George of Nikomedeia, *Oratio in sepulturam Jesu Christi*, PG 100, 1472A.

[48] George of Nikomedeia, *Oratio in sepulturam Jesu Christi*, PG 100, 1476A. For the contrast of the different periods of time in the lament, Maguire 1981, 96-97.

[49] George of Nikomedeia, *Oratio in sepulturam Jesu Christi*, PG 100, 1457B-C.

[50] George of Nikomedeia, *Oratio in sepulturam Jesu Christi*, PG 100, 1468A-B.

[51] George of Nikomedeia, *Oratio in sepulturam Jesu Christi*, PG 100, 1472C.

[52] George prepares the lament by noting that the disciples were scattered about because of their fear of the Jews and draws a contrast between them and the Virgin whose desire for her beloved overcame the danger. George of Nikomedeia, *Oratio in sepulturam Jesu Christi*, PG 100, 1464B.

[53] George of Nikomedeia, *Oratio in sepulturam Jesu Christi*, PG 100, 1465B.

[54] George of Nikomedeia, *Oratio in sepulturam Jesu Christi*, PG 100, 1464B.

[55] George of Nikomedeia, *Oratio in sepulturam Jesu Christi*, PG 100, 1465A.

[56] George of Nikomedeia, *Oratio in sepulturam Jesu Christi*, PG 100, 1465A-B.

[57] George of Nikomedeia, *Oratio in sepulturam Jesu Christi*, PG 100, 1465B.

[58] George of Nikomedeia, *Oratio in sepulturam Jesu Christi*, PG 100, 1465C-D.

[59] George of Nikomedeia, *Oratio in sepulturam Jesu Christi*, PG 100, 1468A.

[60] George of Nikomedeia, *Oratio in sepulturam Jesu Christi*, PG 100, 1468B-C.

[61] George of Nikomedeia, *Oratio in sepulturam Jesu Christi*, PG 100, 1472A.

[62] George of Nikomedeia, *Oratio in sepulturam Jesu Christi*, PG 100, 1472B.

[63] George of Nikomedeia, *Oratio in sepulturam Jesu Christi*, PG 100, 1473B.

[64] George of Nikomedeia, *Oratio in sepulturam Jesu Christi*, PG 100, 1477C-1480B.

[65] George of Nikomedeia, *Oratio in sepulturam Jesu Christi*, PG 100, 1464B.

[66] For Mary's spiritual guidance in the Church, Kniazeff 1990, 68ff.

[67] George of Nikomedeia, *Oratio in sepulturam Jesu Christi*, PG 100, 1476D.

[68] George of Nikomedeia, *Oratio in sepulturam Jesu Christi*, PG 100, 1477A-B.

[69] George of Nikomedeia, *Oratio in sepulturam Jesu Christi*, PG 100, 1464A.

[70] George of Nikomedeia, *Oratio in sepulturam Jesu Christi*, PG 100, 1464B.

[71] George of Nikomedeia, *Oratio in sepulturam Jesu Christi*, PG 100, 1469B-C.

[72] George of Nikomedeia, *Oratio in sepulturam Jesu Christi*, PG 100, 1473D.

[73] George of Nikomedeia, *Oratio in sepulturam Jesu Christi*, PG 100, 1476B-C.

[74] Nellas 1987.

[75] George of Nikomedeia, *Oratio in sepulturam Jesu Christi*, PG 100, 1484A.

[76] George of Nikomedeia, *Oratio in sepulturam Jesu Christi*, PG 100, 1484B-C.

[77] George of Nikomedeia, *Oratio in sepulturam Jesu Christi*, PG 100, 1484C-1485B.

[78] George of Nikomedeia, *Oratio in sepulturam Jesu Christi*, PG 100, 1488A-C.

[79] George of Nikomedeia, *Oratio in sepulturam Jesu Christi*, PG 100, 1488B.

[80] George of Nikomedeia, *Oratio in*

sepulturam Jesu Christi, PG 100, 1488C-D.

[81] George of Nikomedeia, *Oratio in sepulturam Jesu Christi, PG* 100, 1488D.
[82] George of Nikomedeia, *Oratio in sepulturam Jesu Christi, PG* 100, 1489A-B: 'I venerate your suffering,...I venerate your Cross,...I venerate the nails,...I venerate the wounds in your limbs. .I venerate the rod...I venerate the sponge...'.
[83] George of Nikomedeia, *Oratio in sepulturam Jesu Christi, PG* 100, 1489C.
[84] George of Nikomedeia, *Oratio in sepulturam Jesu Christi, PG* 100, 1489C.
[85] George of Nikomedeia, *In immaculatae Virginis in sepulcro assistentiam,*

et gratiarum actio pro gloriosa resurrectione, PG 100, 1497B.

[86] George of Nikomedeia, *In immaculatae Virginis in sepulcro assistentiam, PG* 100, 1500C.
[87] George of Nikomedeia, *In immaculatae Virginis in sepulcro assistentiam, PG* 100, 1501C-D.
[88] George of Nikomedeia, *In immaculatae Virginis in sepulcro assistentiam, PG* 100. 1504B.
[89] Belting 1980-1981, 1-16; Belting 1994, 261-296.
[90] Belting 1980-1981, 1-16, figs 4-5; Chatzidakis and Sofianos 1990, pl. on 64.

74

Mosaic icon of the Virgin Episkepsis

107 × 73.5 cm (mosaic area: 95 × 62 cm)
Tesserae on wood
Late 13th century
Constantinople (?)
Athens, Byzantine Museum, Inv. no. T145

This treasured mosaic icon comes from Trigleia in Asia Minor. A holy relic of refugees leaving their homeland on the south shore of the Sea of Marmara in 1922, it was given on loan to the Byzantine Museum by the Asia Minor Relics Commission. Its rescuer was Philippos Kavounidis, who also rescued a fourteenth-century two-sided icon of the Virgin Pantobasilissa, now in the Pantobasilissa church at Rafina (Acheimastou-Potamianou 1991, 8ff., figs 9-10). This latter work was in all probability the 'icon of veneration' of the Pantobasilissa church at Trigleia, dating from the Palaio-logan period (Mango and Ševčenko 1973, 235ff.; Ousterhout 1991, 87). It shared a tradition of 'miraculous discovery' with the present mosaic. The latter was deposited in the church of St Basil, which was then renamed Holy Episkepsis.

Mosaic icons were one of Byzantium's costliest forms of art. The majority were small images, veritable masterpieces, mainly made in the city's imperial workshops. Of large mosaic icons, barely a dozen survive. One of these is the present example, which is now in the Byzantine Museum, and was perhaps originally a despotic icon placed in an inter-columnar space of the iconostasis. Its size sets it apart from the other extant works.

The icon's panel is made up of three pieces of wood, with a thinner frame nailed on. Here and there the mosaic has disappeared, exposing the surface of the wood, scored so that the gum mastic adheres better. The frame, the joints of which are still partly overlapped by the tesserae, will have had a silver (or gold and silver) revetment. There will have been six miniature icons or ornaments on each of the two long sides: this can be deduced from the rectangular slots at regular intervals. A deeper slot in the middle of the lower part of the frame may have been for keeping the icon steady in procession. The mosaic has not escaped wear and tear. As the wooden joints have opened up, the tesserae nearest them have fallen off. The consequent deterioration, though limited in extent, significantly affects the overall impression, of the faces particularly. There are other minor gaps elsewhere.

As is generally the case with mosaic images, the tesserae are of various sizes. For the faces they are small, for the garments they are bigger, and they are larger still for the ground, which is gold. Here they are laid in horizontal rows, but change direction at the boundary with the figures, to echo the figures' outline in their undulations and follow the figures' circular movement in the golden haloes. The Virgin, depicted in the Eleousa type, is shown to just below the hip, holding the Christ-Child in her right arm, and (like the Hodegetria) with her left hand in a gesture of prayer. The Infant, snugging in her loving embrace, has one arm wound round her neck and his right hand stretched out in a gesture of speech. He leans his head backwards for the caress that brings the two figures together, and looks intently at the Theotokos, whose meditative gaze is fixed on the viewer. Her slender figure reaches majestically to the edge of the picture. She is clad in blue with striations of gold, a touch of red on neck and hand, and of silver on the headband and on the crosses at head and shoulder. Her halo, outlined above her in red and silver, fuses with a row of scarlet tesserae defining the edge of the image in golden space. The Christ-Child wears a green-gold chiton with a red clavus on the arm and a brown-gold himation. The halo has silver rays and red outline. On the ground there are inscriptions – freehand, and again with red tesserae: ΜΗΡ ΘΥ ΕΠΙСΚΕΨΙС (Mother of God, the Episkepsis) and IC XC (Jesus Christ).

The appellation Episkepsis (Shelter) for the Virgin is known from hymnology. It is found in various descriptions of her, and is an affirmation of her miraculous intervention in any time of need. She is the 'shelter of the weak', sheltering, succouring, and protecting all Christian souls. Though usually independent of the Glykophilousa type, the name is charged, here above all, with direct appeal to the Mother tenderly embracing her Only-Begotten Son, the sharpness of fear hidden in her eyes, sleeplessly aware of the agony of the coming Passion. In this sense, the calm of the composition, the Virgin's gesture, and her gaze of profound feeling towards the believer take on a special meaning.

The main iconographic elements of this mosaic icon connect it with two classicizing works of the Middle Byzantine period. One is a wall-painting in the New Church of Tokali at Göreme (Cappadocia); the other is the Virgin of Vladimir, an icon of Constantino-politan origin, in Moscow (Panayiotidi 1992, 461-462ff., figs 236a and 237b; Vocoto-

poulos 1995, no. 25). The direction of the gazes, the restrained attitudes, and the gestures of Christ in the present icon recall both of the above. Further elements which correspond are, in the mosaic icon, the parallel placing of the feet (here covered by the himation), and, in the Vladimir icon, the gesture of the Hodegetria and the Child's tiny hand on his mother's neck. In two other icons of similar type – the so-called Virgin of Damascus, originally from Rhodes, and now in Valetta in Malta (Acheimastou-Potamianou 1992, pl. 31), and the later Virgin of the Don, now in Moscow, and attributed to Theophanes the Greek (*Vijantija, Balkany, Rus'*, no. 64) – the legs of the young Christ are similarly bare to the knee, and in the second of these, in a pose which is the same as in the Virgin Episkepsis, resting on Mary's arm.

The Virgin shown to just below hip-length is familiar from such superb Middle Byzantine representations as the mosaics of the Hosios Loukas monastery (N. Chatzidakis 1996, pls 31-32), the mosaics of Monreale (Kitzinger 1960, pl. 102), and a Sinai mosaic icon (Voco-topoulos 1995, no. 74). Also related to these is the Virgin Episkepsis in a Palaiologan icon of the Virgin Eleousa now in the Philotheou monastery on Mt Athos (Tsigaridas 1992, pl. 355). There is a certain similarity between the last and the present icon in the portrayal of the Virgin's countenance and in the treatment of the maphorion. There is, moreover, an interesting analogy between the maphorion's detailed treatment here and that of the Kom-nenian 'Virgin of Monreale'. There too, the little curving fold of Christ's chiton falls on her hand in the same delectable way – an indication of the Episkepsis painter's very wide workshop experience. Characteristic also are the five-point crosses on the head and shoulder, a motif typical of Middle Byzantine representations. These occur sporadically in Palaiologan mosaic depictions of the Virgin in the Byzantine capital city (Lazarev 1967, fig. 427; N. Chatzidakis 1994, fig. 182; Voco-topoulos 1995, fig. 87).

The probability that the Byzantine Museum's majestic Eleousa was executed by a Constantinopolitan mosaicist is hinted at by the location of the town of Trigleia, which lies within the capital's broader region, on the Sea of Marmara. This is supported by the evidence that Trigleia was, from the thirteenth century at least, a dependent patri-archal exarchate (Evangelidis 1934, 61). That our icon was intended for an important ecclesiastical monument in the area is clear, from the size and brilliance of the expensive

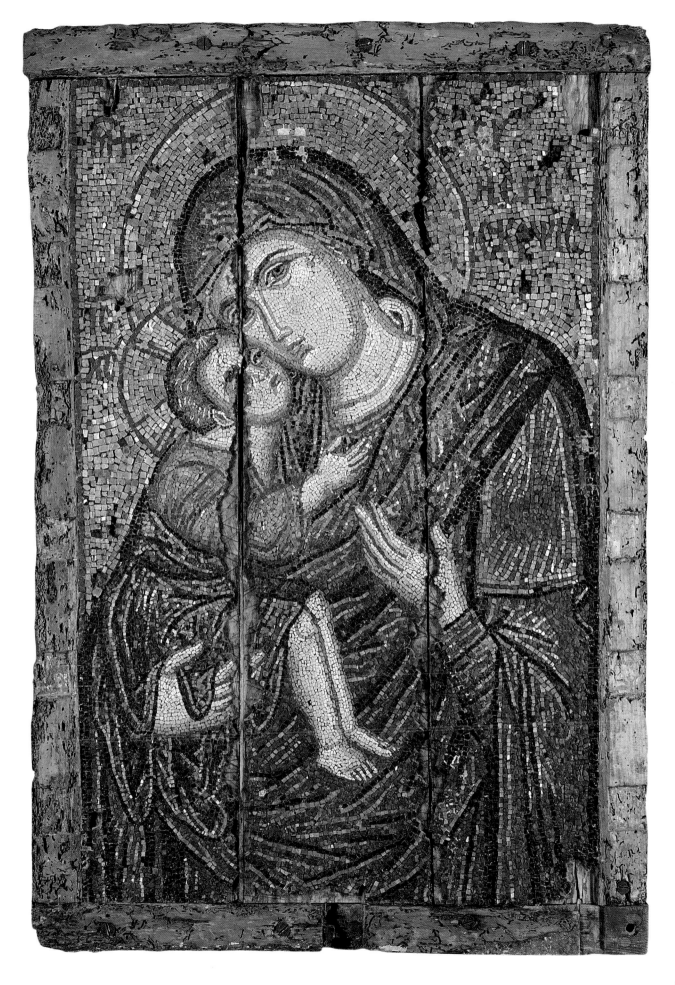

465

mosaic work, which on grounds of technique should probably be dated to the latter years of the thirteenth century.

On beholding the icon, the overwhelming impression is of its delightful coloration, with strong deep-toned hues, and its luxuriance with its lavish use of gold and silver tesserae, which would have been enhanced when the frame was adorned with costly materials and decorated with appropriate figures. The most brilliant element is the clear-cut chrysography, glittering on the deep-hued fabrics. It carves out folds and illumined planes, vibrates to the lustre of the gold firmament, and envelops the figures in its linear density. On the Virgin's maphorion, to the right, the patterns are austere: on the Christ Child's himation they fall, in a tender whisper, in a multitude of curvilinear folds. In the thirteenth century, gold tracery on the Virgin's maphorion and garments is rare, though appropriate to major art works (Vocotopoulos 1995, nos 65, 74; Folda 1995, 501ff., figs 1, 2). It enlivens and lightens the material's volume, which is modelled with deep shadows in the sharp folds and at the edges. The amply-lit faces and the limbs have finely-rounded contours, gently-passing shadows, and a clean, unified perception of volume. Certain elements — the delicacy of expression, the type of the Christ-Child — recall another very different kind of mosaic representation, the Virgin in the Porta Panagia church at Trikala, dating to about 1285 (N. Chatzidakis 1994, figs 162, 164). There is a resemblance with the draughtsmanship in the features and the layout of the maphorion folds in a late thirteenth-century icon of the Virgin Enthroned — the Kahn Madonna, now in the National Gallery at Washington, D.C. (Folda 1995, fig. 1). Its sense of plasticity of volume, its use of a red outline for exposed areas, and the richness and quality of its colouring, all bring the present icon close to two further works: a mosaic icon executed with greater perfection of technique and dating to the third quarter of the thirteenth century, that of St Nicholas in the Stavronikita monastery on Mt Athos, (Karakatsani 1974, 138ff., fig. 53; Vocotopoulos 1995, no. 92), and the mosaics of the Parigoritissa at Arta, dating to 1294-1296 (Orlandos 1963, figs 13-20; Nicol 1985, 48ff.). Similarly characteristic of this period are the refreshingly clear-cut features, the strong, weighty use of colour, and the breadth and sumptuousness of a monumental composition.

Myrtali Acheimastou-Potamianou

Conservation:
Byzantine Museum, Photis Zachariou, 1958.

Exhibitions:
Byzantine Art, an European Art, Zappeion, Athens 1964; *Ειδική Έκθεση Κειμηλίων Προσφύγων*, Byzantine Museum, Athens 1982-1983.

Literature:
Xenopoulos 1925, 44ff.; Sotiriou 1931², 77, no. 145, pl. XI; Evangelidis 1934, 58ff.; Felicetti-Liebenfels 1956, 64, pl. 73e; Sotiriou 1960, 16, no. 145, pl. XLII; *Byzantine Art, an European Art*, no. 168; Weitzmann et al. 1965, XXVIIff., LXXXIIIff., pl. 51; Chatzidakis 1974, 335, fig. 1; Furlan 1979, no. 23; *Ειδική Έκθεση Κειμηλίων Προσφύγων*, no. 1; Demus 1991, no. 1, 15ff., (with previous bibliography), pl. I'; Baltoyanni 1992, 883ff., fig. 3; Acheimastou-Potamianou 1998, no. 7, 34, fig. on 35.

75

Icon of the Virgin Eleousa

115 × 71.5 cm
Egg tempera on wood
12th century
Macedonia
Athens, Byzantine Museum,
Inv. no. BM1136, T137

The Virgin is shown here in a variant of the Eleousa type, which is nearly the same as the iconography of the Virgin Kykkotissa. With both arms she holds the Christ-Child, reclining in her embrace her right arm round his body, and passed her left between his bare legs. Her head inclines deeply towards him, so that her face rests gently on his. Christ turns his face and eyes towards his mother and, with his left arm bent at the elbow and placed beneath her cheek, seems to support her bending head. He is clothed in a blue-grey chiton that leaves his robust arms bare. Round his waist is a red girdle, shown as a wavy line. Red, too, are the straps that rise from the girdle and pass over his shoulders. The right arm seems to hang down, holding a closed red scroll in horizontal position.

This representation can be linked iconographically to the type of the Virgin Kykkotissa (Mouriki 1985-1986, 27; Baltoyianni 1994, 82). Christ's bare, parted legs, his torso turned three-quarters towards the viewer, and his dangling hand are all elements found at Kykkos. In both representations, the Child is dressed in the same way: in a sleeveless chiton and with the himation falling about his waist.

The differences that emerge from a comparison of the Byzantine Museum icon with the Komnenian Virgin of Kykkos — as known from what are most likely faithful copies — are that in the former icon the Child does not turn his face towards the beholder, and that the Virgin's clasp of Christ's hand with the scroll in it — so telling a detail of the Kykkos icon — is not shown. This divergence in iconography seems to imply that the type of the present icon is the more faithful of the two to the Eleousa iconography as crystallized in the first years after Iconoclasm.

Especially important for the progress and development of the present image was a detail in the type which was to survive into the Palaiologan era, namely the placing of Christ's hand under his mother's chin. In common with the bare legs — which were by now crossed — this is a feature which can be

seen in a whole series of Palaiologan icons, and was to persist in fifteenth- and sixteenth-century Cretan icons of the Virgin of Tenderness (Baltoyanni 1991-1992, 219-238). Some of the best-known Palaiologan examples of its use are: a fourteenth-century icon in the Philotheou monastery (Tsigaridas 1992, 654), the wall-painting with the Eleousa in the church of St Alypios at Kastoria (Orlandos 1938, 173-175; Pelekanidis 1953, pl. 178; Tsigaridas 1992, 655), the wall-painting of the same subject at Treskavac (Subotić 1971, fig. 28), and the wall-painting in the Rassiotissa church at Kastoria (Gounaris 1978, 157). In all of the above, the type is presented in such a way as to make its meaning crystal-clear. In the present icon, too, Christ reclines in the Virgin's embrace, his left hand to her face. His legs are bare, but are now stretched out and crossed.

From the point of view of typology and meaning, this unconventional way of depicting Christ is identical to that in the Christ Anapeson, a work whose iconography seems to hark back to the first post-Iconoclast years. It is also to this period — an era when the earliest humanist portrayals of the Eleousa, with their very particular significance, were beginning to make their appearance — that the concept of the Anapeson's Entombment and Resurrection and the subject of Christ as an infant in his mother's arms should probably be assigned. The second of these themes reappears in a homily by Patriarch Photios for the dedication of the Virgin and Child mosaic in the sanctuary apse of Hagia Sophia. In the homily, the Christ in this mosaic is referred to as 'reclining', which is the plainest possible linguistic and conceptual synonymity with the Christ Anapeson (Baltoyanni 1991-1992, 229).

In short, the present icon is one of the earliest attempts known to render the infant Christ in his mother's arms in the same spirit as the Entombment and Resurrection of Christ Anapeson. Moreover, there are very specific elements, particularly of style, that advocate the icon's attribution to a twelfth-century Macedonian workshop. The fact that this representation was frequently repeated in the Palaiologan era is, we believe an indication that it was specially well-loved, surviving as a model even for much later eras.

The principal stylistic features that should be mentioned here are the icon's silver ground and its restricted colour range, confined to purple and sienna-brown, picked out with added brushstrokes of red and blue. The

paint is grainy and applied in smooth planes, with no modelling or burnishing. The drapery is indicated by a few superficial lines, and the fingers and facial features are contoured in black.

Two of the elements that enable us to date this icon to the twelfth century are the Virgin's narrow, shadowy eyes and the flat arches of the eyebrows. These are twelfth-century features which are also encountered in an archangel in the sanctuary of the chapel of the Virgin Mary on Patmos (Acheimastou-Potamianou 1994, fig. 50); the Visitation at Kurbinovo (Acheimastou-Potamianou 1994, fig. 60), and the Eleousa in the Enkleistra of St Neophytos at Paphos (Papageorgiou 1996, fig. 93). For all this last Eleousa's classical, Constantinopolitan air, which sets it markedly apart from our icon, both are identical as regards the eyes and eyebrows and, above all, in the mood of the figure.

The long nose with its cleft base and strong, narrow incurving sides are the defining features of the treatment of the Virgin in the present icon; and they are also commonplace elements in painting of the twelfth century. The physiognomy of Christ is also interesting, with the broad bare forehead, small delicate nose, and large eyes. Twelfth-century parallels for this treatment of the features of the infant Christ, by no means a common one, can be found in the youthful figures (souls) in the wall-painting of Paradise, in the crypt of the Bačkovo monastery (Bakalova 1977, fig. 101), and in another youthful figure, one of the Forty Martyrs in a twelfth-century wall-painting in St Nicholas of the Roof in Cyprus (Stylianou 1997[2], fig. 22). In both cases, the face of these related youthful figures is oval, the forehead is broad, and the hair is long, falling to the neck.

Here it should be added that this treasured icon, revealed by removing a more recent layer that covered it, has one further interesting feature. During restoration at the Byzantine Museum, it proved to have the earliest overpainting yet known for a Byzantine icon the red wavy line for the girdle of Christ, its two thin straps, and the red scroll in the Child's right hand, are all later additions to the original image. Overpainting was also detected on the icon's silver ground. The later additions, which must mostly have replaced lost parts of the original picture, have not been removed from this icon. New elements can also be observed in parts of the Virgin's maphorion, on the right side of the wimple (*kekryphalos*) covering her head.

In view of the above remarks, the Christ-Child's red girdle and its form which had made dating this icon much of a problem, can now be given a different origin. Girdles of this kind are found in thirteenth-century portrayals with Romanesque elements. The same girdle round the waist of Christ (now shown as 'Emmanuel Enthroned') is observed in a miniature in a gospelbook once belonging to the Serb prince Vukan, and now in the Publiskaia Library (F.p. 1,82) at St Petersburg (Radojčić 1969, 15, pl. 8). The miniature in the Serbian manuscript has, despite its Byzantine features, a Western, Romanesque air, and its elements can be linked with the Christ in an icon (T2512) of the Brephokratousa, now in the Byzantine Museum at Athens (Cat. no. 63), which is attributed to a Western workshop and dated to the early thirteenth century (*Conversation with God*, no. 3). The Child's legs, large and emphatically protruding in our icon, are treated in a similar way in the Serbian miniature. There is the same girdle round Christ's waist in a thirteenth-century Galaktotrophousa known as the *Madonna del Pilerio*, in the Palazzo Arcivescovile at Cosenza (Rotili 1980, 163, pl. LXVII).

It has now been shown that those features of the present icon which caused problems of dating and workshop origin, are later additions, due to the intervention of a non-Byzantine workshop. In view of this, the icon can be assigned, on the grounds of its remaining iconographic, stylistic and other features, to a late twelfth-century Byzantine workshop. Furthermore, its robust style, combined with the classical ethos of the twelfth-century figures and other specific elements, place it as the product of a Macedonian workshop, which was probably following a Constantinopolitan model of the same period. Lastly, the iconography of this model must either have been created in the Komnenian era, at the same time as the valuable and inventive portrayal of the Virgin Kykkotissa, or have preceded it, since some of its main features still remain very obviously faithful to the type of the Eleousa.

Chryssanthi Baltoyanni

Conservation:
Stavros Baltoyannis, 1996; Vassiliki Galakou 1998.

Exhibitions:
Glory of Byzantium, The Metropolitan Museum of Art, New York 1997; *Conversation with God*, Hellenic Centre, London 1998.

Literature:
Sotiriou 1931[2], 77; Sotiriou 1932, 90, fig. 57; Sotiriou 1955, 19, pl. XXI; Felicetti-Liebenfels 1956, 90, pl. 112; Sotiriou 1962, 20, pl. 19; Chatzidakis 1966, 17-18, pls 9a-9b, n. 4; Chatzidakis 1967, 17; Michailidis 1970, 17, pl. 13a-b; Pallas 1971b, 231, 244-245, 251, 257, pl. 60; Chatzidakis 1972, 122-124, 136, pl. 43; Kalokyris 1972, 98, 161, 164-166, pl. 32; Chatzidakis 1976, 360, pl. XLVI; N. Chatzidakis 1981, 87-88; Hadermann-Misguich 1983, 11-12, pl. 1, fig. 2; Chatzidakis 1984, 15, fig. 4, pl. 4; Baltoyanni 1985, 48; Acheimastou-Potamianou 1985, 85; Baltoyanni 1986, 46; Baltoyanni 1991-1992, 224-225, fig. 5; Panayiotidi 1992, 654, pl. 354; *Glory of Byzantium*, no. 71; *Conversation with God*, no. 2.

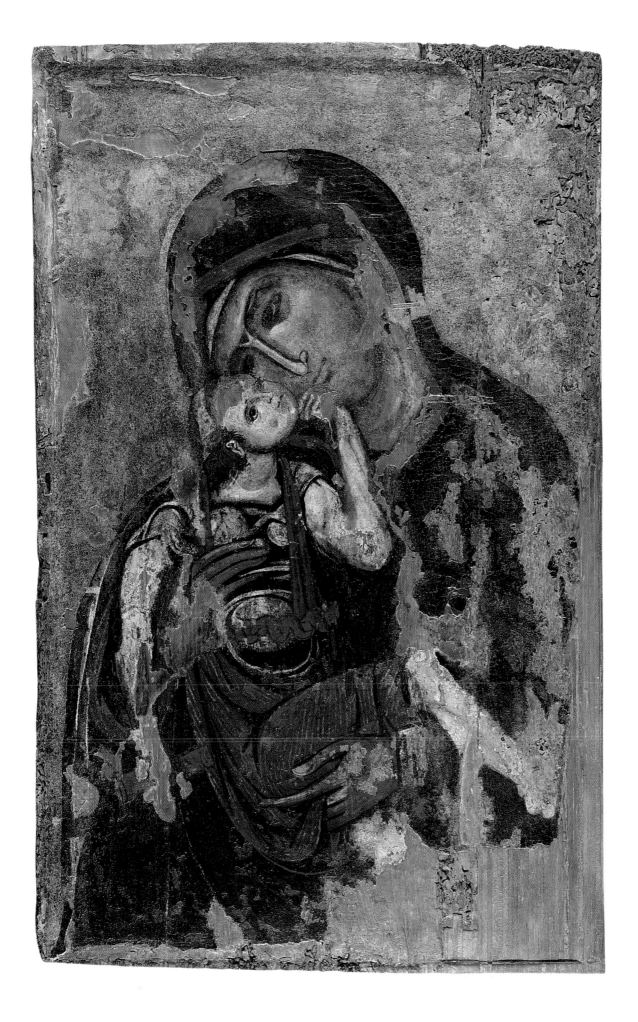

469

76

Icon of the Virgin Eleousa

95 × 59 cm
Egg tempera on wood
12th century
Nicosia, church of the Virgin Chrysaliniotissa
Nicosia, Byzantine Museum of the
Archbishop Makarios III Foundation

This icon of the Eleousa is painted on thick canvas glued to a single wooden panel whose edges form a narrow, integral, raised frame. It has suffered extensive damage, with loss of wood at all four corners. These lost parts were completed when the icon was restored, and can easily be distinguished from the original. Three trusses were also added to the back. Damage to the wood has resulted in the loss of parts of the head and body of the Virgin, the body of Christ, and the gold ground.

It seems that the icon had already suffered damage by the time of the Venetian Occupation of Cyprus, and that it was substantially repainted in the sixteenth century. Of the original icon only the Virgin's face and neck – with the wimple around them – and Christ's face, part of his hair, and his neck have survived (Papageorgiou 1991, 14, fig. 7). The gold ground, the Virgin's hands, himation and maphorion, and all of Christ's body and his garments are due to overpainting. The icon is of course not alone in this respect: in the Virgin of Vladimir from Russia – again an Eleousa – only the faces of the Mother of God and Christ are preserved, of the original figures (Antonova and Mnieva 1963, 58-64, pls 7-9).

The Virgin, shown at waist-length, her head turned slightly to the right, holds the Christ-Child in her right arm and places her left hand on his right knee. As is usual, she gazes not a Christ but into infinity. Christ, again as is usual in this type (Baltoyianni 1994, *passim*) – embraces the Mother of God with both hands, rests his face on hers and looks at her tenderly.

The artist who overpainted the icon appears to have followed the original scheme of composition, though it is not absolutely certain if the pose of the Virgin's hand was exactly the same. To judge by the colour of the *kekryphalos*, still preserved under the later overpainting, and bearing in mind that it is usually the same colour as the chiton, the Virgin's chiton was originally of the same colour as it is today. This cannot be said for the maphorion, which is an unusual dark brown,

with numerous striations and restrained laminae of gold all over it. Its border is red, with a triple gold line, as are the ornamental bands at the wrist of the left sleeve of the chiton.

The lavish use of chrysography is reminiscent of sixteenth- and seventeenth-century icons of the Virgin, such as on the icon in the church of the Archangel at Lefkoniko, of St Charalambos at Kato Drys, of the Archangel in the village of Aghios Nikolaos at Paphos, and of St Marina at Oras (Papageorgiou 1991, figs 82, 86a-b, and 90). On the hem of the left arm of the Virgin's maphorion in the present icon is an inscription reading: ΔΕΗCΙC ΤΟΥ ΔΟΥΛΟΥ [COY] ΚΩΝCΤΑΝΤΙΝΟΥ (Prayer of [Thy] servant Constantine).

Two principal features of the Virgin are her oval face and the arched eyebrows merging with the shadow at the base of the nose. The nose is aquiline, like that of the Mother of God in the two-sided icon in the Virgin Theoskepasti church at Paphos (Papageorgiou 1991, fig. 15a; 1992, pl. 255; 1996, fig. 94; 1997, 105; Sophocleous 1994, figs 12a-b) and in the Hodegetria church at Lania (Sophocleous 1994, 81, fig. 11). The face is modelled in warm ruddy ochre with light shading round the edge. Red is diffused over the face, and is not, as in icons of the late twelfth and the thirteenth century (Papageorgiou 1992, 485), applied to the cheekbones in dabs. A red line emphasizes the eyelashes and nose, as in a whole series of Late Komnenian wall-paintings and icons (Papageorgiou 1992, 487; Mouriki 1986, passim). The flesh on the forehead is lightened with white and yellow. Restrained white and yellow highlights are inserted at the corners of the eyes and the side of the nose, as in the icon of the Virgin Theoskepasti at Paphos, the faces in the Annunciation on the royal doors at Lefkara, and the face of Anna the Prophetess (Luke 2:36) in the fragment of an icon of the Presentation of Christ from the katholikon of the St John Lampadistes monastery at Kalopanayotis (Papageorgiou 1991, figs 15a, 12, and 22). The figure of Christ is modelled in exactly the same way. Two features not found in other twelfth- and thirteenth-century Cypriot icons of Christ (Papageorgiou 1991, *passim*) are worth noting: his relatively narrow forehead, and the rendering of his hair.

Christ's chiton is greenish blue with gold striations, a slight difference from the original chiton, which was plain blue: only a very small fragment of the latter has been preserved, at

the neck opening. On the right arm there is a red clavus with gold striations. The himation is red with dense gold brushstrokes.

The Virgin's maphorion, her hands and Christ's hands are matt in colours, rather reminiscent of the colours of Mary's and Christ's faces and the right palm of the Virgin with the Carmelite monks, seen in the church of St Kassianos (Papageorgiou 1991, fig. 31): in both cases there has been later intervention. As has been observed (Mouriki 1986, 19), the circumference of Christ's halo has punched decorations. But the halo, like the gold ground on which it is incised, is due to later overpainting, and consequently cannot be called in evidence to date the original work.

The icon has been variously dated to the first half of the twelfth century (Papageorgiou 1991, 13-14) or to the early thirteenth (Mouriki 1986, 19). Detailed examination of its style and iconography helps date it to the second half of the twelfth century. The Virgin's face is more oval than fleshy, just as in the wall-paintings of the Virgin Arakiotissa and the Virgin in the Nativity in the church of the Virgin of Arakos, as well as the Virgin of Vladimir, dating to the first third of the twelfth century (Antonova and Mnieva 1963, pls 7-9; Nicolaïdès 1996, figs 3 and 63). The white highlights on the forehead, at the edge of the eye, and on the side of the nose are rather restrained, like those on the face of the icon of the Virgin in the Theoskepasti church at Paphos. In common with a series of icons and wall-paintings from the last quarter of the twelfth century, nose and eyelids are outlined in red (Papageorgiou 1992, 485, no. 6). The modelling of the faces is achieved by a gradual toning down of the reddish brown: this does not happen in thirteenth-century icons or in many late twelfth- or early thirteenth-century wall-paintings in the church of the Virgin at Amasgou, Cyprus (Boyd 1976, figs CD, 23, 36-37, 39), the church of the Transfiguration at Pskov (Lazarev 1966, figs 77-81) and Nereditsa (Lazarev 1966, 96-97), but it does occur in the Enkleistra and Arakiotissa icons of the Virgin Eleousa (Papageorgiou 1991, figs 9-10).

Athanasios Papageorgiou

Conservation:
Photis Zachariou, 1967.

Exhibitions:
Geneva 1968; Prähistorische Staatssammlung,
Munich 1968; Pushkin Museum of Fine Arts,
Moscow 1970; Hermitage, Leningrad 1970;
Zappeion, Athens 1973; *Icons from Cyprus*,
Benaki Museum, Athens 1976.

Literature:
Icons from Cyprus, no. 3; Papageorgiou 1991, 14,
fig. 7.

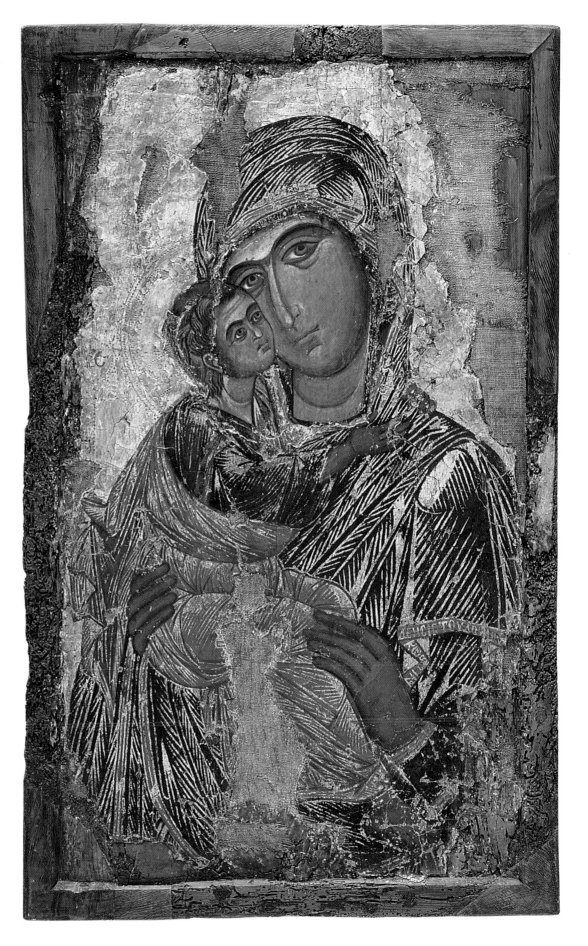

471

77

Icon of the Virgin Thalassomachousa

122.5 × 93 cm
Egg tempera on wood
Early 13th century
Zakynthos, Strophadon and Hagiou
Dionysiou monastery

The icon of the Virgin Thalassomachousa (Battling with the Sea) comes from the Strophadon monastery, where it was until lately in the narthex of the katholikon of the Transfiguration (also known as the Virgin Pantochara, that is Joy to All Men). This monastery, built like a fortress, and once a wealthy foundation, with many monks, can trace its origin to Byzantine times. It stands on the larger of the two Strophades islets, in open water off Zakynthos. Here it was that a scion of a local ruling family — the young novice Daniel, whose 'lay' name was Draganigos Sigouros — entered monastic life; he later become the protector of Zakynthos as St Dionysios. It was in this monastery that he asked to be buried, as in fact he was in about 1622, when he went to his long rest.

'Thy august icon even as a treasure trove, Sea-battling Virgin from the city of Byzas, the Strophadon monastery received, when it reached it in a marvellous way...' These words of the hymn briefly sum up a tradition of the Strophadon monks, namely the story of a miracle-working icon, recounted in many versions and relating how this arrived at the monastery from Constantinople itself, riding upright on the waves. It had been thrown into the sea during Iconoclasm, to keep it safe from the Iconoclasts; and so it became known as 'the Virgin Battling with the Sea'. The name was given for another reason as well: whenever the monks were prevented from travelling by stormy weather, they poured oil from the Virgin's never-sleeping lamp on the troubled waters, and the sea would become calm.

This large icon — probably originally a despotic icon on the iconostasis — was recently moved by the clergy to the Strophadon and Hagiou Dionysiou monastery on Zakynthos. In the course of conservation, the overpainting was removed from the figures and the ground. The wood was damaged and had been coated with one new layer of gesso after another. In one or two places the Post-Byzantine overpainting on the Virgin's maphorion was preserved: the garment is a lighter colour than the original reddish brown, with linear and angular folds, and flo-ral motifs at the shoulder. Of the gold ground very little remains. The paint has disappeared at the extremities of the figures, except for small patches surviving low on the left edge. New wood has been added to the damaged part of the icon on the right from top to bottom. Of the original chamfered frame, which was nailed on, only the left side remains.

The Mother of God is portrayed to waist-length, in the type of the Eleousa. She holds her Only-Begotten Son low to her left with both hands, and, with a graceful inclination of the head, tenderly touches his cheek with hers. Her gaze is serious and of a rare melancholy, lost in the thought of the coming Passion: 'those secret thoughts unfolding within herself', as Pallas (1965, 167ff., 176) puts it. The Christ-Child sits sideways, snug in his mother's arms, his legs seemingly crossed, his left arm stretched in front of him onto the Virgin's arm, and his right arm bent well back. He makes a gesture of blessing with his right hand, while his left, in a parallel position, rests on his right knee, holding a closed scroll tied with a brown and gold cord. He raises his head and gazes upon his mother, in response to her affectionate caress, a loving expression on his face.

The type of the Virgin Eleousa was perhaps familiar even in pre-Iconoclastic times. This seems probable from a full-length wall-painting of the Mother of God in the church of Santa Maria Antiqua in Rome (Nordhagen 1990, 312ff.). In post-Iconoclastic times it became widely popular and, after the Hodegetria herself, was one of Byzantium's best-loved types. In the iconographic variant of the Virgin Thalassomachousa — which is a rare one — it is closely linked with a twelfth-or thirteenth-century icon in the Kremlin (Putsko 1992, 539, pl. 297). There the Virgin wears a dark wimple and holds the full-bodied Christ-Child low down, in exactly the same way as in the present icon. Christ is portrayed in the same pose, but his gestures are a little altered, for he is, somewhat strangely, blessing with the left hand. The Child's gesture with a sign of blessing, which is rather uncommon in the Eleousa type, is also found in a small number of *dexiokratousa* icons of later date (Fisković 1988, fig. 3; Tsigaridas 1976, 288, pl. 233a). The most important is the late fourteenth-century two-sided icon of the Virgin of the Don, now in Moscow, which has been attributed to the great Constantinopolitan painter Theophanes the Greek (*Vijantija, Balkany, Rus'*, no. 64). This is a type which was faithfully reproduced in other Russian icons (*Vijantija, Balkany, Rus'*, nos 79, 92). The Child's gesture of blessing, uncommon even later on, is equally rare in fifteenth- and sixteenth-century Cretan icons of the Virgin Eleousa (*Icons, Russian Pictures and Works of Art*, Sotheby's, London 1987, lot. 237; Baltoyianni 1994, no. 48; Acheimastou-Potamianou 1998, no. 10), a group to which the icon of the Virgin Pantochara in the Strophadon monastery belongs (Konomos 1996[2], unnumbered pl.).

The Virgin Thalassomachousa is the earliest icon of those few that survived natural disaster and looting in the monastery on the Strophades islet, and the nobility of its technique proclaims its traditional origin. A masterpiece, it can be assigned to a painter at Constantinople and was probably produced in the first years of the thirteenth century. The dating is arrived at firstly from the features that bespeak its high merit (despite the distortion by damage and later intervention); and secondly from its iconographic type, directly related to that of the Kremlin icon and here found in a variant unrecorded elsewhere. The icon's presence in the Strophadon monastery is further support for the tradition connecting the foundation's refurbishment by Theodores I Laskaris, Emperor of Nicaea (1204-1222) and his daughter Irene, both of whom 'are commemorated in the church's registers as (its) founders' (Zois 1963, 620; Konomos 1967, 154).

The gentle Thalassomachousa, her head bowed low to the up lifted face of the Christ-Child, is very similar to the late twelfth-century Eleousa in the Byzantine Museum at Athens (Acheimastou-Potamianou 1998, no. 3, figs on 21-22). Here the facial features are stylized in the same way, with the intensity of a firm, heavy line to define the dramatic essence of the Late Komnenian portrayal. Though differing in style, the works are akin in other respects: the impressive stature and pose of the Mother of God the low, comfortable crossover of the maphorion at the front, revealing her dark blue chiton, closed at the neck (with a delicate gold border, as in the Thalassomachousa icon), and something that is a commonplace of representations of this period, a double decorative band on the arm. There is also a resemblance in the way the Christ-Child stretches out both legs — very much as in the earlier icon — onto the arm in which the Virgin holds him, and in the sweetness of the serious expression, his gaze full of care for his mother.

In the Zakynthos icon the Komnenian style is echoed mainly in Christ's elaborate pose and the opulent drapery of his garment, where the dense gold striations, with their dynamic patterning, enhance its twirling movement. As they cascade extravagantly over the shoulder and down the arm behind, they recall similar patterns on late twelfth-century figures, such as those, abeit simpler, in wall-paintings in St Nicholas of Kasnitzes at Kastoria (Pelekanidis and Chatzidakis 1984, figs 1, 9, 11, 15 and 16). The Komnenian pictorial style also pervades in the harmonious composition of the group, and is similarly apparent in the Virgin's maphorion, with its deep-hued folds wherever the garment is visible. It can best be seen in the detail, however, of the long flowing curve of the maphorion's gold-embellished border, which dips in front to allow the exquisite line of the throat to protrude, in the red lining, in the restless multiple folds of the fringed border on the arm, where red is also prominent, and in the calligraphy of the sixteen-rayed stars decorating the Virgin's head and shoulder, with the first of the stars placed off-centre. The monumental mien, the joyous colouring, the simplicity and dignity of mood, and the interpretation of Komnenian features are very much in the spirit of the thirteenth century too. The figures' sensitive expressions are rendered in tones of refined spirituality: the painting style gracefully allays the pathos and the Virgin's calm inwardness is encapsulated in her lovely almond eyes, with the hazy greenish reflections of the shadows around them connecting up the eyebrows. The modelling on the wheaten faces is soft, smooth and translucent, enhancing the noble features, so wonderfully drawn, with a thirteenth-century attention to physical beauty. The countenances are outlined in subdued greenish shadows, from which there is a transition to the softer light red of the cheeks, lips, nose and eyelids, while a few white linear highlights impart brilliance and emphasize the volumes, sometimes lightly, sometimes firmly, but always tactfully. The coloration of the garments is in keeping with the composition and palette of the thirteenth century: reddish brown and gold, a soft red, dark blue for the Virgin, a sweet lambent green and light brown and gold for the Christ-Child. And the execution, too, is of the thirteenth century, giving more plasticity to the figures, particularly in the way the Child's limbs are traced under the soft material of his robe.

Myrtali Acheimastou-Potamianou

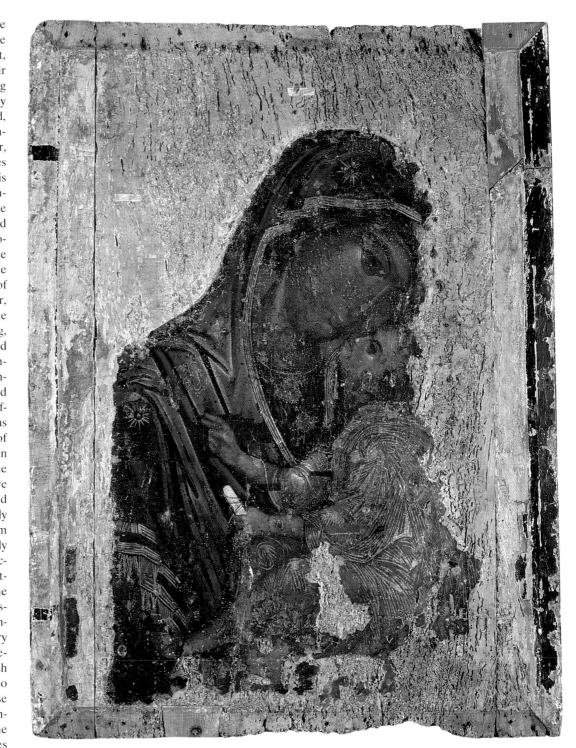

Conservation:
Zakynthos Museum 1980-1981, V. Alexiou, K. Barbas.

Literature:
Konomos 1988, 46; Konomos 1996[2], unnumbered pl.; Acheimastou-Potamianou 1998, no. 2, 46-48, figs on 47, 49; Acheimastou-Potamianou 1999, 19, fig. 2.

78

The Virgin Dexiokratousa

52 × 29.5 × 2 cm
Egg tempera on wood
About 1200
Cyprus (?)
Thessaloniki, Museum of Byzantine Culture,
Inv. no. BEI 49

This icon came to light in the late 1950s, in the cemetery chapel of St Paraskevi at Thessaloniki. Coated as it was (and had been since the 18th century) with a thick layer of resinous substances, it was thought to depict St Paraskevi, for which reason it had been inset in the centre of a larger icon with scenes from her life all round it. To fit it into the centre of the second, Post-Byzantine icon, large parts of its wooden panel were cut away, mainly at the sides, as were the added frame and its arched top. Generally speaking the work is in a mediocre state of preservation, since the paint surface has suffered flaking and scoring. There is no trace of the haloes, or of gold used for the ground.

The Virgin, depicted waist length, turns towards Christ, whom she holds on her right, with a marked inclination of the head towards him. Her left hand makes the gesture of supplication and veneration standard for the Hodegetria. The Christ-Child, small of body, raises his right hand in blessing towards the Virgin, on whom he concentrates his gaze, and in his left hand holds a scroll, which he props diagonally on his left thigh.

The relation between the two figures is full of vivid oppositions. The noble face of the Virgin, with its refined features dominated by the large almond eyes and their heavy brows, is in contrast to the unshapely face of Christ, very little suited to the infancy of the figure portrayed. The robustness of the Child's visage is intensified by a distortion of its left side, with an expression of indifference counterpointing the Virgin's visage with its discreetly depicted traits and expression of subdued melancholy. There are comparable contrasts in the colours of each figure's attire. The Virgin's garments are in saturated colours. The maphorion, black save for an occasional lightening on the head in a deep blue-green and a gold band on the border, finds its counterweight in Christ's off-white chiton, with subtle patterns in bright carmine, and the grainy red clavus on the arm. And whereas the dark-hued maphorion (the folds of which have disappeared) obviates all plasticity from the Virgin's body, imparting a transcendence, the

drapery of Christ's clothing, heightened with grainy red in the angles, delineates the corporeal volumes.

There is analogous differentiation in the modelling of the flesh, which is based on the bold mixing of warm colours without any smooth gradation from illumined to shadowy areas. Once again, the Virgin is rendered with delicate precision, while the treatment of Christ is spare and with deliberate carelessness. The dark olive-green underpaint on the Virgin's face — visible on the contour, in the region of the eyes, on the right side of the nose and on the triangle at base — is lightened with pale ochre and red, in smoothed planes with bright highlights. The mouth is a carmine red, and the left cheek is carmine, lightened and emphasized by a thick smear of white. The nose, the chin, and the creases on the neck are all contoured with lines of grainy red. Seagreen and thick black brushstrokes shape the eyebrows and contour the eyes: the gaze acquires intensity with successive brushstrokes of grainy red and white on the upper eyelid. White is used with great freedom on the smooth surfaces and with brushstrokes of uneven thickness to highlight the area above the eyebrows, the outer corner of the eye, and the curve of the upper lip, while it also gives definition to the rouging on the cheek.

The iconographic and stylistic features of this icon prompt its comparison with late twelfth- and early thirteenth-century work. The archetype of the iconographic type of the *dexiokratousa* relates to a Palestine *acheiropoietos* icon, the earliest known example of which is an encaustic icon at Santa Maria Nova in Rome (Grabar 1968, 529; Belting 1994, 72, 124ff., pl. I). This type enjoyed considerable popularity during the Middle Byzantine period, when its specific iconographic characteristics were crystallized. The increase in representations of this type of Hodegetria instead of the hieratic type, from the mid-twelfth century onward, coincides with an emphasis on the cult of the Virgin, the development of a Marian cycle, and the appearance of a popular piety that ascribed miraculous properties to icons of the Virgin, and particularly to those 'not made with hands' (Velmans 1970, 380ff.).

The relationship of the Thessaloniki icon to, above all, Cypriot icons and Italian painting can be seen most clearly in the details of its style and iconography. The treatment of the Virgin's right hand, for instance, with the thumb set unnaturally apart from the forefinger, is often found in Italian works (Gar-

rison 1976, 53, no. 67; 62, no. 110; 65, no. 125), but rather rarely in Byzantine icons. Two further examples are the Virgin Arakiotissa in Cyprus (Papageorgiou 1976, no. 6; Papageorgiou 1991, 18, fig. 11) and the Hodegetria in the Archaeological Collection at Kastoria (E. Pelekanidis 1983, 389ff., pl. 2; Tsigaridas 1988, 317ff., figs 36-37). The exaggerated raising of the top of the maphorion — a device for enhancing the volume of the Virgin that had already appeared in manuscript miniatures by the end of the eleventh century (Mavropoulou-Tsioumi 1974, 360ff., fig. 1) — continued to be used both in Byzantine icons (Acheimastou-Potamianou 1998, 20ff., no. 3) and in Italian panels (Garrison 1976, no. 67). The distortion of the lower part of Christ's face has its parallel in an early thirteenth-century icon of the Brephokratousa, now in the Byzantine Museum at Athens (Cat. no. 63). This is recognizably a Cypriot work, with Christ propping the closed scroll on his thigh in a similar way (Mouriki 1987, 403ff.; Acheimastou-Potamianou 1998, 24, no. 4). The red of the scroll, on the separation of volumes the two faces, the dominant role of red in the modelling, the system of white linear highlights, and the realism in the subdued expression of feelings in the Thessaloniki icon, are all commonplaces of late twelfth- and early thirteenth-century Cypriot icons. The Virgin's melancholy gaze is found in both Byzantine and Western paintings of around the year 1200 (Mouriki 1987, 413). The directing of Christ's gaze and hand in blessing towards the Virgin is a particular feature of 'Crusader' icons (Weitzmann 1963, 196, fig. 22) and of Italian works with strong Byzantine influence from the first decades of the thirteenth century (Garrison 1984, 223ff., pl. 1). It is also normal in Italian and Dalmatian art for the icon to have an arched top.

The present icon is ambivalent: it is neither typically Byzantine nor clearly Western. This poses problems of origin. Any thoughts of attributing it to an Italian workshop are quelled by the different emphasis of Italian art — on plasticity in the figural values, on compact handling of space, on ornate haloes — and by the its strongly pragmatist nature. But we cannot even be sure that the icon was painted at Thessaloniki. The Latin Occupation of the city was so brief (1204-1224) that there was hardly time to set up Frankish workshops producing works of mixed style and iconography, which is what happened in regions that remained in Crusader hands for a longer period. Most probably this icon is a work imported from the Eastern

Mediterranean — Cyprus, perhaps, where under the Lusignan dynasty there developed an idiosyncratic artistic idiom founded on the island's strong Komnenian tradition and utilizing elements of iconography and style mainly of Western but also of Eastern origin (Mouriki 1985-1986, 9ff.). It is in any case reasonable to suppose that a centre such as Thessaloniki would have had relations with these regions: suggestive in this connection are the visit of the Metropolitan of Thessaloniki to Cyprus in 1191 as the representative of the Emperor Isaac II Angelos, and the presence of the same prelate at the Crusader camp at Acre not very long afterwards.

Anastasia Tourta

Conservation:
Stavros Baltoyannis, 1964.

Exhibitions:
Byzantine Art, an European Art, Zappeion, Athens 1964; *Θεσσαλονίκη, Ιστορία και Τέχνη*, White Tower, Thessaloniki 1985-1998.

Literature:
Byzantine Art, an European Art, no. 714; Chatzidakis 1965, 13, no. 3; Chatzidakis 1966, 18, no. 2, pl. 8 a-b; Tourta 1986, 85ff., no. IV 22; Tourta 1992a, 607ff.

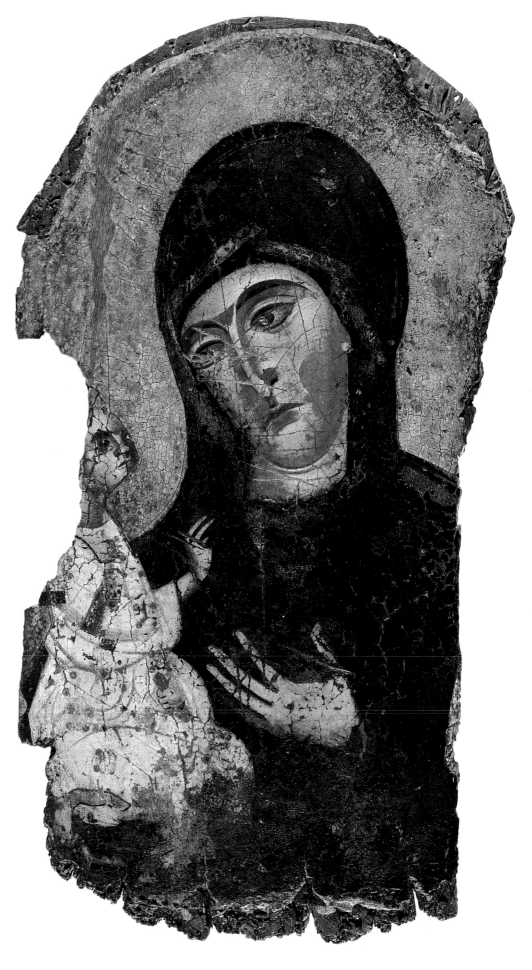

79

Icon of the Virgin and Child

107.5 × 53.9 (max.) × 2.5 (max.) cm
Egg tempera on wood
Late 13th—early 14th century
Northern Greece (?)
Athens, Private Collection

This icon has a 6-cm wide integral raised frame and was originally painted as a despotic icon for placing on a church iconostasis. It was very probably burnt in some fire, judging by the scorch-marks on the back. The sides have been trimmed, more so on the left, but after conservation new wood was added all the way round, restoring it to what may be regarded as its original dimensions, and the work was attached to the frame with three diagonal trusses. The panel was primed with cloth and gesso and there is some loss of the paint surface.

The Virgin Brephokratousa is portrayed in an unusual variant, gazing directly at the beholder as she holds the Christ-Child in front of her breast with both hands. She supports his thigh and pelvis with the right hand, and clasps his shoulder with the left. Christ sits easily in his mother's arms and looks straight at her. He makes the gesture of blessing and holding a closed scroll which he props on his thigh. The figures are projected against a ground of warm yellow ochre. They have broad haloes (now badly damaged). The Virgin wears a grey-green headband and a dark chiton, over which is an aubergine maphorion wrapped across the chest. Thin lines of ochre define the edges of the maphorion and there are three decorative cruciform stars, in white and ochre, one on the forehead, and the other two on her shoulders (the one on the right shoulder can barely be made out). The Christ-Child wears an orange-red chiton belted at the waist with a green girdle. In the top corners of the icon, fragmentarily preserved, is the abbreviation MP Θ (Mother of God), and above Christ's head are traces of the inscription: IC XC (Jesus Christ).

The wheaten flesh underpaint takes on an olive cast at the edges. The flesh tints are rose-red, and the highlights are applied to the prominent points in order to indicate volume. The modelling is fairly soft, though never entirely painterly, since contours are defined by lines of light brown and there are no intermediate hues. The outlines of the Virgin's maphorion are in grey and black, while the folds of the garments end in angular planes with rather abrupt furrows. The laminations of Christ's chiton are painted in yellow ochre, almost as planes, ending in comb-like highlights. This does not mean that the figures are two-dimensional in aspect; a feeling of three-dimensional space is created by the artist's extraordinary care in modelling the faces, with the elaborate illuminating highlights the rose and white flesh underpaint, which becomes more intensely red on the cheeks, and by the Virgin's lowered shoulders and the relaxed pose of Christ's body, as if turning slightly to the right. The light and shade on the eyebrows and eyes, with their heavy, emphatically underlined lids, the melancholy gaze, the robust noses, the tightly-pursed red lips; the strong chins: all these features strengthen the feeling of stereometric substance in both figures. The high necks, the creases at the throat and the articulations of the hands (particularly of the Virgin Mary), with their long delicate fingers, are an indication of the lengths to which this artist takes his mannered style and of the close attention he pays to detail.

The iconographic type followed in this representation is not known to us from any other example. It is possibly a combination of iconographic elements traditional in variants on the Hodegetria and Eleousa types. Where the Mother of God holds the Christ-Child with both arms, her hands support the lower part of his body and are placed in the bottom part of the painting, as in a late twelfth-century triptych in Sinai (Mouriki 1990, 112, figs 54-55), in two other Sinai icons of the early thirteenth century (Mouriki 1991, figs 1, 12), and in a two-sided icon from Rhodes, showing the Virgin Hodegetria and St Luke, and dating to the first half of the fourteenth century (*Byzantine and Post Byzantine Art*, no. 82). Ordinarily, in the above examples, Christ is shown reclining in his mother's arms, in a posture like that of Christ Anapeson, a foreshadowing of his coming Passion (Todić 1994). He makes a gesture of blessing with his right hand and holds a closed scroll in his left, which is extended downwards. The oldest known examples of this type are, probably, a representation of the enthroned Virgin Brephokratousa, dating to the 1180s, in the apse of Sts Anargyroi at Kastoria, and another, dating to 1191, in the apse of St George at Kurbinovo, (Hadermann-Misguich 1975, 3-67, figs 8, 9 and 11). These representations are expressive of a tendency to humanize the Hodegetria type, for they show the Child uneasy in his mother's arms. They are, moreover, the earliest known depictions in which this particular type is enriched with symbolic and doctrinal content, for Christ's posture portends his future Sacrifice (Baltoyanni 1994, esp. 80-83 and 106-111). However the present representation is different from those of the above kind: the Virgin's hands do not simply support the lower part of the Christ's body, and he is not reclining as far back as in the Anapeson portrayal.

In representations where the Virgin Brephokratousa supports Christ's legs and pelvis with the right hand, and either uses the left to clasp his shoulder or back, or else passes it under his armpit—details akin to the present icon—the pose of the Christ Child varies a good deal. Either he lies back in his mother's arms as in the representations in the conches in the Kastoria and Kurbinovo churches mentioned above, in the late thirteenth-century icon of the 'Lady of Life' Virgin at Nesebar in Bulgaria (Paskaleva 1987, no. 8; Mouriki 1991, fig. 28); and in the early fourteenth-century icon (Cat. no. 81) in the Museum of Byzantine Culture at Thessaloniki (Weitzmann et al. 1968, no. 58; Vocotopoulos 1995, no. 100); or he is almost upright and deep in melancholy, as in the mid-fourteenth-century Pushkin Museum icon (*Vizantija, Balkany, Rus'*, no. 19). Or he is turning towards his mother, the Virgin Eleousa, as in the icon from the second half of the fourteenth century, in the Hermitage Museum in St Peterburg (Bank 1985, no. 276; *Vizantija, Balkany, Rus'*, no. 33). The present icon might fit into this series of variants, were it not for the fact that it preserves an older model, one closer to the Hodegetria type, since the posture of the Lord recalls representations such as that of the early fourteenth-century Virgin Psychosostria (Saviour of Souls) in the church of the Virgin Peribleptos (now the church of St Clement) at Ochrid (Balabanov 1995, fig. 72; *Trésors médiévaux*, no. 26) and of slightly earlier works, such as two icons dating to the last third of the thirteenth century, in the Vatopedi monastery (Tsigaridas 1996, 363-364, fig. 308; 373, fig. 317).

The posture of Christ in the present icon is probably the result of a combination of pictorial elements. Not only do these reveal the figure's particular emotional nuances in the various different iconographic types, thus taking on a particular specific gravity, in accordance with the interpretation of the Church Fathers, they also reveal the icon-painter's spiritual state and the message he was conveying in this particular work. Christ's sad gaze, fixed on his mother, can

be traced to representations of the Brephokratousa where he is shown as pensive or even brooding, as he becomes aware of or has a vision of his coming Passion. The relaxed position of the legs, on the other hand, and the upright scroll, symbol of Christ's teaching and the work of salvation in the Divine Economy, hark back to representations of the Hodegetria where Christ looks the beholder more or less straight in the eye, austerely, with a determination to carry out his work (Vloberg 1952, 426-435; Baltoyianni 1994, *passim*). In the present icon the Mother of God, supporting her son with her hands at various points of his body as she looks the viewer full in the face, seems to do more than just support him protectively in her arms. Mary, as 'Communion spoon' and 'doorway of no passage', seems rather to offer Christ to mankind, which is called on to believe in him, accept his law, and live according to God, sharing in the Church's life and Mysteries. From Early Christian times onwards, the Mother of God was regarded as the bestower of 'the bread of consolation' — Christ, that is to say — and her symbol is 'the cup of salvation'. It may not be fortuitous that similar expressions occur in comparable contexts of inquiry both in the preceding period and in the era of the Hesychast dispute itself, where the doctrine of the Incarnation and the question of the life of Mystery, above all the Mystery of the Eucharist, were two main issues that left their mark on Byzantine spirituality (Meyendorff 1975, 93-106, esp. 98 ff.).

This icon shows a number of technical similarities with the two Vatopedi icons mentioned earlier. Its stereometric treatment of the figures, its indication of volume, the interest in the third dimension, the broad modelling, the sturdy, vigorous facial features: all these are elements from Early Palaiologan style — the 'heavy style' or 'volume style', as it has been termed. The type of Christ's physiognomy is one which recurs, similarly treated, in the Vatopedi icons, while the Virgin's oval face reappears in a similar form in the icon of the same period from Nesebar in Bulgaria. The linearity observable in certain features of the present icon may of course be not so much an indication of date as due to individuality in the painter's technique.

From the foregoing remarks on the iconography and style of this work, it is reasonable to assign it to the hand of a good icon-painter of the late thirteenth or early fourteenth century. He appears to have been well-informed about current developments in the icono-

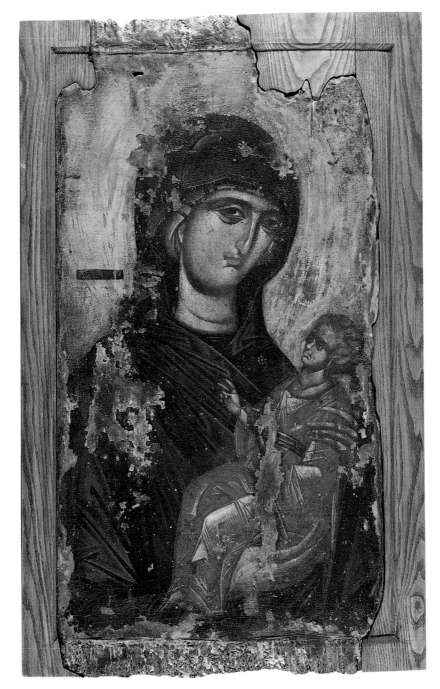

graphic type of the Virgin Brephokratousa. Here he has left us his own statement — unless it is a copy of some prototype we are unaware of — about the Virgin Mary, the Mother of God made Man, perhaps influenced by Hesychast theology. The substitution of ochre for gold on the ground and on Christ's chiton, the attempt to render the figures realistically with sturdy features in the physiognomy, and the stylistic kinship with works in the 'volume style' which flourished principally in Northern Greece or Southern Serbia suggest that in all probability the icon was produced from a workshop in one or other of these regions.

Yannis D. Varalis

Conservation:
Photis Zachariou.

Exhibitions:
From Byzantium to El Greco, Royal Academy of Arts, London 1987.

Literature:
From Byzantium to El Greco, no. 13.

477

Icon of the Virgin Eleousa

105 × 85 × 5 cm
Egg tempera on wood
Second half of the 14th century
Thessaloniki, Church of the Virgin Dexia
Thessaloniki, Museum of Byzantine Culture,
Inv. no. BEI 780

This icon has suffered significant losses of its painted surface, for a large vertical crack down the middle of the panel has destroyed the top of the Virgin's halo, the right side of her face and neck, and the bottom of Christ's face. There is equally severe damage to the Virgin's left arm and part of her torso, as well as to Christ's torso on the left. This damage, which evidently occurred long ago, led the eighteenth-century owners of the icon to paint the representation of the Crucifixion on the back: their intention was to continue using the panel, since the inference from its size is that it was a despotic icon. The reverse thus became the principal face of the icon. Similar cases of damaged Byzantine icons being repaired and overpainted on the obverse or painted a new on the reverse are not uncommon from Thessaloniki.

The icon has a wide, integral, raised frame, and raised wooden haloes. The figure of the Virgin, bearing the inscription Η ΕΛΕΟΥCΑ (The Merciful), has a strong natural presence, and the breadth of her body occupies the whole width of the icon. She is portrayed waist-length, turned three-quarters to the left, with a slight balancing tilt of the head. She puts her arms protectively round the upright Christ-Child, who strains towards her, impetuously. She supports him behind with her left arm, and with four fingers of her right hand (the thumb hidden) she gently touches his knee. Christ's forward thrust is indicated by the bent knee of the outstretched right leg. He embraces his mother, passing his right arm round her neck and resting his outstretched left hand on her breast. The faces of both figures touch tenderly. The inclination of their heads creates an imagined circle as the centre of the composition, which has balance and stability thanks to the diagonal axes created by the figures of the Virgin and Christ and the horizontal axes formed by the position of the Virgin's hands.

The Theotokos is clad in a broad, dark reddish brown maphorion with wide stylized folds described in dark brown. The sombre garment is enlivened by gold star-shaped ornaments at head and shoulder, a gold band on the hem, and long gold fringes below the right shoulder. There are also gold decorative bands on the sleeve of the dark blue-green inner garment, and the headband is of the same colour. Christ's garb is idiosyncratic: a long ochre chiton with dense lines of gold and a deep green clavus running from top to bottom, worn over a long light green inner garment visible on the right leg. A flimsy gold sandal is tied on his foot.

Although much of the Virgin's face is now missing, it is still remarkable for the nobility of its features: deeply-shadowed eyes, a long delicate nose, a small mouth, and a strikingly fleshy chin. Christ's face, with all the sap of youth, has a high forehead and a short retroussé nose. Special attention is lavished on the Virgin's hands, with their finely-drawn, long, slender fingers and supple joints. The flesh is modelled in a painterly manner, with soft gradations of rich opaque tones. The relief quality of the volumes is emphasized by freely-drawn white highlights. Photochemical analysis has shown that no less than five layers of colour were used for the flesh: olive-green with admixtures of green and red, greeny yellow with admixtures of bright red, white, and olive-green with a very thin layer of white (N. Chatzidakis et al. 1985-1986, 241). The coloration of the garments was achieved in a similar but simpler way.

The inscription present specifies the figure as the Virgin Eleousa. The iconographic type of the Virgin Eleousa or Glykophilousa is characterized by the tender closeness of the mother's and the child's face, and the former's gesture of embrace (Grabar 1975, 28ff.). The icon's particular features—Christ in upright pose and in profile, with both arms passed round the Virgin's neck, and the way in which her right hand touches his knee—recall a Constantinopolitan icon in the monastery of St Catherine at Sinai: a hexaptych with scenes of Christ's Miracles and Passion, above which are representations of five different miraculous icons of the Virgin (Sotiriou 1956-1958, pls 146-149; 125-126; Grabar 1975, fig. 3). The corresponding depiction of the Virgin in the Sinai icon has the inscription 'The Blachernitissa', and a similar inscription accompanies another representation of the Virgin on an icon dated 1310-1311 at the Bačkovo monastery, this being the closest iconographic parallel for the present icon and the Sinai icon (Grabar 1975, 34, no. 9, fig. 18). The same iconographic type—varying only in the different gesture for the Virgin's right hand, the clothing of Christ, and the position of Christ to the right of his mother—is found in twelfth- and thirteenth-century icons in Georgia, Dalmatia, Venice, and Sinai (Thierry 1979, 69, fig. 16; Petricoli 1975, 11ff., fig. 1; Lange 1964, 109ff., no. 39; Sotiriou 1956-1958, pl. 201).

Christ's upright pose, also known from lead seals of the twelfth and thirteenth centuries (Laurent 1963, 450ff., nos 604-605, pl. 82), occurs, with some differences, in two Athonite icons of the Virgin in a variant on the Hodegetria type. One is a thirteenth-century icon in the Vatopedi monastery (Tsigaridas 1996, 362ff., fig. 308), and the other is an icon of about 1383-1384 in the of St Paul monastery (Tsigaridas 1998, 30, fig. 10). Yet one more element connecting the Vatopedi icon with the Thessaloniki icon is the gentle gesture with which the Virgin touches Christ's knee, an iconographic detail known from other Palaiologan works from Northern Greece, for example a Thessaloniki icon from the first half of the fourteenth century, now in the Byzantine Museum at Athens (Acheimastou-Potamianou 1998, 44, no. 10), and a late fourteenth-century icon reputedly from the church of St Sophia in Thessaloniki, and now kept in the Vatopedi monastery (Loverdou-Tsigarida 1996, 496, fig. 438).

There are other elements besides the icon's provenance from a church in Thessaloniki that point to its having been made in that city, which was in Palaiologan times a great centre of art, of equal standing to Constantinople, with which it was in constant touch. This is further borne out here by the fact that the iconographic type of the Virgin is a faithful copy of a Constantinopolitan model.

The figure of the Virgin, so strong and vigorous, displays affinity with a couple of almost identical two-sided icons that have the Virgin Brephokratousa on one face. These works, products of the same workshop, and now in Thessaloniki and on Mt Athos (Tourta 1992, 65ff., no. 1; 1998, forthcoming; Tsigaridas 1998, 22ff., fig. 6), show the same breadth in the pictorial treatment of the figures, and the same discreet opulence in the gold ornaments on the clothes; they also have the type of Christ's physiognomy in common. However, they are obviously of a more monumental character, and so a date in the late thirteenth or early fourteenth century, around 1300, has been proposed for them. The present icon also shows similarities with a Veroia icon of the Virgin, dating to 1314-1315, but there is a difference in the flatter modelling of the latter (Papazotos 1995, 47ff., pl. 21).

There are also elements of technique—for instance the wide, integral, raised frame and the raised wood or gesso haloes—that connect the present icon with other works from Thessaloniki. The wide frame is distinctive of the Macedonia region, and can be found on quite a number of icons of Thessalonikan provenance (Acheimastou-Potamianou 1998, 40ff., no. 9; 44ff., no. 10; 56, no. 14). The haloes are found in three further icons from Thessaloniki. The first is of the Virgin *dexiokratousa*, a twelfth-century work in the Vlatadon monastery treasury, and unpublished, the second, also unpublished, is of the Hodegetria, on one side of a two-sided thirteenth- or fourteenth-century icon now in the Museum of Byzantine Culture at Thessaloniki, and the third is the Christ Pantokrator, from the second half of the fourteenth century, in the Byzantine Museum at Athens (Acheimastou-Potamianou 1998, 56, no. 14).

The firm yet noble figure of the Virgin, the sturdy figure of Christ, with its lively, impulsive movement, the pictorial quality of the modelling, the chromatic harmonies and discreet opulence of the garments, the well-balanced composition and the technical competence in the execution all place the present icon among the finest examples of painting from the second decade of the fourteenth century in the Macedonia region.

Anastasia Tourta

Conservation:
Tassos Margaritof, 1959.

Exhibitions:
Byzantine Treasures of Thessaloniki, Museum of Byzantine Culture, Thessaloniki 1994.

Literature:
N. Chatzidakis et al. 1985-1986, 215-246, fig. 9; N. Chatzidakis 1995, 495-498; *Byzantine Treasures of Thessaloniki*, no. 1.

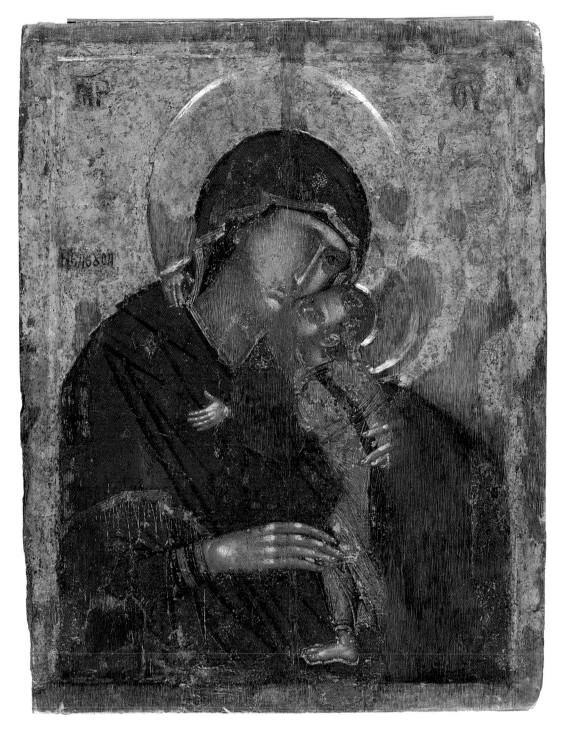

81
Icon of the Virgin and Child

87 × 65.5 × 3 cm
Egg tempera on wood
First quarter of the 14th century
Thessaloniki, church of the Presentation
of Christ
Thessaloniki, Museum of Byzantine Culture,
Inv. no. BEI 166

This icon is has a wide, integral, raised frame with a red border. The wood and the painting are by and large in good condition, except that the folds of the Virgin's maphorion have been lost, as have some of the gold striations on the garments of both figures.

The Virgin, inclined slightly to her left, holds the Christ-Child with both arms, her right hand placed under his thighs and her left arm round his waist. Christ leans half back diagonally, in an awkward pose, with his right hand outstretched in a gesture of speech and with a scarlet scroll dangling in his left hand's loose grip.

The Virgin's purple maphorion has an orange decorative band round the head, with traces of chrysography, and a gold floral ornament on her forehead. There are decorative gold lines on the dark green and blue *kekryphalos* and on the double band on her inner garment's sleeve, visible at the right wrist. Christ's chiton, normally a simple garment, here surprises us with its discreet opulence. A dark grey-green, it is sprinkled with gold fleurs-de-lis on the body. The sleeves have a wide band with gold geometric and floral motifs, at the height of the upper arm. Thickset gold striations lighten Christ's apricot himation, tightly belted at the waist, and the two red vertical bands of his chiton.

The serious face of the Mother of God, with its harmonious features, is dominated by its distant and numinous gaze. The youthful face of Christ, on the other hand, with its intense sideways gaze, has a more down-to-earth expression. The modelling of the flesh is careful and precise. The greenish underpaint can still be seen at the edges of the faces (on the right side of the Virgin's and the left side of Christ's), in the eye sockets and below the nose. The flesh tints are in burnt sienna, which, thinned out with white, mould the volumes, while the prominent points (on the forehead above the eyebrows, around the eyes, on the upper lip, on the chin, and at the throat) are picked out with deft, off-white highlights. The transparent light brown iris of the eye is defined by a dark-brown contour, and the eyebrows are formed with light brown brushstrokes. The lips are in two tones of red, with the deeper of the two for the upper lip. Grainy red lines of varying thickness are used to outline the nose, hands, and haloes. Grainy red is again used for the abbreviations M(HTH)P Θ(EO)Y and the apocalyptic inscription on Christ's halo, O ΩN, (I am the being) referring us to the Book of Exodus (3:14). The hands of Christ and the Virgin, with their fine draughtsmanship and emphasized finger-joints, are modelled with similar finesse. The curls of Christ's short light brown hair are shaped by thick brushstrokes of darker brown.

In contrast to the soft painterly modelling of the faces and hands, the treatment of the drapery is rigid and stylized. This is only really obvious on Christ's clothing, since the folds of the Virgin's maphorion are partially effaced. Christ's himation is crisscrossed by an array of stiff geometric folds, defined by their 'fishtail' ends. The folds of his chiton are shaped by lighter tonal gradations of the basic grey-green.

The special features of this iconographic type are the way in which the Virgin holds the Christ-Child in her arms, and his semi-recumbent pose. The type recurs in a range of variants in thirteenth- and fourteenth-century icons, among them the icon from the cave church of the Virgin at Prespa and now in the Museum of Medieval Art at Korça (*Museum of Albanian Medieval Art* 1987, unnumbered fig.). Others are two icons in the monastery of St Catherine at Sinai, one from the early thirteenth century (Mouriki 1990, 112, figs 54-55) and one from the later fourteenth century (Sotiriou 1956-1958, pl. 227; fig. 199), two icons in the Chilandari monastery, from the second half of the fourteenth century (Petković 1997, 99-100), and a series of thirteenth- and fourteenth-century icons in Southern Italy showing strong Byzantine influence (*Icone di Puglia*, 106ff., nos 5, 6, 7, 8, 11). The Thessaloniki icon's main difference from all of these lies in the hieratic pose and distant expression of the Virgin, features that recall the Hodegetria type.

The physiognomies of the Virgin and Child in the present icon are typical of the Palaiologan period: Christ has a high forehead, a short nose, and a receding chin. The modelling is painterly, with soft chiaroscuro, the mood calm, and the composition well-balanced. These features link the icon with wall-paintings and icons executed in Greece and Serbia during the first quarter of the fourteenth century. Identical portrait types of the Virgin and Child and very similar expressive treatment of the figures can be seen in the Brephokratousa in the wall-paintings of the St Nicholas Orphanos church at Thessaloniki (Xyngopoulos 1964, pl. 144) and in the Milutin church at Studenica (Millet and Frolow 1962, pl. 69.1). But the present work's closest links in iconography and style are with the Hodegetria icon in the Chilandari monastery (Vocotopoulos 1995, 120, 214, no. 99; Petković 1997, 75; *Treasures of Mount Athos*, no. 2.16). The similarities here include not only the extraordinary facial similitude of the Virgin in both icons, but also the contrast between the delicate painterly modelling of the flesh and the stiff, stylized treatment of the drapery, extending even to such details as the backfold of the maphorion at the central point of the Virgin's head, or the triangular opening of Christ's chiton on his chest.

Comparison of the Thessaloniki icon with those mentioned above, points to a date in the first quarter of the fourteenth century and its attribution on stylistic grounds to the artistic output of Thessaloniki.

Anastasia Tourta

Conservation:
Tassos Margaritof 1960.

Exhibitions:
Byzantine Treasures of Thessaloniki, Museum of Byzantine Culture, Thessaloniki 1994.

Literature:
Sotiriou 1931[2], 75, pl. Δ′, 1956-1958, 16, pl. XIV; Chatzidakis n.d., 36, no. 8; Chatzidakis 1965, XXX-XXXI, 58; Vocotopoulos 1995, 121, 214-215, no. 100; *Byzantine Treasures of Thessaloniki*, no. 19.

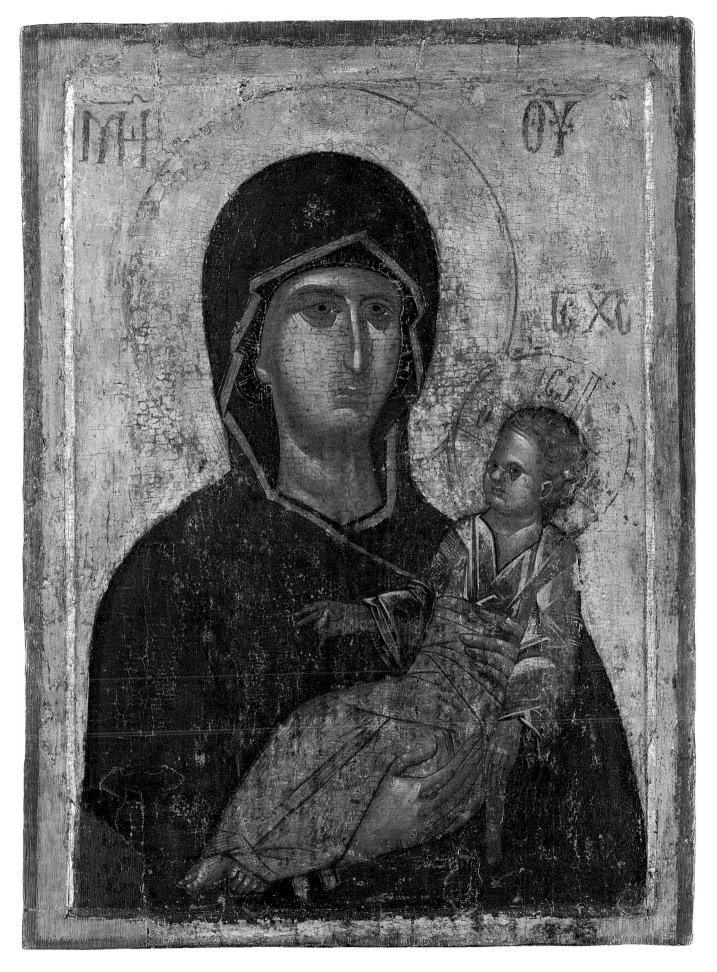

43.5 × 36 × 2.8 cm
Egg tempera on wood
Early 14th century
Veroia
Tinos, Holy Foundation of the Evangelistria

This icon has a 4.5-cm wide, integral, raised frame with a border of cinnabar red. The painted surface has a gold ground, rather clumsily applied. The figures' haloes have no traces of gold and are rendered without embellishment in an olive-green pigment. The icon was long ago subjected to hasty cleaning, with the result that there is extensive damage to the gold ground, the Virgin's face, and the gold striations on the garments. The back is primed, and bears a foliate cross, which has now largely disappeared.

The Virgin is depicted half-length, holding the Christ-Child to her right. She inclines her head, pressing her face to the little face of the Child, as she lifts her left hand towards him, in the typical gesture of the Hodegetria. She wears a dark red maphorion with freely-drawn striations which render the drapery and a decorative orange border-band, on which faint traces of the gold striations which would originally have covered its whole length can be seen. Her chiton and wimple (*kekryphalos*) are dark blue.

Christ sits easily in the crook of his mother's arm, stretching out his right hand to caress her, while his left arm is brought behind her neck. In similar examples of the Eleousa, Christ's left arm is folded round her neck, as in the most famous icon of this type, the Virgin of Vladimir (Weitzmann et al. 1982, fig. on 55), and as in Palaiologan examples, such as the Eleousa in the church of St Basil at Veroia (Papazotos 1995, 48-49, fig. 24). Here, however, the fingers of his left hand are not visible, hidden behind the Virgin's neck, as in the Madonna Eleousa in the National Museum in Pisa (Cat. no. 69).

Christ wears a pale grey-blue chiton that leaves bare his crossed shins. His orange himation, with the Virgin's fingers half-buried in its folds, was originally decorated all over with chrysography, but this has almost entirely disappeared.

The two-figure group is framed by two full-length venerating archangels, depicted uncommonly large for the proportions of the image. Michael, on the left, wears brown shoes, a blue himation, and a striking pink chiton with pale grey-blue shadowing in the folds. Facing him is Gabriel, in a dark red himation and a dark blue chiton. Both archangels stretch out their covered hands towards the Virgin and Child. The figures are accompanied by identificatory inscriptions in capital letters, and the Virgin is further accompanied by the appellation Η ΠΕΡΙ-ΒΛΕΠΤΟΣ (The Peribleptos).

Stylistically the icon is distinguished by the soft, painterly execution. The underpaint for the flesh is brown, modelled in a pale ochre, with slight rouging on the cheeks. The modelling is integral, with white highlight painted freely on the prominent parts. A thin red line follows the contour of the Virgin's nose in a kind of shading, and similar lines emphasize the corners of the eyes. For the mouths of the two central figures, a vivid cinnabar red is used on the upper lip, and a softer rose-red on the fleshy lower.

The features of the two central figures are of great interest. Christ is depicted with chubby, childish cheeks, a snub nose and large eyes, wide open and fixed on his mother's face. His figure and the movement of his body are full of life and energy. The Virgin's refined, finely-drawn features, by contrast, are stamped by the grief in the gaze which she turns on the viewer, and the somehow bitter contraction of her mouth (Kazanaki-Lappa 1988, 37-38). The contrasting countenances of the two figures is a common characteristic in depictions of the Virgin Eleousa from the twelfth century onwards, such as the Virgin of Vladimir (Belting 1994, 287). The dignified figures of the two archangels are more succinctly drawn, with quick brushstrokes: Gabriel, on the right, is the better preserved of the two.

Christ's portrait type recurs in a whole series of Palaiologan icons, such as a Hodegetria in the Vatopedi monastery, dated to the last quarter of the thirteenth century (*Treasures of Mount Athos*, no. 2.10), and in the Virgin Psychosostria in Ochrid, dated at the beginning of the fourteenth century (Vocotopoulos 1995, 208, fig. 75). There is a still closer resemblance between the features of Christ's physiognomy in the present icon and those of the Christ Emmanuel in the scene of the bath, in the Milutin church at Studenica, where as well as the wide-open eyes and the round face there is a similar treatment of the hair (Velmans 1978, 45-46, fig. 14).

The elegant figure of the Theotokos can be paralleled with an icon of the Virgin Eleousa in the church of St Basil in Veroia, that follows the same iconography (Papazotos 1995, 48-49, fig. 24; *Ceremony and Faith*, no. 12). In that panel, dated around the years 1310-1320, the Virgin has the same delicate physical features and, turns sorrowfully towards the viewer, but lacks the grievous mouth contraction that characterizes her portrait in the present icon. Furthermore, these two panels share similar broad, coloured haloes, plainly painted without gold. On the present icon, however, the modelling is more uniform in the pale faces, where the pinkish pigment is barely visible on the bright planes.

Iconographically, the present work displays close affinities with the Pisa icon mentioned above (Cat. no. 69), as well as with the mosaic icon of the Virgin of Tenderness bearing the appellation Episkepsis, now in the Byzantine Museum at Athens (Cat. no. 74). In the latter Christ also has bare legs, though they are parallel rather than crossed, and his pose is the same, tenderly hitched from his mother's neck, while the characteristic movement of the Virgin is reproduced too. Christ appears with his bare legs crossed in several thirteenth-century icons of the Virgin and Child (Mouriki 1987, 403ff., fig. 1; Mouriki 1991, figs 1, 12), and this feature became very popular in fourteenth-century depictions of the Virgin Eleousa (Tatić-Djurić 1976, figs 5, 11-13; Tsigaridas 1992, 653ff.).

The tender, human embrace of the two, overcast by the Virgin's sorrow, was a basic component of this representation as early as the tenth century (Thierry 1979, 59ff.; Panayotidi 1992, 463-464), and it was to take on special significance in Palaiologan depictions of the subject (Velmans 1967, 49ff.; Velmans 1978, 41). As is well known, the iconographic type of the Virgin Eleousa was inspired by sermons and hymns that accompanied the Passion services (Pallas 1965, 167; Belting 1980-1981, 8-9; Maguire 1979). In the tender yet melancholic embrace of the two figures, Christ's coming Passion was foretold, as was the Mother of God's heart-rending embrace of the dead Christ, an embrace which figures in the scenes of the Lamentation, equivalent both in meaning and iconography to the Virgin Eleousa (Tatić-Djurić 1976, 265-267; Belting 1994, 285-287; Maguire 1981, 102-105).

In the composition adopted by the painter of the present icon, the reference to the coming Passion was underlined still further by the emphasis given to Christ's bare calves. This iconographic detail is typical of the Christ of

the Presentation in the Temple in numerous post-Iconoclastic representations that reflect liturgical texts referring to Symeon's prophecy concerning Christ's future Sacrifice (Maguire 1980-1981, 267-269; Baltoyianni 1994b, 18-19). The allusion of the present icon to the Passion is reinforced by the foliate cross depicted on the reverse. A similar representation covers the back of several Eleousa icons, such as the Virgin of Vladimir (Belting 1980-1981, 9, figs 12-13), the Virgin Eleousa in the Byzantine Museum, Athens (Cat. no. 75) and the icon venerated in the Philotheou monastery on Mt Athos (Tsigaridas 1992, 654, fig. 355).

The image on the icon is completed by the appellation 'The Peribleptos', which links the icon with the famous Peribleptos monastery at Constantinople, founded by Romanos III Argyros (1028-1034). The Peribleptos church is known to have been restored by Michael VIII Palaiologos after Constantinople was retaken from the Latins, and henceforth played an important role throughout the Palaiologan era (Janin 1953, 227-231; Mango 1972, 217-218). As with other appellations for the Virgin, 'The Peribletos' occurred on a variety of iconographic types. A characteristic example is the famous Peribleptos icon in the homonymous church at Ochrid, which represents the Hodegetria (Djurić 1961b, no. 8; *Trésors médiévaux*, no. 25).

Of special significance was an icon of the Virgin Peribleptos from the church of the same name at Veroia, the region from which the present icon comes (Papazotos 1995, 53-54, fig. 43). It too belongs to the type of the Eleousa with the Christ-Child in her right arm, and is accompanied by two full-length angels, just as in the present icon. The Veroia Peribleptos, an icon of monumental dimensions (164 × 104 cm), continues, because of its overpainting, to pose problems of precise dating and stylistic affiliation. Nevertheless, it has been recognized as a work of pictorial excellence, with a style connecting it, in all probability, with a competent workshop of the years around 1370-1380.

The existence of two iconographically parallel portable icons with a common appellation at Veroia in the fourteenth century is a reminder of the importance of the local cult of the Virgin Peribleptos in this area. At the same time, it reflects the particular influence exerted in that period by the restored church at Constantinople from which the cult spread outwards.

Anastasia Drandaki

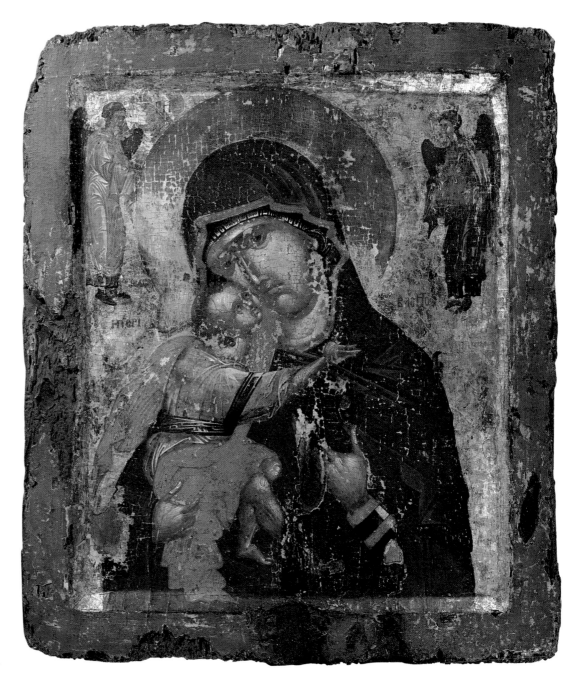

Literature:
Kazanaki-Lappa 1988, 47-48.

83

Two-sided icon: A. *The Virgin Hodegetria*
B. *The Man of Sorrows*

115 × 77 cm
Egg tempera on wood
Last quarter of 12th century
Kastoria, Byzantine Museum, Inv. no. 457/90

This two-sided icon from Kastoria is, as can
be seen from the slots in the underside of its
frame, a processional icon with a specific litur-
gical function connected with the Passiontide
Offices of Holy Week.

A. The principal face shows the Virgin
Brephokratousa, frontally and in bust, in the
'austere' Hodegetria type. Her maphorion is
aubergine, her himation dark blue. Christ,
also shown frontally, holds a closed scroll in
his left hand and makes a gesture of blessing
with his right. He wears an orange chiton and
a brown himation. In the top corners of the
icon there are two miniature venerating
angels in bust, symmetrically framing the Vir-
gin. The figures in the icon, which has a defin-
ing red border, are projected against a
ground of yellow ochre doing duty for gold.
The haloes are of silver, known to have been
used for portable icons in Kastoria and
Cyprus from the twelfth century onwards.

B. On the secondary face, Christ is shown in
the iconographic type of the Man of Sorrows.
He is in bust, in front of the Cross, already
dead, and naked. His halo his inscribed, and
on his Cross is the legend: [BAC]IΛEYC
THC ΔOΞHC (King of Glory). The ground
in dark blue.

The Kastoria two-sided icon is of much inter-
est for its iconography, since in showing Christ
and the Virgin, the two protagonists in the
Divine Drama, together, it links it with the
services of Holy Week. More specifically, the
Man of Sorrows, a conception inspired by the
Old Testament (Isaiah 53:8), is connected
with the fact that services whose subject was
Christ's Passion flourished in the monaster-
ies of Constantinople from the eleventh cen-
tury onwards (Pallas 1965, 197ff.; Belting
1980-1981, 5ff.). These needed a single
iconographic subject which would combine
the Crucifixion, the Deposition, the Lam-
entation, and the Entombment. The Virgin
on the two-sided icon, with her emotionally-
charged face constrasting with Christ's calm
expression, also brings to mind the image
of the suffering Virgin in representations of
Christ's Passion: such as the Crucifixion, the
Deposition, and the Lamentation. At the

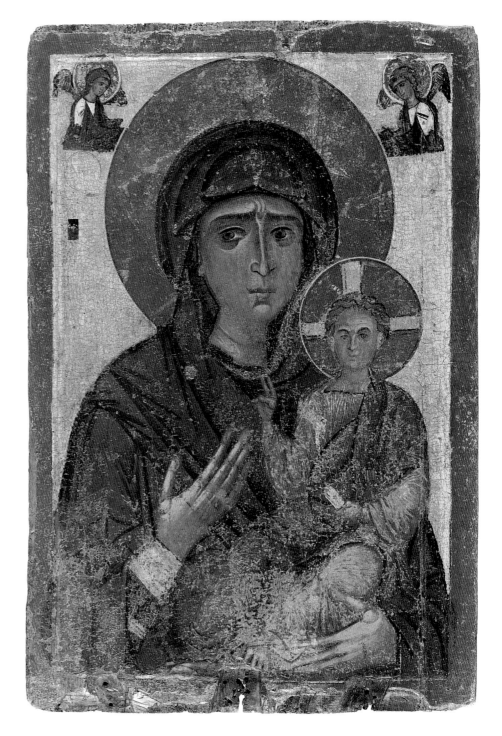

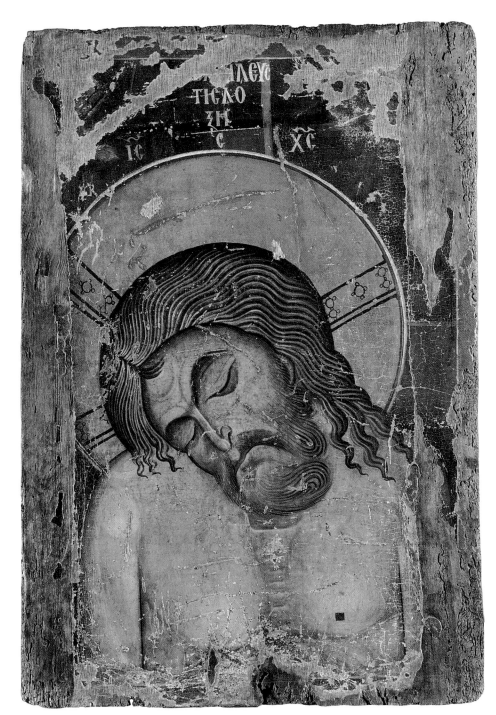

same time, Christ 'Man of Sorrows' belongs to a category of subjects that link art and liturgy. For this is the pictorial symbol of the Church itself, founded on Christ's Sacrifice upon the Cross, which is ceaselessly repeated in the coming together for the Eucharist (Pallas 1965, 280-282).

From the point of view of style, the type of the Virgin's physiognomy, with the frown on her face and the expressive intensity of her gaze, connects with paintings of the late twelfth century, such as the icon of the Virgin (about 1183) from the Enkleistra of St Neophytos in Cyprus (Papageorgiou 1991, fig. 9).

The Man of Sorrows on the present icon, a subject also familiar from Middle Byzantine portable icons, illuminated manuscripts, and wall-paintings (Pallas 1965, 201), is the oldest representation of this type on a portable icon. Stylistically, the Kastoria Man of Sorrows is directly linked, as regards physiognomy, facial features, and the linear rendering of hair and beard, to works from the last quarter of the twelfth century, such as the Christ of the Lamentation (about 1180) in the church of Sts Anargyroi at Kastoria (Pelekanides and Chatzidakis 1984, 33, fig. 12).

Euthymios Tsigaridas

Exhibitions:
From Byzantium to El Greco, Royal Academy of Arts, London 1987; *Holy Image - Holy Space*, Walters Art Gallery, Baltimore 1988; *Ceremony and Faith*, Hellenic Antiquities Museum, Melbourne, Byzantine Museum, Athens 1999.

Literature:
Chatzidakis 1976, 184-185, pl. XXXVII, 20-21; Belting 1994, 262-265, fig. 163; Carr 1995, 121, pls 10.1, 10.2; *From Byzantium to El Greco*, no. 8; *Holy Image - Holy Space*, no. 9; *Ceremony and Faith*, no. 10.

84

Two-sided icon: A. *The Crucifixion*
B. *The Virgin Hodegetria*

87 × 63 cm
Egg tempera on wood
A. 9th century and 13th century. B. 16th
century
Epirus, Peta, Evangelistria monastery
Athens, Byzantine Museum, Inv. no. T157

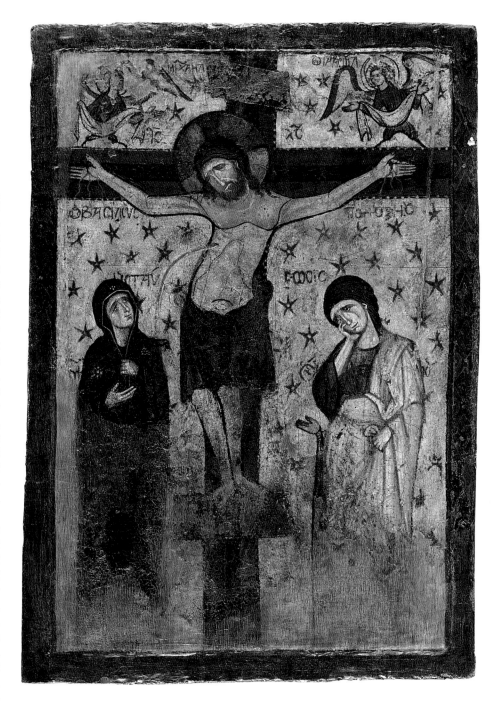

A. At the centre of the composition is Christ, on the Cross, with a slight drooping of his head and body to the left. He is framed by the standing figures of the Virgin and St John. From the side of the Crucified, issues blood mingled with water. The Cross, its outline studded with pearls, reaches to the edges of the icon. The Virgin lifts her head and eyes towards her Son: her right hand is to her breast in a gesture of prayer, and with her left she holds her maphorion in check. St John rests his cheek on his right hand in deep despair, and holds part of his himation with his left hand. Above, right and left, are the two Archangels Michael and Gabriel. With bird feet, they perch on the horizontal arms of the Cross, spreading out liturgical veils on their open hands. The icon's yellow ground is spangled with numerous red stars. Part of the figure of Michael and the bottom of the three principal figures and of the Cross has flaked away.

In this scene, discovered when the icon was cleaned in the Conservation Laboratory of the Byzantine Museum, Athens (Margaritof 1959, 144-148), three different layers of painting can be made out. The earliest layer is from the ninth century (Weitzmann et al. 1965, XXV). Of this there survive: the Cross, the two angels with bird feet, the body of the Crucified, part of the original figure of John, preserving only his hand in the gesture of prayer, and a vessel, that was held by an angel, on the Virgin's left shoulder, symbolizing the Church. The starry ground and the inscriptions are thought to have been added in the tenth century (Sotiriou 1959, 136; Margaritof 1959, 145, fig. 1). The Virgin, St John, and the head of Christ belong to the thirteenth-century phase of painting.

The composition is distinguished by its economy of means. It is confined to just three figures, and omits both the rock of Golgotha and the skull of Adam. The liturgical veils held by the two angels and the eucharistic vessel (with which an angel, or perhaps a personification of the Church, collects the blood and water from Christ's side) emphasize the icon's doctrinal meaning.

Rare archaizing elements of iconography combine in the original ninth-century Crucifixion. As can now be seen from the rose red of his naked body, uncovered when the overpainting was removed (Margaritof 1959, 148, fig. 2; N. Chatzidakis et al. 1985-1986, 223ff., fig. 23), Christ was shown alive on the Cross, with eyes open. This iconographic element can be ascribed to Early Byzantine representations, and was to survive until the eleventh century, when it became regular to portray Christ already dead. Two other archaizing features are the deep purple of Christ's loincloth, and the omission of Adam's skull at the base of the Cross (Sotiriou 1959, 137). The portrayal of the angels with bird feet is unique. Notably uncommon, too, is the liturgical veil spread out on their arms: normally they simply hold part of their robe. The iconography and style of this Crucifixion point to the early Middle Byzantine period, and perhaps to the ninth century (Weitzmann et al. 1965, XXV; Acheimastou-Potamianou 1998, 12).

The Virgin, St John and the head of Christ all belong to the third and last phase. They reflect the high level of early thirteenth-century Byzantine art, a model for Italian painters of this period (Sotiriou 1959, 142; Vocotopoulos 1964, 204-205). The three figures' subdued grief and pathos, and the econ-

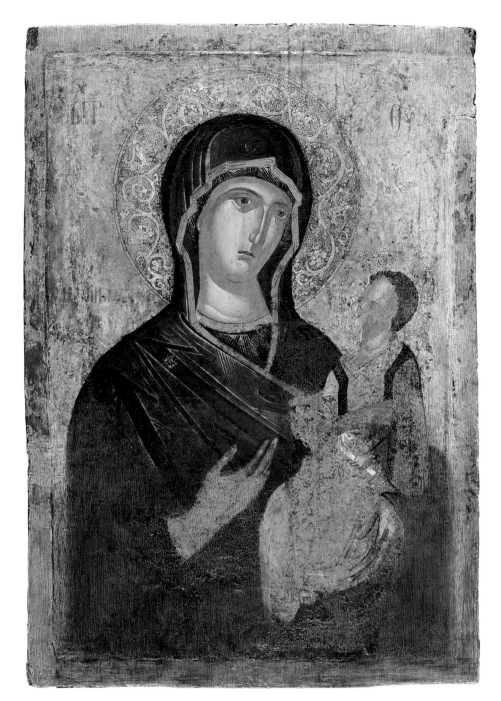

the original Crucifixion on the obverse (Margaritof 1959, 148, fig. 2).

In his iconography of the Virgin, the painter did not follow the 'austere' frontal type of the triumphant Byzantine Hodegetria. Instead, there is gentle movement by the Theotokos towards the Christ Child, indicated by a slight inclination of her head.

The Pammakaristos icon shows direct stylistic dependence on paintings of the Epirote School (Acheimastou-Potamianou 1983). The closest comparable example is the wall-painting of the 'Virgin as Mediatrix', in the Barlaam monastery at Meteora, a work by Frangos Katelanos (Baltoyanni 1998, 36).

Kalliopi-Faidra Kalafati

Conservation:
Tassos Margaritof, 1958.

Exhibitions
Byzantine Art, an European Art, Zappeion, Athens 1964; *Conversation with God,* The Hellenic Centre, London 1998.

Literature:
Sotiriou 1924, 97, fig. 31; Sotiriou 1931², 78, fig. 34; Margaritof 1959, 144-148; Sotiriou 1959, 135-143; Chatzidakis 1960, 11, pl. 7; Sotiriou 1962, 17, pl. XII; *Byzantine Art, an European Art,* no. 184; Weitzmann et al. 1965, XXV, LXXXIII, figs on 44, 45, 46, 47; Chatzidakis 1974, 335-336, fig. 15; Weitzmann et al. 1980, 66, 224, figs on 92-93; N. Chatzidakis et al. 1985-1986, 215, 220-22, 229, 232, figs 1, 2, 23, 24; Baltoyianni 1994b, 30ff.; Acheimastou-Potamianou 1998, 12-17; *Conversation with God,* no. 1.

omy of colour and composition, link the portrayal with two thirteenth-century icons, one at Veroia and one in Cyprus (Acheimastou-Potamianou 1998, 16).

B. The Mother of God is shown waist-length, with the Christ-Child in her arms to her left, in the type of the Hodegetria. She turns slightly towards the Child and brings her right hand in front of her breast. Her deep purple maphorion is touched with ochre (doing duty for gold) in the folds and adorned with stars. Christ turns his face and torso towards his mother. He makes a gesture of blessing with his right hand, and holds a closed scroll in his left. He wears a sleeved

chiton and a himation that covers only his legs. The two figures have gold haloes adorned with scrolling flowering tendrils, on a gold ground. The representation is painted on a gold ground. Above the Virgin's right shoulder is an inscription in red capital letters: ΠΑΜΜΑΚΑΡΙСΤΟС (The Pammakaristos, Most Blessed). There is obvious damage to Christ's head and right hand, and to the lower part of the icon.

Examination with X-rays shows that this image with the Virgin Pammakaristos, painted on the reverse of the Crucifixion, was an overpainting. It probably concealed an earlier Virgin, perhaps of the same date as

487

85
Icon of the Lamenting Virgin

75.5 × 45 cm
Egg tempera on wood
Third quarter of the 14th century
Northern Greece (?)
Athens, Benaki Museum, Inv. no. 36363

The Virgin is depicted, facing right and lamenting. Her head is bowed slightly forward and the palm of her left hand is brought close to her cheek. Her right hand is in front of her breast with the palm turned inwards. The Virgin's brow is furrowed, her nose aquiline and her lips compressed with grief. Her attire is very dark in colour. She wears a deep blue himation and *kekryphalos* and a dark brown maphorion. This drab monotony is relieved only by the cuffs, which are ochre-brown. The icon has an integral frame damaged at the edges.

The posture and gesture of the Virgin give the impression that she belongs in a scene of the Crucifixion, or in one of Lamentation, as her hair showing under the *kekryphalos* seems to indicate. Her pose would seem to make sense only if Christ were next to her and she were expressing her deep sorrow. It is difficult therefore to accept this icon as an independent representation of the lamenting Virgin. It must originally have been complemented by a panel bearing an image of Christ as Man of Sorrows. Of the few surviving examples, a diptych from the monastery of the Transfiguration at Meteora offers the most complete representation of the lamenting Virgin and the Man of Sorrows on two adjacent and connecting leaves. It dates from the early fourteenth century (Belting 1980-1981, figs 4-5; Chatzidakis and Sofianos 1990, pl. on 65). A later inscription on the back of the diptych gives instructions on how these two panels should be placed side by side on the Epitaphios on Easter Saturday. It is highly probable that this later inscription copies an earlier one, in which case the use of this diptych was connected with the Passion Offices (Belting 1980-1981, 7-8).

A lamenting Virgin has also survived on a panel in the Tretyakov Gallery, Moscow, which dates from the late thirteenth century (*Vizantija, Balkany, Rus'*, no. 2). The corresponding panel with Christ is missing here as well as in the Benaki example. Very few such Byzantine diptychs have survived, but it seems that they had an impact in the West from the thirteenth century onwards. A thirteenth-century Italian diptych recently acquired by the National Gallery, London, seems to suggest this (Cannon 1999, 107-112, figs 54-55). In the latter, however, the Virgin is shown holding the Christ-Child on one panel rather than lamenting, while Christ remains as the Man of Sorrows on the other. The pairing of the Virgin Brephokratousa with the Man of Sorrows occurs on two-sided Byzantine icons as well. These were processional icons used for the Passion ritual. The earliest surviving example comes from Kastoria (Cat. no. 83) and dates to the twelfth century (*Glory of Byzantium*, no. 72 with previous bibliography). On both the Kastoria icon and the London diptych the Virgin with the Christ-Child is of the Hodegetria type, adding weight to the hypothesis that a Byzantine prototype was used by the Italian painter of the diptych.

The theme of the lamenting Virgin has its roots in Byzantine hymnography and homiletic literature. The lament of the Virgin came to link the cult of Mary with the Passion of the Lord. The *kontakion* of Romanos the Melodos (Grosdidier de Matons 1967, 160-184; Grosdidier de Matons 1977, 243ff.) was the first instance when these two themes were combined. After a break of almost two centuries the lament of the Virgin is encountered in the Iconoclastic period, while the ninth century witnessed the apogee of this literary theme that was subsequently incorporated in the liturgical books of the Church and was used as a model by Byzantine artists. The lament represents the combination of the two themes that acquired distinct prominence during the Iconoclastic Controversy: the Passion of Christ and the place of the Virgin in the Mystery of the Incarnation (Tsironis 1998). The lament of the Virgin over the dead body of Christ is encountered in two ninth-century homilies by George of Nikomedeia. One is read on Good Friday and the other on Easter Saturday. Such homilies seem to antedate the lamenting Virgin on the Benaki icon. They were used on similar occasions and mainly served, therefore, functions connected with the liturgy of Holy Week.

Both the iconographic and stylistic features of the Virgin in the present icon have succeeded in rendering the deep emotional state of a lamenting person. The dark colours of the Virgin's drapery enhance the sadness of her countenance. Though the style of this icon is reminiscent of early fourteenth-century works, it is later than these. The closest parallel to this icon is to be found in the Great Deesis series of icons in the Chilandari monastery, which date from the third quarter of the fourteenth century. (Weitzmann et al. 1982, pls on 188-191; *Treasures of Mount Athos*, nos 2.25, 2.26, 2.27). The dark shadows outlining the face, the furrowed forehead, the hooked nose and the tight lips of the lamenting Virgin are also found in the rendering of the Archangel Gabriel's face from Chilandari. The fine black lines of the eyes and eyebrows, the white flecks on the pupils of the eyes and the shadows beneath them, which characterize the faces of the Evangelists Matthew and Luke from Chilandari, are also to be found in the face of the lamenting Virgin. It is obvious that like these the present icon was produced in a workshop in Northern Greece.

Maria Vassilaki

Conservation:
Kalypso Milanou 2000.

Literature:
Unpublished.

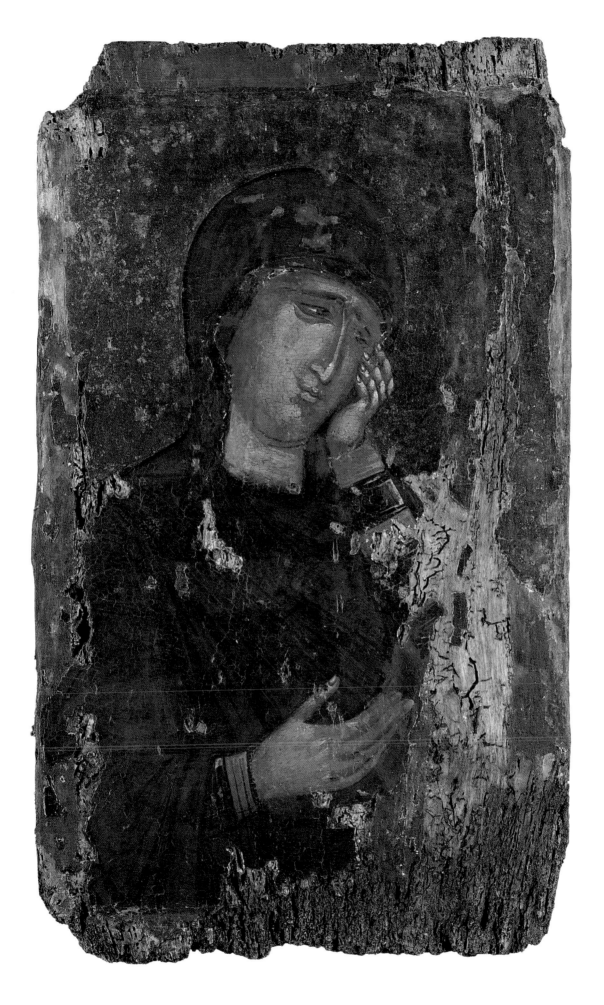

489

86

Two-sided icon: A. *The Virgin Kataphyge and St John the Theologian.* B. *The Vision of Ezekiel and Habbakuk*

93 × 61 cm
Egg tempera on wood
About 1370-1395
Thessaloniki (?)
From the monastery of St John the Theologian in Poganovo, near Dimitrovgrad, Yugoslavia.
The icon was donated to the National Archaeological Museum in Sofia in 1920, Inv. no. 2057. Now exhibited in the National Art Gallery. Old Bulgarian Art Collection Sofia, church of Alexander Nevski, The Crypt.

The two-sided icon from the Poganovo monastery depicts the Theotokos Kataphyge and St John the Theologian on one side and the Vision of the Prophet Ezekiel on the other. The characteristics of the icon may be seen as emblems for the latest stage in the development of Byzantine art. It has a rare iconographic programme, a rare appellation for the Virgin and was evidently commissioned for a special occasion.

A. On the front is an image of the Virgin with the appellation Η ΚΑΤΑΦΥΓΗ (The Refuge). She wears a blue chiton, and over it a dark blue maphorion, embroidered with gold. Her attitude is one of deep sorrow. St John the Theologian, the patron saint of the Poganovo monastery, is depicted as an aged man. His chiton is blue and his himation lilac. His pose expresses sadness and meditation. Between the two figures there are traces of a dedicatory inscription: ...E]N Χ(ΡΙCΤ)Ω ΤΩ Θ(Ε)Ω ΠΙCΤΗ ΒΑCΙΛΙCCΑ (In Christ the God Faithful Queen). This inscription can be completed as follows: [ΕΛΕΝΗ Ε]Ν Χ(ΡΙCΤ)Ω ΤΩ Θ(Ε)Ω ΠΙCΤΗ ΒΑCΙΛΙCCΑ (Helena in Christ the God Faithful Queen). The eminent Bulgarian scholar Gerasimov (1959) identified the donor of the icon as the Byzantine Empress Helena Dragas, the wife of Manuel II Palaiologos (1391-1425) and dated the icon to 1395. Grabar (1959; 1961), Xyngopoulos (1962), Weitzmann (1978), Bozhkov (1976) and Gerov (1999) studied the icon and agreed with Gerasimov's dating. Babić (1987), however, identified the donor as Helena, the wife of John Uglesa (1366-1371), the Serbian Despot and Governor of Serres, and dated the work to 1371. The new dating is accepted by Subotić (1993) and Vocotopoulos (1995). Unfortunately, nowadays there is no trace of the name of the donor. Even recent infrared photography by Mihail Enev

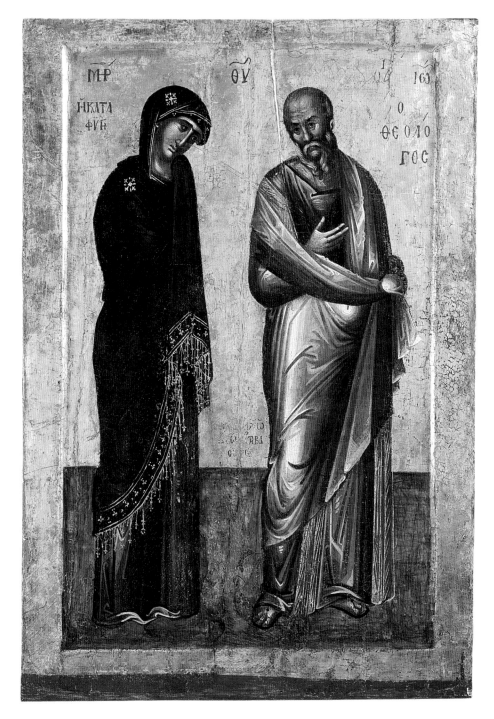

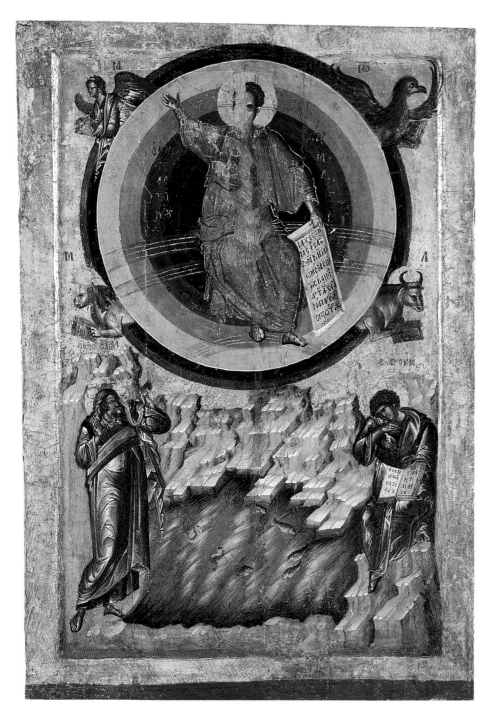

gave negative results. Consequently, every identification will remain in the sphere of hypothesis.

B. On the back of the icon is Christ Emmanuel seated in glory, with the symbols of the Four Evangelists ranged round him. Seated on a rainbow, he holds a scroll with the text: ΙΔΟΥ Ο ΘΕΟC ΗΜΩΝ ΕΦ'ΟΝ ΕΛΠΙΖΟΜΕΝ ΚΑΙ ΗΓΑΛΛΙΩΜΕΘΑ ΕΠΙ ΤΗ CΩΤΗΡΙΑ ΗΜΩΝ. ΑΥΤΟC ΔΩCΕΙ ΑΝΑΠΑΥCΙΝ ΤΩ ΟΙΚΩ ΤΟΥΤΩ (Behold this is our God; we have waited for him; we will be glad and rejoice in his salvation, Give rest to this house) (Isaiah 25:9-11). A second inscription, Ο ΕΝ ΤΩ ΛΑΤΟΜΟΥ ΘΑΥΜΑ (The Miracle in Latanos), is placed on either side of the figure of Christ. The vision is revealed to two prophets, Ezekiel on the left, and Habbakuk on the right. Ezekiel raises his arms in fear, while Habbakuk places his right hand on his chest and in his left holds an open book which rests on his left knee. The text in the book: ΥΙΕ ΑΝΘΡΩΠΟΥ, ΚΑΤΑΦΑΓΕ ΤΗΝ ΚΕΦΑΛΙΔΑ ΤΑΥΤΗΝ (Son of man, eat what you find; eat this scroll), comes from Ezekiel (3:1). The landscape is unusual because of the waters plentifully stocked with fish, the so called 'living waters', which are rarely encountered in Byzantine art and are usually associated with the Apocalypse (Revelation 7:17; 21:6 and 22:1) and death.

The icon, artistically a highly accomplished work, is unprecedented iconographically. It was painted by an extremely talented master, shaping messages of special moment, as a commission of a distinguished donor for a specific occasion, and its commemorative significance is unassailable. The Vision of the Prophet Ezekiel, who was a herald of the Last Judgement, symbolizes the Resurrection and Salvation of the righteous and is depicted in the twelfth-century frescoes in the ossuary church of the Bačkovo monastery (Bakalova 1977, 67-68, 70). The Theotokos Kataphyge and St John the Theologian also refer to the Resurrection and Salvation. The appellation Kataphyge, rarely associated with the Theotokos, is borrowed from Byzantine hymnography, in which the Mother of God is recognized as a supporter of the faithful as well as a refuge for righteous souls striving for spiritual salvation (Grabar 1959; Xyngopoulos 1962; Bakalova 1991). The unusual composition on the front of the icon, with the image of the Virgin and St John the Theologian, could also be explained with the help of hymns. The liturgy for the dormition of St John the Theologian (26 September), composed by Archbishop Symeon of Thessaloniki (1416/17-1429), reveals the relationship

between the saint and the Theotokos, noting that the apostle, a theologian, experienced a change in his life when the Virgin was entrusted to him, each finding a refuge and support in the other (Voordeckers 1983). The icon offers a visual interpretation of the liturgical text and pays respect to the patron of the monastery in a manner similar to the celebration of the liturgy honouring him. The eschatological theme makes it clear that this work also commemorates and pays homage to the recently deceased relative of the donor.

The quality of the Poganovo icon ranks it among the greatest works of art from the last decades of the Byzantine Empire. The work displays elements of classical beauty valued in the fourteenth century, such as exquisite contours, ideally balanced volumes and compositional details, gently modelled drapery, and harmonious, warm hues. It also a distinctive mood of pensiveness and contemplation, emotions that are forcefully expressed. With its somewhat 'dramatizing' rather than 'counter-balancing' features, the icon is not a product of early-fourteenth-century Constantinopolitan art. Probably created in Thessaloniki during the siege of the city by the Turks, it captures a dramatic intensity characteristic of Byzantine art towards the end of the fourteenth century. This stylistic tendency mirrors the anxiety of those tragic times, when most regions of Byzantium, the Balkan Slavic states and other centres of Orthodox Medieval culture in southeastern Europe succumbed to domination by successive waves of Ottoman conquerors.

Elka Bakalova

Conservation:
Vera Nedkova, 1952.

Exhibitions:
Kunstschätze in bulgarischen Museen und Klöstern, Essen 1961; *Trésors des Musées Bulgares*, Gallerie Charpentier, Paris 1963; *Sztuka starobulgarska*, Warsaw 1969; *Régi bolgar muveset*, Budapest 1970; *Icônes bulgares. IXe-XIXe siècle*, Musée du Petit Palais, Paris 1976; *Ikonen aus Bulgarien*, Museum der Angewandte Kunst, Vienna 1977; *Icônes bulgares du IXe au XIXe siècle*, Musées royaux d'Art et d'Histoire, Brussels 1977; *Ikonen aus Bulgarien*, Munich 1978; *Icons from Bulgaria (from the 9th to the 19th centuries)*, Courtauld Institute Galleries, London 1978; *Tesori dell'arte cristiana in Bulgaria*, Mercati di Traiano, Rome 2000.

Literature:
Vodach za Narodnia Muzei v Sofia 1923, 210;

Gerasimov 1959, 279-288; Grabar 1959, 289-304; Miiatev 1961; Xyngopoulos 1961, 363-380; Pandurski 1963; Weitzmann et al. 1965; Bozhkov and Tchernev 1966; Bossilkov 1966; Bakalova 1972, 74; Skrobucha 1975, 91-92; Bozhkov 1976, 2-7; *Icônes bulgares*; Bakalova 1977, 67-68, 70; Weitzmann 1978, 132, fig. 47; Babić 1980, 24-25, figs 32-33; Paskaleva 1981, 27-28, 57, 74-83; Velmans 1982, 32-40, figs 33-35; Prashkov 1985, 13, 62-65; Bozhkov 1987, pls 44, 45, 47; Voordeckers 1983, 61-62; Babić 1987, 57-67; Bakalova 1991, 3-20; Subotić 1993, 25-38; Gerov et al. 1999, 25-26; Bakalova 2000, 152-154 (forthcoming).

Bibliography / Glossary / Index

Bibliography

Edited by Phyllia Kanari

AAA: *Athens Annals of Archaeology*

AASS: *Acta Sanctorum*, Paris 1863-1940

AB: *Analecta Bollandiana*

AbhHeidelb: *Abhandlungen der Heidelberger Akademie der Wissenschaften, phil.-hist. Klasse*

ABME: Ἀρχεῖον τῶν Βυζαντινῶν Μνημείων τῆς Ἑλλάδος

ACO: *Acta conciliorum oecumenicorum*, E. Schwartz ed., Berlin-Leipzig 1922-1974

Acta Norv: *Acta ad archaeologiam et artium historiam pertinentia, Institutum Romanum Norvegiae*

ΑΔ: Ἀρχαιολογικὸ Δελτίο

ΑΕ: Ἀρχαιολογικὴ Ἐφημερίς

AIPhO: *Annuaire de l'Institut de philologie et d'histoire orientales et slaves*

Ἀνάλεκτα: Ἀνάλεκτα Ἱεροσολυμιτικῆς σταχυολογίας, A. Papadopoulos-Kerameus ed., St Petersburg 1891-1897, rpr. Brussels 1963

AntTard: *Antiquité Tardive*

AOC: *Archives de l'Orient chrétien*

ArtB: *Art Bulletin*

ArteChr: *Arte Christiana*

ArtH: *The Art History*

ASNSP: *Annali della Scuola Normale Superiore di Pisa*

BAG: *Greek-English Lexicon of the New Testament and Other Early Christian Literature*, A Translation and Adaptation of W. Bauer's, *Griechisch-Deutsches Wörterbuch*, by W.F. Arndt and F.W. Gringrich, 1957, 1969²

BHG: *Biblioteca hagiographica graeca*, F. Halkin ed., Brussels 1957

BICR: *Bolletino dell'Istituto Centrale del Restauro*

BIFAO: *Bulletin de l'Institut français d'archéologie orientale*

BMGS: *Byzantine and Modern Greek Studies*

BNJ: *Byzantinisch-Neugrichische Jahrbücher*

Bull dell'Ist. Storico Italiano per il Medio Evo e Arch. Muratoriano: *Bollettino dell'Istituto Storico Italiano per il Medio Evo e Archivio Muratoriano*

BollArte: *Bollettino d'Arte*

Bonn ed.: CSHB: *Corpus scriptorum historiae byzantinae*

CI: *Codex Justinianus*, P. Krüger ed., Berlin 1929

Dig: *Digesta*, Th. Mommsen and P. Krüger eds, Berlin 1928

Nov: *Novellae*, F. Schoell and G. Kroll eds, Berlin 1928

BSA: *Annual of the British School at Athens*

BSl: *Byzantinoslavica*

BullSocAntFr: *Bulletin de la Société nationale des antiquaires de France*

BurlMag: *Burlington Magazine*

ByzF: *Byzantinische Forschungen*

BZ: *Byzantinische Zeitschrift*

CahA: *Cahiers Archéologiques*

CC, Ser. Apocryphorum: *Corpus christianorum, Series Apocryphorum*

CCSG: *Corpus christianorum, Series graeca*

CFHB: *Corpus Fontium Historiae Byzantinae*

CIEB: *Congrès International d'Etudes Byzantines*

CorsiRav: *Corsi di Cultura sull Arte Ravennate e Bizantina*

CPG: *Corpus Patrum Graecorum*

CSEL: *Corpus scriptorum ecclesiasticorum orientalium*

CSHB: *Corpus Scriptorum Historiae Byzantinae*

DACL: *Dictionnaire d'archéologie chrétienne et de liturgie*

ΔΧΑΕ: Δελτίο τῆς Χριστιανικῆς Ἀρχαιολογικῆς Ἑταιρείας

DOP: *Dumbarton Oaks Papers*

DOS: *Dumbarton Oaks Studies*

ΕΛΑ: Ἐπετηρὶς Λαογραφικοῦ Ἀρχείου

EO: *Échos d'Orient*

FHG: *Fragmenta historicorum graecorum*, K. Müller ed., Paris 1841-1883

GOTR: *Greek Orthodox Theological Review*

HE: *Historia Ecclesiastica*

Hesperia: *Hesperia. Journal of the American School of Classical Studies at Athens*

HThR: *Harvard Theological Review*

HUkSt: *Harvard Ukrainian Studies*

ΘΗΕ: Θρησκευτικὴ καὶ Ἠθικὴ Ἐγκυκλοπαιδεία

JbAChr: *Jahrbuch für Antike und Christentum*

JECS: *Journal of Early Christian Studies*

JGettyMusJ: *The J. Paul Getty Museum Journal*

JIAN: *Journal International d'Archéologie Numismatique*

JÖB: *Jahrbuch der Österreichischen Byzantinistik*

JÖBG: *Jahrbuch der Österreichischen Byzantinistik Gesellschaft*

JRVI: *Jbornik radova Vizantološkog instituta*

JTS: *Journal of Theological Studies*

JWalt: *Journal of the Walters Art Gallery*

ΚυπρΣπ: Κυπριακαὶ Σπουδαί

Mansi: J. D. Mansi, *Sacrorum conciliorum nova et amplissima collectio*, Paris-Leipzig 1901-1927

MN: *American Numismatic Society Museum Notes*

MNM: *American Numismatic Society Museum Notes and Monographs*

MonPiot: *Monuments et mémoires publiés par l'Académie des inscriptions et belles-lettres: Fondation Eugène Piot*

ΝέοςΕλλ: Νέος Ἑλληνομνήμων

NH: *Natural History*

OCA: *Orientalia christiana, analecta*

OCP: *Orientalia christiana periodica*

ΠΑΑ: Πρακτικὰ τῆς Ἀκαδημίας Ἀθηνῶν

ΠΑΕ: Πρακτικὰ τῆς ἐν Ἀθήναις Ἀρχαιολογικῆς Ἑταιρείας

Past and Present: *Past and Present: a Journal of Historical Studies*

PBSR: *Papers of the British School at Rome*

PG: *Patrologiae cursus completus, Series graeca*, J.-P. Migne ed., Paris 1857-1866

PL: *Patrologiae cursus completus, Series latina*, J.-P. Migne ed., Paris 1844-1880

PO: *Patrologia orientalis*, R. Graffin and F. Nau eds, Paris 1903-

PSb: *Palestinskij Sbornik*

PSRL: *Polnoe Sobranie Russkikh Letopsei*

RBA: *Revue Belge d'Archéologie et d'Histoire de l'Art*

RDAC: *Report of the Department of Antiquities of Cyprus*

REA: *Revue des études anciennes*

REB: *Revue des études byzantines*

RL: *La Revue du Louvre et des musées de France*

RHC grecs: *Recueil des historiens des Croisades grecs*, 2 vols, Paris 1875-1881

RHR: *Revue de l'histoire des religions*

RIASA: *Rivista dell'Istituto nazionale di archeologia e storia dell'arte*

RIC: *Royal Imperial Coinage*

RN: *Revue numismatique*

ROL: *Revue de l'Orient latin*

RömJahrKunst: *Römisches Jahrbuch für Kunstgeschichte*

RSNum: *Revue suisse numismatique*

SBN: *Studi bizantini e neoellenici*

SC: *Sources chrétiennes*

SChH: *Studies in Church History*

Scientia veterum

SettStu: *Settimane di Studio del Centro Italiano di Studi sull'alto medioevo*

SubsHag: *Subsidia hagiographica*

Symposium XAE: *Symposium XAE Abstracts of Papers,*

TheolSt: *Theological Studies*

TM: *Traveaux et Mémoires*

ΤεχνΧϱ: *Τεχνικά Χρονικά*

VChr: *Vigiliae Christianae*

VizVrem: *Vizantijskij Vremennik*

WS: *Wiener Studien*

ZLU: *Zbornik za Likovne Umetnosti*

ZborMuzBeograd: *Zbornik Narodnog Muzeja Beograd*

ZRVI: *Zbornik radova Vizantološkog Instituta*

Aegean: *The Aegean. The Epicentre of Greek Civilization*, Athens 1992.

A Guide to the Early Christian and Byzantine Antiquities: *A Guide to the Early Christian and Byzantine Antiquities in the Department of British and Mediaeval Antiquities*, London 1921².

Abdel-Malek 1980: Laila Halim Abdel-Malek, *Joseph Tapestries and Related Coptic Textiles*, Ph.D. diss., Boston University 1980.

Abel 1988: U. Abel, *Ikonen - bilden av det heliga*, Hedemora 1988.

Acheimastou 1966: Myrtali Acheimastou, Αμφιπρόσωπες εικόνες της Ρόδου. Η εικόνα της Οδηγήτριας και του Αγίου Νικολάου, *ΑΔ* 21 (1966), 62-83.

Acheimastou-Potamianou 1983: Myrtali Acheimastou-Potamianou, *Η μονή των Φιλανθρωπηνών και η πρώτη φάση της μεταβυζαντινής ζωγραφικής*, Athens 1983.

Acheimastou-Potamianou 1985-1986: Myrtali Acheimastou-Potamianou, Η ερμηνεία μιας τοιχογραφίας στη μονή της Βλαχέρνας κοντά στην Άρτα, *ΔΧΑΕ* 13 (1985-1986), 301-306.

Acheimastou-Potamianou 1991: Myrtali Acheimastou-Potamianou, Βυζαντινό Μουσείο, *ΑΔ* 46 (1991), Χρονικά, 6-10.

Acheimastou-Potamianou 1994: Myrtali Acheimastou-Potamianou, *Byzantine Wall-Paintings*, Athens 1994.

Acheimastou-Potamianou 1995: Myrtali Acheimastou-Potamianou, Μαρμάρινη εικόνα δεομένης Παναγίας, άλλοτε στο Βυζαντινό Μουσείο, *ΔΧΑΕ* 18 (1995), 9-13.

Acheimastou-Potamianou 1997: Myrtali Acheimastou-Potamianou, *Icons of Zakynthos*, Athens 1997.

Acheimastou-Potamianou 1998: Myrtali Acheimastou-Potamianou, *The Icons of the Byzantine Museum*, Athens 1998.

Acheimastou-Potamianou 1998-1999: Myrtali Acheimastou-Potamianou, Παρατηρήσεις σε δύο αμφιπρόσωπες εικόνες της μονής Παντοκράτορος στο Άγιον Όρος, *ΔΧΑΕ* 20 (1998-1999), 309-316.

Achimastou-Potamianou 1981: Myrtali Achimastou-Potamianou, The Byzantine Wall Paintings of Vlacherna Monastery (area of Arta), in *Actes du XVe CIEB*, II, 4-14.

Actes du XIVe CIEB, Bucarest 1971, Bucarest 1975.

Actes du XVe CIEB, Athènes 1976, Athens 1979, 1981.

Affreschi e icone dalla Grecia: *Affreschi e icone dalla Grecia (10.-17. Secolo)*, exh. cat., Palazzo Strozzi, Florence, 16 September-16 November 1986, Athens 1986.

Age of Spirituality: *Age of Spirituality: Late Antique and Early Christian Art, Third to Seventh Century*, K. Weitzmann ed., New York 1979.

Ainalov 1902: D.V. Ainalov, Encaustic Icons from Sinai (in Russian), *VizVrem* 9 (1902), 343-377.

Aldama 1970: J.A. Aldama, *Maria en la Patristica de los siglos I y II*, Madrid 1970.

Alexakis 1996: A. Alexakis, *Codex Parisinus Graecus 1115 and Its Archetype*, Washington D.C. 1996.

Alexander 1952: P.J. Alexander, Hypatius of Ephesus: A Note on Image Worship in the Sixth Century, *HThR* 45 (1952), 177-184.

Alexiou 1974: Margaret Alexiou, *The Ritual Lament in Greek Tradition*, Cambridge, MA 1974.

Alexiou 1975: Margaret Alexiou, The Lament of the Virgin in Byzantine Literature and Modern Greek Folk Song, *BMGS* 1 (1975), 111-140.

Alpatov and Lazarev 1925: M. Alpatov and V. Lazarev, Ein byzantinisches Tafelwerk aus der Komnenen Epoche, *Jahrbuch Preussischen Kunstssammlungen* 46/2 (1925), 140-155.

Amiranaschvili 1972: S. Amiranaschvili, *The Khakhuli Triptych*, Tbilisi 1972.

Andaloro 1972-1973: Marina Andaloro, La datazione della tavola di S. Maria in Trastevere, *RIASA* 19-20 (1972-1973), 139-215.

Andaloro 1995: Marina Andaloro, Un gruppo di tavole per l'arredo liturgico. L'Odigitria di Santa Maria de Latinis e il Cancelliere Matteo d'Aiello, *Federico e la Sicilia dalla terra alla corona*, exh. cat., Palermo 1995, 443-447.

Anderson 1982: J.C. Anderson, The Seraglio Octateuch and the Kokkinobaphos Master, *DOP* 36 (1982), 83-114.

Anderson 1991: J. Anderson, The Illustrated Sermons of James the Monk: Their Dates, Order, Place in the History of Byzantine Art, *Viator* 22 (1991), 69-120.

Andreescu-Treadgold and Treadgold 1997: Irina Andreescu-Treadgold and W. Treadgold, Procopius and the Imperial Panels of S. Vitale, *ArtB* 79 (1997), 708-723.

Angelidi 1994: Christine Angelidi, Un texte patriographique et édifiant: le 'discours narratif' sur les Hodègoi, *REB* 52 (1994), 113-149.

Angelidi 1998a: Christine Angelidi, Μιχαήλ Ψελλός: Ἡ ματιά του φιλότεχνου', *Σύμμεικτα* 12 (1998), 75-85.

Angelidi 1998b: Christine Angelidi, *Pulcheria. La castita al potere*, Milan 1998.

Ανωτέρα ἐπισκίασις ἐπὶ τοῦ Ἄθω: *Ανωτέρα ἐπισκίασις ἐπὶ τοῦ Ἄθω. Ἤτοι διήγησις περὶ τῶν θαυματουργῶν εἰκόνων τῆς Θεοτόκου*, Mount Athos 1994.

Antinoe Cent'Anni Dopo: *Antinoe Cent'Anni Dopo*, exh. cat., Palazzo Mecici Riccardi, Florence 1998.

Antonopoulos 1986: E. Antonopoulos, Προλεγόμενα για μια τυπολογία της παιδικής ηλικίας και της νεότητας στη βυζαντινή εικονογραφία, *Πρακτικά του Διεθνούς Συμποσίου: Ιστορικότητα της παιδικής ηλικίας και της νεότητας*, 1, Athens 1986, 271-286.

Antonopoulos 1998: E. Antonopoulos, Παιδαριογέρων: Η απεικόνιση της πρώιμης σοφίας, *Πρακτικά του Διεθνούς Συμποσίου: Οι χρόνοι της Ιστορίας. Για μια ιστορία της παιδικής ηλικίας και της νεότητας*, Athens 1998, 215-231.

Antonopoulou 1997: Theodora Antonopoulou, *The Homilies of the Emperor Leo VII*, Leiden 1997.

Antonova 1960: Irina Alexandrovna Antonova, Ikonograficeskij tip Perivlepti i russkie ikoni Bogomateri le XIV veke, *Iz istorii russkogo I zapadno-evropejskogo iskusstva*, Moscow 1960, 103-117.

Antonova and Mnieva 1963: Irina Alexandrovna Antonova and N.E. Mnieva, *Drevneruskoi Zivopisi*, Moscow 1963.

Aristarches 1900: Aristarches, *Τοῦ ἐν ἁγίοις πατρός ἡμῶν Φωτίου λόγοι καὶ ὁμιλίαι ὀγδοήκοντα τρεῖς*, Constantinople 1900.

Aristarkh 1878: Igumen Aristarkh, Letopis' Bogoljubovo monastyria s 1158 po 1770 g. / The Chronicle of the Bogoljubovo Monastery from 1158 to 1770, *Chtenia Obschestva Istorii Drevnei Rusi*, 1 (1878).

Arts of the Middle Ages: *Arts of the Middle Ages*, exh. cat., Museum of Fine Arts, Boston 1940.

Aslanapa et al. 1989: O. Aslanapa, S. Yetkin and A. Altun, *The Iznik Tile Kiln Excavations (the Second Round: 1981-1988)*, Istanbul 1989.

Aspra-Vardavakis 1992: Mary Aspra-Vardavakis, *Οἱ μικρογραφίες τοῦ Ἀκαθίστου στὸν κώδικα Garrett 13, Princeton*, Athens 1992.

Aspra-Vardavakis forthcoming: Mary Aspra-Vardavakis, Observations on a 13th-century Sinaitic Diptych Representing St Procopius, the Virgin Kykkotissa and Saints Along the Border, *Byzantine Icons. Art, Technique and Technology. Acts of the International Conference held at the Gennadios Library*, Athens 1998, forthcoming.

Atalla 1989: N.S. Atalla, *Coptic Art-L'art copte*, 2 vols, Cairo 1989.

Atanassov 1995: G. Atanassov, Croix-encolpions proche-orientales de la région de Dobroudja du Sud (Bulgarie), *Akten des XII. Internationalen Kongresses für Christliche Archäologie, JbAChr Ergänzungsband*, Münster 1995, 483-501.

Atiya 1968: A.S. Atiya, *A History of Eastern Christianity*, London 1968.

Auzépy 1995a: Marie-France Auzépy, L'Adversus Constantinum Caballinum et Jean de Jérusalem, *Στέφανος*. Studia byzantina ac slavica, Vladimiro Vavřinck ad annum sexagesium quintum dedicata, *BSl* 56 (1995), 323-338.

Auzépy 1995b: Marie-France Auzépy, La carrière d'André de Crète, *BZ* 88 (1995), 1-12.

Auzépy 1995c: Marie-France Auzépy, L'évolution de l'attitude face au miracle à Byzance, *Miracles, prodiges et merveilles au moyen-âge*, 31-46.

Auzépy 1997: Marie-France Auzépy, *La Vie d'Étienne le Jeune par Étienne le Diacre*, Birmingham

Byzantine and Ottoman Monographs 3, Aldershot, Hampshire 1997.

Avner 1982: T. Avner, The Impact of the Liturgy on Style and Content: The Triple-Christ Scene in Taphou 14, *JÖB* 32/5 (1982), 459-467.

Αμητός: Αμητός, Τιμητικός τόμος για τον καθηγητή Μανόλη Ανδρόνικο, Thessaloniki 1986.

Babić 1968: Gordana Babić, L'image symbolique de la 'porte fermée' à Saint-Clément d'Ohrid, *Synthronon* 1968, 145-151.

Babić 1973: Gordana Babić, L'iconographie constantinopolitaine de l'Acathiste de la Vierge a Cozia (Valachie), *ZRVI* 14-15 (1973), 173-189.

Babić 1980: Gordana Babić, *Ikone*, Zagreb 1980.

Babić 1987: Gordana Babić, Sur l'icône de Poganovo et la Vassilissa Hélène, *L'art de Thessalonique et des pays balkaniques et les courants spirituels au XIVe siècle*, Belgrade 1987, 57-67.

Babić 1988: Gordana Babić, Il modello e la replica nell'arte bizantina delle icone, *ArteChr* 76 (1988), 61-78.

Babić 1991: Gordana Babić, Le maphorion de la Vierge et le psaume 44 (45) sur les images du XIVe siècle, *Ευφρόσυνον*, 1, 57-64.

Babić 1994: Gordana Babić, Les images byzantines et leurs degrés de signification: l'exemple de l'Hodigitria, *Byzance et les images*, 189-222.

Bacci 1997: M. Bacci, Due tavole della Vergine nella Toscana occidentale del primo Duecento, *ASNSP* 4/2 (1997), 1-60.

Bacci 1998: M. Bacci, *Il pennello dell'Evangelista. Storia delle immagini sacre attribuite a san Luca*, Pisa 1998.

Badawy 1978: A. Badawy, *Coptic Art and Archaeology*, The Massachusetts Institute of Technology, Cambridge 1978.

Bagatti 1936: B. Bagatti, *Il Cimitero di Commodilla o dei Martiri Felici ed Adautto*, Vatican 1936.

Bakalova 1972: Elka Bakalova, Sur la peinture bulgare de la seconde moitié du XIVe siècle, *L'école de la Morava et son temps*, Belgrade 1972, 61-75.

Bakalova 1977: Elka Bakalova, *L'église ossuaire de Bačkovo*, Sofia 1977.

Bakalova 1991: Elka Bakalova, Aspecti na saotnoshenieto slovsen tekst-izobrazhenie v bulgarskoto srednovekovie (pesennopoetichna obrznost-visualni saotnosheniia), *Problemi na izkustvoto*, 1 (1991), 3-20.

Bakalova 2000: Elka Bakalova, The Earliest Surviving Icons from Bulgaria: From the Eleventh through the Fourteenth Century, *Glory of Byzantium Symposium*, New York 2000, 152-154 (forthcoming).

Bakirtzis 1988: Ch. Bakirtzis, Μαρμάρινη εικόνα της Αγίας Θεοδώρας από τη Θεσσαλονίκη, *Ελληνικά* 39 (1988), 158-163.

Balabanov 1995: K. Balabanov, *Icons of Macedonia*, Skopje 1995.

Balard 1991: M. Balard, I Pisani in Oriente dalla guerra di Acri al 1406, *Bollettino storico pisano* 60 (1991), 1-16.

Baldovin 1987: J.F. Baldovin, *The Urban Charac-ter of Christian Worship. The Origins, Development and Meaning of Stational Liturgy*, Rome 1987.

Baltoyanni 1985: Chrysanthi Baltoyanni, *Icons. Demetrios Ekonomopoulos Collection*, Athens 1985.

Baltoyanni 1991: Chryssanthi Baltoyanni, Η Κοίμηση του Ανδρέου Ρίτζου του Λονδίνου και η εξάρτησή της από τη ζωγραφική και τα ιδεολογικά ρεύματα του 14ου αιώνα, *Ευφρόσυνον*, 1, 353-372.

Baltoyanni 1991-1992: Chryssanthi Baltoyanni, Η Παναγία Γλυκοφιλούσα και το 'ανακλινόμενον βρέφος' σε εικόνα της συλλογής Λοβέρδου, *ΔΧΑΕ* 16 (1991-1992), 219-236.

Baltoyanni 1993-1994: Chryssanthi Baltoyanni, Christ The Lamb and the 'Ενώτιον' of the Law in a Wall Painting of Araka, *ΔΧΑΕ* 16 (1993-1994), 53-58.

Baltoyanni 1994a: Chryssanthi Baltoyanni, Παραλλαγή της Παναγίας του Πάθους, σε εικόνα της Θεσσαλονίκης από τον κύκλο του Ανδρέα Ρίτζου, *Θυμίαμα*, 23-33.

Baltoyanni 1997: Chryssanthi Baltoyanni, Η οσιομάρτυς Θεοδοσία της θεοφυλάκτου βασιλίδος των πόλεων γέννημα θρέμμα, σε εικόνα ομώνυμου ναού στη Χώρα Νάξου, *17th Symposium XAE* 1997, 48.

Baltoyianni 1986: Chryssanthi Baltoyanni, *Icônes de collections privées en Grèce*, exh. cat., Institut Français d'Athènes, Athens 1986.

Baltoyianni 1994b: Chryssanthi Baltoyianni, *Icons. The Mother of God in the Incarnation and the Passion*, Athens 1994.

Bank 1977: Alice Bank, *Byzantine Art in the Collections in the USSR*, Leningrad 1977.

Bank 1985: Alice Bank, *Byzantine Art in the Collections of Soviet Museums*, Leningrad 1985.

Baratte 1985: F. Baratte, Héros et chasseurs: la tenture d'Artemis de la Fondation Abegg à Riggisberg, *MonPiot* 67 (1985), 31-76.

Barber 1991: Ch. Barber, The Koimesis Church, Nicaea. The Limits of Representation on the Eve of Iconoclasm, *JÖB* 41 (1991), 43-60.

Barber 1993: Ch. Barber, From Transformation to Desire: Art and Worship after Byzantine Iconoclasm, *ArtB* 75 (1993), 7-16.

Baynes 1949a: N.H. Baynes, The Finding of the Virgin's Robe, *AIPhO* 9(1949), 87-95, rpr. in Baynes 1955, 240-247.

Baynes 1949b: N.H. Baynes, The Supernatural Defenders of Constantinople, *AB* 67 (1949), 165-177, rpr. in Baynes 1955, 248-260.

Baynes 1955: N.H. Baynes, *Byzantine Studies and Other Essays*, London 1955.

Beckwith 1961: J. Beckwith, *The Art of Constantinople*, London 1961.

Beckwith 1966: J. Beckwith, Problèmes posés par certaines sculptures sur ivoire du Haut Moyen Age, *Les Monuments historiques de la France*, 1-2 (1966), rpr. in Beckwith 1989.

Beckwith 1975: J. Beckwith, A Byzantine Gold and Enamelled Pectoral Cross, *Beiträge zur Kunst des Mittelalters, Festschrift für Hans Wentzel zum 60.* Geburtstag, Berlin 1975, 29-31.

Beckwith 1979[2]: J. Beckwith, *Early Christian and Byzantine Art* (Pelican History of Art), Harmondsworth 1979[2].

Beckwith 1989: J. Beckwith, *Studies in Byzantine and Medieval Western Art*, London 1989.

Bekker 1838: *Theophanes Continuatus, Ioannes Cameniata, Symeon Magister, Georgius Monachus*, I. Bekker ed., *CSHB* 43, Bonn 1838.

Bekker 1842: *Leonis Grammatici Chronographia*, I. Bekker ed., *CSHB* 26, Bonn 1842.

Bekker 1853: *Michael Attaliota*, I. Bekker ed., *CSHB* 50, Bonn 1853.

Bellinger 1956: A. Bellinger, The Coins and Byzantine Imperial Policy, *Speculum* 31 (1956), 70-81.

Bellini Pietri 1913: A. Bellini Pietri, *Guida di Pisa*, Pisa 1913.

Belting 1970: H. Belting, *Das illuminierte Buch in der spätbyzantinischen Gesellschaft*, Heidelberg 1970.

Belting 1972: H. Belting, Eine Gruppe Konstantinopler Reliefs aus dem 11. Jahrhundert, *Pantheon* 30 (1972), 263-270.

Belting 1980-1981: H. Belting, An Image and its Function in the Liturgy: the Man of Sorrows in Byzantium, *DOP* 34-35 (1980-1981), 1-16

Belting 1981: H. Belting, *Das Bild und sein Publikum im Mittelalter. Form und Funktion früher Bildtafeln der Passion*, Berlin 1981.

Belting 1982: H. Belting, The 'Byzantine' Madonnas: New Facts about Their Italian Origin and Some Observations on Duccio, *Studies in the History of Art* 12 (1982), 7-22.

Belting 1990: H. Belting, *Bild und Kult. Eine Geschichte des Bildes vor dem Zeitalter der Kunst*, Munich 1990.

Belting 1994: H. Belting, *Likeness and Presence. A History of the Image before the Era of Art*, Chicago 1994.

Belting, Mango and Mouriki 1978: H. Belting, C. Mango and Doula Mouriki, *The Mosaics and Frescoes of St. Mary Pammakaristos (Fethiye Çamii) at Istanbul*, DOS 15, Washington D.C. 1978.

Belting-Ihm 1976: Christa Belting-Ihm, *Sub matris tutela, Untersuchungen zur Vorgeschichte der Schutzmandel Madonna*, AbhHeidelb 3, Heidelberg 1976.

Bendall 1988: S. Bendall, *A Private Collection of Palaeologan Coins*, (private publication), 1988.

Benesević 1911: V.N. Benesević, *Catalogus codicum manuscriptorum graecorum qui in monasterio sanctae Catherinae in Monte Sina asservantur*, St Petersburg 1911.

Bentchev 1992: I. Bentchev, *Bibliographie der Gottesmutterikonen*, Bonn 1992.

Berenson 1930: B. Berenson, Two Twelfth-Century Paintings from Constantinople, *Studies in Medieval Painting*, New Haven 1930, 1-16.

Berger 1982: A. Berger, *Das Bad in der byzantinischen Zeit*, Munich 1982.

Berger 1988: A. Berger, *Untersuchungen zu den Patria Konstantinoupoleos*, Bonn 1988.

Bertaux 1903: E. Bertaux, *L'Art dans l'Italie mérid-*

ionale, Paris-Rome 1903.

Bertelé 1958: T. Bertelé, La Vergine aghiosoritissa nella numismatica bizantina, *REB* 16 (1958), 233-234.

Bertelé 1978: T. Bertelé, *Numismatique byzantine*, Cécile Morrisson ed., Wetteren 1978.

Bertelli 1961a: C. Bertelli, La Madonna del Pantheon, *BollArte* 46 (1961), 24-32.

Bertelli 1961b: C. Bertelli, *La Madonna di Santa Maria in Trastevere, Storia-Iconografia-Stile di un dipinto romano dell'ottavo secolo*, Rome 1961.

Bertelli 1961c: C. Bertelli, "L'immagine della 'Madonna Tempuli' dopo il restauro", *Archivum Fratrum Praedicatorum*, 31 (1961), 82-111.

Bertelli 1964: C. Bertelli, Il Restauro della Madonna della Clemenza, *BICR* 41-44 (1964), 37-219.

Bertelli 1994: C. Bertelli, La pittura medievale a Roma e nel Lazio, *La pittura in Italia*.

Bettini 1944: S. Bettini, *Mosaici Antichi di San Marco a Venezia*, Bergamo 1944.

Bianco-Fiorin 1975: Marisa Bianco-Fiorin, Icone di scuola cretese et cretese-veneziana – Secoli XV-XVII, *Pittura su tavola dalle Collezioni dei Civici Musei di Storia ed Arte di Trieste*, exh. cat., Milan 1975.

Bidez and Hansen 1960: J. Bidez and J.C. Hansen, *Sozomenus, Historia Ecclesiastica*, Berlin 1960.

Boese 1966: H. Boese, *Die lateinischen Handschriften der Sammlung Hamilton zu Berlin*, Wiesbaden 1966.

Boespflug and Zaluska 1995: F. Boespflug and Y. Zaluska, Note sur l'iconographie du prologue de Jean, *Recherches de Science Religieuse, Autour du prologue de Jean, Hommage à Xavier Léon-Dufour SJ*, 83, no. 2, Paris 1995, 293-303.

Bogdanović, Djurić and Medaković 1978: D. Bogdanović, V. Djurić and D. Medaković, *Chilandar on the Holy Mountain*, Belgrade 1978.

Bogomater' Vladimirskaya/The Virgin of Vladimir: Bogomater' Vladimirskaya K 600-letiu Sretenia ikony Bogomateri Vladimirskoi v Moskve 26augusta (8 sentiabria) 1395 goda. Sbornik materialov. Katalog vystavki/The Virgin of Vladimir Anniversary of the 600th Meeting of the Icon with the Virgin of Vladimir in Moscow, August 26 1395. Collection of the Materials and exh. cat., State Tretyakov Gallery, Moscow 1995.

Bogomater'. Polnoie illiustririvannoe opisanie ee zemnoi zhizni I posviaschennykh ee imeni chudotvornykh ikon / The Mother of God. A Complete Illustrated Description of Her Earthly Life and the Miraculous Icons dedicated to Her Name, E. Poseljanin ed., St Petersburg 1909.

Boissonade 1962: A. Boissonade, *Anecdota Graeca*, 4 vols, Paris 1829-1832, rpr. Hildesheim 1962.

Bologna 1964: F. Bologna, *Early Italian Painting, Romanesque and Early Medieval Art*, Leipzig 1964.

Bologna 1988: F. Bologna, Le tavole più antiche e un ex voto del XV secolo, *Insediamenti virginiani in Irpinia. Il Goleto Montevergine Loreto*, V. Pacelli ed., Cava dei Tirreni 1988, 117-143.

Bomford et al. 1989: D. Bomford, Jill Dunkerton, Dillian Gordon, A. Roy, *Art in the Making. Itali-

an Painting before 1400*, exh. cat., London 1989.

Bonnafos 1968: Edith Bonnafos, *Byzantinisme et Christianisme*, Chef d'œuvre de l'Art, Paris 1968.

Borboudakis 1991: M. Borboudakis, Παρατηρήσεις στη ζωγραφική του Σκλαβεροχωρίου, *Ευφρόσυνον*, 1, 375-398.

Borboudakis 1998a: M. Borboudakis, Εικόνες της Μονής Σινά, in E. Doxiadi, *Από τα Πορτραίτα Φαγιούμ στις Απαρχές της Τέχνης των Βυζαντινών Εικόνων (μια συμβολή για μιαν άλλη προσέγγιση)*, Iraklion 1998, 154-160.

Borboudakis 1998b: M. Borboudakis, *Από τα Πορτραίτα Φαγιούμ στις Απαρχές της Τέχνης των Βυζαντινών Εικόνων (μια συμβολή για μιαν άλλη προσέγγιση)*, Iraklion 1998.

Borchgrave d'Altena 1956: J. Borchgrave d'Altena, La Vierge byzantine de l'évêque de Liège, *RBA* 25 (1956), 133-144.

Borkopp and Schellewald 1995: Birgitt Borkopp and B. Schellewald, Hinter vorgehaltener Hand – Byzantinische Elfenbeinkunst im Westen, *Studien zur byzantinischen Kunstgeschichte*, Festschrift für H. Hallensleben zum 65. Geburtstag, B. Borkopp et al. eds, Amsterdam 1995, 147-171.

Borsari 1991: S. Borsari, Pisani a Bisanzio nel XII secolo, *Bollettino storico pisano* 60 (1991), 59-86.

Bouras 1979: Laskarina Bouras, *The Cross of Adrianople*, Athens 1979.

Bouras 1981: Laskarina Bouras, Παλαιοχριστιανικά και βυζαντινά θυμιατήρια του Μουσείου Μπενάκη, *Αρχαιολογία* 1 (November 1981), 64-70.

Boyd 1974: Susan Boyd, The Church of Panagia Amasgou, Monagri, Cyprus, *DOP* 28 (1974), 276-328.

Boyd 1992: Susan A. Boyd, A 'Metropolitan' Treasure from a Church in the Provinces: An Introduction to the Study of the Sion Treasure, *Ecclesiastical Silver Plate*, 5-37.

Bozhkov and Tchernev 1966: A. Bozhkov and T. Tchernev, *Nazionalna khudozhestvena galeria Sofia-antichno I srednovekovno izkustvo*, exh. cat., National Gallery of Art, Sofia 1966.

Bozhkov 1976: A. Bozhkov, Za siuzheta na bilateralnata ikona ot Poganovskiia manastir, *Izkustvo* 9 (1976), 2-7.

Bozhkov 1987: A. Bozhkov, *Bulgarian Icons*, Sofia 1987.

Bray 1959: W. Bray, *The Weekday Lessons from Luke in the Greek Gospel Lectionary*, Chicago 1959.

Breck 1920: J. Breck, Pre-Gothic Ivories in the Pierpont Morgan Collection, *The Metropolitan Museum of Art Bulletin* 15 (1920), 17-20.

Breck and Rogers 1925: J. Breck and M. R. Rogers, *The Metropolitan Museum of Art. The Pierpont Morgan Wing*, New York 1925.

Breckenridge 1959: J.D. Breckenridge, *The Numismatic Iconography of Justinian II*, *MNM* 144, New York 1959.

Bréhier 1973[2]: L. Bréhier, *La sculpture et les arts mineurs byzantins*, London 1973[2] (1st ed. 1936).

Brock 1983: S.P. Brock, *The Harp of the Spirit.*

Eighteen Poems of St. Ephrem, London 1983[2].

Brouskari 1985: Maria S. Brouskari, *The Museum of Paul and Alexandra Canellopoulos*, Athens 1985.

Brown 1981: P. Brown, *The Cult of the Saints: its Rise and Function in Latin Christianity*, London 1981.

Brown 1988: P. Brown, *The Body and Society. Men, Women and Sexual Renunciation in Early Christianity*, New York 1988.

Browning 1963: R. Browning, An Unpublished Corpus of Byzantine Poems, *Byzantion* 33 (1963), 289-316.

Brubaker 1998: Leslie Brubaker, Icons before Iconoclasm? *SettStu* 45 (1998), 1215-1254.

Brubaker 1999: Leslie Brubaker, *Vision and Meaning in Ninth-Century Byzantium*, Cambridge 1999.

Buchthal 1957: H. Buchthal, *Miniature Painting in the Latin Kingdom of Jerusalem*, Oxford 1957.

Buchthal 1961: H. Buchthal, An Illuminated Gospel Book of About 1100 A.D., *Special Bulletin of the National Gallery of Victoria*, Victoria 1961, 1-13.

Buchthal 1975: H. Buchthal, Toward a History of Palaeologan Illumination, *The Place of Book Illumination in Byzantine Art*, Princeton 1975, 143-177.

Buchthal and Belting 1978: H. Buchthal and H. Belting, *Patronage in Thirteenth-Century Constantinople: An Atelier of Late Byzantine Book Illumination and Calligraphy*, Washington D.C. 1978.

Buckton 1983-1984: D. Buckton, The Beauty of Holiness: Opus Interrasile from a Late Antique Workshop, *Jewellery Studies* 1 (1983-1984), 15-19.

Buckton 1988: D. Buckton, Bogus Byzantine enamels in Baltimore and Washington D.C., *JWalt* 46 (1988), 11–24.

Buckton 1995: D. Buckton, 'Chinese whispers': the Premature Birth of the Typical Byzantine Enamel, *Byzantine East, Latin West*, 591–596.

Buckton 1998: D. Buckton, The Gold Icon of St Demetrios, *Der Welfenschatz und sein Umkreis*, J. Ehlers and D. Kötzsche eds, Mainz 1998, 277–286.

Bulgarie Médiévale: La Bulgarie Médiévale, Art et Civilisation, exh. cat., Grand Palais, June 13-August 18, 1980, Paris 1980.

Buschhausen 1971: H. Buschhausen, *Die Spätrömischen Metallscrinia und frühchristlichen Reliquiare*, exh. cat., Vienna 1971.

Byzance et les images: Byzance et les images, A. Guillou and J. Durand eds, Paris 1984.

Byzance: Byzance. L'art byzantin dans les collections publiques françaises, exh. cat., Musée du Louvre, 3 November 1992-1 February 1993, J. Durand ed., Paris 1992.

Byzantine and Post-Byzantine Art: Byzantine and Post-Byzantine Art, exh. cat., Athens, Old University, Athens 1986.

Byzantine Art, an European Art: Byzantine Art, an European Art, 9th Exhibition of the Council of Europe, exh. cat., Athens 1964 (Lectures, Athens 1966).

Byzantine Court Culture: Byzantine Court Culture

from 826 to 1204, H. Maguire ed., Washington D.C. 1997.

Byzantine East, Latin West: *Byzantine East, Latin West: art historical studies in honor of Kurt Weitzmann*, Doula Mouriki, Sl. Ćurčić, G. Galavaris, H.L. Kessler, G. Vikan editorial board, C. Moss and Katherine Kiefer eds, Princeton 1995.

Byzantine Macedonia: *Byzantine Macedonia*, exh. cat., Melbourne 1999.

Byzantine Magic: *Byzantine Magic*, H. Maguire ed., Washington D.C. 1995.

Byzantine Medieval Cyprus: *Byzantine Medieval Cyprus*, exh. cat., Thessaloniki 1997, Demetra Papanikola-Bakirtzis and Maria Iacovou eds, Nicosia 1998.

Byzantine Treasures: *Byzantine Treasures of Thessaloniki. The Journey of Return*, exh. cat., Thessaloniki 1994.

Byzantium and Islam in Scandinavia: *Byzantium and Islam in Scandinavia, Acts of a Symposium at Uppsala University, June 15-16 1996*, Elisabeth Piltz ed., Jonsered 1998.

Byzantium at Princeton: *Byzantium at Princeton, Byzantine Art and Archaeology at Princeton University*, exh. cat., S. Ćurčić and A. St. Clair eds, Princeton 1986.

Byzantium in the 12th Century: *Byzantium in the 12th Century. Canon Law, State and Society*, N. Oikonomides ed., Athens 1991.

Byzantium in the Ninth Century: *Byzantium in the Ninth Century. Dead or Alive*, Leslie Brubacker ed., Aldershot 1998.

Byzantium: *Byzantium: Treasures of Byzantine Art and Culture*, exh. cat., London, British Museum, D. Buckton ed., London 1994.

ByzSigillography: *Studies in Byzantine Sigillography*, N. Oikonomides ed., Washington D.C. 1987.

Βυζάντιο και Γεωργία: *Βυζάντιο και Γεωργία. Καλλιτεχνικές και πολιτιστικές σχέσεις*, Athens 1990.

Cacharelias 1995: D. Cacharelias, *The Mount Athos Esphigmenou 14 Codex: Pagan and Christian Myths in Middle Byzantine Manuscript Illumination*, Ph.D. dissertation, New York 1995.

Camelot 1969: *Ignace d'Antioche, Polycarpe de Smyrne, Lettres. Martyre de Polycarpe*, Th. Camelot ed., SC 10, Paris 1969.

Cameron 1976: *Flavius Cresconius Corripus. In Laudem Iustini Augusti minoris*, Averil Cameron ed., London 1976.

Cameron 1978: Averil Cameron, The Theotokos in Sixth-Century Constantinople: a City Finds its Symbol, *JThS* 29 (1978), 79-108.

Cameron 1979a: Averil Cameron, Images of Authority: Élites and Icons in Late Sixth-Century Byzantium, *Past and Present* 84 (1979), 3-25.

Cameron 1979b: Averil Cameron, The Virgin's Robe: an Episode in the History of Early Seventh-Century Constantinople, *Byzantion* 49 (1979), 42-56.

Cameron 1981: Averil Cameron, *Continuity and Change in Sixth-Century Byzantium*, Collected Studies, London 1981.

Cameron 1983: Averil Cameron, The History of the Image of Edessa: The Telling of a Story, *Okeanos*, 80-94.

Cameron 1987: Averil Cameron, The Construction of Court Ritual: the Byzantine Book of Ceremonies, *Rituals of Royalty*, 106-136.

Cameron 1989: Averil Cameron, Virginity as Metaphor, *History as Text*, 184-205.

Cameron 1991: Averil Cameron, *Christianity and the Rhetoric of Empire*, Berkeley and Los Angeles 1991.

Cameron 1992: Averil Cameron, The Language of Images: the Rise of Icons and Christian Representation, *The Church and the Arts*, D.Wood ed., Oxford 1992, 1-42.

Cannon 1999: Joanna Cannon, The Stoclet 'Man of Sorrows': a Thirteenth-century Diptych Reunited, *BurlMag* 141 (1999), 107-112.

Carli 1994: E. Carli, *La pittura a Pisa dalle origini alla 'bella maniera'*, Pisa 1994.

Caro 1971: R. Caro, *La Homiletica Mariana Griega en el Siglo V*, Marian Library Studies 3, Dayton, Ohio 1971.

Carr 1980: Annemarie Weyl Carr, Diminutive Byzantine Manuscripts, *Codices manuscripti* 6 (1980), 130-161.

Carr 1982: Annemarie Weyl Carr, Gospel Frontispieces of the Komnenian Period, *Gesta* 21 (1982), 3-20.

Carr 1987: Annemarie Weyl Carr, *Byzantine Illumination, 1150-1250: The Study of a Provincial Tradition*, Chicago-London 1987.

Carr 1991: Annemarie Weyl Carr, The Thirteenth-Century Murals of Lysi, Cyprus, in Davezac, Carr and Morrocco 1991, 15-113.

Carr 1993-1994: Annemarie Weyl Carr, The Presentation of an Icon on Sinai, *ΔΧΑΕ* 17 (1993-1994), 239-248.

Carr 1995: Annemarie Weyl Carr, Byzantines and Italians on Cyprus: Images from Art, *DOP* 49 (1995), 339-357.

Carr 1997: Annemarie Weyl Carr, Court Culture and Cult Icons in Middle Byzantine Constantinople, *Byzantine Court Culture*, 81-99.

Carr 2000: Annemarie Weyl Carr, The Presentation of an Ikon on Cyprus: The Virgin Veiled by God, *Reading Medieval Images*, Elisabeth Sears and Thelma Thomas eds, Ann Arbor 2000, forthcoming.

Carr forthcoming: Annemarie Weyl Carr, *Pursuing the Life of an Icon, The Virgin of Kykkos*, forthcoming.

Carr forthcoming: Annemarie Weyl Carr, Threads of Authority. The Virgin Mary's Veil in the Middle Ages, *Robing and Honor. The Medieval World of Investiture*, S. Gordon ed., Boston, forthcoming.

Carroll 1992: M.P. Carroll, *The Cult of the Virgin Mary. Pyschological Origins*, Princeton 1992.

Casson 1935: S. Casson, A Byzantine Master, *BurlMag* 66 (1935), 184-187.

Castelfranchi 1989: Maria Pia Falla Castelfranchi, Disiecta membra. La pittura bizantina in Calabria (secoli IX-XII), *Italian Church Decoration of the Middle Ages and Early Renaissance*, W. Tronzo ed., Bologna 1989 (Villa Spelman Colloquia 1), 81-100.

Cattapan 1973: M. Cattapan, I pittori Andrea e Nicola Rizo da Candia, *Θησαυρίσματα* 14 (1973), 238-282.

Cavallo 1982: G. Cavallo, Vera von Falkenhausen and Rafaella Farioli Campanati, *I Bizantini in Italia*, Milan 1982.

Cecchelli 1944: C. Cecchelli, *La cattedra di Massimiano ed altri avorii romano-orientali*, Rome 1944.

Ceremony and Faith: *Ceremony and Faith. Byzantine Art and the Divine Liturgy*, exh. cat., Hellenic Antiquities Museum, Melbourne 1999, Athens 1999.

Chadwick 1974: H. Chadwick, Moschus and Sophronius, *JThS* 25 (1974), 41-74.

Chatzidakis 1965: M. Chatzidakis, Βυζαντινό και Χριστιανικό Μουσείο, *ΑΔ* 20 (1965), Β1 Χρονικά, 11-20.

Chatzidakis 1966: M. Chatzidakis, Βυζαντινό και Χριστιανικό Μουσείο, *ΑΔ* 21 (1966), Β1 Χρονικά, 16-35.

Chatzidakis 1967: M. Chatzidakis, An Encaustic Icon of Christ at Sinai, *ArtB* 49 (1967), 197-208.

Chatzidakis 1974: M. Chatzidakis, *Το Βυζαντινό Μουσείο*, Athens 1974.

Chatzidakis 1976: M. Chatzidakis, L'évolution de l'icône aux 11e-13e siècles et la transformation du templon, *Actes du XVe CIEB*, I, 359-368.

Chatzidakis 1977: M. Chatzidakis, *Icons of Patmos*, Athens 1977.

Chatzidakis 1979: M. Chatzidakis, Παναγία η Επισκοπιανή, μια βυζαντινή εικόνα στη Ζάκυνθο, *Θησαυρίσματα* 16 (1979), 387-391.

Chatzidakis and Sofianos 1990: M. Chatzidakis and D. Sofianos, *The Great Meteoron. History and Art*, Athens 1990.

Chatzidakis n. d.: M. Chatzidakis, *Βυζαντινό Μουσείο Αθηνών, Εικόνες*, Athens n. d.

N. Chatzidakis 1994: Nano Chatzidakis, *Byzantine Mosaics*, Athens 1994.

N. Chatzidakis 1995: Nano Chatzidakis, A Fourteenth-Century Icon of the Virgin Eleousa in the Byzantine Museum of Athens, *Byzantine East, Latin West*, 495-498.

N. Chatzidakis 1996: Nano Chatzidakis, *Hosios Loukas*, Athens 1996.

N. Chatzidakis 1998: Nano Chatzidakis, *Icons. The Velimezis Collection*, Athens 1998.

N. Chatzidakis et al. 1985-1986: Nano Chatzidakis, J. Philippon, P. Ausset, I. Chryssoulakis and A. Alexopoulou, Συμβολή των φυσικοχημικών μεθόδων ανάλυσης στη μελέτη δεκατριών εικόνων του Βυζαντινού Μουσείου Αθηνών, *ΔΧΑΕ* 13 (1985-1986), 215-245.

Chatzipsaltis 1950: K. Chatzipsaltis, Τὸ ἀνέκδοτο κείμενο τοῦ ἀλεξανδριανοῦ κώδικος 176 (366). Παραδόσεις και ἱστορία τῆς μονῆς Κύκκου, *ΚυπρΣπ* 14 (1950), 39-69.

Cheynet and Morrisson 1995: J.-C. Cheynet and Cécile Morrisson, Texte et image sur les sceaux byzantins: les raisons d'un choix iconographique, *Studies in Byzantine Sigillography* 4 (1995), 9-32.

Chifletio 1661: I. Chifletio, *Vetus Imago Sanctissimae Deiparae in Jaspide Viridi ... inscripta Nicephoro Botaniatae, Graecorum Imperatori*, 1661.

Christ and Paranikas 1871: Andrew of Crete, *Great Canon*, W. Christ and M. Paranikas, *Anthologia Graeca Carminum Christianorum*, Leipzig 1871.

Chrysostomides 1997: Julian Chrysostomides, An Investigation Concerning the Authenticity of the Letter of the Three Patriarchs, in Munitiz et al. 1997, xvii-xxxviii.

Chudotvornaja ikona: *Chudotvornaja ikona v Vizantii i Drevnei Rusi / The Miracle-working Icon in Byzantium and Old Rus'*, A. Lidov ed., Moscow 1996.

Chudotvornyie ikony v vostocnokhristianskoi kul'ture / The Miracle-working Icons in East Christian Culture, 2 vols: The Icons of the Mother of God, A. Lidov ed., 2000.

Ciggaar 1976: Krinje Ciggaar, Une description de Constantinople traduite par un pèlerin anglais, *REB* 34 (1976), 211-267.

Ciggaar 1995: Krinje N. Ciggaar, Une description de Constantinople dans le *Tarragonensis* 55, *REB* 53 (1995), 117-140.

Cirac Estopañan 1943: S. Cirac Estopañan, *Bizancio y España. El legado de la basilissa María y de los déspotas Thomas y Esaú de Joannina*, 2 vols, Barcelona 1943.

Clark 1950: K.W. Clark, *Checklist of the Manuscripts in St Catherine's Monastery, Mount Sinai, microfilmed for the Library of Congress, 1950*, Washington D.C. 1952.

Clark 1983: Elizabeth A. Clark, *Women in the Early Church*, Wilmington, Delaware 1983.

Clark 1986: Elizabeth A. Clark, *Ascetic Piety and Women's Faith*, Lewiston, NY 1986.

Clark 1999: Elizabeth A. Clark, *Reading Renunciation. Acseticism and Scripture in Early Christianity*, Princeton 1999.

Coche de la Ferté 1974: É. Coche de la Ferté, Un bracelet d' époque romaine à usage obstétrique, *Syria* 51 (1974), 265-289.

Coche de La Ferté and Hadjidakis 1957: É. Coche de La Ferté and M. Hadjidakis, *Collection H. Stathatos, les objets byzantins et post-byzantins*, Limoges 1957.

Collection Hélène Stathatos III: Collection Hélène Stathatos III. Objets antiques et byzantins, Strasbourg 1963.

Combefis 1648: *Novum auctarium, II=Hist. haeresis monothelitarum sanctaeque in eam sextae synodi actorum vindiciae*, F. Combefis ed., Paris 1648.

Cómez-Moreno 1968: C. Cómez-Moreno, *Medieval Art from Private Collections*, The Metropolitan Museum of Art, New York 1968.

Connor 1991: Carolyn L. Connor, *Art and Miracles in Medieval Byzantium. The Crypt at Hosios Loukas and Its Frescoes*, Princeton 1991.

Constans 1995: N.P. Constans, Weaving the Body of God: Proclus of Constantinople, the Theotokos, and the Loom of the Flesh, *JECS* 3, 2 (1995), 169-194.

Conversation with God: *Conversation with God, Icons from the Byzantine Museum of Athens (9th-15th centuries)*, exh. cat., The Hellenic Centre, London 1999.

Coquin, Leroy and van Moorsel 1989: R.-G. Coquin, J. Leroy and P. van Moorsel, La croix, dite de Théodote, du Musée de Berlin-Est, *BIFAO* 89 (1989), 73-80.

Cormack 1969: R. Cormack, The Mosaic Decoration of St. Demetrios, Thessaloniki. A Re-examination in the Light of the Drawings of W.S. George, *BSA* 64 (1969), 17-52.

Cormack 1981: R. Cormack, Interpreting the Mosaics of S. Sophia at Istanbul, *ArtH* 4 (1981), 131-149, rpr. in Cormack 1989a, VIII.

Cormack 1985a: R. Cormack, *Writing in Gold. Byzantine Society and its Icons*, London 1985.

Cormack 1985b: R. Cormack, *The Church of Saint Demetrios. The Watercolours and Drawings of W.S. George*, Thessaloniki 1985.

Cormack 1988: R. Cormack, Miraculous Icons in Byzantium and their powers, *ArteChr* 76 (1988), 55-60.

Cormack 1989a: R. Cormack, *The Byzantine Eye. Studies in Art and Patronage*, London 1989.

Cormack 1989b: R. Cormack, The Triumph of Orthodoxy, *National Art Collections Fund Review 1989*, (London 1989), 93-94.

Cormack 1991: R. Cormack, Reading Icons, *Valör. Konstvetenskapliga Studier* 4 (1991), 1-28.

Cormack 1997a: R. Cormack, Women and Icons, and Women in Icons, *Women, Men and Eunuchs. Gender in Byzantium*, Liz James ed., London 1997, 24-51.

Cormack 1997b: R. Cormack, Ο καλλιτέχνης στην Κωνσταντινούπολη: αριθμοί, κοινωνική θέση, ζητήματα απόδοσης, *Το πορτραίτο*, 45-76.

Cormack 1997c: R. Cormack, *Painting the Soul. Icons, Death Masks and Shrouds*, London 1997.

Cormack 2000: R. Cormack, *Byzantine Art*, Oxford History of Art, Oxford 2000.

Cormack and Hawkins 1977: R. Cormack and E.J.W. Hawkins, The Mosaics of St Sophia at Istanbul: the Rooms above the southwest Vestibule and Ramp, *DOP* 31 (1977), 175-251.

Corrie 1973: Rebecca W. Corrie, The Seitenstetten Missal and the Persistence of Italo-Byzantine Influence in P. Huber, *Bild und Botschaft*, Zurich-Freiburg 1973.

Corrie 1990: Rebecca W. Corrie, The Political Meaning of Coppo di Marcovaldo's Madonna and Child in Siena, *Gesta* 29 (1990), 61-75.

Corrie 1996: Rebecca W. Corrie, Coppo di Marcovaldo's *Madonna del Bordone* and the Meaning of the Bare-Legged Christ Child in Siena and the East, *Gesta* 35 (1996), 43-65.

Corrie 1998: Rebecca W. Corrie, The Perugia Triptych and the Transmission of Byzantine Art to the *Maniera Greca*, Acts XVIIIth International Congress of Byzantine Studies, Selected Papers, Moscow 1991, Volume III: Art History, Architecture, Music, I. Ševčenko and G.G. Litavrin eds, Shepherdstown, WV 1998, 35-56.

Corrigan 1978: Kathleen A. Corrigan, The Ivory Scepter of Leo VI: A Statement of Post-Iconoclastic Imperial Ideology, *ArtB* 60 (1978), 406-417.

Corrigan 1992: Kathleen Corrigan, *Visual Polemics in the Ninth-Century Byzantine Psalters*, Cambridge 1992.

Corrigan 1995: Kathleen Corrigan, Text and Image on an Icon of the Crucifixion at Mount Sinai, *The Sacred Image*, 45-62.

Corsini 1967: A. Corsini, ὁ ἰατρὸς ὁ ἀγαπητός' (San Luca), *Scientia veterum* 16/106 (1967), 7-22.

Cotsonis 1994: J. Cotsonis, *Byzantine Figural Processional Crosses*, exh. cat., Dumbarton Oaks, Washington D.C. 1994.

Coulin-Weibel 1952: Adèle Coulin Weibel, *Two Thousand Years of Textiles. The Figured Textiles of Europe and the Near East*, New York 1952.

Cunningham 1988: Mary Cunningham, The Mother of God in Early Byzantine Homilies, *Sobornost* 10.2 (1988), 53-67.

Cunningham 1991: *The Life of Michael the Synkellos*, Mary Cunningham ed., Belfast 1991.

Cunningham and Allen 1998: Mary B. Cunningham and P. Allen eds, *Preacher and Audience. Studies in Early Christian and Byzantine Homiletics*, Leiden 1998.

Cutler 1981: A. Cutler, Art in Byzantine Society: Motive Forces of Byzantine Patronage, *Akten XVI. Internationaler Byzantinistenkongress* 1/2 (*JÖB* 31/2), Vienna 1981, 759-787.

Cutler 1984: A. Cutler, *The Aristocratic Psalters in Byzantium*, Paris 1984.

Cutler 1985: A. Cutler, *The Craft of Ivory. Sources, Techniques and Uses in the Mediterranean World*, Washington D.C. 1985.

Cutler 1987: A. Cutler, The Cult of the Galaktotrophousa in Byzantium and Italy, *JÖB* 37 (1987), 335-350.

Cutler 1988: A. Cutler, Un triptyque byzantin en ivoire: La Nativité du Louvre, *RL* 38 (1988), 21-28, rpr. in Cutler 1998, pt XV.

Cutler 1994: A. Cutler, *The Hand of the Master. Craftsmanship, Ivory, and Society in Byzantium (9th-11th Centuries)*, Princeton 1994.

Cutler 1998: A. Cutler, *Late Antique and Byzantine Ivory Carving*, Aldershot 1998.

Cutler and Nesbitt 1986: A. Cutler and J.W. Nesbitt, *L'arte bizantina e il suo pubblico*, I, Turin 1986.

Cutler and North forthcoming: A. Cutler and W. North, Bertoldus Ignotus and Ottonian Episcopal, *Consuetudo* (forthcoming).

Cutler and Spieser 1996: A. Cutler and J.M. Spieser, *Byzance Médiévale 700-1204*, Paris 1996.

Czerwenka-Papadopoulos 1984: Karoline Czerwenka-Papadopoulos, Eine wiener Ikone aus dem Umkreis des Andreas Ritzos, *Βυζάντιος*, Festschrift für Herbert Hunger, Vienna 1984,

203-212.

Da Morrona 1812: A. Da Morrona, *Pisa illustrata nelle arti del disegnio*, Livorno 1812.

Dagron 1984: G. Dagron, *Constantinople Imaginaire: études sur le recueil des Patria*, Paris 1984.

Dalton 1901: O.M. Dalton, *Catalogue of Early Christian Antiquities and Objects from the Christian East in the Department of British and Mediaeval Antiquities and Ethnography of the British Museum*, London 1901.

Dalton 1921: O.M. Dalton, *British Museum. A Guide to the Early Christian and Byzantine Antiquities in the Department of British and Medieval Antiquities*, London 1921.

Dalton 1961: O.M. Dalton, *Byzantine Art and Archaeology*, Oxford 1911, rpr. 1961.

Daniel and Maltomini 1990: R.W. Daniel and F. Maltomini, *Supplementum magicum*, I, Opladen 1990.

Davezac, Carr and Morrocco 1991: B. Davezac, Annemarie Weyl Carr and L.J. Morrocco, *A Byzantine Masterpiece Recovered, the Thirteenth-Century Murals of Lysi, Cyprus*, Austin, Texas 1991.

Davis 1995: R. Davis, *The Lives of the Ninth-Century Popes (Liber Pontificalis)*, Liverpool 1995.

de Boor 1978: Georgius Monachus, *Chronicon*, C. de Boor ed., *BSGR* 2, Stuttgart 1978.

de Castris 1986: P.L. de Castris, Pittura del Duecento e del Trecento a Napoli nel Meridione, *La Pittura in Italia: il Duecento e il Trecento*, E. Castelnuovo ed., Milan 1986, II, 463.

De Creta a Toledo: *De Creta a Toledo, Iconos Griegos de la Colección Velimezis*, exh. cat., Museo de Santa Cruz, Toledo 1999.

de Grüneisen 1930: W. de Grüneisen, *Collection De Grüneisen. Catalogue Raisonné*, Paris 1930.

de Kreek 1994: M.L. de Kreek, *De kerkschat van het Onze-Lieve-Vrouwekapittel te Maastricht*, Utrecht–Amsterdam 1994.

de Mély 1899: F. de Mély, Le camée byzantin de Nicéphore Botoniate à l'Heiligenkreutz (Autriche), *MonPiot* 6 (1899), 195-200.

de Santos Otero 1984: A. de Santos Otero, *Los Evangelios Apocrifos*, Madrid 1984[4].

De vera effigie: *De vera effigie Mariae. Antiche icone romane*, exh. cat., P. Amato ed., Milan-Rome 1988.

de Wald 1941: E. de Wald, *The Illustrations in the Manuscripts of the Septuagint. III. Psalms and Odes. Part 1: Vaticanus Graecus 1927*, Princeton 1941.

Deichmann 1958: F.W. Deichmann, *Frühchristliche Bauten und Mosaiken von Ravenna*, Baden-Baden 1958.

Delatte 1927: A. Delatte, *Anecdota atheniensia*, I, Liege 1927.

Delehaye 1936: H. Delehaye, *Étude sur le légendier romain, SubsHag.* 23, Brussels 1936.

del Francia 1976: L. del Francia, Le thème de la Nativité dans les tissus coptes, à propos d'un exemplaire inédit, *Acts of the First International Congress of Egyptology*, Cairo 1976, 221-224.

Delivorrias 1980: A. Delivorrias, *Guide to the Benaki Museum*, Athens 1980.

Dellas 1996: G. Dellas, Η εκκλησία του Αγίου Νικολάου στη μεσαιωνική πόλη της Ρόδου, *16th Symposium XAE*, 1996, 58-59.

Demangel and Mamboury 1939: R. Demangel and E. Mamboury, *Le quartier des Manganes et la première région de Constantinople*, Paris 1939.

Demus 1949: O. Demus, *The Mosaics of Norman Sicily*, London 1949.

Demus 1954: O. Demus, Die Reliefikonen der Westfassade von S. Marco. Bemerkungen zur venezianischen Plastik und Ikonographie des 13. Jahrhunderts, *JÖBG* 3 (1954), 87-107.

Demus 1958a: O. Demus, Zwei Konstantinopler Marienikonen des 13. Jahrhunderts, *JÖBG* 7 (1958), 87–104.

Demus 1958b: O. Demus, Die Entstehung des Palaeologenstils in der Malerei, *Berichte zum XI. Internationalen Byzantinisten-Kongress*, Munich 1958, 4/2, 1-63.

Demus 1960: O. Demus, *The Church of S. Marco in Venice*, Washington D.C. 1960.

Demus 1968: O. Demus, *Romanische Wandmalerei*, Munich 1968.

Demus 1970: O. Demus, *Byzantine Art and the West*, New York 1970.

Demus 1984: O. Demus, *The Mosaics of San Marco in Venice*, 4 vols, Chicago 1984.

Demus 1987: O. Demus, San Marco revisited, *DOP* 41 (1987), 155-156.

Demus 1991: O. Demus, *Die Byzantinischen Mosaikikonen, I. Die grossformatigen Ikonen*, Vienna 1991.

Dennis 1993: G. Dennis, Religious Services in the Byzantine Army, *Εὐλόγημα*, 107-117.

Dennison 1918: W. Dennison, *A Gold Treasure of the Late Roman Period*, New York 1918.

Der Nersessian 1960: Sirarpie Der Nersessian, Two Images of the Virgin in the Dumbarton Oaks Collection, *DOP* 14 (1960), 69-86.

Der Nersessian 1970: Sirarpie Der Nersessian, *L'illustration des psautiers grecs du Moyen Age II, Londres, Add. 19.352*, Bibliothèque des Cahiers Archéologiques 5, Paris 1970.

Der Welfenschatz und sein Umkreis: *Der Welfenschatz und sein Umkreis*, J. Ehlers and D. Kötzsche eds, Mainz 1998.

Deshman 1989: R. Deshman, Servants of the Mother of God in Byzantine and Medieval Art, *Word and Image* 5/1 (1989), 33-70.

Detorakis 1979: Th. Detorakis, *Κοσμάς ο Μελωδός. Βίος και Έργο, Ανάλεκτα Βλατάδων* 28, Thessaloniki 1979.

Devos 1953: P. Devos, La dossier hagiographique de S. Jacques l'intercis, *AB* 71 (1953), 157-210.

Devos 1954: La dossier hagiographique de S. Jacques l'intercis, *AB* 72 (1954), 213-256.

Deycks 1851: *De itinere terrae sanctae*, F. Deycks ed., Stuttgart 1851.

Di Dario Guida 1992: Maria Pia Di Dario Guida, *Icone di Calabria e altre icone meridionali*, Messina 1992.

Diehl 1957: C. Diehl, *Byzantium, Greatness and Decline*, trans. Naomi Walford, New Brunswick, N.J. 1957.

Diekamp 1938: F. Diekamp, *Analecta Patristica. Texte und Abhandlungen zur griechischen Patristik*, *OCA* 117, Rome 1938.

Dimand 1925: M.S. Dimand, Early Christian Weavings from Egypt, *Bulletin of the Metropolitan Museum of Art* 20 (1925), 55-58.

Dimitrokallis 1962: G. Dimitrokallis, Ο ναός του Αγίου Μάμαντος στην Ποταμιά Νάξου, *ΤεχνΧρ* 220 (1962), 39-60.

Djadovo 1992: *Djadovo, Bulgarian, Dutch, Japanese Expedition, Vol. 1, Mediaeval Settlement and Necropolis (11th-12th Century)*, A. Fol, R. Katincarov, J. Best, N. de Vries, K. Shoju and H. Suzuki eds, Tokyo 1992.

Djurić 1961a: V.J. Djurić, Freske crkvice Sv. Besrebrenika despota Jovana Ugqeše u Vatopedu i wihov značaj za ispitivawe solunskog porekla resavskog 'ivopisa, *ZRVI* 7 (1961), 125-136.

Djurić 1961b: V. Djurić, *Icônes de Jugoslavie*, Belgrade 1961.

Dmitrievskij 1965: A. Dmitrievskij, *Opisanie liturgitseskich rukopisej*, 1-2, rpr. Hildesheim 1965.

Dodd 1961: E.C. Dodd, *Byzantine Silver Stamps*, DOS 7, Washington D.C. 1961.

Dolezal 1991: Marie-Lyon Dolezal, *The Middle Byzantine Lectionary: Textual and Pictorial Expression of Liturgical Ritual*, Ph.D. dissertation, University of Chicago 1991.

Dolezal 1996: Marie-Lyon Dolezal, Illuminating the Liturgical Word: Text and Image in a Decorated Lectionary (M. Athos, Dionysiou Monastery, cod. 587), *Word and Image* 12/1 (1996), 23-60.

Donkeva-Petkova 1976: L. Donkeva-Petkova, Une croix pectorale reliquaire en or récemment trouvée à Pliska, *CahA* 25 (1976), 59-66.

DOSeals: *Catalogue of the Byzantine Seals at Dumbarton Oaks and in the Fogg Museum of Art*, 3 vols, Washington D.C. 1991-1996.

Downey 1957: G. Downey, *Nikolaos Mesarites: Description of the Church of the Holy Apostles at Constantinople*, Transactions of the American Philosophical Society 47 (1957).

Drandaki 1996: Anastasia Drandaki, Κρητική εικόνα με θέμα την Αναστήλωση των εικόνων από το Μουσείο Μπενάκη, *VIII International Congress of Cretan Studies*, Herakleion 1996, 183.

Drandakis 1952: N.B. Drandakis, Ανασκαφή παρεκκλησίων του Μυστρά, *ΠΑΕ* 1952, 497-519.

Drandakis 1964: N. Drandakis, Μεσαιωνικά Κυκλάδων, *ΑΔ* 19 (1964), Χρονικά, 420-435.

Drandakis 1988: N. Drandakis, *Οι Παλαιοχριστιανικές Τοιχογραφίες στη Δροσιανή της Νάξου*, Athens 1988.

Drandakis 1998: N. Drandakis, Το εικονογραφικό θέμα Άνωθεν οι προφήται' σε τοιχογραφία της Μεγίστης Λαύρας του Αγίου Όρους, *ΔΧΑΕ* 20 (1998), 195-200.

Drevneishaia redaktsia Skazania ob ikone Vladimirskoi Bogomateri / The Oldest Version

of the Miracle Story of the Virgin of Vladimir, ed. by V.A. Kuchkin and T.A. Sumnikova, *Chudotvornaia ikona*, 476-509, 552-553.

Drosogianni 1998: Fani A. Drosogianni, Παλαιοχριστιανικές τοιχογραφίες στην Εκατονταπυλιανή της Πάρου, *Η Εκατονταπυλιανή και η Χριστιανική Πάρος, Πρακτικά Επιστημονικού Συμποσίου*, (Πάρος 15-19 Σεπτ. 1996), Paros 1998, 55-84.

du Bourguet 1964: P. du Bourguet, *Musée National du Louvre. Catalogue des étoffes coptes*, I, Paris 1964.

Duchesne 1913: *L'iconographie byzantine dans un document grec du IXe siècle*, L. Duchesne ed., Grottaferrata 1913.

Dufrenne 1966: Suzy Dufrenne, *L'illustration des psautiers grecs du Moyen Age I. Pantocrator 61, Paris Grec 20, British Museum 40731*, Bibliothèque des Cahiers Archéologiques, 1, Paris 1966.

Duffrenne 1978: Suzy Duffrenne, *Les Illustrations du psautier d'Utrecht. Sources et rapport carolingien*, Paris 1978.

Dufrenne and Canart 1988: Suzy Dufrenne and P. Canart, *Die Bibel des Patricius Leo*, Zurich 1988.

Dujčev 1962: I. Dujčev, *Miniatiurite na Manasievate letopis*, Sofia 1962.

Duthuit 1930: G. Duthuit, Musée du Louvre, Antiquités égyptiennes. Cuirs ouvragés et broderies coptes, *Bulletin des musées de France*, 4 (1930), 77-79.

Early Christian and Byzantine Art: Early Christian and Byzantine Art, exh. cat., Baltimore 1947.

East Christian Art: East Christian Art, exh. cat., Y. Petsopoulos ed., London 1987.

Ebbinghaus 1990: A. Ebbinghaus, *Die altrussischen Marienikonen-Legenden*, Berlin 1990.

Ebersold 1921: J. Ebersold, *Sanctuaires de Byzance, Recherches sur les anciens trésors des églises de Constantinople*, Paris 1921.

Ecclesiastical Silver Plate: Ecclesiastical Silver Plate in Sixth-Century Byzantium, Susan A. Boyd and Marlia Mundell Mango eds, Washington D.C. 1986.

Effenberger and Severin 1992: E. Effenberger and H.-G. Severin, *Das Museum für Spätantike und byzantinische Kunst*, Berlin 1992.

Ehrhard 1938: A. Ehrhard, *Überlieferung und Bestand der hagiographischen und homiletischen Literatur der griechischen Kirche*, II, Leipzig 1938.

Ειδική Έκθεση Κειμηλίων Προσφύγων: Ειδική Έκθεση Κειμηλίων Προσφύγων, exh. cat., Byzantine Museum of Athens, Athens 1982.

Εικόνες Κρητικής Τέχνης: Εικόνες Κρητικής Τέχνης, Από το Χάνδακα ως τη Μόσχα και την Αγία Πετρούπολη, exh. cat., Herakleion 1993.

Eleopoulos 1967: N. E. Eleopoulos, Ή βιβλιοθήκη καὶ τὸ βιβλιογραφικὸ ἐργαστήριο τῆς μονῆς τῶν Στουδίου, Athens 1967.

Elliott 1993: J. K. Elliott, *The Apocryphal New Testament*, Oxford 1993.

Entwistle and Cowell 1994: C.J.S. Entwistle and M. Cowell, A Note on a Middle Byzantine Silver Weight, Θυμίαμα, 91-93.

Epstein 1986: Anne W. Epstein, *Tokali Kilise: Tenth-Century Metropolitan Art in Byzantine Cappadocia*, DOS 22, Washington D.C. 1986.

Etinhof 1977: Olga Etinhof, Obraz Chrama v Ikonographii Bogomater c Prorokami XI-XII Vekov, *Drevnerusskoe Iskusstvo Issledovanniia i Atributsii*, Leningrad 1977, 37-55.

Etinhof 1988: Olga Etinhof, A Byzantine Painting in the Hermitage (Style and Iconography), (in Russian), *Bostochnoe Sredizemnomor'e i Kavkaz IV-XVI vv.*, Leningrad 1988, 141-159.

Etinhof 1999: Olga E. Etinhof, Krannei istorii ikony 'Vladimirskaya Bogomater' i traditsia Vlakhernskogo Bogorodichnogo kulta na Rusi v XI-XII vv. / The Virgin of Vladimir and the Tradition of the Virgin in Blachernai in Rus' in the 11th to 12th Centuries, *Drevnerusskoie iskusstvo*, 290-305.

Eubel 1913: C. Eubel, *Hierarchia catholica medii aevi*, I, Münster, 1913.

Εὐλόγημα: Εὐλόγημα. Studies in Honor of Robert Taft, S.J.E. Carr, S. Parenti, A.A. Thiermeyer, E. Velkovska eds, Rome 1993.

Ευφρόσυνον: Ευφρόσυνον, Αφιέρωμα στον Μανόλη Χατζηδάκη, 2 vols, Athens 1991-1992.

Eustathiades 1931: Θεοτοκάριον, Ἁγιορειτικὴ Βιβλιοθήκη, 1, S. Eustathiades ed., Chennevières-sur-Marne 1931.

Eustratiades 1921: S. Eustratiades, Λόγος εἰς τὴν γέννησιν τοῦ Κυρίου καὶ Θεοῦ καὶ Σωτῆρος ἡμῶν Ἰησοῦ Χριστοῦ, *Νέος Ποιμὴν* 3/1 (1921), 23-42.

Eustratiades 1930: S. Eustratiades, Ἡ Θεοτόκος ἐν τῇ ὑμνογραφίᾳ, Paris 1930.

Eustratiades 1936: S. Eustratiades, Θεοφάνης ὁ Γραπτός, *Νέα Σιὼν* 31 (1936), 339-344, 403-416, 467-487, 525-540.

Euthymiadis 1993: S. Euthymiadis, Le panégyrique de S. Théophane le Confesseur par S. Théodore Stoudite (*BHG* 1792b). Édition critique et texte intégral, *AB* 111 (1993), 259-290.

Evangelidis 1934: T.E. Evangelidis, Βρύλλειον-Τρίγλεια, Ἱστορικὴ καὶ γεωγραφικὴ μελέτη ἀπὸ τοῦ Ε΄ αἰῶνος π.Χ. μέχρι τῶν καθ᾽ ἡμᾶς, Athens 1934.

Evseeva 1999: Lilia Evseeva, Broderie du 1498 et la cérémonie de couronnement, *Drevnerusskoie iskusstvo. Vizantia i Rus'. K stoletiu A.N. Grabara* (St Petersburg 1999), 430-438.

Eyice 1955: S. Eyice, *Istanbul. Petit Guide à travers les monuments byzantins et turcs*, Istanbul 1955.

Faberzhe, Goryna and Skurlov 1997: T.F. Faberzhe, A.S. Goryna and V.V. Skurlov, *Faberzhe i peterburgskie iuveliry: sbornik memuarov, statei, arkhivnykh dokumentov po istorii russkogo iuvelirnogo iskusstva, posviashchaetsia 150-letiiu so dnia rozhdeniia Karla Faberzhe 1846–1996*, St Petersburg 1997, 341-349.

Feissel 1988: D. Feissel, L'architecte Viktôrinos, et ces fortifications de Justinien dans les provinces balkaniques, *BullSocAntFr* (1988) 136-146.

Felicetti-Liebenfels 1956: W. Felicetti-Liebenfels, *Geschichte der byzantinischen Ikonenmalerei*, Lausanne 1956.

Festugière 1970: A.-J. Festugière, *Vie de Théodore de Sykéôn*, SubsHag 48, Brussels 1970.

Fillitz and Pippal 1987: H. Fillitz and M. Pippal, *Schatzkunst. Die Goldschmiede- und Elfenbeinarbeiten aus Österreichischen Schatzkammern des Hochmittelalters*, Salzburg and Vienna 1987.

Finney 1994: P. Corby Finney, *The Invisible God. The Earliest Christians on Art*, Oxford 1994.

Fîratlî 1990: N. Fîratlî, C. Metzger, Annie Pralong, J.-P. Sodini, *La sculpture byzantine figurée au Musée archéologique d'Istanbul*, Paris 1990.

Flemming 1981: J. Flemming, Das Triptychon der Muttergottes von Chachuli. Seine Ikonographie und seine staatpolitische Bedeutung, *Georgica* 4 (1981), 41-48.

Flemming 1989: Das Triptychon von Chachuli. Ein Zeignis der Kunstpolitik Davids des Erbauers, *IVe Symposium international sur l'art Georgien, (Tbilisi 1983)*, Tbilisi 1989, 525-540.

Flury-Lemberg 1988: M. Flury-Lemberg, *Textile Conservation and Research*, Abegg-Stiftung, Berne 1988.

Folda 1995: J. Folda, The Kahn and Mellon Madonnas: Icon or Altarpiece?, *Byzantine East, Latin West*, 501-510.

Foundoulaki 1999: Vassiliki Foundoulaki, *The Triumph of Orthodoxy Icon in the British Museum*, PhD thesis, University of London 1999.

Frantz, Thompson and Travlos 1988: Alison Frantz, H.A. Thompson and J. Travlos, The Athenian Agora, *Late Antiquity A.D. 267-700*, Princeton 1988.

Freytag 1985: R.L. Freytag, *Die autonome Theotokosdarstellung der frühen Jahrhunderte*, 2 vols, Munich 1985.

Friedländer 1912: P. Friedländer, *Johannes von Gaza und Paulus Silentiarius: Kunstbeschreibungen justinianischer Zeit*, Leipzig and Berlin 1912.

Friend 1927: Alisson M. Friend, The Portraits of the Evangelists in Greek and Latin Manuscripts, *Art Studies* 5 (1927), 115-147.

Frinta 1965: M.S. Frinta, An Investigation of the Punched Decoration of Medieval Italian and Non-Italian Panel Paintings, *ArtBull* 47 (1965), 261-265

Froehner 1897: W. Froehner, *Collections du Château de Goluchôw: l'orfèvrerie*, Paris 1897.

Frolov 1938: A. Frolov, La 'podea': un tissu décoratif de l'église byzantine, *Byzantion* 13 (1938), 461-504.

Frolow 1944: A. Frolow, La dédicace de Constantinople dans la tradition byzantine, *RHR* 127 (1944), 61-67.

Frolow 1965: A. Frolow, *Les reliquaires de la Vraie Croix*, Paris 1965.

From Byzantium to El Greco: From Byzantium to El Greco: Greek Frescoes and Icons, exh. cat., Royal Academy of Arts, London 1987.

Frühchristliche und Koptische Kunst, Akademie der bildenden Künste, Vienna 1964.

Furlan 1979: I. Furlan, *Le icone byzantine a mosaico*, Milano 1979.

Galavaris 1958: G. Galavaris, The Symbolism of Imperial Costume as Displayed on Byzantine Coins, *MN* 8 (1958), 99-117.

Galavaris 1959: G.P. Galavaris, The Mother of God 'Stabbed with a Knife', *DOP* 13 (1959), 229-233.

Galavaris 1960-1961: G. Galavaris, The Representation of the Virgin and Child on a 'Thokos' on Seals of the Constantinopolitan Patriarchs, *ΔXAE* 4/2 (1960-1961), 153-181.

Galavaris 1969: G. Galavaris, *The Illustrations of the Liturgical Homilies of Gregory of Nazianzus*, Princeton 1969.

Galavaris 1970: G. Galavaris, *Bread and the Liturgy. The Symbolism of Early Christian and Byzantine Bread Stamps*, Madison, Milwaukee-London 1970.

Galavaris 1980: G. Galavaris, Majestas Mariae in Late Greek and Russian Icons, *Icons and East Christian Works of Art*, M. van Rijn ed., London 1980, 7-18.

Galavaris 1990: G. Galavaris, Early Icons (from the 6th to the 11th century), *Sinai*, 91-101.

Galavaris 1993-1994: G. Galavaris, Two Icons of St. Theodosia at Sinai, *ΔXAE* 17 (1993-1994), 313-316.

Galavaris 1994: G. Galavaris, The Cross in the Book of Ceremonies by Constantine Porphyrogenitus, *Θυμίαμα*, 95-99.

Galavaris 1995: G. Galavaris, *Ελληνική Τέχνη, Ζωγραφική Βυζαντινών Χειρογράφων*, Athens 1995.

Galavaris 1997: G. Galavaris, Η τεχνοτροπία ως προσέγγιση του θείου στα βυζαντινά νομίσματα, *Οβολός* 2 (1997), 105-119; Styles as an Approach to the Holy in Byzantine Coins, 120-129.

Galavaris 1999: G. Galavaris, A Niello Cross at Sinai, *Römische Historische Mitteilungen* 41 (1999), 171-187.

Gambero 1999: L. Gambero S.M., *Mary and the Fathers of the Church. The Blessed Virgin Mary in Patristic Thought*, San Francisco 1999.

Gardthausen 1886: V. Gardthausen, *Catalogus codicorum graecorum sinaiticorum*, London 1886.

Garidis 1998: M. Garidis, Icônes du XIIIe et du XIVe siècle dans l'aire du Patriarcat de Jérusalem, *Ευψυχία, Mélanges offerts à Hélène Arhweiler*, 2 vols, Paris 1998, 225-238.

Garland 1999: Linda Garland, *Byzantine Empresses, Women and Power in Byzantium AD 527-1204*, London and New York 1999.

Garrison 1949: E.B. Garrison, *Italian Romanesque Panel Painting. An Illustrated Index*, Florence 1949.

Garrison 1976: E.B. Garrison, *Italian Romanesque Panel Painting, An Illustrated Index*, New York 1976.

Garrison 1984: E.B. Garrison, Post-war Discoveries: Early Italian Paintings, 3, The Madonna di sotto gli organi, Early Italian Painting: *Selected Studies*, 1, London 1984, 223-233.

Gautier 1970: P. Gautier, Diatribes de Jean l'Oxite contre Alexis Ier Comnène, *REB* 28 (1970), 5-55.

Gautier 1974: P. Gautier, Le Typikon du Christ Sauveur Pantocrator, *REB* 32 (1974), 1-145.

Gautier 1975: Nikephoros Bryennios, *Histoire* ed. and trans. P. Gautier, *CFHB* 9, Brussels 1975.

Gautier 1981: P. Gautier, La Diataxis de Michel Attaliate, *REB* 39 (1981), 5-144.

Gedeon 1885: M. Gedeon, Ὁ Ἄθως, Ἀναμνήσεις, Ἔγγραφα, Σημειώσεις, Constantinople 1885.

Gedeon 1900: M. Gedeon, Ἐκκλησίαι βυζαντιναί ἐξακριβούμεναι, Constantinople 1900.

Gelao 1988: Carla Gelao, *La Pinacoteca Provinciale di Bari. Opere dall'XI al XVIII secolo*, Rome 1988.

Gentz 1996[2]: G. Gentz, *Die Kirchengeschichte des Nicephorus Callistus Xanthopoulos und ihre Quellen*, Berlin 1966[2].

Gerasimov 1959: T. Gerasimov, L'icône bilatérale de Poganovo au Musée Archéologique de Sofia, *CahA* 10 (1959), 279-288.

Gero 1975: S. Gero, Hypatius of Ephesus on the Cult of Images, *Christianity, Judaism and Other Greco-Roman Cults, Studies for Morton Smith at Sixty*, 2, Leiden 1975, 208-216.

Gerov et al. 1999: G. Gerov, Ljudmila Dobreva, A. Kuyumdzhiev, Mariela Stoykova and Petia Cholakova, *National Art Gallery. Old Bulgarian Art Collection. The Crypt Guide*, St. Alexander Nevski Cathedral, Sofia 1999.

Gerstel 1999: Sharon Gerstel, *Beholding the Sacred Mysteries. Programs of the Byzantine Sanctuary*, Seattle and London 1999.

Gertz 1920: *Scriptores minores historiae Danicae medii aevi*, M.C. Gertz ed., Copenhagen 1920.

Gioles 1981: N. Gioles, *Η Ανάληψις του Χριστού βάσει των μνημείων της Α' χιλιετηρίδος*, Athens 1981.

Gioles 1993-1994: N. Gioles, Οι ψηφιδωτές εικόνες του Οικουμενικού Πατριαρχείου και οι αναθέτες τους, *ΔXAE* 17 (1993-1994), 249-258.

Giustiniani 1656: M. Giustiniani, *Dell'origine della Madonna di Costantinopoli, ossia d'Itria, e delle di lei traslazioni libri due*, Roma 1656.

Gligorijević-Maksimović 1989: M. Gligorijević-Maksimović, Le tabernacle a Dečani. Origine et developpement du theme iconographique, *Dečani et l'art Byzantin au milieu du XIVe siècle*, Belgrade 1989, 319-336.

Glory of Byzantium: *The Glory of Byzantium: Art and Culture of the Middle Byzantine Era, AD 843–1261*, exh. cat., New York, Metropolitan Museum of Art, 1997, Helen C. Evans and W. D. Wixom eds, New York 1997.

Goldschmidt and Weitzmann 1930, 1934, 1979[2]: A. Goldschmidt and K. Weitzmann, *Die byzantinischen Elfenbeinskulpturen des X.-XIII. Jahrhunderts*, 2 vols, Berlin 1930, 1934, 1979[2].

Golubtsov 1908: A.P. Golubtsov, *Chinovniki moskovskogo Uspenskogo sobora i vykhody patriarkha Nikona* / The Ceremonials of the Dormition Cathedral in Moscow, Moscow 1908.

Gonosová and Kondoleon 1994: Anna Gonosová and Christine Kondoleon, *Art of Late Rome and Byzantium in the Virginia Museum of Fine Arts*, Richmond 1994.

Gordillo 1954: M. Gordillo, *Mariologia Orientalis*, OCA 141, Rome 1954.

Gordon 1981: Dillian Gordon, A Sienese Verre Églomisé and its Setting, *BurlMag* 123 (1981), 148-153.

Gouillard 1967: J. Gouillard, Le synodikon de l'orthodoxie, édition et commentaire, *TM* 2 (1967), 1-316.

Gounaris 1978: G. Gounaris, *Οι τοιχογραφίες των Αγίων Αποστόλων και της Παναγίας Ρασιώτισσας στην Καστοριά*, Thessaloniki 1978.

Gounaris 1986: G. Gounaris, Φορητή εικόνα "Άνωθεν οι προφήται" από τη Μυτιλήνη, *Αμητός*, 227-238.

Grabar 1928: A. Grabar, *La peinture religieuse en Bulgarie*, Paris 1928.

Grabar 1956: A. Grabar, Iconographie de la Sagesse divine et de la Vierge, *CahA* 8 (1956), 254-261, rpr. in *L'art de la fin de l'antiquité*, 555-560.

Grabar 1958: André Grabar, *Les ampoules de Terre Sainte (Monza-Bobbio)*, Paris 1958.

Grabar 1959: A. Grabar, A propos d'une icône byzantine au Musée de Sofia, *CahA* 10 (1959), 289-304.

Grabar 1960: A. Grabar, Une pyxide en ivoire à Dumbarton Oaks, *DOP* 14 (1960), 121-146.

Grabar 1966a: A. Grabar, *Byzantium: From the Death of Theodosius to the Rise of Islam* (S. Gilbert and J. Emmons trans.), London 1966.

Grabar 1966b: A. Grabar, *L'Age d'Or de Justinien*, Paris 1966.

Grabar 1967: A. Grabar, *The Golden Age of Justinian*, New York 1967.

Grabar 1968a: A. Grabar, *L'art de la fin de l'antiquité et du moyen age*, 3 vols, Paris 1968.

Grabar 1968b: A. Grabar, *Early Christian Art*, New York 1968.

Grabar 1968c: A. Grabar, Découverte à Rome d'une icône de la Vierge à l'encaustique, *L'art de la fin de l'Antiquité et du Moyen Âge*, I, Paris 1968, 529-534.

Grabar 1969: A. Grabar, La précieuse croix de la Lavra Saint-Athanase au Mont-Athos, *CahA* 19 (1969), 99-125.

Grabar 1974: A. Grabar, L'Hodigitria et l'Eléousa, *ZLU* 10 (1974), 10-16.

Grabar 1975a: A. Grabar, *Les revêtements en or et en argent des icônes byzantines du moyen âge* (Bibliothèque de l'Institut Hellénique d'Études Byzantines et Post-byzantines de Venise, no. 7), Venice 1975.

Grabar 1975b: A. Grabar, Les images de la Vierge de Tendresse. Type iconographique et thème (à propos de deux icônes à Decani), *Zograf* 6 (1975), 25-30.

Grabar 1976a: A. Grabar, *Sculptures byzantines du Moyen Age, II (XIe-XIVe siècle)*, Paris 1976.

Grabar 1976b: A. Grabar, Une source d'inspiration de l'iconographie byzantine tardive; Les

cérémonies du culte de la Vierge, *CahA* 25 (1976), 144-147.

Grabar 1977: A. Grabar, Remarques sur l'iconographie byzantine de la Vierge, *CahA* 26 (1977), 169-178.

Grabar 1978: A. Grabar, Notes sur les mosaiques de Saint-Démétrios à Salonique, *Byzantion* 48 (1978), 64-77.

Grabar 1979: A. Grabar, Remarques sur l'iconographie byzantine de la Vierge, *L'art paléochrétienne et l'art byzantin*, Variorum Reprints, study IX, London 1979.

Grabar 1980: A. Grabar, *Christian Iconography, A Study of its Origins*, London 1980.

Grabar 1984², 1998: A. Grabar, *L'iconoclasme byzantin. Dossier archéologique*, Paris 1984², 1998.

Grabar and Manoussacas 1979: A. Grabar and M. Manoussacas, *L'illustration du manuscrit de Skylitzès de la Bibliothèque Nationale de Madrid*, Venice 1979.

Graef 1985: Hilda Graef, Mary. *A History of Doctrine and Devotion*, 2 vols, London 1985 (1st edn in 2 vols, London 1963, 1965).

Graf 1890: H. Graf, *Kataloge des Bayerischen Nationalmuseums München: Romanische Alterthümer*, vol. 1, Munich 1890.

Greece at the Benaki Museum: D. Fotopoulos and A. Delivorrias, *Greece at the Benaki Museum*, Athens 1997.

Greek Jewellery 6,000 Years of Tradition: *Greek Jewellery 6,000 Years of Tradition*, exh. cat., Villa Bianca, Thessaloniki 1997.

Greek Jewellery: *Greek Jewellery from the Benaki Museum Collections*, Athens 1999.

Grégoire, 1922: H. Grégoire, *Recueil des inscriptions grecques-chrétiennes d'Asie Mineure*, Paris 1922.

Greifenhagen 1970-1975: A. Greifenhagen, *Schmuckarbeiten in Edelmetall*, Berlin 1970-1975.

Grierson 1961: Ph. Grierson, The Date of the Dumbarton Oaks Epiphany Medallion, *DOP* 15 (1961), 221-224.

Grierson 1962: Ph. Grierson, The Tombs and Obits of the Byzantine Emperors (337-1042), *DOP* 16 (1962), 1-63.

Grierson 1963: P. Grierson A Misattributed Miliaresion of Basil II, *ZRVI* 8/1 (1963), 111-116.

Grierson 1973a: Ph. Grierson, *Catalogue of the Byzantine Coins in the Dumbarton Oaks Collection and in the Whittemore Collection, III₁: Leo III to Michael III 717-867*, Washington D.C. 1973.

Grierson 1973b: Ph. Grierson, *Catalogue of the Byzantine Coins in the Dumbarton Oaks Collection and in the Whittemore Collection, III₂, Basil I to Nicephorus III 867-1081*, Washington D.C. 1973.

Grierson 1982: P. Grierson, *Byzantine Coins*, London / Berkeley / Los Angeles 1982.

Grierson 1999a: Ph. Grierson, *Catalogue of the Byzantine Coins in the Dumbarton Oaks Collection and in the Whittemore Collection*, V₁: Michael VIII to Constantine XI 1258-1453,

Introduction, Appendices and Bibliography, Washington D.C. 1999.

Grierson 1999b: Ph. Grierson, *Catalogue of the Byzantine Coins in the Dumbarton Oaks Collection and in the Whittemore Collection*, V₂: Michael VIII to Constantine XI 1258-1453, Catalogue, Concordances and Indexes, Washington D.C. 1999.

Grierson 1999c: Ph. Grierson, *Byzantine Coinage*, Washington D.C. 1999.

Griffith 1982: S. Griffith, Eutychius of Alexandria on the Emperor Theophilus and Iconoclasm in Byzantium: a Tenth-Century Moment in Christian Apologetics in Arabic, *Byzantion* 52 (1982), 154-190.

Grigoriadou 1975: Hélène Grigoriadou, L'image de la déésis royale dans une fresque du XIVe siècle à Castoria, *Actes du XIVe CIEB*, II, 47-52.

Grillmeier-Bacht 1965, 1975²: A. Grillmeier-Bacht, *Christ in Christian Thought. From Apostolic Times to Chalcedon (451)*, I, trans. J.S. Bowden, New York 1965, 1975².

Grosdidier de Matons 1964-1981: J. Grosdidier de Matons, *Hymnes*, 5 vol, Paris 1964-1981.

Grosdidier de Matons 1977: J. Grosdidier de Matons, *Romanos le Mélode et les origines de la poésie religieuse à Byzance*, Paris 1977.

Grumel 1931: V. Grumel, Le 'miracle habituel' de Notre-Dame des Blachernes à Constantinople, *EO* 30 (1931), 129-146.

Grumel 1932: V. Grumel, Le mois de Marie des Byzantins, *EO* 31 (1932), 257-269.

Grumel 1934: V. Grumel, Le patriarcat et les patriarches d'Antioche sous la seconde domination byzantine (969-1084), *EO* 33 (1934), 129-147.

Guide 1936: *Guide*, Benaki Museum, Athens 1936.

Guiraud 1992: H. Guiraud, *Le Trésor d'Eauze. Bijoux et monnaies du IIIᵉ siècle après J.-C.*, D. Schaad ed., Toulouse 1992.

Hadermann-Misguich 1975: Lydie Hadermann-Misguich, *Kurbinovo, Les fresques de Saint-Georges et la peinture byzantine du XIIe siècle*, Brussels 1975.

Hadermann-Misguich 1983: Lydie Hadermann-Misguich, Pelagonitissa et Kardiotissa, Variantes extremes du type de Tendresse, *Byzantion* 53 (1983), 9-16.

Hadermann-Misguich 1979: Lydie Hadermann-Misguich, La peinture monumentale tardo-comnène et ses prolongements aux XIIIe siècle, *Actes du XVe CIEB*, 97-128.

Hadermann-Misguich 1985: Lydie Hadermann-Misguich, La peinture monumentale du XIIe siècle à Chypre, *CorsiRav* 32 (1985), 233-258.

Hadjidakis 1944: M. Hadjidakis, Un anneau byzantin du Musée Benaki, *BNJ* 17 (1944), 174-206.

Hahnloser and Polacco 1994: H.R. Hahnloser and R. Polacco, *La Pala d'Oro*, Venice 1994.

Haldon 1990a: J.F. Haldon, *Byzantium in the Seventh Century. The Transformation of a Culture*, Cambridge 1990.

Haldon 1990b: J.F. Haldon, *Constantine Porphyro-*

genitus. Three Military Treatises on Imperial Military Expeditions, CFHB 28, Vienna 1990.

Halkin 1959: F. Halkin, Une nouvelle Vie de Constantin dans un légendier de Patmos, *AB* 77 (1959), 63-107.

Halkin 1960: F. Halkin, Le règne de Constantin d'après la Chronique inédite du pseudo-Syméon, *Byzantion* 29-30 (1959-1960), 7-27.

Halkin 1989: F. Halkin, Un diacre réconcilié avec son ami défunt (*BHG* 1322d), *SBN*, n.s. 26 (1989), 107-202.

Hamann-Mac Lean and Hallensleben 1963: R. Hamann-Mac Lean and H. Hallensleben, *Die Monumentalmalerei in Serbien und Makedonien vom 11. bis zum frühen 14. Jahrhundert*, Gießen 1963.

Handbook of the Byzantine Collection 1946: *Handbook of the Byzantine Collection*, Dumbarton Oaks, Washington D.C. 1946.

Handbook of the Byzantine Collection 1955: *Handbook of the Byzantine Collection*, Dumbarton Oaks, Washington D.C. 1955.

Handbook of the Byzantine Collection 1967: *Handbook of the Byzantine Collection*, Dumbarton Oaks, Washington D.C. 1967.

Hansen 1995²: *Kirchengeschichte*, G.C. Hansen ed., Berlin 1995².

Harrison and Firatli 1966: R.M. Harrison and N. Firatli, Excavations at Saraçhane in Istanbul. Second and Third Preliminary Reports, *DOP* 20 (1966), 223-238.

Harrisson 1986: R. M. Harrisson, *Excavations at Saraçhane in Istanbul*, 1, Princeton, 1986.

Havice 1984: Christine Havice, The Marginal Miniatures in the Hamilton Psalter (Kupferstichkabinett 78 A 9), *Jahrbuch der Berliner Museen* 26 (1984), 79-142.

Η δόξα του Βυζαντίου: *Η δόξα του Βυζαντίου στο Όρος Σινά, Θρησκευτικοί θησαυροί από την Ιερά Μονή της Αγίας Αικατερίνης, Μουσείο Μπενάκη, 17 Σεπτεμβρίου-24 Οκτωβρίου 1997*, Athens 1997

Heisenberg 1973: A. Heisenberg, Zur Geschichte der lateinischen Kaisertums und der Kirchenunion, *Quellen und Studien zur spätbyzantinischen Geschichte*, II, London 1973.

Hendy 1967: M.F. Hendy, *Coinage and Money in the Byzantine Empire 1081-1261*, Washington D.C. 1967.

Hendy 1969: M. Hendy, *Coinage and Money in the Byzantine Empire 1081-1261*, Dumbarton Oaks Studies 12, Washington D.C. 1969.

Hendy 1999: M. Hendy, *Catalogue of the Byzantine Coins in the Dumbarton Oaks Collection and in the Whittemore Collection*, 4, Alexius I to Michael VIII, 1081-1261, 1, Alexius I to Alexius V (1081-1204), 2. The Emperors of Nicaea and their Contemporaries (1204-1261), Washington D.C. 1999.

Hennecke and Schneemelcher 1963: E. Hennecke and W. Schneemelcher, *New Testament Apocrypha*, Philadelphia 1963.

Hermann 1967: A. Hermann, Das erste Bad des

Heilands und des Helden in spatantiker Kunst und Legende, *JbAChr* 10 (1967), 61-81.

Hermeneia/Ἑρμηνεία: Διονυσίου τοῦ ἐκ Φουρνᾶ, Ἑρμηνεία τῆς ζωγραφικῆς τέχνης, A. Papadopoulos-Kerameus ed., St Petersburg 1909.

Herrin 1982: Judith Herrin, Women and the Faith in Icons in Early Christianity, *Culture, Ideology and Politics*, London 1982, 56-83.

Hetherington 1974: P. Hetherington, *The 'Painter's Manual' of Dionysius of Fourna*, London 1974.

Higgins 1961: R.A. Higgins, *Greek and Roman Jewellery*, London 1961.

Hill 1996: S. Hill, *The Early Byzantine Churches of Cilicia and Isauria*, Aldershot 1996.

History as Text: History as Text. The Writing of Ancient History, Averil Cameron ed., London 1989.

Hoenigswald 1982: A. Hoenigswald, The 'Byzantine' Madonnas: Technical Investigation, *Studies in the History of Art* 12 (1982), 25-31.

Hofmann 1938: G. Hofmann, *Vescovaldi Cattolici della Grecia*, OCA 115 (1938).

Holy Image - Holy Space: Holy Image - Holy Space, Icons and Frescoes from Greece, exh. cat., Walters Art Gallery 1988, Baltimore 1988.

Hopkins 1999: K. Hopkins, *A World Full of Gods. Pagans, Jews and Christians in the Roman Empire*, London 1999.

Hörandner 1974: W. Hörandner, *Theodoros Prodromos. Historische Geschichte, CFHB*, Vienna 1974.

Horden 1986: P. Horden, The Confraternities of Byzantium, *Volunteer Religion*, W.J. Sheils and Diana Wood eds, SChH 23 (Oxford 1986), 25-45.

Horna 1903: K. Horna, Die Epigramme des Theodoros Balsamon, *WS* 25 (1903), 165-217.

Howard Marshall 1978: I. Howard Marshall, *The Gospel of Luke. A Commentary on the Greek Text*, Exeter 1978.

Hunter 1987: D. Hunter, Resistance to the Virginal Ideal in Late Fourth-Century Rome: the Case of Jovinian, *TheolSt* 48 (1987), 45-64.

Hutter 1977: Irmgard Hutter, *Corpus der byzantinischen Miniaturhandschriften*, 1, Stuttgart 1977.

Hutter 1978: Irmgard Hutter, *Corpus der byzantinischen Miniaturhandschriften*, 2, Stuttgart 1978.

Hutter 1982: Irmgard Hutter, *Corpus der byzantinischen Miniaturhandschriften*, 3, Stuttgart 1982.

Hutter 1993: Irmgard Hutter, *Corpus der byzantinischen Miniaturhandschriften*, 4, Stuttgart 1993

Hutter 1995: Irmgard Hutter, Die Geschichte des Lincoln College Typikons, *JÖB* 45 (1995), 79-114.

Hutter 1997: Irmgard Hutter, *Corpus der byzantinischen Miniaturhandschriften*, 5, Stuttgart 1997.

Hutter and Canart 1991: Irmgard Hutter and P. Canart, *Das Marienhomiliar des Mönchs Jakobos von Kokkinobaphos*, Zurich 1991.

Hyatt Mayor 1957: A. Hyatt Mayor, Gifts that Make the Museum, *The Metropolitan Museum of ArtB* 16 (1957), 85-107.

Θυμίαμα: Θυμίαμα στη μνήμη της Λασκαρίνας

Μπούρα, Maria Vassilaki, Electra Georgoula, A. Delivorrias and A. Markopoulos eds, Athens 1994.

Iakovleva 1996: A. Iakovleva, Our Lady Hodigitria (Perevleptia) of the Museums of the Kremlin: A Newly Introduced Example of the Palaologian Art, *Acts of the XVIII International Byzantine Congress (Moscow 1991), Byzantine Studies. Selected Papers*, III. Art, History, Music, I. Ševčenko and G. Litavrin eds, Byzantine Studies Press, Moscow 1996, 109-13.

Iatridis 1981: B. Iatridis, Μέτρηση των συστατικών των κραμάτων τριών θυμιατηρίων, *Αρχαιολογία* 1 (November 1981), 73-74.

Icone di Puglia: Icone di Puglia e Basilicata dal medioevo al Settecento, P. Belli D'Elia ed., exh. cat., Bari 1988, Milan 1988.

Icônes bulgares du IXe au XIXe siècle: Icônes bulgares du IXe au XIXe siècle, Musées royaux d'art et d'histoire, Brussels 1977.

Icônes bulgares. IXe-XIXe siècle: Icônes bulgares. IXe-XIXe siècle, Musée du Petit Palais, Paris 1976.

Icons from Bulgaria (from the 9th to the 19th centuries), Courtauld Institute Galleries, London 1978.

Icons from Cyprus: Icons from Cyprus, exh. cat., Benaki Museum, Athens 1976.

Ihm 1960: Christa Ihm, *Die Programme der christlichen Apsismalerei vom vierten Jahrundert bis zur Mitte des achten Jahrunderderts*, Wiesbaden 1960.

Ikonen aus Bulgarien, Museum der Angewandte Kunst, Vienna 1977.

Ikonen: Ikonen: Restorierung und Naturwissenschaftliche Erforschung, beiträge des internationalen Kolloquiums in Recklinghausen 1994, I. Bentchev and Eva Haustein-Bartsch eds, Munich 1997.

Ikonomaki-Papadopoulos 1980: Yota Ikonomaki-Papadopoulos, *Ἐκκλησιαστικά Ἀργυρά*, Athens 1980.

Ikonomaki-Papadopoulos 1997: Yota Ikonomaki-Papadopoulos, Post Byzantine Silver Work, *Treasures of Mount Athos*, 366-368.

Ikonomaki-Papadopoulos et al. 2000: Yota Ikonomaki-Papadopoulos, Brigitte Pitarakis and Katia Loverdou-Tsigarida, *Τα εγκόλπια της Μονής Βατοπαιδίου*, Athens 2000.

Il Tesoro: Il Tesoro di San Marco: Il Tesoro e il Museo, H. R. Hahnloser ed., Florence 1971.

Iliffe 1950: J.H. Iliffe, A Byzantine gold enkolpion from Palestine, *Quarterly of the Department of Antiquities in Palestine* 14 (1950).

Illuminated Greek MSS: Illuminated Greek Manuscripts from American Collections, G. Vikan ed., Princeton 1973.

Imellos 1958-1959: S.D. Imellos, Δημώδεις παραδόσεις ἐκ Νάξου, *ΕΛΑ* 11-12 (1958-1959), 200-228.

IV SIAG: IVe Symposium international sur l'art Georgien, Tbilisi 1983, vol. I, Tbilisi 1989.

Jahn and Michaelis 1976: O. Jahn and A. Michaelis, *The Acropolis of Athens*, Chicago 1976.

James 1924: M.R. James, *The Apocryphal New Testament*, Oxford 1924.

James and Webb 1991: Elizabeth James and Ruth Webb, To Understand Ultimate Things and Enter Secret Places: Ekphrasis and Art in Byzantium, *ArtH* 14 (1991) 1-17.

Janes 1998: D. Janes, *God and Gold in Late Antiquity*, Cambridge 1998.

Janin 1953: R. Janin, *La géographie ecclésiastique de l'empire byzantin, I: Le siège de Constantinople et le patriarcat oecuménique, 3: Les églises et les monastères*, Paris 1953, 1969[2].

Jeffreys 1982: Elisabeth Jeffreys, The Sevastokratorissa Eirene as Literary Patroness: The Monk Iakovos, *JÖB* 32/3 (1982), 63-71.

Jerphanion 1925-1942: G. de Jerphanion, *Une nouvelle province de l'Art Byzantin, Les églises rupestres de Cappadoce*, 2 vols, Paris 1925-1942.

Jewellery Ancient to Modern: Jewellery Ancient to Modern, exh. cat., The Walters Art Gallery, Baltimore, New York 1979.

Jewellery through 7000 Years: Jewellery through 7000 Years, exh. cat., London, British Museum, 1976, H. Tait ed., London 1976.

Johns 1996: C. Johns, *The Jewellery of Roman Britain*, London 1996.

Jolivet-Lévy 1991: Catherine Jolivet-Lévy, *Les églises de Cappadoce. Le programme iconographique de l'abside et de ses abords*, Paris 1991.

Jolivet-Lévy 1998: Catherine Jolivet- Lévy, Note sur la réprésentation des archanges en costume impérial dans l'iconographie byzantine, *CahA* 46 (1998), 121-128.

Jugie 1913: M. Jugie, L'Église de Chalcopratia et le culte de la ceinture de la Sainte Vierge à Constantinople, *EO* 16 (1913), 308-312.

Jugie 1944: M. Jugie, *La mort et l'assomption de la Sainte Vierge*, Studi e testi 114, Vatican 1944.

Kalavrezou 1990: Ioli Kalavrezou, Images of the Mother: When the Virgin Mary Became the Meter Theou, *DOP* 44 (1990), 165-172.

Kalavrezou-Maxeiner 1985: Ioli Kalavrezou-Maxeiner, *Byzantine Icons in Steatite*, 2 vols, Byzantina Vindobonensia 15, Vienna 1985.

Kalligas 1937: M. Kalligas, Φορητὴ εἰκὼν ἐν Freising, *AE* 1937/2, 501-516.

Kalogeras 1955: K.E. Kalogeras, Μονεμβασία, ἡ Βενετία τῆς Πελοποννήσου, Texte und Forschungen zur byzantinisch-neugriechischen Philologie 46, Athens 1955.

Kalokyris 1972: K. Kalokyris, Ἡ Θεοτόκος εἰς τὴν εἰκονογραφίαν τῆς Ἀνατολῆς καὶ τῆς Δύσεως, Thessaloniki 1972.

Kalokyris 1973: K. Kalokyris, *The Byzantine Wall Paintings of Crete*, New York 1973.

Kaper Koraon: Marlia Mundell Mango, *Silver from Early Byzantium. The Kaper Koraon and Related Treasures*, Baltimore 1986.

Karakatsani 1974: Agapi Karakatsani, Οι εικόνες της Μονής Σταυρονικήτα, in Ch. Patrinelis, Agapi Karakatsani and Maria Theochari, *Μονή Σταυρονικήτα, Ιστορία-Εικόνες-Χρυσοκεντήματα*, Athens 1974, 41-140.

Karakatsani 1985-1986: Agapi Karakatsani, Σχόλια σε μια εικόνα του Στιχηροῦ τῶν Χριστουγέννων, *ΔΧΑΕ* 13 (1985-1986), 93-96.

Karavidopoulos 1999: I. Karabidopoulos, *Ἀπόκρυφα Χριστιανικά κείμενα. 1: Ἀπόκρυφα Εὐαγγέλια*, Thessaloniki 1999.

Kartsonis 1986: Anna D. Kartsonis, *Anastasis. The Making of an Image*, Princeton 1986.

Kartsonis 1994: Anna Kartsonis, Protection against All Evil: Function, Use, and Operation of Byzantine Historiated Phylacteries, *ByzF* 20 (1994), 73-102.

Kašanin 1938: M. Kašanin, Ohridske ikone, *Umetnički pregled*, 1, Belgrade 1938, 301-307.

Kastanophyllis 1992: K. Kastanophyllis, *Ἱστορικὸ Παναγίας Προυσιώτισσας*, Proussos 1992.

Katsioti 1994: Angeliki Katsioti, Οι τοιχογραφίες του Ταξιάρχη Μιχαήλ στον Εμπολα-Βαθύ Καλύμνου, *Κάλυμνος, Ελληνορθόδοξος ορισμός του Αιγαίου*, Athens 1994, 215-258.

Kazanaki-Lappa 1988: Maria Kazanaki-Lappa, Μια παλαιολόγεια εικόνα Βρεφοκρατούσας του τύπου της Γλυκοφιλούσας, *8th Symposium XAE*, Athens 1988, 47-48.

Kazdhan and Epstein 1985: A.P. Kazdhan and Ann Wharton Epstein, *Change in Byzantine Culture in the Eleventh and Twelfth Centuries*, Berkeley-Los Angeles-London 1985.

Kazhdan 1987: A. Kazhdan, Constantin imaginaire, Byzantine Legends of the Ninth Century about Constantine the Great, *Byzantion* 57 (1987), 196-250.

Kazhdan 1989: A. Kazhdan, Kosmas of Jerusalem: a More Critical Approach to his Biography, *BZ* 82 (1989), 122-132.

Kazhdan 1990: A. Kazhdan, Kosmas of Jerusalem: Can we Speak of His Political Views? *Le Museon* 103 (1990), 329-346, rpr. Kazhdan 1993.

Kazhdan 1993: A. Kazhdan, *Authors and Texts in Byzantium*, Variorum Reprints 1993.

Keil and Hörmann 1951: J. Keil and H. Hörmann, *Die Johanneskirche. Forschungen in Ephesos*, IV/3, Vienna 1951.

Kelly 1977, 1985[5]: J.D. Kelly, *Early Christian Doctrines*, London 1977, 1985[5].

Kendrick 1922: A.F. Kendrick, *Catalogue of Textiles from Burying-Grounds in Egypt*, Victoria and Albert Museum, London, I, 1920; II, 1921; III, 1922.

Kephalliniadis 1990: N.A. Kephalliniadis, *Η λατρεία της Παναγίας στα ελληνικά νησιά*, Athens 1990.

Kessler 1993: H.L. Kessler, Medieval Art as Argument, *Iconography at the Crossroads*, B. Cassidy ed., Princeton 1993, 59-70.

Khitrowo 1889: *Itinéraires russes en Orient*, B. De Khitrowo ed., Paris 1889.

Khuskivadze 1981: Leila Z. Khuskivadze, *Gruzinskie emali*, Tbilisi 1981.

Khuskivadze 1984: Leila Khuskivadze, *Medieval Cloisonné Enamels in Georgian State Museum of Fine Arts* (in Georgian, Russian and English), Tbilisi 1984.

Kidonopoulos 1994: V. Kidonopoulos, *Bauten in Konstantinopel. 1204-1328*, Wiesbaden 1994.

Kitzinger 1954: E. Kitzinger, The Cult of Images in the Era before Iconoclasm, *DOP* 8 (1954), 83-150.

Kitzinger 1955: E. Kitzinger, On Some Icons of the Seventh Century (1955), rpr. in Kitzinger 1976, 233-255.

Kitzinger 1958: E. Kitzinger, Byzantine Art in the Period between Justinian and Iconoclasm, *Berichte zum XI. Internationalen Byzantinisten-Kongress, München 1958*, Munich 1958, IV/1, 1-50.

Kitzinger 1960: E. Kitzinger, *The Mosaics of Monreale*, Palermo 1960.

Kitzinger 1976: E. Kitzinger, *The Art of Byzantium and the Medieval West: Selected Studies*, W.E. Kleinbauer ed., Bloomington and London 1976.

Kitzinger 1977: E. Kitzinger, *Byzantine Art in the Making. Main Lines of Stylistic Development in Mediterranean Art 3rd-7th Century*, London 1977.

Kitzinger 1990: E. Kitzinger, *The Mosaics of St Mary's of the Admiral in Palermo*, Washington D.C. 1990.

Klein 1933: D. Klein, *Lukas als Maler der Maria (Ikonographie der Lukas-Madonna)*, Hamburg 1933.

Kodakis 1998: C. Kodakis, *Εἰς τὴν Θεοτόκον συναγωγὴ Πατερικῶν ᾠδῶν, προσηγοριῶν καὶ ἐπιθέτων*, Thessaloniki 1998.

Koenen 1998: Ulrike Koenen, Byzantinische Elfenbeine aus westlichen Werkstätte, *Chartulae. Festschrift für Wilhelm Speyer*, JbAChr Ergätzungband 28, Münster 1998, 199-227.

Koltsida-Makri 1996: Ioanna Koltsida-Makri, *Βυζαντινά μολυβδόβουλλα, Συλλογή Ορφανίδη-Νικολαΐδη, Νομισματικό Μουσείο Αθηνών*, Athens 1966.

Kondakov 1902: N. Kondakov, *Icons from Sinai and Athos from the Collection of P. Uspenskij* (in Russian), St Petersburg 1902.

Kondakov 1909: N. Kondakov, *Makedonia*, St Petersburg 1909.

Kondakov 1914-1915: N. Kondakov, *Ikonografija Bogomateri*, 2 vols, St Petersburg 1914-1915.

Kondakov 1914-1915: N. Kondakov, *Iconography of the Mother of God*, St Petersburg 1914-1915.

Kondakov and Bakradze 1890: N. P. Kondakov and Dimitrii Bakradze, *Opis' pamiatnikov drevnosti v nekotorykh khramakh i monastyriakh Gruzii*, St Petersburg 1890.

Konomos 1964: D. Konomos, *Ναοί καὶ Μονὲς στη Ζάκυνθο*, Athens 1964.

Konomos 1967: D. Konomos, *Εκκλησίες και Μοναστήρια στη Ζάκυνθο*, Athens 1967.

Konomos 1988: D. Konomos, *Ζάκυνθος - Πεντακόσια Χρόνια (1478-1978)*, 5, *Τέχνης Οδύσσεια, Α'. Θρησκευτική Τέχνη - Ζωγραφική*, Athens 1988.

Koptische Kunst–Chrsitentum am Nil 1: *Koptische Kunst–Chrsitentum am Nil* 1, exh. cat., Villa Hügel, Essen 1963.

Koptische Kunst-Christentum am Nil 2: *Koptische Kunst-Christentum am Nil* 2, exh. cat., Kunsthaus Zürich, 1963-1964.

Kotta 1937: Venetia Kotta, Περὶ σπανίας παραστάσεως τῆς Θεοτόκου ἐπὶ εἰκόνος τοῦ Βυζαντινοῦ Μουσείου Ἀθηνῶν, *AE* 1937/2, 674-686.

Kotter 1969-1988: *Die Schriften des Johannes von Damaskos*, B. Kotter ed., 7 vols, Berlin-New York 1969-1988.

Kötzsche 1933: Lieselotte Kötzsche, Die Marienseide in der Abegg-Stiftung. Bemerkungen zur Ikonographie der Szenenfolge, *Begegnung von Heidentum und Christentum im spätantiken Ägypten, Riggisberger Berichte* 1 (1993), 183-194.

Kourkoutidou-Nikolaidou 1972: Eftychia Kourkoutidou-Nikolaidou, Χαλκοί σταυροί εκ του Περιθεωρίου, *AAA* 5/3, Athens 1972, 374-381.

Kreek 1994: M.L. de Kreek, *De kerkschat van het Onze-Lieve-Vrouwekapittel te Maastricht*, Utrecht–Amsterdam 1994.

Kreidl-Papadopoulos 1981: Karoline Kreidl-Papadopoulos, *Ikonen und Kultobjekte der Ostkirche aus dem Besitz des Kunsthistorischen Museums und der griechischen Kirche in Wien*, exh. cat., Kunsthistorisches Museum, Sammlung für Plastik und Kunstgewerbe, 25 September-30 October 1981, Vienna 1981.

Krönig 1965: W. Krönig, Das Tafelbild der Hodegetria in Monreale, *Miscellanea pro arte. Festschrift für Hermann Schnitzler*, Düsseldorf 1965, 179-184.

Kuhn and Tait 1996: *Thirteen Coptic Acrostic Hymns from Manuscript M574 of the Pierpont Morgan Library*, K.H. Kuhn and W.J. Tait eds, Oxford 1996.

Kühnel 1988: G. Kühnel, *Wall Painting in the Latin Kingdom of Jerusalem*, Berlin 1988.

Kunst der Spätantike im Mittelmeerraum: *Spätantike und byzantinische Kleinkunst aus Berliner Besitz*, exh. cat., Berlin, Kaiser-Friedrich-Museum 1939, H. Schlunk ed., Berlin 1939.

Kunstschätze in bulgarischen Museen und Klöstern, exh. cat., Essen 1961.

L'arte copte: *L'arte copte*, exh. cat., Petit Palais, Paris 1964.

L'Exposition d'art byzantin à Paris: *L'Exposition d'art byzantin à Paris*, exh. cat., Paris 1931.

La miniature Armenienne: *La miniature Armenienne XIIIe-XIVe siècles (Collection du Matenadaram, Erevan)*, Leningrad 1984.

La pittura in Italia: *La pittura in Italia. L'Altomedioevo*, C. Bertelli ed., Milan 1994.

La Seta e la sua via: *La Seta e la sua via*, Palazzo delle Espositioni, Università degli studi di Roma 'La Sapienza', exh. cat., Rome 1994.

Lackner 1985: W. Lackner, Ein byzantinisches Marienmirakel, *Βυζαντινά* 13/2 (1985), 833-860.

Lafontaine-Dosogne 1964, 1992[2]: Jacqueline Lafontaine-Dosogne, *Iconographie de l'enfance de la Vierge dans l'Empire byzantin et en Occident*, Brussels 1964, 1992[2].

Lafontaine-Dosogne 1972: Jacqueline Lafontaine-

Dosogne, L'Eglise rupestre dite Eski Baca Kilisesi et la place de la Vierge dans les absides cappadociennes, *JÖB* 21 (1972), 163-180.

Lafontaine-Dosogne 1975: Jacqueline Lafontaine-Dosogne, Iconography of the Cycle of the Life of the Virgin, in Underwood 1975, 4, 161-194.

Lafontaine-Dosogne 1984: Jacqueline Lafontaine-Dosogne, L'illustration de la première partie de l'Hymne Akathiste et sa relation avec les mosaïques de l'Enfance de la Kariye Djami, *Byzantion* 54/2 (1984), 648-702.

Lafontaine-Dosogne 1987: Jacqueline Lafontaine-Dosogne, L'illustration du cycle des mages suivant l'homélie sur la Nativité attribué à Jean Damascène, *Museon* 100/1-4 (1987), 211-224.

Lake 1909: K. Lake, *The Early Days of Monasticism in Mount Athos*, Oxford 1909, rpr. in Ἁγιορειτική Βιβλιοθήκη 5 (1940-1941), 35-50.

Lampros 1878: S. Lampros, Αἱ Ἀθῆναι περὶ τὰ τέλη τοῦ δωδεκάτου αἰῶνος, Athens 1878.

Lampros 1911: S. Lampros, Ὁ Μαρκιανὸς κῶδιξ 524, *ΝέοςΕλλ* 8 (1911), 3-59, 113-192.

Lampros 1912: S. Lampros, Τὰ Πάτρια τοῦ Ἁγίου Ὄρους, *ΝέοςΕλλ* 9 (1912) 123-137.

Lange 1964: R. Lange, *Die byzantinische Reliefikone*, Recklinghausen 1964.

Laourdas 1959: B. Laourdas, Φωτίου Ὁμιλίαι, Thessaloniki 1959.

Lappa-Zizeka and Rizou-Kouroupou 1991: Evridiki Lappa-Zizeka and Matoula Rizou-Kouroupou, Κατάλογος Ἑλληνικῶν Χειρογράφων τοῦ Μουσείου Μπενάκη, Athens 1991.

Lash 1989: E. Lash, Mary in Eastern Christian Literature, *Epiphany* 1989, 310-321.

Laurent 1952: V. Laurent, *La Collection Orghidan*, Paris 1952.

Laurent 1956: *La Vie merveilleuse de Saint Pierre d'Atroa*, V. Laurent ed., SubsHag 29, Brussels 1956.

Laurent 1963: V. Laurent, *Le corpus des sceaux de l'empire byzantin*, 1. *L'Eglise*, Paris 1963.

Laurent 1965: V. Laurent, *Le corpus des sceaux de l'empire byzantin*, 2. *L'Eglise*, Paris 1965.

Laurent 1972: V. Laurent, *Le corpus des sceaux de l'empire byzantin*, 3. *L'Eglise*, Paris 1972.

Laurent 1981: V. Laurent, *Le corpus des sceaux de l'empire byzantin*, II, *L'administration centrale*, Paris 1981.

Lavrent'evskaia letopis'/ The Lavrent'evskaia Chronicle in *Polnoie Sobranie Russkikh Letopisei*, I, Moscow 1997.

Lazareff 1933: V. Lazareff, Early Italo-Byzantine Painting in Sicily, *BurlMag* 63 (1933), 279-287.

Lazareff 1938: V. Lazareff, Studies in the Iconography of the Virgin, *ArtB* 20 (1938), 26-65.

Lazareff 1966: V. Lazareff, *Old Russian Murals and Mosaics From the XI to the XVI Centuries*, London 1966.

Lazarev 1967: V. Lazarev, *Storia della pittura bizantina*, Turin 1967.

Lazareff 1971: V. Lazareff, *Vizantiskij zivopisi*, Moscow 1971.

Lazarev 1986: V. Lazarev, *Istoria Vizantijskoi zhivopisi/History of Byzantine Painting*, 2 vols, Moscow 1986.

Lazović et al. 1977: M. Lazović, N. Durr, H. Durand, C. Houriet and F. Schweizer, Objets byzantins de la collection du Musée d'art et d'histoire, *Geneva* 25 (1977).

Le Grand 1895: *Liber peregrinationis ad loca sancta*, L. Le Grand ed., *ROL* 3 (1895) 566-669.

Le Trésor de Saint-Marc: *Le trésor de Saint-Marc de Venise*, exh. cat., Galeries Nationales du Grand Palais, Paris 1984.

Ledit n.d.: J. Ledit, *Marie dans la Liturgie de Byzance*, Théologie Historique 39, Paris n.d.

Leib 1933: B. Leib ed., *Anne Comnène Alexiade*, 3 vols, Paris 1933.

Leib 1937: *Anne Comnène, Alexiade*, I, B. Leib ed., Paris 1937.

Lemerle 1949: P. Lemerle, Un bois sculpté de l'Annonciation, *MonPiot* 43 (1949), 98-118.

Leroy 1964: J. Leroy, *Les manuscrits syriaques à peintures conservées dans les bibliothèques d'Europe et d'Orient*, Paris 1964.

Letts 1926: M. Letts, *Pero Tafur, Travels and Adventures* (trans.), London 1926.

Lib.pont.: *Le Liber pontificalis*, L. Duchesne ed., 3 vols, Paris 1886-1957.

Lidov 1996: A. Lidov, Odigitria Konstantinopol'skaia, *Chudotvornye ikony*.

Lidov 1998: A. Lidov, Byzantine Church Decoration and the Great Schism of 1054, *Byzantion* 68 (1998), 381-405.

Lidov 2000: A. Lidov, *Mandilion. Istoria relikvii, in Spas Nerukotvornyi v russkoi ikone* / The Mandylion in Russian Icons, Moscow 2000, forthcoming.

Limberis 1994: Vasiliki Limberis, *Divine Heiress. The Virgin Mary and the Creation of Christian Constantinople*, London and New York 1994.

Lindahl 1980: F. Lindahl, *Dagmarkorset, Orø-og Roskildekorset*, Copenhagen 1980.

Lipsius 1883-1890: *Die apokryphen Apostelgeschichten und Apostellegenden. Ein Beitrag zur altchristlichen Literaturgeschichte und zu einer zusammenfassenden Darstellung der neutestamentlichen Apokryphen*, R.A. Lipsius ed., Braunschweig 1883-1890.

Little and Husband 1987: Ch. T. Little and T. Husband, *The Metropolitan Museum of Art: Europe in the Middle Ages*, New York 1987.

Littlewood 1985: A. Littlewood, *Michaelis Pselli, Oratoria minora*, Stuttgart 1985.

Lixačeva 1972: V.D. Lixačeva, The Illumination of the Greek Manuscript of the Akathistos Hymn, *DOP* 26 (1972) 255-262.

Longhurst 1927a: Margaret H. Longhurst, A Byzantine Disc from South Kensington, *BurlMag* 50 (1927), 107-108.

Longhurst 1927b: Margaret H. Longhurst, *Catalogue of Carvings in Ivory: Victoria and Albert Museum*, London 1927.

Loverdou-Tsigarida 1996: Katia Loverdou-Tsigarida, Byzantine Small Art Works, *Monastery of Vatopaidi*, 2, 458-499.

Loverdou-Tsigarida 1997: Katia Loverdou-Tsigarida, Byzantine Minor Art, *Treasures of Mount Athos*, 311-316.

Lowden 1997: J. Lowden, *Early Christian and Byzantine Art*, London 1997.

Maas 1910: P. Maas, *Frühbyzantinische Kirchenpoesie*, Bonn 1910.

Maas and Trypanis 1963: *Sancti Romani Melodi cantica genuina*, P. Maas and K.A. Trypanis eds, Oxford 1963.

Macchiarella 1981: G. Macchiarella, *Il ciclo di affreschi della cripta del santuario di Santa Maria del Piano presso Ausonia*, Rome 1981.

Macrides and Magdalino 1988: Ruth Macrides and P. Magdalino, The Architecture of Ekphrasis: Construction and Context of Paul the Silentiary's Poem on Hagia Sophia, *BMGS* 12 (1988), 47-82.

Magdalino 1986: P. Magdalino, Church, Bath and Diakonia, *Church and People in Byzantium. 20th Spring Symposium of Byzantine Studies*, Rosemary Morris ed., Birmingham 1986, 165-188.

Magdalino 1988: P. Magdalino, The Bath of Leo the Wise and the 'Macedonian Renaissance' revisited: Topography, Ceremonial, Ideology, *DOP* 42 (1988), 97-118.

Magdalino 1993: P. Magdalino, *The Empire of Manuel I Komnenos*, 1143-1180, Cambridge 1993.

Magdalino 1996: P. Magdalino, *Constantinople médiévale*, Paris 1996.

Magdalino and Nelson 1982: P. Magdalino and R. Nelson, The Emperor in Byzantine Art of the Twelfth Century, *ByzF* 8 (1982), 123-183.

Magoulias 1984: H.J. Magoulias, *O City of Byzantium, Annals of Niketas Choniates*, Detroit, Mich. 1984.

Maguire 1980-1981: H. Maguire, The Iconography of Symeon with the Christ Child in Byzantine Art, *DOP* 34-35 (1980-1981), 261-269.

Maguire 1981: H. Maguire, *Art and Eloquence in Byzantium*, Princeton 1981.

Maguire 1983: H. Maguire, The Self-Conscious Angel: Character Study in Byzantine Paintings of the Annunciation, *Okeanos*, 377-392.

Maguire 1990: H. Maguire, Garments Pleasing to God: the Significance of Domestic Textile Designs in the Early Byzantine Period, *DOP* 44 (1990), 215-224.

Maguire 1992: H. Maguire, The Mosaics of Nea Moni. An Imperial Reading, *DOP* 46 (1992), 205-214.

Maguire 1997a: H. Maguire, Magic and Money in the Early Middle Ages, *Speculum* 72.4 (1997), 1037-1054.

Maguire 1997b: H. Maguire, The Heavenly Court, *Byzantine Court Culture*, 247-258.

Majeska 1981: G. P. Majeska, The Sanctification of the First Region: Urban Reorientation in Palaeologan Constantinople, *Actes du XVe CIEB*, 359-365.

Majeska 1984: G.P. Majeska, *Russian Travelers to Constantinople in the Fourteenth and Fifteenth Centuries*, DOS 19, Washington D.C. 1984.

Makarios 1997: Archbishop Makarios, Κύπρος η Αγία Νήσος, 2 vols, Nicosia 1997.

Makk 1975: F. Makk, Traduction et commentaire de l'homélie écrite probablement par Théodore le Syncelle sur le siège de Constantinople en 626, *Acta Universitatis de Attila Jozsef nominata, Acta antiqua et archeologica 19, Opuscula byz.* 3 (Szeged 1975), 9-47, 74-96.

Mango 1958: C. Mango, *The Homilies of Photios, Patriarch of Constantinople,* English Translation, Introduction and Commentary, DOS 3, Cambridge MA 1958.

Mango 1962: C. Mango, *Materials for the Study of the Mosaics of St. Sophia at Istanbul,* Washington D.C. 1962.

Mango 1967: C. Mango, *Die Mosaiken, Die Hagia Sophia,* H. Kahler ed., Berlin 1967.

Mango 1972: C. Mango, *The Art of the Byzantine Empire 312-1453: Sources and Documents,* Englewood Cliffs, New Jersey 1972, 1986².

Mango 1978: C. Mango, The Date of the Studios Basilica at Istanbul, *BMGS* 4 (1978), 115-122.

Mango 1984: C. Mango, St. Michael and Attis, *ΔΧΑΕ* 12 (1984), 39-62.

Mango 1988: C. Mango, La croix dite de Michel le Cérulaire et la croix de Saint-Michel de Sykéon, *CahA* 36 (1988), 41-49.

Mango 1991: C. Mango, The Palace of Marina, the Poet Palladas and the Bath of Leo VI, *Ευφρόσυνον,* 1, 321-330.

Mango 1993-1994 : C. Mango, The Chalkoprateia Annunciation and the Pre-Eternal Logos, *ΔΧΑΕ* 17 (1993-1994), 165-170.

Mango 1994a: C. Mango, Notes d'épigraphie et d'archéologie Constantinople, Nicée, *TM* 12 (1994), 343-357.

Mango 1994b: C. Mango, On the Cult of Saints Cosmas and Damian at Constantinople, *Θυμίαμα,* 189-192.

Mango 1995: C. Mango, The Conversion of the Parthenon into a Church: The Tübingen Theosophy, *ΔΧΑΕ* 18 (1995), 201-203.

Mango 1998: C. Mango, The Origins of the Blachernae Shrine at Constantinople, *Acta XIII Congressus Internationalis Archaeologiae Christianae,* II, Vatican City and Split 1998, 61-76.

Mango and Ertuğ 1997: C. Mango and A. Ertuğ, *Hagia Sophia, a Vision of Empires,* Istanbul 1997.

Mango and Hawkins 1965: C. Mango and E.J.W. Hawkins, The Apse Mosaics of St Sophia at Istanbul. Report on Work Carried out in 1964, *DOP* 19 (1965), 115-151

Mango and Hawkins 1966: C. Mango and E. Hawkins, The Hermitage of St Neophytos and its Wall Paintings, *DOP* 20 (1966), 119-206.

Mango and Scott 1997: *The Chronicle of Theophanes the Confessor. Byzantine and Near Eastern History AD 284-813,* C. Mango and R. Scott eds, Oxford 1997.

Mango and Ševčenko 1973: C. Mango and I. Ševčenko, Some Churches and Monasteries on the South Shore of the Sea of Marmara, *DOP* 27 (1973), 235-277.

Margaritof 1959: T. Margaritof, Έκθεση καθαρισμού της αμφιπρόσωπης εικόνας του Βυζαντινού Μουσείου, *ΔΧΑΕ* 4/1 (1959), 144-148.

Margounios 1620: Maximos Margounios, Συναξάρια ἤτοι βίοι Ἁγίων ἐκ τῆς ἑλληνικῆς γλώττης μεταφρασθέντες εἰς τὴν καθομιλουμένην, Venice 1620.

Marinakis 1994: Th. Marinakis, Παναγίες Θαυματουργές, Thessaloniki 1994.

Martin 1954: J.R. Martin, *The Illustration of the Heavenly Ladder of John Climacus,* Princeton 1954.

Martiniani-Reber 1991: Marielle Martiniani-Reber, *Tissus coptes,* Musée d'art et d'histoire, Geneva 1991.

Maspero 1943: J. Maspero, *Fouilles exécutées à Baouit,* MIFAO 59, Cairo 1943.

Masterpieces of Byzantine Art: *Masterpieces of Byzantine Art,* exh. cat., Royal Scottish Museum, Edinburgh, and Victoria and Albert Museum, London 1958.

Mathews 1976: T. F. Mathews, *The Byzantine Churches of Istanbul, A Photographic Survey,* University Park PA. 1976.

Mathews 1993: T.F. Mathews, *The Clash of Gods. An Interpretation of Early Christian Art,* Princeton 1993.

Mathews 1995: T.F. Mathews, *Art and Architecture in Byzantium and Armenia,* collected studies Variorum, Aldershot 1995.

Mathews 1998: T.F. Mathews, *The Art of Byzantium,* London 1998.

Mavropoulou-Tsioumi 1974: Chryssanthi Mavropoulou-Tsioumi, Εικονογραφικά στοιχεία από τον κώδικα αριθ. 762 της μονής Βατοπεδίου, *Κληρονομία* 6 (1974), 357-379.

McCormick 1986: M. McCormick, *Eternal Victory. Triumphal Rulership in Late Antiquity, Byzantium, and the Early Medieval West,* Cambridge, Paris 1986.

McCown 1922: *The Testament of Solomon,* C. McCown ed., Leipzig 1922.

McVey 1989: Kathleen McVey, trans., *Ephrem the Syrian. Hymns, Classics of Western Spirituality,* New York 1989.

Medieval Pictorial Embroidery: *Medieval Pictorial Embroidery. Byzantium, Balkans, Russia,* exh. cat., Moscow 1991.

Megaw and Hawkins 1962: A.H.S. Megaw and E. Hawkins, The Church of the Holy Apostles at Perachorio Cyprus and its Frescoes, *DOP* 16 (1962), 277-348.

Megaw and Hawkins 1977: A.H.S. Megaw and E.J.W. Hawkins, *The Church of the Panagia Kanakaria at Lythrankomi in Cyprus,* Washington D.C. 1977.

Megaw and Stylianou 1963: A.H.S. Megaw and A. Stylianou, *Cyprus, Byzantine Mosaics and Frescoes,* New York 1963.

Melville Jones 1987: *Eustathios of Thessalonike. The Capture of Thessalonike,* trans. J.R. Melville Jones, Byzantina Australiensia 8, Canberra 1987.

Mercati 1959: S. Mercati, Sulla croce bizantina degli Zaccaria nel tesoro del duomo di Genova, *Bollettino della Badia Greca di Grottaferrata,* 13 (1959), 29-43.

Meyendorff 1975: J. Meyendorff, *Spiritual Trends in Byzantium in the Late Thirteenth and Early Fourteenth Centuries,* in Underwood 1975, 4, 93-106.

Meyendorff 1984: *St Germanus of Constantinople on the Divine Liturgy,* J. Meyendorff ed., Crestwood, New York 1984.

Meyer 1896: Ph. Meyer, Des Joseph Bryennios Schrifften Leben und Bildung, *BZ* 5 (1896), 74-111.

Meyer 1999: M. Meyer, *Ancient Christian Magic: Coptic Texts of Ritual Power,* Princeton 1999.

Miiatev 1932: K. Miiatev, Relief en bronze de la Vierge du Musée de Plovdiv, *Seminarium Kondakovianum* 5 (1932), 39-45 (in Russian, with French summary).

Miklosich and Müller 1860-1890: F. Miklosich and I. Müller, *Acta et Diplomata Monasteriorum et ecclesiarum orientis,* 6 vols, Vienna 1860-1890.

Milanou 1994: Kalypso Milanou, The Icon Virgin and Child and Scenes from Christ's Life with Apostles, *Ikonen,* 61-68.

Miljković-Pepek 1975-1978: P. Miljković-Pepek, Une église du village Velmei de la région d'Ohrid, *Zbornik, Arheološki Muzej na Makedonija* 8-9 (1975-1978), 105-130.

Miller 1855-1857: *Manueliis Philae Carmina,* 2 vols, E. Miller ed., Paris 1855-1857.

Miller 1968: D.V. Miller, Legends of the Icon of Our Lady of Vladimir: A Study of the Development of Moskovite National Consciousness, *Speculum* 43 (1968), 657-663.

Millet 1910: G. Millet, *Monuments byzantins de Mistra,* Album, Paris 1910.

Millet 1916: G. Millet, *Recherches sur l'iconographie de l'Evangile aux XIVe, Xve et XVIe siècles d'après les monuments de Mistra, de la Macédoine et du Mont Athos,* Paris 1916 1960².

Millet and Frolow 1962: G. Millet and A. Frolow, *La Peinture du Moyen Age en Yugoslavie,* Paris 1962.

Milliken 1922: W. Milliken, A Byzantine Ivory in the Morgan Collection, *Art in America* 19 (1922), 197-202.

Milliken 1926: W.M. Milliken, The Stroganoff Ivory, *The Bulletin of The Cleveland Museum of Art* 13 (1926), 25-29.

Milošević 1958: D. Milošević, Jedna ohridska ikona u Narodnom muzeju, *ZNM* I (1958), 187-205.

Milošević 1969: D. Milošević, *Sredwovekovna umetnost u Srbiji,* Belgrade 1969.

Milošević 1980: D. Milošević, *Umetnost u sredwovekovnoj Srbiji od 12. do 17. veka,* Belgrade 1980.

Miracles, prodiges et merveilles au moyen-âge: *Miracles, prodiges et merveilles au moyen-âge,* Congrès des historiens médiévistes de l'enseignement supérieur publique (Orleans 1994), Paris 1995.

Mirror of the Medieval World: *Mirror of the Medieval*

World, W. Wixom ed., New York 1999.

Mitchell 1993: J. Mitchell, The Crypt Reappraised, *San Vincenzo al Volturno 1: the 1980-86 Excavations*. R. Hodges ed., Rome-London 1993 (Arch. Monographs of the British School at Rome 7), 75-114.

Molinier 1896: Emile Molinier, *Catalogue des ivoires*, Musée du Louvre: *Département des Objects d'art du Moyen Age, de la Renaissance et des Temps Modernes*, Paris 1896.

Monastery of Vatopaidi: *The Holy and Great Monastery of Vatopaidi, Tradition-History-Art*, Mount Athos 1998

Moran 1986: K. Moran, *Singers in Late Byzantine and Slavonic Painting*, Leiden 1986.

Morath 1940: G.W. Morath, *Die Maximianskathedra in Ravenna*, Freiburger theologische Studien 54, Freiburg im Breisgau 1940.

Morisani 1962: O. Morisani, *Gli affreschi di S. Angelo in Formis*, Cava dei Tirreni 1962.

Morrison 1970: Cécile Morrison, *Catalogue des monnaies byzantines de la Bibliothèque Nationale*, 2 vols, Paris 1970.

Morrisson and Zacos 1978: C. Morrisson and G. Zacos, L'image de l'empereur byzantin sur les sceaux et les monnaies, *La monnaie, mirroir des rois*, Paris 1978, 57-72.

Moskva I grečeskaja kul'tura: *Moskva I grečeskaja kul'tura*, exh. cat., Church of the Annunciation, Kremlin, Moscow 1997.

Mouriki-Charalambous 1970: Doula Mouriki-Charalambous, Αι βιβλικαί προεικονίσεις της Παναγίας εις τον τρούλλον της Περιβλέπτου του Μυστρά, *ΑΔ* 25 (1970), Α', Μελέται, 217-251.

Mouriki 1970: Doula Mouriki, Περί βυζαντινού κύκλου του βίου της Παναγίας εις φορητήν εικόνα της μονής του Όρους Σινά, *AE* 1970, 125-153.

Mouriki 1984: Doula Mouriki, The Wall Paintings of the Church of Panagia at Moutoullas, Cyprus, *Byzanz und der Westen. Studien zur Kunst des Europäischen Mittelalters*, Vienna 1984, 171-213.

Mouriki 1985: Doula Mouriki, *The Mosaics of Nea Moni on Chios*, Athens 1985.

Mouriki 1985-1986: Doula Mouriki, Thirteenth-Century Icon Painting in Cyprus, *The Griffon*, 1-2 (1985-1986), 9-112.

Mouriki 1987: Doula Mouriki, A Thirteenth-Century Icon with a Variant of the Hodegetria in the Byzantine Museum of Athens, *DOP* 41 (1987), 403-414.

Mouriki 1988: Doula Mouriki, Four Thirteenth-Century Sinai Icons by the Painter Peter, *Studenica et l'art byzantin autour de l'année 1200*, Belgrade 1988, 329-347.

Mouriki 1990a: Doula Mouriki, La présence géorgienne au Sinaï d'après le témoignage des icônes de Sainte Catherine, *Βυζάντιο και Γεωργία*, 39-40.

Mouriki 1990b: Doula Mouriki, Icons from 12th to 15th Century, *Sinai*, 101-125.

Mouriki 1991: Doula Mouriki, Variants of the Hodegetria on two Thirteenth-Century Sinai

Icons, *CahA* 39 (1991), 153-182.

Mouriki 1994: Doula Mouriki, Portraits of St. Theodosia in Five Icons, *Θυμίαμα*, 213-219.

Müller-Wiener 1977: W. Müller-Wiener, *Bildlexikon zur Topographie Istanbul*, Tübingen 1977.

Mundell Mango 1987: Marlia Mundell Mango, in *East Christian Art*.

Mundell Mango 1992: Marlia Mundell Mango, The Monetary Value of Silver Revetments and Objects Belonging to Churches, A.D. 300-700, *Ecclesiastical Silver Plate*, 126-132.

Mundell Mango 1994: Marlia Mundell-Mango, The Significance of Byzantine Tinned Copper Objects, *Θυμίαμα*, 221-228.

Mundell Mango 1997: Marlia Mundell Mango, Continuity of 4th/5th-century Silver Plate in the 6th/7th Centuries in the Eastern Empire, *AntTard* 5 (1997), 83-92.

Mundell Mango and Northover 1990: Marlia Mundell Mango and P. Northover in Sotheby's London, *Sale Catalogue Icons, Russian Pictures and Works of Art*, 3 November 1990.

Munitiz 1997: J.A. Munitiz, Wonder-Working Icons and the Letter to Theophilus, *ByzF* 24 (1997), 115-123.

Munitiz et al. 1997: J.A. Munitiz, Julian Chrysostomides, Eirene Harvalia-Crook and Ch. Dendrinos eds, *The Letter of the Three Patriarchs to the Emperor Theophilos and Related Texts*, Camberley, Surrey 1997.

Murad 1970: K. Murad, *Catalogue of All Manuscripts in the Monastery of St Catherine on Mount Sinai*, Wiesbaden 1970.

Muraro 1970: M. Muraro, *Paolo da Venezia*, University Park-London 1970.

Murray 1977: Sister Charles Murray, Art and the Early Church, *JThSt* 28 (1977), 303-345.

Nau 1910: *Nestorius, Livre d'Heraclide de Damas*, trans. F. Nau, Paris 1910.

Nelson 1980: R. Nelson, *The Iconography of Preface and Miniature in the Byzantine Gospel Book*, New York 1980.

Nelson 1999: R.S. Nelson, Taxation with Representation. Visual Narrative and the Political Field of the Kariye Çamii, *ArtH* 22 (1999), 56-82.

Nesbitt 1988: J. Nesbitt, *Byzantium. The Light in the Age of Darkness*, New York 1988.

Nesbitt and Wiita 1975: J. Nesbitt and J. Wiita, A Confraternity of the Comnenian Era, *BZ* 68 (1975), 360-384.

Neumann 1962: C.W. Neumann, *The Virgin Mary in the Works of Saint Ambrose*, Paradosis 17, Fribourg-en-Suisse 1962.

Nicol 1985: D.M. Nicol, Thomas Despot of Epiros and the Foundation Date of the Paregoritissa at Arta, *Βυζαντινά* 13/2 (1985), *Δώρημα στον Ιωάννη Καραγιαννόπουλο*, 751-758.

Nicolaïdès 1996: A. Nicolaïdès, L'église de la Panagia Anakiotissa à Lagoudera, Chypre: Etudes iconographiques des fresques de 1192, *DOP* 50 (1996), 1-137.

Niebuhr 1897: *Ioannes Zonarae Epitomae*, B.G.

Niebuhr ed., III, CSHB 46, Bonn 1897.

Nikolaeva 1977: Tatiana Vasilevna Nikolaeva, *Drevnerusskaja Zivopis Zagorskogo muzeja*, Moscow 1977.

Nikolajević 1980: I. Nikolajević, Images votives de Salone et de Dyrrachium, *ZRVI* 19 (1980), 59-70.

Nilgen 1981: Ursula Nilgen, Maria Regina-Ein politischer Kultbildtypus?, *RömJahrKunst* 19 (1981), 3-33.

Noll 1958: R. Noll, *Vom Altertum zum Mittelalter: Spätantike altchristliche, völkerwanderungszeitliche und frühmittelalterliche Denkmaler der Antikensammlungen*, Vienna 1958.

Nomidis 1996: N. Nomidis, *Οἱ ἐγκαταστάσεις τῶν Λατίνων ἐν Βυζαντίῳ*, Athens 1996.

Nordhagen 1961: Per J. Nordhagen, The Origin of the Washing of the Child in the Nativity Scene, *BZ* 54 (1961), 333-337.

Nordhagen 1965: Per J. Nordhagen, The Mosaics of John VII (705-707 A.D.), *ActaNorv* 2 (1965), 121-166.

Nordhagen 1968: Per J. Nordhagen, *The Frescoes of John VII (705-707) in S. Maria Antiqua in Rome*, *ActaNorv* 3, Rome 1968.

Nordhagen 1987: Per J. Nordhagen, Icons Designed for the Display of Sumptnous Votive Gifts, *DOP* 41 (1987), 453-460.

Nunn 1986: Valerie Nunn, The Encheirion as Adjunct to the Icon in the Middle Byzantine Period, *BMGS* 10 (1986), 73-102.

ODB: *The Oxford Dictionnary of Byzantium*, A. P. Kazhdan ed., 3 vols, New York-Oxford 1991.

Oddy and La Niece 1986: A. Oddy and Susan La Niece, Byzantine Gold Coins and Jewellery, *Gold Bulletin* 19 (1986), 19–27.

Oikonomides 1976: N. Oikonomides, Leo VI and the Narthex Mosaic of Saint Sophia, *DOP* 30 (1976) 151-172.

Oikonomides 1985: N. Oikonomides, Some Remarks on the Apse Mosaics of St Sophia, *DOP* 39 (1985), 111-115

Oikonomides 1986: N. Oikonomides, *A Collection of Dated Byzantine Lead Seals*, Washington D.C. 1986.

Oikonomides 1991: N. Oikonomides, The Holy Icon as an Asset, *DOP* 45 (1991), 35-44.

Oikonomidès 1995: N. Oikonomidès, L'épigraphie des bulles de plomb, in G. Cavallo and C. Mango eds, *Epigrafia medievale greca e latina. Ideologia e funzione*, Spoleto 1995, 153-168.

Oikonomos 1864: Κωνσταντίνος Οἰκονόμος ὁ ἐξ Οἰκονόμων, Κτιτορικὸν ἢ Προσκυνητάριον τῆς Ἱερᾶς καὶ βασιλικῆς μονῆς τοῦ Μεγάλου Σπηλαίου, Athens 1864.

Οι Πύλες του Μυστηρίου: *Οι Πύλες του Μυστηρίου, Θησαυροί της Ορθοδοξίας από την Ελλάδα*, National Gallery and Alexandros Soutsos Museum, exh. cat., M. Borboudakis ed., Athens 1994.

Okeanos: Okeanos. Essays Presented to Ihor Ševčenko on His Sixtieth Birthday, C. Mango and O. Pritsak eds (*HUSt* 7), Cambridge, MA 1983.

Omont 1927: H. Omont, *Miniatures des Homélies*

sur la Vierge du moine Jacques, Paris 1927.

Omont n.d.: H. Omont, Evangiles avec peintures byzantines du XIe siècle, Paris n.d.

Opitz 1934-1935: Athanasius Werke, H. G. Opitz ed., Berlin, Leipzig, 1934-1935.

Orlandos 1963: A. Orlandos, Ἡ Παρηγορήτισσα τῆς Ἄρτης, Athens 1963.

Orlandos 1973: A. Orlandos, Σταχυολογήματα ἐκ μονῶν τῆς Πίνδου, ABME 4 (1938), 167-197.

Ornamenta Ecclesiae: Ornamenta Ecclesiae, exh. cat., Schnütgen Museum, Cologne 1985.

Orsi 1942: P. Orsi, Sicilia Bizantina, Rome 1942.

Osborne 1985: J. Osborne, The Roman Catacombs in the Middle Ages, PBSR 53 (1985), 278-328.

Ostashenko 1997: Elena Ostashenko, Ikona 'Bogomateri Perivlepta'-novii pamiatnik rannepaleologovskoj zivopisi iz sobranija Muzeja-zapovednika Moskovskii Kreml, Vizantija. Rus. Zapadnaja Europa. Tezisi dokladov konferentsiji, posviaschionnoi, 100-letiju so dnia rozdenija professora V.N. Lazareva (1897-1976), Moscow 29 September- 2 October 1997, St Petersburg 1997, 24.

Ostrogorsky 1970: G. Ostrogorsky, O Verovanjima I Shvatanjima Vizantinaca, Belgrade 1970.

Ousterhout 1991: R. Ousterhout, Constantinople, Bithynia and Regional Developments in Later Paleologan Architecture, The Twilight of Byzantium: Aspects of Cultural and Religious History in the Late Byzantine Empire, S. Ćurčić and Doula Mouriki eds, Princeton 1991, 75-110.

Ousterhout 1995: R. Ousterhout, The Virgin of the Chora. An Image and its Contexts, Illinois Byzantine Studies 4, Chicago and Urbana 1995.

Ousterhout 1998: R. Ousterhout, Reconstructing ninth-century Constantinople, Byzantium in the Ninth Century. Dead or Alive, Leslie Brubacker ed., Aldershot 1998, 115-130.

Pace 1985: V. Pace, Presenze e influenze cipriote nella pittura duecentesca italiana, XXXIII CorsiRav Seminario Int. di Studi su 'Cipro e il Mediterraneo orientale', Ravenna 1985, 259-298.

Pace 1987: V. Pace, La chiesa abbaziale di Grottaferrata e la sua decorazione nel medioevo, Boll. Della Badia greca di Grottaferrata, XLI (1987), 47-87 (rpr., with updated bibl: V. Pace, Arte a Roma nel Medioevo, Naples 2000, n. XIX, esp. 448-453).

Pace 1993: V. Pace, Fra la maniera greca e la lingua franca. Su alcuni aspetti delle relazioni fra la pittura umbro-toscana, la miniatura della Cilicia e le icone di Cipro e della Terrasanta, Il classicismo: Medioevo Rinascimento Barocco. Atti del colloquio Cesare Gnudi, Bologna 1993, 71–89.

Pace 1994: V. Pace, La pittura medievale nel Molise in Basilicata e Calabria, La pittura in Italia, 270-288.

Pace 1996: V. Pace, Circolazione e ricezione delle icone bizantine: i casi di Andria, Matera e Damasco, Studi in onore di Michele D'Elia, Matera-Spoleto 1996, 157-165;

Pace 1998: V. Pace, Il Mediterraneo e la Puglia: circolazione di modelli e di maestranze, Andar per mare. Puglie e Mediterraneo tra mito e storia,

exh. cat., Bari 1997, R. Cassano, R. Lorusso Romito and M. Milella eds, Bari 1998, 287-300.

Pace forthcoming: V. Pace, Da Bisanzio alla Sicilia: la Madonna col Bambino del Sacramentario di Madrid (ms. 52 della Biblioteca Nazionale di Madrid), Mélanges Vojislav Koraè. Zograf, 27, forthcoming.

Pagels 1988: Elaine Pagels, Adam, Eve and the Serpent, London 1988.

Paliouras 1997: A. Paliouras, Το μοναστήρι της Παναγίας στον Προυσσό, Athens 1997.

Pallas 1965: D. Pallas, Die Passion und die Bestattung Christi in Byzanz. Der Ritus - das Bild, (Miscellanea Byzantina Monacensia 2), Munich 1965.

Pallas 1971a: D. Pallas, Η Θεοτόκος Ζωοδόχος Πηγή, ΑΔ 26 (1971), 201-223.

Pallas 1971b: D. Pallas, Η ζωγραφική στην Κωνσταντινούπολη μετά την Άλωση, ΑΔ 26 (1971), Μελέται, 239-263.

Pallas 1986: D. I. Pallas, L'ordonnance originale des objets cultuels du monastère de Hagios Neophytos, Πρακτικά του Δευτέρου Διεθνούς Κυπριολογικού Συνεδρίου (Nicosia 20-25 April 1982), 2, Μεσαιωνικόν Τμῆμα, Nicosia 1986, 529-537.

Panayotidi 1992: Maria Panayotidi, Η εικόνα της Παναγίας Γλυκοφιλούσας στο Μοναστήρι του Πετριτζού, Ευφρόσυνον, 2, 459-468.

Pandurski 1963: V. Pandurski, Ikonata prez vtorata bulgarska, Godishnik na Duhovnata akademia, III, Sofia 1963.

Papachryssanthou 1974: Denise Papachryssanthou, La Vie ancienne de Saint Pierre l'Athonite. Date, composition et valeur historique, AB 92 (1974), 19-61.

Papachryssanthou 1992: Denise Papachryssanthou, Ο Αθωνικός Μοναχισμός. Αρχές και Οργάνωση, Athens 1992.

Papadaki-Oekland 1973-1974: Stella Papadaki-Oekland, Οι Τοιχογραφίες της Αγίας Άννας στο Αμάρι, Παρατηρήσεις σε μια παράλλαγή της Δεήσεως, ΔΧΑΕ 7 (1973-1974), 31-54.

Papadopoulos 1928: J. Papadopoulos, Les palais et les églises des Blachernes, Thessaloniki 1928.

Papadopoulos-Kerameus 1909: A. Papadopoulos-Kerameus, Varia Graeca Sacra, St Petersburg 1909.

Papadopoulos-Kerameus 1963: A. Papadopoulos-Kerameus, Ἱεροσολυμιτικὴ Βιβλιοθήκη, 5 vols, St Petersburg 1891-1915, rpr. Brussels 1963.

Papageorgiou 1968: A. Papageorgiou, Εἰκών τοῦ Χριστοῦ ἐν τῷ ναῷ τῆς Παναγίας τοῦ Ἄρακος, ΚυπρΣπ 32 (1968) 45-55.

Papageorgiou 1969: A. Papageorgiou, Icônes de Chypre, Geneva 1969.

Papageorgiou 1970: A. Papageorgiou, Icons of Cyprus, New York 1970.

Papageorgiou 1976a: A. Papageorgiou, Byzantines Icons of Cyprus, Benaki Museum 1976.

Papageorgiou 1976b: A. Papageorgiou, Δυο βυζαντινές εικόνες του 12ου αιώνα, RDAC (1976), 267-274.

Papageorgiou 1988: A. Papageorgiou, Δυο

υστεροκομνήψειες εικόνες, RDAC (1988/2), 239-244.

Papageorgiou 1991: A. Papageorgiou, Εικόνες της Κύπρου, Nicosia 1991.

Papageorgiou 1992: A. Papageorgiou, Η αμφιπρόσωπη εικόνα της εκκλησίας της Παναγίας Θεοσκέπαστης στην Πάφο, Ευφρόσυνον, 2, 484-489.

Papageorgiou 1993: A. Papageorgiou, Εικόνες της Κύπρου, Nicosia 1992 (in English 1992, in German 1995, in French 1997).

Papageorgiou 1996: A. Papageorgiou, Ιερά Μητρόπολις Πάφου, Ιστορία και Τέχνη, Nicosia 1996.

Papageorgiou 1997: A. Papageorgiou, Η βυζαντινή τέχνη της Κύπρου 12ος-15ος αιώνας, Byzantine Medieval Cyprus, 95-127.

Papageorgiou 1999a: A. Papageorgiou, Ο Άγιος Τριφύλλιος, Nicosia 1999.

Papageorgiou 1999b: A. Papageorgiou, Η εικόνα της Παναγίας 'Ελεούσας' της εκκλησίας της Παναγίας Χρυσαλινιώτισσας, RDAC (1999), 327-336.

Papamastorakis 1989-1990: T. Papamastorakis, Ένα εικαστικό εγκώμιο του Μιχαήλ Η' Παλαιολόγου: οι εξωτερικές τοιχογραφίες στο καθολικό της μονής της Μαυριώτισσας στην Καστοριά, ΔΧΑΕ 15 (1989-1990), 221-240.

Papamastorakis 1998: T. Papamastorakis, Icons 13th-16th century, Icons of the Holy Monastery of Pantokrator, Mount Athos 1998, 41-145.

Papastavrou 1993: Hélène Papastavrou, Le voile, symbole de l'Incarnation, CahA (1993), 141-168.

Papatheophanous-Tsouri 1979: Evangelia Papatheophanous-Tsouri, Εικόνα Παναγίας Γαλακτοτροφούσας από τη Ρόδο, ΑΔ 34 (1979), Α', Μελέτες, 1-14.

Papazotos 1980: Th. Papazotos, Εικόνα Παναγίας Οδηγήτριας από το ναό 'του Χριστού' Βέροιας, Μακεδονικά 20 (1980), 167-174.

Papazotos 1995: Th. Papazotos, Byzantine Icons of Verroia, Athens 1995.

Parry 1996: K. Parry, Depicting the Word. Byzantine Iconophile Thought of the Eighth and Ninth Centuries, Leiden, New York and Cologne 1996.

Paskaleva 1981: Kostadinka Paskaleva, Ikony Bolgarii, Sofia 1981.

Paskaleva 1987: Kostadinka Paskaleva, Bulgarian Icons Through the Centuries, Sofia 1987.

Patlagean 1988: Evelyne Patlagean, Les Stoudites, l'empereur et Rome, Bisanzio, Roma e l'Italia nell'alto medioevo, 1, Spoleto 1988, 429-460.

Pätzold 1989: A. Pätzold, Akathistos-Hymnos. Die Bilderzyklen in der byzantinischen Wandmalerei des 14. Jahrhundert, Stuttgart 1989.

Pazaras 1999: Th. Pazaras, Sculpture in Macedonia in the Middle Byzantine Period, Byzantine Macedonia.

Peirce and Tyler 1927: H. Peirce and R. Tyler, Deux Mouvements dans l'Art Byzantin du Xe Siècle, Aréthuse 4 (1927), 129-135.

Peirce and Tyler 1932-1934: H. Peirce and R. Tyler,

L'art byzantin, 2 vols, Paris 1932-1934.

Peirce and Tyler 1941: H. Peirce and R. Tyler, *Three Byzantine Works of Art*, Cambridge, MA 1941.

Pelekanides and Chatzidakis 1984, S. Pelekanides and M. Chatzidakis, *Καστοριά*, Athens 1984.

Pelekanides et al. 1973: St. Pelekanides, P.C. Christou, Chryssanthi Tsioumis and S.N. Kadas, *The Treasures of Mount Athos. The Illuminated Manuscripts*, 1, Athens 1973.

Pelekanides et al. 1975: St. Pelekanides, P.C. Christou, Chryssanthi Tsioumis and S.N. Kadas, *The Treasures of Mount Athos. The Illuminated Manuscripts*, 2, Athens 1975.

Pelekanides et al. 1979: St. Pelekanides, P.C. Christou, Chryssanthi Tsioumis and S.N. Kadas, *The Treasures of Mount Athos. The Illuminated Manuscripts*, 3, Athens 1979.

Pelekanidi 1983: Eleni Pelekanidi, Η εικόνα της Οδηγήτριας της Αρχαιολογικής Συλλογής Καστοριάς, *Αφιέρωμα στη μνήμη Στυλιανού Πελεκανίδη*, Thessaloniki 1983, 389-396.

Pelikan 1996: J. Pelikan, *Mary Through the Centuries. Her Place in History and Culture*, New Haven and London 1996.

Pertusi 1948-1949: A. Pertusi, Una akolouthia militare inedita del X secolo, *Aevum* 22-23 (1948-1949), 145-168.

Pertusi 1959: *Bellun Avaricum*, 1-9, A. Pertusi ed., Studia patristica et byzantina 7, Ettal 1959.

Peschlow 1982: U. Peschlow, Die Johanneskirche des Studios in Istanbul. Bericht uber die jungsten Untersuchungsergebnisse, *JÖB* 43/4, (1982), 429-433.

Petit 1902: R.P.L. Petit, *Vie de Saint Michel Maléinos*, ROC 7 (1902).

Petković 1997: S. Petković, *Εικόνες Ιεράς Μονής Χιλανδαρίου*, Mount Athos 1997.

Petricioli 1975: I. Petricioli, Novootkrivena ikona Bogorodice u Zadru, *Zograf* 6 (1975), 11-13.

Petrov 1912: N. Petrov, *Album of Objects in the Ecclesiastical Museum at Kiev. Part I. Icons from Sinai and Athos in the Uspenskij Collection* (in Russian), Kiev 1912.

Pierides 1971: A. Pierides, *Jewellery in the Cyprus Museum*, Nicosia 1971.

Piltz 1998: Elisabeth Piltz, Byzantine Illuminations in the Kongelige Bibliothek in Copenhagen, *Byzantium and Islam in Scandinavia*, 123-135.

Pimenova 1990: M.M. Pimenova, Vizantijsakaja ikona 'Bogoroditsa Perivlepta', kontsa XIV, *Drevnerusskoje I narodnoje iskusstvo Soobsenija Zagorskogo muzeja-zapovednika*, Moskow 1990, 17-27.

Pitarakis 1996: Brigitte Pitarakis, *Les croix-reliquaires pectorales en bronze : recherches sur la production des objets métalliques à Byzance*, Unpublished doctoral thesis, Université de Paris I-Panthéon-Sorbonne, Paris 1996.

Pitarakis 1998a: Brigitte Pitarakis, Mines anatoliennes exploitées par les Byzantins: recherches récentes, *RN* 153 (1998), 141-185.

Pitarakis 1998b: Brigitte Pitarakis, Un groupe de croix-reliquaires pectorales en bronze à décor en relief attribuable à Constantinople avec le Crucifié et la Vierge Kyriotissa, *CahA* 46 (1998), 81-102.

Pitsakis 1991: K.G. Pitsakis, Η έκταση της εξουσίας ενός υπερορίου πατριάρχη: Ο πατριάρχης Αντιοχείας στην Κωνσταντινούπολη τον 12ο αιώνα, *Byzantium in the 12th Century*, 119-133.

Plümacher 1972: E. Plümacher, *Lukas als hellenistischer Schriftsteller. Studien zur Apostelgeschichte*, Göttingen 1972.

Polzer 1999a: J. Polzer, Some Byzantine and Byzantinizing Madonnas paintend *(sic)* during the later Middle Ages – Part 1, *ArteChr* 87/791 (1999), 83-90.

Polzer 1999b: J. Polzer, Some Byzantine and Byzantinizing Madonnas paintend *(sic)* during the later Middle Ages – Part 2, *ArteChr* 87/792 (1999), 167-182.

Popova 1991: Olga S. Popova, Vizantijskie ikoni XIV- pervoi polïvini XV v., *Vizantija. Balkani. Rus'*, 37-38.

Popović and Ivanisević 1988 : M. Popović and V. Ivanisević, Branikevo cité médiévale, *Starinar* 39 (1988), 125-179.

Prashkov 1985: L. Prashkov, *Bulgarski ikoni. Razvitie, technologia, restavrazia*, Sofia 1985.

Preger 1907: *Scriptores Originum Constantinopolitarum*, T. Preger ed., Leipzig 1901-1907, rpr. New York 1975.

Preisendanz 1974: K. Preisendanz, *Papyri graecae magicae. Die griechischen Zauberpapyri*, 2, Stuttgart 1974.

Prelog 1994 :M. Prelog, *The Basilica of St. Euphrasius in Poreč*, Zagreb-Poreč 1994.

Proorov 1972: G.M. Proorov, A Codicological Analysis of the Illuminated *Akathistos* to the Virgin (Moscow, State Historical Museum, *Synodal gr. 429*), *DOP* 26 (1972), 237-352.

Pučko 1975: V. Pučko, Ikono bogomateri Agiosoritissy, *ZborMusBeograd* (1975), 354-362.

Puschmann 1878: *Alexander of Tralles*, T. Puschmann ed., Vienna 1878-1879.

Pyrros 1866: Dionysios Pyrros Archimandrite, *Περιγραφὴ τῆς ἐν τῆ νήσῳ Τήνῳ εὑρεθείσης ἁγίας καὶ θαυματουργοῦ εἰκόνος τῆς Κυρίας ἡμῶν καὶ τῶν θαυμάτων αὐτῆς*, Syra 1866.

Questions of Authenticity: *Questions of Authenticity among the Arts of Byzantium*, exh. cat., Susan Boyd and G. Vikan eds, Washington D.C. 1981.

Radojčić 1962: S. Radojčić, *Icônes de Serbie et de Macédoine*, Belgrade 1962.

Radojčić 1966: S. Radojčić, Zur Geschichte des silbergetriebenen Reliefs in der byzantinischen Kunst, *Tortulae - Studien zu altchristlichen und byzantinischen Monumenten*, Römische Quartalschift 30, Supplementheft, Rome-Freiburg-Vienna (1966), 229-242.

Radojčić 1969: S. Radojčić, *Geschichte der serbischen Kunst. Von den Anfangen bis zum Ende des Mittelalters*, Grundriss der slavischen Philologie und Kulturgeschichte, Berlin 1969.

Radojčić 1975: S. Radojčić, Za istoriju srebrnog reqefa u vizantijskoj umetnosti, *Uzori i dela starih srpskih umetnika*, Belgrade 1975.

Randall 1985: R.H. Randall, *Masterpieces of Ivory from the Walters Art Gallery*, New York and Baltimore 1985.

Rapp 1995: Claudia Rapp, Byzantine Hagiographers as Antiquarians, Seventh to Tenth Centuries, *ByzF* 21 (1995), 31-44.

Régi bolgar muveset: *Régi bolgar muveset*, Budapest 1970.

Renaud 1926: *Michel Psellos. Chronographie ou histoire d'un siècle de Byzance (976-1077)*, E. Renaud ed. and trans., 2 vols, Paris 1926.

Restle 1998: Marcell Restle, Die byzantinische Münzprägurng, *Rom und Byzance* 1, 37-45.

Rhalles and Potles 1966[2]: G.A. Rhalles and M. Potles, *Σύνταγμα των θείων κανόνων*, 6 vols, Athens 1966[2].

Richmond and Gillam 1951: I.A. Richmond and J.P. Gillam, The Temple of Mithras at Carrowburgh, *Archaeologia Aeliana* 29.4 (1951), 1-92.

Richter-Siebels 1990: I. Richter-Siebels, *Die palästinensichen Weihrauchgefässe mit Reliefszenen aus dem Leben Christi*, Inaugural-Dissertation zur Erlangung des Grades eines Dors der Philosophie des Fachbereichs Geschichtswissenschaften der Freien Universität Berlin, Berlin 1990.

Riehl 1905: B. Riehl, D*ie Kunstdenkmäler des Reg. Bez. Oberbayern*, 1, part 3, 1905.

Rituals of Royalty: *Rituals of Royalty. Power and Ceremonial in Traditional Societies*, Cambridge 1987.

Rizzi 1980: A. Rizzi, Un' icona costantinopitana del XII secolo a Venezia: La Madonna Nicopoia, *Θησαυρίσματα* 17 (1980), 290-306.

Rom und Byzanz 1: *Rom und Byzanz. Schatzkammerstücke aus bayerischen Sammlungen*, exh. cat., Bayerisches Nationalmuseum, R. Baumstark ed., Munich 1998.

Rom und Byzanz 2: *Rom und Byzanz. Archäologische Kostbarkeiten aus Bayern*, exh. cat., L. Wamser and Gisela Zahlhass eds, Munich 1998.

Romano 1980: R. Romano, *Nicola Callicle, Carmi*, Naples 1980.

Rosenqvist 1986: *The Life of St Irene Abbess of Chrysobalanton*, J.O. Rosenqvist ed., Acta Universitatis Uppsaliensis 1, Uppsala 1986.

Ross 1941: M.C. Ross, The Collection, *Bulletin of the Fogg Museum of Art* 9 (1941), 75-76.

Ross 1962: M.C. Ross, *Catalogue of the Byzantine and Early Medieval Antiquities in the DOC, I, Metalwork, Ceramics, Glass, Glyptics, Painting*, Washington D.C. 1962.

Ross 1965, 2001: M. Ross, *Catalogue of the Byzantine and Early Medieval Antiquities in the Dumbarton Oaks Collection*, 2 vols, Washington D.C. 1965, 2001.

Ross 1965: M.C. Ross, *Catalogue of the Byzantine and Early Medieval Antiquities in the Dumbarton Oaks Collection, II: Jewelry, Enamels and Art of the Migration Period*, Washington D.C., 1965.

Rotili 1980: M. Rotili, *Arte bizantina in Calabria e*

in Basilicata, Cava dei Tirreni 1980.

Ruggieri 1988: V. Ruggieri, Consecrazione e dedicazione di chiesa, secondo il Barberinianus graecus 336, *OCP* 54 (1988), 79-118.

Ruseva-Slokoska 1991: Ljudmila Ruseva-Slokoska, *Roman Jewellery: a Collection of the National Archeological Museum Sofia*, London 1991.

Russel 1987: J. Russell, *The Mosaic Inscriptions of Anemurium*, Vienna 1987.

Russian Pictures, Icons 1984: Sotheby's catalogue *Russian Pictures, Icons*, 15 Feb 1984.

Russo 1979: E. Russo, L'affresco di Turtura nel cimitero di Commodilla, l'icona di S. Maria di Trastevere e le più antiche feste della Madonna in Roma, *Bull dell' Ist. Storico Italiano per il Medio Evo e Arch. Muratoriano* 88 (1979), 35-85.

Russo 1980-1981: E. Russo, L'affresco di Turtura nel cimitero di Commodilla, l'icona di S. Maria in Trastevere e le più antiche feste della Madonna a Roma, *Bull dell' Ist. Storico Italiano per il Medio Evo e Arch. Muratoriano* 89 (1980-1981), 71-150.

Rutschowscaya 1986: Marie-Hélène Rutschowscaya, *Catalogue des bois de l'Egypte copte*, Musée du Louvre, Paris 1986.

Rutschowscaya 1990: Marie-Hélène Rutschowscaya, *Tissus coptes*, Paris 1990.

Rutschowscaya 1997: Marie-Hélène Rutschowscaya, *L'Egypte ancienne au Louvre*, Paris 1997.

Rydén 1976: L. Rydén, The Vision of the Virgin at Blachernai and the Feast of Pokrov, *AB* 94 (1976), 63-82.

Rydén 1995: *The Life of St Andrew the Fool*, L. Rydén ed., 2, Uppsala 1995.

Sacopoulo 1975: M. Sacopoulo, *La Theotokos à la Mandorle de Lythrankomi*, Paris 1975.

Sailing from Byzantium: *Sailing from Byzantium: Palaiologan Coins a Selection from the Collection of Petros N. Protonotarios*, The Byzantine Festival in London 1998, exh. cat., London 1998.

Santamaria Mannino 1983: P. Santamaria Mannino, La vergine 'kykkiotissa' in due icone laziali del Duecento, *Roma anno 1300*, Atti della IV sett. di studi di storia dell'arte medievale dell'università di Roma 'La sapienza' (Rome 1980), A.M. Romanini ed., Rome 1983, 487-496.

Sarksaune 1987: O. Sarksaune, *The Proof from Prophecy: A Study in Justin Martyr's Proof-Text Tradition*, Leiden 1987.

Schennikova 1996: Ludmila A. Schennikova, Chudotvornaia ikona 'Bogomater Vladimirskaia' kak Odigitria evangelista Luki / The Miracle-Working Icon of Our Lady of Vladimir as the Hodigitria of St. Luke the Evangelist, in *Chudotvornaia ikona*, 252-302, 544.

Ščhepkina 1977: M.B. Ščhepkina, *Miniatjury Chludovskoj psaltyri: Grečeskij illjustrirovannyj kodeks IX veka*, Moscow 1977.

Schermann 1907: *Prophetarum vitae fabulosae*, T. Schermann ed., Leipzig 1907.

Schlunk 1940: H. Schlunk, Eine Gruppe datierbarer byzantinischer Ohrringe, *Berliner Museen: Berichte aus den Preußischen Kunstsammlungen*

61 (1940), 42-47.

Schmit 1927: T. Schmit, *Die Koimesis-Kirche von Nikaia*, Berlin and Leipzig 1927.

Schulz 1986: H.-J. Schulz, *The Byzantine Liturgy. Symbolic Structure and Faith Expression*, New York 1986.

Seeck 1962²: *Notitia dignitatum*, O. Seeck ed, Berlin 1876, rpr. Frankfurt 1962.

Segall 1938: Berta Segall, *Museum Benaki, Katalog der Goldschmiede-Arbeiten*, Athens 1938.

Seibt 1976: W. Seibt, *Die Skleroi. Eine Prosopographisch-sigillographische Studie*, Vienna 1976.

Seibt 1985: W. Seibt, Der Bildtypus der Theotokos Nikopoios. Zur Ikonographie der Gottesmutter-Ikone, die 1030/31 in der Blachernenkirche wieder aufgefunden wurde, *Βυζαντινά* 13/1 (1985), 549-564.

Seibt 1987: W. Seibt, Die Darstellungen der Theotokos auf byzantinische Bleisiegeln besonders im 11. Jahrhundert, *ByzSigillography*, 35-56.

Seibt and Zarnitz 1997: W. Seibt and Marie-Louise Zarnitz, *Das byzantinische Bleisiegel als Kunstwerk*, exh. cat., Vienna 1997.

Ševčenko 1953: I. Ševčenko, Notes on Stephen, The Novgorodian Pilgrim to Constantinople in the XIV Century, *Südforschungen* 12 (1953), 165-175

Ševčenko 1983: Nancy Patterson Ševčenko, *The Life of Saint Nicholas in Byzantine Art*, Turin 1983.

Ševčenko 1984: Nancy Patterson Ševčenko, The Tomb of Isaak Komnenos at Pherrai, *GOTR* 29/2 (1984), 135-139.

Ševčenko 1990: Nancy Patterson Ševčenko, *Illustrated Editions of the Metaphrastian Menologion*, Chicago 1990.

Ševčenko 1991: Nancy Patterson Ševčenko, Icons in the Liturgy, *DOP* 45 (1991), 45-57.

Ševčenko 1992: I. Ševčenko, The Sion Treasure: The Evidence of the Inscriptions, in *Ecclesiastical Silver Plate*, 39-56.

Ševčenko 1993-1994: Nancy Patterson Ševčenko, The Representation of Donors and Holy Figures on Four Byzantine Icons, *ΔΧΑΕ* 17 (1993-1994), 157-164.

Ševčenko 1994a: Nancy Patterson Ševčenko, Close Encounters: Contact between Holy Figures and the Faithful as Represented in Byzantine Works of Art, *Byzance et les images*, 255-285.

Ševčenko 1994b: Nancy Patterson. Ševčenko, The Limburg Staurothek and its Relics, *Θυμίαμα*, 289-294.

Ševčenko 1995: Nancy Patterson Ševčenko, Servants of the Holy Icon, *Byzantine East, Latin West*, 547-553.

Ševčenko forthcoming: Nancy Patterson Ševčenko, The Journey of the Soul from Death to Judgment, forthcoming in *DOP*.

Seven Thousand Years of Jewellery: *Seven Thousand Years of Jewellery*, exh. cat., H. Tait ed., London 1986.

Severin 1970: H. G. Severin, Oströmische Plastik unter Valens und Theodosius I, *Jarhbuch Berlin-*

er Museum 12 (1970), 211-232.

Sewter 1953: E.R.A. Sewter, *Fourteen Byzantine Rulers: The Chronographia of Michael Psellus*, Harmondsworth 1953.

Shalina 1996: Irina A. Shalina, 'Bogomater' Efesskaia-Polotskaia-Korsunskaia-Toropetskaia: istoricheskie imena I arkhetip chudotvornoi ikony / Our Lady of Ephesus, Polotsk, Chersones and Toropets. Historical Names and the Archetype of a Miracle-working Icon, *Chudotvornaia ikona*, 200-209, 543.

Shalina 1999: Irina A. Shalina, Vtornichnye shestvia s ikonoi Bogomater' Odigitria v Konstantinopole / The Tuesday processions with the Hodigitria Icon in Constantinople, *Vizantia i Khristianskii Vostok*, Material from the Conference in Memory of Alice Bank (St Petersburg 1999), 58-62.

Shapley 1979: F.R. Shapley, *Catalogue of Italian Paintings*, Washington D.C. 1979.

Sherwood 1962: P. Sherwood, Byzantine Mariology, *Eastern Churches Quarterly* 14 (1962), 384-409.

Sidorenko 1996: Galina Sidorenko, The Heel of the Saviour. On an Iconographic Motif of Certain Miracle-Working Icons, *Chudotvornaja ikona*, 321-335, 546.

Sinai: *Sinai. Treasures of the Monastery of Saint Catherine*, K.A. Manafis ed., Athens 1990.

Siotis 1994²: M.A. Siotis, *Ἱστορία καὶ θεολογία τῶν ἱερῶν εἰκόνων*, Athens 1994².

Skaug 1983: E. Skaug, Punch Marks - what are they worth? Problems of Tuscan Workshop Interrelationships in the Mid-Fourteenth Century: the Ovile Master and Giovanni da Milano, *La pittura nel XIV e XV secolo: il contributo dell'analisi tecnica alla storia dell'arte*, H.W. Van Os ed., Bologna 1983, 253-282.

Skrobucha 1975: H. Skrobucha, *Mesiterwerke der Ikonenmalerei*, Recklinghausen 1975.

Smirnova 1989: Engelina Smirnova, *Icônes de l'école de Moscou*. XIVe-XVIIe siècles, Leningrad 1989.

Snee 1998: R. Snee, Gregory Nazianzen's Anastasia Church: Arianism, the Goths, and Hagiography, *DOP* 52 (1998), 157-186.

Snessoreva 1909: S. Snessoreva, *Zemnaia zhizn' Presviatoi Bogorodotsy i opisanie sviatykh chudutvornykh ee ikon* / The Earthly Life of the Ever-holy Mother of God and description of Her Holy Miraculous Icons, St Petersburg 1891, 1898, 1909.

Sodini 1992: J.P. Sodini, La sculpture protobyzantine, *Byzance*, 30-33.

Sophocleous 1990: S. Sophocleous, *Le patrimoine des icônes de Limassol, Chypre, 12e-16e siècle*, 3 vols, Thèse de doctorat, Université de Strasbourg 1990.

Sophocleous 1992: S. Sophocleous, *Οι Δεσποτικές εικόνες της Μονής του Μεγάλου Αγρού*, Nicosia 1992.

Sophocleous 1993: S. Sophocleous, Η εικόνα της Κυκκώτισσας στον Άγιο Θεόδωρο του Αγρού,

Επετηρίδα Κέντρων Μελετών Ιερᾶς Μονῆς Κύκκου 2 (1993), 329-337.

Sophocleous 1994: S. Sophocleous, *Icons of Cyprus 7th–20th century*, Nicosia 1994.

Sotiriou 1918: G. A. Sotiriou, Περὶ τῆς μονῆς τοῦ Μεγάλου Σπηλαίου καὶ τῶν ἐν αὐτῇ κειμηλίων, *ΑΔ* 4 (1918), supp., 46-80.

Sotiriou 1924: G. Sotiriou, Ὁδηγός Βυζαντινοῦ Μουσείου Ἀθηνῶν, Athens 1924.

Sotiriou 1926: G. Sotiriou, Βυζαντιναὶ ἀνάγλυφοι εἰκόνες, *Recueil d'études, dediées à la memoire de N. Kondakov*, Prague 1926, 125-138.

Sotiriou 1931²: G. Sotiriou, Ὁδηγός Βυζαντινοῦ Μουσείου, Athens 1931², rpr. 1956.

Sotiriou 1933: G. Sotiriou, Φορητὴ ψηφιδωτὴ εἰκόνα τῆς Παμμακαρίστου τοῦ Πατριαρχικοῦ Ναοῦ τῆς Κωνσταντινουπόλεως, *ΠΑΑ* 8 (1933), 359-368.

Sotiriou 1939: G. Sotiriou, Icônes byzantines du monastère du Sinai, *Byzantion* 14 (1939), 325-327.

Sotiriou 1956-1958: G. and Maria Sotiriou, *Icônes du Mont Sinai*, 2 vols, Athens 1956-1958.

Sotiriou 1959: Maria G. Sotiriou, Ἀμφιπρόσωπος εἰκὼν τοῦ Βυζαντινοῦ Μουσείου ἐκ τῆς Ἠπείρου, *ΔΧΑΕ* (1959), 135-143.

Sotiriou 1962: G. Sotiriou, *A Guide to the Byzantine Museum of Athens*, Athens 1962.

Spanke 1988: D. Spanke, Bildformular und Bildexemplar. Die 'Schöne Maria zu Regensburg' und der Wandel der Identität sakraler Bilder in der frühen Neuzeit, *Das Münster* 51 (1988), 212-221.

Spätantike und frühes Christentum: *Spätantike und frühes Christentum*, exh. cat., Liebighaus-Museum Alter Plastik, Frankfurt 1983.

Spatharakis 1976: I. Spatharakis, *The Portrait in Byzantine Illuminated Manuscripts*, Leiden 1976.

Spatharakis 1981: I. Spatharakis, *Corpus of Dated Illuminated Greek Manuscripts to the Year 1453*, 2 vols, Leiden 1981.

Speck 1980: P. Speck, *Zufälliges zum Bellum Avaricum des Georgios Pisides*, Miscellanea Byzantina Monacensia 24, Munich 1980.

Speck 1989: P. Speck, Eine Interpolation in den Bilderreden des Johannes von Damaskos, *BZ* 82 (1989), 114-117.

Speck 1990: P. Speck, Ich bin's nicht, Kaiser Konstantin ist es gewesen. Die Legenden vom Einfluß des Teufels, des Juden und des Moslem auf den Ikonoklasmus, *Poikila Byzantina* 10 (1990).

Speck 1991: P. Speck, Wunderheilige und Bilder. Zur Frage des Beginns der Bilderverehrung, *Poikila Byzantina* 11 (1991), 163-247.

Speck 1994: P. Speck, Das Teufelsschloß. Bilderverehrung bei Anastasios Sinaites? *Poikila Byzantina* 13 (1994), 293-309.

Speck 1997: P. Speck, Adversus Iudaeos – pro imaginibus. Die Gedanken und Argumente des Leontios von Neapolis und des Georgios von Zypern, *Poikila Byzantina* 15 (1997), 131-176.

Spier 1987: J. Spier, A Byzantine Pendant in the J. Paul Getty Museum, *JGettyMusJ* 15 (1987), 5-14.

Spieser 1991: J.-M. Spieser, Liturgie et pro-grammes iconographiques, *TM* 11 (1991), 575-590.

Spieser 1998: J.-M. Spieser, The Representation of Christ in the Apses of Early Christian Churches, *Gesta* 37/1 (1998), 63-73.

Splendeur de Byzance: *Splendeur de Byzance*, Europalia, Musées Royaux d'Art et d'Histoire, exh. cat., Brussels 1982.

Splendori di Bisanzio: *Splendori di Bisanzio. Testimonianze e riflessi d'arte e cultura bizantina nelle chiese d'Italia*, exh. cat., Milan 1990.

Spyridakis 1949: K. Spyridakis, Ἡ περιγραφὴ τῆς μονῆς Κύκκου ἐπὶ τῇ βάσει ἀνέκδοτου χειρογράφου, *ΚυπρΣπ* 13 (1949), 1-29.

Sreznevskij 1881: *Ruy Gonzales de Clavijo. The Spanish Embassy to Samarkand 1403-1406*, London 1971, rpr. with foreword by I. Dujèev of I. Sreznevskij, *Ruy Gonzales de Clavijo, Itinéraire de l'ambassade espagnole à Samarkande en 1403-1406*, St Petersburg 1881.

Sterligova 1996: I. Sterligova, O znachenii dragot-sennogo ubora v pochitanii sviatych ikon / On the Meaning of the Precious Decoration in the Worship of Holy Icons in *Chudotvornaia ikona*, 123-132, 540.

Sterligova 2000: I. Sterligova, *Dragotsennyi ubor drevnerusskikh ikon XI - XIV vekov/ The Precious Decoration of Old Russian Icons from the 11th to 14th Centuries*, Moscow 2000.

Sternbach 1892: *Georgii Pisidiae carmina inedita*, L. Sternbach ed., WS 14 1892.

Sternbach 1900: *Historia Avarorum, Analecta Avarica*, L. Sternbach ed., Cracow 1900.

Striker and Kuban 1997: C.L. Striker and Y.D. Kuban, *Kalenderhane in Istanbul. The Buildings, their History, Architecture, and Decoration*, Mainz 1997.

Strycker 1961: E. de Strycker, *La forme la plus ancienne du Protévangile de Jacques*, SubsHag 33, Brussels 1961.

Strzygowski 1891: J. Strzygowski, *Byzantinische Denkmäler*, Vienna 1891.

Strzygowsky 1899: J. Strzygowsky, *Der Bildkreis des griechischen Physiologus, des Kosmas Indikopleustes und Oktateuch nach Handschriften der Bibliothek zu Smyrna*, Leipzig 1899.

Stubblebine 1966: J. Stubblebine, Two Byzantine Madonnas from Calahorra, Spain, *ArtB* 48 (1966), 379-381.

Stylianou 1960: A. and Judith Stylianou, Donors and Dedicatory Inscriptions. Supplications in the Painted Churches of Cyprus, *JÖB* 9 (1960), 97-128.

Stylianou 1985: A. and Judith Stylianou, *The Painted Churches of Cyprus*, Trigraph-London 1985.

Stylianou 1997²: A. and Judith Stylianou, *The Painted Churches of Cyprus*, Nicosia 1997².

Subotić 1971: G. Subotić, *L'école de peinture d'Ochride au XVe siècle*, Belgrade 1971.

Subotić 1993: G. Subotić, l'icône de la vassilissa Hélène et les fondateurs du monastère de Poganovo, *Saobstenja* 25 (1993), 25-38

Synaxarium CP: *Synaxarium ecclesiae Constanti-nopolitanae. Propylaeum ad Acta SS Novembris*, H. Delehaye ed., Paris 1902.

Synthronon: *Synthronon. Art et archéologie de la fin de l'antiquité et du moyen age*, Bibliothèque des Cahiers Archéologiques, 2 vols, Paris 1968.

Taft 1995: R.F. Taft, *Liturgy in Byzantium and Beyond*, Collected Studies Variorum 1995.

Talbot 1994: Alice-Mary Talbot, Epigrams of Manuel Philes on the Theotokos tes Peges and Its Art, *DOP* 48 (1994), 135-165.

Talbot Rice 1935: D. Talbot Rice, Byzantine repoussé metal work, *Apollo* 22 (1935), 206-211.

Talbot Rice 1959: D. Talbot Rice, *The Art of Byzantium*, London 1959.

Tartuferi 1991: A. Tartuferi, *Giunta Pisano*, Soncino 1991.

Tatić-Djurić 1969: Mirjana Tatić-Djurić, Ikona Bogorodice 'Prekrasne', njeno poreklo I rasprostranjenost (L'icône de la Vierge Peribleptos, son origine et sa diffusion), *Zbornik Svetozara Radojčića* (Mélanges Svetozar Radojčića), Belgrade 1969, 335-354.

Tatić-Djurić 1972: Mirjana Tatić-Djurić, La porte du verbe, type et signification de la Vierge des Blachernes, *ZLU* 8 (1972), 63-88.

Tatić-Djurić 1976: Mirjana Tatić-Djurić, Eléousa, A la recherche du type iconographique, *JÖB* 25 (1976), 259-267.

Tatić-Djurić 1981: Mirjana Tatić-Djurić, L'icône de Kyriotissa, *Actes du XVe CIEB*, II/2, 758-786.

Tatić-Djurić 1984: Mirjana Tatić-Djurić, *Poznate ikone od XII do XVIII veka*, Belgrade 1984.

Tatić-Djurić 1987-1988: Mirjana Tatić-Djurić, L'Hymne "Ἐπί σοι χαίρει" dans les monastères de Vulkano et de Mardaki en Messénie, Πρακτικά του Γ' Διεθνούς Συνεδρίου Πελοποννησιακών Σπουδών (Kalamata 1985), *Πελοποννησιακά*-Supp. 13, 3 (1987-1988), 353-364.

Tatić-Djurić 1995: Mirjana Tatić-Djurić, L'icône de l'Odigitria et son culte au XVIe siècle, *Byzantine East, Latin West*, 557-564.

Tchubinasvili 1957: G. N. Tchubinasvili, *Gruzinskoje tchekannoje iskusstvo*, Tbilisi 1957.

Tea 1961: Eva Tea, *Santa Maria Antiqua*, Rome 1961.

Temple 1990: *Early Christian and Byzantine Art*, R. Temple ed., London 1990.

Tesori dell'arte christiana in Bulgaria: *Tesori dell'arte christiana in Bulgaria*, exh. cat., Mercati di Traiano, Rome 2000.

Teteriatnikov 1998: Natalia B. Teteriatnikov, *Mosaics of Hagia Sophia, Istanbul: the Fossati Restoration and the Work of the Byzantine Institute*, Washington D.C. 1998.

Textiles of Late Antiquity: *Textiles of Late Antiquity*, exh. cat., Annemarie Stauffer, Marsha Hill, Helen C. Evans and Daniel Walker eds, The Metropolitan Museum of Art, New York 1995.

The Church and the Arts: *The Church and the Arts*, D.Wood ed., Oxford 1992.

The Cleveland Museum of Art. Selected Works, Haarlem 1966.

The Craftsman's Handbook: Cennino d'Andrea

513

Cennini, *The Craftsman's Handbook, The Italian 'Il Libro dell' Arte'*, trans. D. V. Thompson Jr., New Haven 1933, London 1960².

The Luminous Eye: The Luminous Eye. The Spiritual World Vision of St Ephrem, S.P. Brock ed., Rome 1985; rpr. Kalamazoo 1990.

The Medieval Treasury: The Medieval Treasury. The Art of the Middle Ages in the Victoria and Albert Museum, P. Williamson ed., London 1998³.

The Miraculous Image: The Miraculous Image. The Icons of Our Lady in the Tretyakov Gallery, exh. cat., A. Lidov and G. Sidorenko eds, Moscow 1999.

The Monastery of Mega Spelaion: The Monastery of Mega Spelaion. Brief History, Diocese of Kalavryta 1988.

The Museum of Albanian Mediaeval Art Korça, Tirana 1987.

The Pierpont Morgan Treasures: Loan Exhibition in Honor of the Junius Spencer Morgan Memorial. November 10 through December 18, 1960, Wadsworth Atheneum, Hartford 1960.

The Sacred Image: The Sacred Image East and West, R. Ousterhout and Leslie Bruebaker eds, Chicago and Urbana 1995.

The Treasury of San Marco: The Treasury of San Marco, Venice, exh. cat., D. Buckton ed., *The Treasury of San Marco*, (London, British Museum, 1984, and New York, Metropolitan Museum of Art, 1985), Milan 1984.

The Year 1200: The Year 1200, exh. cat., The Metropolitan Museum of Art, New York 1970.

Themelis 1907: P.T. Themelis, Ὁ Ἀκάθιστος Ὕμνος, *Νέα Σιών* 6 (1907), 826-833.

Theotokos: Theotokos. A Theological Encyclopedia, M. O'Carroll ed., Wilmington, Delaware 1982.

Thierry 1979: Nicole Thierry, La Vierge de Tendresse à l'époque macédoine, *Zograf* 10 (1979), 59-70.

Tischendorf 1853: K. Tischendorf, *Evangelia Apocrypha*, Leipzig 1853, 1966, 1987.

Todić 1986: B. Todić, Les Fresques de Studenica, in M. Kašanin, Mirjana Canak-Medić, J. Maksimović, B. Todić and M. Sakota, *Manastir Studenica (Monastère de Studenica)*, Belgrade 1986.

Todić 1994: B. Todić, Anapeson, iconographie et signification du thème, *Byzantion* 64 (1994), 134-165.

Τὸ πορτραῖτο: Τὸ πορτραῖτο τοῦ καλλιτέχνη στο Βυζάντιο, Maria Vassilaki ed., Herakleion 1997.

Topping 1997: E.C. Topping, *Sacred Songs. Studies in Byzantine Hymnography*, Minneapolis 1997.

Torp 1999: H. Torp, Una vergine *hodigitria* del periodo iconoclastico nel 'tempietto longobardo' di Cividale, *Arte d'Occidente. Temi e metodi. Studi in onore di Angiola Maria Romanini*, Roma 1999, 583-599.

Totev 1983: T. Totev, *Preslavsko zlatno s"krovishche*, Sofia 1983.

Totev 1987: T. Totev, L'atelier de céramique peinte du monastère royal de Preslav, *CahA* 35 (1987), 65-80.

Tougher 1997: S. Tougher, *The Reign of Leo VI*

(886-912), Leiden 1997.

Touratsoglou 1992: I. Touratsoglou, Ἐγκόλπιο στεατίτη ἀπὸ τη Βέροια, *Ευφρόσυνον*, 2, 601-605.

Tourta 1986: Anastasia Tourta, *Θεσσαλονίκη, Ιστορία και Τέχνη*, Athens 1986.

Tourta 1992a: Anastasia Tourta, Εικόνα Δεξιοκρατούσας Παναγίας στη Θεσσαλονίκη, *Ευφρόσυνον*, 2, 607-617.

Tourta 1992b: Anastasia Tourta, *Συλλογή εικόνων Δημοτικής Πινακοθήκης Θεσσαλονίκης*, Thessaloniki 1992.

Tourta forthcoming: Anastasia Tourta, Οι περιπέτειες μιας βυζαντινής εικόνας από τη Θεσσαλονίκη. Ζητήματα τέχνης, *Byzantine Icons. Art, Technique and Technology. Acts of the International Conference held at the Gennadios Library*, Athens 1998, forthcoming.

Trapp 1986: E. Trapp, *Militärs und Höflinge im Ringen um das Kaisertum. Byzantinische Geschichte von 969 bis 1118 nach der Chronik des Johannes Zonaras*, Byzantinische Geschichtschreiber 16, Graz 1986.

Travlos and Frantz 1965: J. Travlos and Alison Frantz, The Church of St Dionysios the Areopagite and the Palace of the Achbishop of Athens in the 16th Century, *Hesperia* 34 (1965), 157-202.

Treadgold 1982: W. Treadgold, The Unpublished Saint's Life of the Empress Irene (*BHG* 2205), *ByzF* 6 (1982), 237-251.

Treasures of Mount Athos: Treasures of Mount Athos, exh. cat., Museum of Byzantine Culture, Thessaloniki 1997.

Trésors des Musées Bulgares: Trésors des Musées Bulgares, Gallerie Charpentier, Paris 1963.

Trésors Médiévaux: Trésors Médiévaux de la République de Macédoine, exh. cat., Paris 9 February-3 May 1999, Thermes de Cluny, Paris 1999.

Trypanis 1968: C.A. Trypanis ed., *Fourteen Early Byzantine Cantica*, Vienna 1968.

Tsigaridas 1988: E.N. Tsigaridas, La peinture à Kastoria et en Macédoine grècque occidentale vers l' année 1200. Fresques et icônes, *Studenica et l'art byzantin autour de l'année 1200* (September 1986), Belgrade 1988, 309-320.

Tsigaridas 1992: E. Tsigaridas, Η χρονολόγηση των τοιχογραφιών του ναού του Αγίου Αλυπίου Καστοριάς, *Ευφρόσυνον*, 2, 648-656.

Tsigaridas 1995: E.N. Tsigaridas, Φορητές εικόνες του 15ου αιώνα του Βυζαντινού Μουσείου της Καστοριάς, *Διεθνές Συμπόσιο: Βυζαντινή Μακεδονία* (324-1430 μ.Χ.), Θεσσαλονίκη 29-31 Οκτωβρίου 1992, Thessaloniki 1995, 345-367.

Tsigaridas 1997: E. Tsigaridas, *Portable Icons, Treasures of Mount Athos*, 47-52.

Tsigaridas 1998a: E. Tsigaridas, Portable Icons, *Monastery of Vatopaidi*, 350-417.

Tsigaridas 1998b: E. Tsigaridas, Icons of the 12th-14th centuries, *The Holy Monastery of Aghiou Pavlou. The Icons*, Mt Athos 1998, 19-38.

Tsigaridas 2000: E.N. Tsigaridas, Φορητές εικόνες στη Μακεδονία και το Άγιον Όρος κατά τον

13ο αιώνα, *ΔΧΑΕ* 21 (2000), 123-156.

Tsiknopoulos 1971: I.P. Tsiknopoulos, Ἀκολουθία τοῦ ἁγίου ἀποστόλου καὶ εὐαγγελιστῆ Λουκᾶ, *ΚυπρΣπ* 35 (1971), 255-274.

Tsilipakou 1998: Agathoniki Tsilipakou, Βυζαντινές μαρμάρινες εικόνες από τη Θεσσαλονίκη, *Βυζαντινά* 19 (1998), 269-381.

Tsironis 1998: Niki J. Tsironis, *The Lament of the Virgin Mary from Romanos the Melode to George of Nicomedia: an Aspect of the Development of Marian Cult*, PhD thesis, King's College, London 1998.

Tsironis 1998b: Niki J. Tsironis, Historicity and Poetry in Ninth-Century Homiletics: The Homilies of Patriarch Photios and George of Nicomedia, *Studies in Early Christian and Byzantine Homiletics*, P. Allen and Mary Cunningham eds, Brill Leiden 1988, 295-316.

Tsirpanlis 1995: Z. Tsirpanlis, *Ανέκδοτα έγγραφα για τη Ρόδο και τις Νότιες Σποράδες από το αρχείο των Ιωαννιτών ιπποτών 1421-1453*, Rhodes 1995.

Tsoulias 1996: Th.Tsoulias, *Τα ιερά προσκυνήματα της Παναγίας ανά την Ορθοδοξία*, 2 vols, Katerini 1996.

Turilov 1996: A. Turilov ed., Rasskazy o chudotvornykh ikonakh monastyria Chilandar v russkoi zapisi XVI veka / The Stories on Miracle-Working Icons of the Chilandar Monastery in the 16th-Century Russian recording, *Chudotvornaia ikona*, 510-529, 553.

Turilov 2000: A. Turilov, Skazania o chudotvornykh ikonakh v kontekste istorii ikh pochitania na Rusi / The Miracle Stories on the Icons in the Context of Their Veneration in Old Rus, *Relics in the Art and Culture of the Eastern Christian World. Abstracts of Papers and Material from the International Symposium*, A. Lidov ed., Moscow 2000.

Turner 1990: D. Turner, The Origins and Accession of Leo V (813-820), *JÖB* 40 (1990), 171-203.

Underwood 1959: P.A. Underwood, The Evidence of Restorations in the Sanctuary Mosaics of the Church of the Dormition at Nicaea, *DOP* 13 (1959), 235-244.

Underwood 1975: P. Underwood, *The Kariye Djami*, 4 vols, Princeton N.J. 1975.

Urbaniak-Walczak 1993: K. Urbaniak-Walczak, Die Geburtsdarstellung in der Thekla Haymanot Kapelle der Al-Mu'allaqah Kirche in Alt-Cairo, *Acts of the Fifth International Congress of Coptic Studies*, Washington 1992, 2, part E, Rome 1993, 471-489.

Uspenskij 1850: P. Uspenskij, *Second Journey to Sinai* (in Russian), Kiev 1850.

Vaklinova 1981: Margarita Vaklinova, *Mittelalterliche Schmuckstücke aus Bulgarien*, Sofia 1981.

Van Den Hoek, Feissel and Herrmann 1994: A. van Den Hoek, D. Feissel and J. J. Herrmann, Lucky Wearers: A Ring in Boston and a Greek Epigraphic Tradition of Late Roman and Byzantine Times, *Journal of the Museum of Fine Arts, Boston* 6 (1994), 41-62.

Van der Vin 1980: J.P.A. van der Vin, *Travellers to*

Greece and Constantinople, 2 vols, Leiden 1980.

Vandier 1945: J. Vandier, Une annonciation copte, *Bulletin monumental* 103 (1945), 250-255.

Van Dieten 1972: J.L. van Dieten, *Geschichte der Patriarchen von Sergios I. bis Johannes VI*, Amsterdam 1972.

Van Dieten 1975: J.-L.A. van Dieten ed., *Nicetae Choniatae Historia*, 3, *CFHB* 11, Berlin 1975.

Van Dijk 1999: Anne van Dijk, The Angelic Salutation in Early Byzantine and Medieval Annunciation Imagery, *ArtB* 81 (1999), 420-436.

Van Esbroeck 1987: M. van Esbroeck, Jalons sur l'histoire de la transmission manuscrite de l'homélie de Proclus sur la Vierge (BHG 1129), *Text und Textkritik. Festschrift J. Dümmer*, Berlin 1987, 149-164.

Van Esbroeck 1988: M. van Esbroeck, Le culte de la Vierge de Jérusalem à Constantinople aux 6e-7e siècles, *REB* 46 (1988), 181-190

Van Esbroeck 1995: M. van Esbroeck, *Aux origines de la Dormition de la Vierge*, Aldershot 1995.

Vandier 1944: J. Vandier, *La réligion égyptienne*, Paris 1944.

Vassilaki 1992: Maria Vassilaki, The Benaki Museum Icon of the Virgin of Tenderness (no. 2972), *XVIth International Congress of Byzantine Studies (Moscow 1991)*, Summaries of Communications, Moscow 1991, II, 1213.

Veglery 1909-1910: G. P. Veglery, Θεοτόκος η Θεραπειώτισσα, *JIAN* 12 (1909-1910), 327-336.

Velmans 1967: Tania Velmans, Les valeurs affectives dans la peinture murale byzantine au XIIIe siècle et la manière de les répresenter, *L'art byzantin du XIIIe siècle, Symposium de Sopoćani*, 1965, Belgrade 1967, 49-57.

Velmans 1968: Tania Velmans, L' iconographie de la Fontaine de Vie dans la tradition byzantine à la fin du moyen age, *Synthronon*, 119-134.

Velmans 1971: Tania Velmans, *La Tétraévangile de la Laurentienne*, Paris 1971.

Velmans 1972: Tania Velmans, Une illustration inédite de l'Acathiste et l'iconographie des hymnes liturgiques à Byzance, *CahA* 22 (1972), 131-165.

Velmans 1976: Tania Velmans, Rayonnement de l'icône au XIIe et au début du XIIIe siècle, *Actes du XVe CIEB*, 375-419.

Velmans 1977: Tania Velmans, *La Peinture murale byzantine a la fin du moyen age*, 1, Paris 1977.

Velmans 1978, Tania Velmans, L'Heritage antique dans la peinture murale byzantine à l'époque du roi Milutin (1282-1321), *L'art byzantin au debut du XIVe siècle, Symposium de Gračanica* 1973, 39-52.

Velmans 1980-1981: Tania Velmans, L'image de la Déisis dans les églises de Georgie et dans celles d'autres regions du monde byzantin, *CahA* 29 (1980-1981), 47-102.

Velmans 1982: Tania Velmans, Sviluppo e prestigio dell'icone alla fine del Medioevo. Un fenomeno sociale e religioso (XII-XIV sec.), *Oriente Cristiano*, 22 (1982), 32-40.

Venezia e Bisanzio: *Venezia e Bisanzio*, exh. cat., I. Furlan ed., Palazzo Ducale, Venice 1974.

Vermaseren 1959-1960: J. Vermaseren, *Corpus inscriptionum et monumentorum religionis Mithriacae*, 2 vols, 1959-1960.

Vermeule 1975: C. Vermeule, Numismatics in Antiquity; The Preservation and Display of Coins in Ancient Greece and Rome, *RSN* 54 (1975), 5-32.

Verpaux 1966: *Pseudo-Kodinos, Traité des offices*, J. Verpaux ed., Paris 1966.

Viellefond 1935: J.-R. Viellefond, Les pratiques religieuses dans l'armée byzantine d'après les traités militaires, *REA* 37 (1935), 322-330.

Vikan 1982: G. Vikan, *Byzantine Pilgrimage Art*, Washington D.C. 1982.

Vikan 1984: G. Vikan, Art, Medicine, and Magic in Early Byzantium, *DOP* 38 (1984), 65-86.

Vikan 1986: G. Vikan, Preface to *Kaper Koraon*, x-xii.

Vikan 1987: G. Vikan, Early Christian and Byzantine Rings in the Zucker Family Collection, *JWalt* 45 (1987), 32-43.

Vikan 1989: G. Vikan, Ruminations on Edible Icons: Originals and Copies in the Art of Byzantium, *Studies in the History of Art* 20 (1989), 47-59.

Vikan 1990a: G. Vikan, Art and Marriage in Early Byzantium, *DOP* 44 (1990), 145-163.

Vikan 1990b: G. Vikan, Pilgrims in Magi's Clothing: the Impact of Mimesis on Early Byzantine Pilgrimage Art, *The Blessings of Pilgrimage*, R. Ousterhout ed., Urbana 1990.

Vikan 1991/92: G. Vikan, Two Byzantine Amuletic Armbands and the Group to which they Belong, *JWalt* 49/50 (1991/92), 33-51.

Vikan 1995: G. Vikan, *Catalogue of the Sculpture in the Dumbarton Oaks Collection from the Ptolemaic Period to the Renaissance*, Washington D.C. 1995.

Vikan 1998: G. Vikan, Byzantine Pilgrim's Art, *Heaven on Earth. Art and the Church in Byzantium*, L. Safran ed., Pennsylvania 1998, 229-266.

Vizantija Balkanji, Rus': *Vizantija, Balkanji, Rusj, Ikonji kontEa XIII - pervoj polovinij XV veka, K XVIII Me?dunarodnomu Kongressu Vizantinistov*, exh. cat., Gallery Tretyakov, Moscow 1991.

Vlachakis 1979: Η εικόνα της Παναγίας της Επισκοπιανής στη Κρήτη πριν από τη μεταφορά της στη Ζάκυνθο, *Θησαυρίσματα* 16 (1979), 255-268.

Vlassopoulo 1860: J.C. Vlassopoulo, *Notices statistiques sur l'île de Tine*, St Petersburg 1860.

Vloberg 1952: M. Vloberg, *Les types iconographiques de la Mère de Dieu dans l'art byzantin. Maria. Études sur la Sainte Vierge*, Paris 1952.

Vocotopoulos 1990: P.L. Vocotopoulos, *Εικόνες της Κερκύρας*, Athens 1990.

Vocotopoulos 1995: P.L. Vocotopoulos, *Βυζαντινές εικόνες*, Athens 1995.

Vocotopoulos 1998: P.L. Vocotopoulos, Δύο παλαιολόγειες εικόνες στα Ιεροσόλυμα, *ΔΧΑΕ* 20 (1998), 291-307.

Vodach za Narodnia Muzei v Sofia: *Vodach za Narodnia Muzei v Sofia* / Guide of the National Museum in Sofia, Sofia 1923.

Vogt 1967[2]: *Constantine VII Porphyrogénète. Livre des cérémonies*, A. Vogt ed., 2 vols, Paris 1967[2].

Volbach 1930: W.F. Volbach, *Staatliche Museen zu Berlin. Mittelalterliche Bildwerke aus Italien und Byzanz*, Berlin and Leipzig 1930.

Volbach 1952[2]: W.F. Volbach, *Elfenbeinarbeiten der Spätantike und des frühen Mittelalters*, Mainz 1952[2].

Volbach 1961: W.F. Volbach, *Early Christian Art*, London 1961.

Volbach 1966: W.F. Volbach, *Il tessuto nell'arte antica*, Milan 1966.

Volbach 1976[3]: W.F. Volbach, *Elfenbeinarbeiten der Spätantike und des frühen Mittelalters*, Mainz 1976[3].

Volbach and Lafontaine-Dosogne 1968: W.F. Volbach and Jacqueline Lafontaine-Dosogne, *Byzanz und der christliche Osten*. Propyläen Kunstgeschichte 3, Berlin 1968.

Von Dobschütz 1899: E. von Dobschütz, *Christusbilder, Texte und Untersuchungen zur Geschichte der altchristlichen Literatur*, Neue Folge 3, Leipzig 1899.

Von Dobschütz 1903: E. von Dobschütz, Maria Romaia. Zwei unbekannte Texte, *BZ* 12 (1903), 173-214.

Von Falkenhausen 1986: Vera von Falkenhausen, Pisa e Bisanzio nei secoli XII e XIII, *Il Duomo e la civiltà pisana del suo tempo*, Pisa 1986, 61-71.

Von Premerstein et al. 1906: A. von Premerstein, C. Wessely and J. Mantuani, *De codicis Dioscuridei Aniciae Iulianae nunc vindobonensis Med. Gr. I, Lugduni, Sijthoff, historia, forma, scriptura, picturis*, Leiden 1906.

Voordeckers 1983: E. Voordeckers, L'interprétation liturgique de quelques icônes byzantines, *Byzantion* 53/1 (1983), 52-68.

Wallraff 1998: M. Wallraff, Markianos, ein prominenter Konvertit vom Novatianismus zur Orthodoxie, *VChr* 52 (1998), 1-29.

Walter 1982: C. Walter, Portraits of Local Bishops: a Note on their Significance, *ZRVI* 21 (1982), 1-17, rpr. in Walter 1993a, study 11.

Walter 1993a: C. Walter, *Prayer and Power in Byzantine and Papal Imagery*, Aldershot 1993.

Walter 1993b: C. Walter, A New Look at the Byzantine Sanctuary Barrier, *REB* 51 (1993), 203-228.

Walter 1997a: C. Walter, IC XC NHKA The Apotropaic Function of the Victorius Cross, *REB* 55 (1997), 193-215.

Walter 1997b: C. Walter, Iconographical Considerations, in Munitiz et al. 1997, li-lxxviii.

Wasowicz 1990: A. Wasowicz, Traditions antiques dans les scènes de l'Annonciation, *Dialogues d'histoire ancienne* 16/2 (1990), 163-77.

We Three Kings: We Three Kings. The Magi in Art and Legend, exh. cat. Buckinghamshire Art Gallery, Aylesbury 1995.

Wealth of the Roman World: *Wealth of the Roman World: Gold and Silver, AD 300-700*, exh. cat., British Museum, J.P.C. Kent and K.S. Painter

eds, London 1977.

Weibel 1952: Adèle Coulin Weibel, *Two Thousand Years of Textiles. The Figured Textiles of Europe and the Near East*, New York 1952.

Weis 1958: A. Weis, Ein vorjustinianischer Ikonentypus in S. Maria Antiqua, *RömJahrKunst* 8 (1958), 17-61.

Weitzmann 1947: K. Weitzmann, Byzantine Art and Scholarship in America, *AJA* 51 (1947), 394-418.

Weitzmann 1963: K. Weitzmann, Thirteenth-Century Crusader Icons on Mount Sinai, *ArtB* XLV (1963), 179-203, rpr. in Weitzmann 1982a, 291-324.

Weitzmann 1966a: K. Weitzmann, Various Aspects of Byzantine Influence on the Latin Countries from the Sixth to the Twelfth Century, *DOP* 20 (1966), 1-24.

Weitzmann 1966b: K. Weitzmann, Icon Painting in the Crusader Kingdom, *DOP* 20 (1966), 49-83, rpr. in Weitzmann 1982a, 325-386.

Weitzmann 1972a: K. Weitzmann, *Catalogue of the Byzantine and Early Medieval Antiquities in the Dumbarton Oaks Collection. III, Ivories and Steatites*, Washington D.C. 1972.

Weitzmann 1972b: K. Weitzmann, The Ivories of the So-called Grado Chair, *DOP* 26 (1972), 43-91.

Weitzmann 1976a: K. Weitzmann, *The Monastery of Saint Catherine at Mount Sinai: The Icons*, vol.1, *From the Sixth to the Tenth Century*, Princeton 1976.

Weitzmann 1976b: K. Weitzmann, The Ode Pictures of the Aristocratic Psalter Recension, *DOP* 30 (1976), 65-84, rpr. in Weitzmann 1980, essay 4.

Weitzmann 1980: K. Weitzmann, *Byzantine Liturgical Psalters and Gospels*, London 1980.

Weitzmann 1982a: K. Weitzmann, *Studies in the Arts at Sinai. Essays by Kurt Weitzmann*, Princeton 1982.

Weitzmann 1982b: K. Weitzmann, Crusader Icons and la Maniera Greca, *Il Medio Oriente e l'Occidente, nell'Arte del XIII Secolo, Atti del XXIV Congresso Internazionale di Storia del Arte* (Bologna 1979), 2, H. Belting ed., Bologna 1982.

Weitzmann and Galavaris 1990: K. Weitzmann and G. Galavaris, *The Monastery of Saint Catherine at Mount Sinai. The Illuminated Greek Manuscripts. 1: From the Ninth to the Twelfth Century*, Princeton 1990.

Weitzmann et al. 1965: K. Weitzmann, M. Chatzidakis, K. Miatev and S. Radojčić, *Frühe Ikonen, Sinai, Griechenland, Bulgarien, Jugoslawien*, Vienna and Munich 1965.

Weitzmann et al. 1968: K. Weitzmann, M. Chatzidakis, K. Miatev and S. Radojčić, *Icons from South-Eastern Europe and Sinai*, London 1968.

Weitzmann et al. 1982: K. Weitzmann, G. Alibegašvili, A. Volskaja, M. Chatzidakis, Gordana Babić, M. Alpatov and T. Voinescu, *The Icon*, New York 1982.

Wellen 1961: G. Wellen, *Theotokos, Eine Iconigraphische Abhandlung uber das Gottesmutterbild, in Fruhchristlicher Zeit*, Utrecht Antwerpen 1961.

Wellesz 1957: E. Wellesz, *The Akathistos Hymn*, Copenhagen 1957.

Wenger 1952: A. Wenger, Note inédite sur les empereurs Theodose I, Arcadius, Theodose II, Leon I, *REB* 10 (1952), 47-59.

Wenger 1955: A. Wenger, *L'Assomption de la Très Sainte Vierge dans la tradition byzantine du VIe au Xe siècle. Études et documents*, AOC 5, Paris 1955.

Wentzel 1956: H. Wentzel, Mittelalterliche Gemmen in den Sammlungen Italiens, *Mitteilungen des Kunsthistorischen Institutes in Florenz* 7 (1956), 239-279.

Wentzel 1959: H. Wentzel, Datierte und datierbare byzantinische Kameen, *Festschrift Friedrich Winkler*, Berlin 1959, 9-21.

Wescher 1931: P. Wescher, *Beschreibendes Verzeichnis der Miniaturen-Handschriften und Einzelblätter des Kupferstichkabinetts der Staatlichen Museen Berlin*, Leipzig 1931.

Wessel 1963: Kl. Wessel, *Koptische Kunst.Die Spätantike in Ägypten*, Recklinghausen 1963.

Wessel 1967: K. Wessel, *Die byzantinische Emailkunst vom 5. bis 13. Jahrhundert* (Beiträge zur Kunst des christlichen Ostens, 4), Recklinghausen 1967.

Wessel 1978: Kl. Wessel, Die stillende Gottesmutter, *Studien zur altägyptischen Kultur* 8 (1978).

Whittemore 1936: T. Whittemore, *The Mosaics of S. Sophia at Istanbul, 1933-4. The Mosaics of the Southern Vestibule*, Oxford 1936.

Whittemore 1942: T. Whittemore, *The Mosaics of Haghia Sophia at Istanbul. Third Preliminary Report*, Oxford 1942.

Willis 1968: G. Willis, The Consecration of Churches down to the Ninth Century, *Further Essays in Early Roman Liturgy*, London 1968, 135-173.

Winfield 1969: D. Winfield, Hagios Chrysostomos, Trikomo, Asinou, Byzantine Painters at Work, *Πρακτικά του Πρώτου Διεθνούς Κυπρολογικού Συνεδρίου*, Λευκωσία 1969, 2, Nicosia 1972.

Winfield 1971: D.C. Winfield, Reports on Work at Monagri, Lagoudera, Hagios Neophytos, Cyprus, *DOP* 25 (1971), 259-264.

Winfield n.d.: D. Winfield, *The Church of Panagia tou Arakos Lagoudera*, A Guide. Nicosia n.d.

Witakowski 1996: *Pseudo-Dionysius of Tel-Mahre Chronicle*, trans. W. Witakowski, Liverpool 1996.

Wolf 1990: G. Wolf, *Salus populi romani. Die Geschichte römischer Kultbilder im Mittelalter*, Weinheim 1990.

Wolff 1948: R.L. Wolff, Footnote to an Incident of the Latin Occupation of Constantinople: the Church and Icon of the Hodigitria, *Traditio* 6 (1948), 319-328.

Wolters 1964: C. Wolters, Beobachtungen am Freisinger Lukasbild, *Kunstchronik* 17 (1964), 85-91.

Wright 1882: *Joshua the Stylite. The Chronicle of Joshua the Stylite*, trans. W. Wright, Cambridge 1882.

Wulff 1909: O. Wulff, *Altchristliche und Mittelalterliche byzantinische und italienische Bildwerke, I, Altchristliche Bildwerke*, Berlin 1909.

Wulff and Alpatoff 1925: O. Wulff and M. Alpatoff, *Denkmäler der Ikonenmalerei in Kunstgeschichtlicher Folge*, Dresden 1925.

Xenopoulos 1925: S. Xenopoulos, Ψηφιδωτὴ εἰκὼν ἡ ῾Επίσκεψις᾽ ἐν τῷ Βυζαντινῷ Μουσείῳ ᾽Αθηνῶν, *ΔΧΑΕ* 2/2 (1925), 44-53.

Xyngopoulos 1930: S. Xyngopoulos, Πήλινον βυζαντινὸν θυμιατήριον, *ΑΕ* 1930, 127-140.

Xyngopoulos 1936: S. Xyngopoulos, *Μουσεῖον Μπενάκη, Κατάλογος τῶν εἰκόνων*, Athens 1936.

Xyngopoulos 1951 : A. Xyngopoulos, *Συλλογὴ ῾Ελένης Σταθάτου*, Athens 1951.

Xyngopoulos 1957: A. Xyngopoulos, *Σχεδίασμα ἱστορίας τῆς θρησκευτικῆς ζωγραφικῆς μετὰ τὴν ῞Αλωσιν*, Athens 1957.

Xyngopoulos 1964: A. Xyngopoulos, Οἱ τοιχογραφίες τοῦ ῾Αγίου Νικολάου ᾽Ορφανοῦ Θεσσαλονίκης, Athens 1964.

Xyngopoulos 1964-1965: A. Xyngopoulos, Νέαι προσωπογραφίαι τῆς Μαρίας Παλαιολογίνας καὶ τοῦ Θωμᾶ Πρελιούμποβιτς, *ΔΧΑΕ* 4/4 (1964-1965), 53-67.

Xyngopoulos 1967: A. Xyngopoulos, L'art byzantin du XIIIe siècle, *Symposium de Sopoćani* 1963, Belgrade 1967.

Yeroulanou 1988: Aimilia Yeroulanou, The Byzantine Openwork Gold Plaque in the Walters Art Gallery, *JWalt* 46 (1988), 2-10.

Yeroulanou 1999: Aimilia Yeroulanou, *Diatrita. Gold Pierced-Work Jewellery from the 3rd to the 7th Century*, Athens 1999.

Young 1997: F. Young, *Biblical Exegesis and the Formation of Christian Culture*, Cambridge 1997.

Zacos and Veglery 1972: G. Zacos and A. Veglery, *Byzantine Lead Seals*, 1, Basel 1972.

Zacos and Veglery 1986: G. Zacos and A. Veglery, *Patriarchal Lead Seals of the Years 552-1450*, Istanbul 1986.

Zahn 1929: R. Zahn, *Sammlung Baurat Schiller, Berlin*, Berlin 1929

Zalesskaja 1967: Vera Zalesskaja, The Byzantine Votive Objects in the Collection of the Hermitage Museum and Their Prototypes, *PSb* 17 (1967), 84-89 (in Russian).

Zepos, Jus: *Jus graecoromanum*, J. and P. Zepos eds, 8 vols, Athens 1931; rpr. Aalen 1962.

Zerlentis 1913: P. Zerlentis, ῾Ιστορικαὶ ῎Ερευναι περὶ τὰς ᾽Εκκλησίας τῶν Νήσων, Α᾽ Ερμούπολις Syra 1913.

Zias 1969: N. Zias, Εἰκόνες του βίου και της κοιμήσεως του αγίου Νικολάου, *ΔΧΑΕ* 5 (1969), 275-298.

Zimelien: *Zimelien. Abendländische Handschriften des Mittelalters aus der Sammlungen der Stiftung Preussischer Kulturbesitz - Berlin*, Berlin 1975.

Zuchold 1993: G.-H. Zuchold, *Der 'Klosterhof' des Prinzen Karl von Preussen im Park Von Schloss Glienicke in Berlin*, 2 vols, Berlin 1993.

Glossary

Acheiropoietos
Gr. 'not made by human hands'. Epithet attributed to holy portraits believed to have been miraculously executed by divine powers.

Akakia
Purple silk purse carried by the emperor during ceremonies.

Ampullae
Small flasks or phials, usually made of lead or clay, in which pilgrims brought back oil, water or earth from holy places.

Anapeson
The image of the Christ-Child reclining asleep, in a symbolic allusion to his future Passion.

Anargyroi
Gr. 'without money'. Epithet attributed to the 'penniless' healing saints, such as Cosmas and Damianos, who treated the sick without taking payment.

Anastasis
Gr. 'Resurrection'. The Orthodox image for the Resurrection, depicting Christ's Descent into Hell. He stands upon its shattered gates and brings back to life Old Testament figures. It symbolizes the Salvation of Mankind.

Augusta
Lat. 'Empress'. A title conferred on certain imperial wives.

Augustaion
Main square of Constantinople, in which stood the church of Hagia Sophia and the main entrance to the Imperial Palace.

Basilica
A type of large, long and narrow building used for public assemblies in the Roman period. In Christian ecclesiastical architecture specifically, it is a church of oblong plan, comprising a nave with two or more lateral aisles and terminating in an apse at the east end.

Bema
Sanctuary of an Orthodox church.

Cameo
Carved semiprecious stones, on which the representation is in relief.

Chalke
Vestibule of the main entrance to the Great Palace, Constantinople.

Chlamys
Gr. 'mantle'. A standard garment of Byzantine court costume, worn fastened at the right shoulder or in the front.

Ciborium
Canopy with a domed or pyramidal upper structure resting on columns.

Clavus, **Clavi**
Vertical stripe decorating a tunic, insignium of rank.

Cloisonné
Enamel technique in which the colours are separated by thin strips of metal.

Colobium
A long tunic, sleeveless or with short sleeves.

Contraposto
A twisting of the figure in its own axis. A pose in which the upper body turns away strongly from the lower.

Deesis
A representation of Christ flanked by the Virgin and Saint John the Baptist, and/or other holy persons, in intercession.

Despotic
Epithet used for icons of Christ and the Virgin, placed either side of the Royal Door of the iconostasis.

Divitision
Long silk tunic worn by the emperor and some court dignitaries on important state occasions.

Dodekaorton
Gr. The Twelve Great Feasts of the liturgical calendar.

Ekphrasis
Gr. 'description'. Formal description, often delivered orally, of works of art and of other subjects, such as hunts, festivals, cities and gardens.

enkolpion, enkolpia
Gr. pectoral. Reliquary with a sacred image worn on the chest.

Epistyle
Gr. The beam of the iconostasis in an Orthodox church.

Eucharist
Holy Communion.

Eulogia, **Eulogies**
See ampulla, ampullae.

Examiton
Byzantine term for silk compound-weave, weft-faced textiles with complimentary wefts in two series, usually of different colours and a main warp and a binary warp.

Ex-voto
Votive offering.

Fibula
A clasp of gilt bronze, gold or silver, for securing a cloak, shawl or overgarment, usually placed on the wearer's shoulder.

Flabellum
Metal liturgical fan symbolizing the seraphim and the cherubim, the celestial beings who hymn and protect the Lord around his heavenly throne.

Hetoimasia
Gr. 'preparation'. The throne prepared in readiness for Christ's Second Coming.

Iconoclasm/Iconoclastic Controversy
The movement in the Byzantine Empire against the use and veneration of sacred images, which lasted, with intervals, from 726 until 843.

Iconoclast
Gr. 'image destroyer'. Supporter of Iconoclasm.

Iconophile/Iconodule
Gr. 'image lover'. Opponent of Iconoclasm, supporter of the veneration of icons.

Iconostasis
Gr. The icon-covered screen separating the sanctuary from the nave in Orthodox churches.

Katholikon
Gr. modern term used for the principal church in a monastic complex, usually dedicated to the monastery's patron.

Kekryphalos
Gr. Tippet or wimple worn around the Virgin's face under the maphorion.

Kerykeion
Gr. A messenger's staff. In Byzantine iconography it is carried by angelic heralds, such as Gabriel in the Annunciation.

Koimesis
Gr. The Dormition of the Virgin, the Orthodox equivalent of the Western Assumption; one of the Twelve Great Feasts of the Orthodox Church, celebrated on 15 August.

Lectionary
Liturgical book of texts read at services (lections), ordered according to the Church calendar.

Loros
Long stole, often bejewelled, worn on festive occasions by the emperor or empress, and, rarely, by certain dignitaries; archangels are often shown wearing imperial raiment including loroi.

Man of Sorrows
An iconographic type of the Christ of the Passion, in which he is depicted lifeless, in bust, upright and naked, with his arms hanging or crossed over his chest.

Maniakion
Gr. necklace, torque.

Manus Dei
Lat. 'Hand of God'.

Maphorion
Gr. Long veil worn over the head and shoulders; typical attire of the Virgin, whose *maphorion*, the most sacred relic of Constantinople, was enshrined in the Blachernai Monastery.

Mappa
A kerchief thrown by the consul, as a signal for the games to commence in the circus. An emblem of consular authority until the 6th century, the *mappa* later became an insignium of the emperor.

Maria Regina
The Virgin depicted as Queen; an iconographic type in Western Christian tradition.

Menologion
An anthology of the Lives of the saints, according to their feast days in each month of the liturgical calendar.

Miles
Lat. Military official.

Narthex
Gr. A vestibule-like space preceding the nave of the church.

Niello
A mixture of sulphur and silver used in the decoration of metal objects to produce a colour contrast against the background.

Omophorion
Gr. A long white stole decorated with crosses worn by bishops over the phelonion.

Orans/Orant
Lat. 'praying'. A posture of prayer of Early Christian origin, in which the figure is depicted frontal, with raised outstreched arms. In Middle Byzantine art it is used in images of the Virgin Blachernitissa.

Palladium
An image, a symbol or a relic on which the safety and prosperity of the people who believe in it depends.

Pallium
Lat. cloak, or cope. A liturgical vestment worn by the Roman Pope and bishops.

Panagia
Gr. All Holy. The Greek name for the Virgin.

Panagiarion
Gr. a liturgical paten for the portion of bread offered to the Virgin during a specific service of the day.

Pantokrator
Gr. 'Ruler of All'. Epithet of Christ, represented bearded, frontal, blessing with his right hand and holding the Gospelbook in his left. A bust of Christ Pantokrator often adorned the summit of the dome in Byzantine churches.

Pendilia or Pendulia
Ornaments hanging from the side of a crown.

Phelonion
A vestment worn by clerics in the Orthodox Church, equivalent to the Latin chasuble.

Podea
A textile covering the lower part of an icon stand, often with figural embroidery, hence the designation 'embroidered icon'.

Praefectus urbi
Prefect of the city.

Praepositus sacri cubiculi
Grand Chamberlain in the Byzantine imperial court.

Proskynesis
Gr. 'prostration'. Gesture of reverence, before the emperor, prelates or icons.

Pyxis
Gr. 'small box'. The term used conventionally to describe a cylindrical container made of ivory.

Skaramangion
A lavish belted tunic with long sleeves worn by officials. The purple *skaramangion* was only worn by the emperor.

Stasidin
Gr. 'full length'.

Staurotheke
Reliquary for a fragment of the True Cross.

Sticharion
A long robe with sleeves worn by the Orthodox clergy. An undergarment for priests and bishops, it is worn as outer garment, usually plain white for deacons.

Suppedaneum
Lat. 'footstool'.

Synkellos
Byzantine title of the patriarch's adviser, who often became his successor.

Tablion
Rectangular or trapezoidal decorated panel attached to the edge of a chlamys, an insignium of rank.

Templon
Chancel barrier, a low screen in Byzantine churches, separating the sanctuary from the nave.

Theotokos
Gr. Mother of God.

Tourmarchis
Commander of the Byzantine army.

Typikon
Liturgical calendar and monastic rule of the Eastern Church, with instruction for each day's services.

Index

Nesebar, *see* Bulgaria

Nestorios, Patriarch of Constantinople 10, 31, 80, 93

New Church at Tokali, *see* Cappadocia

Nicaea II, *see* Council of Nicaea

Nicaea, siege of 31

Nicholas Kallikles 379, 380

Nicholas Mesarites 382

Nicholas Skleros, Byzantine official 377, 379

St Nicholas, church at Curtea de Arges, *see* Romania

St Nicholas, church at Manastir, *see* Manastir

St Nicholas at Velmej, *see* Ochrid

St Nicholas Kasnitzis, church at Kastoria, *see* Greece

St Nicholas Kyritzis, church at Kastoria, *see* Greece

St Nicholas of the nun Eupraxia, church at Kastoria, *see* Greece

St Nicholas of Gourna, church at Kastoria, *see* Greece

St Nicholas of the Roof, *see* Cyprus

St Nicholas Orphanos, church at Thessaloniki, *see* Greece

St Nicholas Tzotza, church at Kastoria, *see* Greece

Nikephoros I, Patriarch 35, 96, 112, 114, 309, 375, 396

Nikephoros Botaneiates, Emperor 241, 300, 304, 313, 364, Cat. no 17

Nikephoros Choniates, *dux* of the fleet 233

Nikephoros Kallistos Xanthopoulos 48, 49, 379, 383
 Ecclesiastical History 48, 373, 374

Nikephoros Phokas, Emperor 211, 326, 365, 398, 400

Niketas Choniates 332

Niketas David the Paphlagonian 23

Notitia urbis Constantinopolitanae 17

Novgorod, *see* Russia

Numismatic Museum, Athens, *see* Greece

Ochrid 129, 152, 402
 Icon Museum 348, 406, 482, Pl. 142
 St Nicholas at Velmej 348
 Peribleptos 130, 131, 134, 135, 271, 476, 483, Pls 74, 78, 80
 St Sophia 126, 128, 427, Pl. 72
 Zaum 127

Oikonomion, *see* Constantinople

Old Cathedral at Veroia, *see* Greece

Opus interrasile 290, 292, 294

Opus plumatile 270, 272

Origen 4, 68

Osiris 274

Otto, German Emperor 398

Oxford paten 203, 207, Pl. 136

Palaiologan period 84, 132, 152, 164, 212, 245

Palamism 376

Palatine Anthology 338

Palestine 65, 81

Palladium 51, 54, 84, 87, 116, 129, 144, 373, 410,

418

Pallas Athena 28, 56

Pammakaristos, *see* Constantinople

Pamphilia 87

Panagia Chalkeon, church at Thessaloniki, *see* Greece

Panagia Soumela 87

Panagiarion 190, 192, 193, Pls 121, 127, 129

Paneas 79

Pantalica, *see* Italy

Pantanassa monastery at Mystras, *see* Greece

St Panteleimon, church at Nerezi near Skopje, *see* Nerezi

St Panteleimon monastery, *see* Mt Athos

St Panteleimon on Salamina, *see* Greece

Pantheon (Santa Maria ad Martyres), *see* Italy

Pantokrator monastery, Athos, *see* Mt Athos

Pantokrator monastery at Constantinople, *see* Constantinople

Paolo Veneziano 418, 448

Papiani, *see* Greece

Papyri, magical 283

St Paraskevi, cemetery chapel at Thessaloniki, *see* Greece

Parigoritissa, church at Arta, *see* Greece

Paris
 Bibliothèque Nationale Pls 107-108
 Cabinet des Medailles Pl. 122
 Musée de Cluny, Pls 138, 139
 Musée du Louvre, Pls 131, 141, 166, 171, 176, 177, Cat. nos 6, 9, 21, 39.

Paris Psalter 305

Parthenon, *see* Greece

Paschal I, Pope 95

Patmos, *see* Greece

Patria of Constantinople 361, 374, 375

Patria of Mt Athos 34

Patriarchal Palace, *see* Constantinople

Patriarchate of Antioch 53, 84

St Paul monastery, *see* Mt Athos

Paul, Bishop 17

Paul the Silentiary 108, 197, 219, 237

Peć, *see* Medieval Serbia

Pela chalice 195

Pelagia, nun 88

Pelendri, *see* Cyprus

Pelion, *see* Greece

Peribleptos, church at Constantinople, *see* Constantinople

Peribleptos monastery at Mystras, *see* Greece

Peribleptos, church at Ochrid, *see* Ochrid

Peter the Athonite, *Vita* 33, 35

Peter of Atroa 32

Peter, Bishop of Thebes 214, Pl. 157

St Peter, church of, on the island of Velik Grad, Prespa, *see* Prespa

St Peter, church at Rome, *see* Italy

Sts Peter and Marcellinus, catacomb, *see* Italy

Phaneromeni monastery on Salamina, *see* Greece

Philagathos Kerameus of Sicily 391

Philanthropinon monastery at Ioannina, *see* Greece

Philanthropinon monastery at Meteora,

see Greece

Philip, Bishop 304

Philippicus 21

Philotheou monastery, *see* Mt Athos

Photios, Patriarch 22, 42, 44, 99, 100, 103, 105, *passim* in 107-123, 149, 150, 170, 338, 375, 377, 396, 454, 456, 457, 469

Physiologus manuscript, once in Smyrna 302

Piazza Armerina, *see* Italy

Pietro Cavallini 418

Pisa, *see* Italy

Pliny the Elder 219, 220

Pliska reliquary cross 309

Podea/podeai 53, 56, 340, Pl. 23

Pokrov, *see* Russia

St Polyeuktos, *see* Constantinople

Polotsk, *see* Russia

Porta Panagia, church in Thessaly, *see* Greece

Porto Lagos, Thrace, *see* Greece

Presbeia 296, 329

Presentation of the Virgin, church at Niochori, Rhodes, *see* Greece

Presentation of the Virgin, church at Sklaverochori, Crete, *see* Greece

Preslav, Bulgaria 358

St Priscilla, catacomb, *see* Italy

Proairesis 42

Processions, with miracle-working icons 50, 51, 147, 296, 325, 327, Pls 211, 213

Procopius, historian 21, 103

Prodromos monastery at Serres, *see* Greece

Proklos 10, 12

Proskynetaria 48

Protevangelium of James 5, 60, 68, 69, 70, 72, 129, 130, 131, 155, 266, 269, 270, 274, 291, 402

Proussos monastery in Evrytania, *see* Greece

Pseudo-John the Theologian 75, 131
 On the Dormition of the Holy Mother of God 73

Pseudo-Kodinos 147

Pseudo-Nonnos 392

Pulcheria, Augusta 12, 19, 49, 53, 145, 364, 373, 374, 382, 383

Pushkin Madonna 438, 439, 442

Pushkin Museum, Moscow, *see* Russia

Qeledjilar in Cappadocia, *see* Cappadocia

Rabbula Gospels 269

Ravanica, *see* Medieval Serbia

Research Centre for East Christian Culture, *see* Russia

Restoration of Icons 27, 38, 125, 295, 340, 375, 377, 454, 456, Cat. no. 32

Robe, relic of the Virgin, *see* maphorion

Roman Catholic cathedral at Naxos, *see* Greece

Roman sarcophagi 268

Romania
 Curtea de Arges
 St Nicholas 131
 Humor 136
 Suçevita 136
 Vatra Moldovitei 136

Romanos chalice 198, Pls 130, 135

Athens, Benaki Museum 140, 179 (photo. Makis Skiadaressis), Cat. nos 23, 24, 25, 26, 40, 41, 42, 44, 45, 46, 47, 48, 49, 50, 51, 52, 53, 73, 85 (photo. Makis Skiadaressis). Byzantine Museum 86, 91, 92, 143, 146 (photo. Makis Skiadaressis), Cat. nos 63, 64, 74, 75, 84 (photo. Makis Skiadaressis). British School at Athens 47, 197, 198. 1st Ephorate of Byzantine Antiquities 25, 27, 28, 29, 30, 226 (photo. Studio Kontos). P. & A. Kanellopoulos Museum, Cat. nos 7, 15 (photo. Makis Skiadaressis). National Archaeological Museum 180, 183. Numismatic Museum 9, 152, 162 (photo. Makis Skiadaressis). Ekdotike Athenon S.A. Publishing House 42, 55, 73, 95, 103. Melissa Publishing House 54. Titos Papamastorakis 120. Myrtalli Acheimastou-Potamianou 211. Private collection Cat. nos 35, 79 (photo. Makis Skiadaressis).

Baltimore, Walters Art Gallery Cat. no. 59.

Bari, Soprintendenza per I B.A.A.A.S. della Puglia 224. Pinacoteca Provinciale Cat. no. 72.

Belgrade, National Museum Cat. no. 61. Prof. G. Subotič 19, 74, 77, 78, 80, 81.

Berlin, Staatliche Museen zu Berlin-Preussischer Kulturbesitz Museum für Spätantike und byzantinische Kunst 11, 12, 109 (photo. J. Liepe), 106, 111 (photo. J. Anders), 185, Cat. nos 37, 54 (photo. J. Anders).

Cambridge Mass., Harvard College Library 210.

Cappadocia, Tokali Kilise, A.J. Wharton 18.

Cleveland, The Cleveland Museum of Art 125, 163, 170, Cat. no. 19.

Constantinople (Istanbul) 7, 10, 16, 20, 60, 61, 64, 66, 67, 68 69, 70 (photo. Studio Kontos).

Cuenca, Museo Diocesano Cat. no. 30.

Florence, Biblioteca Medicea Laurenziana 96 (photo. Microfoto s.r.l). 4, 5, 6, 45, 46, 51, 52, 56, 57, 164 (photo. Scala).

Istanbul, Archaeological Museum 132, 133, 186.

Jerusalem, Greek Orthodox Patriarchate, Patriarchal Library Cat. no. 56.

Kastoria, Byzantine Museum Cat. no. 83 (photo. Makis Skiadaressis).

Kiev, Museum of Western and Oriental Arts Cat. no. 2.

Limassol Cat. nos 36, 62, 76 (photo. Vassos Stylianou).

London, Axia, Yannis Petsopoulos 14. British Library, 99. British Museum 128, Cat. nos 3, 11, 16, 32, 43, 60. Courtauld Institute of Art 62. Cyril Mango 8. Victoria and Albert Museum, Picture Library 165, 173, 178, Cat. nos 17 (photo. I Thomas), 20.

Maastricht, Onze Lieve Vrouw 118.

Macedonia, Museum of Macedonia, Archaeological, Ethnological and Historical 142.

Madrid, Biblioteca Nacional 207, 223.

Moscow, State Historical Museum 13, 23, 100, 105. The State Museum of the Moscow Kremlin212, 213, Cat. no. 29.

Munich, Bayerisches Nationalmuseum 113 (photo. Walter Haberland). Bayerische Staatsbibliothek 112. Private collection of Christian Schmidt Cat. no. 22 (photo. Makis Skiadaressis), 4, 5, 10 (M. Eberlein), 13, 14, 18, 27.

Naxos 93, 94 (photo. Spyros Panayotopoulos). Catholic cathedral, Cat. no. 67 (photo. Spyros Panayotopoulos).

New York, The Metropolitan Museum of Art 15, 17, 119, Cat. nos 8, 31, 58.

Oxford, Ashmolean Museum 136.

Palermo 219 (photo. Publifoto).

Paris, Bibliothèque Nationale de France 107, 108, 122. Réunion des Musées Nationaux 131, 138, 139, 141, 166, 171, 176, 177, Cat. nos 6 (photo. Chuzeville) 9, 21 (photo. H. Lewandgwski) 39. Musée du Louvre 169 (photo. Jean-Luc Bovot).

Pisa, Michele Bacci 38, 39, 40, 43, 44. Soprintendenza per I B.A.A.A.S. di Pisa Cat. nos 69, 70.

Rome, Vatican Library 98, 101. Foto Pontificia Commissione di Archeologia Sacra 196. Valentino Pace 201, 215, 216, 217, 218, 220, 223. Archivio Fotografico Soprintendenza per I B.A.S. 195, 200.

Rhodes, 4th Ephorate of Byzantine Antiquities Cat. no. 66.

Sinai 82, 83, 84, 85, 87, 88, 90, Cat. nos 1, 28, 55, 71 (photo. Spyros Panayotopoulos)

Sofia, Archaeological Institute and Museum Cat. no. 86.

Spoleto, Arcidiocesi di Spoleto-Norcia 205, 209.

St Petersburg, National Library of Russia 104. The State Hermitage 134.

Stuttgart, Württenbergisches Landmuseum 126.

Thessaloniki, 26; 53, 76, 79 (photo. Sotiris Chaidemenos), 71, 75 (photo. Studio Kontos). Museum of Byzantine Culture 187, 188 (photo. Makis Skiadaressis), Cat. nos 81, 81 (photo. Makis Skiadaressis).

Tinos, Ecclesiastical Fundation of the Evangelistric 82 (photo. Makis Skiadaressis).

Toronto, University of Toronto, Art Centre 124.

Utrecht, Museum Catharijneconvent Cat. no.57 (photo R. de Heer).

Venice, Biblioteca Marciana 114, 115. San Marco 116, 184, 192, 194, 208.

Veroia, 11th Ephorate of Byzantine Antiquities Cat. nos 33, 64 (photo. Sotiris Chaidemenos).

Vienna, Kunsthistorisches Museum 123.

Virginia, Richmond, Virginia Museum of Fine Arts 174, 175.

Washington, Dumbarton Oaks, Byzantine Collection 144, 145, 147, 148, 149, 151, 153, 154, 155, 156, 157, 158, 159, 160, 161, 172, Cat. nos 12, 38. Dumbarton Oaks, Visual Resources 1, 3, 31, 32, 33, 34, 35, 36, 37, 48, 49, 58, 59, 63, 65, 110, 117, 181, 182, 202, 203, 204, 206. National Gallery, Office of Visual Services Cat. no. 68.

Zakynthos, 6th Ephorate of Byzantine Antiquities, Museum of Zakynthos Cat. no. 34. The Holy Archbishopric of Zakynthos Cat. no. 77.

Photographs taken from publications
Antinoe Cent'Anni Dopo, no. 1: 2; *Bogomater' Vladimirskaya (The Virgin of Vladimir)*, no. 1: 21, 24; *Byzantine Magic*, Pl. 1b on 55: 168; *Chudotvornaia ikona*, book cover: 22; Cutler and Spieser 1996, pl. 208: 72, pl. 145: 130, 135, pl. 123: 137; *De Vera Effigie Mariae*, fig. 1 on 35: 199; *Glory of Byzantium*, pl. on vi: 89; *Icone di Calabria*, pl. VII: 221, pl. XVII: 222; Kalavrezou-Maxeiner 1985, pls 65, 129; Lange 1964, no. 9: 193; Lazarev 1986, fig. 81: 50; *Monastery of Vatopaidi*, pl. 406: 191; Paliouras 1997, pl. 44: 41; Pelekanides et al. 1973, pl. 123: 102; Pelekanides et al. 1979, pl. 8: 97; Rutschowscaya 1990, pl. on 133: 167; *Sailing from Byzantium*, nos 3, 4: 150; Chatzidakis and Sofianos 1990, pl. on 65: 225, 227, 228; *Treasures of Mt Athos*, no. 9.5: 121, 127, no. 9.8: 190.

1